IMAGEANALYSIS. Basic routines for 2D and 3D image analysis and processing. Includes support for level curve extraction from 2D images and level surface extraction from 3D images.

INTERPOLATION. Interpolation of data. Akima, bilinear, bicubic, B-spline, piecewise quadratic, spherical interpolation, thin plate splines, trilinear, tricubic, vector field interpolation. Scattered data interpolation uses Delaunay triangulation/tetrahedralization.

INTERSECTION. A multitude of intersection routines for either a test query (does intersection exist) or find query (what is the intersection set, and when does it occur when one or both objects are moving).

MATH. Basic support for points, vectors, matrices, quaternions, and polynomials. Also provides fast function evaluation for a few trigonometric functions.

MESHES. Various implementations of vertex-edge-triangle tables for use in graphics and imaging applications.

NUMERICS. Root finding via bisection, eigensolver for symmetric matrices, integration, linear system solving, minimization without derivative calculations, solving systems of ordinary differential equations, polynomial root finding.

PHYSICS. Source code particularly relevant to this book. Deformable surface meshes. Volume interpolation for free-form deformation. Numerical solver for linear complementarity problems (LCP). Support for the physics of particle systems. Mass-spring systems. Computation of mass and inertia for rigid, convex polyhedral bodies. Fast overlap detection for intervals (1D), axis-aligned rectangles (2D), and axis-aligned boxes (3D) that allow for fast intersection testing using time coherence.

RATIONALARITHMETIC. Exact integer and rational arithmetic functions. Supports exact conversion from floating-point types to rational numbers.

SURFACES. Abstract surface class (metric tensor, curvature tensor, principal curvatures and directions), parametric surfaces (position, derivatives, tangents, normals), implicit surfaces, polynomial surfaces, B-spline and NURBS surfaces.

SYSTEM. Encapsulation of operating system specific needs (Windows, Linux, or Macintosh).

TESSELLATION. Delaunay triangulation and tetrahedralization.

RENDERERS DIRECTORY

The graphics engine has an abstract API for the rendering system. The renderers for specific platforms are implemented to use this API.

DX. The DirectX 9 renderer that runs on Microsoft Windows platforms.

OPENGL. The OpenGL renderers that run on Microsoft Windows, Linux, and Macintosh. The nonwindowing portion of the OpenGL code is the same for all the platforms. Window-specific code occurs for GLUT (for all platforms), Wgl (Windows OpenGL), and Agl (Apple OpenGL).

The Morgan Kaufmann Series in Interactive 3D Technology

Series Editor: David H. Eberly, Magic Software, Inc.

The game industry is a powerful and driving force in the evolution of computer technology. As the capabilities of personal computers, peripheral hardware, and game consoles have grown, so has the demand for quality information about the algorithms, tools, and descriptions needed to take advantage of this new technology. We plan to satisfy this demand and establish a new level of professional reference for the game developer with the *Morgan Kaufmann Series in Interactive 3D Technology*. Books in the series are written for developers by leading industry professionals and academic researchers and cover the state of the art in real-time 3D. The series emphasizes practical, working solutions and solid software-engineering principles. The goal is for the developer to be able to implement real systems from the fundamental ideas, whether it be for games or for other applications.

Game Physics
David H. Eberly

Collision Detection in Interactive 3D Environments
Gino van den Bergen

3D Game Engine Design: A Practical Approach to Real-Time Computer Graphics
David H. Eberly

Forthcoming

Essential Mathematics for Games and Interactive Applications: A Programmers Guide
Jim Van Verth and Lars Bishop

Physically-Based Rendering
Matt Pharr and Greg Humphreys

Real-Time Collision Detection
Christer Ericson

GAME PHYSICS

DAVID H. EBERLY
Magic Software, Inc.

with a contribution by
KEN SHOEMAKE
Otter Enterprises

ELSEVIER

AMSTERDAM • BOSTON • HEIDELBERG • LONDON
NEW YORK • OXFORD • PARIS • SAN DIEGO
SAN FRANCISCO • SINGAPORE • SYDNEY • TOKYO

MORGAN KAUFMANN IS AN IMPRINT OF ELSEVIER

MORGAN KAUFMANN PUBLISHERS

Publishing Director Diane D. Cerra
Senior Editor Tim Cox
Publishing Services Manager Simon Crump
Production Editor Sarah Manchester
Project Management Elisabeth Beller
Editorial Coordinator Rick Camp
Cover Design Chen Design Associates, San Francisco
Cover Image Chen Design Associates, San Francisco
Text Design Rebecca Evans
Composition Windfall Software, using ZzTeX
Technical Illustration Dartmouth Publishing
Copyeditor Yonie Overton
Proofreader Jennifer McClain
Indexer Steve Rath
Interior Printer The Maple-Vail Book Manufacturing Group
Cover Printer Phoenix Color Corporation

Morgan Kaufmann Publishers is an imprint of Elsevier.
500 Sansome Street, Suite 400, San Francisco, CA 94111

This book is printed on acid-free paper.

Library of Congress Control Number: 2003023187

ISBN: 1-55860-740-4

For information on all Morgan Kaufmann publications,
visit our website at *www.mkp.com*.

Printed in the United States of America
07 06 05 5 4 3

TRADEMARKS

The following trademarks, mentioned in this book and the accompanying CD-ROM, are the property of the following organizations:

- DirectX, Direct3D, Visual C++, DOS, and Windows are trademarks of Microsoft Corporation.
- OpenGL is a trademark of Silicon Graphics, Inc.
- Radeon is a trademark of ATI Technologies, Inc.
- GeForce and the Cg Language are trademarks of nVIDIA Corporation.
- NetImmerse and R-Plus are trademarks of Numerical Design, Ltd.
- MathEngine is a trademark of Criterion Studios.
- The Havok physics engine is a trademark of Havok.com.
- SoftImage is a trademark of Avid Technology, Inc.
- Falling Bodies is a trademark of Animats.
- The Vortex physics engine is a trademark of CMLabs Simulations, Inc.
- Prince of Persia 3D is a trademark of Brøderbund Software, Inc.
- XS-G and Canyon Runner are trademarks of Greystone Technology.
- Mathematica is a trademark of Wolfram Research, Inc.
- Turbo Pascal is a trademark of Borland Software Corporation.
- The 8086 and Pentium are trademarks of Intel Corporation.
- Macintosh is a trademark of Apple Corporation.
- Gigi and VAX are trademarks of Digital Equipment Corporation.
- MASPAR is a trademark of MasPar Computer Corporation.

CONTENTS

CHAPTER

1

CHAPTER

2

CHAPTER
3

CHAPTER
4

APPENDIX B

AFFINE ALGEBRA 669

APPENDIX C

CALCULUS 691

APPENDIX

D

ORDINARY DIFFERENCE EQUATIONS 727

FIGURES

TABLES

PREFACE

The evolution of the games industry clearly has been motivated by the gamers' demands for more realistic environments. 3D graphics on a 2D graphics card necessarily requires a classical software renderer. Historically, rasterization of triangles was the bottleneck on 2D cards because of the low *fill rate,* the rate at which you can draw pixels during rasterization. To overcome fill rate limitations on consumer cards the *graphics hardware accelerator* was born in order to off-load the rasterization from the 2D card and the *central processing unit* (CPU) to the accelerator. Later generations of graphics cards, called 3D graphics cards, took on the role of handling the standard work of a 2D graphics card (drawing windows, bitmaps, icons, etc.) as well as supporting rasterization that the 3D graphics requires. In this sense the adjective "accelerator" for a combined 2D/3D card is perhaps a misnomer, but the term remains in use.

As fill rates increased, the complexity of models increased, further driving the evolution of graphics cards. Frame buffer and texture memory sizes increased in order to satisfy the gamers' endless desires for visual realism. With enough power to render a large number of triangles at real-time rates, the bottleneck of the cards was no longer the fill rate. Rather it was the front end of the graphics pipeline that provides the rasterizers with data. The processes of transforming the 3D triangle meshes from world coordinates to camera coordinates, lighting vertices, clipping, and finally projecting and scaling to screen coordinates for the purposes of rasterization became a performance issue.

The next generation of graphics cards arrived and were called *hardware transform and lighting* (HW T&L) cards, the name referring to the fact that now the work of the graphics pipeline had been off-loaded from the CPU to the *graphics processing unit* (GPU). Although the intent of HW T&L cards was to support the standard graphics pipeline, most of these cards also supported some animation, namely *skin-and-bones* or *skinning,* in which the vertices of a triangle mesh (the "skin") are associated with a matrix hierarchy (the "bones"), and a set of offsets and a set of weights relative to the bones. As the matrices vary during runtime, the vertices are computed from the matrices, offsets, and weights, and the triangle mesh deforms in a natural way. Thus, we have some hardware support for *deformable bodies*.

The standard graphics pipeline is quite low-level when it comes to lighting of vertices. Dynamic lights in a scene and normal vectors at vertices of a triangle mesh are combined to produce vertex colors that are interpolated across the triangles by the rasterizer. Textured objects are rendered by assigning texture coordinates to the vertices of a mesh, where the coordinates are used as a lookup into a texture image. The rasterizer interpolates these coordinates during rasterization, then performs a lookup on a per-pixel basis for each triangle it rasterizes in the mesh. With a lot of

creativity on the artists' end, the vertex coloring and texturing functions can be used to produce high-quality, realistic renderings. Fortunately, artists and programmers can create more interesting effects than a standard graphics pipeline can handle, producing yet more impetus for graphics cards to evolve. The latest generation of graphics cards are now programmable and support *vertex shading*, the ability to incorporate per-vertex information in your models and tell the rasterizer how to interpolate them. Clever use of vertex shading allows you to control more than color. For example, displacement mapping of vertices transfers some control of positional data to the rasterizer. And the cards support *pixel shading*, the ability to incorporate per-pixel information via images that no longer are required to represent texture data. Dot3 bump-mapping is the classic example of an effect obtained by a pixel-shader function. You may view vertex shading as a generalization of the vertex coloring function and pixel shading as a generalization of the basic texturing function.

The power of current generation graphics cards to produce high-quality visual effects is enormous. Much of the low-level programming you would do for software rendering is now absorbed in the graphics card drivers and the graphics APIs (application programmer interfaces) built on top of them, such as OpenGL and DirectX, which allows programmers to concentrate at a higher level in a graphics engine. From a visual perspective, game designers and programmers have most of what they need to create realistic-looking worlds for their gamer customers. But since you are reading this preface, you already know that visual realism is only half the battle. *Physical realism* is the other half. A well-crafted, good-looking character will attract your attention for the wrong reasons if it walks through a wall of a room. And if the characters cannot realistically interact with objects in their physical environment, the game will not be as interesting as it could be.

Someday we programmers will see significant hardware support for physics by off-loading work from the CPU to a *physics processing unit* (PPU). Until that day arrives we are, so to speak, at the level of software rendering. We need to implement everything ourselves, both low-level and high-level, and it must run on the CPU. Moreover, we need real-time rates. Even if the renderer can display the environment at 60 frames per second, if the physics system cannot handle object interactions fast enough, the frame rate for the game will be abysmally low. We are required to understand how to model a physical environment and implement that model in a fast, accurate, and robust manner. Physics itself can be understood in an intuitive manner—after all, it is an attempt to quantify the world around us. Implementing a physical simulation on a computer, though, requires more than intuition. It requires mathematical maturity as well as the ability and patience to synthesize a large system from a collection of sophisticated, smaller components. This book is designed to help you build such a large system, a *physics engine* as it were.

Game Physics focuses on the topic of real-time physical simulation on consumer hardware. I believe it is a good companion to my earlier book, *3D Game Engine Design*, a large tome that discusses the topic of constructing a real-time graphics engine for consumer hardware. The two disciplines, of course, will be used simultaneouly in a game application. *Game Physics* has a similar philosophy to *3D Game Engine*

Design in two ways. First, both books were conceived while working on commercial engines and tools to be used for building games—the occurrence of the word "game" in the titles reflects this—but the material in both books applies to more than just game applications. For example, it is possible to build a virtual physics laboratory for students to explore physical concepts. Second, both books assume that the reader's background includes a sufficient level of mathematics. In fact, *Game Physics* requires a bit more background. To be comfortable with the material presented in this book, you will need some exposure to linear algebra, calculus, differential equations, and numerical methods for solving differential equations. All of these topics are covered in an undergraduate program in mathematics or computer science. Not to worry, though: as a refresher, the appendices contain a review of the essential concepts of linear algebra, affine algebra, calculus, and difference equations that you will need to read this book. Two detailed chapters are included that cover differential equations and numerical methods for solving them.

I did not call the book *3D Game Physics* because the material is just as appropriate for 1- or 2D settings. Many of the constrained physical models are of lower dimension. For example, a simple pendulum is constrained to move within a plane, even though a rendering of the physical system is in three dimensions. In fact, the material is applicable even to projects that are not game-related, for example, supporting a virtual physics laboratory for students to explore physical concepts. I did call the book *Game Physics* and I expect that some readers may object to the title since, in fact, I do not cover all possible topics one might encounter in a game environment. Moreover, some topics are not discussed in as much depth as some might like to see. With even a few years to write a book, it is impossible to cover all the relevant topics in sufficient detail to support building a fully-featured physics engine that rivals what you see commercially. Some projects just require a team of more than one. I specifically avoided getting into fluid dynamics, for example, because that is an enormous topic all on its own. I chose to focus on the mechanics of rigid bodies and deformable bodies so that you can build a reasonable, working system for physical simulation. Despite this restricted coverage, I believe there is a significant amount of content in this book to make it worth every minute of your reading time. This content includes both the written text *and* a vast amount of source code on the CD-ROM that accompanies the book, including both the Wild Magic graphics engine and components and applications for physics support. I have made every attempt to present all the content in a manner that will suit your needs.

As in the production of any book, the author is only part of the final result. The reviewers for an early draft of this book were extremely helpful in providing guidance for the direction the book needed to take. The original scope of the book was quite large, but the reviewers' wisdom led me to reduce the scope to a manageable size by focusing on a few topics rather than providing a large amount of background material that would detract from the main purpose of the book—showing you the essentials of physical simulation on a computer. I wish to personally thank the reviewers for their contributions: Ian Ashdown (byHeart Consultants), Colin Barrett (Havok), Michael Doherty (University of the Pacific), Eric Dybsand (Glacier Edge Technology), David

Eberle (Havok), Todd Growney (Electronic Arts), Paul Hemler (Wake Forest University), Jeff Lander (Darwin 3D), Bruce Maxim (University of Michigan—Dearborn), Doug McNabb (Rainbow Studios), Jon Purdy (University of Hull), and Craig Reinhart (California Lutheran University). Thanks also go to Tim Cox, my editor; Stacie Pierce, editorial coordinator; and Rick Camp, editorial assistant for the book. Tim has been patient with my seemingly endless delays in getting a final draft to him. Well, the bottom line is that the draft arrived. Now it is your turn to enjoy reading the book!

About the CD-ROM

Limited Warranty

The Publisher warrants the media on which the software is furnished to be free from defects in materials and workmanship under normal use for 30 days from the date that you obtain the Product. The warranty set forth above is the exclusive warranty pertaining to the Product, and the Publisher disclaims all other warranties, express or implied, including, but not limited to, implied warranties of merchantability and fitness for a particular purpose, even if the Publisher has been advised of the possibility of such purpose. Some jurisdictions do not allow limitations on an implied warranty's duration; therefore the above limitations may not apply to you.

Limitation of Liability

Your exclusive remedy for breach of this warranty will be the repair or replacement of the Product at no charge to you or the refund of the applicable purchase price paid upon the return of the Product, as determined by the publisher in its discretion. In no event will the publisher, and its directors, officers, employees, and agents, or anyone else who has been involved in the creation, production, or delivery of this software be liable for indirect, special, consequential, or exemplary damages, including, without limitation, for lost profits, business interruption, lost or damaged data, or loss of goodwill, even if the Publisher or an authorized dealer or distributor or supplier has been advised of the possibility of such damages. Some jurisdictions do not allow the exclusion or limitation of indirect, special, consequential, or exemplary damages or the limitation of liability to specified amounts; therefore the above limitations or exclusions may not apply to you.

License Agreements

The accompanying CD-ROM contains source code that illustrates the ideas in the book. Each source file has a preamble stating which license agreement pertains to it. The formal licenses are contained in the files found in the following locations on the CD-ROM:

```
MagicSoftware/WildMagic2/License/WildMagic.pdf
MagicSoftware/WildMagic2/License/GamePhysics.pdf
```

The source code in the following directory trees is covered by the `GamePhysics.pdf` agreement:

```
MagicSoftware/WildMagic2/Source/Physics
MagicSoftware/WildMagic2/Applications/Physics
```

Use of the files in the Physics directories requires ownership of this book. All other code is covered by the `WildMagic.pdf` agreement.

The grant clause of the `WildMagic.pdf` agreement is:

We grant you a nonexclusive, nontransferable, and perpetual license to use The Software subject to the terms and conditions of the Agreement:

1. There is no charge to you for this license.

2. The Software may be used by you for noncommercial products.

3. The Software may be used by you for commercial products provided that such products are not intended to wrap The Software solely for the purposes of selling it as if it were your own product. The intent of this clause is that you use The Software, in part or in whole, to assist you in building your own original products. An example of acceptable use is to incorporate the graphics portion of The Software in a game to be sold to an end user. An example that violates this clause is to compile a library from only The Software, bundle it with the headers files as a Software Development Kit (SDK), then sell that SDK to others. If there is any doubt about whether you can use The Software for a commercial product, contact us and explain what portions you intend to use. We will consider creating a separate legal document that grants you permission to use those portions of The Software in your commercial product.

The grant clause of the `GamePhysics.pdf` agreement is:

We grant you a nonexclusive, nontransferable, and perpetual license to use The Software subject to the terms and conditions of the Agreement:

1. You must own a copy of The Book ("Own The Book") to use The Software. Ownership of one book by two or more people does not satisfy the intent of this constraint.

2. The Software may be used by you for *noncommercial products*. A noncommercial product is one that you create for yourself as well as for others to use at no charge. If you redistribute any portion of the source code of The Software to another person, that person must Own The Book. Redistribution of any portion of the source code of The Software to a group of people requires each person in that group to Own The Book. Redistribution of The Software in binary format, either as part of an executable program or as part of a dynamic link library, is allowed with no obligation to Own The Book by the receiving person(s), subject to the constraint in item 4.

3. The Software may be used by you for *commercial products*. The source code of The Software may not be redistributed with a commercial product. Redistribution of The Software in binary format, either as part of an executable program or as part of a dynamic link library, is allowed with no obligation to Own The Book by the receiving person(s), subject to the constraint in item 4. Each member of a development team for a commercial product must Own The Book.

4. Redistribution of The Software in binary format, either as part of an executable program or as part of a dynamic link library, is allowed. The intent of this Agreement is that any product, whether noncommercial or commercial, is not built solely to wrap The Software for the purposes of redistributing it or selling it as if it were your own product. The intent of this clause is that you use The Software, in part or in whole, to assist you in building your own original products. An example of acceptable use is to incorporate the physics portion of The Software in a game to be sold to an end user. An example that violates this clause is to compile a library from only The Software, bundle it with the headers files as a Software Development Kit (SDK), then sell that SDK to others. If there is any doubt about whether you can use The Software for a commercial product, contact us and explain what portions you intend to use. We will consider creating a separate legal document that grants you permission to use those portions of The Software in your commercial product.

Installing and Compiling the Source Code

The Wild Magic engine is portable and runs on PCs with the Microsoft Windows 2000/XP operating systems or Linux operating systems. Renderers are provided for both OpenGL (version 1.4) and Direct3D (version 9). The engine also runs on Apple computers with the Macintosh OS X operating system (version 10.2.3 or higher). Project files are provided for Microsoft Developer Studio (version 6 or 7) on Microsoft Windows. Make files are provided for Linux. Project Builder files are provided for the Macintosh.

For convenience of copying, the platforms are stored in separate directories on the root of the CD-ROM. The root of the CD-ROM contains three directories and one PDF file:

```
Windows
Linux
Macintosh
ReleaseNotes2p1.pdf
```

Copy the files from the directory of your choice. The directions for installing and compiling are found in the PDF file. *Please read the release notes carefully before attempting to compile.* Various modifications must be made to your development environment and some tools must be installed in order to have full access to all the

features of Wild Magic. A portable graphics and physics engine is a nontrivial system. If only we were so lucky as to have a "go" button that would set up our environment automatically!

Updates and Bug Fixes

Regularly visit the Magic Software, Inc. web site, *www.magic-software.com*, for updates and bug fixes. A history of changes is maintained at the source code page of the site.

CHAPTER 1

INTRODUCTION

1.1 A BRIEF HISTORY OF THE WORLD

The first real experience I had with a "computing device" was in the early 1970s when I attended my first undergraduate college, Albright College in Reading, Pennsylvania, as a premedical student. The students with enough financial backing could afford handheld calculators. The rest of us had to use slide rules—and get enough significant digits using them in order to pass our examinations. I was quite impressed with the power of the slide rule. It definitely was faster than the previous generation of computing to which I was accustomed: pencil and paper. I did not survive the program at the college (my grades were low enough that I was asked to leave) and took a few year's break to explore a more lucrative career.

> "There is no reason anyone would want a computer in their home."
>
> *Ken Olson, founder and president of Digital Equipment Corporation*

Deciding that managing a fast-food restaurant was not quite the career I thought it would be, I returned to the college track and attended Bloomsburg University (BU) in Bloomsburg, Pennsylvania, as a mathematics major, a field that suited me more than chemistry and biology did. During my stay I was introduced to an even more powerful computing device, a mainframe computer. Writing Fortran programs by punching holes in Hollerith cards [1] was even better than having to use a slide rule,

1. Herman Hollerith used punched cards to represent the data gathered for the 1890 American census. The cards were then used to read and collate the data by machines. Hollerith's company became International Business Machines (IBM) in 1924.

except for the occasional time or two when the high-speed card reader decided it was really hungry. By the end of my stay I had access to a monitor/terminal, yet another improvement in the computing environment. Linear programming problems were a lot easier to solve this way than with the slower modes of computing! I finished up at BU and decided graduate school was mandated.

> ### "I think there is a world market for maybe five computers."
> *Thomas J. Watson, former chairman of IBM*

Next stop, the University of Colorado at Boulder (CU) in 1979. I took a liking to differential equations and got another shot at punching cards, this time to numerically solve the differential equations of motion for a particular physical system. I understood the theory of differential equations and could properly analyze the phase space of the nonlinear equations to understand why I should expect the solution to have certain properties. However, I could not compute the solution that I expected— my first introduction to being careless about applying a numerical method without understanding its stability and how that relates to the physical system. The remainder of my stay at CU was focused on partial differential equations related to combustion with not much additional computer programming.

> ### "Computers are useless. They can only give you answers."
> *Pablo Picasso*

After graduating in 1984, I started my academic career at the University of Texas at San Antonio (UTSA) in the Division of Mathematics, Computer Science, and Statistics. The university had recently started an engineering program and designed four courses for applied mathematics and computer science relevant to the new program. The two applied mathematics courses were your standard fare for an engineering program and included topics on differential equations, numerical methods, and physics concepts. The two computer science courses were somewhat unique in that both required students to work on the fast personal computers that were available at the time: 4.77 MHz Intel 8086 machines. The first course was introductory programming with Borland's Turbo Pascal 3. The second course was on computer graphics. Although Turbo Pascal supported graphics primitives, my requirements for the course included writing device drivers for the state-of-the-art graphics card: the Enhanced Graphics Adapter (EGA). With a blazingly fast CPU, Microsoft's Disk Operating System (DOS), 20M of hard disk space, 640K of accessible system memory, and an EGA card with four 64K memory chips (one chip per color plane), we were able to produce some fine quality output rivaling that of the 2D computer games of that era. The output was almost as good as what we could produce on the department's DEC Gigi that was attached to a VAX 730 and allowed you to draw to the monitor by sending cryptic escape sequences of the type that you normally see in printer drivers.

> ## "640K ought to be enough for anybody."
> *William ("Bill") H. Gates, cofounder of Microsoft Corporation*

During my tenure at UTSA, I became more involved in computer-related topics and less involved in theoretical considerations in my research field of differential equations. In particular I became involved with the University of Texas Health Science Center's Department of Radiology. The field of medical imaging was quite interesting to me with its inherent connection to computer graphics and visualization, but also of interest were aspects of geometry and numerical methods since we were interested in analyzing and extracting anatomical information from 3D medical images. My interest in the topic was strong enough that I decided to leave UTSA in 1991 and become a "retread" by studying computer science and medical imaging at the University of North Carolina (UNC) at Chapel Hill.

While at UNC I had access to more powerful equipment. We did not have a Cray supercomputer with a couple of powerful processors, but we did have a massively parallel machine appropriately named the MASPAR with 8196 processors, individually not very powerful, but a natural architecture for 2D image processing. Still, there was a strong attraction to compute numerically on a personal computer, to see the results graphically and immediately, if not sooner. At the time I had upgraded my Intel 8086 machine to an Intel 80486 machine with a floating point coprocessor. I was able to implement many algorithms of interest in image analysis, including constructing something called *ridges* that are defined in terms of differential equations. The same programming issues that arose at CU bit me again: applying numerical methods for differential equation solvers without thought about the stability of the methods or about their applicability to the problem at hand. Another problem of interest was to compute *geodesic curves* on surfaces, curves that represent the shortest surface path between two points on the surface. The formulation of the problem is akin to what you see in Lagrangian dynamics in physical modeling and results in yet more differential equations to solve numerically.[2]

> ## "If you were plowing a field, which would you rather use? Two strong oxen or 1024 chickens?"
> *Seymour Cray, father of supercomputing*

> ## "The PC is the LSD of the '90s."
> *Timothy Leary, educator and psychologist*

2. Specifically, a geodesic curve on a surface is the natural extension of a straight line in a plane—it has zero curvature. The physical analogy is that a particle traveling along a geodesic has zero acceleration while satisfying the constraint of remaining on the surface.

After leaving UNC, I eventually found my way into the games industry in 1997 by signing on at Numerical Design Ltd. (*www.ndl.com*), a company cofounded by J. Turner Whitted, credited with the invention of ray tracing, and Robert Whitton, a mathematics professor at Davidson College. The company's business model had been focused on contract work in computer graphics, and they had developed a photorealistic ray tracing package called R-Plus. Times were changing and they had decided that a product-oriented business model was better than a contract-based model. When I arrived the code base for NetImmerse was in its infancy. The goal of the product was a real-time graphics engine for 3D games. At the time the Voodoo 1 graphics accelerator from the company 3Dfx (now defunct) had arrived on the scene. This was a true accelerator in the sense that it coexisted with a standard 2D graphics card. As you are already aware, this type of graphics technology started a whole new trend in the computer industry leading to significant evolution of central processing units (CPUs) and off-loading of a lot of work to graphics processing units (GPUs). The standard development machine at NDL in 1997 was a Pentium 133 MHz with 32M of system memory, not a lot of power compared to present-day machines but at the time quite a good system.

One of the first customers for NetImmerse was Broderbund, a software company that intended to use the package for their upcoming game *Prince of Persia 3D* (*POP3D*). The game engine needed a lot of help to evolve and keep up with the features that *POP3D* required. In particular, the collision detection system of NetImmerse was crude and needed improvement. The game engine was overhauled, including the addition of quaternions to support fast keyframe animations. The collision detection and response system was built from scratch, used hierarchical culling for collision purposes, and used an oriented bounding box (OBB) tree–based hierarchy to support collision detection of the triangle mesh geometry [GLM96], but with an enhancement to predict the time of first contact of moving objects (see Section 5.3). The system also implemented 3D picking (intersection of line/ray/segment with objects), something heavily used in *POP3D* to allow the Prince to jump and catch ledges, and other related movements with constraints. The collision system was functional, but not what I would call sophisticated. CPUs were finally reaching speeds of 800 MHz by the time *POP3D* shipped in 1999, but they still did not have sufficient power for complex geometric environments. The collision system was also used succesfully in an arcade game called *XS-G* (originally called *Canyon Runner*) that was shipped by Greystone Technology in 1998.

As CPUs and GPUs evolved due to consumer demands in the gaming arena, the graphics cards became powerful enough to give players a visually rich and convincing environment for the games. But consumers are relentless and wanted more *physical realism*. Predicting a trend in this direction, the company MathEngine (*www.mathengine.com*) was started to build what was called a *physics engine*. The product was a good one, but some of the demonstrations showed *jittering* objects in resting contact with a flat surface. The problem is that applying numerical methods to the differential equations of motion is not enough. Stability of the methods is important, but also important is having a robust system that integrates collision de-

tection and collision response involving multiple rigid bodies. Resting contact is now a classic problem that requires great care when implementing to avoid the jittering objects. While I was at NDL, Steven Collins, the CTO of a Dublin-based company called Telekinesys, Inc. contacted us to see what we thought about their physics engine and how it handled problems like resting contact. The demonstrations were very convincing and showed that, in fact, you can obtain physical realism with good frame rates even on current consumer CPUs. Eventually, Telekinesys announced their new technology, and the company name changed to Havok.com (*www.havok.com*). Their commerical physics engine is an extremely good product. Many of the robustness issues that show up in any product attempting to handle geometric queries on a computer with floating point arithmetic have been solved by the Havok folks. In fact, in January of 2003 I walked into my favorite store, Intrex Computers, to satisfy my latest silicon craving. On display was a computer with an ATI Radeon 9700 graphics card running a demonstration from Havok.com that showed a creature in exotic garb dancing about. The clothing was flowing in a very believable manner— no self-intersections of the cloth and running at real-time rates. All I wanted was a hard drive, but I also walked out with a new graphics card *and* the desire to write my own physics engine. You know the feeling

Other companies, of course, have bought into the idea that you can do realistic physics in real time. The various modeling packages have plug-ins to help artists with the physics. A particularly good and robust plug-in for the modeling package SoftImage (*www.softimage.com*) is the dynamics package Animats from John Nagle (*www.animats.com*). John has spent a lot of time figuring out how to avoid all the annoying floating point pitfalls that arise in any package that you build to handle physics, collision, and distance and intersection calculations. Also noteworthy is the Vortex physics engine from CMLabs (*www.cm-labs.com*). A commercial package for robust distance calculations between convex polyhedra is named SOLID 3 and written by Gino van den Bergen (*www.libsolid.com*); earlier versions are available for free (*www.dtecta.com*). No doubt you will discover many other related packages. Just as the number of commercial graphics engines increases as the technology becomes more commonly known to people, so will the commercial physics engines.

The games industry has gone through quite an evolutionary period over the past few decades. The computers of 10 years ago are nowhere near the powerful machines we have today. I started out with a 4.77 MHz Intel 8086 machine and a 2D EGA graphics card. Now I have machines with very fast CPUs and lots of system memory, and they all have 3D graphics hardware. These include a Macintosh system, a Linux system, and a few Microsoft Windows PCs (maintaining portable source code comes at a price). These systems are all capable of real-time graphics and real-time physics, whereas the systems of a decade ago just did not have that kind of power.

"Grove giveth and Gates taketh away."
Bob Metcalfe, Ethernet inventor and founder of 3Com Corporation, on the trend of hardware speedups not keeping up with software demands

Nevertheless, a major theme in this brief historical journey of mine is, *The mathematics and physics that you will deal with in this book is not new*. Much of the computer graphics research that appears in the literature of the past decade is motivated by the power that machines have now (or soon will have). Much of what occurs in that research is a reapplication of classic mathematical and physical concepts and shows that the researchers appreciate the importance and power of mathematics and physics in achieving their goals. Thus, you too should appreciate the power of all things mathematical and physical. As readers of my books certainly know, I have not shied away from mathematics, because it is my language for understanding the technical world around me. I wish it to be your language, too. After all, you will need it in order to appreciate fully the complexities and difficulties in implementing a robust physical simulation on a computer. What else can I say!

> **"A mathematician is a device for turning coffee into theorems."**
> *Paul Erdos, mathematician. My variant: "A computer graphics researcher is a device*
> *for turning coffee into SIGGRAPH papers."*

> **"For the things of this world cannot be made known without**
> **a knowledge of mathematics."**
> *Roger Bacon, 12th-century philosopher*

> **"It is the merest truism, evident at once to unsophisticated observation,**
> **that mathematics is a human invention."**
> *From* The Logic of Modern Physics, *by P. W. Bridgman, physicist*

> **"Omnia apud me mathematica fiunt"**
> **(With me everything turns into mathematics).**
> *René Descartes*

> **"A mathematician, like a painter or a poet, is a maker of patterns.**
> **If his patterns are more permanent than theirs, it is because they are**
> **made with ideas."**
> *G. H. Hardy, mathematician*

1.2 A SUMMARY OF THE TOPICS

Physics concepts and their application to games is quite a large topic. Rather than attempt to provide brief summaries of all possible topics, in other words a survey book, I decided to focus on the subset that most programmers seem to ask questions

about in the various Usenet newsgroups: mechanics, rigid bodies, deformable bodies, and collision detection and response systems. These topics are discussed in depth and require a minimum mathematical background that includes linear algebra and calculus, both univariate and multivariate. Also helpful would be some exposure to ordinary differential equations and to numerical methods that solve these, but if you have not had this exposure, a couple of chapters provide enough material to support what you will need for implementing a physical simulation.

Chapter 2 introduces curves in two dimensions and in three dimensions as representative paths of a particle. The chapter introduces the physical concepts of position, velocity, and acceleration. The choice of coordinate system is important in an application, so the standard systems are covered, including polar coordinates, cylindrical coordinates, and spherical coordinates. The motion of particles along paths in the absence of forces is called kinematics. In addition to kinematics of a single particle, we also look into the kinematics of a particle system. This material is the all-important foundation for the physics engines discussed in Chapter 5.

The remainder of Chapter 2 is an introduction to the standard concepts that you see in a course on physics, starting with Newton's laws of motion. The topics of force, torque, equilibrium, linear and angular momentum, center of mass, moments and products of inertia, and kinetic and potential energy are discussed in detail with the goal of being able to calculate these quantities on a computer. Computing the center of mass and the inertia tensor for a solid convex polyhedron is necessary for the physics engines of Chapter 5.

Chapter 3 is about dynamics: the interaction of rigid bodies when forces and torques are present in the physical system. The classical approach in an introductory physics course uses Newtonian dynamics and the famous formula of Newton's second law of motion, $\mathbf{F} = m\mathbf{a}$, where m is the constant mass of an object, \mathbf{a} is its acceleration, and \mathbf{F} is the applied force. I do not spend a lot of time delving into this approach. The coverage is sufficient to support the general purpose physics engines that use Newton's second law for simulation.

The majority of Chapter 3 is spent on Lagrangian dynamics, a framework for setting up the equations of motion for objects when constraints are present. In Lagrangian dynamics, the equations of motion naturally incorporate the constraints. A Newtonian formulation requires that forces of constraint be part of the term \mathbf{F} in the equation of motion, and the constraint forces are sometimes difficult to derive. For example, you will see in the Lagrangian approach that frictional forces are easier to deal with than in the Newtonian approach. For many games, a designer's specific knowledge of the physical system can be exploited to good effect by formulating the simulation using Lagrangian dynamics, the result being that the computational time of the simulation is reduced, compared to a general-purpose system using Newtonian dynamics.

Euler's equations of motion are also discussed in Chapter 3, because a few problems are more naturally formulated in terms of Euler angles than in terms of other dynamics systems. Although Hamiltonian dynamics is of importance, especially in dealing with the n-body problem, I made the decision not to include a discussion of

it in this book, since the other approaches are sufficient to allow implementations on a computer.

Chapter 4 is about deformable bodies. There are many ways to simulate deformation; we will address a subset in this book. In all cases you should consider these "hacked" physics in the sense that at no time do we use a real physical model for the actual material that makes up the bodies. The real models do not lend themselves to the fast computation that a game requires. All that is required of a hacked physics approach in a game is that the deformations look *believable* to the player. I do cover mass-spring systems for the purposes of deformation, but even these might not be as realistic a model for deformable objects as you might wish.

Another method that I have included for describing deformable objects includes the use of control point surfaces where you vary the control points in some suitable manner to cause the surface to deform as you desire. A brief discussion is given for B-spline curves and surfaces and for nonuniform rational B-spline(s) (NURBS) curves and surfaces. The presentation is limited to the computational aspects of curves and surfaces, including optimizations that allow fast evaluation. You are referred to other sources for a more detailed look at the properties of B-splines and NURBS.

Free-form deformation is a method for deforming an object and uses a volumetric approach. The object is embedded in a portion of space that is defined via a control point lattice. The volume of space is deformed, causing the object itself to deform.

The final deformation method is based on the object's surface being defined implicitly. The popular term for such surfaces is *metaballs*. I prefer to call them what they are, implicit surfaces. The discussion of this topic shows how you define a 3D lattice of sample points, trilinearly interpolate to obtain a continuous representation of a function defined on the volume occupied by the lattice, then extract the implicit surface as the level surface of the constructed function. Implicit surfaces are deformed by varying the constructed function itself.

Chapter 5 is about what most readers probably think of as the meat of game physics—the physics engine. The chapter describes a general system for handling a collection of rigid bodies, including collision detection and collision response. A general system is one that uses Newton's second law of motion, $\mathbf{F} = m\mathbf{a}$, to control the motion of objects. The constraint forces are unknown to the system and must be calculated based on the information that is provided by the collision detection system.

I discuss the impulse-based approach that Brian Mirtich [Mir96b] and David Baraff [Bar01] made popular, but by all means this is not the only approach you can take. My goal is to go into significant detail about the impulse-based approach so that you (1) understand the layout of a general physics engine, (2) see what complications arise, and (3) learn to evaluate what its strengths and weaknesses are. Other approaches to building a robust physics engine are based on trying to fix the weaknesses of the previous-generation engine. Once you understand the impulse-based engine, you should be able to start experimenting with modifications; references to other approaches are provided, so you have a nearly endless supply of ideas to investigate. For instance, a good tutorial site for rigid body dynamics is [Hec98].

The first section of Chapter 5 is about unconstrained motion. This gives you an idea of how to design a data structure to represent a rigid body and how to solve the differential equations of motion for a body that does not interact with other bodies in its environment. Section 5.2 complicates matters by allowing interaction between bodies, referred to as constrained motion. As you will see, building a collision detection and response system for constrained motion is a formidable task! I have provided enough pseudocode to allow you to build a working engine if you choose to do so. Source code is provided for a working engine with which you can experiment. A lot of code was written by George Innis of Magic Software, Inc. after reading a draft of this book—hopefully evidence that other folks will be able to implement real systems from my descriptions.

The last subsection of the material on constrained motion (Section 5.2.5) proposes a different approach that I think should be investigated. I propose that an implementation can detect and provide enough information about the constraints imposed by the contact set found by the collision detection system so that, rather than continuing to solve the general $\mathbf{F} = m\mathbf{a}$, the system can construct the Lagrangian equations of motion and switch to the appropriate set when necessary. This approach would be of particular importance when dealing with frictional forces since Lagrangian dynamics do a better job of incorporating the friction into the equations. The physics engine that Thomas Jakobsen designed and developed for IO Interactive already hints at this [Jak01] by using projection of the system state variables onto a manifold described by the constraints.

Section 5.3 is on collision detection with convex polyhedra. This is generally the hardest part of a physics engine to implement in a robust manner while not using too much computational time that is allotted per time frame. I discuss the method of separating axes because it burdens you with the minimum information needed to test if two objects overlap, but provides as much information as you need to actually compute the contact set between two noninterpenetrating objects.

Section 5.4 is about using spatial and temporal coherence of the rigid body objects to reduce the amount of time spent detecting collisions. A couple of basic systems are mentioned, one using bounding spheres, but a more effective one using axis-aligned bounding boxes. Many approaches to collision detection are abundant in the literature. I do not attempt to describe any of them in great detail since my goal with this book is not to focus heavily on the collision detection portion of an engine, but rather to focus on the collision response. That said, I do provide references in Section 5.5 so that you can investigate the topics yourself, many of which are available through the geometry web site of Ming Lin and Dinesh Manocha of the Computer Science Department at the University of North Carolina [GAM03]. A couple of fine books on collision detection are forthcoming from Morgan Kaufmann Publishers, one by Gino van den Bergen [vdB03] and one by Christer Ericson of Sony Interactive [Eriar].

Chapter 6 is a brief discussion of how to obtain some physical effects through the use of *shader programs* on programmable graphics cards. Vertex shaders allow displacement of vertices to obtain *visual effects* of the physical simulation, but it is important to note that the displaced vertices are not accessible to the main program.

Until that capability is added to programmable graphics cards, you will not be able to use the vertex locations for any type of intersection or collision testing. The chapter has examples of vertex shaders for vertex displacement and for skin-and-bones animation. Other examples are along the lines of optical effects (still in the realm of physics), including reflection and refraction effects. In a sense shader programs provide a form of hacked physics. As graphics hardware evolves, look for the ability to rapidly read data from the graphics card into system memory, thereby allowing for intersection and collision testing.

The remaining four chapters of the book provide mathematical background. As such they are a bit more difficult to read than the previous chapters. Chapter 7 is on the topic of linear programming (LP), the linear complementarity problem (LCP), and mathematical programming (MP) generally. One application of the material is to use LCP methods to compute the distance between convex polygons or convex polyhedra. Another application is to use LCP methods to compute resting contact forces and to use MP methods, namely, constrained quadratic minimization, to compute impulsive contact forces at the points of contact among a collection of interacting rigid bodies. The LCP method also is useful in computing distance between points, convex polygons, and convex polyhedra.

Chapter 8 is a brief overview of the theory of differential equations. This material is provided for those readers who want to understand the basic theory of differential equations relevant to physical simulation. The overview is at the level of what you will find in an undergraduate textbook on the topic; it is intentionally limited in scope but should give you enough of the flavor of what analysis of differential equations is all about.

Chapter 9 is on numerical methods for solving differential equations. This is a *large* chapter that shows you a vast collection of methods, including how the methods are derived using basic mathematical principles. The methods include Euler's method, higher-order Taylor methods, methods obtained by an integral formulation, and the all-popular and robust Runge-Kutta methods. These are all *single-step methods* that require information only at the previous time step to generate information at the current time step. I also discuss *multistep methods* that use multiple previous times to generate information at the current step. These methods include the concept of a predictor-corrector that attempts to provide good estimates of the solution from ones that are less precise. Extrapolation methods are also covered, leading to the Bulirsch–Stoer method that uses rational polynomial extrapolation to produce highly accurate results with a minimum of computation cost. A class of methods that is very popular now in the games arena, and has been used for a long time in molecular dynamics, is the *Verlet methods*. A section of the chapter is devoted to these methods, including the standard Verlet method, the Leap Frog method, and the Velocity Verlet method. I also included a reasonable alternative called the *Gear fifth-order predictor-corrector method*. Thus, you have a large collection of solvers, all of them implemented in the source code on the CD-ROM that accompanies the book.

Implementing a numerical method is only half the battle. Understanding the stability of a method, how to choose an appropriate step size, and how to evaluate

the trade-offs between accuracy and computation time is the other half of the battle. Perhaps the most important part of Chapter 9 is the section on numerical stability and its relationship to physical stability of equilibrium solutions. You might think of this as an irrelevant mathematical exercise, but in fact I provide a stability analysis for a handful of methods when applied to the simple pendulum problem. This gives you the blueprint to follow when analyzing the stability of methods for your particular applications. The last section of the chapter discusses the problem of *stiffness*, another issue related to the stability of numerical solvers.

Chapter 10 is on quaternions, one of the most misunderstood and abused topics in the Usenet newsgroups (in my opinion). Yes, these are mathematical in flavor, but in fact a physical simulation benefits from using these because of the resulting reduced memory in representing rotations and in the reduced computation time in actually rotating or updating the equations of motion for a physical system. The molecular dynamics folks have been using these for a really long time, so you can find a lot of online material discussing quaternions in the context of that field, including higher-order methods for numerically solving the quaternion differential equation that shows up in the physical simulation.

I provide the classical approach to how quaternions relate to rotations and I provide a linear algebraic approach to try to motivate the connection by considering rotation in four dimensions. Section 10.4, "From Rotation Matrices to Quaternions," was written by Ken Shoemake, famous for introducing the joys and necessities of quaternions to the computer graphics and animation communities. The final two sections involve interpolation of quaternions and derivatives of time-varying quaternions, the latter section being related to how you derive the equation of motion for updating orientations of rigid bodies when quaternions are used to represent the orientations.

1.3 Examples and Exercises

Quite a few examples and exercises are provided in this book. The examples are worked through in detail, of course, with some of them implemented in source code, which is on the CD-ROM. The exercises are for you to try. They vary in difficulty and are marked accordingly: easy Ⓔ, medium Ⓜ, or hard Ⓗ. The assignment of these labels is my own choosing and may not agree with someone else's assessment of the level of difficulty. The answers to selected exercises are on the CD-ROM. I recommend that you make a significant attempt to answer the questions before looking up the answer. The answers to the remaining exercises are available only through your instructor, with access provided by Morgan Kaufmann Publishers.

BASIC CONCEPTS FROM PHYSICS

In this chapter we review some of the basic concepts of physics that are relevant to the analysis of motion and interaction of *rigid bodies*. A rigid body is classified according to the type of region that contains its mass, the topic of Section 2.1. Section 2.2 introduces curves in two or three dimensions as representative paths of a particle in the absence of forces. This topic is referred to as *kinematics*. The section introduces the physical concepts of position, velocity, and acceleration. Many applications are better handled with an appropriate choice of coordinate system. The Cartesian system is usually convenient, but we also take a look at polar coordinates, cylindrical coordinates, and spherical coordinates. In addition to kinematics of a single particle, we also look into the kinematics of particle systems and of solid bodies. This material is the foundation for the physics engines discussed in Chapter 5.

The remainder of this chapter is an introduction to the standard concepts that you see in a course on physics, starting with Newton's laws of motion in Section 2.3. The topic of forces is discussed in Section 2.4 with specific reference to forces you will see throughout the book in the examples: gravitational forces, spring forces, and frictional forces. The closely related topics of torque and equilibrium are also covered in the section. Various measures of momenta are discussed in Section 2.5, including linear and angular momentum, first-order moments and their relationship to the center of mass of an object, and moments and products of inertia. The last part of Section 2.5 shows how to compute the center of mass and the inertia tensor for a solid polyhedron of constant mass, something you will need to implement in the physics engines discussed in Chapter 5. Work and energy are the final topic of the chapter.

The kinetic energy is an important quantity in the development of Lagrangian dynamics. The potential energy is important when dealing with conservative forces such as gravity.

2.1 RIGID BODY CLASSIFICATION

A rigid body is characterized by the region that its mass lives in. The simplest body is a *single particle* of mass m that occupies a single location \mathbf{x}. A *particle system* is a collection of a finite number of particles, say, p of them, the ith particle having mass m_i and located at \mathbf{x}_i, $1 \leq i \leq p$. Single particles and particle systems are examples of *discrete material* since the number of particles is finite. Various physical quantities involve summations over the particles in a system. The standard notation is

$$Q_{\text{total}} = \sum_{i=1}^{p} Q_i$$

where Q_i is some physical quantity associated with the ith particle and Q_{total} is the summary quantity for all the particles. Although the equation here involves a scalar-valued physical quantity, vector-valued quantities will be encountered as well.

Another type of body is referred to as a *continuous material*, consisting of infinitely many particles that lie in a bounded region of space, denoted R. We refer to such a rigid body as a *continuum of mass*. Within the category of a continuum of mass we have a further set of classifications. The region R can be a bounded segment of a curve, whether in one, two, or three dimensions. Mathematically we may refer to such a rigid body as a *curve mass*. Physically we may call the body a *wire*. R can be a bounded region in the plane (two-dimensional mass living in two dimensions) or a bounded portion of a surface in space (two-dimensional mass living in three dimensions). Mathematically we may refer to such a rigid body as a *surface mass*. Physically we may call the body a *lamina* or, in two dimensions, a *planar lamina*. Finally, R can be a solid occupying a bounded region of space. Mathematically we may refer to such a body as a *volume mass*. Physically we may call the body a *solid*.

Various physical quantities involve summations over all particles of mass in the region. The summation notation for particle systems no longer applies and is replaced by integration over the region. The method of integration depends on the category of region. Generically we will use the notation

$$Q_{\text{total}} = \int_R Q \, dR$$

where R is the region, dR is an infinitesimal portion of the region, and Q is the physical quantity of interest and can be scalar- or vector-valued. An analysis for a particular type of rigid body, whether for mathematical purposes or for a computer implementation, must provide the specific type of integration in order to compute

the integral. For a curve mass, the integration is computed as a line integral, where the curve is parameterized by a single parameter and the limits of integration depend on that parameterization. For a surface mass in the plane, the integration is computed as a double integral, where the limits of integration depend on how the region is represented. For a surface mass in space, the integration is via a surface integral whose evaluation may very well involve Stokes's Theorem. For a volume mass, the integration is computed as a triple integral, where the limits of integration depend on how the region is represented. Throughout the book I will use the generic notation $\int_R Q \, dR$ when presenting general physical topics. I will resort to the specific type of integration when demonstrating the concepts with examples.

2.2 RIGID BODY KINEMATICS

The study of motion of objects without considering the influence of external forces is referred to as *kinematics*. The basics of the topic are presented in this section. We look at the three basic types of rigid bodies: a single particle, a particle system, and a continuum of mass. For the purposes of rigid body kinematics, the analyses for particle systems and continuous materials are the same.

2.2.1 SINGLE PARTICLE

Let us focus first on the kinematics of a single particle. Although we might start directly with the analysis of a particle moving through space, many situations arise where the particle is constrained to moving within a plane. We start our analysis with particle motion in the xy-plane, ignoring the z-component of the position. If the constraining plane is another one at some arbitrary orientation in space, basic methods of linear algebra may be applied to represent the particle's position with respect to an orthonormal basis of two vectors in that plane. The ideas we present here for the xy-plane apply directly to the coordinates within the general plane.

Whether in two or three dimensions we may choose Cartesian coordinates to represent the particle's position. However, some problems are better formulated in different coordinate systems. Particle motion is first discussed in Cartesian coordinates, but we also look at polar coordinates for 2D motion and at cylindrical or spherical coordinates for 3D motion since these coordinate systems are the most common ones you will see in applications.

Planar Motion in Cartesian Coordinates

First let us consider when the particle motion is constrained to be planar. In Cartesian coordinates, the *position* of the particle at time t is

$$\mathbf{r}(t) = x(t)\,\boldsymbol{\imath} + y(t)\,\boldsymbol{\jmath} \tag{2.1}$$

where $\imath = (1, 0)$ and $\jmath = (0, 1)$. The *velocity* of the particle at time t is

$$\mathbf{v}(t) = \dot{\mathbf{r}} = \dot{x}\,\imath + \dot{y}\,\jmath \qquad (2.2)$$

The dot symbol denotes differentiation with respect to t. The *speed* of the particle at time t is the length of the velocity vector, $|\mathbf{v}|$. If $s(t)$ denotes the arc length measured along the curve, the speed is $\dot{s} = |\mathbf{v}|$. The quantity $\dot{s} = ds/dt$ is intuitively read as "change in distance per change in time," what you expect for speed. The *acceleration* of the particle at time t is

$$\mathbf{a}(t) = \dot{\mathbf{v}} = \ddot{\mathbf{r}} = \ddot{x}\,\imath + \ddot{y}\,\jmath \qquad (2.3)$$

At each point on the curve of motion we can define a unit-length tangent vector by normalizing the velocity vector,

$$\mathbf{T}(t) = \frac{\mathbf{v}}{|\mathbf{v}|} = (\cos(\phi(t)), \sin(\phi(t))) \qquad (2.4)$$

The right-hand side of equation (2.4) defines $\phi(t)$ and is valid since the tangent vector is unit length. A unit-length normal vector is chosen as

$$\mathbf{N}(t) = (-\sin(\phi(t)), \cos(\phi(t))) \qquad (2.5)$$

The normal vector is obtained by rotating the tangent vector $\pi/2$ radians counterclockwise in the plane. A *coordinate system* at a point on the curve is defined by *origin* $\mathbf{r}(t)$ and *coordinate axis directions* $\mathbf{T}(t)$ and $\mathbf{N}(t)$. Figure 2.1 illustrates the coordinate systems at a couple of points on a curve. The coordinate system $\{\mathbf{r}(t); \mathbf{T}(t), \mathbf{N}(t)\}$ is called a *moving frame*.

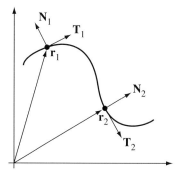

Figure 2.1 A couple of coordinate systems at points on a curve.

The velocity and acceleration vectors may be represented in terms of the curve tangent and normal. The velocity is a minor rearrangement of equation (2.4),

$$\mathbf{v} = |\mathbf{v}|\mathbf{T} = \dot{s}\mathbf{T} \tag{2.6}$$

The acceleration is obtained by differentiating the last equation,

$$\mathbf{a} = \dot{\mathbf{v}} = \frac{d}{dt}(\dot{s}\mathbf{T}) = \ddot{s}\,\mathbf{T} + \dot{s}\frac{d\mathbf{T}}{dt} = \ddot{s}\,\mathbf{T} + \dot{s}^2\frac{d\mathbf{T}}{ds}$$

Differentiating the tangent vector in equation (2.4) with respect to arc length s produces

$$\frac{d\mathbf{T}}{ds} = \frac{d}{ds}(\cos\phi, \sin\phi) = \frac{d\phi}{ds}(-\sin\phi, \cos\phi) = \kappa\mathbf{N}(s)$$

where $\kappa = d\phi/ds$ is the *curvature* of the curve at arc length s. Observe that large angular changes in the normal vector over a small length of curve equate to large curvature values. The acceleration is therefore

$$\mathbf{a} = \ddot{s}\,\mathbf{T} + \kappa\dot{s}^2\mathbf{N} \tag{2.7}$$

The component $\ddot{s}\,\mathbf{T}$ is called the *tangential acceleration*, the acceleration in the direction of motion. The component $\kappa\dot{s}^2\mathbf{N}$ is called the *normal acceleration* or *centripetal acceleration*, the acceleration that is perpendicular to the direction of motion. Equations (2.6) and (2.7) may be used to show that the curvature is

$$\kappa = \frac{\mathbf{v} \cdot \mathbf{a}^{\perp}}{|\mathbf{v}|^3} = \frac{\dot{x}\ddot{y} - \dot{y}\ddot{x}}{(\dot{x}^2 + \dot{y}^2)^{3/2}} \tag{2.8}$$

where $(\alpha, \beta)^{\perp} = (\beta, -\alpha)$.

The rate of change of the tangent vector with respect to arc length is related to the normal vector. You might be curious about the rate of change of the normal vector with respect to arc length. It is

$$\frac{d\mathbf{N}}{ds} = \frac{d}{ds}(-\sin\phi, \cos\phi) = \frac{d\phi}{ds}(-\cos\phi, -\sin\phi) = -\kappa\mathbf{T}$$

Summarizing the s-derivatives in a format matrix notation:

$$\begin{bmatrix} \dfrac{d\mathbf{T}}{ds} \\[2ex] \dfrac{d\mathbf{N}}{ds} \end{bmatrix} = \begin{bmatrix} 0 & \kappa \\ -\kappa & 0 \end{bmatrix} \begin{bmatrix} \mathbf{T} \\ \mathbf{N} \end{bmatrix} \tag{2.9}$$

Observe that the coefficient matrix is skew-symmetric, a common theme when computing the derivatives of the vectors in a frame.

EXAMPLE
2.1

Construct the various vectors and quantities mentioned earlier for a parabolic curve $\mathbf{r}(t) = t\imath + t^2\jmath$. For simplicity of notation, we use $\mathbf{r} = (t, t^2)$.

The velocity is $\mathbf{v} = (1, 2t)$ and the speed is just the length of the velocity vector, $\dot{s} = \sqrt{1 + 4t^2}$. The magnitude of tangential acceleration is $\ddot{s} = 4t/\sqrt{1 + 4t^2}$. The acceleration is $\mathbf{a} = (0, 2)$. The unit-length tangent and normal vectors are

$$\mathbf{T} = \frac{(1, 2t)}{\sqrt{1 + 4t^2}}, \qquad \mathbf{N} = \frac{(-2t, 1)}{\sqrt{1 + 4t^2}}$$

Finally, the curvature is $\kappa = 2/(1 + 4t^2)^{3/2}$. ∎

Planar Motion in Polar Coordinates

The particle motion may also be represented using polar coordinates. The choice of Cartesian form versus polar form depends on your application. The position vector is represented as a unit-length vector $\mathbf{R} = \mathbf{r}/|\mathbf{r}|$ and a distance $r = |\mathbf{r}|$ from the origin,

$$\mathbf{r} = |\mathbf{r}|\frac{\mathbf{r}}{|\mathbf{r}|} = r\mathbf{R} \tag{2.10}$$

Since $\mathbf{R} = \mathbf{r}/|\mathbf{r}|$ is unit length, we may write it as $\mathbf{R} = (\cos\theta, \sin\theta)$, where θ depends on t. A unit-length vector perpendicular to \mathbf{R} is $\mathbf{P} = (-\sin\theta, \cos\theta)$ and is obtained by a $\pi/2$ counterclockwise rotation of \mathbf{R} in the plane. The moving frame $\{\mathbf{r}(t); \mathbf{R}(t), \mathbf{P}(t)\}$ provides an alternate coordinate system to the tangent-normal one. Figure 2.2 shows the polar frames at points on a curve, the same curve shown in Figure 2.1.

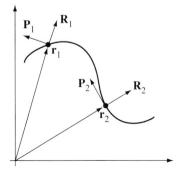

Figure 2.2 A polar coordinate frame at a point on a curve.

The derivatives of the frame directions with respect to time are summarized in formal matrix notation:

$$\begin{bmatrix} \dot{\mathbf{R}} \\ \dot{\mathbf{P}} \end{bmatrix} = \begin{bmatrix} 0 & \dot{\theta} \\ -\dot{\theta} & 0 \end{bmatrix} \begin{bmatrix} \mathbf{R} \\ \mathbf{P} \end{bmatrix} \tag{2.11}$$

Notice the similarity to equation (2.9).

The velocity is represented in the polar frame by

$$\mathbf{v} = \dot{\mathbf{r}} = \frac{d}{dt}\,(r\mathbf{R}) = \dot{r}\mathbf{R} + r\dot{\mathbf{R}} = \dot{r}\mathbf{R} + r\dot{\theta}\mathbf{P} \tag{2.12}$$

The acceleration is represented in the polar frame by

$$\mathbf{a} = \dot{\mathbf{v}} = \ddot{r}\mathbf{R} + \dot{r}\dot{\mathbf{R}} + \frac{d}{dt}\left(r\dot{\theta}\right)\mathbf{P} + r\dot{\theta}\dot{\mathbf{P}} = (\ddot{r} - r\dot{\theta}^2)\mathbf{R} + (r\ddot{\theta} + 2\dot{r}\dot{\theta})\mathbf{P} \tag{2.13}$$

EXAMPLE 2.2

Construct the various quantities for a spiral $r = \theta$, where θ is a function of time t.

The position is $\mathbf{r} = \theta\mathbf{R} = (\theta\cos\theta, \theta\sin\theta)$, the velocity is $\mathbf{v} = \dot{\theta}\mathbf{R} + \theta\dot{\theta}\mathbf{P} = \dot{\theta}(\cos\theta - \theta\sin\theta, \sin\theta + \theta\cos\theta)$, and the acceleration is $\mathbf{a} = (\ddot{\theta} - \theta\dot{\theta}^2)\mathbf{R} + (\theta\ddot{\theta} + 2\dot{\theta}^2)\mathbf{P} = \ddot{\theta}(\cos\theta - \theta\sin\theta, \sin\theta + \theta\cos\theta) + \dot{\theta}^2(-\theta\cos\theta - 2\sin\theta, -\theta\sin\theta + 2\cos\theta)$. ∎

Spatial Motion in Cartesian Coordinates

We now consider the spatial case. In Cartesian coordinates the position of a particle at time t is

$$\mathbf{r}(t) = x(t)\,\boldsymbol{\iota} + y(t)\,\boldsymbol{\jmath} + z(t)\,\boldsymbol{k} \tag{2.14}$$

where $\boldsymbol{\iota} = (1, 0, 0)$, $\boldsymbol{\jmath} = (0, 1, 0)$, and $\boldsymbol{k} = (0, 0, 1)$. The *velocity* of the particle at time t is

$$\mathbf{v}(t) = \dot{\mathbf{r}} = \dot{x}\,\boldsymbol{\iota} + \dot{y}\,\boldsymbol{\jmath} + \dot{z}\,\boldsymbol{k} \tag{2.15}$$

The *speed* of the particle at time t is the length of the velocity vector, $|\mathbf{v}|$. If $s(t)$ denotes the arc length measured along the curve, the speed is $\dot{s} = |\mathbf{v}|$. The *acceleration* of the particle at time t is

$$\mathbf{a}(t) = \dot{\mathbf{v}} = \ddot{\mathbf{r}} = \ddot{x}\,\boldsymbol{\iota} + \ddot{y}\,\boldsymbol{\jmath} + \ddot{z}\,\boldsymbol{k} \tag{2.16}$$

At each point on the curve of motion we can define a unit-length tangent vector by normalizing the velocity vector:

$$\mathbf{T}(t) = \frac{\mathbf{v}}{|\mathbf{v}|} \tag{2.17}$$

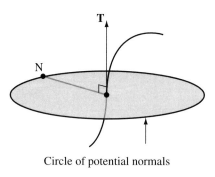

Circle of potential normals

Figure 2.3 A curve, a tangent vector at a point, and the circle of choices for the normal vector. The circle lies in the plane containing the point and perpendicular to the tangent.

In 2D we had only two choices for unit-length vectors that are perpendicular to the curve. We chose the one that is always a counterclockwise rotation from the tangent vector. As long as the tangent vector is a continuous function of t (the angle $\phi(t)$ is a continuous function), the normal vector is also a continuous function. In 3D there are infinitely many choices for a unit-length vector perpendicular to the tangent vector, an entire circle of them in the plane that is perpendicular to \mathbf{T} and centered at the point on the curve. Figure 2.3 shows a curve, a tangent at a point, and the circle of choices for the normal.

Which one do we choose for a normal vector \mathbf{N}? Keeping consistent with the 2D setting, since \mathbf{T} is a unit-length vector, $\mathbf{T} \cdot \mathbf{T} = 1$. Differentiating with respect to the arc length parameter s yields $\mathbf{T} \cdot d\mathbf{T}/ds = 0$, and as a result the vector $d\mathbf{T}/ds$ is perpendicular to the tangent. We use this vector to define both the normal vector and the curvature κ as a function of the arc length s,

$$\frac{d\mathbf{T}}{ds} = \kappa(s)\mathbf{N}(s) \tag{2.18}$$

The velocity satisfies equation (2.6) and the acceleration satisfies equation (2.7), the vector quantities living in three dimensions in both cases.

The normal is a unit-length vector in the direction of $d\mathbf{T}/ds$, but notice that there are two choices for such a vector. Think of the second choice as the negative of the first, $-\mathbf{N}(s)$. The curvature function that must be associated with the second choice is the negative of the first, $-\kappa(s)$, so that the product of curvature and normal still produces $d\mathbf{T}/ds$. If the curve were planar, we could resort to the two-dimensional construction and select a normal that is a counterclockwise rotation from the tangent within that plane. This reasoning does not apply to a nonplanar curve. The choice

of normal should be made in an attempt to maintain a continuous function $\mathbf{N}(s)$. Exercise 2.1 is designed to show that it is not always possible to do this. Once a choice is made for the normal vector, the curvature is $\kappa = \mathbf{N} \cdot d\mathbf{T}/ds$. The sign of the curvature depends on which of the two possible \mathbf{N} was chosen.

EXERCISE (H)[1] Consider a curve defined in two pieces. The first piece is $\mathbf{r}(t) = (t, t^3, 0)$ for $t \le 0$ and
2.1 the second piece is $\mathbf{r}(t) = (t, 0, t^3)$ for $t \ge 0$. Prove that \mathbf{r}, \mathbf{v}, and \mathbf{a} are continuous at $t = 0$ by showing $\lim_{t \to 0} \mathbf{r}(t) = \mathbf{r}(0)$, $\lim_{t \to 0} \mathbf{v}(t) = \mathbf{v}(0)$, and $\lim_{t \to 0} \mathbf{a}(t) = \mathbf{a}(0)$. Construct the normal vectors for each piece as a function of t; call this $\mathbf{N}(t)$. Prove that $\lim_{t \to 0^-} \mathbf{N}(t) = (0, 1, 0)$ and $\lim_{t \to 0^+} \mathbf{N}(t) = (0, 0, 1)$. Since the one-sided limits have different values, $\mathbf{N}(t)$ is not continuous at $t = 0$. Changing the sign of the normal on one piece of the curve cannot change the conclusion. ▪

The acceleration vector in 3D satisfies the relationship shown in equation (2.7). The curvature, however, is

$$\kappa = \sigma \frac{|\mathbf{v} \times \mathbf{a}|}{|\mathbf{v}|^3} \tag{2.19}$$

where σ is a sign parameter that is 1 or -1 and chosen, if possible, to make the normal vector continuous. A formula for the normal vector may be derived that contains the sign parameter,

$$\mathbf{N} = \frac{\sigma (\mathbf{v} \times \mathbf{a}) \times \mathbf{v}}{|\mathbf{v} \times \mathbf{a}| \, |\mathbf{v}|} \tag{2.20}$$

The tangent \mathbf{T} and normal \mathbf{N} only account for two of the three degrees of freedom in space. A third unit-length vector, called the *binormal vector*, is defined by

$$\mathbf{B} = \mathbf{T} \times \mathbf{N} \tag{2.21}$$

The coordinate system $\{\mathbf{r}(t); \mathbf{T}(t), \mathbf{N}(t), \mathbf{B}(t)\}$ is a moving frame for the curve. The binormal is perpendicular to the tangent and normal vectors, so $\mathbf{B} \cdot \mathbf{T} = 0$ and $\mathbf{B} \cdot \mathbf{N} = 0$ for all t. Differentiating with respect to arc length s, we obtain

$$0 = \frac{d\mathbf{B}}{ds} \cdot \mathbf{T} + \mathbf{B} \cdot \frac{d\mathbf{T}}{ds} = \frac{d\mathbf{B}}{ds} \cdot \mathbf{T} + \kappa \mathbf{B} \cdot \mathbf{N} = \frac{d\mathbf{B}}{ds} \cdot \mathbf{T}$$

The binormal is unit length, so $\mathbf{B} \cdot \mathbf{B} = 1$ for all t. Differentiating with respect to s and dividing by 2, we obtain

$$0 = \mathbf{B} \cdot \frac{d\mathbf{B}}{ds}$$

1. Exercises vary in difficulty and are marked accordingly: easy (E), medium (M), or hard (H).

The last two displayed equations show that the derivative of the binormal is perpendicular to both \mathbf{T} and \mathbf{B}. It must therefore be parallel to \mathbf{N} and represented as

$$\frac{d\mathbf{B}}{ds} = -\tau \mathbf{N} \tag{2.22}$$

for some scalar function τ, called the *torsion* of the curve. The choice of minus sign is the standard convention. The curvature measures how the curve wants to bend within the plane spanned by the tangent and normal to the curve. The torsion measures how the curve wants to bend out of that plane.

To this point we know how the derivatives $d\mathbf{T}/ds$ and $d\mathbf{B}/ds$ relate to the tangent, normal, and binormal. We may complete the set of relationships by computing $d\mathbf{N}/ds$. The normal is $\mathbf{N} = \mathbf{B} \times \mathbf{T}$. Differentiating with respect to s yields

$$\frac{d\mathbf{N}}{ds} = \mathbf{B} \times \frac{d\mathbf{T}}{ds} + \frac{d\mathbf{B}}{ds} \times \mathbf{T} = \kappa \mathbf{B} \times \mathbf{N} - \tau \mathbf{N} \times \mathbf{T} = -\kappa \mathbf{T} + \tau \mathbf{B} \tag{2.23}$$

Equations (2.18), (2.22), and (2.23) are called the *Frenet-Serret equations* for the curve. In a formal matrix notation,

$$\begin{bmatrix} \dfrac{d\mathbf{T}}{ds} \\[2mm] \dfrac{d\mathbf{N}}{ds} \\[2mm] \dfrac{d\mathbf{B}}{ds} \end{bmatrix} = \begin{bmatrix} 0 & \kappa & 0 \\ -\kappa & 0 & \tau \\ 0 & -\tau & 0 \end{bmatrix} \begin{bmatrix} \mathbf{T}(s) \\ \mathbf{N}(s) \\ \mathbf{B}(s) \end{bmatrix} \tag{2.24}$$

An explicit formula for the torsion is obtained as follows. The derivative of acceleration, sometimes called a measure of *jerk*, is

$$\dot{\mathbf{a}} = \frac{d}{dt} \left(\ddot{s}\,\mathbf{T} + \kappa \dot{s}^2 \mathbf{N} \right) = \left(\dddot{s} - \kappa^2 \dot{s}^3 \right) \mathbf{T} + \left[\frac{d}{dt} \left(\kappa \dot{s}^2 \right) + \kappa \ddot{s}\dot{s} \right] \mathbf{N} + \left(\tau \kappa \dot{s}^2 \right) \mathbf{B}$$

A simple calculation shows that $\mathbf{v} \times \mathbf{a} = \kappa \dot{s}^2 \mathbf{B}$. Consequently, $\mathbf{v} \times \mathbf{a} \cdot \dot{\mathbf{a}} = \tau \kappa^2 \dot{s}^6 = \tau |\mathbf{v} \times \mathbf{a}|^2$. The torsion is

$$\tau = \frac{\mathbf{v} \times \mathbf{a} \cdot \dot{\mathbf{a}}}{|\mathbf{v} \times \mathbf{a}|^2} \tag{2.25}$$

Spatial Motion in Cylindrical Coordinates

A point (x, y, z) is represented in cylindrical coordinates as $x = r \cos \theta$, $y = r \sin \theta$, and z as given, where r is the distance in the xy-plane from the origin $(0, 0, 0)$ to (x, y, z) and z is the vertical height of the point above that plane. The angle satisfies $\theta \in [0, 2\pi)$. Figure 2.4 shows a typical point (x, y, z) and its related parameters r and θ.

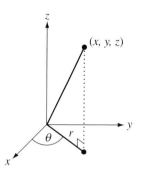

Figure 2.4 Cylindrical coordinates $(x, y, z) = (r \cos \theta, r \sin \theta, z)$.

Using notation similar to that of planar motion in polar coordinates, a unit-length vector in the xy-plane is $\mathbf{R} = (\cos \theta, \sin \theta, 0)$. A perpendicular vector in the plane is $\mathbf{P} = (-\sin \theta, \cos \theta, 0)$. The vertical direction is $k = (0, 0, 1)$. The moving frame for the curve is $\{\mathbf{r}(t); \mathbf{R}(t), \mathbf{P}(t), k\}$. The position of a point is

$$\mathbf{r} = r\mathbf{R} + zk \tag{2.26}$$

The velocity is

$$\mathbf{v} = \dot{\mathbf{r}} = \dot{r}\mathbf{R} + r\dot{\theta}\mathbf{P} + \dot{z}k \tag{2.27}$$

The acceleration is

$$\mathbf{a} = \dot{\mathbf{v}} = (\ddot{r} - r\dot{\theta}^2)\mathbf{R} + (r\ddot{\theta} + 2\dot{r}\dot{\theta})\mathbf{P} + \ddot{z}k \tag{2.28}$$

Observe that the position, velocity, and acceleration have the same \mathbf{R} and \mathbf{P} components as the polar representations in two dimensions, but have additional components in the z-direction. The time derivatives of the frame vectors are shown below in formal matrix notation:

$$\begin{bmatrix} \dot{\mathbf{R}} \\ \dot{\mathbf{P}} \\ \dot{k} \end{bmatrix} = \begin{bmatrix} 0 & \dot{\theta} & 0 \\ -\dot{\theta} & 0 & 0 \\ 0 & 0 & 0 \end{bmatrix} \begin{bmatrix} \mathbf{R} \\ \mathbf{P} \\ k \end{bmatrix} \tag{2.29}$$

As always, the coefficient matrix for rates of change of frame vectors is skew-symmetric.

EXERCISE (E) Construct the position, velocity, and acceleration vectors in cylindrical coordinates
2.2 for the helix $(\cos(t), \sin(t), t)$. ■

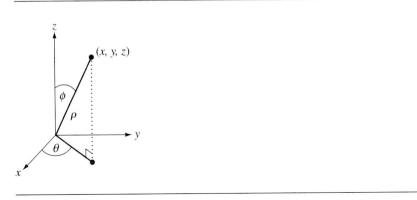

Figure 2.5 Spherical coordinates $(x, y, z) = (\rho \cos \theta \sin \phi, r \sin \theta \sin \phi, \rho \cos \phi)$.

Spatial Motion in Spherical Coordinates

A point (x, y, z) is represented in spherical coordinates as $x = \rho \cos \theta \sin \phi$, $y = \rho \sin \theta \sin \phi$, and $z = \rho \cos \phi$, where $\theta \in [0, 2\pi)$ and $\phi \in [0, \pi]$. Figure 2.5 shows a typical point (x, y, z) and its related parameters ρ, θ, and ϕ.

The position of a point is

$$\mathbf{r} = \rho \mathbf{R} \tag{2.30}$$

where $\mathbf{R} = (\cos \theta \sin \phi, \sin \theta \sin \phi, \cos \phi)$ is a unit-length vector. Two unit-length vectors that are perpendicular to \mathbf{R} are $\mathbf{P} = (-\sin \theta, \cos \theta, 0)$ and $\mathbf{Q} = \mathbf{R} \times \mathbf{P} = (-\cos \theta \cos \phi, -\sin \theta \cos \phi, \sin \phi)$. A moving frame for the curve is $\{\mathbf{r}(t); \mathbf{P}(t), \mathbf{Q}(t), \mathbf{R}(t)\}$. The derivatives of the moving frame are shown in equation (2.31). The formal representation in terms of vectors and matrices is intended to emphasize that the coefficient matrix is skew-symmetric:

$$\begin{bmatrix} \dot{\mathbf{P}} \\ \dot{\mathbf{Q}} \\ \dot{\mathbf{R}} \end{bmatrix} = \begin{bmatrix} 0 & \dot{\theta} \cos \phi & -\dot{\theta} \sin \phi \\ -\dot{\theta} \cos \phi & 0 & \dot{\phi} \\ \dot{\theta} \sin \phi & -\dot{\phi} & 0 \end{bmatrix} \begin{bmatrix} \mathbf{P} \\ \mathbf{Q} \\ \mathbf{R} \end{bmatrix} \tag{2.31}$$

The proof of these equations is left as an exercise. The velocity of a point is

$$\mathbf{v} = \dot{\rho} \mathbf{R} + \rho \dot{\mathbf{R}} = \left(\rho \dot{\theta} \sin \phi\right) \mathbf{P} + \left(-\rho \dot{\phi}\right) \mathbf{Q} + \left(\dot{\rho}\right) \mathbf{R} \tag{2.32}$$

where equation (2.31) was used to replace the derivative of \mathbf{R}. Another application of a time derivative and equation (2.31) produces the acceleration of a point,

$$\mathbf{a} = \left((\rho\ddot{\theta} + 2\dot{\rho}\dot{\theta}) \sin\phi + 2\rho\dot{\theta}\dot{\phi}\cos\phi \right) \mathbf{P}$$

$$+ \left(\rho(\dot{\theta}^2 \sin\phi\cos\phi - \ddot{\phi}) - 2\dot{\rho}\dot{\phi} \right) \mathbf{Q} \qquad (2.33)$$

$$+ \left(\ddot{\rho} - \rho(\dot{\phi}^2 + \dot{\theta}^2 \sin^2\phi) \right) \mathbf{R}$$

EXERCISE (E) Construct the position, velocity, and acceleration in spherical coordinates for the
2.3 spherical helix $(\cos(t), \sin(t), t)/\sqrt{1+t^2}$. What happens to the helix as time increases without bound? ▪

EXERCISE (M) Verify the formulas in equation (2.31). *Hint:* Compute the partial derivatives with
2.4 respect to θ and ϕ of **R**, **P**, and **Q**; then use the chain rule from calculus to obtain the
time derivatives. ▪

Motion About a Fixed Axis

A classic question is how to compute the position, velocity, and acceleration of a
particle that is rotating about a fixed axis and is a constant distance from that axis. For
the sake of argument, assume that the axis is a line that contains the origin and whose
unit-length direction is **D**. We may choose the coordinate system so that **D** plays the
role of k in equation (2.26) and $\mathbf{R}(t) = (\cos\theta(t), \sin\theta(t), 0)$ is radial to that axis.
The 3-tuple shown in Figure 2.6 is relative to a fixed coordinate system at the origin
with an orthonormal set of axes $\boldsymbol{\xi}$, $\boldsymbol{\eta}$, and **D**. That is, $\mathbf{R} = (\cos\theta)\boldsymbol{\xi} + (\sin\theta)\boldsymbol{\eta}$. In this
system the *angular speed* is $\sigma(t) = \dot{\theta}(t)$. The *angular velocity* is $\mathbf{w}(t) = \sigma(t)\mathbf{D}$. The
angular acceleration is $\boldsymbol{\alpha}(t) = \dot{\sigma}(t)\mathbf{D}$. Figure 2.6 illustrates the motion.

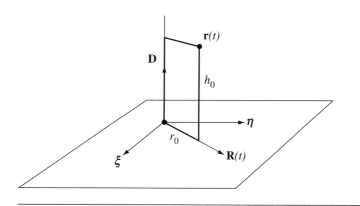

Figure 2.6 Motion of a particle about a fixed axis, a constant distance from the axis.

The position for the particle in motion about the axis is

$$\mathbf{r}(t) = r_0 \mathbf{R}(t) + h_0 \mathbf{D} \qquad (2.34)$$

where r_0 is the constant distance from the particle to the axis and where h_0 is the constant height above the plane $\mathbf{D} \cdot \mathbf{r} = 0$. From equation (2.27) the velocity is

$$\mathbf{v}(t) = r_0 \sigma \mathbf{P} = r_0 \sigma \mathbf{D} \times \mathbf{R} = \mathbf{w} \times \mathbf{r} \qquad (2.35)$$

where we have used the facts that r_0 and h_0 are constants, so their derivatives are always zero, and $\dot{\theta} = \sigma$. This formula should be intuitive. The cross product of the axis direction and the position vector is tangent to the circle of motion. From equation (2.28) the acceleration is

$$\mathbf{a}(t) = -r_0 \sigma^2 \mathbf{R} + r_0 \ddot{\theta} \mathbf{P} = -r_0 \sigma^2 \mathbf{R} + r_0 \dot{\sigma} \mathbf{D} \times \mathbf{R} = -r_0 \sigma^2 \mathbf{R} + \boldsymbol{\alpha} \times \mathbf{r} \quad (2.36)$$

The vector $-r_0 \sigma^2 \mathbf{R}$ is the *centripetal acceleration* of the particle. The vector $\boldsymbol{\alpha} \times \mathbf{r}$ is the *tangential acceleration* of the particle and, of course, is a vector that is tangent to the circle of motion.

Motion About a Moving Axis

To motivate the concept of angular velocity for a time-varying axis with unit-length direction vector $\mathbf{D}(t)$, let us take a closer look at motion about a fixed axis. Equation (2.34) tells you the position of the particle that is rotating about the fixed axis, $\mathbf{r}(t) = r_0(\cos(\theta(t))\boldsymbol{\xi} + \sin(\theta(t))\boldsymbol{\eta}) + h_0 \mathbf{D}$. The initial position is $\mathbf{r}_0 = \mathbf{r}(0) = r_0 \boldsymbol{\xi}$. Positions at later times are determined by a rotation of $\mathbf{r}(t)$ about the axis \mathbf{D} by an angle $\theta(t)$, namely, $\mathbf{r}(t) = R(t)\mathbf{r}_0$, where $R(t)$ is the rotation matrix corresponding to the specified rotation about the axis. For any vector $\mathbf{u} = (u_1, u_2, u_3)$, define the skew-symmetric matrix:

$$\text{Skew}(\mathbf{u}) = \begin{bmatrix} 0 & -u_3 & u_2 \\ u_3 & 0 & -u_1 \\ -u_2 & u_1 & 0 \end{bmatrix}$$

This matrix has the property that $\text{Skew}(\mathbf{u})\mathbf{r} = \mathbf{u} \times \mathbf{r}$. The derivation in Chapter 10 that leads to equation (10.14) shows that the rotation matrix is

$$R(t) = I + (\sin(\theta(t)))\,\text{Skew}(\mathbf{D}) + (1 - \cos(\theta(t)))\,\text{Skew}(\mathbf{D})^2$$

We can also write the linear velocity as

$$\dot{\mathbf{r}}(t) = \mathbf{w}(t) \times \mathbf{r}(t) = \text{Skew}(\mathbf{w}(t))\mathbf{r}(t)$$

where the angular velocity is $\mathbf{w}(t) = \dot{\theta}(t)\mathbf{D}$. Differentiating $\mathbf{r}(t) = R(t)\mathbf{r}_0$ directly, we obtain

$$\dot{\mathbf{r}}(t) = \dot{R}(t)\mathbf{r}_0 = \dot{R}(t)R^{\mathrm{T}}R\mathbf{r}_0 = (\dot{R}(t)R^{\mathrm{T}})\mathbf{r}(t) \tag{2.37}$$

Equating this to the previously displayed equation, we have

$$\dot{R}(t)R^{\mathrm{T}} = \mathrm{Skew}(\mathbf{w}(t))$$

or

$$\dot{R}(t) = \mathrm{Skew}(\mathbf{w}(t))R(t) \tag{2.38}$$

These equations tell us the rate of change of the rotation in terms of the current rotation and the current angular velocity.

Now consider what happens if we allow the unit-length direction vector to vary with time, $\mathbf{D}(t)$. The rotation matrix corresponding to this direction vector and rotation angle $\theta(t)$ is

$$R(t) = I + (\sin(\theta(t)))\,\mathrm{Skew}(\mathbf{D}(t)) + (1 - \cos(\theta(t)))\,\mathrm{Skew}(\mathbf{D}(t))^2 \tag{2.39}$$

The initial point \mathbf{r}_0 is still transformed by $\mathbf{r}(t) = R(t)\mathbf{r}_0$ and the linear velocity is still provided by equation (2.37). A rotation matrix satisfies the identity $I = RR^{\mathrm{T}}$. Taking the time derivative, $0 = \dot{R}R^{\mathrm{T}} + R\dot{R}^{\mathrm{T}} = \dot{R}R^{\mathrm{T}} + (\dot{R}R^{\mathrm{T}})^{\mathrm{T}}$, or $(\dot{R}R^{\mathrm{T}})^{\mathrm{T}} = -\dot{R}R^{\mathrm{T}}$. Thus, $S(t) = \dot{R}(t)R^{\mathrm{T}}(t)$ is a skew-symmetric matrix. We have already made this observation for rotation matrices that arise in specific coordinate systems, namely, equations (2.9) and (2.29). Since $S(t)$ is a skew-symmetric matrix, it can be written as $S(t) = \mathrm{Skew}(\mathbf{w}(t))$.

We saw that for a fixed axis \mathbf{D}, the angular velocity is $\mathbf{w} = \dot{\theta}\mathbf{D}$. A natural question to ask is how the angular velocity relates to $\theta(t)$ and $\mathbf{D}(t)$ in the general case. We can directly calculate this by computing $\dot{R}(t)$ for the matrix in equation (2.39) followed by computing $\dot{R}R^{\mathrm{T}}$. Some algebraic and trigonometric manipulations and the identity $\mathrm{Skew}(\mathbf{D})^3 = -\,\mathrm{Skew}(\mathbf{D})$ for a unit-length vector \mathbf{D} will lead you to

$$\mathbf{w} = \dot{\theta}\mathbf{D} + (\sin\theta)\dot{\mathbf{D}} + (\cos\theta - 1)\dot{\mathbf{D}} \times \mathbf{D} \tag{2.40}$$

Because \mathbf{D} is unit length, $\mathbf{D} \cdot \dot{\mathbf{D}} = 0$, in which case $\dot{\mathbf{D}}$ is perpendicular to \mathbf{D}. Thus, \mathbf{D}, $\dot{\mathbf{D}}$, and $\dot{\mathbf{D}} \times \mathbf{D}$ are mutually orthogonal. The angular velocity is a linear combination of these three vectors.

EXERCISE (E) Prove equation (2.40) is true. ▪
2.5

2.2.2 PARTICLE SYSTEMS AND CONTINUOUS MATERIALS

In the last section we discussed the basic concepts of kinematics for a single particle. Let us now look at the same concepts for a discrete set of particles, a particle system, so to speak, or a continuous material. In this general discussion we are not assuming the body is rigid.

When a body moves through the world, each point in the body travels along a path that is measured in *world coordinates*. At time 0, if \mathcal{P} is a body point specified in world coordinates, the position after time t in world coordinates is denoted $\mathcal{X}(t; \mathcal{P})$. The inclusion of \mathcal{P} as an argument of the function indicates that we are thinking of many paths, each path generated by a starting point \mathcal{P}. By our definition, $\mathcal{X}(0; \mathcal{P}) = \mathcal{P}$. The world coordinates of the body points are what an observer measures when he is standing at the world origin using a known set of directions for the world coordinate axes. We will refer to this observer as the *world observer*.

We can also measure points in *body coordinates*. You can imagine such a coordinate system as the one that an observer situated in the body uses to measure the location of body points. We will refer to this observer as the *body observer*. The body observer stands at a special point that we call the *body origin*. He also has his own view of three coordinate axes called the *body axes*. The axis directions are assumed to form a right-handed orthonormal set. The body origin and axes never change from the body observer's point of view, but the world observer sees these change over time.

If the world observer measures the point at $\mathcal{X}(t; \mathcal{P})$, the body observer sees this point relative to his origin, measuring it as a vector $\mathbf{b}(t; \mathcal{P})$. Again the inclusion of \mathcal{P} as an argument indicates that there are many paths, one for each initial point \mathcal{P}. If the body is rigid, then necessarily \mathbf{b} is independent of time; its time derivative is identically zero. If \mathcal{C} is what the world observer sees as the body origin at time 0, at time t he sees $\mathcal{X}(t; \mathcal{C})$. Of course the body observer always measures this as a relative difference $\mathbf{0}$ regardless of the time t. The world observer sees the body axis directions as orthonormal vectors measured in world coordinates; call these $\mathbf{U}_i(t)$ for $i = 0, 1, 2$. For convenience the world coordinate vectors can be stored as the columns of a rotation matrix $R(t) = [\mathbf{U}_0(t)\ \mathbf{U}_1(t)\ \mathbf{U}_2(t)]$. Figure 2.7 illustrates the two coordinate systems, but in two dimensions to keep the diagrams simple.

The relative difference between the world point and world center is $\mathbf{r}(t; \mathcal{C}) = \mathcal{X}(t; \mathcal{P}) - \mathcal{X}(t; \mathcal{C}) = R(t)\mathbf{b}(t; \mathcal{P})$. The transformation that produces the world coordinates of body points at time t, given the location of points as measured by the body observer, is

$$\mathcal{X}(t; \mathcal{P}) = \mathcal{X}(t; \mathcal{C}) + \mathbf{r}(t; \mathcal{P}) = \mathcal{X}(t; \mathcal{C}) + R(t)\mathbf{b}(t; \mathcal{P}) \tag{2.41}$$

The orientation changes are uncoupled from the translation changes.

Consider a time-varying vector written in the body coordinate system, $\boldsymbol{\xi}(t) = R(t)\mathbf{s}(t)$. The body coordinates $\mathbf{s}(t)$ vary with time since $\boldsymbol{\xi}(t)$ does. The time derivative is

$$\frac{d\boldsymbol{\xi}}{dt} = R\frac{d\mathbf{s}}{dt} + \dot{R}\mathbf{s} = R\frac{d\mathbf{s}}{dt} + \dot{R}R^{\mathsf{T}}\boldsymbol{\xi} = \frac{D\boldsymbol{\xi}}{Dt} + \mathbf{w} \times \boldsymbol{\xi} \tag{2.42}$$

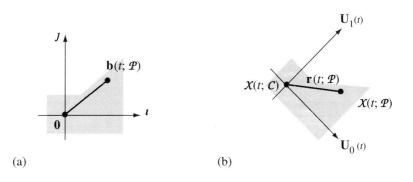

Figure 2.7 (a) The body coordinate system as seen by the body observer. (b) The body coordinate system as seen by the world observer.

where $\dot{R}R^{T} = \mathrm{Skew}(\mathbf{w})$ and \mathbf{w} is the angular velocity of the body measured in world coordinates as determined by equation (2.38). The last equality of equation (2.42) defines

$$\frac{D\boldsymbol{\xi}}{Dt} = R(t)\frac{d\mathbf{s}}{dt}$$

a quantity that measures the rate of change of $\boldsymbol{\xi}$ relative to the body coordinate system. The rate of change $d\boldsymbol{\xi}/dt$ is what the world observer sees. The quantity $D\boldsymbol{\xi}/Dt$ represents the time rate of change of $\boldsymbol{\xi}$ relative to the body coordinates since $d\mathbf{s}/dt$ is what the body observer measures. The body observer does not see the change $\mathbf{w} \times \boldsymbol{\xi}$ because he is rotating with the body coordinate system.

The body origin has world velocity $\mathbf{v}_{\mathrm{cen}} = d\mathcal{X}(t; \mathcal{C})/dt$ and world acceleration $\mathbf{a}_{\mathrm{cen}} = d\mathbf{v}_{\mathrm{cen}}/dt$. Differentiating equation (2.41) with respect to time, the world velocity $\mathbf{v}_{\mathrm{wor}} = d\mathcal{X}(t; \mathcal{P})/dt$ is

$$\mathbf{v}_{\mathrm{wor}} = \mathbf{v}_{\mathrm{cen}} + R\frac{d\mathbf{b}}{dt} + \dot{R}\mathbf{b} = \mathbf{v}_{\mathrm{cen}} + \frac{D\mathbf{r}}{Dt} + \mathbf{w} \times \mathbf{r} \tag{2.43}$$

where \mathbf{w} is the angular velocity of the body at time t in world coordinates. The terms of the equation are

- $\mathbf{v}_{\mathrm{cen}}$, the velocity of the body origin relative to the world coordinates, sometimes referred to as the *drag velocity*,
- $D\mathbf{r}/Dt$, the velocity of \mathcal{P} measured relative to the body coordinates, and
- $\mathbf{w} \times \mathbf{r}$, the velocity due to rotation of the frame.

The world acceleration $\mathbf{a}_{\text{wor}} = d\mathbf{v}_{\text{wor}}/dt$ is obtained by differentiating equation (2.43) with respect to time,

$$\mathbf{a}_{\text{wor}} = \mathbf{a}_{\text{cen}} + \frac{d}{dt}\left(\frac{D\mathbf{r}}{Dt}\right) + \frac{d}{dt}(\mathbf{w} \times \mathbf{r})$$

The vector $D\mathbf{r}/Dt$ is measured in the body coordinate system, so equation (2.42) applies to it,

$$\frac{d}{dt}\left(\frac{D\mathbf{r}}{Dt}\right) = \frac{D}{Dt}\left(\frac{D\mathbf{r}}{Dt}\right) + \mathbf{w} \times \frac{D\mathbf{r}}{Dt} = \frac{D^2\mathbf{r}}{Dt^2} + \mathbf{w} \times \frac{D\mathbf{r}}{Dt}$$

Similarly, equation (2.42) is applied to $\mathbf{w} \times \mathbf{r}$ to obtain

$$\frac{d}{dt}(\mathbf{w} \times \mathbf{r}) = \frac{D(\mathbf{w} \times \mathbf{r})}{Dt} + \mathbf{w} \times (\mathbf{w} \times \mathbf{r}) = \mathbf{w} \times \frac{D\mathbf{r}}{Dt} + \frac{D\mathbf{w}}{Dt} \times \mathbf{r} + \mathbf{w} \times (\mathbf{w} \times \mathbf{r})$$

Observe that $D\mathbf{w}/Dt = d\mathbf{w}/dt$ since we may apply equation (2.42) to \mathbf{w} and use the identity $\mathbf{w} \times \mathbf{w} = \mathbf{0}$. The last three displayed equations combine to form an equation for the acceleration,

$$\mathbf{a}_{\text{wor}} = \mathbf{a}_{\text{cen}} + \mathbf{w} \times (\mathbf{w} \times \mathbf{r}) + \frac{D\mathbf{w}}{Dt} \times \mathbf{r} + 2\mathbf{w} \times \frac{D\mathbf{r}}{Dt} + \frac{D^2\mathbf{r}}{Dt^2} \qquad (2.44)$$

The terms of the equation are

- \mathbf{a}_{cen}, the translational acceleration of the body origin relative to the world coordinates,
- $\mathbf{w} \times (\mathbf{w} \times \mathbf{r})$, the centripetal acceleration due to rotation of the frame,
- $(D\mathbf{w}/Dt) \times \mathbf{r}$, the tangential acceleration due to angular acceleration,
- $2\mathbf{w} \times (D\mathbf{r}/Dt)$, the Coriolis acceleration, and
- $D^2\mathbf{r}/Dt^2$, the acceleration of \mathcal{P} relative to the body.

The first three terms collectively are called the *drag acceleration*.

EXERCISE Ⓜ **2.6** Consider a rigid sphere of radius 1 and center at $\mathbf{0}$ that rotates about its center. The angular velocity is $\mathbf{w}(t) = (\cos(t), \sin(t), \sqrt{3})$. Does the path of the point starting at $(0, 0, 1)$ ever reach this same point at a later time? If it were not to reach $(0, 0, 1)$ again, is there some other constant angular speed for which it will reach that point again? ∎

EXERCISE Ⓜ **2.7** Consider the same rigid sphere of the preceding exercise, but whose angular velocity is unknown. Suppose the path of the point starting at $(0, 0, 1)$ is $((1 - t^2)\cos(\pi t)$, $(1 - t^2)\sin(\pi t), t^2)/\sqrt{(1 - t^2)^2 + t^4}$ for $t \in [-1, 1]$. What is the angular velocity $\mathbf{w}(t)$? If $\mathbf{r}(t)$ is the path traversed by $(1, 0, 0)$ over the time interval $[-1, 1]$, then by

definition $\mathbf{r}(-1) = (1, 0, 0)$. What is $\mathbf{r}(1)$? If you have difficulties constructing all the components of this point, can you say something about any of the components? ▨

EXERCISE 2.8 Ⓜ In the constructions of this section, the standard first-derivative operator d/dt was applied to vector quantities. This operator has certain rules associated with it. The operator D/Dt was introduced in this section and I used the same rules for it. For example, I used the rule $D(\mathbf{A} \times \mathbf{B})/Dt = \mathbf{A} \times (D\mathbf{B}/Dt) + (D\mathbf{A}/Dt) \times \mathbf{B}$. What is the relationship between d/dt and D/Dt? Use this relationship to prove that the differentiation rules for d/dt are equally valid for D/Dt. ▨

2.3 NEWTON'S LAWS

We have seen the concepts of position, velocity, and acceleration of a point; all are relevant in describing the motion of an object. A key concept is one of *inertia*, the tendency of an object at rest to remain at rest. Although we tend to think of the *mass* of an object as a measure of the amount of matter making up the object, it is just as valid to think of mass as a measure of the inertia of the object. The standard unit of measurement for mass is a *kilogram.*

Another key concept is *force*, the general mechanism for changing the mechanical state of an object. Empirically we know that a force is a vector quantity, so it has a direction and a magnitude. For our purposes, forces are what lead to changes in velocity of an object and cause objects to interact with each other. An *external force* is one whose source is outside the system of interest. From experimental studies we know that the net external force on an object causes it to accelerate in the direction of the force. Moreover, the magnitude of the acceleration of the object is proportional to the magnitude of the force (the larger the force, the more the object accelerates) and inversely proportional to the mass of the object (the heavier the object, the less it accelerates). The standard unit of measurement for the magnitude of a force is a *newton.* One newton is the required magnitude of a force to give a one-kilogram mass an acceleration of one meter per second2.

An introductory course to physics summarizes these concepts as a statement of *Newton's laws of physics*:

- *First law.* In the absence of external forces, an object at rest will remain at rest. If the object is in motion and no external forces act on it, the object remains in motion with constant velocity. (*Only forces can change an object's motion.*)

- *Second law.* For an object of constant mass over time, its acceleration \mathbf{a} is proportional to the force \mathbf{F} and inversely proportional to the mass m of the object: $\mathbf{a} = \mathbf{F}/m$. We normally see this written as $\mathbf{F} = m\mathbf{a}$. If the mass changes over time, the more general statement of the law is

$$\mathbf{F} = \frac{d}{dt}(m\mathbf{v}) = m\mathbf{a} + \frac{dm}{dt}\mathbf{v} \qquad (2.45)$$

where **v** is the velocity of the object. The quantity $m\mathbf{v}$ is the *linear momentum* of the object. Thus, the second law states that the application of an external force on an object causes a change in the object's momentum over time. (*An object's path of motion is determined from the applied forces.*)

- *Third law.* If a force is exerted on one object, there is a force of equal magnitude but opposite direction on some other body that interacts with it. (*Action and reaction always occur between interacting objects.*)

The most important law for this book is the second one, although we will deal specifically with constant mass. The *equations of motion* $\mathbf{F} = m\mathbf{a}$ will be used to establish the path of motion for an object by numerically solving the second-order differential equations for position.

Each of the vector quantities of position, velocity, and acceleration is measured with respect to *some* coordinate system. This system is referred to as the *inertial frame*. If $\mathbf{x} = (x_1, x_2, x_3)$ is the representation of the position in the inertial frame, the components x_1, x_2, and x_3 are referred to as the *inertial coordinates*. Although in many cases the inertial frame is considered to be fixed (relative to the stars, as it were), the frame can have a constant linear velocity and no rotation and still be inertial. Any other frame of reference is referred to as a *noninertial frame*. In many situations it is important to know whether the coordinate system you use is inertial or noninertial. In particular, we will see later that kinetic energy must be measured in an inertial system.

2.4 FORCES

A few general categories of forces are described here. We restrict our attention to those forces that are used in the examples that occur throughout this book. For example, we are not going to discuss forces associated with electromagnetic fields.

2.4.1 GRAVITATIONAL FORCES

Given two point masses m and M that have gravitational interaction, they attract each other with forces of equal magnitude but opposite direction, as indicated by Newton's third law. The common magnitude of the forces is

$$F_{\text{gravity}} = \frac{GmM}{r^2} \tag{2.46}$$

where r is the distance between the points and $G \doteq 6.67 \times 10^{-11}$ newton-meters2 per kilogram2. The units of G are selected, of course, so that F_{gravity} has units of newtons. The constant is empirically measured and is called the *universal gravitational constant*.

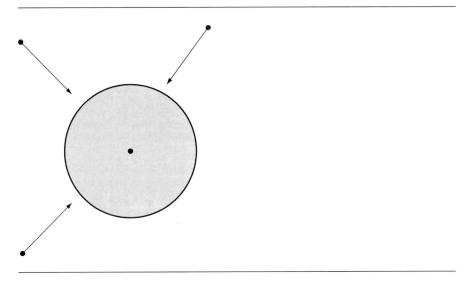

Figure 2.8 Gravitational forces on objects located at various places around the Earth.

In the special case of the Earth represented as a single-point mass M located at the center of the Earth and an object represented as a single-point mass m located on or above the Earth's surface, the gravitational force exerted on the object by the Earth is

$$\mathbf{F} = -F_{\text{gravity}}\mathbf{R} \qquad (2.47)$$

where \mathbf{R} is a unit-length vector whose direction is that of the vector from the center of the Earth to the center of the object. In the special case where the two objects are the Earth and the Sun, the equations of motion $\mathbf{F} = m\mathbf{a}$ that represent the path the Earth travels around the Sun may be solved in closed form to produce *Kepler's laws*. We do so in detail in Section 2.3. Figure 2.8 shows the Earth and the forces exerted on various objects above its surface.

If the object does not vary much in altitude and its position does not move far from its initial position, we can make an approximation to the equation of gravitational force by assuming that the Earth's surface is flat (a plane), at least within the vicinity of the object, and that the direction of the gravitational force is normal to the plane. Moreover, the distance r is approximately a constant, the radius of the Earth, so $g = GM/r^2 \doteq 9.81$ meters per second2 is approximately a constant. If we choose \mathbf{U} as the unit-length upward direction (increasing altitude above the plane), the gravitational force exerted on the object by the Earth is

$$\mathbf{F} = -mg\mathbf{U} \qquad (2.48)$$

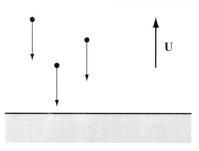

Figure 2.9 Gravitational forces on objects located nearly on the Earth's surface, viewed as a flat surface.

Figure 2.9 shows the Earth viewed as a flat surface and the forces exerted on various objects above it.

The *weight w* of the object is different than its mass, namely, $w = mg$, the magnitude of the gravitational force exerted on the object. Astronauts of course are weightless when in orbit, but still have the same mass as on the Earth's surface.

2.4.2 SPRING FORCES

One end of a spring is attached to a fixed point. The other end is free to be pushed or pulled in any direction. The unstretched length of the spring is L. Experiments have shown that for small displacements Δ of the end of the spring, the force exerted by the spring on the end has a magnitude proportional to $|\Delta|$ and a direction opposite that of the displacement. That is, if the end of the spring is pulled away from the fixed point, the direction of the force is toward the fixed point, and vice versa. If \mathbf{U} is a unit-length vector pointing in the direction from the fixed end to the free end, the force is

$$\mathbf{F} = -c\Delta\mathbf{U} \qquad (2.49)$$

where $c > 0$ is the constant of proportionality called the *spring constant*. For very stiff springs, c is large, and vice versa. This law for spring forces is known as *Hooke's law*. The law breaks down if $|\Delta|$ is very large, so be careful if you have a physics application involving springs; you might want to modify the force equation when $|\Delta|$ is large. Figure 2.10 illustrates a spring that is stretched or compressed.

Hooke's law will be applied in upcoming examples where we think of two points connected by an elastic line segment. This will be useful in modeling deformable objects as a system of masses connected by elastic threads.

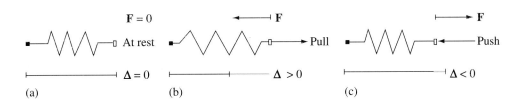

Figure 2.10 (a) Unstretched spring. (b) Force due to stretching the spring. (c) Force due to compressing the string.

2.4.3 FRICTION AND OTHER DISSIPATIVE FORCES

A *dissipative force* is one for which energy of the system decreases when motion takes place. Typically the energy is transferred out of the system by conversion to heat. A simple model for the magnitude of a dissipative force applied to a rigid object is

$$F_{\text{dissipative}} = c|\mathbf{v}|^n \tag{2.50}$$

where \mathbf{v} is the object's velocity, $c > 0$ is a scalar of proportionality, and $n \geq 0$ is an integer power. In most applications you probably will choose c to be a constant, but in general it may vary with position, for example, when the underlying material on which the object moves is not homogeneous. The value c may also vary with time. A simple model for a dissipative force also usually includes the assumption that the direction of the force is opposite the motion of the object, that is, in the direction $-\mathbf{v}$. In our applications in this book we will consider two special types of dissipative forces, *friction* and *viscosity*.

Friction

A *frictional force* between two objects in contact opposes the sliding of one (moving) object over the surface of the adjacent (nonmoving) object. The frictional force is tangent to the surface of the adjacent object and opposite in direction to the velocity of the moving object. The magnitude of the frictional force is assumed to be proportional to the magnitude of the *normal force* between surfaces. It is also assumed to be independent of the area of contact and independent of the speed of the object once that object starts to move. These assumptions argue that $n = 0$ in equation (2.50), so the frictional force is modeled as

$$\mathbf{F} = \begin{cases} -c_k \frac{\mathbf{v}}{|\mathbf{v}|}, & \mathbf{v} \neq \mathbf{0} \\ \mathbf{0}, & \mathbf{v} = \mathbf{0} \end{cases} \tag{2.51}$$

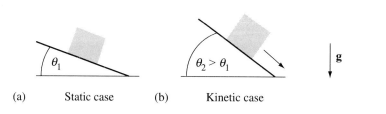

Figure 2.11 A block in contact with an inclined plane. (a) Static friction is dominant and the block remains at rest. (b) Gravity is dominant and the block slides, so kinetic friction applies.

where c_k is referred to as the *coefficient of kinetic friction*. The coefficient is the ratio of the magnitudes of frictional force over normal force, $c_k = F_{\text{friction}}/F_{\text{normal}}$, but with the correct physical units so that the right-hand side of equation (2.51) has units of force.

Physically the transition between the nonzero and zero force cases involves another concept called *static friction*. For example, if an object is in contact with a flat surface and initially not moving, an external force is applied to the object to make it move. If the magnitude of the external force is sufficiently small, it is not enough to exceed the force due to static friction. As that magnitude increases, eventually the static friction is overcome and the object moves. At that instant the frictional force switches from static to kinetic; that is, the first case in equation (2.51) comes into play since the object is now moving. Another physical constant is the *coefficient of static friction*, denoted c_s. It is the ratio of the maximum frictional force over normal force, $c_s = \max(F_{\text{friction}})/F_{\text{normal}}$, and with the correct physical units assigned to it. The classical experiment to illustrate the transition from the static to the kinetic case is a block of one material resting on an inclined plane of another material. Both materials are subject to gravitational force. Figure 2.11 illustrates.

Initially the angle of incline is small enough so that the static friction force dominates the gravitational force. The block remains at rest even though the plane is tilted. As the angle of incline increases, the gravitational force exerts a stronger influence on the block, enough so that it overcomes static friction. At that instant the block starts to slide down the plane. When it does, the frictional force switches from static to kinetic.

Viscosity

A *viscous* force has magnitude, modeled by equation (2.50), when $n = 1$. The typical occurrence of this type of force is when an object is dragged through a thick fluid.

The force is modeled to have direction opposite to that of the moving object:

$$\mathbf{F} = -F_{\text{dissipative}} \frac{\mathbf{v}}{|\mathbf{v}|} = -(c|\mathbf{v}|) \frac{\mathbf{v}}{|\mathbf{v}|} = -c\mathbf{v} \tag{2.52}$$

where $c > 0$ is a scalar of proportionality. Unlike friction that has a discontinuity when the speed is zero, a viscous force is continuous with respect to speed.

2.4.4 TORQUE

The concept of torque is one you are familiar with in everyday life. One example is replacing a tire on an automobile. You have to remove the lug nuts with a wrench. In order to turn a nut, you have to exert a force on the end of the wrench. The more force you apply, the easier the nut turns. You might also have noticed that the longer the wrench, the easier the nut turns. The ease of turning is proportional to both the magnitude of the applied force and the length of the wrench. This product is referred to as *torque* or *moment of force*. When you need a nut tightened, but not too much, you can use a tool called a torque wrench that is designed to stop turning the nut if the torque exceeds a specified amount.

The formal mathematical definition for torque applied to a single particle of mass m is given below. Let \mathbf{F} be the applied force. Let \mathbf{r} be the position of the particle relative to the origin. The torque is the quantity

$$\boldsymbol{\tau} = \mathbf{r} \times \mathbf{F} \tag{2.53}$$

In the analogy of a wrench and bolt, the bolt is located at the origin, the wrench lies along the vector \mathbf{r}, and the force \mathbf{F} is what you exert on the end of the wrench. Figure 2.12 illustrates torque due to a single force.

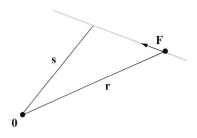

Figure 2.12 Torque from a force exerted on a particle.

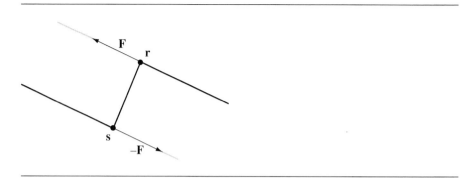

Figure 2.13 A force couple.

Notice that **F** is not necessarily perpendicular to **r**. The applied force on the particle can be in any direction, independent of the position of the particle. The gray line indicates the line of force for **F**. If the particle were on that line at a different position **s** relative to the origin, the torque on it is $\mathbf{s} \times \mathbf{F}$. Since $\mathbf{r} - \mathbf{s}$ is a vector on the line of force, it must be that $(\mathbf{r} - \mathbf{s}) \times \mathbf{F} = \mathbf{0}$. That is, $\mathbf{r} \times \mathbf{F} = \mathbf{s} \times \mathbf{F}$ and the torque is the same no matter where the particle is located along the line of force.

Two forces of equal magnitude, opposite direction, but different lines of action are said to be a *couple*. Figure 2.13 shows two such forces. The torque due to the couple is $\boldsymbol{\tau} = (\mathbf{r} - \mathbf{s}) \times \mathbf{F}$. The location of **r** and **s** on their respective lines is irrelevant. As you vary **r** along its line, the torque does not change. Neither does the torque change when you vary **s** along its line.

For a system of p particles located at positions \mathbf{r}_i with applied forces \mathbf{F}_i for $1 \le i \le p$, the torque is

$$\boldsymbol{\tau} = \sum_{i=1}^{p} \mathbf{r}_i \times \mathbf{F}_i \tag{2.54}$$

If the object is a continuum of mass that occupies a region R, the torque is

$$\boldsymbol{\tau} = \int_R \mathbf{r} \times \mathbf{F} \, dR \tag{2.55}$$

where **F** is the applied force that varies with position **r**.

Important: The torque due to internal forces in an object must sum to zero. This is an immediate consequence of Newton's third law. The essence of the argument is in considering two points in the object. The first point is at position \mathbf{r}_1 and exerts a force **F** on the second point at position \mathbf{r}_2. The second point exerts a force $-\mathbf{F}$ on the first point (Newton's third law). The lines of force are the same, having direction

F and containing both positions \mathbf{r}_1 and \mathbf{r}_2. The total torque for the two points is $\mathbf{r}_1 \times \mathbf{F} + \mathbf{r}_2 \times (-\mathbf{F}) = (\mathbf{r}_1 - \mathbf{r}_2) \times \mathbf{F} = \mathbf{0}$. The last equality is true since $\mathbf{r}_1 - \mathbf{r}_2$ is on the line of force.

2.4.5 EQUILIBRIUM

Forces on an object are said to be *concurrent* if their lines of action all pass through a common point. If an object is a point mass, then all forces acting on the object are concurrent, the common point being the object itself. An example of nonconcurrent forces is a rigid rod with opposite direction forces applied at the end points. Figure 2.14 illustrates. The forces at the end points of the rod are parallel, but the lines through the end points and whose directions are those of the forces do not

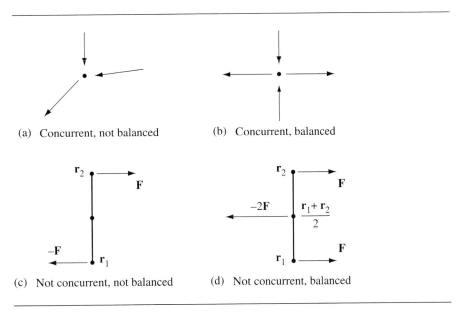

(a) Concurrent, not balanced (b) Concurrent, balanced

(c) Not concurrent, not balanced (d) Not concurrent, balanced

Figure 2.14 (a) All forces applied to a point mass are concurrent but are not "balanced," so the point moves. (b) All forces are concurrent but do balance, so the point does not move. (c) A rigid rod with nonconcurrent forces applied to the end points. The forces are equal in magnitude but opposite in direction. The rod rotates about its center. (d) Nonconcurrent forces are applied to three locations; two forces of equal magnitudes and directions at the end points and one force of twice the magnitude of an end-point force but opposite in direction applied to the rod center. The rod is "balanced" and does not rotate about its center.

intersect in a common point, so those forces are not concurrent. In Figure 2.14(c), (d) the forces lead to a torque about the center of the rod.

An object is said to be in *equilibrium* if two conditions are met. The first condition is that the sum of all external forces acting on the object must be zero. That is, if \mathbf{F}_i for $1 \leq i \leq n$ are the external forces, then $\sum_{i=1}^{n} \mathbf{F}_i = \mathbf{0}$. The second condition is that the torques on the object must sum to zero, as we see intuitively in Figure 2.14(c), (d). The two end points have mass, but the rod connecting them is assumed to be massless. Let the lower end point be at position \mathbf{r}_1 and the upper end point be at position \mathbf{r}_2. Let the force applied to the upper point be \mathbf{F} and the force applied to the lower point be $-\mathbf{F}$. We have a force couple with total torque $\boldsymbol{\tau} = \mathbf{r}_2 \times \mathbf{F} + \mathbf{r}_1 \times (-\mathbf{F}) = (\mathbf{r}_2 - \mathbf{r}_1) \times \mathbf{F}$. The torque is a nonzero vector perpendicular to the plane of the diagram. This configuration is not in equilibrium even though the sum of the forces is $\mathbf{F} + (-\mathbf{F}) = \mathbf{0}$. In Figure 2.14(d), the center point is $(\mathbf{r}_1 + \mathbf{r}_2)/2$. The system shown has a total torque of zero, assuming the vectors at the end points are both \mathbf{F} and the vector at the center point $(\mathbf{r}_1 + \mathbf{r}_2)/2$ is $-2\mathbf{F}$. The total torque is $\boldsymbol{\tau} = \mathbf{r}_1 \times \mathbf{F} + \mathbf{r}_2 \times \mathbf{F} + (\mathbf{r}_1 + \mathbf{r}_2)/2 \times (-2\mathbf{F}) = \mathbf{0}$. This system is in equilibrium since the forces sum to zero and the torques sum to zero.

An important observation is that an object in equilibrium is not necessarily stationary. It is possible that the inertial frame in which the object is measured is moving with constant velocity. However, another coordinate system may be chosen in which the object is not moving. A simple example, to a first approximation, is the fact that you are currently reading this book while in equilibrium sitting in your chair, even though the Earth is rotating with an angular speed of 1000 miles per hour! The first approximation is that your current physical location moves along a straight line with constant velocity, at least over a short period of time, thus making it an inertial frame.

For a single particle, the second condition for equilbrium is a consequence of the first condition. Let the particle be located at \mathbf{r} and let the applied forces be \mathbf{F}_i for $1 \leq i \leq n$. Assume that the sum of forces is zero, $\sum_{i=1}^{n} \mathbf{F}_i = 0$. The total torque on the particle is

$$\boldsymbol{\tau} = \sum_{i=1}^{n} \mathbf{r} \times \mathbf{F}_i = \mathbf{r} \times \sum_{i=1}^{n} \mathbf{F}_i = \mathbf{r} \times \mathbf{0} = \mathbf{0}$$

For a particle system whose external forces sum to zero, the total torque is not necessarily zero, in which case the second condition for equilibrium is independent of the first. However, it is true that the torque relative to one point is the same as the torque relative to another. Let the particles be at positions \mathbf{r}_i for $1 \leq i \leq p$. Let the forces on particle i be $\mathbf{F}_j^{(i)}$ for $1 \leq j \leq n_i$ (the number of forces per particle may vary). The torque relative to an origin \mathbf{A} for a single particle subject to a single force is

$$(\mathbf{r}_i - \mathbf{A}) \times \mathbf{F}_j^{(i)}$$

The total torque for the particle is

$$\sum_{j=1}^{n_i} (\mathbf{r}_i - \mathbf{A}) \times \mathbf{F}_j^{(i)}$$

The total torque for the particle system, relative to origin **A**, is

$$\tau_{\mathbf{A}} = \sum_{i=1}^{p} \sum_{j=1}^{n_i} (\mathbf{r}_i - \mathbf{A}) \times \mathbf{F}_j^{(i)} = \sum_{i=1}^{p} (\mathbf{r}_i - \mathbf{A}) \times \mathbf{G}^{(i)}$$

where

$$\mathbf{G}^{(i)} = \sum_{j=1}^{n_i} \mathbf{F}_j^{(i)}$$

is the total applied force on particle i. The total torque relative to another origin **B** is

$$\tau_{\mathbf{B}} = \sum_{i=1}^{p} (\mathbf{r}_i - \mathbf{B}) \times \mathbf{G}^{(i)}$$

The difference is

$$\tau_{\mathbf{A}} - \tau_{\mathbf{B}} = \sum_{i=1}^{p} (\mathbf{B} - \mathbf{A}) \times \mathbf{G}^{(i)} = (\mathbf{B} - \mathbf{A}) \times \sum_{i=1}^{p} \mathbf{G}^{(i)} = (\mathbf{B} - \mathbf{A}) \times \mathbf{0} = \mathbf{0}$$

where the $\mathbf{G}^{(i)}$ summing to zero is the mathematical statement that the net force on the particle system is zero. Thus, $\tau_{\mathbf{A}} = \tau_{\mathbf{B}}$ and the torque is the same about any point. A similar argument applies to a continuum of mass. When setting up equations of equilibrium, it is enough to require the sum of the external forces to be zero *and* the torque about a single point to be zero.

2.5 MOMENTA

In this section we are presented with the definitions for various physical quantities that are relevant to understanding the motion of an object undergoing external forces. We already saw one such quantity, torque. The first portion of this section introduces the concepts of linear and angular momentum. The second portion covers the concept you should be most familiar with, mass of an object. We derive formulas for computing the center of mass of an object, whether it consists of a finite number of point masses (discrete) or is a solid body (continuous). The construction of the center of mass involves a quantity called a *moment*, a summation for discrete masses and an

integral for continuous masses. The third portion discusses moments and products of inertia, a topic that is particularly important when discussing motion of a rigid body.

2.5.1 LINEAR MOMENTUM

We have already seen the concept of *linear momentum* in the presentation of Newton's second law of motion for a single particle. The linear momentum is the product,

$$\mathbf{p} = m\mathbf{v} \tag{2.56}$$

where m is the mass of the particle and \mathbf{v} is its velocity. The applied force and momentum are related by $\mathbf{F} = d\mathbf{p}/dt$; that is, an applied force on the particle causes a change in its linear momentum. For a system of p particles of masses m_i and velocities \mathbf{v}_i for $1 \le i \le p$, the linear momentum is

$$\mathbf{p} = \sum_{i=1}^{p} m_i \mathbf{v}_i \tag{2.57}$$

If the object is a continuum of mass that occupies a region R, the linear momentum is

$$\mathbf{p} = \int_R \mathbf{v}\, dm = \int_R \delta \mathbf{v}\, dR \tag{2.58}$$

where $dm = \delta\, dR$ is an infinitesimal measurement of mass. The function δ is the mass density. The density and velocity \mathbf{v} may depend on spatial location; they cannot be factored outside the integral. In a loose sense the integration over the region is a summation of the linear momenta of the infinitely many particles occupying that region. You will find the trichotomy represented by equations (2.56), (2.57), and (2.58) throughout the rest of this book. We will consider physical systems that consist of a single particle, of multiple particles, or of a continuum of mass.

An important physical law is the *conservation of linear momentum*. The law states that if the net external force on a system of objects is zero, the linear momentum is a constant. This law is an immediate consequence of Newton's second law. In the single particle case, if \mathbf{F}_i for $1 \le i \le n$ are the external forces acting on the particle, then

$$\mathbf{0} = \sum_{i=1}^{n} \mathbf{F}_i = \frac{d(m\mathbf{v})}{dt} = \frac{d\mathbf{p}}{dt}$$

The derivative of \mathbf{p} is the zero vector, which implies that \mathbf{p} is a constant. Similar arguments apply in the cases of a discrete system and of a continuous system.

2.5.2 ANGULAR MOMENTUM

Linear momentum has some intuition about it. You think of it as a measure of inertia, the tendency to *remain in motion along a straight line* in the absence of any external forces. *Angular momentum* is less intuitive but is similar in nature. The quantity measures the tendency to *continue rotating about an axis*. For a single particle of mass m, the angular momentum of that particle about the origin is

$$\mathbf{L} = \mathbf{r} \times \mathbf{p} = \mathbf{r} \times m\mathbf{v} \tag{2.59}$$

where \mathbf{r} is the vector from the origin to the particle and \mathbf{v} is the velocity of the particle. The angular momentum vector \mathbf{L} is necessarily perpendicular to both \mathbf{r} and \mathbf{v}. The direction of \mathbf{L} is that of the axis of rotation at each instant of time. For a system of p particles of masses m_i, positions \mathbf{r}_i relative to the origin, and velocities \mathbf{v}_i for $1 \le i \le p$, the angular momentum is

$$\mathbf{L} = \sum_{i=1}^{p} \mathbf{r}_i \times m_i \mathbf{v}_i \tag{2.60}$$

If the object is a continuum of mass that occupies a region R, the angular momentum is

$$\mathbf{L} = \int_R \mathbf{r} \times \mathbf{v} \, dm = \int_R \delta \, \mathbf{r} \times \mathbf{v} \, dR \tag{2.61}$$

where $dm = \delta \, dR$ is an infinitesimal measurement of mass. The function δ is the mass density. The density, position \mathbf{r}, and velocity \mathbf{v} may depend on spatial location.

Just as force is the time derivative of linear momentum, torque is the time derivative of angular momentum. To see this, differentiate equation (2.59) with respect to time:

$$\frac{d\mathbf{L}}{dt} = \frac{d(\mathbf{r} \times \mathbf{p})}{dt} \qquad \text{From equation (2.59)}$$

$$= \mathbf{r} \times \frac{d\mathbf{p}}{dt} + \frac{d\mathbf{r}}{dt} \times \mathbf{p} \qquad \text{Using the chain rule} \tag{2.62}$$

$$= \mathbf{r} \times \mathbf{F} \qquad \text{From Newton's second law and } \mathbf{v} \times \mathbf{v} = \mathbf{0}$$

$$= \tau \qquad \text{From equation (2.53)}$$

Similar constructions may be applied to the pair of equations (2.60) and (2.54) or to the pair (2.61) and (2.55).

Another important physical law is the *conservation of angular momentum*. The law states that if the net external force on a system of objects is zero, the angular momentum is a constant. The proof is similar to that of the conservation of linear

momentum. In the single particle case, if \mathbf{F}_i for $1 \le i \le n$ are the external forces acting on the particle, then

$$\frac{d\mathbf{L}}{dt} = \sum_{i=1}^{n} \mathbf{r} \times \mathbf{F}_i = \mathbf{r} \times \sum_{i=1}^{n} \mathbf{F}_i = \mathbf{r} \times \mathbf{0} = \mathbf{0}$$

The derivative of \mathbf{L} is the zero vector, which implies that \mathbf{L} is a constant. Similar arguments apply in the cases of a discrete system and of a continuous system.

2.5.3 CENTER OF MASS

In many mechanical systems, each object can behave as if its mass is concentrated at a single point. The location of this point is called the *center of mass* of the object. This section shows how to define and compute the center of mass in one, two, and three dimensions, both for discrete sets of points and continuous materials.

Discrete Mass in One Dimension

Consider two masses m_1 and m_2 on the x-axis at positions x_1 and x_2. The line segment connecting the two points is assumed to have negligible mass. Gravity is assumed to exert itself in the downward direction. You can imagine this system as a child's seesaw that consists of a wooden plank, a supporting base placed somewhere between the ends of the plank, and two children providing the masses at the ends. Figure 2.15 illustrates the system. The supporting base is drawn as a wedge whose uppermost vertex is positioned at \bar{x}.

If we select $\bar{x} = x_1$, clearly the system is not balanced since the torque induced by the mass m_2 will cause that mass to fall to the ground. Similarly, the system is not balanced for $\bar{x} = x_2$. Your intuition should tell you that there is a proper choice of \bar{x} between x_1 and x_2 at which the system is balanced. If $m_1 = m_2$, the symmetry of the situation suggests that $\bar{x} = (x_1 + x_2)/2$, the midpoint of the line segment. For different masses, the choice of \bar{x} is not immediately clear, but we can rely on equilibrium of forces to help us. The force on mass m_i due to gravity g is $m_i g$. The

Figure 2.15 Balancing discrete masses on a line. The center of mass for two masses viewed as the balance point for a seesaw on a fulcrum.

torque for mass m_i about the position \bar{x} is $m_i g (x_i - \bar{x})$. For the system to balance at \bar{x}, the total torque must be zero,

$$0 = m_1 g (x_1 - \bar{x}) + m_2 g (x_2 - \bar{x}) = g [(m_1 x_1 + m_2 x_2) - (m_1 + m_2)\bar{x}]$$

The solution to the equation is

$$\bar{x} = \frac{m_1 x_1 + m_2 x_2}{m_1 + m_2} = \frac{m_1}{m_1 + m_2} x_1 + \frac{m_2}{m_1 + m_2} x_2 = w_1 x_1 + w_2 x_2 \qquad (2.63)$$

which is a weighted average of the positions of the masses called the *center of mass*. If m_1 is larger than m_2, your intuition should tell you that the center of mass should be closer to x_1 than to x_2. The coefficient of x_1, $w_1 = m_1/(m_1 + m_2)$, is larger than the coefficient of x_2, $w_2 = m_2/(m_1 + m_2)$, so in fact the center of mass is closer to x_1, as expected.

A similar formula is derived for the center of mass \bar{x} of p masses m_1 through m_p located at positions x_1 through x_p. The total torque is zero, $\sum_{i=1}^{p} m_i g (x_i - \bar{x}) = 0$, the solution being

$$\bar{x} = \frac{\sum_{i=1}^{p} m_i x_i}{\sum_{i=1}^{p} m_i} = \sum_{i=1}^{p} \frac{m_i}{\sum_{j=1}^{p} m_j} x_i = \sum_{i=1}^{p} w_i x_i \qquad (2.64)$$

The sum $\sum_{i=1}^{p} m_i$ is the *total mass of the system* and the sum $\sum_{i=1}^{p} m_i x_i$ is the *moment of the system about the origin*.

Continuous Mass in One Dimension

The center of mass for a discrete set of masses was simple enough to compute. All you need are the masses themselves and their locations on the x-axis. However, you might very well be interested in computing the center of mass for a wire of finite length. Let us assume that the end points of the wire are located at a and b, with $a < b$. The wire consists of a continuum of particles, infinitely many, so to speak. Each particle has an infinitesimal amount of mass—call this dm—and is located at some position x. The infinitesimal mass is distributed over an infinitesimal interval of length dx. The mass values can vary over this interval, so we need to know the mass density $\delta(x)$ at each point x. The units of density are mass per unit length, from which it follows $dm = \delta(x)\,dx$. Figure 2.16 is the continuous analogy of Figure 2.15. The gray levels are intended to illustrate varying density, dark levels for large density and light levels for small density.

The infinitesimal force due to gravity is $g\,dm$ and the infinitesimal torque about a position \bar{x} is $(x - \bar{x})g\,dm$. For \bar{x} to be the center of mass, the total torque must be zero. You should recognize this as a problem suited for calculus. The summation that

Figure 2.16 Balancing continuous masses on a line. The center of mass for the wire is viewed as the balance point for a seesaw on a fulcrum. A general point location x is shown, labeled with its corresponding mass density $\delta(x)$.

occurred for discrete point sets is replaced by integration for a continuum of points. The equilibrium condition for torque is

$$\int_a^b (x - \bar{x})\, g\, dm = g \int_a^b (x - \bar{x})\delta(x)\, dx = 0$$

This equation can be solved to produce the center of mass:

$$\bar{x} = \frac{\int_a^b x\delta(x)\, dx}{\int_a^b \delta(x)\, dx} \tag{2.65}$$

The integral $\int_a^b \delta\, dx$ is the *total mass of the system* and the integral $\int_a^b x\delta\, dx$ is the *moment of the system about the origin*. If the density of the system is constant, say, $\delta(x) = c$ for all x, equation (2.65) reduces to

$$\bar{x} = \frac{\int_a^b xc\, dx}{\int_a^b c\, dx} = \frac{\int_a^b x\, dx}{\int_a^b dx} = \frac{(b^2 - a^2)/2}{b - a} = \frac{b + a}{2}$$

As expected, the center of mass for a constant density wire is situated at the midpoint of the wire.

Discrete Mass in Two Dimensions

The extension of the computation of the center of mass from one to two dimensions is straightforward. Let the p masses be m_i and located at (x_i, y_i) for $1 \leq i \leq p$. Imagine these lying on a thin, massless plate. Gravity is assumed to exert itself in the downward direction; the magnitude of the force is g. The center of mass is the point (\bar{x}, \bar{y}), such that the plate balances when placed on a support at that location. Figure 2.17 illustrates this.

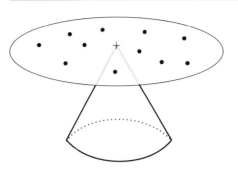

Figure 2.17 Balancing discrete masses in a plane.

The gravitational force exerted on each mass is $m_i g$. The torque about (\bar{x}, \bar{y}) is $m_i g(x_i - \bar{x}, y_i - \bar{y})$. The total torque must be the zero vector,

$$\sum_{i=1}^{p} m_i g(x_i - \bar{x}, y_i - \bar{y}) = (0, 0)$$

The equation is easily solved to produce the center of mass:

$$(\bar{x}, \bar{y}) = \frac{\sum_{i=1}^{p} m_i(x_i, y_i)}{\sum_{i=1}^{p} m_i} = \left(\frac{\sum_{i=1}^{p} m_i x_i}{\sum_{i=1}^{p} m_i}, \frac{\sum_{i=1}^{p} m_i y_i}{\sum_{i=1}^{p} m_i} \right) \qquad (2.66)$$

The sum $m = \sum_{i=1}^{p} m_i$ is the *total mass of the system*. The sum $M_y = \sum_{i=1}^{p} m_i x_i$ is the *moment of the system about the y-axis* and the sum $M_x = \sum_{i=1}^{p} m_i y_i$ is the *moment of the system about the x-axis*.

The center of mass formula has some interesting interpretations. First, observe that if you look only at the x-components of the mass locations (i.e., project the masses onto the x-axis), \bar{x} is the center of mass of the projected points. Similarly, \bar{y} is the center of mass of the points projected onto the y-axis. Second, observe that the thin, massless plate containing the masses balances when placed on a fulcrum whose top edge contains the center of mass and is parallel to either of the coordinate axes. Figure 2.18 illustrates this.

EXERCISE Ⓔ Show that the plate balances on a fulcrum containing the center of mass *regardless* of
2.9 the fulcrum's orientation. ▪

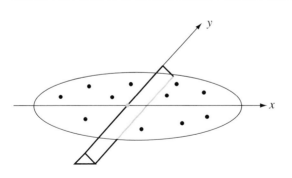

Figure 2.18 Balancing discrete masses in a plane on a fulcrum.

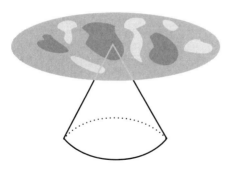

Figure 2.19 Balancing continuous masses in a plane. The shades of gray indicate variable mass density.

Continuous Mass in Two Dimensions

Now let us consider the case of a continuum of mass that lies in a bounded region R in the xy-plane. As in the one-dimensional case, each point in the region has an associated infinitesimal mass, dm. The mass is distributed over an infinitesimal rectangle of size dx by dy and having area $dA = dx\, dy$, the distribution represented by a density function $\delta(x, y)$ with units of mass per unit area. Thus, the infinitesimal mass is $dm = \delta\, dA = \delta\, dx\, dy$. Figure 2.19 illustrates.

The infinitesimal torque relative to a location (\bar{x}, \bar{y}) is $(x - \bar{x}, y - \bar{y})g\,dm$. The equilibrium condition is

$$\iint_R (x - \bar{x}, y - \bar{y})g\,dm = 0$$

The center of mass is obtained by solving this equation:

$$\begin{aligned}
(\bar{x}, \bar{y}) &= \frac{\iint_R (x, y)\delta(x, y)\,dx\,dy}{\iint_R \delta(x, y)\,dx\,dy} \\[2mm]
&= \left(\frac{\iint_R x\,\delta(x, y)\,dx\,dy}{\iint_R \delta(x, y)\,dx\,dy}, \frac{\iint_R y\,\delta(x, y)\,dx\,dy}{\iint_R \delta(x, y)\,dx\,dy} \right)
\end{aligned} \tag{2.67}$$

The integral $m = \iint_R \delta\,dx\,dy$ is the *total mass of the system*. The integral $M_y = \iint_R x\delta\,dx\,dy$ is the *moment of the system about the y-axis* and the integral $M_x = \iint_R y\delta\,dx\,dy$ is the *moment of the system about the x-axis*.

EXAMPLE 2.3

Consider the region R bounded by the parabola $y = x^2$ and the line $y = 1$. Let the mass density be constant, $\delta(x, y) = 1$ for all (x, y). Figure 2.20 shows the region.

Your intuition should tell you that the center of mass must lie on the y-axis, $\bar{x} = 0$, and the value \bar{y} should be closer to $y = 1$ than it is to $y = 0$. The total mass of the system is

$$m = \iint_R dy\,dx = \int_{-1}^{1} \int_{x^2}^{1} dy\,dx = \int_{-1}^{1} 1 - x^2\,dx = \frac{4}{3}$$

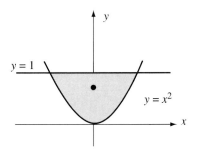

Figure 2.20 A continuous mass bounded by a parabola and a line.

*(Example 2.3
continued)*

The moment about the y-axis is

$$M_y = \iint_R x \, dy \, dx = \int_{-1}^{1} \int_{x^2}^{1} x \, dy \, dx = \int_{-1}^{1} x(1 - x^2) \, dx = \left. \frac{x^2}{2} - \frac{x^4}{4} \right|_{-1}^{1} = 0$$

The moment about the x-axis is

$$M_x = \iint_R y \, dy \, dx = \int_{-1}^{1} \int_{x^2}^{1} y \, dy \, dx = \int_{-1}^{1} \frac{1 - x^4}{2} \, dx = \frac{4}{5}$$

The center of mass is therefore $(\bar{x}, \bar{y}) = (M_y, M_x)/m = (0, 3/5)$. As predicted, the center of mass is on the y-axis and is closer to $y = 1$ than to $y = 0$. ▪

In many situations the continuous mass is in a bounded region with positive area. But we must also consider the case where the mass is distributed along a curve. The typical physical example is one of computing the center of mass of a planar wire whose mass density varies with arc length along the wire. Let the curve be continuously differentiable and specified parametrically by $(x(t), y(t))$ for $t \in [a, b]$. In terms of arc length s, the mass density is $\bar{\delta}(s)$. In terms of the curve parameter, it is specified parametrically as $\delta(t)$. The infinitesimal mass at the position corresponding to t is distributed over an infinitesimal arc length ds of the wire. The infinitesimal mass is $dm = \delta(t) \, ds$, where $ds = \sqrt{\dot{x}^2 + \dot{y}^2} \, dt$ for parametric curves (again, the dot symbol denotes differentiation with respect to t). The total mass of the wire is therefore

$$m = \int_0^L \bar{\delta}(s) \, ds = \int_a^b \delta(t) \sqrt{\dot{x}^2 + \dot{y}^2} \, dt$$

where s is the arc length parameter and L is the total length of the curve. The rightmost integral is the formulation in terms of the curve parameter, making it the integral that is actually evaluated. The moment about the y-axis is

$$M_y = \int_0^L x \bar{\delta}(s) \, ds = \int_a^b x(t) \delta(t) \sqrt{\dot{x}^2 + \dot{y}^2} \, dt$$

and the moment about the x-axis is

$$M_x = \int_0^L y \bar{\delta}(s) \, ds = \int_a^b y(t) \delta(t) \sqrt{\dot{x}^2 + \dot{y}^2} \, dt$$

The center of mass is

$$(\bar{x}, \bar{y}) = \frac{(M_y, M_x)}{m}$$

$$= \frac{\left(\int_a^b x(t)\delta(t) \sqrt{\dot{x}^2 + \dot{y}^2}\, dt, \int_a^b y(t)\delta(t) \sqrt{\dot{x}^2 + \dot{y}^2}\, dt\right)}{\int_a^b \delta(t) \sqrt{\dot{x}^2 + \dot{y}^2}\, dt} \tag{2.68}$$

EXAMPLE 2.4

Compute the center of mass for a wire of constant density 1 and that lies on the hemicircle $x^2 + y^2 = 1$ for $y \geq 0$, as shown in Figure 2.21.

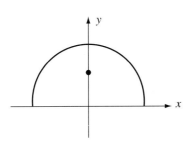

Figure 2.21

A continuous mass in the shape of a hemicircle.

By symmetry, the center of mass should lie on the y-axis, $\bar{x} = 0$, so let us calculate only the value for \bar{y}. The curve is parameterized by $(x(t), y(t)) = (\cos(t), \sin(t))$ for $t \in [0, \pi]$. The derivative of the curve is $(x'(t), y'(t)) = (-\sin(t), \cos(t))$. The total mass is

$$m = \int_0^\pi \sqrt{\dot{x}^2 + \dot{y}^2}\, dt = \int_0^\pi dt = \pi$$

The length of the hemicircle is π units of distance, but keep in mind that the units of mass are not distance. The moment about the x-axis is

$$M_x = \int_0^\pi y(t)\sqrt{\dot{x}^2 + \dot{y}^2}\, dt = \int_0^\pi \sin(t)\, dt = 2$$

The y-value for the center of mass is therefore $\bar{y} = M_x/m = 2/\pi \doteq 0.64$. The center of mass is clearly not on the wire itself. If the wire were to be placed on a thin, massless plate, the balancing point for the plate and wire would be at $(0, 2/\pi)$. ▪

EXERCISE 2.10 Ⓜ

Show that the center of mass for the half-disk $x^2 + y^2 \leq 1$, with $y \geq 0$, has $\bar{x} = 0$ and $\bar{y} = 4/(3\pi) \doteq 0.42$. The y-value is smaller than that of the wire, as is to be expected since the additional mass inside the hemicircle should bias the y-value toward the origin. ▪

Discrete Mass in Three Dimensions

Let the p masses be m_i and located at (x_i, y_i, z_i) for $1 \leq i \leq p$. Imagine these lying within a massless gel. Gravity is assumed to exert itself in the downward direction; the magnitude of the force is g. The center of mass is the point $(\bar{x}, \bar{y}, \bar{z})$, such that the gel balances when a support is embedded at that location. The gravitational force exerted on each mass is $m_i g$. The torque about $(\bar{x}, \bar{y}, \bar{z})$ is $m_i g(x_i - \bar{x}, y_i - \bar{y}, z_i - \bar{z})$. The total torque must be the zero vector,

$$\sum_{i=1}^{p} m_i g(x_i - \bar{x}, y_i - \bar{y}, z_i - \bar{z}) = (0, 0, 0)$$

The equation is easily solved to produce the center of mass:

$$(\bar{x}, \bar{y}, \bar{z}) = \frac{\sum_{i=1}^{p} m_i(x_i, y_i, z_i)}{\sum_{i=1}^{p} m_i} = \left(\frac{\sum_{i=1}^{p} m_i x_i}{\sum_{i=1}^{p} m_i}, \frac{\sum_{i=1}^{p} m_i y_i}{\sum_{i=1}^{p} m_i}, \frac{\sum_{i=1}^{p} m_i z_i}{\sum_{i=1}^{p} m_i} \right) \quad (2.69)$$

The sum $m = \sum_{i=1}^{p} m_i$ is the *total mass of the system*. The sum $M_{yz} = \sum_{i=1}^{p} m_i x_i$ is the *moment of the system about the yz-plane*, the sum $M_{xz} = \sum_{i=1}^{p} m_i y_i$ is the *moment of the system about the xz-plane*, and the sum $M_{xy} = \sum_{i=1}^{p} m_i z_i$ is the *moment of the system about the xy-plane*.

Continuous Mass in Three Dimensions

We have three different possibilities to consider. The mass can be situated in a bounded volume, on a surface, or along a curve.

Volume Mass

In the case of a bounded volume V, the infinitesimal mass dm at (x, y, z) is distributed in an infinitesimal cube with dimensions dx, dy, and dz and volume $dV = dx\, dy\, dz$. The density of the distribution is $\delta(x, y, z)$, so the infinitesimal mass is $dm = \delta\, dV = \delta\, dx\, dy\, dz$. The total torque is the zero vector,

$$\iiint_V (x - \bar{x}, y - \bar{y}, z - \bar{z})g\, dm = 0$$

The center of mass is obtained by solving this equation:

$$(\bar{x}, \bar{y}, \bar{z}) = \frac{\iiint_V (x, y, z)\delta\, dx\, dy\, dz}{\iiint_V \delta\, dx\, dy\, dz}$$

$$= \left(\frac{\iiint_V x\, \delta\, dx\, dy\, dz}{\iiint_V \delta\, dx\, dy\, dz}, \frac{\iiint_V y\, \delta\, dx\, dy\, dz}{\iiint_V \delta\, dx\, dy\, dz}, \frac{\iiint_V z\, \delta\, dx\, dy\, dz}{\iiint_V \delta\, dx\, dy\, dz} \right) \quad (2.70)$$

The integral $m = \iiint_V \delta \, dx \, dy \, dz$ is the *total mass of the system*. The integral $M_{yz} = \iiint_V x\delta \, dx \, dy \, dz$ is the *moment of the system about the yz-plane*, the integral $M_{xz} = \iiint_V y\delta \, dx \, dy \, dz$ is the *moment of the system about the xz-plane*, and the integral $M_{xy} = \iiint_V z\delta \, dx \, dy \, dz$ is the *moment of the system about the xy-plane*.

EXAMPLE 2.5

Compute the center of mass of the solid hemisphere $x^2 + y^2 + z^2 \le 1$, with $z \ge 0$, assuming the density is a constant $\delta \equiv 1$. From the symmetry, we know that $\bar{x} = \bar{y} = 0$. The numerical value of the total mass should be the same as the volume of the hemisphere, $m = 2\pi/3$. Let us verify that anyway. The mass integral is computed using a change to spherical coordinates:

$$m = \iiint_V dx \, dy \, dz$$

$$= \int_0^{\pi/2} \int_0^1 \int_0^{2\pi} \rho^2 \sin\phi \, d\theta \, d\rho \, d\phi$$

$$= \left(\int_0^{\pi/2} \sin\phi \, d\phi \right) \left(\int_0^1 \rho^2 \, d\rho \right) \left(\int_0^{2\pi} d\theta \right)$$

$$= (1)(1/3)(2\pi)$$

$$= 2\pi/3$$

The moment about the xy-plane is

$$M_{xy} = \iiint_V z \, dx \, dy \, dz$$

$$= \int_0^{\pi/2} \int_0^1 \int_0^{2\pi} (\rho \cos\phi)\rho^2 \sin\phi \, d\theta \, d\rho \, d\phi$$

$$= \left(\int_0^{\pi/2} \sin\phi \cos\phi \, d\phi \right) \left(\int_0^1 \rho^3 \, d\rho \right) \left(\int_0^{2\pi} d\theta \right)$$

$$= (1/2)(1/4)(2\pi)$$

$$= \pi/4$$

The z-value of the center of mass is $\bar{z} = M_{xy}/m = 3/8 = 0.375$. As you might have predicted, the point is closer to the xy-plane than to the pole of the hemisphere. ∎

Surface Mass

In the case of a bounded surface S, the infinitesimal mass dm at (x, y, z) is distributed in an infinitesimal surface area dS. The representation of dS depends on

how the surface is defined. If the surface is the graph of the function $z = f(x, y)$, then

$$dS = \sqrt{1 + \left(\frac{\partial f}{\partial x}\right)^2 + \left(\frac{\partial f}{\partial y}\right)^2}\, dx\, dy$$

If the surface is defined parametrically as $\mathbf{P}(u, v) = (x(u, v), y(u, v), z(u, v))$, then

$$dS = \left|\frac{\partial \mathbf{P}}{\partial u} \times \frac{\partial \mathbf{P}}{\partial v}\right|\, du\, dv$$

The density of the distribution is δ and is assumed to be a function defined at each point on the surface. Solving the equilibrium equation for torque, the center of mass for the surface is

$$(\bar{x}, \bar{y}, \bar{z}) = \frac{\iint_S (x, y, z)\delta\, dS}{\iint_S \delta\, dS} = \left(\frac{\iint_S x\, \delta\, dS}{\iint_S \delta\, dS}, \frac{\iint_S y\, \delta\, dS}{\iint_S \delta\, dS}, \frac{\iint_S z\, \delta\, dS}{\iint_S \delta\, dS}\right) \quad (2.71)$$

where the integration is performed over the two-dimensional surface (hence, the use of double integrals). The integral $m = \iint_S \delta\, dS$ is the *total mass of the system*. The integral $M_{yz} = \iint_S x\delta\, dS$ is the *moment of the system about the yz-plane*; the integral $M_{xz} = \iint_S y\delta\, dS$ is the *moment of the system about the xz-plane*; and the integral $M_{xy} = \iint_S z\delta\, dS$ is the *moment of the system about the xy-plane*.

EXAMPLE 2.6

Compute the center of mass of the hemisphere $x^2 + y^2 + z^2 = 1$, with $z \geq 0$, assuming the density is a constant $\delta \equiv 1$. From the symmetry, we know that $\bar{x} = \bar{y} = 0$. The numerical value of the total mass should be the same as the area of the hemisphere, $m = 2\pi$. The mass integral is computed using a change to spherical coordinates with $\delta = 1$:

$$m = \iint_S dS$$

$$= \int_0^{\pi/2} \int_0^{2\pi} \sin\phi\, d\theta\, d\phi$$

$$= \left(\int_0^{\pi/2} \sin\phi\, d\phi\right)\left(\int_0^{2\pi} d\theta\right)$$

$$= 2\pi$$

The moment about the xy-plane is

$$M_{xy} = \iint_S z \, dS$$

$$= \int_0^{\pi/2} \int_0^{2\pi} (\cos \phi) \sin \phi \, d\theta \, d\phi$$

$$= \left(\int_0^{\pi/2} \sin \phi \cos \phi \, d\phi \right) \left(\int_0^{2\pi} d\theta \right)$$

$$= \pi$$

The z-value of the center of mass is $\bar{z} = M_{xy}/m = 1/2 = 0.5$. This value is closer to the pole than its counterpart for the solid hemisphere, as expected. ◾

Curve Mass

Last of all, suppose that the continuous material is a wire that consists of mass distributed along a curve in three dimensions. Let the curve be continuously differentiable and specified parametrically by $(x(t), y(t), z(t))$ for $t \in [a, b]$. In terms of arc length, s, the mass density is $\bar{\delta}(s)$. In terms of the curve parameter, it is specified parametrically as $\delta(t)$. The infinitesimal mass at the position corresponding to t is distributed over an infinitesimal arc length ds of the wire. The infinitesimal mass is $dm = \delta(t) \, ds$, where $ds = \sqrt{\dot{x}^2 + \dot{y}^2 + \dot{z}^2} \, dt$ for parametric curves in space; the dot symbol denotes differentiation with respect to t. The total mass of the wire is therefore

$$m = \int_0^L \bar{\delta}(s) \, ds = \int_a^b \delta(t) \sqrt{\dot{x}^2 + \dot{y}^2 + \dot{z}^2} \, dt$$

where s is the arc length parameter and L is the total length of the curve. The rightmost integral is the formulation in terms of the curve parameter, making it the integral that is actually evaluated. The moment about the yz-plane is

$$M_{yz} = \int_0^L x\bar{\delta}(s) \, ds = \int_a^b x(t)\delta(t) \sqrt{\dot{x}^2 + \dot{y}^2 + \dot{z}^2} \, dt$$

The moment about the xz-plane is

$$M_{xz} = \int_0^L y\bar{\delta}(s) \, ds = \int_a^b y(t)\delta(t) \sqrt{\dot{x}^2 + \dot{y}^2 + \dot{z}^2} \, dt$$

And the moment about the xy-plane is

$$M_{xy} = \int_0^L z\bar{\delta}(s)\, ds = \int_a^b z(t)\delta(t)\, \sqrt{\dot{x}^2 + \dot{y}^2 + \dot{z}^2}\, dt$$

The center of mass is

$$(\bar{x}, \bar{y}, \bar{z}) = \frac{(M_{yz}, M_{xz}, M_{xy})}{m} = \frac{\int_a^b (x(t), y(t), z(t))\, \delta(t)\, \sqrt{\dot{x}^2 + \dot{y}^2 + \dot{z}^2}\, dt}{\int_a^b \delta(t)\, \sqrt{\dot{x}^2 + \dot{y}^2 + \dot{z}^2}\, dt} \tag{2.72}$$

EXAMPLE
2.7

Compute the center of mass of a constant density wire in the shape of a helix, $(x(t), y(t), z(t)) = (\cos t, \sin t, t)$ for $t \in [0, 2\pi]$. For simplicity, set the density to 1. The mass of the wire is

$$m = \int_0^{2\pi} \sqrt{\dot{x}^2 + \dot{y}^2 + \dot{z}^2}\, dt$$

$$= \int_0^{2\pi} \sqrt{1 + t^2}\, dt$$

$$= \frac{1}{2} \left(t\sqrt{1 + t^2} + \ln(t + \sqrt{1 + t^2}) \right) \Big|_0^{2\pi}$$

$$= \frac{2\pi\sqrt{1 + 4\pi^2} + \ln(2\pi + \sqrt{1 + 4\pi^2})}{2} \doteq 21.2563$$

The moment about the yz-plane is

$$M_{yz} = \int_0^{2\pi} x(t)\sqrt{\dot{x}^2 + \dot{y}^2 + \dot{z}^2}\, dt = \int_0^{2\pi} (\cos t)\sqrt{1 + t^2}\, dt \doteq 0.386983$$

This integral cannot be evaluated in terms of elementary functions. A numerical integration leads to the approximation shown in the equation. Similarly,

$$M_{xz} = \int_0^{2\pi} y(t)\sqrt{\dot{x}^2 + \dot{y}^2 + \dot{z}^2}\, dt = \int_0^{2\pi} (\sin t)\sqrt{1 + t^2}\, dt \doteq -5.82756$$

The last moment can be calculated in closed form and is

$$M_{xy} = \int_0^{2\pi} z(t)\sqrt{\dot{x}^2 + \dot{y}^2 + \dot{z}^2}\, dt = \int_0^{2\pi} t\sqrt{1 + t^2}\, dt = \frac{(1 + 4\pi^2)^{3/2}}{3}\Big|_0^{2\pi} \doteq 85.5115$$

The center of mass is

$$(\bar{x}, \bar{y}, \bar{z}) = (M_{yz}, M_{xz}, M_{xy})/m$$

$$\doteq (0.018206, -0.274157, 4.022878) \quad \blacksquare$$

2.5.4 MOMENTS AND PRODUCTS OF INERTIA

Another moment quantity of physical significance is *moment of inertia*. This is a measure of the rotational inertia of a body about an axis. The more difficult it is to set the object into rotation, the larger the moment of inertia about that axis. Intuitively this happens if the object's mass is large or if its distance from the axis is large. Empirical studies for a single particle show that the moment of inertia is mr^2, where m is the mass of the particle and r is its distance to the axis. For completeness, we look at the one- and two-dimensional problems and define moment of inertia with respect to a point since there is no concept of rotation about a line in those dimensions.

Moment of Inertia in One Dimension

Given a discrete set of p particles with masses m_i and located on the real line at positions x_i, the total mass is $m = \sum_{i=1}^{p} m_i$. The moment with respect to the origin $x = 0$ is $M_0 = \sum_{i=1}^{p} m_i x_i$. This quantity showed up when computing the center of mass $\bar{x} = \sum_{i=1}^{p} m_i x_i / \sum_{i=1}^{p} m_i = M_0/m$. The motivation for \bar{x} is that it is the location for which $\sum_{i=1}^{p} m_i(x_i - \bar{x}) = 0$. The quantities $\sum_{i=1}^{p} m_i$ and $\sum_{i=1}^{p} m_i x_i$ are special cases of $\sum_{i=1}^{p} m_i x_i^k$, where $k = 0$ for the mass and $k = 1$ for the moment. The special case $k = 2$ has great physical significance itself. The quantity

$$I_0 = \sum_{i=1}^{p} m_i x_i^2 \tag{2.73}$$

is referred to as the *moment of inertia with respect to the origin of the real line*. The *moment of inertia with respect to the center of mass* is

$$I = \sum_{i=1}^{p} m_i(x_i - \bar{x})^2 = I_0 - m\bar{x}^2 \tag{2.74}$$

For a continuous mass located on the interval $[a, b]$ of the real line and with mass density $\delta(x)$, the total mass is $m = \int_a^b \delta(x)\,dx$ and the moment about the origin is $M_0 = \int_a^b x\delta(x)\,dx$. The center of mass is $\bar{x} = M_0/m$. The *moment of inertia with respect to the origin* is

$$I_0 = \int_a^b x^2\delta(x)\,dx \tag{2.75}$$

and the *moment of inertia with respect to the center of mass* is

$$I = \int_a^b (x - \bar{x})^2\delta(x)\,dx = I_0 - m\bar{x}^2 \tag{2.76}$$

with the right-hand side occurring just as in the discrete case.

Moment of Inertia in Two Dimensions

Given a discrete set of p particles with masses m_i and located in the plane at positions (x_i, y_i), the total mass is $m = \sum_{i=1}^{p} m_i$. The moment with respect to the y-axis was defined as $M_y = \sum_{i=1}^{p} m_i x_i$ and the moment with respect to the x-axis was defined as $M_x = \sum_{i=1}^{p} m_i y_i$. The center of mass is $(\bar{x}, \bar{y}) = (M_y/m, M_x/m)$. We can define the *moment of inertia with respect to the origin* as

$$I_0 = \sum_{i=1}^{p} m_i(x_i^2 + y_i^2) \tag{2.77}$$

The *moment of inertia with respect to the center of mass* is

$$I = \sum_{i=1}^{p} m_i \left|(x_i, y_i) - (\bar{x}, \bar{y})\right|^2 = I_0 - m(\bar{x}^2 + \bar{y}^2) \tag{2.78}$$

For a continuous mass located in the region R of the plane and having mass density $\delta(x, y)$, the total mass is $m = \iint_R \delta(x, y)\, dx\, dy$ and the moments with respect to the y- and x-axes are $M_y = \iint_R x\delta(x, y)\, dx\, dy$ and $M_x = \iint_R y\delta(x, y)\, dx\, dy$. The center of mass is $(\bar{x}, \bar{y}) = (M_y/m, M_x/m)$. The *moment of inertia with respect to the origin* is

$$I_0 = \iint_R (x^2 + y^2)\delta(x, y)\, dx\, dy \tag{2.79}$$

and the *moment of inertia with respect to the center of mass* is

$$I = \iint_R ((x - \bar{x})^2 + (y - \bar{y})^2)\delta(x, y)\, dx\, dy = I_0 - m(\bar{x}^2 + \bar{y}^2) \tag{2.80}$$

with the right-hand side occurring just as in the discrete case.

Moment of Inertia in Three Dimensions

Of course the interesting case is in three dimensions. We could easily define a moment of inertia relative to a point, just as we did in one and two dimensions. However, keeping in mind that we are interested mainly in the motion of rigid bodies, if one point on the body rotates about a line (even if only instantaneously), then all other points rotate about that same line. In this sense it is more meaningful to define a moment of inertia relative to a line.

Given an origin \mathcal{O} and a discrete set of p particles with masses m_i located at $\mathbf{r}_i = (x_i, y_i, z_i)$ relative to \mathcal{O}, the total mass is $m = \sum_{i=1}^{p} m_i$. The moments with respect to the xy-, xz-, and yz-planes were defined, respectively, as $M_{xy} = \sum_{i=1}^{p} m_i z_i$,

$M_{xz} = \sum_{i=1}^{p} m_i y_i$, and $M_{yz} = \sum_{i=1}^{p} m_i x_i$. The center of mass is $(\bar{x}, \bar{y}, \bar{z}) = (M_{yz}/m, M_{xz}/m, M_{xy}/m)$. The *moments of inertia about the x-, y-, and z-axes* are, respectively,

$$I_{xx} = \sum_{i=1}^{p} m_i(y_i^2 + z_i^2), \qquad I_{yy} = \sum_{i=1}^{p} m_i(x_i^2 + z_i^2), \quad \text{and}$$

(2.81)

$$I_{zz} = \sum_{i=1}^{p} m_i(x_i^2 + y_i^2)$$

The *moment of inertia about a line L through origin* \mathcal{O}, given parametrically as $\mathcal{O} + t\mathbf{D}$ with unit-length direction vector $\mathbf{D} = (d_1, d_2, d_3)$, is the sum of $m_i r_i^2$, where r_i is the distance from \mathbf{r}_i to the line, or

$$
\begin{aligned}
I_L &= \sum_{i=1}^{p} m_i \left(|\mathbf{r}_i|^2 - (\mathbf{D} \cdot \mathbf{r}_i)^2 \right) \\
&= d_1^2 \sum_{i=1}^{p} m_i(y_i^2 + z_i^2) + d_2^2 \sum_{i=1}^{p} m_i(x_i^2 + z_i^2) + d_3^2 \sum_{i=1}^{p} m_i(x_i^2 + y_i^2) \\
&\quad - 2d_1 d_2 \sum_{i=1}^{p} m_i x_i y_i - 2d_1 d_3 \sum_{i=1}^{p} m_i x_i z_i - 2d_2 d_3 \sum_{i=1}^{p} m_i y_i z_i \\
&= d_1^2 I_{xx} + d_2^2 I_{yy} + d_3^2 I_{zz} - 2d_1 d_2 I_{xy} - 2d_1 d_3 I_{xz} - 2d_2 d_3 I_{yz}
\end{aligned}
$$

(2.82)

where the first three terms contain the moments of inertia about the coordinate axes and the last three terms have newly defined quantities called the *products of inertia*,

$$I_{xy} = \sum_{i=1}^{p} m_i x_i y_i, \qquad I_{xz} = \sum_{i=1}^{p} m_i x_i z_i, \quad \text{and} \quad I_{yz} = \sum_{i=1}^{p} m_i y_i z_i \quad (2.83)$$

Equation (2.82) may be written in matrix form as

$$I_L = \mathbf{D}^{\mathrm{T}} \begin{bmatrix} I_{xx} & -I_{xy} & -I_{xz} \\ -I_{xy} & I_{yy} & -I_{yz} \\ -I_{xz} & -I_{yz} & I_{zz} \end{bmatrix} \mathbf{D} =: \mathbf{D}^{\mathrm{T}} J \mathbf{D} \qquad (2.84)$$

where the last equality defines the symmetric matrix J, called the *inertia tensor* or *mass matrix*,

$$J = \begin{bmatrix} I_{xx} & -I_{xy} & -I_{xz} \\ -I_{xy} & I_{yy} & -I_{yz} \\ -I_{xz} & -I_{yz} & I_{zz} \end{bmatrix} \qquad (2.85)$$

Moments and products of inertia are similar for a continuum of mass occupying a region R. The moments of inertia are

$$I_{xx} = \int_R y^2 + z^2 \, dm, \qquad I_{yy} = \int_R x^2 + z^2 \, dm, \qquad I_{zz} = \int_R x^2 + y^2 \, dm \quad (2.86)$$

and the products of inertia are

$$I_{xy} = \int_R xy \, dm, \qquad I_{xz} = \int_R xz \, dm, \qquad I_{yz} = \int_R yz \, dm \qquad (2.87)$$

Equation (2.84) is the same whether the mass is discrete or continuous.

The reason for the use of the term *mass matrix* is clear by considering a single particle of mass m, located at \mathbf{r} relative to the origin, and that rotates about a fixed axis. As indicated by equations (2.34), (2.35), and (2.36), the position is $\mathbf{r} = (x, y, z)$; the velocity is $\mathbf{v} = \mathbf{w} \times \mathbf{r}$, where \mathbf{w} is the angular velocity; and the acceleration is $\mathbf{a} = -\sigma^2 \mathbf{r} + \boldsymbol{\alpha} \times \mathbf{r}$, where σ is the angular speed and $\boldsymbol{\alpha}$ is the angular acceleration. The angular momentum is

$$\mathbf{L} = \mathbf{r} \times m\mathbf{v} = m\mathbf{r} \times (\mathbf{w} \times \mathbf{r}) = m(|\mathbf{r}|^2 I - \mathbf{r}\mathbf{r}^T)\mathbf{w} = J\mathbf{w} \qquad (2.88)$$

where the inertia tensor for a single particle is

$$J = m\left(|\mathbf{r}|^2 I - \mathbf{r}\mathbf{r}^T\right) = m \begin{bmatrix} y^2 + z^2 & -xy & -xz \\ -xy & x^2 + z^2 & -yz \\ -xz & -yz & x^2 + y^2 \end{bmatrix}$$

Notice the similarity of the angular momentum equation $\mathbf{L} = J\mathbf{w}$ to the linear momentum equation $\mathbf{p} = m\mathbf{v}$. The coefficient of linear velocity in the latter equation is the mass m. The coefficient of angular velocity in the former equation is the mass matrix J. Similarly, the torque is

$$\boldsymbol{\tau} = \mathbf{r} \times m\mathbf{a}$$
$$= m\mathbf{r} \times (-\sigma^2\mathbf{r} + \boldsymbol{\alpha} \times \mathbf{r}) = m\mathbf{r} \times (\boldsymbol{\alpha} \times \mathbf{r}) = m(|\mathbf{r}|^2 I - \mathbf{r}\mathbf{r}^T)\boldsymbol{\alpha} = J\boldsymbol{\alpha}$$
$$(2.89)$$

Notice the similarity of the torque equation $\boldsymbol{\tau} = J\boldsymbol{\alpha}$ to Newton's second law $\mathbf{F} = m\mathbf{a}$. The coefficient of linear acceleration in Newton's second law is the mass m, whereas the coefficient of angular acceleration in the torque equation is the mass matrix J. Equations (2.88) and (2.89) apply as well to particle systems and continuous mass, where the world and body origins coincide.

Equation (2.84) is a quadratic form that has a maximum and a minimum, both *eigenvalues* of the matrix J. From linear algebra (see [Str88] for example or see Appendix A), a scalar λ is an eigenvalue of J with a corresponding eigenvector $\mathbf{V} \neq \mathbf{0}$, such that $J\mathbf{V} = \lambda\mathbf{V}$. The intuition, at least for real-valued eigenvalues, is

that the vector **V** has only its length changed by J but not its direction. The unit-length directions **D** that generate the extreme values are eigenvectors corresponding to the eigenvalues. Using techniques from linear algebra and matrix theory, we can factor J using an eigendecomposition, $J = RMR^\mathrm{T}$, where $M = \mathrm{Diag}(\mu_1, \mu_2, \mu_3)$ is a diagonal matrix whose diagonal entries are the eigenvalues of J. The matrix $R = [\mathbf{U}_1\,\mathbf{U}_2\,\mathbf{U}_3]$ is an orthogonal matrix whose columns are eigenvectors of J, listed in the order of the eigenvalues in M. The eigenvalues μ_i are called the *principal moments of inertia*, and the columns \mathbf{U}_i are called the *principal directions of inertia*.

Equation (2.62) shows us that torque is just the time derivative of angular momentum. Equation (2.42) shows us how to compute the time derivative of a vector in a moving frame for the rigid body. In particular, we can apply this formula to the angular momentum:

$$\begin{aligned}
\boldsymbol{\tau} &= \frac{d\mathbf{L}}{dt} \\[6pt]
&= \frac{D\mathbf{L}}{Dt} + \mathbf{w} \times \mathbf{L} \\[6pt]
&= \frac{D(J\mathbf{w})}{Dt} + \mathbf{w} \times (J\mathbf{w}) \\[6pt]
&= J\frac{D\mathbf{w}}{Dt} + \mathbf{w} \times (J\mathbf{w}) \\[6pt]
&= J\frac{d\mathbf{w}}{dt} + \mathbf{w} \times (J\mathbf{w})
\end{aligned} \qquad (2.90)$$

This vector-valued equation may be viewed as equations of motion for a rigid body. When $\boldsymbol{\tau}$ and \mathbf{w} are represented in a body coordinate system where the coordinate axis directions are the principal directions of inertia, equation (2.90) reduces to

$$\boldsymbol{\tau} = M\frac{d\mathbf{w}}{dt} + \mathbf{w} \times (M\mathbf{w}) \qquad (2.91)$$

where M is the diagonal matrix of principal moments. This equation is referred to as *Euler's equations of motion*. Mathematically, equation (2.91) is derived from equation (2.90) by replacing J by RMR^T and by replacing the world coordinate representations $\boldsymbol{\tau}$ and \mathbf{w} by the body coordinate representations $R^\mathrm{T}\boldsymbol{\tau}$ and $R^\mathrm{T}\mathbf{W}$. In the process you need to use the identity $(R\mathbf{a}) \times (R\mathbf{b}) = R(\mathbf{a} \times \mathbf{b})$ when R is a rotation matrix.

EXAMPLE 2.8

Compute the inertia tensor for a solid triangle of constant mass density $\delta = 1$ with vertices at $(0, 0)$, $(a, 0)$, and $(0, b)$.

(Example 2.8 continued)

The region of integration R is determined by $z = 0$, $0 \leq x \leq a$, and $0 \leq y \leq b(1 - x/a)$. Since the mass density is always 1, the mass is just the area of the triangle, $m = ab/2$. The quantity I_{xx} is

$$I_{xx} = \iint_R (y^2 + z^2)\, dR$$

$$= \int_0^a \int_0^{b(1-x/a)} y^2\, dy\, dx$$

$$= \int_0^a \left. \frac{y^3}{3} \right|_0^{b(1-x/a)} dx$$

$$= \int_0^a \frac{(b(1 - x/a))^3}{3}\, dx$$

$$= \left. -\frac{ab^3(1 - x/a)^4}{12} \right|_0^a$$

$$= \frac{ab^3}{12}$$

$$= \frac{mb^2}{6}$$

Similar integrations yield $I_{yy} = ma^2/6$, $I_{zz} = m(a^2 + b^2)/6$, $I_{xy} = mab/12$, $I_{xz} = 0$, and $I_{yz} = 0$. ▪

EXAMPLE 2.9

Consider a box centered at the origin with dimensions $2a > 0$, $2b > 0$, and $2c > 0$. The vertices are $(\pm a, \pm b, \pm c)$, where you have eight choices for the signs in the components. Let the mass density be 1.

1. Compute the inertia tensor for the eight vertices of the box where all masses are 1 (discrete points).

2. Compute the inertia tensor for the box treated as a wireframe of masses where the 12 edges are the wires (curve mass).

3. Compute the inertia tensor for the box treated as a hollow body (surface mass).

4. Compute the inertia tensor for the box treated as a solid (volume mass).

SOLUTION 1

The moments and products of inertia are easily calculated by setting up a table (Table 2.1). The total mass is $m = 8$.

Table 2.1 | Moments and products of inertia for vertices

Point	I_{xx}	I_{yy}	I_{zz}	I_{xy}	I_{xz}	I_{yz}
(a, b, c)	$b^2 + c^2$	$a^2 + c^2$	$a^2 + b^2$	ab	ac	bc
$(a, b, -c)$	$b^2 + c^2$	$a^2 + c^2$	$a^2 + b^2$	ab	$-ac$	$-bc$
$(a, -b, c)$	$b^2 + c^2$	$a^2 + c^2$	$a^2 + b^2$	$-ab$	ac	$-bc$
$(a, -b, -c)$	$b^2 + c^2$	$a^2 + c^2$	$a^2 + b^2$	$-ab$	$-ac$	bc
$(-a, b, c)$	$b^2 + c^2$	$a^2 + c^2$	$a^2 + b^2$	$-ab$	$-ac$	bc
$(-a, b, -c)$	$b^2 + c^2$	$a^2 + c^2$	$a^2 + b^2$	$-ab$	ac	$-bc$
$(-a, -b, c)$	$b^2 + c^2$	$a^2 + c^2$	$a^2 + b^2$	ab	$-ac$	$-bc$
$(-a, -b, -c)$	$b^2 + c^2$	$a^2 + c^2$	$a^2 + b^2$	ab	ac	bc
Sum	$m(b^2 + c^2)$	$m(a^2 + c^2)$	$m(a^2 + b^2)$	0	0	0

SOLUTION 2

The moments and products of inertia can be calculated for each of the 12 edges, then summed. Consider the edge (x, b, c) for $|x| \le a$. The moments and products of inertia for this edge are

$$I_{xx} = \int_{-a}^{a} y^2 + z^2 \, dx = (b^2 + c^2) \int_{-a}^{a} dx = 2a(b^2 + c^2)$$

$$I_{yy} = \int_{-a}^{a} x^2 + z^2 \, dx = \int_{-a}^{a} x^2 + c^2 \, dx = x^3/3 + c^2 x \Big|_{-a}^{a} = 2(a^3/3 + ac^2)$$

$$I_{zz} = \int_{-a}^{a} x^2 + y^2 \, dx = \int_{-a}^{a} x^2 + b^2 \, dx = x^3/3 + b^2 x \Big|_{-a}^{a} = 2(a^3/3 + ab^2)$$

$$I_{xy} = \int_{-a}^{a} xy \, dx = b \int_{-a}^{a} x \, dx = 0$$

$$I_{xz} = \int_{-a}^{a} xz \, dx = c \int_{-a}^{a} x \, dx = 0$$

$$I_{yz} = \int_{-a}^{a} yz \, dx = bc \int_{-a}^{a} dx = 2abc$$

Similar integrals must be evaluated for the other edges. Table 2.2 shows the moments and products of inertia for the edges. The total mass is the sum of the lengths of the edges, $m = 8(a + b + c)$.

Table 2.2 Moments and products of inertia for edges

Edge	I_{xx}	I_{yy}	I_{zz}	I_{xy}	I_{xz}	I_{yz}
(x, b, c)	$2a(b^2 + c^2)$	$2(a^3/3 + ac^2)$	$2(a^3/3 + ab^2)$	0	0	$2abc$
$(x, b, -c)$	$2a(b^2 + c^2)$	$2(a^3/3 + ac^2)$	$2(a^3/3 + ab^2)$	0	0	$-2abc$
$(x, -b, c)$	$2a(b^2 + c^2)$	$2(a^3/3 + ac^2)$	$2(a^3/3 + ab^2)$	0	0	$-2abc$
$(x, -b, -c)$	$2a(b^2 + c^2)$	$2(a^3/3 + ac^2)$	$2(a^3/3 + ab^2)$	0	0	$2abc$
(a, y, c)	$2(b^3/3 + bc^2)$	$2b(a^2 + c^2)$	$2(b^3/3 + ba^2)$	0	$2abc$	0
$(a, y, -c)$	$2(b^3/3 + bc^2)$	$2b(a^2 + c^2)$	$2(b^3/3 + ba^2)$	0	$-2abc$	0
$(-a, y, c)$	$2(b^3/3 + bc^2)$	$2b(a^2 + c^2)$	$2(b^3/3 + ba^2)$	0	$-2abc$	0
$(-a, y, -c)$	$2(b^3/3 + bc^2)$	$2b(a^2 + c^2)$	$2(b^3/3 + ba^2)$	0	$2abc$	0
(a, b, z)	$2(c^3/3 + cb^2)$	$2(c^3/3 + ca^2)$	$2c(a^2 + b^2)$	$2abc$	0	0
$(a, -b, z)$	$2(c^3/3 + cb^2)$	$2(c^3/3 + ca^2)$	$2c(a^2 + b^2)$	$-2abc$	0	0
$(-a, b, z)$	$2(c^3/3 + cb^2)$	$2(c^3/3 + ca^2)$	$2c(a^2 + b^2)$	$-2abc$	0	0
$(-a, -b, z)$	$2(c^3/3 + cb^2)$	$2(c^3/3 + ca^2)$	$2c(a^2 + b^2)$	$2abc$	0	0
Sum	$\frac{m}{3}\frac{(b+c)^3+3a(b^2+c^2)}{a+b+c}$	$\frac{m}{3}\frac{(a+c)^3+3b(a^2+c^2)}{a+b+c}$	$\frac{m}{3}\frac{(a+b)^3+3c(a^2+b^2)}{a+b+c}$	0	0	0

(Example 2.9 continued)

SOLUTION 3

The moments and products of inertia can be calculated for each of six faces, then summed. Consider the face $z = c$ with $|x| \le a$ and $|y| \le b$. The moments and products of inertia for this face are

$$I_{xx} = \int_{-b}^{b} \int_{-a}^{a} y^2 + z^2 \, dx \, dy = 4a(b^3/3 + bc^2)$$

$$I_{yy} = \int_{-b}^{b} \int_{-a}^{a} x^2 + z^2 \, dx \, dy = 4b(a^3/3 + ac^2)$$

$$I_{zz} = \int_{-b}^{b} \int_{-a}^{a} x^2 + y^2 \, dx \, dy = 4ab(a^2 + b^2)/3$$

$$I_{xy} = \int_{-b}^{b} \int_{-a}^{a} xy \, dx \, dy = 0$$

$$I_{xz} = \int_{-b}^{b} \int_{-a}^{a} xz \, dx \, dy = 0$$

$$I_{yz} = \int_{-b}^{b} \int_{-a}^{a} yz \, dx \, dy = 0$$

Table 2.3 Moments and products of inertia for faces

Face	I_{xx}	I_{yy}	I_{zz}	I_{xy}	I_{xz}	I_{yz}
$z = c$	$4ab(b^2 + 3c^2)/3$	$4ab(a^2 + 3c^2)/3$	$4ab(a^2 + b^2)/3$	0	0	0
$z = -c$	$4ab(b^2 + 3c^2)/3$	$4ab(a^2 + 3c^2)/3$	$4ab(a^2 + b^2)/3$	0	0	0
$y = b$	$4ac(c^2 + 3b^2)/3$	$4ac(a^2 + c^2)/3$	$4ac(a^2 + 3b^2)/3$	0	0	0
$y = -b$	$4ac(c^2 + 3b^2)/3$	$4ac(a^2 + c^2)/3$	$4ac(a^2 + 3b^2)/3$	0	0	0
$x = a$	$4bc(b^2 + c^2)/3$	$4bc(c^2 + 3a^2)/3$	$4bc(b^2 + 3a^2)/3$	0	0	0
$x = -a$	$4bc(b^2 + c^2)/3$	$4bc(c^2 + 3a^2)/3$	$4bc(b^2 + 3a^2)/3$	0	0	0
Sum	$\frac{m}{3}\frac{a(b+c)^3+bc(b^2+c^2)}{ab+ac+bc}$	$\frac{m}{3}\frac{b(a+c)^3+ac(a^2+c^2)}{ab+ac+bc}$	$\frac{m}{3}\frac{c(a+b)^3+ab(a^2+b^2)}{ab+ac+bc}$	0	0	0

Similar integrals must be evaluated for the other faces. Table 2.3 shows the moments and products of inertia for the faces. The total mass is the sum of the areas of the faces, $m = 8(ab + ac + bc)$.

SOLUTION 4

The total mass is the volume of the box, $m = 8abc$. The moments and products of inertia are

$$I_{xx} = \int_{-c}^{c}\int_{-b}^{b}\int_{-a}^{a} y^2 + z^2 \, dx \, dy \, dz = \frac{8abc(b^2 + c^2)}{3} = \frac{m(b^2 + c^2)}{3}$$

$$I_{yy} = \int_{-c}^{c}\int_{-b}^{b}\int_{-a}^{a} x^2 + z^2 \, dx \, dy \, dz = \frac{8abc(a^2 + c^2)}{3} = \frac{m(a^2 + c^2)}{3}$$

$$I_{zz} = \int_{-c}^{c}\int_{-b}^{b}\int_{-a}^{a} x^2 + y^2 \, dx \, dy \, dz = \frac{8abc(a^2 + b^2)}{3} = \frac{m(a^2 + b^2)}{3}$$

$$I_{xy} = \int_{-c}^{c}\int_{-b}^{b}\int_{-a}^{a} xy \, dx \, dy \, dz = 0$$

$$I_{xz} = \int_{-c}^{c}\int_{-b}^{b}\int_{-a}^{a} xz \, dx \, dy \, dz = 0$$

$$I_{yz} = \int_{-c}^{c}\int_{-b}^{b}\int_{-a}^{a} yz \, dx \, dy \, dz = 0 \quad \blacksquare$$

EXERCISE Ⓔ Repeat the experiment of Example 2.9 using a tetrahedron instead of a box. The
2.11 vertices are $(0, 0, 0)$, $(a, 0, 0)$, $(0, b, 0)$, and $(0, 0, c)$, where $a > 0$, $b > 0$, and $c > 0$.

EXERCISE (H) Compute the inertia tensor for the planar object in Example 2.3, but treated as a 3D
2.12 object (a surface mass). ◼

EXERCISE (H) Compute the inertia tensor for the hemicircle wire in Example 2.4, but treated as a
2.13 3D object (a curve mass). ◼

EXERCISE (M) *Transfer of Axes.* The derivation of equation (2.82) used any specified origin \mathcal{O} and
2.14 produced the quantities I_{xx}, I_{yy}, I_{zz}, I_{xy}, I_{xz}, and I_{yz}. Let the total mass of the
system be m. Suppose that the origin is chosen as the center of mass $(\bar{x}, \bar{y}, \bar{z})$ and
that coordinate axes are chosen so that they are parallel to those used at origin \mathcal{O}. If
the corresponding inertia quantities are \bar{I}_{xx}, \bar{I}_{yy}, \bar{I}_{zz}, \bar{I}_{xy}, \bar{I}_{xz}, and \bar{I}_{yz}, show that $I_{xx} = \bar{I}_{xx} + m(\bar{y}^2 + \bar{z}^2)$, $I_{yy} = \bar{I}_{yy} + m(\bar{x}^2 + \bar{z}^2)$, $I_{zz} = \bar{I}_{zz} + m(\bar{x}^2 + \bar{y}^2)$, $I_{xy} = \bar{I}_{xy} + m\bar{x}\bar{y}$, $I_{xz} = \bar{I}_{xz} + m\bar{x}\bar{z}$, and $I_{yz} = \bar{I}_{yz} + m\bar{y}\bar{z}$. Compare this result with equations (2.74), (2.76), (2.78), and (2.80).

Conclude that the moment of inertia about a line L containing the center of mass
and having unit-length direction \mathbf{D} is

$$I_L = \mathbf{D}^T \begin{bmatrix} \bar{I}_{xx} + m(\bar{y}^2 + \bar{z}^2) & -(\bar{I}_{xy} + m\bar{x}\bar{y}) & -(\bar{I}_{xz} + m\bar{x}\bar{z}) \\ -(\bar{I}_{xy} + m\bar{x}\bar{y}) & \bar{I}_{yy} + m(\bar{x}^2 + \bar{z}^2) & -(\bar{I}_{yz} + m\bar{y}\bar{z}) \\ -(\bar{I}_{xz} + m\bar{x}\bar{z}) & -(\bar{I}_{yz} + m\bar{y}\bar{z}) & \bar{I}_{zz} + m(\bar{x}^2 + \bar{y}^2) \end{bmatrix} \mathbf{D}$$

The significance of this result is that an application needs only to compute the inertia
tensor relative to the body's center of mass. The inertia tensor for other coordinate
frames is then easily calculated from this tensor. ◼

We will look at moments of inertia in more detail in Section 3.2 when dealing
with rigid body motion.

2.5.5 MASS AND INERTIA TENSOR OF A SOLID POLYHEDRON

In a game environment the objects that physically interact typically are constructed
as simple polyhedra. In order to set up the equations of motion for such objects, we
need to compute the mass and inertia tensor for a solid polyhedron. This can be quite
a difficult task if the mass density of the object is variable but turns out to be relatively
simple for constant mass density. For the sake of simplicity we will assume that the
mass density is $\rho = 1$. For any other value you will need to multiply the mass and
inertia tensors by that value.

A mathematical algorithm for computing the mass and inertia tensor for solid
polyhedra of constant mass density is described by Mirtich [Mir96a]. The construc-
tion uses the Divergence Theorem from calculus for reducing volume integrals to
surface integrals, a reduction from three-dimensional integrals to two-dimensional
integrals. The polyhedron surface is a union of planar faces, so the surface integrals

are effectively integrals in various planes. Projection of these faces onto coordinate planes are used to set up yet another reduction in dimension. Green's Theorem, the two-dimensional analog of the Divergence Theorem, is used to reduce the planar integrals to line integrals around the boundaries of the projected faces.

Two important points emphasized in the paper are (1) the projection of the polyhedron faces onto the appropriate coordinate planes to avoid numerical problems and (2) the reduction using Green's Theorem to obtain common subexpressions, which are integrals of polynomials of one variable, to avoid redundant calculations. Item (2) occurs to handle polyhedron faces with four or more vertices. Item (1) is necessary in order to robustly compute what is required by item (2). When the polyhedron faces are triangles, neither items (1) nor (2) are necessary. A simpler construction is provided here when the polyhedron faces are triangles. A consequence of the formulas as derived in this document is that they require significantly less computational time than Mirtich's formulas.

Reduction of Volume Integrals

The mass, center of mass, and inertia tensor require computing volume integrals of the type

$$\int_V p(x, y, z) \, dV$$

where V is the volumetric region of integration and dV is an infinitesimal measure of volume. The function $p(x, y, z)$ is a polynomial selected from $1, x, y, z, x^2, y^2, z^2,$ $xy, xz,$ and yz. We are interested in computing these integrals where V is the region bounded by a simple polyhedron. A volume integral may be converted to a surface integral via the Divergence Theorem from calculus:

$$\int_V p(x, y, z) \, dV = \int_V \nabla \cdot \mathbf{F} \, dV = \int_S \mathbf{N} \cdot \mathbf{F} \, dS$$

where S is the boundary of the polyhedron, a union of triangular faces, and where dS is an infinitesimal measure of surface area. The function $\mathbf{F}(x, y, z)$ is chosen so that $\nabla \cdot \mathbf{F} = p$. The vector \mathbf{N} denotes outward-pointing, unit-length surface normals. The choices for \mathbf{F} in the Mirtich paper are given in Table 2.4.

The computational effort is now devoted to calculating the integrals $\int_S \mathbf{N} \cdot \mathbf{F} \, dS$. The boundary S is just the union of polyhedral faces \mathcal{F}. An outward-pointing, unit-length normal to face \mathcal{F} is denoted by $\mathbf{N}_{\mathcal{F}} = (\hat{\eta}_x, \hat{\eta}_y, \hat{\eta}_z)$. The surface integral decomposes to

$$\int_S \mathbf{N} \cdot \mathbf{F} \, dS = \sum_{\mathcal{F} \in S} \int_{\mathcal{F}} \mathbf{N}_{\mathcal{F}} \cdot \mathbf{F} \, dS \qquad (2.92)$$

Table 2.4 Generation of polynomials by vector fields

p	\mathbf{F}	p	\mathbf{F}
1	$(x, 0, 0)$	y^2	$(0, y^3/3, 0)$
x	$(x^2/2, 0, 0)$	z^2	$(0, 0, z^3/3)$
y	$(0, y^2/2, 0)$	xy	$(x^2y/2, 0, 0)$
z	$(0, 0, z^2/2)$	xz	$(0, 0, z^2x/2)$
x^2	$(x^3/3, 0, 0)$	yz	$(0, y^2z/2, 0)$

The integrals to be computed are now reduced to

$$\int_V dV = \sum_{\mathcal{F} \in S} \hat{\eta}_x \int_{\mathcal{F}} x \, dS \qquad \int_V y^2 \, dV = \frac{1}{3} \sum_{\mathcal{F} \in S} \hat{\eta}_y \int_{\mathcal{F}} y^3 \, dS$$

$$\int_V x \, dV = \frac{1}{2} \sum_{\mathcal{F} \in S} \hat{\eta}_x \int_{\mathcal{F}} x^2 \, dS \qquad \int_V z^2 \, dV = \frac{1}{3} \sum_{\mathcal{F} \in S} \hat{\eta}_z \int_{\mathcal{F}} z^3 \, dS$$

$$\int_V y \, dV = \frac{1}{2} \sum_{\mathcal{F} \in S} \hat{\eta}_y \int_{\mathcal{F}} y^2 \, dS \qquad \int_V xy \, dV = \frac{1}{2} \sum_{\mathcal{F} \in S} \hat{\eta}_x \int_{\mathcal{F}} x^2y \, dS$$

$$\int_V z \, dV = \frac{1}{2} \sum_{\mathcal{F} \in S} \hat{\eta}_z \int_{\mathcal{F}} z^2 \, dS \qquad \int_V yz \, dV = \frac{1}{2} \sum_{\mathcal{F} \in S} \hat{\eta}_y \int_{\mathcal{F}} y^2z \, dS$$

$$\int_V x^2 \, dV = \frac{1}{3} \sum_{\mathcal{F} \in S} \hat{\eta}_x \int_{\mathcal{F}} x^3 \, dS \qquad \int_V xz \, dV = \frac{1}{2} \sum_{\mathcal{F} \in S} \hat{\eta}_z \int_{\mathcal{F}} z^2x \, dS$$

We now need to compute integrals of the form

$$\hat{\eta}_\ell \int_{\mathcal{F}} q(x, y, z) \, dS \tag{2.93}$$

where ℓ is one of x, y, or z and where q is one of x, x^2, y^2, z^2, x^3, y^3, z^3, x^2y, y^2z, or z^2x.

Computation by Reduction to Line Integrals

Although we do not need to compute a surface integral when $q(x, y, z) = 1$, we use it as motivation. Notice that $\int_{\mathcal{F}} dS$ is the area A of the polygonal face. The area may be computed as a three-dimensional quantity:

$$A = \int_{\mathcal{F}} dS = \frac{1}{2} \mathbf{N}_{\mathcal{F}} \cdot \sum_{i=0}^{n-1} \mathbf{P}_i \times \mathbf{P}_{i+1}$$

where the polygon vertices are $\mathbf{P}_i = (x_i, y_i, z_i)$, $0 \le i \le n - 1$, and the vertices are ordered counterclockwise relative to the face normal $\mathbf{N}_{\mathcal{F}}$. Modular indexing is used so that $\mathbf{P}_n = \mathbf{P}_0$. This formula occurs in [Arv91] and is derived using Stokes's Theorem from calculus. The computation is not as efficient as it can be. A discussion of various methods for computing area (and volume) is found in [SE02].

An efficient method for computing the area is to project the polygon onto a coordinate plane, compute the area in two dimensions, and adjust the result to account for the projection. The plane of the polygonal face is $\hat{\eta}_x x + \hat{\eta}_y y + \hat{\eta}_z z + w = 0$, where $w = -\mathbf{N}_{\mathcal{F}} \cdot \mathbf{P}_0$. As long as $\hat{\eta}_z \neq 0$, we may project onto the xy-plane. The plane equation is written $z = f(x, y) = -(w + \hat{\eta}_x x + \hat{\eta}_y y)/\hat{\eta}_z$. The infinitesimal surface area in terms of the independent variables x and y is

$$dS = \sqrt{1 + \left(\frac{\partial f}{\partial x}\right)^2 + \left(\frac{\partial f}{\partial y}\right)^2} \, dx \, dy$$

$$= \sqrt{1 + \left(\frac{-\hat{\eta}_x}{\hat{\eta}_z}\right)^2 + \left(\frac{-\hat{\eta}_y}{\hat{\eta}_z}\right)^2} \, dx \, dy = \frac{1}{|\hat{\eta}_z|} \, dx \, dy$$

where we have used the fact that $|\mathbf{N}_{\mathcal{F}}| = 1$. The surface integral becomes

$$\int_{\mathcal{F}} dS = \frac{1}{|\hat{\eta}_z|} \int_R dx \, dy$$

where R is the region bounded by the projected polygon. That polygon has vertices $\mathbf{Q}_i = (x_i, y_i)$. A planar integral may be converted to a line integral via Green's Theorem, the two-dimensional analog of the Divergence Theorem:

$$\int_R p(x, y) \, dx \, dy = \int_L \nabla \cdot \mathbf{G} \, dx \, dy = \int_L \mathbf{M} \cdot \mathbf{G} \, ds$$

where L is the boundary of the region R and where ds is an infinitesimal measure of arc length. The function $\mathbf{G}(x, y)$ is chosen so that $\nabla \cdot \mathbf{G} = p$. The vector \mathbf{M} denotes outward-pointing, unit-length curve normals. In our special case $p(x, y) = 1$ and L is a polygon. Many choices exist for \mathbf{G}, one being $\mathbf{G} = (x, 0)$. The boundary is the union of edges \mathcal{E}. An outward-pointing, unit-length normal to the edge is denoted $\mathbf{M}_{\mathcal{E}}$. The area integral decomposes to

$$\int_L \mathbf{M} \cdot \mathbf{G} \, ds = \sum_{\mathcal{E}} \int_{\mathcal{E}} \mathbf{M}_{\mathcal{E}} \cdot \mathbf{G} \, ds \tag{2.94}$$

Note the similarity to equation (2.92). If edge \mathcal{E} is the line segment connecting \mathbf{Q}_i to \mathbf{Q}_{i+1} and has length $L_i = |\mathbf{Q}_{i+1} - \mathbf{Q}_i|$, then the edge is parameterized by $(x(s), y(s)) = (1 - s/L_i)\mathbf{Q}_i + (s/L_i)\mathbf{Q}_{i+1}$ for $s \in [0, L_i]$. At first glance you might choose the edge normals to be $\mathbf{M}_i = (y_{i+1} - y_i, x_i - x_{i+1})/L_i$. This is a correct choice if the \mathbf{Q}_i are counterclockwise ordered. When $\hat{\eta}_z > 0$, a counterclockwise traversal of the \mathbf{P}_i results in a counterclockwise traversal of the \mathbf{Q}_i. But when $\hat{\eta}_z < 0$, the \mathbf{Q}_i are traversed clockwise; the previous formula for \mathbf{M}_i must be negated. In general $\mathbf{M}_i = \mathrm{Sign}(\hat{\eta}_z)(y_{i+1} - y_i, x_i - x_{i+1})/L_i$. The integral of equation (2.94) is rewritten as

$$
\int_L \mathbf{M} \cdot \mathbf{G}\, ds = \sum_{i=0}^{n-1} \int_0^{L_i} \mathbf{M}_i \cdot (x(s), 0)\, ds
$$

$$
= \mathrm{Sign}(\hat{\eta}_z) \sum_{i=0}^{n-1} \frac{y_{i+1} - y_i}{L_i} \int_0^{L_i} \left(1 - \frac{s}{L_i}\right) x_i + \left(\frac{s}{L_i}\right) x_{i+1}\, ds
$$

$$
= \mathrm{Sign}(\hat{\eta}_z) \sum_{i=0}^{n-1} (y_{i+1} - y_i) \int_0^1 (1 - t)x_i + t x_{i+1}\, dt \tag{2.95}
$$

$$
= \frac{\mathrm{Sign}(\hat{\eta}_z)}{2} \sum_{i=0}^{n-1} (x_{i+1} + x_i)(y_{i+1} - y_i)
$$

$$
= \frac{\mathrm{Sign}(\hat{\eta}_z)}{2} \sum_{i=0}^{n-1} x_i(y_{i+1} - y_{i-1})
$$

where the third equality is based on the change of variables $s = L_i t$. The last equality uses modular indexing ($y_n = y_0$ and $y_{-1} = y_{n-1}$); it results in a reduction of one-third the arithmetic operations from the previous equation. The proof of equality is left as an exercise.

One potential source of numerical error is when $\hat{\eta}_z$ is nearly zero. The division by $|\hat{\eta}_z|$ is ill-conditioned. In this case we may project onto another coordinate plane. The same ill-conditioning can occur for one of those, but not both since at least one of the components of $\mathbf{N}_{\mathcal{F}}$ must be larger or equal to $1/\sqrt{3}$ in magnitude. The area of the polygonal face is computed accordingly:

$$
A = \begin{cases}
\frac{1}{|\hat{\eta}_z|} \int_{R_{xy}} dx\, dy = \frac{1}{2\hat{\eta}_z} \sum_{i=0}^{n-1} x_i(y_{i+1} - y_{i-1}), & |\hat{\eta}_z| = \max\{|\hat{\eta}_x|, |\hat{\eta}_y|, |\hat{\eta}_z|\} \\[1mm]
\frac{1}{|\hat{\eta}_x|} \int_{R_{yz}} dy\, dz = \frac{1}{2\hat{\eta}_x} \sum_{i=0}^{n-1} y_i(z_{i+1} - z_{i-1}), & |\hat{\eta}_x| = \max\{|\hat{\eta}_x|, |\hat{\eta}_y|, |\hat{\eta}_z|\} \\[1mm]
\frac{1}{|\hat{\eta}_y|} \int_{R_{zx}} dz\, dx = \frac{1}{2\hat{\eta}_y} \sum_{i=0}^{n-1} z_i(x_{i+1} - x_{i-1}), & |\hat{\eta}_y| = \max\{|\hat{\eta}_x|, |\hat{\eta}_y|, |\hat{\eta}_z|\}
\end{cases} \tag{2.96}
$$

where R_{xy}, R_{yz}, and R_{zx} are the regions of projection of the polygonal face.

The construction of $\int_S q(x, y, z)\, dS$ is handled in a similar manner except that now the integrand has variables, the dependent one needing replacement using the appropriate formulation of the plane equation:

$$\int_S q(x, y, z)\, dS \tag{2.97}$$

$$= \begin{cases} \frac{1}{|\hat{\eta}_z|} \int_{R_{xy}} q(x, y, -(w + \hat{\eta}_x x + \hat{\eta}_y y)/\hat{\eta}_z)\, dx\, dy, & |\hat{\eta}_z| = \max\{|\hat{\eta}_x|, |\hat{\eta}_y|, |\hat{\eta}_z|\} \\ \frac{1}{|\hat{\eta}_x|} \int_{R_{yz}} q(-(w + \hat{\eta}_y y + \hat{\eta}_z z)/\hat{\eta}_x, y, z)\, dy\, dz, & |\hat{\eta}_x| = \max\{|\hat{\eta}_x|, |\hat{\eta}_y|, |\hat{\eta}_z|\} \\ \frac{1}{|\hat{\eta}_y|} \int_{R_{zx}} q(x, -(w + \hat{\eta}_x x + \hat{\eta}_z z)/\hat{\eta}_y, z)\, dz\, dx, & |\hat{\eta}_y| = \max\{|\hat{\eta}_x|, |\hat{\eta}_y|, |\hat{\eta}_z|\} \end{cases}$$

Each integrand is a polynomial of two independent variables. A function \mathbf{G} must be chosen so that $\nabla \cdot \mathbf{G}$ is that polynomial. When $|\hat{\eta}_z|$ is the maximum absolute normal component, \mathbf{G} will have components that depend on x and y. Using the same notation that led to equation (2.95), the integral is

$$\int_S q(x, y, z)\, dS$$

$$= \frac{1}{|\hat{\eta}_z|} \sum_{i=0}^{n-1} \int_0^{L_i} \mathbf{M}_i \cdot \mathbf{G}(x(s), y(s))\, ds$$

$$= \frac{\text{Sign}(\hat{\eta}_z)}{|\hat{\eta}_z|} \sum_{i=0}^{n-1} \frac{(y_{i+1} - y_i, x_i - x_{i+1})}{L_i} \cdot \int_0^{L_i} \mathbf{G}((1 - s/L_i)\mathbf{Q}_i + (s/L_i)\mathbf{Q}_{i+1})\, ds$$

$$= \frac{1}{\hat{\eta}_z} \sum_{i=0}^{n-1} (y_{i+1} - y_i, x_i - x_{i+1}) \cdot \int_0^1 \mathbf{G}((1 - t)\mathbf{Q}_i + t\mathbf{Q}_{i+1})\, dt$$

At this point the remaining work involves selecting \mathbf{G} for each integrand of equation (2.97) and computing the integral $\int_0^1 \mathbf{G}(1 - t)\mathbf{Q}_i + t\mathbf{Q}_{i+1})\, dt$. See [Mir96a] for all the tedious details. I summarize the formulas below. The notation used in that paper is that (α, β, γ) is a permutation of the usual coordinates, chosen from one of (x, y, z), (y, z, x), or (z, x, y). The projection integrals are $\pi_f = \int_R f\, d\alpha\, d\beta$, where R is the projection of the polygonal face onto the $\alpha\beta$-plane and f is some polynomial function:

$$\int_{\mathcal{F}} \alpha\, dS = |\hat{\eta}_\gamma|^{-1} \pi_\alpha$$

$$\int_{\mathcal{F}} \beta\, dS = |\hat{\eta}_\gamma|^{-1} \pi_\beta$$

$$\int_{\mathcal{F}} \gamma\, dS = -|\hat{\eta}_\gamma|^{-1} \hat{\eta}_\gamma^{-1} (\hat{\eta}_\alpha \pi_\alpha + \hat{\eta}_\beta \pi_\beta + w\pi_1)$$

$$\int_{\mathcal{F}} \alpha^2 \, dS = |\hat{\eta}_\gamma|^{-1} \pi_{\alpha^2}$$

$$\int_{\mathcal{F}} \beta^2 \, dS = |\hat{\eta}_\gamma|^{-1} \pi_{\beta^2}$$

$$\int_{\mathcal{F}} \gamma^2 \, dS = |\hat{\eta}_\gamma|^{-1} \hat{\eta}_\gamma^{-2} (\hat{\eta}_\alpha^2 \pi_{\alpha^2} + 2\hat{\eta}_\alpha \hat{\eta}_\beta \pi_{\alpha\beta} + \hat{\eta}_\beta^2 \pi_{\beta^2} + 2w(\hat{\eta}_\alpha \pi_\alpha + \hat{\eta}_\beta \pi_\beta) + w^2 \pi_1)$$

$$\int_{\mathcal{F}} \alpha^3 \, dS = |\hat{\eta}_\gamma|^{-1} \pi_{\alpha^3}$$

$$\int_{\mathcal{F}} \beta^3 \, dS = |\hat{\eta}_\gamma|^{-1} \pi_{\beta^3}$$

$$\int_{\mathcal{F}} \gamma^3 \, dS = -|\hat{\eta}_\gamma|^{-1} \hat{\eta}_\gamma^{-3} (\hat{\eta}_\alpha^3 \pi_{\alpha^3} + 3\hat{\eta}_\alpha^2 \hat{\eta}_\beta \pi_{\alpha^2\beta} + 3\hat{\eta}_\alpha \hat{\eta}_\beta^2 \pi_{\alpha\beta^2} + \hat{\eta}_\beta^3 \pi_{\beta^3} +$$

$$3w(\hat{\eta}_\alpha^2 \pi_{\alpha^2} + 2\hat{\eta}_\alpha \hat{\eta}_\beta \pi_{\alpha\beta} + \hat{\eta}_\beta^2 \pi_{\beta^2}) + 3w^2(\hat{\eta}_\alpha \pi_\alpha + \hat{\eta}_\beta \pi_\beta) + w^3 \pi_1)$$

$$\int_{\mathcal{F}} \alpha^2\beta \, dS = |\hat{\eta}_\gamma|^{-1} \pi_{\alpha^2\beta}$$

$$\int_{\mathcal{F}} \beta^2\gamma \, dS = -|\hat{\eta}_\gamma|^{-1} \hat{\eta}_\gamma^{-1} (\hat{\eta}_\alpha \pi_{\alpha\beta^2} + \hat{\eta}_\beta \pi_{\beta^3} + w \pi_{\beta^2})$$

$$\int_{\mathcal{F}} \gamma^2\alpha \, dS = |\hat{\eta}_\gamma|^{-1} \hat{\eta}_\gamma^{-2} (\hat{\eta}_\alpha^2 \pi_{\alpha^3} + 2\hat{\eta}_\alpha \hat{\eta}_\beta \pi_{\alpha^2\beta} + \hat{\eta}_\beta^2 \pi_{\alpha\beta^2} + 2w(\hat{\eta}_\alpha \pi_{\alpha^2} + \hat{\eta}_\beta \pi_{\alpha\beta}) + w^2 \pi_\alpha)$$

The projection integrals are

$$\pi_1 = \frac{\mathrm{Sign}(\hat{\eta}_\gamma)}{2} \sum_{i=0}^{n-1} (\beta_{i+1} - \beta_i)(\alpha_{i+1} + \alpha_i)$$

$$\pi_\alpha = \frac{\mathrm{Sign}(\hat{\eta}_\gamma)}{6} \sum_{i=0}^{n-1} (\beta_{i+1} - \beta_i)(\alpha_{i+1}^2 + \alpha_{i+1}\alpha_i + \alpha_i^2)$$

$$\pi_\beta = -\frac{\mathrm{Sign}(\hat{\eta}_\gamma)}{6} \sum_{i=0}^{n-1} (\alpha_{i+1} - \alpha_i)(\beta_{i+1}^2 + \beta_{i+1}\beta_i + \beta_i^2)$$

$$\pi_{\alpha^2} = \frac{\mathrm{Sign}(\hat{\eta}_\gamma)}{12} \sum_{i=0}^{n-1} (\beta_{i+1} - \beta_i)(\alpha_{i+1}^3 + \alpha_{i+1}^2\alpha_i + \alpha_{i+1}\alpha_i^2 + \alpha_i^3)$$

$$\pi_{\alpha\beta} = \frac{\mathrm{Sign}(\hat{\eta}_\gamma)}{24} \sum_{i=0}^{n-1} (\beta_{i+1} - \beta_i)(\beta_{i+1}(3\alpha_{i+1}^2 + 2\alpha_{i+1}\alpha_i + \alpha_i^2) + \beta_i(\alpha_{i+1}^2 + 2\alpha_{i+1}\alpha_i + 3\alpha_i^2))$$

$$\pi_{\beta^2} = -\frac{\text{Sign}(\hat{\eta}_\gamma)}{12} \sum_{i=0}^{n-1} (\alpha_{i+1} - \alpha_i)(\beta_{i+1}^3 + \beta_{i+1}^2\beta_i + \beta_{i+1}\beta_i^2 + \beta_i^3)$$

$$\pi_{\alpha^3} = \frac{\text{Sign}(\hat{\eta}_\gamma)}{20} \sum_{i=0}^{n-1} (\beta_{i+1} - \beta_i)(\alpha_{i+1}^4 + \alpha_{i+1}^3\alpha_i + \alpha_{i+1}^2\alpha_i^2 + \alpha_{i+1}\alpha_i^3 + \alpha_i^4)$$

$$\pi_{\alpha^2\beta} = \frac{\text{Sign}(\hat{\eta}_\gamma)}{60} \sum_{i=0}^{n-1} (\beta_{i+1} - \beta_i)(\beta_{i+1}(4\alpha_{i+1}^3 + 3\alpha_{i+1}^2\alpha_i + 2\alpha_{i+1}\alpha_i^2 + \alpha_i^3)$$
$$+ \beta_i(\alpha_{i+1}^3 + 2\alpha_{i+1}^2\alpha_i + 3\alpha_{i+1}\alpha_i^2 + 4\alpha_i^3))$$

$$\pi_{\alpha\beta^2} = -\frac{\text{Sign}(\hat{\eta}_\gamma)}{60} \sum_{i=0}^{n-1} (\alpha_{i+1} - \alpha_i)(\alpha_{i+1}(4\beta_{i+1}^3 + 3\beta_{i+1}^2\beta_i + 2\beta_{i+1}\beta_i^2 + \beta_i^3)$$
$$+ \alpha_i(\beta_{i+1}^3 + 2\beta_{i+1}^2\beta_i + 3\beta_{i+1}\beta_i^2 + 4\beta_i^3))$$

$$\pi_{\beta^3} = -\frac{\text{Sign}(\hat{\eta}_\gamma)}{20} \sum_{i=0}^{n-1} (\alpha_{i+1} - \alpha_i)(\beta_{i+1}^4 + \beta_{i+1}^3\beta_i + \beta_{i+1}^2\beta_i^2 + \beta_{i+1}\beta_i^3 + \beta_i^4)$$

Notice that the formula for π_1 is exactly what we derived for the area of the polygonal face.

An example of how these are used is

$$\hat{\eta}_x \int_S x \, dS = \begin{cases} |\hat{\eta}_z^{-1}|\hat{\eta}_x\pi_x, & |\hat{\eta}_z| = \max\{|\hat{\eta}_x|, |\hat{\eta}_y|, |\hat{\eta}_z|\} \\ |\hat{\eta}_y^{-1}|\hat{\eta}_x\pi_x, & |\hat{\eta}_y| = \max\{|\hat{\eta}_x|, |\hat{\eta}_y|, |\hat{\eta}_z|\} \\ -|\hat{\eta}_x^{-1}|(\hat{\eta}_y\pi_y + \hat{\eta}_z\pi_z + w\pi_1), & |\hat{\eta}_x| = \max\{|\hat{\eta}_x|, |\hat{\eta}_y|, |\hat{\eta}_z|\} \end{cases}$$

$$= \begin{cases} \frac{\hat{\eta}_x}{6\hat{\eta}_z} \sum_{i=0}^{n-1}(y_{i+1} - y_i)(x_{i+1}^2 + x_{i+1}x_i + x_i^2), & |\hat{\eta}_z| = \max\{|\hat{\eta}_x|, |\hat{\eta}_y|, |\hat{\eta}_z|\} \\ -\frac{\hat{\eta}_x}{6\hat{\eta}_y} \sum_{i=0}^{n-1}(z_{i+1} - z_i)(x_{i+1}^2 + x_{i+1}x_i + x_i^2), & |\hat{\eta}_y| = \max\{|\hat{\eta}_x|, |\hat{\eta}_y|, |\hat{\eta}_z|\} \\ -\frac{\hat{\eta}_y}{6\hat{\eta}_x} \sum_{i=0}^{n-1}(z_{i+1} - z_i)(y_{i+1}^2 + y_{i+1}y_i + y_i^2) \\ \frac{\hat{\eta}_z}{6\hat{\eta}_x} \sum_{i=0}^{n-1}(y_{i+1} - y_i)(z_{i+1}^2 + z_{i+1}z_i + z_i^2) \\ \frac{\hat{\eta}_x x_0 + \hat{\eta}_y y_0 + \hat{\eta}_z z_0}{2\hat{\eta}_x} \sum_{i=0}^{n-1}(z_{i+1} - z_i)(y_{i+1} + y_i), & |\hat{\eta}_x| = \max\{|\hat{\eta}_x|, |\hat{\eta}_y|, |\hat{\eta}_z|\} \end{cases} \quad (2.98)$$

As we will see in the next section, these formulas reduce greatly when the polyhedron has triangle faces.

Computation by Direct Parameterization of Triangles

Let the triangular face be counterclockwise ordered and have vertices $P_i = (x_i, y_i, z_i)$, $0 \le i \le 2$. Two edges are

$$E_i = P_i - P_0 = (x_i - x_0, y_i - y_0, z_i - z_0) = (\alpha_i, \beta_i, \gamma_i)$$

for $1 \le i \le 2$. A parameterization of the face is

$$\begin{aligned}
P(u, v) &= P_0 + uE_1 + vE_2 \\
&= (x_0 + \alpha_1 u + \alpha_2 v, \ y_0 + \beta_1 u + \beta_2 v, \ z_0 + \gamma_1 u + \gamma_2 v) \qquad (2.99) \\
&= (x(u, v), y(u, v), z(u, v))
\end{aligned}$$

where $u \ge 0$, $v \ge 0$ and $u + v \le 1$. The infinitesimal measure of surface area is

$$dS = \left| \frac{\partial P}{\partial u} \times \frac{\partial P}{\partial v} \right| \, du \, dv = |E_1 \times E_2| \, du \, dv$$

and the outer-pointing unit-length face normal is

$$N_{\mathcal{F}} = \frac{E_1 \times E_2}{|E_1 \times E_2|} = \frac{(\beta_1\gamma_2 - \beta_2\gamma_1, \ \alpha_2\gamma_1 - \alpha_1\gamma_2, \ \alpha_1\beta_2 - \alpha_2\beta_1)}{|E_1 \times E_2|} = \frac{(\delta_0, \delta_1, \delta_2)}{|E_1 \times E_2|}$$

The integrals in equation (2.93) reduce to

$$\begin{aligned}
(N_{\mathcal{F}} \cdot \ell) & \int_{\mathcal{F}} q(x, y, z) \, dS \\
&= (E_1 \times E_2 \cdot \ell) \int_0^1 \int_0^{1-v} q(x(u, v), y(u, v), z(u, v)) \, du \, dv
\end{aligned} \qquad (2.100)$$

where $x(u, v)$, $y(u, v)$, and $z(u, v)$ are the components of the parameterization in equation (2.99).

The integrals on the right-hand side of equation (2.100) can be computed symbolically, either by hand or by a symbolic algebra package. The formulas listed on page 75 were computed using Mathematica. Common subexpressions may be obtained by some additional factoring. Define:

$$s_n(w) = \sum_{i=0}^{n} w_0^{n-i} w_1^i, \quad f_0(w) = 1, \quad \text{and} \quad f_n(w) = s_n(w) + w_2 f_{n-1}(w) \quad \text{for } n \ge 1$$

Think of these as macros where the input argument is a textual replacement wherever w occurs in the right-hand sides. Also define the macro:

$$g_i(w) = f_2(w) + w_i f_1(w) + w_i^2$$

The specific expressions required in the surface integrals are listed below in terms of w. Each macro is expanded three times, once for each of x, y, and z:

$$f_1(w) = w_0 + w_1 + w_2 = [w_0 + w_1] + w_2$$

$$f_2(w) = w_0^2 + w_0 w_1 + w_1^2 + w_2 f_1(w)$$

$$= [[w_0^2] + w_1\{w_0 + w_1)\}] + w_2\{f_1(w)\}$$

$$f_3(w) = w_0^3 + w_0^2 w_1 + w_0 w_1^2 + w_1^3 + w_2 f_2(w) \qquad (2.101)$$

$$= w_0\{w_0^2\} + w_1\{w_0^2 + w_0 w_1 + w_1^2\} + w_2\{f_2(w)\}$$

$$g_i(w) = \{f_2(w)\} + w_i(\{f_1(w)\} + w_i)$$

The square brackets [] indicate that the subexpression is computed and saved in temporary variables for later use. The curly braces { } indicate that the subexpression was computed earlier and can be accessed from temporary variables. The number of subexpressions that must be stored at any one time is small, so cache coherence should not be an issue when enough floating point registers are available for storing the subexpressions (see the pseudocode on page 76 in this text).

The integrals are

$$(\mathbf{N}_{\mathcal{F}} \cdot \imath) \int_{\mathcal{F}} x \, dS = \frac{\delta_0}{6} f_1(x) \qquad (\mathbf{N}_{\mathcal{F}} \cdot \jmath) \int_{\mathcal{F}} y^3 \, dS = \frac{\delta_1}{20} f_3(y)$$

$$(\mathbf{N}_{\mathcal{F}} \cdot \imath) \int_{\mathcal{F}} x^2 \, dS = \frac{\delta_0}{12} f_2(x) \qquad (\mathbf{N}_{\mathcal{F}} \cdot \mathbf{k}) \int_{\mathcal{F}} z^3 \, dS = \frac{\delta_2}{20} f_3(z)$$

$$(\mathbf{N}_{\mathcal{F}} \cdot \jmath) \int_{\mathcal{F}} y^2 \, dS = \frac{\delta_1}{12} f_2(y) \qquad (\mathbf{N}_{\mathcal{F}} \cdot \imath) \int_{\mathcal{F}} x^2 y \, dS = \frac{\delta_0}{60} (y_0 g_0(x) + y_1 g_1(x) + y_2 g_2(x))$$

$$(\mathbf{N}_{\mathcal{F}} \cdot \mathbf{k}) \int_{\mathcal{F}} z^2 \, dS = \frac{\delta_2}{12} f_2(z) \qquad (\mathbf{N}_{\mathcal{F}} \cdot \jmath) \int_{\mathcal{F}} y^2 z \, dS = \frac{\delta_1}{60} (z_0 g_0(y) + z_1 g_1(y) + z_2 g_2(y))$$

$$(\mathbf{N}_{\mathcal{F}} \cdot \imath) \int_{\mathcal{F}} x^3 \, dS = \frac{\delta_0}{20} f_3(x) \qquad (\mathbf{N}_{\mathcal{F}} \cdot \mathbf{k}) \int_{\mathcal{F}} z^2 x \, dS = \frac{\delta_2}{60} (x_0 g_0(z) + x_1 g_1(z) + x_2 g_2(z))$$

Comparison to Mirtich's Formulas

Let us compare the formulas for $Q_x = (\mathbf{N}_{\mathcal{F}} \cdot \imath) \int_{\mathcal{F}} x \, dS$. Our derivation led to the formula

$$Q_x = \frac{\delta_0}{6} f_1(x) = \frac{\delta_0}{6} (x_0 + x_1 + x_2) \qquad (2.102)$$

In equation (2.98) there are three possibilities for computing Q_x. In the case $\gamma = z$,

$$Q_x = \frac{\delta_0}{6} \frac{(y_1 - y_0)(x_1^2 + x_0 x_1 + x_0^2) + (y_2 - y_1)(x_2^2 + x_1 x_2 + x_1^2) + (y_0 - y_2)(x_0^2 + x_0 x_2 + x_2^2)}{(x_1 - x_0)(y_2 - y_0) - (x_2 - x_0)(y_1 - y_0)}$$

The final formula requires much more computational time than the one derived in this document. In fact, the numerator is exactly divisible by the denominator and the fraction reduces to $x_0 + x_1 + x_2$, as it should to be equivalent to the Q_x in equation (2.102). The reduction was verified using Mathematica. If $\gamma = x$, equation (2.98) produces

$$Q_x = -\frac{1}{\delta_0}\left(\frac{\delta_1}{6} \sum_{i=0}^{2} (z_{i+1} - z_i)(y_{i+1}^2 + y_{i+1}y_i + y_i^2) - \frac{\delta_2}{6} \sum_{i=0}^{2} (y_{i+1} - y_i)(z_{i+1}^2 + z_{i+1}z_i + z_i^2) \right.$$

$$\left. - \frac{\delta_0 x_0 + \delta_1 y_0 + \delta_2 z_0}{2} \sum_{i=0}^{2} (z_{i+1} - z_i)(y_{i+1} + y_i) \right)$$

The correctness of this formula was verified using Mathematica; in fact, it reduces to equation (2.102). The computational requirements for this expression are enormous compared to that of equation (2.102).

Comparisons between the formulas for the other integrals is possible, but you will find that the differences in computational time become even greater than in the example shown here.

Pseudocode

SOURCE CODE

PolyhedralMass-
Properties

The pseudocode for computing the integrals is quite simple. The polyhedron vertices are passed as the array p[]. The number of triangles is tmax. The array index[] has tmax triples of integers that are indices into the vertex array. The return values are the mass, the center of mass, and the inertia tensor.

```
constant Real oneDiv6 = 1/6;
constant Real oneDiv24 = 1/24;
constant Real oneDiv60 = 1/60;
constant Real oneDiv120 = 1/120;

MACRO Subexpressions(w0,w1,w2,f1,f2,f3,g0,g1,g2)
{
    // These are the expressions discussed in equation (2.101).
    temp0 = w0 + w1;
    f1 = temp0 + w2;
    temp1 = w0 * w0;
    temp2 = temp1 + w1 * temp0;
```

```
        f2 = temp2 + w2 * f1;
        f3 = w0 * temp1 + w1 * temp2 + w2 * f2;
        g0 = f2 + w0 * (f1 + w0);
        g1 = f2 + w1 * (f1 + w1);
        g2 = f2 + w2 * (f1 + w2);
}

void Compute (Point p[], int tmax, int index[], Real& mass, Point& cm,
    Matrix& inertia)
{
    // order: 1, x, y, z, x^2, y^2, z^2, xy, yz, zx
    Real integral[10] = {0,0,0,0,0,0,0,0,0,0};
    for (t = 0; t < tmax; t++)
    {
        // get vertices of triangle t
        i0 = index[3 * t];
        i1 = index[3 * t + 1];
        i2 = index[3 * t + 2];
        x0 = p[i0].x;
        y0 = p[i0].y;
        z0 = p[i0].z;
        x1 = p[i1].x;
        y1 = p[i1].y;
        z1 = p[i1].z;
        x2 = p[i2].x;
        y2 = p[i2].y;
        z2 = p[i2].z;

        // get edges and cross product of edges
        a1 = x1 - x0;
        b1 = y1 - y0;
        c1 = z1 - z0;
        a2 = x2 - x0;
        b2 = y2 - y0;
        c2 = z2 - z0;
        d0 = b1 * c2 - b2 * c1;
        d1 = a2 * c1 - a1 * c2;
        d2 = a1 * b2 - a2 * b1;

        // compute integral terms
        Subexpressions(x0,x1,x2,f1x,f2x,f3x,g0x,g1x,g2x);
        Subexpressions(y0,y1,y2,f1y,f2y,f3y,g0y,g1y,g2y);
        Subexpressions(z0,z1,z2,f1z,f2z,f3z,g0z,g1z,g2z);
```

```
        // update integrals
        integral[0] += d0 * f1x;
        integral[1] += d0 * f2x;
        integral[2] += d1 * f2y;
        integral[3] += d2 * f2z;
        integral[4] += d0 * f3x;
        integral[5] += d1 * f3y;
        integral[6] += d2 * f3z;
        integral[7] += d0 * (y0 * g0x + y1 * g1x + y2 * g2x);
        integral[8] += d1 * (z0 * g0y + z1 * g1y + z2 * g2y);
        integral[9] += d2 * (x0 * g0z + x1 * g1z + x2 * g2z);
    }
    integral[0] *= oneDiv6;
    integral[1] *= oneDiv24;
    integral[2] *= oneDiv24;
    integral[3] *= oneDiv24;
    integral[4] *= oneDiv60;
    integral[5] *= oneDiv60;
    integral[6] *= oneDiv60;
    integral[7] *= oneDiv120;
    integral[8] *= oneDiv120;
    integral[9] *= oneDiv120;

    mass = integral[0];

    // center of mass
    cm.x = integral[1] / mass;
    cm.y = integral[2] / mass;
    cm.z = integral[3] / mass;

    // inertia relative to world origin
    inertia.xx = integral[5] + integral[6];
    inertia.yy = integral[4] + integral[6];
    inertia.zz = integral[4] + integral[5];
    inertia.xy = -integral[7];
    inertia.yz = -integral[8];
    inertia.xz = -integral[9];

    // inertia relative to center of mass
    inertia.xx -= mass * (cm.y * cm.y + cm.z * cm.z);
    inertia.yy -= mass * (cm.z * cm.z + cm.x * cm.x);
    inertia.zz -= mass * (cm.x * cm.x + cm.y * cm.y);
    inertia.xy += mass * cm.x * cm.y;
    inertia.yz += mass * cm.y * cm.z;
    inertia.xz += mass * cm.z * cm.x;
}
```

The format of the input vertices and triangle connectivity array is useful if the input comes from triangle meshes that are also used for drawing. However, for even greater speed you may exchange some memory usage by passing in a single array of a more complicated triangle data structure that stores the three vertices and the cross product of two edges. This format will avoid the indirect lookup of vertices, the vector subtraction used to compute edges, and the cross product operation.

**EXERCISE
2.15**

(E) Implement the pseudocode for computing the mass, center of mass, and inertia tensor for a polyhedron.

(H) Implement the Mirtich algorithm for computing the mass, center of mass, and inertia tensor for a polyhedron.

(M) Set up a profiling experiment to compare the average time per polyhedron required to compute the physical quantities.

2.6 ENERGY

This section is a brief one and describes the concepts of work, kinetic energy, and potential energy. The concept of kinetic energy is important in the development of Lagrangian dynamics. The concept of potential energy is important in the realm of conservative forces.

2.6.1 WORK AND KINETIC ENERGY

Consider a particle of mass m that is constrained to travel along a straight line whose direction is the unit-length vector \mathbf{D}. Suppose that a constant force \mathbf{F} is applied to the particle while it is moving. Figure 2.22 illustrates the situation.

If $L = |\mathbf{x}_1 - \mathbf{x}_0|$ is the distance traveled by the particle over a given time interval, the *work* done by the force on the particle over that time is defined to be the product

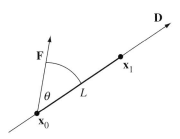

Figure 2.22 A force applied to a particle traveling on a straight line from position \mathbf{x}_0 to \mathbf{x}_1.

of the magnitude of the force along the direction of the line and the distance traveled. In the simple illustration of Figure 2.22, the work is

$$W = (|\mathbf{F}| \cos \theta)L = (\mathbf{F} \cdot \mathbf{D})L \qquad (2.103)$$

Observe that the component of the force in the direction of the line is $(\mathbf{F} \cdot \mathbf{D})\mathbf{D}$. The work is just the magnitude of that component times the distance traveled.

The path of the particle may very well be any smooth curve $\mathbf{x}(t)$. In this case we resort to the usual infinitesimal argument from calculus. Over an infinitesimal amount of time dt, the path looks like a line, and that line is the tangent line to the curve at the initial position of the particle. The infinitesimal amount of distance traveled by the particle during this instant of time is ds, the element of arc length. The direction at the initial instant of time is the unit-length tangential direction $\mathbf{D} = d\mathbf{x}/ds$. Using equation (2.103) as our motivation, the infinitesimal amount of work dW done by the force on the particle is

$$dW = (\mathbf{F} \cdot \mathbf{D}) \, ds = \left(\mathbf{F} \cdot \frac{d\mathbf{x}}{ds} \right) ds$$

The total work done by the force on the particle as it travels over an arc length L is

$$W = \int_0^L \mathbf{F} \cdot \frac{d\mathbf{x}}{ds} \, ds \qquad (2.104)$$

However, we usually know the position as a function of time t rather than as a function of arc length s. The infinitesimal amount of work is

$$dW = \left(\mathbf{F} \cdot \frac{d\mathbf{x}}{ds} \right) ds = (\mathbf{F} \cdot d\mathbf{x}) = \left(\mathbf{F} \cdot \frac{d\mathbf{x}}{dt} \right) dt$$

The total work done by the force on the particle as it travels over a time interval $[t_0, t_1]$ is

$$W = \int_{t_0}^{t_1} \mathbf{F} \cdot \frac{d\mathbf{x}}{dt} \, dt = \int_{t_0}^{t_1} \mathbf{F} \cdot \mathbf{v} \, dt \qquad (2.105)$$

where $\mathbf{v}(t)$ is the velocity of the particle.

In this development it is important to keep in mind that the position $\mathbf{x}(t)$ may not be entirely controlled by \mathbf{F}. Other forces can be acting on the particle at the same time. For example, the particle might be subject to gravitational force and \mathbf{F} represents a wind force. The quantity W in equation (2.105) represents the work done by the wind on the particle, but does not include work done by gravity.

EXAMPLE 2.10

A projectile of mass m follows a parabolic path $\mathbf{x}(t) = (t, 0, t(100 - t))$ for $t \in [0, 100]$. The projectile is subject to gravitational force $\mathbf{F} = (0, 0, -mg)$, where $g > 0$ is a constant. Compute the work done by the force over the specified interval.

The velocity of the projectile is $\mathbf{v} = (1, 0, 100 - 2t)$. The work done by the force is

$$W = \int_0^{100} \mathbf{F} \cdot \mathbf{v} \, dt$$

$$= \int_0^{100} (0, 0, -mg) \cdot (1, 0, 100 - 2t) \, dt$$

$$= 2mg \int_0^{100} t - 50 \, dt$$

$$= 2500mg \quad \blacksquare$$

EXERCISE Ⓜ **A** particle travels in the circular path $\mathbf{x}(t) = (r\cos(\omega t), r\sin(\omega t), 1)$. A constant
2.16 wind force is applied to the particle, $\mathbf{F} = (1, 1, 1)$. What is the work done by the wind
on the particle during one period of rotation $0 \leq t \leq 2\pi/\omega$? What is a time interval
over which the work is a maximum? Repeat the experiment, but for a time-varying
wind $\mathbf{F} = (t, t, 1)$. ▨

If \mathbf{F} is the net force on a particle and it does fully control the position, the integral
in equation (2.105) can be integrated in closed form for a constant mass particle. In
this case Newton's second law allows us to use $\mathbf{F} = m\mathbf{a}$:

$$W = \int_{t_0}^{t_1} m\mathbf{a} \cdot \mathbf{v} \, dt = \int_{t_0}^{t_1} \frac{d}{dt}\left(\frac{m}{2}|\mathbf{v}|^2\right) dt = \frac{m}{2}\left(|\mathbf{v}(t_1)|^2 - |\mathbf{v}(t_0)|^2\right)$$

The quantity W represents the work required to change the velocity of the particle
from $\mathbf{v}(t_0)$ to $\mathbf{v}(t_1)$. If the particle starts out at rest, that is, $\mathbf{v}(t_0) = \mathbf{0}$, then W is referred
to as *kinetic energy*. In general, kinetic energy for a moving particle is

$$T = \frac{m}{2}|\mathbf{v}|^2 \tag{2.106}$$

By construction, kinetic energy is measured with respect to an inertial frame of
reference. That frame is used to specify the position $\mathbf{x}(t)$ of the particle.

Kinetic energy is additive in the sense that for a system of particles, the kinetic
energy of the system is the sum of the kinetic energies of the individual particles. For
continuous material, the addition is in the sense of integration over a curve, surface,
or volumetric region, just as we have seen in other parts of this chapter.

2.6.2 CONSERVATIVE FORCES AND POTENTIAL ENERGY

The work done by a force on a particle traveling along a path $\mathbf{x}(t)$ for $t \in [t_0, t_1]$ is
defined by equation (2.105). The particle starts at $\mathbf{x}_0 = \mathbf{x}(t_0)$ and ends at $\mathbf{x}(t_1)$. By
definition, the work done on the force depends on the path taken by the particle

between the end points \mathbf{x}_0 and \mathbf{x}_1. In many physical situations, though, the work is *independent of the path* given the right type of force. When this happens, the force is said to be *conservative*.

EXAMPLE 2.11

A particle is allowed to move between two points (x_0, y_0, z_0) and (x_1, y_1, z_1) along a smooth path $(x(t), y(t), z(t))$ connecting them, $t \in [t_0, t_1]$. The particle is subjected to a gravitational force $\mathbf{F} = -mg\mathbf{k}$. The work done by gravity is

$$
\begin{aligned}
W &= \int_{t_0}^{t_1} \mathbf{F} \cdot \mathbf{v} \, dt \\
&= \int_{t_0}^{t_1} -mg\mathbf{k} \cdot (\dot{x}(t), \dot{y}(t), \dot{z}(t)) \, dt \\
&= -mg \int_{t_0}^{t_1} \dot{z}(t) \, dt \\
&= -mg(z(t_1) - z(t_0))
\end{aligned}
\tag{2.107}
$$

Regardless of how you choose the path connecting the two points, the work is always a constant times the difference in heights of the end points. That is, W is independent of the path of the particle and gravitational force is a conservative force. ▪

EXAMPLE 2.12

One end of a spring is attached to the origin $(0, 0, 0)$ and the other end is attached to a particle whose position $\mathbf{x}(t)$ varies with time, $t \in [t_0, t_1]$. The spring constant is $c > 0$ and the unstretched spring length is L. The force exerted on the particle by the spring is $\mathbf{F} = -c(\mathbf{x} - \boldsymbol{\ell})$ where $\boldsymbol{\ell} = L\mathbf{x}/|\mathbf{x}|$, a vector of constant length L in the same direction as \mathbf{x}. The work done by the spring force is

$$
\begin{aligned}
W &= \int_{t_0}^{t_1} \mathbf{F} \cdot \mathbf{v} \, dt \\
&= \int_{t_0}^{t_1} -c(\mathbf{x} - \boldsymbol{\ell}) \cdot \dot{\mathbf{x}} \, dt \\
&= \int_{t_0}^{t_1} -c(\mathbf{x} - \boldsymbol{\ell}) \cdot (\dot{\mathbf{x}} - \dot{\boldsymbol{\ell}}) \, dt \\
&= -c \int_{t_0}^{t_1} \frac{d}{dt} \frac{1}{2} |\mathbf{x} - \boldsymbol{\ell}|^2 \, dt \\
&= -(c/2)(|\mathbf{x}(t_1) - \boldsymbol{\ell}(t_1)|^2 - |\mathbf{x}(t_0) - \boldsymbol{\ell}(t_0)|^2)
\end{aligned}
\tag{2.108}
$$

The introduction of $(\mathbf{x} - \boldsymbol{\ell}) \cdot \dot{\boldsymbol{\ell}}$ in the integrand is valid since (1) $\mathbf{x} - \boldsymbol{\ell}$ is parallel to $\boldsymbol{\ell}$ and (2) $\dot{\boldsymbol{\ell}}$ is perpendicular to $\boldsymbol{\ell}$ because $\boldsymbol{\ell} \cdot \boldsymbol{\ell} = L^2$ implies $\boldsymbol{\ell} \cdot \dot{\boldsymbol{\ell}} = 0$. That is, $(\mathbf{x} - \boldsymbol{\ell}) \cdot \dot{\boldsymbol{\ell}} = 0$. The work depends only on the end points and not on the path connecting them, so the spring force is a conservative force. ▪

EXAMPLE 2.13

A particle moves from $(0, 0, 0)$ to $(1, 1, 0)$ and is subject to the spatially varying force $\mathbf{F} = (y, -x, 0)$. This force is not conservative. The work done by the force when the particle travels along the line segment $(t, t, 0)$ for $t \in [0, 1]$ is

$$W_1 = \int_0^1 \mathbf{F} \cdot \mathbf{v}\, dt = \int_0^1 (t, -t, 0) \cdot (1, 1, 0)\, dt = 0$$

The work done by the force when the particle travels along the parabolic arc $(t, t^2, 0)$ for $t \in [0, 1]$ is

$$W_2 = \int_0^1 \mathbf{F} \cdot \mathbf{v}\, dt = \int_0^1 (t, -t, 0) \cdot (1, 2t, 0)\, dt = \int_0^1 t - 2t^2\, dt = -1/6 \neq W_1$$

The work done by the force depends on the path taken by the particle. ▪

Other examples of nonconservative forces include friction, viscous drag when moving through a fluid, and many forces that have explicit dependence on time and velocity.

Consider a system of p particles with masses m_i and positions $(\hat{x}_i, \hat{y}_i, \hat{z}_i)$ for $1 \leq i \leq p$. These positions are referred to as the *reference system*. Conservative forces \mathbf{F}_i are applied to the particles in a *general system*, where the positions are (x_i, y_i, z_i), and work is measured as the general system is transferred to the reference system. The work done by the forces in transferring the system is referred to as the *potential energy* that the general system has with respect to the reference system. This quantity is denoted V and is defined by

$$V = -\sum_{i=1}^{p} \int_0^1 \mathbf{F}_i \cdot \mathbf{v}_i\, dt \qquad (2.109)$$

The paths implicit in the integration connect $(\hat{x}_i, \hat{y}_i, \hat{z}_i)$, at time 0, to (x_i, y_i, z_i), at time 1. Because the forces are conservative, any smooth paths that are parameterized by $t \in [0, 1]$ will do. The potential energy is therefore dependent only on the general system; the reference positions are assumed to be constant. That is, as a function we have

$$V = V(x_1, y_1, z_1, \ldots, x_p, y_p, z_p)$$

so that V is dependent on $3p$ variables. From calculus the total derivative of V is

$$dV = \frac{\partial V}{\partial x_1}dx_1 + \frac{\partial V}{\partial y_1}dy_1 + \frac{\partial V}{\partial z_1}dz_1 + \cdots + \frac{\partial V}{\partial x_p}dx_p + \frac{\partial V}{\partial y_p}dy_p + \frac{\partial V}{\partial z_p}dz_p$$

$$= \sum_{i=1}^{p}\left(\frac{\partial V}{\partial x_i}dx_i + \frac{\partial V}{\partial y_i}dy_i + \frac{\partial V}{\partial z_i}dz_i\right)$$

In terms of infinitesimal quantities, the potential energy is

$$dV = -\sum_{i=1}^{p}\mathbf{F}_i \cdot d\mathbf{x}_i = -\sum_{i=1}^{p}\left(F_{x_i}dx_i + F_{y_i}dy_i + F_{z_i}dz_i\right)$$

where each force is specified componentwise as $\mathbf{F}_i = (F_{x_i}, F_{y_i}, F_{z_i})$. In order to be independent of path, the right-hand sides of the last two differential equations must be equal. Thus,

$$F_{x_i} = -\frac{\partial V}{\partial x_i}, \qquad F_{y_i} = -\frac{\partial V}{\partial y_i}, \qquad F_{z_i} = -\frac{\partial V}{\partial z_i}$$

for all i. In compact vector notation, $\mathbf{F}_i = -\nabla_i V$, where ∇_i denotes the gradient operator with respect to the three variables x_i, y_i, and z_i.

By definition, if \mathbf{F} is a conservative force, there is a potential energy function V for which $\mathbf{F} = -\nabla V$. But how do you know if you have a conservative force? The answer lies in the same condition. If it were the case that $(F_1, F_2, F_3) = \mathbf{F} = -\nabla V$, then

$$F_1 = -\frac{\partial V}{\partial x}, \qquad F_2 = -\frac{\partial V}{\partial y}, \qquad F_3 = -\frac{\partial V}{\partial z}$$

Assuming V has continuous second-order partial derivatives, the mixed partials are equal. That is, $\partial^2 V/\partial x \partial y = \partial^2 V/\partial y \partial x$, $\partial^2 V/\partial x \partial z = \partial^2 V/\partial z \partial x$, and $\partial^2 V/\partial y \partial z = \partial^2 V/\partial z \partial y$. In terms of the function components, it is necessary that

$$\frac{\partial F_1}{\partial y} = \frac{\partial F_2}{\partial x}, \qquad \frac{\partial F_1}{\partial z} = \frac{\partial F_3}{\partial x}, \quad \text{and} \quad \frac{\partial F_2}{\partial z} = \frac{\partial F_3}{\partial y} \qquad (2.110)$$

Equations (2.110) are referred to as an *exactness* test. As it turns out, these conditions are sufficient as well as necessary for the existence of a potential energy function V for which $\mathbf{F} = -\nabla V$. If the conditions in the equation are satisfied, \mathbf{F} must be a conservative force.

EXAMPLE 2.14

In Example 2.11, the gravitational force is $(F_1, F_2, F_3) = (0, 0, -mg)$, a constant force. The conditions in equation (2.110) are trivially satisfied since all the derivatives of the F_i are zero.

In Example 2.12, the spring force is $(F_1, F_2, F_3) = -c(x, y, z)$. The exactness conditions are satisfied:

$$\frac{\partial F_1}{\partial y} = 0 = \frac{\partial F_2}{\partial x}, \qquad \frac{\partial F_1}{\partial z} = 0 = \frac{\partial F_3}{\partial x}, \qquad \frac{\partial F_2}{\partial z} = 0 = \frac{\partial F_3}{\partial y}$$

so the force is conservative.

In Example 2.13, the force is $(F_1, F_2, F_3) = (y, -x, 0)$. This force is not conservative since

$$\frac{\partial F_1}{\partial y} = 1 \neq -1 = \frac{\partial F_2}{\partial x}$$

The other two exactness tests are true, but as long as one of the three fails, the force is not conservative. ▨

One very important consequence of having a conservative force is that the total energy of the system is conserved. Let $\mathbf{F}(\mathbf{x})$ be the force and let $V(\mathbf{x})$ be the potential energy function for which $\mathbf{F} = -\nabla V$. The kinetic energy is $T = m|\dot{\mathbf{x}}|^2/2$ and the total energy is

$$E = T + V = \frac{1}{2} m|\dot{\mathbf{x}}|^2 + V(\mathbf{x}) \tag{2.111}$$

The time derivative of the energy is

$$\frac{dE}{dt} = \frac{d(T+V)}{dt} = m\dot{\mathbf{x}} \cdot \ddot{\mathbf{x}} + \dot{\mathbf{x}} \cdot \nabla V = \dot{\mathbf{x}} \cdot (m\ddot{\mathbf{x}} - \mathbf{F}) = 0$$

where the last equality follows from Newton's second law, $m\ddot{\mathbf{x}} = \mathbf{F}$.

CHAPTER **3**

RIGID BODY MOTION

hapter 2 introduced the topic of kinematics, the motion of a body along a path in the absence of external forces. Given the position, we can compute velocity and acceleration by differentiation. This chapter is about *dynamics*, the interaction of rigid bodies when forces and torques are present in the physical system. The classical approach in an introductory physics course uses Newtonian dynamics and the famous formula of Newton's law of motion, $\mathbf{F} = m\mathbf{a}$, where m is the constant mass of an object, \mathbf{a} is its acceleration, and \mathbf{F} is the applied force. The applied force determines the acceleration of the object, so velocity and position are obtained by integration, exactly the opposite process we saw in kinematics. The coverage of Newtonian dynamics is brief, yet sufficient to support the general-purpose physics engines that use Newton's second law for simulation, as described in Chapter 5.

The majority of this chapter is on the topic of *Lagrangian dynamics*, a framework for setting up the equations of motion for objects when constraints are present. In Lagrangian dynamics, the equations of motion are derived from the kinetic energy function and naturally incorporate the constraints. A Newtonian formulation requires that forces of constraint be part of the term \mathbf{F} in the equation of motion; the constraint forces are sometimes difficult to derive. Frictional forces are difficult to deal with in a general-purpose physics engine that uses Newtonian dynamics. In the Lagrangian approach frictional forces are easier to deal with. An entire section is devoted to various examples involving objects moving on a rough plane, that is, a plane whose material causes frictional forces.

A game designer's specific knowledge of what the game physics will entail can exploit that knowledge to good effect by formulating the simulations using Lagrangian dynamics. The result is that the computational time of the simulation is reduced compared to a general-purpose system using Newtonian dynamics. Even more important

is that the robustness problems with enforcing nonpenetration in a general-purpose engine are reduced. In the situation where you explicitly know the constraining surface on which an object must lie, you can periodically check if numerical round-off errors have caused the object to be slightly off the surface, then correct the position accordingly. On the other hand, a simulation modeled with Lagrangian dynamics is specific to each physics application, thus requiring more programming development time. My choice is to spend more time on the programming and gain the faster and more robust applications. In addition, Euler's equations of motion are discussed in this chapter because a few problems are more naturally formulated in terms of Euler angles than in terms of other dynamics systems.

The classic textbook covering mechanics, including the topics mentioned in this chapter, is [GPS02]. The text is on the heavy side with mathematics compared to what you see in a standard physics course. In my opinion, the ultimate textbook for Lagrangian dynamics is a title in the Schaum's Outline Series, [Wel67]. The presentation shirks away from many direct derivative computations and uses the infinitesimal approach that is popular among physicists to motivate some of the derivations (not my personal preference), but the book has a lot of good examples for you to try. If you are able to understand these and correctly work the exercises, you will be in a very good position to solve any similar problem that comes your way in an application.

3.1 NEWTONIAN DYNAMICS

The section on kinematics describes the position, velocity, and acceleration of a particle in motion along a curve and having no external forces acting on it. Dynamics, on the other hand, describes how the particle must move when external forces are acting on it. I assume that the mass m of the particle is constant over time, so Newton's law states that $\mathbf{F} = m\mathbf{a}$, where \mathbf{F} are the external forces acting on the particle and \mathbf{a} is the acceleration of the particle. If there are no external forces, $\mathbf{F} = \mathbf{0}$, the acceleration is $\mathbf{a}(t) = \mathbf{0}$. This equation integrates to $\mathbf{v}(t) = \mathbf{v}_0$, a constant. That is, the particle travels with constant velocity when the acceleration is zero. Integrating again yields $\mathbf{r}(t) = t\mathbf{v}_0 + \mathbf{r}_0$, where \mathbf{r}_0 is the initial location of the particle at time zero. The path of motion is a straight line, as expected when no forces act on the object.

In the case of kinematics, we postulated the path of a particle and computed the velocity and acceleration from it by differentiation. In the case of dynamics, we are specifying the acceleration and must integrate to obtain the velocity and acceleration. This is not always possible in a closed form, so many problems require numerical methods to approximate the solution.

EXAMPLE
3.1

Let us take a look at a classic problem of motion of the Earth about the Sun. The equations describing the motion are called *Kepler's laws*, after Johann Kepler, who established the first two laws in 1609 and the third law in 1616. The basis for the equation is that the Sun exerts a gravitational force on the Earth according to an inverse-squared-distance law. Let M be the mass of the Sun and m be the mass of

the Earth. Let r be the distance between the Earth and Sun. Let the position of the Sun define the origin of the coordinate system. The force exerted is

$$\mathbf{F} = -\frac{GMm}{r^2}\mathbf{R}$$

where G is a positive constant whose value is determined by empirical means. The vector \mathbf{R} is unit length and in the direction of the vector from the Sun to the Earth. The minus sign states that the force on the Earth is attracting it toward the Sun. Newton's law states that the acceleration \mathbf{a} of the Earth is determined by

$$m\mathbf{a} = \mathbf{F} = -\frac{GMm}{r^2}\mathbf{R} = -\frac{GMm}{r^3}\mathbf{r}$$

where we have used $\mathbf{r} = r\mathbf{R}$. Dividing by the Earth's mass and using $\mathbf{a} = \dot{\mathbf{v}}$:

$$\dot{\mathbf{v}} = -\frac{GM}{r^3}\mathbf{r} \tag{3.1}$$

Now consider:

$$\frac{d}{dt}(\mathbf{r} \times \mathbf{v}) = \mathbf{r} \times \dot{\mathbf{v}} + \dot{\mathbf{r}} \times \mathbf{v} = \mathbf{r} \times \left(-\frac{GM}{r^3}\mathbf{r}\right) + \mathbf{v} \times \mathbf{v} = -\frac{GM}{r^3}\mathbf{r} \times \mathbf{r} + \mathbf{v} \times \mathbf{v} = \mathbf{0}$$

This implies $\mathbf{r} \times \mathbf{v} = \mathbf{c}_0$, a constant vector for all time. Observe that the angular momentum of the Earth is $\mathbf{r} \times m\mathbf{v}$, so the implication is that the angular momentum is a constant vector for all time. Another immediate consequence of the constancy is that

$$0 = \mathbf{r} \cdot \mathbf{r} \times \mathbf{v} = \mathbf{r} \cdot \mathbf{c}_0$$

The motion is necessarily within a plane containing the Sun's location and having normal vector \mathbf{c}_0.

Kepler's First Law *Equal areas in the plane of motion are swept out in equal time intervals.* To see that this is true, consider an infinitesimal area dA swept out by moving the Earth from current position \mathbf{r} by an infinitesimal change in position $d\mathbf{r}$. Figure 3.1 illustrates this.

The infinitesimal area is that of a triangle with two sides \mathbf{r} and $\mathbf{r} + d\mathbf{r}$. The area of the triangles is half the magnitude of the cross product of two edges, so $dA = |\mathbf{r} \times d\mathbf{r}|/2$. On the macroscopic level,

$$\dot{A} = \frac{1}{2}|\mathbf{r} \times \dot{\mathbf{r}}| = \frac{1}{2}|\mathbf{r} \times \mathbf{v}| = \frac{1}{2}|\mathbf{c}_0|.$$

The rate of change in the swept area is constant, so equal areas are swept out in equal time intervals.

(Example 3.1 continued)

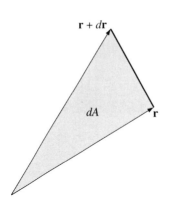

Figure 3.1 The infinitesimal area dA swept out by motion of the Earth over an infinitesimal change in position $d\mathbf{r}$. The swept region is effectively a triangle whose sides are \mathbf{r} and $\mathbf{r} + d\mathbf{r}$.

Kepler's Second Law *The orbit of the Earth is an ellipse with the Sun as one of the focal points.* To see that this is true, consider:

$$\frac{d}{dt}\left(\mathbf{v} \times \mathbf{c}_0\right) = \dot{\mathbf{v}} \times \mathbf{c}_0$$

$$= -\frac{GM}{r^3}\mathbf{r} \times \mathbf{c}_0$$

$$= -\frac{GM}{r^3}\mathbf{r} \times (\mathbf{r} \times \mathbf{v})$$

$$= -\frac{GM}{r^3}\mathbf{r} \times \left(\mathbf{r} \times \left(r\dot{\mathbf{R}} + \dot{r}\mathbf{R}\right)\right)$$

$$= -\frac{GM}{r^3}\mathbf{r} \times \left(r\mathbf{r} \times \dot{\mathbf{R}}\right)$$

$$= -GM\mathbf{R} \times \left(\mathbf{R} \times \dot{\mathbf{R}}\right)$$

$$= -GM\left(\left(\mathbf{R} \cdot \dot{\mathbf{R}}\right)\mathbf{R} - \left(\mathbf{R} \cdot \mathbf{R}\right)\dot{\mathbf{R}}\right)$$

$$= GM\dot{\mathbf{R}}$$

Integrating yields $\mathbf{v} \times \mathbf{c}_0 = GM\mathbf{R} + \mathbf{c}_1$ for some constant vector \mathbf{c}_1. Define $\gamma_0 = |\mathbf{c}_0|$ and $\gamma_1 = |\mathbf{c}_1|$ and observe that

$$\gamma_0^2 = |\mathbf{c}_0|^2$$
$$= \mathbf{r} \times \mathbf{v} \cdot \mathbf{c}_0$$
$$= \mathbf{r} \cdot \mathbf{v} \times \mathbf{c}_0$$
$$= \mathbf{r} \cdot (GM\mathbf{R} + \mathbf{c}_1)$$
$$= GMr + \mathbf{r} \cdot \mathbf{c}_1$$
$$= GMr + r\gamma_1 \cos \theta$$

where θ is the angle between \mathbf{r} and \mathbf{c}_1. In polar coordinates (r, θ), the equation is solved for r as a function of θ:

$$r(\theta) = \frac{\gamma_0^2}{GM + \gamma_1 \cos \theta} = \frac{e\rho}{1 + e \cos \theta} \tag{3.2}$$

which gives an ellipse with eccentricity $e = \gamma_1/(GM)$ and where $\rho = \gamma_0^2/\gamma_1$. The major axis length is $2a = r(0) + r(\pi) = 2\rho e/(1 - e^2)$. The minor axis length is $2b = 2a\sqrt{1 - e^2}$. The area of the ellipse is $A = \pi ab$.

Kepler's Third Law *The square of the period of the motion is proportional to the cube of the major axis length.* The proof is as follows. The areal rate of change is $\dot{A} = \gamma_0/2$. Integrating over one period of time $t \in [0, T]$ yields the total area of the ellipse, $A = \gamma_0 T/2$. Therefore, the period is

$$T = \frac{2A}{\gamma_0} = \frac{2\pi a^2 \sqrt{1 - e^2}}{\sqrt{GMa(1 - e^2)}} = \frac{2\pi}{\sqrt{GM}} a^{3/2}$$

or $T^2 = Ka^3$ for a constant of proportionality K. ▪

EXERCISE Ⓜ
3.1
Convert equation (3.2) to Cartesian coordinates and verify that it does in fact represent an ellipse. ▪

EXERCISE Ⓗ
3.2
Solve equation (3.1) using a differential equation solver. The left-hand side of that equation is replaced by $\ddot{\mathbf{r}}$, so the equation is second-order in position. Use $GM = 1$ for the right-hand side of the equation. Choose an initial position $\mathbf{r}(0)$ and an initial velocity $\dot{\mathbf{r}}(0)$ that are perpendicular vectors. ▪

EXERCISE Ⓗ
3.3

SOURCE CODE

KeplerPolarForm

Consider the polar coordinate form for acceleration given in equation (2.13). We saw in equation (3.2) that the motion of the Earth is along an elliptical path that defines r as a function of θ. However, we had not considered how θ varies in time. This exercise is designed to give you that information.

1. Derive two second-order differential equations, $\ddot{r} - r\dot{\theta}^2 = -GM/r^2$ and $r\ddot{\theta} + 2\dot{r}\dot{\theta} = 0$, that are the equations of motion in polar coordinates.

2. Show that the equation with $\ddot{\theta}$ implies $\alpha = M r^2 \dot{\theta}$ is a constant. The value α is angular momentum, so this physical system exhibits conservation of angular momentum as well as conservation of total energy. Since α is a constant, argue that $\dot{\theta}$ always has the same sign, in which case r may be thought of as a function of θ, $r = r(\theta)$.

3. Use the expression for α to eliminate $\dot{\theta}$ in the equation with \ddot{r} to obtain $\ddot{r} - \alpha^2/(M^2 r^3) = -GM/r^2$. This may be solved numerically for $r(t)$, but you might find that the singularity at $r = 0$ causes quite a fuss!

4. The potential energy is $V(\theta) = -GM/r$. Equivalently, $r = -GM/V$. I emphasized earlier that I am thinking of r as a function of θ, so V is also a function of θ. Its first derivative with respect to θ is denoted V' and its second derivative with respect to θ is denoted V''. Dots above variables will still be reserved to indicate time derivatives.

 (a) Show that $\dot{r} = GM V' \dot{\theta}/V^2 = \alpha V'/(GM^2)$.

 (b) Show that $\ddot{r} = \alpha V'' \dot{\theta}/(GM^2) = \alpha^2 V'' V^2/(G^3 M^5)$.

 (c) Use the last result in $\ddot{r} - \alpha^2/(M^2 r^3) = -GM/r^2$ to obtain $V'' + V = -G^2 M^4/\alpha^2$. Show that the general solution to this equation is $V(\theta) = c_0 \sin(\theta) + c_1 \cos(\theta) - G^2 M^4/\alpha^2$.

 (d) Determine c_0 and c_1 from the initial data r_0, \dot{r}_0, θ_0, and $\dot{\theta}_0$.

5. From conservation of momentum, show that $\dot{\theta} = \alpha V^2/(G^2 M^3)$.

6. Using the formula for $V(\theta)$ and the differential equation for θ, conclude that

$$\dot{\theta} = \frac{\alpha}{G^2 M^3} \left(c_0 \sin(\theta) + c_1 \cos(\theta) - \frac{G^2 M^4}{\alpha^2} \right)^2, \qquad \theta(0) = \theta_0$$

The result of this exercise is a first-order nonlinear differential equation that can be solved by standard numerical methods. Can you solve for $\theta(t)$ in closed form? ∎

EXAMPLE 3.2

Here is a second example and it is formulated for motion of a particle relative to the moving frame of a rigid body. Newton's second law is $\mathbf{F} = m\mathbf{a}$, where the acceleration \mathbf{a} is given in equation (2.44). The problem is to determine the path of motion of a particle that is freely falling toward the Earth, the rigid body, subject only to gravitational force. If the Earth were not rotating, the path of motion would clearly be a line containing the center of the Earth and the initial particle location. Fortunately, the Earth does rotate, so the problem is a bit more complex!

The world coordinate system is chosen so that its origin is at the center of the Earth. One of the coordinate axes is chosen to be in the direction from the Earth's center to the North Pole. The Earth rotates about this axis with angular velocity \mathbf{w}. Since we are dealing with a single particle, the center of mass is the particle's location and, subsequently, the origin of the moving frame. The moving frame directions are chosen to be those of spherical coordinates, $\boldsymbol{\xi}_1 = \mathbf{P}$, $\boldsymbol{\xi}_2 = \mathbf{Q}$, and $\boldsymbol{\xi}_3 = \mathbf{R}$. The force on

the particle due to gravity is $-mg\mathbf{R}$, where m is the mass of the particle and $g > 0$ is the gravitational constant. Since \mathbf{R} points away from the Earth's center, the minus sign in the force expression indicates the Earth is attracting the particle toward it. Equation (2.44) describes the path \mathbf{r} of the particle relative to the Earth's center.

We will take the usual liberties that you see in many physics applications. The equation of motion is quite complicated, so we will make a few simplifying assumptions that lead to a more tractable problem. First, let us assume that the time interval for which we want to know the path of motion is small. Over this time the difference between the particle and the world origin $\boldsymbol{\Delta}$ is effectively a constant. If it were identically a constant, then $\ddot{\boldsymbol{\Delta}} = \mathbf{0}$. We also assume that the angular velocity does not change significantly during the time interval. The mathematical approximation is $\dot{\mathbf{w}} = \mathbf{0}$. Finally, the number of seconds per day is approximately 86,400. The angular speed is $|\mathbf{w}| \doteq 2\pi/86{,}400$. The radius of the Earth is approximately 6440 kilometers. Assuming the particle is relatively near the Earth's surface, its position \mathbf{r} is of the order of magnitude of the Earth's radius. The magnitude of $\mathbf{w} \times (\mathbf{w} \times \mathbf{r})$ is of the order of $|\mathbf{w}|^2|\mathbf{r}| \doteq 3.4 \times 10^{-5}$, a very small number. The mathematical approximation to this term is $\mathbf{w} \times (\mathbf{w} \times \mathbf{r}) = \mathbf{0}$.

Using all the approximations in the equation of motion leads to

$$\frac{D^2\mathbf{r}}{Dt^2} = -2\mathbf{w} \times \frac{D\mathbf{r}}{Dt} - g\mathbf{R} \qquad (3.3)$$

This is a linear second-order system of ordinary differential equations in the unknown $\mathbf{r}(t)$. If we supply an initial position $\mathbf{r}_0 = \mathbf{r}(0)$ and an initial velocity $\mathbf{v}_0 = D\mathbf{r}(0)/Dt$, the equation can be solved in closed form. We may integrate equation (3.3) to obtain

$$\frac{D\mathbf{r}}{Dt} = \mathbf{v}_0 - 2\mathbf{w} \times (\mathbf{r} - \mathbf{r}_0) - gt\mathbf{R} = -2\mathbf{w} \times \mathbf{r} + (\mathbf{v}_0 + \mathbf{w} \times \mathbf{r}_0) - gt\mathbf{R} \quad (3.4)$$

Define $\mathbf{w} = \omega\mathbf{u}$ where \mathbf{u} is the normalized vector for \mathbf{w} and $\omega = |\mathbf{w}|$. Using methods for solving linear systems of differential equations, equation (3.4) can be solved as

$$\mathbf{r} = \text{Rot}(-2\omega t, \mathbf{u})\mathbf{r}_0 + (\mathbf{v}_0 + 2\mathbf{w} \times \mathbf{r}_0)\,t - (gt^2/2)\mathbf{R} \qquad (3.5)$$

where $\text{Rot}(\theta, \mathbf{u})$ denotes the rotation matrix about the axis with unit-length direction \mathbf{u} by the angle θ. Observe that if there were no rotation, that is, $\mathbf{w} = \mathbf{0}$, equation (3.5) is instead $\mathbf{r} = \mathbf{r}_0 + t\mathbf{v}_0 - (gt^2/2)\mathbf{R}$, exactly the equation you see in standard physics for a freely falling body where the Earth's rotation is considered neglible. ▪

EXERCISE (H)
3.4
Suppose that the particle represents a booster rocket that was fired from Cape Canaveral. Suppose the rocket traveled vertically upward to an altitude of 10 kilometers. At that point the rocket starts falling to Earth. Assuming the physical model of the last example applies for all time, how long does it take for the rocket to reach the ground? Where on Earth does it strike the ground? ▪

EXAMPLE
3.3

SOURCE CODE

FoucaultPendulum

This example is a model of the *Foucault pendulum*. The pendulum consists of a particle of mass m attached to one end of a wire of length L of negligible mass. The other end of the wire is attached to a joint at position \mathcal{O}. The joint is assumed to be frictionless. The only forces acting on the particle are gravity and the tension in the wire. Figure 3.2 shows the pendulum relative to a fixed frame with origin \mathcal{O}. We assume the Earth is rotating and that its angular velocity \mathbf{w} is in the direction from the center of the Earth \mathcal{C} to the North Pole, just as in the previous example.

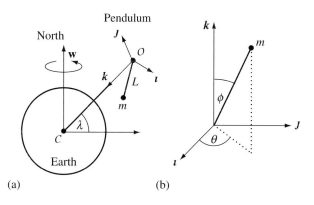

(a) (b)

Figure 3.2 The Foucault pendulum. The pendulum joint is at \mathcal{O}, the mass is m and is attached to the pendulum rod of length L. The gravitational force acts in the direction k, a unit-length vector from the joint to the center of the Earth.

The fixed frame vectors are k, a vector in the direction from \mathcal{O} to the center of the earth; \jmath, a vector in the plane of \mathbf{w} and k; and \imath, a vector pointing out of the page and perpendicular to the other two frame vectors. The mass at the end of the wire is represented in spherical coordinates relative to \mathcal{O}. The position is

$$\mathbf{r} = L\mathbf{R}(\theta, \phi)$$

where the angle ϕ is measured between the wire and the vertical k and the angle θ is measured from the \imath axis in the (\imath, \jmath) plane as shown in Figure 3.2(b). The angular velocity is represented in the fixed frame as

$$\mathbf{w} = \omega \left[(\cos \lambda)\jmath - (\sin \lambda)k \right]$$

where ω is the angular speed and λ is the latitude measured from the equator.

The simplifications that were made in the last example are also made here. The gravitational force is approximately mgk and the tension in the wire is $-m\tau\mathbf{R}$ for

some scalar $\tau > 0$. The equation of motion for the pendulum is

$$\frac{D^2\mathbf{r}}{dt^2} = -2\mathbf{w} \times \frac{D\mathbf{r}}{dt} + gk - \tau\mathbf{R} \tag{3.6}$$

Equations (2.32) and (2.33) apply, but with $\rho = L$, a constant for all time. The velocity is

$$\frac{D\mathbf{r}}{dt} = L\left[\left(\dot{\theta}\sin\phi\right)\mathbf{P} - \left(\dot{\phi}\right)\mathbf{Q}\right]$$

and the acceleration is

$$\frac{D^2\mathbf{r}}{dt^2} = L\big[\left(\ddot{\theta}\sin\phi + 2\dot{\theta}\dot{\phi}\cos\phi\right)\mathbf{P}$$
$$+ \left(\dot{\theta}^2\sin\phi\cos\phi - \ddot{\phi}\right)\mathbf{Q} - \left(\dot{\phi}^2 + \dot{\theta}^2\sin^2\phi\right)\mathbf{R}\big]$$

These may be substituted into equation (3.6) to obtain three equations, one for each spherical frame direction.

The first equation of motion is

$$L(\ddot{\theta}\sin\phi + 2\dot{\theta}\dot{\phi}\cos\phi) = \mathbf{P}\cdot\frac{D^2\mathbf{r}}{dt^2}$$
$$= -2\mathbf{w}\times\frac{D\mathbf{r}}{dt}\cdot\mathbf{P} + gk\cdot\mathbf{P} - \tau\mathbf{R}\cdot\mathbf{P}$$
$$= -2\mathbf{w}\cdot\frac{D\mathbf{r}}{dt}\times\mathbf{P}$$
$$= -2\mathbf{w}\cdot\left(L\dot{\phi}\mathbf{R}\right)$$
$$= -2L\dot{\phi}\left(\mathbf{w}\cdot\mathbf{R}\right)$$
$$= 2L\omega\dot{\phi}\left(-\cos\lambda\sin\theta\sin\phi + \sin\lambda\cos\phi\right)$$

The L terms cancel, so the first equation of motion has been simplified to

$$\ddot{\theta}\sin\phi + 2\dot{\theta}\dot{\phi}\cos\phi = 2\omega\dot{\phi}\left(-\cos\lambda\sin\theta\sin\phi + \sin\lambda\cos\phi\right) \tag{3.7}$$

(Example 3.3 continued)

The second equation of motion is

$$L(\dot{\theta}^2 \sin \phi \cos \phi - \ddot{\phi}) = \mathbf{Q} \cdot \frac{D^2 \mathbf{r}}{dt^2}$$

$$= -2\mathbf{w} \times \frac{D\mathbf{r}}{dt} \cdot \mathbf{Q} + gk \cdot \mathbf{Q} - \tau \mathbf{r} \cdot \mathbf{Q}$$

$$= -2\mathbf{w} \cdot \frac{D\mathbf{r}}{dt} \times \mathbf{Q} + g \sin \phi$$

$$= -2\mathbf{w} \cdot \left((L\dot{\theta} \sin \phi) \mathbf{R} \right) + g \sin \phi$$

$$= 2L\omega\dot{\theta} \sin \phi \, (- \cos \lambda \sin \theta \sin \phi + \sin \lambda \cos \phi) + g \sin \phi$$

Dividing by the L term, the second equation of motion simplifies to

$$\dot{\theta}^2 \sin \phi \cos \phi - \ddot{\phi} = 2\omega\dot{\theta} \sin \phi \, (- \cos \lambda \sin \theta \sin \phi + \sin \lambda \cos \phi) + \frac{g}{L} \sin \phi \quad (3.8)$$

The third equation is

$$-L(\dot{\phi}^2 + \dot{\theta}^2 \sin^2 \phi) = \mathbf{R} \cdot \frac{D^2 \mathbf{r}}{dt^2}$$

$$= -2\mathbf{w} \times \frac{D\mathbf{r}}{dt} \cdot \mathbf{R} + gk \cdot \mathbf{R} - \tau \mathbf{R} \cdot \mathbf{R}$$

$$= 2L\mathbf{w} \cdot \left[(\dot{\phi})\mathbf{P} + (\dot{\theta} \sin \phi)\mathbf{Q} \right] + g \, (k \cdot \mathbf{R}) - \tau$$

which simplifies to

$$\tau = L \left[\dot{\phi}^2 + \dot{\theta}^2 \sin^2 \phi + 2\dot{\phi} \, (\mathbf{w} \cdot \mathbf{P}) + 2\dot{\theta} \sin \phi \, (\mathbf{w} \cdot \mathbf{Q}) \right] + g \, (k \cdot \mathbf{R}) \quad (3.9)$$

This is an equation of constraint and says that for static equilibrium, the tension in the wire, $-m\tau\mathbf{R}$, must have τ satisfy the equation. Therefore, only the two equations (3.7) and (3.8) control the motion through the time-varying angles $\theta(t)$ and $\phi(t)$. (Figure 3.3—also Color Plate 3.3—shows some screen shots from the Foucault pendulum application found on the CD-ROM.)

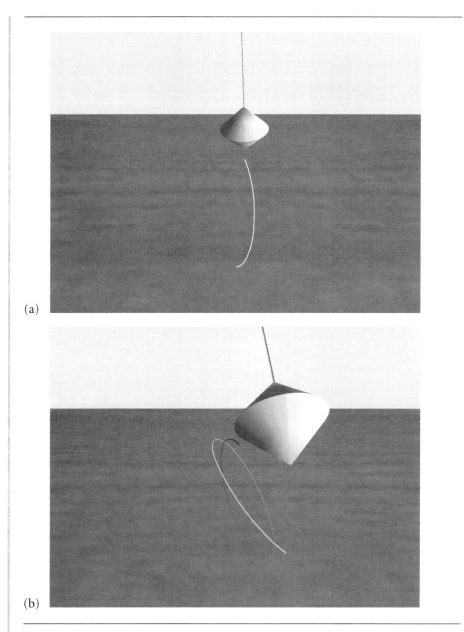

(a)

(b)

Figure 3.3 The Foucault pendulum. The figures show the path of the pendulum tip in the horizontal plane. New points on the path are colored white, but the intensity of the older points along the path gradually decreases. (See also Color Plate 3.3.) ◼

EXAMPLE
3.4

The *simple pendulum* model is obtained by neglecting the angular velocity over a small period of time. The angle θ is constant and the angular speed ω may as well be assumed to be zero. Under these assumptions, equation (3.7) is a tautology and offers no information. Equation (3.8) is a single nonlinear differential equation in ϕ:

$$\ddot{\phi} + \frac{g}{L} \sin \phi = 0 \qquad (3.10)$$

Let the initial conditions be $\phi(0) = \phi_0 > 0$ and $\dot{\phi}(0) = 0$. That is, the mass at the end of the wire starts off at some nonzero angle from the vertical and is released with zero speed. Since the joint of the pendulum is frictionless, your intuition is that for some future time $T > 0$, the angle $\phi(T) = -\phi_0$, the motion is periodic, and T is the half-period. So what is this time T?

Multiply equation (3.10) by $2\dot{\phi}$ to obtain

$$0 = 2\dot{\phi}\ddot{\phi} + \frac{2g}{L}\dot{\phi} \sin \phi = \frac{d}{dt}\left(\dot{\phi}^2 - \frac{2g}{L} \cos \phi\right)$$

An integration leads to

$$\dot{\phi}^2 = \frac{2g}{L}\left(\cos \phi - \cos \phi_0\right)$$

We may take the square root and choose the appropriate sign to indicate that the angle is initially decreasing in time,

$$\dot{\phi} = -\sqrt{\frac{2g}{L}\left(\cos \phi - \cos \phi_0\right)}$$

In differential form, we have

$$\frac{d\phi}{\sqrt{\cos \phi - \cos \phi_0}} = -\sqrt{\frac{2g}{L}}\, dt$$

Integrating yields

$$\int_{\phi_0}^{\phi} \frac{d\psi}{\sqrt{\cos \psi - \cos \phi_0}} = -\sqrt{\frac{2g}{L}}\, t$$

Since we require $\phi(T) = -\phi_0$,

$$\int_{\phi_0}^{-\phi_0} \frac{d\psi}{\sqrt{\cos \psi - \cos \phi_0}} = -\sqrt{\frac{2g}{L}}\, T$$

Solving for the time,

$$T = \sqrt{\frac{L}{2g}} \int_{-\phi_0}^{\phi_0} \frac{d\psi}{\sqrt{\cos\psi - \cos\phi_0}} = \sqrt{\frac{2L}{g}} \int_{0}^{\phi_0} \frac{d\psi}{\sqrt{\cos\psi - \cos\phi_0}} \quad (3.11)$$

Chapter 9 includes a section on the stability of numerical solutions that solve differential equations. In particular Example 9.1 is provided for a stability analysis of the simple pendulum. It is not as easy as you might think to obtain a robust solution that exhibits periodic behavior.

Under the assumption that we want the pendulum to continue swinging with no other external forces acting on it, including friction, there is no reason to solve the problem for more than one period of oscillation. The differential equation can be solved over one period to produce a sequence of sampled angles. Angles for other times during that period can be interpolated from the samples, and we can use periodicity to calculate times larger than the first period. In order to proceed, we need to calculate the half-period T, the time difference between the two angles where the pendulum has stopped. Once known, we can use a stable numerical method to solve the differential equation over that half-period, store the computed samples for use by the application over its lifetime, and use periodicity and interpolate as needed.

The integral in equation (3.11) is not solvable in closed form. The integral is *improper* since the integrand becomes infinite at the upper limit of integration; that is, when ψ approaches ϕ_0. Such integrals must be split into two integrals, the first integral numerically integrated by standard methods. The integrand of the second integral is approximated by some function to remove the singularity at the upper limit. Equation (3.11) is split into

$$\int_{0}^{\phi_0 - \varepsilon} \frac{d\psi}{\sqrt{\cos\psi - \cos\phi_0}} + \int_{\phi_0 - \varepsilon}^{\phi_0} \frac{d\psi}{\sqrt{\cos\psi - \cos\phi_0}}$$

for a sufficiently small $\varepsilon > 0$. The quadratic approximation from the Taylor series for $\cos\psi$ expanded about ϕ_0 is

$$\cos\theta \doteq \cos\phi_0 - (\sin\phi_0)(\psi - \phi_0) - \frac{1}{2}(\cos\phi_0)(\psi - \phi_0)^2$$

Substituting this in the second integrand and making the change of variables $z = \phi_0 - \psi$ leads to the approximation:

$$\int_{\phi_0 - \varepsilon}^{\phi_0} \frac{d\psi}{\sqrt{\cos\psi - \cos\psi_0}} \doteq \int_{0}^{\varepsilon} \frac{dz}{\sqrt{(\sin\phi_0)z - (\cos\phi_0)z^2/2}}$$

$$= \sqrt{\frac{2}{\cos\phi_0}} \left(\frac{\pi}{2} - \sin^{-1}\left(1 - \frac{\varepsilon\cos\phi_0}{\sin\phi_0} \right) \right)$$

(Example 3.4 continued) As ε approaches zero, the approximation (and integral itself) goes to zero. You need to choose ε in your numerical methods so that the calculations in the first integral are well behaved; that is, the denominator of the integrand stays sufficiently away from zero to avoid introducing significant floating point errors. ▪

EXERCISE Ⓜ **3.5** Selecting $2L/g = 1$ and $\phi_0 = \pi/6$, estimate T using numerical integration. ▪

EXERCISE Ⓗ **3.6** Redo the derivation that led to the integral for T in equation (3.11) to take into account that the initial speed is $\dot{\phi}(0) = \dot{\phi}_0 > 0$. That is, the mass of the pendulum is initially positioned at a nonzero angle from the vertical and is then given a small push further away from the vertical.

1. What is the time $\tau > 0$ at which the mass reaches its maximum angle from the vertical? *Hint:* Notice that $\dot{\phi}(\tau) = 0$. If $\phi_1 = \phi(\tau)$ is the maximum angle, show that

$$\phi_1 = \cos^{-1}\left(\cos\phi_0 - \frac{L\dot{\phi}_0^2}{2g}\right)$$

Subsequently show that

$$\tau = \int_{\phi_0}^{\phi_1} \frac{d\psi}{\sqrt{\dot{\phi}_0^2 + 2g(\cos\psi - \cos\phi_0)/L}}$$

2. What is the half-period $T > 0$ of the pendulum? *Hint:* Use a numerical estimate obtained from equation (3.11) when the initial data of the pendulum is $\phi(0) = \phi_1$ and $\dot{\phi}_0 = 0$.

Example 9.1 uses $\phi_0 = 0.1$, $\dot{\phi}_0 = 1$, and $g/L = 1$. In your constructions of the current example, show that $\tau \doteq 1.59$ and $T \doteq 3.37$ and compare to the numerical results obtained by the Runge-Kutta method in Example 9.1 as some assurance that your results are good approximations. ▪

3.2 LAGRANGIAN DYNAMICS

Let us revisit the basic formulation of Newton's second law. For a constant mass m undergoing a force \mathbf{F}, the motion of the mass over time is governed by

$$\mathbf{F} = m\mathbf{a} = m\dot{\mathbf{v}} = m\ddot{\mathbf{x}} \qquad (3.12)$$

where $\mathbf{x}(t)$ is the position, $\mathbf{v}(t) = \dot{\mathbf{x}}(t)$ is the velocity, and $\mathbf{a}(t) = \ddot{\mathbf{x}}(t)$ is the acceleration of the mass at time t. Each of these vector quantities is measured with re-

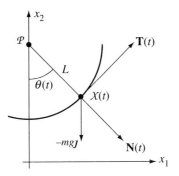

Figure 3.4 The simple pendulum. The motion is constrained to a plane. The mass is located at position $X(t)$ at time t and is always a fixed length L from the joint \mathcal{P}. The angle formed by the pendulum rod with the vertical is $\theta(t)$. The curve of motion is a circle with tangent $\mathbf{T}(t)$ and outward pointing normal $\mathbf{N}(t)$. The only force acting on the mass is gravitational, $-mg\jmath$, where m is the mass of the particle, g is the gravitational constant, and $-\jmath$ is the direction of the force (vertically downward). The joint \mathcal{P} provides no frictional force.

spect to *some* coordinate system. This system is referred to as the *inertial frame*. If $\mathbf{x} = (x_1, x_2, x_3)$ is the representation of the position in the inertial frame, the components x_1, x_2, and x_3 are referred to as the *inertial coordinates*. Although in many cases the inertial frame is considered to be fixed (relative to the stars, as it were), the frame can have a constant linear velocity and no rotation and still be inertial. Any other frame of reference is referred to as a *noninertial frame*. Newton's second law, which we saw in equation (3.12), is simple to state and remember, but its simplicity can disguise the complexity of the problem at hand. Consider the simple pendulum problem from the last section, shown in Figure 3.4.

The only postulated force is gravitational, $\mathbf{F} = -mg\jmath$, where g is a positive constant. You might be tempted to directly apply Newton's second law to obtain the equations of motion $m\ddot{\mathbf{x}} = -mg\jmath$. An integration of these will show that the mass drops straight to the ground, which is not the correct motion! The problem is that \mathbf{F} must represent all relevant forces. The pendulum has an additional force, the force that constrains the mass to be attached to the end of the rod, thus causing the mass to move along a circular path over time. This force is referred to as a *constraining force* or a *reactive force*. Newton's second law requires that the constraining forces occur in addition to the external forces applied to the mass. This example motivates what is called *Lagrangian dynamics*. We will discuss this topic, then return to the pendulum example to illustrate how to construct the *Lagrangian equations of motion*.

3.2.1 EQUATIONS OF MOTION FOR A PARTICLE

From Newton's second law, equation (3.12), we may compute the small amount of work dW that is done by \mathbf{F} when we move the mass at position \mathbf{x} by a small displacement $d\mathbf{x}$. Recall from Section 2.6.1 that the work done is

$$dW = \mathbf{F} \cdot d\mathbf{x}$$

The displacement of the mass and the force need not be in the same direction. Using equation (3.12) we have

$$m\ddot{\mathbf{x}} \cdot d\mathbf{x} = \mathbf{F} \cdot d\mathbf{x} \tag{3.13}$$

The right-hand side is the small amount of work done by the force for the given displacement. The left-hand side is the corresponding small change in the kinetic energy of the mass. Equation (3.13) is referred to as *D'Alembert's equation*.

Let $\mathbf{x} = (x_1, x_2, x_3)$ and $\mathbf{F} = (F_1, F_2, F_3)$. With no constraints on the position, the displacement can be in any direction. In particular, setting $d\mathbf{x} = \imath$ and substituting into D'Alembert's equation produces $m\ddot{x}_1 = m\ddot{\mathbf{x}} \cdot \imath = \mathbf{F} \cdot \imath = F_1$. Similarly, the displacement can be \jmath or k, producing $m\ddot{x}_2 = F_2$ or $m\ddot{x}_3 = F_3$. The three equations written in vector form are $m\ddot{\mathbf{x}} = \mathbf{F}$, which is Newton's second law. Of course this should come as no surprise. The power of D'Alembert's equation is in naturally supporting the idea of constraints on the position, as we now demonstrate.

Motion on a Curve

Consider the simplest situation when the mass is constrained to follow a curve in space. The curve may be parameterized by a variable q, say, $\mathbf{x}(q)$. The derivative vector $d\mathbf{x}/dq$ is tangent to the path of motion. The small displacements $d\mathbf{x}$ can now occur only so that the mass remains on the curve. In this sense the displacement is *infinitesimal*. The infinitesimal displacements $d\mathbf{x}$ in D'Alembert's equation may be replaced by positional derivatives:

$$m\ddot{\mathbf{x}} \cdot \frac{d\mathbf{x}}{dq} = \mathbf{F} \cdot \frac{d\mathbf{x}}{dq} \tag{3.14}$$

This equation will be reformulated, the construction requiring a few derivative identities from calculus. An application of the chain rule yields

$$\dot{\mathbf{x}} = \frac{d\mathbf{x}}{dt} = \frac{d\mathbf{x}}{dq}\frac{dq}{dt} = \frac{d\mathbf{x}}{dq}\dot{q} \tag{3.15}$$

Treating $\dot{\mathbf{x}}$ as a formal function of both q and \dot{q}, we may compute the partial derivative of equation (3.15) with respect to \dot{q} to obtain

$$\frac{d\mathbf{x}}{dq} = \frac{\partial}{\partial \dot{q}}\left(\frac{d\mathbf{x}}{dq}\dot{q}\right) = \frac{\partial \dot{\mathbf{x}}}{\partial \dot{q}} \tag{3.16}$$

Another identity is

$$\frac{d}{dt}\left(\frac{d\mathbf{x}}{dq}\right) = \frac{d}{dq}\left(\frac{d\mathbf{x}}{dq}\right)\dot{q} = \frac{\partial}{\partial q}\left(\frac{d\mathbf{x}}{dq}\dot{q}\right) = \frac{\partial \dot{\mathbf{x}}}{\partial q} \tag{3.17}$$

where the first equality is an application of the chain rule, the second equality treats \dot{q} as a variable independent of q, and the third equality uses equation (3.15). Finally, the product rule,

$$\frac{d}{dt}\left(\frac{d\mathbf{x}}{dt}\cdot\frac{d\mathbf{x}}{dq}\right) = \frac{d^2\mathbf{x}}{dt^2}\cdot\frac{d\mathbf{x}}{dq} + \frac{d\mathbf{x}}{dt}\cdot\frac{d}{dt}\left(\frac{d\mathbf{x}}{dq}\right)$$

produces the identity

$$\ddot{\mathbf{x}}\cdot\frac{d\mathbf{x}}{dq} = \frac{d}{dt}\left(\dot{\mathbf{x}}\cdot\frac{d\mathbf{x}}{dq}\right) - \dot{\mathbf{x}}\cdot\frac{d}{dt}\left(\frac{d\mathbf{x}}{dq}\right) \tag{3.18}$$

Replacing equations (3.16) and (3.17) into (3.18) and multiplying by the mass m yields

$$\begin{aligned}
m\ddot{\mathbf{x}}\cdot\frac{d\mathbf{x}}{dq} &= \frac{d}{dt}\left(m\dot{\mathbf{x}}\cdot\frac{\partial\dot{\mathbf{x}}}{\partial\dot{q}}\right) - m\dot{\mathbf{x}}\cdot\frac{\partial\dot{\mathbf{x}}}{\partial q} \\
&= \frac{d}{dt}\left(\frac{\partial}{\partial\dot{q}}\left(\frac{1}{2}m|\dot{\mathbf{x}}|^2\right)\right) - \frac{\partial}{\partial q}\left(\frac{1}{2}m|\dot{\mathbf{x}}|^2\right) \\
&= \frac{d}{dt}\left(\frac{\partial T}{\partial\dot{q}}\right) - \frac{\partial T}{\partial q}
\end{aligned} \tag{3.19}$$

where $T = m|\dot{\mathbf{x}}|^2/2$ is the kinetic energy of the system. Replacing equation (3.19) into equation (3.14) and defining $F_q = \mathbf{F}\cdot d\mathbf{x}/dq$, we have the *Lagrangian equation of motion* for a single particle constrained to a curve:

$$\frac{d}{dt}\left(\frac{\partial T}{\partial\dot{q}}\right) - \frac{\partial T}{\partial q} = F_q \tag{3.20}$$

The scalar value F_q is referred to as a *generalized force*. Although called a force, it is not a force since it is not vector valued and since the physical units are not those of a force. An important distinction between the Newtonian equations of motion, equation (3.12), and the Lagrangian equations of motion, equation (3.20), is that the force term in equation (3.12) includes external and constraining forces, but the force term in equation (3.20) eliminates the constraining forces.

EXAMPLE
3.5

Returning to our simple pendulum problem, let us set up the Lagrangian equations of motion. The mass is constrained to lie on a circle of radius L centered at \mathbf{P}. The position is parameterized by the angle θ, the constraint variable that we named q in the general discussion of the Lagrangian equations of motion. The position is

$$\mathbf{x}(\theta) = \mathbf{P} + L\mathbf{N}(\theta)$$

where $\mathbf{N}(\theta) = (\sin\theta, -\cos\theta)$ is normal to the circle and where $\mathbf{T}(\theta) = (\cos\theta, \sin\theta)$ is tangent to the circle. The derivative of position with respect to θ and the velocity are, respectively,

$$\frac{d\mathbf{x}}{d\theta} = L\frac{d\mathbf{N}}{d\theta} = L\mathbf{T} \quad \text{and} \quad \dot{\mathbf{x}} = \frac{d\mathbf{x}}{dt} = \frac{d\mathbf{x}}{d\theta}\frac{d\theta}{dt} = L\dot{\theta}\mathbf{T}$$

The kinetic energy is

$$T = \frac{1}{2}m|\dot{\mathbf{x}}|^2 = \frac{1}{2}mL^2\dot{\theta}^2.$$

and its derivatives with respect to θ and $\dot{\theta}$ are

$$\frac{\partial T}{\partial \theta} = 0 \quad \text{and} \quad \frac{\partial T}{\partial \dot{\theta}} = mL^2\dot{\theta}$$

The left-hand side of equation (3.20) becomes

$$\frac{d}{dt}\left(\frac{\partial T}{\partial \dot{\theta}}\right) - \frac{\partial T}{\partial \theta} = \frac{d}{dt}\left(mL^2\dot{\theta}\right) = mL^2\ddot{\theta}$$

The right-hand side of equation (3.20) is

$$F_\theta = \mathbf{F} \cdot \frac{d\mathbf{x}}{d\theta} = (-mg\mathbf{J}) \cdot (L\mathbf{T}) = -mgL\sin\theta$$

Equating the left-hand and right-hand sides produces $mL^2\ddot{\theta} = -mgL\sin\theta$, or $\ddot{\theta} + (g/L)\sin\theta = 0$, just like we derived in equation (3.10). ∎

EXERCISE Ⓜ
3.7

SOURCE CODE
BeadSlide

A bead of mass m is attached to a frictionless wire whose shape is defined by the spiral curve $\mathbf{x}(q) = (q, q^2, q^3)$. The bead is subject to the gravitational force $\mathbf{F} = -mg\mathbf{k}$, where g is a positive constant. Initially, the bead is held fixed at $(1, 1, 1)$, then released to slide down the wire. How long does the bead take to reach the origin $(0, 0, 0)$? ∎

Motion on a Surface

We now constrain the mass to lie on a parametric surface, $\mathbf{x}(q_1, q_2)$, where q_1 and q_2 are independent parameters. The infinitesimal displacements in equation (3.13) are

now constrained to be tangential to the surface at the point in question. In particular, the derivatives $\partial \mathbf{x}/\partial q_1$ and $\partial \mathbf{x}/\partial q_2$ are tangent vectors, so D'Alembert's equation becomes

$$m\ddot{\mathbf{x}} \cdot \frac{\partial \mathbf{x}}{\partial q_i} = \mathbf{F} \cdot \frac{\partial \mathbf{x}}{\partial q_i}, \qquad i = 1, 2 \tag{3.21}$$

The construction used in the case of motion on a curve applies to these equations as well to produce the Lagrangian equations of motion. An application of the chain rule to the velocity yields

$$\dot{\mathbf{x}} = \frac{d\mathbf{x}}{dt} = \frac{\partial \mathbf{x}}{\partial q_1}\frac{dq_1}{dt} + \frac{\partial \mathbf{x}}{\partial q_2}\frac{dq_2}{dt} = \frac{\partial \mathbf{x}}{\partial q_1}\dot{q}_1 + \frac{\partial \mathbf{x}}{\partial q_2}\dot{q}_2 \tag{3.22}$$

Treating $\dot{\mathbf{x}}$ as a formal function of q_1, q_2, \dot{q}_1, and \dot{q}_2, we may compute the partial derivative of equation (3.22) with respect to \dot{q}_i to obtain

$$\frac{\partial \mathbf{x}}{\partial q_i} = \frac{\partial}{\partial \dot{q}_i}\left(\frac{\partial \mathbf{x}}{\partial q_1}\dot{q}_1 + \frac{\partial \mathbf{x}}{\partial q_2}\dot{q}_2\right) = \frac{\partial \dot{\mathbf{x}}}{\partial \dot{q}_i}, \qquad i = 1, 2 \tag{3.23}$$

Another identity is

$$\frac{d}{dt}\left(\frac{\partial \mathbf{x}}{\partial q_1}\right) = \frac{\partial}{\partial q_1}\left(\frac{\partial \mathbf{x}}{\partial q_1}\right)\dot{q}_1 + \frac{\partial}{\partial q_2}\left(\frac{\partial \mathbf{x}}{\partial q_1}\right)\dot{q}_2 \qquad \text{By the chain rule}$$

$$= \frac{\partial}{\partial q_1}\left(\frac{\partial \mathbf{x}}{\partial q_1}\right)\dot{q}_1 + \frac{\partial}{\partial q_1}\left(\frac{\partial \mathbf{x}}{\partial q_2}\right)\dot{q}_2 \qquad \begin{array}{l}\text{Order of differentiation}\\\text{unimportant}\end{array}$$

$$= \frac{\partial}{\partial q_1}\left(\frac{\partial \mathbf{x}}{\partial q_1}\dot{q}_1 + \frac{\partial \mathbf{x}}{\partial q_2}\dot{q}_2\right) \qquad \text{Differentiation is linear}$$

$$= \frac{\partial \dot{\mathbf{x}}}{\partial q_1} \qquad \text{Using equation (3.22)}$$

A similar construction applies to differentiating with respect to q_2. The two formulas are jointly represented as

$$\frac{d}{dt}\left(\frac{\partial \mathbf{x}}{\partial q_i}\right) = \frac{\partial \dot{\mathbf{x}}}{\partial q_i}, \qquad i = 1, 2 \tag{3.24}$$

Just as in equation (3.18), the product rule may be applied to obtain

$$\ddot{\mathbf{x}} \cdot \frac{d\mathbf{x}}{dq} = \frac{d}{dt}\left(\dot{\mathbf{x}} \cdot \frac{d\mathbf{x}}{dq}\right) - \dot{\mathbf{x}} \cdot \frac{d}{dt}\left(\frac{d\mathbf{x}}{dq}\right) \tag{3.25}$$

Replacing equations (3.23) and (3.24) into (3.25) and multiplying by the mass m yields

$$m\ddot{\mathbf{x}} \cdot \frac{\partial \mathbf{x}}{\partial q_i} = \frac{d}{dt}\left(m\dot{\mathbf{x}} \cdot \frac{\partial \dot{\mathbf{x}}}{\partial \dot{q}_i}\right) - m\dot{\mathbf{x}} \cdot \frac{\partial \dot{\mathbf{x}}}{\partial q_i}$$

$$= \frac{d}{dt}\left(\frac{\partial}{\partial \dot{q}_i}\left(\frac{1}{2}m|\dot{\mathbf{x}}|^2\right)\right) - \frac{\partial}{\partial q_i}\left(\frac{1}{2}m|\dot{\mathbf{x}}|^2\right) \qquad (3.26)$$

$$= \frac{d}{dt}\left(\frac{\partial T}{\partial \dot{q}_i}\right) - \frac{\partial T}{\partial q_i}$$

where $T = m|\dot{\mathbf{x}}|^2/2$ is the kinetic energy of the system. Replacing equation (3.26) into equation (3.21) and defining $F_{q_i} = \mathbf{F} \cdot \partial\mathbf{x}/\partial q_i$, we have the *Lagrangian equations of motion* for a single particle constrained to a surface:

$$\frac{d}{dt}\left(\frac{\partial T}{\partial \dot{q}_i}\right) - \frac{\partial T}{\partial q_i} = F_{q_i}, \qquad i = 1, 2 \qquad (3.27)$$

EXAMPLE 3.6

We have a ball constrained to lie on a flat, frictionless table. A rubber band is attached to the ball, the other end attached to a point on the table. The rubber band is unstretched when the ball is located at the same attachment point on the table. What are the Lagrangian equations of motion?

SOURCE CODE

BallRubberBand

The ball has mass m. The forces on the ball due to the rubber band are assumed to follow Hooke's law: The magnitude of the force is negatively proportional to the length of the rubber band. If the ball is pulled to stretch the rubber band, the force is in the direction along the rubber band away from the ball and has magnitude cL, where $c > 0$ is a constant and L is the length of the stretched rubber band. Figure 3.5 illustrates.

We may assume that the table surface is in the x_1x_2-plane, $x_3 = 0$, in which case $\mathbf{x} = (x_1, x_2, 0)$. The kinetic energy is $T = m(x_1^2 + x_2^2)$ and the force is $\mathbf{F} = -c(x_1, x_2, 0)$ for some positive constant c. The constraint variables are $q_1 = x_1$ and $q_2 = x_2$, so we will use just the x-names rather than keep track of the q-names. The relevant partial derivatives in equation (3.27) are

$$\frac{\partial T}{\partial x_1} = 0, \qquad \frac{\partial T}{\partial x_2} = 0,$$

$$\frac{\partial T}{\partial \dot{x}_1} = m\dot{x}_1, \qquad \frac{\partial T}{\partial \dot{x}_2} = m\dot{x}_2,$$

$$\frac{d}{dt}\left(\frac{\partial T}{\partial \dot{x}_1}\right) = m\ddot{x}_1, \qquad \frac{d}{dt}\left(\frac{\partial T}{\partial \dot{x}_2}\right) = m\ddot{x}_2$$

Figure 3.5 A ball of mass m on a flat table. A rubber band connects the ball to a fixed point on the table. The force \mathbf{F} due to the rubber band is shown. The position \mathbf{x} of the ball is shown together with its velocity $\dot{\mathbf{x}}$.

The generalized forces are

$$F_{x_1} = \mathbf{F} \cdot \frac{\partial \mathbf{x}}{\partial x_1} = -c(x_1, x_2, 0) \cdot (1, 0, 0) = -cx_1$$

$$F_{x_2} = \mathbf{F} \cdot \frac{\partial \mathbf{x}}{\partial x_2} = -c(x_1, x_2, 0) \cdot (0, 1, 0) = -cx_2$$

The Lagrangian equations of motion are therefore

$$m\ddot{x}_1 = -cx_1, \qquad m\ddot{x}_2 = -cx_2$$

Consequently, each component of the position adheres to simple harmonic motion with frequency $\omega = \sqrt{c/m}$. For an initial position $\mathbf{x}(0) = (p_1, p_2, 0)$ and velocity $\dot{\mathbf{x}}(0) = (v_1, v_2, 0)$, the solutions to the differential equations are $x_1(t) = p_1 \cos(\omega t) + (v_1/\omega) \sin(\omega t)$ and $x_2(t) = p_2 \cos(\omega t) + (v_2/\omega) \sin(\omega t)$. ▪

EXERCISE Ⓜ In Example 3.6, show that the path of motion is an ellipse. At what time will the ball
3.8 reach the origin? ▪

EXERCISE Ⓔ In Example 3.6, assume that the table is covered with a viscous fluid. Let the viscous
3.9 force on the ball be in the opposite direction of motion of the ball, say, $\mathbf{G} = -a\dot{\mathbf{x}}$ for
 some constant $a > 0$. What are the Lagrangian equations of motion? At what time
 will the ball reach the origin? ▪

E X A M P L E
3.7

SOURCE CODE

BallHill

A ball is placed at the top of a hill whose shape is an elliptical paraboloid. The hill is assumed to be frictionless. The only force acting on the ball is gravitational force. The ball is slightly pushed so that it may slide down the hill. What are the Lagrangian equations of motion? Figure 3.6 illustrates.

Figure 3.6

A ball is at the top of a frictionless hill. With a small push, the ball will slide down the hill.

The vertical axis is assumed to be the x_3-axis. The gravitational force is $\mathbf{F} = -mg\mathbf{k}$. The height of the hill is $a_3 > 0$, so the ground is considered to be the plane $x_3 = 0$. The cross section of the hill on the ground is an ellipse with semimajor axis length a_1 (in the x_1 direction) and semiminor axis length a_2 (in the x_2 direction). The equation of the paraboloid is $x_3 = a_3 - (x_1/a_1)^2 - (x_2/a_2)^2$. The ball is constrained to

$$\mathbf{x} = \left(x_1, x_2, a_3 - \left(\frac{x_1}{a_1} \right)^2 - \left(\frac{x_2}{a_2} \right)^2 \right)$$

so once again $q_1 = x_1$ and $q_2 = x_2$ and we will just use the x-names.

The time derivative of x_3 is

$$\dot{x}_3 = -\frac{2x_1\dot{x}_1}{a_1^2} - \frac{2x_2\dot{x}_2}{a_2^2}$$

The kinetic energy is

$$T = \frac{m}{2} \left(\dot{x}_1^2 + \dot{x}_2^2 + \dot{x}_3^2 \right) = \frac{m}{2} \left(\dot{x}_1^2 + \dot{x}_2^2 + \left(\frac{2x_1\dot{x}_1}{a_1^2} + \frac{2x_2\dot{x}_2}{a_2^2} \right)^2 \right)$$

The relevant terms in equation (3.27) are

$$\frac{\partial T}{\partial x_1} = \frac{4m\dot{x}_1}{a_1^2} \left(\frac{x_1\dot{x}_1}{a_1^2} + \frac{x_2\dot{x}_2}{a_2^2} \right)$$

$$\frac{\partial T}{\partial x_2} = \frac{4m\dot{x}_2}{a_2^2}\left(\frac{x_1\dot{x}_1}{a_1^2} + \frac{x_2\dot{x}_2}{a_2^2}\right)$$

$$\frac{\partial T}{\partial \dot{x}_1} = m\left(\dot{x}_1 + \frac{4x_1}{a_1^2}\left(\frac{x_1\dot{x}_1}{a_1^2} + \frac{x_2\dot{x}_2}{a_2^2}\right)\right)$$

$$\frac{\partial T}{\partial \dot{x}_2} = m\left(\dot{x}_2 + \frac{4x_2}{a_2^2}\left(\frac{x_1\dot{x}_1}{a_1^2} + \frac{x_2\dot{x}_2}{a_2^2}\right)\right)$$

$$\frac{d}{dt}\left(\frac{\partial T}{\partial \dot{x}_1}\right) = m\left(\ddot{x}_1 + \frac{4x_1}{a_1^2}\left(\frac{x_1\ddot{x}_1 + \dot{x}_1^2}{a_1^2} + \frac{x_2\ddot{x}_2 + \dot{x}_2^2}{a_2^2}\right) + \frac{4\dot{x}_1}{a_1^2}\left(\frac{x_1\dot{x}_1}{a_1^2} + \frac{x_2\dot{x}_2}{a_2^2}\right)\right)$$

$$\frac{d}{dt}\left(\frac{\partial T}{\partial \dot{x}_2}\right) = m\left(\ddot{x}_2 + \frac{4x_2}{a_2^2}\left(\frac{x_1\ddot{x}_1 + \dot{x}_1^2}{a_1^2} + \frac{x_2\ddot{x}_2 + \dot{x}_2^2}{a_2^2}\right) + \frac{4\dot{x}_2}{a_2^2}\left(\frac{x_1\dot{x}_1}{a_1^2} + \frac{x_2\dot{x}_2}{a_2^2}\right)\right)$$

$$\frac{\partial \mathbf{x}}{\partial x_1} = \left(1, 0, -\frac{2x_1}{a_1^2}\right)$$

$$\frac{\partial \mathbf{x}}{\partial x_2} = \left(0, 1, -\frac{2x_2}{a_2^2}\right)$$

$$F_{x_1} = (-mg\mathbf{k})\cdot\frac{\partial \mathbf{x}}{\partial x_1} = \frac{2mgx_1}{a_1^2}$$

$$F_{x_2} = (-mg\mathbf{k})\cdot\frac{\partial \mathbf{x}}{\partial x_2} = \frac{2mgx_2}{a_2^2}$$

The Lagrangian equations of motion are

$$\ddot{x}_1 + \frac{4x_1}{a_1^2}\left(\frac{x_1\ddot{x}_1 + \dot{x}_1^2}{a_1^2} + \frac{x_2\ddot{x}_2 + \dot{x}_2^2}{a_2^2}\right) = \frac{2gx_1}{a_1^2}$$

$$\ddot{x}_2 + \frac{4x_2}{a_2^2}\left(\frac{x_1\ddot{x}_1 + \dot{x}_1^2}{a_1^2} + \frac{x_2\ddot{x}_2 + \dot{x}_2^2}{a_2^2}\right) = \frac{2gx_2}{a_2^2}$$

Observe that this is a coupled system of second-order differential equations since \ddot{x}_1 and \ddot{x}_2 appear implicitly in both equations. The equations may be algebraically manipulated to obtain two explicit equations, one for each of the second derivatives. (Figure 3.7—also Color Plate 3.7—shows some screen shots from the ball/hill application found on the CD-ROM.)

(Example 3.7 continued)

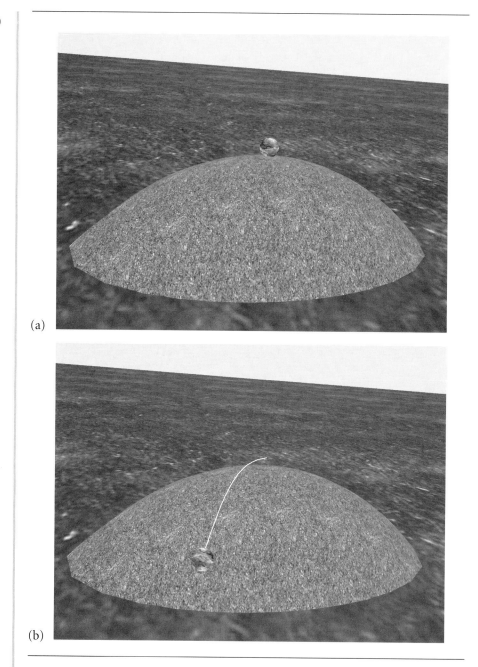

(a)

(b)

Figure 3.7 A ball rolling down a hill. Image (b) shows the path of the center of the ball as it rolls down the hill. The ball rotates at a speed commensurate with its downhill velocity. (See also Color Plate 3.7.) ▪

EXERCISE (M) The equations of Example 3.7 appear to be quite complex. However, if the paraboloid
3.10 is circular, say, $a_1 = a_2 = 1$, the radial symmetry of the surface should stoke your
intuition and allow you to deduce that the ball will roll directly down the hill. That
is, the path in the $x_1 x_2$-plane is along a ray that starts at the origin. If r is the radial
distance in the plane from the origin, prove that

$$\ddot{r} + \frac{2r(2\dot{r}^2 - g)}{1 + 4r^2} = 0$$

Choose $a_3 = 1$ so that the intersection of the hill and the ground plane occurs at
$r = 1$. Numerically solve this differential equation for $g = 1$ with the initial conditions
$r(0) = 0$ and $\dot{r}(0) = 1$. Estimate the time $T > 0$ when the ball reaches the ground, that
is, the time T at which $r(T) = 1$. ▪

EXERCISE (E) In Example 3.7, verify that a solution to the system of differential equations is
3.11 $(x_1(t), x_2(t)) = (v_1 t, v_2 t)$.

(M) Does this mean that the path of motion will always project to a straight line in the
plane $x_3 = 0$?

(H) Justify your answer. ▪

EXERCISE In Example 3.7, include a second force in addition to the gravitational force. That
3.12 force is due to wind blowing on the particle with constant velocity **W**.

(E) Derive the Lagrangian equations of motion.

(M) Determine conditions on **W** that prevent the ball from rolling to the ground plane.

▪

EXERCISE (M) A frictionless metal chute is constructed in the shape of half a cylinder of radius R
3.13 and length L. The chute is aligned to be parallel to the x_1 axis. One end of the chute is
attached to the ground plane $x_3 = 0$. The other end is raised by a height H. Figure 3.8
illustrates the situation: a ball is placed at the top of the chute and released (initial
velocity is zero). The only force acting on the ball is gravitational force. Construct
the Lagrangian equations of motion for the ball. What are these equations if you
modify the problem by coating the chute with a viscous oil? Assume that the viscous
force is negatively proportional to the ball's velocity. With or without viscosity, verify
that if the ball starts in the middle of the chute, the path of motion is a straight line.

▪

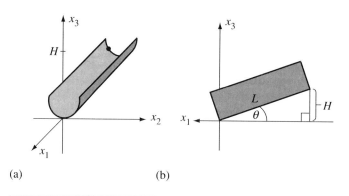

(a) (b)

Figure 3.8 (a) A metal chute of length L, one end attached to the origin, the other end raised by a height H. (b) Side view of the chute.

EXERCISE 3.14 Ⓗ For the mathematically inclined: If the mass always lies on a frictionless height field, the graph of the function $x_3 = h(x_1, x_2)$, and the only force acting on the mass is gravitational force, derive the Lagrangian equations of motion. ▪

Determining Constraint Forces

In general you can think of having a Lagrangian equation for each degree of freedom in the system. When the particle is constrained to a curve, you have one degree of freedom and one equation governing the particle's motion. When constrained to a curve, you have two degrees of freedom and two equations governing the motion. Later, we will study particle systems with many degrees of freedom. Even though we are in three dimensions, the degrees of freedom may very well be greater than three. A Lagrangian equation occurs for each degree of freedom.

The construction that led to the Lagrangian equations applies equally well to additional parameters, even if those parameters are not freely varying. However, the generalized forces in these equations must include terms from the forces of constraint. These additional equations allow us to determine the actual constraint forces.

EXAMPLE 3.8 Consider the simple pendulum problem. In polar coordinates we can represent the position as $\mathbf{x}(r, \theta) = \mathbf{P} + r\mathbf{N}(\theta)$. The pendulum requires a constant radius, $r = L$ for all time. The radius is not free to vary. However, if we think of r as variable, we may construct two Lagrangian equations. In this setting we can think of the constraint force \mathbf{C} to be an applied force. The positional derivatives are

$$\frac{\partial \mathbf{x}}{\partial \theta} = r\mathbf{T}, \qquad \frac{\partial \mathbf{x}}{\partial r} = \mathbf{N}, \qquad \frac{d\mathbf{x}}{dt} = \frac{\partial \mathbf{x}}{\partial \theta}\dot{\theta} + \frac{\partial \mathbf{x}}{\partial r}\dot{r} = r\dot{\theta}\mathbf{T} + \dot{r}\mathbf{N}$$

The kinetic energy is

$$T = \frac{m}{2}\left(r^2\dot{\theta}^2 + \dot{r}^2\right)$$

and the relevant derivatives are

$$\frac{\partial T}{\partial \theta} = 0$$

$$\frac{\partial T}{\partial r} = mr\dot{\theta}^2$$

$$\frac{\partial T}{\partial \dot{\theta}} = mr^2\dot{\theta}^2$$

$$\frac{\partial T}{\partial \dot{r}} = m\dot{r}$$

$$\frac{d}{dt}\left(\frac{\partial T}{\partial \dot{\theta}}\right) = m\left(r^2\ddot{\theta} + 2r\dot{r}\dot{\theta}\right)$$

$$\frac{d}{dt}\left(\frac{\partial T}{\partial \dot{r}}\right) = m\ddot{r}$$

The generalized force for the θ variable is

$$F_\theta = (-mg\mathbf{J} + \mathbf{C}) \cdot \frac{\partial \mathbf{x}}{\partial \theta} = -mg\sin\theta + \mathbf{C} \cdot \mathbf{T}$$

The generalized force for the r variable is

$$F_r = (-mg\mathbf{J} + \mathbf{C}) \cdot \frac{\partial \mathbf{x}}{\partial r} = mg\cos\theta + \mathbf{C} \cdot \mathbf{N}$$

The equations of motion are

$$0 = \frac{d}{dt}\left(\frac{\partial T}{\partial \dot{\theta}}\right) - \frac{\partial T}{\partial \dot{\theta}} - F_\theta = mL\ddot{\theta} + 2m\dot{r}\dot{\theta} + mg\sin\theta - \mathbf{C} \cdot \mathbf{T}$$

and

$$0 = \frac{d}{dt}\left(\frac{\partial T}{\partial \dot{r}}\right) - \frac{\partial T}{\partial \dot{r}} - F_r = m\ddot{r} - mr\dot{\theta}^2 - mg\cos\theta - \mathbf{C} \cdot \mathbf{N}$$

*(Example 3.8
continued)*

These may be solved to obtain $\mathbf{C} \cdot \mathbf{N} = m(\ddot{r} - r\dot{\theta}^2) - mg \cos\theta$ and $\mathbf{C} \cdot \mathbf{T} = m(r\ddot{\theta} + 2\dot{r}\dot{\theta}) + mg \sin\theta$. Using the normal and tangent vectors as a basis, we have

$$\mathbf{C} = (m(\ddot{r} - r\dot{\theta}^2) - mg \cos\theta)\mathbf{N} + (m(r\ddot{\theta} + 2\dot{r}\dot{\theta}) + mg \sin\theta)\mathbf{T}$$

When $r = L$ for all time, we found earlier that $L\ddot{\theta} + g \sin\theta = 0$ for all time. The constraint function reduces to

$$\mathbf{C} = -m(L\dot{\theta}^2 + g \cos\theta)\mathbf{N}(\theta)$$

Just to verify that this makes sense, consider when the mass is at the origin and not moving; that is, $\theta = 0$ and $\dot{\theta} = 0$. The constraint force is $\mathbf{C} = -mg\mathbf{N}(0) = -mg(\sin(0), -\cos(0)) = mg_{J}$. It exactly balances the gravitational force $-mg_{J}$, as expected.

Also observe that the normal component of the gravitational force is $-mg \cos\theta$. You might have tried selecting $-mg \cos\theta$ as the constraining force, but the actual force has the term $-mL\dot{\theta}^2$ in addition to the gravitational one. The constraining force, therefore, also must counter a force due to the motion of the particle itself. ▨

3.2.2 TIME-VARYING FRAMES OR CONSTRAINTS

If the frame of reference varies over time or if the constraining curve or surface varies over time, the Lagrangian equations of motion in equations (3.20) or (3.27) still apply. The method of proof is general, so covers both the curve and surface cases. The constraining parameters may be written as a vector \mathbf{q}. In the case of a curve, the vector has one component $\mathbf{q} = (q_1)$. In the case of a surface it is $\mathbf{q} = (q_1, q_2)$. In general let m denote the number of constraining variables. The position as a function of the constraining parameters and time is $\mathbf{x}(t, \mathbf{q})$. You need to be careful now about what the time derivatives mean. The velocity vector is the *total derivative* of position with respect to time. As such, you use ordinary differentiation with respect to t:

$$\dot{\mathbf{x}} = \frac{d\mathbf{x}}{dt}$$

But now the position has an explicit dependency on time that represents either the reference frame moving or the constraining curve/surface changing. The rate of change of position with respect to time in that sense is represented by the partial derivative with respect to t. The chain rule from calculus relates the two:

$$\frac{d\mathbf{x}}{dt} = \frac{\partial \mathbf{x}}{\partial t} + \sum_{i=1}^{m} \frac{\partial \mathbf{x}}{\partial q_i}\dot{q}_i \qquad (3.28)$$

Observe that this is the analogy of the identity from equation (3.22). The extension of equation (3.23) to our new situation is

$$\frac{\partial \mathbf{x}}{\partial q_j} = \frac{\partial}{\partial \dot{q}_j} \left(\frac{\partial \mathbf{x}}{\partial t} + \sum_{i=1}^{m} \frac{\partial \mathbf{x}}{\partial q_i} \dot{q}_i \right) = \frac{\partial \dot{\mathbf{x}}}{\partial \dot{q}_j} \qquad (3.29)$$

The extension of equation (3.24) is

$$\frac{d}{dt} \left(\frac{\partial \mathbf{x}}{\partial q_j} \right) = \frac{\partial}{\partial t} \left(\frac{\partial \mathbf{x}}{\partial q_j} \right) + \sum_{i=1}^{m} \frac{\partial}{\partial q_i} \left(\frac{\partial \mathbf{x}}{\partial q_j} \right) \dot{q}_i \qquad \text{By the chain rule}$$

$$= \frac{\partial}{\partial q_j} \left(\frac{\partial \mathbf{x}}{\partial t} \right) + \sum_{i=1}^{m} \frac{\partial}{\partial q_j} \left(\frac{\partial \mathbf{x}}{\partial q_i} \right) \dot{q}_i \qquad \begin{array}{l}\text{Order of differentiation}\\\text{unimportant}\end{array}$$

$$\qquad\qquad\qquad\qquad\qquad\qquad\qquad\qquad\qquad (3.30)$$

$$= \frac{\partial}{\partial q_j} \left(\frac{\partial \mathbf{x}}{\partial t} + \sum_{i=1}^{m} \frac{\partial \mathbf{x}}{\partial q_i} \dot{q}_i \right) \qquad \text{Differentiation is linear}$$

$$= \frac{\partial \dot{\mathbf{x}}}{\partial q_j} \qquad \text{Using equation (3.28)}$$

Since all the identities are used in deriving the Lagrangian equations of motion, whether equation (3.20) or (3.27), these identities must equally apply when the position function has the explicit time component. The equations of motion for time-varying frames or constraints are still

$$\frac{d}{dt} \left(\frac{\partial T}{\partial \dot{q}_j} \right) - \frac{\partial T}{\partial q_j} = F_{q_j} \qquad (3.31)$$

for all indices j.

EXAMPLE 3.9

Let us revisit the simple pendulum problem that is illustrated in Figure 3.4 and whose equations of motion are derived in Example 3.5. Rather than having the joint remain fixed over time, we allow it to vary in time, say, $\mathbf{P}(t)$. The position function is

$$\mathbf{x}(t, \theta) = \mathbf{P}(t) + L\mathbf{N}(\theta)$$

The total time derivative is

$$\dot{\mathbf{x}} = \frac{d\mathbf{x}}{dt} = \frac{\partial \mathbf{x}}{\partial t} + \frac{\partial \mathbf{x}}{\partial \theta} \dot{\theta} = \dot{\mathbf{P}} + L\dot{\theta}\mathbf{T}$$

The kinetic energy is

$$T = \frac{m}{2} \left| \dot{\mathbf{P}} + L\dot{\theta}\mathbf{T} \right|^2 = \frac{m}{2} \left(\dot{\mathbf{P}} \cdot \dot{\mathbf{P}} + 2L\dot{\theta}\dot{\mathbf{P}} \cdot \mathbf{T} + L^2\dot{\theta}^2 \right)$$

*(Example 3.9
continued)*

The relevant derivatives are

$$\frac{\partial T}{\partial \theta} = \frac{m}{2}\left(2L\dot{\theta}\dot{\mathbf{P}} \cdot \frac{d\mathbf{T}}{d\theta}\right) = -mL\dot{\theta}\dot{\mathbf{P}} \cdot \mathbf{N}$$

$$\frac{\partial T}{\partial \dot{\theta}} = \frac{m}{2}\left(2L\dot{\mathbf{P}} \cdot \mathbf{T} + 2L^2\dot{\theta}\right) = mL\left(\dot{\mathbf{P}} \cdot \mathbf{T} + L\dot{\theta}\right)$$

and

$$\frac{d}{dt}\left(\frac{\partial T}{\partial \dot{\theta}}\right) = mL\left(\dot{\mathbf{P}} \cdot \dot{\mathbf{T}} + \ddot{\mathbf{P}} \cdot \mathbf{T} + L\ddot{\theta}\right) = mL\left(\ddot{\mathbf{P}} \cdot \mathbf{T} - \dot{\theta}\dot{\mathbf{P}} \cdot \mathbf{N} + L\ddot{\theta}\right)$$

The generalized force is

$$F_\theta = (-mg\mathbf{J}) \cdot \frac{\partial \mathbf{x}}{\partial \theta} = (-mg\mathbf{J}) \cdot (L\mathbf{T}) = -mgL\sin\theta$$

Combining these into equation (3.20) produces

$$L\ddot{\theta} + \ddot{\mathbf{P}} \cdot \mathbf{T} + g\sin\theta = 0$$

In the case where $\mathbf{P}(t)$ is a constant (the joint is fixed as in the original problem), we obtain $L\ddot{\theta} + g\sin\theta = 0$ as before. However, you should also notice that if the joint has constant linear velocity, $\mathbf{P}(t) = \mathbf{A} + t\mathbf{B}$, then we still obtain $L\ddot{\theta} + g\sin\theta = 0$. This should come as no surprise since the frame of reference is moving with constant linear velocity and is still an inertial frame.

Also curious is that if you were to hold the pendulum joint in the fingers of one hand, hold the mass away from the vertical with the fingers of your other hand, then drop the entire system, the angle formed by the mass never changes! Assuming no air resistance, the joint acceleration is controlled by gravity, $\ddot{\mathbf{P}} = -g\mathbf{J}$. The differential equation reduces to $L\ddot{\theta} = 0$. The initial angle is $\theta(0) = \theta_0$ and the initial angular speed is $\dot{\theta}(0) = 0$. The solution to the equation is $\theta(t) = \theta_0$ for all $t \geq 0$. ▪

EXERCISE
3.15

Ⓜ A rigid, frictionless rod of length L has one end attached to the origin of 3-space. The initial direction of the rod is $(1, 0, 1)/\sqrt{2}$. Thus, the other end of the rod is at $L(1, 0, 1)/\sqrt{2} = (a, 0, a)$. A mass m is constrained to move on the rod and has initial location at $(b, 0, b)$, where $0 < b < a$. One end of a spring is attached to the mass. The other end is attached to a joint at location $(c, 0, 0)$ for some positive constant c. The spring is unstretched in this initial configuration. Figure 3.9 illustrates the setup.

The rod is rotated about the x_3-axis so that the angle θ between the rod and axis remains constant. The rotation occurs with angular speed θt for $t \geq 0$. Determine the equations of motion for the mass. What is the position $(0, d, d)$ of the mass when the rod reaches the x_1x_3-plane for the first time? ▪

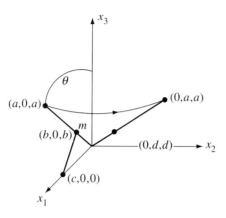

Figure 3.9 The initial configuration of a rigid rod containing a mass that is attached to a spring.

3.2.3 INTERPRETATION OF THE EQUATIONS OF MOTION

We now look at a simple, yet elegant way of interpreting the Lagrangian equations of motion. The position of the particle constrained to a curve or surface is $\mathbf{x}(t, \mathbf{q})$, where $\mathbf{q} = (q_1)$ for a curve or $\mathbf{q} = (q_1, q_2)$ for a surface. The partial derivatives of position with respect to the q_j are tangent vectors. Unit-length tangent vectors are therefore

$$\mathbf{T}_j = \frac{1}{|\partial \mathbf{x}/\partial q_j|} \frac{\partial \mathbf{x}}{\partial q_j} = \frac{1}{L_j} \frac{\partial \mathbf{x}}{\partial q_j}$$

where the last equality defines L_j as the length of the partial derivative vector. The component of acceleration of the particle in each of the tangent directions, denoted by a_{q_j}, is computed by projection onto the tangent:

$$a_{q_j} = \mathbf{a} \cdot \mathbf{T}_j = \frac{1}{L_j} \left(\ddot{\mathbf{x}} \cdot \frac{\partial \mathbf{x}}{\partial q_j} \right)$$

$$= \frac{1}{mL_j} \left(\frac{d}{dt} \left(\frac{\partial T}{\partial \dot{q}_j} \right) - \frac{\partial T}{\partial q_j} \right)$$

$$= \frac{1}{mL_j} F_{q_j}$$

We have used the Lagrangian equations of motion, equation (3.31), in this construction. Now recall that the generalized force is

$$F_{q_j} = \mathbf{F} \cdot \frac{\partial \mathbf{x}}{\partial q_j} = L_j \mathbf{F} \cdot \mathbf{T}_j$$

Define the quantity $f_{q_j} = \mathbf{F} \cdot \mathbf{T}_j$, the projection of the force onto the tangent vector \mathbf{T}_j. That is, f_{q_j} is the component of force in the tangent direction. Thus, $a_{q_j} = F_{q_j}/(mL_j)$ or

$$ma_{q_j} = f_{q_j} \tag{3.32}$$

for each constraining variable q_j. You should recognize the similarity to Newton's second law. As a matter of fact, the Lagrangian formulation is the natural extension of Newton's second law when the motion is constrained to a manifold (curve or surface).

3.2.4 EQUATIONS OF MOTION FOR A SYSTEM OF PARTICLES

Consider a system of p particles, particle i having mass m_i and located at position \mathbf{x}_i, $1 \le i \le p$. D'Alembert's equation (3.13) applies to each particle when displaced by an infinitesimal amount $d\mathbf{x}_i$ and influenced by a force \mathbf{F}_i. The derivations for the equations of motion are applied for each such particle, to produce a Lagrangian equation of motion for each constraint of interest:

$$\frac{d}{dt}\left(\frac{\partial K_i}{\partial \dot{q}_j}\right) - \frac{\partial K_i}{\partial q_j} = \mathbf{F}_i \cdot \frac{\partial \mathbf{x}_i}{\partial q_j}$$

where $K_i = m_i |\dot{\mathbf{x}}_i|^2/2$ is the kinetic energy of the particle. The total kinetic energy is

$$T = \sum_{i=1}^{p} K_i = \frac{1}{2} \sum_{i=1}^{p} m_i |\dot{\mathbf{x}}_i|^2$$

and the total generalized force for the q_j coordinate is

$$F_{q_j} = \sum_{i=1}^{p} \mathbf{F}_i \cdot \frac{\partial \mathbf{x}_i}{\partial q_j}$$

The Lagrangian equations of motion are obtained by summing those for the individual particles, leading to

$$\frac{d}{dt}\left(\frac{\partial T}{\partial \dot{q}_j}\right) - \frac{\partial T}{\partial q_j} = F_{q_j}, \quad j \ge 1 \tag{3.33}$$

Three masses m_1, m_2, and m_3 are aligned vertically and are subject to gravitational force. The first two masses are attached by a spring with spring constant c_1 and unstretched length L_1. The second two masses are attached by a spring with spring constant c_2 and unstretched length L_2. The mass m_i is located at z_i vertical units with respect to the ground plane. The particle system has three degrees of freedom represented by the variables z_i, $1 \leq i \leq 3$. Figure 3.10 illustrates the situation.

Figure 3.10

Three masses aligned vertically and subject to gravitational force.

The force due to gravity on mass m_i is $\mathbf{G}_i = -m_i g \mathbf{k}$ for $1 \leq i \leq 3$. The force due to the spring connecting masses m_1 and m_2 is

$$\mathbf{G}_4 = -c_1(z_1 - z_2 - L_1)\mathbf{k}$$

The leading sign is negative as shown by the following argument. When the spring is unstretched, the magnitude of the spring force is zero. The separation between the two masses is $z_1 - z_2 = L_1$. If the mass m_2 is pulled upward to a new position $z_1 + \delta$, where $\delta > 0$, the force on m_2 must be in the downward direction. This force is $-c_1 \delta \mathbf{k}$. Since both c_1 and δ are positive, the leading negative sign guarantees that the force is downward. Similarly, the force due to the spring connecting masses m_2 and m_3 is

$$\mathbf{G}_5 = -c_2(z_2 - z_3 - L_2)\mathbf{k}$$

The force on m_1 is $\mathbf{F}_1 = \mathbf{G}_1 + \mathbf{G}_4$. The force on m_2 is $\mathbf{F}_2 = \mathbf{G}_2 - \mathbf{G}_4 + \mathbf{G}_5$. The negative sign on the \mathbf{G}_4 term occurs because an increase in z_2 causes the first spring to compress, in which case that spring must exert a force in the opposite direction. The force on m_3 is $\mathbf{F}_3 = \mathbf{G}_3 - \mathbf{G}_5$. The negative sign on the \mathbf{G}_5 term occurs because an increase in z_3 causes the second spring to compress, in which case that spring must exert a force in the opposite direction.

*(Example 3.10
continued)*

The kinetic energy for the system is

$$T = \frac{1}{2} \sum_{i=1}^{3} m_i \dot{z}_i^2$$

The relevant derivatives are $\partial T/\partial z_i = 0$, $\partial T/\partial \dot{z}_i = m_i \dot{z}_i$, and $d(\partial T/\partial \dot{z}_i)/dt = m_i \ddot{z}_i$ for $1 \le i \le 3$.

The Lagrangian equations of motion are therefore $m_i \ddot{z}_i = \mathbf{F}_i \cdot k$, or

$$m_1 \ddot{z}_1 = -c_1(z_1 - z_2 - L_1) - m_1 g$$

$$m_2 \ddot{z}_2 = -c_2(z_2 - z_3 - L_2) + c_1(z_1 - z_2 - L_1) - m_2 g$$

$$m_3 \ddot{z}_3 = c_2(z_2 - z_3 - L_2) - m_3 g$$

Setting $\mathbf{z} = [z_1 \, z_2 \, z_3]^{\mathrm{T}}$, the system of equations in matrix form is

$$\ddot{\mathbf{z}} = \begin{bmatrix} -\dfrac{c_1}{m_1} & \dfrac{c_1}{m_1} & 0 \\[2mm] \dfrac{c_1}{m_2} & -\dfrac{c_1+c_2}{m_2} & \dfrac{c_2}{m_2} \\[2mm] 0 & \dfrac{c_2}{m_3} & -\dfrac{c_2}{m_3} \end{bmatrix} \mathbf{z} + \begin{bmatrix} \dfrac{c_1 L_1}{m_1} - g \\[2mm] \dfrac{c_2 L_2 - c_1 L_1}{m_2} - g \\[2mm] -\dfrac{c_2 L_2}{m_3} - g \end{bmatrix}$$

This is a second-order linear system of differential equations. Using methods from linear systems of differential equations, it may be reduced to a first-order system by setting

$$\mathbf{x} = [x_1 \, x_2 \, x_3 \, x_4 \, x_5 \, x_6] = [z_1 \, z_2 \, z_3 \, \dot{z}_1 \, \dot{z}_2 \, \dot{z}_3]^{\mathrm{T}}$$

leading to

$$\dot{\mathbf{x}} = \begin{bmatrix} 0 & 0 & 0 & 1 & 0 & 0 \\[1mm] 0 & 0 & 0 & 0 & 1 & 0 \\[1mm] 0 & 0 & 0 & 0 & 0 & 1 \\[1mm] -\dfrac{c_1}{m_1} & \dfrac{c_1}{m_1} & 0 & 0 & 0 & 0 \\[1mm] \dfrac{c_1}{m_2} & -\dfrac{c_1+c_2}{m_2} & \dfrac{c_2}{m_2} & 0 & 0 & 0 \\[1mm] 0 & \dfrac{c_2}{m_3} & -\dfrac{c_2}{m_3} & 0 & 0 & 0 \end{bmatrix} \mathbf{x} + \begin{bmatrix} 0 \\[1mm] 0 \\[1mm] 0 \\[1mm] \dfrac{c_1 L_1}{m_1} - g \\[1mm] \dfrac{c_2 L_2 - c_1 L_1}{m_2} - g \\[1mm] -\dfrac{c_2 L_2}{m_3} - g \end{bmatrix}$$

This is of the form $\dot{\mathbf{x}} = A\mathbf{x} + \mathbf{b}$ and may be solved in closed form using the methods of linear systems of differential equations. The matrix A happens to be invertible, so the solution is

$$\mathbf{x} = e^{At}\mathbf{x}_0 - A^{-1}\mathbf{b}$$

where \mathbf{x}_0 is an initial condition (see Section 8.5). However, this solution will involve trigonometric functions. Since these are expensive to calculate, a numerical differential equation solver may be used instead to obtain a good approximation to the solution while requiring less computational time to calculate. ▪

EXERCISE Ⓜ
3.16

SOURCE CODE

DoublePendulum

Consider a modification of the simple pendulum problem, a *double pendulum problem,* so to speak. In addition to the mass m_1 attached to a rigid rod of length r_1, a second mass m_2 is attached via a rigid rod of length r_2 to the first mass. The second rod pivots at the location of m_1 and does so without friction. Figure 3.11 illustrates. Construct the equations of motion as two coupled differential equations in the unknown angles $\theta_1(t)$ and $\theta_2(t)$.

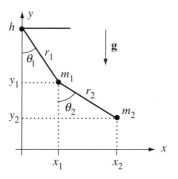

Figure 3.11 A modification of the simple pendulum problem. ▪

3.2.5 EQUATIONS OF MOTION FOR A CONTINUUM OF MASS

As expected, the Lagrangian equations of motion are also valid for a continuum of mass, whether a curve mass, a surface mass, or a volume mass. The summations that occur in the formulas for kinetic energy and generalized forces for particle systems are replaced by integrals. Rather than write separate formulas for curve masses (single integral), surface masses (double integral), and volume masses (triple integral), we use a suggestive notation with one integral whose domain of integration R generically refers to the correct type of object. The mass density is δ and varies over R. The infinitesimal measure of mass is $dm = \delta\, dR$, where dR is an infinitesimal measure of

arc length, surface area, or volume, depending on what type of object R represents. The kinetic energy is

$$T = \frac{1}{2} \int_R |\mathbf{v}|^2 \, dm$$

where the world velocity is \mathbf{v}. That is, the kinetic energy must be measured in an inertial frame; in our case this frame is labeled as the world frame. For each constraint variable q_j, the generalized force is

$$F_{q_j} = \int_R \mathbf{F} \cdot \frac{\partial \mathbf{x}}{\partial q_j} \, dR$$

where \mathbf{F} represents the applied forces on the object. The Lagrangian equations of motion are

$$\frac{d}{dt}\left(\frac{\partial T}{\partial \dot{q}_j}\right) - \frac{\partial T}{\partial q_j} = F_{q_j}$$

for all j.

Although the kinetic energy is computed from the velocity in the inertial frame, we may compute it using a transformation to local coordinates. For a rigid body we do this by equation (2.43):

$$\mathbf{v} = \mathbf{v}_{\text{cen}} + \mathbf{w} \times \mathbf{r}$$

where \mathbf{v}_{cen} is the velocity of the point \mathcal{C} identified as the origin of the body and where \mathbf{w} is the angular velocity of the body measured in the inertial frame. The relative position \mathbf{r} is from a rigid body point to the body origin. The kinetic energy in this case is

$$
\begin{aligned}
T &= \frac{1}{2} \int_R |\mathbf{v}|^2 \, dm \\
&= \frac{1}{2} \int_R |\mathbf{v}_{\text{cen}}|^2 + 2\mathbf{v}_{\text{cen}} \cdot \mathbf{w} \times \mathbf{r} + |\mathbf{w} \times \mathbf{r}|^2 \, dm \\
&= \frac{1}{2}|\mathbf{v}_{\text{cen}}|^2 \int_R dm + \mathbf{v}_{\text{cen}} \cdot \mathbf{w} \int_R \mathbf{r} \, dm + \frac{1}{2} \int_R \left(|\mathbf{w}|^2|\mathbf{r}|^2 - (\mathbf{w} \cdot \mathbf{r})^2\right) \, dm \\
&= \frac{1}{2}m|\mathbf{v}_{\text{cen}}|^2 + m\mathbf{v}_{\text{cen}} \cdot \mathbf{w} \times \mathbf{r}_{\text{cm}} + \frac{1}{2}\mathbf{w}^{\mathsf{T}} J \mathbf{w}
\end{aligned}
$$

where m is the total mass of the body, \mathbf{r}_{cm} is the position of the center of mass of the rigid body relative to \mathcal{C}, and J is the inertial tensor of the rigid body as specified in equation (2.84). If we choose \mathcal{C} to be the center of mass, the middle term vanishes

since $\mathbf{r}_{cm} = \mathbf{0}$. We may also choose the local coordinate basis vectors to be the principal directions of motion (see Section 2.5.4, the portion on inertia of 3D objects). If the principal directions are \mathbf{u}_i, $1 \leq i \leq 3$, they may be written as the columns of a rotation matrix $Q = [\mathbf{u}_1 \mid \mathbf{u}_2 \mid \mathbf{u}_3]$. By definition of principal directions, the inertial tensor satisfies the equation $J = QDQ^T$, where D is a diagonal matrix whose diagonal entries μ_1, μ_2, and μ_3 are the principal moments. The world angular velocity \mathbf{w} is represented in terms of the principal direction basis as $\mathbf{w} = Q\boldsymbol{\xi}$. Consequently, $\mathbf{w}^T J \mathbf{w} = \boldsymbol{\xi}^T D \boldsymbol{\xi}$. If $\boldsymbol{\xi} = [\xi_1 \, \xi_2 \, \xi_3]^T$, then the kinetic energy in this special case is

$$T = \frac{1}{2}m|\mathbf{v}_{cm}|^2 + \frac{1}{2}\left(\mu_1\xi_1^2 + \mu_2\xi_2^2 + \mu_3\xi_3^2\right) \tag{3.34}$$

where \mathbf{v}_{cm} is the world velocity of the center of mass. The formula is quite aesthetic. The first term is the energy due to the linear velocity of the center of mass. The last terms are the energies due to the angular velocity about principal direction lines through the center of mass. Although these formulas for kinetic energy were derived using integrals, they apply equally well to particle systems (the construction works for sums and integrals).

Equation (2.44) allows a similar simplification to the generalized force integral. Using Newton's law, an infinitesimal force $d\mathbf{F}$ applied to a particle in R of infinitesimal mass dm satisfies the relationship $d\mathbf{F} = \mathbf{a} \, dm$, where \mathbf{a} is the acceleration applied to that particle. Integrating over the entire region to obtain the total force \mathbf{F} and applying the aforementioned equation:

$$\begin{aligned}
\mathbf{F} &= \int_R \mathbf{a} \, dm \\
&= \int_R \mathbf{a}_{cen} + \mathbf{w} \times (\mathbf{w} \times \mathbf{r}) + \frac{d\mathbf{W}}{dt} \times \mathbf{r} \, dm \\
&= \mathbf{a}_{cen} \int_R dm + \mathbf{w} \times \left(\mathbf{w} \times \int_R \mathbf{r} \, dm\right) + \frac{d\mathbf{W}}{dt} \times \int_R \mathbf{r} \, dm \\
&= m\mathbf{a}_{cen} + m\mathbf{w} \times (\mathbf{w} \times \mathbf{r}_{cm}) + m\frac{d\mathbf{W}}{dt} \times \mathbf{r}_{cm}
\end{aligned}$$

where m is the total mass of the body, \mathbf{a}_{cen} is the world acceleration of the point \mathcal{C} identified as the body origin, and \mathbf{r}_{cm} is the position of the center of mass relative to \mathcal{C}. If we choose \mathcal{C} to be the center of mass, then $\mathbf{r}_{cm} = \mathbf{0}$ and

$$\mathbf{F} = m\mathbf{a}_{cm} \tag{3.35}$$

That is, the external forces applied to the rigid body act as if they are applied to a single particle located at the center of mass of the body and having mass equal to the

total mass of the body. The generalized force for the rigid body may be calculated based only on the center of mass and how it is constrained.

EXAMPLE

3.11

This example is a modification of the simple pendulum problem, but we treat this as a fully 3D problem. The z-axis is perpendicular to the plane of the diagram. The simple pendulum consists of a single-point mass located at the end of a rigid, massless rod. The other end of the rod is attached to a frictionless joint at $(0, y_0, 0)$. The rod-point object is replaced by a triangular object as shown in Figure 3.12.

The triangle is isosceles with base length b and height h. Its mass density is constant, $\delta = 1$, so the total mass is the area of the triangle (in units of mass), $m = bh/2$. The center of mass is located at $(\bar{x}, \bar{y}, \bar{z})$. The distance from the pendulum joint to the center of mass is L and the angle formed with the vertical is θ, so the center of mass location is $(\bar{x}, \bar{y}, \bar{z}) = (L \sin \theta, y_0 - L \cos \theta, 0)$.

We assign a local coordinate frame using the principal directions of motion associated with the inertial tensor. From the symmetry of the object, the principal directions are $(\cos \theta, \sin \theta, 0)$, $(- \sin \theta, \cos \theta, 0)$, and $(0, 0, 1)$. The first two of these are drawn in the figure as small black arrows at the center of mass. Although we could compute the principal moments associated with the first two principal directions, it is not necessary since the world angular velocity, $\mathbf{w} = (0, 0, \dot{\theta})$, is already a multiple of the principal direction. The zero-components of this vector multiply the principal moments in equation (3.34). The only relevant moment is μ_3 associated with the direction $(0, 0, 1)$. The kinetic energy is

$$T = \frac{1}{2}mL^2\dot{\theta}^2 + \frac{1}{2}\mu_3\dot{\theta}^2 = \frac{mL^2 + \mu_3}{2}\dot{\theta}^2$$

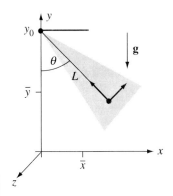

Figure 3.12 | A triangle pendulum.

Since the body is rigid, according to equation (3.35) the gravitational force $\mathbf{F}_{grav} = -mg\jmath$ acts as if it is applied at the center of mass. The generalized force is

$$F_\theta = \mathbf{F}_{grav} \cdot \frac{\partial(\bar{x}, \bar{y}, \bar{z})}{\partial\theta} = (-mg\jmath) \cdot L(\cos\theta, \sin\theta, 0) = -mgL\sin\theta$$

The Lagrangian equation of motion is

$$(mL^2 + \mu_3)\ddot{\theta} = \frac{d}{dt}\left(\frac{\partial T}{\partial\dot{\theta}}\right) - \frac{\partial T}{\partial\theta} = F_\theta = -mgL\sin\theta$$

or $\ddot{\theta} + c\sin\theta = 0$, where $c = mgL/(mL^2 + \mu_3)$. Note the similarity to the equation of motion for the simple pendulum. As the base of the triangle shrinks to zero, all the while maintaining constant mass, the limiting case is the rod itself (of the simple pendulum problem). The principal moment μ_3 is zero in the limiting case and $c = g/L$, exactly what occurs in the simple pendulum problem. ▪

A couple of observations about the last example are in order. Although we have set up the equations of motion, a numerical implementation must have available the values of the mass m and the principal moment μ_3. Under the stated assumptions, the center of mass is the area of the triangle. In your implementation, you simply need to supply the dimensions of the triangle. However, if the triangle is more complicated—namely, the mass density ρ is not constant—you must compute the center of mass for the triangle, most likely using a numerical integrator applied to $m = \int_R \delta\, dR$, where R is the region of the plane that the triangle occupies. Also, the principal moment μ_3 must be computed, also by numerical integration when δ is not a constant. In general for any rigid body, in order to construct the kinetic energy specified by equation (3.34), you will need to compute the mass and inertia tensor of the body. These calculations are typically done before the simulation starts and stored with the data structures representing the rigid body and its motion.

The second observation is that if the triangle in the last example is replaced by another planar object of the same mass m and having the same principal directions of motion and principal moments leading to the same value μ_3, the equation of motion for the planar object is identical to that of the triangle. The triangle and planar object are said to be *dynamically equivalent*.

EXERCISE Ⓔ
3.17

In the Foucault pendulum example (Example 3.3), replace the massless rod and single-point mass by a cone of height h and base radius r. Compute the equations of motion. ▪

EXAMPLE
3.12

Consider the physical system shown in Figure 3.13. This example has a mixture of point-mass objects and a planar mass.

SOURCE CODE

MassPulleySpring

A gravitational force is applied, but note that the y-axis has been selected to point downward, so $\mathbf{g} = g\jmath$ where $g > 0$. The masses and locations are labeled in the figure

*(Example 3.12
continued)*

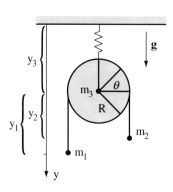

Figure 3.13 A system consisting of two masses, a pulley with mass, and a spring.

as is the radius of the pulley. The other relevant quantities are the spring constant
$c > 0$, the unstretched spring length $L > 0$, and the principal moment of inertia of
the pulley I, measured with respect to the z-axis that is perpendicular to the plane of
the figure.

This system has two degrees of freedom, the vertical distance y_3 from the ceiling
to the center of mass of the pulley and the vertical distance y_1 from the vertical
location of the center of mass of the pulley to the mass m_1. The vertical distance y_2
is automatically determined because the length of the wire connecting m_1 and m_2,
namely, $(y_1 - y_3) + (y_2 - y_3) + \pi R = \ell$, a constant.

The kinetic energy of the first mass is $m_1(\dot{y}_3^2 + \dot{y}_1^2)/2$ and the kinetic energy of the
second mass is $m_2(\dot{y}_3^2 + \dot{y}_2^2)/2 = m_2(\dot{y}_3^2 - \dot{y}_1^2)/2$. The kinetic energy of the pulley
is calculated using equation (3.34). The component associated with the velocity of
the center of mass is $m_3\dot{y}_3^2/2$. The component associated with the angular velocity is
$I\dot{\theta}^2/2$, where θ is an angle measured from the horizontal line through the center of
the pulley, as shown in Figure 3.13. Notice that for an angle θ as shown, the length of
the subtended arc on the pulley circumference is $R\theta$. The rate of change is $R\dot{\theta}$, where
$\dot{\theta}$ is the angular speed of the pulley. Any change in arc length amounts to a change in
the y_1 vertical distance; that is, $\dot{y}_1 = R\dot{\theta}$. The kinetic energy component is, therefore,
$I(\dot{y}_1/R)^2/2$. The total kinetic energy is

$$T = \frac{m_1}{2}(\dot{y}_3 + \dot{y}_1)^2 + \frac{m_2}{2}(\dot{y}_3 - \dot{y}_1)^2 + \frac{m_3}{2}\dot{y}_3^2 + \frac{I}{2R^2}\dot{y}_1^2$$

The principal moment, measured with respect to the center of the pulley, is $I = \int_D r^2\,r\,dr\,d\theta$, where D is the disk $r \le R$. The integral is easily calculated to produce
$I = \pi R^4/2$.

The relevant derivatives of the kinetic energy are (1) $\partial T/\partial y_3 = 0$, $\partial T/\partial y_1 = 0$, $\partial T/\partial \dot{y}_3 = \alpha \dot{y}_3 + \beta \dot{y}_1$, where $\alpha = m_1 + m_2 + m_3$ and $\beta = m_1 - m_2$, and (2) $\partial T/\partial \dot{y}_1 = \beta \dot{y}_3 + \gamma \dot{y}_1$, where $\gamma = m_1 + m_2 + I/R^2$.

The position of mass m_1 is $(y_3 + y_1)J$. The generalized forces for this mass are

$$F_{y_3} = m_1 g J \cdot \frac{\partial((y_3 + y_1)J)}{\partial y_3} = m_1 g$$

$$F_{y_1} = m_1 g J \cdot \frac{\partial((y_3 + y_1)J)}{\partial y_1} = m_1 g$$

The position of mass m_2 is $(y_3 + y_2)J$. The generalized forces for this mass are

$$F_{y_3} = m_2 g J \cdot \frac{\partial((y_3 + y_2)J)}{\partial y_3} = m_2 g$$

$$F_{y_1} = m_2 g J \cdot \frac{\partial((y_3 + y_2)J)}{\partial y_1} = -m_2 g$$

The negative sign on the right-hand side occurs because $(y_1 - y_3) + (y_2 - y_3) = \ell - \pi R$ (a constant) implies $\partial y_2/\partial y_1 = -1$. The position of the center of the pulley is $y_3 J$. The generalized forces for the pulley are

$$F_{y_3} = (m_3 g + c(L - y_3))J \cdot \frac{\partial(y_3 J)}{\partial y} = m_3 g + c(L - y_3)$$

$$F_{y_1} = (m_3 g + c(L - y_3))J \cdot \frac{\partial(y_3 J)}{\partial y_1} = 0$$

The Lagrangian equations of motion are

$$\alpha \ddot{y}_3 + \beta \ddot{y}_1 = F_{y_3} = m_1 g + m_2 g + m_3 g + c(L - y_3) = \alpha g + c(L - y_3)$$

and

$$\beta \ddot{y}_3 + \gamma \ddot{y}_1 = F_{y_1} = m_1 g - m_2 g = \beta g$$

The equations are uncoupled by solving the second for \ddot{y}_1 and replacing in the first:

$$\ddot{y}_3 = \frac{c\gamma}{\alpha\gamma - \beta^2}(L - y_3) + g$$

This is a second-order linear differential equation with a nonhomogeneous term. (Figure 3.14—also Color Plate 3.14—shows some screen shots from the mass/pulley/spring application found on the CD-ROM.)

(Example 3.12 continued)

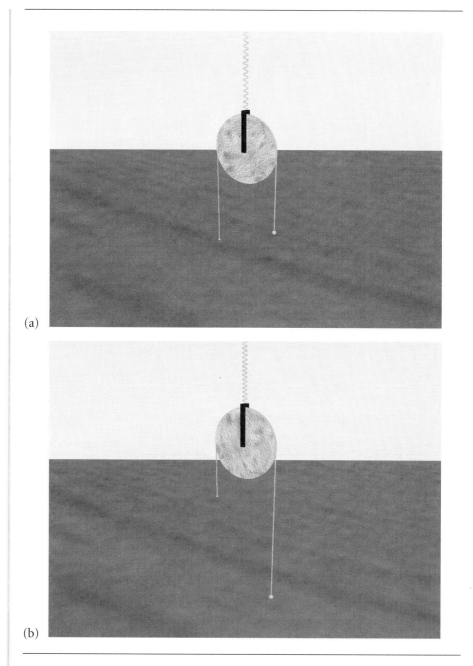

(a)

(b)

Figure 3.14 A mass pulley spring system shown at two different times. The spring expands and compresses, and the pulley disk rotates during the simulation. The system stops when a mass reaches the center line of the pulley or the ground. (See also Color Plate 3.14.)

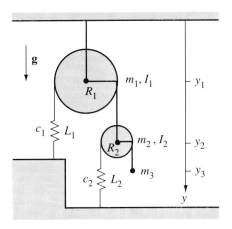

Figure 3.15 A system of two pulleys, two springs, and a mass.

EXERCISE Ⓔ In Example 3.12, solve the final differential equation explicitly for y_3, then solve for
3.18 y_1 and y_2 explicitly. ▪

EXERCISE Ⓜ Compute the equations of motion for the physical system shown in Figure 3.15. The
3.19 spring constants c_1 and c_2 and the unstretched lengths L_1 and L_2 are labeled in the
figure. The masses, moments of inertia, and radii of the pulleys are shown, as well as
the mass of the single particle. ▪

EXAMPLE Figure 3.16 shows a physical system consisting of a rigid, but massless, pipe that has
3.13 a slight bend in it. The vertical portion of the pipe freely rotates about the z-axis
with angular speed $\dot{\theta}$. At the end of the pipe is a solid, cylindrical disk of constant
mass density. The radius of the disk is a and the thickness is b. The disk freely rotates
about the cylinder axis with angular speed $\dot{\psi}$. The force acting on the system is given
generically by **F**. We wish to determine the equations of motion for the system.

The bend in the joint is h units above the end of the pipe. The bent portion of the pipe
has length L. The local coordinate system at the center of mass uses spherical coordi-
nates, where $\mathbf{P} = (-\sin\theta, \cos\theta, 0)$, $\mathbf{Q} = (-\cos\theta\cos\phi, -\sin\theta\cos\phi, \sin\phi)$, and
$\mathbf{R} = (\cos\theta\sin\phi, \sin\theta\sin\phi, \cos\phi)$. If \mathcal{O} denotes the origin of the physical system,
the center of mass \mathcal{C} of the disk is located relative to the origin by

$$\mathbf{r} = \mathcal{C} - \mathcal{O} = h k + L\mathbf{R}$$

*(Example 3.13
continued)*

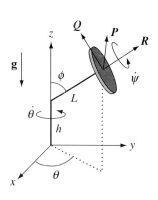

Figure 3.16 A physical system with a bent pipe rotating about the z-axis and a disk rotating about its axis.

The velocity of the center of mass is

$$\mathbf{v}_{\text{cm}} = \frac{d\mathbf{r}}{dt} = L\dot{\mathbf{R}} = L\left(\dot{\theta}\sin\phi\mathbf{P} - \dot{\phi}\mathbf{Q}\right)$$

The world coordinates of the angular velocity of the pipe about its shaft is $\mathbf{w}_{\text{pipe}} = \dot{\theta}k$. The world coordinates of the angular velocity of the disk is $\mathbf{w}_{\text{disk}} = \dot{\psi}\mathbf{R}$, where ψ is the angular measurement made in the plane of \mathbf{P} and \mathbf{Q}. The world coordinates of the angular velocity of the physical system as a whole is the sum of the angular velocities,

$$\mathbf{w} = \mathbf{w}_{\text{pipe}} + \mathbf{w}_{\text{disk}} = \dot{\theta}k + \dot{\psi}\mathbf{R}$$

We may write the angular velocity in local coordinates using the fact that $k = \cos\phi\mathbf{R} + \sin\phi\mathbf{Q}$:

$$\mathbf{w} = 0\mathbf{P} + \dot{\theta}\sin\phi\mathbf{Q} + (\dot{\psi} + \dot{\theta}\cos\phi)\mathbf{R}$$

in which case the local coordinates are

$$\boldsymbol{\xi} = (0,\, \dot{\theta}\sin\phi,\, \dot{\psi} + \dot{\theta}\cos\phi)$$

From equation (3.34) the kinetic energy is

$$T = \frac{1}{2}mL^2(\dot{\theta}^2\sin^2\phi + \dot{\phi}^2) + \frac{1}{2}\mu_2\dot{\theta}^2\sin^2\phi + \frac{1}{2}\mu_3(\dot{\psi} + \dot{\theta}\cos\phi)^2$$

where m is the mass of the disk and where μ_2 and μ_3 are principal moments for the disk. Although we do not need the value here, by symmetry $\mu_1 = \mu_2$. The only degrees of freedom are θ and ψ since ϕ is constant. The relevant derivatives are

$$\frac{\partial T}{\partial \theta} = 0, \qquad \frac{\partial T}{\partial \psi} = 0$$

$$\frac{\partial T}{\partial \dot{\theta}} = (mL^2 + \mu_2)\dot{\theta} \sin^2 \phi + \mu_3(\dot{\psi} + \dot{\theta} \cos \phi) \cos \phi,$$

$$\frac{\partial T}{\partial \dot{\psi}} = \mu_3(\dot{\psi} + \dot{\theta} \cos \phi)$$

$$\frac{d}{dt}\left(\frac{\partial T}{\partial \dot{\theta}}\right) = (mL^2 + \mu_2)\ddot{\theta} \sin^2 \phi + \mu_3(\ddot{\psi} + \ddot{\theta} \cos \phi) \cos \phi,$$

$$\frac{d}{dt}\left(\frac{\partial T}{\partial \dot{\psi}}\right) = \mu_3(\ddot{\psi} + \ddot{\theta} \cos \phi)$$

The generalized forces are

$$F_\theta = \mathbf{F} \cdot \frac{\partial \mathbf{r}}{\partial \theta} = \mathbf{F} \cdot \frac{\partial (h\mathbf{k} + L\mathbf{R})}{\partial \theta} = \mathbf{F} \cdot L(-\sin\theta \sin\phi, \cos\theta \sin\phi, 0)$$

and

$$F_\psi = \mathbf{F} \cdot \frac{\partial \mathbf{r}}{\partial \psi} = \mathbf{F} \cdot \frac{\partial (h\mathbf{k} + L\mathbf{R})}{\partial \psi} = \mathbf{F} \cdot (0, 0, 0) = 0$$

The fact that $F_\psi = 0$ is to be expected. The center of mass is invariant with respect to the rotation of the disk, so the applied force cannot affect it.

The equations of motion are therefore

$$(mL^2 + \mu_2)\ddot{\theta} \sin^2 \phi + \mu_3(\ddot{\psi} + \ddot{\theta} \cos \phi) \cos \phi = F_\theta$$

and

$$\mu_3(\ddot{\psi} + \ddot{\theta} \cos \phi) = 0$$

The equations may be solved explicitly for the second-derivative terms:

$$\ddot{\theta} = \frac{F_\theta}{(mL^2 + \mu_2) \sin^2 \phi}, \qquad \ddot{\psi} = \frac{-F_\theta \cos \phi}{(mL^2 + \mu_2) \sin^2 \phi}$$

The principal moment μ_3 does not enter into the solution. This does not mean the angular speeds of the pipe and disk are unaffected by physical characteristics

(Example 3.13 continued) of the disk. The solution still has μ_2 in it. If you increase μ_2 (i.e., make the disk heavier, increase its radius, or make it thicker), the right-hand sides of the differential equations become smaller because of the presence of μ_2 in the denominators. This in turn causes the angular accelerations to become smaller, leading to reduced angular speeds. ▪

EXERCISE (E) In Example 3.13, show that $\mu_2 = m(a^2/2 + b^2/12)$ and $\mu_3 = ma^2/2$. ▪
3.20

EXERCISE (M) In Example 3.13, if the only applied force is gravitational, say, $\mathbf{F} = -mg\mathbf{k}$, show that
3.21 the angular speeds of the pipe and disk are constant over time. ▪

EXERCISE (M) Consider a solid disk that is attached by a massless rod to the origin. The disk rolls
3.22 on the plane $z = y \tan \alpha$ for a small positive angle α. Gravitational forces are present and the plane is assumed to be rough so that frictional forces come into play. Figure 3.17 illustrates.

The disk has radius $a > 0$ and thickness $b > 0$. One end of the rod is attached to the origin, the other end to the center of the face closest to the origin. The distance from the rod to the center of mass is L units. The physical system has one degree of freedom, the angle θ. Construct the equation of motion for θ. (See Section 3.2.7 for a model of motion of a solid box over a plane with frictional forces.) ▪

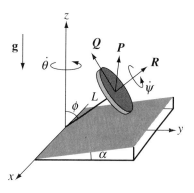

Figure 3.17 A solid disk that rolls on a rough, inclined plane.

3.2.6 EXAMPLES WITH CONSERVATIVE FORCES

Recall that a Lagrangian equation of motion for the constraint variable q is of the form

$$\frac{d}{dt}\left(\frac{\partial T}{\partial \dot{q}}\right) - \frac{\partial T}{\partial q} = F_q$$

where $F_q = \mathbf{F} \cdot d\mathbf{x}/dq$ is a generalized force. If \mathbf{F} is a conservative force, then $\mathbf{F} = -\nabla V$ for some potential energy function V, in which case

$$F_q = \mathbf{F} \cdot \frac{d\mathbf{x}}{dq} = -\nabla V \cdot \frac{d\mathbf{x}}{dq} = -\frac{\partial V}{\partial q}$$

The Lagrangian equation of motion for a conservative force is

$$\frac{d}{dt}\left(\frac{\partial T}{\partial \dot{q}}\right) - \frac{\partial T}{\partial q} = -\frac{\partial V}{\partial q}$$

The potential function in mechanical problems is almost always independent of time derivatives \dot{q}, so if we define the scalar function $L = T - V$, called a *Lagrangian function*, the equation of motion for a conservative force is

$$\frac{d}{dt}\left(\frac{\partial L}{\partial \dot{q}}\right) - \frac{\partial L}{\partial q} = 0 \tag{3.36}$$

EXAMPLE 3.14

A simple model of a diving board is presented here. Figure 3.18 illustrates. The board has length r and is massless, but has a mass m on the end that represents someone standing on the end of the board (and can be affected by gravity). The

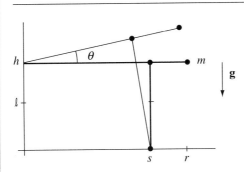

Figure 3.18 A simple diving board.

(Example 3.14 continued)

flexibility of the board is modeled by a spring attached between the board and the ground. This spring affects the angular motion of the board about the joint at $(0, h)$. The spring is located at position s and has spring constant $c > 0$. The spring is un-stretched with length ℓ, not necessarily the height h of the joint above the ground. The location of the mass is measured by the angle θ relative to the horizontal. The position of the mass is $\mathbf{x} = (0, h) + r(\cos\theta, \sin\theta)$. The velocity is $\dot{\mathbf{x}} = r(-\sin\theta, \cos\theta)\dot\theta$. The kinetic energy is $T = mr^2\dot\theta^2/2$.

The potential energy due to a change in height from the board's horizontal position is the magnitude of the force multiplied by the change in height, as seen in equation (2.107). For an angle θ, the change in height is $r\sin\theta$. The contribution to potential energy is $V_{\text{gravity}} = mgr\sin\theta$. The potential energy due to the spring stretching was derived in equation (2.108). It depends only on the end points (s, h) and $(s\cos\theta, h + s\sin\theta)$. The stretched length at the first end point is $h - \ell$. The stretched length at the second end point is the value

$$\sqrt{s^2(\cos\theta - 1)^2 + (h + s\sin\theta)^2} - \ell$$

The contribution is

$$V_{\text{spring}} = \frac{c}{2}\left(\left(\sqrt{s^2(\cos\theta - 1)^2 + (h + s\sin\theta)^2} - \ell\right)^2 - (h - \ell)^2\right)$$

The total potential energy is $V = V_{\text{gravity}} + V_{\text{spring}}$. The constant $(h - \ell)^2$ may be ignored since the derivative of V is all that matters in the Lagrangian equations of motion. Moreover, if you want to make an approximation by allowing θ to be only a small angle, then $\cos\theta \doteq 1$ and $\sin\theta \doteq \theta$, so $V \doteq (c/2)(h + s\theta - \ell) + mgr\theta$ is a reasonable approximation.

Using the approximation for potential energy, the Lagrangian is

$$L = T - V = \frac{1}{2}mr^2\dot\theta^2 - \frac{1}{2}c(h + s\theta - \ell)^2 - mgr\theta$$

The Lagrangian equation of motion is

$$0 = \frac{d}{dt}\left(\frac{\partial L}{\partial\dot\theta}\right) - \frac{\partial L}{\partial q}$$

$$= \frac{d}{dt}(mr^2\dot\theta) - (-cs(h + s\theta - \ell) - mgr) = mr^2\ddot\theta + cs(h + s\theta - \ell) + mgr$$

If the spring is such that the diving board is in static equilibrium at $\theta = 0$, that is, $cs(h - \ell) + mgr = 0$, then the equation of motion is $\ddot\theta + ((cs^2)/(mr^2))\theta = 0$, and the board exhibits simple harmonic motion. ∎

EXERCISE Ⓔ Construct the equations of motion for Example 3.14, but without the approximation
3.23 involving a small angle θ. ■

EXAMPLE Consider a double pendulum that consists of two rigid and massless rods. The first
3.15 rod is attached to a frictionless joint on the ceiling and has length r_1. The other end
of the rod has a mass m_1 attached. The second rod is attached to the other end of the
first rod, this joint also frictionless, and has length r_2. A mass m_2 is attached to the
other end of the second rod. The only applied force is gravitational. See Figure 3.11
for an illustration.

Mass m_i is located at (x_i, y_i) for $i = 1, 2$. The kinetic energy is $T = m_1(\dot{x}_1^2 + \dot{y}_1^2)/2 +$
$m_2(\dot{x}_2^2 + \dot{y}_2^2)/2$. However, we have only two degrees of freedom, which may as well
be chosen to be the angles θ_1 and θ_2. Trigonometric identities lead to $x_1 = r_1 \sin \theta_1$,
$h - y_1 = r_1 \cos \theta_1$, $x_2 - x_1 = r_2 \sin \theta_2$, and $y_1 - y_2 = r_2 \cos \theta_2$. Solving for the com-
ponents:

$$x_1 = r_1 \sin \theta_1$$

$$y_1 = h - r_1 \cos \theta_1$$

$$x_2 = r_1 \sin \theta_1 + r_2 \sin \theta_2$$

$$y_2 = h - r_1 \cos \theta_1 - r_2 \cos \theta_2$$

and the derivatives are

$$\dot{x}_1 = r_1 \dot{\theta}_1 \cos \theta_1$$

$$\dot{y}_1 = r_1 \dot{\theta}_1 \sin \theta_1$$

$$\dot{x}_2 = r_1 \dot{\theta}_1 \cos \theta_1 + r_2 \dot{\theta}_2 \cos \theta_2$$

$$\dot{y}_2 = r_1 \dot{\theta}_1 \sin \theta_1 + r_2 \dot{\theta}_2 \sin \theta_2$$

The kinetic energy is therefore

$$T = \frac{m_1}{2} r_1^2 \dot{\theta}_1^2 + \frac{m_2}{2} \left(r_1^2 \dot{\theta}_1^2 + r_2^2 \dot{\theta}_2^2 + 2 r_1 r_2 \dot{\theta}_1 \dot{\theta}_2 \cos(\theta_1 - \theta_2) \right)$$

The contribution to potential energy from mass m_1 is $-m_1 g(h - y_1)$ and the contri-
bution from mass m_2 is $-m_2 g(h - y_2)$, so the total potential energy is

$$V = -m_1 g(h - y_1) - m_2 g(h - y_2) = -(m_1 + m_2) g r_1 \cos \theta_1 - m_2 g r_2 \cos \theta_2$$

(Example 3.15 continued)

The Lagrangian $L = T - V$ is

$$L = \frac{m_1}{2}r_1^2\dot{\theta}_1^2 + \frac{m_2}{2}\left(r_1^2\dot{\theta}_1^2 + r_2^2\dot{\theta}_2^2 + 2r_1r_2\dot{\theta}_1\dot{\theta}_2\cos(\theta_1 - \theta_2)\right)$$
$$+ (m_1 + m_2)gr_1\cos\theta_1 + m_2gr_2\cos\theta_2$$

and its relevant derivatives are

$$\frac{\partial L}{\partial \theta_1} = -m_2r_1r_2\dot{\theta}_1\dot{\theta}_2\sin(\theta_1 - \theta_2) - (m_1 + m_2)gr_1\sin\theta_1$$

$$\frac{\partial L}{\partial \theta_2} = m_2r_1r_2\dot{\theta}_1\dot{\theta}_2\sin(\theta_1 - \theta_2) - m_2gr_2\sin\theta_2$$

$$\frac{\partial L}{\partial \dot{\theta}_1} = m_1r_1^2\dot{\theta}_1 + m_2(r_1^2\dot{\theta}_1 + r_1r_2\dot{\theta}_2\cos(\theta_1 - \theta_2))$$

$$\frac{\partial L}{\partial \dot{\theta}_2} = m_2(r_2^2\dot{\theta}_2 + r_1r_2\dot{\theta}_1\cos(\theta_1 - \theta_2))$$

$$\frac{d}{dt}\left(\frac{\partial L}{\partial \dot{\theta}_1}\right) = m_1r_1^2\ddot{\theta}_1 + m_2(r_1^2\ddot{\theta}_1 + r_1r_2(-\dot{\theta}_2(\dot{\theta}_1 - \dot{\theta}_2)\sin(\theta_1 - \theta_2) + \ddot{\theta}_2\cos(\theta_1 - \theta_2)))$$

$$\frac{d}{dt}\left(\frac{\partial L}{\partial \dot{\theta}_2}\right) = m_2(r_2^2\ddot{\theta}_2 + r_1r_2(-\dot{\theta}_1(\dot{\theta}_1 - \dot{\theta}_2)\sin(\theta_1 - \theta_2) + \ddot{\theta}_1\cos(\theta_1 - \theta_2)))$$

The two Lagrangian equations of motion are

$$0 = \frac{d}{dt}\left(\frac{\partial L}{\partial \dot{\theta}_1}\right) - \frac{\partial L}{\partial \theta_1}$$
$$= (m_1 + m_2)r_1(r_1\ddot{\theta}_1 + g\sin\theta_1) + m_2r_1r_2(\ddot{\theta}_2\cos(\theta_1 - \theta_2) + \dot{\theta}_2^2\sin(\theta_1 - \theta_2))$$

$$0 = \frac{d}{dt}\left(\frac{\partial L}{\partial \dot{\theta}_2}\right) - \frac{\partial L}{\partial \theta_2}$$
$$= m_2r_2(r_2\ddot{\theta}_2 + g\sin\theta_2) + m_2r_1r_2(\ddot{\theta}_1\cos(\theta_1 - \theta_2) - \dot{\theta}_1^2\sin(\theta_1 - \theta_2))$$

The two equations may be solved simultaneously to produce explicit formulas for the second derivatives $\ddot{\theta}_1$ and $\ddot{\theta}_2$. ∎

EXERCISE Ⓜ In the double pendulum problem, replace the rigid rods by massless springs whose
3.24 spring constants are c_1 and c_2 and whose unstretched lengths are ℓ_1 and ℓ_2. Calculate
 the kinetic energy, the potential energy, the Lagrangian, and the equations of motion.
 ▪

EXERCISE Ⓜ Compute the equations of motion for the triple pendulum problem where all the rods
3.25 are rigid. This problem adds one more massless rod to the system: one end is attached
 to mass m_2 (the joint is frictionless) and the free end has a mass m_3 attached to it. The
 rod length is r_3. ▪

EXAMPLE *Two-body problem.* This is the same problem discussed in Example 3.1 that was
3.16 derived with Newtonian dynamics and that led to Kepler's laws. We now derive
 the equations of motion using Lagrangian dynamics. Consider two particles with
 masses m_i and positions (x_i, y_i, z_i) for $i = 1, 2$. The center of mass is $(x, y, z) =$
 $(m_1(x_1, y_1, z_1) + m_2(x_2, y_2, z_2))/(m_1 + m_2)$. The particles may be represented in the
 coordinate system whose origin is the center of mass and whose axes are parallel to
 the world coordinate axes. Specifically,

$$(x_i, y_i, z_i) = (x, y, z) + r_i \mathbf{R}(\theta, \phi)$$

where $\mathbf{R}(\theta, \phi) = (\cos\theta \sin\phi, \sin\theta \sin\phi, \cos\phi)$ is in the direction from particle 1
to particle 2. Using the fact that the total moment about the center of mass is zero,
namely, $\sum_{i=1}^{2} m_i(x_i - x, y_i - y, z_i - z) = (0, 0, 0)$, the radial values must satisfy
$m_1 r_1 + m_2 r_2 = 0$. Define r to be the distance between the particles, so $r = r_2 - r_1$.
Consequently, $r_1 = -m_2 r/(m_1 + m_2)$ and $r_2 = m_1 r/(m_1 + m_2)$. In this notation the
gravitational force exerted by particle 1 on particle 2 is

$$\mathbf{F} = -\frac{Gm_1 m_2}{r^2} \mathbf{R}(\theta, \phi)$$

where G is the gravitational constant. This force is conservative with potential energy
$V = -Gm_1 m_2/r$. The kinetic energy is

$$T = \frac{1}{2} \sum_{i=1}^{2} m_i(\dot{x}_i^2 + \dot{y}_i^2 + \dot{z}_i^2)$$

$$= \frac{m_1 + m_2}{2}\left(\dot{x}^2 + \dot{y}^2 + \dot{z}^2\right) + \frac{m_1 m_2}{2(m_1 + m_2)}\left(\dot{r}^2 + r^2(\dot{\phi}^2 + \dot{\theta}^2 \sin^2\phi)\right)$$

(Example 3.16
continued)

For simplicity we will assume that the center of mass travels through space with constant linear velocity. In this case the Lagrangian function is

$$L = T - V = \frac{c_1}{2}\left(\dot{r}^2 + r^2(\dot{\phi}^2 + \dot{\theta}^2 \sin^2 \phi)\right) + \frac{c_2}{r}$$

where $c_1 = m_1 m_2/(m_1 + m_2)$ and $c_2 = Gm_1 m_2$.

The relevant derivatives of L are

$$\frac{\partial L}{\partial r} = c_1 r(\dot{\phi}^2 + \dot{\theta}^2 \sin^2 \phi) - \frac{c_2}{r^2} \qquad \frac{\partial L}{\partial \dot{r}} = c_1 \dot{r}$$

$$\frac{\partial L}{\partial \theta} = 0 \qquad\qquad\qquad \frac{\partial L}{\partial \dot{\theta}} = c_1 r^2 \dot{\theta} \sin^2 \phi$$

$$\frac{\partial L}{\partial \phi} = c_1 r^2 \dot{\theta}^2 \sin \phi \cos \phi \qquad \frac{\partial L}{\partial \dot{\phi}} = c_1 r^2 \dot{\phi}$$

The Lagrangian equations of motion are

$$0 = \frac{d}{dt}\left(\frac{\partial L}{\partial \dot{r}}\right) - \frac{\partial L}{\partial r} = c_1 \ddot{r} - c_1 r(\dot{\phi}^2 + \dot{\theta}^2 \sin^2 \phi) + \frac{c_2}{r}$$

$$0 = \frac{d}{dt}\left(\frac{\partial L}{\partial \dot{\theta}}\right) - \frac{\partial L}{\partial \theta} = c_1 \frac{d}{dt}\left(r^2 \dot{\theta} \sin^2 \phi\right)$$

$$0 = \frac{d}{dt}\left(\frac{\partial L}{\partial \dot{\phi}}\right) - \frac{\partial L}{\partial \phi} = c_1 \left(\frac{d}{dt}\left(r^2 \dot{\phi}\right) - r^2 \dot{\theta}^2 \sin \phi \cos \phi\right)$$

The second equation implies $r^2 \dot{\theta} \sin^2 \phi = \alpha$ is a constant. If we choose $\dot{\theta}(0) = 0$, then $\alpha = 0$, which in turn implies $\dot{\theta}(t) = 0$ for all time. Therefore, the motion of the two particles must be in the plane $\theta = \theta_0$. If the value $\dot{\theta}(0) \neq 0$, it is still the case that the motion is in a plane, but the analysis is a bit more complicated and left as an exercise. The third equation of motion reduces to $d(r^2\dot{\phi})/dt = 0$, so $r^2 \dot{\phi} = \beta$, a constant for all time. Replacing this in the first equation of motion, dividing by c_1, and defining $\gamma = c_2/c_1$, we have

$$\ddot{r} = \frac{\beta^2}{r^3} - \frac{\gamma}{r^2}$$

This equation may be solved numerically for $r(t)$ when initial conditions $r(0)$ and $\dot{r}(0)$ are selected. The angle is obtained by one more integration, $\phi(t) = \phi(0) + \int_0^t \beta/r^2(\tau)\,d\tau$, with $\phi(0)$ selected as an initial condition.

How does this relate back to Example 3.1 on Kepler's laws? At first glance you might have thought we found explicit solutions for $r(t)$ and $\phi(t)$. This is not so. What we found was a relationship between the two,

$$r(t) = \frac{e\rho}{1 + e \cos \phi(t)}$$

an equation of an ellipse. To obtain a numerical solution for r and ϕ as functions of time, you would need to solve $\ddot{\mathbf{r}} = -(Gm_1/r^2)\mathbf{r}$, where $\mathbf{r} = r\mathbf{R}$. In the derivation in that example we also showed that $\mathbf{r} \times \dot{\mathbf{r}} = \mathbf{c}_0$ for some constant vector \mathbf{c}_0. This constant is determined from the initial position $\mathbf{r}(0)$ and initial velocity $\dot{\mathbf{r}}(0)$, namely, $\mathbf{c}_0 = \mathbf{r}(0) \times \dot{\mathbf{r}}(0)$. This information can be used to reduce the differential equation to one involving motion in a plane whose normal is \mathbf{c}_0.

As it turns out, the ellipse equation does satisfy the second-order equation for $r(t)$ that we just derived using Lagrangian dynamics. Taking a derivative leads to

$$\dot{r} = \frac{e^2 \rho \dot{\phi} \sin \phi}{(1 + e \cos \phi)^2} = \frac{r^2 \dot{\phi} \sin \phi}{\rho} = \frac{\beta \sin \phi}{\rho}$$

Taking another derivative:

$$\ddot{r} = \frac{\beta}{\rho} \cos \phi = \frac{\beta}{\rho} \frac{\beta}{r^2} \frac{1}{e} \left(\frac{e\rho}{r} - 1 \right) = \frac{\beta^2}{r^3} - \frac{\beta^2}{e\rho} \frac{1}{r^2}$$

For this to equate to our Lagrangian equation we need $\beta^2 = e\rho\lambda$. ▪

EXERCISE Ⓜ In Example 3.16, if $\dot{\theta}(0) \neq 0$, show that the motion of the particles is still in a plane.
3.26 What is the equation of that plane? *Hint:* The plane will depend on the choices for $\dot{\theta}(0)$ and $\dot{\phi}(0)$. ▪

EXERCISE Ⓜ Write a computer program to solve the Lagrangian equations of motion in Exam-
3.27 ple 3.16. ▪

3.2.7 EXAMPLES WITH DISSIPATIVE FORCES

This section contains some examples for setting up the equations of motion when at least one of the applied forces is dissipative. The first example is a slight modification of the simple pendulum. Other examples are slightly more complicated.

EXAMPLE Consider the simple pendulum problem that is illustrated in Figure 3.4. The joint
3.17 at \mathcal{P} is now assumed to apply a frictional force \mathbf{F}_{fric} to impede the motion of the rod. The gravitational force is $\mathbf{F}_{\text{grav}} = -mg\mathbf{\jmath}$. The position of the mass is $\mathbf{x} = (r \sin \theta, h - r \cos \theta)$, where the joint is a height h above the ground. The velocity is

(Example 3.17 continued)

SOURCE CODE

SimplePendulum-
Friction

$\mathbf{v} = r\dot{\theta}(\cos\theta, \sin\theta)$. The kinetic energy is $T = m|\mathbf{v}|^2/2 = mr^2\dot{\theta}^2/2$. The generalized force is $F_\theta = (\mathbf{F}_{\text{grav}} + \mathbf{F}_{\text{fric}}) \cdot d\mathbf{x}/d\theta$. The Lagrangian equation of motion is

$$mr^2\ddot{\theta} = \frac{d}{dt}\left(\frac{\partial T}{\partial\dot{\theta}}\right) - \frac{\partial T}{\partial\theta} = F_\theta = -mgr\sin\theta + \mathbf{F}_{\text{fric}} \cdot r(\cos\theta, \sin\theta)$$

The frictional force is assumed not to contain a static friction component.

If the frictional force is kinetic friction, the force is modeled by $\mathbf{F}_{\text{fric}} = -c\mathbf{v}/|\mathbf{v}|$ for some constant $c > 0$. The force is in the opposite direction of velocity. The equation of motion reduces to

$$0 = \ddot{\theta} + \frac{c}{mr}\frac{\dot{\theta}}{|\dot{\theta}|} + \frac{g}{r}\sin\theta = \ddot{\theta} + a\sigma(\dot{\theta}) + b\sin\theta$$

where $a = c/(mr)$, $b = g/r$, and $\sigma(t)$ acts as a switch. If $t > 0$, then $\sigma(t) = 1$. If $t < 0$, then $\sigma(t) = -1$. To avoid the singularity at $t = 0$, we define $\sigma(0) = 0$.

If the dissipative force is viscous, for example, when the joint has a layer of oil to prevent overheating, the force is modeled by $\mathbf{F}_{\text{fric}} = -c\mathbf{v}$ for some constant $c > 0$. The equation of motion reduces to

$$\ddot{\theta} + \frac{c}{m}\dot{\theta} + \frac{g}{r}\sin\theta = 0$$

If the pendulum has only small oscillations about the vertical so that θ is nearly zero and $\sin\theta \doteq \theta$, an approximation to the equation of motion is

$$\ddot{\theta} + \frac{c}{m}\dot{\theta} + \frac{g}{r}\theta = 0$$

This is a second-order linear differential equation whose solution may be written in closed form (see Section 8.3). If we set $a = c/m$ and $b = g/r$, the characteristic equation is $\lambda^2 + a\lambda + b = 0$. If $a^2 > 4b$, this equation has two negative real-valued roots $\lambda_1 = (-a - \sqrt{a^2 - 4b})/2$ and $\lambda_2 = (-a + \sqrt{a^2 - 4b})/2$. The solution to the differential equation with initial conditions $\theta(0) = \theta_0 \neq 0$ and $\dot{\theta}_0 = \dot{\theta}(0)$ is

$$\theta(t) = \frac{(\lambda_2\theta_0 - \dot{\theta}_0)\exp(\lambda_1 t) - (\lambda_1\theta_0 - \dot{\theta}_0)\exp(\lambda_2 t)}{\lambda_2 - \lambda_1}$$

No sinusoidal terms occur, so the pendulum cannot continually oscillate about its rest position. In the limit as $t \to \infty$ (physically after a large amount of time), the right-hand side of the equation becomes zero, that is, $\theta(\infty) = \lim_{t\to\infty}\theta(t) = 0$. The condition $a^2 > 4b$ is equivalent to $c > 2m\sqrt{g/r}$. The coefficient of friction of the joint is sufficiently large to prevent oscillation about the rest position, and after a large amount of time the damping causes the pendulum to stop. (*Question:* If $\theta_0 > 0$ and $\dot{\theta}_0 = 0$, does the pendulum ever pass the origin? That is, does there exist a time $T > 0$ for which $\theta(T) < 0$? How about when $\dot{\theta}_0 < 0$?)

If $a^2 = 4b$, the characteristic equation has a repeated real-valued root, $\lambda = -a/2$. The solution to the differential equation is

$$\theta(t) = ((\dot{\theta}_0 - \lambda\theta_0)t + \theta_0)\exp(\lambda t)$$

Just as in the previous case, $\theta(\infty) = \lim_{t\to\infty}\theta(t) = 0$ and the pendulum eventually stops. The condition $a^2 = 4b$ is equivalent to $c = 2m\sqrt{g/r}$ and the coefficient is still large enough to prevent oscillation about the rest position. (*Question:* If $\theta_0 > 0$ and $\dot{\theta}_0 = 0$, does the pendulum ever pass the origin? That is, does there exist a time $T > 0$ for which $\theta(T) < 0$? How about when $\dot{\theta}_0 < 0$?)

The last case is $a^2 < 4b$. The characteristic equation has two nonreal roots, $\lambda_1 = \rho - i\omega$ and $\lambda_2 = \rho + i\omega$, where $\rho = -a/2$ and $\omega = \sqrt{4b - a^2}/2$. The solution to the differential equation is

$$\theta(t) = \exp(\rho t)\left(\theta_0\cos(\omega t) + \frac{\dot{\theta}_0 - \rho\theta_0}{\omega}\sin(\omega t)\right)$$

In this case the pendulum does oscillate about the rest position, but the amplitude of the oscillation decays exponentially over time. Once again $\omega(\infty) = \lim_{t\to\infty}\theta(t) = 0$, so the pendulum eventually stops. The condition $a^2 < 4b$ is equivalent to $c < 2m\sqrt{g/r}$. Physically this means the coefficient of friction is sufficiently small and cannot prevent the oscillations, but the slightest amount of friction is enough to stop the pendulum after a long time. ▪

EXERCISE Ⓔ
3.28

Compute the equations of motion for the double pendulum of Example 3.15 assuming that both joints have kinetic friction. Repeat the exercise when both joints have a dissipative viscous force. ▪

The next few examples deal with kinetic friction on flat surfaces. The examples increase in complexity. The first involves a single particle, the second involves multiple particles, the third involves a curve mass, and the fourth involves an areal mass. The last example is typical of what you can expect in a 3D simulation when one object slides over another.

One Particle on a Rough Plane

SOURCE CODE

RoughPlaneParticle1

A single particle is constrained to move on an inclined plane and is subject to gravitational force. The plane forms an acute angle ϕ with the horizontal, so the height relative to the horizontal is $z = y\tan\phi$. The plane is two-dimensional. We choose coordinates x and w with w shown in Figure 3.19. Basic trigonometric definitions show us that $y = w\cos\phi$ and $z = w\sin\phi$. A single particle with mass m, initial position $\mathbf{r}_0 = (x_0, y_0, z_0)$, and initial velocity $\mathbf{v}_0 = (\dot{x}_0, \dot{y}_0, \dot{z}_0)$ is shown. A portion of the path $\mathbf{r}(t)$ traveled by the particle is also shown. The velocity, of course, is $\mathbf{v}(t) = \dot{\mathbf{r}}(t)$.

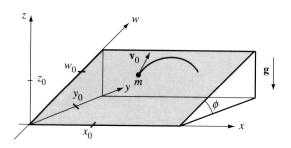

Figure 3.19 An inclined plane that forms an angle ϕ with the horizontal. The particle has mass m. It is located at $\mathbf{r}_0 = (x_0, y_0, z_0)$; hash marks are shown on the axes corresponding to x_0, y_0, z_0, and w_0, where $y_0 = w_0 \cos \phi$ and $z_0 = w_0 \sin \phi$.

In terms of x and w, the kinetic energy is

$$T(x, w) = \frac{m}{2} \left(\dot{x}^2 + \dot{y}^2 + \dot{z}^2 \right) = \frac{m}{2} \left(\dot{x}^2 + \dot{w}^2 \right)$$

The relevant derivatives are $\partial T / \partial x = 0$, $\partial T / \partial w = 0$, $\partial T / \partial \dot{x} = m\dot{x}$, $\partial T / \partial \dot{w} = m\dot{w}$, $d(\partial T / \partial \dot{x})/dt = m\ddot{x}$, and $d(\partial T / \partial \dot{w})/dt = m\ddot{w}$.

The gravitational force is $\mathbf{F}_{\text{grav}} = -mg\mathbf{k}$. The frictional force is $\mathbf{F}_{\text{fric}} = -c\mathbf{v}/|\mathbf{v}|$, where $c = \mu mg \cos \phi > 0$. The constant μ depends on the material properties of the mass and inclined plane. The generalized forces are

$$F_x = (\mathbf{F}_{\text{grav}} + \mathbf{F}_{\text{fric}}) \cdot \frac{d\mathbf{r}}{dx}$$

$$= \left(-mg\mathbf{k} - c\frac{\mathbf{v}}{|\mathbf{v}|} \right) \cdot (1, 0, 0)$$

$$= -\frac{c\dot{x}}{\sqrt{\dot{x}^2 + \dot{w}^2}}$$

and

$$F_w = (\mathbf{F}_{\text{grav}} + \mathbf{F}_{\text{fric}}) \cdot \frac{d\mathbf{r}}{dw}$$

$$= \left(-mg\mathbf{k} - c\frac{\mathbf{v}}{|\mathbf{v}|} \right) \cdot (0, \cos \phi, \sin \phi)$$

$$= -mg \sin \phi - \frac{c\dot{w}}{\sqrt{\dot{x}^2 + \dot{w}^2}}$$

The Lagrangian equations are

$$m\ddot{x} + \frac{c\dot{x}}{\sqrt{\dot{x}^2 + \dot{w}^2}} = 0, \qquad m\ddot{w} + \frac{c\dot{w}}{\sqrt{\dot{x}^2 + \dot{w}^2}} + mg \sin \phi = 0$$

Just as in the pendulum example, the frictional terms are undefined at zero velocity, when $\dot{x}^2 + \dot{w}^2 = 0$. When this happens, define the ratios to be zero (no friction at that instant). In the event that the inclined surface is exactly on the horizontal, the angle is $\phi = 0$ and $w = y$. The generalized force due to gravity has no effect on the particle's motion since $mg \sin \phi = 0$.

Two Particles on a Rough Plane

Consider two particles with positions $\mathbf{r}_i = (x_i, y_i)$ and masses m_i for $i = 1, 2$. The xy-plane is a rough surface and so provides a frictional force on the particles. The particles are interconnected with a massless rod that does not touch the plane. Thus, the particle system is a rigid body that has three degrees of freedom: the location (x, y) of the center of mass and an orientation angle θ formed by the rod with the x-axis. Figure 3.20 illustrates.

The lengths L_i are measured from the center of mass to the particles. The particle positions are $\mathbf{r}_1 = (x + L_1 \cos \theta, y + L_1 \sin \theta)$ and $\mathbf{r}_2 = (x - L_2 \cos \theta, y - L_2 \sin \theta)$. The velocities are $\mathbf{v}_1 = (\dot{x} - L_1\dot{\theta} \sin \theta, \dot{y} + L_1\dot{\theta} \cos \theta)$ and $\mathbf{v}_2 = (\dot{x} + L_2\dot{\theta} \sin \theta, \dot{y} - L_2\dot{\theta} \cos \theta)$. The frictional forces are $\mathbf{F}_i = -c_i\mathbf{v}_i/|\mathbf{v}_i|$, where $c_i = \mu m_i g$ with μ depending on the material properties, and g is the gravitational constant.

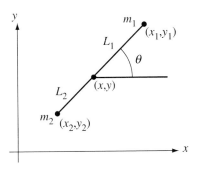

Figure 3.20 Two particles, connected by a massless rod, that slide along a rough plane.

The kinetic energy is

$$T(x, y, \theta) = \sum_{i=1}^{2} \frac{m_i}{2} \left(\dot{x}_i^2 + \dot{y}_i^2 \right)$$

$$= \frac{m_1}{2} \left((\dot{x} - L_1 \dot{\theta} \sin \theta)^2 + (\dot{y} + L_1 \dot{\theta} \cos \theta)^2 \right) +$$

$$\frac{m_2}{2} \left((\dot{x} + L_2 \dot{\theta} \sin \theta)^2 + (\dot{y} - L_2 \dot{\theta} \cos \theta)^2 \right) \qquad (3.37)$$

$$= \frac{m_1 + m_2}{2} (\dot{x}^2 + \dot{y}^2) + \frac{m_1 L_1^2 + m_2 L_2^2}{2} \dot{\theta}^2$$

$$= \frac{\mu_0}{2} (\dot{x}^2 + \dot{y}^2) + \frac{\mu_2}{2} \dot{\theta}^2$$

where the last equality defines the constants μ_0 and μ_2. Formally, a term with $(m_1 L_1 - m_2 L_2)$ appears, but just as in Example 3.16 on the two-body problem, $m_1 L_1 - m_2 L_2 = 0$. If $L = L_1 - L_2$, then $L_1 = m_2 L/(m_1 + m_2)$ and $L_2 = m_1 L/(m_1 + m_2)$. The relevant derivatives of kinetic energy are

$$\frac{\partial T}{\partial x} = 0, \qquad \frac{\partial T}{\partial y} = 0, \qquad \frac{\partial T}{\partial \theta} = 0,$$

$$\frac{\partial T}{\partial \dot{x}} = \mu_0 \dot{x}, \qquad \frac{\partial T}{\partial \dot{y}} = \mu_0 \dot{x}, \qquad \frac{\partial T}{\partial \dot{\theta}} = \mu_2 \dot{\theta},$$

$$\frac{d}{dt} \left(\frac{\partial T}{\partial \dot{x}} \right) = \mu_0 \ddot{x}, \qquad \frac{d}{dt} \left(\frac{\partial T}{\partial \dot{y}} \right) = \mu_0 \ddot{y}, \qquad \frac{d}{dt} \left(\frac{\partial T}{\partial \dot{\theta}} \right) = \mu_2 \ddot{\theta}$$

The generalized force corresponding to x is

$$F_x = \sum_{i=1}^{2} \mathbf{F}_i \cdot \frac{\partial \mathbf{r}_i}{\partial x}$$

$$= \sum_{i=1}^{2} -c_i \frac{\mathbf{v}_i}{|\mathbf{v}_i|} \cdot (1, 0)$$

$$= -\frac{c_1 (\dot{x} - L_1 \dot{\theta} \sin \theta)}{\sqrt{(\dot{x} - L_1 \dot{\theta} \sin \theta)^2 + (\dot{y} + L_1 \dot{\theta} \cos \theta)^2}} - \frac{c_2 (\dot{x} + L_2 \dot{\theta} \sin \theta)}{\sqrt{(\dot{x} + L_2 \dot{\theta} \sin \theta)^2 + (\dot{y} - L_2 \dot{\theta} \cos \theta)^2}}$$

The generalized force corresponding to y is

$$F_y = \sum_{i=1}^{2} \mathbf{F}_i \cdot \frac{\partial \mathbf{r}_i}{\partial y}$$

$$= \sum_{i=1}^{2} -c_i \frac{\mathbf{v}_i}{|\mathbf{v}_i|} \cdot (0, 1)$$

$$= -\frac{c_1(\dot{y} + L_1\dot{\theta}\cos\theta)}{\sqrt{(\dot{x} - L_1\dot{\theta}\sin\theta)^2 + (\dot{y} + L_1\dot{\theta}\cos\theta)^2}} - \frac{c_2(\dot{y} - L_2\dot{\theta}\cos\theta)}{\sqrt{(\dot{x} + L_2\dot{\theta}\sin\theta)^2 + (\dot{y} - L_2\dot{\theta}\cos\theta)^2}}$$

The generalized force corresponding to θ is

$$F_\theta = \sum_{i=1}^{2} \mathbf{F}_i \cdot \frac{\partial \mathbf{r}_i}{\partial \theta}$$

$$= -\frac{c_1\mathbf{v}_1}{|\mathbf{v}_1|} \cdot L_1(-\sin\theta, \cos\theta) - \frac{c_2\mathbf{v}_2}{|\mathbf{v}_2|} \cdot L_2(\sin\theta, -\cos\theta)$$

$$= -\frac{c_1 L_1(-\dot{x}\sin\theta + \dot{y}\cos\theta + L_1\dot{\theta})}{\sqrt{(\dot{x} - L_1\dot{\theta}\sin\theta)^2 + (\dot{y} + L_1\dot{\theta}\cos\theta)^2}} - \frac{c_2 L_2(\dot{x}\sin\theta - \dot{y}\cos\theta + L_2\dot{\theta})}{\sqrt{(\dot{x} + L_2\dot{\theta}\sin\theta)^2 + (\dot{y} - L_2\dot{\theta}\cos\theta)^2}}$$

The Lagrangian equations of motion are

$$\mu_0\ddot{x} = F_x, \qquad \mu_0\ddot{y} = F_y, \qquad \mu_2\ddot{\theta} = F_\theta \qquad\qquad (3.38)$$

Multiple Particles on a Rough Plane

The example for two particles on a rough plane can be extended to more particles, leading to only a slightly more complicated set of equations. Consider $p > 1$ particles with positions $\mathbf{r}_i = (x_i, y_i)$ and masses m_i for $1 \le i \le p$. The particle system is a rigid body that has three degrees of freedom: the location (x, y) of the center of mass and an orientation angle θ. At least one point is not located at the center of mass. With a renumbering of the particles if necessary, let that point be (x_1, y_1). We choose θ to be the angle between $(x_1 - x, y_1 - y)$ and the x-axis direction $(1, 0)$. Thus, $x_1 = x + L_1\cos\theta$ and $y_1 = L_1\sin\theta$, where L_1 is the length of $(x_1 - x, y_1 - y)$. The differences between the points and the center of mass form fixed angles with $(x_1 - x, y_1 - y)$:

$$x_i = x + L_i\cos(\theta + \phi_i), \qquad y_i = y + L_i\sin(\theta + \phi_i), \qquad 1 \le i \le p$$

where L_i is the length of $(x_i - x, y_i - y)$ and ϕ_i is the angle between $(x_i - x, y_i - y)$ and $(x_1 - x, y_1 - y)$. By definition of θ, it is the case that $\phi_1 = 0$. The frictional forces are $\mathbf{F}_i = -c_i \mathbf{v}_i / |\mathbf{v}_i|$, where $\mathbf{v}_i = \dot{\mathbf{r}}_i$, $c_i = \mu m_i g$ with μ depending on the material properties, and g is the gravitational constant.

The kinetic energy is

$$
\begin{aligned}
T &= \sum_{i=1}^{p} \frac{m_i}{2} \left(\dot{x}_i^2 + \dot{y}_i^2 \right) \\
&= \sum_{i=1}^{p} \frac{m_i}{2} \left(\left(\dot{x} - L_i \dot{\theta} \sin(\theta + \phi_i) \right)^2 + \left(\dot{y} + L_i \dot{\theta} \cos(\theta + \phi_i) \right)^2 \right) \\
&= \left(\sum_{i=1}^{p} m_i \right) \frac{1}{2} (\dot{x}^2 + \dot{y}^2) + \left(\sum_{i=1}^{p} m_i L_i^2 \right) \frac{1}{2} \dot{\theta}^2 \\
&= \frac{\mu_0}{2} (\dot{x}^2 + \dot{y}^2) + \frac{\mu_2}{2} \dot{\theta}^2
\end{aligned}
\tag{3.39}
$$

where the last equation defines the constants μ_0 and μ_2. Just as in the case of two particles, the choice of the center of mass as the origin causes a few formal terms to vanish when computing kinetic energy. Specifically, that choice implies

$$
\sum_{i=1}^{p} m_i L_i \cos(\theta + \phi_i) = 0 \quad \text{and} \quad \sum_{i=1}^{p} m_i L_i \sin(\theta + \phi_i) = 0
$$

This is exactly the same form as equation (3.37). The generalized forces are

$$
F_x = \sum_{i=1}^{p} \mathbf{F}_i \cdot \frac{\partial \mathbf{r}_i}{\partial x} = \sum_{i=1}^{p} -\frac{c_i \mathbf{v}_i}{|\mathbf{v}_i|} \cdot (1, 0) = -\sum_{i=1}^{p} \frac{c_i (\dot{x} - L_i \dot{\theta} \sin(\theta + \phi_i))}{|\mathbf{v}_i|}
$$

$$
F_y = \sum_{i=1}^{p} \mathbf{F}_i \cdot \frac{\partial \mathbf{r}_i}{\partial y} = \sum_{i=1}^{p} -\frac{c_i \mathbf{v}_i}{|\mathbf{v}_i|} \cdot (0, 1) = -\sum_{i=1}^{p} \frac{c_i (\dot{y} + L_i \dot{\theta} \cos(\theta + \phi_i))}{|\mathbf{v}_i|}
$$

$$
\begin{aligned}
F_\theta &= \sum_{i=1}^{p} \mathbf{F}_i \cdot \frac{\partial \mathbf{r}_i}{\partial \theta} = \sum_{i=1}^{p} -\frac{c_i \mathbf{v}_i}{|\mathbf{v}_i|} \cdot L_i(-\sin(\theta + \phi_i), \cos(\theta + \phi_i)) \\
&= -\sum_{i=1}^{p} \frac{c_i L_i(-\dot{x} \sin(\theta + \phi_i) + \dot{y} \cos(\theta + \phi_i) + L_i \dot{\theta})}{|\mathbf{v}_i|}
\end{aligned}
$$

The Lagrangian equations of motion are

$$
\mu_0 \ddot{x} = F_x, \qquad \mu_0 \ddot{y} = F_y, \qquad \mu_2 \ddot{\theta} = F_\theta
\tag{3.40}
$$

which is the same as for two particles, equation (3.38).

A Thin Rod on a Rough Plane

This example is an extension of the one for two particles connected by a thin, massless rod. Now the rod itself has mass and is in contact with the rough plane at every point. The system still has three degrees of freedom: the center of mass (x, y) of the rod and the angle θ formed by the rod with the positive x-axis direction. The rod is parameterized by $\mathbf{r}(L) = (x + L \cos \theta, y + L \sin \theta)$ for $L \in [-L_2, L_1]$. The velocity is $\mathbf{v}(L) = (\dot{x} - L\dot{\theta} \sin \theta, \dot{y} + L\dot{\theta} \cos \theta)$. The total length of the rod is $L_1 + L_2$. The mass distribution is not necessarily uniform; mass density is the function $\delta(L)$. The total mass μ_0 and second moment μ_2 are

$$\mu_0 = \int_{-L_2}^{L_1} \delta(L) \, dL \qquad \text{and} \qquad \mu_2 = \int_{-L_2}^{L_1} \delta(L) L^2 \, dL$$

The kinetic energy is

$$T(x, y, \theta) = \int_{-L_2}^{L_1} \frac{1}{2} \delta(L) |\mathbf{v}(L)|^2 \, dL$$

$$= \int_{-L_2}^{L_1} \frac{1}{2} \delta(L) \left((\dot{x} - L\dot{\theta} \sin \theta)^2 + (\dot{y} + L\dot{\theta} \cos \theta)^2 \right) dL \quad (3.41)$$

$$= \frac{\mu_0}{2} (\dot{x}^2 + \dot{y}^2) + \frac{\mu_2}{2} \dot{\theta}^2$$

Just as in the case of particle systems, some terms in the formal construction of kinetic energy vanish due to the choice of the center of mass as the origin. Specifically, $\int_{-L_2}^{L_1} \delta L \cos \theta \, dL = 0$ and $\int_{-L_2}^{L_1} \delta L \sin \theta \, dL = 0$. This is exactly of the form shown in equation (3.37).

The frictional force is $\mathbf{F}(L) = -c\mathbf{v}(L)/|\mathbf{v}(L)|$, where c is allowed to vary for each particle in the rod (c is allowed to be a function of L), but is assumed not to vary with position or velocity. The generalized force F_x is now formulated as an integral rather than as a sum:

$$F_x = \int_{-L_2}^{L_1} \mathbf{F}(L) \cdot \frac{\partial \mathbf{r}(L)}{\partial x} \, dL$$

$$= \int_{-L_2}^{L_1} -c \frac{\mathbf{v}}{|\mathbf{v}|} \cdot (1, 0) \, dL$$

$$= \int_{-L_2}^{L_1} \frac{-c(\dot{x} - L\dot{\theta} \sin \theta)}{\sqrt{(\dot{x} - L\dot{\theta} \sin \theta)^2 + (\dot{y} + L\dot{\theta} \cos \theta)^2}} \, dL$$

Similarly, the generalized force F_y is

$$F_y = \int_{-L_2}^{L_1} \mathbf{F}(L) \cdot \frac{\partial \mathbf{r}(L)}{\partial y} \, dL$$

$$= \int_{-L_2}^{L_1} -c \frac{\mathbf{v}}{|\mathbf{v}|} \cdot (1, 0) \, dL$$

$$= \int_{-L_2}^{L_1} \frac{-c(\dot{y} + L\dot{\theta} \cos \theta)}{\sqrt{(\dot{x} - L\dot{\theta} \sin \theta)^2 + (\dot{y} + L\dot{\theta} \cos \theta)^2}} \, dL$$

and the generalized force F_θ is

$$F_\theta = \int_{-L_2}^{L_1} \mathbf{F}(L) \cdot \frac{\partial \mathbf{r}(L)}{\partial \theta} \, dL$$

$$= \int_{-L_2}^{L_1} -c \frac{\mathbf{v}}{|\mathbf{v}|} \cdot L(- \sin \theta, \cos \theta) \, dL$$

$$= \int_{-L_2}^{L_1} \frac{-cL(-\dot{x} \sin \theta + \dot{y} \cos \theta + L\dot{\theta})}{\sqrt{(\dot{x} - L\dot{\theta} \sin \theta)^2 + (\dot{y} + L\dot{\theta} \cos \theta)^2}} \, dL$$

The Lagrangian equations of motion are the same as those in equation (3.38).

EXERCISE (H) How do the formulas for kinetic energy, generalized forces, and the Lagrangian equa-
3.29 tions of motion change if the mass is distributed along a curve rather than a straight
 line segment? ▪

A Flat Board on a Rough Plane

This example is an extension of the one for multiple particles on a rough surface. We
now consider a continuum of mass in the region R, as shown in Figure 3.21.

 The system has three degrees of freedom: the center of mass (x, y) of the rod and
an angle θ that represents the orientation of the region relative to the positive x-axis.
The rod is parameterized in a local coordinate system whose origin is the center of
mass and whose orthonormal axes are chosen to be $(\cos \theta, \sin \theta)$ and $(- \sin \theta, \cos \theta)$:

$$\mathbf{r}(\alpha, \beta) = (x, y) + \alpha(\cos \theta, \sin \theta) + \beta(- \sin \theta, \cos \theta)$$

The velocity is

$$\mathbf{v}(\alpha, \beta) = (\dot{x}, \dot{y}) + \dot{\theta}(\alpha(- \sin \theta, \cos \theta) - \beta(\cos \theta, \sin \theta))$$

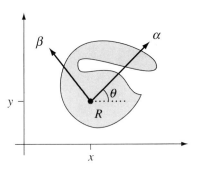

Figure 3.21 A flat board on a rough plane.

Since the region R represents a rigid body, the local coordinates (α, β) for a particle are independent of the orientation of the body. The distance between the particle at (α, β) and the center of mass is $L = \sqrt{\alpha^2 + \beta^2}$. The mass density is the function $\delta(\alpha, \beta)$ and is allowed to vary over the region. In the integral quantities used in the following, the infinitesimal for the region is $dR = d\alpha\, d\beta$.

The kinetic energy is

$$
\begin{aligned}
T &= \frac{1}{2} \int_R \delta |\mathbf{v}|^2 \, dR \\
&= \frac{1}{2} \int_R \delta \left((\dot{x} - \dot{\theta}(\alpha \cos\theta + \beta \sin\theta))^2 + (\dot{y} + \dot{\theta}(\alpha \cos\theta - \beta \sin\theta))^2 \right) \, dR \\
&= \left(\int_R \delta \, dR \right) \frac{1}{2}(\dot{x}^2 + \dot{y}^2) + \left(\int_R (\alpha^2 + \beta^2)\delta \, dR \right) \frac{1}{2}\dot{\theta}^2 \qquad (3.42) \\
&= \frac{\mu_0}{2}(\dot{x}^2 + \dot{y}^2) + \frac{\mu_2}{2}\dot{\theta}^2
\end{aligned}
$$

where

$$
\mu_0 = \int_R \delta \, dR \quad \text{and} \quad \mu_2 = \int_R (\alpha^2 + \beta^2)\delta \, dR
$$

Once again some formal terms in the computation of kinetic energy vanish due to the choice of the center of mass as the origin. Specifically, $\int_R \delta(\alpha \sin\theta + \beta \cos\theta) \, dR = 0$ and $\int_R \delta(\alpha \cos\theta - \beta \sin\theta) \, dR = 0$. The form of the kinetic energy is the same as in equation (3.39).

The frictional forces are $\mathbf{F} = -c\mathbf{v}/|\mathbf{v}|$, where c is allowed to vary with α and β. The generalized force F_x is

$$F_x = \int_R \mathbf{F} \cdot \frac{\partial \mathbf{r}}{\partial x} \, dR$$

$$= \int_R -c \frac{\mathbf{v}}{|\mathbf{v}|} \cdot (1, 0) \, dR$$

$$= \int_R \frac{-c(\dot{x} - \dot{\theta}(\alpha \sin \theta + \beta \cos \theta))}{|\mathbf{v}|} \, dR$$

The generalized force F_y is

$$F_y = \int_R \mathbf{F} \cdot \frac{\partial \mathbf{r}}{\partial y} \, dR$$

$$= \int_R -c \frac{\mathbf{v}}{|\mathbf{v}|} \cdot (0, 1) \, dR$$

$$= \int_R \frac{-c(\dot{y} + \dot{\theta}(\alpha \cos \theta - \beta \cos \theta))}{|\mathbf{v}|} \, dR$$

The generalized force F_θ is

$$F_\theta = \int_R \mathbf{F} \cdot \frac{\partial \mathbf{r}}{\partial \theta} \, dR$$

$$= \int_R -c \frac{\mathbf{v}}{|\mathbf{v}|} \cdot (-\alpha \sin \theta - \beta \cos \theta, \alpha \cos \theta - \beta \sin \theta) \, dR$$

$$= \int_R \frac{-c(-(\alpha \sin \theta + \beta \cos \theta)\dot{x} + (\alpha \cos \theta - \beta \sin \theta)\dot{y} + (\alpha^2 + \beta^2)\dot{\theta})}{|\mathbf{v}|} \, dR$$

The Lagrangian equations of motion are exactly the ones shown in equation (3.40).

A Solid Box on a Rough Plane

The problem we now look at is a variation on the one involving a particle on an inclined plane as shown in Figure 3.19. Instead of a particle, we have a solid box of dimensions $2a$, $2b$, and $2h$. The box has constant mass density. A side view of the box and plane is shown in Figure 3.22.

In addition to sliding down the plane, the box is also rotating about its local vertical axis with angular speed $\dot{\theta}$. The center of mass is located at $\mathbf{r} = (x, w \cos \phi - h \sin \phi, w \sin \phi + h \cos \phi)$. The contribution to the kinetic energy due

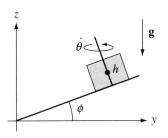

Figure 3.22 A side view of a solid box on a rough, inclined plane.

to the velocity of the center of mass is $m(\dot{x}^2 + \dot{w}^2)/2$, where m is the mass of the box. Since the box has angular velocity, we need to compute the contribution due to the rotation as indicated by equation (3.34). The angular velocity in world coordinates is $\mathbf{w} = \dot{\theta}(0, -\sin\phi, \cos\phi)$. Local coordinates for the box are as follows. The box's vertical direction is $\mathbf{u}_3 = [0 \; -\sin\phi \; \cos\phi]^T$. The other two coordinate axes vary with θ because of the rotation. A reference frame is $\mathbf{u}'_1 = [1\,0\,0]^T$ and $\mathbf{u}'_2 = [0 \; \cos\phi \; \sin\phi]^T$. The frame that rotates with the box as θ varies is

$$\mathbf{u}_1 = \cos\theta\,\mathbf{u}'_1 - \sin\theta\,\mathbf{u}'_2 = [\cos\theta \quad -\sin\theta\cos\phi \quad -\sin\theta\sin\phi]^T$$

and

$$\mathbf{u}_2 = \sin\theta\,\mathbf{u}'_1 + \cos\theta\,\mathbf{u}'_2 = [\sin\theta \quad \cos\theta\cos\phi \quad \cos\theta\sin\phi]^T$$

The local coordinates for the angular velocity are $\boldsymbol{\xi} = [\xi_1\,\xi_2\,\xi_3]^T$, where $\mathbf{w} = \sum_{i=1}^3 \xi_i\mathbf{u}_i$. In our case, $\mathbf{w} = \dot{\theta}\mathbf{u}_3$, so $\boldsymbol{\xi} = [0\,0\,\dot{\theta}]^T$. From Example 2.9 we saw that the principal moment for the vertical axis is $\mu_3 = (a^2 + b^2)/3$, so the contribution of the angular velocity to the kinetic energy is $\dot{\theta}^2 m(a^2 + b^2)/3$. The total kinetic energy is

$$T = \frac{1}{2}m(\dot{x}^2 + \dot{w}^2) + \frac{1}{6}m(a^2 + b^2)\dot{\theta}^2 \qquad (3.43)$$

The system has three degrees of freedom given by x, w, and θ, so there will be three Lagrangian equations of motion: $m\ddot{x} = F_x$, $m\ddot{w} = F_w$, and $m(a^2 + b^2)\ddot{\theta}/3 = F_\theta$, where the right-hand sides of the equations are the generalized forces.

The center of mass is located at \mathbf{r} as mentioned earlier. You might be tempted to construct the generalized forces by dotting the applied forces $\mathbf{F}_{grav} + \mathbf{F}_{fric}$ with the partial derivatives of \mathbf{r} with respect to x, w, and θ. However, that would be an error in analysis. The contributions of the gravitational force to the generalized forces

may be computed by assuming that gravity applies only to the center of mass. The frictional forces apply only to the face of the box that is sliding on the plane. In this sense we need to compute the contribution of friction to the generalized forces in the same manner as in the example of a flat board on a rough plane (see Figure 3.21). In that example replace y by w and use the generalized forces exactly as shown in the example.

EXERCISE Ⓔ
3.30

In the discussion about a box sliding on a rough plane, the kinetic energy in equation (3.43) was computed using equation (3.34). First, the box half-height h does not appear to affect the kinetic energy. Does this make sense to you? Second, the expression does not have terms of the form $\dot{x}\dot{\theta}$ or $\dot{w}\dot{\theta}$. In the example of a flat board sliding over a rough plane, the kinetic energy in equation (3.42) was computed directly as an integral over the velocity of points in the board. This latter formula has terms involving $\dot{x}\dot{\theta}$ and $\dot{y}\dot{\theta}$ (thinking of y and w as the same variable). From the perspective of friction, the sliding box and sliding flat board are identical in nature since the friction of the sliding box is only relevant for its bottom flat face. Why is it, then, that one expression has the $\dot{x}\dot{\theta}$ and $\dot{w}\dot{\theta}$ terms but not the other expression? ▪

EXERCISE Ⓜ
3.31

Write a computer program that implements the example of a box sliding on a rough plane. The example, as modeled, uses only kinetic friction. Incorporate static friction into your program by specifying a minimum angle $\phi_{\min} > 0$ for which static friction prevents the box from moving when the plane is inclined at an angle ϕ smaller than ϕ_{\min}, but allows movement when the angle of inclination is larger than ϕ_{\min}. ▪

3.3 EULER'S EQUATIONS OF MOTION

Sometimes a physical application is more naturally modeled in terms of rotations about axes in a coordinate system. The prototypical example is that of a spinning top, where the top rotates about its axis of symmetry but simultaneously the entire top is rotating about a vertical axis. Euler's equations of motion are the likely choice for determining the motion of such an object. These equations are the focus of this section.

Consider a rigid body with origin \mathcal{O} that coincides with the origin of the world coordinate system. The basis vectors for the world are $\boldsymbol{\eta}_i$ for $1 \leq i \leq 3$. The rigid body is given its own basis vectors $\boldsymbol{\xi}_i$ for $1 \leq i \leq 3$, such that $\boldsymbol{\eta}_3$ and $\boldsymbol{\xi}_3$ are not parallel. The plane spanned by $\boldsymbol{\eta}_1$ and $\boldsymbol{\eta}_2$ intersects the plane spanned by $\boldsymbol{\xi}_1$ and $\boldsymbol{\xi}_2$ in a line. That line passes through the origin and has unit-length direction **N**. Figure 3.23(a) illustrates the two coordinate systems.

The angle between $\boldsymbol{\eta}_3$ and $\boldsymbol{\xi}_3$ is ϕ, the angle between **N** and $\boldsymbol{\eta}_1$ is θ, and the angle between **N** and $\boldsymbol{\xi}_1$ is ψ. The positive direction for the angles is shown in Figure 3.23(a). By definition, **N** lies in the plane spanned by $\boldsymbol{\eta}_1$ and $\boldsymbol{\eta}_2$. Moreover, it

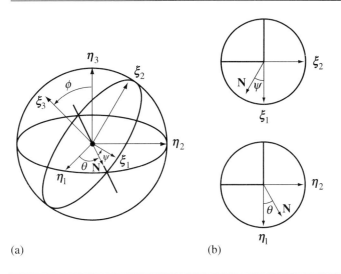

(a) (b)

Figure 3.23 The world coordinates and body coordinates for a rigid body where both systems have the same origin.

must lie on the unit circle centered at the origin. The vector also lies on the unit circle centered at the origin of the plane spanned by ξ_1 and ξ_2. As such we may write it as

$$\mathbf{N} = (\cos \theta)\eta_1 + (\sin \theta)\eta_2 = (\cos \psi)\xi_1 - (\sin \psi)\xi_2 \tag{3.44}$$

Figure 3.23(b) illustrates the location of \mathbf{N} relative to the various axes of the planes.

The three angles ϕ, θ, and ψ completely determine the orientation of the body relative to the world coordinates. Observe that $\dot{\phi}$ is the angular speed of rotation about \mathbf{N}, $\dot{\theta}$ is the angular speed of rotation about η_3, and $\dot{\psi}$ is the angular speed of rotation about ξ_3. The angular velocity of the rigid body is the sum of the axial angular velocities $\mathbf{w} = \dot{\phi}\mathbf{N} + \dot{\theta}\eta_3 + \dot{\psi}\xi_3$. The vector ξ_3 is obtained from η_3 by a rotation about the \mathbf{N} axis through an angle ϕ. Using a standard rotation formula and using equation (3.44) for cross products:

$$\xi_3 = \eta_3 + (\sin \phi)\mathbf{N} \times \eta_3 + (1 - \cos \phi)\mathbf{N} \times (\mathbf{N} \times \eta_3)$$

$$= \eta_3 + (\sin \phi)(-(\cos \theta)\eta_2 + (\sin \theta)\eta_1) + (1 - \cos \phi)(-\eta_3) \tag{3.45}$$

$$= (\sin \theta \sin \phi)\eta_1 - (\cos \theta \sin \phi)\eta_2 + (\cos \phi)\eta_3$$

The angular velocity in world coordinates is

$$
\begin{aligned}
\mathbf{w} &= \dot{\phi}\mathbf{N} + \dot{\theta}\boldsymbol{\eta}_3 + \dot{\psi}\boldsymbol{\xi}_3 \\
&= \dot{\phi}((\cos\theta)\boldsymbol{\eta}_1 + (\sin\theta)\boldsymbol{\eta}_2) + \dot{\theta}\boldsymbol{\eta}_3 + \dot{\psi}((\sin\theta\sin\phi)\boldsymbol{\eta}_1 \\
&\quad - (\cos\theta\sin\phi)\boldsymbol{\eta}_2 + (\cos\phi)\boldsymbol{\eta}_3) \\
&= (\dot{\phi}\cos\theta + \dot{\psi}\sin\theta\sin\phi)\boldsymbol{\eta}_1 + (\dot{\phi}\sin\theta - \dot{\psi}\cos\theta\sin\phi)\boldsymbol{\eta}_2 \\
&\quad + (\dot{\theta} + \dot{\psi}\cos\phi)\boldsymbol{\eta}_3
\end{aligned}
\tag{3.46}
$$

Similarly, the vector $\boldsymbol{\eta}_3$ is obtained from $\boldsymbol{\xi}_3$ by a rotation about the \mathbf{N} axis through an angle $-\phi$. Using a standard rotation formula and using equation (3.44) for cross products:

$$
\begin{aligned}
\boldsymbol{\eta}_3 &= \boldsymbol{\xi}_3 - (\sin\phi)\mathbf{N}\times\boldsymbol{\xi}_3 + (1-\cos\phi)\mathbf{N}\times(\mathbf{N}\times\boldsymbol{\xi}_3) \\
&= \boldsymbol{\xi}_3 - (\sin\phi)(-(\cos\psi)\boldsymbol{\xi}_2 - (\sin\psi)\boldsymbol{\xi}_1) + (1-\cos\phi)(-\boldsymbol{\xi}_3) \\
&= (\sin\psi\sin\phi)\boldsymbol{\xi}_1 + (\cos\psi\sin\phi)\boldsymbol{\xi}_2 + (\cos\phi)\boldsymbol{\xi}_3
\end{aligned}
\tag{3.47}
$$

The angular velocity in body coordinates is

$$
\begin{aligned}
\mathbf{w} &= \dot{\phi}\mathbf{N} + \dot{\theta}\boldsymbol{\eta}_3 + \dot{\psi}\boldsymbol{\xi}_3 \\
&= \dot{\phi}((\cos\psi)\boldsymbol{\xi}_1 - (\sin\psi)\boldsymbol{\xi}_2) + \dot{\theta}((\sin\psi\sin\phi)\boldsymbol{\xi}_1 + (\cos\psi\sin\phi)\boldsymbol{\xi}_2 \\
&\quad + (\cos\phi)\boldsymbol{\xi}_3) + \dot{\psi}\boldsymbol{\xi}_3 \\
&= (\dot{\phi}\cos\psi + \dot{\theta}\sin\psi\sin\phi)\boldsymbol{\xi}_1 + (-\dot{\phi}\sin\psi + \dot{\theta}\cos\psi\sin\phi)\boldsymbol{\xi}_2 \\
&\quad + (\dot{\psi} + \dot{\theta}\cos\phi)\boldsymbol{\xi}_3
\end{aligned}
\tag{3.48}
$$

The angular velocity in world coordinates is useful in setting up Euler's general equations of motion, equation (2.90). The angular velocity in body coordinates, when the $\boldsymbol{\xi}_i$ are chosen to be principal directions of the inertia tensor, is useful in setting up Euler's special equations of motion, equation (2.91). If the principal moments are μ_i, the body coordinates of the torque are τ_i, and the body coordinates of the angular velocity are w_i, then the special equations are

$$
\begin{aligned}
\mu_1\dot{w}_1 + (\mu_3 - \mu_2)w_2 w_3 &= \tau_1 \\
\mu_2\dot{w}_2 + (\mu_1 - \mu_3)w_1 w_3 &= \tau_2 \\
\mu_3\dot{w}_3 + (\mu_2 - \mu_1)w_1 w_2 &= \tau_3
\end{aligned}
\tag{3.49}
$$

EXAMPLE
3.18

Consider a freely spinning top whose tip is fixed in place. The top is assumed to be symmetric about the axis of the third principal direction vector, in which case $\mu_1 = \mu_2$. We assume no torques on the top, a situation that can be approximated by assuming the center of mass is effectively at the tip of the top. Figure 3.24 shows the configuration.

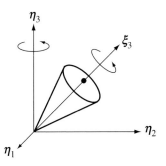

Figure 3.24

A freely spinning top with tip fixed at the origin of the world coordinate system.

The world coordinate axes η_i are shown. The body coordinate axes are ξ_i—the principal directions of the inertia tensor—but only the axis of symmetry is shown.

The Euler equations, equation (3.49), reduce to

$$\mu_1 \dot{w}_1 + (\mu_3 - \mu_1)w_2 w_3 = 0, \qquad \mu_1 \dot{w}_2 - (\mu_1 - \mu_3)w_1 w_3 = 0, \qquad \mu_3 \dot{w}_3 = 0$$

The last equation implies the component $w_3 = c$, a constant. Define $\lambda = c(\mu_3 - \mu_1)/\mu_1$. The first two equations are then $\dot{w}_1 + \lambda w_2 = 0$ and $\dot{w}_2 - \lambda w_1 = 0$. Taking derivatives and replacing one equation in the other leads to $\ddot{w}_1 + \lambda^2 w_1 = 0$. This is the differential equation for simple harmonic motion. A solution is $w_1 = \alpha \cos(\lambda t)$. The other component is determined from the second differential equation by substituting in w_1, the result being $w_2 = \alpha \sin(\lambda t)$. The angular velocity of the top in body coordinates is

$$\mathbf{w} = (\alpha \cos(\lambda t))\boldsymbol{\xi}_1 + (\alpha \sin(\lambda t))\boldsymbol{\xi}_2 + c\boldsymbol{\xi}_3$$

The angular speed is $|\mathbf{w}| = \sqrt{\alpha^2 + c^2}$, a constant. If the top rotates only about its axis of symmetry, then $\alpha = 0$ must occur so that \mathbf{w} is parallel to $\boldsymbol{\xi}_3$. However, the top can be rotating about the η_3 axis while simultaneously rotating about its axis of symmetry. In this case the angular velocity is not parallel to $\boldsymbol{\xi}_3$, and $\alpha \neq 0$ is required.

(Example 3.18 continued)

In world coordinates the torque τ and angular momentum \mathbf{L} are related by $\tau = d\mathbf{L}/dt$. Since the torque is assumed to be zero, the rate of change of angular momentum is zero. Thus, the angular momentum vector is constant. Moreover, we know that $\mathbf{L} = J\mathbf{w}$ in world coordinates. For \mathbf{L} to be a constant and \mathbf{w} to be time varying, J must also be time varying. In the specified body coordinates, the angular momentum vector is

$$\mathbf{L} = M\mathbf{w} = (\mu_1\alpha\cos(\lambda t))\boldsymbol{\xi}_1 + (\mu_1\alpha\sin(\lambda t))\boldsymbol{\xi}_2 + (\mu_3 c)\boldsymbol{\xi}_3$$

The first two coefficients are time varying, but so are the principal directions, and all must be in order to guarantee the angular momentum vector is constant. This equation says that the angular momentum vector rotates about the body axis $\boldsymbol{\xi}_3$ with constant angular speed λ. However, we know \mathbf{L} is fixed in world space, and it must be parallel to $\boldsymbol{\eta}_3$, so the body axis $\boldsymbol{\xi}_3$ is rotating about $\boldsymbol{\eta}_3$ with angular speed $-\lambda$. ∎

EXAMPLE 3.19

SOURCE CODE

FreeTopFixedTip

This example is a modification of Example 3.18. Now we assume that the center of mass is located ℓ units of distance from the origin along the axis of symmetry. The total mass of the top is m. Using the same notation as in our general discussion earlier in this section, the torque is

$$\tau = \mathbf{r} \times \mathbf{F}_{\text{grav}}$$

$$= (\ell\boldsymbol{\xi}_3) \times (-mg\boldsymbol{\eta}_3)$$

$$= (mg\ell\sin\phi)\mathbf{N}$$

$$= (mg\ell\sin\phi\cos\psi)\boldsymbol{\xi}_1 + (-mg\ell\sin\phi\sin\psi)\boldsymbol{\xi}_2$$

Euler's equations are

$$\mu_1\dot{w}_1 + (\mu_3 - \mu_1)w_2 w_3 = mg\ell\sin\phi\cos\psi$$

$$\mu_1\dot{w}_2 - (\mu_3 - \mu_1)w_1 w_3 = -mg\ell\sin\phi\sin\psi$$

$$\mu_3\dot{w}_3 = 0$$

As in the previous example, $w_3 = c$, a constant. Define $\lambda = c(\mu_3 - \mu_1)/\mu_1$ and $\alpha = mg\ell/\mu_1$. The first two equations of motion are

$$\dot{w}_1 + \lambda w_2 = \alpha\sin\phi\cos\psi, \qquad \dot{w}_2 - \lambda w_1 = -\alpha\sin\phi\sin\psi$$

Multiplying the first by w_1, the second by w_2, and adding:

$$\frac{d}{dt}\left(w_1^2 + w_2^2\right) = 2\alpha\sin\phi(w_1\cos\psi - w_2\sin\psi)$$

Equation (3.48) may be used to show that $w_1^2 + w_2^2 = \dot{\phi}^2 + \dot{\theta}^2\sin^2\phi$ and $w_1\cos\psi - w_2\sin\psi = \dot{\phi}$. Consequently,

$$\frac{d}{dt}\left(\dot{\phi}^2 + \dot{\theta}^2 \sin^2 \phi\right) = 2\alpha\dot{\phi} \sin \phi = -\frac{d}{dt}(2\alpha \cos \phi)$$

Integrating leads to

$$\dot{\phi}^2 + \dot{\theta}^2 \sin^2 \phi = \beta - 2\alpha \cos \phi$$

where the right-hand side is a constant.

In body coordinates we know that the angular momentum is

$$\mathbf{L} = M\mathbf{w} = \mu_1 w_1 \boldsymbol{\xi}_1 + \mu_1 w_2 \boldsymbol{\xi}_2 + c\mu_3 \boldsymbol{\xi}_3$$

Dotting with $\boldsymbol{\eta}_3$ and defining $\gamma = \mathbf{L} \cdot \boldsymbol{\eta}_3$, we have

$$\gamma = \mathbf{L} \cdot \boldsymbol{\eta}_3$$
$$= \mu_1 w_1 \boldsymbol{\xi}_1 \cdot \boldsymbol{\eta}_3 + \mu_1 w_2 \boldsymbol{\xi}_2 \cdot \boldsymbol{\eta}_3 + c\mu_3 \boldsymbol{\xi}_3 \cdot \boldsymbol{\eta}_3$$
$$= \mu_1 w_1 \sin \psi \sin \phi + \mu_1 w_2 \cos \psi \sin \phi + c\mu_3 \cos \phi$$

where the last equality follows from dotting equation (3.47) with the $\boldsymbol{\xi}_i$. But $\boldsymbol{\tau} = d\mathbf{L}/dt$ and $\boldsymbol{\tau} \cdot \boldsymbol{\eta}_3 = 0$ imply that $d(\mathbf{L} \cdot \boldsymbol{\xi}_3)/dt = 0$, so $\gamma = \mathbf{L} \cdot \boldsymbol{\xi}_3$ is a constant. Once again we may substitute the body coordinates for \mathbf{w} from equation (3.48) to obtain

$$\mu_1 \dot{\theta} \sin^2 \phi + c\mu_3 \cos \phi = \gamma$$

Finally, equation (3.48) is used once more to produce

$$c = w_3 = \dot{\psi} + \dot{\theta} \cos \phi$$

This has been a long mathematical construction. Let us summarize what we have so far, three differential equations involving the three angles ϕ, θ, and ψ:

$$\dot{\phi}^2 + \dot{\theta}^2 \sin^2 \phi = \beta - 2\alpha \cos \phi, \quad \mu_1 \dot{\theta} \sin^2 \phi + c\mu_3 \cos \phi = \gamma, \quad \dot{\psi} + \dot{\theta} \cos \phi = c$$

The second equation can be solved for $\dot{\theta} = (\gamma - c\mu_3 \cos \phi)/(\mu_1 \sin^2 \phi)$. Defining the constants $\delta = \gamma/\mu_1$ and $\varepsilon = c\mu_3/\mu_1$ and replacing $\dot{\theta}$ in the first equation:

$$\dot{\phi}^2 + \left(\frac{\delta - \varepsilon \cos \phi}{\sin \phi}\right)^2 = \beta - 2\alpha \cos \phi$$

This differential equation involves only the angle ϕ. Solving for the first derivative:

$$\frac{d\phi}{dt} = \sqrt{(\beta - 2\alpha \cos \phi) - \left(\frac{\delta - \varepsilon \cos \phi}{\sin \phi}\right)^2}$$

(Example 3.19 continued) You should convince yourself why the positive square root is chosen instead of the negative one. In a numerical implementation, to avoid the many trigonometric function calls that can be expensive to evaluate, the change of variables $p = \cos\phi$ may be used. The derivative is $\dot{p} = -\dot{\phi}\sin\phi$ and $\sin^2\phi = 1 - p^2$. The differential equation becomes

$$\frac{dp}{dt} = -\sqrt{(1-p^2)(\beta - 2\alpha p) - (\delta - \varepsilon p)^2} \qquad (3.50)$$

This equation cannot be solved in closed form, even if we were to separate variables and solve for t as an integral of a function of p. It may be solved numerically to obtain p as a function of t, say, $p(t)$. The other angles are computed by numerically integrating

$$\frac{d\theta}{dt} = \frac{\gamma - c\mu_3\cos\phi}{\mu_1\sin^2\phi} = \frac{\delta - \varepsilon p}{1 - p^2} \qquad (3.51)$$

and

$$\frac{d\psi}{dt} = c - \dot{\theta}\cos\phi = c - p\frac{\delta - \varepsilon p}{1 - p^2} \qquad (3.52)$$

Although you can solve equations (3.50), (3.51), and (3.52) as a system of differential equations, an alternative is to solve the first equation by generating a sequence of samples (t_i, p_i), fitting those samples with a parametric curve in t, then using that curve in a numerical integration of the second and third equations with respect to t. Yet another alternative is to multiply the second and third equations by dt/dp to obtain $d\theta/dp = F(p)$ and $d\psi/dp = G(p)$, where the right-hand sides are functions of only p. Numerical integrators may be applied to solve for θ and ψ as functions of p. (Figure 3.25—also Color Plate 3.25—shows some screen shots from the free top application found on the CD-ROM.) ▪

EXERCISE Ⓗ **3.32** Write a computer program that uses a differential equation solver to solve equations (3.50), (3.51), and (3.52).

If you are feeling bold, add the following to your program. Assuming the top is a cone of height h and radius r, detect when $\phi(t)$ reaches an angle for which the cone becomes tangent to the horizontal plane. At that instant, the physical system should change to one that models the cone rolling around the plane, still with its tip connected to the origin (see Exercise 3.22). The plane is considered rough, so friction comes into play. In this mode the cone should eventually stop rolling. ▪

*(Example 3.19
continued)*

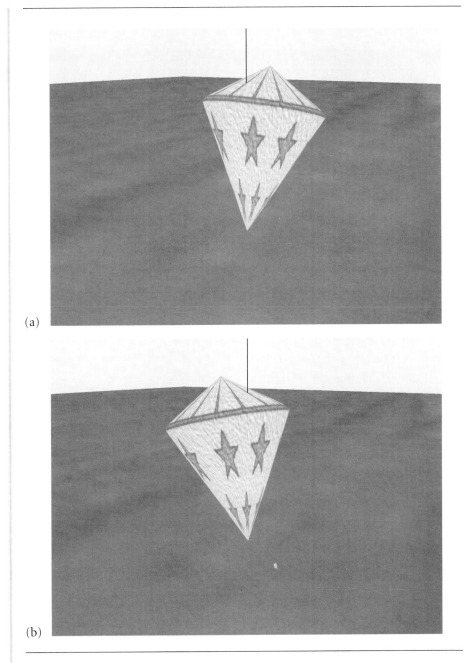

(a)

(b)

Figure 3.25

Two "snapshots" of a freely spinning top. The black line is the vertical axis. The white line is the axis of the top. (See also Color Plate 3.25.) ■

EXERCISE (H) Compute the Lagrangian equations of motion for the freely spinning top subject to
3.33 torque as in Example 3.19. ▪

EXERCISE (H) Compute equations of motion (Eulerian or Lagrangian) for the freely spinning top
3.34 with no torque, where the tip is allowed to move on the xy-plane. ▪

EXERCISE (H) Compute equations of motion (Eulerian or Lagrangian) for the freely spinning top
3.35 with torque, where the tip moves in the x-direction of the xy-plane according to
 $x(t) = \alpha \sin \lambda t$, $y(t) = 0$. ▪

CHAPTER 4

DEFORMABLE BODIES

In the last chapter we focused on rigid bodies and their behavior under various forces. In reality, no body is rigid, but for many bodies the assumption of rigidity is a close approximation to the actual physical conditions. For example, a ball bearing made of steel may be treated as a spherical rigid body. The equations of motion for reasonable forces applied to the ball bearing are good approximations to the physics. However, if the ball bearing is struck with a hard hammer with sufficient force, the bearing will deform, most likely into an elliptical-shaped object.

In some physics applications, the objects we want to model are considered to be *deformable bodies*, ones for which the rigid body analyses do not apply. This first section of the chapter gives you a brief description of some concepts related to deformation. The other sections provide four alternatives for modeling deformable bodies in a manner that is computationally reasonable on current computers.

4.1 ELASTICITY, STRESS, AND STRAIN

The primary concept for a deformable body is *elasticity*. This is the property by which the body returns to its original shape after the forces causing the deformation are removed. A plastic rod in the shape of a line segment can be easily bent and returned to its original form. A similarly shaped rod made of steel is more difficult to bend but will bend slightly and return to its original shape once the bending force is removed. The rod can be significantly bent so that it does not return to its initial shape once the force is removed. Such catastrophic behavior will not be dealt with in this book. Clearly, the amount of force necessary to deform a steel rod is greater than that required to deform a plastic rod.

161

The *stress* within a solid object is the magnitude of the applied force divided by the surface area over which the force acts. The stress is large when the force magnitude is large or when the surface area is small, both intuitive behaviors. For example, if a heavy rigid body of mass m subject to gravitational force sits on the circular top of a cylinder of radius r, the stress on the cylinder is $mg/(\pi r^2)$, where g is the gravitational constant. A heavier mass causes more stress. A thinner cylinder has more stress generated by the same body. Since stress is the ratio of force magnitude to area of influence, it is effectively *pressure* and has the units of pressure, *pascals*. One pascal is defined to be one newton per meter2.

The *strain* on an object is the fractional deformation caused by stress. The quantity is dimensionless since it measures a change in a dimension relative to the original dimension. Although the method of measuring a change depends on the particular type of object and how a force is applied, the simplest example to illustrate is a thin rod of elastic material that is fixed at one end, the other end pulled. If the rod has initial length L and changes length by ΔL due to the force pulling on the end, the strain on the rod is $\Delta L/L$.

By themselves, stress and strain do not appear to contain information about the specific material to which a force is applied. The amount of stress to produce a strain in a material does depend on that material. This suggests calculating the ratio of stress to strain for materials. Three variations of this ratio are presented here: *Young's modulus*, the *shear modulus*, and the *bulk modulus*. Loosely speaking, the three moduli represent the stress to strain ratio in a linear direction, along a planar region, and throughout a volume region.

If a wire of length L and cross-sectional area A has a force with magnitude F applied to one end, a change in length ΔL occurs. Young's modulus is the ratio of stress to strain:

$$Y = \frac{\text{linear stress}}{\text{linear strain}} = \frac{F/A}{\Delta L/L}$$

Consider a thin rectangular slab whose thickness is L units and whose other dimensions are x and y. L is assumed to be small relative to x and y. The large faces have area $A = xy$. One face is attached to a flat table. A tangential force of magnitude F and direction that of the x dimension is applied to the other face. This causes a shearing stress of F/A units. The rectangular slab slightly deforms into a parallelepiped whose volume is the same as the slab. The area of the large faces also remains the same. The slab has an edge length of L, but increases slightly by an amount ΔL due to the shearing. The shearing strain is $\Delta L/L$ and represents the strain of the one face attempting to move parallel to the other. The shearing modulus is

$$S = \frac{\text{planar stress}}{\text{planar strain}} = \frac{F/A}{\Delta L/L}$$

Finally, consider a material occupying a region of volume V. A force of magnitude F is uniformly distributed over the surface of the material, the direction of the force perpendicular at each point of the surface. You may consider the application of the force as an attempt to compress the material. If the surface area is A, the pressure on the material is $P = F/A$. If the pressure is increased by an amount ΔP, the volume decreases by an amount ΔV. The volume stress is ΔP and the volume strain is $\Delta V/V$. The bulk modulus is

$$B = \frac{\text{volume stress}}{\text{volume strain}} = \frac{\Delta P}{\Delta V/V}$$

In all three cases the measurement is stress versus strain, but the difference lies in the dimensionality, so to speak, of how the material changes shape due to the stress.

A calculus-based approach to understanding deformation of a solid material is typically used in a course on continuum mechanics. However, the limitations of current consumer hardware preclude us from implementing such an approach while maintaining a reasonable running time for a physics simulation of deformable bodies. Instead, we will look at a few alternatives to modeling deformable bodies. The first one is based on physical principles and requires solving systems of differential equations. The other alternatives are not physically based, but as long as the results look physically correct, they are good choices for deformation in that they avoid the numerical stability issues associated with differential equation solvers.

The first alternative models a body as a system of point masses connected by springs. The quantity of masses, the configuration of springs, and the choice of spring constants depend on the particular needs of an application. The mathematical model of such a system will involve Hooke's law and result in a system of differential equations that must be numerically solved.

The second alternative models a body by explicitly defining its boundary to be a parametric surface with control points. In order to localize the deformation to small portions of the surface, we would like a surface with local control. This suggests using B-spline or NURBS surfaces (which we discuss in Section 4.3). The control points may be varied over time to simulate time-varying forces applied to the surface of the body.

The third alternative involves free-form deformation of a region that contains the body. The surface of the body may be represented as a triangle mesh or as a parametric surface with control points. In the latter case a triangle mesh can be generated from the parametric surface for the purposes of display of the physical simulation. The idea is that the deformation region is parameterized by three variables and has a small number of control points that can be modified by the application. As the control points change, the region is deformed. The vertices for the triangle mesh or the control points for the parametric surface are located in the deformation region. As the region is deformed, the vertices or surface control points are moved about, causing the corresponding triangle meshes to deform.

The fourth alternative models a body as a region bounded by a surface defined implicitly by $F(x, y, z) = 0$ for a suitably chosen function F. We will choose the convention that the interior of the body is the set of points for which $F(x, y, z) < 0$. A force on the body is simulated by adding a deformation function $D(x, y, z)$ to $F(x, y, z)$ and setting the deformed surface to be the surface defined implicitly by $F(x, y, z) + D(x, y, z) = 0$, the interior of the deformed body being $F(x, y, z) + D(x, y, z) < 0$.

4.2 MASS-SPRING SYSTEMS

A deformable body can be modeled as a system of point masses connected by springs. The bodies can be curve masses (e.g., hair or rope), surface masses (e.g., cloth or the surface of a body of water), or volume masses (e.g., a gelatinous blob or a moving, viscous material). The time complexity of the system is related to the number of masses and how they are interconnected. We will look at some simple configurations to illustrate the key ideas. Curve masses are modeled as a one-dimensional array of particles, surface masses as two-dimensional arrays, and volume masses as three-dimensional arrays. Sections 4.2.1–4.2.3 cover those cases. Section 4.2.4 discusses less regular configurations and the issues that arise when implementing them.

4.2.1 ONE-DIMENSIONAL ARRAY OF MASSES

A curve mass is thought of as a polyline, open with two end points or closed with no end points. Each vertex of the polyline represents a mass. Each edge represents a spring connecting the two masses at the end points of the edge. Figure 4.1 shows two such configurations.

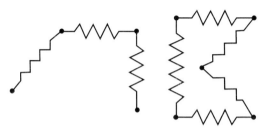

Figure 4.1 Two curve mass objects represented as mass-spring systems.

A motivating example we looked at earlier is Example 3.10, in which three masses aligned in the vertical direction were connected with two springs and allowed to fall due to gravitational forces. The masses are m_i and located at height z_i for $1 \le i \le 3$. Two springs connect the masses, one between m_1 and m_2 with spring constant $c_1 > 0$ and rest length L_1 and one between m_2 and m_3 with spring constant $c_2 > 0$. The gravitational force constant is $g > 0$. We determined the equations of motion as

$$
\begin{array}{rcl}
m_1 \ddot{z}_1 &=& -c_1(z_1 - z_2 - L_1) \qquad\qquad - m_1 g \\
m_2 \ddot{z}_2 &=& +c_1(z_1 - z_2 - L_1) \quad -c_2(z_2 - z_3 - L_2) \quad - m_2 g \\
m_3 \ddot{z}_3 &=& +c_2(z_2 - z_3 - L_2) \qquad\qquad - m_3 g
\end{array}
$$

The organization of the terms on the right-hand side of the equation are suggestive of the pattern that occurs if more masses are added to a vertical chain of particles. The force on the boundary particle at z_1 has a contribution due to the spring below the mass, that contribution prefixed by a minus sign. The force on the boundary particle at z_3 has a contribution due to the spring above the mass, that contribution prefixed by a plus sign. The force on the interior particle at z_2 has two contributions, one from the spring above the mass (prefixed with a plus sign) and one from the spring below the mass (prefixed with a minus sign).

We can generalize the equations of motion to handle p particles in the chain. The masses are m_i and the positions are z_i for $1 \le i \le p$. The system has $p - 1$ springs with constants $c_i > 0$ and rest lengths L_i for $1 \le i \le p - 1$. Spring i connects masses m_i and m_{i+1}. The boundary points are at z_1 and z_p. All other points are interior points. The equation of motion for an interior point is modeled by

$$
m_i \ddot{z}_i = c_{i-1}(z_{i-1} - z_i - L_{i-1}) - c_i(z_i - z_{i+1} - L_i) - m_i g \tag{4.1}
$$

for $1 \le i \le p$. If we define $c_0 = z_0 = L_0 = c_p = L_p = z_{p+1} = 0$, then this equation applies to all points in the system.

In our example every particle is falling due to gravitational forces. If we were to attach the boundary point z_1 to some rigid object, perhaps the ceiling in a room, a constraint is introduced into the system. Since z_1 is now a constant over time, the first differential equation becomes $0 = -c_1(z_1 - z_2 - L_1) - m_1 g$ and no longer applies in solving the remaining equations. Rather, it becomes part of the forces of constraint for the system (see Section 3.2.1). This is not to say that the physical attributes at z_1 no longer affect the system. For example, if the joint at which z_1 is attached has friction, that force becomes a term in the differential equation for z_2. Similarly, other particles in the system can be tacked down and their differential equations removed from the system. If you tack down an interior point z_i, the linear chain is decomposed into two smaller linear chains, each with a fixed boundary point. The smaller systems may be solved separately.

Also in our example, the vertical chain of masses is only one-dimensional with regard to position, in this case vertical position z. In general, the masses can be located

anywhere in space. When formulated in a full spatial setting, another variation is allowed: masses m_1 and m_p can be connected by yet another spring. If that spring has constant $c_p > 0$ and rest length L_p, equation (4.1) still applies, but wrapped indexing is required: $c_0 = c_p$, $z_0 = z_{p+1}$, and $L_0 = L_p$. Finally, forces other than gravitational ones can be applied to the particles.

The general formulation for an open linear chain is as follows. The masses m_i are located at positions \mathbf{x}_i for $1 \leq i \leq p$. The system has $p - 1$ springs connecting the masses, spring i connecting m_i and m_{i+1}. At an interior point i, two spring forces are applied, one from the spring shared with point $i - 1$ and one from the spring shared with point $i + 1$. The differential equation for this point is

$$
m_i \ddot{\mathbf{x}}_i = c_{i-1} \left(|\mathbf{x}_{i-1} - \mathbf{x}_i| - L_{i-1} \right) \frac{\mathbf{x}_{i-1} - \mathbf{x}_i}{|\mathbf{x}_{i-1} - \mathbf{x}_i|}
$$
$$
+ c_i \left(|\mathbf{x}_{i+1} - \mathbf{x}_i| - L_i \right) \frac{\mathbf{x}_{i+1} - \mathbf{x}_i}{|\mathbf{x}_{i+1} - \mathbf{x}_i|} + \mathbf{F}_i
$$

(4.2)

where \mathbf{F}_i represents other forces acting on particle i, such as gravitational or wind forces. Just as in the case of vertical masses, with the proper definitions of c_0, c_p, L_0, L_p, \mathbf{x}_0, and \mathbf{x}_{p+1}, equation (4.2) also handles fixed boundary points and closed loops.

EXAMPLE 4.1

SOURCE CODE

Rope

This application shows how to solve the equations of motion for a one-dimensional array of masses connected by springs. Figure 4.2—also Color Plate 4.2—shows some screen shots from this application found on the CD-ROM. ∎

4.2.2 TWO-DIMENSIONAL ARRAY OF MASSES

The equations of motion for a linear chain of masses are provided by equation (4.2). At an interior particle i, the two force terms due to Hooke's law occur because two springs are attached to the particle and its neighbors. A surface mass can be represented by a collection of particles arranged as a two-dimensional array. An interior particle has four neighbors as shown in Figure 4.3.

The masses are m_{i_0, i_1} and are located at \mathbf{x}_{i_0, i_1} for $0 \leq i_0 < n_0$ and $0 \leq i_1 < n_1$. The spring to the right of a particle has spring constant $c_{i_0, i_1}^{(0)}$ and resting length $L_{i_0, i_1}^{(0)}$. The spring below a particle has spring constant $c_{i_0, i_1}^{(1)}$ and resting length $L_{i_0, i_1}^{(1)}$. The understanding is that the spring constants and resting lengths are zero if the particle has no such spring in the specified direction.

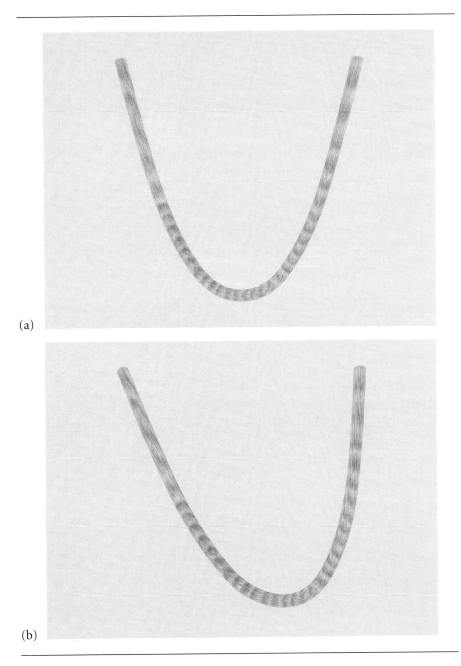

(a)

(b)

Figure 4.2 A rope modeled as a linear chain of springs. Image (a) shows the rope at rest with only gravity acting on it. Image (b) shows the rope subject to a wind force whose direction changes by small random amounts. (See also Color Plate 4.2.)

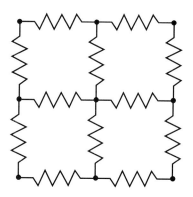

Figure 4.3 A surface mass represented as a mass-spring system with the masses organized as a two-dimensional array.

The equation of motion for particle (i_0, i_1) has four force terms due to Hooke's law, one for each neighboring particle. That equation is

$$
\begin{aligned}
m_{i_0,i_1} \ddot{\mathbf{x}}_{i_0,i_1} = {} & c_{i_0-1,i_1} \left(|\mathbf{x}_{i_0-1,i_1} - \mathbf{x}_{i_0,i_1}| - L_{i_0-1,i_1} \right) \frac{\mathbf{x}_{i_0-1,i_1} - \mathbf{x}_{i_0,i_1}}{|\mathbf{x}_{i_0-1,i_1} - \mathbf{x}_{i_0,i_1}|} \\
& + c_{i_0+1,i_1} \left(|\mathbf{x}_{i_0+1,i_1} - \mathbf{x}_{i_0,i_1}| - L_{i_0+1,i_1} \right) \frac{\mathbf{x}_{i_0+1,i_1} - \mathbf{x}_{i_0,i_1}}{|\mathbf{x}_{i_0+1,i_1} - \mathbf{x}_{i_0,i_1}|} \\
& + c_{i_0,i_1-1} \left(|\mathbf{x}_{i_0,i_1-1} - \mathbf{x}_{i_0,i_1}| - L_{i_0,i_1-1} \right) \frac{\mathbf{x}_{i_0,i_1-1} - \mathbf{x}_{i_0,i_1}}{|\mathbf{x}_{i_0,i_1-1} - \mathbf{x}_{i_0,i_1}|} \quad (4.3) \\
& + c_{i_0,i_1+1} \left(|\mathbf{x}_{i_0,i_1+1} - \mathbf{x}_{i_0,i_1}| - L_{i_0,i_1+1} \right) \frac{\mathbf{x}_{i_0,i_1+1} - \mathbf{x}_{i_0,i_1}}{|\mathbf{x}_{i_0,i_1+1} - \mathbf{x}_{i_0,i_1}|} \\
& + \mathbf{F}_{i_0,i_1}
\end{aligned}
$$

As in the case of linear chains, with the proper definition of the spring constants and resting lengths at the boundary points of the mesh, equation (4.3) applies to the boundary points as well as the interior points.

EXAMPLE 4.2

SOURCE CODE

Cloth

This application shows how to solve the equations of motion for a two-dimensional array of masses connected by springs. Figure 4.4—also Color Plate 4.4—shows some screen shots from this application found on the CD-ROM.

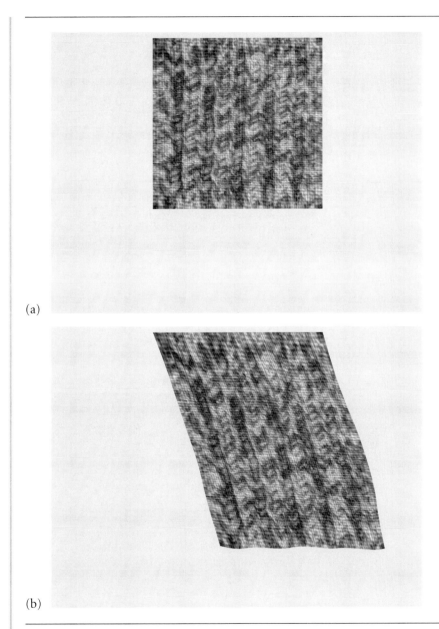

(a)

(b)

Figure 4.4 | A cloth modeled as a rectangular array of springs. Wind forces make the cloth flap about. Notice that the cloth in image (b) is stretched in the vertical direction. The stretching occurs while the gravitational and spring forces balance out in the vertical direction during the initial portion of the simulation. (See also Color Plate 4.4.)

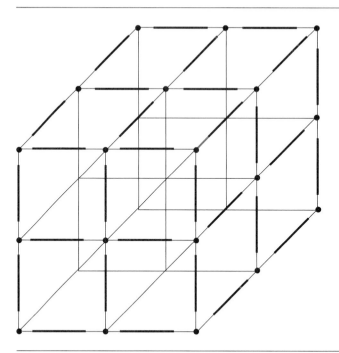

Figure 4.5 A volume mass represented as a mass-spring system with the masses organized as a three-dimensional array. Only the masses and springs on the three visible faces are shown. The other connections are shown, but without their springs.

4.2.3 THREE-DIMENSIONAL ARRAY OF MASSES

A volume mass can be represented by a collection of particles arranged as a three-dimensional array. An interior particle has eight neighbors as shown in Figure 4.5.

The masses are m_{i_0,i_1,i_2} and are located at \mathbf{x}_{i_0,i_1,i_2} for $0 \le i_j < n_j$, $j = 0, 1, 2$. In the direction of positive increase of index i_j, the spring has a spring constant $c^{(j)}_{i_0,i_1,i_2}$ and resting length $L^{(j)}_{i_0,i_1,i_2}$ for $j = 0, 1, 2$. The understanding is that the spring constants and resting lengths are zero if the particle has no such spring in the specified direction.

The equation of motion for particle (i_0, i_1, i_2) has eight force terms due to Hooke's law, one for each neighboring particle. That equation is

$$m_{i_0,i_1,i_2}\ddot{\mathbf{x}}_{i_0,i_1,i_2} = c_{i_0-1,i_1,i_2}\left(\left|\mathbf{x}_{i_0-1,i_1,i_2} - \mathbf{x}_{i_0,i_1,i_2}\right| - L_{i_0-1,i_1,i_2}\right)\frac{\mathbf{x}_{i_0-1,i_1,i_2} - \mathbf{x}_{i_0,i_1,i_2}}{\left|\mathbf{x}_{i_0-1,i_1,i_2} - \mathbf{x}_{i_0,i_1,i_2}\right|}$$

$$+ c_{i_0+1,i_1,i_2}\left(\left|\mathbf{x}_{i_0+1,i_1,i_2} - \mathbf{x}_{i_0,i_1,i_2}\right| - L_{i_0+1,i_1,i_2}\right)\frac{\mathbf{x}_{i_0+1,i_1,i_2} - \mathbf{x}_{i_0,i_1,i_2}}{\left|\mathbf{x}_{i_0+1,i_1,i_2} - \mathbf{x}_{i_0,i_1,i_2}\right|}$$

$$+ c_{i_0,i_1-1,i_2}\left(\left|\mathbf{x}_{i_0,i_1-1,i_2} - \mathbf{x}_{i_0,i_1,i_2}\right| - L_{i_0,i_1-1,i_2}\right)\frac{\mathbf{x}_{i_0,i_1-1,i_2} - \mathbf{x}_{i_0,i_1,i_2}}{\left|\mathbf{x}_{i_0,i_1-1,i_2} - \mathbf{x}_{i_0,i_1,i_2}\right|}$$

$$+ c_{i_0,i_1+1,i_2}\left(\left|\mathbf{x}_{i_0,i_1+1,i_2} - \mathbf{x}_{i_0,i_1,i_2}\right| - L_{i_0,i_1+1,i_2}\right)\frac{\mathbf{x}_{i_0,i_1+1,i_2} - \mathbf{x}_{i_0,i_1,i_2}}{\left|\mathbf{x}_{i_0,i_1+1,i_2} - \mathbf{x}_{i_0,i_1,i_2}\right|}$$

$$+ c_{i_0,i_1,i_2-1}\left(\left|\mathbf{x}_{i_0,i_1,i_2-1} - \mathbf{x}_{i_0,i_1,i_2}\right| - L_{i_0,i_1,i_2-1}\right)\frac{\mathbf{x}_{i_0,i_1,i_2-1} - \mathbf{x}_{i_0,i_1,i_2}}{\left|\mathbf{x}_{i_0,i_1,i_2-1} - \mathbf{x}_{i_0,i_1,i_2}\right|}$$

$$+ c_{i_0,i_1,i_2+1}\left(\left|\mathbf{x}_{i_0,i_1,i_2+1} - \mathbf{x}_{i_0,i_1,i_2}\right| - L_{i_0,i_1,i_2+1}\right)\frac{\mathbf{x}_{i_0,i_1,i_2+1} - \mathbf{x}_{i_0,i_1,i_2}}{\left|\mathbf{x}_{i_0,i_1,i_2+1} - \mathbf{x}_{i_0,i_1,i_2}\right|}$$

$$+ \mathbf{F}_{i_0,i_1,i_2} \tag{4.4}$$

With the proper definition of the spring constants and resting lengths at the boundary points of the mesh, equation (4.4) applies to the boundary points as well as interior points.

EXAMPLE 4.3

This application shows how to solve the equations of motion for a three-dimensional array of masses connected by springs. Figure 4.6—also Color Plate 4.6—shows some screen shots from this application found on the CD-ROM. ▪

SOURCE CODE

GelatinCube

4.2.4 ARBITRARY CONFIGURATIONS

In general you can set up an arbitrary configuration for a mass-spring system of p particles with masses m_i and location \mathbf{x}_i. Each spring added to the system connects two masses, say, m_i and m_j. The spring constant is $c_{ij} > 0$ and the resting length is L_{ij}.

Let \mathcal{A}_i denote the set of indices j such that m_j is connected to m_i by a spring, the set of *adjacent indices*, so to speak. The equation of motion for particle i is

$$m_i\ddot{\mathbf{x}}_i = \sum_{j\in\mathcal{A}_i} c_{ij}\left(\left|\mathbf{x}_j - \mathbf{x}_i\right| - L_{ij}\right)\frac{\mathbf{x}_j - \mathbf{x}_i}{\left|\mathbf{x}_j - \mathbf{x}_i\right|} + \mathbf{F}_i \tag{4.5}$$

Figure 4.6 A gelatinous cube that is oscillating due to random forces. The cube is modeled by a three-dimensional array of mass connected by springs. (See also Color Plate 4.6.)

The technical difficulty in building a differential equation solver for an arbitrary graph is encapsulated solely by a vertex-edge table that stores the graph. Whenever the numerical solver must process particle i via equation (4.5), it must be able to iterate over the adjacent indices to evaluate the Hooke's law terms.

<table>
<tr><td>

EXAMPLE
4.4

SOURCE CODE

GelatinBlob

</td><td>

This application shows how to solve the equations of motion for a collection of masses connected by springs. The mass-spring configuration forms an arbitrary topology that is not representable as a two- or three-dimensional array of connections. Figure 4.7—also Color Plate 4.7—shows some screen shots from this application found on the CD-ROM. ▪

</td></tr>
</table>

4.3 CONTROL POINT DEFORMATION

A deformable body can be modeled as a parametric surface with control points that are varied according to the needs of an application. Although this approach is not physically based, a careful adjustment of control points can make the surface deform in a manner that is convincing to the viewer. To obtain localized deformations to small portions of a surface, a good choice for surface representation is B-splines or NURBS. A surface need not be a spline patch; it can be constructed from curves in a couple of ways. A tube surface can be constructed from a central curve and a radius function. If the control points of the central curve and the radius are time varying, the resulting tube surface deforms. A surface may also be generated from a spline curve as a surface of revolution or as a cylinder surface.

This chapter provides a brief summary of B-spline and NURBS curves, B-spline and NURBS surfaces, tube surfaces, and cylinder surfaces. The summary is confined to the processes of how such curves and surfaces are evaluated. The focus on evaluation is because you will want your deformable surfaces to be updated as rapidly as possible so as not to unnecessarily consume cycles during the game application runtime. A more thorough understanding of B-spline and NURBS curves and surfaces may be obtained by reading books such as [CRE01, Far90, Far99, Rog01]. The construction here is closest to that of [Rog01], a good book for an engineering-style approach to NURBS. Section 4.3.5 describes the applications on the CD-ROM that use the ideas reviewed in Sections 4.3.1–4.3.4.

4.3.1 B-SPLINE CURVES

The control points for a B-spline curve are \mathbf{B}_i, $0 \le i \le n$. The construction is dimensionless, so the control points can be in whatever dimension interests you. The degree

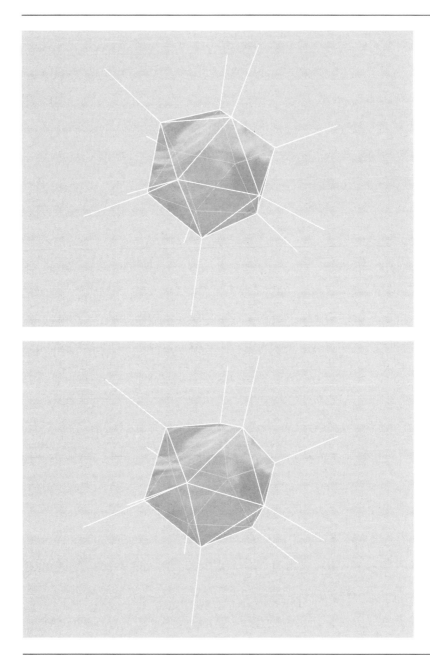

Figure 4.7 A gelatinous blob that is oscillating due to small, random forces. This blob has the masses located at the vertices of an icosahedron with additional masses of infinite weight to help stabilize the oscillations. The springs connecting the blob to the infinite masses are shown in white. (See also Color Plate 4.7.)

d of the curve must be selected so that $1 \le d \le n$. The curve itself is defined by

$$\mathbf{X}(u) = \sum_{i=0}^{n} N_{i,d}(u)\mathbf{B}_i \qquad (4.6)$$

where the functions $N_{i,d}(u)$ are called the *B-spline basis functions*. These functions are defined recursively and require selection of a sequence of scalars u_i for $0 \le i \le n + d + 1$. The sequence must be nondecreasing, that is, $u_i \le u_{i+1}$. Each u_i is referred to as a *knot*, the total sequence a *knot vector*. The basis function that starts the recursive definition is

$$N_{i,0}(u) = \begin{cases} 1, & u_i \le u < u_{i+1} \\ 0, & \text{otherwise} \end{cases} \qquad (4.7)$$

for $0 \le i \le n + d$. The recursion itself is

$$N_{i,j}(u) = \frac{u - u_i}{u_{i+j} - u_i} N_{i,j-1}(u) + \frac{u_{i+j+1} - u}{u_{i+j+1} - u_{i+1}} N_{i+1,j-1}(u) \qquad (4.8)$$

for $1 \le j \le d$ and $0 \le i \le n + d - j$. The *support* of a function is the closure of the set of points on which the function is nonzero. The support of $N_{i,0}(u)$ is clearly $[u_i, u_{i+1}]$. In general, the support of $N_{i,j}(u)$ is $[u_i, u_{i+j+1}]$. We will use this information later to show how $\mathbf{X}(u)$ for a specific value of u depends only on a small number of control points, the indices of those points related to the choice of u. This property is called *local control* and will be important when you want to deform a portion of a curve (or surface) by varying only those control points affecting that portion.

The knots can be within any domain, but I will choose them to be in $[0, 1]$ to provide a standardized interface for B-spline and NURBS curves and surfaces.

Types of Knot Vectors

The main classification of the knot vector is that it is either *open* or *periodic*. If open, the knots are either *uniform* or *nonuniform*. Periodic knot vectors have uniformly spaced knots. The use of the term *open* is perhaps a misnomer since you can construct a closed B-spline curve from an open knot vector. The standard way to construct a closed curve uses periodic knot vectors.

An open, uniform knot vector is defined by

$$u_i = \begin{cases} 0, & 0 \le i \le d \\ \frac{i-d}{n+1-d}, & d+1 \le i \le n \\ 1, & n+1 \le i \le n+d+1 \end{cases}$$

An open, nonuniform knot vector is in the same format except that the values u_i for $d + 1 \le i \le n$ are user defined. These must be selected to maintain monotonicity $0 \le u_{d+1} \le \cdots \le u_{n+1} \le 1$. A periodic knot vector is defined by

$$u_i = \frac{i - d}{n + 1 - d}, \qquad 0 \le i \le n + d + 1$$

Some of the knots are outside the domain $[0, 1]$, but this occurs to force the curve to have period 1. When evaluating $\mathbf{X}(u)$, any input value of u outside $[0, 1]$ is reduced to this interval by periodicity before evaluation of the curve point.

Evaluation

The straightforward method for evaluation of $\mathbf{X}(u)$ is to compute all of $N_{i,d}(u)$ for $0 \le i \le n$ using the recursive formulas from equations (4.7) and (4.8). The pseudocode to compute the basis function values is shown below. The value n, degree d, knots u[], and control points B[] are assumed to be globally accessible.

```
float N (int i, int j, float u)
{
    if ( j > 0 )
    {
        c0 = (u - u[i]) / (u[i + j] - u[i]);
        c1 = (u[i + j + 1] - u) / (u[i + j + 1] - u[i + 1]);
        return c0 * N(i,j - 1,u) + c1 * N(i + 1,j - 1,u);
    }
    else  // j == 0
    {
        if ( u[i] <= u && u < u[i + 1] )
            return 1;
        else
            return 0;
    }
}

Point X (float u)
{
    Point result = ZERO;
    for (i = 0; i <= n; i++)
        result += N(i,d,u) * B[i];
    return result;
}
```

Table 4.1 Recursive dependencies for B-spline basis functions for $n = 4$ and $d = 2$

	$N_{0,2}$	$N_{1,2}$	$N_{2,2}$	$N_{3,2}$	$N_{4,2}$			
	↓ ↘	↓ ↘	↓ ↘	↓ ↘	↓ ↘			
	$N_{0,1}$	$N_{1,1}$	$N_{2,1}$	$N_{3,1}$	$N_{4,1}$	$N_{5,1}$		
	↓ ↘	↓ ↘	↓ ↘	↓ ↘	↓ ↘	↓ ↘		
	$N_{0,0}$	$N_{1,0}$	$N_{2,0}$	$N_{3,0}$	$N_{4,0}$	$N_{5,0}$	$N_{6,0}$	
Open uniform	0	0	$[0$	$\frac{1}{3}$	$\frac{2}{3}$	$1)$	1	1
Open nonuniform	0	0	$[0$	u_3	u_4	$1)$	1	1
Periodic	$-\frac{2}{3}$	$-\frac{1}{3}$	$[0$	$\frac{1}{3}$	$\frac{2}{3}$	$1)$	$\frac{4}{3}$	$\frac{5}{3}$

This is an inefficient algorithm because many of the basis functions are evaluated twice. For example, the value $N_{0,d}(u)$ requires computing $N_{0,d-1}(u)$ and $N_{1,d-1}(u)$. The value $N_{1,d}(u)$ also requires computing $N_{1,d-1}(u)$, as well as $N_{2,d-1}(u)$. The recursive dependencies are illustrated in Table 4.1 for $n = 4$ and $d = 2$. The various types of knot vectors are shown below the table of basis function values.

The rows of knot vectors include brackets [and). These indicate that an evaluation for a specified $u \in [0, 1)$ requires searching for the bounding interval $[u_i, u_{i+1})$ containing u. Only those knots in the bracketed portion need to be searched. The search returns the index of the left end point i, where $d \leq i \leq n$. For an open knot vector, the knots corresponding to other indices are included for padding. For a periodic knot vector, the knots corresponding to other indices are included to force the periodicity.

To avoid the redundant calculations, you might think to evaluate the table from the bottom up rather than from the top down. In our example you would compute $N_{i,0}(u)$ for $0 \leq i \leq 6$ and save these for later access. You would then compute $N_{i,1}(u)$ for $0 \leq i \leq 5$ and look up the values $N_{j,0}(u)$ as needed. Finally, you would compute $N_{i,2}$ for $0 \leq i \leq 4$. The pseudocode follows.

```
Point X (float u)
{
    float basis[d + 1][n + d + 1];   // basis[j][i] = N(i,j)

    for (i = 0; i <= n + d; i++)
    {
        if ( u[i] <= u && u < u[i + 1] )
            basis[0][i] = 1;
        else
            basis[0][i] = 0;
    }
```

```
    for (j = 1; j <= d; j++)
    {
        for (i = 0; i <= n + d - j; i++)
        {
            c0 = (u - u[i]) / (u[i + j] - u[i]);
            c1 = (u[i + j + 1] - u) / (u[i + j + 1] - u[i + 1]);
            basis[i][j] = c0 * basis[j - 1][i] + c1 * basis[j - 1][i + 1];
        }
    }

    Point result = ZERO;
    for (i = 0; i <= n; i++)
        result += basis[d][i] * B[i];
    return result;
}
```

This is a reasonable modification but still not as efficient as it could be. For a single value of u, only *one* of $N_{i,0}(u)$ is 1; the others are all zero. In our example suppose that $u \in [u_3, u_4)$ so that $N_{3,0}(u)$ is 1 and all other $N_{i,0}(u)$ are 0. The only nonzero entries from Table 4.1 are shown as boxed quantities in Table 4.2.

The boxed entries cover a triangular portion of the table. The values on the left diagonal edge and on the right vertical edge are computed first since each value effectively depends only on one previous value, the other value already known to be zero. If $N_{i,0}(u) = 1$, the left diagonal edge is generated by

$$N_{i-j,j}(u) = \frac{u_{i+1} - u}{u_{i+1} - u_{i-j+1}} N_{i-j+1,j-1}(u)$$

and the right vertical edge is generated by

$$N_{i,j}(u) = \frac{u - u_i}{u_{i+j} - u_i} N_{i,j-1}(u)$$

Table 4.2 Nonzero values (boxed) from Table 4.1 for $N_{3,0}(u) = 1$

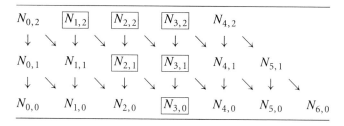

both evaluated for $1 \leq j \leq d$. The interior values are computed using the recursive formula, equation (4.8). The pseudocode for computing the curve point follows.

```
Point X (float u)
{
    float basis[d + 1][n + d + 1];  // basis[j][i] = N(i,j)

    // get i for which u[i] <= u < u[i + 1]
    i = GetKey(u);

    // evaluate left diagonal and right vertical edges
    for (j = 1; j <= d; j++)
    {
        c0 = (u - u[i]) / (u[i + j] - u[i]);
        c1 = (u[i + 1] - u) / (u[i + 1] - u[i - j + 1]);
        basis[j][i] = c0 * basis[j - 1][i];
        basis[j][i - j] = c1 * basis[j - 1][i - j + 1];
    }

    // evaluate interior
    for (j = 2; j <= d; j++)
    {
        for (k = i - j + 1; k < i; k++)
        {
            c0 = (u - u[k]) / (u[k + j] - u[k]);
            c1 = (u[k + j + 1] - u) / (u[k + j + 1] - u[k + 1]);
            basis[j][k] = c0 * basis[j - 1][k] * fInvD0 +
                c1 * basis[j - 1][k + 1];
        }
    }

    Point result = ZERO;
    for (j = i - d; j <= i; j++)
        result += basis[d][j] * B[j];
    return result;
}
```

The only remaining issue is how to compute index i from the input parameter u. For optimal efficiency, the computation should take into account whether the knot vector is open or periodic and if open, whether the knots are uniformly or nonuniformly spaced. The pseudocode follows. Observe that the choice is made to clamp u to $[0, 1]$ when the spline is open and to wrap u to $[0, 1]$ when the spline is periodic.

```
int GetKey (float& u) const
{
    if ( knot vector is open )  // open splines clamp to [0,1]
    {
        if ( u <= 0 ) { u = 0; return d; }
        if ( u >= 1 ) { u = 1; return n; }
    }
    else  // periodic splines wrap to [0,1]
    {
        if ( u < 0 || u > 1 ) u -= floor(u);
    }

    int i;
    if ( knots are uniformly spaced )
    {
        i = d + floor((n + 1 - d) * u);
    }
    else  // knots are nonuniformly spaced
    {
        for (i = d + 1; i <= n + 1; i++) { if ( u < u[i] ) break; }
        i--;
    }

    return i;
}
```

In all cases the search for the bounding interval $[u_i, u_{i+1}]$ of u produces an index i, for which $d \leq i \leq n$ (according to the discussion immediately following Table 4.1).

The basis function data and operations can be encapsulated into a class BasisFunction so that a B-spline curve class has a basis function object for the parameter u. For the purposes of curve evaluation, only two public interface functions must exist for a BasisFunction class. One function computes the basis function values at u and returns the index i of the nonzero basis value $N_{i,0}(u)$, call it int Compute(float u). The function returns the index i. The GetKey function described earlier becomes a nonpublic helper function for Compute. Another function is an accessor to the values $N_{i,d}(u)$, call it float Basis(int i). The BasisFunction class stores the degree d internally, so only i needs to be passed. The curve evaluator does not need access to basis function values $N_{i,j}(u)$ for $j < d$. The B-spline curve itself can be encapsulated in a class BSplineCurve. This class manages the control points B[], knows the degree d of the curve, and has a BasisFunction member called Nu. The curve evaluator becomes a member function of BSplineCurve and is

```
Point BSplineCurve::X (float u)
{
    int i = Nu.Compute(u);
    Point result = ZERO;
    for (int j = i - d; j <= i; j++)
        result += Nu.Basis(j) * B[j];
    return result;
}
```

Local Control

Our goal is to dynamically modify the control points of the B-spline curve in order to deform only a portion of that curve. If we were to change exactly one control point \mathbf{B}_j in equation (4.6), what part of the curve is affected? The modified \mathbf{B}_j is blended into the curve equation via the basis function $N_{j,d}(u)$. The curve associated with those parameters u for which this function is not zero is affected by the change. The set of such u is exactly what we called the support of the function, in this case the interval $[u_j, u_{j+d+1}]$. The property such that changing a control point affects only a small portion of the curve is referred to as *local control*.

The practical application of local control is that in drawing the curve, you create a polyline approximation by selecting samples $\bar{u}_k \in [0, 1]$ for $0 \le k < m$, with $\bar{u}_k < \bar{u}_{k+1}$ for all k. The curve points are $\mathbf{P}_k = \mathbf{X}(\bar{u}_k)$. The polyline consists of the line segments $\langle \mathbf{P}_k, \mathbf{P}_{k+1} \rangle$ for $0 \le k < m - 1$. If we were to change control point \mathbf{B}_j, only some of the line segments need to be recomputed. Specifically, define k_{\min} and k_{\max} to be the extreme indices for which $\bar{u}_k \in [u_j, u_{j+d+1}]$. The polyline points \mathbf{P}_k for $k_{\min} \le k \le k_{\max}$ are the only ones to be recomputed.

Closed Curves

In order to obtain closed curves, additional control points must be included by the curve designer or automatically generated by the B-spline curve implementation. If the latter, and the implementation allows the user to dynamically modify control points, the additional control points must be modified accordingly.

Closing a B-spline curve with an open knot vector is simple. If the curve has control points \mathbf{B}_i for $0 \le i \le n$, the first control point must be duplicated, $\mathbf{B}_{n+1} = \mathbf{B}_0$. An additional knot must also be added. The extra knot is automatically calculated for uniformly spaced knots, but the curve design must specify the extra knot for nonuniformly spaced knots.

Closing a B-spline curve with a periodic knot vector requires the first d control points to be duplicated, $\mathbf{B}_{n+i} = \mathbf{B}_i$ for $0 \le i < d$. Since a periodic knot vector has uniformly spaced knots, the d additional knots are automatically calculated.

EXAMPLE
4.5

SOURCE CODE

BSplineCurve-
Examples

Figure 4.8 shows six pairs of B-spline curves, pairs (a)–(f). The left image in each pair is generated from the eight ordered control points (0, 0), (1, 0), (2, 0), (2, 1), (2, 2), (1, 2), (0, 2), and (0, 1). The right image uses the same control points except that (2, 2) is replaced by (2.75, 2.75). Also, the light gray portions of the curves in the right images are those points that were affected by modifying the control point (2, 2) to (2.75, 2.75). In order to avoid confusion between the two uses of the term open, a curve is labeled as either closed or not closed.

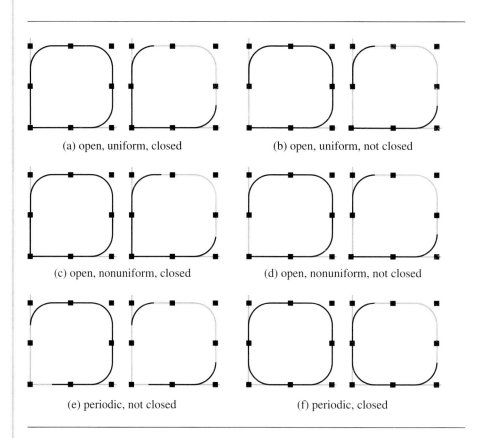

(a) open, uniform, closed (b) open, uniform, not closed

(c) open, nonuniform, closed (d) open, nonuniform, not closed

(e) periodic, not closed (f) periodic, closed

Figure 4.8 Six pairs of B-spline curves of various types. The right image of each pair shows the deformed curve by modifying one control point.

Table 4.3 shows the knot vectors and the parameter intervals affected by modifying the control point (2, 2). The nonuniform knot vectors were just chosen arbitrarily. The other knot vectors were automatically generated.

Table 4.3 Knot vectors and parameter intervals affected by modifying the control point

open, uniform, not closed	$\{0, 0, 0, \frac{1}{6}, \frac{2}{6}, \frac{3}{6}, \frac{4}{6}, \frac{5}{6}, 1, 1, 1\}$	$[\frac{2}{6}, \frac{5}{6}]$
open, nonuniform, not closed	$\{0, 0, 0, 0.1, 0.2, 0.4, 0.7, 0.8, 1, 1, 1\}$	$[0.2, 0.8]$
periodic, not closed	$\{-\frac{2}{6}, -\frac{1}{6}, 0, \frac{1}{6}, \frac{2}{6}, \frac{3}{6}, \frac{4}{6}, \frac{5}{6}, 1, \frac{7}{6}, \frac{8}{6}\}$	$[\frac{2}{6}, \frac{5}{6}]$
open, uniform, closed	$\{0, 0, 0, \frac{1}{7}, \frac{2}{7}, \frac{3}{7}, \frac{4}{7}, \frac{5}{7}, \frac{6}{7}, 1, 1, 1\}$	$[\frac{2}{7}, \frac{5}{7}]$
open, nonuniform, closed	$\{0, 0, 0, 0.1, 0.2, 0.4, 0.7, 0.8, 0.9, 1, 1, 1\}$	$[0.2, 0.8]$
periodic, closed	$\{-\frac{2}{8}, -\frac{1}{8}, 0, \frac{1}{8}, \frac{2}{8}, \frac{3}{8}, \frac{4}{8}, \frac{5}{8}, \frac{6}{8}, \frac{7}{8}, 1, \frac{9}{8}, \frac{10}{8}\}$	$[\frac{2}{8}, \frac{5}{8}]$

4.3.2 NURBS CURVES

As we touched on earlier, NURBS is an acronym for **N**on**U**niform **R**ational **B**-**S**pline(s). B-spline curves are piecewise polynomial functions. The concept of NURBS provides a level of generality by allowing the curves to be piecewise, rational polynomial functions; that is, the curve components are ratios of polynomial functions. The mathematics of NURBS is quite deep and is described concisely in [Far99]. Not to de-emphasize the theoretical foundations, but for our purposes the use of NURBS is for the greater flexibility in constructing shapes than that which B-splines provide.

The control points for a NURBS curve are \mathbf{B}_i for $0 \le i \le n$, just as in the case of B-spline curves. However, *control weights* are also provided, w_i for $0 \le i \le n$. The construction is dimensionless; the control points can be m-tuples. The idea for defining NURBS is quite simple. The $(m + 1)$–tuples $(w_i \mathbf{B}_i, w_i)$ are used to create a B-spline curve $(\mathbf{Y}(u), w(u))$. These tuples are treated as homogeneous coordinates. To project back to m-dimensional space, you divide by the last component: $\mathbf{X}(u) = \mathbf{Y}(u)/w(u)$. The degree d of the curve is selected so that $1 \le d \le n$. The NURBS curve is defined by

$$\mathbf{X}(u) = \frac{\sum_{i=0}^{n} N_{i,d}(u) w_i \mathbf{B}_i}{\sum_{i=0}^{n} N_{i,d}(u) w_i} \tag{4.9}$$

where $N_{i,d}(u)$ are the B-spline basis functions discussed earlier.

EXAMPLE 4.6

The classical example of the greater flexibility of NURBS compared to B-splines is illustrated in 2D. A quadrant of a circle cannot be represented using polynomial curves, but it can be represented as a NURBS curve of degree 2. The curve is $x^2 + y^2 = 1$, $x \ge 0$, $y \ge 0$. The general parameterization is

$$(x(u), y(u)) = \frac{w_0(1 - u)^2(1, 0) + w_1 2u(1 - u)(1, 1) + w_2 u^2(0, 1)}{w_0(1 - u)^2 + w_1 2u(1 - u) + w_2 u^2}$$

(Example 4.6 continued)

for $u \in [0, 1]$. The requirement that $x^2 + y^2 = 1$ leads to the weights constraint $2w_1^2 = w_0 w_2$. The choice of weights $w_0 = 1$, $w_1 = 1$, and $w_2 = 2$ leads to a well-known parameterization:

$$(x(u), y(u)) = \frac{(1 - u^2, 2u)}{1 + u^2}$$

If you were to tessellate the curve with an odd number of uniform samples of u, say, $u_i = i/(2n)$ for $0 \leq i \leq 2n$, then the resulting polyline is not symmetric about the midpoint $u = 1/2$. To obtain a symmetric tessellation, you need to choose $w_0 = w_2$. The weight constraint then implies $w_0 = w_1\sqrt{2}$. The parameterization is then

$$(x(u), y(u)) = \frac{(\sqrt{2}(1 - u)^2 + 2u(1 - u), \, 2u(1 - u) + \sqrt{2}u^2)}{\sqrt{2}(1 - u)^2 + 2u(1 - u) + \sqrt{2}u^2}$$

In either case we have a ratio of quadratic polynomials.

An algebraic construction of the same type, but quite a bit more tedious to solve, produces a ratio of quartic polynomials. The control points and control weights are required to be symmetric to obtain a tessellation that is symmetric about its midpoint. The middle weight is chosen as $w_2 = 4$, as shown:

$$(x(u), y(u))$$

$$= \frac{(1 - u)^4 w_0(1, 0) + 4(1 - u)^3 u w_1(x_1, y_1) + 24(1 - u)^2 u^2(x_2, x_2) + 4(1 - u)u^3 w_1(y_1, x_1) + u^4 w_0}{(1 - u)^4 w_0 + 4(1 - u)^3 u w_1 + 24(1 - u)^2 u^2 + 4(1 - u)u^3 w_1 + u^4 w_0}$$

The parameters are $x_1 = 1$, $y_1 = (\sqrt{3} - 1)/\sqrt{3}$, $x_2 = (\sqrt{3} + 1)/(2\sqrt{3})$, $w_1 = 3/\sqrt{2}$, and $w_0 = 4\sqrt{3}(\sqrt{3} - 1)$. ∎

We already have all the machinery in place to deal with the basis functions. The NURBS curve can be encapsulated in a class `NURBSCurve` that manages the control points `B[]`, the control weights `W[]`, the degree `d`, and has a `BasisFunction` member `Nu`. The curve evaluator is

```
Point NURBSCurve::X (float u)
{
    int i = Nu.Compute(u);
    Point result = ZERO;
    float totalW = 0;
    for (int j = i - d; j <= i; j++)
    {
        float tmp = Nu.Basis(j)*W[j];
        result += tmp*B[j];
        totalW += tmp;
    }
}
```

```
        result /= totalW;
        return result;
    }
```

The next example shows a dynamic deformation of a planar NURBS curve and is used as the foundation for the three-dimensional deformation that we will see in Example 4.10.

EXAMPLE
4.7

SOURCE CODE

NURBSCurve-
Example

Consider a NURBS curve with 13 control points that are initially on the same straight line. The knot vector is open with uniformly spaced knots. The curve is necessarily a line segment. The control points must be moved to deform the central portion of the curve into a closed loop. The control weights are all 1 except for points 3, 5, 7, and 9, whose weights are 3/10. These weights were chosen to produce a final closed loop that is nearly circular. Figure 4.9 shows the initial line segment and its control points. It also shows how the control points evolve early in the process.

The end control points 0 and 12 remain fixed. Control points 1 and 11 are constrained to lie on the initial line segment, but move toward the midpoint of the segment with constant speed; they will eventually coincide. Control points 5, 6, and 7 move vertically upward with constant speed. Control points 3 and 4 move toward the vertical line containing point 5. Control points 8 and 9 move toward the vertical line containing point 7. Control points 2 and 6 move toward the vertical line containing point 6 and will eventually coincide. Figure 4.10 shows the control points and curves

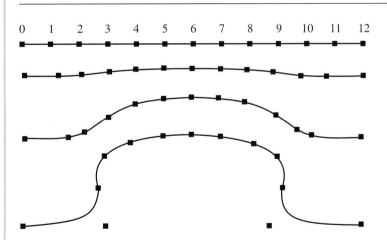

Figure 4.9 The initial control points and curve are shown at the top of the figure. The evolved control points and curve are shown at three later times, with time increasing from top to bottom in the figure.

(Example 4.7 continued)

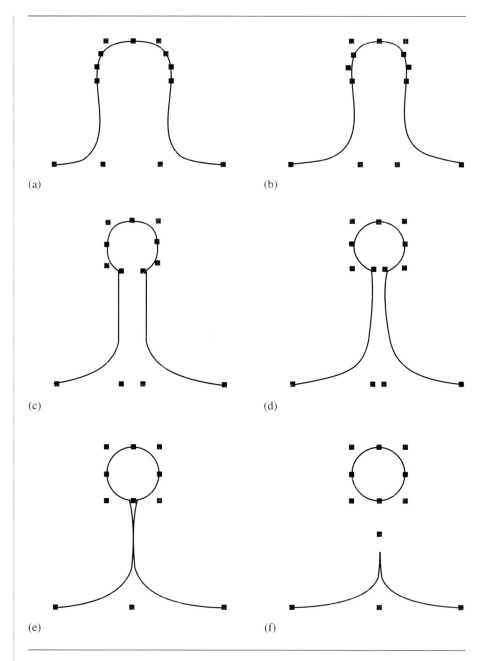

(a)

(b)

(c)

(d)

(e)

(f)

Figure 4.10 The control points and curve at later times in the evolution.

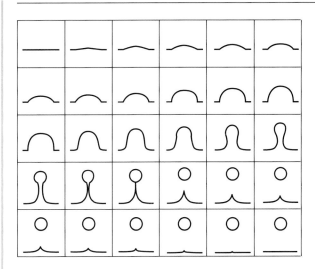

Figure 4.11 Deformation of a line segment into a closed curve that splits away from the original curve.

much further along in time. The time sequence is from (a)–(f). In image (e), control points 1 and 11 finally coincide as do control points 2 and 6. At that instant the NURBS curve is split into two NURBS curves as shown in image (f). The closed curve has a periodic knot vector. The closed curve continues to move vertically upward by uniform translations of the control points. The other curve has 5 control points with points 1 and 3 coinciding. The curve evolves back to a line segment by translating the middle control point 2 so that it too coincides with control points 1 and 3. Figure 4.11 shows an entire sequence of frames of the deformation. The sequence of images is top row to bottom row, left to right in each row. ■

4.3.3 B-SPLINE SURFACES

The simplest extension of the concept of B-spline curves to surfaces is to blend a rectangular array of control points \mathbf{B}_{i_0, i_1} for $0 \le i_0 \le n_0$ and $0 \le i_1 \le n_1$. The blending occurs separately in each dimension, leading to a *rectangle surface patch*. The degree must be specified for each dimension, d_0 and d_1, with $1 \le d_i \le n_i$. The surface patch is defined by

$$\mathbf{X}(u, v) = \sum_{i_0=0}^{n_0} \sum_{i_1=0}^{n_1} N_{i_0, d_0}(u) N_{i_1, d_1}(v) \mathbf{B}_{i_0, i_1} \tag{4.10}$$

Once again we already have the mechanism in place for computing the basis functions. The B-spline surface is encapsulated in a class BSplineSurface and manages the control points B[] [], the degrees d0 and d1, and has BasisFunction objects Nu and Nv. The surface evaluation is

```
Point BSplineSurface::X (float u, float v)
{
    int i0 = Nu.Compute(u), i1 = Nv.Compute(v);
    Point result = ZERO;
    for (int j0 = i0 - d0; j0 <= i0; j0++)
    {
        for (int j1 = i1 - d1; j1 <= i1; j1++)
            result += Nu.Basis(j0) * Nv.Basis(j1) * B[j0][j1];
    }
    return result;
}
```

4.3.4 NURBS SURFACES

B-spline surface patches are piecewise polynomial functions of two variables. NURBS surface patches are piecewise rational polynomial functions of two variables. Just as for curves, the construction involves fitting homogeneous points in one higher dimension with a B-spline surface $(\mathbf{Y}(u, v), w(u, v))$, then projecting back to your application space by dividing by the $w(u, v)$ term: $\mathbf{X}(u, v) = \mathbf{Y}(u, v)/w(u, v)$. NURBS surfaces have greater flexibility than B-spline surfaces.

A NURBS *rectangle surface patch* is built from control points \mathbf{B}_{i_0, i_1} and weights w_{i_0, i_1} for $0 \leq i_0 \leq n_0$ and $0 \leq i_1 \leq n_1$. The degrees d_i are user selected with $1 \leq d_i \leq n_i$. The surface patch is defined by

$$\mathbf{X}(u, v) = \frac{\sum_{i_0=0}^{n_0} \sum_{i_1=0}^{n_1} N_{i_0, d_0}(u) N_{i_1, d_1}(v) w_{i_0, i_1} \mathbf{B}_{i_0, i_1}}{\sum_{i_0=0}^{n_0} \sum_{i_1=0}^{n_1} N_{i_0, d_0}(u) N_{i_1, d_1}(v) w_{i_0, i_1}} \tag{4.11}$$

The B-spline construction in one higher dimension uses the homogeneous control points $(w_{i_0, i_1} \mathbf{B}_{i_0, i_1}, w_{i_0, i_1})$.

EXAMPLE 4.8

The classical example of the greater flexibility of NURBS compared to B-splines is illustrated in 3D. An octant of a sphere cannot be represented using a polynomial surface patch, but it can be represented as a triangular NURBS surface patch of degree 4. A simple parameterization of $x^2 + y^2 + z^2 = 1$ can be made by setting $r^2 = x^2 + y^2$. The sphere is then $r^2 + z^2 = 1$. Now apply the parameterization for a circle,

$$(r, z) = \frac{(1 - u^2, 2u)}{1 + u^2}$$

But $(x/r)^2 + (y/r)^2 = 1$, so another application of the parameterization for a circle is

$$\frac{(x, y)}{r} = \frac{(1 - v^2, 2v)}{1 + v^2}$$

Combining these produces

$$(x(u, v), y(u, v), z(u, v)) = \frac{((1 - u^2)(1 - v^2), (1 - u^2)2v, 2u(1 + v^2))}{(1 + u^2)(1 + v^2)}$$

The components are ratios of quartic polynomials. The domain is $u \geq 0$, $v \geq 0$, and $u + v \leq 1$. In barycentric coordinates, set $w = 1 - u - v$ so that $u + v + w = 1$ with u, v, and w nonnegative. In this setting, you can think of the octant of the sphere as a mapping from the uvw-triangle with vertices $(1, 0, 0)$, $(0, 1, 0)$, and $(0, 0, 1)$. Although a valid parameterization, a symmetric subdivision of the uvw-triangle does not lead to a symmetric tessellation of the sphere.

Another parameterization is provided in [Far90]. This one chooses symmetric control points and symmetric weights:

$$(x(u, v), y(u, v), z(u, v)) = \frac{\sum_{i=0}^{4} \sum_{j=0}^{4-i} w_{i,j,4-i-j} \mathbf{P}_{i,j,4-i-j} B_{i,j}(u, v)}{\sum_{i=0}^{4} \sum_{j=0}^{4-i} w_{i,j,4-i-j} B_{i,j}(u, v)}$$

where

$$B_{i,j}(u, v) = \frac{4!}{i!j!(4 - i - j)!} u^i v^j (1 - u - v)^{4-i-j}, \quad u \geq 0, \quad v \geq 0, \quad u + v \leq 1$$

are the Bernstein polynomials. The control points $\mathbf{P}_{i,j,k}$ are defined in terms of three constants, $a_0 = (\sqrt{3} - 1)/\sqrt{3}$, $a_1 = (\sqrt{3} + 1)/(2\sqrt{3})$, and $a_2 = 1 - (5 - \sqrt{2})(7 - \sqrt{3})/46$:

\mathbf{P}_{040}					$(0, 1, 0)$				
\mathbf{P}_{031}	\mathbf{P}_{130}				$(0, 1, a_0)$	$(a_0, 1, 0)$			
\mathbf{P}_{022}	\mathbf{P}_{121}	\mathbf{P}_{220}		$=$	$(0, a_1, a_1)$	$(a_2, 1, a_2)$	$(a_1, a_1, 0)$		
\mathbf{P}_{013}	\mathbf{P}_{112}	\mathbf{P}_{211}	\mathbf{P}_{310}		$(0, a_0, 1)$	$(a_2, a_2, 1)$	$(1, a_2, a_2)$	$(1, a_0, 0)$	
\mathbf{P}_{004}	\mathbf{P}_{103}	\mathbf{P}_{202}	\mathbf{P}_{301}	\mathbf{P}_{400}	$(0, 0, 1)$	$(a_0, 0, 1)$	$(a_1, 0, a_1)$	$(1, 0, a_0)$	$(1, 0, 0)$

The control weights $w_{i,j,k}$ are defined in terms of four constants, $b_0 = 4\sqrt{3}(\sqrt{3} - 1)$, $b_1 = 3\sqrt{2}$, $b_2 = 4$, and $b_3 = \sqrt{2}(3 + 2\sqrt{2} - \sqrt{3})/\sqrt{3}$:

w_{040}					b_0				
w_{031}	w_{130}				b_1	b_1			
w_{022}	w_{121}	w_{220}		$=$	b_2	b_3	b_2		
w_{013}	w_{112}	w_{211}	w_{310}		b_1	b_3	b_3	b_1	
w_{004}	w_{103}	w_{202}	w_{301}	w_{400}	b_0	b_1	b_2	b_1	b_0

*(Example 4.8
continued)*

Both the numerator and denominator polynomial are quartic polynomials. Notice that each boundary curve of the triangle patch is a quartic polynomial of one variable that is exactly what was shown earlier for a quadrant of a circle. ∎

We can encapsulate NURBS rectangle patches into a class NURBSSurface and give it two BasisFunction members, just like we did for BSplineSurface. The class manages the control points B[] [] and the control weights W[] []. The surface evaluation is

```
Point NURBSSurface::X (float u, float v)
{
    int i0 = Nu.Compute(u), i1 = Nv.Compute(v);
    Point result = ZERO;
    float totalW = 0;
    for (int j0 = i0 - d0; j0 <= i0; j0++)
    {
        for (int j1 = i1 - d1; j1 <= i1; j1++)
        {
            float tmp = Nu.Basis(j0) * Nv.Basis(j1) * W[j0][j1];
            result += tmp * B[j0][j1];
            totalW += tmp;
        }
    }
    result /= totalW;
    return result;
}
```

4.3.5 SURFACES BUILT FROM CURVES

In order to avoid the complexity of dealing with a naturally defined surface patch such as B-spline or NURBS rectangle patches, sometimes it is convenient to build a surface from curves. The idea is that the curves are easier to work with and potentially lead to less expensive dynamic updates of the surface. A few types of surfaces built from curves are described here. In all cases the parameter space is $(u, v) \in [0, 1]^2$.

A triangle mesh is constructed by partitioning the parameter space into a rectangular grid, each rectangle representing two triangles. Figure 4.12 illustrates this.

The numbers n and m do not have to be the same. Generally, you want a lot of samples in u to capture the shape of the curve (n large), but fewer samples in v since the surface is relatively flat in that direction (m small). The grid samples are $(u_i, v_j) = (i/n, j/m)$ for $0 \le i < n$ and $0 \le j < m$. The vertices are stored in a single array in lexicographic order: $k = i + n * j$ where $0 \le k < nm$. The triangles are stored in an array of triples of k-indices, a total of $2(n - 1)(m - 1)$ triples. Pseudocode to generate the vertices, normals, uniform texture coordinates, and triangles is as follows:

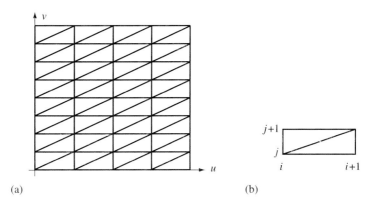

Figure 4.12 (a) The decomposition of (u, v) space into an $n \times m$ grid of rectangles, each rectangle consisting of two triangles. A typical rectangle is shown in (b), with lower corner index (i, j) corresponding to $u = i/n$ and $v = j/m$.

```
// generate vertices
//   X(u,v) = point on the surface at (u,v)
//   N(u,v) = normal on the surface at (u,v)
int vquantity = n * m;
Point3 vertex[vquantity], normal[vquantity];
Point2 texcoord[vquantity];

for (j = 0, k = 0; j < m; j++)
{
    float v = j/(m - 1.0);
    for (i = 0; i < n; i++)
    {
        float u = i/(n - 1.0);
        vertex[k] = X(u,v);
        normal[k] = N(u,v);
        texcoord[k] = Point2(u,v);
        k++;
    }
}

// generate triangles
int tquantity = 2 * (n - 1) * (m - 1);
int indices[3 * tquantity];
for (j = 0, k = 0; j < m - 1; j++)
{
```

```
for (i = 0; i < n - 1; i++)
{
    int v0 = i + n * j;
    int v1 = v0 + 1;
    int v2 = v1 + n;
    int v3 = v0 + n;
    indices[k++] = v0;
    indices[k++] = v1;
    indices[k++] = v2;
    indices[k++] = v0;
    indices[k++] = v2;
    indices[k++] = v3;
}
}
```

If the surface is closed in the u-direction, that is, $\mathbf{X}(1, v) = \mathbf{X}(0, v)$, the first and last columns of vertices of the mesh coincide. The texture coordinates of the first and last columns do not coincide, since the first column has $u = 0$ and the last column has $u = 1$. The texture image should be designed accordingly to make sure the seam is not visible. The same care must be taken if the surface is closed in the v-direction or in both directions.

Cylinder Surfaces

Surface patches might provide more curvature variation than is needed for a particular model. For example, a curved archway is curved in one dimension and flat in another. A single curve may be built to represent the curved dimension, then extruded linearly for the flat dimension. The surface obtained by this operation is said to be a *cylinder surface*. Figure 4.13 illustrates the process.

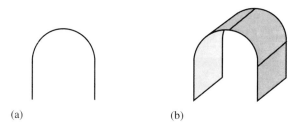

(a) (b)

Figure 4.13 A cylinder surface (b) obtained by extruding the curve (a) in a direction oblique to the plane of the curve.

Figure 4.14 A generalized cylinder surface obtained by linearly interpolating pairs of points on
two curves.

If $\mathbf{Y}(u)$ is a parameterization of the curve for $u \in [0, 1]$, and if \mathbf{D} is the desired
amount of linear translation of the curve, the cylinder surface is parameterized by

$$\mathbf{X}(u, v) = \mathbf{Y}(u) + v\mathbf{D}$$

for $v \in [0, 1]$. First-order partial derivatives are $\partial \mathbf{X}/\partial u = \mathbf{Y}'(u)$ and $\partial \mathbf{X}/\partial v = \mathbf{D}$.
Normal vectors to the surface are the cross product of the derivatives,

$$\mathbf{N}(u) = \frac{\mathbf{Y}'(u) \times \mathbf{D}}{|\mathbf{Y}'(u) \times \mathbf{D}|}$$

Notice that the normal does not depend on v.

Generalized Cylinder Surfaces

Some applications might require that a starting and ending curve be specified and an
interpolation applied between them to generate a surface. This is called a *generalized
cylinder surface*. Figure 4.14 illustrates.

If $\mathbf{Y}_0(u)$ and $\mathbf{Y}_1(u)$ are the starting and ending curves, $u \in [0, 1]$, the generalized
cylinder surface is parameterized by

$$\mathbf{X}(u, v) = (1 - v)\mathbf{Y}_0(u) + v\mathbf{Y}_1(u)$$

for $v \in [0, 1]$. The first-order derivatives are $\partial \mathbf{X}/\partial u = (1 - v)\mathbf{Y}_0'(u) + v\mathbf{Y}_1'(u)$ and
$\partial \mathbf{X}/\partial v = \mathbf{Y}_1(u) - \mathbf{Y}_0(u)$. Normal vectors to the surface are

$$\mathbf{N}(u, v) = \frac{((1 - v)\mathbf{Y}_0'(u) + v\mathbf{Y}_1'(u)) \times (\mathbf{Y}_1(u) - \mathbf{Y}_0(u))}{|((1 - v)\mathbf{Y}_0'(u) + v\mathbf{Y}_1'(u)) \times (\mathbf{Y}_1(u) - \mathbf{Y}_0(u))|}$$

**EXAMPLE
4.9**

SOURCE CODE

FlowingSkirt

This application shows a flowing skirt. The skirt is modeled as a generalized cylinder
surface whose control points are varied over time to produce the deformation. Figure
4.15—also Color Plate 4.15—shows some screen shots from this application found
on the CD-ROM.

(Example 4.9 continued)

(a)

(b)

Figure 4.15 A skirt modeled by a generalized cylinder surface. Wind-like forces are acting on the skirt and are applied in the radial direction. Image (a) shows the skirt after wind is blowing it about. Image (b) shows a wireframe view of the skirt so that you can see it consists of two closed curve boundaries and is tessellated between. (See also Color Plate 4.15.) ▪

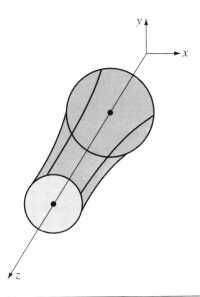

Figure 4.16 A surface of revolution.

Revolution Surfaces

A *revolution surface* is obtained by revolving a curve about a line that does not intersect the curve. To simplify the discussion, suppose that the line is the z-axis and the curve is $(x(u), z(u))$ in the xz-plane. The parameter $u \in [0, 1]$ and $x(u) > 0$. The intersection of the surface and a plane of constant z, given by $z(u)$ for a specified u, is a circle whose radius is $x(u)$ as shown by Figure 4.16.

The surface is parameterized as

$$\mathbf{X}(u, v) = (x(u) \cos(2\pi v), x(u) \sin(2\pi v), z(u))$$

for $(u, v) \in [0, 1]^2$.

EXAMPLE 4.10

SOURCE CODE

WaterDrop-
Formation

The curve deformation in Example 4.7 may be used to generate a control point deformation of a surface. The surface is constructed as a surface of revolution of the curve about the vertical axis. Figure 4.17—also Color Plate 4.17—shows some screen shots from this application found on the CD-ROM.

(Example 4.10 continued)

Figure 4.17 A water drop modeled as a control point surface of revolution. The surface dynamically changes to show the water drop forming, separating from the main body of water, then falling to the floor. The evolution is from left to right and top to bottom. (See also Color Plate 4.17.) ▪

Tube Surfaces

A surface in the shape of a tube can be generated by specifying the central curve of the tube, say, $\mathbf{C}(v)$ for $v \in [0, 1]$, and by specifying a closed planar curve $\mathbf{Y}(u) = (y_1(u), y_2(u))$ to represent the boundary of a cross section of the surface. The cross section for a given v is within a plane whose coordinate system has origin $\mathbf{C}(v)$ and one unit-length coordinate direction $\mathbf{T}(v) = \mathbf{C}'(v)/|\mathbf{C}'(v)|$, a tangent to the central curve. The other two unit-length coordinate directions are chosen as desired, call them $\mathbf{N}(v)$ and $\mathbf{B}(v)$. The three vectors form a right-handed orthonormal set. The names are suggestive of using the Frenet frame for the curve, where \mathbf{N} is the curve normal and $\mathbf{B} = \mathbf{T} \times \mathbf{N}$ is the curve binormal. However, other choices are always possible. The tube surface is constructed as

$$\mathbf{X}(u, v) = \mathbf{C}(v) + y_1(u)\mathbf{N}(v) + y_2\mathbf{B}(v)$$

for $(u, v) \in [0, 1]^2$. The classical tube surface is one whose cross sections are circular, $\mathbf{Y}(u) = r(\cos u, \sin u)$ for a positive radius r. More generally, the radius can be allowed to vary with v. For example, a surface of revolution is a tube surface whose central curve is a line segment and whose radius varies based on the curve that was revolved about the line segment. Figure 4.18—also Color Plate 4.18—shows a tube surface that was built so that the inside surface is visible to the camera.

We now look at an example of a deformation of a tube surface. The central curve of the tube is a control point curve. The control points are modified over time, thereby causing the tube surface itself to deform over time.

EXAMPLE 4.11

This application shows a wriggling snake. The snake is modeled as a tube surface whose central curve is a control point curve. The control points are varied over time to produce the deformation. Figure 4.19—also Color Plate 4.19—shows some screen shots from this application found on the CD-ROM. ▪

SOURCE CODE

WrigglingSnake

4.4 FREE-FORM DEFORMATION

The deformation methods of the last section are useful for deforming a surface that is defined parametrically based on user-specified control points. In a game environment we need to display the deforming object in addition to handling it in a physical simulation. The typical representation of an object in the game is a triangle mesh. The parametric surface may be tessellated to produce that representation. Although the resulting mesh is required for display, that same mesh might also be used if the object participates in a collision detection system. The mesh dynamically changes as the control points are deformed, the vertices having to be recalculated after each modification of the control points. The triangle connectivity can be calculated once and maintained during the deformations.

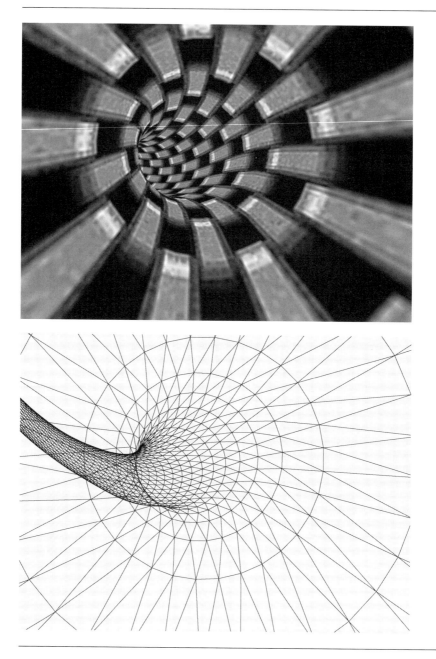

Figure 4.18 A closed tube surface whose central axis is a helix. (See also Color Plate 4.18.) ▪

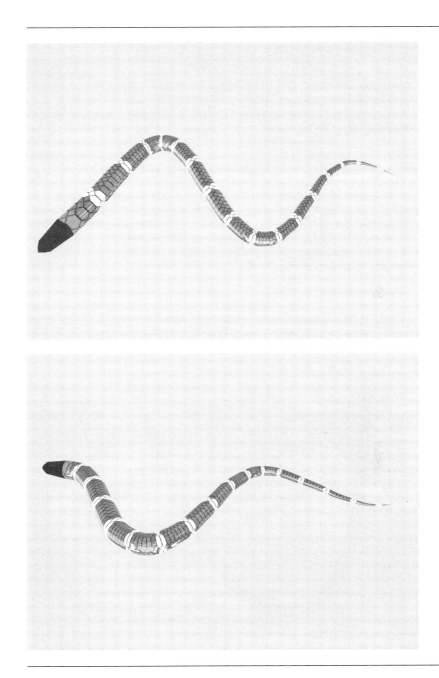

Figure 4.19 A wriggling snake modeled as a tube surface whose central curve is a control point curve. (See also Color Plate 4.19.)

In many cases, though, the triangle meshes are constructed by artists using a modeling package. No underlying control point surface is used to build those meshes. If the game application requires deforming these meshes, how do we do this? Certainly it is possible to construct a control point surface that, in some sense, approximates the triangle mesh. However, that is generally a difficult algorithm to implement and even more difficult to obtain approximations that an artist will agree looks like the original mesh.

A good alternative is to embed the triangle mesh in a volume of space that itself may be deformed via control points. The parameterization of the volume by three parameters is just the natural extension of the parameterization of surfaces by two parameters. The vertices of the triangle mesh initially are assigned parameters based on where they lie in the volume. The control points of the volume are then modified dynamically, causing a deformation of the volume, which in turn causes the vertices to move about. This process is called *free-form deformation* (FFD) and was formally introduced in [SP86], but earlier works exist regarding volume deformation with the goal of analyzing surface deformation, for example, [Barr84]. The FFD algorithm uses a blending of control points using Bernstein polynomials, producing a Bézier volume patch that is a natural extension of a Bézier rectangle patch. A B-spline representation of the volume may be used instead [GP89].

Equation (4.10) extends to a lattice of control points \mathbf{B}_{i_0,i_1,i_2} for $0 \le i_0 \le n_0$, $0 \le i_1 \le n_1$, and $0 \le i_2 \le n_2$. The degree must be specified for each dimension, d_0, d_1, and d_2 with $1 \le d_i \le n_i$. The volume patch is defined by

$$\mathbf{X}(u, v, w) = \sum_{i_0=0}^{n_0} \sum_{i_1=0}^{n_1} \sum_{i_2=0}^{n_2} N_{i_0,d_0}(u) N_{i_1,d_1}(v) N_{i_2,d_2}(w) \mathbf{B}_{i_0,i_1,i_2} \qquad (4.12)$$

Just as for B-spline curves and surfaces, we have the mechanism in place for computing the basis functions. The B-spline volume is encapsulated in a class BSplineVolume and manages the control points B[][][] and the degrees d0, d1, and d2 and has BasisFunction objects Nu, Nv, and Nw. The volume evaluation is

```
Point BSplineVolume::X (float u, float v, float w)
{
    int i0 = Nu.Compute(u);
    int i1 = Nv.Compute(v);
    int i2 = Nw.Compute(w);
    Point result = ZERO;
    for (int j0 = i0 - d0; j0 <= i0; j0++)
    {
        for (int j1 = i1 - d1; j1 <= i1; j1++)
        {
```

```
    for (int j2 = i1 - d2; j2 <= i2; j2++)
    {
        result += Nu.Basis(j0) * Nv.Basis(j1) *
            Nw.Basis(j2) * B[j0][j1][j2];
    }
        }
    }

    return result;
}
```

Assuming the control points are selected so that the volume patch encloses the application's triangle mesh, for each mesh vertex P_i we need to compute the corresponding parameters (u_i, v_i, w_i) so that $X(u_i, v_i, w_i) = P_i$. In general, this is a difficult problem in that this equation represents three polynomial equations of three unknown variables that must be solved by some numerical method. Keeping in mind our application is to deform the mesh, we can make this a simple problem. Choose the control points so that the initial volume is an axis-aligned box containing the triangle mesh. If the box is $[x_{min}, x_{max}] \times [y_{min}, y_{max}] \times [z_{min}, z_{max}]$, then the control points are

$$\mathbf{B}_{i_0, i_1, i_2} = \mathbf{M} + (\Delta_x i_0, \Delta_y i_1, \Delta_z i_2)$$

where $\mathbf{M} = (x_{min}, y_{min}, z_{min})$, $\Delta_x = (x_{max} - x_{min})/n_0$, $\Delta_y = (y_{max} - y_{min})/n_1$, and $\Delta_z = (z_{max} - z_{min})/n_2$. The volume function reduces as follows:

$$\mathbf{X}(u, v, w) = \sum_{i_0=0}^{n_0} \sum_{i_1=0}^{n_1} \sum_{i_2=0}^{n_2} N_{i_0, d_0}(u) N_{i_1, d_1}(v) N_{i_2, d_2}(w)(\mathbf{M} + (\Delta_x i_0, \Delta_y i_1, \Delta_z i_2))$$

$$= c_0 \mathbf{M} + c_1 \Delta_x \mathbf{i} + c_2 \Delta_y \mathbf{j} + c_3 \Delta_z \mathbf{k}$$

where

$$c_0 = \sum_{i_0=0}^{n_0} \sum_{i_1=0}^{n_1} \sum_{i_2=0}^{n_2} N_{i_0, d_0}(u) N_{i_1, d_1}(v) N_{i_2, d_2}(w)$$

$$= \left(\sum_{i_0=0}^{n_0} N_{i_0, d_0}(u) \right) \left(\sum_{i_1=0}^{n_1} N_{i_1, d_1}(v) \right) \left(\sum_{i_2=0}^{n_2} N_{i_2, d_2}(w) \right)$$

$$= 1 \cdot 1 \cdot 1 = 1$$

We used the well-known property for basis functions, $\sum_{i=0}^{n} N_{i,d}(t) = 1$ for all $t \in [0, 1]$. Similarly,

$$c_1 = \sum_{i_0=0}^{n_0} \sum_{i_1=0}^{n_1} \sum_{i_2=0}^{n_2} i_0 N_{i_0,d_0}(u) N_{i_1,d_1}(v) N_{i_2,d_2}(w)$$

$$= \left(\sum_{i_0=0}^{n_0} i_0 N_{i_0,d_0}(u) \right) \left(\sum_{i_1=0}^{n_1} N_{i_1,d_1}(v) \right) \left(\sum_{i_2=0}^{n_2} N_{i_2,d_2}(w) \right)$$

$$= u \cdot 1 \cdot 1 = u$$

where we use the property $\sum_{i=0}^{n} N_{i,d}(t) = t$ for $t \in [0, 1]$. The same argument shows that $c_2 = v$ and $c_3 = 2$. Therefore,

$$X(u, v, w) = M + n_0 \Delta_x u \imath + n_1 \Delta_y v \jmath + n_2 \Delta_z w k$$

for the initially selected control points. The parameters to locate a mesh vertex $P_i = X(u_i, v_i, w_i)$ are simply $u_i = \imath \cdot (P_i - M)/\Delta_x$, $v_i = \jmath \cdot (P_i - M)/\Delta_y$, and $w_i = k \cdot (P_i - M)/\Delta_z$.

The straightforward approach to deforming the surface is to modify the control points and recompute $X(u_i, v_i, w_i)$ for all i. Although this certainly works, it is less efficient than it can be. The input parameters never change for a mesh vertex. Each time the B-spline volume function is calculated, the basis functions $N_{i_0,d_0}(u_i)$, $N_{i_1,d_1}(v_i)$, and $N_{i_2,d_2}(w_i)$ are calculated. These may be calculated once and stored for use in later volume evaluations. Another optimization is possible if only a few control points are modified at each step. To indicate the dependence of the volume function on the control points, let us write the function as $X(u, v, w; B)$. The mesh vertex positions for the initial set of control points are

$$P_i = X(u_i, v_i, w_i; B)$$

for all i. The control points are modified to $B_{i_0,i_1,i_2} + dB_{i_0,i_1,i_2}$ where the control point perturbations might be nonzero only for a few control points. In an interactive modeling package, the interface will most likely support dragging one control point at a time, in which case dB_{i_0,i_1,i_2} is nonzero for exactly one triple of indices, but zero for all the others. The new mesh vertex positions are

$$Q_i = X(u_i, v_i, w_i; B + dB) = X(u_i, v_i, w_i; B) + X(u_i, v_i, w_i; dB) = P_i + dP_i$$

where the perturbation of the old mesh vertices is denoted by $dP_i = X(u_i, v_i, w_i; dB)$. If you keep track of the original mesh vertices and measure only the control point perturbations, the new mesh vertices may be rapidly computed. The evaluation of

the perturbation $\mathbf{X}(u_i, v_i, w_i; \mathbf{dB})$ is implemented to avoid multiplying the basis functions by a point $\mathbf{dB}_{i_0, i_1, i_2}$ when that point is the zero vector.

EXAMPLE
4.12

SOURCE CODE

FreeForm-
Deformation

This programming example is a full implementation of the free-form deformation using a B-spline volume function. The application constructs the axis-aligned bounding box for a triangle mesh, computes the parameter triples for the mesh vertices, and displays the mesh. The volume is drawn as a wireframe box with line segments connecting the control points. The interface allows you to select a control point and drag it with the mouse. For each change the embedded triangle mesh is updated. The program also has an option for randomly perturbing the current set of control points so that the mesh wiggles. This option is toggled with the r/R keys. Figure 4.20—also Color Plate 4.20—shows some screen shots from this application found on the CD-ROM. ▪

The ideas of FFD have been extended by various researchers. An *extended free-form deformation* (EFFD) was developed in [Coq90] that allows the surface to be embedded in a collection of multiple volumes to gain better control over the spatial deformations. These results were developed more from an engineering perspective than from a desire to obtain physically meaningful deformations. Along the latter lines the paper [HML99] describes an algorithm to preserve the total volume enclosed by the surface during the deformation. This is a reasonable goal, but it implicitly assumes that the object's mass density is constant throughout the deformation. For some objects this assumption makes sense, but for others it does not. Consider a foam ball that is deformed by squeezing it. Clearly, the volume is not preserved, but the total mass is preserved. The next step in developing deformation models of the free-form type should have the goal of modifying the mass density function so that the total mass is preserved. By accurately computing the mass density during deformation, the inertia tensor for the deformed object can then be calculated for use in physical simulations.

4.5 IMPLICIT SURFACE DEFORMATION

A body is modeled as the region $F(x, y, z) \leq 0$ for a suitably chosen function F. The surface of the body is implicitly defined by $F(x, y, z) = 0$. A force on the body is simulated by adding a deformation function $D(x, y, z)$ to $F(x, y, z)$. The deformed body is the region $F(x, y, z) + D(x, y, z) \leq 0$ and has a surface implicitly defined by $F(x, y, z) + D(x, y, z) = 0$. A simple example in two dimensions will illustrate the concept.

(a)

(b)

Figure 4.20 Free-form deformation. Image (a) shows the initial configuration where all control
points are rectangularly aligned. Image (b) shows that some control points have been
moved and the surface is deformed. The control point shown in darker gray in (b) is
the point at which the mouse was clicked on and moved. (See also Color Plate 4.20.)

EXAMPLE
4.13

Consider a planar body in the shape of a circular disk defined by $F(x, y) = x^2 + y^2 - 1 \leq 0$. The boundary of the object is the circle defined by $F(x, y) = 0$, namely, $x^2 + y^2 = 1$. Figure 4.21(a) illustrates the object before deformation.

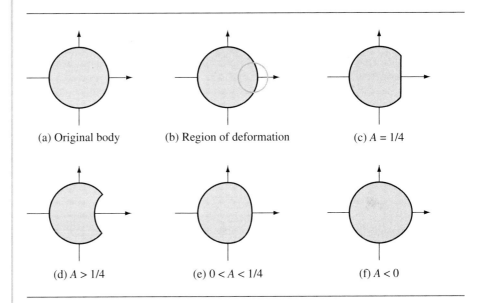

(a) Original body (b) Region of deformation (c) A = 1/4

(d) A > 1/4 (e) 0 < A < 1/4 (f) A < 0

Figure 4.21

A disk-shaped body and various deformations of it.

A force is to be applied to the body at the point $(1, 0)$ to produce a deformed body, with some possibilities shown in Figure 4.21(c)–(f). You have a lot of flexibility in choosing the deformation functions. A simple one to illustrate is

$$D(x, y) = \begin{cases} A(1 - 4((x - 1)^2 + y^2)), & (x - 1)^2 + y^2 < 1/4 \\ 0, & \text{otherwise} \end{cases}$$

This function is continuous. It is differentiable everywhere except on the circle $(x - 1)^2 + y^2 = 1/4$. This small circle intersects the original one at $x = 7/8$. Outside this circle the level curve is defined by $F(x, y) = 0$ and produces a large circular arc $x^2 + y^2 = 1$ for $x \leq 7/8$. Inside this circle the level curve is

$$0 = F(x, y) + D(x, y) = (1 - 4A)x^2 + (1 - 4A)y^2 + 8Ax - (1 + 3A)$$

If $A = 1/4$, the level curve is the line segment $x = 7/8$ with $|y| \leq \sqrt{15}/8$. For $A \neq 1/4$, divide by $1 - 4A$ and complete the square on x to obtain the factored equation:

$$\left(x + \frac{4A}{1 - 4A}\right)^2 + y^2 = \frac{1 - A + 4A^2}{(1 - 4A)^2}$$

(Example 4.13 continued)

This is the equation for a circle. Notice that the end points of the large circular arc, $(7/8, \pm\sqrt{15}/8)$, are always on the arc defined by this new circle.

A time-varying deformation may be induced by allowing the amplitude A of the deformation to vary with time. For example, $A(t) = ct$ for a positive constant c causes a gradual depression in the disk. Oscillatory behavior can be induced by something like $A(t) = c \sin(t)$ for a positive constant c. ∎

In the example the deformation $D(x, y)$ is symmetric about the point $(1, 0)$, that center point considered to be the point of application of the simulated force. Generally, D is required neither to be symmetric nor to be viewed as having a center point that is on the boundary of the object. We could just as easily have added $D(x, y) = A(1 - 4((x - x0)^2 + (y - y0)^2))$ for any point (x_0, y_0) in the plane. Of course, if the region of influence does not intersect the level curve defining the object boundary, no deformation occurs.

The example is also a continuous one. In practice we will have discrete objects, polygonal objects in the plane (approximations to the level curve object boundaries), and triangle mesh objects in space (approximations to the level surface object boundaries). Given a continuous representation $F = 0$ of the object boundary, we need to construct the approximations. This requires extraction of curves or surfaces from data generated by sampling F on a regular lattice. The curves and surfaces are extracted from the data using methods from image analysis. Keeping in mind we want to have a reasonably fast simulation, the deformation D can be defined to be nonzero within a small region so that only a handful of pixels/voxels will be affected by the deformation. The level curves/surfaces need be updated only at those pixels/voxels.

4.5.1 LEVEL SET EXTRACTION

A standard isosurface extraction algorithm for a 3D image is the Marching Cubes algorithm [LC87]. The image is assumed to be defined on a regular lattice of size $N_0 \times N_1 \times N_2$ with integer points (x, y, z), where $0 \le x < N_0$, $0 \le y < N_1$, and $0 \le z < N_2$. The image values themselves are $F(x, y, z)$. An isosurface is of the form $F(x, y, z) = c$ for some specified level value c where x, y, and z are treated as continuous variables. A voxel in the image is a rectangular solid whose corners are eight neighboring lattice points (x_0, y_0, z_0), $(x_0 + 1, y_0, z_0)$, $(x_0, y_0 + 1, z_0)$, $(x_0 + 1, y_0 + 1, z_0)$, $(x_0, y_0, z_0 + 1)$, $(x_0 + 1, y_0, z_0 + 1)$, $(x_0, y_0 + 1, z_0 + 1)$, and $(x_0 + 1, y_0 + 1, z_0 + 1)$. Figure 4.22 illustrates the level surface contained by a single voxel.

The Marching Cubes algorithm analyzes each voxel in the image and determines if the isosurface intersects it. If so, the algorithm produces a triangle mesh for the voxel that is intended to approximate that portion of the isosurface inside the voxel. By selecting a level value that cannot be an image value, for example, by selecting a noninteger value when the image has only integer values, the voxel analysis requires determining the signs of $G(x, y, z) = F(x, y, z) - c$ at the eight corners, each sign positive or negative. If two adjacent corners have opposite signs, and if the image

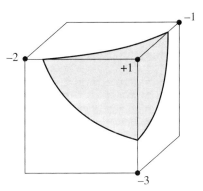

Figure 4.22 This is an illustration of a level surface $F(x, y, z) = 0$, a cube whose eight corners
correspond to image samples. Four of the image values are shown, one positive and
three negative. Assuming the image values vary continuously, each edge connecting
a positive and negative value must have a point where the image is zero. The level
surface $F(x, y, z) = 0$ necessarily passes through those zero-points, as illustrated by
the triangular-shaped surface shaded in gray.

values are assumed to be linear along the edge connecting the corners, the isosurface
$G(x, y, z) = 0$ must intersect the edge in a single point somewhere along the edge.
The complexity of the surface of intersection is related to the sign changes that occur
on all the edges of the voxel.

The heart of the Marching Cubes algorithm is that only a small number of sign
combinations is possible, two signs at each of eight corners for a total of 256 com-
binations. Each combination is analyzed to determine the nature of the isosurface of
intersection; a triangle mesh is selected to represent that intersection. These meshes
are stored in a table of size 256. The sign analysis for a voxel leads to an index into the
table to select a triangle mesh representing the surface of intersection for that voxel.
The strength of this algorithm is the speed in which the triangle meshes are generated
for the entire isosurface, the performance due to the simplicity of the table lookups.

The Marching Cubes algorithm has two undesirable consequences. The first con-
sequence is that for a typical 3D medical image and typical isosurface, the number
of triangles in the mesh is on the order of a million. The generation of the mesh cer-
tainly requires only a small amount of time, but most rendering systems are slow to
render millions of triangles per frame, even with graphics hardware acceleration. Of
course, the large number of triangles is a problem with any isosurface extraction al-
gorithm that works at the voxel level. The second undesirable consequence is that the
triangle mesh table can lead to topological inconsistencies in the mesh. Specifically,
the two meshes generated at adjacent voxels might have triangles that should share

edges, but do not, thereby producing holes in the final mesh. How these holes occur will be discussed later in this section.

One approach that addresses the issue of the large number of triangles is to apply mesh reduction algorithms to the extracted surface [DZ91, GH97, HDD+93, SZL92, Tur92]. The idea is to extract the triangles at the voxel level, build the triangle mesh using data structures that store the adjacency information for vertices, edges, and triangles, then attempt to reduce triangles according to some heuristic. The algorithm in [GH97] is based on the concept of an edge collapse, where an edge is removed, the triangles sharing the edge are removed, and the remaining triangles affected by the removed triangles are modified to preserve the local topology. Although the reduced meshes are quality representations of the isosurface and can be quickly rendered, the reduction scheme is computationally expensive, thus offsetting the speed of an extraction algorithm such as Marching Cubes. In our context of deformable surfaces, the computation time is kept to a minimum by selecting deformation functions that require updating only a small subset of voxels in the lattice.

In this section I provide an extraction algorithm that has no ambiguities and preserves the topology of the isosurface itself when the image data within each voxel has a continuous representation using trilinear interpolation of the image values at the eight corners. The table lookup of Marching Cubes is replaced by constructing an edge mesh on the voxel faces. That mesh approximates the intersection of the isosurface with the faces. The mesh is then triangulated using an extension of an ear-clipping algorithm for planar polygons [O'R98] to three dimensions. The triangulation does not introduce new points (called Steiner points in the computational geometry literature), something other researchers have tried in attempts to remove the topological ambiguities of Marching Cubes. The triangulation is fast and efficient, but it is also possible to avoid the runtime cost by having a table lookup. The table has 256 entries, just as in Marching Cubes, but each entry that has potential ambiguities stores multiple triangle meshes. Selection of the correct mesh in the table entry is based on a secondary index. The concepts are first discussed for 2D images to give the reader intuition on how the algorithms apply to 3D images.

4.5.2 ISOCURVE EXTRACTION IN 2D IMAGES

A 2D image is assumed to be defined on a regular lattice of size $N_0 \times N_1$ with integer points (x, y), where $0 \leq x < N_0$ and $0 \leq y < N_1$. The image values themselves are $F(x, y)$. An isocurve is of the form $F(x, y) = c$ for some specified level value c, where x and y are treated as continuous variables. A pixel in the image is a rectangle whose corners are four neighboring lattice points (x_0, y_0), $(x_0 + 1, y_0)$, $(x_0, y_0 + 1)$, and $(x_0 + 1, y_0 + 1)$. I choose $F(x, y)$ to be a bilinear interpolation of the four image values F_{00}, F_{10}, F_{01}, and F_{11} at the corners, respectively. The continuous representation of the image over the entire pixel is given below, where $\delta_x = x - x_0$ and $\delta_y = y - y_0$:

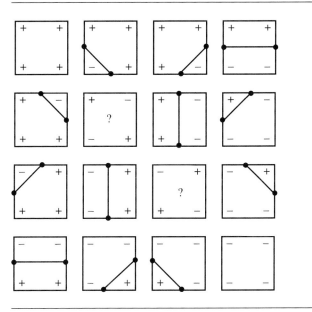

Figure 4.23 The 16 possible sign configurations for a pixel.

$$F(x, y) = (1 - \delta_y)((1 - \delta_x)F_{00} + \delta_x F_{10}) + \delta_y((1 - \delta_x)F_{01} + \delta_x F_{11}) \quad (4.13)$$

The equation $F(x, y) = c$ is a quadratic equation in x and y when the xy term appears, a linear equation when xy does not. The isocurves for F when viewed as a function on all of the plane are either hyperbolas or lines. As in 3D, I make the simplifying assumption that the level value c is chosen not to be an image value. The isocurves can intersect interior edge points of a pixel, but cannot intersect the corner points. I also work with $G(x, y) = F(x, y) - c$ and its isocurves generated by $G(x, y) = 0$.

The specialization of Marching Cubes to 2D images is usually referred to as Marching Squares. The isocurve extraction for $G(x, y) = 0$ on a pixel is performed by analyzing the signs of G at the four corners. Since the signs can be only $+1$ or -1, there are 16 possible sign configurations. Figure 4.23 shows these.

In the case of sign changes on two edges, clearly we can connect the two edge points with a line segment. The actual isocurve is either a portion of a hyperbola or a line segment. In the first case, the segment connecting the two edge points is a reasonable approximation to the isocurve. In the second case, the segment is exactly the isocurve. Figure 4.23 shows the approximating segments in the unambiguous

Figure 4.24 The three possible resolutions for the ambiguous pixel cases.

cases. However, two cases are ambiguous and are labeled with question marks. The possible resolutions are shown in Figure 4.24.

The question is how to select which of the three possibilities in Figure 4.24 to lead to a mesh that is topologically consistent with the isocurves. The answer is based on an analysis of the quadratic equation $G(x, y) = 0$ to actually determine what the isocurves look like. For simplicity, we may consider the problem when $0 \leq x \leq 1$ and $0 \leq y \leq 1$ and where the pixel-image values are $(0, 0, G_{00})$, $(1, 0, G_{10})$, $(0, 1, G_{01})$, and $(1, 1, G_{11})$. The equation is of the form

$$G(x, y) = a_{00} + a_{10}x + a_{01}y + a_{11}xy$$

where $a_{00} = G_{00}$, $a_{10} = G_{10} - G_{00}$, $a_{01} = G_{01} - G_{00}$, and $a_{11} = G_{00} - G_{10} - G_{01} + G_{11}$. Of course the interesting case is when all four edges have sign changes. We may consider the case $G_{00} < 0$, $G_{10} > 0$, $G_{01} > 0$, and $G_{11} < 0$. The opposite signs case has a similar analysis. Notice that $a_{00} < 0$, $a_{10} > 0$, $a_{01} > 0$, and $a_{11} < 0$. The four edge points where $G(x, y) = 0$ are $(0, \bar{y}_0)$, $(1, \bar{y}_1)$, $(\bar{x}_0, 0)$, and $(\bar{x}_1, 0)$. The linear interpolation will show that

$$\bar{x}_0 = \frac{-G_{00}}{G_{10} - G_{00}}, \qquad \bar{x}_1 = \frac{-G_{01}}{G_{11} - G_{01}}, \qquad \bar{y}_0 = \frac{-G_{00}}{G_{01} - G_{00}}, \qquad \bar{y}_1 = \frac{-G_{10}}{G_{11} - G_{10}}$$

Since $a_{11} \neq 0$, the product $a_{11}G(x, y)$ is not formally zero and can be factored as

$$a_{11}G(x, y) = (a_{00}a_{11} - a_{01}a_{10}) + (a_{01} + a_{11}x)(a_{10} + a_{11}y)$$

Moreover, some algebra will show that $a_{00}a_{11} - a_{01}a_{10} = G_{00}G_{11} - G_{01}G_{10}$. Define $\Delta = G_{00}G_{11} - G_{01}G_{10}$. I consider the two cases when Δ is zero or nonzero.

If $\Delta = 0$, then $a_{11}G(x, y) = (a_{01} + a_{11}x)(a_{10} + a_{11}y)$. The isocurves $G = 0$ occur when $x = -a_{01}/a_{11}$ and $y = -a_{10}/a_{11}$. The isocurves in the entire plane consist of the vertical and horizontal lines defined by the two equations. Thus, the right-most

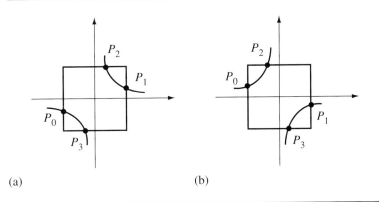

(a) (b)

Figure 4.25 Two possible configurations for hyperbolic isocurves with pixels superimposed. The four edge intersections are P_0, P_1, P_2, and P_3 as marked.

pixel in Figure 4.24 shows the isocurve structure within the pixel. In this case the line segments forming the plus-sign are exactly the isocurves. The center of the plus sign was not found by edge intersections but is added to the vertex-edge data structure for storing the edge mesh representing the total isocurve for the image. That is, when a plus-sign configuration is encountered, we add the four edge intersections and plus-sign center as vertices to the mesh and we add the four segments to the mesh edges that connect the edge intersections with the center point.

If $\Delta \neq 0$, then the isocurves of $G = 0$ are hyperbolas with asymptotes $x = -a_{01}/a_{11}$ and $y = -a_{10}/a_{11}$. The two possible graphs are shown in Figure 4.25.

To distinguish which configuration is correct for the given pixel, observe that a pair of edge points is on the same hyperbolic component whenever the signs of the expression $a_{01} + a_{11}x$ are the same at those points. This test follows from the observation that points (x, y) on the vertical asymptote satisfy $a_{01} + a_{11}x = 0$. Points to the right of the vertical asymptote satisfy $a_{01} + a_{11}x > 0$ for Figure 4.25(a) and $a_{01} + a_{11}x < 0$ for Figure 4.25(b). Points to the left of the vertical asymptote have opposite sign: $a_{01} + a_{11}x < 0$ for Figure 4.25(a) and $a_{01} + a_{11}x > 0$ for Figure 4.25(b). Let $\sigma(P)$ denote the sign of $a_{01} + a_{11}x$ for point $P = (x, y)$. Some simple computations produce

$$\sigma(P_0) = \text{Sign}(a_{01}) = \text{Sign}(G_{01} - G_{00}) = -\text{Sign}(G_{00})$$

and

$$\sigma(P_1) = \text{Sign}(a_{01} + a_{11}) = \text{Sign}(G_{11} - G_{10} = \text{Sign}(G_{00})$$

Now $\sigma(P_2) = \text{Sign}(a_{01} + a_{11}\bar{x}_0)$. Some algebra will show that the argument of the right-hand side is

$$a_{01} + a_{11}\bar{x}_0 = \frac{G_{01}G_{10} - G_{00}G_{11}}{G_{10} - G_{00}}$$

Therefore,

$$\sigma(P_2) = \text{Sign}(G_{01}G_{10} - G_{00}G_{11})\,\text{Sign}(G_{10} - G_{00}) = -\text{Sign}(\Delta)\,\text{Sign}(G_{00})$$

Similarly, $\sigma(P_3) = \text{Sign}(a_{01} + a_{11}\bar{x}_1)$, where

$$a_{01} + a_{11}\bar{x}_1 = \frac{G_{01}G_{10} - G_{00}G_{11}}{G_{11} - G_{01}}$$

Therefore,

$$\sigma(P_3) = \text{Sign}(G_{01}G_{10} - G_{00}G_{11})\,\text{Sign}(G_{10} - G_{00}) = \text{Sign}(\Delta)\,\text{Sign}(G_{00})$$

Each of the four signs is computed and the points are grouped into two pairs, each pair having the same sign. Equivalently, we may analyze the signs of $\text{Sign}(G_{00})\sigma(P_i)$ and pair the points accordingly. In this formulation, the modified signs are

$$\text{Sign}(G_{00})\sigma(P_0) = -1$$

$$\text{Sign}(G_{00})\sigma(P_1) = +1$$

$$\text{Sign}(G_{00})\sigma(P_2) = -\text{Sign}(\Delta)$$

$$\text{Sign}(G_{00})\sigma(P_3) = +\text{Sign}(\Delta)$$

Clearly, P_0 and P_1 can never be paired just as P_2 and P_3 can never be paired. This should be clear geometrically from Figure 4.25. We pair (P_0, P_2) and (P_1, P_3) when $\Delta > 0$ or (P_0, P_3) and (P_1, P_2) when $\Delta < 0$.

Table 4.4 summarizes all the possible vertex-edge configurations based on analysis of the bilinear function for the pixel. The signs at the four pixels are written from left to right and correspond to the signs of G_{00}, G_{10}, G_{01}, and G_{11}, in that order. The sign of Δ is only relevant in the ambiguous cases, so nothing is listed in this column in the unambiguous cases. The names P_0, P_1, P_2, and P_3 always refer to edge points on the edges $x = 0$, $x = 1$, $y = 0$, and $y = 1$, respectively. The center point, if any, is labeled C.

4.5.3 ISOSURFACE EXTRACTION IN 3D IMAGES

A 3D image is assumed to be defined on a regular lattice of size $N_0 \times N_1 \times N_2$ with integer points (x, y, z), where $0 \le x < N_0$, $0 \le y < N_1$, and $0 \le z < N_2$. The image values themselves are $F(x, y, z)$. An isosurface is of the form $F(x, y, z) = c$ for

Table 4.4 The vertex-edge configurations for a pixel

Signs				Sign of Δ	Edges
+	+	+	+		
+	+	+	−		$\langle P_0, P_3 \rangle$
+	+	−	+		$\langle P_1, P_3 \rangle$
+	+	−	−		$\langle P_0, P_1 \rangle$
+	−	+	+		$\langle P_1, P_2 \rangle$
				+	$\langle P_0, P_2 \rangle, \langle P_1, P_3 \rangle$
+	−	+	−	−	$\langle P_0, P_3 \rangle, \langle P_1, P_2 \rangle$
				0	$\langle P_0, C \rangle, \langle P_1, C \rangle, \langle P_2, C \rangle, \langle P_3, C \rangle$
+	−	−	+		$\langle P_2, P_3 \rangle$
+	−	−	−		$\langle P_0, P_2 \rangle$
−	+	+	+		$\langle P_0, P_2 \rangle$
−	+	+	−		$\langle P_2, P_3 \rangle$
				0	$\langle P_0, C \rangle, \langle P_1, C \rangle, \langle P_2, C \rangle, \langle P_3, C \rangle$
−	+	−	+	−	$\langle P_0, P_3 \rangle, \langle P_1, P_2 \rangle$
				+	$\langle P_0, P_2 \rangle, \langle P_1, P_3 \rangle$
−	+	−	−		$\langle P_1, P_2 \rangle$
−	−	+	+		$\langle P_0, P_1 \rangle$
−	−	+	−		$\langle P_1, P_3 \rangle$
−	−	−	+		$\langle P_0, P_3 \rangle$
−	−	−	−		

some specified level value c, where x, y, and z are treated as continuous variables. A voxel in the image is a rectangular solid whose corners are eight neighboring lattice points (x_0, y_0, z_0), $(x_0 + 1, y_0, z_0)$, $(x_0, y_0 + 1, z_0)$, $(x_0 + 1, y_0 + 1, z_0)$, $(x_0, y_0, z_0 + 1)$, $(x_0 + 1, y_0, z_0 + 1)$, $(x_0, y_0 + 1, z_0 + 1)$, and $(x_0 + 1, y_0 + 1, z_0 + 1)$. I chose $F(x, y, z)$ to be a trilinear interpolation of the eight image values, which are F_{000}, F_{100}, F_{010}, F_{110}, F_{001}, F_{101}, F_{011}, and F_{111} at the corners, respectively. The continuous representation of the image over the entire voxel follows, where $\delta_x = x - x_0$, $\delta_y = y - y_0$, and $\delta_z = z - z_0$:

$$F(x, y, z) = (1 - \delta_z)((1 - \delta_y)((1 - \delta_x)F_{000} + \delta_x F_{100})$$

$$+ \delta_y((1 - \delta_x)F_{010} + \delta_x F_{110})) \tag{4.14}$$

$$+ \delta_z((1 - \delta_y)((1 - \delta_x)F_{001} + \delta_x F_{101}) + \delta_y((1 - \delta_x)F_{011} + \delta_x F_{111})))$$

The equation $F(x, y, z) = c$ is a cubic equation in x, y, and z when the xyz term appears, a quadratic equation when xyz does not, and a linear equation when none of xyz, xy, xz, or yz occur. I make the simplifying assumption that the level value c is chosen not to be an image value. The isosurfaces can intersect interior edge points of any of the 12 edges of a voxel, but cannot intersect the corner points. I also work with $G(x, y, z) = F(x, y, z) - c$ and its isosurfaces generated by $G(x, y, z) = 0$.

Table-Based Mesh Selection

As I mentioned in the introduction, the Marching Cubes algorithm is based on the fact that each corner has an image value that is either positive or negative, leading to 256 possible sign configurations. The corner sign values are used to construct an index into a precomputed table of 256 triangle meshes. I discussed the analogy of this in 2D and showed the ambiguities that arise in two sign configurations. In 2D, rather than having a precomputed table of 16 edge meshes, we needed a secondary index to select one of three edge meshes that can occur in each of the two ambiguous cases. Thus, we have a total of 20 edge meshes from which to select. The same ambiguities arise in 3D. In fact, the ambiguities have a more serious consequence: the triangle mesh generated by adjacent voxels can have topological inconsistencies. In particular, when two voxels share a face that is ambiguous in the 2D sense, the table lookup can produce triangle meshes that do not properly share edges on the common face. Figure 4.26 illustrates this.

The voxel on the right had its edge points on the ambiguous face paired differently than the voxel on the left. This leads to a triangle mesh where a pair of triangles occurs, one triangle from each voxel, but the triangles touch at a single edge point rather than sharing an entire edge. To remedy this, all we need to do is make sure

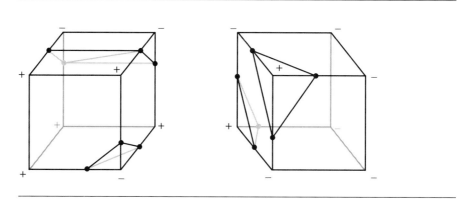

Figure 4.26 Topological inconsistencies introduced in two voxels sharing an ambiguous face.

that the pairing of edge points on ambiguous faces occurs according to the scheme I constructed for 2D. Interpolating each face bilinearly is consistent with the trilinear interpolation assumed for the entire voxel.

In the 2D setting, I mentioned that the precomputed table of edge meshes has a primary and a secondary index. The primary index takes on 16 values, each value representing a sign configuration for the corners of the pixel. The secondary index is 0 for the nonambiguous cases; that is, if the primary index corresponds to a non-ambiguous case, the entry in the table stores a single edge mesh. Assuming the edge meshes in the table entry are stored as an array with zero-based indexing, the secondary index of 0 will always locate the correct (and only) mesh. For the ambiguous case, the secondary index takes on three values that represent whether the quantity Δ I defined earlier is zero, positive, or negative. The table entries for the ambiguous cases have arrays of three edge meshes.

A similar construction can be applied in 3D. However, the table construction can be a bit tedious. An ambiguity for a voxel occurs whenever one or more of its faces is an ambiguous case in 2D. Suppose that exactly one face is ambiguous (e.g., Figure 4.26). Marching Cubes has a single triangle mesh to approximate the isosurface of the voxel. However, the ambiguous face has one of three possible interpretations, so the table entry for this case really needs an array of three triangle meshes. As in 2D, a secondary index can be used to select the correct mesh. Now suppose that exactly two faces are ambiguous. Each face can be resolved in one of three ways, thus leading to nine possible triangle meshes for the table entry of the given primary index. Worst case, of course, is that all six faces are ambiguous, requiring a secondary index that takes on $3^6 = 729$ values. Consequently, the tables will be quite large but still constructible.

Ear-Clipping–Based Mesh Construction

An alternative to the table lookup is to generate the triangle mesh for each voxel at runtime. The concept is quite simple. The edge meshes of a voxel are generated for each face of the voxel. A vertex-edge data structure is used to store the isosurface points on the edges of the voxel and to keep track of which points are paired by an edge. The assumptions that the image is trilinearly interpolated on the voxel and that the level values are not image values guarantee that isosurface points on the voxel edges share exactly two mesh edges.

If a plus-sign configuration occurs on the face of a voxel, then the center point of that configuration is added as a vertex of the mesh. That point shares four edges. Thus, a vertex shares either two or four edges. The triangle generation amounts to finding a vertex sharing two edges, locating its two adjacent vertices, adding the triangle formed by those three vertices to a list, then removing the original vertex and the two edges it shares. If necessary, an edge is added to connect the remaining adjacent vertices. This process is repeated until no more vertices exist that share

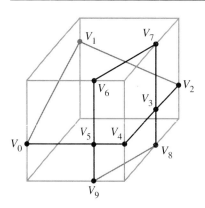

Figure 4.27 A voxel and its extracted edge mesh.

exactly two edges. I illustrate with an example. Figure 4.27 shows a voxel and the edge mesh generated by analyzing the six faces using the 2D algorithm.

Vertices V_3 and V_5 are centers of plus-sign configurations and share four edges each. The other vertices share two edges each. Vertex V_0 shares two edges. The adjacent vertices are V_1 and V_5. The triangle $\langle V_5, V_0, V_1 \rangle$ is added to a list. V_0 and its edges to the adjacent vertices are removed from the edge mesh. A new edge is added to connect V_5 and V_1. Figure 4.28(a) shows the resulting edge mesh.

V_1 shares two edges. The adjacent vertices are V_5 and V_2. The triangle $\langle V_5, V_1, V_2 \rangle$ is added to the list. V_1 and its edges to the adjacent vertices are removed from the edge mesh. A new edge is added to connect V_5 and V_2. Figure 4.28(b) shows the resulting edge mesh.

V_2 shares two edges. The adjacent vertices are V_5 and V_3. The triangle $\langle V_5, V_2, V_3 \rangle$ is added to the list. V_2 and its edges to the adjacent vertices are removed from the edge mesh. A new edge is added to connect V_5 and V_3. Figure 4.28(c) shows the resulting edge mesh.

V_4 shares two edges. The adjacent vertices are V_5 and V_3. The triangle $\langle V_5, V_4, V_3 \rangle$ is added to the list. V_4 and its edges to the adjacent vertices are removed from the edge mesh. An edge already exists between V_5 and V_3, so a new one does not have to be added. Figure 4.28(d) shows the resulting edge mesh.

V_6 shares two edges. The adjacent vertices are V_5 and V_7. The triangle $\langle V_5, V_6, V_7 \rangle$ is added to the list. V_6 and its edges to the adjacent vertices are removed from the edge mesh. A new edge is added to connect V_5 and V_7. Figure 4.28(e) shows the resulting edge mesh.

V_7 shares two edges. The adjacent vertices are V_5 and V_3. The triangle $\langle V_5, V_7, V_3 \rangle$ is added to the list. V_7 and its edges to the adjacent vertices are removed from the edge

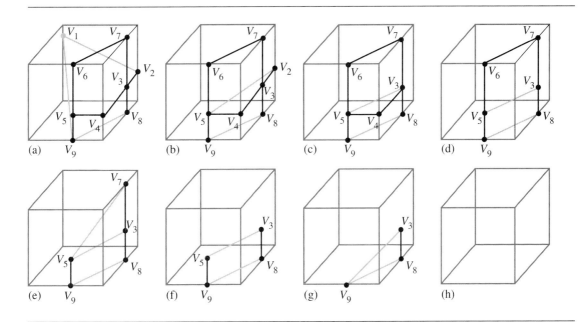

Figure 4.28 Triangle removal in the edge mesh of Figure 4.27.

mesh. An edge already exists between V_5 and V_3, so a new one does not have to be added. Figure 4.28(f) shows the resulting edge mesh.

V_5 shares two edges. The adjacent vertices are V_3 and V_9. The triangle $\langle V_3, V_5, V_9 \rangle$ is added to the list. V_5 and its edges to the adjacent vertices are removed from the edge mesh. A new edge is added to connect V_3 and V_9. Figure 4.28(g) shows the resulting edge mesh.

Finally, V_3 shares two edges. The adjacent vertices are V_8 and V_9. The triangle $\langle V_8, V_3, V_9 \rangle$ is added to the list. V_3 and its edges to the adjacent vertices are removed from the edge mesh. No more vertices exist, so the triangulation is finished. Figure 4.28(h) shows the voxel with all vertices and edges removed.

EXAMPLE 4.14

SOURCE CODE

BouncingBall

An example of implicit surface deformation is provided in the source code on the CD-ROM. A deformable body initially in the shape of a sphere is bounced on a floor. When the body hits the floor, it starts to deform. At the instant of maximum deformation, the body bounces off the floor and gradually returns to its spherical shape.

The floor is represented by the xy-plane ($z = 0$). The spherical body is defined implicitly *at time* 0 by $F(x, y, z) = x^2 + y^2 + (z - 1)^2 - 1 = 0$. The center point of the body is denoted $\mathbf{C}(t) = (c_1(t), 0, c_3(t))$ and is a hard-coded path for the purposes of simplifying the demonstration. The body bounces back and forth striking

*(Example 4.14
continued)*

the plane in only the points $(2, 0, 0)$ and $(-2, 0, 0)$. At time zero the center is at $(0, 0, 2)$ and the body is not in contact with the floor. The x-coordinate of the center is $c_1(t) = 2 \sin(\pi t/2)$ for $t \in [0, 1]$. During that same time interval the z-coordinate is defined as $c_3(t) = 2 - t^2$. The body is not in contact with the floor until the time reaches one. At that instant a time-varying deformation is applied to the body. The path of the center during the deformation is allowed to be downward only.

A slight complication arises because of the body motion. The body surface can be defined implicitly using world coordinates, but then F should additionally depend on t. To avoid this we will use a local coordinate system for the body and define the deformations within that system. We may therefore consider $F(x, y, z) = x^2 + y^2 + (z - 1)^2 - 1 = 0$ as defining the body surface in local coordinates but translate the surface itself to world coordinates when displaying the object.

The time interval of deformation and the actual z-value of the path of the center depend on how the deformation is defined. Consider using

$$D(x, y, z; t) = \begin{cases} A(t)(1 - x^2 - y^2 - z^2); & x^2 + y^2 + z^2 \leq 1, t \in [1, 1+d] \\ 0; & \text{otherwise} \end{cases}$$

where $A(t) = 4(t - 1)(1 + d - t)/d^2$. The time interval over which the deformation is applied is $[1, 1 + d]$ for some selected duration $d > 0$. The amplitude $A(t)$ varies from 0 at time $t = 1$, to 1 at time $t = 1 + d/2$, back to 0 at time $t = 1 + d$. The deformation is implicitly defined by $F(x, y, z) + D(x, y, z) = 0$, leading to

$$x^2 + y^2 + \left(z - \frac{1}{1 - A}\right)^2 = \frac{1 - A + A^2}{(1 - A)^2}$$

which is the equation for a sphere. The portion of the original sphere contained in the region of influence $x^2 + y^2 + z^2 \leq 1$ is replaced by a spherical section from the previously displayed equation. By symmetry, the minimum point of that section occurs at $x = y = 0$, so $z_{\min} = (1 - \sqrt{1 - A + A^2})/(1 - A) \in [0, 1/2]$ for $A \in [0, 1]$. In the limit as A approaches 1, z_{\min} approaches $1/2$. When that limit is reached, the deformed section of the body is a flat disk. So that the visual display of the body will make it appear as if it is in contact with the floor, the locally defined level surface for the deformed body should be translated downward by subtracting z_{\min} from the z-coordinates of the vertices. Figure 4.29—also Color Plate 4.29—shows some screen shots from this application found on the CD-ROM.

The level surface extractor is configured to update only those voxels that are affected by the deformation. We know by design that only the portion of the body below $z = 1/2$ is affected. Moreover, we can limit our search for new voxels that define the next deformable surface by examining those vertically neighboring voxels intersected by the current deformable surface, thus taking advantage of continuity in time.

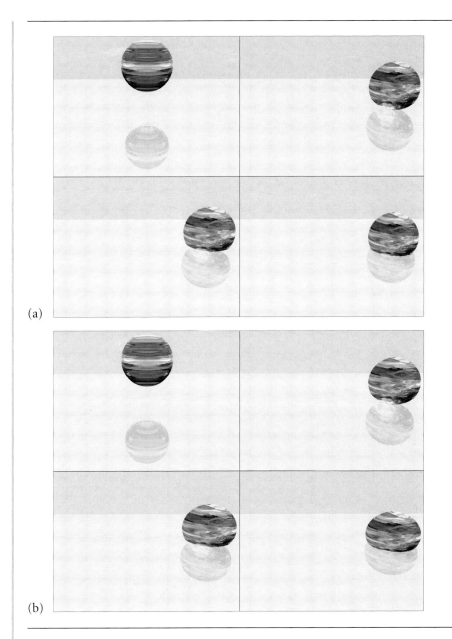

(a)

(b)

Figure 4.29 A bouncing ball with deformation based on implicit surfaces. Image (a) shows the bouncing ball with only the implicit surface deformation. Image (b) shows an additional deformation of nonuniform scaling by applying an affine transformation. (See also Color Plate 4.29.)

*(Example 4.14
continued)*

The deformed ball as constructed here most likely does not look physically realistic. You would expect a ball hitting the ground to flatten vertically and expand horizontally about its middle. The deformation function we used does not cause that to happen. Although we could choose a different deformation function and/or increase the region of influence of the function, a cheaper alternative involving more hacked physics is to apply a nonuniform scaling to the vertices of the triangle mesh after the effects of the deformation are calculated. The x- and y-components may be scaled by a factor $\sigma_1 > 1$. The z-component may be scaled by a factor $\sigma_2 < 1$. Figure 4.29(b) shows some screen shots for the modified physical simulation that uses the affine deformation to get nonuniform scaling. ▪

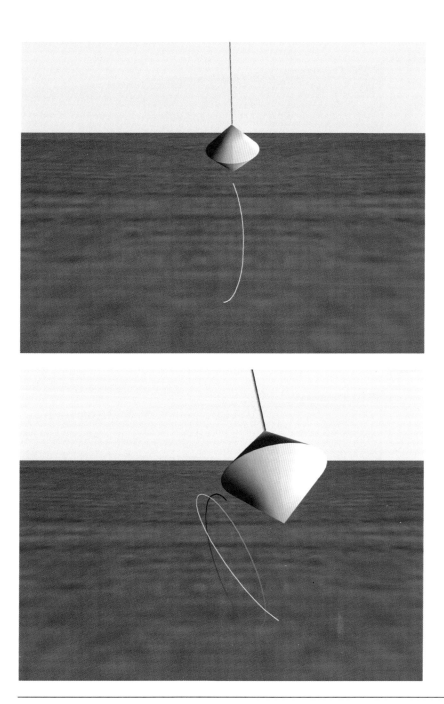

Plate 3.3 The Foucault pendulum. The figures show the path of the pendulum tip in the horizontal plane. New points on the path are colored white, but the intensity of the older points along the path gradually decreases. (See page 97.)

a

b

Plate 3.7 A ball rolling down a hill. Image (b) shows the path of the center of the ball as it rolls down the hill. The ball rotates at a speed commensurate with its downhill velocity. (See page 110.)

Plate 3.14 A mass pulley spring system shown at two different times. The spring expands and compresses, and the pulley disk rotates during the simulation. The system stops when a mass reaches the center line of the pulley or the ground. (See page 128.)

Plate 3.25 Two "snapshots" of a freely spinning top. The black line is the vertical axis. The white line is the axis of the top. (See page 159.)

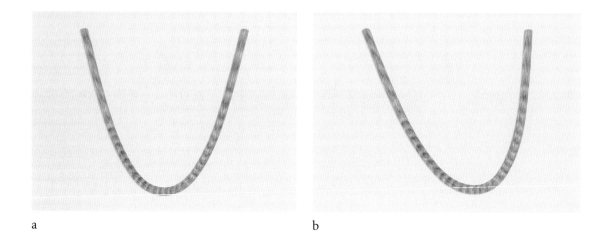

a b

Plate 4.2 A rope modeled as a linear chain of springs. Image (a) shows the rope at rest with only gravity acting on it. Image (b) shows the rope subject to a wind force whose direction changes by small random amounts. (See page 167.)

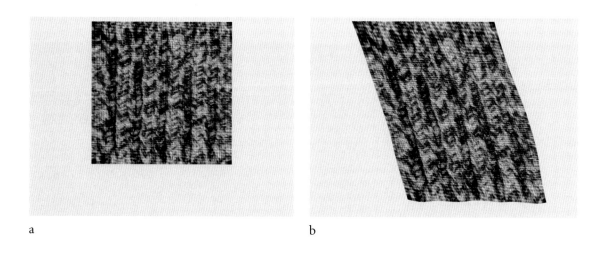

a b

Plate 4.4 A cloth modeled as a rectangular array of springs. Wind forces make the cloth flap about. Notice that the cloth in image (b) is stretched in the vertical direction. The stretching occurs while the gravitational and spring forces balance out in the vertical direction during the initial portion of the simulation. (See page 169.)

Plate 4.6 A gelatinous cube that is oscillating due to random forces. The cube is modeled by a three-dimensional array of mass connected by springs. (See page 172.)

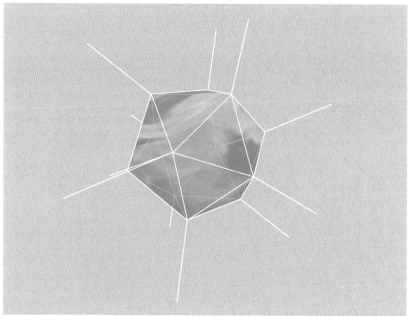

Plate 4.7 A gelatinous blob that is oscillating due to small, random forces. This blob has the masses located at the vertices of an icosahedron with additional masses of infinite weight to help stabilize the oscillations. The springs connecting the blob to the infinite masses are shown in white. (See page 174.)

a

b

Plate 4.15 A skirt modeled by a generalized cylinder surface. Wind-like forces are acting on the skirt and are applied in the radial direction. Image (a) shows the skirt after wind is blowing it about. Image (b) shows a wireframe view of the skirt so that you can see it consists of two closed curve boundaries and is tessellated between. (See page 194.)

Plate 4.17 A water drop modeled as a control point surface of revolution. The surface dynamically changes to show the water drop forming, separating from the main body of water, then falling to the floor. The evolution is from left to right and top to bottom. (See page 196.)

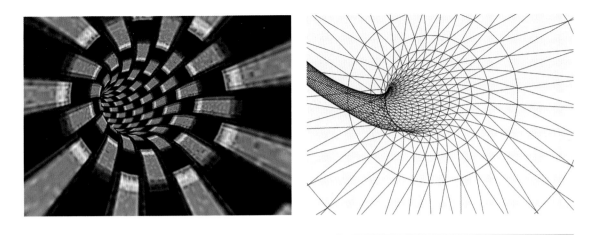

Plate 4.18 A closed tube surface whose central axis is a helix. (See page 198.)

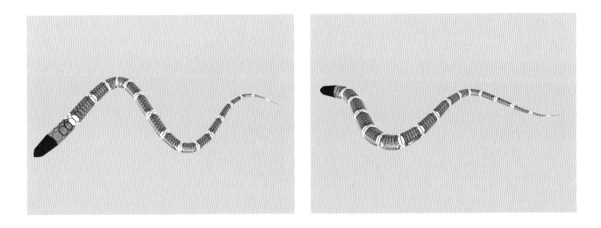

Plate 4.19 A wriggling snake modeled as a tube surface whose central curve is a control point curve. (See page 199.)

a

b

Plate 4.20 Free-form deformation. Image (a) shows the initial configuration where all control points are rectangularly aligned. Image (b) shows that some control points have been moved and the surface is deformed. The control point shown in red in (b) is the point at which the mouse was clicked on and moved. (See page 204.)

Plate 4.29 A bouncing ball with deformation based on implicit surfaces. Image (a) shows the
bouncing ball with only the implicit surface deformation. Image (b) shows an additional
deformation of nonuniform scaling by applying an affine transformation. (See page
219.)

a

b

Plate 6.1 Two screen shots from the `BasicShader` application. Image (a) shows a rendering using just the pixel shader. Image (b) shows a rendering using both the vertex shader and the pixel shader. (See page 376.)

a

b

Plate 6.2 Screen shots from the VertexNoise shader application. (a) *Top row*: The original model and its wireframe view. *Bottom row*: The output of the VertexNoise shader and its wireframe view. The vertex displacement is significantly large. (b) *Top row*: The vertices displaced with a smaller maximum displacement, but same scale of noise. *Bottom row*: The vertices displaced with the same maximum displacement as in the bottom row of (a), but with a larger scale noise. (See page 377.)

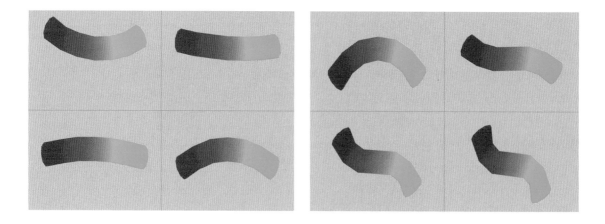

Plate 6.4 Two screen shots from the skinning application. The bones are randomly generated to cause the object to continuously deform. The sequence of deformations is from left to right, top then bottom, within each screen shot. (See page 380.)

Plate 6.5 Two screen shots from the rippling ocean application. The images were captured at two different times in the simulation. (See page 382.)

a b

Plate 6.7 Two screen shots from the refraction shader application. Image (a) shows refraction, but no reflection. Image (b) shows refraction and reflection. (See page 385.)

Plate 6.8 Two screen shots from the Fresnel shader application. (See page 387.)

Plate 6.9 Screen shots from the iridescence shader application. The two images show a textured torus in two different orientations and with various amounts of interpolation to produce the iridescent sheen. (See page 389.)

CHAPTER 5

PHYSICS ENGINES

We arrive at the topic I believe most readers will think of as the heart of game physics—the physics engine. This chapter describes a general system for handling a collection of rigid bodies, including collision detection and collision response. The system uses Newton's second law of motion, $\mathbf{F} = m\mathbf{a}$, to control the motion of objects. The constraint forces are unknown to the system and must be calculated based on the information that is provided by the collision detection system. A natural requirement for a general system is that the rigid bodies never interpenetrate. A model for satisfying the requirement is the impulse-based approach that Brian Mirtich [Mir96b] and David Baraff [Bar01] made popular, but by all means this is not the only approach one can take. My goal is to go into significant detail about the impulse-based approach so that you

- Understand the layout of a general physics engine.
- See what complications arise.
- Learn to evaluate its strengths and weaknesses.

Other approaches to building a robust physics engine are based on trying to fix the weaknesses of the previous-generation engine. Once you understand the impulse-based engine, you should be able to start experimenting with modifications; references to other approaches are provided, so you have a nearly endless supply of ideas to investigate.

A physics engine naturally partitions the physical simulation into two phases, *collision detection* and *collision response*. Collision detection refers to the process of determining if two bodies are currently intersecting or will intersect at a future time. Even though we are concerned with nonpenetration, an implementation has to deal

with penetration due to numerical round-off errors. A collision detection system must be prepared to deal with all cases and report time-zero intersections and/or penetrations when they occur. The time of intersection is important, especially in the case of moving objects that are currently not intersecting but will do so at a later time. The first such time is called the *contact time*. In many situations just knowing that two objects will intersect is sufficient information. I refer to this as a *test-intersection query*, the end result a Boolean value: true if an intersection will occur, false if not. In other situations we will want to know *where* the objects intersect at the time of contact. The set of intersection points is referred to as the *contact set* or *contact manifold*, the latter term appropriate when the intersection set is not a finite set but a continuum of points. For example, the intersection set of a box sitting on a table is the set of points on a face of the box. When the contact set is desired, I refer to this as a *find-intersection query*. As you would expect, in most cases a find-intersection query is more expensive than a test-intersection query for a given pair of objects.

Collision detection is about determining the contact time and the contact set for two moving objects. At the time they intersect we need to decide how the objects will continue moving, the collision response, so to speak. For example, if a rigid ball strikes a flat surface at an angle, you most likely want the ball to bounce away from the surface. In particular, you will want to reflect the velocity vector through the normal of the surface so that the angle of incidence is equal to the angle of reflection. The method of response falls into two categories based on how the objects collide: colliding contact and resting contact.

General analysis of two rigid bodies is quite intractable for real-time game physics. The geometric nature of the bodies can be quite complicated, preventing any reasonable attempt at modeling their dynamics. To simplify matters, we will restrict our attention to rigid bodies that are convex polyhedra.

Section 5.1 of this chapter is about unconstrained motion. The goal is to show you the basic design and data structure to represent a rigid body that supports solving the differential equations of motion for a body that does not interact with other bodies in its environment. Section 5.2 complicates matters by allowing interaction between bodies, referred to as constrained motion. Building a robust collision detection and response system for constrained motion requires a lot of patience because there is a lot of machinery to understand and implement. Enough pseudocode is provided to allow you to build a working engine if you choose to do so. Source code is provided for a rudimentary, working engine that you can experiment with.

Section 5.2.5 proposes a different approach to constrained motion than what a general-purpose engine provides and one that I think should be investigated. I propose that an implementation can detect and provide enough information about the constraints imposed by the contact set found by the collision detection system so that rather than continually solving Newton's equations of motion, the system can construct the Lagrangian equations of motion and switch to the appropriate set of equations when necessary. This approach is of particular importance when dealing with frictional forces since Lagrangian dynamics do a better job of incorporating the

friction into the equations. The paper [Jak01] by Thomas Jakobsen already hints at this by using projection of the system state variables onto a manifold described by the constraints.

Handling generally shaped rigid bodies is not tractable for real-time physics on consumer hardware. Instead, the bodies are restricted to be convex polyhedra (or unions of convex polyhedra). Collision detection of convex polyhedra is discussed in Section 5.3. Perhaps it is debatable, but in my opinion this is the hardest part of a physics engine to implement in a *robust* manner while not using too much computational time that is allotted per time frame. I discuss the method of separating axes because it provides the minimum information needed to test if two objects overlap, but ample information to actually compute the contact set between two noninterpenetrating objects.

Section 5.4 is about using spatial and temporal coherence of the rigid body objects to reduce the amount of time spent detecting collisions. Two basic systems are mentioned, one using bounding spheres and one using axis-aligned bounding boxes, the latter more likely to be effective in practice.

Finally, Section 5.5 briefly discusses some variations that researchers have tried for collision detection or response.

5.1 Unconstrained Motion

For unconstrained motion, Newtonian dynamics may be used rather than Lagrangian dynamics to establish the equations of motion. The equations of motion for a single particle of mass m with world position \mathbf{x}, world velocity $\mathbf{v} = \dot{\mathbf{x}}$, and world acceleration $\mathbf{a} = \dot{\mathbf{v}} = \ddot{\mathbf{x}}$ are in the form of Newton's second law:

$$m\ddot{\mathbf{x}} = m\dot{\mathbf{v}} = m\mathbf{a} = \mathbf{F}(t)$$

The right-hand side represents all forces applied to the particle. The dependence on time is indicated just to remind you that the force can change dynamically. This is a second-order differential equation in \mathbf{x}. Numerical differential equation solvers are typically set up to solve first-order systems. We can transform our single second-order equation into two first-order equations by allowing the velocity to be one of the variables: $\dot{\mathbf{x}} = \mathbf{v}$, $\dot{\mathbf{v}} = \mathbf{F}/m$. The vector $\mathbf{S}(t) = [\mathbf{x}\ \mathbf{v}]^{\mathrm{T}}$ is referred to as the *state vector* for the system. The system of differential equations is

$$\frac{d\mathbf{S}}{dt} = \frac{d}{dt}\begin{bmatrix} \mathbf{x} \\ \mathbf{v} \end{bmatrix} = \begin{bmatrix} \dot{\mathbf{x}} \\ \dot{\mathbf{v}} \end{bmatrix} = \begin{bmatrix} \mathbf{v} \\ \frac{\mathbf{F}}{m} \end{bmatrix}$$

The physical simulation is a matter of updating the state vector over time using the differential equation solvers.

Newton's second law applies equally as well to a system of n particles. If the ith particle has mass m_i, position \mathbf{x}_i, velocity \mathbf{v}_i, and applied force \mathbf{F}_i, then the state vector is a list of all pairs of positions and velocities, $\mathbf{S} = [\mathbf{x}_1 \, \mathbf{v}_1 \cdots \mathbf{x}_n \, \mathbf{v}_n]^{\mathrm{T}}$, and the system of differential equations is

$$\frac{d\mathbf{S}}{dt} = \frac{d}{dt}\begin{bmatrix} \mathbf{x}_1 \\ \mathbf{v}_1 \\ \vdots \\ \mathbf{x}_n \\ \mathbf{v}_n \end{bmatrix} = \begin{bmatrix} \dot{\mathbf{x}}_1 \\ \dot{\mathbf{v}}_1 \\ \vdots \\ \dot{\mathbf{x}}_n \\ \dot{\mathbf{v}}_n \end{bmatrix} = \begin{bmatrix} \mathbf{v}_1 \\ \frac{\mathbf{F}_1}{m_1} \\ \vdots \\ \mathbf{v}_n \\ \frac{\mathbf{F}_n}{m_n} \end{bmatrix}$$

This is conceptually the same as a system of one particle. The numerical differential equation solver just has to deal with more variables and equations.

A typical game application, though, has rigid bodies that are not single points. The physical concepts we introduced earlier come into play. Section 2.2.2 showed us the kinematics for a solid rigid body. In particular, we saw how to construct the position, velocity, and acceleration vectors for each point \mathcal{P} in the solid. We identified an object center point \mathcal{C}. As noted many times, the equations of motion greatly simplify when that point is chosen to be the center of mass of the object. The path of the center of mass was denoted by $\mathcal{X}(t; \mathcal{C})$. To work solely with vectors in this section, we will use the difference $\mathbf{x}(t) = \mathcal{X}(t; \mathcal{C}) - \mathcal{O}$, where \mathcal{O} is the origin of the world. The velocity of the center of mass measured in world coordinates was denoted by $\mathbf{v}_{\mathrm{cen}}(t)$. We will drop the subscript in this section and use just the notation $\mathbf{v}(t)$. The position and velocity are related by

$$\frac{d\mathbf{x}(t)}{dt} = \mathbf{v}(t) \tag{5.1}$$

A restatement of equation (2.56), the linear momentum of the rigid body, is

$$\mathbf{p}(t) = m\mathbf{v}(t) \tag{5.2}$$

where m is the total mass of the body. Since the mass is a constant, we may keep track of either (linear) velocity or linear momentum in the state of the system. We choose the state to include \mathbf{x} and \mathbf{p}. The driving force behind the center of mass is $\mathbf{F}(t)$, the equations of motion provided by Newton's second law, equation (2.45),

$$\frac{d\mathbf{p}(t)}{dt} = \mathbf{F}(t) \tag{5.3}$$

The abstract operations to determine the location of the center of mass given an applied force $\mathbf{F}(t)$ are

1. Compute \mathbf{p} from \mathbf{F} by integrating equation (5.3).

2. Compute **v** from **p** by dividing by m in equation (5.2).

3. Compute **x** from **v** by integrating equation (5.1).

In practice these steps are handled simultaneously by a numerical differential equation solver.

An analogous set of equations tells us how the orientation matrix $R(t)$ is affected by an externally applied torque. The analogy to mass m is the inertia tensor (mass matrix) J defined in equation (2.85). Keep in mind that the inertia tensor is constructed relative to some coordinate system. In this section we are computing it relative to the center of mass of the object. The analogy to linear velocity **v** is the angular velocity **w**. The analogy to linear momentum is angular momentum **L**. The relationship between angular velocity and the orientation matrix is equation (2.38),

$$\frac{dR(t)}{dt} = \text{Skew}(\mathbf{w}(t))R(t) \tag{5.4}$$

The relationship between angular momentum and angular velocity is equation (2.88),

$$\mathbf{L}(t) = J(t)\mathbf{w}(t) \tag{5.5}$$

The inertia tensor is measured in world coordinates. Since the object is moving and rotating, J does vary with time. The driving torque behind the orientation is $\boldsymbol{\tau}(t)$, the equations of motion provided by equation (2.62),

$$\frac{d\mathbf{L}(t)}{dt} = \boldsymbol{\tau}(t) \tag{5.6}$$

The abstract operations to determine the orientation of the rigid body given an applied torque $\boldsymbol{\tau}(t)$ are analogous to those for determining the location:

1. Compute **L** from $\boldsymbol{\tau}$ by integrating equation (5.6).

2. Compute **w** from **L** by dividing by J in equation (5.5). The division is in the matrix sense—you need to multiply by the inverse matrix J^{-1}.

3. Compute R from **w** by integrating equation (5.4).

Recomputing the inertia tensor $J(t)$ and its inverse $J^{-1}(t)$ for each time step of the simulation can be expensive depending on how complex the shape of the rigid body is. We can eliminate the direct computation by an observation. Recall that $\mathbf{r}(t; \mathcal{P}) = R(t)\mathbf{b}(\mathcal{P})$, where $R(t)$ is the orientation matrix and $\mathbf{b}(\mathcal{P})$ is the location of point \mathcal{P} measured in body coordinates. If B denotes the region of space that the rigid body occupies, the inertia tensor is

$$J(t) = \int_B \left(|\mathbf{r}|^2 I - \mathbf{r}\mathbf{r}^T \right) dm, \qquad \text{Definition of inertia tensor}$$

$$= \int_B \left(|R\mathbf{b}|^2 I - (R\mathbf{b})(R\mathbf{b}^T) \right) dm, \qquad \text{Definition of } \mathbf{r}$$

$$= \int_B \left(|\mathbf{b}|^2 I - R\mathbf{b}\mathbf{b}^T R^T \right) dm, \qquad \text{Rotation preserves length}$$

$$= \int_B \left(|\mathbf{b}|^2 R R^T - R\mathbf{b}\mathbf{b}^T R^T \right) dm, \qquad \text{Rotations satisfy } I = R R^T$$

$$= R \left(\int_B \left(|\mathbf{b}|^2 - R\mathbf{b}\mathbf{b}^T \right) dm \right) R^T, \qquad R \text{ is constant with respect to the integration}$$

$$= R(t) J_{\text{body}} R(t)^T$$

(5.7)

where J_{body} is the inertia tensor measured in the body coordinate frame and is independent of time since the body is rigid. The inverse matrix is easy to compute:

$$J(t)^{-1} = R(t) J_{\text{body}}^{-1} R(t)^T \tag{5.8}$$

Another observation that leads to a robust implementation is that we can use quaternions to represent the orientation matrix. Chapter 10 provides a large amount of background material on quaternions and how they relate to rotations. The main problem when numerically integrating equation (5.4) over many time steps is that numerical error builds up, and the computed matrix $R(t)$ is no longer precisely a rotation matrix. We may easily correct for this situation. If $\hat{R}(t) = [\hat{\mathbf{u}}_0 \ \hat{\mathbf{u}}_1 \ \hat{\mathbf{u}}_2]$ is the output of the differential equation solver, Gram-Schmidt orthonormalization may be applied to its columns to generate a set of orthonormal vectors that become the columns of the orientation matrix, $R(t) = [\mathbf{u}_0 \ \mathbf{u}_1 \ \mathbf{u}_2]$. Specifically,

$$\mathbf{u}_0 = \frac{\hat{\mathbf{u}}_0}{|\hat{\mathbf{u}}_0|}, \qquad \mathbf{u}_1 = \frac{\hat{\mathbf{u}}_1 - (\hat{\mathbf{u}}_1 \cdot \mathbf{u}_0)\mathbf{u}_0}{|\hat{\mathbf{u}}_1 - (\hat{\mathbf{u}}_1 \cdot \mathbf{u}_0)\mathbf{u}_0|}, \qquad \mathbf{u}_2 = \mathbf{u}_0 \times \mathbf{u}_1$$

The orthonormalization does not have to be applied at every step, but often enough to avoid numerical problems. If $q(t)$ is a quaternion that represents $R(t)$, and if $\omega(t)$ is the (not necessarily unit-length) quaternion that corresponds to the angular velocity $\mathbf{w}(t)$, then the differential equation for $q(t)$ equivalent to equation (5.4) is

$$\frac{dq(t)}{dt} = \frac{1}{2}\omega(t)q(t) \tag{5.9}$$

See Chapter 10 for the derivation of this equation. A numerical integration still occurs and produces an output $\hat{q}(t)$ that can be normalized to unit length $q(t)$ to account for the numerical round-off errors, but the frequency of normalization can be chosen

smaller than for rotation matrices. Treating $q(t)$ as a vector in four dimensions, the normalization is

$$q = \frac{\hat{q}}{|\hat{q}|}$$

where $|\hat{q}|$ is the length of the input 4-tuple. This normalization is less expensive to compute than Gram-Schmidt orthonormalization for rotation matrices.

Now to put all this together. For a single rigid body, the state vector is expanded to

$$\mathbf{S}(t) = \begin{bmatrix} \mathbf{x}(t) \\ q(t) \\ \mathbf{p}(t) \\ \mathbf{L}(t) \end{bmatrix} \tag{5.10}$$

The applied force is $\mathbf{F}(t)$ and the applied torque is $\boldsymbol{\tau}(t)$. The equations of motion are

$$\frac{d\mathbf{S}}{dt} = \frac{d}{dt} \begin{bmatrix} \mathbf{x} \\ q \\ \mathbf{p} \\ \mathbf{L} \end{bmatrix} = \begin{bmatrix} \dot{\mathbf{x}} \\ \dot{q} \\ \dot{\mathbf{p}} \\ \dot{\mathbf{L}} \end{bmatrix} = \begin{bmatrix} m^{-1}\mathbf{p} \\ \omega q/2 \\ \mathbf{F} \\ \boldsymbol{\tau} \end{bmatrix} \tag{5.11}$$

The force $\mathbf{F}(t)$ and torque $\boldsymbol{\tau}(t)$ are always computable at time t. The state values for $\mathbf{p}(t)$, $q(t)$, and $\mathbf{L}(t)$ at time t are maintained by the physics simulator. The orientation matrix $R(t)$ is computed from $q(t)$. The angular velocity is determined by equations (5.5) and (5.8), namely,

$$\mathbf{w}(t) = J^{-1}(t)\mathbf{L}(t) = R(t)J_{\text{body}}^{-1}R(t)^{\mathsf{T}}\mathbf{L}(t)$$

The corresponding quaternion ω is computed from $\mathbf{w}(t)$. After these calculations we know all the quantities on the right-hand side of equation (5.11) and can apply the numerical differential equation solver to compute the values at the next time $t + \Delta t$ for a suitably chosen step size $\Delta t > 0$.

For n rigid bodies, the state vector contains n blocks of values, each block the position, orientation, linear momentum, and angular momentum of a single rigid body. The state vector of the entire system is

$$\mathbf{S}(t) = \begin{bmatrix} \mathbf{x}_1(t) \\ q_1(t) \\ \mathbf{p}_1(t) \\ \mathbf{L}_1(t) \\ \vdots \\ \mathbf{x}_n(t) \\ q_n(t) \\ \mathbf{p}_n(t) \\ \mathbf{L}_n(t) \end{bmatrix} \tag{5.12}$$

For the ith rigid body, the applied force is $\mathbf{F}_i(t)$ and the applied torque is $\boldsymbol{\tau}_i(t)$. The equations of motion are

$$
\frac{d\mathbf{S}}{dt} = \frac{d}{dt}
\begin{bmatrix}
\mathbf{x}_1(t) \\
q_1(t) \\
\mathbf{p}_1(t) \\
\mathbf{L}_1(t) \\
\vdots \\
\mathbf{x}_n(t) \\
q_n(t) \\
\mathbf{p}_n(t) \\
\mathbf{L}_n(t)
\end{bmatrix}
=
\begin{bmatrix}
\dot{\mathbf{x}}_1(t) \\
\dot{q}_1(t) \\
\dot{\mathbf{p}}_1(t) \\
\dot{\mathbf{L}}_1(t) \\
\vdots \\
\dot{\mathbf{x}}_n(t) \\
\dot{q}_n(t) \\
\dot{\mathbf{p}}_n(t) \\
\dot{\mathbf{L}}_n(t)
\end{bmatrix}
=
\begin{bmatrix}
m_1^{-1}\mathbf{p}_1 \\
\omega_1 q_1/2 \\
\mathbf{F}_1 \\
\boldsymbol{\tau}_1 \\
\vdots \\
m_n^{-1}\mathbf{p}_n \\
\omega_n q_n/2 \\
\mathbf{F}_n \\
\boldsymbol{\tau}_n
\end{bmatrix}
= \mathbf{G}(t, \mathbf{S})
\qquad (5.13)
$$

The nonlinear system of differential equations $\dot{\mathbf{S}} = G(t, \mathbf{S})$ is solved numerically to compute the state at any time during the physical simulation.

5.1.1 An Illustrative Implementation

We have seen how to set up the differential equations that model the unconstrained motion of a rigid body. An implementation of the ideas is provided in [Bar01] using the C programming language as the basis. Of course, this is just to illustrate the concepts. Your actual implementation will require a lot more effort to manage all the rigid body data, and it will have to interact with a collision detection system. The structure to represent rigid bodies is

```
struct RigidBody
{
    /* constant quantities */
    double mass;  /* mass of rigid body */
    double massinv;  /* inverse mass of rigid body */
    matrix jbody;  /* inertia tensor in body coordinates */
    matrix jbodyinv;  /* inverse inertia tensor in body coordinates */

    /* state variables */
    point x;  /* position of center of mass */
    quaternion q;  /* orientation of rigid body q = (w,x,y,z) */
    vector p;  /* linear momentum */
    vector L;  /* angular momentum */

    /* derived quantities, internal and external use */
    matrix R;  /* orientation matrix of rigid body */
    vector v;  /* linear velocity */
    vector w;  /* angular velocity */
```

```
    /* derived quantities, for differential equation solver */
    matrix jinv;  /* inverse inertia tensor in world coordinates */
    quaternion halfWQ;  /* 0.5*w*q */

    /* computed quantities */
    vector force, torque;
};
```

A global array of bodies is used in the simulation. Before the simulation begins, the mass and body-coordinate inertia and inverse inertia tensors are computed and stored in the rigid body structures.

```
#define NBODIES <number of bodies goes here>
RigidBody body[NBODIES];

void InitializeBodyConstants ()
{
    for (i = 0; i < NBODIES; i++)
    {
        /* The mass and inertia tensor of the body is specific to
           the application.  Whatever you need these to be, set
           those values here.  For rigid bodies that are convex
           polyhedra, you will want to use the construction
           provided in Section 2.5.5, "Mass and Inertia Tensor of
           a Solid Polyhedron."
        */
        initialize body[i].mass;
        initialize body[i].jbody;

        body[i].massinv = 1.0/body[i].mass;
        body[i].jbodyinv = InvertMatrix(body[i].jbody);
    }
}
```

If the rigid bodies are polyhedra, the mass and inertia tensor can be computed using the algorithm in Section 2.5.5. A function `InitializeBodyState()` has the responsibility to initialize the state variables and the derived quantities of the rigid bodies.

```
void ComputeDerivedQuantities (RigidBody* rb)
{
    rb->R = ConvertToMatrix(rb->q);
    rb->jinv = rb->R * rb->jbodyinv*Transpose(rb->R);
    rb->v = rb->massinv * rb->p;
```

```
        rb->w = rb->jinv * rb->L;
        rb->halfWQ = 0.5 * ConvertToQuaternion(rb->w) * rb->q;
}

void InitializeBodyState ()
{
    /* initialized the body values at time t = 0 */
    for (i = 0; i < NBODIES; i++)
    {
        /* state variables, your choice based on application */
        initialize body[i].x;
        initialize body[i].q;
        initialize body[i].p;
        initialize body[i].L;

        ComputeDerivedQuantities(&body[i]);
    }
}
```

The numerical differential equation solver is assumed to accept the input state as an array of floating point numbers. The decision to represent a rigid body using the structure RigidBody requires you to copy the state variables into an array for each rigid body.

```
void CopyRigidBodyToStateArray (RigidBody* rb, double* s)
{
    for (i = 0; i < 3; i++)
        *s++ = rb->x[i];  /* copy position */
    for (i = 0; i < 4; i++)
        *s++ = rb->q[i];  /* copy orientation */
    for (i = 0; i < 3; i++)
        *s++ = rb->p[i];  /* copy linear momentum */
    for (i = 0; i < 3; i++)
        *s++ = rb->L[i];  /* copy angular momentum */
}
```

The numerical solver computes an output state for the next time step based on the input state. After doing so, the output state must be copied back into the rigid body structure. The derived quantities are computed after the copy occurs.

```
void CopyStateArrayToRigidBody (double* s, RigidBody* rb)
{
    for (i = 0; i < 3; i++)
        rb->x[i] = *s++;  /* copy position */
    for (i = 0; i < 4; i++)
        rb->q[i] = *s++;  /* copy orientation */
```

```
    for (i = 0; i < 3; i++)
        rb->p[i] = *s++;   /* copy linear momentum */
    for (i = 0; i < 3; i++)
        rb->L[i] = *s++;   /* copy angular momentum */

    ComputeDerivedQuantities(rb);
}
```

In fact, equation (5.13) is set up so that the numerical solver can calculate output state for the entire set of rigid bodies. The state array is a single array of sufficient size to store all rigid body state. We assume two global state arrays, one for the input state and one for the output state.

```
/* STATE_SIZE = (sizeof(point) + sizeof(quaternion) +
                 2 * sizeof(vector)) / sizeof(double) */
#define STATE_SIZE 13
double inState[STATE_SIZE], outState[STATE_SIZE];
```

The input state is initialized by

```
void CopyAllRigidBodiesToStateArray (double* s)
{
    for (i = 0; i < NBODIES; i++)
        CopyRigidBodyToStateArray(&body[i],&s[i*STATE_SIZE]);
}
```

The differential equation solver will generate the output state, which must be copied back to the rigid bodies.

```
void CopyStateArrayToAllRigidBodies (double* s)
{
    for (i = 0; i < NBODIES; i++)
        CopyStateArrayToRigidBody(&s[i * STATE_SIZE],&body[i]);
}
```

This copy occurs after each time step in case other parts of the application require the information. For example, if the rigid body is represented by a triangle mesh and stored in body coordinates, the position and orientation will be needed by the graphics system for the model-to-world transformation matrix that is used to display the object in the world. We will also need a helper function for transferring between the input and output states.

```
void CopyOutStateToInState ()
{
    memcpy(inState,outState,NBODIES * STATE_SIZE * sizeof(double));
}
```

This allows us to call the numerical solver within a loop, each time feeding it the input state.

The numerical differential equation solver requires knowing the initial time t, the initial state $\mathbf{S}(t)$, the time step $\Delta t > 0$, and the right-hand side functions $\mathbf{G}(t, \mathbf{S})$ of the state differential equation. The output of the solver is an approximation to $\mathbf{S}(t + \Delta t)$. Generic solvers require \mathbf{G} to be provided as an array of functions. The solver in [Bar01] is not quite in this form; rather ours takes advantage of the fact that the functions to handle a single rigid body are the same for all other rigid bodies. The solver also assumes a function that computes the force and torque for a rigid body. Finally, the assumption is that the state information is correct for all rigid bodies for the current time.

```
void ComputeForceAndTorque (double t, RigidBody* rb)
{
    /* Application-specific calculations that compute the values
       rb->force and rb->torque. */
}

void ComputeG (RigidBody* rb, double* result)
{
    for (i = 0; i < 3; i++)
        *result++ = rb->v[i];        // dx/dt = p/m = v
    for (i = 0; i < 4; i++)
        *result++ = rb->halfWQ[i];   // dq/dt = w*q/2
    for (i = 0; i < 3; i++)
        *result++ = rb->force[i];    // dp/dt = F
    for (i = 0; i < 3; i++)
        *result++ = rb->torque[i];   // dL/dt = T
}

void G (double t, double* input, double* result)
{
    /* computation of force/torque require bodies to store
       current state */
    CopyStateArrayToAllRigidBodies(input);
    for (i = 0; i < NBODIES; i++)
    {
        ComputeForceAndTorque(t,&body[i]);
        ComputeG(&body[i],&result[i * STATE_SIZE]);
    }
}
```

The differential equation solver is available as a function:

```
typedef void (*GFunction)(double, double*, double*);
void Solve (double t, double dt, double* S0, double* S1, GFunction G);
```

where t is the current time, dt is the time step, S0 is the input state, S1 is the output state, and G is the function corresponding to the right-hand side $\mathbf{G}(t, \mathbf{S})$ of the system of equations. For the sake of illustration, a numerical solver that uses Euler's method follows.

```
void Solve (double t, double dt, double* S0, double* S1,
    GFunction G)
{
    G(t,S0,S1);
    for (i = 0; i < NBODIES * STATE_SIZE; i++)
        S1[i] = S0[i] + dt * S1[i];
}
```

In practice you will most likely use a Runge-Kutta fourth-order solver. Moreover, you will include code for the renormalization of the orientation quaternion after the loop.

Finally, we arrive at the simulation loop, written as a self-contained operation.

```
void DoSimulation ()
{
    InitializeBodyConstants();
    InitializeBodyState();
    CopyAllRigidBodiesToStateArray(outState);

    double t = <your choice of initial time>;
    double dt = <your choice of time step>;
    for (int step = 1; step <= maxSteps; step++, t += dt)
    {
        CopyOutStateToInState();
        Solve(t,dt,inState,outState,G);
        CopyStateArrayToAllRigidBodies(outState);
        /* display bodies and other application work goes here */
    }
}
```

In practice you do not want to tie together the physics and graphics in this manner. Instead, each iteration of the simulation loop is called within the application's idle function to obtain a coarse-level form of time slicing. In that way the various game systems (graphics, physics, networking, AI, etc.) can be scheduled in an appropriate manner.

5.1.2 A PRACTICAL IMPLEMENTATION

Keep in mind that the code and pseudocode shown previously is designed to illustrate how all the pieces come together in the physics simulation. In practice you will want an implementation that is object oriented and more efficient than the illustrative one. Let us take a closer look at the illustrative example.

The main sources of inefficiency are all the copying of data between the RigidBody structures and the state arrays. Assuming Euler's method is in use, manually stepping through the DoSimulation function we have

```
initialize rigid bodies;

/* copy so that rbvalues == outstate */
CopyAllRigidBodiesToStateArray(outState);

step = 1;

/* copy so that instate == outstate */
CopyOutStateToInState();

/* called in G, not necessary to do this */
CopyStateArrayToAllRigidBodies(instate);

/* changed in Solve */
outstate = new values;

/* copy so that rbvalues == outstate */
CopyStateArrayToAllRigidBodies(outstate);
```

An invariant of the loop is that the rigid bodies and the output state array always store the same values. Note that the CopyStateArrayToAllRigidBodies function call within the function G is not necessary because the rigid bodies already have the same values as the input state at that moment. A differential equation solver using multiple function evaluations, when used in the illustrative code, does require the copy. For example, the midpoint method uses two function evaluations. The implementation of the solver for this method is

```
void Solve (double t, double dt, double* S0, double* S1,
    GFunction G)
{
    G(t,S0,S1);
    for (i = 0; i < NBODIES * STATE_SIZE; i++)
        V[i] = S0[i] + 0.5 * dt * S1[i];

    G(t + 0.5 * dt,V,S1);
```

```
        for (i = 0; i < NBODIES * STATE_SIZE; i++)
            S1[i] = S0[i] + dt * S1[i];
}
```

This solver does require a temporary array V of the same size as the state arrays. Manually stepping through the simulation:

```
initialize rigid bodies;

/* copy so that rbvalues == outstate */
CopyAllRigidBodiesToStateArray(outState);

step = 1;

/* copy so that instate == outstate */
CopyOutStateToInState();

/* called in G, not necessary to do this */
CopyStateArrayToAllRigidBodies(instate);

V = temporary values;

/* called in G, necessary since rbvalues != V */
CopyStateArrayToAllRigidBodies(V);

/* changed in Solve */
outstate = new values;

/* copy so that rbvalues == outstate */
CopyStateArrayToAllRigidBodies(outstate);
```

The copy in the first call of G is not necessary, but the second one is. The rigid body values are the same as the input state values after the first call, but the rigid body values need to be set to temporary V values for the second call. The copy in that second call guarantees that the computation for force and torque will occur with the current body values and that the computations in ComputeG will occur with the current values.

The redundant copy in the first call of G is easily remedied by adding a Boolean parameter.

```
void G (bool doCopy, double t, double* input, double* result)
{
    if ( doCopy )
        CopyStateArrayToAllRigidBodies(input);
```

```
for (i = 0; i < NBODIES; i++)
{
    ComputeForceAndTorque(t,&body[i]);
    ComputeG(&body[i],&result[i * STATE_SIZE]);
}
}
```

Euler's method calls G(false,t,S0,S1), whereas the midpoint method calls G(false, t,S0,S1) the first time and G(true,t + 0.5 * dt,V,S1) the second time.

But why are we copying in the first place? The design of the structure RigidBody is intended to allow public access to human-readable data members. The design of the state array is to be true to the formulation of equation (5.13). Neither design is necessary. Instead, we will use an object-oriented approach whereby the interface hides the representation of the data and allows access to it through public member functions. The main design goal of our rigid body class is to encapsulate the state handling to support a simulation of the form:

```
void DoSimulation ()
{
    RigidBody body[n];
    for (i = 0; i < n; i++)
        body[i].Initialize(<parameters>);

    double t = <your choice of initial time>;
    double dt = <your choice of time step>;
    for (int step = 1; step <= maxSteps; step++, t += dt)
    {
        for (i = 0; i < n; i++)
            body[i].Update(t,dt);

        /* display bodies and other application work goes here */
    }
}
```

The class definition is shown next. The position is X, the orientation as a quaternion is Q, the linear momentum is P, the angular momentum is L, the orientation as a matrix is R, the linear velocity is V, and the angular velocity is W. The mass is mass and the inertia tensor in body coordinates is inertia. The interface is written in a simplified manner for illustrative purposes. The actual interface in the source code is more extensive.

```
class RigidBody
{
public:
    RigidBody (double mass, matrix inertia);
```

```
    virtual ~RigidBody ();

    void SetState (point X, quaternion Q, vector P, vector L);
    void GetState (point& X, quaternion& Q, vector& P, vector& L);

    // force/torque function format
    typedef vector (*Function)
    (
        double,       // time of application
        point,        // position
        quaternion,   // orientation
        vector,       // linear momentum
        vector,       // angular momentum
        matrix,       // orientation
        vector,       // linear velocity
        vector        // angular velocity
    );

    // for computing external forces and torques
    void SetForceFunction (Function force);
    void SetTorqueFunction (Function torque);

    // Runge-Kutta fourth-order differential equation solver
    void Update (double t, double dt);

protected:
    // convert (Q,P,L) to (R,V,W)
    void Convert (quaternion Q, vector P, vector L,
        matrix& R, vector& V, vector& W) const;

    // constant quantities
    double m_mass, m_invMass;
    matrix m_inertia, m_invInertia;

    // state variables
    vector m_X;       // position
    quaternion m_Q;   // orientation
    vector m_P;       // linear momentum
    vector m_L;       // angular momentum

    // derived state variables
    matrix m_R;       // orientation matrix
    vector m_V;       // linear velocity
    vector m_W;       // angular velocity
```

```
// force and torque functions
Function m_force;
Function m_torque;
};
```

The constructor and the SetState member function make up the initialization portion of the physical simulation. The conversion from the primary state (quaternion orientation, linear momentum, and angular momentum) to the secondary state (matrix orientation, linear velocity, and angular velocity) is handled via the member function Convert. The conversions require access to the rigid body mass and inertia tensor, thus this function is nonstatic.

```
void RigidBody::Convert (quaternion Q, vector P, vector L,
    matrix& R, vector& V, vector& W) const
{
    Q.ToRotationMatrix(R);
    V = m_invMass * P;
    W = R * m_invInertia * Transpose(R) * L;
}
```

Rather than having force and torque data members to store the current force and torque, we use function pointers. The force and torque vectors are required only during the differential equation update step, so there is no need to store the vectors with the rigid body. The force and torque functions take as input the current time and a list of state information. As noted earlier, one of the reasons the illustrative example code copies data from the state array to the rigid bodies during the multifunction evaluation differential equation solver is to make sure that the force and torque are computed with the current state values. These state values persist only for the lifetime of the update call of the solver since they are only needed temporarily by the multifunction evaluation algorithm. They may as well be stack variables, the main consequence being that the global state arrays are no longer necessary; each rigid body is now responsible for updating itself. The member function Update implements a Runge-Kutta fourth-order solver.

```
void RigidBody::Update (double t, double dt)
{
    double halfdt = 0.5 * dt, sixthdt = dt / 6.0;
    double tphalfdt = t + halfdt, tpdt = t + dt;

    vector XN, PN, LN, VN, WN;
    quaternion QN;
    matrix RN;

    // A1 = G(t,S0), B1 = S0 + (dt / 2) * A1
    vector A1DXDT = m_V;
```

```
    quaternion A1DQDT = 0.5 * m_W * m_Q;
    vector A1DPDT = m_force(t,m_X,m_Q,m_P,m_L,m_R,m_V,m_W);
    vector A1DLDT = m_torque(t,m_X,m_Q,m_P,m_L,m_R,m_V,m_W);
    XN = m_X + halfdt * A1DXDT;
    QN = m_Q + halfdt * A1DQDT;
    PN = m_P + halfdt * A1DPDT;
    LN = m_L + halfdt * A1DLDT;
    Convert(QN,PN,LN,RN,VN,WN);

    // A2 = G(t + dt / 2,B1), B2 = S0 + (dt / 2) * A2
    vector A2DXDT = VN;
    quaternion A2DQDT = 0.5 * WN * QN;
    vector A2DPDT = m_force(tphalfdt,XN,QN,PN,LN,RN,VN,WN);
    vector A2DLDT = m_torque(tphalfdt,XN,QN,PN,LN,RN,VN,WN);
    XN = m_X + halfdt * A2DXDT;
    QN = m_Q + halfdt * A2DQDT;
    PN = m_P + halfdt * A2DPDT;
    LN = m_L + halfdt * A2DLDT;
    Convert(QN,PN,LN,RN,VN,WN);

    // A3 = G(t + dt / 2,B2), B3 = S0 + dt * A3
    vector A3DXDT = VN;
    quaternion A3DQDT = 0.5 * WN * QN;
    vector A3DPDT = m_force(tphalfdt,XN,QN,PN,LN,RN,VN,WN);
    vector A3DLDT = m_torque(tphalfdt,XN,QN,PN,LN,RN,VN,WN);
    XN = m_X + dt * A3DXDT;
    QN = m_Q + dt * A3DQDT;
    PN = m_P + dt * A3DPDT;
    LN = m_L + dt * A3DLDT;
    Convert(QN,PN,LN,RN,VN,WN);

    // A4 = G(t + dt,B3), S1 = S0 + (dt / 6) * (A1 + 2 * A2 + 2 * A3 + A4)
    vector A4DXDT = VN;
    quaternion A4DQDT = 0.5 * WN * QN;
    vector A4DPDT = m_force(tpdt,XN,QN,PN,LN,RN,VN,WN);
    vector A4DLDT = m_torque(tpdt,XN,QN,PN,LN,RN,VN,WN);
    m_X = m_X + sixthdt * (A1DXDT + 2.0 * (A2DXDT + A3DXDT) + A4DXDT);
    m_Q = m_Q + sixthdt * (A1DQDT + 2.0 * (A2DQDT + A3DQDT) + A4DQDT);
    m_P = m_P + sixthdt * (A1DPDT + 2.0 * (A2DPDT + A3DPDT) + A4DPDT);
    m_L = m_L + sixthdt * (A1DLDT + 2.0 * (A2DLDT + A3DLDT) + A4DLDT);
    Convert(m_Q,m_P,m_L,m_R,m_V,m_W);
}
```

After each call to Update, all rigid body state variables have correct and consistent information due to the last call to Convert.

5.2 CONSTRAINED MOTION

The previous section was about the unconstrained motion of rigid bodies that are assumed not to interact with each other. We used the equations of motion that follow from Newtonian dynamics, a natural choice in the absence of constraints on the bodies. In realistic applications we, in fact, have to deal with interaction among many objects. A physics engine must decide what to do when two objects collide. The approach in [Bar01] is to enforce *nonpenetration constraints*. When one object collides with another, the two are not allowed to penetrate into each other. Despite the constraints imposed by collisions between objects, the Newtonian approach is still used to drive the physical simulation. The collision response for objects in contact falls into two categories based on how the objects collide at a point, either a *colliding contact* or a *resting contact*. When all contact points are known, the differential equation solver is interrupted during the simulation and the various physical parameters are adjusted based on the type of contact. The solver is then restarted using the new parameters. Adjustment of the physical parameters at points of colliding contact requires the introduction of *impulsive forces*. Adjustment of the physical parameters at points of resting contact requires computing *contact forces*. Sections 5.2.1 and 5.2.2 cover these topics in detail. The Baraff approach is quite popular with people interested in adding physical simulations to their games, but this approach is not the only way to go about handling the physics. For example, Section 5.2.5 presents an alternative that is based on Lagrangian dynamics, a natural choice for dealing with motion in the presence of constraints.

5.2.1 COLLISION POINTS

Let us now define what is meant by colliding contact and resting contact. At a point of contact of two objects we need to decide how the objects will continue moving, the collision response, so to speak. For example, if a rigid ball strikes a flat surface at an angle, you most likely want the ball to bounce away from the surface. In particular, your natural instinct is to reflect the velocity vector through the normal of the surface so that the angle of incidence is equal to the angle of reflection. This type of contact between moving rigid bodies is called *colliding contact* because the velocities of the bodies cause them to tend to penetrate into each other. Figure 5.1(a) shows a point of colliding contact.

The velocity of body A, shown in Figure 5.1(a) as \mathbf{V}_A, has direction into the body B at the point of contact \mathcal{P}. If A has zero velocity at \mathcal{P} or has velocity perpendicular to the surface of body B at \mathcal{P}, the point of contact is said to be a *resting contact*. This situation is shown in part (b) of the figure. The last possibility is that bodies A and B are separating, as shown in part (c) of the figure. The figure also shows a normal vector \mathbf{N} to the surface of body B at the contact point \mathcal{P}. The algebraic quantity

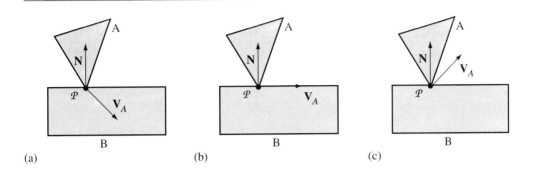

Figure 5.1 (a) Colliding contact. Body A moves into body B. (b) Resting contact. Body A rests on body B and attempts neither to move into B nor to separate from B. Body A is allowed to slide along B. (c) Separation. Body A has a velocity that separates it from body B.

that distinguishes between the three cases is the magnitude of the velocity \mathbf{V}_A in the direction of the normal \mathbf{N}:

$$\mathbf{N} \cdot \mathbf{V}_A < 0 \qquad \text{Colliding contact}$$

$$\mathbf{N} \cdot \mathbf{V}_A = 0 \qquad \text{Resting contact} \qquad\qquad (5.14)$$

$$\mathbf{N} \cdot \mathbf{V}_A > 0 \qquad \text{Separation}$$

The dot product $\mathbf{N} \cdot \mathbf{V}_A$ is the speed of body A in the normal direction.

Recall that we are restricting our attention to rigid bodies in the shape of convex polyhedra. The contact set between two convex polyhedra is potentially more complicated than just a single point that arises because of a vertex-face intersection. The set is infinite in the case of edge-face or face-face intersections. To simplify matters we will work with a *reduced contact set* that consists only of vertex-face or edge-edge intersections, the latter case only when the edges are not parallel. If the collision system detects an edge-face intersection, we will record only an edge end point (a vertex) if it is contained in the face and an edge-edge intersection point if the edge overlaps an edge of the face. If a face-face intersection is detected, the only recorded points are vertices of one face contained in the other face or edge-edge intersections, one edge from each face. Figure 5.2 illustrates this.

The point \mathcal{P}_0 is generated by a vertex of B and a face of A; the point \mathcal{P}_2 is generated by a vertex of A and a face of B; and points \mathcal{P}_1 and \mathcal{P}_3 are generated by edges of A and B.

The reduction to a finite point set helps to minimize the time spent in the physical simulation. However, this is only an approximation to the actual physics. If our target goal is N frames per second, the computational time available for one frame is $1/N$

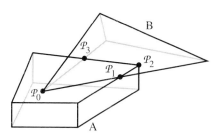

Figure 5.2 The reduced contact set for two convex polyhedra A and B.

seconds. If the physics simulation does not use all of this time, ideally we would calculate the line segment of intersection in an edge-face intersection or the polygon of intersection in a face-face intersection, then proceed with the collision response accordingly. We also process the reduced contact set a point at a time. The collision response becomes dependent on the order and is not quite physically correct. This can be a problem, especially when a rigid body makes simultaneous contact with two (or more) other rigid bodies.

5.2.2 COLLISION RESPONSE FOR COLLIDING CONTACT

Let us now formulate how our physics simulation will respond at a point of colliding contact. Let t_0 denote the first time of contact between a pair of rigid bodies A and B. Let \mathcal{P}_0 be the contact point. If the point is a vertex-face intersection, we choose the convention that the vertex is from the first body and the face is from the second body. Let \mathbf{N}_0 be the unit-length, outer pointing normal for the face. If the point is an edge-edge intersection, let \mathbf{N}_0 be the unit-length cross product of the edge directions. The vector is chosen to point outside the second body of the pair. For a brief time interval before the collision, the path of the point on the first body contributing to the intersection is $\mathcal{P}_A(t)$ for $t \leq t_0$, and $\mathcal{P}_A(t_0) = \mathcal{P}_0$. During that same time interval the second body is (potentially) moving; the path of the point on it that contributes to the intersection is $\mathcal{P}_B(t)$ for $t \leq t_0$, and $\mathcal{P}_B(t_0) = \mathcal{P}_0$. Backing up in time, the normal vector at the point on the second body contributing to the intersection is $\mathbf{N}(t)$, and $\mathbf{N}(t_0) = \mathbf{N}_0$. The signed distance between the body points contributing to the intersection, as measured in the normal direction, is

$$d(t) = \mathbf{N}(t) \cdot (\mathcal{P}_A(t) - \mathcal{P}_B(t)) \tag{5.15}$$

The velocity component in the normal direction has magnitude

$$\dot{d}(t) = \mathbf{N}(t) \cdot (\dot{\mathcal{P}}_A(t) - \dot{\mathcal{P}}_B(t)) + \dot{\mathbf{N}}(t) \cdot (\mathcal{P}_A(t) - \mathcal{P}_B(t)) \tag{5.16}$$

At the instant of contact, $d(t_0) = 0$ and $\dot{d}(t_0) = \mathbf{N}_0 \cdot (\dot{\mathcal{P}}_A(t_0) - \dot{\mathcal{P}}_B(t_0))$. The quantity $\dot{d}(t_0)$ is exactly what was mentioned in equation (5.14) for determining the type of contact point that \mathcal{P}_0 is.

In Section 2.2 on kinematics, we derived the velocity equation for a particle, namely, equation (2.43). We have two particles in motion, hence two velocity equations:

$$\dot{\mathcal{P}}_A = \mathbf{v}_A + \mathbf{w}_A \times \mathbf{r}_A, \qquad \dot{\mathcal{P}}_B = \mathbf{v}_B + \mathbf{w}_B \times \mathbf{r}_B \qquad (5.17)$$

where \mathbf{v}_C is the velocity of the center of mass \mathcal{X}_C of body C (C is either A or B), \mathbf{w}_C is the angular velocity of the body about its center of mass, and $\mathbf{r}_C = \mathcal{P}_C - \mathcal{X}_C$ is the location of the point relative to the center of mass. Equation (2.43) also had a term $D\mathbf{r}_C/Dt$, but for rigid bodies it is the zero vector. At the contact time, the speed of \mathcal{P}_0 in the normal direction \mathbf{N}_0 is

$$d(t_0) = \mathbf{N}_0 \cdot ((\mathbf{v}_A(t_0) + \mathbf{w}_A(t_0) \times \mathbf{r}_A(t_0)) - (\mathbf{v}_B(t_0) + \mathbf{w}_A(t_0) \times \mathbf{r}_B(t_0))) \quad (5.18)$$

All the quantities on the right-hand side of this equation are known during the physics simulation at the contact time and are stored as part of the state information of the rigid body, just as in the case of unconstrained motion. Thus, after the collision detection system reports all contact points, we may iterate over them and determine which of them are colliding contacts, resting contacts, or separating points.

Impulses

To prevent interpenetration at \mathcal{P}_0 when $\dot{d}(t_0) < 0$, the relative velocity $\dot{\mathcal{P}}_A(t) - \dot{\mathcal{P}}_B(t)$ must be changed in a discontinuous manner. Of course, this is not physically possible since any forces acting on the bodies takes some time to change the velocity smoothly.

EXAMPLE 5.1

To illustrate, consider a one-dimensional problem where a particle located at $x(t)$ on a line travels with constant velocity $\dot{x}(t) = v_0 > 0$. The implication, of course, is that no forces are acting on the particle. The path of motion is $x(t) = x_0 + v_0 t$, where x_0 is the initial position of the particle. If the particle strikes an object located at $x_1 > x_0$ at time $t_0 > 0$, so that $x_1 = x_0 + v_0 t_0$, you would expect the object to give way over some time interval $[t_0, t_0 + \varepsilon]$, for a small positive ε. During this interval the particle and object remain in contact at the common position $x(t) = x_1 + p(t)$ for some function $p(t)$ such that $p(t_0) = 0$, $\dot{p}(t_0) = v_0$, $p(t_0 + \varepsilon) = 0$, and $p(t) > 0$ for $t \in (t_0, t_0 + \varepsilon)$. For illustrative purposes, let $p(t) = v_0(t - t_0)(t_0 + \varepsilon - t)/\varepsilon$ whose graph is a parabola. During the interval of contact the velocity of the particle is $\dot{x}(t) = \dot{p}(t) = v_0(\varepsilon - 2(t - t_0))/\varepsilon$. At the first contact, $v_0 = \dot{x}(t_0) = \dot{p}(t_0)$. At time $t_0 + \varepsilon/2$ the particle and object come to rest, $\dot{x}(t_0 + \varepsilon/2) = 0$. The particle then reverses direction. At time $t_0 + \varepsilon$ the particle's velocity is $\dot{x}(t_0 + \varepsilon) = -v_0$.

(Example 5.1 continued)

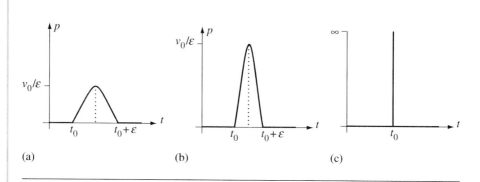

(a) (b) (c)

Figure 5.3 The effects on $p(t)$ as ε approaches zero: (a) small ε; (b) smaller ε; and (c) really small ε (like zero).

The particle had velocity v_0 at time t_0 and now has the opposite velocity $-v_0$ at time $t_0 + \varepsilon$. The change in velocity occurred over a time period of duration $\varepsilon > 0$. This is true no matter how small the duration is, so consider taking a limit and let ε go to zero. Intuitively, by letting $\varepsilon = 0$, we have changed the velocity in a discontinuous manner:

$$\dot{x}(t) = \begin{cases} v_0, & t \le t_0 \\ -v_0, & t > t_0 \end{cases}$$

Mathematically, however, the limit is not defined. Consider what has to happen to $p(t)$ as ε approaches zero. Figure 5.3 shows the graph of $p(t)$ for various values of ε.

The interval on which $p(t) > 0$ gets smaller while the maximum value of p, namely, v_0/ε, gets larger. The limiting function appears to be

$$\delta(t - t_0) = \begin{cases} 0, & t \ne t_0 \\ \infty, & t = t_0 \end{cases}$$

The physicists refer to $\delta(t - t_0)$ as the *Dirac delta function*. It is not a function in the mathematical sense, but the mathematicians refer to such an entity as a *generalized function*. Its properties are defined in terms of integrals rather than using the informal definition. For example, one important property is

$$\int_0^t g(\tau)\delta(\tau - t_0)\,d\tau = \begin{cases} g(t_0) & \text{if } 0 \le t_0 \le t \\ 0 & \text{otherwise} \end{cases} \tag{5.19}$$

In the special case when $g(t) \equiv 1$ we have $\int_0^t \delta(\tau - t_0)\,d\tau = u(t - t_0)$, where $u(s) = 1$ for $s \ge 0$ and $u(s) = 0$ for $s < 0$. The velocity of our particle is consequently

$\dot{x}(t) = v_0(1 - 2u(t - t_0))$ and the acceleration is $\ddot{x}(t) = -2v_0\delta(t - t_0)$. The quantity $f(t) = -2mv_0\delta(t - t_0)$ is referred to as an *impulsive force*. ▨

For a discussion of delta functions in the context of differential equations, see [Bra84]. A key idea discussed in that book is that an integration of Newton's second law of motion produces

$$m\mathbf{v}(t) - m\mathbf{v}(0) = \int_0^t \mathbf{F}(\tau)\, d\tau$$

The integral on the right-hand side of this equation is called the *impulse imparted by the force*. If we allow the force $\mathbf{F}(t)$ to include impulsive forces as motivated by Example 5.1, then we can cause a discontinuity in the linear momentum of the system. This is exactly what we do in our physical simulation at a point of colliding contact.

Computing the Change of Velocity

Rather than constructing an impulsive function that leads to a discontinuous change in velocity at a point of colliding contact, we will select the desired velocity to be used at that point *after* the impulse is applied. I mentioned earlier that the intuitive choice you want to make for the new velocity is a reflection of the old velocity through the normal vector. That is, if \mathbf{v}^- is the (relative) velocity before the impulse and \mathbf{N} is the unit-length outer pointing normal, you can write

$$\mathbf{v}^- = \mathbf{N}^\perp + (\mathbf{N} \cdot \mathbf{v}^-)\mathbf{N}$$

where \mathbf{N}^\perp is that portion of \mathbf{v}^- after projecting out the component in the \mathbf{N} direction. The velocity after the impulse is selected to be

$$\mathbf{v}^+ = \mathbf{N}^\perp - (\mathbf{N} \cdot \mathbf{v}^-)\mathbf{N}$$

Figure 5.4(a) illustrates the reflection.

The perfect reflection represents no loss of kinetic energy during the collision event. We may, however, want to incorporate loss of energy to make the collision response a bit more realistic. We can do this by introducing a *coefficient of restitution*, $\varepsilon \in [0, 1]$, and generate a postimpulse velocity of

$$\mathbf{v}^+ = \mathbf{N}^\perp - \varepsilon(\mathbf{N} \cdot \mathbf{v}^-)\mathbf{N}$$

Figure 5.4(c) shows such a vector. No kinetic energy is lost when $\varepsilon = 1$ and the reflection is perfect. The maximum amount of kinetic energy is lost when $\varepsilon = 0$ and the bodies remain in contact at the contact point, a change from colliding contact to resting contact.

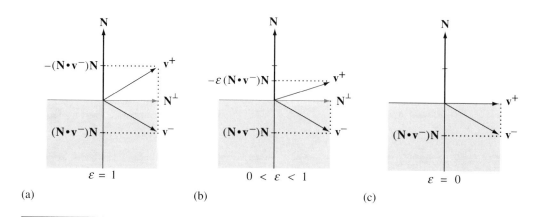

Figure 5.4 (a) Reflection of the preimpulse velocity \mathbf{v}^- through the contact normal to obtain the postimpulse velocity \mathbf{v}^+. (b) An imperfect reflection that represents a loss of kinetic energy. (c) An imperfect reflection that represents a maximum loss of kinetic energy.

In the following discussion, the contact time t_0 is omitted from function arguments for clarity. Let $\dot{\mathcal{P}}_A^-$ and $\dot{\mathcal{P}}_A^+$ denote preimpulse and postimpulse velocities for \mathcal{P}_0 as measured from body A. Let $\dot{\mathcal{P}}_B^-$ and $\dot{\mathcal{P}}_B^+$ denote the similar quantities for body B. From equation (5.17) we have

$$\dot{\mathcal{P}}_A^{\pm} = \mathbf{v}_A^{\pm} + \mathbf{w}_A^{\pm} \times \mathbf{r}_A, \qquad \dot{\mathcal{P}}_B^{\pm} = \mathbf{v}_B^{\pm} + \mathbf{w}_B^{\pm} \times \mathbf{r}_B \tag{5.20}$$

where the use of the plus and minus superscripts on the velocity terms is clear from context. The impulsive force changes velocities at the contact time but not the positions of \mathcal{P}_0 relative to the centers of mass, so the \mathbf{r} terms do not require plus/minus superscripts.

Let us begin by postulating an impulsive force $\mathbf{F} = f\mathbf{N}_0$ that affects body A at the colliding contact point. The scalar f is the magnitude of the impulse that we need to compute to obtain the desired postimpulse velocity vector. The impulsive force has a contribution that changes the velocity of the center of mass, $f\mathbf{N}_0/m_A$, where m_A is the mass of body A. The preimpulse and postimpulse linear velocities are related by

$$\mathbf{v}_A^+ = \mathbf{v}_A^- + \frac{f\mathbf{N}_0}{m_A} \tag{5.21}$$

The corresponding change in linear momentum is $\mathbf{p}_A^+ = \mathbf{p}_A^- + f\mathbf{N}_0$. The impulsive force also has a contribution that changes the angular velocity of the body via an impulsive torque, $J_A^{-1}(\mathbf{r}_A \times f\mathbf{N}_0)$, where J_A is the inertia tensor at the contact time

and is measured in world coordinates. The preimpulse and postimpulse angular velocities are related by

$$\mathbf{w}_A^+ = \mathbf{w}_A^- + J_A^{-1}(\mathbf{r}_A \times f\mathbf{N}_0) \tag{5.22}$$

The corresponding change in angular momentum is $\mathbf{L}_A^+ = \mathbf{L}_A^- + \mathbf{r}_A \times f\mathbf{N}_0$. Substituting equations (5.21) and (5.22) into the velocity equation (5.20) and applying a few algebraic steps produces

$$\dot{\mathcal{P}}_A^+ = \dot{\mathcal{P}}_A^- + f\left(\frac{\mathbf{N}_0}{m_A} + J_A^{-1}(\mathbf{r}_A \times \mathbf{N}_0)\right) \times \mathbf{r}_A \tag{5.23}$$

The opposite direction impulsive force $-\mathbf{F}$ is applied to body B. A construction similar to the previous one produces $\mathbf{v}_B^+ = \mathbf{v}_B^- - f\mathbf{N}_0/m_B$, $\mathbf{p}_B^+ = \mathbf{p}_B^- - f\mathbf{N}_0$, $\mathbf{w}_B^+ = \mathbf{w}_B^- - J_B^{-1}(\mathbf{r}_B \times f\mathbf{N}_0)$, $\mathbf{L}_B^+ = \mathbf{L}_B^- - \mathbf{r}_B \times f\mathbf{N}_0$, and

$$\dot{\mathcal{P}}_B^+ = \dot{\mathcal{P}}_B^- - f\left(\frac{\mathbf{N}_0}{m_B} + J_B^{-1}(\mathbf{r}_B \times \mathbf{N}_0)\right) \times \mathbf{r}_B \tag{5.24}$$

Equations (5.23) and (5.24) are combined to form the relative velocity

$$\dot{\mathcal{P}}_A^+ - \dot{\mathcal{P}}_B^+ = (\dot{\mathcal{P}}_A^- - \dot{\mathcal{P}}_B^-) \tag{5.25}$$

$$+ f\left(\frac{\mathbf{N}_0}{m_A} + \frac{\mathbf{N}_0}{m_B} + (J_A^{-1}(\mathbf{r}_A \times \mathbf{N}_0)) \times \mathbf{r}_A + (J_B^{-1}(\mathbf{r}_B \times \mathbf{N}_0)) \times \mathbf{r}_B\right)$$

The final step in computing the magnitude f involves our choice of how the postimpulse relative velocity relates to the preimpulse one. In particular, we choose a coefficient of restitution $\varepsilon \in [0, 1]$ and require that

$$\mathbf{N}_0 \cdot (\dot{\mathcal{P}}_A^+ - \dot{\mathcal{P}}_B^+) = -\varepsilon\mathbf{N}_0 \cdot (\dot{\mathcal{P}}_A^- - \dot{\mathcal{P}}_B^-) \tag{5.26}$$

Dot equation (5.25) with \mathbf{N}_0, substitute equation (5.26) into the left-hand side, use equation (5.20), and solve to obtain

$$f = \frac{-(1 + \varepsilon)(\mathbf{N}_0 \cdot (\mathbf{v}_A^- - \mathbf{v}_B^-) + (\mathbf{w}_A^- \cdot (\mathbf{r}_A \times \mathbf{N}_0) - \mathbf{w}_B^- \cdot (\mathbf{r}_B \times \mathbf{N}_0)))}{m_A^{-1} + m_B^{-1} + (\mathbf{r}_A \times \mathbf{N}_0)^{\mathrm{T}} J_A^{-1}(\mathbf{r}_A \times \mathbf{N}_0) + (\mathbf{r}_B \times \mathbf{N}_0)^{\mathrm{T}} J_B^{-1}(\mathbf{r}_B \times \mathbf{N}_0)} \tag{5.27}$$

where $\mathbf{r}_A = \mathcal{P}_0 - \mathcal{X}_A$ and $\mathbf{r}_B = \mathcal{P}_0 - \mathcal{X}_B$. Some algebraic steps were performed to factor out the common expressions $\mathbf{r}_A \times \mathbf{N}_0$ and $\mathbf{r}_B \times \mathbf{N}_0$. The right-hand side of equation (5.27) depends only on constants $(\varepsilon, m_A^{-1}, J_A^{-1}, m_B^{-1}, J_B^{-1})$, preimpulse rigid body state $(\mathcal{X}_A, \mathbf{v}_A^-, \mathbf{w}_A^-, \mathcal{X}_B, \mathbf{v}_B^-, \mathbf{w}_B^-)$, and the contact information $(\mathcal{P}_0, \mathbf{N}_0)$. The inverse inertia tensors J_A^{-1} and J_B^{-1} are positive definite, implying $\boldsymbol{\xi}^{\mathrm{T}} J_A^{-1} \boldsymbol{\xi} > 0$ and $\boldsymbol{\xi}^{\mathrm{T}} J_B^{-1} \boldsymbol{\xi} > 0$ for any $\boldsymbol{\xi} \neq \mathbf{0}$. Consequently, the denominator of f must be positive, so the division is not of numerical concern in an implementation.

Pseudocode for processing a point of colliding contact follows and uses the `RigidBody` structure discussed in the illustrative implementation for unconstrained motion.

```
void ProcessCollidingContact (RigidBody A, RigidBody B, point P,
    vector N)
{
    // compute impulse force
    const double e = <coefficient of restitution>;
    vector rA = P - A.x;
    vector rB = P - B.x;
    vector kA = Cross(rA,N);
    vector kB = Cross(rB,N);
    vector uA = A.jinv * kA;
    vector uB = B.jinv * kB;
    double fNumer = -(1 + e) * (Dot(N,A.v - B.v) + Dot(A.w,kA)
        - Dot(B.w,kA));
    double fDenom = A.massinv + B.massinv + Dot(kA,uA)
        + Dot(kB,uB);
    double f = fNumer / fDenom;
    vector impulse = f * N;

    // apply impulse to bodies to change linear/angular momentum
    A.p += impulse;
    B.p -= impulse;
    A.L += f * kA;
    B.L -= f * kB;

    // compute derived quantities, linear/angular velocity
    A.v = A.p * A.massinv;
    B.v = A.p * B.massinv;
    A.w += f * uA;
    B.w += f * uB;
}
```

Notice that this function does not modify the centers of mass or orientations of the rigid bodies. Only the differential equation solver may change these quantities and only because of a positive increment in time. The colliding contact processing represents the application of an impulse at the current instant of time.

Before we look at a couple of simple examples, let us make an observation. In virtual environments you will want some immovable objects, the ground clearly an ideal candidate. We can simulate an immovable object by specifying that it has infinite mass and infinite principal moments, the former preventing translation of the center of mass, the latter preventing rotation about the center of mass. Since our simulations

are using only the inverse mass and inverse inertia tensor, we can instead set the inverse mass to zero and the inverse inertia tensor to the zero matrix. The velocities and momenta of an immovable object should also be set to zero. The values for the center of mass and orientation are irrelevant in the simulation.

EXAMPLE 5.2

Consider a constant density square traveling with constant linear velocity toward a sloped plane of 45 degrees from the horizontal. The square is assumed to have zero angular velocity (not rotating about its center). The sloped plane is immovable. The coefficient of restitution is assumed to be $\varepsilon = 1$ for a completely elastic collision. *Gravity is not assumed here.* Figure 5.5 illustrates.

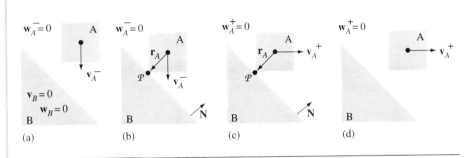

Figure 5.5

(a) The square traveling toward a sloped plane. (b) The preimpulse configuration at the instant of contact. (c) The postimpulse configuration at the instant of contact. (d) The square moving away from the plane.

The square is labeled as body A and the slope as body B. Since the slope is immovable, $\mathbf{v}_B = \mathbf{w}_B = \mathbf{0}$ always, and $m_B^{-1} = 0$ and $J_B^{-1} = 0$.

The point of contact is \mathcal{P} and the unit-length outer pointing normal to the slope is \mathbf{N}. The position of the contact point relative to body A is $\mathbf{r}_A = \mathcal{P} - \mathcal{X}_A$, where \mathcal{X}_A is the center of mass of A. In this special situation of a square and 45 degree slope, the normal is $\mathbf{N} = -\mathbf{r}_A/|\mathbf{r}_A|$, in which case $\mathbf{r}_A \times \mathbf{N} = \mathbf{0}$. The impulse magnitude is $f = -2m_A\mathbf{N} \cdot \mathbf{v}_A^-$. The postimpulse linear velocity is $\mathbf{v}_A^+ = \mathbf{v}_A^- - 2(\mathbf{N} \cdot \mathbf{v}_A^-)\mathbf{N}$ and the postimpulse angular velocity is $\mathbf{w}_A^+ = \mathbf{w}_A^- + f J_A^{-1}(\mathbf{r}_A \times \mathbf{N}) = \mathbf{0}$. Therefore, the square travels downward and bounces to the right with no change in linear speed or angular velocity. ▪

EXERCISE 5.1 Ⓔ

Did you expect the result of Example 5.2 to be that the square obtains a nonzero angular velocity and starts to rotate after the impulse is applied? Speculate why the square maintains a zero angular velocity.

Suppose body A is rectangular in shape, but not a square, and axis-aligned as the square was. At the point of contact the normal \mathbf{N} and the relative position \mathbf{r}_A are not parallel, so $\mathbf{u} = \mathbf{r}_A \times \mathbf{N} \neq 0$. Show that the postimpulse velocities are

$$\mathbf{v}_A^+ = \mathbf{v}_A^- - \frac{2\mathbf{N} \cdot \mathbf{v}_A^-}{1 + \mathbf{u}^T m_A J_A^{-1} \mathbf{u}} \mathbf{N}, \qquad \mathbf{w}_A^+ = -\frac{2\mathbf{N} \cdot \mathbf{v}_A^-}{1 + \mathbf{u}^T m_A J_A^{-1} \mathbf{u}} m_A J_A^{-1} \mathbf{u}$$

Make an intuitive argument that if the rectangle is wider than tall, the angular velocity corresponds to a clockwise rotation around the vector pointing out of the plane of the figure toward you. Similarly, argue that if the rectangle is taller than wide, the angular velocity corresponds to a counterclockwise rotation about that same vector. Now analyze the term $J_A^{-1}\mathbf{u}$ and show how its values relate to the direction of rotation.

Multiple Contact Points

Example 5.2 and Exercise 5.1 are useful as a simple verification of the ideas regarding impulses. Both involve a two-dimensional setting. What happens in a three-dimensional setting? Specifically, let us add thickness to the rectangle of Exercise 5.1 and consider an axis-aligned box that is traveling vertically toward the sloped plane in such a way that the contact occurs along an entire edge of the box. Figure 5.6 illustrates.

According to the convention mentioned earlier, the collision detection system will report only the end points of the edge as collision points. I previously made an innocuous statement about processing the collision points sequentially. The conse-

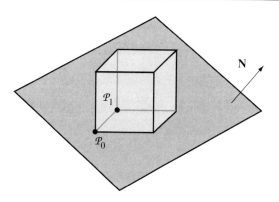

Figure 5.6 An axis-aligned box colliding with a sloped plane along an entire edge of the box, $(1 - s)\mathcal{P}_0 + s\mathcal{P}_1$ for $s \in [0, 1]$.

quences of doing so must be weighed against the extra time needed to implement a system that can handle points simultaneously.

Let us process the contact points sequentially starting with \mathcal{P}_0. The relative position in body A is $\mathbf{r}_0 = \mathcal{P}_0 - \mathcal{X}_A$. Define $\mathbf{u}_0 = \mathbf{r}_0 \times \mathbf{N}$. The magnitude of the impulsive force and the postimpulse velocities are

$$f_0 = -\frac{2m_A \mathbf{N} \cdot \mathbf{v}_A^-}{1 + \mathbf{u}_0^T m_A J_A^{-1} \mathbf{u}_0}, \qquad \mathbf{v}_A^+ = \mathbf{v}_A^- + (f_0 \mathbf{N})/m_A, \qquad \mathbf{w}_A^+ = f_0 J_A^{-1} \mathbf{u}_0$$

In our full three-dimensional setting, $J_A^{-1} \mathbf{u}_0$ is not the zero vector! This means that the box's postimpulse angular velocity is not zero and the box will begin rotating. Now for the conundrum. Do we process the impulsive force at \mathcal{P}_1 next? Or should we run one time step of the differential equation solver first? Either way we have issues to consider. The impulsive force at \mathcal{P}_0 was used to change the state of the rigid body A. Point \mathcal{P}_1 was a collision point determined based on the previous state. If you were to run the differential equation solver first, it is quite possible that \mathcal{P}_1 would no longer be a collision point. In our example the angular velocity due to the impulse at \mathcal{P}_0 could rotate the corner at \mathcal{P}_1 up off the sloped plane, in which case we do not have to even consider that point. On the other hand, the angular velocity could cause that corner of the box to rotate through the plane, violating the nonpenetration constraint. To avoid this dilemma, perhaps we should process the impulse at \mathcal{P}_1 first. The dilemma here is that we just finished computing postimpulse velocities due to \mathcal{P}_0. In order to retain a dependence on that point, you would most likely use the postimpulse velocities from \mathcal{P}_0 as preimpulse velocities for \mathcal{P}_1. The relative position in body A is $\mathbf{r}_1 = \mathcal{P}_1 - \mathcal{X}_A$. Define $\mathbf{u}_1 = \mathbf{r}_1 \times \mathbf{N}$. The magnitude of the impulsive force and the postimpulse (postpostimpulse?) velocities are

$$f_1 = -\frac{2m_A \mathbf{N} \cdot \mathbf{v}_A^+}{1 + \mathbf{u}_1^T m_A J_A^{-1} \mathbf{u}_1}, \qquad \mathbf{v}_A^{++} = \mathbf{v}_A^+ + (f_1 \mathbf{N})/m_A, \qquad \mathbf{w}_A^{++} = \mathbf{w}_A^+ + f_1 J_A^{-1} \mathbf{u}_1$$

It is not clear that this produces a reasonably correct physical response.

The simplest thing to do from an implementation perspective is to process a collision point and change the state of the rigid bodies sharing that point, the changes based on the impulsive force introduced at the point, then run the differential equation solver for one time step. Next, the collision detection system is enabled. If an interpenetration has occurred, rerun the differential equation solver using a smaller time step. Repeat until no interpenetrations occur or until a maximum number of iterations has occurred.

The latter constraint is necessary because it is quite possible that interpenetration occurs for any increase in time. In this case great care must be taken about how to proceed. You will need a system that can decide if motion is possible, and if so, what that motion is. This is where even commercial packages can run into problems. Getting a generic system to work in all cases is more of an art than a science. Invariably, you will need to use knowledge of the types of objects you have and the environment in which they are interacting in order to adapt the generic system for your application. A more

complicated solution is to process the points simultaneously. In our example of a box colliding with a plane, let us make the problem even more general and determine how to introduce an impulsive force that applies to the entire edge of intersection rather than just to end points of the edge.

Our approach requires a better understanding of delta functions, introduced in Example 5.1. The delta function of that example was motivated as the limit of a function as a parameter ε was decreased to zero. Equation (5.19) shows the *selection property* of a delta function; integrating a function $g(t)$ against a delta function selects the function value $g(t_0)$, where t_0 is the discontinuity of the delta function. As shown in that example, the selection is for the time variable. Delta functions can be defined to select spatial variables as well.

EXAMPLE 5.3

Define the function $u(x, y, \eta, \varepsilon) = 1/(4\eta\varepsilon)$ for $|x| \leq \eta$ and $|y| \leq \varepsilon$, but zero otherwise, for $\eta > 0$ and $\varepsilon > 0$. The volume of the region bounded by the graph of $u(x, y, \eta, \varepsilon)$ and the xy-plane is 1 regardless of the choice of ε. For any continuous function $g(x, y)$, define the functions $\phi(x, y)$ and $\psi(y)$ so that $\partial\phi/\partial x = g(x, y)$ and $d\psi/dy = g(0, y)$. Consider the integral

$$I(\eta, \varepsilon) = \int_{\mathbb{R}^2} g(x, y)u(x, y, \eta, \varepsilon)\, dx\, dy = \int_{-\varepsilon}^{\varepsilon} \int_{-\eta}^{\eta} \frac{g(x, y)}{4\eta\varepsilon}\, dx\, dy$$

We may compute the limits of $I(\eta, \varepsilon)$ as η and ε approach zero. This is done informally here (with apologies to mathematicians who cringe at swapping the order of limit and integration without justification):

$$\lim_{\varepsilon\to 0}\lim_{\eta\to 0} I(\eta, \varepsilon) = \lim_{\varepsilon\to 0}\lim_{\eta\to 0} \int_{-\varepsilon}^{\varepsilon} \int_{-\eta}^{\eta} \frac{g(x, y)}{4\eta\varepsilon}\, dx\, dy$$

$$= \lim_{\varepsilon\to 0}\lim_{\eta\to 0} \int_{-\varepsilon}^{\varepsilon} \frac{\phi(\eta, y) - \phi(-\eta, y)}{4\eta\varepsilon}\, dy \qquad \text{Definition of } \phi$$

$$= \lim_{\varepsilon\to 0} \int_{-\varepsilon}^{\varepsilon} \lim_{\eta\to 0} \frac{\phi(\eta, y) - \phi(-\eta, y)}{4\eta\varepsilon}\, dy \qquad \begin{array}{l}\text{Interchange limit,}\\\text{integration}\end{array}$$

$$= \lim_{\varepsilon\to 0} \int_{-\varepsilon}^{\varepsilon} \lim_{\eta\to 0} \frac{g(\eta, y) + g(-\eta, y)}{4\varepsilon}\, dy \qquad \text{l'Hôpital's rule}$$

$$= \lim_{\varepsilon\to 0} \int_{-\varepsilon}^{\varepsilon} \frac{g(0, y)}{2\varepsilon}\, dy$$

$$= \lim_{\varepsilon\to 0} \frac{\psi(\varepsilon) - \psi(-\varepsilon)}{2\varepsilon} \qquad \text{Definition of } \psi$$

$$= \lim_{\varepsilon\to 0} \frac{g(0, \varepsilon) + g(0, -\varepsilon)}{2} \qquad \text{l'Hôpital's rule}$$

$$= g(0, 0)$$

If we informally think of $\delta(x, y)$ as the limit of $u(x, y, \eta, \varepsilon)$ when η and ε go to zero, we have the selection property

$$
\int_{y_1}^{y_2} \int_{x_1}^{x_2} g(x, y)\delta(x - x_0, y - y_0) \, dx \, dy
$$

$$
= \begin{cases} g(x_0, y_0), & x_1 \le x \le x_2, \quad y_1 \le y \le y_2 \\ 0 & \text{otherwise} \end{cases}
$$

(5.28)

This is a two-dimensional analog of equation (5.19). ■

We can use the last example to formulate the impulse function at a single point of contact. The example showed the selection for a scalar function of two spatial variables, but the idea clearly extends to vector-valued functions of three spatial variables. The impulse occurs at a spatial point \mathcal{P}_0 and at a time t_0, so the function may be defined using the selection property of the delta function, both in time and space. The function to which the selection is applied is $\mathbf{G}(\mathcal{X}, t) = f\mathbf{N}_0$, a constant in space and time. The formulation below is a bit loose with the mathematical notation so as not to cloud the issue with facts:

$$
\mathbf{F} = \int_{\mathcal{X}} \int_t \mathbf{G}(\mathcal{X}, t)\delta(t - t_0)\delta(\mathcal{X} - \mathcal{P}_0) \, d\mathcal{X} \, dt
$$

$$
= \int_{\mathcal{X}} \mathbf{G}(\mathcal{X}, t_0)\delta(\mathcal{X} - \mathcal{P}_0) \, d\mathcal{X}
$$

$$
= \mathbf{G}(\mathcal{P}_0, t_0)
$$

$$
= f\mathbf{N}_0
$$

Yet one more variation of the delta function is needed to handle the case of colliding contact of a box edge with the sloped plane.

EXAMPLE 5.4

Define $u(x, y, \varepsilon) = 1/(4\varepsilon)$ for $|x| \le 1$ and $|y| \le \varepsilon$, but zero otherwise, for $\varepsilon > 0$. The volume of the region bounded by the graph of $u(x, y, \varepsilon)$ and the xy-plane is 1 regardless of the choice of ε. For any continuous function $g(x, y)$, define the function $\phi(x, y)$ so that $\partial\phi/\partial y = g(x, y)$. Consider the integral

$$
I(\varepsilon) = \int_{\mathbb{R}^2} g(x, y)u(x, y, \varepsilon) \, dy \, dx = \int_{-1}^{1} \int_{-\varepsilon}^{\varepsilon} \frac{g(x, y)}{4\varepsilon} \, dy \, dx
$$

We may compute the limit of $I(\varepsilon)$ as ε approaches zero. This is again done informally:

(Example 5.4 continued)

$$\lim_{\varepsilon \to 0} I(\varepsilon) = \lim_{\varepsilon \to 0} \int_{-1}^{1} \int_{-\varepsilon}^{\varepsilon} \frac{g(x, y)}{4\varepsilon} \, dy \, dx$$

$$= \lim_{\varepsilon \to 0} \int_{-1}^{1} \frac{\phi(x, \varepsilon) - \phi(x, -\varepsilon)}{4\varepsilon} \, dx \qquad \text{Definition of } \phi$$

$$= \int_{-1}^{1} \lim_{\varepsilon \to 0} \frac{\phi(x, \varepsilon) - \phi(x, -\varepsilon)}{4\varepsilon} \, dx \qquad \text{Interchange limit, integration}$$

$$= \int_{-1}^{1} \lim_{\varepsilon \to 0} \frac{g(x, \varepsilon) + g(x, -\varepsilon)}{4} \, dx \qquad \text{l'Hôpital's rule}$$

$$= (1/2) \int_{-1}^{1} g(x, 0) \, dx$$

You might have noticed that the right-hand side is the average value (in the integral sense of calculus) of $g(x, 0)$ over the line segment $(x, 0)$ for $|x| \le 1$. Informally, $\int_{-1}^{1} g(x, 0) \, dx$ "adds" up all the g values along the segment. The "total number of values" that are added is the length of the interval, in our case 2. The average is just the ratio of these two numbers.

Informally, the delta function that is obtained by letting ε approach zero in $u(x, y, \varepsilon)$ has the *averaging property* rather than a selection property. The integral of $g(x, y)$ against the delta function produces the average value of g on the line segment connecting $(-1, 0)$ and $(1, 0)$. ∎

Using some more informal notation, let S denote a line segment in space. Let $\mathbf{G}(\mathcal{X})$ be a vector-valued function of the spatial variable \mathcal{X}. Let $\delta(\mathcal{X}, S)$ denote the type of delta function we constructed in the last example. This delta function has the averaging property

$$\int_{\mathcal{X}} \mathbf{G}(\mathcal{X}) \delta(\mathcal{X}, S) \, d\mathcal{X} = \frac{\int_{\mathcal{X} \in S} \mathbf{G}(\mathcal{X}) \, dS}{\int_{\mathcal{X} \in S} dS} = \frac{\int_{\mathcal{X} \in S} \mathbf{G}(\mathcal{X}) \, dS}{\text{Length}(S)} \qquad (5.29)$$

Now we can address the problem of computing an impulsive force when the contact set is a line segment (the box edge in our example). Let f be a to-be-determined scalar constant and let \mathbf{N} be the outward unit-length normal to the sloped plane. Let the edge have end points \mathcal{P}_0 and \mathcal{P}_1. The edge is denoted by S and has an arc length parameterization $(1 - s/\ell)\mathcal{P}_0 + (s/\ell)\mathcal{P}_1$ for $s \in [0, \ell]$, where $\ell = |\mathcal{P}_1 - \mathcal{P}_0|$. The update of the linear velocity for body A is

$$\mathbf{v}_A^+ = \mathbf{v}_A^- + m_A^{-1} \int_{\mathcal{X}} \int_t f\mathbf{N}\delta(t - t_0)\delta(\mathcal{X}, S)\, dt\, d\mathcal{X}$$

$$= \mathbf{v}_A^- + m_A^{-1} \int_{\mathcal{X}} f\mathbf{N}\delta(\mathcal{X}, S)\, d\mathcal{X}$$

$$= \mathbf{v}_A^- + m_A^{-1}\ell^{-1} \int_{\mathcal{X} \in S} f\mathbf{N}\, dS \qquad (5.30)$$

$$= \mathbf{v}_A^- + m_A^{-1}\ell^{-1}(\ell f\mathbf{N})$$

$$= \mathbf{v}_A^- + m_A^{-1} f\mathbf{N}$$

The update of the linear velocity for body B is

$$\mathbf{v}_B^+ = \mathbf{v}_B^- - m_B^{-1} f\mathbf{N} \qquad (5.31)$$

The update of the angular velocity for body A is

$$\mathbf{w}_A^+ = \mathbf{w}_A^- + J_A^{-1} \int_{\mathcal{X}} \int_t \mathbf{r}_A(\mathcal{X}, t) \times f\mathbf{N}\, \delta(t - t_0)\delta(\mathcal{X}, S)\, dt\, d\mathcal{X}$$

$$= \mathbf{w}_A^- + J_A^{-1} \int_{\mathcal{X}} \mathbf{r}_A(\mathcal{X}, t_0) \times f\mathbf{N}\, \delta(\mathcal{X}, S)\, d\mathcal{X}$$

$$= \mathbf{w}_A^- + J_A^{-1}\ell^{-1} \int_{\mathcal{X} \in S} \mathbf{r}_A(\mathcal{X}, t_0) \times f\mathbf{N}\, dS$$

$$= \mathbf{w}_A^- + J_A^{-1}\ell^{-1} \left(\int_{\mathcal{X} \in S} \mathbf{r}_A(\mathcal{X}, t_0)\, dS \right) \times f\mathbf{N} \qquad (5.32)$$

$$= \mathbf{w}_A^- + J_A^{-1}\ell^{-1} \left(\int_0^\ell (1 - s/\ell)\mathcal{P}_0 + (s/\ell)\mathcal{P}_1 - \mathcal{X}_A\, ds \right) \times f\mathbf{N}$$

$$= \mathbf{w}_A^- + J_A^{-1} \left((\mathcal{P}_0 + \mathcal{P}_1)/2 - \mathcal{X}_A \right) \times f\mathbf{N}$$

$$= \mathbf{w}_A^- + J_A^{-1}\mathbf{r}_A(\mathcal{M}, t_0) \times f\mathbf{N}$$

where $\mathcal{M} = (\mathcal{P}_0 + \mathcal{P}_1)/2$. The update of the angular velocity for body B is

$$\mathbf{w}_B^+ = \mathbf{w}_B^- - J_A^{-1}\mathbf{r}_A(\mathcal{M}, t_0) \times f\mathbf{N} \qquad (5.33)$$

The update formulas for the angular velocities have a physically intuitive appeal. The torque applied to the line segment shows up as a torque applied to the center of mass of the line segment. The construction of equation (5.27) from equations

(5.20) through (5.26) is still valid for the line segment of contact, but applied to the midpoint. The magnitude of the impulse is therefore

$$f = \frac{-(1+\varepsilon)(\mathbf{N} \cdot (\mathbf{v}_A^- - \mathbf{v}_B^-) + (\mathbf{w}_A^- \cdot (\mathbf{r}_A \times \mathbf{N}) - \mathbf{w}_B^- \cdot (\mathbf{r}_B \times \mathbf{N})))}{m_A^{-1} + m_B^{-1} + (\mathbf{r}_A \times \mathbf{N})^{\mathrm{T}} J_A^{-1}(\mathbf{r}_A \times \mathbf{N}) + (\mathbf{r}_B \times \mathbf{N})^{\mathrm{T}} J_B^{-1}(\mathbf{r}_B \times \mathbf{N})} \qquad (5.34)$$

where $\mathbf{r}_A = \mathcal{M} - \mathcal{X}_A$ and $\mathbf{r}_B = \mathcal{M} - \mathcal{X}_B$.

EXERCISE (H)
5.2
The collision system suggested in [Bar01] computes only a finite set of contact points (the reduced contact set; see Figure 5.2). If an edge of body A intersects a face of body B, only the end points of the edge, \mathcal{P}_0 and \mathcal{P}_1, are stored by the system. Derive equations for the velocity updates and the impulse magnitude, analogous to equations (5.30) through (5.34), that correspond to applying an impulsive force simultaneously to the end points. (*Hint*: The delta function for a point and the delta function for a segment are limits of functions whose volumes are always 1.) ▪

EXERCISE (H)
5.3
Suppose your collision system computes the full set of intersection points for two colliding (but not interpenetrating) convex polyhedra. The set consists of either a single point, a line segment, or a convex polygon. We have seen how to compute an impulse force for a single point or for a line segment. If the intersection is a convex polygon, derive equations for the velocity updates and the impulse magnitude, analogous to equations (5.30) through (5.34).

Now suppose the collision system stores only the vertices of a convex polygon of intersection. Derive equations for the velocity updates and the impulse magnitude, analogous to equations (5.30) through (5.34), that correspond to applying an impulsive force simultaneously to the vertices. (*Hint*: Same as for Exercise 5.2.) ▪

We finish the colliding contact discussion with an example that illustrates another problem with which a collision system must deal.

EXAMPLE
5.5
Consider a rectangle traveling downward that intersects two other objects simultaneously. Figure 5.7 illustrates. As shown in the figure, body A intersects body B at \mathcal{P}_0 and body C at \mathcal{P}_1. The outward unit-length normals at the contact points are \mathbf{N}_0 and \mathbf{N}_1. The velocity of body A is $\mathbf{v}_A^- = (0, -\lambda)$ for $\lambda > 0$. The slope of the diagonal line of B is -1 and the slope of the diagonal line of C is 2. As we saw in Example 5.2, an impulsive force applied to \mathcal{P}_0 (with coefficient of restitution $\varepsilon = 1$) causes a postimpulse velocity:

Figure 5.7 A rectangle travels downward and intersects two objects simultaneously.

$$\mathbf{v}_A^+ = \mathbf{v}_A^- + \frac{f_0 \mathbf{N}_0}{m_A}$$

$$= \mathbf{v}_A^- - 2(\mathbf{N}_0 \cdot \mathbf{v}_A^-)\mathbf{N}_0$$

$$= (0, -\lambda) + (\lambda, \lambda)$$

$$= (\lambda, 0)$$

If we were to apply that impulse without considering the other contact point, body A tends to move to the right. It cannot because body C impedes the motion of body A in that direction. Similarly, if we apply the impulse at \mathcal{P}_1, the postimpulse velocity is

$$\mathbf{v}_A^+ = \mathbf{v}_A^- + \frac{f_1 \mathbf{N}_1}{m_A}$$

$$= \mathbf{v}_A^- - 2(\mathbf{N}_1 \cdot \mathbf{v}_A^-)\mathbf{N}_1$$

$$= (0, -\lambda) + (-4\lambda/5, \lambda/5)$$

$$= (-4\lambda/5, -3\lambda/5)$$

Body B impedes the motion of body A in this direction. Applying simultaneous impulses (see Exercise 5.2), the postimpulse velocity is

$$\mathbf{v}_A^+ = \mathbf{v}_A^- + \frac{f_0 \mathbf{N}_0 + f_1 \mathbf{N}_1}{2m_A}$$

$$= (\lambda/10, -4\lambda/5)$$

*(Example 5.5
continued)*
The implied motion is to the right and downward, in which case both bodies B and C impede the motion of A. So how do you handle this situation in a physically meaningful manner? Two choices are (1) require body A to stop or (2) require body A to bounce upward.

If body A is very heavy compared to bodies B and C, the first choice is reasonable. The choice is also reasonable when you have a body that you want to collide with an immovable surface, and you want the body not to bounce at the instant of collision but to slide down the surface. The initial contact is colliding contact, but you want the component of velocity in the surface-normal direction set to zero rather than reflected as in the impulse approach. This is an instantaneous change from being a colliding contact to a resting contact. The body still has a nonzero velocity, but it is now orthogonal to the surface normal, so the body can slide along the surface.

If instead you want the body to bounce upward, you will need an algorithm to determine the new velocity of the center of mass of A. This might be as simple as reversing the direction and choosing $\mathbf{v}_A^+ = -\mathbf{v}_A^-$. Of course, you also need to compute a new angular velocity \mathbf{w}_A^+. If the slope of the diagonal edge for C were chosen to be 1, the symmetry of the contact would imply $\mathbf{w}_A^+ = \mathbf{0}$. With a slope of 2 as shown in Figure 5.7, your physical intuition says that body A should "slip downhill" a little bit more at \mathcal{P}_1 than at \mathcal{P}_0. The normals at the contact points can be used to generate the angular velocity. For our current example, you might arbitrarily choose $\mathbf{w}_A^+ = \xi \mathbf{N}_0 \times \mathbf{N}_1$, where ξ is the x-component of $\mathbf{N}_0 + \mathbf{N}_1$. ■

Simultaneous Processing of Contact Points

Either choice in Example 5.5 appears to require feedback from the user or application about how to update the rigid body parameters when the body has multiple colliding contact points. In hopes that we can build a collision detection and response system that is completely automated, let us reconsider how impulse forces were chosen.

By definition, at a point of colliding contact the magnitude of the velocity in the normal direction at the point of contact is negative. Equation (5.16) provides us with a formula for the relative velocity. At the instant of contact, $\dot{d}(t_0) = \mathbf{N}_0 \cdot (\dot{\mathcal{P}}_A(t_0) - \dot{\mathcal{P}}_B(t_0))$, where \mathbf{N}_0 is the normal at the contact point \mathcal{P}_0. The paths on bodies A and B for the points that meet at time t_0 are $\mathcal{P}_A(t)$ and $\mathcal{P}_B(t)$, with $\mathcal{P}_A(t_0) = \mathcal{P}_0 = \mathcal{P}_B(t_0)$. The relative velocity between the points on the path is $\dot{\mathcal{P}}_A(t) - \dot{\mathcal{P}}_B(t)$. The construction of impulse functions was based on two assumptions:

1. The points of colliding contact will be processed one at a time.

2. The relative velocity must be reflected through the contact normal using equation (5.26).

In light of Example 5.5, both of these assumptions create problems.

What we want physically is to avoid interpenetration of body A into body B when $\dot{d}(t_0) < 0$ is negative. To avoid the interpenetration, body B must exert a *contact force* C on body A at the point of contact. Such a force must satisfy four conditions:

1. **C** acts only at the instant of contact, not before and not later.

2. **C** must be a repulsive force. It cannot act like glue between the bodies.

3. **C** must prevent the interpenetration of the bodies.

4. The system cannot gain kinetic energy from the introduction of this contact force.

We postulate an impulsive force of the form $\mathbf{C} = f\mathbf{N}_0$ for some scalar $f \geq 0$ at the point of contact \mathcal{P}_0. The use of an impulsive force satisfies condition 1. To satisfy condition 2, we need $f \geq 0$ so that the force repels the first body away from the second one.

Let us consider what condition 3 means at a single contact point such as the configuration of Example 5.2 (using a square or a rectangle). The pre- and postimpulse velocities are related by equation (5.25), but with $m_B^{-1} = 0$ $J_B^{-1} = 0$, and $\dot{\mathcal{P}}_B = \mathcal{O}$:

$$\dot{\mathcal{P}}_A^+ - \mathcal{O} = (\dot{\mathcal{P}}_A^- - \mathcal{O}) + f\left(\frac{\mathbf{N}_0}{m_A} + (J_A^{-1}(\mathbf{r}_A \times \mathbf{N}_0)) \times \mathbf{r}_A\right)$$

The normal component of the preimpulse world velocity is $\dot{d}^- = \mathbf{N}_0 \cdot (\dot{\mathcal{P}}_A^- - \mathcal{O})$ and the normal component of the postimpulse world velocity is $\dot{d}^+ = \mathbf{N}_0 \cdot (\dot{\mathcal{P}}_A^+ - \mathcal{O})$. Thus,

$$\dot{d}^+ = \dot{d}^- + f\left(m_A^{-1} + (\mathbf{r}_A \times \mathbf{N}_0)^T J_A^{-1}(\mathbf{r}_A \times \mathbf{N}_0)\right) \tag{5.35}$$

If $\dot{d}^- \geq 0$, the bodies are separating so we may select $f = 0$ (no impulse), in which case $\dot{d}^+ = \dot{d}^-$ (no change in world velocity). If $\dot{d}^- < 0$, body A is trying to penetrate into body B. We must prevent this by choosing $f > 0$ large enough so that $\dot{d}^+ \geq 0$. If $f_0 > 0$ is chosen so that $\dot{d}^+ = 0$, we have met our constraint of nonpenetration. But any choice of $f > f_0$ leads to $\dot{d}^+ > 0$ and we still satisfy the constraint. The larger we choose f, the larger the impulse, and consequently the larger the magnitude of the normal component of the postimpulse velocity. An unwanted degree of freedom exists in the simplest of configurations.

This is where condition 4 comes into play. By choosing a sufficiently large value for f, we obtain a postimpulse value for \dot{d}^+ that exceeds $|\dot{d}^-|$, causing an increase in the kinetic energy of the system. We need to bound the postimpulse value so that the kinetic energy remains the same or even decreases; that is, the constraint $\dot{d}^+ \leq |\dot{d}^-|$ is required. We are still analyzing the case for $\dot{d}^- < 0$, so the constraint is $\dot{d}^+ \leq -\dot{d}^-$. Combining this with equation (5.35) we obtain

$$f \leq \frac{-2\dot{d}^-}{m_A^{-1} + (\mathbf{r}_A \times \mathbf{N}_0)^T J_A^{-1}(\mathbf{r}_A \times \mathbf{N}_0)} = f_{max} \tag{5.36}$$

where the last equality defines f_{max}. This equation tells us that we need an impulsive force to generate a nonnegative postimpulse velocity $\dot{d}^+ \geq 0$, but the impulsive force cannot be too large. This limits our choice of f to a bounded interval $[0, f_{max}]$, but we still have a degree of freedom to eliminate. We can do so by setting a goal for the postimpulse velocity to be as close as possible to the reflected preimpulse velocity while satisfying all the constraints of the system. In our special configuration of one contact point, we can choose $f = f_{max}$ and the postimpulse velocity is the reflection of the preimpulse velocity, just as we saw in Example 5.2.

Now for a slightly more complicated example, the multiple contact configuration of Example 5.5. The impulse equation for linear velocity is

$$\mathbf{v}_A^+ = \mathbf{v}_A^- + \frac{f_0 \mathbf{N}_0 + f_1 \mathbf{N}_1}{m_A}$$

and the impulse equation for angular velocity is

$$\mathbf{w}_A^+ = \mathbf{w}_A^- + \frac{f_0 \mathbf{N}_0 + f_1 \mathbf{N}_1}{m_A}$$

Define $\mathbf{r}_i = \mathcal{X}_A - \mathcal{P}_i$, where \mathcal{X}_A is the center of mass of body A and \mathcal{P}_i are the collision points, $i = 0, 1$. The outer normals at the collision points are \mathbf{N}_i. Bodies B and C are not moving. The preimpulse and postimpulse world velocities of body A are related by

$$\dot{\mathcal{P}}_A^+ - \mathcal{O} = (\dot{\mathcal{P}}_A^- - \mathcal{O}) + \sum_{i=0}^{1} f_i \left(\frac{\mathbf{N}_i}{m_A} + (J_A^{-1}(\mathbf{r}_i \times \mathbf{N}_i)) \times \mathbf{r}_i \right)$$

The normal component of the preimpulse world velocity at the ith contact point is $\dot{d}_i^- = \mathbf{N}_i \cdot (\dot{\mathcal{P}}_i^- - \mathcal{O})$ and the normal component of the postimpulse world velocity is $\dot{d}^+ = \mathbf{N}_0 \cdot (\dot{\mathcal{P}}_A^+ - \mathcal{O})$. Thus,

$$\dot{d}_0^+ = \dot{d}_0^- + a_{00} f_0 + a_{01} f_1$$

$$\dot{d}_1^+ = \dot{d}_1^- + a_{10} f_0 + a_{11} f_1$$

for appropriate constants a_{ij}. Our constraints to satisfy conditions 1, 2, and 3 are $f_i \geq 0$ and $\dot{d}_i^+ \geq 0$. Condition 4 may be satisfied by requiring $\dot{d}_i^+ \leq |\dot{d}_i^-|$.

As in the example of a single point of contact, we must analyze cases based on the signs of \dot{d}_i^-. Taking a hint from that example, let us set goals for what we want \dot{d}_i^+ to be. If $\dot{d}_0^- \geq 0$, our goal is $\dot{d}_0^+ = \dot{d}_0^-$. In the single-point example, we would choose $f_0 = 0$ to support the goal. This two-point example causes us to think twice about doing so. The choice for $f_0 = 0$ does not directly force the goal. Instead, we get $\dot{d}_0^+ = \dot{d}_0^- + a_{01} f_1$. Well, we can always then choose $f_1 = 0$ so that $\dot{d}_0^+ = \dot{d}_0^-$ as desired. Unfortunately, the other postimpulse velocity equation becomes $\dot{d}_1^+ = \dot{d}_1^-$, which is a problem when $\dot{d}_1^- < 0$, the implication being that body A will penetrate body C. The

two postimpulse velocity equations are coupled, causing us to obtain our goal not as "equality" but "get as close as you can."

More formally, if $\dot{d}_i^- \geq 0$, our goal for \dot{d}_i^+ is to make it as close to \dot{d}_i as possible while maintaining its nonnegativity. If $\dot{d}_i^- < 0$, our goal for \dot{d}_i^+ is to make it as close to $-\dot{d}_i$ as possible while maintaining its nonnegativity. We can achieve these goals in the sense of least-squares, whereby we minimize the length of a vector rather than requiring the vector to be zero. Define:

$$b_i = \begin{cases} 0, & \dot{d}_i^- \geq 0 \\ 2\dot{d}_i^-, & \dot{d}_i^- < 0 \end{cases}$$

We want to choose (f_0, f_1) to make the length of the vector $(a_{00}f_0 + a_{01}f_1 + b_0, a_{10}f_0 + a_{11}f_1 + b_1)$ as small as possible. The minimization is constrained by $f_i \geq 0$ and $a_{i0}f_0 + a_{i1}f_1 + \dot{d}_i^- \geq 0$ for $i = 0, 1$. You should recognize this as a convex quadratic programming problem, which we discuss in Chapter 7.

Let us look at an even more complicated example and set up the general formulation for choosing the impulsive functions at all the contact points simultaneously.

EXAMPLE 5.6

Four rigid bodies with six points of contact are shown in Figure 5.8. It is irrelevant to us whether or not the contact points are colliding or resting. We require impulsive contact forces $\mathbf{C}_i = f_i \mathbf{N}_i$ for $1 \leq i \leq 6$. Using the same superscript notation as before

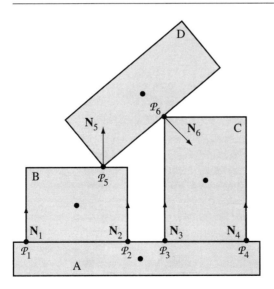

Figure 5.8 Four rigid bodies with six points of contact. The centers of mass of the four bodies are also shown.

*(Example 5.6
continued)*

for indicating preimpulse and postimpulse quantities, the simultaneous updates of the linear momenta of the centers of mass using the impulsive forces are

$$m_A \mathbf{v}_A^+ = m_A \mathbf{v}_A^- - f_1 \mathbf{N}_1 - f_2 \mathbf{N}_2 - f_3 \mathbf{N}_3 - f_4 \mathbf{N}_4$$

$$m_B \mathbf{v}_B^+ = m_B \mathbf{v}_B^- + f_1 \mathbf{N}_1 + f_2 \mathbf{N}_2 - f_5 \mathbf{N}_5$$

$$m_C \mathbf{v}_C^+ = m_C \mathbf{v}_C^- + f_3 \mathbf{N}_3 + f_4 \mathbf{N}_4 + f_6 \mathbf{N}_6$$

$$m_D \mathbf{v}_D^+ = m_D \mathbf{v}_D^- + f_5 \mathbf{N}_5 - f_6 \mathbf{N}_6$$

The simultaneous updates of the angular momenta using the impulsive torques are

$$J_A \mathbf{w}_A^+ = J_A \mathbf{w}_A^- - f_1 \mathbf{r}_A^1 \times \mathbf{N}_1 - f_2 \mathbf{r}_A^2 \times \mathbf{N}_2 - f_3 \mathbf{r}_A^1 \times \mathbf{N}_3 - f_4 \mathbf{r}_A^1 \times \mathbf{N}_4$$

$$J_B \mathbf{w}_B^+ = J_B \mathbf{w}_B^- + f_1 \mathbf{r}_B^1 \times \mathbf{N}_1 + f_2 \mathbf{r}_B^2 \times \mathbf{N}_2 - f_5 \mathbf{r}_B^5 \times \mathbf{N}_5$$

$$J_C \mathbf{w}_C^+ = J_C \mathbf{w}_C^- + f_3 \mathbf{r}_C^3 \times \mathbf{N}_3 + f_4 \mathbf{r}_C^4 \times \mathbf{N}_4 + f_6 \mathbf{r}_C^6 \times \mathbf{N}_6$$

$$J_D \mathbf{w}_D^+ = J_D \mathbf{w}_D^- + f_5 \mathbf{r}_D^5 \times \mathbf{N}_5 - f_6 \mathbf{r}_D^6 \times \mathbf{N}_6$$

where $\mathbf{r}_\gamma^i = \mathcal{P}_i - \mathcal{X}_\gamma$ for body γ and contact point i.

Each contact point leads to a relative velocity equation, which we will index by i. For example, consider the contact point \mathcal{P}_1 involving bodies A and B. By our convention, the pair of bodies is ordered as (B, A) since a vertex of B intersects a face of A.

$$\dot{d}_1^+ = \mathbf{N}_1 \cdot ((\mathbf{v}_B^+ + \mathbf{w}_B^+ \times \mathbf{r}_B^1) - (\mathbf{v}_A^+ + \mathbf{w}_A^+ \times \mathbf{r}_A^1))$$

$$= \mathbf{N}_1 \cdot \left[m_B^{-1}(f_1 \mathbf{N}_1 + f_2 \mathbf{N}_2 - f_5 \mathbf{N}_5) \right.$$

$$+ (J_B^{-1}(f_1 \mathbf{r}_B^1 \times \mathbf{N}_1 + f_2 \mathbf{r}_B^2 \times \mathbf{N}_2 - f_5 \mathbf{r}_B^5)) \times \mathbf{r}_B^1$$

$$- m_A^{-1}(-f_1 \mathbf{N}_1 - f_2 \mathbf{N}_2 - f_3 \mathbf{N}_3 - f_4 \mathbf{N}_4)$$

$$\left. - (J_A^{-1}(-f_1 \mathbf{r}_A^1 \times \mathbf{N}_1 - f_2 \mathbf{r}_A^2 \times \mathbf{N}_2 - f_3 \mathbf{r}_A^3 \times \mathbf{N}_3 - f_4 \mathbf{r}_A^4 \times \mathbf{N}_4)) \times \mathbf{r}_A^1 \right] + \dot{d}_1^-$$

$$= a_{11} f_1 + a_{12} f_2 + a_{13} f_3 + a_{14} f_4 + a_{15} f_5 + a_{16} f_6 + \dot{d}_1^-$$

where

$$a_{11} = \mathbf{N}_1 \cdot \left[(m_B^{-1} \mathbf{N}_1 + (J_B^{-1}(\mathbf{r}_B^1 \times \mathbf{N}_1)) \times \mathbf{r}_B^1) - (-m_A^{-1} \mathbf{N}_1 - (J_A^{-1}(\mathbf{r}_A^1 \times \mathbf{N}_1)) \times \mathbf{r}_A^1) \right]$$

$$a_{12} = \mathbf{N}_1 \cdot \left[(m_B^{-1} \mathbf{N}_2 + (J_B^{-1}(\mathbf{r}_B^2 \times \mathbf{N}_2)) \times \mathbf{r}_B^1) - (-m_A^{-1} \mathbf{N}_2 - (J_A^{-1}(\mathbf{r}_A^2 \times \mathbf{N}_2)) \times \mathbf{r}_A^1) \right]$$

$$a_{13} = \mathbf{N}_1 \cdot \left[(\mathbf{0}) - (-m_A^{-1}\mathbf{N}_3 - (J_A^{-1}(\mathbf{r}_A^3 \times \mathbf{N}_3)) \times \mathbf{r}_A^1) \right]$$

$$a_{14} = \mathbf{N}_1 \cdot \left[(\mathbf{0}) - (-m_A^{-1}\mathbf{N}_4 - (J_A^{-1}(\mathbf{r}_A^4 \times \mathbf{N}_4)) \times \mathbf{r}_A^1) \right]$$

$$a_{15} = \mathbf{N}_1 \cdot \left[(-m_B^{-1}\mathbf{N}_5 - (J_B^{-1}(\mathbf{r}_B^5 \times \mathbf{N}_5)) \times \mathbf{r}_B^1) - (\mathbf{0}) \right]$$

$$a_{16} = \mathbf{N}_1 \cdot \left[(\mathbf{0}) - (\mathbf{0}) \right]$$

$$\dot{d}_1^- = \mathbf{N}_1 \cdot \left[(\mathbf{v}_B^- + \mathbf{w}_B^- \times \mathbf{r}_B^1) - (\mathbf{v}_A^- + \mathbf{w}_A^- \times \mathbf{r}_A^1) \right]$$

These expressions were not simplified to be suggestive of the general formula and an algorithm to compute it. The simplest term to explain is $a_{16} = 0$. The two bodies sharing the contact point \mathcal{P}_1 are B and A. Point \mathcal{P}_6 is not part of either of these bodies, so the contact force $f_6\mathbf{N}_6$ does not contribute to resolution at \mathcal{P}_1. The term a_{12} has a couple of similar expressions, one involving values for body B, the other involving values for body A. The different subscripts B and A are one difference. The other difference is that the second expression has minus signs. This has to do with the fact that if the contact force on the first body is $\pm f\mathbf{N}$, then the contact force on the second body is $\mp f\mathbf{N}$ (reversed direction). Both expressions occur in a_{12} because \mathcal{P}_2 is also shared by bodies B and A. The second expression in the term a_{13} occurs because \mathcal{P}_3 is part of body A, thus indirectly affecting body B. However, the first expression is $\mathbf{0}$ because \mathcal{P}_3 is not a point of body B. Finally, a_{11} contains both expressions since \mathcal{P}_1 is shared by both bodies.

Similar expressions can be constructed for the other contact points to obtain $\dot{d}_i^+ = \sum_{i=1}^6 a_{ij} f_j + \dot{d}_i^-$ for $1 \leq i \leq 6$. ∎

In the general case we have a collection of rigid bodies and n contact points \mathcal{P}_i for $1 \leq i \leq n$. The velocity at \mathcal{P}_i in the normal direction \mathbf{N}_i has magnitude

$$\dot{d}_i^+ = \sum_{i=1}^n a_{ij} f_j + \dot{d}_i^- \tag{5.37}$$

where the contact force at \mathcal{P}_i is $\pm f_i\mathbf{N}_i$, the sign chosen based on the body that is sharing the contact point. The general formula for the a_{ij} is listed next; the pair of bodies is (α, β):

$$a_{ij} = \sigma_\alpha^{ij}(m_\alpha^{-1}\mathbf{N}_i \cdot \mathbf{N}_j + (\mathbf{r}_\alpha^i \times \mathbf{N}_i)^{\mathsf{T}} J_\alpha^{-1}(\mathbf{r}_\alpha^j \times \mathbf{N}_j))$$
$$- \sigma_\beta^{ij}(m_\beta^{-1}\mathbf{N}_i \cdot \mathbf{N}_j + (\mathbf{r}_\beta^i \times \mathbf{N}_i)^{\mathsf{T}} J_\beta^{-1}(\mathbf{r}_\beta^j \times \mathbf{N}_j)) \tag{5.38}$$

where σ_γ^{ij} is $+1$ when \mathcal{P}_j is in the body γ and the force direction is $+\mathbf{N}_j$, is -1 when \mathcal{P}_j is in the body γ and the force direction is $-\mathbf{N}_j$, or is 0 when \mathcal{P}_j is not in the body

γ. Convince yourself from the physical situation that $a_{ji} = a_{ij}$; that is, the matrix $A = [a_{ij}]$ is symmetric. You can also verify this by direct manipulation of the general formula for the a_{ij} values. The preimpulse velocities are

$$\dot{d}_i^- = \mathbf{N}_i \cdot \left[(\mathbf{v}_\alpha^- + \mathbf{w}_\alpha^- \times \mathbf{r}_\alpha^i) - (\mathbf{v}_\beta^- + \mathbf{w}_\beta^- \times \mathbf{r}_\beta^i) \right] \qquad (5.39)$$

Let us reformulate our conditions using vector and matrix notation. Let \mathbf{f} be the $n \times 1$ vector that stores the magnitudes of the impulsive forces. The magnitudes are nonnegative, a condition we may write succinctly as $\mathbf{f} \geq \mathbf{0}$. Let $\dot{\mathbf{d}}^-$ be the $n \times 1$ vector that stores the preimpulse velocities and let $\dot{\mathbf{d}}^+$ be the $n \times 1$ vector that stores the postimpulse velocities. To avoid interpenetrations we need $\dot{\mathbf{d}}^+ \geq \mathbf{0}$. Equation (5.37) is written as $\dot{\mathbf{d}}^+ = A\mathbf{f} + \dot{\mathbf{d}}^-$ where $A = [a_{ij}]$ is an $n \times n$ matrix. Define the $n \times 1$ vector \mathbf{b} to have ith component $b_i = 0$ if $\dot{d}_i^- \geq 0$ and $b_i = 2\dot{d}_i^-$ if $\dot{d}_i^- < 0$. Define the $n \times 1$ vector \mathbf{c} to have ith component $c_i = |\dot{d}_i^-|$.

The problem is abstracted to the following. We want to choose \mathbf{f} to minimize the convex quadratic function $|A\mathbf{f} + \mathbf{b}|^2$ subject to the constraints $\mathbf{f} \geq \mathbf{0}$ (forces are repulsive), $A\mathbf{f} + \mathbf{b} \geq \mathbf{0}$ (bodies cannot interpenetrate), and $A\mathbf{f} + \mathbf{b} \leq \mathbf{c}$ (kinetic energy cannot be gained via impulses). This is a convex quadratic programming problem that can be formulated as a linear complementarity problem (LCP) and solved using the Lemke algorithm of Chapter 7.

An illustrative implementation will be provided later in this chapter. For now it is sufficient to mention the general order of operations:

1. The collision detection system calculates all contact points for the current state of the rigid bodies.

2. The contact points and rigid body states are used to compute the matrix A and vector $\dot{\mathbf{d}}^-$.

3. The LCP solver computes \mathbf{f} and $\dot{\mathbf{d}}^+$. We are guaranteed of no interpenetration since $\dot{\mathbf{d}}^+ \geq \mathbf{0}$ is a postcondition of the LCP solver.

4. The postimpulse velocities are computed from \mathbf{f} and the normal vectors at the collision points. These velocites replace the preimpulse values in the rigid bodies.

5. The differential equation solver computes the new positions and orientations of the rigid bodies.

6. Repeat step 1.

This process will be modified when we take into account that some of the contact points are resting contact, as described in Section 5.2.3.

E X E R C I S E Ⓜ
5.4

The postcondition of any system that instantaneously updates the linear and angular velocities for a collection of rigid bodies is that no instantaneous interpenetration can occur at any contact point. The original design of processing the colliding points sequentially does not satisfy this postcondition (see Example 5.5). The LCP-based

method of this subsection does satisfy the postcondition. The sequential processing is conceptually simpler to implement. The LCP-based method requires a high-powered piece of software that is difficult to implement (robustly). Is there a middle ground?

Explore the following two concepts (mentally or programatically, whatever):

1. In sequential processing, postimpulse velocities at a contact point shared by two bodies is computed, call them \mathbf{v}_A^+ and \mathbf{v}_B^+. Before actually updating the rigid body states, determine if the new velocity is consistent with the postcondition. That is, if body A has contact points \mathcal{P}_i and contact normals \mathbf{N}_i for $1 \leq i \leq n$, and if body B has contact points \mathcal{Q}_j and contact normals \mathbf{M}_j for $1 \leq j \leq m$, compute the values $\alpha_i = \mathbf{N}_i \cdot \mathbf{v}_A^+$ and $\beta_j = \mathbf{M} \cdot \mathbf{v}_B^+$. If $\alpha_i \geq 0$ for all i and $\beta_j \geq 0$ for all j, then the postcondition is satisfied. If satisfied, update the rigid body states for these two bodies, call the differential equation solver, and proceed as usual. If not satisfied, repeat the process on the next contact point. If the set of current contact points becomes empty because the postcondition was never satisfied, set the new velocities to be zero.

2. In simultaneous processing, iterate over the rigid bodies. For a body A, let \mathcal{P}_i be the contact points contained by that body and let \mathbf{N}_i be the contact normals, $1 \leq i \leq n$. Assume that any body B that shares a contact point with A is at rest. Construct vectors \mathbf{v}^+ and \mathbf{w}^+ using impulsive forces so that if body A is updated with these velocities, no interpenetration can occur with any neighboring body B. If at least one of these velocities is nonzero, update the state of body A, call the differential equation solver, and proceed as usual. If both velocities are forced to be zero, repeat the process on the next rigid body.

Both concepts require that your collision detection system support a query whose input is a rigid body and whose output is the set of current contact points and normals for that body. ▪

5.2.3 COLLISION RESPONSE FOR RESTING CONTACT

If two rigid bodies A and B are in contact at time t_0 at a point \mathcal{P}_0, and if \mathbf{N}_0 is an outward, unit-length normal for body B, we distinguish between colliding contact, resting contact, or separation based on the normal component of the velocity of body A relative to body B. Equation (5.15) provides us with the function $d(t)$, a measure of signed distance between the two body points $\mathcal{P}_A(t)$ and $\mathcal{P}_B(t)$ that meet at \mathcal{P}_0 at time t_0. By the definition, $d(t_0) = 0$. The relative velocity has a normal component given by equation (5.16). That component is $\dot{d}(t)$. A contact point is a colliding contact when $\dot{d}(t_0) < 0$ (body A moves into body B), a separation contact when $\dot{d}(t_0) > 0$ (body A moves away from body B), or a resting contact when $\dot{d}(t_0) = 0$. The latter case is the one we now analyze.

At a resting contact \mathcal{P}_0 the distance and relative velocity are zero. If body A has an acceleration $a\mathbf{N}_0$ relative to body B at \mathcal{P}_0 with $a < 0$, body A is attempting to accelerate into body B at the instant of contact. Clearly, we need to measure the relative acceleration to determine if this situation occurs. The relative acceleration is provided by the time derivative $\ddot{d}(t)$, which we can compute by differentiating equation (5.16):

$$\ddot{d}(t) \tag{5.40}$$

$$= \mathbf{N}(t) \cdot (\ddot{\mathcal{P}}_A(t) - \ddot{\mathcal{P}}_B(t)) + 2\dot{\mathbf{N}}(t) \cdot (\dot{\mathcal{P}}_A(t) - \dot{\mathcal{P}}_B(t)) + \ddot{\mathbf{N}} \cdot (\mathcal{P}_A(t) - \mathcal{P}_B(t))$$

At the time of contact, $\ddot{d}(t_0) = \mathbf{N}_0 \cdot (\ddot{\mathcal{P}}_A(t_0) - \ddot{\mathcal{P}}_B(t_0)) + 2\dot{\mathbf{N}}(t_0) \cdot (\dot{\mathcal{P}}_A(t_0) - \dot{\mathcal{P}}_B(t_0))$, where the last term of equation (5.40) is zero since $\mathcal{P}_A(t_0) = \mathcal{P}_0 = \mathcal{P}_B(t_0)$. In order to compute the relative acceleration, we need a formula for the normal $\mathbf{N}(t)$ so that we can compute the first derivative and evaluate $\dot{\mathbf{N}}(t_0)$. We have two cases to consider. The first case is for a vertex-face intersection, where $\mathbf{N}(t_0)$ is the face normal of body B. Equation (2.42) tells us how a vector quantity changes in the world coordinate system of a body. The normal vector derivative for this case is

$$\dot{\mathbf{N}}(t) = \mathbf{w}_B(t) \times \mathbf{N}(t) \tag{5.41}$$

where $D\mathbf{N}/Dt = \mathbf{0}$ since the body is rigid. The angular velocity of body B is used since the normal rotates with B. The second case is for an edge-edge intersection, where the normal is formed by taking the cross product of an edge of A and an edge of B, then normalized. Since each edge rotates due to the angular velocity of its respective body, the normal derivative is more complicated to compute. As a function of time the normal is $\mathbf{N}(t) = \mathbf{E}_A(t) \times \mathbf{E}_B(t)/L(t)$ with $L(t) = |\mathbf{E}_A(t) \times \mathbf{E}_B(t)|$. Using the product and quotient rules from vector calculus, the derivative is

$$\dot{\mathbf{N}} = \frac{L(\mathbf{E}_A \times \dot{\mathbf{E}}_B + \dot{\mathbf{E}}_A \times \mathbf{E}_B) - \dot{L}(\mathbf{E}_A \times \mathbf{E}_B)}{L^2} = \frac{\mathbf{E}_A \times \dot{\mathbf{E}}_B + \dot{\mathbf{E}}_A \times \mathbf{E}_B - \dot{L}\mathbf{N}}{L}$$

Now since $L^2 = (\mathbf{E}_A \times \mathbf{E}_B) \cdot (\mathbf{E}_A \times \mathbf{E}_B)$, its derivative is $2L\dot{L} = 2(\mathbf{E}_A \times \mathbf{E}_B) \cdot (\mathbf{E}_A \times \dot{\mathbf{E}}_B + \dot{\mathbf{E}}_A \times \mathbf{E}_B)$, in which case

$$\dot{L} = (\mathbf{E}_A \times \dot{\mathbf{E}}_B + \dot{\mathbf{E}}_A \times \mathbf{E}_B) \cdot \mathbf{N}$$

Using equation (2.42), the edge derivatives are $\dot{\mathbf{E}}_A = \mathbf{w}_A \times \mathbf{E}_A$ and $\dot{\mathbf{E}}_B = \mathbf{w}_B \times \mathbf{E}_B$. Combining all these steps produces

$$\mathbf{U} = \mathbf{E}_A \times (\mathbf{w}_B \times \mathbf{E}_B) + (\mathbf{w}_A \times \mathbf{E}_A) \times \mathbf{E}_B, \qquad \dot{\mathbf{N}} = \frac{\mathbf{U} - (\mathbf{U} \cdot \mathbf{N})\mathbf{N}}{L} \tag{5.42}$$

An implementation for computing the normal derivative acts on whether the contact point is a vertex-face or an edge-edge intersection and uses either equation (5.41) or equation (5.42), accordingly.

We also need to compute $\dot{\mathcal{P}}_A(t) - \dot{\mathcal{P}}_B(t)$ and $\ddot{\mathcal{P}}_A(t) - \ddot{\mathcal{P}}_B(t)$. These follow from an application of equations (2.43) and (2.44), the latter equation containing linear acceleration terms with $\dot{\mathbf{v}} = \mathbf{a}$ and angular acceleration terms that can be evaluated using equation (2.90), $\dot{\mathbf{w}} = J^{-1}(\boldsymbol{\tau} - \mathbf{w} \times J\mathbf{w})$. The final formula for the relative acceleration at the point and time of contact is

$$
\begin{aligned}
\ddot{d}(t_0) = \mathbf{N}_0 \cdot {} & ((\dot{\mathbf{v}}_A + \dot{\mathbf{w}}_A \times \mathbf{r}_A + \mathbf{w}_A \times (\mathbf{w}_A \times \mathbf{r}_A)) \\
& - (\dot{\mathbf{v}}_B + \dot{\mathbf{w}}_B \times \mathbf{r}_B + \mathbf{w}_B \times (\mathbf{w}_B \times \mathbf{r}_B))) \\
& + 2(\mathbf{w}_B \times \mathbf{N}_0) \cdot ((\mathbf{v}_A + \mathbf{w}_A \times \mathbf{r}_A) - (\mathbf{v}_B + \mathbf{w}_B \times \mathbf{r}_B)) \\
= \mathbf{N}_0 \cdot {} & ((\mathbf{a}_A + (J_A^{-1}\boldsymbol{\tau}_A) \times \mathbf{r}_A) - (\mathbf{a}_B + (J_B^{-1}\boldsymbol{\tau}_B) \times \mathbf{r}_B)) + e
\end{aligned}
\tag{5.43}
$$

where the second equality groups the acceleration and torque terms together for our later convenience. The term e contains all the remaining terms from the first equality, including those portions from the torque equation of the form $J^{-1}(\mathbf{w} \times J\mathbf{w})$.

To avoid the interpenetration of body A into body B when $\ddot{d}(t_0) < 0$, body B must exert a *contact force* \mathbf{C} on body A. Such a force must satisfy three conditions:

1. \mathbf{C} must prevent the interpenetration of the bodies.

2. \mathbf{C} must be a repulsive force. It cannot act like glue between the bodies.

3. \mathbf{C} must become zero when the bodies separate.

We postulate that $\mathbf{C} = g\mathbf{N}_0$ for some scalar $g \geq 0$ at the point of contact \mathcal{P}_0. The value of g is chosen to satisfy condition 1. The nonnegativity of the magnitude g satisfies condition 2. To satisfy condition 3 we specify that $g\ddot{d}(t_0) = 0$. If the bodies separate an instant after the contact, we have $\ddot{d}(t_0 + \varepsilon) > 0$ and $g = 0$ is required. If $\ddot{d}(t_0) = 0$, the bodies are not separating, so the choice of g is irrelevant.

Just as for colliding contact, the contact force at a resting contact of a rigid body A has a contribution to changing the velocity of the center of mass, $g m_A^{-1}\mathbf{N}_0$, and a contribution to changing the angular velocity of the body about its center, $g(J_A^{-1}(\mathbf{r}_A \times \mathbf{N}_0)) \times \mathbf{r}_A$. The computation of contact forces must be done simultaneously for all points of contact, each point contributing terms of this type. We use Example 5.6 to illustrate, the same one that was used to illustrate computing impulse forces for the simultaneous handling of contact points.

EXAMPLE 5.7

Let \mathbf{F}_γ denote the external forces applied to body γ and let \mathbf{T}_γ denote the external torques applied to body γ. The external forces contribute to the linear acceleration of the centers of mass, and the external torques contribute to the angular acceleration of the bodies about their centers of mass. The postulated contact forces $g_i\mathbf{N}_i$ at the

*(Example 5.7
continued)*

points of contact \mathcal{P}_i contribute as well. A quick glance at Figure 5.8 will convince you that the resolution of forces at the centers of mass produces

$$m_A\mathbf{a}_A = -g_1\mathbf{N}_1 - g_2\mathbf{N}_2 - g_3\mathbf{N}_3 - g_4\mathbf{N}_4 + \mathbf{F}_A$$

$$m_B\mathbf{a}_B = g_1\mathbf{N}_1 + g_2\mathbf{N}_2 - g_5\mathbf{N}_5 + \mathbf{F}_B$$

$$m_C\mathbf{a}_C = g_3\mathbf{N}_3 + g_4\mathbf{N}_4 + g_6\mathbf{N}_6 + \mathbf{F}_C$$

$$m_D\mathbf{a}_D = g_5\mathbf{N}_5 - g_6\mathbf{N}_6 + \mathbf{F}_D$$

The torque resolution is

$$\boldsymbol{\tau}_A = -g_1\mathbf{r}_A^1 \times \mathbf{N}_1 - g_2\mathbf{r}_A^2 \times \mathbf{N}_2 - g_3\mathbf{r}_A^1 \times \mathbf{N}_3 - g_4\mathbf{r}_A^1 \times \mathbf{N}_4 + \mathbf{T}_A$$

$$\boldsymbol{\tau}_B = g_1\mathbf{r}_B^1 \times \mathbf{N}_1 + g_2\mathbf{r}_B^2 \times \mathbf{N}_2 - g_5\mathbf{r}_B^5 \times \mathbf{N}_5 + \mathbf{T}_B$$

$$\boldsymbol{\tau}_C = g_3\mathbf{r}_C^3 \times \mathbf{N}_3 + g_4\mathbf{r}_C^4 \times \mathbf{N}_4 + g_6\mathbf{r}_C^6 \times \mathbf{N}_6 + \mathbf{T}_C$$

$$\boldsymbol{\tau}_D = g_5\mathbf{r}_D^5 \times \mathbf{N}_5 - g_6\mathbf{r}_D^6 \times \mathbf{N}_6 + \mathbf{T}_D$$

where $\mathbf{r}_\gamma^i = \mathcal{P}_i - \mathcal{X}_\gamma$ for body γ and contact point i.

Each contact point leads to a relative acceleration equation of the form in equation (5.43), so we will index those equations with i. In each equation the acceleration terms we grouped together can have their accelerations and torques replaced by the expressions we obtained in the resolution of forces. For example, consider the contact point \mathcal{P}_1 involving bodies A and B. By our convention, the pair of bodies is ordered as (B, A) since a vertex of B intersects a face of A:

$$\ddot{d}_1 = \mathbf{N}_1 \cdot ((\mathbf{a}_B + (J_B^{-1}\boldsymbol{\tau}_B) \times \mathbf{r}_B^1) - (\mathbf{a}_A + (J_A^{-1}\boldsymbol{\tau}_A) \times \mathbf{r}_A^1)) + e_1$$

$$= \mathbf{N}_1 \cdot \Big[m_B^{-1}(g_1\mathbf{N}_1 + g_2\mathbf{N}_2 - g_5\mathbf{N}_5 + \mathbf{F}_B)$$

$$+ (J_B^{-1}(g_1\mathbf{r}_B^1 \times \mathbf{N}_1 + g_2\mathbf{r}_B^2 \times \mathbf{N}_2 - g_5\mathbf{r}_B^5 + \mathbf{T}_B)) \times \mathbf{r}_B^1$$

$$- m_A^{-1}(-g_1\mathbf{N}_1 - g_2\mathbf{N}_2 - g_3\mathbf{N}_3 - g_4\mathbf{N}_4 + \mathbf{F}_A)$$

$$- (J_A^{-1}(-g_1\mathbf{r}_A^1 \times \mathbf{N}_1 - g_2\mathbf{r}_A^2 \times \mathbf{N}_2 - g_3\mathbf{r}_A^3 \times \mathbf{N}_3$$

$$- g_4\mathbf{r}_A^4 \times \mathbf{N}_4 + \mathbf{T}_A)) \times \mathbf{r}_A^1 \Big] + e_1$$

$$= a_{11}g_1 + a_{12}g_2 + a_{13}g_3 + a_{14}g_4 + a_{15}g_5 + a_{16}g_6 + b_1$$

where the a_{ij} are exactly the same as those computed in Example 5.6! The term b_1 is

$$b_1 = e_1 + \mathbf{N}_1 \cdot \Big[(m_B^{-1}\mathbf{F}_B + (J_B^{-1}\mathbf{T}_B) \times \mathbf{r}_B^1) - (m_A^{-1}\mathbf{F}_A + (J_A^{-1}\mathbf{T}_A) \times \mathbf{r}_A^1) \Big]$$

Similar expressions can be constructed for the other contact points to obtain $\ddot{d}_i = \sum_{i=1}^{6} a_{ij}g_j + b_i$ for $1 \leq i \leq 6$. \blacksquare

In the general case we have a collection of rigid bodies and n contact points \mathcal{P}_i for $1 \leq i \leq n$. The acceleration at \mathcal{P}_i in the normal direction \mathbf{N}_i has magnitude

$$\ddot{d}_i = \sum_{i=1}^{n} a_{ij}g_j + b_i \tag{5.44}$$

where the a_{ij} are provided by equation (5.38). The general formula for the b_i is listed below:

$$b_i = e_i + \mathbf{N}_i \cdot \left[(m_\alpha^{-1}\mathbf{F}_\alpha + (J_\alpha^{-1}\mathbf{T}_\alpha) \times \mathbf{r}_\alpha^i) - (m_\beta^{-1}\mathbf{F}_\beta + (J_\beta^{-1}\mathbf{T}_\beta) \times \mathbf{r}_\beta^i) \right] \tag{5.45}$$

where

$$\begin{aligned}
e_i = \mathbf{N}_i \cdot &\left[\left((J_\alpha^{-1}(\mathbf{L}_\alpha \times \mathbf{w}_\alpha)) \times \mathbf{r}_\alpha^i + \mathbf{w}_\alpha \times (\mathbf{w}_\alpha \times \mathbf{r}_\alpha^i) \right) \right. \\
&\left. - \left((J_\beta^{-1}(\mathbf{L}_\beta \times \mathbf{w}_\beta)) \times \mathbf{r}_\beta^i + \mathbf{w}_\beta \times (\mathbf{w}_\beta \times \mathbf{r}_\beta^i) \right) \right] \\
&+ 2\dot{\mathbf{N}}_i \cdot \left[(\mathbf{v}_\alpha + \mathbf{w}_\alpha \times \mathbf{r}_\alpha^i) - (\mathbf{v}_\beta + \mathbf{w}_\beta \times \mathbf{r}_\beta^i) \right]
\end{aligned} \tag{5.46}$$

and where \mathbf{F}_γ is the external force and \mathbf{T}_γ is the external torque on body γ. The quantity $\mathbf{L}_\gamma = J_\gamma \mathbf{w}_\gamma$ is the angular momentum of body γ.

We now know how to compute the accelerations \ddot{d}_i, *given the contact forces*. However, the original problem was to *choose the contact forces* to prevent interpenetration. Let us reformulate our conditions using vector and matrix notation. Let \mathbf{g} be the $n \times 1$ vector that stores the magnitudes of the contact forces. The magnitudes are all non-negative. We may write this succinctly as $\mathbf{g} \geq \mathbf{0}$, a shortcut for stating $g_i \geq 0$ for all i. Let $\ddot{\mathbf{d}}$ be the $n \times 1$ vector that stores the accelerations. To avoid interpenetrations we need $\ddot{\mathbf{d}} \geq \mathbf{0}$. If the bodies separate at resting contact point i an instant after the contact has occurred, we require that the contact force become zero. The mathematical formulation is $\ddot{d}_i g_i = 0$. In vector notation this is $\ddot{\mathbf{d}} \circ \mathbf{g} = \mathbf{0}$. Finally, equation (5.44) is written as $\ddot{\mathbf{d}} = A\mathbf{g} + \mathbf{b}$, where $A = [a_{ij}]$ is an $n \times n$ matrix and $\mathbf{b} = [b_i]$ is an $n \times 1$ vector.

In summary, given A and \mathbf{b}, we need to compute $\ddot{\mathbf{d}}$ and \mathbf{g} that satisfy $\ddot{\mathbf{d}} = A\mathbf{g} + \mathbf{b}$ subject to the constraints $\ddot{\mathbf{d}} \geq \mathbf{0}$ and $\mathbf{g} \geq \mathbf{0}$ and subject to the complementarity condition $\ddot{\mathbf{d}} \circ \mathbf{g} = \mathbf{0}$. This is a linear complementarity problem (LCP), which we discuss briefly in Section 5.2.2 and cover in Chapter 7 in more detail. In particular, it is of the form of equation (7.5) where M is our A, \mathbf{q} is our \mathbf{b}, \mathbf{w} is our $\ddot{\mathbf{d}}$, and \mathbf{z} is our \mathbf{g}.

The order of operations listed for handling colliding contact is modified to the following:

1. The collision detection system calculates all contact points for the current state of the rigid bodies.

2. The contact points and rigid body states are used to compute the matrix A, vector $\dot{\mathbf{d}}^-$, and vector \mathbf{b}.

3. The LCP solver computes \mathbf{f} and $\dot{\mathbf{d}}^+$ from the inputs A and $\dot{\mathbf{d}}^-$. The LCP solver computes \mathbf{g} and $\ddot{\mathbf{d}}$ from the inputs A and \mathbf{b}. We are guaranteed of no interpenetration since $\dot{\mathbf{d}}^+ \geq \mathbf{0}$ and $\ddot{\mathbf{d}} \geq \mathbf{0}$ are postconditions of the LCP solver.

4. The postimpulse velocities are computed from \mathbf{f} and the normal vectors at the collision points. These velocities replace the preimpulse values in the rigid bodies.

5. The resting contact forces involving the \mathbf{g} are included when computing the total forces and torques on the rigid bodies.

6. The differential equation solver computes the new positions and orientations of the rigid bodies.

7. Repeat step 1.

Section 5.2.4 expands on this.

5.2.4 AN ILLUSTRATIVE IMPLEMENTATION

The rigid bodies are convex polyhedral solids. We will assume the existence of a collision detection system that handles convex polyhedra. Section 5.3 provides details of such a system. The structure RigidBodies used earlier will also be used here. We need another structure for representing contact points:

```
struct Contact
{
    RigidBody A;        // body containing vertex
    RigidBody B;        // body containing face
    point P;            // contact point
    vector N;           // outward unit-length normal of face
    vector EA;          // edge from A
    vector EB;          // edge from B
    bool isVFContact;   // true if vertex-face, false if edge-edge
}
```

If the contact point is a vertex-face intersection, then N is valid but the edges EA and EB are not. If the contact point is an edge-edge intersection, then all fields are valid. All point and vector quantities are assumed to be in world coordinates.

The highest-level view of the physical simulation is listed below. It is assumed that the initialization of the rigid bodies results in no interpenetrations.

```
void DoSimulation ()
{
    // For the arrays, size() indicates the number of array elements.

    array<RigidBody> body;
    for (i = 0; i < body.size(); i++)
        body[i].Initialize(<parameters>);

    array<Contact> contact;

    double t = <your choice of initial time>;
    double dt = <your choice of time step>;

    for (int step = 1; step <= maxSteps; step++, t += dt)
    {
        DoCollisionDetection(t,dt,body,contact);
        if ( contact.size() > 0 )
            DoCollisionResponse(t,dt,body,contact);
    }
}
```

The function DoCollisionDetection removes all old contact points from the array contact before inserting new ones.

The collision response function is

```
void DoCollisionReponse (double t, double dt, array<RigidBody> body,
    array<Contact> contact)
{
    matrix A;
    vector preRelVel, postRelVel, impulseMag;
    vector restingB, relAcc, restingMag;

    ComputeLCPMatrix(contact,A);

    // guarantee no interpenetration by postRelVel >= 0
    ComputePreImpulseVelocity(contact,preRelVel);
    Minimize(A,preRelVel,postRelVel,impulseMag);
    DoImpulse(contact,impulseMag);

    // guarantee no interpenetration by relAcc >= 0
    ComputeRestingContactVector(contact,restingB);
    LCPSolver(A,restingB,relAcc,restingMag);
    DoMotion(t,dt,contact,restingMag,body);
}
```

```
// Minimize |A * f + b|^2 subject to f >= 0, c - b >= A * f >= -b.
// The i-th component of b is b[i] = 0 if dneg[i] >= 0 and
// b[i] = 2 * dneg[i] if dneg[i] < 0.  The i-th component of
// c is c[i] = |dneg[i]|.  The inputs are A and dneg.  The
// outputs are dpos and f.
//
void Minimize (matrix A, vector dneg, vector& dpos, vector& f);

// The parameter names match those in the chapter discussing
// LCP.  The input is the matrix M and vector q.  The output
// is the vector w and the vector z.
//
void LCPSolver (matrix M, vector q, vector& w, vector& z);
```

The function ComputeLCPMatrix computes the matrix $A = [a_{ij}]$ whose entries are defined by equation (5.38).

```
void ComputeLCPMatrix (array<Contact> contact, matrix& A)
{
    for (i = 0; i < contact.size(); i++)
    {
        Contact ci = contact[i];
        vector rANi = Cross(ci.P - ci.A.x,ci.N);
        vector rBNi = Cross(ci.P - ci.B.x,ci.N);

        for (j = 0; j < contact.size(); j++)
        {
            Contact cj = contact[j];
            vector rANj = Cross(cj.P - cj.A.x,cj.N);
            vector rBNj = Cross(cj.P - cj.B.x,cj.N);

            A[i][j] = 0;

            if ( ci.A == cj.A )
            {
                A[i][j] += ci.A.massinv * Dot(ci.N,cj.N);  // force term
                A[i][j] += Dot(rANi,ci.A.jinv * rANj);  // torque term
            }
            else if ( ci.A == cj.B )
            {
                A[i][j] -= ci.A.massinv * Dot(ci.N,cj.N);  // force term
                A[i][j] -= Dot(rANi,ci.A.jinv * rANj);  // torque term
            }
```

```
                if ( ci.B == cj.A )
                {
                    A[i][j] += ci.B.massinv * Dot(ci.N,cj.N);  // force term
                    A[i][j] += Dot(rBNi,ci.B.jinv * rBNj);  // torque term
                }
                else if ( ci.B == cj.B )
                {
                    A[i][j] -= ci.B.massinv * Dot(ci.N,cj.N);  // force term
                    A[i][j] -= Dot(rBNi,ci.B.jinv * rBNj);  // torque term
                }
            }
        }
    }
}
```

The function ComputePreImpulseVelocity computes the preimpulse velocities \dot{d}_i^- defined by equation (5.39).

```
void ComputePreImpulseVelocity (array<Contact> contact, vector& ddot)
{
    for (i = 0; i < contact.size(); i++)
    {
        contact ci = contact[i];
        RigidBody A = ci.A;
        RigidBody B = ci.B;

        vector rAi = ci.P - A.x;
        vector rBi = ci.P - B.x;
        vector velA = A.v + Cross(A.w,rAi);
        vector velB = B.v + Cross(B.w,rBi);
        ddot[i] = Dot(ci.N,velA - velB);
    }
}
```

The function ComputeRestingContactVector computes the vector $\mathbf{b} = [b_i]$ defined by equation (5.45). The derivative of the normal vector is computed using equations (5.41) and (5.42).

```
void ComputeRestingContactVector (array<Contact> contact, vector& b)
{
    for (i = 0; i < contact.size(); i++)
    {
        contact ci = contact[i];
        RigidBody A = ci.A, B = ci.B;
```

```
        // body A terms
        vector rAi = ci.P - ci.A.x;
        vector wAxrAi = Cross(A.w,rAi);
        vector At1 = A.massinv * A.force;
        vector At2 = Cross(A.jinv * (A.torque + Cross(A.L,A.w)),rAi);
        vector At3 = Cross(A.w,wAxrAi);
        vector At4 = A.v + wAxrAi;

        // body B terms
        vector rBi = ci.P - ci.B.x;
        vector wBxrBi = Cross(B.w,rBi);
        vector Bt1 = B.massinv * B.force;
        vector Bt2 = Cross(B.jinv * (B.torque + Cross(B.L,B.w)),rBi);
        vector Bt3 = Cross(B.w,wBxrBi);
        vector Bt4 = B.v + wBxrBi;

        // compute the derivative of the contact normal
        vector Ndot;
        if ( ci.isVFContact )
        {
            Ndot = Cross(B.w,ci.N);
        }
        else
        {
            vector EAdot = Cross(A.w,ci.EA);
            vector EBdot = Cross(B.w,ci.EB);
            vector U = Cross(ci.EA,EBdot) + Cross(EAdot,ci.EB);
            Ndot = (U - Dot(U,ci.N) * ci.N) / Length(ci.N);
        }

        b[i] = Dot(ci.N,At1 + At2 + At3 - Bt1 - Bt2 - Bt3) +
            Dot(Ndot,At4 - Bt4);
    }
}
```

The function DoImpulse has the responsibility of replacing the preimpulse linear and angular velocities by the postimpulse vectors. The motivation was given in Example 5.6. That example shows that it suffices to iterate over the contacts and impulse magnitudes and incrementally update the velocities.

```
void DoImpulse (array<Contact> contact, vector f)
{
    for (i = 0; i < contact.size(); i++)
    {
        contact ci = contact[i];
```

```
// update linear/angular momentum
vector impulse = f[i] * ci.N;
ci.A.p += impulse;
ci.B.p -= impulse;
ci.A.L += Cross(ci.P - ci.A.x,impulse);
ci.B.L -= Cross(ci.P - ci.B.x,impulse);

// compute linear/angular velocity
ci.A.v = ci.A.massinv * ci.A.p;
ci.B.v = ci.B.massinv * ci.B.p;
ci.A.w = ci.A.jinv * ci.A.L;
ci.B.w = ci.B.jinv * ci.B.L;
    }
}
```

Finally, the function DoMotion implements the differential equation solver. It also must incorporate the resting contact forces into the solver in addition to any externally applied forces. We used a Runge-Kutta method for solving the differential equations for unconstrained motion. This method uses multiple function evaluations and requires some careful programming to handle the forces and torques. The structure RigidBody in the illustrative implementation for unconstrained motion has two members, force and torque, that are intended to store the current externally applied force and torque at the current time of the simulation. To support solvers that use multiple function evaluations and to avoid the copying in the illustrative implementation, we designed a C++ class RigidBody that had function members for computing the external force and torque. Let us modify this class by adding two data members to store the current external force and torque in addition to having the force and torque function members. Moreover, we will add two data members to store the resting contact forces. Only the modified interface is shown:

```
class RigidBody
{
public:
    void AppendInternalForce (vector intForce)
    {
        m_internalForce += intForce;
    }

    void AppendInternalTorque (vector intTorque)
    {
        m_internalTorque += intTorque;
    }
```

```
protected:
    // external force/torque at current time of simulation
    vector m_externalForce, m_externalTorque;

    // Resting contact force/torque.  Initially zero, changed by
    // simulator before call to ODE solver, ODE solver uses for
    // motion of bodies, then reset to zero for next pass.
    vector m_internalForce, m_internalTorque;

    // force/torque functions (same as before)
    Function m_force, m_torque;
};
```

The initialization of the rigid body objects must now include calling the force and torque member functions m_force and m_torque to initialize the data members m_externalForce and m_externalTorque. The member function RigidBody::Update must also be modified to support these changes. The old function had the following lines of code for the first step of the Runge-Kutta solver:

```
//  A1 = G(t,S0), B1 = S0 + (dt / 2) * A1
 .
 .
 .
vector A1DPDT = m_force(t,m_X,m_Q,m_P,m_L,m_R,m_V,m_W);
vector A1DLDT = m_torque(t,m_X,m_Q,m_P,m_L,m_R,m_V,m_W);
 .
 .
 .
```

The force and torque evaluation are at the current time, but we are now storing those values in the rigid body itself. The new function replaces these lines by

```
//  A1 = G(t,S0), B1 = S0 + (dt / 2) * A1
 .
 .
 .
vector A1DPDT = m_externalForce + m_internalForce;
vector A1DLDT = m_externalTorque + m_internalTorque;
 .
 .
 .
m_internalForce = 0;
m_internalTorque = 0;

//  A2 = G(t + dt / 2,B1), B2 = S0 + (dt / 2) * A2
 .
 .
 .
```

```
// A3 = G(t + dt / 2,B2), B3 = S0 + dt * A3
.
.
.

// A4 = G(t + dt,B3), S1 = S0 + (dt / 6) * (A1 + 2 * A2 + 2 * A3 + A4)
.
.
.
```

The inclusion of the internal quantities takes into account that, just before the update function is called, the collision response system needs to set the internal quantities to support resting contact. After using the internal values for the first step, I have set them to zero. They are not used in steps 2, 3, or 4 because the time in those steps is later than the current time; separation potentially has occurred and the resting contact forces must become zero as specified in our analysis. However, it is possible that after the half-step in time, resting contact still exists, so you might want to use the internal force and torque terms in the later steps.

The dilemma is that we are now in the middle of running the differential equation solver. If we want more accurate information about contact after the first step, we would have to exit after the first step and rerun the other parts of the collision system to once again find out which intersections are resting contacts. By doing so, our solver is nothing more than an Euler's method and we suffer from its lack of robustness and stability. I chose to zero out the internal values for simplicity. You might very well experiment and rewrite the solver to use the internal values for all the steps. One last change must be made to the solver to maintain the invariant that the external force and torque members are those of the current simulation time. Two lines of code must be added to the end of RigidBody::Update after the fourth step is complete:

```
// A4 = G(t + dt,B3), S1 = S0 + (dt / 6) * (A1 + 2 * A2 + 2 * A3 + A4)
.
.
.

Convert(m_Q,m_P,m_L,m_R,m_V,m_W);

// new lines to make force and torque correspond to new time t + dt
m_externalForce = m_force(tpdt,m_X,m_Q,m_P,m_L,m_R,m_V,m_W);
m_externalTorque = m_torque(tpdt,m_X,m_Q,m_P,m_L,m_R,m_V,m_W);

void DoMotion (double t, double dt, array<Contact> contact, vector g,
    array<RigidBody> body)
{
    // update internal force/torque
    for (i = 0; i < contact.size(); i++)
    {
        contact ci = contact[i];
        vector resting = g[i] * ci.N;
```

```
        ci.A.AppendInternalForce(resting);
        ci.A.AppendInternalTorque(Cross(ci.p - ci.A.x,resting));
        ci.B.AppendInternalForce(-resting);
        ci.B.AppendInternalTorque(-Cross(ci.p - ci.B.x,resting));
    }

    // update rigid bodies
    for (i = 0; i < body.size(); i++)
        body[i].Update(t,dt);
}
```

5.2.5 LAGRANGIAN DYNAMICS

The extensive system for constrained motion that we have studied so far is designed to be general. Other than requiring the rigid bodies to be modeled as convex polyhedra, no assumptions are made about how the environment might constrain the objects. In fact, the main role of the collision detection system is to determine the constraints dynamically, then let the collision response system know with which constraints it has to work. Such a general dynamics system is useful for many game applications but is not necessary for all situations arising in a game. Just as game designers will take into account the strengths and limitations of a graphics engine when deciding on the complexity of art content, they will also consider the strengths and limitations of a physics engine.

For example, automatic and efficient occlusion culling in a graphics engine is a difficult task to implement. Portal systems are particularly useful for limiting the depth complexity of an indoor scene while allowing the player to move in unconstrained ways. However, if a level is built in such a way that the player looks through a door (portal) of a room and can see through another door across the room, followed by a long path of visible doors of yet more adjacent rooms, the portal system performance can decrease quite rapidly. Yes, a general portal system is quite powerful, but it has its limitations. A level designer will arrange for such a configuration not to happen, knowing that the portal system is good for a couple of doors along the line of sight. Thus, the designer establishes the constraints during development time to keep the performance reasonable at runtime.

Careful consideration of how to build an environment to allow the physics engine to perform well is also called for. For example, suppose that a game requires a character to navigate through a room filled with boxes in order to reach an exit on the other side of the room. The environment is designed to make it challenging—no open path is available when the character enters the room. In order to reach the exit, boxes must be moved around, some of them easy to move, others too heavy to move. Moreover, the player must discover that some boxes need to be moved, but that can happen only when they are pushed by other boxes; the other boxes block the path to

ones that need to be moved. A general collision system can be used for this environment. Since the boxes are in resting contact with the floor, the system must compute the appropriate contact forces to keep the boxes from sinking through the floor. The collision detection system also spends a lot of time reporting that the boxes are intersecting the floor! No doubt we will want the floor to have friction. As commercial physics engine developers will remind you regularly, getting the general collision system to work correctly in the presence of static and dynamic friction is quite a difficult chore.

But we know that the boxes are on the floor and will remain so—that is our design. Let us take advantage of the fact that we know a constraint of the system at development time. What better way to take advantage of known constraints than by using Lagrangian dynamics? We covered this topic in extensive detail in Section 3.2. At the end of that section we even derived the equations of motion for a box moving over a rough plane. And if you did your homework (Exercise 3.31), you are ready to test out the environment you just built! Well, not quite. We still have the dynamic situation of boxes being pushed by the character and colliding with other boxes. A collision detection system is still required, but even this system can be specialized for our environment.

Two of our boxes can collide only with edge-face or face-face contact. Although the general collision detection system can handle this as contact between 3D objects, we can do better. If you view the boxes from above, they all appear as rectangles. The specialized collision detection system needs to work only in 2D. An edge-face intersection in 3D is detected as a vertex-edge intersection in 2D. A face-face intersection in 3D is detected as an edge-edge intersection in 2D. The Lagrangian equations of motion for this collection of boxes will involve only floor variables (x, y) but not the height variable z. The outline of how the system works is analogous to what the general system did, except that now we are working in only two dimensions.

There is a drawback to what I just described. The collision system is specifically written for this room (and similar rooms if you like). In the object-oriented approach, the general differential equation solver was built into the `RigidBody` class. In our Lagrangian setting, the equations of motion depend on the constraints. Moreover, our intent is that the constraints are known at development time. A general collision system is a reusable component, a good thing as any software engineer will tell you. The Lagrangian approach might very well lead to building a lot of components that are not reusable, thus increasing your development costs. Hopefully, the Lagrangian components you build, such as for a room of objects sitting on a floor, will be useful across levels and across games.

Can we find middle ground? That is, can we use Lagrangian dynamics even if our constraints change dynamically? I think so, but I believe such an engine will require that a lot of thought be put into its design. To illustrate what I have in mind, consider a book on a table as shown in Figure 5.9.

The book can be pushed around the table, all the while using the Lagrangian equations of motion with the constraint that the center of mass of the book is a

Figure 5.9 A book resting on a table. Forces applied to the book include only gravitational (force vertically downward) and those used to push the book around the table (force has only a horizontal component).

constant height above the table. If the book is pushed to the edge of the table and a small part of it extends past the edge, the book remains on the table, our constraint still applies, and the Lagrangian equations of motion remain as they are. However, if the book is pushed far enough past the table's edge, gravity will exert enough force to make the book start to fall off the table. The collision detection system is constantly reporting to us the polygon of intersection between the book and the table. This information is what we use to decide if the book rests on the table or if the area of intersection is small enough that torque causes the book to lift off the table and start to fall to the floor.

At the instant the book starts to fall, our constraint of constant height center of mass is invalid and we need a new set of equations of motion. The book will slide along the edge of the table while rotating about a line through its center of mass (the line perpendicular to the plane of the figure), constraints that might be difficult to dynamically convert to equations of motion. A physics engine that is a hybrid between the general collision system and a Lagrangian-based one appears to be called for. In our book-table example, once the book starts to fall, we enable the general system. Once the book strikes the floor and attains a resting position, we switch back to the Lagrangian-based engine.

I will leave the ideas at that. The development of an engine of this type is a challenge I pose to those of you who have the energy and desire to follow such a path!

5.3 Collision Detection with Convex Polyhedra

In this chapter our rigid bodies have been selected to be convex polyhedra of constant mass density. The short name for convex polyhedron is *polytope*, a term we will use throughout the remainder of this section. The invariant of the collision detection and response system is *nonpenetration of the polyhedra*. The collision detection system must compute points of contact between each pair of polytopes. The response of

the system is designed so that at all points of contact, the polytopes move with nonnegative velocity relative to the normal directions at the contact points, thus maintaining the nonpenetration invariant.

Now we take a close look at how to compute the contact points. Since we must find actual intersection points, a test-intersection geometric query will not suffice. A find-intersection geometric query must be formulated. For two stationary polytopes a find-intersection query must compute the polytope of intersection. If we were just to use a generic intersection algorithm, we would be ignoring the fact that our invariant prevents interpenetration. Because of our invariant, the intersection must consist of points, line segments, or convex polygons; intersection regions with volume are disallowed. Assuming a collision detection and response system designed to handle a finite set of contact points, the find-intersection query might very well detect a line segment of intersection but need only report the end points as the contact points. Similarly, only the vertices of a convex polygon of intersection need to be reported. Thus, a find-intersection query should be tailored to our needs.

We have an additional problem to deal with. Time is a continuous variable in the physical setting, but we are using a differential equation solver to estimate motion over small time intervals. Let $\mathcal{P}(t)$ be the path of a point on a moving polytope. The equations of motion determine this path, but we do not know the path in closed form. Knowing the location of a point $\mathcal{P}_0 = \mathcal{P}(t_0)$ at the current time t_0, our goal is to determine the location $\mathcal{P}_1 = \mathcal{P}(t_1)$ at the next sampled simulation time $t_1 = t_0 + \Delta t$. The differential equation solver produces a point \mathcal{Q}_1 that is an *approximation* to \mathcal{P}_1. The collision system might very well report that \mathcal{Q}_1 is outside (or inside) another polytope when in fact \mathcal{P}_1 is inside (or outside) that polytope, the collision result being in error. For most game applications, if a collision is reported when in fact there is none, the system is effectively conservative in its handling in that some action will be taken to "prevent" the collision; the only harm done is that some extra cycles are spent on the event. More serious, though, is for the collision system *not to report a collision* when in fact there is one. For those of you with some experience programming with collision detection systems, I am certain you have seen the situation where an object (whose motion is controlled by an input device such as a mouse or joystick) slightly interpenetrates a wall because the collision system failed to report the intersection. When you attempt to steer the object away from the wall, it becomes stuck because now the collision system *does detect an intersection*, this one between the object and the opposite side of the wall. In some collision detection systems you might even see the object stutter, a high-frequency oscillation of a system in conflict, one portion trying to pull the object out of the wall and another portion pulling it into the wall. We would like to avoid such behavior in our collision detection system.

Even if we were able to compute the exact value \mathcal{P}_1, the system can still be in error. The problem now is that we have incremented t_0 to t_1 by a positive increment in time. It is possible that \mathcal{P}_0 and \mathcal{P}_1 are both outside another polytope, but at some time $t_2 \in [t_0, t_1]$ the point $\mathcal{P}(t_2)$ is inside that polytope. The time step Δt of the differential equation solver was too large to "notice" the collision event. Although your instinct

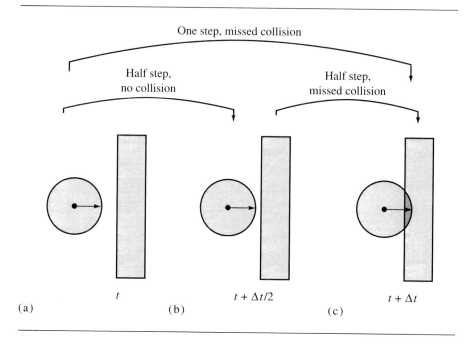

One step, missed collision

Half step,
no collision

Half step,
missed collision

t

$t + \Delta t/2$

$t + \Delta t$

(a) (b) (c)

Figure 5.10 (a) Object at time t_0. (b) Object at time $t_0 + \Delta t/2$. (c) Object at time $t_0 + \Delta t$.

might be to choose a smaller value for Δt, you can do so, move the object in two time steps, and miss the intersection again. Figure 5.10 illustrates.

 In fact, the reduction in time step has problems *exactly* in those circumstances that we are interested in—contact without interpenetration. A classical solution to the problem, and one mentioned in [Bar01], is to use a bisection method. Let $B_0(t)$ and $B_1(t)$ denote the solid polytopes at time t (as sets of points). The assumption is that two polytopes are not intersecting at time t_0, $B_0(t_0) \cap B_1(t_0) = \emptyset$ (the intersection is the empty set). The polytopes are to be moved during the time interval $[t_0, t_1]$, the difference $\Delta t = t_1 - t_0$ supplied by the application. If $B_0(t_1)$ and $B_1(t_1)$ intersect and the intersection set has volume, say, $I = B_0(t_1) \cap B_1(t_1) \neq \emptyset$ with Volume$(I) > 0$, the time step was too large. Now try the motion with half the time step, the final time being $t_m = (t_0 + t_1)/2$. The intersect set is $I = B_0(t_m) \cap B_1(t_m)$. If $I \neq \emptyset$ and Volume$(I) > 0$, the half step was also too large and we repeat the bisection of the time interval. If $I = \emptyset$, the half step was too large and we search for potential intersection on the other half interval $[t_m, t_1]$. Our goal is to obtain an intersection $I \neq \emptyset$ with Volume$(I) = 0$. The pseudocode is

```
void GetContactSet (double t0, double t1, polytope B0(t),
    polytope B1(t), double& tContact, set& I)
{
```

```
// precondition:  B0(t0) and B1(t0) do not intersect

I = GetIntersection(B0(t1),B1(t1));
if ( I is the empty_set )
{
    tContact = <irrelevant>;
    return;
}
if ( Volume(I) == 0 )
{
    tContact = t1;
    return;
}

for (i = 1; i <= maxIterations; i++)
{
    tm = (t0 + t1)/2;
    I = GetIntersection(B0(tm),B1(tm));
    if ( I is the empty_set )
        t0 = tm;
    else if ( Volume(I) > 0 )
        t1 = tm;
    else
    {
        tContact = tm;
        return;
    }
}
}
```

Well, this is still not a correct algorithm for two reasons. First, it can terminate immediately when $B_0(t_1)$ and $B_1(t_1)$ do not intersect and the system reports that no intersection has occurred. Second, it is possible that the system reports contact points at the *last time of contact*. However, if the time steps are small compared to the sizes and velocities of the polytopes, the algorithm should have reasonable behavior. Observe that the pseudocode contains a function call GetIntersection that requires computing the polytope of intersection for two purposes, testing if the intersection is empty and measuring the volume if not. As mentioned earlier, we want to avoid a generic intersection calculator for polytopes because they can be somewhat expensive to execute. Moreover, it would be useful to have an intersection system that can *predict* the time of collision on the interval $[t_0, t_1]$ rather than search for one by sampling the interval.

This section addresses how we go about testing for intersection of polytopes and predicting when they intersect. A powerful algorithm is used, called the *method of separating axes*. A detailed description of the method for moving as well as stationary

objects and for 2D (convex polygons) and 3D (convex polyhedra) is provided in the books [Ebe00] and [SE02]. A summary of the method is provided here, but with some additional material that is relevant to objects participating in a constrained dynamics system. In particular, we want to take advantage of *time coherence* to help minimize calculations at the next time step by caching information from the previous time step.

5.3.1 THE METHOD OF SEPARATING AXES

We have been using the term *convex* when referring to the polyhedra that represent our rigid bodies. A reminder of what that term means is in order: A set C is convex if given any two points \mathcal{P} and \mathcal{Q} in C, the line segment $(1 - t)\mathcal{P} + t\mathcal{Q}$ for $t \in [0, 1]$ is also in C. Figure 5.11 shows a convex set and a nonconvex set in the plane.

A test for nonintersection of two convex objects is simply stated: If there exists a line for which the intervals of projection of the two objects onto that line do not intersect, then the objects do not intersect. Such a line is called a *separating line* or, more commonly, a *separating axis*. Figure 5.12 illustrates.

The translation of a separating line is also a separating line, so it is sufficient to consider lines that contain the origin. Given a line containing the origin \mathcal{O} and with unit-length direction \mathbf{D}, the projection of a convex set C onto the line is the interval

$$I = [\lambda_{\min}(\mathbf{D}), \lambda_{\max}(\mathbf{D})] = [\min\{\mathbf{D} \cdot (\mathcal{X} - \mathcal{O}) : \mathcal{X} \in C\}, \max\{\mathbf{D} \cdot (\mathcal{X} - \mathcal{O}) : \mathcal{X} \in C\}]$$

where possibly $\lambda_{\min}(\mathbf{D}) = -\infty$ or $\lambda_{\max}(\mathbf{D}) = +\infty$, these cases arising when the convex set is unbounded. Two convex sets C_0 and C_1 are *separated* if there exists a direc-

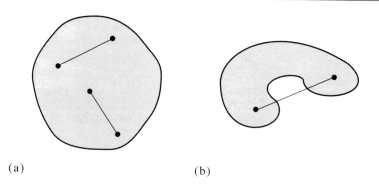

(a) (b)

Figure 5.11 (a) A convex set. No matter which two points you choose in the set, the line segment connecting them is in the set. (b) A nonconvex set. The line segment connecting two specific points is not (fully) contained in the set.

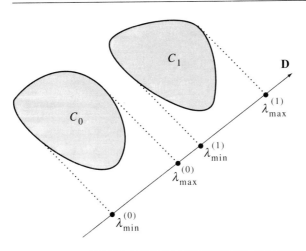

Figure 5.12 Nonintersecting convex objects and a separating line for them. The algebraic condition for separation is $\lambda_{\text{max}}^{(0)}(\mathbf{D}) < \lambda_{\text{min}}^{(1)}(\mathbf{D})$ as indicated in equation (5.47).

tion \mathbf{D} such that the projection intervals I_0 and I_1 do not intersect. Specifically, they do not intersect when

$$\lambda_{\text{min}}^{(0)}(\mathbf{D}) > \lambda_{\text{max}}^{(1)}(\mathbf{D}) \quad \text{or} \quad \lambda_{\text{max}}^{(0)}(\mathbf{D}) < \lambda_{\text{min}}^{(1)}(\mathbf{D}) \tag{5.47}$$

The superscript corresponds to the index of the convex set. Although the comparisons are made where \mathbf{D} is unit length, the comparison results are invariant to changes in length of the vector. This follows from $\lambda_{\text{min}}(t\mathbf{D}) = t\lambda_{\text{min}}(\mathbf{D})$ and $\lambda_{\text{max}}(t\mathbf{D}) = t\lambda_{\text{max}}(\mathbf{D})$ for $t > 0$. The Boolean value of the pair of comparisons is also invariant when \mathbf{D} is replaced by the opposite direction $-\mathbf{D}$. This follows from $\lambda_{\text{min}}(-\mathbf{D}) = -\lambda_{\text{max}}(\mathbf{D})$ and $\lambda_{\text{max}}(-\mathbf{D}) = -\lambda_{\text{min}}(\mathbf{D})$. When \mathbf{D} is not unit length, the intervals obtained for the separating line tests are not the projections of the object onto the line, rather they are scaled versions of the projection intervals. We make no distinction between the scaled projection and regular projection. We will also use the terminology that the direction vector for a separating line is called a *separating direction*, a direction that is not necessarily unit length.

Please note that in two dimensions, the terminology for separating line or axis is potentially confusing. The separating line separates the *projections* of the objects on that line. The separating line does *not* partition the plane into two regions, each containing an object. In three dimensions, the terminology should not be confusing since a plane would need to be specified to partition space into two regions, each containing an object. No real sense can be made for partitioning space by a line.

5.3.2 STATIONARY OBJECTS

The method of separating axes for stationary objects determines whether or not two objects intersect, a test-intersection query. We will analyze the method for convex polygons in 2D to motivate the ideas, then extend the method to convex polyhedra in 3D.

Convex Polygons

The following notation is used throughout this section. Let C_j for $j = 0, 1$ be the convex polygons with vertices $\mathcal{P}_i^{(j)}$ for $0 \leq i < N_j$ that are counterclockwise ordered. The edges of the polygons have direction vectors $\mathbf{E}_i^{(j)} = \mathcal{P}_{i+1}^{(j)} - \mathcal{P}_i^{(j)}$ for $0 \leq i < N_j$ and where modular indexing is used to handle wraparound (index N is the same as index 0; index -1 is the same as index $N - 1$). Outward normal vectors to the edges are $\mathbf{N}_i^{(j)}$. No assumption is made about the length of the normal vectors; an implementation may choose the length as needed. Regardless of length, the condition of outward pointing means

$$\left(\mathbf{N}_i^{(j)}\right)^{\perp} \cdot \mathbf{E}_i^{(j)} > 0$$

where $(x, y)^{\perp} = (-y, x)$. All the pseudocode relating to convex polygons will use the class shown:

```
class ConvexPolygon
{
public:
    // N, number of vertices
    int GetN();

    // V[i], counterclockwise ordered
    Point GetVertex (int i);

    // E[i] = V[i + 1] - V[i]
    Vector GetEdge (int i);

    // N[i], N[i].x * E[i].y - N[i].y * E[i].x > 0
    Vector GetNormal (int i);
};
```

All functions are assumed to handle the wraparound. For example, if the input value is N, the number of vertices, then GetVertex returns \mathcal{P}_0 and GetEdge returns $\mathcal{P}_1 - \mathcal{P}_0$. If the input value is -1, then GetVertex returns \mathcal{P}_{N-1} and GetEdge returns $\mathcal{P}_0 - \mathcal{P}_{N-1}$. Only the relevant interface is supplied for clarity of the presentation. The implementation details will vary with the needs of an application.

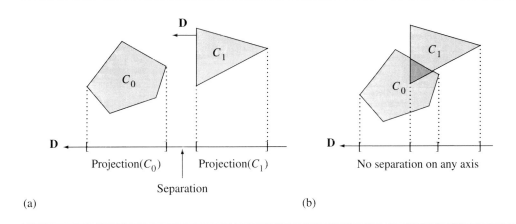

Figure 5.13 (a) Nonintersecting convex polygons. (b) Intersecting convex polygons.

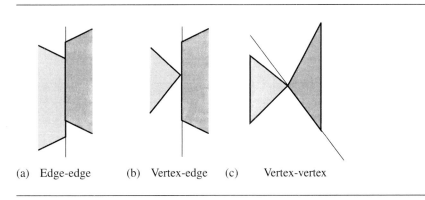

Figure 5.14 (a) Edge-edge contact. (b) Vertex-edge contact. (c) Vertex-vertex contact.

For a pair of convex polygons, only a finite set S of direction vectors needs to be considered for separation tests. That set contains only the normal vectors to the edges of the polygons. Figure 5.13(a) shows two nonintersecting polygons that are separated along a direction determined by the normal to an edge of one polygon. Figure 5.13(b) shows two polygons that intersect; there are no separating directions.

The intuition for why only edge normals must be tested is based on having two convex polygons just touching with no interpenetration. Figure 5.14 shows the three possible configurations: edge-edge contact, vertex-edge contact, and vertex-vertex contact.

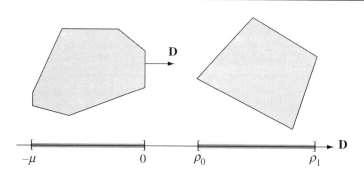

Figure 5.15 Two polygons separated by an edge-normal direction of the first polygon.

The lines between the polygons are perpendicular to the separation lines that would occur for one object translated away from the other by an infinitesimal distance. The vertex-vertex edge case has a low probability of occurrence. The collision system should report this as a vertex-face collision to be consistent with our classification of contact points (vertex-face or edge-edge with appropriately assigned normal vectors).

A naive implementation of the method of separating axes selects a potential separating direction \mathbf{D}, computes the intervals of projection by projecting the vertices of both polygons onto that line, then tests if the intervals are separated. This requires computing N_i projections for polygon C_i and keeping track of the minimum and maximum projection values for each polygon. In the worst case that the polygons intersect, N_0 directions are tested from C_0, each requiring $N_0 + N_1$ projections, and N_1 directions are tested from C_1, each requiring $N_0 + N_1$ projections. The total number of projections is $(N_0 + N_1)^2$.

A smarter algorithm avoids projecting all the vertices for the polygons by only testing for separation using the maximum of the interval for the first polygon and the minimum of the interval for the second polygon. If \mathbf{D} is an outward pointing normal for the edge $\mathcal{P}_{i+1}^{(0)} - \mathcal{P}_i^{(0)}$ of C_0, then the projection of the C_0 onto the separating line $\mathcal{P}_i^{(0)} + t\mathbf{D}$ is $[-\mu, 0]$, where $\mu > 0$. If the projection of C_1 onto this line is $[\rho_0, \rho_1]$, then the reduced separation test is $\rho_0 > 0$. Figure 5.15 illustrates two separated polygons using this scheme.

The value μ is irrelevant since we only need to compare ρ_0 to 0. Consequently, there is no need to project the vertices of C_0 to calculate μ. Moreover, the vertices of C_1 are projected one at a time either until the projected value is negative, in which case \mathbf{D} is no longer considered for separation, or until all projected values are positive, in which case \mathbf{D} is a separating direction.

```
bool TestIntersection (ConvexPolygon C0, ConvexPolygon C1)
{
    // Test edges of C0 for separation.  Because of the
    // counterclockwise ordering, the projection interval for
    // C0 is [m,0], where m <= 0.  Only try to determine if C1
    // is on the 'positive' side of the line.
    for (i0 = C0.GetN()-1, i1 = 0; i1 < C0.GetN(); i0 = i1++)
    {
        P = C0.GetVertex(i1);
        D = C0.GetNormal(i0);
        if ( WhichSide(C1,P,D) > 0 )
        {
            // C1 is entirely on 'positive' side of line P + t * D
            return false;
        }
    }

    // Test edges of C1 for separation.  Because of the
    // counterclockwise ordering, the projection interval for
    // C1 is [m,0], where m <= 0.  Only try to determine if C0
    // is on the 'positive' side of the line.
    for (i0 = C1.GetN()-1, i1 = 0; i1 < C1.GetN(); i0 = i1++)
    {
        P = C1.GetVertex(i1);
        D = C1.GetNormal(i0);
        if ( WhichSide(C0,P,D) > 0 )
        {
            // C0 is entirely on 'positive' side of line P + t * D
            return false;
        }
    }

    return true;
}

int WhichSide (ConvexPolygon C, Point P, Vector D)
{
    // C vertices are projected onto line P + t * D.  Return value
    // is +1 if all t > 0, -1 if all t < 0, or 0 if the line
    // splits the polygon.

    posCount = 0;
    negCount = 0;
    zeroCount = 0;
```

```
for (i = 0; i < C.GetN(); i++)
{
    t = Dot(D,C.GetVertex(i) - P);
    if ( t > 0 )
        posCount++;
    else if ( t < 0 )
        negCount++;
    else
        zeroCount++;

    if ( (posCount > 0 and negCount > 0) or zeroCount > 0 )
        return 0;
}
return posCount ? 1 : -1;
}
```

In the worst case, the polygons do not intersect. We have processed N_0 edge normals of C_0, each requiring N_1 projections for C_1, and N_1 edge normals of C_1, each requiring N_0 projections for C_0. The total number of projections is $2N_0N_1$, still a quadratic quantity but considerably smaller than $(N_0 + N_1)^2$.

We can do even better in an asymptotic sense as the number of vertices becomes large. A form of bisection may be used to find an extreme point of the projection of the polygon [O'R98]. The bisection effectively narrows in on sign changes of the dot product of edges with the specified direction vector. For a polygon of N_0 vertices, the bisection is of order $O(\log N_0)$, so the total algorithm is $O(\max\{N_0 \log N_1, N_1 \log N_0\})$.

Given two vertex indices i_0 and i_1 of a polygon with N vertices, the *middle index* of the indices is described by the following pseudocode.

```
int GetMiddleIndex (int i0, int i1, int N)
{
    if ( i0 < i1 )
        return (i0 + i1) / 2;
    else
        return ((i0 + i1 + N) / 2) (mod N);
}
```

The division of two integers returns the largest integer smaller than the real-value ratio and the mod operation indicates calculating the remainder after dividing the argument by N. Observe that if $i_0 = i_1 = 0$, the function returns a valid index. The condition when $i_0 < i_1$ has an obvious result—the returned index is the average of the input indices, certainly supporting the name of the function. For example, if the polygon has $N = 5$ vertices, inputs $i_0 = 0$ and $i_1 = 2$ lead to a returned index of

1. The other condition handles wraparound of the indices. If $i_0 = 2$ and $i_1 = 0$, the implied set of ordered indices is $\{2, 3, 4, 0\}$. The middle index is selected as 3 since $3 = (2 + 0 + 5)/2 \bmod 5$.

The bisection algorithm to find the extreme value of the projection is

```
int GetExtremeIndex (ConvexPolygon C, Vector D)
{
    i0 = 0;
    i1 = 0;
    while ( true )
    {
        mid = GetMiddleIndex(i0,i1,C.GetN());
        if ( Dot(D,C.GetEdge(mid)) > 0 )
        {
            if ( mid != i0 )
                i0 = mid;
            else
                return i1;
        }
        else
        {
            if ( Dot(D,C.GetEdge(mid - 1)) < 0 )
                i1 = mid;
            else
                return mid;
        }
    }
}
```

Using the bisection method, the intersection testing pseudocode is

```
bool TestIntersection (ConvexPolygon C0, ConvexPolygon C1)
{
    // Test edges of C0 for separation.  Because of the
    // counterclockwise ordering, the projection interval for
    // C0 is [m,0], where m <= 0.  Only try to determine if C1
    // is on the 'positive' side of the line.
    for (i0 = C0.GetN()-1, i1 = 0; i1 < C0.GetN(); i0 = i1++)
    {
        P = C0.GetVertex(i1);
        D = C0.GetNormal(i0);
```

```
        if ( Dot(D,C1.GetVertex(GetExtremeIndex(C1,-D)) - P) > 0 )
        {
            // C1 is entirely on 'positive' side of line P + t * D
            return false;
        }
    }

    // Test edges of C1 for separation.  Because of the
    // counterclockwise ordering, the projection interval for
    // C1 is [m,0], where m <= 0.  Only try to determine if C0
    // is on the 'positive' side of the line.
    for (i0 = C1.N-1, i1 = 0; i1 < C1.N; i0 = i1++)
    {
        P = C1.GetVertex(i1);
        D = C1.GetNormal(i0);
        if ( Dot(D,C0.GetVertex(GetExtremeIndex(C0,-D)) - P) > 0 )
        {
            // C0 is entirely on 'positive' side of line P + t * D
            return false;
        }
    }

    return true;
}
```

Let us consider an alternate formulation of the bisection problem. Just as we would do in the 3D problem, the vertices, edges, and normals of the convex polygon are stored in body coordinates. The polygon additionally stores the center of mass (the body origin) and an orientation matrix that transforms the body coordinate axes to the world coordinates. We will transform a potential separating direction \mathbf{D} from world coordinates to body coordinates and continue the separation process in those coordinates. Figure 5.16 illustrates the initial part of the process of determining which polygon vertex or edge is extremal.

If $\mathbf{D} = \mathbf{N}_i$, then all points on the edge \mathbf{E}_i are extremal. If \mathbf{D} is strictly between \mathbf{N}_0 and \mathbf{N}_1, then \mathcal{P}_1 is the unique extremal point in that direction. Similar arguments apply for \mathbf{D} strictly between any pair of consecutive normals. The normal points on the circle decompose the circle into arcs, each arc corresponding to an extremal vertex of the polygon. An end point of an arc corresponds to an entire edge being extremal. The testing of \mathbf{D} to determine the full set of extremal points is can be summarized as follows.

- Vertex \mathcal{P}_i is optimal when $\mathbf{N}_{i-1}^{\perp} \cdot \mathbf{D} > 0$ and $\mathbf{N}_i^{\perp} \cdot \mathbf{D} < 0$

- Edge \mathbf{E}_i is optimal when $\mathbf{N}_{i-1}^{\perp} \cdot \mathbf{D} = 0$ and $\mathbf{N}_i^{\perp} \cdot \mathbf{D} < 0$

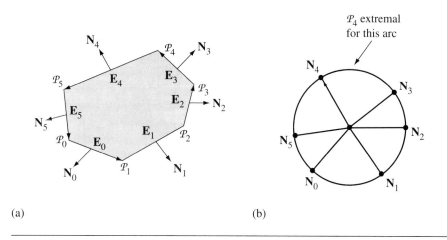

(a) (b)

Figure 5.16 (a) A convex polygon. (b) A unit circle whose vertices correspond to normal directions of the polygon and whose arcs connecting the vertices correspond to vertices of the polygon (the *polar dual* of the polygon).

where $(x, y)^\perp = (-y, x)$. The indexing is computed in the modular sense, $\mathbf{N}_{-1} = \mathbf{N}_5$. Since we will be projecting the extremal point onto a potential separating axis, we can collapse the two tests into a single test and just use one vertex of an extremal edge as the to-be-projected point:

- Vertex \mathcal{P}_i is optimal when $\mathbf{N}_{i-1}^\perp \cdot \mathbf{D} \geq 0$ and $\mathbf{N}_i^\perp \cdot \mathbf{D} < 0$

Generally, there are N arcs for an N-sided polygon. We could search the arcs one at a time and test if \mathbf{D} is on that arc, but then we are back to an $O(N)$ search. Instead, we can create a *binary space partitioning tree* (BSP tree) for the circle that supports an $O(\log N)$ search. Effectively, this is a binary search of an ordered array of numbers, so thinking of it as a BSP tree might not be useful to you. However, in 3D we will construct something similar that is a BSP tree in the sense you are used to. A simple illustration using the polygon of Figure 5.16 suffices. Figure 5.17 illustrates the construction of the BSP tree. The unit disk is recursively split into sectors, each split representing a test $\mathbf{N}_j^\perp \cdot \mathbf{D} \geq 0$.

The vertices on the circle are \mathbf{N}_i for $0 \leq i \leq 5$. The circular arcs are denoted $A_{ij} = \langle \mathbf{N}_i, \mathbf{N}_j \rangle$, where $j = (i + 1) \bmod 6$. The set of all vertices and the set of all arcs are used to initialize the process. These are shown at the top of Figure 5.17. The root node of the tree claims the first normal in the list, namely, \mathbf{N}_0, and uses it for computing dot products with other vectors, $\mathbf{N}_0^\perp \cdot \mathbf{D} \geq 0$. When creating the tree, the remaining normals in the input set are tested. If $\mathbf{N}_0^\perp \cdot \mathbf{N}_i \geq 0$, vector \mathbf{N}_i is placed in a set of vectors that will be used to create the right child of the root (marked as T in the

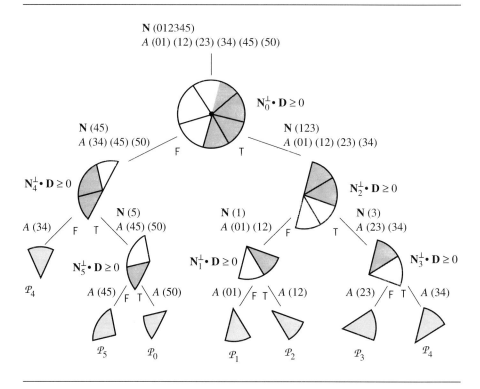

Figure 5.17 A BSP tree constructed by recursive splitting of the unit disk. Each node is labeled with the test used for the split. The subsectors consisting of points satisfying the test are shaded in dark gray. The leaf nodes are shaded in light gray and labeled with a vertex that is extremal.

figure); otherwise \mathbf{N}_i is placed in another set of vectors that will be used to create the left child of the root (marked as F in the figure).

The set of arcs is also processed at each node. The end points of the arc A_{ij} are normals for which we have already computed $d_i = \mathbf{N}_0^{\perp} \cdot \mathbf{N}_i$ and $d_j = \mathbf{N}_0^{\perp} \cdot \mathbf{N}_j$. If $d_i \geq 0$ and $d_j \geq 0$, then the arc is placed in a set of arcs that will be used to create the right child of the root. If $d_i \leq 0$ and $d_j \leq 0$, then the arc is placed in a set of arcs that will be used to create the left child. If $d_i d_j < 0$, then the arc is split in a sense, but we do not need to literally subdivide it into two subarcs. Instead, we just add that arc to both sets to be used in constructing the child subtrees. In our example the only arc that is split is A_{34}. In fact, this will be the *only split* and represents the wraparound, so to speak, of the circle.

The process just described is applied recursively. At the end, each interior node of the tree has been assigned a normal vector for testing purposes. Each leaf node was given an arc A_{ij}, but not a normal. The last index j is that of the extreme vertex represented by the leaf node.

Some pseudocode is provided. Let us assume a class for a BSP node as shown next. The class ConvexPolygon described earlier is given a new data member of type BSPNode.

```
class BSPNode
{
public:
    // normal index (interior node), vertex index (leaf node)
    int I;

    // if Dot(E,D) >= 0, D gets propagated to this child
    BSPNode R;

    // if Dot(E,D) < 0, D gets propagated to this child
    BSPNode L;
};

class ConvexPolygon
{
public:
    // N, number of vertices
    int GetN();

    // P[i], counterclockwise ordered
    Point GetVertex (int i);

    // E[i] = P[i + 1] - P[i]
    Vector GetEdge (int i);

    // N[i], N[i].x * E[i].y - N[i].y * E[i].x > 0
    Vector GetNormal (int i);

    BSPNode tree;
};
```

The BSP tree must be able to access the vertices and edges of the polygon, so the creation of the tree involves passing the polygon as a parameter. Since $\mathbf{N}_i^{\perp} = \mathbf{E}_i$, the direction of the edge, and since we are assuming the edges are stored in the polygon,

we do not need a Perp function. The pseudocode is written for clarity and thus not optimized.

```
void CreateTree (ConvexPolygon C)
{
    // Create the root node first, knowing that the only split can
    // occur here.

    array<int> NIR, NIL;  // normal index sets

    // Arc index sets, array element written {j0,j1},
    // AIR[i][0] = j0, AIR[i][1] = j1.
    array<int,int> AIR, AIL;
    array<int> d(C.GetN());
    d[0] = 0;
    for (i = 1; i < C.GetN(); i++)
    {
        d[i] = Dot(C.GetEdge(0),C.GetNormal(i));

        if ( d[i] >= 0 )
            NIR.append(i);
        else
            NIL.append(i);

        if ( d[i-1] >= 0 and d[i] >= 0 )
            AIR.append({i-1,i});
        else if ( d[i-1] <= 0 and d[i] <= 0 )
            AIL.append({i-1,i});
        else // d[i-1] * d[i] < 0
        {
            AIR.append({i-1,i});
            AIL.append({i-1,i});
        }
    }
    AIL.append({C.GetN()-1,0});  // always left!

    C.tree = CreateNode(0,CreateNode(C,NIR,AIR),
        CreateNode(C,NIL,AIL));
}

BSPNode CreateNode (int I, BSPTree R, BSPTree L)
{
    BSPNode node;
```

```
        node.I = I;
        node.R = R;
        node.L = L;
        return node;
    }

BSPNode CreateNode (ConvexPolygon C, array<int> NI, array<int,int> AI)
{
    array<int> NIR, NIL;
    array<int> d(NI.size());
    d[0] = NI[0];
    for (i = 1; i < NI.size(); i++)
    {
        d[i] = Dot(C.GetEdge(NI[0]),C.GetNormal(NI[i]));
        if ( d[i] >= 0 )
            NIR.append(NI[i]);
        else
            NIL.append(NI[i]);
    }

    array<int,int> AIR, AIL;
    for (i = 0; i < AI.size(); i++)
    {
        if ( d[AI[i][0]] >= 0 and d[AI[i][1]] >= 0 )
            AIR.append(AI[i]);
        else
            AIL.append(AI[i]);
    }

    BSPNode RChild;
    if ( NIR.size() > 0 )
        RChild = CreateNode(C,NIR,AIR);
    else
        RChild = CreateNode(AIR[0][1],null,null);

    BSPNode LChild;
    if ( NIL.size() > 0 )
        LChild = CreateNode(C,NIL,AIL);
    else
        LChild = CreateNode(AIL[0][1],null,null);

    return CreateNode(NI[0],RChild,LChild);
}
```

Once the BSP tree has been constructed, locating an extreme vertex for a potential separating direction **D** can be done using the following pseudocode. This function replaces the one that was used for the bisection of indices shown earlier. The TestIntersection function corresponding to that bisection remains the same.

```
int GetExtremeIndex (ConvexPolygon C, Vector D)
{
    BSPTree node = C.tree;
    while ( node.R )
    {
        if ( Dot(C.GetEdge(node.I),D) >= 0 )
            node = node.R;
        else
            node = node.L;
    }
    return node.I;
}
```

The leaf nodes have no children and internal nodes have two children, so the test on one child pointer is sufficient to identify leaf nodes.

Convex Polyhedra

The following notation is used throughout this section. Let C_j for $j = 0, 1$ be the convex polyhedra with vertices $\mathcal{P}_i^{(j)}$ for $0 \le i < N_j$, edges with directions $\mathbf{E}_i^{(j)}$ for $0 \le i < M_j$, and faces that are planar convex polygons whose vertices are ordered counterclockwise as you view the face from outside the polyhedron. The outward normal vectors for the faces are $\mathbf{N}_i^{(j)}$ for $0 \le i < L_j$. All the pseudocode relating to convex polyhedra will use the class shown next.

```
class ConvexPolyhedron
{
public:
    int GetVCount ();  // number of vertices
    int GetECount ();  // number of edges
    int GetFCount ();  // number of faces
    Point GetVertex (int i);
    Vector GetEdge (int i);
    Vector GetNormal (int i);
};
```

Only the relevant interface is supplied for clarity of the presentation. The implementation details will vary with the needs of an application.

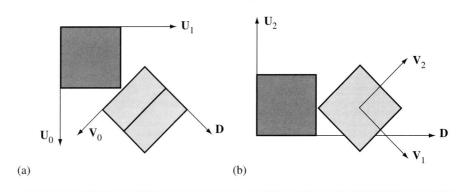

Figure 5.18 Two views of two cubes that are not separated by any face normal but are separated by a cross product of two edges, one from each cube.

The ideas of separation of convex polygons extend to convex polyhedra. For a pair of convex polyhedra, only a finite set of direction vectors needs to be considered for separating tests. The intuition is similar to that of convex polygons. If the two polyhedra are just touching with no interpenetration, the contact is one of face-face, face-edge, face-vertex, edge-edge, edge-vertex, or vertex-vertex. The set of potential separating directions that capture these types of contact include the normal vectors to the faces of the polyhedra and vectors generated by a cross product of two edges, one from each polyhedron. The necessity of testing more than just the face normals is shown by Figure 5.18.

The first cube (dark gray) has unit-length face normals $U_0 = (1, 0, 0)$, $U_1 = (0, 1, 0)$, and $U_2 = (0, 0, 1)$. The second cube (light gray) has unit-length face normals $V_0 = (1, -1, 0)/\sqrt{2}$, $V_1 = (1, 1, -\sqrt{2})/2$, and $V_2 = (1, 1, \sqrt{2})/2$. The other vector shown in the figure is $D = (1, 1, 0)/\sqrt{2}$. Figure 5.18(a) shows a view of the two cubes when looking in the direction $-U_2$. Figure 5.18(b) shows a view when looking along the direction $U_2 \times D$. In view (a), neither U_0, U_1, nor V_0 are separating directions. In view (b), neither U_2, V_1, nor V_2 are separating directions. No face axis separates the two cubes, yet they are not intersecting. A separating direction is $D = U_2 \times V_0$, a cross product of edges from the cubes.

The pseudocode for using the method of separating axes to test for intersection of two polyhedra, similar to the naive implementation in 2D, is

```
bool TestIntersection (ConvexPolyhedron C0, ConvexPolyhedron C1)
{
    // test faces of C0 for separation
    for (i = 0; i < C0.GetFCount(); i++)
    {
        D = C0.GetNormal(i);
```

```
            ComputeInterval(C0,D,min0,max0);
            ComputeInterval(C1,D,min1,max1);
            if ( max1 < min0 || max0 < min1 )
                return false;
        }

        // test faces of C1 for separation
        for (j = 0; j < C1.GetFCount(); j++)
        {
            D = C1.GetNormal(j);
            ComputeInterval(C0,D,min0,max0);
            ComputeInterval(C1,D,min1,max1);
            if ( max1 < min0 || max0 < min1 )
                return false;
        }

        // test cross products of pairs of edges
        for (i = 0; i < C0.GetECount(); i++)
        {
            for (j = 0; j < C1.GetECount(); j++)
            {
                D = Cross(C0.GetEdge(i),C1.Edge(j));
                ComputeInterval(C0,D,min0,max0);
                ComputeInterval(C1,D,min1,max1);
                if ( max1 < min0 || max0 < min1 )
                    return false;
            }
        }

        return true;
    }

    void ComputeInterval (ConvexPolyhedron C, Vector D, double& min,
        double& max)
    {
        min = Dot(D,C.GetVertex(0));
        max = min;
        for (i = 1; i < C.GetVCount(); i++)
        {
            value = Dot(D,C.GetVertex(i));
            if ( value < min )
                min = value;
            else
                max = value;
        }
    }
```

The function ComputeInterval is $O(N)$ for a polyhedron of N vertices. A quick glance at the code shows that you need $L_0(N_0 + N_1) + L_1(N_0 + N_1) + M_0M_1(N_0 + N_1) = (L_0 + L_1 + M_0M_1)(N_0 + N_1)$ units of time to execute the test (cubic order). Since all pairs of edges are tested in the worst case, the time is at least quadratic. Our only hope in reducing the time complexity is to have a faster algorithm for finding extreme vertices for convex polyhedra, just as we did for convex polygons.

The asymptotically better algorithm for finding the extreme points of a convex polygon in 2D does have a counterpart for polytopes in 3D. Given N vertices, it is possible to find extreme points in $O(\log N)$ time [Kir83, DK90]. The algorithm requires preprocessing the polytope to build a data structure, called the *Dobkin-Kirkpatrick hierarchy*, that supports the queries. The preprocessing requires $O(N)$ time. A well-written presentation of the algorithm is provided in [O'R98] and has enough information and pseudocode to assist you in implementing the algorithm. The idea is to construct a sequence of nested polytopes C_0, \ldots, C_k, where the innermost polytope C_k is either a triangle or a tetrahedron and the outermost polytope C_0 is the original one. The extremal query relies on quickly finding the extreme point on C_i given the extreme point on C_{i+1}; in fact, this can be done in constant time, $O(1)$. The construction of the nested polytopes shows that $k = O(\log N)$, so the total query executes in $O(\log N)$ time.

Here is a brief summary of the ideas presented in [O'R98] to give you an idea of the complexity of implementing the algorithm. The vertices and edges of a polytope form a planar graph. The construction of C_{i+1} from C_i is based on locating a *maximum independent set* of vertices for the graph of C_i. A set of vertices is *independent* if no two vertices are adjacent. An independent set S is *maximum* if no other independent set has more vertices than does S. The vertices in the maximum independent set are removed from C_i, one at a time. On removal of a vertex \mathcal{P}, a hole is introduced into the current polytope. The neighboring vertices of \mathcal{P}—call this set $N(\mathcal{P})$—must be triangulated to generate the faces that fill in the hole. The triangulation is accomplished via a convex hull algorithm. After removal of a maximum independent set of vertices from C_i, we have C_{i+1}. However, the construction must support the extremal query; *linking* steps must occur between faces of C_{i+1} and C_i. The pseudocode mentioned in [O'R98] is

```
void ComputeHierarchy (ConvexPolyhedron C)
{
    int i = 0;
    C.hier.poly[0] = C;  // the assignment copies C into poly[0]
    while ( C.hier.poly[0].N > 4 )
    {
        set<point> S = GetMaximumIndependentSet(C.hier.poly[i]);
        C.hier.poly[i+1] = C.hier.poly[i];
        for ( each P in S ) do
        {
            delete P from C.hier.poly[i+1];
            triangulate the hole by constructing ConvexHull(N(V));
```

```
                insert the triangles into C.hier.poly[i+1];
                link each new triangle of C.hier.poly[i+1] to P;
            }
            link unchanged faces of C.hier.poly[i+1] to C.hier.poly[i];
        }
    }
```

As it turns out, constructing a maximum independent set of a graph is NP-complete [CLR90, ch. 36]. To obtain a polynomial time construction of the hierarchy, an approximation is required. This is provided by [Ede87, Theorem 9.8] and is proved that the hierarchy construction remains $O(N)$ and the extremal query remains $O(\log N)$. The approximation produces a sufficiently large independent set, although not necessarily a maximum independent set. The pseudocode is

```
set<point> GetLargeIndependentSet (ConvexPolyhedron C)
{
    set<point> S = empty;
    mark all vertices P in C of degree(P) >= 9;
    while ( some nodes remain unmarked ) do
    {
        choose an unmarked node P;
        mark P and all neighbors in N(P);
        S.insert(P);
    }
}
```

The function call GetMaximumIndependentSet in the hierarchy construction is replaced by a call to the function GetLargeIndependentSet.

The extremal query is based on the following result, formulated for the direction $\mathbf{D} = (0, 0, 1)$, but easily adaptable to other directions [EM85]. If \mathcal{M}_i is the extreme point for C_i and \mathcal{M}_{i+1} is the extreme point for C_{i+1}, then either $\mathcal{M}_i = \mathcal{M}_{i+1}$ or \mathcal{M}_{i+1} has the largest z-value among the vertices adjacent to \mathcal{M}_i. Although the obvious approach now is just to search the neighbors directly, the problem is that the number of neighbors can be quite large and lead to an $O(N)$ query rather than an $O(\log N)$ query. The search must be narrowed to some subset of neighbors.

The key is to project C_{i+1} onto a coordinate plane parallel to the z-axis. That projection is a convex polygon whose extreme vertex \mathcal{M}'_{i+1} in the z-direction is the projection of \mathcal{M}_{i+1}. Two edges of the convex polygon share \mathcal{M}'_{i+1}, call them \mathbf{L}'_{i+1} and \mathbf{R}'_{i+1}. These edges are projections of some edges \mathbf{L}_{i+1} and \mathbf{R}_{i+1} that share \mathcal{M}_{i+1}. The *umbrella parents* of an edge \mathbf{E} of C_{i+1} are defined as follows. If \mathbf{E} is not an edge of C_i, then it was generated for C_{i+1} by the removal of a vertex \mathbf{V} from C_i. In this case \mathbf{V} is the sole umbrella parent of \mathbf{E} ("umbrella" refers to the umbrella of faces sharing \mathbf{V}). If \mathbf{E} is an edge of C_i, then its umbrella parents are the two vertices of C_i at the tips of the triangle faces that share \mathbf{E}. This allows us to narrow the search for the extreme

point: If \mathcal{M}_i is the extreme point for C_i and \mathcal{M}_{i+1} is the extreme point for C_{i+1}, then either $\mathcal{M}_i = \mathcal{M}_{i+1}$ or \mathcal{M}_{i+1} has the largest z-value among the umbrella parents of the edges \mathbf{L}_{i+1} and \mathbf{R}_{i+1}. The pseudocode for the query as presented in [O'R98] is listed below. It is assumed that the sequence of nested polytopes was already constructed.

```
point GetExtremePoint (ConvexPolyhedron C, Vector D)
{
    // polys 0 through k = size - 1
    int k = C.hier.size() - 1;
    array<point> M[k + 1];

    // extreme of triangle or tetrahedron
    M[k] = GetExtremeVertex(C.hier.poly[k]);

    compute extreme edges L[k] and R[k];
    for (i = k - 1; i >= 0; i--)
    {
        M[i] = SelectExtremeFrom(M[i + 1],Parents(L[i + 1]),
            Parents(R[i + 1]));

        if ( M[i] not equal to M[i + 1] ) then
        {
            for (all edges incident to M[i]) do
                save extreme edges L[i] and R[i];
        }
        else
        {
            compute L[i] from L[i + 1];
            compute R[i] from R[i + 1];
        }
    }
    return M[0];
}
```

The summary here should give you the idea that the implementation of the Dobkin-Kirkpatrick hierarchy and the extremal queries is tractable, but tedious. An alternative that is easier to implement is presented here and is the extension of the BSP tree construction used for finding extreme points for convex polygons. The construction of the BSP tree is $O(N \log N)$ and the query is $O(\log N)$ as long as you have a balanced tree. The asymptotic order of construction of the BSP data structure is worse than the $O(N)$ construction of the data structure for the Dobkin-Kirkpatrick hierarchy, but since a collision system does the constructions on start-up of the simulation, and since the BSP tree is easy code to write, the comparison of asymptotic times is irrelevant.

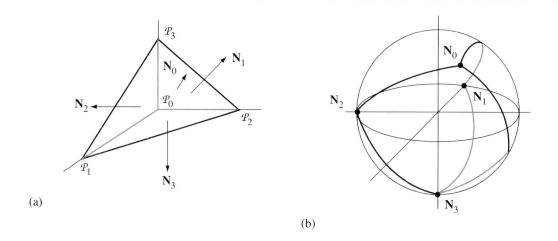

(a)

(b)

Figure 5.19 (a) A tetrahedron. (b) A unit sphere whose vertices correspond to normal directions of the tetrahedron, whose great circle arcs connecting the vertices correspond to edges of the tetrahedron, and whose spherical polygons correspond to vertices of the tetrahedron (the *spherical dual* of the tetrahedron).

Let \mathbf{D} be a unit-length direction. If $\mathbf{D} = \mathbf{N}_i$, the normal to the ith face of the polytope, then all points on that face are extremal. Let \mathbf{E}_{ij} be the edge shared by faces i and j. The face normals \mathbf{N}_i and \mathbf{N}_j are in the plane through the origin and with normal vector \mathbf{E}_{ij}. If \mathbf{D} is also in this plane and in the smaller of the two sectors that are bounded by \mathbf{N}_i and \mathbf{N}_j, then all points on the edge are extremal. In all other cases some vertex is the unique extreme point in the specified direction. Figure 5.19 shows a tetrahedron and a unit sphere with points corresponding to the face normals of the tetrahedron.

The tetrahedron has vertices $\mathcal{P}_0 = (0, 0, 0)$, $\mathcal{P}_1 = (1, 0, 0)$, $\mathcal{P}_2 = (0, 1, 0)$, and $\mathcal{P}_3 = (0, 0, 1)$. The face normals are $\mathbf{N}_0 = (1, 1, 1)/\sqrt{3}$, $\mathbf{N}_1 = (-1, 0, 0)$, $\mathbf{N}_2 = (0, -1, 0)$, and $\mathbf{N}_3 = (0, 0, -1)$. The sphere is partitioned into four spherical triangles. The interior of the spherical triangle with $\langle \mathbf{N}_0, \mathbf{N}_1, \mathbf{N}_2 \rangle$ corresponds to those directions for which \mathcal{P}_3 is the unique extreme point. Observe that the three normals forming the spherical triangle are the normals for the faces that share vertex \mathcal{P}_3.

Generally, the normal and edge directions of a polytope lead to a partitioning of the sphere into spherical convex polygons. The interior of a single spherical convex polygon corresponds to the set of directions for which a vertex of the polytope is the unique extreme point. The number of edges of the spherical convex polygon is the number of polytope faces sharing that vertex. Just as for convex polygons in 2D, we can construct a BSP tree of the spherical polygons and use it for fast determination of

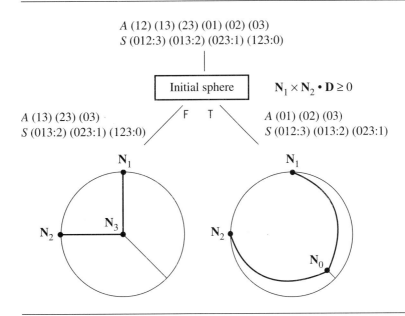

Figure 5.20 The root of the BSP tree and the two hemispheres obtained by splitting. Both children are displayed with a viewing direction $(0, 0, -1)$. The right child is the top of the sphere viewed from the outside, and the left child is the bottom of the sphere viewed from the inside.

extreme vertices. The method used for 2D extends to 3D with each node of the BSP tree representing a hemisphere determined by $\mathbf{E} \cdot \mathbf{D} \geq 0$ for an edge direction \mathbf{E} of the polytope.

The tetrahedron of Figure 5.19 has six edges $\mathbf{E}_{ij} = \mathbf{N}_i \times \mathbf{N}_j$, listed as $\{\mathbf{E}_{12}, \mathbf{E}_{13}, \mathbf{E}_{23}, \mathbf{E}_{01}, \mathbf{E}_{02}, \mathbf{E}_{03}\}$. Please note that the subscripts correspond to normal vector indices, not to vertex indices. Each arc of the sphere corresponds to an edge of the tetrahedron, label the arcs A_{ij}. The root node of the tree claims arc A_{12} for splitting. The condition $\mathbf{N}_1 \times \mathbf{N}_2 \cdot \mathbf{D} \geq 0$ splits the sphere into two hemispheres. Figure 5.20 shows those hemispheres with viewing direction $(0, 0, -1)$.

The set of arcs and the set of spherical faces are inputs to the BSP tree construction. These sets are shown at the top of the figure. An arc is specified by A_{ij} and connects \mathbf{N}_i and \mathbf{N}_j. A spherical face is $S_{i_1, \ldots, i_n : j}$ and has vertices \mathbf{N}_{i_1} through \mathbf{N}_{i_n}. The vertex \mathcal{P}_j of the original polyhedron is the extreme vertex corresponding to the face. The ordering of the indices for arcs and spherical faces is irrelevant. In our example the spherical faces all have three vertices, so they are specified by $S_{i, j, k : \ell}$.

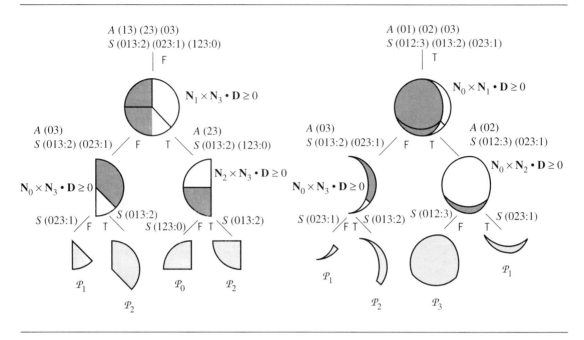

Figure 5.21 The BSP trees for the children of the root.

Figure 5.21 shows the BSP trees for the children of the root. During BSP tree construction, the root node claims the first arc A_{12} and uses the vector $\mathbf{E} = \mathbf{N}_1 \times \mathbf{N}_2$ for testing other vectors corresponding to arcs A_{ij}. Let $d_i = \mathbf{E} \cdot \mathbf{N}_i$ and $d_j = \mathbf{E} \cdot \mathbf{N}_j$. If $d_i \geq 0$ and $d_j \geq 0$, then the arc is completely on one side of the hemisphere implied by \mathbf{E}. A_{ij} is placed in a set that will be used to generate the BSP tree for the right child of the root. If $d_i \leq 0$ and $d_j \leq 0$, then the arc is completely on the other side of the hemisphere and is placed in a set that will be used to generate the BSP tree for the left child of the root. If $d_i d_j < 0$, then the arc is partially in each hemisphere and is added to both sets. This is exactly the algorithm we used in 2D.

In 3D we have some additional work in that the spherical faces must be processed by the tree to propagate to the leaf nodes the indices of the extreme vertices represented by those nodes. In fact, the processing is similar to that for arcs. Let $S_{i,j,k:\ell}$ be a face to be processed at the root node. Let $d_i = \mathbf{E} \cdot \mathbf{N}_i$, $d_j = \mathbf{E} \cdot \mathbf{N}_j$, and $d_k = \mathbf{E} \cdot \mathbf{N}_k$. If $d_i \geq 0$, $d_j \geq 0$, and $d_k \geq 0$, then the spherical face is completely on one side of the hemisphere implied by \mathbf{E}. $S_{i,j,k:\ell}$ is placed in a set that will be used to generate the BSP tree for the right child of the root. If $d_i \leq 0$, $d_j \leq 0$, and $d_k \leq 0$, then the face is completely on the other side of the hemisphere and is placed in a set that will be used to generate the BSP tree for the right child of the root. Otherwise, the arc is partially in each hemisphere and is added to both sets. In general for a spherical face

with *n* vertices, the face is used for construction of the right child if all dot products are nonnegative, for construction of the left child if all dot products are nonpositive, or for construction of both children if some dot products are positive and some are negative.

In a typical application we have a vertex-edge-face data structure to represent the polygon vertices, edges, faces, and the adjacency information between them. The data structure will support the BSP tree construction in a convenient manner. Finally, for theoretical purposes, this algorithm is easily extendable to higher dimensions.

Pseudocode for the BSP tree construction in 3D follows. The class BSPNode is the same as before, except that the index member stores an edge index k when the arc at the node is A_{ij} with $\mathbf{N}_i \times \mathbf{N}_j = \mathbf{E}_k$. The convex polyhedron interface has what was postulated earlier, plus additional support for the BSP construction and query. For simplicity of the presentation, the code is not optimized.

```
class SArc
{
public:
    // indices of polyhedron normals that form the spherical arc
    int f[2];

    // index of edge shared by polyhedron faces
    int e;
};

class SPolygon
{
public:
    // indices of polyhedron normals that form the spherical polygon
    array<int> f;

    // index of extreme vertex corresponding to this polygon
    int v;
};

class ConvexPolyhedron
{
public:
    // previous interface
    int GetVCount ();  // number of vertices
    int GetECount ();  // number of edges
    int GetFCount ();  // number of faces
    Point GetVertex (int i);
```

```
        Vector GetEdge (int i);
        Vector GetNormal (int i);

        // additional support for extremal queries
        void GetFacesSharedByVertex (int i, array<int> f);
        void GetFacesSharedByEdge (int i, int f[2]);
        Vector GetFaceNormal (int i);
        BSPNode tree;
};
```

The BSP tree construction is

```
void CreateTree (ConvexPolyhedron C)
{
    array<SArc> A(C.GetECount());
    for (i = 0; i < C.GetECount(); i++)
    {
        C.GetFacesSharedByEdge(i,A[i].f);
        A[i].e = i;
    }

    array<SPolygon> S(C.GetVCount());
    for (i = 0; i < C.GetVertexCount(); i++)
    {
        C.GetFacesSharedByVertex(i,S[i].f);
        S[i].v = i;
    }

    C.tree = CreateNode(C,A,S);
}

BSPNode CreateNode (int I, BSPNode R, BSPNode L)
{
    BSPNode node;
    node.I = I;
    node.R = R;
    node.L = L;
    return node;
}

BSPNode CreateNode (ConvexPolyhedron C, array<SArc> A,
    array<SPolygon> S)
{
    Vector E = C.GetEdge(A[0].e);
```

```
array<SArc> AR, AL;
for (i = 1; i < A.size(); i++)
{
    d0 = Dot(E,C.GetNormal(A[i].f[0]));
    d1 = Dot(E,C.GetNormal(A[i].f[1]));
    if ( d0 >= 0 and d1 >= 0 )
        AR.append(A[i]);
    else if ( d0 <= 0 and d1 <= 0 )
        AL.append(A[i]);
    else
    {
        AR.append(A[i]);
        AL.append(A[i]);
    }
}

array<SPolygon> SR, SL;
for (i = 0; i < S.size(); i++)
{
    posCount = 0;
    negCount = 0;
    for (j = 0; j < S[i].f.size(); j++)
    {
        d = Dot(E,C.GetNormal(S[i].f[j]));
        if ( d > 0 )
            posCount++;
        else if ( d < 0 )
            negCount++;
        if ( posCount > 0 and negCount > 0 )
            break;
    }

    if ( posCount > 0 and negCount == 0 )
        SR.append(S[i]);
    else if ( neg > 0 and posCount == 0 )
        SL.append(S[i]);
    else
    {
        SR.append(S[i]);
        SL.append(S[i]);
    }
}

BSPNode RChild;
```

```
        if ( AR.size() > 0 )
            RChild = CreateNode(C,AR,SR);
        else
            RChild = CreateNode(SR[0].v,null,null);

        BSPNode LChild;
        if ( AL.size() > 0 )
            LChild = CreateNode(C,AL,SL);
        else
            LChild = CreateNode(SL[0].v,null,null);

        return CreateNode(A[0].e,RChild,LChild);
    }
```

The query for an extreme point associated with a direction **D** is

```
int GetExtremeIndex (ConvexPolyhedron C, Vector D)
{
    BSPTree node = C.tree;
    while ( node.R )
    {
        if ( Dot(C.GetEdge(node.I),D) >= 0 )
            node = node.R;
        else
            node = node.L;
    }
    return node.I;
}
```

The $O(\log N)$ query requires a balanced BSP tree. An application can check the output of the algorithm to see if it is balanced. If it is not, most likely a random permutation of the input sets will increase the likelihood of a balanced tree.

With the extremal query support in place, the function ComputeInterval called by TestIntersection can be implemented as

```
void ComputeInterval (ConvexPolyhedron C, Vector D, double& min,
    double& max)
{
    min = Dot(D,C.GetVertex(GetExtremeIndex(C,-D)));
    max = Dot(D,C.GetVertex(GetExtremeIndex(C,D)));
}
```

The function involves two calls to $O(\log N)$ functions, making it also an $O(\log N)$ function.

5.3.3 OBJECTS MOVING WITH CONSTANT LINEAR VELOCITY

The method of separating axes is used to test for intersection of two stationary convex polyhedra. The set of potential separating axes consists of the face normals for the polyhedra and cross products of edges, each product using an edge from each of the participating polyhedra. As described earlier, a collision detection system can be implemented using a bisection technique. At the first time step, no polyhedra are intersecting. For the next time step, the physical simulation decides how each polyhedron should move based on constraints (using a differential equation solver for the equations of motion). All the polyhedra are moved to their desired locations. Each pair of convex polyhedra are tested for intersection using the method of separating axes. If any pair reports interpenetration, then the system is restarted at the first time step, but with a time increment that is half of what was tried the first time.

The strategy is not bad when only a small number of polyhedra are in the system and when the frequency of contact (or close contact) is small. However, for large numbers of polyhedra in close proximity, a lot of time can be spent in restarting the system. A quick hack to reduce the time is to restart the system only for those pairs that reported an interpenetration. When the bisection is completed, all the objects have been moved to a new state with no interpenetrations, but the time step is (potentially) different for the objects, an implied change in the speeds of some of the objects. For a system that runs on the order of 30 frames per second or larger, this is not usually a noticeable problem.

An alternative to the bisection approach is to attempt to predict the time of collision between two polyhedra. For a small change in time an assumption we can make is that the polyhedra are moving with constant linear velocity and zero angular velocity. Whether or not the assumption is reasonable will depend on your application. The method of separating axes can be extended to handle polyhedra moving with constant linear velocity and to report the first time of contact between a pair. The algorithm is attributed to Ron Levine in a post to the SourceForge game developer algorithms mailing list [Lev00]. As we did for stationary objects, let us first look at the problem for convex polygons to illustrate the ideas for convex polyhedra.

Separation of Convex Polygons

If C_0 and C_1 are convex polygons with linear velocities \mathbf{V}_0 and \mathbf{V}_1, it can be determined via projections if the polygons will intersect for some time $T \geq 0$. If they do intersect, the first time of contact can be computed. It is enough to work with a stationary polygon C_0 and a moving polygon C_1 with velocity \mathbf{V} since one can always use $\mathbf{V} = \mathbf{V}_1 - \mathbf{V}_0$ to perform the calculations as if C_0 were not moving.

If C_0 and C_1 are initially intersecting, then the first time of contact is $T = 0$. Otherwise, the convex polygons are initially disjoint. The projection of C_1 onto a line with direction \mathbf{D} not perpendicular to \mathbf{V} is itself moving. The speed of the projection along the line is $\sigma = (\mathbf{V} \cdot \mathbf{D})/|\mathbf{D}|^2$. If the projection interval of C_1 moves away from

the projection interval of C_0, then the two polygons will never intersect. The cases when intersection might happen are those when the projection intervals for C_1 move toward those of C_0.

The intuition for how to predict an intersection is much like that for selecting the potential separating directions in the first place. If the two convex polygons intersect at a first time $T_{first} > 0$, then their projections are not separated along any line at that time. An instant before first contact, the polygons are separated. Consequently, there must be at least one separating direction for the polygons at time $T_{first} - \varepsilon$ for small $\varepsilon > 0$. Similarly, if the two convex polygons intersect at a last time $T_{last} > 0$, then their projections are also not separated at that time along any line, but an instant after last contact, the polygons are separated. Consequently, there must be at least one separating direction for the polygons at time $T_{last} + \varepsilon$ for small $\varepsilon > 0$. Both T_{first} and T_{last} can be tracked as each potential separating axis is processed. After all directions are processed, if $T_{first} \le T_{last}$, then the two polygons do intersect with first contact time T_{first}. It is also possible that $T_{first} > T_{last}$, in which case the two polygons cannot intersect.

Pseudocode for testing for intersection of two moving convex polygons is given next. The time interval over which the event is of interest is $[0, T_{max}]$. If knowing an intersection at *any* future time is desired, then set $T_{max} = \infty$. Otherwise, T_{max} is finite. The function is implemented to indicate there is no intersection on $[0, T_{max}]$, even though there might be an intersection at some time $T > T_{max}$.

```
bool TestIntersection (ConvexPolygon C0, Vector V0,
    ConvexPolygon C1, Vector V1, double tmax, double& tfirst,
    double& tlast)
{
    V = V1 - V0;  // process as if C0 is stationary, C1 is moving
    tfirst = 0;
    tlast = INFINITY;

    // test edges of C0 for separation
    for (i0 = C0.GetN() - 1, i1 = 0; i1 < C0.GetN(); i0 = i1++)
    {
        D = C0.GetNormal(i0);
        ComputeInterval(C0,D,min0,max0);
        ComputeInterval(C1,D,min1,max1);
        speed = Dot(D,V);
        if ( NoIntersect(tmax,speed,min0,max0,min1,max1,
                        tfirst,tlast) )
        {
            return false;
        }
    }
}
```

```
    // test edges of C1 for separation
    for (i0 = C1.N - 1, i1 = 0; i1 < C1.N; i0 = i1++)
    {
        D = C1.GetNormal(i0);
        ComputeInterval(C0,D,min0,max0);
        ComputeInterval(C1,D,min1,max1);
        speed = Dot(D,V);
        if ( NoIntersect(tmax,speed,min0,max0,min1,max1,
                        tfirst,tlast) )
        {
            return false;
        }
    }
    return true;
}

bool NoIntersect (double tmax, double speed, double min0,
    double max0, double min1, double max1, double& tfirst,
    double& tlast)
{
    if ( max1 < min0 )
    {
        // interval(C1) initially on 'left' of interval(C0)

        if ( speed <= 0 ) // intervals moving apart
            return true;

        t = (min0 - max1)/speed;
        if ( t > tfirst )
            tfirst = t;
        if ( tfirst > tmax )
            return true;

        t = (max0 - min1)/speed;
        if ( t < tlast )
            tlast = t;
        if ( tfirst > tlast )
            return true;
    }
    else if ( max0 < min1 )
    {
        // interval(C1) initially on 'right' of interval(C0)

        if ( speed >= 0 )  // intervals moving apart
            return true;
```

```
        t = (max0 - min1)/speed;
        if ( t > tfirst )
            tfirst = t;
        if ( tfirst > tmax )
            return true;

        t = (min0 - max1)/speed;
        if ( t < tlast )
            tlast = t;
        if ( tfirst > tlast )
            return true;
    }
    else
    {
        // interval(C0) and interval(C1) overlap

        if ( speed > 0 )
        {
            t = (max0 - min1)/speed;
            if ( t < tlast )
                tlast = t;
            if ( tfirst > tlast )
                return true;
        }
        else if ( speed < 0 )
        {
            t = (min0 - max1)/speed;
            if ( t < tlast )
                tlast = t;
            if ( tfirst > tlast )
                return true;
        }
    }
    return false;
}
```

The function `ComputeInterval(C,D,min,max)` computes the projection interval [min, max] of a convex polygon C onto the line of direction D using the fast extremal queries described earlier that use an approach based on BSP trees. The pseudocode as written projects the convex polygons onto the line $t\mathbf{D}$. In an implementation, you most likely will want to avoid floating point problems in the projection values when the vertices have large components. An additional parameter to `ComputeInterval` should be a point approximately near one (or both) polygons, something as simple as choosing a vertex \mathcal{P} of a polygon. The projection is onto $\mathcal{P} + t\mathbf{D}$ instead.

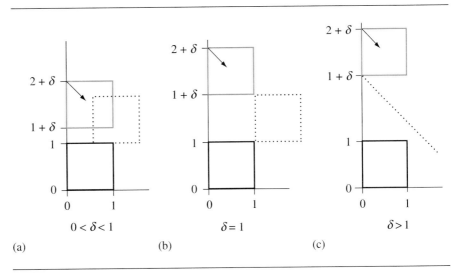

Figure 5.22 (a) Edge-edge intersection predicted. (b) Vertex-vertex intersection predicted. (c) No intersection predicted.

The following example illustrates the ideas. The first box is the unit cube $0 \leq x \leq 1$ and $0 \leq y \leq 1$ and is stationary. The second box is initially $0 \leq x \leq 1$ and $1 + \delta \leq y \leq 2 + \delta$ for some $\delta > 0$. Let its velocity be $(1, -1)$. Whether or not the second box intersects the first box depends on the value of δ. The only potential separating axes are $(1, 0)$ and $(0, 1)$. Figure 5.22 shows the initial configuration for three values of δ, one where there will be an edge-edge intersection, one where there will be a vertex-vertex intersection, and one where there is no intersection.

The black box is stationary. The gray box is moving. The black vector indicates the direction of motion. The dotted boxes indicate where the moving box first touches the stationary box. In Figure 5.22(c), the dotted line indicates that the moving box will miss the stationary box. For $\mathbf{D} = (1, 0)$, the pseudocode produces min0 = 0, max0 = 1, min1 = 0, max1 = 1, and speed = 1. The projected intervals are initially overlapping. Since the speed is positive, T = (max0-min1)/speed = 1 < TLast = INFINITY and TLast is updated to 1. For $\vec{D} = (0, 1)$, the pseudocode produces min0 = 0, max0 = 1, min1 = 1+delta, max1 = 2+delta, and speed = -1. The moving projected interval is initially on the right of the stationary projected interval. Since the speed is negative, T = (max0-min1)/speed = delta > TFirst = 0 and TFirst is updated to delta. The next block of code sets T = (min0-max1)/speed = 2+delta. The value TLast is not updated since $2 + \delta < 1$ cannot happen for $\delta > 0$. On exit from the loop over potential separating directions, $T_{\text{first}} = \delta$ and $T_{\text{last}} = 1$. The objects intersect if and only if $T_{\text{first}} \leq T_{\text{last}}$, or $\delta \leq 1$. This condition is consistent with the images in Figure 5.22.

Figure 5.22(a) has $\delta < 1$ and Figure 5.22(b) has $\delta = 1$, intersections occurring in both cases. Figure 5.22(c) has $\delta > 1$ and no intersection occurs.

Contact Set for Convex Polygons

Although we are interested in nonpenetration intersections for moving objects, I mention the stationary case just for completeness. The find-intersection query for two stationary convex polygons is a special example of Boolean operations on polygons. If the polygons have N_0 and N_1 vertices, there is an intersection algorithm of order $O(N_0 + N_1)$ for computing the intersection [O'R98]. A less efficient algorithm is to clip the edges of each polygon against the other polygon. The order of this algorithm is $O(NM)$. Of course, the asymptotic analysis applies to large N and M, so the latter algorithm is potentially a good choice for triangles and rectangles.

Given two moving convex objects C_0 and C_1, initially not intersecting and with velocities \mathbf{V}_0 and \mathbf{V}_1, we showed earlier how to compute the first time of contact T, if it exists. Assuming it does, the sets $C_0 + T\mathbf{V}_0 = \{\mathcal{X} + T\mathbf{V}_0 : \mathcal{X} \in C_0\}$ and $C_1 + T\mathbf{V}_1 = \{\mathcal{X} + T\mathbf{V}_1 : \mathcal{X} \in C_1\}$ are just touching with no interpenetration. See Figure 5.14 for the various configurations.

The TestIntersection function can be modified to keep track of which vertices or edges are projected to the end points of the projection interval. At the first time of contact, this information is used to determine how the two objects are oriented with respect to each other. If the contact is vertex-edge or vertex-vertex, then the contact set is a single point, a vertex. If the contact is edge-edge, the contact set is a line segment that contains at least one vertex. Each end point of the projection interval is generated by either a vertex (unique extreme) or an edge (nonunique extreme). A class to store all the relevant projection information is

```
class ProjInfo
{
public:
    double min, max;  // projection interval [min,max]
    int index[2];
    bool isUnique[2];
};
```

The zero-indexed entries of the array correspond to the minimum of the interval. If the minimum is obtained from the unique extreme vertex \mathbf{V}_i, then index[0] stores i and isUnique[0] is true. If the minimum is obtained from an edge \mathbf{E}_j, then index[0] stores j and isUnique[0] stores false. The same conventions apply for the one-indexed entries corresponding to the maximum of the interval.

To support calculation of the contact set and the new configuration structure, we need to modify the extremal query GetExtremeIndex. The version we developed just returned the index of an extreme vertex with no information about whether it

is unique or an end point of an extreme edge. We now need this information. The revised query is

```
int GetExtremeIndex (ConvexPolyhedron C, Vector D, bool& isUnique)
{
    BSPTree node = C.tree;
    isUnique = true;
    while ( node.R )
    {
        d = Dot(C.GetEdge(node.I),D);
        if ( d > 0 )
            node = node.R;
        else if ( d < 0 )
            node = node.L;
        else  // d == 0
        {
            // direction is an edge normal, edge is extreme
            isUnique = false;
            break;
        }
    }
    return node.I;
}
```

Of course, in an implementation using floating point numbers, the test on the dot product d would use some application-specified value $\varepsilon > 0$ and replace $d > 0$ by $d > \varepsilon$ and $d < 0$ by $d < -\varepsilon$. Function ComputeInterval must be modified to provide more information than just the projection interval.

```
void ComputeInterval (ConvexPolyhedron C, Vector D, ProjInfo& info)
{
    info.index[0] = GetExtremeIndex(C,-D,info.isUnique[0]);
    info.min = Dot(D,C.GetVertex(info.index[0]));
    info.index[1] = GetExtremeIndex(C,+D,info.isUnique[1]);
    info.max = Dot(D,C.GetVertex(info.index[1]));
}
```

The NoIntersect function accepted as input the projection intervals for the two polygons. Now those intervals are stored in the ProjInfo objects, so NoIntersect must be modified to reflect this. In the event that there will be an intersection between the moving polygons, it is necessary that the projection information be saved for later use in determining the contact set. As a result, NoIntersect must keep track of the ProjInfo objects corresponding to the current first time of contact. Finally, the contact set calculation will require knowledge of the order of the projection intervals.

NoIntersect will set a flag side with value $+1$ if the intervals intersect at the maximum of the C_0 interval and the minimum of the C_1 interval, or with value -1 if the intervals intersect at the minimum of the C_0 interval and the maximum of the C_1 interval. The modified pseudocode is

```
bool NoIntersect (double tmax, double speed, ProjInfo info0,
    ProjInfo info1, ProjInfo& curr0, ProjInfo& curr1, int& side,
    double& tfirst, double& tlast)
{
    if ( Cfg1.max < info0.min )
    {
        if ( speed <= 0 )
            return true;

        t = (info0.min - info1.max)/speed;
        if ( t > tfirst )
        {
            tfirst = t;
            side = -1;
            curr0 = info0;
            curr1 = info1;
        }
        if ( tfirst > tmax )
            return true;

        t = (info0.max - info1.min)/speed;
        if ( t < tlast )
            tlast = t;
        if ( tfirst > tlast )
            return true;
    }
    else if ( info0.max < info1.min )
    {
        if ( speed >= 0 )
            return true;
        t = (info0.max - info1.min)/speed;
        if ( t > tfirst )
        {
            tfirst = t;
            side = +1;
            curr0 = info0;
            curr1 = info1;
        }
        if ( tfirst > tmax )
            return true;
```

```
        t = (info0.min - info1.max)/speed;
        if ( t < tlast )
            tlast = t;
        if ( tfirst > tlast )
            return true;
    }
    else
    {   if ( speed > 0 )
        {
            t = (info0.max - info1.min)/speed;
            if ( t < tlast )
                tlast = t;
            if ( tfirst > tlast )
                return true;
        }
        else if ( speed < 0 )
        {
            t = (info0.min - info1.max)/speed;
            if ( t < tlast )
                tlast = t;
            if ( tfirst > tlast )
                return true;
        }
    }
    return false;
}
```

With the indicated modifications, TestIntersection has the equivalent formulation

```
bool TestIntersection (ConvexPolygon C0, Vector V0,
    ConvexPolygon C1, Vector V1, double tmax, double& tfirst,
    double& tlast)
{
    ProjInfo info0, info1, curr0, curr1;
    V = V1 - V0;   // process as if C0 stationary and C1 moving
    tfirst = 0;
    tlast = INFINITY;

    // process edges of C0
    for (i0 = C0.GetN() - 1, i1 = 0; i1 < C0.GetN(); i0 = i1++)
    {
        D = C0.GetNormal(i0);
        ComputeInterval(C0,D,info0);
        ComputeInterval(C1,D,info1);
```

```
    speed = Dot(D,v);
    if ( NoIntersect(tmax,speed,info0,info1,curr0,curr1,side,
                     tfirst,tlast) )
    {
        return false;
    }
}

// process edges of C1
for (i0 = C1.GetN() - 1, i1 = 0; i1 < C1.GetN(); i0 = i1++)
{
    D = C1.GetNormal(i0);
    ComputeInterval(C0,D,info0);
    ComputeInterval(C1,D,info1);
    speed = Dot(D,v);
    if ( NoIntersect(tmax,speed,info0,info1,curr0,curr1,side,
                     tfirst,tlast) )
    {
        return false;
    }
}

return true;
}
```

The `FindIntersection` pseudocode has exactly the same implementation as `TestIntersection`, but with one additional block of code (after the two loops) that is reached if there will be an intersection. When the polygons will intersect at time T, they are effectively moved with their respective velocities and the contact set is calculated. Let $Q_i^{(j)} = \mathcal{P}_i^{(j)} + T\mathbf{V}_j$ represent the polygon vertices after motion. In the case of edge-edge contact, for the sake of argument, suppose that the contact edges are $\mathbf{E}_0^{(0)}$ and $\mathbf{E}_0^{(1)}$. Figure 5.23 illustrates the configurations for two triangles.

Because of the counterclockwise ordering of the polygons, observe that the two edge directions are parallel, but in opposite directions. The edge of the first polygon is parameterized as $Q_0^{(0)} + s\mathbf{E}_0^{(0)}$ for $s \in [0, 1]$. The edge of the second polygon has the same parametric form, but with $s \in [s_0, s_1]$ where

$$s_0 = \frac{\mathbf{E}_0^{(0)} \cdot \left(Q_1^{(1)} - Q_0^{(0)}\right)}{|\mathbf{E}_0|^2} \quad \text{and} \quad s_1 = \frac{\mathbf{E}_0^{(0)} \cdot \left(Q_0^{(1)} - Q_0^{(0)}\right)}{|\mathbf{E}_0|^2}$$

The overlap of the two edges occurs for $\bar{s} \in I = [0, 1] \cap [s_0, s_1] \neq \emptyset$. The corresponding points in the contact set are $\mathcal{P}_0^{(0)} + T\mathbf{V}_0 + \bar{s}\mathbf{E}_0^{(0)}$ for $\bar{s} \in I$.

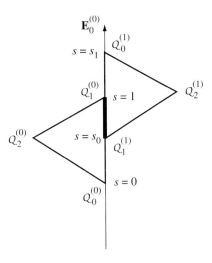

Figure 5.23 Edge-edge contact for two moving triangles.

In the event the two polygons are initially overlapping, the contact set is more expensive to construct. This set can be constructed by standard methods involving Boolean operations on polygons.

The pseudocode is shown next. The intersection is a convex polygon and is returned in the last two arguments of the function. If the intersection set is nonempty, the return value of the function is true. The set must itself be convex. The number of vertices in the set is stored in quantity and the vertices, in counterclockwise order, are stored in the array I[]. If the return value is false, the last two arguments of the function are invalid and should not be used.

```
bool FindIntersection (ConvexPolygon C0, Vector V0,
    ConvexPolygon C1, Vector W1, double tmax, double& tfirst,
    double& tlast, int& quantity, Point I[])
{
    ProjInfo info0, info1, curr0, curr1;
    V = V1 - V0;  // process as if C0 stationary and C1 moving
    tfirst = 0;
    tlast = INFINITY;

    // process edges of C0
    for (i0 = C0.GetN() - 1, i1 = 0; i1 < C0.GetN(); i0 = i1++)
    {
        D = C0.GetNormal(i0);
```

```
        ComputeInterval(C0,D,info0);
        ComputeInterval(C1,D,info1);
        speed = Dot(D,v);
        if ( NoIntersect(tmax,speed,info0,info1,curr0,curr1,side,
                         tfirst,tlast) )
        {
            return false;
        }
    }

    // process edges of C1
    for (i0 = C1.GetN() - 1, i1 = 0; i1 < C1.GetN(); i0 = i1++)
    {
        D = C1.GetNormal(i0);
        ComputeInterval(C0,D,info0);
        ComputeInterval(C1,D,info1);
        speed = Dot(D,v);
        if ( NoIntersect(tmax,speed,info0,info1,curr0,curr1,side,
                         tfirst,tlast) )
        {
            return false;
        }
    }

    // compute the contact set
    GetIntersection(C0,V0,C1,V1,curr0,curr1,side,tfirst,quantity,I);
    return true;
}
```

The intersection calculator pseudocode is shown next. Observe how the projection types are used to determine if the contact is vertex-vertex, edge-vertex, or edge-edge.

```
void GetIntersection (ConvexPolygon C0, Vector V0, ConvexPolygon C1,
    Vector V1, ProjInfo info0, ProjInfo info1, int side,
    double tfirst, int& quantity, Point I[])
{
    if ( side == 1 )  // C0-max meets C1-min
    {
        if ( info0.isUnique[1] )
        {
            // vertex-vertex or vertex-edge intersection
            quantity = 1;
            I[0] = C0.GetVertex(info0.index[1]) + tfirst * V0;
        }
```

```
    else if ( info1.isUnique[0] )
    {
        // vertex-vertex or edge-vertex intersection
        quantity = 1;
        I[0] = C1.GetVertex(info1.index[0]) + tfirst * V1;
    }
    else
    {
        // edge-edge intersection
        P = C0.GetVertex(info0.index[1]) + tfirst * V0;
        E = C0.GetEdge(info0.index[1]);
        Q0 = C1.GetVertex(info1.index[0]);
        Q1 = C1.GetVertex(info1.index[0] + 1);
        s0 = Dot(E,Q1-P) / Dot(E,E);
        s1 = Dot(E,Q0-P) / Dot(E,E);
        FindIntervalIntersection(0,1,s0,s1,quantity,interval);
        for (i = 0; i < quantity; i++)
            I[i] = P + interval[i] * E;
    }
}
else if ( side == -1 )  // C1-max meets C0-min
{
    if ( info1.isUnique[1] )
    {
        // vertex-vertex or vertex-edge intersection
        quantity = 1;
        I[0] = C1.GetVertex(info1.index[1]) + tfirst * V1;
    }
    else if ( info0.isUnique[0] )
    {
        // vertex-vertex or edge-vertex intersection
        quantity = 1;
        I[0] = C0.GetVertex(info0.index[0]) + tfirst * V0;
    }
    else
    {
        // edge-edge intersection
        P = C1.GetVertex(info1.index[1]) + tfirst * V1;
        E = C1.GetEdge(info1.index[1]);
        Q0 = C0.GetVertex(info0.index[0]);
        Q1 = C0.GetVertex(info0.index[0] + 1);
        s0 = Dot(E,Q1-P) / Dot(E,E);
        s1 = Dot(E,Q0-P) / Dot(E,E);
        FindIntervalIntersection(0,1,s0,s1,quantity,interval);
```

```
            for (i = 0; i < quantity; i++)
                I[i] = P + interval[i] * E;
        }
    }
    else  // polygons were initially intersecting
    {
        ConvexPolygon C0Moved = C0 + tfirst * V0;
        ConvexPolygon C1Moved = C1 + tfirst * V1;
        FindPolygonIntersection(C0Moved,C1Moved,quantity,I);
    }
}
```

The final case is the point at which the two polygons were initially overlapping so that the first time of contact is $T = 0$. FindPolygonIntersection is a general routine for computing the intersection of two polygons. In our collision detection system with the nonpenetration constraint, we should not need to worry about the last case, although you might want to trap the condition for debugging purposes.

Separation of Convex Polyhedra

The structure of the algorithm for convex polyhedra moving with constant linear velocity is similar to the one for convex polygons, except for the set of potential separating axes that must be tested. The pseudocode is

```
bool TestIntersection (ConvexPolyhedron C0, Vector V0,
    ConvexPolyhedron C1, Vector V1, double tmax,
    double& tfirst, double& tlast)
{
    V = V1 - V0;  // process as if C0 stationary, C1 moving
    tfirst = 0;
    tlast = INFINITY;

    // test faces of C0 for separation
    for (i = 0; i < C0.GetFCount(); i++)
    {
        D = C0.GetNormal(i);
        ComputeInterval(C0,D,min0,max0);
        ComputeInterval(C1,D,min1,max1);
        speed = Dot(D,V);
        if ( NoIntersect(tmax,speed,min0,max0,min1,max1,
                         tfirst,tlast) )
        {
            return false;
        }
    }
```

```
// test faces of C1 for separation
for (j = 0; j < C1.GetFCount(); j++)
{
    D = C1.GetNormal(j);
    ComputeInterval(C0,D,min0,max0);
    ComputeInterval(C1,D,min1,max1);
    speed = Dot(D,V);
    if ( NoIntersect(tmax,speed,min0,max0,min1,max1,
                        tfirst,tlast) )
    {
        return false;
    }
}

// test cross products of pairs of edges
for (i = 0; i < C0.GetECount(); i++)
{
    for (j = 0; j < C1.GetECount(); j++)
    {
        D = Cross(C0.GetEdge(i),C1.GetEdge(j));
        ComputeInterval(C0,D,min0,max0);
        ComputeInterval(C1,D,min1,max1);
        speed = Dot(D,V);
        if ( NoIntersect(tmax,speed,min0,max0,min1,max1,
                            tfirst,tlast) )
        {
            return false;
        }
    }
}

return true;
}
```

The function NoIntersect is exactly the one used in the two-dimensional problem.

Contact Set for Convex Polyhedra

The find-intersection query for two stationary convex polyhedra is a special example of Boolean operations on polyhedra. Since we are assuming nonpenetration in our collision system, we do not need to implement this.

Given two moving convex objects C_0 and C_1, initially not intersecting, with velocities \mathbf{V}_0 and \mathbf{V}_1, if $T > 0$ is the first time of contact, the sets $C_0 + T\mathbf{V}W_0 = \{\mathcal{X} + T\mathbf{V}_0 : \mathcal{X} \in C_0\}$ and $C_1 + T\mathbf{V}_1 = \{\mathcal{X} + T\mathbf{V}_1 : \mathcal{X} \in C_1\}$ are just touching with no

interpenetration. As indicated earlier for convex polyhedra, the contact is one of face-face, face-edge, face-vertex, edge-edge, edge-vertex, or vertex-vertex. The analysis is slightly more complicated than that of the 2D setting, but the ideas are the same—the relative orientation of the convex polyhedra to each other must be known to properly compute the contact set.

The TestIntersection function can be modified to keep track of which vertices, edges, or faces are projected to the end points of the projection interval. At the first time of contact, this information is used to determine how the two objects are oriented with respect to each other. If the contact is vertex-vertex, vertex-edge, or vertex-face, then the contact point is a single point, a vertex. If the contact is edge-edge, the contact is typically a single point, but can be an entire line segment. If the contact is edge-face, the contact set is a line segment. Finally, if the contact is face-face, the intersection set is a convex polygon. This is the most complicated scenario and requires a two-dimensional convex polygon intersector. Each end point of the projection interval is generated either by a vertex, an edge, or a face. Similar to the implementation for the two-dimensional problem, a projection information class can be defined.

```
class ProjInfo
{
public:
    double min, max;  // projection interval [min,max]
    int index[2];
    enum Type { V, E, F };
    Type type[2];
};
```

The zero-indexed values correspond to the minimum of the interval, the one-indexed values to the maximum. If the extreme point is exactly a vertex, the type is set to V. If the extreme points are exactly an edge, the type is set to E. If the extreme points are exactly a face, the type is set to F.

Just as for convex polygons, the extremal query must be modified to support calculation of the contact set via ProjInfo. In particular, we need to know the enumerated type to assign based on the extremal set.

```
int GetExtremeIndex (ConvexPolyhedron C, Vector D,
    ProjInfo::Type& type)
{
    BSPTree node = C.tree;
    array<int> edges;
    while ( node.R )
    {
        d = Dot(C.GetEdge(node.i),D);
```

```
            if ( d > 0 )
                node = node.R;
            else if ( d < 0 )
                node = node.L;
            else
            {
                node = node.R;
                edges.append(node.I);
                type++;
            }
        }

    if ( edges.size() == 0 )
    {
        type = ProjInfo::V;
        return node.I;  // vertex index at leaf node
    }
    else if ( edges.size() == 1 )
    {
        type = ProjInfo::E;
        return edges[0];  // edge index at interior node
    }
    else
    {
        type = ProjInfo::F;
        return C.GetFaceFromEdges(edges);
    }
}
```

Note that you need another interface function for `ConvexPolyhedron`,

```
class ConvexPolyhedron
{
public:
    // other members...

    int GetFaceFromEdges (array<int> edges);
};
```

that can determine the face bounded by the input edges. Alternatively, you could build more information into the BSP tree nodes so that this information is immediately available. Function `ComputeInterval` must be modified to provide more information than just the projection interval.

```
void ComputeInterval (ConvexPolyhedron C, Vector D, ProjInfo& info)
{
    info.index[0] = GetExtremeIndex(C,-D,info.type[0]);
    info.min = Dot(D,C.GetVertex(info.index[0]));
    info.index[1] = GetExtremeIndex(C,+D,info.type[1]);
    info.max = Dot(D,C.GetVertex(info.index[1]));
}
```

The NoIntersect function that was modified in two dimensions to accept Proj-Info objects instead of projection intervals is used exactly as is for the three-dimensional problem, so I do not restate that code here. With all modifications to this point, TestIntersection is rewritten as

```
bool TestIntersection (ConvexPolyhedron C0, Vector V0,
    ConvexPolyhedron C1, Vector V1, double tmax, double& tfirst,
    double& tlast)
{

    ProjInfo info0, info1, curr0, curr1;
    V = V1 - V0;  // process as if C0 stationary, C1 moving
    tfirst = 0;
    tlast = INFINITY;

    // test faces of C0 for separation
    for (i = 0; i < C0.GetFCount(); i++)
    {
        D = C0.GetNormal(i);
        ComputeInterval(C0,D,info0);
        ComputeInterval(C1,D,info1);
        speed = Dot(D,V);
        if ( NoIntersect(tmax,speed,info0,info1,curr0,curr1,side,
                        tfirst,tlast) )
        {
            return false;
        }
    }

    // test faces of C1 for separation
    for (j = 0; j < C1.GetFCount(); j++)
    {
        D = C1.GetNormal(j);
        ComputeInterval(C0,D,info0);
        ComputeInterval(C1,D,info1);
        speed = Dot(D,V);
```

```
        if ( NoIntersect(tmax,speed,info0,info1,curr0,curr1,side,
                          tfirst,tlast) )
        {
            return false;
        }
    }

    // test cross products of pairs of edges
    for (i = 0; i < C0.GetECount(); i++)
    {
        for (j = 0; j < C1.GetECount(); j++)
        {
            D = Cross(C0.GetEdge(i),C1.GetEdge(j));
            ComputeInterval(C0,D,info0);
            ComputeInterval(C1,D,info1);
            speed = Dot(D,V);
            if ( NoIntersect(tmax,speed,info0,info1,curr0,curr1,
                             side,tfirst,tlast) )
            {
                return false;
            }
        }
    }

    return true;
}
```

The FindIntersection pseudocode has exactly the same implementation as TestIntersection but with one additional block of code (after all the loops) that is reached if there will be an intersection. When the polyhedra intersect at time T, they are effectively moved with their respective velocities and the contact set is calculated. The pseudocode follows. The intersection is a convex polyhedron and is returned in the last argument of the function, but keep in mind that for nonpenetration we should have only a convex polygon in 3D. If the intersection set is nonempty, the return value is true. Otherwise, the original moving convex polyhedra do not intersect and the function returns false.

```
bool FindIntersection (ConvexPolyhedron C0, Vector W0,
    ConvexPolyhedron C1, Point W1, double tmax, double& tfirst,
    double& tlast, ConvexPolyhedron& I)
{
    ProjInfo info0, info1, curr0, curr1;
    V = V1 - V0;  // process as if C0 stationary, C1 moving
```

```
tfirst = 0;
tlast = INFINITY;

// test faces of C0 for separation
for (i = 0; i < C0.GetFCount(); i++)
{
    D = C0.GetNormal(i);
    ComputeInterval(C0,D,info0);
    ComputeInterval(C1,D,info1);
    speed = Dot(D,V);
    if ( NoIntersect(tmax,speed,info0,info1,curr0,curr1,side,
                    tfirst,tlast) )
    {
        return false;
    }
}

// test faces of C1 for separation
for (j = 0; j < C1.GetFCount(); j++)
{
    D = C1.GetNormal(j);
    ComputeInterval(C0,D,info0);
    ComputeInterval(C1,D,info1);
    speed = Dot(D,V);
    if ( NoIntersect(tmax,speed,info0,info1,curr0,curr1,side,
                    tfirst,tlast) )
    {
        return false;
    }
}

// test cross products of pairs of edges
for (i = 0; i < C0.GetECount(); i++)
{
    for (j = 0; j < C1.GetECount(); j++)
    {
        D = Cross(C0.GetEdge(i),C1.GetEdge(j));
        ComputeInterval(C0,D,info0);
        ComputeInterval(C1,D,info1);
        speed = Dot(D,V);
        if ( NoIntersect(tmax,speed,info0,info1,curr0,curr1,
                        side,tfirst,tlast) )
        {
```

```
                        return false;
                    }
                }
            }

        // compute the contact set
        GetIntersection(C0,V0,C1,V1,curr0,curr1,side,tfirst,I);
        return true;
}
```

The intersection calculator pseudocode follows.

```
void GetIntersection (ConvexPolyhedron C0, Vector V0,
    ConvexPolyhedron C1, Vector V1, ProjInfo info0,
    ProjInfo info1, int side, double tfirst,
    ConvexPolyhedron& I)
{
    if ( side == 1 )  // C0-max meets C1-min
    {
        if ( info0.type[1] == ProjInfo::V )
        {
            // vertex-{vertex/edge/face} intersection
            I.InsertFeature(C0.GetVertex(info0.index[1]) + tfirst * V0);
        }
        else if ( info1.type[0] == ProjInfo::V )
        {
            // {vertex/edge/face}-vertex intersection
            I.InsertFeature(C1.GetVertex(info1.index[0]) + tfirst * V1);
        }
        else if ( info0.type[1] == ProjInfo::E )
        {
            Segment E0 = C0.GetESegment(info0.index[1]) + tfirst * V0;
            if ( info1.type[0] == ProjInfo::E )
            {
                Segment E1 = C1.GetESegment(info1.index[0]) + tfirst * V1;
                I.InsertFeature(IntersectSegmentSegment(E0,E1));
            }
            else
            {
                Polygon F1 = C1.GetFPolygon(info1.index[0]) + tfirst * V1;
                I.InsertFeature(IntersectSegmentPolygon(E0,F1));
            }
        }
```

```
                else if ( info1.type[0] == ProjInfo::E )
                {
                    Segment E1 = C1.GetESegment(info1.index[0]) + tfirst * V1;
                    if ( info0.type[1] == ProjInfo::E )
                    {
                        Segment E0 = C0.GetESegment(info0.index[1]) + tfirst * V0;
                        I.InsertFeature(IntersectSegmentSegment(E1,E0));
                    }
                    else
                    {
                        Polygon F0 = C0.GetFPolygon(info0.index[1]) + tfirst * V0;
                        I.InsertFeature(IntersectSegmentPolygon(E1,F0));
                    }
                }
                else  // info0.type[1] and info1.type[0] both ProjInfo::F
                {
                    // face-face intersection
                    Polygon F0 = C0.GetFPolygon(info0.index[1]) + tfirst * V0;
                    Polygon F1 = C1.GetFPolygon(info1.index[0]) + tfirst * V1;
                    I.InsertFeature(IntersectPolygonPolygon(F0,F1));
                }
            }
            else if ( side == -1 )  // C1-max meets C0-min
            {
                if ( info1.type[1] == ProjInfo::V )
                {
                    // vertex-{vertex/edge/face} intersection
                    I.InsertFeature(C1.GetVertex(info1.index[1]) + tfirst * V1);
                }
                else if ( info0.type[0] == ProjInfo::V )
                {
                    // {vertex/edge/face}-vertex intersection
                    I.InsertFeature(C0.GetVertex(info0.index[0]) + tfirst * V0);
                }
                else if ( info1.type[1] == ProjInfo::E )
                {
                    Segment E1 = C1.GetESegment(info1.index[1]) + tfirst * V1;
                    if ( info0.type[0] == ProjInfo::E )
                    {
                        Segment E0 = C0.GetESegment(info0.index[0]) + tfirst * V0;
                        I.InsertFeature(IntersectSegmentSegment(E1,E0));
                    }
                    else
                    {
```

```
                        Polygon F0 = C0.GetFPolygon(info0.index[0]) + tfirst * V0;
                        I.InsertFeature(IntersectSegmentPolygon(E1,F0));
                    }
                }
                else if ( info0.type[0] == ProjInfo::E )
                {
                    Segment E0 = C0.GetESegment(info0.index[0]) + tfirst * V0;
                    if ( info1.type[1] == ProjInfo::E )
                    {
                        Segment E1 = C1.GetESegment(info1.index[1]) + tfirst * V1;
                        I.InsertFeature(IntersectSegmentSegment(E0,E1));
                    }
                    else
                    {
                        Polygon F1 = C1.GetFPolygon(info1.index[1]) + tfirst * V1;
                        I.InsertFeature(IntersectSegmentPolygon(E0,F1));
                    }
                }
                else  // info1.type[1] and info0.type[0] both ProjInfo::F
                {
                    // face-face intersection
                    Polygon F0 = C0.GetFPolygon(info0.index[0]) + tfirst * V0;
                    Polygon F1 = C1.GetFPolygon(info1.index[1]) + tfirst * V1;
                    I.InsertFeature(Intersection(F0,F1));
                }
            }
        }
        else  // polyhedra were initially intersecting
        {
            ConvexPolyhedron M0 = C0 + tfirst * V0;
            ConvexPolyhedron M1 = C1 + tfirst * V1;
            I = IntersectionPolyhedronPolyhedron(M0,M1);
        }
    }
}
```

The type Segment refers to a line segment and the type Polygon refers to a convex polygon in 3D. The various functions Intersect<Type1><Type2> are almost generic intersection calculators. I say "almost" meaning that you know the two objects *must* intersect since the separating axis results say so. Given that they intersect, you can optimize generic intersection calculators to obtain your results. The possible outputs from the intersection calculators are points, line segments, or convex polygons, referred to collectively as "features." The class ConvexPolyhedron must support construction by allowing the user to insert any of these features. I simply used the name InsertFeature to cover all the cases (overloading of the function name, so to speak).

The function `GetESegment` returns some representation of a line segment, for example, a pair of points. The calculation `S+t*V` where `S` is a `Segment`, `V` is a vector, and `t` is a floating point number requires the vector class to support scalar-times-vector. Moreover, the expression requires addition to be defined for a `Segment` object and a `Vector` object. Similarly, `GetFPolygon` returns some representation of the convex polygon face, for example, an ordered array of points. The calculation `F+t*V` requires addition to be defined for a `Polygon` object and a `Vector` object.

As you can see, this is the workhorse of the collision system, the geometric details of calculating intersections of line segments and convex polygons. You should expect that this is a likely candidate for the bottleneck in your collision system. For this reason you will see simplified systems such as [Bar01], where the contact set is reduced to a container of points. The preceding intersection calculator can be greatly optimized for such a system.

5.3.4 ORIENTED BOUNDING BOXES

So far we have discussed collision detection for convex polyhedra in general terms. A very common polyhedron used in applications is an *oriented bounding box*, the acronym *OBB* used for short. The term *box* is enough to describe the shape, but the modifier *bounding* applies when the box contains a more complex object and is used as a coarse measure of that portion of space the object occupies. The modifier *oriented* refers to the fact that the box axes are not necessarily aligned with the standard coordinate axes. Details are presented in Section 5.4 on the use of bounding boxes (and volumes) in the context of minimizing the work the collision detection system must do by *not* processing pairs of objects, if you can cheaply determine that they will not intersect. A descriptive name for this process is *collision culling*, suggestive of the culling that a graphics engine does in order not to draw objects if you can cheaply determine that they are not visible.

An OBB is defined by a center point \mathcal{C} that acts as the origin for a coordinate system whose orthonormal axis directions are \mathbf{U}_i for $i = 0, 1, 2$. The directions are normal vectors to the faces of the OBB. The half-widths or *extents* of the box along the coordinate axes are $e_i > 0$ for $i = 0, 1, 2$. Figure 5.24 shows an OBB and the intersection of the coordinate axes with three faces of the box.

The eight vertices of the OBB are of the form

$$\mathcal{P} = \mathcal{C} + \sigma_0 e_0 \mathbf{U}_0 + \sigma_1 e_1 \mathbf{U}_1 + \sigma_2 e_2 \mathbf{U}_2$$

where $|\sigma_i| = 1$ for $i = 0, 1, 2$; that is, we have eight choices for the signs σ_i.

Our interest is restricted to testing when two OBBs intersect, whether stationary or moving. As a convex polyhedron, an OBB has six faces and 12 edges. If we just blindly applied the test-intersection query for a pair of convex polyhedra, the number of potential separating axis tests is 156: six face normals for the first OBB, six face normals for the second OBB, and $144 = 12 * 12$ edge-edge pairs. In the worst case

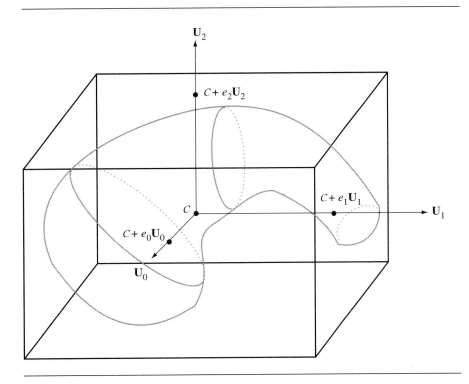

Figure 5.24 An OBB with center point \mathcal{C}, coordinate axis directions \mathbf{U}_0, \mathbf{U}_1, and \mathbf{U}_2, and extents e_0, e_1, and e_2 along the coordinate axes. The object bounded by the box is shown in gray.

we would try all 156 axes only to find the OBBs are intersecting. That is quite a large number of tests for such simple looking objects! The nature of an OBB, though, is that the symmetry allows us to reduce the number of tests. You probably already observed that we have three pairs of parallel faces, so we only need to consider three face normals for an OBB for the purposes of separation. Similarly, only three edge directions are unique and happen to be those of the face normals. Thus, for a pair of OBBS we have only 15 potential separating axis tests: three face normals for the first OBB, three face normals for the second OBB, and $9 = 3 * 3$ edge-edge pairs.

We still have to project an OBB onto a potential separating axis $\mathcal{Q} + t\mathbf{D}$. Although the fast extremal query for general convex polyhedra may be applied, the symmetry of the OBB allows us to quickly determine the interval of projection. Since a vertex must be an extreme point, it suffices to try to find a vertex \mathcal{P} that maximizes the dot product

$$\mathbf{D} \cdot (\mathcal{P} - \mathcal{Q}) = \mathbf{D} \cdot (\mathcal{C} - \mathcal{Q}) + e_0\sigma_0\mathbf{D} \cdot \mathbf{U}_0 + e_1\sigma_1\mathbf{D} \cdot \mathbf{U}_1 + e_2\sigma_2\mathbf{D} \cdot \mathbf{U}_2$$

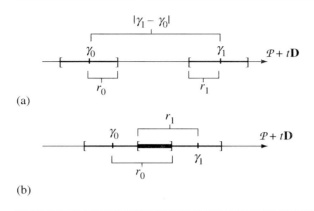

(a)

(b)

Figure 5.25 The projection intervals of two OBBs onto a line $\mathcal{P} + t\mathbf{D}$. (a) The intervals are disjoint, so the OBBs are separated. (b) The intervals overlap, so the line is not a separating axis.

The sign σ_0 is either 1 or -1. To make the term $\sigma_0 \mathbf{D} \cdot \mathbf{U}_0$ as large as possible, we want $\sigma_0 = 1$ when $\mathbf{D} \cdot \mathbf{U}_0 > 0$ and $\sigma_0 = -1$ when $\mathbf{D} \cdot \mathbf{U}_0 < 0$. If $\mathbf{D} \cdot \mathbf{U}_0 = 0$, it does not matter what the choice is for σ_0. The resulting quantity can be written as the single term $|\mathbf{D} \cdot \mathbf{U}_0|$. The same argument applies to the other terms, so

$$\max \mathbf{D} \cdot (\mathcal{P} - \mathcal{Q}) = \mathbf{D} \cdot (\mathcal{C} - \mathcal{Q}) + e_0 |\mathbf{D} \cdot \mathbf{U}_0| + e_1 |\mathbf{D} \cdot \mathbf{U}_1| + e_2 |\mathbf{D} \cdot \mathbf{U}_2|$$

Similarly, the minimum is

$$\min \mathbf{D} \cdot (\mathcal{P} - \mathcal{Q}) = \mathbf{D} \cdot (\mathcal{C} - \mathcal{Q}) - e_0 |\mathbf{D} \cdot \mathbf{U}_0| - e_1 |\mathbf{D} \cdot \mathbf{U}_1| - e_2 |\mathbf{D} \cdot \mathbf{U}_2|$$

Therefore, the projection interval is $[\gamma - r, \gamma + r]$, where $\gamma = \mathbf{D} \cdot (\mathcal{C} - \mathcal{Q})$ and $r = \sum_{i=0}^{2} e_i |\mathbf{D} \cdot \mathbf{U}_i|$.

Given two oriented bounding boxes, one with center \mathbf{C}_0, axes \mathbf{A}_i, and extents a_i, and one with center \mathbf{C}_1, axes \mathbf{B}_i, and extents b_i, let the projection intervals onto a line $\mathcal{Q} + t\mathbf{D}$ be $[\gamma_0 - r_0, \gamma_0 + r_0]$ and $[\gamma_1 - r_1, \gamma_1 + r_1]$. Figure 5.25 shows two cases, one with separated intervals and one with overlapping intervals.

The algebraic condition that describes the separated intervals in Figure 5.25(a) of the figure is $|\gamma_1 - \gamma_0| > r_0 + r_1$. In words, this says that the distance between the centers of the projected intervals is larger than the sum of the radii of the intervals. The intervals in Figure 5.25(b) overlap, so $|\gamma_1 - \gamma_0| < r_0 + r_1$. If the intervals are just touching, $|\gamma_1 - \gamma_0| = r_0 + r_1$. This last case is important when dealing with moving OBBs.

Define $r = |\gamma_1 - \gamma_0|$. A closer look at the algebraic condition for separation of the projected intervals shows that

$$r = |\gamma_1 - \gamma_0| = |\mathbf{D} \cdot (\mathcal{C}_1 - \mathcal{Q}) - \mathbf{D} \cdot (\mathcal{C}_0 - \mathcal{Q})| = |\mathbf{D} \cdot (\mathcal{C}_1 - \mathcal{C}_0)|$$

This means we need to specify only the direction \mathbf{D} and not worry about providing a point \mathcal{Q} on the line. Also,

$$r_0 = \sum_{i=0}^{2} a_i |\mathbf{D} \cdot \mathbf{A}_i|, \qquad r_1 = \sum_{i=0}^{2} b_i |\mathbf{D} \cdot \mathbf{B}_i|$$

The condition for separation of the projection intervals is $r > r_0 + r_1$ and is formally expanded as

$$|\mathbf{D} \cdot \mathbf{\Delta}| = r > r_0 + r_1 = \sum_{i=0}^{2} a_i |\mathbf{D} \cdot \mathbf{A}_i| + \sum_{i=0}^{2} b_i |\mathbf{D} \cdot \mathbf{B}_i| \qquad (5.48)$$

where $\mathbf{\Delta} = \mathcal{C}_1 - \mathcal{C}_0$. We have been thinking of \mathbf{D} as a unit-length direction vector. The face normals are already unit-length potential separating directions. A potential separating direction $\mathbf{D} = \mathbf{A}_i \times \mathbf{B}_j$ obtained as a cross product of edges, one edge from each of the OBBs, is not necessarily unit length. We should then use $\mathbf{D}/|\mathbf{D}|$ in equation (5.48) instead of \mathbf{D}. Notice, though, that the truth of the inequality is unchanged whether we use the vector or the normalized vector, since we can multiply through by $|\mathbf{D}|$. Consequently, we do not need to worry about normalizing the cross product.

A further optimization can be made. The formal sum for r_0 is a single term only when \mathbf{D} is a face normal of the first OBB. For example, if $\mathbf{D} = \mathbf{A}_0$, then $r_0 = a_0$. The formal sum for r_1 is also a single term only when \mathbf{D} is a face normal of the second OBB. The summation term of r_0 involves dot products $\mathbf{A}_i \cdot \mathbf{B}_j$ when using face normals of the second OBB for potential separating directions. The summation term of r_1 involves the same dot products when face normals of the first OBB are used for potential separating directions. When $\mathbf{D} = \mathbf{A}_j \times \mathbf{B}_k$, the summation term of r_0 is

$$\mathbf{D} \cdot \mathbf{A}_i = \mathbf{A}_j \times \mathbf{B}_k \cdot \mathbf{A}_i = \mathbf{A}_i \cdot \mathbf{A}_j \times \mathbf{B}_k = \mathbf{A}_i \times \mathbf{A}_j \cdot \mathbf{B}_k = \mathbf{A}_\ell \cdot \mathbf{B}_k$$

where $\{i, j, \ell\} = \{0, 1, 2\}$. For example, if $i = 2$ and $j = 0$, then $\ell = 1$. Similarly, the summation term of r_1 is

$$\mathbf{D} \cdot \mathbf{B}_i = \mathbf{A}_j \times \mathbf{B}_k \cdot \mathbf{B}_i = \mathbf{A}_j \cdot \mathbf{B}_k \times \mathbf{B}_i = \mathbf{A}_j \cdot \mathbf{B}_\ell$$

where again $\{i, j, \ell\} = \{0, 1, 2\}$. Therefore, all the separating axis tests require computing the quantities $c_{ij} = \mathbf{A}_i \cdot \mathbf{B}_j$ and do not need cross product operations. A

Table 5.1 Potential separating directions for OBBs and values for r_0, r_1, and r

D	r_0	r_1	r
\mathbf{A}_0	a_0	$b_0\lvert c_{00}\rvert + b_1\lvert c_{01}\rvert + b_2\lvert c_{02}\rvert$	$\lvert\alpha_0\rvert$
\mathbf{A}_1	a_1	$b_0\lvert c_{10}\rvert + b_1\lvert c_{11}\rvert + b_2\lvert c_{12}\rvert$	$\lvert\alpha_1\rvert$
\mathbf{A}_2	a_2	$b_0\lvert c_{20}\rvert + b_1\lvert c_{21}\rvert + b_2\lvert c_{22}\rvert$	$\lvert\alpha_2\rvert$
\mathbf{B}_0	$a_0\lvert c_{00}\rvert + a_1\lvert c_{10}\rvert + a_2\lvert c_{20}\rvert$	b_0	$\lvert\beta_0\rvert$
\mathbf{B}_1	$a_0\lvert c_{01}\rvert + a_1\lvert c_{11}\rvert + a_2\lvert c_{21}\rvert$	b_1	$\lvert\beta_1\rvert$
\mathbf{B}_2	$a_0\lvert c_{02}\rvert + a_1\lvert c_{12}\rvert + a_2\lvert c_{22}\rvert$	b_2	$\lvert\beta_2\rvert$
$\mathbf{A}_0 \times \mathbf{B}_0$	$a_1\lvert c_{20}\rvert + a_2\lvert c_{10}\rvert$	$b_1\lvert c_{02}\rvert + b_2\lvert c_{01}\rvert$	$\lvert c_{10}\alpha_2 - c_{20}\alpha_1\rvert$
$\mathbf{A}_0 \times \mathbf{B}_1$	$a_1\lvert c_{21}\rvert + a_2\lvert c_{11}\rvert$	$b_0\lvert c_{02}\rvert + b_2\lvert c_{00}\rvert$	$\lvert c_{11}\alpha_2 - c_{21}\alpha_1\rvert$
$\mathbf{A}_0 \times \mathbf{B}_2$	$a_1\lvert c_{22}\rvert + a_2\lvert c_{12}\rvert$	$b_0\lvert c_{01}\rvert + b_1\lvert c_{00}\rvert$	$\lvert c_{12}\alpha_2 - c_{22}\alpha_1\rvert$
$\mathbf{A}_1 \times \mathbf{B}_0$	$a_0\lvert c_{20}\rvert + a_2\lvert c_{00}\rvert$	$b_1\lvert c_{12}\rvert + b_2\lvert c_{11}\rvert$	$\lvert c_{20}\alpha_0 - c_{00}\alpha_2\rvert$
$\mathbf{A}_1 \times \mathbf{B}_1$	$a_0\lvert c_{21}\rvert + a_2\lvert c_{01}\rvert$	$b_0\lvert c_{12}\rvert + b_2\lvert c_{10}\rvert$	$\lvert c_{21}\alpha_0 - c_{01}\alpha_2\rvert$
$\mathbf{A}_1 \times \mathbf{B}_2$	$a_0\lvert c_{22}\rvert + a_2\lvert c_{02}\rvert$	$b_0\lvert c_{11}\rvert + b_1\lvert c_{10}\rvert$	$\lvert c_{22}\alpha_0 - c_{02}\alpha_2\rvert$
$\mathbf{A}_2 \times \mathbf{B}_0$	$a_0\lvert c_{10}\rvert + a_1\lvert c_{00}\rvert$	$b_1\lvert c_{22}\rvert + b_2\lvert c_{21}\rvert$	$\lvert c_{00}\alpha_1 - c_{10}\alpha_0\rvert$
$\mathbf{A}_2 \times \mathbf{B}_1$	$a_0\lvert c_{11}\rvert + a_1\lvert c_{01}\rvert$	$b_0\lvert c_{22}\rvert + b_2\lvert c_{20}\rvert$	$\lvert c_{01}\alpha_1 - c_{11}\alpha_0\rvert$
$\mathbf{A}_2 \times \mathbf{B}_2$	$a_0\lvert c_{12}\rvert + a_1\lvert c_{02}\rvert$	$b_0\lvert c_{21}\rvert + b_1\lvert c_{20}\rvert$	$\lvert c_{02}\alpha_1 - c_{12}\alpha_0\rvert$

convenient summary of the axes and quantities required by $r > r_0 + r_1$ are listed in Table 5.1. The table uses $\alpha_i = \mathbf{\Delta} \cdot \mathbf{A}_i$ and $\beta_i = \mathbf{\Delta} \cdot \mathbf{B}_i$.

A term of the form $c_{10}\alpha_2 - c_{20}\alpha_1$ occurs as a result of $\mathbf{\Delta} = \alpha_0\mathbf{A}_0 + \alpha_1\mathbf{A}_1 + \alpha_2\mathbf{A}_2$, and

$$\mathbf{A}_0 \times \mathbf{B}_0 \cdot \mathbf{\Delta}$$

$$= \alpha_0(\mathbf{A}_0 \times \mathbf{B}_0 \cdot \mathbf{A}_0) + \alpha_1(\mathbf{A}_0 \times \mathbf{B}_0 \cdot \mathbf{A}_1) + \alpha_2(\mathbf{A}_0 \times \mathbf{B}_0 \cdot \mathbf{A}_2)$$

$$= \alpha_0(\mathbf{0}) - \alpha_1\mathbf{A}_2 \times \mathbf{B}_0 + \alpha_2\mathbf{A}_1 \cdot \mathbf{B}_0$$

$$= c_{10}\alpha_2 - c_{20}\alpha_1$$

Pseudocode follows. The code is organized to compute quantities only when needed. The code also detects when two face normals \mathbf{A}_i and \mathbf{B}_j are nearly parallel. Theoretically, if a parallel pair exists, it is sufficient to test only the face normals of the two OBBs for separation. Numerically, though, two nearly parallel faces can lead to all face normal tests reporting no separation along those directions. The cross product directions are tested next, but $\mathbf{A}_i \times \mathbf{B}_j$ is nearly the zero vector and can cause the system to report that the OBBs are not intersecting when in fact they are.

```
bool TestIntersection (OBB box0, OBB box1)
{
    // OBB:  center C; axes U[0], U[1], U[2];
    //       extents e[0], e[1], e[2]

    // values that are computed only when needed
    double c[3][3];     // c[i][j] = Dot(box0.U[i],box1.U[j])
    double absC[3][3];  // |c[i][j]|
    double d[3];        // Dot(box1.C-box0.C,box0.U[i])

    // interval radii and distance between centers
    double r0, r1, r;
    int i;

    // cutoff for cosine of angles between box axes
    const double cutoff = 0.999999;
    bool existsParallelPair = false;

    // compute difference of box centers
    Vector diff = box1.C - box0.C;

    // axis C0 + t * A0
    for (i = 0; i < 3; i++)
    {
        c[0][i] = Dot(box0.U[0],box1.U[i]);
        absC[0][i] = |c[0][i]|;
        if ( absC[0][i] > cutoff )
            existsParallelPair = true;
    }
    d[0] = Dot(diff,box0.U[0]);
    r = |d[0]|;
    r0 = box0.e[0];
    r1 = box1.e[0] * absC[0][0] + box1.e[1] * absC[0][1] +
        box1.e[2] * absC[0][2];
    if ( r > r0 + r1 )
        return false;

    // axis C0 + t * A1
    for (i = 0; i < 3; i++)
    {
        c[1][i] = Dot(box0.U[1],box1.U[i]);
        absC[1][i] = |c[1][i]|;
        if ( absC[1][i] > cutoff )
            existsParallelPair = true;
    }
```

```
d[1] = Dot(diff,box0.U[1]);
r = |d[1]|;
r0 = box0.e[1];
r1 = box1.e[0] * absC[1][0] + box1.e[1] * absC[1][1] +
    box1.e[2] * absC[1][2];
if ( r > r0 + r1 )
    return false;

// axis C0 + t * A2
for (i = 0; i < 3; i++)
{
    c[2][i] = Dot(box0.U[2],box1.U[i]);
    absC[2][i] = |c[2][i]|;
    if ( absC[2][i] > cutoff )
        existsParallelPair = true;
}
d[2] = Dot(diff,box0.U[2]);
r = |d[2]|;
r0 = box0.e[2];
r1 = box1.e[0] * absC[2][0] + box1.e[1] * absC[2][1] +
    box1.e[2] * absC[2][2];
if ( r > r0 + r1 )
    return false;

// axis C0 + t * B0
r = |Dot(diff,box1.U[0])|;
r0 = box0.e[0] * absC[0][0] + box0.e[1] * absC[1][0] +
    box0.e[2] * absC[2][0];
r1 = box1.e[0];
if ( r > r0 + r1 )
    return false;

// axis C0 + t * B1
r = |Dot(diff,box1.U[1])|;
r0 = box0.e[0] * absC[0][1] + box0.e[1] * absC[1][1] +
    box0.e[2] * absC[2][1];
r1 = box1.e[1];
if ( r > r0 + r1 )
    return false;

// axis C0 + t * B2
r = |Dot(diff,box1.U[2])|;
r0 = box0.e[0] * absC[0][2] + box0.e[1] * absC[1][2] +
    box0.e[2] * absC[2][2];
```

```
r1 = box1.e[2];
if ( r > r0 + r1 )
    return false;

if ( existsParallelPair )
{
    // A pair of box axes was (effectively) parallel,
    // boxes must intersect.
    return true;
}

// axis C0 + t * A0 x B0
r = |d[2] * c[1][0] - d[1] * c[2][0]|;
r0 = box0.e[1] * absC[2][0] + box0.e[2] * absC[1][0];
r1 = box1.e[1] * absC[0][2] + box1.e[2] * absC[0][1];
if ( r > r0 + r1 )
    return false;

// axis C0 + t * A0 x B1
r = |d[2] * c[1][1] - d[1] * c[2][1]|;
r0 = box0.e[1] * absC[2][1] + box0.e[2] * absC[1][1];
r1 = box1.e[0] * absC[0][2] + box1.e[2] * absC[0][0];
if ( r > r0 + r1 )
    return false;

// axis C0 + t * A0 x B2
r = |d[2] * c[1][2] - d[1] * c[2][2]|;
r0 = box0.e[1] * absC[2][2] + box0.e[2] * absC[1][2];
r1 = box1.e[0] * absC[0][1] + box1.e[1] * absC[0][0];
fR01 = r0 + r1;
if ( r > fR01 )
    return false;

// axis C0 + t * A1 x B0
r = |d[0] * c[2][0] - d[2] * c[0][0]|;
r0 = box0.e[0] * absC[2][0] + box0.e[2] * absC[0][0];
r1 = box1.e[1] * absC[1][2] + box1.e[2] * absC[1][1];
if ( r > r0 + r1 )
    return false;

// axis C0 + t * A1 x B1
r = |d[0] * c[2][1] - d[2] * c[0][1]|;
r0 = box0.e[0] * absC[2][1] + box0.e[2] * absC[0][1];
r1 = box1.e[0] * absC[1][2] + box1.e[2] * absC[1][0];
```

```
    if ( r > r0 + r1 )
        return false;

    // axis C0 + t * A1 x B2
    r = |d[0] * c[2][2] - d[2] * c[0][2]|;
    r0 = box0.e[0] * absC[2][2] + box0.e[2] * absC[0][2];
    r1 = box1.e[0] * absC[1][1] + box1.e[1] * absC[1][0];
    if ( r > r0 + r1 )
        return false;

    // axis C0 + t * A2 x B0
    r = |d[1] * c[0][0] - d[0] * c[1][0]|;
    r0 = box0.e[0] * absC[1][0] + box0.e[1] * absC[0][0];
    r1 = box1.e[1] * absC[2][2] + box1.e[2] * absC[2][1];
    if ( r > r0 + r1 )
        return false;

    // axis C0 + t * A2 x B1
    r = |d[1] * c[0][1] - d[0] * c[1][1]|;
    r0 = box0.e[0] * absC[1][1] + box0.e[1] * absC[0][1];
    r1 = box1.e[0] * absC[2][2] + box1.e[2] * absC[2][0];
    if ( r > r0 + r1 )
        return false;

    // axis C0 + t * A2 x B2
    r = |d[1] * c[0][2] - d[0] * c[1][2]|;
    r0 = box0.e[0] * absC[1][2] + box0.e[1] * absC[0][2];
    r1 = box1.e[0] * absC[2][1] + box1.e[1] * absC[2][0];
    if ( r > r0 + r1 )
        return false;

    return true;
}
```

5.3.5 BOXES MOVING WITH CONSTANT LINEAR AND ANGULAR VELOCITY

OBBs may certainly be used as objects in and of themselves in an application. A classic application in the industry is having a moving vehicle run through a wall of bricks. A large number of bricks will demand a lot of performance from the physics engine. After the vehicle crashes through the wall, the collision detection system has a lot to handle. The bricks will have both nonzero linear and angular velocities, the actual values dependent on the interactions with other bricks. To avoid performance

issues with the bisection approach to collision, we would like to predict collisions at later times and reduce the desired time step accordingly. But is that not what the differential equation solving is about, predicting future behavior from current state? Taking the time step with the solver just to predict that we should take half the time step puts us right back in the bisection algorithm. The question: Can we predict collisions without actually running the solver?

Well, the answer is "almost." For a physical simulation running at real-time rates, the time step will be a fraction of a second. During the time interval $[0, \Delta t]$, where $\Delta t > 0$ is small, the linear and angular velocities should not change very much. If you assume that the linear and angular velocities are constant over the time step, you can estimate the location of the center of mass and the orientation of the body at the end of that time. The general equations of motion for these quantities are $\dot{\mathbf{x}}(t) = \mathbf{v}(t)$ and $\dot{R}(t) = \text{Skew}(\mathbf{w}(t))R(t)$, where $\mathbf{v}(t)$ is linear velocity and $\mathbf{w}(t)$ is angular velocity. In mathematical terms the assumption of constancy over the time interval produces the approximate equations $\dot{\mathbf{x}}(t) = \mathbf{v}_0$ and $\dot{R}(t) = \text{Skew}(\mathbf{w}_0)R(t)$, where $\mathbf{v}_0 = \mathbf{v}(0)$ and $\mathbf{w}_0 = \mathbf{w}(0)$. These have exact solutions,

$$\mathbf{x}(t) = \mathbf{x}_0 + t\mathbf{v}_0, \qquad R(t) = \text{Rot}(t|\mathbf{w}_0|, \mathbf{w}_0/|\mathbf{w}_0|)R_0$$

where $\mathbf{x}_0 = \mathbf{x}(0)$, $R_0 = R(0)$, and $\text{Rot}(\theta, \mathbf{u})$ is the rotation matrix by an angle θ about an axis whose direction is the unit-length vector \mathbf{u}. We can run our collision detection system using $\mathbf{x}(t)$ and $R(t)$ produced by these equations to predict if any collisions will occur on the time interval $[0, \Delta t]$. If not, we can solve the differential equations using the desired step Δt. If collisions are predicted, the system should report the largest time $T \in [0, \Delta t]$ for which no collisions occur on the interval $[0, T]$. The time step for the differential equation solver is chosen to be T instead of Δt. Our estimates $\mathbf{x}(t)$ and $R(t)$ are essentially a numerical method of the Euler type for solving differential equations, but in our case we are using these estimates in conjunction with the collision system to provide an adaptive time step for the actual differential equation solver (such as Runge-Kutta) that our physical simulator is using.

A collision detection system built on the method of separating axes can handle constant linear and angular velocities with a minimum of computational effort when the objects are oriented bounding boxes.

Constant Linear Velocity

Consider two OBBs whose centers are moving with constant linear velocity, $\mathcal{C}_i + t\mathbf{V}_i$ for $i = 0, 1$ and $t \geq 0$. The OBB axes are assumed not to rotate over time; that is, there is no angular velocity. The general analysis that led to TestIntersection for convex polyhedra moving with constant linear velocities applies here. The difference is that the general case required ComputeInterval for computing the projection intervals of the polyhedra. The intervals are simpler to compute for OBBs. Partial pseudocode

for the test-intersection query is listed below. The organization is similar to the pseudocode for testing stationary OBBs. Blocks of the form

```
if ( r > r0 + r1 )
    return false;
```

are replaced by

```
speed = Dot(D,V);
if ( NoIntersect(tmax,speed,min0,max0,min1,max1,tfirst,tlast) )
    return false;
```

where speed is of type double, D is the relevant potential separating axis, and V is the velocity of the second box relative to the first. The input to NoIntersect consisted of two projection intervals $[\min_0, \max_0]$ and $[\min_1, \max_1]$ on a line $\mathcal{O} + t\mathbf{D}$, where \mathcal{O} is the origin. Now we are projecting onto a line with the same direction but containing the center of the first box. A brief look at the code for NoIntersect will convince you that only the relative position of the projection intervals matters, not the absolute location of their centers. In the pseudocode that follows, the interval values are computed relative to the projected center of the first box.

```
bool TestIntersection (OBB box0, Vector V0, OBB box1, Vector V1,
    double tmax, double& tfirst, double& tlast)
{
    // OBB:  center C; axes U[0], U[1], U[2];
    //       extents e[0], e[1], e[2]

    // values that are computed only when needed
    double c[3][3];      // c[i][j] = Dot(box0.U[i],box1.U[j])
    double absC[3][3];   // |c[i][j]|
    double udc[3];       // Dot(box0.U[i],box1.C-box0.C)
    double udv[3];       // Dot(box0.U[i],V1-V0)

    double center, speed, r0, r1, min0, max0, min1, max1;
    int i;

    // cutoff for cosine of angles between box axes
    const double cutoff = 0.999999;
    bool existsParallelPair = false;

    // compute difference of box centers and velocities
    Vector CDiff = box1.C - box0.C;
    Vector VDiff = V1 - V0;
```

```
tfirst = 0;
tlast = INFINITY;

// axis C0 + t * A0
for (i = 0; i < 3; i++)
{
    c[0][i] = Dot(box0.U[0],box1.U[i]);
    absC[0][i] = |c[0][i]|;
    if ( absC[0][i] > cutoff )
        existsParallelPair = true;
}
udc[0] = Dot(box0.U[0],CDiff);
udv[0] = Dot(box0.U[0],VDiff);
center = udc[0];
speed = udv[0];
r0 = box0.e[0];
r1 = box1.e[0] * absC[0][0] + box1.e[1] * absC[0][1] +
    box1.e[2] * absC[0][2];
min0 = -r0;
max0 = +r0;
min1 = center - r1;
max1 = center + r1;
if ( NoIntersect(tmax,speed,min0,max0,min1,max1,tfirst,tlast) )
    return false;

//*** other face normal cases go here ***

if ( existsParallelPair )
{
    // A pair of box axes was (effectively) parallel,
    // boxes must intersect.
    return true;
}

// axis C0 + t * A0 x B0
center = udc[2] * c[1][0] - udc[1] * c[2][0];
speed = udv[2] * c[1][0] - udv[1] * c[2][0];
r0 = box0.e[1] * absC[2][0] + box0.e[2] * absC[1][0];
r1 = box1.e[1] * absC[0][2] + box1.e[2] * absC[0][1];
min0 = -r0;
max0 = +r0;
min1 = center - r1;
max1 = center + r1;
```

```
    if ( NoIntersect(tmax,speed,min0,max0,min1,max1,tfirst,tlast) )
        return false;

    //*** other edge-edge cases go here ***

    return true;
}
```

The pseudocode for NoIntersect is the same used for convex polyhedra generally.

Constant Angular Velocity

The analysis for constant linear velocity is based on two things, the separating test in equation (5.48) and the time-varying difference between centers $\mathbf{\Delta}(t) = \mathbf{D} \cdot (\mathcal{C}_1 - \mathcal{C}_0) + t\mathbf{D} \cdot (\mathbf{V}_1 - \mathbf{V}_0) = c + t\sigma$. If you consider the first projection interval $[-r_0, r_0]$ to be stationary, the second projection interval is $[c + t\sigma - r_1, c + t\sigma + r_1]$. At time 0 its center is c and it moves with speed σ. Figure 5.26 shows the four cases of interest.

The first two rows of the figure show the moving interval on the right of the stationary one. In the first row $\sigma \geq 0$ and the intervals will never intersect. In the

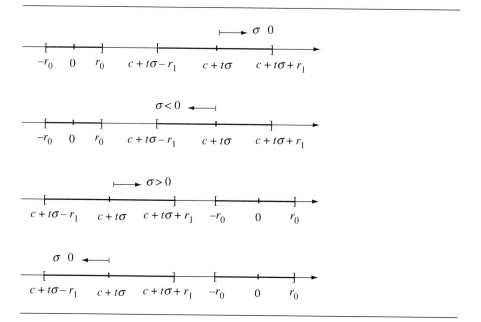

Figure 5.26 Two projected intervals, one stationary and one moving.

second row $\sigma < 0$ and the intervals will intersect at time $t = (r_0 + r_1 - c)/\sigma$. The last two rows of the figure show the moving interval on the left of the stationary one. In the third row $\sigma > 0$ and the intervals will intersect at time $t = -(r_0 + r_1 + c)/\sigma$. In the fourth row $\sigma \leq 0$ and the intervals will never intersect. The constant linear velocities of the bodies leads to a linear equation in t for computing the first time of contact.

We are not so lucky to obtain a simple formulation for bodies moving with constant angular velocities $\mathbf{w}_k, k = 0, 1$, but we can obtain a formulation nonetheless. The constant angular speeds are $\omega_k = |\mathbf{w}_k|$ and the unit-length directions for the axes of rotation are $\mathbf{U}_k = \mathbf{w}_k/|\mathbf{w}_k|$. The rotation matrices corresponding to the angular velocities are

$$R_k(t) = I + \sin(t\omega_k)S_k + (1 - \cos(t\omega_k))S_k^2$$

where $S_k = \text{Skew}(\mathbf{U}_k)$. Let \mathbf{A}_i and \mathbf{B}_j be the OBB axes at time zero. At a later time the axes are $R_0(t)\mathbf{A}_i$ and $R_1(t)\mathbf{B}_j$. The separation condition along an axis based on equation (5.48) is

$$|\mathbf{D}(t) \cdot \mathbf{\Delta}| = r(t) > r_0(t) + r_1(t) = \sum_{i=0}^{2} a_i|\mathbf{D}(t) \cdot R_0(t)\mathbf{A}_i| + \sum_{j=0}^{2} b_j|\mathbf{D}(t) \cdot R_1(t)\mathbf{B}_i|$$

where $\mathbf{\Delta} = \mathcal{C}_1 - \mathcal{C}_0$ does not vary with time (the box centers are stationary). The choices for potential separating direction $\mathbf{D}(t)$ are $R_0(t)\mathbf{A}_i$, $R_1(t)\mathbf{B}_j$, and $(R_0(t)\mathbf{A}_i) \times (R_1(t)\mathbf{B}_j)$.

To get an idea of the complexity of the separating equation, let us look at the case $\mathbf{D}(t) = R_0(t)\mathbf{A}_0$. The simplest distance quantity is $r_0(t) = a_0$. For $r(t)$ and $r_1(t)$, define $\sigma_i(t) = \sin(t\omega_i)$ and $\gamma_i(t) = \cos(t\omega_i)$. The quantity $r(t)$ is

$$r(t) = |(\mathbf{A}_0 \cdot \mathbf{\Delta}) + (S_0\mathbf{A}_0 \cdot \mathbf{\Delta})\sigma_0(t) + (S_0^2\mathbf{A}_0 \cdot \mathbf{\Delta})(1 - \gamma_0(t))|$$

$$= |c_0 + c_1 \sin(\omega_0 t + \psi)|$$

for some constants c_0, c_1, and ψ. The last equality follows from an application of trigonometric identities. The general term in the summation for $r_1(t)$ involves the absolute value of

$$R_0(t)\mathbf{A}_0 \cdot R_1(t)\mathbf{B}_j = d_{00h} + d_{01j}\sigma_1(t) + d_{02j}(1 - \gamma_1(t))$$

$$+ d_{10j}\sigma_0(t) + d_{11j}\sigma_0(t)\sigma_1(t) + d_{12j}\sigma_0(t)(1 - \gamma_1(t))$$

$$+ d_{20j}(1 - \gamma_0(t)) + d_{21j}(1 - \gamma_0(t))\sigma_1(t) + d_{22j}(1 - \gamma_0(t))(1 - \gamma_1(t))$$

where $d_{k\ell j} = S_0^k\mathbf{A}_0 \cdot S_1^\ell\mathbf{B}_j$. Trigonometric identities may be used to reduce this to

$$R_0(t)\mathbf{A}_0 \cdot R_1(t)\mathbf{B}_j = e_j + \sum_{i=0}^{3} f_{ji} \sin(\lambda_i t + \phi_i)$$

where e_j, f_{ji}, and ϕ_i are constants. The frequencies are $\lambda_0 = \omega_0$, $\lambda_1 = \omega_1$, $\lambda_2 = \omega_0 + \omega_1$, and $\lambda_3 = \omega_0 - \omega_1$. The separating equation becomes

$$\left| c_0 + c_1 \sin(\lambda_0 t + \psi) \right| > a_0 + \sum_{j=0}^{2} b_j \left| e_j + \sum_{i=0}^{3} f_{ji} \sin(\lambda_i t + \phi_i) \right|$$

Computing the first time t for which you get equality in the above expression requires a numerical root finder. And keep in mind that the worst case is having to process all 15 separating axes, each yielding a complicated inequality of this form.

We could make yet another approximation and replace $\sin(\omega_k t) \doteq \omega_k t$ and $1 - \cos(\omega_k t) \doteq 0$. The separating equation for potential separating axis $R_0(t)\mathbf{A}_0$ with these approximations is of the form

$$|g_0 + g_1 t| > a_0 + \sum_{j=0}^{2} b_j |h_{j0} + h_{j1} t + h_{j2} t^2|$$

This looks less formidable, but still requires a bit of work to find when equality occurs.

5.4 Collision Culling: Spatial and Temporal Coherence

In a graphics system a standard approach to improving the performance of rendering is to avoid drawing objects that are outside the view frustum. This process is called *culling*. The classic algorithm is to associate a bounding volume with each drawable object and use plane-at-a-time culling. For each frustum plane, the bounding volume is tested to see if it is on the side outside the frustum. If so, then the object contained by it is outside the frustum and need not be drawn. If the bounding volume is not outside any of the planes, the object is drawn. This is not an exact culling algorithm because the bounding volume can be outside the frustum even though not outside any of the six planes. Figure 5.27 illustrates this for bounding spheres.

However, any culling that occurs is better than attempting to draw all objects in the system. Of course, it is essential that the time it takes to cull an object is less than the time spent by the rendering system transforming its triangles into view space and clipping, only to find out that all triangle vertices are outside the frustum.

The essence of view frustum culling is that a bounding volume is a simple geometric entity for which intersection testing with the frustum is much cheaper than intersection testing between the original object and the frustum. The performance of collision detection systems can be enhanced using culling in a similar manner. Our algorithm for determining if two convex polyhedra are intersecting uses the method

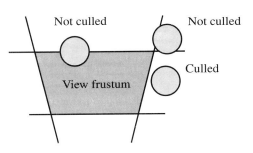

Figure 5.27 Culling of bounding spheres against a view frustum.

of separating axes. If the polyhedra are not intersecting, we will find that out once we project onto one of the $N_0 + N_1 + N_0 N_1$ potential separating directions where polyhedra i has N_i faces. An object in the system tends to interact with only a small subset of the total objects, so you expect most pairs of objects at any given time not to be intersecting. The system can spend a lot of time telling you something you already know. Using view frustum culling as motivation, we should have a bounding volume per convex polyhedra that is simpler in structure and allows us to quickly determine whether two bounding volumes are (or are not) intersecting.

5.4.1 CULLING WITH BOUNDING SPHERES

An obvious choice for a bounding volume of a convex polyhedron is a sphere. Given spheres with centers \mathcal{C}_i and radii r_i for $i = 0, 1$, the spheres do not intersect whenever the distance between their centers is larger than the sum of their radii. The algebraic condition for nonintersection is $|\mathcal{C}_1 - \mathcal{C}_0| > r_0 + r_1$. This should look familiar to you since it is the same form as the inequality for specifying the separation of two projection intervals on a separating axis. The set of potential separating axes for a sphere is the set of *all* directions. When comparing two spheres, we need only project onto a line containing both centers. The separation test in practice is implemented using squared quantities, $|\mathcal{C}_1 - \mathcal{C}_0|^2 > (r_0 + r_1)^2$, to avoid the expensive square root calculation of distance between centers.

Suppose our environment has n convex polyhedra. Let c_p denote the average cost of the intersection testing for two convex polyhedra. Testing all pairs, the total cost for a test-intersection query is

$$c_1 = \frac{n(n-1)}{2} c_p \tag{5.49}$$

Let c_s denote the cost of the intersection testing for two spheres. We still compute an all-pairs, test-intersection query, this time for spheres. If two spheres intersect, the contained polyhedra might or might not intersect. We still have to perform the polyhedra intersection test in this case. If m pairs of spheres intersect where $0 \le m \le n(n-1)/2$, the total cost for a test-intersection query is

$$c_2 = \frac{n(n-1)}{2} c_s + m c_p \qquad (5.50)$$

The culling system needs to be more efficient, so we require that $c_2 < c_1$. This happens when

$$\frac{c_s}{c_p} < 1 - \frac{2m}{n(n-1)}$$

If the expected number of separating axis tests for a pair of polyhedra is k, where $1 \le k \le N_0 + N_1 + N_0 N_1$, then we expect the ratio to be $c_s/c_p = 1/k$ to a first approximation. Consequently, $c_2 < c_1$ implies

$$m < \left(1 - \frac{1}{k}\right) \frac{n(n-1)}{2}$$

That is, the sphere-based culling system is more efficient as long as the number of intersecting spheres does not exceed the fraction $(1 - 1/k)$ of total objects in the system.

Despite the benefits from sphere-based culling, the system requires a comparison of all pairs of n objects. The objects are moving about, so the comparisons occur at each time step. When n is large, this culling system still might not be enough to remedy the sluggishness of the application. Another improvement is called for, one that uses *coherence* of the objects in the system. We have two possibilities for coherence, *spatial coherence* where we take advantage of knowledge about the spatial locations of the objects in the system (locality in space), and *temporal coherence* where we take advantage of the fact that with a small change in time, the new state of the system does not deviate much from its old state (locality in time).

We may modify the sphere-based culling to illustrate how to use spatial coherence to improve the performance of the collision system. A simple idea is to decompose the space known to be occupied by all the objects during the life of the simulation. If the total space is an axis-aligned box, we decompose it into a regular lattice of disjoint, smaller axis-aligned boxes. Each box maintains a list of spheres that are fully or partially inside the box. Figure 5.28 illustrates for a collection of eight spheres and a partition into four boxes.

If B_{ij} denotes the bin in row i and column j, the bins are $B_{00} = \{A, C, D, E\}$, $B_{01} = \{B, D, E\}$, $B_{10} = \{E, F\}$, and $B_{11} = \{E, G, H\}$. As you can see, if a sphere overlaps any box in the decomposition, it is placed into the list of spheres for that bin. For the sake of argument, suppose that we have b bins labeled B_i and the spheres

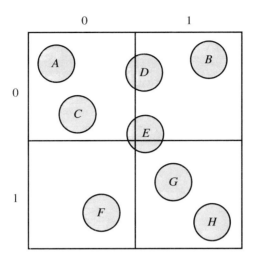

Figure 5.28 Decomposition of space to reduce the number of comparisons between pairs of objects.

are uniformly distributed in the bins. The number of spheres in each bin is n/b, where n is the total number of spheres. Let m_i denote the number of intersecting spheres in bin B_i. The cost for the sphere-based culling in bin i is

$$\frac{(n/b)(n/b-1)}{2}c_s + m_i c_p$$

The total cost is

$$c_3 = \sum_{i=1}^{b} \frac{(n/b)(n/b-1)}{2}c_s + m_i c_p = \frac{n(n/b-1)}{2}c_s + mc_p \qquad (5.51)$$

where $m = \sum_{i=1}^{b} m_i$. The cost of the sphere comparisons in c_3 is approximately $1/b$ that of the cost in c_2 as shown in equation (5.50). If b is a small constant compared to n, the cost of sphere comparisons in equations (5.50) and (5.51) are both $O(n^2)$. However, if we choose b to be on the order of n, say, $b = rn$ for some fraction $r \in (0, 1)$, then the cost of sphere comparisons is $((1/r-1)/2)nc_s$, which is $O(n)$ in time, something quite desirable in a collision system.

Unfortunately, the analysis for the binning is not complete. We have forgotten to include the cost of determining which bins contain the spheres. The algorithm itself requires testing for overlap between a sphere with center \mathcal{C} and radius r and an axis-aligned box $[x_{\min}, x_{\max}] \times [y_{\min}, y_{\max}] \times [z_{\min}, z_{\max}]$. To test for overlap it is

sufficient to compute the distance from the center of the sphere to the solid box and
show that it is less than the radius. The algorithm is listed next. The Sphere class is
assumed to have members C for the center and r for the radius. The AxisAlignedBox
class has six members for the minimum and maximum values on the coordinate axes.

```
bool TestIntersection (Sphere S, AxisAlignedBox B)
{
    double sqrDist = 0.0, d;

    if ( S.C.x < B.xmin )
    {
        d = S.C.x - B.xmin;
        sqrDist += d * d;
    }
    else if ( S.C.x > B.xmax )
    {
        d = S.C.x - B.xmax;
        sqrDist += d * d;
    }

    if ( S.C.y < B.ymin )
    {
        d = S.C.y - B.ymin;
        sqrDist += d * d;
    }
    else if ( S.C.y > B.ymax )
    {
        d = S.C.y - B.ymax;
        sqrDist += d * d;
    }

    if ( S.C.z < B.zmin )
    {
        d = S.C.z - B.zmin;
        sqrDist += d * d;
    }
    else if ( S.C.z > B.zmax )
    {
        d = S.C.z - B.zmax;
        sqrDist += d * d;
    }

    return ( sqrDist < S.r * S.r );
}
```

The return value is `true` whenever the sphere intersects the box and the intersection has positive volume. The cost of this test is denoted c_t, a relatively small cost. The naive algorithm for determining the bins containing the spheres just iterates over all spheres and tests each sphere against all boxes, a double loop, leading to a cost of bnc_t. The cost of the sphere-based culling with binning is now

$$c_4 = \frac{n(n/b - 1)}{2} c_s + mc_p + bnc_t \tag{5.52}$$

We argued earlier that to make the cost of sphere comparisons $O(n)$, we needed $b = rn$ for some fraction r. Unfortunately, this makes the cost of binning $O(n^2)$. This is to be expected: The more bins you select, the cheaper the cost of sphere comparisons, but the more expensive the cost of deciding which bins contain the spheres.

EXERCISE (M) Develop a more efficient algorithm than the naive one for determining which bins
5.5 are intersected by a sphere. How does the cost equation (5.52) change with your new algorithm? ▪

In a dynamic simulation the polyhedra (and spheres) will move each time step of the simulation. The binning algorithm can be applied at each step if you so desire, but we can do better by modifying the algorithm to take advantage of temporal coherence. When the simulation is initialized we can determine which boxes the spheres intersect. On the next step of the simulation the spheres are moved. Under reasonable assumptions on the speeds of the objects, the maximum distance traveled by the spheres should be small compared to the dimensions of a box in the partition, or at least no worse than a couple of box extents. The set of candidate boxes that a sphere now intersects should be quite small, restricted to the current boxes that the sphere intersects and a small ring of neighboring boxes. The set size is constant compared to the total number of spheres in the system, so we can update for each bin the set of spheres overlapping it in $O(n)$ time.

EXERCISE (M) Develop an efficient algorithm that updates each bin's set of spheres overlapping it.
5.6 (*Hint:* Use a breadth-first search starting with the current box containing the sphere.)
▪

EXERCISE (M) Write a computer program to implement sphere-based culling as described in this
5.7 section. The program should use binning to take advantage of spatial coherence and should efficiently update the overlap information of the bins to take advantage of temporal coherence. ▪

One final issue is to be mentioned: The convex polyhedra are both translated and rotated at each time step of the simulation. The bounding spheres after the motion still must be bounds. Depending on how you chose your spheres, you might have to update the bounding spheres for each time step, adding yet one more term to the cost

equation. However, we can avoid this extra cost by choosing the bounding sphere center to be the center of mass of the polyhedron. No matter how the polyhedron rotates about its center of mass, the bounding sphere will contain it. Consequently, the update of the bounding sphere requires translating its center, the exact same translation that is applied to the polyhedron.

5.4.2 Culling with Axis-Aligned Bounding Boxes

Here we investigate another culling system that uses both spatial and temporal coherence. This one performs particularly well in practice. To each convex polyhedron, we associate an axis-aligned bounding box (AABB). If two AABBs do not intersect, then the convex polyhedra contained by them do not intersect. If the AABBs do intersect, we then test if the enclosed polyhedra intersect. Of course, this is the same approach we used for bounding spheres.

We have the same issues to deal with as we did for sphere-based culling. Each time step the convex polyhedra move, their AABBs move. First, we need to update the AABB to make sure it contains the polyhedron. When we used a sphere whose center is the center of mass, only a translation was applied to the center since the sphere is guaranteed to contain the polyhedron regardless of its orientation. This is not the case for AABBs. If the polyhedron rotates, the current AABB is not necessarily a bound and we need to compute a new one. Certainly, an iteration over the vertices of the newly moved polyhedron may be used to compute the extremes along each coordinate axis, but if we have added the fast extremal query support to the convex polyhedra discussed earlier, we can use six queries to compute the AABB.

Second, once the AABBs are updated for all the polyhedra we expect that the intersection status of pairs of polyhedra/AABBs has changed—old intersections might no longer exist, new intersections might now occur. Spatial and temporal coherence will be used to make sure the update of status is efficient.

Intersecting Intervals

The idea of determining intersection between AABBs is based on sorting and update of intervals on the real line, a one-dimensional problem that we will analyze first. The method we describe here is mentioned in [Bar01]. A more general discussion of intersections of rectangles in any dimension is provided in [PS85]. Consider a collection of n intervals $I_i = [b_i, e_i]$ for $1 \le i \le n$. The problem is to efficiently determine all pairs of intersecting intervals. The condition for a single pair I_i and I_j to intersect is $b_j \le e_i$ and $b_i \le e_j$. The naive algorithm for the full set of intervals just compares all possible pairs, an $O(n^2)$ algorithm.

A more efficient approach uses a *sweep algorithm*, a concept that has been used successfully in many computational geometry algorithms. First, the interval end points are sorted into ascending order. An iteration is made over the sorted list (the

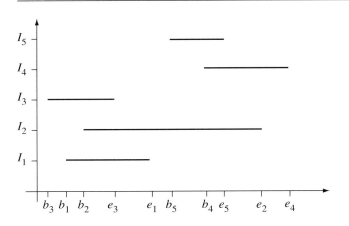

Figure 5.29 The sweep phase of the algorithm.

sweep) and a set of *active intervals* is maintained, initially empty. When a beginning value b_i is encountered, all active intervals are reported as intersecting with interval I_i, and I_i is added to the set of active intervals. When an ending value e_i is encountered, interval I_i is removed from the set of active intervals. The sorting phase is $O(n \log n)$. The sweep phase is $O(n)$ to iterate over the sorted list, clearly asymptotically faster than $O(n \log n)$. The intersecting reporting phase is $O(m)$ to report the m intersecting intervals. The total order is written as $O(n \log n + m)$. The worst-case behavior is when all intervals overlap, in which case $m = O(n^2)$, but for our applications we expect m to be relatively small. Figure 5.29 illustrates the sweep phase of the algorithm.

The sorted interval end points are shown on the horizontal axis of the figure. The set of active intervals is initially empty, $A = \emptyset$. The first five sweep steps are enumerated as follows:

1. b_3 encountered. No intersections reported since A is empty. Update $A = \{I_3\}$.

2. b_1 encountered. Intersection $I_3 \cap I_1$ is reported. Update $A = \{I_3, I_1\}$.

3. b_2 encountered. Intersections $I_3 \cap I_2$ and $I_1 \cap I_2$ reported. Update $A = \{I_3, I_1, I_2\}$.

4. e_3 encountered. Update $A = \{I_1, I_2\}$.

5. e_1 encountered. Update $A = \{I_2\}$.

The remaining steps are easily stated and are left as an exercise.

A warning is in order here: The sorting of the interval end points must be handled carefully when equality occurs. For example, suppose that two intervals $[b_i, e_i]$ and $[b_j, e_j]$ intersect in a single point, $e_i = b_j$. If the sorting algorithm lists e_i before b_j,

when e_i is encountered in the sweep we remove I_i from the set of active intervals. Next, b_j is encountered and intersections of I_j with the active intervals are reported. The interval I_i was removed from the active set on the previous step, so $I_j \cap I_i$ is *not reported*. In the sort, suppose instead that b_j is listed before e_i by the sorting algorithm. Since b_i was encountered earlier in the sweep, the set of active intervals contains I_i. When b_j is encountered $I_j \cap I_i$ *is reported* as an intersection. Clearly, the order of equal values in the sort is important. Our application will require that we report just-touching intersections, so the interval end points cannot be sorted just as a set of floating point numbers. Tags need to be associated with each end point indicating whether it is a beginning point or an ending point. The sorting must take the tag into account to make sure that equal end point values are sorted so that values with a 'begin' tag occur before values with an 'end' tag. The tags are not a burden since, in fact, we need them anyway to decide during the sweep what type of end point we have encountered. Pseudocode for the sort and sweep is

```
struct EndPoint
{
    enum Type { BEGIN = 0, END = 1 };
    Type type;
    double value;
    int interval;  // index of interval containing this end point

    // EndPoint E1, E2;
    // E1 < E2 when
    //    E1.value < E2.value, or
    //    E1.value == E2.value AND E1.type < E2.type
}

struct Interval
{
    EndPoint P[2];
};

void SortAndSweep (int n, Interval I[])
{
    // use O(n log n) sort
    array<EndPoint> L = Sort(n,I);

    // active set of intervals (stored by index in array)
    set<int> A = empty;

    // (i,j) in S means I[i] and I[j] overlap
    set<int,int> S = empty;
```

```
for (i = 0; i < L.size(); i++)
{
    if ( L[i].type == EndPoint::BEGIN )
    {
        for (each j in A) do
            S.Insert(j,L[i].interval);
        A.Insert(L[i].interval);
    }
    else  // L[i].type == EndPoint::END
    {
        A.Remove([L[i].interval]);
    }
}
}
```

Once the sort and sweep has occurred, the intervals are allowed to move about, thus invalidating the order of the end points in the sorted list. We can re-sort the values and apply another sweep, an $O(n \log n + m)$ process. However, we can do better than that. The sort itself may be viewed as a way to know the spatial coherence of the intervals. If the intervals move only a small distance, we expect that not many of the end points will swap order with their neighbors. The modified list is *nearly sorted*, so we should re-sort using an algorithm that is fast for nearly sorted inputs. Taking advantage of the small number of swaps is our way of using temporal coherence to reduce our workload. The insertion sort is a fast algorithm for sorting nearly sorted lists. For general input it is $O(n^2)$, but for nearly sorted data it is $O(n + e)$, where e is the number of exchanges used by the algorithm. Pseudocode for the insertion sort is

```
// input:  A[0] through A[n-1]
// output: array sorted in-place
void InsertionSort (int n, type A[])
{
    for (j = 1; j < n; j++)
    {
        key = A[j];
        i = j-1;
        while ( i >= 0 and A[i] > key )
        {
            Swap(A[i],A[i+1]);
            i--;
        }
        A[i+1] = key;
    }
}
```

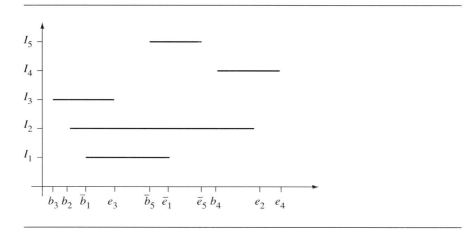

Figure 5.30 The update phase of the algorithm when intervals have moved.

The situation so far is that we applied the sort and sweep algorithm to our collection of intervals, a once-only step that requires $O(n \log n + m)$ time. The output is a set S of pairs (i, j) that correspond to overlapping intervals, $I_i \cap I_j$. Some intervals are now moved and the list of end points is re-sorted in $O(n + e)$ time. The set S might have changed. Two overlapping intervals might not overlap now. Two nonoverlapping intervals might now overlap. To update S we can simply apply the sweep algorithm from scratch, an $O(n + m)$ algorithm, and build S anew. Better, though, is to mix the update with the insertion sort. An exchange of two 'begin' points with two 'end' points does not change the intersection status of the intervals. If a pair of 'begin' and 'end' points is swapped, then we have either gained a pair of overlapping intervals or lost a pair. By temporal coherence, we expect the number of changes in status to be small. If c is the number of changes of overlapping status, we know that $c \leq e$, where e is the number of exchanges in the insertion sort. The value e is expected to be much smaller than m, the number of currently overlapping intervals. Thus, we would like to avoid the full sweep that takes $O(n + m)$ time and update during the insertion sort that takes smaller time $O(n + e)$.

Figure 5.30 illustrates the update phase of the algorithm applied to the intervals shown in Figure 5.29. At the initial time the sorted end points are $\{b_3, b_1, b_2, e_3, e_1, b_5, b_4, e_5, e_2, e_4\}$. The pairs of indices for the overlapping intervals are $S = \{(1, 2), (1, 3), (2, 3), (2, 4), (2, 5), (4, 5)\}$. Now I_1 moves to the right and I_5 moves to the left. The new end points are denoted $\bar{b}_1, \bar{e}_1, \bar{b}_5$, and \bar{e}_5. The list of end points that was sorted but now has had values changed is $\{b_3, \bar{b}_1, b_2, e_3, \bar{e}_1, \bar{b}_5, b_4, e_5, e_2, e_4\}$. The insertion sort is applied to this set of values. The steps follow.

1. Initialize the sorted list to be $L = \{b_3\}$.

2. Insert \bar{b}_1, $L = \{b_3, \bar{b}_1\}$.

3. Insert b_2, $L = \{b_3, \bar{b}_1, b_2\}$.

 (a) Exchange \bar{b}_1 and b_2, $L = \{b_3, b_2, \bar{b}_1\}$. No change to S.

4. Insert e_3, $L = \{b_3, b_2, \bar{b}_1, e_3\}$.

5. Insert \bar{e}_1, $L = \{b_3, b_2, \bar{b}_1, e_3, \bar{e}_1\}$.

6. Insert \bar{b}_5, $L = \{b_3, b_2, \bar{b}_1, e_3, \bar{e}_1, \bar{b}_5\}$.

 (a) Exchange \bar{e}_1 and \bar{b}_5, $L = \{b_3, b_2, \bar{b}_1, e_3, \bar{b}_5, \bar{e}_1\}$. This exchange causes I_1 and I_5 to overlap, so insert $(1, 5)$ into the set $S = \{(1, 2), (1, 3), (1, 5), (2, 3), (2, 4), (2, 5), (4, 5)\}$.

7. Insert b_4, $L = \{b_3, b_2, \bar{b}_1, e_3, \bar{b}_5, \bar{e}_1, b_4\}$.

8. Insert \bar{e}_5, $L = \{b_3, b_2, \bar{b}_1, e_3, \bar{b}_5, \bar{e}_1, b_4, \bar{e}_5\}$.

 (a) Exchange b_4 and \bar{e}_5, $L = \{b_3, b_2, \bar{b}_1, e_3, \bar{b}_5, \bar{e}_1, \bar{e}_5, b_4\}$. This exchange causes I_4 and I_5 to no longer overlap, so remove $(4, 5)$ from the set $S = \{(1, 2), (1, 3), (1, 5), (2, 3), (2, 4), (2, 5)\}$.

9. Insert e_2, $L = \{b_3, b_2, \bar{b}_1, e_3, \bar{b}_5, \bar{e}_1, \bar{e}_5, b_4, e_2\}$.

10. Insert e_4, $L = \{b_3, b_2, \bar{b}_1, e_3, \bar{b}_5, \bar{e}_1, \bar{e}_5, b_4, e_2, e_4\}$.

11. The new list is sorted and the set of overlaps is current.

Intersecting Rectangles

The algorithm for computing all pairs of intersecting axis-aligned rectangles is a simple extension of the algorithm for intervals. An axis-aligned rectangle is of the form $[x_{min}, x_{max}] \times [y_{min}, y_{max}]$. Two such rectangles intersect if there is overlap between both their x-intervals and their y-intervals, as shown in Figure 5.31.

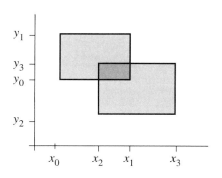

Figure 5.31 Axis-aligned rectangles overlap when both their x-intervals and y-intervals overlap.

The rectangles are $[x_0, x_1] \times [y_0, y_1]$ and $[x_2, x_3] \times [y_2, y_3]$. The rectangles overlap because $[x_0, x_1] \cap [x_2, x_3] \neq \emptyset$ and $[y_0, y_1] \cap [y_2, y_3] \neq \emptyset$.

In the two-dimensional setting we maintain two sorted lists, one for the end points of the x-intervals and one for the end points of the y-intervals. The initial step of the algorithm sorts the two lists. The sweep portion is only slightly more complicated than for one dimension. The condition for overlap is that the x-intervals *and* y-intervals overlap. If we were to sweep the sorted x-list first and determine that two x-intervals overlap, that is not sufficient to say that the rectangles of those x-intervals overlap. We could devise some fancy scheme to sweep both x- and y-lists at the same time, but it is simpler just to do a little extra work. If two x-intervals overlap, we will test for overlap of the corresponding rectangles in both dimensions and update the set of overlapping rectangles as needed.

Once we have the sorted lists and a set of overlapping rectangles, we will move the rectangles and must update the lists and set. The process will use an insertion sort to take advantage of spatial and temporal coherence. The x-list is processed first. If an exchange occurs so that two previously overlapping intervals no longer overlap, the corresponding rectangles no longer overlap so we can remove that pair from the set of overlaps. If an exchange occurs so that two previously nonoverlapping intervals now overlap, the corresponding rectangles may or may not overlap. Just as we did for the initialization phase, we will simply test the corresponding rectangles for overlap in both dimensions and adjust the set of overlaps accordingly.

Intersecting Boxes

You should see clearly that the algorithm for axis-aligned rectangles in two dimensions extends easily to axis-aligned boxes in three dimensions. The collision system itself has the following outline:

1. Generate AABBs for the convex polyhedra of the system using the fast extremal query support built into the polyhedra.

2. Using the sort-and-sweep method, compute the set S of all pairs of intersecting AABBs.

3. Determine which AABBs intersect using the fast insertion sort update.

4. For each pair of intersecting AABBs, determine if the contained convex polyhedra intersect. For those pairs that do, compute the contact sets.

5. The contact sets are inputs for the collision response system that uses impulsive forces to modify the linear/angular velocities and resting contact forces to modify the forces/torques. Apply one step of the differential equation solver to move the convex polyhedra.

6. Recompute the AABBs using the fast extremal query support.

7. Repeat step 3.

5.5 VARIATIONS

Most of this chapter is about how to architect a general rigid body simulation using Newton's second law of motion, $\mathbf{F} = m\mathbf{a}$, and its implications for how position, orientation, linear velocity/momentum, and angular velocity/momentum change over time. In particular, a simulation based on impulsive forces to adjust linear and angular velocities and to prevent interpenetration and based on resting contact forces to prevent interpenetration is covered in detail. The simulation relies on a collision detection system to provide information about the constraints of motion. One requirement for a relatively simple system is that the rigid bodies be convex polyhedra. The intersection testing that we have discussed uses the method of separating axes, both for stationary and for moving objects. The goal is for you to assemble a simulation of this type and see how it performs and what its strengths and weaknesses are. Academic and industrial researchers alike have tried various alternatives in building rigid body simulations. I briefly discuss a few of them here. References are provided to papers so that you can explore them once you are comfortable with the architecture of a simulation system as described in this book.

An alternative to impulsive forces is to use penalty-based methods in order to satisfy nonpenetration constraints. The idea is to track the distance between each pair of polytopes by maintaining the closest features for each pair [LC91, Lin93, CLMP95, Mir98]. This is done using Voronoi regions and allows an $O(1)$ update of the features (temporal and spatial coherence). An algorithm for tracking closest features using BSP trees in the style of what was discussed earlier for extremal queries is [GV91] on multidimensional space partitioning. A recent paper on computing a directional lookup table for finding extremal points uses $O(n)$ preprocessing time for an $O(1)$ lookup [EL00]. Instead of using impulsive forces, the system internally modifies the simulation by adding springs between a pair of closest features that will lead to a colliding contact; the forces due to the springs are part of the force/torque calculations in the differential equation solver. As the distance between the closest features becomes small, the springs exert repulsive forces between the polytopes owning those features. A drawback of this approach is that the springs have large constants in the Hooke's law model, leading to stiff equations that cause numerical stability problems in the differential equation solver (see Chapter 9, "Numerical Methods," and in particular Sections 9.9 and 9.10 on stability and stiff equations, respectively). Maintaining nonpenetration is also difficult with this approach.

People have also tried relaxing the constraint of nonpenetration. The differential equation solver computes the updates for position and orientation and the rigid bodies are moved. The objects may interpenetrate after the motion. The penetration distances can be computed for the polytopes and the objects are moved to undo the penetration. In this approach you need to compute distances between the polyhedra. The Gilbert-Johnson-Keerthi (GJK) distance algorithm [GJK88, vdB99, vdB01b] or the enhanced GJK distance algorithm [Cam97] is suitable for this system. The closest features [LC91] can be tracked to allow fast updating of the distance, another

application of spatial and temporal coherence. The book [vdB03] covers these concepts in detail.

Variations have been tried regarding the linear complementarity problem (LCP) approach. The idea of contact force calculation is revisited in [Bar94], addressing the issues both of speed and of robustness when frictional forces are present. Nonlinear complementarity problems (NCP) have also been used to improve the robustness of calculation of contact forces. Resting contact has problems due to numerical round-off errors. The paper [BS99] deals with this by formulating the problem as an NCP. The brief paper [HKL+99] quickly summarizes the mathematics that goes into setting up an NCP problem for contact force calculation and provides pseudocode for an implementation. The NCP solver itself uses an LCP solver as a subtask. An energy-based approach for contact force computation is [Fau96]. An iterative scheme is used, the first pass handling force and torque computations and a global energy calculation. Subsequent passes redistribute energy about the system of objects. The method also handles static and sliding friction. A change of paradigm occurs in [RKC02b] and uses what is called *Gauss's principle of least constraints*. The LCP-based method is referred to as a *contact space formulation*. The number of degrees of freedom in this formulation is not explicit. The Gauss principle is formulated in what is called *motion space* and makes use of the explicit degrees of freedom to avoid unnecessary calculations. The abstract idea is that a *kinetic norm* is computed involving the constrained acceleration. In the current contact configuration, the norm is minimized to produce the constrained acceleration that is the closest acceleration to the unconstrained acceleration.

A variation on the impulsive force method allows you to simulate friction, as proposed by Gino van den Bergen [vdB01a] in the Usenet newsgroup, `comp.games .development.programming.algorithms`, excerpted as follows:

> Contacts are resolved using impulses. At the time of collision, I have the contact points (I use only points, no higher-dimension simplices), a contact normal and a relative velocity for the contact points. The relative velocity is decomposed into a normal component and a tangential (along the surface) component. I compute the impulse in the direction of the normal that will result in the normal component of the relative velocity being set to zero. (In order to avoid, the objects drifting into each other, you'll have to do a correction using translations of the objects, such that the objects stay in contact, i.e., do not interpenetrate too much.)
>
> I do the same for the tangential component. I compute the impulse that will set the relative velocity along the surface to zero. However, by applying this impulse, your objects will stick to the surface. They cannot slip since the friction is infinite. According to Coulomb's friction law, there is a maximum to the magnitude of the friction impulse that is proportional to the magnitude of the normal impulse. The ratio between the magnitude of the normal impulse and the magnitude of the maximum friction impulse is the friction coefficient. So, given the normal impulse, the magnitude of the maximum friction impulse is computed, and if the magnitude of the tangential impulse is greater than the maximum, the tangential

impulse's magnitude is set to the maximum. In this way, it is possible to have slipping objects.

If the need for realism is really high, you should use different friction coefficients for slipping objects and "sticking" objects (the kinetic friction coefficient is usually smaller than the static coefficient for the same material), but I reckon that you can get by with only one coefficient. This is a games newsgroup after all. (Although, I guess that realistic racing games will use two coefficients for the maximum friction of the tyres.)

Finally, a lot of research has been done on collision detection systems themselves to develop fast, accurate, and robust systems. Some of the earliest work was simply based on algorithms for computing intersections of polyhedra. Nonconvex polyhedra naturally make the problem complicated, but hierarchical bounding volumes provide a relatively simple intersection system for two polyhedra represented as triangle meshes. The general idea is to localize where the intersections can occur by rapid culling of regions where they cannot be. Sphere trees were made popular by [Hub96], whereas oriented bounding box trees (OBB trees) and the method of separating axes were made popular by [GLM96]. A paper on hierarchical trees using axis-aligned bounding boxes is [vdB97]. The Wild Magic source code (also on the CD-ROM for this book) has an implementation for hierarchical bounding volumes. A class in the system is BoundingVolume, an abstract base class whose interface supports constructing the bounding volume tree and supports the intersection queries. The currently supported derived classes implement bounding volumes for spheres, oriented bounding boxes, and the sphere-swept volume types of capsule (sweep a line segment) and lozenge (sweep a rectangle). The class BoundingVolumeTree is used for constructing a bounding volume tree. The CollisionGroup and CollisionRecord classes support the intersection query using the bounding volume trees of two objects. The IntersectingCylinder application shows how this collision system is used.

More sophisticated collision detection systems have been developed by one of the foremost groups in this area, the University of North Carolina GAMMA Research Group [GAM03]. GAMMA is the acronym for **G**eometric **A**lgorithms for **M**odeling, **M**otion, and **A**nimation). One of their original systems was RAPID (**R**obust and **A**ccurate **P**olygon **I**nterference **D**etection), which implements the OBB tree hierarchy of [GLM96] and is the basis for the Wild Magic code. RAPID did not use any coherence for intersection testing. Each test- or find-intersection query started anew the comparison between two OBB trees. If the tree is sufficiently deep, say five or six levels deep, the system can spend a lot of time comparing bounding volumes, especially when the two original triangle meshes are in close proximity to each other. Various systems have been built by UNC GAMMA over the years to improve on the disadvantages of the previous systems. Brief descriptions of some of these are provided here.

I-COLLIDE is an interactive and exact collision detection system that handles large environments of convex polyhedra [CLMP95]. Nonconvex polyhedra must be

decomposed into convex polyhedra for this system to apply. The system uses temporal coherence via Voronoi regions as mentioned earlier in this section [LC91, Lin93]. *V-COLLIDE* [HLC⁺97] is a collision detection system that attempts to be more general than I-COLLIDE and is designed for environments with a large number of polygonal objects. The input models are allowed to be arbitrary (*polygon soups*). The system uses OBB trees as defined in RAPID but uses temporal coherence to speed up the location of possibly intersecting triangles in the system. The intersection candidate triangles are then tested for exact intersection. Similarities and differences among RAPID, I-COLLIDE, and V-COLLIDE are mentioned at [GAM03].

Another alternative intended to be more powerful than I-COLLIDE is *SWIFT*, **S**peedy **W**alking via **I**mproved **F**eature **T**esting [EL00]. This is a package for collision detection, distance computation, and contact determination for polygonal objects undergoing rigid motions. The distance calculations can be approximate when the user specifies an error bound for the distance between objects, or they can be exact. The contact determination uses bounding volume hierarchies and fast updating of closest features, just as earlier packages at UNC do. An evolution of the package is *SWIFT++* [EL01] and it supports nonconvex polyhedra. It also supports a proximity query that detects whether two objects are closer than a specified tolerance.

Other research at UNC includes *DEEP* (**D**ual-space **E**xpansion for **E**stimating **P**enetration depth between convex polytopes) [KLM02]; *PIVOT* (**P**roximity **I**nformation from **VO**ronoi **T**echniques) [IZLM01, IZLM02], systems that use graphics hardware acceleration to support the queries; *PQP* (**P**roximity **Q**uery **P**ackage) [LGLM99], a system that uses sphere-swept volumes and supports overlap testing, distance computation, and tolerance verification; and *IMMPACT* (**I**nteractive **M**assive **M**odel **P**roximity **A**nd **C**ollision **T**esting, a system for partitioning and handling massive models for interactive collision detection [WLML99], where overlap graphs are used for localizing regions of interest. No surprise that IMMPACT also uses bounding volume hierarchies and spatial and temporal coherence.

Recent research regarding speedups, robustness, and accuracy of collision detection are provided by the following papers.

A non–UNC paper on a variation of I-COLLIDE and V-COLLIDE is called *Q-COLLIDE* [CW96] and it uses separating axes to determine intersections rather than tracking closest features but still uses spatial and temporal coherence to speed up the calculations.

An efficient algorithm for collision detection for moving polyhedra is presented in [ST99]. Generally, it has been accepted that two polyhedra, each of $O(n)$ features (vertices, edges, or faces), requires $O(n^2)$ time to compute collisions. This paper shows that in the case of translational movements you can compute intersections in $O(n^{8/5} + \varepsilon)$ time, and in the case of rotational movements you can compute intersections in $O(n^{5/3} + \varepsilon)$ time; both are asymptotically subquadratic.

The paper [SSW99] describes the following setting. A polyhedron is moved through an environment that contains fixed polyhedral obstacles. Given a sequence of prescribed translations and rotations of the single polyhedron, the question is whether or not it can follow those transformations without colliding with the ob-

stacles. Integer arithmetic is used for this algorithm. The maximum number of bits needed for intermediate calculations is shown to be $14L + 22$ where L is the maximal bit size for any input value. By knowing the maximum number of bits needed for the intermediate calculations, you can implement an exact arithmetic library with a fixed number of bytes for the integer type. The time performance of such a library is better than one supporting arbitrary precision arithmetic, the latter relying on dynamic memory management to allocate the integer objects. In a game application that uses floating point values to represent the data, an interface would be needed to hide the details of converting the floating point values to integer values needed as input in the exact arithmetic collision system.

A paper about reducing the time it takes to compute the collision time of two objects is [RKC00]. Under some restrictions on the object motion it is shown that the collision time can be determined by solving polynomial equations of at most degree 3. A similar reduction to small degree polynomials can be made regarding the collision of two rotating OBBs. I showed earlier that the collision time of the intervals of projection of the OBBs onto a potential separating axis is a root to an equation $f(t) = 0$, where $f(t)$ involves sinusoidals of different frequencies. By replacing sine and cosine by polynomials with a bounded error of approximation, the collision time is then computed as the root of a polynomial. Polynomial approximations to sine and cosine can be found on the CD-ROM in the source directory called Numerics.

In the discussion of OBBs moving with linear and/or angular velocity, I made the observation that during the time step of a differential equation solver, you can assume that an OBB is moving with constant linear velocity and constant angular velocity as an approximation to the theoretical motion (which you do not know; that is why the numerical solver is being used). Along these lines the papers [RKC01, RKC02a] propose arbitrary in-between motions in order to accurately predict the first time of contact.

These variations are by no means exhaustive. I apologize in advance for not including references to topics that readers believe should have been included here. An online search of some common terms in game physics (rigid body simulation, collision detection, etc.) will net you a *lot* of links. With a solid understanding of the material in this book, you should be able to quickly identify those links that are relevant to your pursuit of further knowledge in the field of game physics.

CHAPTER **6**

PHYSICS AND SHADER PROGRAMS

A brief introduction to programmable graphics hardware is presented here, the programs called *shader programs*. The ability to program graphics cards was driven by a need for producing more sophisticated *visual* effects than what previous-generation hardware and drivers have allowed. Shader programming examples that illustrate interesting effects are becoming fairly easy to find on the Internet. Although these are usually visual in nature, creative graphics programmers and researchers have produced surprisingly interesting *physical* effects using shader programs. This chapter discusses the two major categories of shader programs, *vertex shaders* and *pixel shaders*. A few applications are also included to illustrate how you can obtain some physical effects through shaders. The applications include deformation by random vertex displacement, skin-and-bones animation, rippling ocean waves, refraction, Fresnel reflection, and iridescence, the last three illustrating optical effects.

6.1 INTRODUCTION

As of the writing of this book, many graphics cards are programmable, the programs themselves called *shader programs* or *shaders*. The term *shading* refers to the process of assigning colors to points on a surface. The classical model is *Gouraud shading*, where the vertices of a triangle are assigned colors by the user or through some algorithmic process. The algorithmic assignment is typically based on lighting models involving: ambient, directional, point, and/or spot lights; material properties that are associated with the surface; and geometric considerations such as the shape of

the surface and how light is reflected based on the normal vector field. The vertex colors are linearly interpolated across the screen-space pixels that correspond to the rendered triangle. In many cases the resulting colors meet only minimal requirements for physical realism. To remedy this and provide the viewer with a more convincing rendering, other sources of color are combined with the vertex colors. The most common method is to combine texture images with the vertex colors.

As with most technology, consumers always have demands for more advanced features. Gamers have ever increasing appetites for better looking special effects. Even with lit and textured surfaces, what happens if an object interferes with a light source that illuminates the surface? The object most likely casts a shadow on the surface. Ambient lighting still allows you to see the surface, albeit dimmer. The shadow might only cover a portion of the surface, the remaining area fully lit by the light source. Real-time shadows have been possible even before programmable graphics cards, but those cards needed to be quite powerful to maintain the real-time frame rate. Effects such as reflection have also been possible in real time. The problem, though, is that the creativity of artists and programmers evolves faster than the graphics cards and drivers can support. Shader programming is designed to allow us to create special effects at our own rate and to implement them immediately.

This chapter is by no means a comprehensive discussion of the topic of shader programming. In my opinion the best book to date that covers both the general theory and the practical aspects of shader languages is [OHHM02]. Although the book does discuss the OpenGL 2.0 API and how it supports shaders, currently that API is not available to the general programmer. For now we have to rely on the OpenGL extension mechanism to access the programmable features of the graphics cards. The book [OHHM02] also mentions DirectX 9.0 and the High Level Shading Language, but at the time the book was printed, not much information was available about that API. As always, the current state of DirectX is available at Microsoft's web site.

By the time this book is in print, the state of shader programming will no doubt have evolved even further. For example, some researchers are already investigating clever uses of depth buffering and occlusion culling that together provide collision detection by the graphics hardware. Real-time performance of such methods depends heavily on the rate at which the depth buffer and other information can be transferred from the graphics card to system memory. Graphics accelerators were designed with the idea of fast writes, not fast reads. At the moment the reading rate is not large enough for the types of complex models we see in games, but eventually the rate will increase.

Initially, shader programs consisted of a small maximum number of sequentially executed statements. The current-generation technology includes the ability to loop, branch, and call subroutines. For example, nVIDIA's GeForce FX series of graphics cards and ATI's Radeon 9800 Pro graphics card support looping, branching, subroutines, and a large maximum number of statements, giving us fully functional and powerful shader languages. Such languages invariably support physical simulation, including solving the differential equations of motion that are discussed in this book.

Specifically, a shader now has the ability to translate the center of mass of a rigid body and set its orientation. The translation and orientation are the components of the model-to-world transformation, a renderer quantity that is always initialized by vertex shaders. The translation and orientation are what are computed by equation (5.11) for a single rigid body or (5.13) for multiple rigid bodies.

6.2 Vertex and Pixel Shaders

A *vertex shader* is a program that allows you to modify attributes of the vertices of a triangle mesh, including the positions and colors of the vertices. The output of the vertex shader is interpolated by the hardware to produce the final colors of the screen-space pixels corresponding to the triangles in the mesh.

Vertex shaders are designed to give you control of only the attributes of the vertices of a triangle. The user has control over the final pixel colors by modifying the vertex attributes. Many special effects require control at the pixel level itself. A *pixel shader* is a program that gives the user such control. The prototypical case is the application of a texture image to the triangle. Recall that the two-dimensional texture coordinates at a vertex are used as lookups into the texture image. During rasterization the vertex texture coordinates are interpolated for each pixel in the final rendering. The interpolated coordinates are used as lookups into the texture image to assign a color per pixel. The responsibility of the programmer is to assign texture coordinates to each vertex and a texture image to be used for the color lookups.

More complex features can be implemented by extending the texture image concept, for example, Dot3 bump-mapping. Additional images are supplied, but they are not used for color lookups. The images contain surface tangent and surface normal information that is used to create the bump-mapped effect.

Source Code

CgConverter

The Wild Magic source code, found on the CD-ROM, has shader programs written in nVIDIA's Cg language. The Cg Toolkit provided by nVIDIA includes a compiler that produces output for both DirectX and OpenGL. Each scene graph object to which a shader program is assigned must also have an associated set of constants that are inputs to the program. Trying to put it all together is a tedious chore of data management. To ease the programmer's burden, a tool is provided, called CgConverter. The tool runs the Cg compiler on a shader program (extension .cg), produces output for both DirectX and OpenGL, and bundles these and other constants together into files that are loaded by Wild Magic applications.

Vertex shaders are compiled to files with an extension of .wvs (**W**ild Magic **V**ertex **S**hader) and pixel shaders are compiled to files with an extension of .wps (**W**ild Magic **P**ixel **S**hader). That said, a programmer can create his own .wvs and .wps files without using the Cg language, instead directly using shader assembly language. There is no "standard" shader language for developers that could minimize the effort in creating shaders for graphics engines. As in most industries, the powers that be will tell you that having standards are important—as long as the standards are theirs. Look for an

extended battle of companies jockeying for position to have the most influence on the outcome. For the time being developers just have to deal with the morass of variations that must be handled for different platforms and graphics APIs. The `CgConverter` tool and Wild Magic shader layer were written by Nolan Walker of the University of North Carolina. Equally important is his diary of comments about his experiences—and frustrations—trying to put it all together. The diary is named `ShaderNotes.pdf` and is on the CD-ROM.

The first release of the `CgConverter` tool contains the source code and project files for the Microsoft Windows platform. To use the tool you must download and install the Cg Toolkit from nVIDIA (*www.nvidia.com*). In order to include shader programs directly in a project and have the converter process them during a build or rebuild command, you need to modify the compiler's global search paths for header files, library files, and executable files to include paths to the appropriate directories created by the installation of Cg. The custom build step for the shader programs must also be set up. Please read the release notes on the CD-ROM that describe how all this is accomplished. The file name is `ReleaseNotes2p1.pdf`.

A simple application, `BasicShader`, that illustrates vertex and pixel shaders is found on the CD-ROM. The file `BasicShader.cg` contains a basic vertex shader and a basic pixel shader. The basic vertex shader is

SOURCE CODE

BasicShader

```
void vmain(
    // In order for this shader to work, your Geometry object must have all
    // of the inputs or the Renderer will give you an assertion error.
    in float4 i_f4Position  : POSITION,
    in float3 i_f3Normal : NORMAL,
    in float2 i_f2Tex : TEXCOORD0,

    out float4 o_f4Position : POSITION,
    out float3 o_f3Lighting : COLOR,
    out float2 o_f2Tex : TEXCOORD0,

    // State variables beginning with Wml will be filled in by Wild Magic
    // automatically.  Some state, such as lights, must be attached to the
    // scene graph.
    uniform float4x4 WmlRendererModViewProj,
    uniform float4x4 WmlRendererMod,

    // Wild Magic will fill out constants to a float4, but you can specify
    // float<n> if you do not need the other information.
    uniform float3 WmlLightPosition0,
    uniform float3 WmlLightAmbient0,
    uniform float3 WmlLightDiffuse0)
{
```

```
    // transform the position
    o_f4Position = mul(WmlRendererModViewProj,i_f4Position);

    // Calculate the diffuse lighting. This is a point light, so we calculate
    // the world position first. Because model->view transform is really a
    // 3x3 matrix, we will save some instructions by changing it to that.
    float3 f3WorldPos = mul((float3x3)WmlRendererMod,(float3)i_f4Position);

    // transform the normal
    float3 f3WorldNorm = mul((float3x3)WmlRendererMod,i_f3Normal);

    // calculate the negative light direction and associated diffuse component
    float3 f3LightDir = (WmlLightPosition0 - f3WorldPos);
    float fDiffuse = dot(f3LightDir,f3WorldNorm);

    // return the lit color
    o_f3Lighting = WmlLightDiffuse0 * fDiffuse + WmlLightAmbient0;

    // pass through the texture coordinates
    o_f2Tex = i_f2Tex;
}
```

The shader assigns each vertex a color based on the vertex position, vertex normal, and a point-light source. The lit color is returned and the shader just allows the texture coordinates to pass through the program unchanged. The constants prefixed with a Wml are automatically assigned by the Wild Magic scene management system.

The OpenGL output of the Cg compiler for the vertex shader is

```
# ARB_vertex_program generated by NVIDIA Cg compiler
# cgc version 1.1.0003, build date Mar  4 2003  12:32:10
# command line args: -q -profile arbvp1 -entry vmain
# nv30vp backend compiling 'vmain' program
PARAM c11 = { 0, 1, 2, 0 };
#vendor NVIDIA Corporation
#version 1.0.02
#profile arbvp1
#program vmain
#semantic vmain.WmlRendererModViewProj
#semantic vmain.WmlRendererMod
#semantic vmain.WmlLightPosition0
#semantic vmain.WmlLightAmbient0
#semantic vmain.WmlLightDiffuse0
#var float4 i_f4Position : $vin.POSITION : POSITION : 0 : 1
```

```
#var float3 i_f3Normal : $vin.NORMAL : NORMAL : 1 : 1
#var float2 i_f2Tex : $vin.TEXCOORD0 : TEXCOORD0 : 2 : 1
#var float4 o_f4Position : $vout.POSITION : POSITION : 3 : 1
#var float3 o_f3Lighting : $vout.COLOR : COLOR : 4 : 1
#var float2 o_f2Tex : $vout.TEXCOORD0 : TEXCOORD0 : 5 : 1
#var float4x4 WmlRendererModViewProj :  : c[0], 4 : 6 : 1
#var float4x4 WmlRendererMod :  : c[4], 4 : 7 : 1
#var float3 WmlLightPosition0 :  : c[8] : 8 : 1
#var float3 WmlLightAmbient0 :  : c[9] : 9 : 1
#var float3 WmlLightDiffuse0 :  : c[10] : 10 : 1
TEMP R0, R1;
ATTRIB v24 = vertex.texcoord[0];
ATTRIB v18 = vertex.normal;
ATTRIB v16 = vertex.position;
PARAM c9 = program.local[9];
PARAM c10 = program.local[10];
PARAM c8 = program.local[8];
PARAM c4[4] = { program.local[4..7] };
PARAM c0[4] = { program.local[0..3] };
  MOV result.texcoord[0].xy, v24;
  DP4 result.position.x, c0[0], v16;
  DP4 result.position.y, c0[1], v16;
  DP4 result.position.z, c0[2], v16;
  DP4 result.position.w, c0[3], v16;
  DP3 R0.x, c4[0].xyzx, v16.xyzx;
  DP3 R0.y, c4[1].xyzx, v16.xyzx;
  DP3 R0.z, c4[2].xyzx, v16.xyzx;
  ADD R1.xyz, c8.xyzx, -R0.xyzx;
  DP3 R0.x, c4[0].xyzx, v18.xyzx;
  DP3 R0.y, c4[1].xyzx, v18.xyzx;
  DP3 R0.z, c4[2].xyzx, v18.xyzx;
  DP3 R0.w, R1.xyzx, R0.xyzx;
  MOV R0.xyz, c10;
  MAD result.color.front.primary.xyz, R0.xyzx, R0.w, c9.xyzx;
END
# 15 instructions
# 2 temp registers
# End of program
```

The DirectX output is

```
// DX8 Vertex shader generated by NVIDIA Cg compiler
// cgc version 1.1.0003, build date Mar  4 2003  12:32:10
```

```
// command line args: -q -profile vs_1_1 -entry vmain
// nv30vp backend compiling 'vmain' program
def c11, 0, 1, 2, 0
//vendor NVIDIA Corporation
//version 1.0.02
//profile vs_1_1
//program vmain
//semantic vmain.WmlRendererModViewProj
//semantic vmain.WmlRendererMod
//semantic vmain.WmlLightPosition0
//semantic vmain.WmlLightAmbient0
//semantic vmain.WmlLightDiffuse0
//var float4 i_f4Position : $vin.POSITION : POSITION : 0 : 1
//var float3 i_f3Normal : $vin.NORMAL : NORMAL : 1 : 1
//var float2 i_f2Tex : $vin.TEXCOORD0 : TEXCOORD0 : 2 : 1
//var float4 o_f4Position : $vout.POSITION : POSITION : 3 : 1
//var float3 o_f3Lighting : $vout.COLOR : COLOR : 4 : 1
//var float2 o_f2Tex : $vout.TEXCOORD0 : TEXCOORD0 : 5 : 1
//var float4x4 WmlRendererModViewProj :  : c[0], 4 : 6 : 1
//var float4x4 WmlRendererMod :  : c[4], 4 : 7 : 1
//var float3 WmlLightPosition0 :  : c[8] : 8 : 1
//var float3 WmlLightAmbient0 :  : c[9] : 9 : 1
//var float3 WmlLightDiffuse0 :  : c[10] : 10 : 1
//const c[11] = 0 1 2 0
  mov oT0.xy, v7
  dp4 oPos.x, c0, v0
  dp4 oPos.y, c1, v0
  dp4 oPos.z, c2, v0
  dp4 oPos.w, c3, v0
  dp3 r0.x, c4.xyz, v0.xyz
  dp3 r0.y, c5.xyz, v0.xyz
  dp3 r0.z, c6.xyz, v0.xyz
  add r1.xyz, c8.xyz, -r0.xyz
  dp3 r0.x, c4.xyz, v3.xyz
  dp3 r0.y, c5.xyz, v3.xyz
  dp3 r0.z, c6.xyz, v3.xyz
  dp3 r0.w, r1.xyz, r0.xyz
  mov r0.xyz, c10
  mad oD0.xyz, r0.xyz, r0.w, c9.xyz
// 15 instructions
// 2 temp registers
// End of program
```

Both outputs are packaged together, with a small amount of "glue," into Basic-Shader.wvs, which is a file that Wild Magic knows how to load and parse.

The basic pixel shader in BasicShader.cg is

```
void pmain(
    in float3 i_f3Lighting : COLOR,
    in float2 i_f2Tex : TEXCOORD0,

    out float3 o_f3Color : COLOR,

    uniform sampler2D s2Tex)
{
    // look up texture with coordinates
    float3 f3TexColor = tex2D(s2Tex,i_f2Tex).rgb;

    // multiply texture color with lighting
    o_f3Color = i_f3Lighting * f3TexColor;
}
```

The input variables for the pixel shader are the output lit color and texture coordinates of the vertex shader.

The OpenGL output of the Cg compiler for the pixel shader is

```
# ARB_fragment_program generated by NVIDIA Cg compiler
# cgc version 1.1.0003, build date Mar  4 2003  12:32:10
# command line args: -q -profile arbfp1 -entry pmain
#vendor NVIDIA Corporation
#version 1.0.02
#profile arbfp1
#program pmain
#semantic pmain.s2Tex
#var float3 i_f3Lighting : $vin.COLOR : COLOR : 0 : 1
#var float2 i_f2Tex : $vin.TEXCOORD0 : TEXCOORD0 : 1 : 1
#var float3 o_f3Color : $vout.COLOR : COLOR : 2 : 1
#var sampler2D s2Tex :  : texunit 0 : 3 : 1
TEMP R0;
TEX R0.xyz, fragment.texcoord[0], texture[0], 2D;
MUL result.color.xyz, fragment.color.primary, R0;
END
# 2 instructions, 1 R-regs, 0 H-regs.
# End of program
```

The DirectX output is

```
// DX8 Vertex shader generated by NVIDIA Cg compiler
// cgc version 1.1.0003, build date Mar  4 2003  12:32:10
// command line args: -q -profile ps_1_1 -entry pmain
//vendor NVIDIA Corporation
//version 1.0.02
//profile ps_1_1
//program pmain
//semantic pmain.s2Tex
//var float3 i_f3Lighting : $vin.COLOR : COLOR : 0 : 1
//var float2 i_f2Tex : $vin.TEXCOORD0 : TEXCOORD0 : 1 : 1
//var float3 o_f3Color : $vout.COLOR : COLOR : 2 : 1
//var sampler2D s2Tex :   : texunit 0 : 3 : 1
ps.1.1
def c0, 0.000000, 0.000000, 0.000000, 0.000000
tex t0
mul r0.rgb, v0, t0
+ mov r0.a, c0.b
// 2 instructions
// End of program
```

Again, both outputs are packaged together, with a small amount of "glue," into BasicShader.wps, which is a file that Wild Magic knows how to load and parse. Figure 6.1—also Color Plate 6.1—shows some screen shots from the BasicShader application.

6.3 Deformation by Vertex Displacement

Source Code

VertexNoise

Vertex displacement is one of the simplest methods to obtain deformation of an object using a shader. The sample application VertexNoise has a shader that permutes the vertex positions based on three-dimensional Perlin noise [EMP+03]. The table of permutations and gradients is precomputed at start-up time and passed as a uniform constant to the vertex shader. This type of noise also can be used to create procedural textures. The vertex shader is a slightly modified version of the one from the nVIDIA Cg Toolkit, the original shader also available at the web site *www.cgshaders.org*.

The shader is applied to a model of a face. Figure 6.2—also Color Plate 6.2—shows some screen shots from the VertexNoise application.

(a)

(b)

Figure 6.1 Two screen shots from the BasicShader application. Image (a) shows a rendering using just the pixel shader. Image (b) shows a rendering using both the vertex shader and the pixel shader. (See also Color Plate 6.1.)

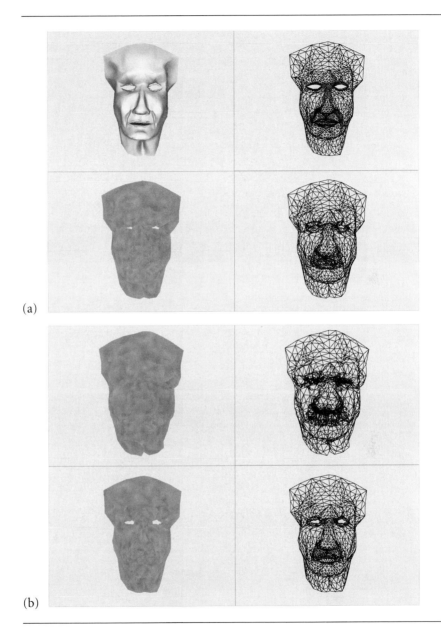

(a)

(b)

Figure 6.2 Screen shots from the VertexNoise shader application. (a) *Top row*: The original model and its wireframe view. *Bottom row*: The output of the VertexNoise shader and its wireframe view. The vertex displacement is significantly large. (b) *Top row*: The vertices displaced with a smaller maximum displacement, but same scale of noise. *Bottom row*: The vertices displaced with the same maximum displacement as in the bottom row of (a), but with a larger scale noise. (See also Color Plate 6.2.)

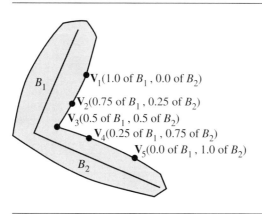

Figure 6.3 A skin-and-bones system consisting of two bones that influence five vertices. The vertex closest to the joint formed by the two bones is equally influenced by the bones. For each vertex farther from the joint, one bone influences it more than the other bone.

6.4 SKIN-AND-BONES ANIMATION

Skin-and-bones animation, or simply *skinning*, is the process of attaching a deformable mesh to a skeletal structure in order to smoothly deform the mesh as the bones move. The skeleton is represented by a hierarchy of *bones*, each bone positioned in the world by a translation and orientation. The *skin* is represented by a triangle mesh for which each vertex is assigned to one or more bones and is a weighted average of the world positions of the bones that influence it. As the bones move, the vertex positions are updated to provide a smooth animation. Figure 6.3 shows a simple configuration of two bones and five vertices.

The intuition of Figure 6.3 should be clear: Each vertex is constructed based on information relative to the bones that affect it. To be more precise, associate with bone B_i the uniform scale s_i, the translation vector \mathbf{T}_i, and the rotation matrix R_i. Let the vertex \mathbf{V}_j be influenced by n_j bones whose indices are k_1 through k_{n_j}. The vertex has two quantities associated with bone B_{k_i}: an offset from the bone, denoted Θ_{jk_i} and measured in the model space of the bone; and a weight of influence, denoted w_{jk_i}. The world space contribution by B_{k_i} to the vertex offset is

$$s_{k_i} R_{k_i} \Theta_{jk_i} + \mathbf{T}_{k_i}$$

This quantity is the transformation of the offset from the bone's model space to

world space. The world space location of the vertex is the weighted sum of all such contributions,

$$\mathbf{V}_j = \sum_{i=1}^{n_j} w_{jk_i} \left(s_{k_i} R_{k_i} \mathbf{\Theta}_{jk_i} + \mathbf{T}_{k_i} \right) \tag{6.1}$$

The skinning application demonstrates the use of a vertex shader to compute the vertex locations of equation (6.1). The application loads four bones (i.e., matrix transformations) as uniform constants to the vertex shader and passes the weights in as texture coordinates. In this application the bone matrices are created procedurally, but other applications can load these from a file of animation data. Skinning animation has been supported by graphics cards before shader support was available, but the number of bones per vertex was limited. With the ability to specify a large number of constants in a shader program, a much larger number of bones per vertex may be used, thus supporting more complex animation sequences. The skinned mesh of a standard biped model such as the one in the `SkinnedBiped` graphics application found on the CD-ROM can be completely handled by a single shader program. Figure 6.4—also Color Plate 6.4—shows some screen shots from the skinning application.

6.5 RIPPLING OCEAN WAVES

SOURCE CODE

RipplingOcean

A shader program that is more complex than the previously mentioned ones shows a rippling ocean water effect with large waves and small bump-mapped ripples. This shader is built using ideas from the book [Eng02], in particular the article, "Rendering Ocean Water," by John Isodoro, Alex Vlachos, and Chris Brennan. The sky texture is edited from Jeremy Engleman's page of public textures *http://art.net/~jeremy/photo/public_texture/*. The plasma height map was made with the *GNU Image Manipulation Program* (GIMP), using the render sky plasma2 effect with the "tile horizontally" and "tile vertically" options enabled. The GIMP is available at *www.gimp.org*.

The `RipplingOcean` application has both a vertex shader and a pixel shader. The vertex shader is responsible for creating the wave displacement effect. The pixel shader is responsible for calculating the water color, the diffuse lighting, and the specular reflection and for putting it all together.

The vertex shader is responsible for many aspects of the rendering. First, the wave effect is obtained by creating a surface that is the sum of four sinusoidal waves, each propagating in the two-dimensional tangent space of the surface. The waves have a specific height along the normal direction, as well as a speed, direction, and offset in that direction. Using only one or two sinusoidal components gives the water an unrealistic appearance. Four sinusoidal waves gives it a very undulating effect. You can easily add another four waves if you want yet more control over fine-scale variations.

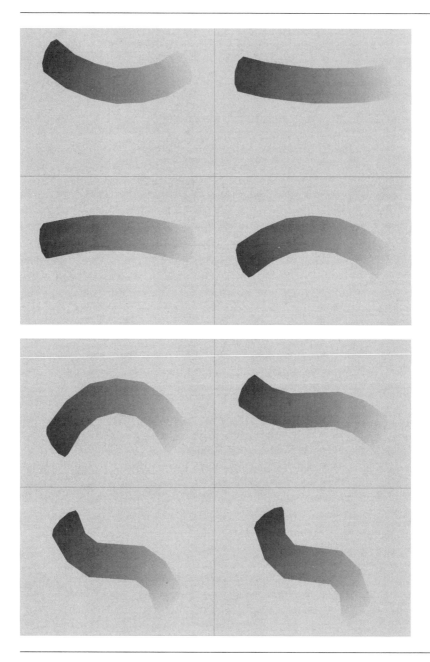

Figure 6.4 Two screen shots from the skinning application. The bones are randomly generated to cause the object to continuously deform. The sequence of deformations is from left to right, top then bottom, within each screen shot. (See also Color Plate 6.4.)

Second, the vertex shader also calculates a number of vectors that the pixel shader uses. A new tangent vector, normal vector, and binormal vector are computed, all based on the cosines of the wave. These vectors are used by the pixel shader to generate a coordinate frame at each pixel. The vertex shader also calculates a view vector for the pixel shader. Finally, it creates two texture coordinates. These coordinates vary with different wave speeds, with one coordinate inverted relative to the other, so that the two image textures are never aligned, a condition that leads to an unnatural rendering.

The pixel shader first samples the plasma height map, which has been converted into a normal map, with both texture coordinates. The resulting bump maps are averaged together to form a new normal vector for the current pixel. Using the normal, tangent, and binormal vectors, the bump-map value is transformed into world space. This value becomes the new normal for the pixel, thereby causing the ripple effect.

The water color is calculated by computing the dot product of the originally calculated normal vector and the view direction and using it as an index into a lookup table for a gradient. When the view direction is nearly perpendicular to the water surface, the water has a green tint. When the view direction is nearly parallel, for example, when looking at the water in the distance, the water has a blue tint. The originally calculated normals are used rather than the new normals, because the latter vector field is too high-frequency for the colors to look realistic. Because of the bump-mapping, blue and green patches appear to be equally distributed over the entire water surface.

The diffuse color is calculated as a dot product of the normal with a directional light. A specular reflection is also calculated. The view direction is reflected through the new normal and a color is looked up from the background image. The magnitude of this color is squared to emphasize the bright parts and then multiplied by the background color. The resulting specular color is multiplied by a Fresnel factor (as a dot product of the view direction and the normal; see Section 6.7). The visual effect is that the water has a large reflectance when the view direction is nearly perpendicular to the surface normal. The reflectance is small when the view direction is nearly parallel to the surface normal. All calculated colors are then combined to obtain the final water color.

Figure 6.5—also Color Plate 6.5—shows some screen shots from the rippling ocean application.

The RipplingOcean shader required many tweaks to make the water look realistic. The most important contributor to the realism is the specular reflection. Without it, the shadowing from the bump-mapping looks very strange. In addition to the specular reflection, offsetting the amount of shadowing from the bump-mapping required that a certain amount of ambience be added to the diffuse color term. Adjusting the ambient color gives the water an appearance anywhere from that seen at sunset to full noon on a clear day. The application has various controls to adjust at runtime, including adjusting the wave height, the wave speed, the ripple frequency, the ripple texture coordinate repeat factor, and the addition of ambient lighting.

Figure 6.5 Two screen shots from the rippling ocean application. The images were captured at two different times in the simulation. (See also Color Plate 6.5.)

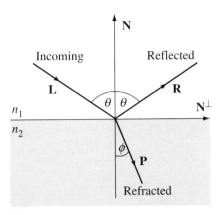

Figure 6.6 Reflection and refraction of a light beam traveling through two media.

6.6 REFRACTION

A beam of light travels through two semitransparent media that are separated by a planar surface. The speed of light through a medium depends on the density of that medium. The difference in densities at the planar surface causes the light to slightly change direction as it crosses from one medium into the other. This bending effect is called *refraction*. The planar surface typically has reflective properties. A portion of the light is reflected, the other portion refracted. Figure 6.6 depicts a beam of light that is reflected and refracted.

The incoming light has direction \mathbf{L} and the unit-length outward surface normal is \mathbf{N}. A unit-length normal to the plane spanned by \mathbf{L} and \mathbf{N} is $\mathbf{L} \times \mathbf{N}/|\mathbf{L} \times \mathbf{N}|$. The vector \mathbf{N}^\perp is also unit length and is defined by

$$\mathbf{N}^\perp = \mathbf{N} \times \frac{\mathbf{L} \times \mathbf{N}}{|\mathbf{L} \times \mathbf{N}|}$$

The angles of incidence and reflection are both θ. Notice that $\cos \theta = -\mathbf{L} \cdot \mathbf{N}$. Some basic trigonometry and linear algebra will convince you that

$$\mathbf{L} = (-\cos \theta)\mathbf{N} + (\sin \theta)\mathbf{N}^\perp$$

The reflected light has direction

$$\mathbf{R} = (\cos \theta)\mathbf{N} + (\sin \theta)\mathbf{N}^\perp = \mathbf{L} + (2 \cos \theta)\mathbf{N} = \mathbf{L} - 2(\mathbf{N} \cdot \mathbf{L})\mathbf{N} \qquad (6.2)$$

The refraction angle ϕ is different than the reflection angle θ because of the difference in densities of the media. The actual amount of bending depends on the ratio of densities, or equivalently, on the ratio of speeds through the media. Physicists assign an equivalent measure called the *index of refraction*. In Figure 6.6 the index of refraction of the first medium is n_1 and the index of refraction of the second medium is n_2. If v_1 and v_2 are the speeds of light through the media, then $n_1/n_2 = v_2/v_1$. The indices of refraction, the reflection angle, and the refraction angle are related by *Snell's law*:

$$n_1 \sin \theta = n_2 \sin \phi$$

It follows that

$$\cos \phi = \sqrt{1 - \left(\frac{n_1}{n_2}\right)^2 \sin^2 \theta}$$

The refracted light has direction

$$
\begin{aligned}
\mathbf{P} &= (-\cos \phi)\mathbf{N} + (\sin \phi)\mathbf{N}^{\perp} \\
&= \left(-\sqrt{1 - \left(\frac{n_1}{n_2}\right)^2 \sin^2 \theta}\,\right)\mathbf{N} + \left(\frac{n_1}{n_2} \sin \phi\right)\mathbf{N}^{\perp} \\
&= \left(\frac{n_1}{n_2} \cos \theta - \sqrt{1 - \left(\frac{n_1}{n_2}\right)^2 \sin^2 \theta}\,\right)\mathbf{N} + \frac{n_1}{n_2}\mathbf{L}
\end{aligned}
\tag{6.3}
$$

The formula is expressed in terms of the independent input values: the surface normal \mathbf{N}, the incoming light direction \mathbf{L}, the angle of incidence θ, and the indices of refraction n_1 and n_2.

Refraction is clearly observed when placing a stick into water. The stick appears to bend at the water surface. Empirical measurements have shown that the index of refraction for air is 1.00029 and the index of refraction for water is 1.333. If the first medium in Figure 6.6 is air and the second medium is water, and if the angle of incidence (angle of reflection) is $\pi/4$ radians (45 degrees), then the refraction angle is $\phi \doteq 0.559328$ radians. This angle is slightly larger than $\pi/6$ radians (30 degrees).

Figure 6.7—also Color Plate 6.7—shows some screen shots from the refraction shader application found on the CD-ROM. The texture image is a modification of one that is available from the Cg texture library at *http://oss.ckk.chalmers.se/textures/*.

The reflection effects in Figure 6.7(b) are produced by Fresnel reflectance, the topic of the next section. Notice that rendering using both refraction and reflection appears to be more realistic than with refraction alone; the model has a glassier look to it.

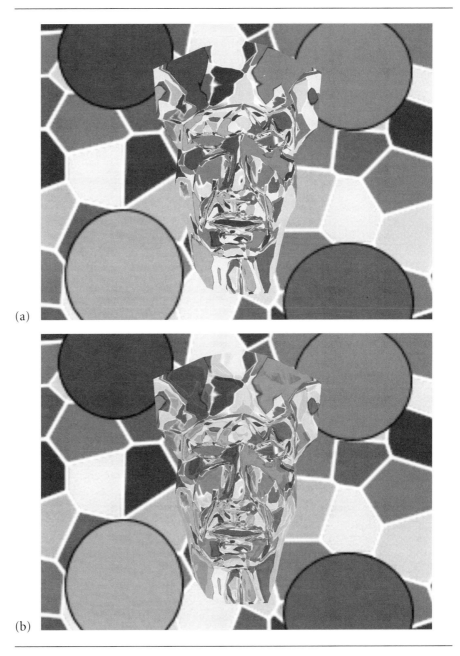

(a)

(b)

Figure 6.7 Two screen shots from the refraction shader application. Image (a) shows refraction, but no reflection. Image (b) shows refraction and reflection. (See also Color Plate 6.7.)

The refraction application uses both a vertex and a pixel shader and calculates refraction and reflection of the environment. The light direction is computed as the view direction from the eye point to a surface vertex. Using the surface normal and the indices of refraction, a refraction vector is computed according to equation (6.3). This vector is used as a lookup into the environment map. If the environment map is a cube map, a shader can directly perform the lookup. If the environment map is a sphere map, a few more calculations are needed to obtain the correct texture coordinates. A reflection vector is calculated in a similar manner according to equation (6.2). A Fresnel factor, as described in the next section, is calculated to determine the strength of the reflection versus the refraction. For a more realistic refraction, a textured quadrilateral that represents the environment map is placed behind the object.

6.7 FRESNEL REFLECTANCE

The *Fresnel effect* is named after Augustin Jean Fresnel, a scientist of the 18th century, who studied and postulated theories for propagation of light as waves. He derived formulas for computing the reflectance of smooth surfaces. The refraction calculations using Snell's law were discussed in the last section, but no indication was given about how much light is reflected and how much is refracted. The *Fresnel factor* is a quantity that measures the fraction of power (of light viewed as electromagnetic radiation) reflected by a surface separating two media. The remaining fraction corresponds to power transmitted through the surface. In fact, the Fresnel factor affects, and is affected by, the *polarization* of light. Polarization is a measure of the orientation of the light (as an electromagnetic field) with respect to the surface normals. The Fresnel effect polarizes the reflected light. For a detailed discussion of the mathematics leading to the Fresnel factor, see [OHHM02].

Figure 6.7(b) shows a surface (a mask of a face) that separates two media. The refraction and Fresnel reflections are both included in the rendered surface. Notice the typical polarization effect of the surface as compared to the lack of it in Figure 6.7(a), a surface where only refraction effects are included.

The Fresnel application is designed to illustrate where the strong Fresnel reflections occur on the face mask model. Figure 6.8—also Color Plate 6.8—shows some screen shots from the Fresnel shader application found on the CD-ROM. The face is black with white highlights, where the strong reflections are. The application uses both a vertex and a pixel shader, just like the refraction application does. The Fresnel factor is a greatly simplified version from the theoretic value, just to minimize the computations in a real-time application.

Fresnel reflections are part of a lighting model that is not included in the standard hardware texture and lighting pipeline. Some media, such as plastic or glass, have reflections that are much stronger when viewed perpendicular to the normal than when they are viewed straight on. The vertex shader of the application incorporates the Fresnel factor by setting the color equal to the square of one minus the dot

Figure 6.8 Two screen shots from the Fresnel shader application. (See also Color Plate 6.8.)

product of the normal and view direction. In the refraction application, the Fresnel factor is used in a typical manner, to bias the amount of reflection used to calculate the pixel color. To generate an even more precise Fresnel factor per pixel, the vertex shader calculates the view direction and normal and outputs these as texture coordinates, which the graphics pipeline will interpolate per pixel and hand off to the pixel shader to finish the calculation. This application is based on an article by Chris Brennan in [Eng02].

6.8 IRIDESCENCE

Yet another optical effect related to reflection and refraction at the surface between two media, *iridescence* is caused by interference when light is partially transmitted through the surface and partially reflected by the surface. The classical occurence of iridescence is with soap bubbles obtained by dipping a circular wire into a soapy solution. When the wire is removed from the solution, bands of color will appear on the soap film. The physical mechanism is a bit complex, the interference caused by some of the light waves being reflected out of phase and interacting with other light waves in phase. The typical hack by computer graphics programmers is to simulate the effects with view-dependent coloring.

The Iridescence shader works in very much the same way that the Fresnel shader works. The shader calculates a per-pixel viewing direction and normal vector. In the pixel shader, a dot product of the viewing direction and normal is computed and used as an input to a one-dimensional gradient texture lookup. When viewed straight on, the gradient texture has a green tint. When viewed at an angle the tint is blue. The looked-up texture color is blended with the original texture and produces an iridescent sheen.

Figure 6.9—also Color Plate 6.9—shows some screen shots from the iridescence shader application found on the CD-ROM. The leaf texture image is available from the Cg texture library at *http://oss.ckk.chalmers.se/textures/*.

The upper left quadrants of both images show the torii with no iridescence. The interpolation factor used to control the iridescence is set to zero in the application. The upper right quadrants show the torii using an interpolation factor of 0.3. The lower left quadrants use an interpolation factor of 0.5, the renderings having good-quality texture detail and iridescence. The lower right quadrants use an interpolation factor of 0.7. The iridescence is stronger but at the cost of quality in the texture detail.

Figure 6.9 Screen shots from the iridescence shader application. The two images show a textured torus in two different orientations and with various amounts of interpolation to produce the iridescent sheen. (See also Color Plate 6.9.)

7

LINEAR COMPLEMENTARITY AND MATHEMATICAL PROGRAMMING

The collision response system of a generic physics engine described in Chapter 5 enforces nonpenetration constraints among all the rigid bodies participating in a physical simulation. When a set of rigid bodies collides simultaneously, the system must guarantee that the velocities and accelerations of the objects do not cause a pair of rigid bodies to start to interpenetrate at a contact point. The mathematical model that arises from the nonpenetration constraints requires us to solve a couple of problems in the form of what is called a *linear complementarity problem* (LCP), which we discussed briefly in Chapter 5. As it turns out, calculation of distances between convex polygons or convex polyhedra can be formulated as an LCP. The applications to nonpenetration and to distance calculations are presented at the end of this chapter. The first part of the chapter is devoted to showing how you can solve an LCP.

The Lemke algorithm is a pivoting method for solving an LCP and is motivated by the classical linear programming problem. We discuss this problem first as well as how you go about solving it. Convex quadratic programming is also solvable by converting to an LCP. The typical convex quadratic functions you encounter are squared distance functions that arise when attempting to compute the separation distance between two convex objects. Linear and quadratic programming are special

391

cases of what is known as *mathematical programming*, a term not to be confused with programming mathematical algorithms.

Applications are provided at the end of the chapter for computing distance between a point and a convex polygon, distance between a point and a convex polyhedron, distance between two convex polygons, and distance between two convex polyhedra. The application to computing contact forces in order to enforce nonpenetration constraints in the collision response system is also summarized, although you will need to read Chapter 5 to see exactly how the LCP formulation is derived. Source code is provided on the CD-ROM for solving the LCP problem and is based on the algorithm discussed in this chapter, using both direct numerical calculations in the pivoting scheme *and* symbolic manipulations to handle degenerate behavior in the system.

7.1 LINEAR PROGRAMMING

The topic of *linear programming* has to do with maximizing a linear function subject to a set of linear inequality contraints. Let us first look at the problem in two dimensions to obtain some intuition about how to solve such problems in higher dimensions.

7.1.1 A TWO-DIMENSIONAL EXAMPLE

Consider the problem of maximizing the linear function $f(x_1, x_2) = x_1 + x_2$ subject to the linear inequality constraints $x_1 \geq 0$, $x_2 \geq 0$, $2x_1 + x_2 \leq 2$, and $x_1 + 2x_2 \leq 3$. Figure 7.1 shows two ways of visualizing the problem.

The four inequality constraints define a convex quadrilateral in the plane. Figure 7.1(a) shows four level curves $f(x_1, x_2) = c$ in the quadrilateral: $c = 1/3$, $c = 2/3$, $c = 1$, and $c = 3/2$. The largest value of c for any level curve in the quadrilateral is $c = 5/3$ and occurs at the vertex $(1/3, 4/3)$. Figure 7.1(b) shows the graph of $x_3 = f(x_1, x_2)$, a plane in three dimensions. The point on the portion of the plane over the quadrilateral domain with largest x_3 value occurs at $(x_1, x_2, x_3) = (1/3, 4/3, 5/3)$.

The example shows that the maximization problem has two important aspects. The first aspect is determining the region defined by the linear inequality constraints. Each constraint defines a half plane. Points satisfying two constraints must be in the intersection of the half planes implied by the constraints. Generally, the intersection of the half planes of all the constraints is either the empty set, in which case the maximization problem has no solution, or a convex set that is possibly unbounded. In most applications the constraints are set up to generate a bounded convex set. Because the boundary of the convex sets is generated by the lines corresponding to equality in the linear inequality constraints, a bounded convex set must be a solid convex polygon. An unbounded convex set has a boundary consisting of linear components (lines, rays, or line segments). Figure 7.2 illustrates various cases.

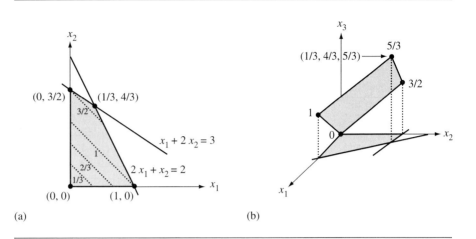

Figure 7.1 (a) Various level curves $f(x_1, x_2) = c$ (straight lines) superimposed on the quadrilateral region implied by the constraints. (b) The graph of $x_3 = f(x_1, x_2)$ (a plane) over the quadrilateral region. The x_3 values at four points on the plane are shown.

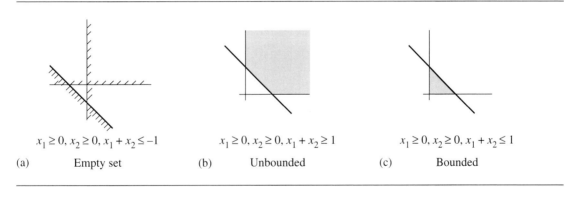

Figure 7.2 (a) Constraints with no solution. The hash marks indicate on which side of the lines the half planes occur. (b) Constraints defining an unbounded convex set. (c) Constraints defining a bounded convex set.

The second important aspect is locating the maximum of the linear function when restricted to the convex domain. Figure 7.1 suggests that the maximum of $f(\mathbf{x})$ occurs at a vertex \mathbf{x} on the convex polygon boundary. This is a correct observation. If f happened to be constant, the maximum is that constant and occurs at every point in the domain, and so at a vertex. If f is not identically a constant, at a point \mathbf{y} in the

interior of the polygon the gradient $\mathbf{d} = \nabla f(\mathbf{y})$ is in the direction of largest increase of f. The function $g(t) = f(\mathbf{y} + t\mathbf{d})$ is strictly increasing in t, so the function value at \mathbf{y} is smaller than function values at points nearby on the ray $\mathbf{y} + \varepsilon\mathbf{d}$. This means $f(\mathbf{y})$ cannot be a maximum for f. The same argument applies on the convex polygon itself to show that the maximum must occur at a vertex. If f is identically a constant on an edge, the maximum along the edge is that constant and occurs at every point of the edge, and so at a vertex. If the function values along an edge are strictly monotone, the maximum must occur at one of the edge end points.

In order to simplify our discussions from here on, let us assume that the constraints forces generate a nonempty bounded convex set. For most physics applications this is a reasonable assumption to make since the constraints are naturally formed based on physical information that indicates a solution is to be expected.

7.1.2 SOLUTION BY PAIRWISE INTERSECTIONS

We have already argued that $f(x_1, x_2)$ must attain its maximum at a vertex of the bounded convex polygonal domain. A natural approach to finding the maximum is to construct all the vertices, evaluate f at each, then select the maximum of these values. Each vertex occurs as the intersection of two lines determined by inequality constraints, so we proceed by solving all possible systems of two equations in two unknowns. In our ongoing example, we have four inequality constraints. If we choose two at a time, the total number of systems is six. The systems and solutions are listed in Table 7.1.

You probably already noticed that the systems produce six points, yet the convex domain shown in Figure 7.1 has only four vertices. Two of the points produced by the system are not in the convex domain. We need to eliminate those points by testing all inequality constraints. Any point not satisfying one of the constraints is discarded. In the presence of a floating point number system, you need to be careful about this step, perhaps by introducing an error tolerance when making the comparison of the

Table 7.1 Solving all possible systems of two equations in two unknowns

System	Solution
$x_1 = 0, \quad x_1 = 0$	$(0, 0)$
$x_1 = 0, \quad 2x_1 + x_2 = 2$	$(0, 2)$
$x_1 = 0, \quad x_1 + 2x_2 = 3$	$(0, 3/2)$
$x_2 = 0, \quad 2x_1 + x_2 = 2$	$(1, 0)$
$x_2 = 0, \quad x_1 + 2x_2 = 3$	$(3, 0)$
$2x_1 + x_2 = 2, \quad x_1 + 2x_2 = 3$	$(1/3, 4/3)$

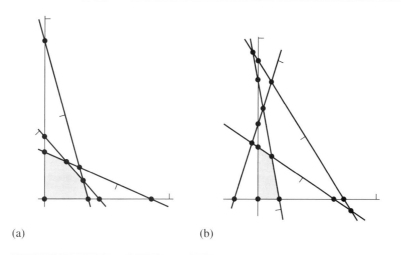

(a) (b)

Figure 7.3 (a) All five constraints are all relevant to forming the convex domain. (b) Two of
the six constraints are redundant since only four of the constraints form the convex
domain.

constraint. In the example, the point $(0, 2)$ is discarded because it fails to satisfy
$x_1 + 2x_2 \leq 3$. The point $(3, 0)$ is discarded because it fails to satisfy $2x_1 + x_2 \leq 2$.
The function is evaluated at the remaining 4 points: $f(0, 0) = 0$, $f(0, 3/2) = 3/2$,
$f(1, 0) = 1$, and $f(1/3, 4/3) = 5/3$. The maximum is $5/3$ and occurs at the vertex
$(1/3, 4/3)$.

If m constraints are specified, $(a_i, b_i) \cdot (x_1, x_2) \leq c_i$ for $1 \leq i \leq m$, the number
of linear systems to solve is the number of ways of choosing two items from a set of
m, namely, $m!/(2!(m-2)!) = m(m-1)/2$. For a large number of constraints, the
computational effort will be quite large. Each point (x_1, x_2) obtained as the solution
of a system of equations is tested by $(a_i, b_i) \cdot (x_1, x_2) \leq c_i$. If this inequality is false,
the point is discarded. The function $f(x_1, x_2)$ is evaluated at the remaining points
and the maximum is selected. Figure 7.3 shows two possible scenarios for constraints.

Figure 7.3(a) has five inequality constraints. The line of each constraint is drawn
and the light gray segment is attached to each point to the side corresponding to
the half plane represented by the constraint. All 10 intersections of pairs of lines
are shown as black dots of which 5 are vertices of the convex domain. Each con-
straint contributes an edge to the domain. Figure 7.3(b) has six inequality constraints.
The 15 intersections of pairs of lines are shown as black dots of which only 4 are
vertices of the convex domain. Only four constraints contribute to edges of the do-
main. The other two are *redundant constraints* in the sense that if you were to ig-
nore those constraints, the convex domain is unaffected and the optimization of the

objective function produces the same result. Notice that redundant constraints jointly generate 9 of the 30 pairwise intersections. Had these constraints not occurred, we would have to solve only six linear systems.

Given m constraints, the pairwise intersection method of the last section requires solving on the order of m^2 linear systems. Effectively this is an exhaustive search for a vertex of the convex domain that produces the maximum function value. In the general dimensional case when you have n independent variables x_1 through x_n and $m > n$ constraints, the exhaustive search for a vertex of the convex domain requires solving all possible combinations of m equations choosing n at a time for a total of $m!/(n!(m-2)!)$. This can be quite an expensive endeavor. The exhaustive search turns out to be suboptimal. A better method that uses a smart search is the *simplex method* invented by Dantzig [Dan63]. We will take a look at this for the general dimensional case.

7.1.3 STATEMENT OF THE GENERAL PROBLEM

Stated in its most general terms for $\mathbf{x} \in \mathbb{R}^n$, the *linear programming* problem is about maximizing the linear function $f(\mathbf{x}) = \mathbf{c}^\mathsf{T}\mathbf{x}$ subject to the n nonnegativity constraints $\mathbf{x} \geq \mathbf{0}$ and the m linear inequality constraints $A\mathbf{x} \leq \mathbf{b}$. The $m \times n$ matrix A, the $n \times 1$ column vector \mathbf{c}, and the $m \times 1$ column matrix \mathbf{b} are all application-specified values. The inequality notation for vectors is shorthand to denote that the inequality holds for each pair of components, that is, $(u_1, \ldots, u_k) \geq (v_1, \ldots, v_k)$ if and only if $u_i \geq v_i$ for $1 \leq i \leq k$. The function f is called the *objective function*. Any vector that satisfies the inequality constraints is called a *feasible vector*. A feasible vector that maximizes the objective function is called an *optimal feasible vector*; there may be more than one such vector. The constraints trim \mathbb{R}^n to a convex domain (possibly empty or nonempty and possibly unbounded). Each vertex of the domain is a solution to exactly n of the $n + m$ constraints and is called a *feasible basis vector*. Using our motivation in two dimensions, the feasible basis vectors are the only feasible vectors that need to be searched for optimality.

The method of solution requires two changes to the constraints $A\mathbf{x} \leq \mathbf{b}$. We are interested in constructing feasible basis vectors that, by definition, are the vertices of the convex domain. These vectors occur as solutions to constraints where the inequality has been replaced by equality. This suggests that we eliminate inequalities in the first place. The first change is therefore to introduce new nonnegative variables called *slack variables*; these take up the slack, so to speak, between the two sides of the inequalities. For a constraint $a_1 x_1 + \cdots + a_n x_n \leq b$, the slack is $s = b - a_1 x_1 - \cdots - a_n x_n \geq 0$. The single inequality constraint is replaced by a new equality constraint $a_1 x_1 + \cdots + a_n x_n + s = b$ and a new nonnegativity constraint $s \geq 0$. In total m slack variables are introduced, s_i for $1 \leq i \leq m$, and stored in the $m \times 1$ column vector \mathbf{s}. In matrix notation, the constraints $A\mathbf{x} \leq \mathbf{b}$ and $\mathbf{x} \geq 0$ are transformed to

$$A\mathbf{x} + \mathbf{s} = \mathbf{b}, \quad \mathbf{x} \geq 0, \quad \mathbf{s} \geq 0 \tag{7.1}$$

where the zero vectors are of the appropriate size in their respective contexts. This form of the linear programming problem is called the *normal form*. The pair (\mathbf{x}, \mathbf{s}) has $n + m$ components, so is a vector in \mathbb{R}^{n+m}. Each equation in $A\mathbf{x} + \mathbf{s} = \mathbf{b}$ represents a hyperplane in \mathbb{R}^{n+m}. These bound a convex domain in \mathbb{R}^{n+m} whose vertices we must search. A vertex (\mathbf{x}, \mathbf{s}) of interest is one for which \mathbf{x} maximizes the objective function. The \mathbf{s} component of that solution is simply discarded.

A search of the vertices implied by the normal-form constraints, equation (7.1), will involve starting at one vertex, then visiting another vertex whose objective function value is larger than that of the current vertex. This requires finding an initial vertex to start the search. To support this, the second change is to introduce more new nonnegative variables called *artificial variables*. For an equality constraint $a_1 x_1 + \cdots + a_n x_n + s = b$, where s is the appropriate slack variable, an artificial variable will be set to the difference of the two sides of the equation. We require that the right-hand side be nonnegative. If $b \geq 0$, the new variable w is set to $w = b - a_1 x_1 - \cdots - a_n x_n - s \geq 0$. If $b < 0$, a multiplication by -1 must occur first, $w = -b + a_1 x_1 + \cdots + a_n x_n + s \geq 0$. In total, m artificial variables are introduced, w_i for $1 \leq i \leq m$, and stored in the $m \times 1$ column vector \mathbf{w}. In matrix notation,

$$\mathbf{w} = D(\mathbf{b} - A\mathbf{x} - \mathbf{s}), \quad \mathbf{x} \geq 0, \ \mathbf{s} \geq 0, \ \mathbf{w} \geq 0 \qquad (7.2)$$

where $D = \text{Diag}(d_1, \ldots, d_m)$ with $d_i = 1$ if $b_i \geq 0$ or $d_i = -1$ if $b_i < 0$. The linear programming problem in this form is called the *restricted normal form*. We associate an *auxiliary objective function* with the constraints of equation (7.2),

$$g(\mathbf{w}) = -\sum_{i=1}^{m} w_i = \sum_{i=1}^{m} d_i \left(\sum_{j=1}^{n} a_{ji} x_j - b_i + s_i \right)$$

Since $w_i \geq 0$ for all i, $g(\mathbf{w}) \leq 0$. The goal is to maximize $g(\mathbf{w})$. If the maximum occurs at $\mathbf{w} \neq 0$, then it is not possible to construct a pair (\mathbf{x}, \mathbf{s}) that solves the linear system in the constraints, equation (7.1). In this case, the original linear programming problem has no solution because the inequality constraints are inconsistent. However, if the maximum does occur at $\mathbf{w} = \mathbf{0}$, we will have found a pair (\mathbf{x}, \mathbf{s}) that is the initial vertex to start a search in the normal-form problem to maximize the original objective function. The search for a maximum of g will always start with $\mathbf{x} = \mathbf{0}$ and $\mathbf{s} = \mathbf{0}$. In this case the initial artificial variables are $\mathbf{w} = D\mathbf{b} \geq \mathbf{0}$.

The normal form and restricted normal form can be solved with the same methods. The simplex method refers to the two-phase process of solving the restricted normal form in optimizing the auxiliary objective function to find an initial feasible basis vector, then solving the normal form in optimizing the objective function, the search starting at the feasible vector found in the first phase. The method is illustrated in Example 7.1.

EXAMPLE
7.1

The objective function is $f(x_1, x_2) = x_1 + x_2$ and is to be maximized with respect to the constraints $x_1 \geq 0$, $x_2 \geq 0$, $-x_1 + x_2 \leq 2$, $2x_1 - x_2 \leq -1$, and $3x_1 + x_2 \leq 3$. Figure 7.4 shows the convex domain implied by the constraints.

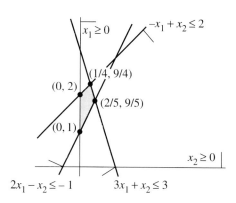

Figure 7.4

The convex domain implied by the two nonnegativity constraints and three linear inequality constraints of the example.

To convert to normal form requires three slack variables, s_1, s_2, and s_3:

$$-x_1 + x_2 + s_1 = 2$$

$$2x_1 - x_2 + s_2 = -1$$

$$3x_1 + x_2 + s_3 = 3$$

To convert to restricted normal form requires three artificial variables, w_1, w_2, and w_3:

$$w_1 = 2 + x_1 - x_2 - s_1$$

$$w_2 = 1 + 2x_1 - x_2 + s_2$$

$$w_3 = 3 - 3x_1 - x_2 - s_3$$

The auxiliary objective function is $g = -(w_1 + w_2 + w_3) = -6 + 3x_2 + s_1 - s_2 + s_3$. As mentioned earlier, the search for a maximum of g always starts with $(x_1, x_2) = (0, 0)$ and $(s_1, s_2, s_3) = (0, 0, 0)$, in which case $(w_1, w_2, w_3) = (2, 1, 3)$ are the initial artificial variables and $g = -6$. The goal is to modify the variables to increase g to zero.

Table 7.2 | Tableau of coefficients and constants (Example 7.1)

	Value	x_1	x_2	s_1	s_2	s_3
g	-6	0	3	1	-1	1
w_1	2	1	-1	-1	0	0
w_2	1	2	-1	0	1	0
w_3	3	3	-3	0	0	-1

The classic method of setup involves storing the various coefficients and constants in a *tableau*. Table 7.2 shows the tableau for this example.

The value column initially contains the constant terms in the equations for g, w_1, w_2, and w_3 and represents the fact that we will always be thinking of the variables in the other columns as being zero. The entries in the other column are the coefficients of those variables in the auxiliary objective function g and in the equality constraints.

Let us analyze the coefficients in the g-row after the value column. The x_1 coefficient is zero since x_1 does not occur in that function. No matter how you modify x_1, g will not change, so we may ignore x_1 at this step of the process. The x_2 coefficient is 3, a positive number. If we increase the value of x_2 from its current value of zero, g will also increase, thereby giving us a chance to force it to become zero. The column entry for x_2 in the w_1-row tells us how w_1 depends on x_2. The coefficient is -1, a negative number, so any increase in x_2 will result in a decrease in w_1. Since we require $w_1 \geq 0$, we cannot increase x_2 by an arbitrary amount. In fact, the most we can increase is to $x_2 = 2$, in which case $w_1 = 0$.

Similarly in the w_2-row and w_3-row, the coefficients are negative, which means that an increase in x_2 will result in decreases in w_2 and w_3. As we increase x_2, all the w_i will decrease simultaneously. When the first w_i value reaches zero, we can no longer increase x_2. Of course, if the coefficient of x_2 in a z-equation is positive, there is no limit on increasing x_2, so we need consider only z-equations for which the x_2 coefficient is negative. The maximum value to which we can increase x_2 is the minimum of the negatives of the ratios of the constant terms and the coefficients. In our current case the ratios for the w_1-row, w_2-row, and w_3-row are $2 = -(2/(-1))$, $1 = -(1/(-1))$, and $1 = -(3/(-3))$, respectively. The w_2-row limits the increase of x_2 to 1.

Once the row corresponding to the limiting increase is identified, the next step is to make the row variable (basic variable) a column variable (nonbasic variable) and vice versa. In our example we solve for x_2 in the w_2 equation to obtain

$$x_2 = 1 - w_2 + 2x_1 + s_2$$

*(Example 7.1
continued)* This equation is substituted into the x_2 terms in the g equation and the other equality constraints:

$$g = -6 + 3x_2 + s_1 - s_2 + s_3 = -3 - 3w_2 + 6x_1 + s_1 + 2s_2 + s_3$$

$$w_1 = 2 + x_1 - x_2 - s_1 = 1 - x_1 + w_2 - s_1 - s_2$$

$$w_3 = 2 - 5x_1 + w_2 - s_2 - s_3$$

The tableau is updated in Table 7.3 by swapping the row variable w_2 with the column variable x_2. The invariant in this process is that the resulting tableau represents a linear programming problem in restricted normal form.

Table 7.3 Updated tableau: Exchanging w_2 with x_2

	Value	x_1	w_2	s_1	s_2	s_3
g	-3	6	-3	1	2	1
w_1	1	-1	1	-1	-1	0
x_2	1	2	-1	0	1	0
w_3	2	-5	1	0	-1	-1

We repeat the process. The column variables are thought of as having value zero. The x_1 coefficient in the g-row is positive, so an increase in x_1 results in an increase in g. The x_1 coefficients in the w_1-row and w_3-row are negative, so w_1 and w_3 will decrease when x_1 is increased. The limiting factor is the minimum of the ratios $1 = -(1/(-1))$ and $2/5 - (2/(-5))$; that is, w_3 will reach zero before w_1 does. We now need to exchange x_1 and w_3 by solving for

$$x_1 = \frac{1}{5}(2 + w_2 - w_3 - s_2 - s_3)$$

and substituting in the g equation and the other constraints:

$$g = -3 + 6x_1 - 3w_2 + s_2 + 2s_2 + s_3 = -\frac{3}{5} - \frac{6}{5}w_3 - \frac{9}{5}w_2 + s_1 + \frac{4}{5}s_2 - \frac{1}{5}s_3$$

$$w_1 = 1 - x_1 + w_2 - s_1 - s_2 = \frac{3}{5} + \frac{1}{5}w_3 + \frac{4}{5}w_2 - s_1 - \frac{4}{5}s_2 + \frac{1}{5}s_3$$

$$x_2 = 1 + 2x_1 - w_2 + s_2 = \frac{9}{5} - \frac{2}{5}w_3 - \frac{3}{5}w_2 + \frac{3}{5}s_2 - \frac{2}{5}s_3$$

Table 7.4 shows the updated tableau.

Table 7.4 Updated tableau: Exchanging x_1 with w_3

	Value	w_3	w_2	s_1	s_2	s_3
g	$-\frac{3}{5}$	$-\frac{6}{5}$	$-\frac{9}{5}$	1	$\frac{4}{5}$	$-\frac{1}{5}$
w_1	$\frac{3}{5}$	$\frac{1}{5}$	$\frac{4}{5}$	-1	$-\frac{4}{5}$	$\frac{1}{5}$
x_2	$\frac{9}{5}$	$-\frac{2}{5}$	$-\frac{3}{5}$	0	$\frac{3}{5}$	$-\frac{2}{5}$
x_1	$\frac{2}{5}$	$-\frac{1}{5}$	$\frac{1}{5}$	0	$-\frac{1}{5}$	$-\frac{1}{5}$

And yet one more repetition of the process. The coefficient of s_1 in the g-row is positive, so an increase in s_1 results in an increase in g. Note that in this step we are increasing a slack variable, not one of the original variables, to increase the auxiliary objective function. The only negative coefficient in the s_1 column is in the w_1 row, so we may increase s_1 until w_1 is zero. We exchange w_1 and s_1 by solving for

$$s_1 = \frac{3}{5} + \frac{1}{5}w_3 + \frac{4}{5}w_2 - w_1 - \frac{4}{5}s_2 + \frac{1}{5}s_3$$

and substituting in the g equation and the other constraints:

$$g = -\frac{3}{5} - \frac{6}{5}w_3 - \frac{9}{5}w_2 + s_1 + \frac{4}{5}s_2 - \frac{1}{5}s_3 = 0 - w_1 - w_2 - w_3$$

$$x_2 = \frac{9}{5} - \frac{2}{5}w_3 - \frac{3}{5}w_2 + \frac{3}{5}s_2 - \frac{2}{5}s_3$$

$$x_1 = \frac{2}{5} - \frac{1}{5}w_3 + \frac{1}{5}w_2 - \frac{1}{5}s_2 - \frac{1}{5}s_3$$

Table 7.5 shows the updated tableau.

Table 7.5 Updated tableau: Exchanging w_1 with s_1

	Value	w_3	w_2	w_1	s_2	s_3
g	0	-1	-1	-1	0	0
s_1	$\frac{3}{5}$	$\frac{1}{5}$	$\frac{4}{5}$	-1	$-\frac{4}{5}$	$\frac{1}{5}$
x_2	$\frac{9}{5}$	$-\frac{2}{5}$	$-\frac{3}{5}$	0	$\frac{3}{5}$	$-\frac{2}{5}$
x_1	$\frac{2}{5}$	$-\frac{1}{5}$	$\frac{1}{5}$	0	$-\frac{1}{5}$	$-\frac{1}{5}$

(Example 7.1 continued)

The current value of g is zero *and* none of the coefficients in the g row is positive, so it is no longer possible to increase any of the nonbasic variables s_2, s_3, w_1, w_2, or w_3 and obtain an increase in g. That is, g does have a maximum of zero and is obtained when $s_2 = s_3 = w_1 = w_2 = w_3 = 0$. The basic variables are x_1, x_2, and s_1 and have values $x_1 = 2/5$, $x_2 = 9/5$, and $s_1 = 3/5$. The vector $(x_1, x_2, s_1, s_2, s_3) = (2/5, 9/5, 3/5, 0, 0)$ is a feasible basis vector for the normal form, equation (7.1), and is the starting point for the search to maximize $f(x_1, x_2) = x_1 + x_2$. Just to verify, replace the feasible vector in the constraints as in equation (7.2), written as $A\mathbf{x} + \mathbf{s} - \mathbf{b}$:

$$-x_1 + x_2 + s_1 - 2 = -2/5 + 9/5 + 3/5 - 2 = 0$$

$$2x_1 - x_2 + s_2 + 1 = 4/5 - 9/5 + 1 = 0$$

$$3x_1 + x_2 + s_3 - 3 = 6/5 + 9/5 - 3 = 0$$

The slack variable s_1 is positive, but the other two are zero. In terms of what is shown in Figure 7.4, $(x_1, x_2) = (2/5, 9/5)$ is a vertex of the convex domain and is the intersection of $2x_1 - x_2 = -1$ and $3x_1 + x_2 = 3$ (slack variables $s_2 = s_3 = 0$). That vertex is not on the other line, but $-x_1 + x_2 < 2$ (slack variable $s_1 > 0$).

Now we are ready to maximize f. The artificial variables w_i are no longer needed, so the tableau no longer contains them. The tableau also contains a row representing f since the auxiliary function g is no longer needed. In terms of the nonbasic variables,

$$f = x_1 + x_2 = \left(\frac{2}{5} - \frac{1}{5}s_2 - \frac{1}{5}s_3 \right) + \left(\frac{9}{5} + \frac{3}{5}s_2 - \frac{2}{5}s_3 \right) = \frac{11}{5} + \frac{2}{5}s_2 - \frac{3}{5}s_3$$

and the initial tableau is shown in Table 7.6.

Table 7.6

Maximizing f

	Value	s_2	s_3
f	$\frac{11}{5}$	$\frac{2}{5}$	$-\frac{3}{5}$
x_1	$\frac{2}{5}$	$-\frac{1}{5}$	$-\frac{1}{5}$
x_2	$\frac{9}{5}$	$\frac{3}{5}$	$-\frac{2}{5}$
s_1	$\frac{3}{5}$	$-\frac{4}{5}$	$\frac{1}{5}$

s_2 and s_3 are nonbasic variables whose initial values are zero. The coefficient of s_2 in the f-row is positive, so an increase in s_2 leads to an increase in f. The negative coefficients in the s_2 column are in the x_1-row and s_1-row. The limiting increase is the

minimum of $2 = -((2/5)/(-1/5))$ and $3/4 = -((3/5)/(-4/5))$, so the s_1 variable decreases to zero before x_1 does. Exchange s_1 and s_2 by solving for

$$s_2 = \frac{1}{4}(3 - 5s_1 + s_3)$$

and substituting in the f equation and the other constraints:

$$f = \frac{11}{5} + \frac{2}{5}s_2 - \frac{3}{5} = \frac{5}{2} - \frac{1}{2}s_1 - \frac{1}{2}s_3$$

$$x_1 = \frac{2}{5} - \frac{1}{5}s_2 - \frac{1}{5}s_3 = \frac{1}{4} + \frac{1}{4}s_1 - \frac{1}{4}s_3$$

$$x_2 = \frac{9}{5} + \frac{3}{5}s_2 - \frac{2}{5}s_3 = \frac{9}{4} - \frac{3}{4}s_1 - \frac{1}{4}s_3$$

Table 7.7 shows the updated tableau.

Table 7.7 Maximizing f: Exchanging s_1 with s_2

	Value	s_1	s_3
f	$\frac{5}{2}$	$-\frac{1}{2}$	$-\frac{1}{2}$
x_1	$\frac{1}{4}$	$\frac{1}{4}$	$-\frac{1}{4}$
x_2	$\frac{9}{4}$	$-\frac{3}{4}$	$-\frac{1}{4}$
s_2	$\frac{3}{4}$	$-\frac{5}{4}$	$\frac{1}{4}$

The coefficients of the nonbasic variables in the f-row are all negative, so no amount of increasing those variables will increase f. Thus, f has a maximum of $5/2$ and it occurs when $s_1 = s_3 = 0$. Consequently, the basic variables are $x_1 = 1/4$, $x_2 = 9/4$, and $s_2 = 3/4$. The pair $(x_1, x_2) = (1/4, 9/4)$ is another vertex of the convex domain shown in Figure 7.4. The slack variables s_1 and s_3 are both zero, therefore that vertex is generated as the intersection of the lines corresponding to $-x_1 + x_2 = 2$ and $3x_1 + x_2 = 3$. The slack variable $s_2 > 0$, so the vertex is not on the line of the other constraint; that is, $2x_1 - x_2 < -1$. ▪

As is true in most algorithms, you have to deal with degenerate cases. The constant terms in the value column are constrained to be nonnegative, but in the previous example were always positive. If a zero constant term is encountered, the corresponding basic variable is zero whenever all the nonbasic variables are zero. The vector of basic and nonbasic variables in this case is referred to as a *degenerate feasible vector*. As suggested in [PFTV88], the zero constant term must be handled by

exchanging the basic variable in that row with a nonbasic variable in a column, sometimes having to make several such exchanges. In fact, the description in [PFTV88] is incomplete because there are three types of degeneracies that can occur. We will discuss these in Section 7.2 showing that the linear programming problem is a special case of the linear complementarity problem (LCP). The method of solution of an LCP is well suited for dealing with the degeneracies.

7.1.4 THE DUAL PROBLEM

The linear programming problem has an associated problem called the *dual problem*. In this context the original problem is referred to as the *primal problem*. The motivation for the dual problem is provided by Example 7.1. We wanted to maximize $f(x_1, x_2) = x_1 + x_2$ subject to the nonnegativity constraints $x_1 \geq 0$ and $x_2 \geq 0$ and the linear inequality constraints $-x_1 + x_2 \leq 2$, $2x_1 - x_2 \leq -1$ and $3x_1 + x_2 \leq 3$. The simplex method was used to show that the maximum of f is 5/2 and occurs at $(x_1, x_2) = (1/4, 9/4)$. Before proceeding with the simplex method, we can in fact use the linear inequality constraints to obtain upper bounds on the maximum of f. For example,

$$f = x_1 + x_2 \leq 3x_1 + x_2 \leq 3$$

This guarantees that $\max(f) \leq 3$. We can also use combinations of constraints to obtain upper bounds:

$$f = x_1 + x_2 = 3(-x_1 + x_2) + 2(2x_1 - x_2) \leq 3(2) + 2(-1) = 4$$

This bound leads to $\max(f) \leq 4$, not as good a bound as the previous case but still a bound. Another possibility is

$$f = x_1 + x_2 \leq 4x_1 + x_2$$

$$= 1(-x_1 + x_2) + 1(2x_1 - x_2) + 1(3x_1 + x_2) \leq 1(2) + 1(-1) + 1(3) = 4$$

again concluding that $\max(f) \leq 4$. Yet one more possibility is

$$f = x_1 + x_2 = \frac{1}{2}(-x_1 + x_2) + \frac{1}{2}(3x_1 + x_2) \leq \frac{1}{2}(2) + \frac{1}{2}(3) = \frac{5}{2}$$

We conclude that $\max(f) \leq 5/2$ but in fact got lucky in that the upper bound really happens to be the maximum value of f.

Perhaps we can choose just the right multipliers for the linear inequality constraints so that we will indeed obtain the maximum value for f. In the example let $y_1 \geq 0$, $y_2 \geq 0$, and $y_3 \geq 0$ be the multipliers for the constraints; that is,

$$y_1(-x_1 + x_2) \leq 2y_1, \qquad y_2(2x_1 - x_2) \leq -y_2, \qquad y_3(3x_1 + x_2) \leq 3y_3$$

The constraints are combined to form the following:

$$2y_1 - y_2 + 3y_3 \geq y_1(-x_1 + x_2) + y_2(2x_1 - x_2) + y_3(3x_1 + x_2)$$
$$= (-y_1 + 2y_2 + 3y_3)x_1 + (y_1 - y_2 + y_3)x_2$$
$$\geq x_1 + x_2 = f$$

The last inequality is what we want to be true, so we have to choose $y_1 \geq 0$, $y_2 \geq 0$, and $y_3 \geq 0$ to make that happen. Specifically, choose $-y_1 + 2y_2 + 3y_3 \geq 1$ and $y_1 - y_2 + y_3 \geq 1$. Our goal is to make the quantity $2y_1 - y_2 + 3y_3$ as small as possible. That is, we want to minimize $g(y_1, y_2, y_3) = 2y_1 - y_2 + 3y_3$ subject to the nonnegativity constraints $y_1 \geq 0$, $y_2 \geq 0$, and $y_3 \geq 0$ and the linear inequality constraints $-y_1 + 2y_2 + 3y_3 \geq 1$ and $y_1 - y_2 + y_3 \geq 1$. You will notice that this is nearly identical in structure to the original problem with the exceptions that we are now minimizing a function and have instead greater-or-equal constraints. This problem is referred to as the *dual problem* for the original problem.

In general, and using vector notation, the primal problem is

$$\text{Maximize } f(\mathbf{x}) = \mathbf{c}^{\mathrm{T}}\mathbf{x} \text{ subject to } \mathbf{x} \geq \mathbf{0} \text{ and } A\mathbf{x} \leq \mathbf{b} \tag{7.3}$$

The dual problem is

$$\text{Minimize } g(\mathbf{y}) = \mathbf{b}^{\mathrm{T}}\mathbf{y} \text{ subject to } \mathbf{y} \geq \mathbf{0} \text{ and } A^{\mathrm{T}}\mathbf{y} \geq \mathbf{c} \tag{7.4}$$

You should convince yourself from the previous example of why A^{T}, \mathbf{b}, and \mathbf{c} show up as they do in the general definition for the dual problem. The dual problem may be solved with the simplex method by introducing slack and artificial variables. Of course the process requires you to decrease the objective function values rather than increase as the primal problem requires.

A few relationships hold between the primal and dual problems. These are referred to as *weak duality*, *unboundedness property*, and *strong duality*.

Weak Duality Principle

If \mathbf{x} is a feasible vector for the primal problem and if \mathbf{y} is a feasible vector for the dual problem, then $f(\mathbf{x}) \leq g(\mathbf{y})$.

The proof is simple. Since \mathbf{x} is a feasible vector for the primal problem, we know that it satisfies the constraints $A\mathbf{x} \leq \mathbf{b}$. The components of the vectors $A\mathbf{x}$ and \mathbf{b} must be ordered by the inequality, so the transposition of the vectors satisfies the same ordering:

$$\mathbf{x}^{\mathrm{T}}A^{\mathrm{T}} = (A\mathbf{x})^{\mathrm{T}} \leq \mathbf{b}^{\mathrm{T}}$$

The **y** components are nonnegative, so multiplying the previous equation by **y** does not change the direction of inequality,

$$\mathbf{x}^T A^T \mathbf{y} \le \mathbf{b}^T \mathbf{y}$$

Also, **y** is a feasible vector for the dual problem so we know that it satisfies the constraints $\mathbf{c} \le A^T \mathbf{y}$. Since **x** has nonnegative components, multiplying by **x** does not change the direction of the inequality,

$$\mathbf{x}^T \mathbf{c} \le \mathbf{x}^T A^T \mathbf{y}$$

Combining this with the previous displayed equation yields

$$f(\mathbf{x}) = \mathbf{c}^T \mathbf{x} = \mathbf{x}^T \mathbf{c} \le \mathbf{x}^T A^T \mathbf{y} \le \mathbf{b}^T \mathbf{y} = g(\mathbf{y})$$

and the proof is complete.

Unboundedness Property

A linear programming problem is said to have an *unbounded solution* if you can make the objective function arbitrarily large. Figure 7.2(b) shows a domain for which the objective function $f(\mathbf{x})$ can be made as large as you like by choosing values of **x** far away from the origin. The unboundedness property is stated in three ways:

1. If the primal problem has an unbounded solution, then the dual problem has no solution and is said to be *infeasible*.
2. If the dual problem has an unbounded solution, then the primal problem is infeasible.
3. The primal problem has a finite optimal solution if and only if the dual problem has a finite optimal solution.

These results are direct consequences of the weak duality principle. For example, if the primal problem has an unbounded solution, then you can force $f(\mathbf{x})$ to be arbitrarily large by choosing appropriate feasible vectors. You can visualize this in 2D by sketching a convex domain for f. One of the boundary components will be a ray. Choose **x** along that ray with increasing length to force the corresponding f values to become large. Given that you can do this, and given $f(\mathbf{x}) \le g(\mathbf{y})$ for a feasible solution **y**, you would also force g to become arbitrarily large. This cannot happen, so there is no such feasible vector **y** and the dual problem cannot be solved.

Strong Duality Principle

If \mathbf{x} is a feasible vector for the primal problem and \mathbf{y} is a feasible vector for the dual problem, then these vectors optimize f and g if and only if $f(\mathbf{x}) = g(\mathbf{y})$.

Let us assume that \mathbf{x} is a feasible vector for the primal problem, \mathbf{y} is a feasible vector for the dual problem, and $f(\mathbf{x}) = g(\mathbf{y})$. From the weak duality principle we know that $f(\mathbf{u}) \leq g(\mathbf{v})$ for any feasible vectors \mathbf{u} and \mathbf{v}. Thus, $\max(f) \leq \min(g)$. The fact that equality occurs in $f(\mathbf{x}) = g(\mathbf{y})$ guarantees that $\max(f) = f(\mathbf{x})$ and $\min(g) = g(\mathbf{y})$.

The proof in the other direction is more complicated and is not proved here. The essence is that in constructing the optimal solution for the primal problem using the simplex method, the details of the construction also allow you to construct the optimal solution for the dual problem with the same function value as that of the primal solution.

7.2 THE LINEAR COMPLEMENTARITY PROBLEM

In the last section we saw a brief overview of the linear programming problem and introduced the concepts of primal problem and dual problem. The strong duality principle states that you can optimize the primal problem or optimize the dual problem to arrive at the same optimum value. An important consequence of this principle is called *complementary slackness*. The vector of slack variables for the primal problem is $\mathbf{s} = \mathbf{b} - A\mathbf{x} \geq 0$. The vector of slack variables for the dual problem is $\mathbf{u} = A^T\mathbf{y} - \mathbf{c}$. Complementary slackness presents the following challenge. If $\mathbf{x} = (x_1, \ldots, x_n)$ is a feasible vector for the primal problem and $\mathbf{y} = (y_1, \ldots, y_m)$ is a feasible vector for the dual problem, then these vectors optimize f and g if and only if *both* of the following apply:

1. Either $x_j = 0$ or $u_j = 0$.
2. Either $y_i = 0$ or $s_i = 0$.

In vector notation we write these conditions as $\mathbf{x} \circ \mathbf{u} = \mathbf{0}$ and $\mathbf{y} \circ \mathbf{s} = \mathbf{0}$, where the circle operator defines a new vector whose components are the products of the components from the input vectors, $\mathbf{u} \circ \mathbf{v} = (u_1, \ldots, u_k) \circ (v_1, \ldots, v_k) = (u_1 v_1, \ldots, u_k v_k)$.

The primal and dual problems combined fit the format for a more general problem (which we discussed briefly in Chapter 5) called the *linear complementarity problem* (LCP): Given a $k \times 1$ vector \mathbf{q} and a $k \times k$ matrix M, construct $k \times 1$ vectors \mathbf{w} and \mathbf{z} such that

$$\mathbf{w} = \mathbf{q} + M\mathbf{z}, \quad \mathbf{w} \circ \mathbf{z} = \mathbf{0}, \quad \mathbf{w} \geq \mathbf{0}, \quad \text{and} \quad \mathbf{z} \geq \mathbf{0} \qquad (7.5)$$

The variables w_i and z_i are said to be *complementary*. The reduction of the primal and dual problems to this form is straightforward. The various quantities in the LCP

are written in block matrix form as

$$
\mathbf{q} = \begin{bmatrix} -\mathbf{c} \\ \hline \mathbf{b} \end{bmatrix}, \quad M = \begin{bmatrix} 0 & A^{\mathrm{T}} \\ \hline -A & 0 \end{bmatrix}, \quad \mathbf{w} = \begin{bmatrix} \mathbf{u} \\ \hline \mathbf{s} \end{bmatrix}, \quad \text{and} \quad \mathbf{z} = \begin{bmatrix} \mathbf{x} \\ \hline \mathbf{y} \end{bmatrix} \quad (7.6)
$$

Make sure you understand the difference in formulations for the linear programming problem and the linear complementarity problem. In the former problem your goal is to optimize a function based on various constraints. In the latter your goal is to satisfy the complementarity condition $\mathbf{w} \circ \mathbf{z} = \mathbf{0}$.

7.2.1 THE LEMKE ALGORITHM

The simplex method may be used to solve an LCP. Although the tableau method works fine, a modern approach uses slightly different terminology which we introduce here. The presentation here is based on Joel Friedman's nicely written online summary of LCP and MP [Fri98]. The equation $\mathbf{w} = \mathbf{q} + M\mathbf{z}$ is considered to be a *dictionary* for the basic variables \mathbf{w} defined in terms of the nonbasic variables \mathbf{z}. The analogy to a dictionary makes sense since each w_i is a new "word" whose definition is provided in terms of already defined "words," z_j. If $\mathbf{q} \geq \mathbf{0}$, the dictionary is said to be *feasible*. In this case, the LCP has a trivial solution of $\mathbf{w} = \mathbf{q}$ and $\mathbf{z} = \mathbf{0}$.

If the dictionary is not feasible, then a two-phase algorithm called the *Lemke algorithm* [PSC92] is applied. The first phase of the algorithm adds an auxiliary variable $z_0 \geq 0$ by modifying the dictionary to

$$
\mathbf{w} = \mathbf{q} + M\mathbf{z} + z_0\mathbf{1}
$$

where $\mathbf{1}$ is the appropriately sized vector whose components are all one. An exchange is made, much like that in the tableau method, between z_0 and some basic variable w_i. That is, z_0 *enters the dictionary* and w_i *leaves the dictionary*. Not just any exchange will do; we need an exchange that will make the modified dictionary feasible.

The second phase of the Lemke algorithm is designed to obtain a dictionary such that *both* of two conditions hold:

1. z_0 is nonbasic.

2. For each i either z_i or w_i is nonbasic.

Note that z_0 is nonbasic to start, enters the dictionary in the first phase, and eventually leaves the dictionary to once again become nonbasic. When z_0 leaves the dictionary, we know that as a nonbasic variable it is thought of as $z_0 = 0$ (just like in the tableau method) and the modified dictionary $\mathbf{w} = \mathbf{q} + M\mathbf{z} + z_0\mathbf{1}$ is restored to the original one $\mathbf{w} = \mathbf{q} + M\mathbf{z}$. The condition that z_i or w_i is nonbasic for each $i \geq 1$ means that either $z_i = 0$ or $w_i = 0$; that is, $\mathbf{w} \circ \mathbf{z} = \mathbf{0}$ and we have solved the LCP. A

dictionary that satisfies conditions 1 and 2 is said to be a *terminal dictionary*. If the dictionary satisfies only condition 2, it is said to be a *balanced dictionary*. The first phase produces a balanced dictionary, but since z_0 is in the dictionary, the dictionary is nonterminal. The procedure to reach a terminal dictionary is iterative, each iteration designed so that a nonbasic variable enters the dictionary and a basic variable leaves the dictionary. The invariant of each iteration is that the dictionary remain feasible and balanced. To guarantee this happens and (hopefully) avoid returning to the same dictionary twice (a cycle, so to speak), if a variable has just left the dictionary, then its complementary variable must enter the dictionary on the next iteration (a variable cannot leave on one iteration and enter on the next iteration and vice versa).

The Lemke algorithm is illustrated with a simple linear programming problem in Example 7.2.

EXAMPLE 7.2

Maximize $f(x_1, x_2) = 2x_1 + x_2$ with respect to the constraints $x_1 \geq 0$, $x_2 \geq 0$, and $x_1 + x_2 \leq 3$. The vectors and matrices implied by this are

$$A = [1 \quad 1], \qquad \mathbf{b} = [3], \qquad \text{and} \qquad \mathbf{c} = \begin{bmatrix} 2 \\ 1 \end{bmatrix}$$

Equation (7.6) makes the conversion to an LCP:

$$\mathbf{q} = \begin{bmatrix} -2 \\ -1 \\ 3 \end{bmatrix}, \qquad M = \begin{bmatrix} 0 & 0 & 1 \\ 0 & 0 & 1 \\ -1 & -1 & 0 \end{bmatrix}, \qquad \mathbf{w} = \begin{bmatrix} u_1 \\ u_2 \\ s_1 \end{bmatrix} = \begin{bmatrix} w_1 \\ w_2 \\ w_3 \end{bmatrix}, \qquad \text{and}$$

$$\mathbf{z} = \begin{bmatrix} x_1 \\ x_2 \\ y_1 \end{bmatrix} = \begin{bmatrix} z_1 \\ z_2 \\ z_3 \end{bmatrix}$$

The initial dictionary with auxiliary variable z_0 is

$$w_1 = -2 + z_0 + z_3$$
$$w_2 = -1 + z_0 + z_3$$
$$w_3 = 3 + z_0 - z_1 - z_2$$

The first phase involves moving z_0 to the dictionary. In order to obtain a feasible dictionary, we need consider only solving for z_0 in an equation that has a negative constant term. Moreover, that constant term should be the largest in magnitude so that, when substituting the new z_0 equation into the other equations, all constant terms are guaranteed to be nonnegative. In this example the first equation is the one

(Example 7.2 continued)

to use. We solve for z_0 (so w_1 leaves the dictionary) and substitute that expression into the other equations:

$$z_0 = 2 + w_1 - z_3$$

$$w_2 = 1 + w_1$$

$$w_3 = 5 + w_1 - z_1 - z_2 - z_3$$

The new constant vector is $(2, 1, 5) \geq (0, 0, 0)$, so we have a feasible dictionary. Since the z_i are nonbasic for all $i \geq 1$, we have a balanced dictionary. The dictionary is not terminal since z_0 is still in it.

The second phase is now initiated. The variable w_1 just left the dictionary, so its complementary variable z_1 must now enter the dictionary. The only way this can happen is by solving the w_3 equation for z_1. The other two equations have no z_1 terms in them, so no substitution by the newly formed z_1 equation is necessary:

$$z_0 = 2 + w_1 - z_3$$

$$w_2 = 1 + w_1$$

$$z_1 = 5 + w_1 - w_3 - z_2 - z_3$$

The variable w_3 left the dictionary, so its complementary variable z_3 must enter the dictionary. We have two equations involving z_3. Just as in the tableau method, we should choose the one that limits an increase in z_3 so that the constant terms in the other equations remain nonnegative. The first equation is limiting since the ratio of constant term and negative z_3 coefficient is 2, whereas the ratio in the last equation is 5. Solving for z_3 and substituting in any other equations containing z_3:

$$z_3 = 2 + w_1 - z_0$$

$$w_2 = 1 + w_1$$

$$z_1 = 3 - w_3 + z_0 - z_2$$

Since z_0 has left the dictionary to return as a nonbasic variable, the process is complete. The dictionary is terminal. The solution to the LCP is $z_0 = z_2 = w_1 = w_3 = 0$ (nonbasic variables are zero) and $z_3 = 2$, $w_2 = 1$, and $z_1 = 3$. In vector form $\mathbf{w} = (0, 1, 0)$ and $\mathbf{z} = (3, 0, 2)$. As required, $\mathbf{w} \circ \mathbf{z} = (0, 0, 0)$. ∎

Now we look at a more complicated problem in the context of the LCP, Example 7.1 solved earlier in this chapter.

EXAMPLE 7.3

We want to maximize $f(x_1, x_2) = x_1 + x_2$ with respect to the constraints $x_1 \geq 0$, $x_2 \geq 0$, $-x_1 + x_2 \leq 2$, $2x_1 - x_2 \leq -1$, and $3x_1 + x_2 \leq 3$. The vectors and matrices implied by this are

$$A = \begin{bmatrix} -1 & 1 \\ 2 & -1 \\ 3 & 1 \end{bmatrix}, \quad b = \begin{bmatrix} 2 \\ -1 \\ 3 \end{bmatrix}, \quad \text{and} \quad c = \begin{bmatrix} 1 \\ 1 \end{bmatrix}$$

Equation (7.6) makes the conversion to an LCP:

$$q = \begin{bmatrix} -1 \\ -1 \\ 2 \\ -1 \\ 3 \end{bmatrix}, \quad M = \begin{bmatrix} 0 & 0 & -1 & 2 & 3 \\ 0 & 0 & 1 & -1 & 1 \\ 1 & -1 & 0 & 0 & 0 \\ -2 & 1 & 0 & 0 & 0 \\ -3 & -1 & 0 & 0 & 0 \end{bmatrix}, \quad w = \begin{bmatrix} u_1 \\ u_2 \\ s_1 \\ s_2 \\ s_3 \end{bmatrix} = \begin{bmatrix} w_1 \\ w_2 \\ w_3 \\ w_4 \\ w_5 \end{bmatrix},$$

$$\text{and} \quad z = \begin{bmatrix} x_1 \\ x_2 \\ y_1 \\ y_2 \\ y_3 \end{bmatrix} = \begin{bmatrix} z_1 \\ z_2 \\ z_3 \\ z_4 \\ z_5 \end{bmatrix}$$

The initial dictionary with auxiliary variable z_0 is

$$w_1 = -1 + z_0 - z_3 + 2z_4 + 3z_5$$

$$w_2 = -1 + z_0 + z_3 - z_4 + z_5$$

$$w_3 = 2 + z_0 + z_1 - z_2$$

$$w_4 = -1 + z_0 - 2z_1 + z_2$$

$$w_5 = 3 + z_0 - 3z_1 - z_2$$

The first phase involves moving z_0 to the dictionary. We do so using the first equation, solve for z_0 (so w_1 leaves the dictionary), and substitute that expression into the other equations:

$$z_0 = 1 + w_1 + z_3 - 2z_4 - 3z_5$$

$$w_2 = 0 + w_1 + 2z_3 - 3z_4 - 2z_5$$

$$w_3 = 3 + w_1 + z_1 - z_2 + z_3 - 2z_4 - 3z_5$$

$$w_4 = 0 + w_1 - 2z_1 + z_2 + z_3 - 2z_4 - 3z_5$$

$$w_5 = 4 + w_1 - 3z_1 - z_2 + z_3 - 2z_4 - 3z_5$$

The new constant vector is $(1, 0, 3, 0, 4) \geq (0, 0, 0, 0, 0)$, so we have a feasible dictionary. Since all z_i for $i \geq 1$ are nonbasic, we have a balanced dictionary. The dictionary is not terminal since z_0 is still in it. The tableau method requires extra care when any

(Example 7.3 continued)

of the constant terms becomes zero. The Lemke algorithm is itself not exempt from the potential problems of zero constants as we will see.

The second phase is now initiated. The variable w_1 just left the dictionary, so its complementary variable z_1 must now enter the dictionary. We have three equations involving z_1 from which to choose one to solve for z_1, but only two have negative coefficients for z_1, the w_4 and w_5 equations. The limiting value for the ratio of the constant term and the negative of the z_1 coefficient comes from the w_4 equation, a ratio of 0 as compared to the ratio 4/3 for the w_5 equation. Solving the w_4 equation for z_1 and substituting into other equations:

$$z_0 = 1 + w_1 + z_3 - 2z_4 - 3z_5$$

$$w_2 = 0 + w_1 + 2z_3 - 3z_4 - 2z_5$$

$$w_3 = 3 + \frac{3}{2}w_1 - \frac{1}{2}w_4 - \frac{1}{2}z_2 + \frac{3}{2}z_3 - 3z_4 - \frac{9}{2}z_5$$

$$z_1 = 0 + \frac{1}{2}w_1 - \frac{1}{2}w_4 + \frac{1}{2}z_2 + \frac{1}{2}z_3 - z_4 - \frac{3}{2}z_5$$

$$w_5 = 4 - \frac{1}{2}w_1 + \frac{3}{2}w_4 - \frac{5}{2}z_2 - \frac{1}{2}z_3 + z_4 + \frac{3}{2}z_5$$

The variable w_4 left the dictionary, so its complementary variable z_4 must enter the dictionary, all the while maintaining a feasible, balanced dictionary. Four equations contain z_4 with a negative coefficient. Two of the equations lead to a limiting ratio of zero. Choosing the w_2 equation, solving for z_4, and substituting in other equations:

$$z_0 = 1 + \frac{1}{3}w_1 + \frac{2}{3}w_2 - \frac{1}{3}z_3 - \frac{5}{3}z_5$$

$$z_4 = 0 + \frac{1}{3}w_1 - \frac{1}{3}w_2 + \frac{2}{3}z_3 - \frac{2}{3}z_5$$

$$w_3 = 3 + \frac{1}{2}w_1 + w_2 - \frac{1}{2}w_4 - \frac{1}{2}z_2 - \frac{1}{2}z_3 - \frac{5}{2}z_5$$

$$z_1 = 0 + \frac{1}{6}w_1 + \frac{1}{3}w_2 - \frac{1}{2}w_4 + \frac{1}{2}z_2 - \frac{1}{6}z_3 - \frac{5}{6}z_5$$

$$w_5 = 4 - \frac{1}{6}w_1 - \frac{1}{3}w_2 + \frac{3}{2}w_4 - \frac{5}{2}z_2 + \frac{1}{6}z_3 + \frac{5}{6}z_5$$

The variable w_2 left the dictionary, so z_2 must enter the dictionary. As before we need to maintain a feasible and balanced dictionary. Two equations contain z_2 with a negative coefficient, the w_5 equation providing a limiting ratio of 8/5 whereas the w_3 equation has a ratio of 6. Solving the w_5 equation for z_2 and substituting in other equations:

$$z_0 = 1 + \frac{1}{3}w_1 + \frac{2}{3}w_2 - \frac{1}{3}z_3 - \frac{5}{3}z_5$$

$$z_4 = 0 + \frac{1}{3}w_1 - \frac{1}{3}w_2 + \frac{2}{3}z_3 - \frac{2}{3}z_5$$

$$w_3 = \frac{11}{5} + \frac{8}{15}w_1 + \frac{16}{15}w_2 - \frac{4}{5}w_4 + \frac{1}{5}w_5 - \frac{8}{15}z_3 - \frac{8}{3}z_5$$

$$z_1 = \frac{4}{5} + \frac{2}{15}w_1 + \frac{4}{15}w_2 - \frac{1}{5}w_4 - \frac{3}{15}w_5 - \frac{2}{15}z_3 - \frac{2}{3}z_5$$

$$z_2 = \frac{8}{5} - \frac{1}{15}w_1 - \frac{2}{15}w_2 + \frac{3}{5}w_4 - \frac{2}{5}w_5 + \frac{1}{15}z_3 + \frac{1}{3}z_5$$

The variable w_5 left the dictionary, so z_5 must enter the dictionary. Four equations contain z_5 with a negative coefficient. The limiting equation is the z_4 equation with a ratio of zero and must be solved for z_5. In doing so, we are now in a predicament. The variable z_4 leaves the dictionary and on the next step w_4 must enter the dictionary. But an earlier step saw us removing w_4 from the dictionary and adding z_4. Continuing along our present path, we will undo all the work we have done only to arrive back at the start. What we have is a *cycle* in the processing. This occurred due to the presence of a zero constant term. The problem occurred in the first phase; to move z_0 into the dictionary, we had multiple choices for the leaving variable, either choice forcing an equation to have a zero constant term. ▪

With our last example in mind, now is a good time to mention two potential problems that might be encountered when using the Lemke algorithm:

1. Cycling due to degeneracies.

2. The variable complementary to the leaving variable cannot enter the dictionary.

The term *degeneracy* refers to a constant term becoming zero. As we saw in Example 7.3, a zero constant term arises when there are multiple choices for the leaving variable. *Cycling* refers to removing a variable from the dictionary that was inserted at an earlier step. In Example 7.3, the cycling occurs because of a degeneracy—a constant term became zero. As it turns out, if we can modify the algorithm to prevent degeneracies, no cycling can occur.

7.2.2 ZERO CONSTANT TERMS

The classical method for handling degeneracies is to apply a *perturbation* to the constant terms. The kth constant term is modified (perturbed) by a power ε^k for some small $\varepsilon \in (0, 1)$. The value of ε is made so that the choice of leaving variable is unambiguous, thus never forcing zero constant terms to occur. The perturbed problem is solved using the Lemke algorithm. The final solution will be a continuous

function of ε, so we can evaluate the solution at $\varepsilon = 0$ (formally, take the limit as ε approaches zero) to obtain the solution to the original problem.

EXAMPLE 7.4

Maximize $f(x_1, x_2) = x_1 + x_2$ subject to the constraints $x_1 \geq 0$, $x_2 \geq 0$, and $x_1 + x_2 \leq 2$. The vectors and matrices implied by this are

$$A = [\,1 \quad 1\,], \qquad \mathbf{b} = [\,2\,], \quad \text{and} \quad \mathbf{c} = \begin{bmatrix} 1 \\ 1 \end{bmatrix}$$

Equation (7.6) makes the conversion to an LCP:

$$\mathbf{q} = \begin{bmatrix} -1 \\ -1 \\ 2 \end{bmatrix}, \quad M = \begin{bmatrix} 0 & 0 & 1 \\ 0 & 0 & 1 \\ -1 & -1 & 0 \end{bmatrix}, \quad \mathbf{w} = \begin{bmatrix} u_1 \\ u_2 \\ s_1 \end{bmatrix} = \begin{bmatrix} w_1 \\ w_2 \\ w_3 \end{bmatrix}, \quad \text{and}$$

$$\mathbf{z} = \begin{bmatrix} x_1 \\ x_2 \\ y_1 \end{bmatrix} = \begin{bmatrix} z_1 \\ z_2 \\ z_3 \end{bmatrix}$$

The initial dictionary with auxiliary variable z_0 is

$$w_1 = -1 + z_0 + z_3$$
$$w_2 = -1 + z_0 + z_3$$
$$w_3 = 2 + z_0 - z_1 - z_2$$

The limiting equations for moving z_0 to the dictionary are the w_1 and w_2 equations, an ambiguous choice. Solving the first leads to $z_0 = 1 - z_3 + w_1$. Replacing it in the second produces $w_2 = 0 + w_1$, a degeneracy.

Instead, add powers of a small number $\varepsilon \in (0, 1)$ to the constant terms:

$$w_1 = (-1 + \varepsilon) + z_0 + z_3$$
$$w_2 = (-1 + \varepsilon^2) + z_0 + z_3$$
$$w_3 = (2 + \varepsilon^3) + z_0 - z_1 - z_2$$

Since $\varepsilon^2 < \varepsilon$, we are forced to use the w_2 equation to solve for z_0. Do so and substitute in the other equations:

$$w_1 = (\varepsilon - \varepsilon^2) + w_2$$
$$z_0 = (1 - \varepsilon^2) + w_2 - z_3$$
$$w_3 = (3 + \varepsilon^3 - \varepsilon^2) + w_2 - z_1 - z_2 - z_3$$

Observe that the constant terms are all positive for small ε. The variable w_2 left the

dictionary, so z_2 must now enter the dictionary. The only equation containing z_2 is the w_3 equation:

$$w_1 = (\varepsilon - \varepsilon^2) + w_2$$

$$z_0 = (1 - \varepsilon^2) + w_2 - z_3$$

$$z_2 = (3 + \varepsilon^3 - \varepsilon^2) + w_2 - w_3 - z_1 - z_3$$

The variable w_3 left the dictionary, so z_3 must enter the dictionary. For small, positive ε, $1 - \varepsilon^2$ is smaller than $3 + \varepsilon^3 - \varepsilon^2$, so the limiting equation is the z_0 equation. Solve for z_3 and substitute in other equations:

$$w_1 = (\varepsilon - \varepsilon^2) + w_2$$

$$z_3 = (1 - \varepsilon^2) + w_2 - z_0$$

$$z_2 = (2 + \varepsilon^3) - w_3 + z_0 - z_1$$

Since z_0 has left the dictionary, the process ends and the dictionary is terminal. The solution to the LCP is $\mathbf{w} = (w_1, w_2, w_3) = (\varepsilon - \varepsilon^2, 0, 0)$ and $\mathbf{z} = (z_1, z_2, z_3) = (0, 2 + \varepsilon^3, 1 - \varepsilon^2)$. Clearly, $\mathbf{w} \circ \mathbf{z} = (0, 0, 0)$. This argument applies for arbitrarily small ε, so we may take the limit as ε approaches zero to obtain $\mathbf{w} = (0, 0, 0)$ and $\mathbf{z} = (0, 2, 1)$. Since $x_1 = z_1 = 0$ and $x_2 = z_2 = 2$, the solution to the original linear programming problem is $\max(f) = f(0, 2) = 2$. ■

In order to evaluate the perturbed solution at $\varepsilon = 0$, a numerical implementation of the Lemke algorithm must allow for the inclusion of ε symbolically. This can be done by maintaining a data structure that implements a polynomial in ε (stored as an array of coefficients), one structure for each equation in the dictionary. The constant term of the polynomial is the constant term of the equation. The higher-order polynomial terms represent the perturbation of the constant term. The implementation also maintains a variable that represents the current value of ε so that the perturbed constant term in the equation can be computed by evaluating the corresponding polynomial at ε. When a terminal dictionary is found, the solution to the original problem is obtained by setting the nonbasic variables to zero and the basic variables to the constant terms of the polynomials.

If no degeneracies occur during the algorithm, there can be no cycling. The proof of this uses an analogy—referred to as the *museum principle* in [Fri98]—to visiting a finite collection of rooms that have the following properties:

1. Each room is labeled "stop" or "continue."

2. All "continue" rooms have one or two doors.

3. If you reach a "stop" room, then your visiting stops.

4. If you reach a "continue" room with one door, then your visiting stops.

5. If you reach a "continue" room with two doors, then your visiting continues, but you must leave the room through the other door from which you entered.

The museum principle states that you will never enter a room twice; that is, your path of visitation does not have a cycle. This principle may be used to show that the second phase of the Lemke algorithm, in the absence of degeneracies, has no cycles and terminates in a finite number of steps.

The analogy is as follows. The feasible, balanced dictionaries are the rooms. Each door corresponds to the act of one variable entering the dictionary and another leaving. A room is labeled "stop" if it is a terminal dictionary. All other rooms are labeled "continue." Each "continue" room corresponds to a feasible, balanced dictionary with z_0 as a basic variable. The dictionary has exactly one pair of complementary variables, both of which are nonbasic. The "continue" room has at most two doors; each of the complementary variables can enter the dictionary in at most one way. Finally, the first phase of the Lemke algorithm produces a "continue" room that has exactly one door, and this is the room in which you start the visitation. To see that there is only one door, consider that z_0 enters the dictionary and a basic variable w_i leaves the dictionary, the choice of w_i made so that the constant terms of the equations are nonnegative. Because we have assumed that there are no degeneracies, there can be only one such w_i. The corresponding equation is solved for z_0 and the w_i term shows up as a nonbasic variable that has a positive coefficient (with value 1). Substituting the z_0 into all other equations, w_i shows up with a positive coefficient (with value 1) in every case. Because all the w_i coefficients are positive and the constant terms are nonnegative, w_i cannot reenter the dictionary. For if you were to solve for w_i, the constant term on the right-hand side would be a negative number, contradicting the fact the invariant of each step is that the dictionary is feasible. Thus, there is no door in which w_i can enter the room, in which case the room has one door (corresponding to z_i entering the dictionary). The rooms satisfy the conditions of the museum principle, and the Lemke algorthm cannot cycle.

7.2.3 THE COMPLEMENTARY VARIABLE CANNOT LEAVE THE DICTIONARY

Degeneracies are one problem with the method of solving an LCP, but the perturbation method discussed earlier circumvents the problems. Another problem with the method is that at some point the variable complementary to the leaving variable cannot enter the dictionary, in which case you cannot proceed with the algorithm.

EXAMPLE 7.5

Maximize $f(x_1, x_2) = 2x_1 + x_2$ subject to the constraints $x_1 \geq 0$, $x_2 \geq 0$, and $-x_1 - x_2 \leq -1$. The initial dictionary with auxiliary variable z_0 is

$$w_1 = -2 + z_0 - z_3$$

$$w_2 = -1 + z_0 - z_3$$

$$w_3 = -1 + z_0 + z_1 + z_2$$

The first phase is to move z_0 into the dictionary by solving the first equation, $z_0 = 2 + w_1 + z_3$, and substituting into the other equations:

$$z_0 = 2 + w_1 + z_3$$

$$w_2 = 1 + w_1$$

$$w_3 = 1 + w_1 + z_1 + z_2 + z_3$$

The variable w_1 left the dictionary, so z_1 must enter it. The only equation containing z_1 is the last, but the coefficient of z_1 is positive. In solving for z_1 we would obtain a negative constant term, violating the feasibility of the dictionary. Therefore, z_1 cannot enter the dictionary. ▪

A sketch of the convex domain defined by the constraints shows us what the problem is. The domain is unbounded, so in fact f is unbounded and has no maximum. The linear programming problem has no solution. Some general statements can be made about the matrix M in the LCP regarding the inability for the complementary variable to enter the dictionary.

First, some definitions. The matrix M is said to be *copositive* if $\mathbf{x}^T M \mathbf{x} \geq 0$ for all $\mathbf{x} \geq \mathbf{0}$. M is said to be *copositive-plus* if (1) it is copositive and (2) $\mathbf{x} \geq \mathbf{0}$, $M\mathbf{x} \geq \mathbf{0}$, and $\mathbf{x}^T M \mathbf{x} = \mathbf{0}$ imply $(M + M^T)\mathbf{x} = \mathbf{0}$. Recall from linear algebra that a matrix M is said to be positive-semidefinite if M is symmetric and $\mathbf{x}^T M \mathbf{x} \geq \mathbf{0}$ for all \mathbf{x}. In contrast, a copositive matrix is not required to be symmetric and the vectors for which we require $\mathbf{x}^T M \mathbf{x} \geq 0$ are only those whose components are all nonnegative.

A simple fact to verify is that the matrix M that comes from complementary slackness and is shown in equation (7.6) is copositive. For any skew-symmetric matrix M, it is the case that $\mathbf{z}^T M \mathbf{z} = 0$. Setting $M = [m_{ij}]$ and $\mathbf{z} = [z_i]$:

$$\mathbf{z}^T M \mathbf{z} = \sum_{i=1}^{n} \sum_{j=1}^{n} z_i m_{ij} z_j$$

$$= \sum_{i<j} z_i m_{ij} z_j + \sum_{i=j} z_i m_{ij} z_j + \sum_{i>j} z_i m_{ij} z_j$$

$$= \sum_{i<j} z_i m_{ij} z_j + 0 - \sum_{i>j} z_i m_{ji} z_j, \qquad \text{Skew symmetry means } m_{ij} = -m_{ji}$$

$$= \sum_{i<j} z_i m_{ij} z_j + 0 - \sum_{j>i} z_i m_{ij} z_j, \qquad \text{Swapping names } i \text{ and } j \text{ in the last summation}$$

$$= 0$$

This is true for all \mathbf{z}, so it is true for $\mathbf{z} \geq \mathbf{0}$. Thus, a skew-symmetric matrix is copositive. M in equation (7.6) is skew-symmetric, therefore copositive.

The main result of this section is

Let M be copositive. If the Lemke algorithm reaches the stage where a complementary variable cannot leave the dictionary, then the linear complementarity problem has no solution.

The proof is somewhat tedious and not presented here. The consequence of the linear complementarity problem regarding a numerical implementation is that when you reach a stage where the complementary variable cannot leave the solution, the program terminates and reports to the caller that the LCP has no solution.

7.3 MATHEMATICAL PROGRAMMING

Now that we have a good understanding of linear programming, I will briefly discuss a generalization called *mathematical programming* (MP). The goal is to minimize $f(\mathbf{x})$ subject to the constraints $\mathbf{g}(\mathbf{x}) \leq \mathbf{0}$, where $f : \mathbb{R}^n \to \mathbb{R}$, the *objective function*, and $\mathbf{g} : \mathbb{R}^n \to \mathbb{R}^m$, the *constraining functions*, are arbitrary functions. The convention used in the mathematical programming is that the objective function is to be minimized. If an application requires maximizing f, you can minimize instead the function $-f$.

Here is some further terminology that will be used later. A point \mathbf{x} satisfying the constraints $\mathbf{g}(\mathbf{x}) \leq \mathbf{0}$ is said to be a *feasible point*. If $g_i(\mathbf{x}) = 0$ for some i, we say that g_i is *active* at \mathbf{x}.

EXAMPLE
7.6

The linear programming problem can be rephrased as a mathematical programming problem. The original problem is to maximize $\mathbf{c}^{\mathrm{T}}\mathbf{x}$ subject to $\mathbf{x} \geq \mathbf{0}$ and $A\mathbf{x} \leq \mathbf{b}$. As a mathematical programming problem, the objective function is $f(\mathbf{x}) = -\mathbf{c}^{\mathrm{T}}\mathbf{x}$, we want to minimize f, and the constraints are combined into $\mathbf{g}(\mathbf{x}) \leq \mathbf{0}$ as

$$\mathbf{g}(\mathbf{x}) = \begin{bmatrix} A\mathbf{x} - \mathbf{b} \\ -\mathbf{x} \end{bmatrix}$$

In this case f is a linear function and \mathbf{g} is an affine function. ▪

EXAMPLE
7.7

You are given a set of points $\{(x_i, y_i)\}_{i=1}^n$ with at least three noncollinear points. Let (x_0, y_0) be the average of the points. Compute the minimum area, axis-aligned ellipse centered at the average that contains all the points.

The average is $(x_0, y_0) = (\sum_{i=1}^n (x_i, y_i))/n$. The axis-aligned ellipse centered at the average is of the form,

$$\left(\frac{x - x_0}{a}\right)^2 + \left(\frac{y - y_0}{b}\right)^2 = 1$$

where $a > 0$ and $b > 0$ are the half-lengths of the ellipse axes. The area of the ellipse is

$$A = \pi ab$$

We want to minimize the area and have all points contained in the ellipse. The containment leads to the constraints

$$\left(\frac{x_i - x_0}{a}\right)^2 + \left(\frac{y_i - y_0}{b}\right)^2 \le 1, \quad 1 \le i \le n$$

In terms of the notation of mathematical programming, the variables are a and b, the objective function is $f(a, b) = \pi ab$, and the constraint functions are $\mathbf{g}(a, b) = (g_1(a, b), \ldots, g_n(a, b), g_{n+1}(a, b), g_{n+2}(a, b))$, where $g_i(a, b) = ((x_i - x_0)/a)^2 + ((y_i - y_0)/b)^2 - 1$, $g_{n+1}(a, b) = -a$, and $g_{n+2}(a, b) = -b$. Both f and \mathbf{g} are nonlinear functions.

The problem can be equivalently formulated in a manner that makes \mathbf{g} an affine function, potentially making the solution a bit easier to construct. Instead of variables a and b, let us choose $u = 1/a^2$ and $v = 1/b^2$. The constraint functions are $g_i(u, v) = (x_i - x_0)^2 u + (y_i - y_0)^2 v - 1$ for $1 \le i \le n$, $g_{n+1}(u, v) = -u$, and $g_{n+2}(u, v) = -v$, all affine functions of u and v. The objective function is $f(u, v) = \pi/\sqrt{uv}$. The uv-domain implied by $\mathbf{g}(u, v) \le \mathbf{0}$ is a bounded region whose boundary is a convex polygon. The graph of f is shown in Figure 7.5. Even though f is nonlinear, the figure should convince you that the minimum must occur on the polygon boundary (not necessarily at a vertex).

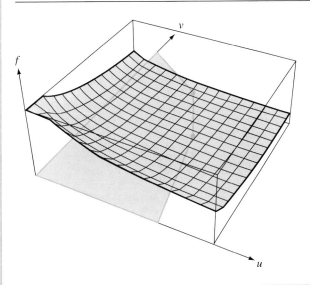

Figure 7.5 Graph of $f(u, v) = \pi/\sqrt{uv}$ in the first quadrant.

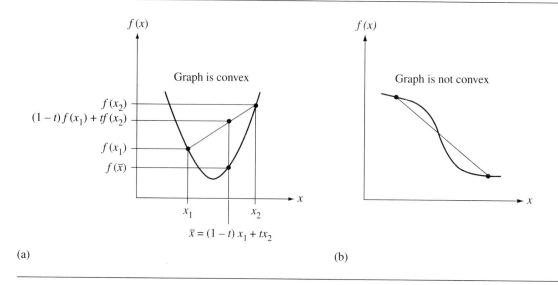

(a) (b)

Figure 7.6 (a) The graph of a convex function. Any line segment connecting two graph points is always above the graph. (b) The graph of a nonconvex function. The line segment connecting two graph points is not always above the graph.

Two categories of mathematical programming problems are of interest to us. The first is called *quadratic programming*. The objective function has a quadratic term in addition to the linear term that appears in the linear programming problem. The constant term is omitted here since f can be minimized without it, then that constant added back in to the result. The function is

$$f(\mathbf{x}) = \mathbf{x}^\mathrm{T} S \mathbf{x} - \mathbf{c}^\mathrm{T} \mathbf{x} \tag{7.7}$$

where S is a symmetric matrix. The constraint functions are still of the form used in linear programming, $\mathbf{g}(\mathbf{x}) = (A\mathbf{x} - \mathbf{b}, -\mathbf{x}) \le \mathbf{0}$.

The second category is *convex programming* and involves objective functions that are *convex functions*. A function $f(\mathbf{x})$ is said to be *convex* if its domain is a convex set and if

$$f((1 - t)\mathbf{x} + t\mathbf{y}) \le (1 - t)f(\mathbf{x}) + tf(\mathbf{y}) \tag{7.8}$$

for all $t \in [0, 1]$ and for all \mathbf{x} and \mathbf{y} in the domain of the function. Since the domain of f is a convex set, $(1 - t)\mathbf{x} + t\mathbf{y}$ is guaranteed to be in the domain for any $t \in [0, 1]$. Thus, the left-hand side of the inequality equation (7.8) is well defined since the input to f is in its domain. Figure 7.6 illustrates the graphs of a convex function and a nonconvex function of one variable.

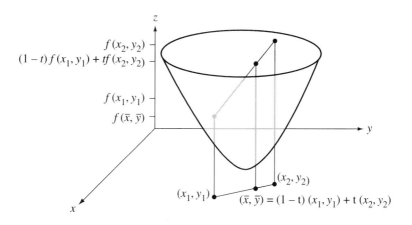

Figure 7.7 The graph of a convex function $f(x, y)$.

Visually, convexity means that any line segment connecting two points on the graph of the function must always lie above the graph. If $f(x)$ has a continuous second-order derivative, it is a convex function when $f''(x) \geq 0$. Figure 7.7 illustrates the graph of a convex function of two variables.

A line segment connecting any two points on the graph of the function must always lie above the graph. Generally, if $f(\mathbf{x})$ for $\mathbf{x} \in \mathbb{R}^n$ has continuous second-order partial derivatives, it is a convex function when the matrix of second-order partial derivatives is positive-semidefinite (the eigenvalues are all nonnegative).

In Example 7.7, the second formulation of the problem that has affine constraints in u and v is both a quadratic programming and a convex programming problem. That is, the objective function is a convex and quadratic function and the constraints are affine.

7.3.1 KARUSH-KUHN-TUCKER CONDITIONS

In calculus we have the concept of a local minimum of a function. If $f(\mathbf{x})$ is the function and \mathbf{x}_0 is a point for which $f(\mathbf{x}) \geq f(\mathbf{x}_0)$ for all \mathbf{x} sufficiently close to \mathbf{x}_0, then \mathbf{x}_0 is referred to as a *local minimum for* f. In mathematical programming a similar concept can be defined. A point \mathbf{x}_0 is a *constrained local minimum* if $f(\mathbf{x}) \geq f(\mathbf{x}_0)$ for all *feasible* \mathbf{x} sufficiently close to \mathbf{x}_0. That is, \mathbf{x} must be close to \mathbf{x}_0 and $\mathbf{g}(\mathbf{x}) \leq \mathbf{0}$. We will assume from here on that both f and \mathbf{g} are differentiable functions. The constraint function is stored as an $m \times 1$ column vector. The gradient of $f(\mathbf{x})$, denoted $\nabla f(\mathbf{x})$, is stored as a $1 \times n$ row vector. The derivative matrix of $\mathbf{g}(\mathbf{x})$, denoted

$D\mathbf{g}(\mathbf{x})$, is stored as an $m \times n$ matrix. The ith row corresponds to the gradient of the ith component, $\nabla g_i(\mathbf{x})$.

An important result for mathematical programming is stated here without proof: If \mathbf{x}_0 is a constrained local minimum for the MP problem, then there exists nonnegative u_i for $0 \le i \le m$, such that

$$u_0 \nabla f(\mathbf{x}_0) + \sum_{i=1}^{m} u_i \nabla g_i(\mathbf{x}_i) = \mathbf{0} \tag{7.9}$$

and such that $u_i = 0$ whenever $g_i(\mathbf{x}_i) < 0$. The left-hand side of equation (7.9) is effectively a summation over active constraints since the u_i are zero for inactive constraints. If the constraints of the MP problem are allowed to include equality constraints, equation (7.9) is still valid, except that the u_i for an equality constraint is allowed to be negative. By making this minor adjustment, the generalized result stated above includes the classical theory of Lagrange multipliers. One final observation: If $u_0 = 0$, equation (7.9) contains information only about the constraint functions and nothing about f. In most applications of interest, information about f allows us to choose $u_0 = 1$.

A feasible \mathbf{x} that satisfies equation (7.9) with $u_0 = 1$, the other u_i as specified in that equation, is said to be a *Karush-Kuhn-Tucker point*, or *KKT point* for short. The conditions for being a KKT point are summarized in vector notation:

$$\mathbf{g}(\mathbf{x}) \le \mathbf{0}, \qquad \nabla f(\mathbf{x}) + \mathbf{u}^{\mathrm{T}} D\mathbf{g}(\mathbf{x}) = \mathbf{0} \quad \text{for } \mathbf{u} \ge \mathbf{0}, \quad \text{and} \quad \mathbf{u} \circ \mathbf{g}(\mathbf{x}) = \mathbf{0} \tag{7.10}$$

where \mathbf{u} is the $m \times 1$ vector whose components are u_1 through u_m mentioned in equation (7.9). Notice that the last expression of equation (7.10) is a complementarity condition.

Recall from calculus that the candidates for minimizing a differentiable function $f(x)$ on an interval $[a, b]$ are those points for which $f'(x) = 0$ and the end points $x = a$ and $x = b$. These points were named *critical points*. For a multivariate differentiable function $f(\mathbf{x})$ defined on a closed and bounded domain, the critical points are those for which $\nabla f(\mathbf{x}) = \mathbf{0}$ and boundary points of the domain. The KKT points are the analogy of critical points in the realm of mathematical programming. Specifically, a constrained local minimum of the MP problem must be a KKT point when the constraints are any of the following types:

1. The constraint function is affine, $\mathbf{g}(\mathbf{x}) = M\mathbf{x} + \mathbf{t}$ for a matrix M and vector \mathbf{t}.

2. The constraint components $g_i(\mathbf{x})$ are convex functions and there is at least one feasible \mathbf{x} at which all constraints are inactive.

3. For any feasible \mathbf{x}, the vectors $\nabla g_i(\mathbf{x})$ are linearly independent.

EXAMPLE
7.8

The linear programming problem is to minimize $f(\mathbf{x}) = -\mathbf{c}^T\mathbf{x}$ subject to $\mathbf{g}(\mathbf{x}) = (A\mathbf{x} - \mathbf{b}, -\mathbf{x}) \leq \mathbf{0}$. The three KKT conditions for this problem are as follows.

The first condition is $\mathbf{g}(\mathbf{x}) \leq \mathbf{0}$, which simply states that \mathbf{x} is feasible.

The second condition is

$$0 = \nabla f(\mathbf{x}) + \mathbf{u}^T D\mathbf{g}(\mathbf{x}) = -\mathbf{c}^T + \mathbf{u}^T \begin{bmatrix} A \\ -I \end{bmatrix}$$

where I is the identity matrix of the appropriate size. Partitioning \mathbf{u} into two blocks of the appropriate sizes, $\mathbf{u} = (\mathbf{u}_d, \mathbf{u}_s)$, the last displayed equation is equivalent to

$$\mathbf{u}_s = -\mathbf{c} + A^T\mathbf{u}_d$$

That is, \mathbf{u}_s are the slack variables for the primal problem and \mathbf{u}_d are the regular variables for the dual problem. The condition $\mathbf{u} \geq \mathbf{0}$ is a statement of dual feasibility.

Using the same block decomposition of \mathbf{u} just described, the third condition is

$$0 = \mathbf{u} \circ \mathbf{g}(\mathbf{x}) = (\mathbf{u}_d, \mathbf{u}_s) \circ (A\mathbf{x} - \mathbf{b}, -\mathbf{x})$$

or $\mathbf{u}_d \circ (A\mathbf{x} - \mathbf{b}) = \mathbf{0}$ and $\mathbf{u}_s \circ \mathbf{x} = \mathbf{0}$, just statements of complementary slackness. ■

7.3.2 CONVEX QUADRATIC PROGRAMMING

The quadratic programming problem is to minimize $f(\mathbf{x}) = \mathbf{x}^T S\mathbf{x} - \mathbf{c}^T\mathbf{x} + K$ for a constant symmetric matrix S, a constant vector \mathbf{c}, and a constant scalar K, subject to $\mathbf{g}(\mathbf{x}) = (A\mathbf{x} - \mathbf{b}, -\mathbf{x}) \leq \mathbf{0}$. We additionally want f to be a convex function; it is sufficient to require S to be positive-semidefinite.

The first KKT condition is a statement of feasibility: $A\mathbf{x} \leq \mathbf{b}$ and $\mathbf{x} \geq 0$. The second KKT condition is

$$0 = \nabla f(\mathbf{x}) + \mathbf{u}^T D\mathbf{g}(\mathbf{x}) = 2\mathbf{x}^T S - \mathbf{c}^T + \mathbf{u}^T \begin{bmatrix} A \\ -I \end{bmatrix}$$

Using the decomposition of $\mathbf{u} = (\mathbf{u}_d, \mathbf{u}_2)$ as in the linear programming problem, the last equation implies

$$\mathbf{u}_s = -\mathbf{x} + 2S\mathbf{x} + A^T\mathbf{u}_d \tag{7.11}$$

and is called the *dual slack* equation. The third KKT condition is the same as in the linear programming problem,

$$\mathbf{u}_d \circ (A\mathbf{x} - \mathbf{b}) = \mathbf{0} \quad \text{and} \quad \mathbf{u}_s \circ \mathbf{x} = \mathbf{0} \tag{7.12}$$

and is called *complementary slackness*.

These conditions allow us to reformulate the quadratic programming problem as a linear complementarity problem,

$$\mathbf{w} = \mathbf{q} + M\mathbf{z}, \quad \mathbf{w} \circ \mathbf{z} = 0, \quad \mathbf{w} \geq \mathbf{0}, \quad \mathbf{z} \geq \mathbf{0}$$

where

$$\mathbf{x}_s = \mathbf{b} - A\mathbf{x}, \quad \mathbf{q} = \begin{bmatrix} -\mathbf{c} \\ \mathbf{b} \end{bmatrix}, \quad M = \begin{bmatrix} 2S & A^{\mathrm{T}} \\ -A & 0 \end{bmatrix}, \quad \mathbf{w} = \begin{bmatrix} \mathbf{u}_s \\ \mathbf{x}_s \end{bmatrix}, \quad \mathbf{z} = \begin{bmatrix} \mathbf{x} \\ \mathbf{u}_d \end{bmatrix}$$

Moreover, the matrix M is positive-semidefinite. To see this,

$$\mathbf{z}^{\mathrm{T}} M \mathbf{z} = \mathbf{z}^{\mathrm{T}} \begin{bmatrix} 2S & A^{\mathrm{T}} \\ -A & 0 \end{bmatrix} \mathbf{z} + \mathbf{z}^{\mathrm{T}} \begin{bmatrix} 0 & A^{\mathrm{T}} \\ -A & 0 \end{bmatrix} \mathbf{z} = \mathbf{z}^{\mathrm{T}} \begin{bmatrix} 2S & 0 \\ 0 & 0 \end{bmatrix} \mathbf{z}$$

where the last equality is valid since the matrix involving just A and $-A$ is skew-symmetric, causing its quadratic form to be zero. The last matrix in the equations is positive-semidefinite since S is positive-semidefinite. The lower right-hand zero block only introduces zero eigenvalues in the larger matrix. As a result, M is also copositive-plus, which means that the Lemke algorithm may be applied, using a perturbation if necessary to eliminate degeneracies, and allowing for proper termination either because a solution is found or because a complementary variable could not leave the dictionary, in which case f has no minimum.

Because the linear complementarity problem is just a reformulated set of KKT conditions, any solution to it must be a KKT point. The additional assumption of convexity allows us to use the following result: If f and g_1 through g_m are convex functions, then any KKT point for the MP problem must be a global minimum.

In summary, the solution to a convex quadratic programming problem may be constructed by solving the corresponding linear complementarity problem using the Lemke algorithm. That algorithm will properly terminate and produce either a minimum for f or indicate that f has no minimum. Since f is convex and the affine constraints are convex, the minimum found by the algorithm must be the global minimum of f.

EXAMPLE 7.9

A solid triangle has vertices $(0, 0)$, $(1, 0)$, and $(0, 1)$. Compute the closest triangle point to $(1, 2)$. A sketch of the triangle and point will convince you that the closest point is on the edge connecting $(1, 0)$ and $(0, 1)$. Although you can use a simple geometric argument to construct the closest point, we will solve this as a convex quadratic programming problem.

We must minimize the squared distance $(x_1 - 1)^2 + (x_2 - 2)^2 = x_1^2 + x_2^2 - 2x_1 - 4x_2 + 5$, where (x_1, x_2) is any point in the solid triangle. We can ignore the constant term and equivalently minimize $f(x_1, x_2) = x_1^2 + x_2^2 - 2x_1 - 4x_2$. The interior of the triangle is the intersection of half planes: $x_1 \geq 0$, $x_2 \geq 0$ and $x_1 + x_2 \leq 1$. The

quantities of interest in the quadratic programming problem are

$$S = \begin{bmatrix} 1 & 0 \\ 0 & 1 \end{bmatrix}, \quad \mathbf{c} = \begin{bmatrix} 2 \\ 4 \end{bmatrix}, \quad A = [\,1 \quad 1\,], \quad \text{and} \quad \mathbf{b} = [1]$$

The quantities of interest in the linear complementarity problem are

$$M = \left[\begin{array}{cc|c} 2 & 0 & 1 \\ 0 & 2 & 1 \\ \hline -1 & -1 & 0 \end{array} \right] \quad \text{and} \quad \mathbf{q} = \begin{bmatrix} -2 \\ -4 \\ \hline 1 \end{bmatrix}$$

The initial modified dictionary is

$$w_1 = -2 + z_0 + 2z_1 + z_3$$
$$w_2 = -4 + z_0 + 2z_2 + z_3$$
$$w_3 = 1 + z_0 - z_1 - z_2$$

In the first phase z_0 enters the dictionary and w_2 leaves the dictionary,

$$w_1 = 2 + w_2 + 2z_1 - 2z_2$$
$$z_0 = 4 + w_2 - 2z_2 - z_3$$
$$w_3 = 5 + w_2 - z_1 - 3z_2 - z_3$$

Since w_2 left the dictionary, z_2 must enter it. The limiting equation is the w_1 equation, so solve that equation for z_2 and substitute in the others:

$$z_2 = 1 - \frac{1}{2}w_1 + \frac{1}{2}w_2 + z_1$$
$$z_0 = 2 + w_1 - 2z_1 - z_3$$
$$w_3 = 2 + \frac{3}{2}w_1 - \frac{1}{2}w_2 - 4z_1 - z_3$$

Since w_1 left the dictionary, z_1 must enter it. The limiting equation is the w_3 equation, so solve that equation for z_1 and substitute in the others:

$$z_2 = \frac{3}{2} - \frac{1}{8}w_1 + \frac{3}{8}w_2 - \frac{1}{4}w_3 - \frac{1}{4}z_3$$
$$z_0 = 1 + \frac{1}{4}w_1 + \frac{1}{4}w_2 + \frac{1}{2}w_3 - \frac{1}{2}z_3$$
$$z_1 = \frac{1}{2} + \frac{3}{8}w_1 - \frac{1}{8}w_2 - \frac{1}{4}w_3 - \frac{1}{4}z_3$$

(*Example 7.9
continued*)

Finally, w_3 left, so z_3 must enter. Two equations are limiting, the z_0 and z_1 equations. No need to apply a perturbation here. We know that cycling should not occur, so solve the z_0 equation for z_3 and substitute:

$$z_2 = 1 - \frac{1}{4}w_1 + \frac{1}{4}w_2 - \frac{1}{2}w_3 + \frac{1}{2}z_0$$

$$z_3 = 2 + \frac{1}{2}w_1 + \frac{1}{2}w_2 + w_3 - 2z_0$$

$$z_1 = 0 + \frac{1}{4}w_1 - \frac{1}{4}w_2 - \frac{1}{2}w_3 + \frac{1}{2}z_0$$

The solution is $\mathbf{w} = (w_1, w_2, w_3) = (0, 0, 0)$ and $\mathbf{z} = (z_1, z_2, z_3) = (0, 1, 2)$. In terms of the original variables, $x_1 = z_1 = 0$ and $x_2 = z_2 = 1$. The closest point on the triangle to $(1, 2)$ is the vertex $(0, 1)$. ■

7.3.3　GENERAL DUALITY THEORY

The linear programming problem was referred to as the primal problem. We discovered an equivalent problem, called the dual problem. The mathematical programming problem has a similar concept of duality. The *primal MP problem* is

Minimize $f(\mathbf{x})$ subject to $\mathbf{g}(\mathbf{x}) \leq \mathbf{0}$

Define $h(\mathbf{x}, \mathbf{u}) = f(\mathbf{x}) + \mathbf{u}^T\mathbf{g}(\mathbf{x})$. Notice that the (row) vector of derivatives of L with respect to \mathbf{x}, denoted $\partial h/\partial \mathbf{x}$, is $\partial h/\partial \mathbf{x} = \nabla f(\mathbf{x}) + \mathbf{u}^T D\mathbf{g}(\mathbf{x})$, exactly the expression that appears in the second KKT condition. Define the *Lagrangian function,*

$$L(\mathbf{u}) = \min_{\mathbf{x} \in \mathbb{R}^n} h(\mathbf{x}, \mathbf{u})$$

The *dual MP problem* is

Maximize $L(\mathbf{u})$ subject to $\mathbf{u} \geq \mathbf{0}$

If $\min(f)$ is the minimum of the primal problem and $\max(L)$ is the maximum of the dual problem, then it is the case that $\max(L) \leq \min(f)$. The difference $\min(f) - \max(L)$ is called the *duality gap*. For the linear programming problem we saw that the duality gap is zero.

We had used the terminology that \mathbf{x} is feasible if $\mathbf{g}(\mathbf{x}) \leq \mathbf{0}$. Similarly, we say that \mathbf{u} is *feasible* for the dual problem if $\mathbf{u} \geq 0$. Results similar to the strong duality principle for linear programming are the following:

1. If there are feasible vectors \mathbf{x} and \mathbf{u} such that $L(\mathbf{u}) = f(\mathbf{x})$, then \mathbf{x} is an optimal solution to the primal problem.

2. If there are feasible vectors \mathbf{x} and \mathbf{u} such that $f(\mathbf{x}) + \mathbf{u}^T\mathbf{g}(\mathbf{x}) = L(\mathbf{u})$ and $\mathbf{u} \circ \mathbf{g}(\mathbf{x}) = \mathbf{0}$, then \mathbf{x} is an optimal solution to the primal problem.

In either case, the duality gap is zero.

7.4 APPLICATIONS

A few applications of LCP methods are presented here. The first subsection includes distance calculations between a point and a convex polygon, a point and a convex polyhedron, two convex polygons, and two convex polyhedra. The second subsection is a brief summary of how one goes about computing impulsive forces and resting contact forces at points of contact between two rigid bodies represented as convex polyhedra.

7.4.1 DISTANCE CALCULATIONS

The origin of the coordinate system in any of these applications is always chosen to be $\mathbf{0}$. The distinction between point and vector is not necessary in this situation, so all quantities are typeset using vector notation.

Distance Between Point and Convex Polygon

Let \mathbf{V}_i for $0 \leq i \leq n - 1$ be the counterclockwise-ordered vertices for a convex polygon. The vertices may occur anywhere in the plane, but to support distance calculations using LCP methods, we require that all the vertices lie in the first quadrant. If the polygon is not in the first quadrant, it is always possible to place it there by a translation of all vertices. Let \mathbf{P} be a point that is outside the polygon. We wish to compute the distance between the point and the polygon.

In order to apply LCP methods to solve this problem, we need to formulate it in terms of convex quadratic programming as discussed in Section 7.3.2. The objective function must be of the form $f(\mathbf{x}) = \mathbf{x}^T S\mathbf{x} - \mathbf{c}^T\mathbf{x} + K$, where S is a positive-semidefinite matrix. The constraints are of the form $A\mathbf{x} \leq \mathbf{b}$ and $\mathbf{x} \geq \mathbf{0}$. The objective function is simple enough to construct. The vector \mathbf{x} is a point that is inside the polygon (includes points on the boundary). We want to choose \mathbf{x} to minimize the squared distance,

$$f(\mathbf{x}) = |\mathbf{x} - \mathbf{P}|^2 = \mathbf{x}^T I\mathbf{x} - 2\mathbf{P}^T\mathbf{x} + |\mathbf{P}|^2$$

where I is the 2×2 identity matrix. Clearly, we should choose $S = I$, which is positive-definite, $\mathbf{c} = 2\mathbf{P}$, and $K = |\mathbf{P}|^2$. Since the polygon vertices are in the first quadrant, we know that $\mathbf{x} \geq \mathbf{0}$.

The remaining constraints occur because \mathbf{x} must be inside the polygon. If \mathbf{N}_i is an outer normal to the polygon edge with direction $\mathbf{V}_{i+1} - \mathbf{V}_i$, then \mathbf{x} is inside the polygon whenever $\mathbf{N}_i \cdot (\mathbf{x} - \mathbf{V}_i) \leq 0$ for all i. The matrix A in the constraints is created by selecting row i to be $\mathbf{N}_i^{\mathrm{T}}$. The vector \mathbf{b} in the constraints is created by selecting row i to be $\mathbf{N}_i \cdot \mathbf{V}_i$.

The conversion to an LCP of the form $\mathbf{w} = \mathbf{q} + M\mathbf{z}$ with $\mathbf{w} \geq \mathbf{0}$, $\mathbf{z} \geq \mathbf{0}$, and $\mathbf{w} \circ \mathbf{z} = \mathbf{0}$ was discussed earlier. We choose inputs

$$M = \left[\begin{array}{c|c} 2S & A^{\mathrm{T}} \\ \hline -A & 0 \end{array} \right], \qquad \mathbf{q} = \left[\begin{array}{c} -\mathbf{c} \\ \hline \mathbf{b} \end{array} \right]$$

The output \mathbf{w} is not important for this application, but the other output is $\mathbf{z} = [\mathbf{x} \,|\, \mathbf{u}_d]^{\mathrm{T}}$. We need only the first block \mathbf{x} of the output, which corresponds to the closest point of the polygon to \mathbf{P}.

Pseudocode for computing the distance from \mathbf{P} to the polygon is listed below. The convex polygon object has an array of vertices denoted vertex.

```
double Distance (vector P, ConvexPolygon C)
{
    int n = C.vertex.size();

    // translate to first quadrant (if necessary)
    vector min = C.vertex[0];
    for (i = 1; i < n; i++)
    {
        if ( C.vertex[i].x < min.x )
            min.x = C.vertex[i].x;
        if ( C.vertex[i].y < min.y )
            min.y = C.vertex[i].y;
    }
    if ( min.x < 0 || min.y < 0 )
    {
        P -= min;
        for (i = 0; i < n; i++)
            C.vertex[i] -= min;
    }

    // compute coefficients of objective function
    matrix S[2][2] = identity_2;  // the 2-by-2 identity matrix
    vector c = 2.0*P;
    // double K = Dot(P,P);  not needed in the code

    // compute constraint matrix and vector
    matrix A[n][2];
```

```
        vector b[n];
        for (i0 = n-1, i1 = 0; i1 < n; i0 = i1++)
        {
            vector normal = Perp(C.vertex[i1]-C.vertex[i0]);
            A[i1][0] = normal.x;
            A[i1][1] = normal.y;
            b[i1] = Dot(normal,C.vertex[i0]);
        }

        // compute inputs for LCP solver
        matrix M[n+2][n+2] = Block(2*S,Transpose(A),-A,zero_nxn);
        vector q[n+2] = Block(-c,b);

        // compute outputs
        vector w[n+2], z[n+2];
        LCPSolver(M,q,w,z);

        // compute closest point and distance to P
        vector closest(z[0],z[1]);
        return sqrt(Dot(closest-P,closest-P));
    }
}

// The parameter names match those in the section discussing LCP
// where w = q + Mz.  The inputs are the matrix M and the vector
// q.  The outputs are the vectors w and z.
void LCPSolver (Matrix M, Vector q, Vector& w, Vector& z);
```

The function Perp takes a vector (x, y) and returns $(y, -x)$. We also assume an implementation of an LCP solver of the form shown in the pseudocode. An actual implementation for an LCP solver is on the CD-ROM.

Distance Between Point and Convex Polyhedron

This problem is nearly identical in formulation to the one for computing the distance from a point to a convex polygon. The convex polyhedron must be translated to the first octant if it is not already located there. The polyhedron is made up of a collection of n faces. The only information we need from the polyhedron for the setup is for face i, a vertex \mathbf{V}_i, and an outer normal \mathbf{F}_i for that face. If the query point is \mathbf{P}, the objective function is still $f(\mathbf{x}) = |\mathbf{x} - \mathbf{P}|^2 = \mathbf{x}^T I \mathbf{x} - 2\mathbf{P}^T \mathbf{x} + |\mathbf{P}|^2$, where \mathbf{x} is a point inside the polyhedron. Because we have required the polyhedron to be in the first octant, we know that $\mathbf{x} \geq \mathbf{0}$. The constraint matrix A is $n \times 3$ with the transpose of the face normal \mathbf{N}_i^T as its ith row. The constraint vector \mathbf{b} is $n \times 1$ with ith row given by $\mathbf{N}_i \cdot \mathbf{V}_i$.

The conversion to an LCP of the form $\mathbf{w} = \mathbf{q} + M\mathbf{z}$ with $\mathbf{w} \geq \mathbf{0}$, $\mathbf{z} \geq \mathbf{0}$, and $\mathbf{w} \circ \mathbf{z} = \mathbf{0}$ was discussed earlier. We choose inputs

$$M = \left[\begin{array}{c|c} 2S & A^{\mathrm{T}} \\ \hline -A & 0 \end{array} \right], \qquad \mathbf{q} = \left[\begin{array}{c} -\mathbf{c} \\ \mathbf{b} \end{array} \right]$$

The output \mathbf{w} is not important for this application, but the other output is $\mathbf{z} = [\mathbf{x} \,|\, \mathbf{u}_d]^{\mathrm{T}}$. We need only the first block \mathbf{x} of the output, which corresponds to the closest point of the polygon to \mathbf{P}.

Pseudocode for computing the distance from \mathbf{P} to the polyhedron follows. The convex polyhedron object is assumed to have any data structures and methods that are necessary to support the calculations.

```
double Distance (vector P, ConvexPolyhedron C)
{
    int nv = C.vertex.size();

    // translate to first octant (if necessary)
    vector min = C.vertex[0];
    for (i = 1; i < nv; i++)
    {
        if ( C.vertex[i].x < min.x )
            min.x = C.vertex[i].x;
        if ( C.vertex[i].y < min.y )
            min.y = C.vertex[i].y;
        if ( C.vertex[i].z < min.z )
            min.y = C.vertex[i].y;
    }
    if ( min.x < 0 || min.y < 0 )
    {
        P -= min;
        for (i = 0; i < nv; i++)
            C.vertex[i] -= min;
    }

    // compute coefficients of objective function
    matrix S[3][3] = identity_3;  // the 3-by-3 identity matrix
    vector c = 2.0*P;
    // double K = Dot(P,P);  not needed in the code

    // compute constraint matrix and vector
    int n = C.face.size();
    matrix A[n][3];
    vector b[n];
```

```
for (i = 0; i < n; i++)
{
    A[i][0] = C.face[i].normal.x;
    A[i][1] = C.face[i].normal.y;
    A[i][2] = C.face[i].normal.z;
    b[i] = Dot(C.face[i].normal,C.face[i].vertex);
}

// compute inputs for LCP solver
matrix M[n+3][n+3] = Block(2*S,Transpose(A),-A,zero_nxn);
vector q[n+3] = Block(-c,b);

// compute outputs
vector w[n+3], z[n+3];
LCPSolver(M,q,w,z);

// compute closest point and distance to P
vector closest(z[0],z[1],z[2]);
return sqrt(Dot(closest-P,closest-P));
}
```

As you can see, the structure of the code is nearly identical to that for convex polygons.

Distance Between Convex Polygons

SOURCE CODE

PolygonDistance

Two convex polygons are specified, the first C_0 with vertices $\mathbf{V}_i^{(0)}$ for $0 \leq i < n_0$ and the second C_1 with vertices $\mathbf{V}_i^{(1)}$ for $0 \leq i < n_1$. Both sequences of vertices are counterclockwise ordered. As we had arranged in the point-object calculators discussed previously, a translation is applied (if necessary) to place both polygons in the first quadrant. Let \mathbf{P}_0 denote a point inside C_0 and let \mathbf{P}_1 denote a point inside C_1. We want to choose one point in each polygon to minimize the squared distance $|\mathbf{P}_0 - \mathbf{P}_1|^2$. The setup to solve this using LCP methods is similar to that for computing distance between a point and a convex polygon, except that the unknown vector \mathbf{x} will be four-dimensional. The unknown vector and the objective function are

$$\mathbf{x} = \begin{bmatrix} \mathbf{P}_0 \\ \mathbf{P}_1 \end{bmatrix}, \qquad f(\mathbf{x}) = |\mathbf{P}_0 - \mathbf{P}_1|^2 = \begin{bmatrix} \mathbf{P}_0^T & | & \mathbf{P}_1^T \end{bmatrix} \begin{bmatrix} I & | & -I \\ \hline -I & | & I \end{bmatrix} \begin{bmatrix} \mathbf{P}_0 \\ \mathbf{P}_1 \end{bmatrix} = \mathbf{x}^T S \mathbf{x}$$

where I is the 2×2 identity matrix. The matrix S is 4×4, has diagonal blocks I and off-diagonal blocks $-I$. S is positive-semidefinite since it is symmetric and its eigenvalues are $\lambda = 0$ and $\lambda = 2$, both nonnegative numbers.

Since the polygons are in the first quadrant, both $\mathbf{P}_0 \geq \mathbf{0}$ and $\mathbf{P}_1 \geq \mathbf{0}$ and the non-negativity constraint $\mathbf{x} \geq \mathbf{0}$ are satisfied. The other constraints arise from requiring that the points be in their convex polygons. Let $\mathbf{N}_i^{(j)}$ denote outer normals for polygon C_j for the edge of direction $\mathbf{V}_{i+1}^{(j)} - \mathbf{V}_i^{(j)}$. The point containment imposes the constraints

$$\mathbf{N}_i^{(j)} \cdot (\mathbf{P}_j - \mathbf{V}_i^{(j)}) \leq 0$$

for $0 \leq i < n_j$. The constraint matrix A is $(n_0 + n_1) \times 4$ and is a block diagonal matrix $A = \mathrm{Diag}(A_0, A_1)$, where A_j is $n_j \times 2$. The ith row of A_j is the transposed normal vector $\mathbf{N}_i^{(j)}$. The constraint vector \mathbf{b} is $(n_0 + n_1) \times 1$ and consists of two blocks \mathbf{b}_j of size $n_j \times 1$. The ith row of \mathbf{b}_j is $\mathbf{N}_i^{(j)} \cdot \mathbf{V}_i^{(j)}$. As before the inputs to the LCP solver are

$$M = \left[\begin{array}{c|c} 2S & A^{\mathrm{T}} \\ \hline -A & 0 \end{array} \right], \qquad \mathbf{q} = \left[\begin{array}{c} \mathbf{0} \\ \hline \mathbf{b} \end{array} \right]$$

but in this case $\mathbf{c} = \mathbf{0}$. The output $\mathbf{z} = [\mathbf{x} \,|\, *]^{\mathrm{T}}$ where the first block produces a pair of closest points on the polygons.

The pseudocode is similar yet again to what we had before.

```
double Distance (ConvexPolygon C0, ConvexPolygon C1)
{
    int n0 = C0.vertex.size(), n1 = C1.vertex.size();

    // translate to first quadrant (if necessary)
    vector min = C0.vertex[0];
    for (i = 1; i < n0; i++)
    {
        if ( C0.vertex[i].x < min.x )
            min.x = C0.vertex[i].x;
        if ( C0.vertex[i].y < min.y )
            min.y = C0.vertex[i].y;
    }
    for (i = 0; i < n1; i++)
    {
        if ( C1.vertex[i].x < min.x )
            min.x = C1.vertex[i].x;
        if ( C1.vertex[i].y < min.y )
            min.y = C1.vertex[i].y;
    }
```

```
if ( min.x < 0 || min.y < 0 )
{
    for (i = 0; i < n0; i++)
        C0.vertex[i] -= min;
    for (i = 0; i < n1; i++)
        C1.vertex[i] -= min;
}

// Compute coefficients of objective function, identity_2 is the
// 2-by-2 identity matrix.
matrix S[4][4] = Block(identity_2,-identity_2,
    -identity_2,identity_2);
vector c = zero_4;  // the 4-by-1 zero vector
// double K = 0;  not needed in the code

// compute constraint matrix and vector
matrix A0[n0][2], A1[n1][2];
vector b0[n0], b1[n1];
for (i0 = n0-1, i1 = 0; i1 < n0; i0 = i1++)
{
    vector normal = Perp(C0.vertex[i1]-C0.vertex[i0]);
    A0[i1][0] = normal.x;
    A0[i1][1] = normal.y;
    b0[i1] = Dot(normal,C0.vertex[i0]);
}
for (i0 = n1-1, i1 = 0; i1 < n0; i0 = i1++)
{
    vector normal = Perp(C1.vertex[i1]-C1.vertex[i0]);
    A1[i1][0] = normal.x;
    A1[i1][1] = normal.y;
    b1[i1] = Dot(normal,C1.vertex[i0]);
}
matrix A[n0+n1][4] = BlockDiagonal(A0,A1);
vector b[n0+n1] = Block(b0,b1);

// compute inputs for LCP solver
int n = n0+n1;
matrix M[n+4][n+4] = Block(2*S,Transpose(A),-A,zero_nxn);
vector q[n+4] = Block(-c,b);

// compute outputs
vector w[n+4], z[n+4];
LCPSolver(M,q,w,z);
```

```
    // compute closest points P0 in C0 and P1 in C1 and
    // distance |P0-P1|
    vector P0(z[0],z[1]), P1(z[2],z[3]);
    return sqrt(Dot(P0-P1,P0-P1));
}
```

Distance Between Convex Polyhedra

The LCP formulation is similar to the previous ones. The convex polyhedra are C_0 and C_1. A translation must be applied to make sure both polyhedra are in the first octant. Let the number of faces of C_j be denoted n_j. The outer pointing normal for face i is $\mathbf{N}_i^{(j)}$ and a vertex on the face for use in constraints is $\mathbf{V}_i^{(j)}$. The goal is to find points $\mathbf{P}_j \in C_j$ that minimize $|\mathbf{P}_0 - \mathbf{P}_1|$. The construction parallels that of distance between convex polygons. The unknown vector is $\mathbf{x}^T = [\mathbf{P}_0^T \,|\, \mathbf{P}_1^T]$ and is six-dimensional. The objective function is $f(\mathbf{x}) = \mathbf{x}^T S \mathbf{x}$, where S is a 6×6 matrix whose diagonal blocks are the 3×3 identity matrix I and whose off-diagonal blocks are $-I$. The eigenvalues of S are 0 and 2, so S is positive-semidefinite. The constraint matrix A is $(n_0 + n_1) \times 6$ and the constraint vector \mathbf{b} is $(n_0 + n_1) \times 1$, both constructed similarly to what was done for convex polygons. Pseudocode is

```
double Distance (ConvexPolyhedron C0, ConvexPolyhedron C1)
{
    int nv0 = C0.vertex.size(), nv1 = C1.vertex.size();

    // translate to first octant (if necessary)
    vector min = C0.vertex[0];
    for (i = 1; i < nv0; i++)
    {
        if ( C0.vertex[i].x < min.x )
            min.x = C0.vertex[i].x;
        if ( C0.vertex[i].y < min.y )
            min.y = C0.vertex[i].y;
    }
    for (i = 0; i < nv1; i++)
    {
        if ( C1.vertex[i].x < min.x )
            min.x = C1.vertex[i].x;
        if ( C1.vertex[i].y < min.y )
            min.y = C1.vertex[i].y;
    }
    if ( min.x < 0 || min.y < 0 )
    {
```

```
    for (i = 0; i < nv0; i++)
        C0.vertex[i] -= min;
    for (i = 0; i < nv1; i++)
        C1.vertex[i] -= min;
}

// Compute coefficients of objective function, identity_3 is the
// 3-by-3 identity matrix.
matrix S[6][6] = Block(identity_3,-identity_3,
    -identity_3,identity_3);
vector c = zero_6;  // the 6-by-1 zero vector
// double K = 0;  not needed in the code

// compute constraint matrix and vector
int n0 = C0.face.size(), n1 = C1.face.size();
matrix A0[n0][2], A1[n1][2];
vector b0[n0], b1[n1];
for (i0 = n0-1, i1 = 0; i1 < n0; i0 = i1++)
{
    vector normal = C0.face[i].normal;
    A0[i1][0] = normal.x;
    A0[i1][1] = normal.y;
    A0[i1][2] = normal.z;
    b0[i1] = Dot(normal,C0.face[i].vertex);
}
for (i0 = n1-1, i1 = 0; i1 < n0; i0 = i1++)
{
    vector normal = C1.face[i].normal;
    A1[i1][0] = normal.x;
    A1[i1][1] = normal.y;
    A1[i1][2] = normal.z;
    b1[i1] = Dot(normal,C1.face[i].vertex);
}
matrix A[n0+n1][6] = BlockDiagonal(A0,A1);
vector b[n0+n1] = Block(b0,b1);

// compute inputs for LCP solver
int n = n0+n1;
matrix M[n+6][n+6] = Block(2*S,Transpose(A),-A,zero_nxn);
vector q[n+6] = Block(-c,b);

// compute outputs
vector w[n+6], z[n+6];
```

```
        LCPSolver(M,q,w,z);

        // compute closest points P0 in C0 and P1 in C1 and
        // distance |P0-P1|
        vector P0(z[0],z[1],z[2]), P1(z[3],z[4],z[5]);
        return sqrt(Dot(P0-P1,P0-P1));
    }
```

Once again we have assumed that the data members and methods of the class for the convex polyhedron have enough structure to support the queries required in the distance calculator.

7.4.2 Contact Forces

The derivation of contact forces for colliding rigid bodies is presented in detail in Section 5.2. The impulsive force construction to modify the linear and angular velocities simultaneously for all contact points was formulated as the following abstract problem: Minimize $|A\mathbf{f} + \mathbf{b}|^2$ subject to the constraints $\mathbf{f} \geq \mathbf{0}$, $A\mathbf{f} + \mathbf{b} \geq \mathbf{0}$, and $A\mathbf{f} + \mathbf{b} \leq \mathbf{c}$, where A is a known $n \times n$ matrix and \mathbf{b} and \mathbf{c} are known $n \times 1$ vectors. The impulse magnitudes \mathbf{f} are required by the collision response system. The postimpulse velocities $\dot{\mathbf{d}}^+ = A\mathbf{f} + \mathbf{b}$ are also required, but can be computed once \mathbf{f} is known. The quadratic function expands to $\mathbf{f}^T(A^TA)\mathbf{f} + (2\mathbf{b}^TA)\mathbf{f} + |\mathbf{b}|^2$. This is a classical problem of quadratic programming, but it cannot be formulated as an LCP. First, the matrix M that would result in such an attempt is not necessarily positive-semidefinite. Second, there is no complementarity condition.

The resting contact force construction to prevent the rigid bodies from interpenetrating was formulated as equation (5.44), $\ddot{\mathbf{d}} = A\mathbf{g} + \dot{\mathbf{b}}$. The outer normals at the n contact points are as before. The resting contact forces are postulated as $g_i\mathbf{N}_i$, where $g_i \geq 0$ is required to satisfy the nonpenetration constraints. The force magnitudes are stored as a vector $\mathbf{g} \geq \mathbf{0}$. The acceleration of the first body in the direction \mathbf{N}_i has magnitude \ddot{d}_i. The magnitudes are stored as a vector $\ddot{\mathbf{d}}$. The nonpenetration constraint requires that $\ddot{\mathbf{d}} \geq \mathbf{0}$. The matrix A is the same one used for impulsive force calculations. The vector \mathbf{b} is defined by equation (5.45). We also had a complementarity condition $\ddot{\mathbf{d}} \circ \mathbf{g} = \mathbf{0}$. Once again an LCP solver can be applied, where $M = A$, $\mathbf{q} = \mathbf{b}$, $\mathbf{w} = \ddot{\mathbf{d}}$, and $\mathbf{z} = \mathbf{g}$. The outputs $\ddot{\mathbf{d}}$ and \mathbf{g} are what the collision response system needs to adjust the forces and torques that are used by the differential equation solver to update the rigid body states. Pseudocode for both of these problems is presented in Section 5.2 immediately following their derivations.

DIFFERENTIAL EQUATIONS

This chapter is a brief summary of the basic concepts you need for working with *ordinary differential equations*. The modifier *ordinary* refers to equations that involve functions of a single independent variable. Rates of change of functions of multiple independent variables fall under the topic of *partial differential equations*, something we will not cover here. Thus, I will refer to ordinary differential equations in this chapter by only the term *differential equations*. A very good undergraduate textbook on the topic of ordinary differential equations is [Bra84], and it emphasizes an applied approach of the flavor of the problems in this book. A graduate textbook that is oriented toward physical applications and covers the advanced mathematical topics you need to fully understand the analysis of the physical models is [HS74].

Since our applications have time-varying quantities in physical simulations, the independent variable in the differential equations is always time t. The derivatives of dependent variables will use the dot notation. For example, if $x(t)$ is a function of t, the first derivative with respect to t is denoted $\dot{x}(t)$ and the second derivative is denoted $\ddot{x}(t)$.

8.1 FIRST-ORDER EQUATIONS

A *first-order differential equation* of a real-valued function $x(t)$ of the independent variable t is

$$\dot{x} = f(t, x) \tag{8.1}$$

The function $f(t, x)$ is a known quantity. The left-hand side of the equation is the formal expression for the first derivative of x with respect to t, which measures the rate of change of x over time. The right-hand side is what we wish the rate of change to be. For the sake of illustration, suppose that $x(t)$ measures the position of an object moving along a straight line. The velocity of the object is $\dot{x}(t)$ and the acceleration is $\ddot{x}(t)$. Equation (8.1) is what we want the velocity to be. Knowing the velocity $\dot{x}(t)$ at any time t, our goal is to determine what the position $x(t)$ is at any time. In a sense we want to integrate the velocity to obtain position.

An instinctive method for solving for position is the following. If we were to specify an initial position $x(0)$, equation (8.1) tells us immediately that the initial velocity is $\dot{x}(0) = f(0, x(0))$. We can differentiate equation (8.1) with respect to t and apply the chain rule from calculus to obtain

$$\ddot{x}(t) = f_t(t, x) + f_x(t, x)\, \dot{x}(t)$$

where $f_t = \partial f / \partial t$ and $f_x = \partial f / \partial x$. The initial acceleration is therefore $\ddot{x}(0) = f_t(0, x(0)) + f_x(0, x(0))\dot{x}(0)$. Assuming that $f(t, x)$ is differentiable of all orders, we could continue differentiating and evaluating to obtain the value of every derivative of $x(t)$. If $x^{(n)}(t)$ denotes the nth derivative of $x(t)$, then we can compute the initial values of all derivatives $x^{(n)}(0)$. If you recall from calculus, the formal Taylor series of $x(t)$ expanded about $t = 0$ is

$$x(t) = \sum_{n=0}^{\infty} \frac{x^{(n)}(0)}{n!} t^n$$

If we can compute all the derivatives of $x(t)$ at time 0, it appears that we have an expression for $x(t)$. I used the term *formal*. The right-hand side is an infinite sum. As you are aware, such a sum does not necessarily have a value. The general topic in calculus is *convergence* (or *divergence*) of the series. Moreover, not all functions have a Taylor series representation. Functions that do and for which the series converges for some interval of t are called *analytic functions*.

Unfortunately, the reality is that the Taylor series approach is not useful, especially for a computer application. We do not have the luxury of computing an infinite number of derivatives! At any rate, the process would require some general expression for partial derivatives of $f(t, x)$. Since f arises in our physical applications as applied forces, we might not even know a formula for it. In most cases $f(t, x)$ itself is not an analytic function, which means, most likely, that $x(t)$ is not representable as a Taylor series. What we need to do instead is numerically solve the equation. That is the topic of Chapter 9. We will look at a few relevant concepts for differential equations before pursing numerical methods for solving them.

An *initial value problem* for a first-order differential equation is of the form

$$\dot{x} = f(t, x), \qquad t \geq t_0, \qquad x(t_0) = x_0 \tag{8.2}$$

The differential equation is specified together with a selected initial time t_0 and initial function value $x_0 = x(t_0)$. These are the types of problems we will see in practice. Some initial value problems can be solved in closed form. For example, consider

$$\dot{x} = f(t), \qquad t \geq t_0, \qquad x(t_0) = x_0$$

where $f(t)$ depends only on time. Formally we can write the solution as an integral,

$$x(t) = x_0 + \int_{t_0}^{t} f(\tau)\, d\tau$$

If a closed form exists for $\int f(t)\, dt$, we can immediately write down the solution for $x(t)$. For example, if $f(t) = t^p$, a polynomial term, then $\int f(t)\, dt = t^{p+1}/(p+1)$. The solution to the differential equation is then $x(t) = x_0 + (t^{p+1} - t_0^{p+1})/(p+1)$. In many cases, though, we do not have a closed form for $\int f(t)\, dt$. The integral itself must be evaluated numerically using a standard numerical integrator.

Another type of problem that can be solved in closed form, so to speak, is a *first-order linear differential equation*. This is of the form

$$\dot{x} = a(t)x + b(t), \qquad t \geq t_0, \qquad x(t_0) = x_0 \qquad (8.3)$$

where $a(t)$ and $b(t)$ are known functions of time. If $b(t) = 0$ for all t, the equation $\dot{x} = a(t)x$ is said to be *homogeneous*. The formal solution is

$$x(t) = x_0 + \exp\left(\int_{t_0}^{t} a(\tau)\, d\tau\right)\left[x_0 + \int_{t_0}^{t} \exp\left(-\int_{t_0}^{s} a(\tau)\, d\tau\right) b(s)\, ds\right]$$

If we can integrate the various integrals in this equation in closed form, we can easily evaluate $x(t)$. If not, numerical integrators are required. The homogeneous equation (8.3) can be solved in closed form when the coefficient $a(t)$ is a constant for all time. That is, $\dot{x} = ax$ for some constant a with $x(t_0) = x_0$ has the solution

$$x(t) = e^{a(t-t_0)}x_0 \qquad (8.4)$$

as you can well verify.

Another special type of equation is a *separable equation*. These are of the form

$$dx/dt = \dot{x} = f(t)/g(x), \qquad t \geq t_0, \qquad x(t_0) = x_0$$

The variables may be *separated* and placed on different sides of the equation, $g(x)\, dx = f(t)\, dt$, then integrated:

$$\int_{x_0}^{x} g(\xi)\, d\xi = \int_{t_0}^{t} f(\tau)\, d\tau$$

The same issue occurs regarding closed formulas for the integrals. If we do not have closed formulas, we must resort to numerical integration to estimate a solution. Even if we do have closed formulas, there is still a potential problem. If $G(x)$ is an antiderivative of $g(x)$, that is, $dG/dx = g$, and if $F(t)$ is an antiderivative of $f(t)$, so that $dF/dt = f$, then the separated and integrated equation becomes $G(x) - G(x_0) = F(t) - F(t_0)$. To solve explicitly for x, we need to be able to invert the function $G(x)$; that is, $x = G^{-1}(F(t) - F(t_0) + G(x_0))$. The inversion might not be possible in closed form, and once again you must resort to numerical techniques. We already saw an application of separable equations to solving the simple pendulum problem, Example 3.4. The separation was not for numerically solving the angle as a function of time; rather, it was to determine an estimate for the period of the pendulum.

The existence of closed formulas for the integrals or for inverse functions might be of pedagogic importance in a class on differential equations but not so in applications. The numerical differential equation solvers work directly with $f(t, x)$ in the equation and only require evaluations of that function.

8.2 EXISTENCE, UNIQUENESS, AND CONTINUOUS DEPENDENCE

Perhaps you might object to the title of this section—just like a mathematician to cloud the issue with facts! There is a good chance that the tutorials you find about physics simulations using differential equations of motion do not discuss the topic mentioned in the section title. Our interest is in numerically solving the initial value problem of equation (8.2). You can apply your favorite numerical solver to the differential equations of your application. A computer is quite happy to produce output without any thought, so to speak. The fundamental question on computer output: Can you trust it?

In the case of the initial value problem, in order for you to trust your output you really should be assured that the problem *has a solution*. This is the *existence question* about the initial value problem. Does there exist a solution to the problem? If there is a solution, your chances of finding it with a computer have just improved. If there is no solution, your output is useless. Better to do some type of analysis before implementing the problem or running a program to solve the problem. To make an analogy, consider solving a linear system of equations $A\mathbf{x} = \mathbf{b}$, where the $n \times n$ coefficient matrix A and the $n \times 1$ vector \mathbf{b} are inputs into the program. The output must be the solution \mathbf{x}, an $n \times 1$ vector. Well, it is quite possible that the linear system does not have a solution. Your linear system solver must be prepared to inform you that is the case. If you implemented Gaussian elimination to row-reduce the augmented matrix $[A \mid \mathbf{b}]$ to upper echelon form $H = [U \mid \mathbf{c}]$, where U is upper triangular, there is no solution to the system when $\text{rank}(U) < \text{rank}(H)$. The

consequence of not trapping the rank condition is that you most likely will generate an exception due to division by zero.

Even if there is a solution, you still might not be able to trust the output of the program. What if there are multiple solutions to the same initial value problem? This is the *uniqueness question* about the initial value problem. Using our analogy of linear systems, it is possible that $A\mathbf{x} = \mathbf{b}$ has multiple solutions. In fact, the theory says that if it has two solutions, it must have infinitely many solutions. This happens when $\text{rank}(U) = \text{rank}(H) < n$. An algorithm based on Gaussian elimination can trap this, report that there are multiple solutions, and terminate. However, your application might want to know more information. For example, the output might be a basis for the affine space of solutions. In the case of differential equations, if the initial value problem has multiple solutions, the physical modeling is more than likely in error. We expect that the modeling produces equations of motion for which there *exists a unique solution*.

Although I will not delve into the gory mathematical details, you can find in [Bra84], as well as in any other textbook on differential equations, the following theorem regarding existence and uniqueness of a solution to the initial value problem of equation (8.2).

Theorem ■ Let $f(t, x)$ and $f_x(t, x)$ be continuous in the rectangle R defined by $t_0 \le t \le t_0 + a$ and $|x - x_0| \le b$ for some positive constants a and b. Let $M = \max_{(t,x) \in R} |f(t, x)|$, a bound on the absolute value of $f(t, x)$ on the rectangle. Define $\alpha = \min(a, b/M)$. The initial value problem $\dot{x} = f(t, x)$ with $x(t_0) = x_0$ has a unique solution $x(t)$ defined for $t_0 \le t \le t_0 + \alpha$. ■

The bound M is guaranteed because a continuous function on a closed and bounded rectangle must have a minimum and a maximum, a standard result from calculus. The proof is not important to us, but the result is. As long as our function $f(t, x)$ has a continuous derivative in x in a small region about the initial point (t_0, x_0), we have a unique solution. In fact, weaker conditions on f than having a continuous x-derivative still lead to existence-uniqueness results. But for all practical purposes the types of functions you expect to occur in the equations of motion will have continuous derivatives.

WARNING ■ If your application "switches on and off" input forces and torques, you do not even have a continuous function. The theory of differential equations will provide you with yet more tools on showing existence and uniqueness, so feel free to investigate this topic in detail. A field of particular interest is *control theory*, by which you try to select $f(t, x)$ to force the solution $x(t)$ to behave in certain ways. For example, a pendulum with a metal end is swinging between two electric magnets. The magnets are either on or off; you get to choose their on/off status over time in order to get the pendulum to stop in the minimum amount of time.

The third portion of the section title is about *continuous dependence* of the solution on the input parameters. If there exists a unique solution for each choice of initial values (t_0, x_0), we can write the solution to indicate its dependence on the values: $x(t; t_0, x_0)$. Our concern is that this function is continuous in t_0 and x_0. Why should we care? Think about it from the perspective of numerical round-off errors. If a small change in the input x_0 results in a very large change in the solution near initial time, we have an ill-conditioned problem whose numerical errors can propagate and lead to significantly incorrect outputs. In the applications we encounter with physical simulation, invariably we do have continuous dependence, so we will not concern ourselves at the moment with theoretical results.

8.3 SECOND-ORDER EQUATIONS

A *second-order differential equation* of a real-valued function $x(t)$ of the independent variable t is

$$\ddot{x} = f(t, x, \dot{x}) \qquad (8.5)$$

The function $f(t, x, \dot{x})$ is a known quantity. The left-hand side of the equation is the formal expression for the second derivative of x with respect to t. For physical applications where $x(t)$ measures position, the second derivative measures acceleration, the rate of change of velocity $\dot{x}(t)$. The right-hand side is what we wish the rate of change to be. From this second-derivative information we wish to construct $x(t)$ itself. The *initial value problem* for the second-order equation is

$$\ddot{x} = f(t, x, \dot{x}), \qquad t \geq t_0, \qquad x(t_0) = x_0, \qquad \dot{x}(t_0) = \dot{x}_0 \qquad (8.6)$$

where t_0, x_0, and \dot{x}_0 are user-supplied inputs.

The initial value problem for a second-order linear differential equation is

$$\ddot{x} = a(t)\dot{x} + b(t)x + c(t), \qquad t \geq t_0, \qquad x(t_0) = x_0, \qquad \dot{x}(t_0) = \dot{x}_0 \quad (8.7)$$

The homogeneous equation is the case $c(t) = 0$ for all t. Additionally, the equation with constant coefficients is

$$\ddot{x} = a\dot{x} + bx, \qquad t \geq t_0, \qquad x(t_0) = x_0, \qquad \dot{x}(t_0) = \dot{x}_0$$

From the classical theory, at least one solution is of the form $x(t) = e^{rt}$ for a constant r that is possibly complex-valued. To determine r, compute the derivatives $\dot{x}(t) = re^{rt}$ and $\ddot{x}(t) = r^2 e^{rt}$ and substitute into the equation to obtain

$$0 = \ddot{x} - a\dot{x} - bx = r^2 e^{rt} - are^{rt} - be^{rt} = (r^2 - ar - b)e^{rt}$$

For this equation to be true for all t, we need $r^2 - ar - b = 0$, a quadratic equation in r. If the equation has two distinct real roots r_1 and r_2, both $e^{r_1 t}$ and $e^{r_2 t}$ are solutions

to the differential equation. The solution to the initial value problem is

$$x(t) = \frac{r_2 x_0 - \dot{x}_0}{r_2 - r_1} e^{r_1(t-t_0)} - \frac{r_1 x_0 - \dot{x}_0}{r_2 - r_1} e^{r_2(t-t_0)} \tag{8.8}$$

This equation is valid even if the roots are distinct, complex-valued numbers. However, the coefficients are then complex-valued and the exponential functions have powers that are complex-valued. If the roots are $\alpha \pm i\beta$, where $\beta \neq 0$, then Euler's identity $e^{i\theta} = \cos\theta + i\sin\theta$) yields

$$e^{(\alpha+i\beta)t} = e^{\alpha t}(\cos(\beta t) + i\sin(\beta t))$$

Some complex arithmetic applied to our solution in order to rearrange it into only real-valued expressions leads to

$$x(t) = \left(x_0 \cos(\beta(t - t_0)) + \frac{\dot{x}_0 - \alpha x_0}{\beta} \sin(\beta(t - t_0)) \right) e^{\alpha(t-t_0)} \tag{8.9}$$

Finally, the quadratic equation can have a repeated real root $r = a/2$ (when $b = a^2/4$). The theory shows that two solutions to the differential equation are e^{rt} and te^{rt}. The solution to the initial value problem is

$$x(t) = \left(x_0 + (\dot{x}_0 - rx_0)(t - t_0) \right) e^{r(t-t_0)} \tag{8.10}$$

An understanding of this example is important for higher-order linear equations with constant coefficients. In particular, the relationship between the roots of the quadratic equation $r^2 - ar - b = 0$ and the types of solutions to the differential equation, namely, e^{rt}, $e^{\alpha t}\cos(\beta t)$, $e^{\alpha t}\sin(\beta t)$, and te^{rt}, is important.

The theory of differential equations includes analysis of second-order equations in the form of equation (8.6). From our perspective we want only to solve the initial value problem numerically. We can do so by formulating the second-order equation as two first-order equations. If we define $v(t) = \dot{x}$, then $\dot{v} = \ddot{x} = f(t, x, \dot{x}) = f(t, x, v)$. The *first-order system of equations with initial conditions* corresponding to equation (8.6) is

$$\begin{bmatrix} \dot{x} \\ \dot{v} \end{bmatrix} = \begin{bmatrix} v \\ f(t, x, v) \end{bmatrix}, \quad t \geq t_0, \quad \begin{bmatrix} x(t_0) \\ v(t_0) \end{bmatrix} = \begin{bmatrix} x_0 \\ \dot{x}_0 \end{bmatrix} \tag{8.11}$$

To be suggestive of the form of equation (8.2), define $\mathbf{y} = [x \ v]^T$, $\mathbf{g}(t, \mathbf{y}) = [v \ f(t, x, v)]^T$, and $\mathbf{y}_0 = [x_0 \ \dot{x}_0]^T$. The initial value problem for the first-order system is

$$\dot{\mathbf{y}} = \mathbf{g}(t, \mathbf{y}), \quad t \geq t_0, \quad \mathbf{y}(t_0) = \mathbf{y}_0 \tag{8.12}$$

The importance of maintaining the form of the equation has to do with developing numerical methods for solving it. Methods that apply to equation (8.2) naturally

extend to systems in the form of equation (8.12). The repackaging also applies to a system of n second-order equations to generate a first-order system of $2n$ equations. This latter case is exactly what we do in our physical simulations. For instance, see Example 3.10.

8.4 GENERAL-ORDER DIFFERENTIAL EQUATIONS

The *nth-order differential equation* of a real-valued function $x(t)$ of the independent variable t is

$$x^{(n)} = f(t, x, x^{(1)}, \ldots, x^{(n-1)}) \tag{8.13}$$

where $x^{(k)}(t)$ denotes the kth-order derivative of $x(t)$. The function $f(t, y_1, \ldots, y_n)$ is a known quantity. The left-hand side of the equation is the formal expression for the nth-order derivative of x with respect to t. The right-hand side is what we wish that derivative to be. We wish to construct $x(t)$ itself from the equation. The *initial value problem* for the nth-order equation is

$$x^{(n)} = f(t, x, x^{(1)}, \ldots, x^{(n-1)}), \quad t \geq t_0, \quad x^{(k)}(t_0) = x_0^{(k)}, \quad 0 \leq k \leq n - 1 \tag{8.14}$$

where t_0 and $x_0^{(k)}$ for $0 \leq k \leq n - 1$ are user-supplied inputs.

The initial value problem for an nth-order linear differential equation is

$$x^{(n)} = \sum_{k=0}^{n-1} a_k(t) x^{(k)} + b(t), \quad t \geq t_0, \quad x^{(k)}(t_0) = x_0^{(k)}, \quad 0 \leq k \leq n - 1 \tag{8.15}$$

The homogeneous equation is the case $b(t) = 0$ for all t. Additionally, the equation with constant coefficients is

$$x^{(n)} = \sum_{k=0}^{n-1} a_k x^{(k)}, \quad t \geq t_0, \quad x^{(k)}(t_0) = x_0^{(k)}, \quad 0 \leq k \leq n - 1 \tag{8.16}$$

for some constants a_k for $0 \leq k \leq n - 1$. Using the second-order linear equation with constant coefficients as the model, we expect a general solution of the form $x(t) = e^{rt}$. The derivatives are $x^{(k)}(t) = r^k e^{rt}$. Substituting into the differential equation leads to

$$0 = x^{(n)} - \sum_{k=0}^{n-1} a_k x = r^n e^{rt} - \sum_{k=0}^{n-1} a_k r^k e^{rt} = \left(r^n - \sum_{k=0}^{n-1} a_k r^k \right) e^{rt} = p(r) e^{rt}$$

where $p(r)$ is a polynomial of degree n and is called the *characteristic polynomial* for the differential equation. The only way to make $p(r)e^{rt} = 0$ for all t is if $p(r) = 0$.

Thus, r must be a root of a polynomial. The Fundamental Theorem of Algebra states that $p(r)$ is factorable into

$$p(r) = \prod_{j=1}^{d} (r - r_j)^{m_j}$$

where r_1 through r_d are the distinct roots, m_j is the multiplicity of root r_j, and $\sum_{j=1}^{d} m_j = n$. We know that the a_k are real-valued, so if a nonreal root occurs, say, $r = \alpha + i\beta$ for $\beta \neq 0$, then its conjugate $\bar{r} = \alpha - i\beta$ is also a root. The values r and \bar{r} are considered to be distinct roots, of course. Thus, nonreal roots occur in pairs. If r_j is a real-valued root, the contribution to the solution of the differential equation is the set of functions $t^\ell e^{r_j t}$ for $0 \leq \ell < m_j$. If $r_j = \alpha_j + i\beta_j$ is a nonreal root, the contribution of r_j and \bar{r}_j to the solution of the differential equation is the set of functions $t^\ell e^{\alpha_j t} \cos(\beta_j t)$ and $t^\ell e^{\alpha_j t} \sin(\beta_j t)$ for $0 \leq \ell < m_j$. If the real-valued roots are indexed by $1 \leq j \leq J_0$ and the complex-valued roots have indices $J_0 < j \leq d$, the general solution to the initial value problem is of the form

$$x(t) = \sum_{j=1}^{J_0} \sum_{\ell=0}^{m_j - 1} C_{\ell, j} t^\ell e^{r_j t} + \sum_{j=J_0+1}^{d} \sum_{\ell=0}^{m_j - 1} \left[D_{\ell, j} \cos(\beta_j t) + E_{\ell, j} \sin(\beta_j t) \right] t^\ell e^{\alpha_j t} \quad (8.17)$$

where the n constants $C_{\ell, j}$, $D_{\ell, j}$, and $E_{\ell, j}$ are determined by the initial conditions of the problem.

Just as we converted the second-order equation to a first-order system, we may convert the nth-order equation to a system. Define $y_k(t) = x^{(k-1)}(t)$ for $1 \leq k \leq n$. Differentiating the equation we obtain

$$\dot{y}_k(t) = \frac{dx^{(k-1)}(t)}{dt} = x^{(k)}(t) = y_{k+1}(t)$$

The last equation is

$$\dot{y}_n(t) = y_{n+1}(t) = x^{(n)}(t) = f(t, x, x^{(1)}, \ldots, x^{(n-1)}) = f(t, y_1, \ldots, y_n)$$

In vector form, define $\mathbf{y} = [y_1 \cdots y_n]^{\mathrm{T}}$, $\mathbf{g}(t, \mathbf{y}) = [y_2 \cdots y_n \, f(t, y_1, \ldots, t_n)]^{\mathrm{T}}$, and $\mathbf{y}_0 = [x_0 \, x_0^{(1)} \cdots x_0^{(n-1)}]^{\mathrm{T}}$. The initial value problem for the first-order system is

$$\dot{\mathbf{y}} = \mathbf{g}(t, \mathbf{y}), \quad t \geq t_0, \quad \mathbf{y}(t_0) = \mathbf{y}_0 \quad (8.18)$$

which is identical to equation (8.12) except for the dimension of \mathbf{y}. Thus, numerical solvers for first-order systems are all that we need to solve nth-order equations.

8.5 SYSTEMS OF LINEAR DIFFERENTIAL EQUATIONS

We have already observed that an nth-order differential equation can be reformulated as a system of n first-order equations. This applies to linear differential equations, of course. A special case of interest, both generally and for physical applications, is the nth-order linear equation with constant coefficients. These equations arise in the stability analysis of the differential equation, a topic discussed Section 8.6.

The nth-order homogeneous linear equation with constant coefficients is equation (8.16), and it has a general solution given by equation (8.17). We can reformulate the equation and its solution in vector-matrix form. Recall that we defined an $n \times 1$ vector \mathbf{y} whose components are $y_k(t) = x^{(k-1)}(t)$ for $1 \leq k \leq n$. The system of equations is

$$\dot{\mathbf{y}} = A\mathbf{y}, \quad t \geq t_0, \quad \mathbf{y}(t_0) = \mathbf{y}_0 \tag{8.19}$$

where A is an $n \times n$ matrix of constants and \mathbf{y}_0 is the vector of initial conditions for the original equation. The matrix A is specifically

$$A = \begin{bmatrix} 0 & 1 & 0 & \cdots & 0 & 0 \\ 0 & 0 & 1 & \cdots & 0 & 0 \\ \vdots & \vdots & \vdots & \ddots & \vdots & \vdots \\ 0 & 0 & 0 & \cdots & 1 & 0 \\ 0 & 0 & 0 & \cdots & 0 & 1 \\ a_0 & a_1 & a_2 & \cdots & a_{n-2} & a_{n-1} \end{bmatrix}$$

The solution to the system of equations may be written as

$$\mathbf{y}(t) = e^{A(t-t_0)}\mathbf{y}_0 \tag{8.20}$$

where $e^{A(t-t_0)}$ is formally the exponential of a matrix power. Of course we need to define what this means. Notice the similarity of this solution to the one for a single first-order, linear, constant-coefficient, homogeneous equation (8.4).

Recall that the Taylor series for the exponential function is

$$e^x = \sum_{k=0}^{\infty} \frac{x^k}{k!}$$

and that it converges for any real-valued input x. If we formally replace x by an $n \times n$ matrix of constants A, we have an expression for exponentiating a matrix:

$$e^A = \sum_{k=0}^{\infty} \frac{A^k}{k!}$$

An advanced course on matrix analysis covers the topic of convergence of such a series; for example, see [HJ85]. The series does in fact converge for any matrix. The

practical issue, though, is evaluating the series in order to compute the differential equation solution in equation (8.20). Since we already know the format of the general solution for the nth-order equation with constant coefficients, equation (8.17), we expect that evaluation of the exponential $e^{A(t-t_0)}$ to depend somehow on the roots of the characteristic polynomial $p(r) = r^n - \sum_{k=0}^{n-1} a_k r^k$.

The characteristic polynomial does, in fact, show up in the problem. From linear algebra, the characteristic equation of a square matrix A is defined to be $\det(rI - A) = 0$. The determinant is indeed the characteristic polynomial $p(r) = \det(rI - A)$. A fact well known in linear algebra is the Cayley-Hamilton Theorem that states $p(A) = 0$, whereby you replace r formally by the matrix A in the characteristic polynomial. In our case we obtain the equation

$$A^n = \sum_{k=0}^{n-1} a_k A^k$$

The nth power of A is decomposed into a linear combination of smaller powers of the matrix. The ramification for evaluating e^A is that the term A^n in the power series formula can be replaced by a linear combination of smaller powers. The next term is

$$A^{n+1} = A \cdot A^n$$

$$= A \sum_{k=0}^{n-1} a_k A^k$$

$$= A \left(a_0 I + a_1 A + \cdots + a_{n-1} A^{n-1} \right)$$

$$= a_0 I + a_1 A^2 + \cdots + a_{n-1} A^n$$

$$= a_0 I + a_1 A^2 + \cdots + a_{n-1} \sum_{k=0}^{n-1} a_k A^k$$

$$= \sum_{k=0}^{n-1} b_k A^k$$

where the constants b_k are computed by grouping together like powers of A. We can repeat this procedure to obtain

$$A^{n+m} = \sum_{k=0}^{n-1} c_{m,k} A^k$$

for any $m \geq 0$. When $m = 0$ we have $c_{0,k} = a_k$ and when $m = 1$ we have $c_{1,k} = b_k$ from the formula we derived for A^{n+1}. Replacing in the power series:

$$\sum_{k=0}^{\infty} \frac{A^k}{k!} = \sum_{k=0}^{n-1} \frac{A^k}{k!} + \sum_{k=n}^{\infty} \frac{A^k}{k!}$$

$$= \sum_{k=0}^{n-1} \frac{A^k}{k!} + \sum_{m=0}^{\infty} \frac{A^{n+m}}{(n+m)!}$$

$$= \sum_{k=0}^{n-1} \frac{A^k}{k!} + \sum_{m=0}^{\infty} \sum_{k=0}^{n-1} \frac{c_{m,k}}{(n+m)!} A^k$$

$$= \sum_{k=0}^{n-1} \frac{A^k}{k!} + \sum_{k=0}^{n-1} \left(\sum_{m=0}^{\infty} \frac{c_{m,k}}{(n+m)!} \right) A^k$$

$$= \sum_{k=0}^{n-1} \left(\frac{1}{k!} + \sum_{m=0}^{\infty} \frac{c_{m,k}}{(n+m)!} \right) A^k$$

$$= \sum_{k=0}^{n-1} d_k A^k$$

where the last equation defines $d_k = \sum_{m=0}^{\infty} c_{m,k}/(n+m)!$ Thus, the infinite sum is replaced by a finite sum of the powers A^k with $k < n$. Unfortunately, this does not help us reach our final goal of computability because the d_k are still infinite sums.

Well, it takes quite a bit more of the power of linear algebra to get us to our goal. We need to be able to decompose A in such a way as to make the computation of e^A a reasonable endeavor. The motivation comes from *diagonalizable matrices*. The matrix A is diagonalizable if there exists a diagonal matrix D and an invertible matrix P such that $A = PDP^{-1}$. Powers of such matrices are easy to compute. For example,

$$A^2 = (PDP^{-1})(PDP^{-1}) = PD(P^{-1}P)DP^{-1} = PDIDP^{-1} = PD^2 P^{-1}$$

The square of a diagonal matrix $D = \text{Diag}(d_1, \ldots, d_n)$ is $D^2 = \text{Diag}(d_1^2, \ldots, d_n^2)$. Repeating the process we see that

$$A^k = (PDP^{-1})^k = PD^k P^{-1}$$

where $D^k = \text{Diag}(d_1^k, \ldots, d_n^k)$. The exponential matrix is

$$e^A = \sum_{k=0}^{\infty} \frac{A^k}{k!} = \sum_{k=0}^{\infty} \frac{PD^k P^{-1}}{k!} = P \left(\sum_{k=0}^{\infty} \frac{D^k}{k!} \right) P^{-1} = P \ \text{Diag}(e^{d_1}, \ldots, e^{d_n}) \ P^{-1}$$

A special case where A is diagonalizable is when it is a symmetric matrix. The factorization is $A = RDR^T$, where the columns of R are eigenvectors of A and the

diagonal entries of D are eigenvalues. Not all matrices are diagonalizable, so what to do? A handful of decomposition formulas can help you compute e^A, some good for mathematical reasons and others good for numerical reasons. Your best bet numerically is to use what is called the *S plus N decomposition*. The mathematical details of the decomposition are presented in [HS74]. A square matrix A with real-valued entries can always be decomposed as $A = S + N$, where S is a *semisimple matrix* and N is a *nilpotent matrix*. A real-valued matrix N is said to be nilpotent if $N^p = 0$ for some power $p > 0$, but $N^k \neq 0$ for powers $1 \leq k < p$. A real-valued matrix S is said to be semisimple if, as an operator on n-tuples of complex number, it is diagonalizable. If we were to attempt to use the diagonalizability of S directly, we would have $S = PDP^{-1}$ for a diagonal matrix D and an invertible matrix P. The problem is that D can have nonreal diagonal terms (complex conjugate roots of the characteristic equation) and P can have nonreal terms. To avoid the nonreal values we need to factor $S = PEP^{-1}$, where P is a real-valued invertible matrix and E is of the form

$$
E = \begin{bmatrix}
r_1 & & & & & & \\
& \ddots & & & & & \\
& & r_{J_0} & & & & \\
& & & \begin{bmatrix} \alpha_{J_0+1} & -\beta_{J_0+1} \\ \beta_{J_0+1} & \alpha_{J_0+1} \end{bmatrix} & & & \\
& & & & \ddots & & \\
& & & & & \begin{bmatrix} \alpha_d & -\beta_d \\ \beta_d & \alpha_d \end{bmatrix} &
\end{bmatrix}
\tag{8.21}
$$

where the distinct real-valued roots of the characteristic equation are r_j for $1 \leq j \leq J_0$ and the distinct nonreal roots are $r_j = \alpha_j \pm \iota\beta_j$ for $J_0 < j \leq d$. The factorization $S = PEP^{-1}$ is always possible for a semisimple matrix.

First, it is important to know that the properties of the exponential function of a matrix are not always the same as for real numbers. If a and b are real numbers, then $e^{a+b} = e^a e^b = e^b e^a = e^{b+a}$. If A and B are matrices, generally $e^{A+B} \neq e^A e^B$ and generally $e^A e^B \neq e^B e^A$. The failure for equality of $e^A e^B$ and $e^B e^A$ should be intuitive; you are already aware that matrix multiplication is not commutative. The failure for equality of e^{A+B} and $e^A e^B$ is not obvious. Now these terms are equal under very special conditions, in particular when the input matrices themselves commute, $AB = BA$.

The decomposition $A = S + N$ has the property that $SN = NS$, so in fact we can write $e^A = e^{S+N} = e^S e^N$. Since S is semisimple, it is factorable as $S = PEP^{-1}$, where P is invertible and E is a matrix of the form in equation (8.21). Since N is nilpotent, the infinite sum of e^N is really a finite one because $N^k = 0$ for $k \geq p$,

$$
e^N = \sum_{k=0}^{\infty} \frac{N^k}{k!} = \sum_{k=0}^{p-1} \frac{N^k}{k!}
$$

Combining these leads to a concise formula for e^A,

$$e^A = e^S e^N = P e^E P^{-1} \sum_{k=0}^{p-1} \frac{N^k}{k!}$$

when $D = \text{Diag}(d_1, \ldots, d_n)$. The only remaining computation is e^E, a matrix that is shown to be

$$e^E = \begin{bmatrix} e^{r_1} & & & & & & \\ & \ddots & & & & & \\ & & e^{r_{J_0}} & & & & \\ & & & e^{\alpha_{J_0+1}} \begin{bmatrix} \cos(\beta_{J_0+1}) & -\sin(\beta_{J_0+1}) \\ \sin(\beta_{J_0+1}) & \cos(\beta_{J_0+1}) \end{bmatrix} & & & \\ & & & & \ddots & \\ & & & & & e^{\alpha_d} \begin{bmatrix} \cos(\beta_d) & -\sin(\beta_d) \\ \sin(\beta_d) & \cos(\beta_d) \end{bmatrix} \end{bmatrix}$$

(8.22)

The solution to the linear system of differential equations in equation (8.20) is therefore

$$\mathbf{y}(t) = e^{A(t-t_0)} \mathbf{y}_0 = \left(P \, e^{E(t-t_0)} P^{-1} \sum_{k=0}^{p-1} \frac{N^k (t-t_0)^k}{k!} \right) \mathbf{y}_0$$

(8.23)

The bulk of the work in computing the solution is therefore in numerically computing the decomposition $A = S + N$ and factoring $S = PEP^{-1}$.

8.6 EQUILIBRIA AND STABILITY

An intuitive description of the concepts of *equilibria* and *stability* of solutions comes from the simple pendulum problem of Example 3.4. The differential equation that models the motion of the pendulum relative to the vertical, and measured in terms of the angle $\theta(t)$ formed with the vertical, is

$$\ddot{\theta} + \frac{g}{L} \sin\theta = 0, \quad t \geq 0, \qquad \theta(0) = \theta_0, \ \dot{\theta}(0) = \dot{\theta}_0$$

If we were to let the pendulum hang straight down and not give it an initial push, it would remain in the vertical position forever. The initial conditions for this configuration are $\theta_0 = 0$ and $\dot{\theta}_0 = 0$. The solution to the differential equation is $\theta(t) \equiv 0$, where the three-barred symbol denotes "equal for all t." This solution is referred to as an *equilibrium solution*. Moreover, the solution is *stable* in the sense that if you were to just slightly push the pendulum, the motion is about the equilibrium solution and remains so for all time.

Now suppose you were to position the pendulum so that it was vertically upward and had no initial velocity. The initial conditions are $\theta_0 = \pi$ and $\dot{\theta}_0$. Observe that $\theta(t) \equiv \pi$ is a solution to the differential equation with the specified initial conditions. This solution is also an equilibrium solution, but it is *unstable* in the sense that if you were to just slightly push the pendulum, the motion would take the pendulum far away from $\theta_0 = \pi$.

We can write the simple pendulum model as a system of equations of the form of equation (8.18) by defining $y_1 = \theta(t)$, $y_2 = \dot{\theta}(t)$, $\mathbf{y}(t) = [y_1\ y_2]^\mathrm{T}$, $\mathbf{y}_0 = [\theta_0\ \dot{\theta}_0]$, and $\mathbf{g}(t, \mathbf{y}) = [y_2 - (g/L)\sin y_1]^\mathrm{T}$, namely,

$$\dot{\mathbf{y}} = \mathbf{g}(t, \mathbf{y})$$

In this form the equilibrium solutions are $\mathbf{y} \equiv (0, 0)$ and $\mathbf{y} \equiv (\pi, 0)$.

In general, an *equilibrium solution* to equation (8.18) is $\mathbf{y}(t) \equiv \mathbf{y}_0$ where $\mathbf{g}(t, \mathbf{y}_0) \equiv 0$. Just as in the pendulum problem we want to know if we start the system near an equilibrium solution, will it remain nearby for all time (stable)? Or will it immediately move away from the equilibrium (unstable)? To answer this question we need a formal definition for stability. The definition is more general in that it may be applied to *any* solution of the differential equation, not just to an equilibrium solution. The intuitive concept is that a solution is stable when other solutions nearby at initial time tend to stay nearby for all time.

The classical stability results are developed for *autonomous systems of equations*. These are differential equations where the right-hand side does not explicitly depend on t; that is, the differential equation is $\dot{\mathbf{y}} = \mathbf{g}(\mathbf{y})$.

Definition ▪ Let $\mathbf{y} = \boldsymbol{\phi}(t)$ be a solution to $\dot{\mathbf{y}} = \mathbf{g}(\mathbf{y})$. The solution is *stable* if every solution $\boldsymbol{\psi}(t)$ of the differential equation that is close to $\boldsymbol{\phi}(t)$ at initial time $t = 0$ remains close for all future time. In mathematical terms, this is reminiscent of the definition for a limit: For each choice of $\varepsilon > 0$ there is a $\delta > 0$ such that $|\boldsymbol{\psi}(t) - \boldsymbol{\phi}(t)| < \varepsilon$ whenever $|\boldsymbol{\psi}(0) - \boldsymbol{\phi}(0)| < \delta$. If at least one solution $\boldsymbol{\psi}(t)$ does not remain close, then $\boldsymbol{\phi}(t)$ is said to be *unstable*. ▪

For a stable solution the ε-δ definition says that you select the maximum amount of error ε you can tolerate between $\boldsymbol{\psi}(t)$ and $\boldsymbol{\phi}(t)$. The value δ, which depends on your choice of ε, tells you how close to $\boldsymbol{\phi}(0)$ you have to start in order to stay within that error.

8.6.1 STABILITY FOR CONSTANT-COEFFICIENT LINEAR SYSTEMS

The stability of solutions for constant-coefficient linear systems $\dot{\mathbf{y}} = A\mathbf{y}$ is completely determinable. The motivation for the general results is provided by the following example.

Consider a second-order equation with characteristic polynomial $r^2 - ar - b = 0$. Suppose that the polynomial has two distinct real-valued roots r_1 and r_2. The solution to the initial value problem is listed in equation (8.8). Generally,

$$x(t) = C_1 e^{r_1 t} + C_2 e^{r_2 t}$$

An equilibrium solution is $\phi(t) \equiv 0$. In order for $x(t)$ to remain close to $\phi(t)$ for all time, we need to understand what happens to $x(t)$ as t becomes large (as $t \to \infty$ in the mathematical vernacular). The behavior of $x(t)$ for large t is dependent, of course, on the behavior of its components $e^{r_1 t}$ and $e^{r_2 t}$. If $r_1 < 0$ and $r_2 < 0$, both exponentials decay to zero, in which case $\lim_{t \to \infty} x(t) = 0$. In fact, $x(t)$ remains "close" to zero. However, if $r_1 > 0$, the exponential term $e^{r_1 t}$ becomes unbounded regardless of the value of r_2 and $x(t)$ does not stay close to zero. The same instability occurs if $r_2 > 0$ regardless of the value of r_1. That brings us to the case of $r_1 = 0$ and $r_2 < 0$ (or similarly, $r_1 < 0$ and $r_2 = 0$). The solution is $x(t) = C_1 + C_2 e^{r_2 t}$ and the limiting behavior is $\lim_{t \to \infty} x(t) = C_1$. The solution remains close to zero but does not approach zero when $C_1 \neq 0$. Being stable does not require the limit to be zero, only that you stay close for all time. Thus, the equilbrium solution is stable when $r_1 \leq 0$ and $r_2 \leq 0$ but unstable when either $r_1 > 0$ or $r_2 > 0$.

If the roots of the characteristic equation are $\alpha \pm i\beta$, where $\beta \neq 0$, the initial value problem has a solution provided by equation (8.9). Generally,

$$x(t) = (C_1 \cos(\beta t) + C_2 \sin(\beta t)) e^{\alpha t}$$

The graph of this function has sinusoidal oscillations, but the amplitude is exponential. If $\alpha < 0$, then the amplitude decays to zero over time. That is, $\lim_{t \to \infty} x(t) = 0$. The equilibrium solution $\phi(t) \equiv 0$ is stable in this case. If $\alpha > 0$, the oscillations are unbounded and the equilibrium solution is unstable. If $\alpha = 0$, the function $x(t)$ remains bounded for all time, which means it remains close to the zero solution ("close" in the sense that it does not move unboundedly away from the zero solution). The equilbrium solution is stable when $\alpha \leq 0$, but unstable when $\alpha > 0$.

Another case occurs when the characteristic polynomial has a repeated real root $r = a/2$. Equation (8.10) provides the solution to the initial value problem. Generally,

$$x(t) = (C_1 + C_2 t) e^{rt}$$

If $r < 0$, the solution decays to zero; the equilibrium solution is stable. If $r > 0$, the solution becomes unbounded; the equilibrium solution is unstable. If $r = 0$, $x(t)$ still becomes unbounded (generally for any nonzero C_2) and the equilbrium solution is unstable. This behavior is slightly different than the previous cases when a root was zero or the real part of a root was zero: The equilibrium solution is stable when $r < 0$ but unstable when $r \geq 0$. The general stability result is listed next without proof.

Theorem ▪ Consider the constant-coefficient linear equation $\dot{\mathbf{y}} = A\mathbf{y}$.

1. Every solution is stable if all the eigenvalues of A have negative real parts.

2. Every solution is unstable if at least one eigenvalue of A has positive real parts.

3. Suppose that the eigenvalues of A all have real parts that are zero or negative. List those eigenvalues with zero real parts as $r_j = i\beta_j$ for $1 \leq j \leq \ell$ and let the multiplicity of r_j relative to the characteristic equation be m_j. Every solution is stable if A has m_j linearly independent eigenvectors for each r_j. Otherwise, every solution is unstable. ▪

The first two conditions of the theorem are clearly illustrated by our example for a second-order equation, when the characteristic roots are distinct. The third condition is illustrated regardless of whether the characteristic roots are repeated or distinct. In the case of two distinct real roots, when $r_1 = 0$ and $r_2 < 0$ we have stability. The matrix A has an eigenvalue $r = 0$ of multiplicity 1 and one linearly independent eigenvector to go with it. In the case of two distinct nonreal roots, when $\alpha = 0$ we have stability. Each nonreal root is an eigenvalue of A with multiplicity 1, each eigenvalue having one linearly independent eigenvector to go with it. In the case of a repeated real root, the matrix A has an eigenvalue $r = a/2$ of multiplicity 2, but only one linearly independent eigenvector $(1, a/2)$, so the equilibrium solution is unstable.

Notice that when all the eigenvalues of A have negative real parts, the limit of any solution $x(t)$ as t approaches infinity is 0. Thus, the equilibrium solution $\phi(t) \equiv 0$ is stable. The limit being zero is quite a strong condition. In this case we say that the zero solution is *asymptotically stable*. The concept applies to any solution:

Definition ▪ Let $\mathbf{y} = \phi(t)$ be a solution to $\dot{\mathbf{y}} = \mathbf{g}(\mathbf{y})$. The solution is *asymptotically stable* if it is stable and if every solution $\psi(t)$ that is close to $\phi(t)$ at initial time $t = 0$ approaches $\phi(t)$ as t approaches infinity. ▪

8.6.2 Stability for General Autonomous Systems

This last section shows the stability properties for constant-coefficient, linear systems of equations. Other than the mass-spring systems, our physics applications were invariably nonlinear. We would still like to know the stability of the physical systems at equilibrium points. Consider the general autonomous system,

$$\dot{\mathbf{y}} = A\mathbf{y} + \mathbf{g}(\mathbf{y})$$

where A is an $n \times n$ matrix of constants and where $\mathbf{g}(\mathbf{y})$ is an $n \times 1$ vector for which $\mathbf{g}(\mathbf{y})/\|\mathbf{y}\|$ is continuous and which is zero when \mathbf{y} is zero. The norm of the vector is the *max norm*, $\|\mathbf{y}\| = \max\{|y_1|, \ldots, |y_n|\}$, and is not the length of the vector. The stability analysis is summarized by the following.

Theorem ▪ Consider the equilibrium solution $\mathbf{y}(t) \equiv \mathbf{0}$ of $\dot{\mathbf{y}} = A\mathbf{y} + \mathbf{g}(\mathbf{y})$, where $\mathbf{g}(\mathbf{y})/\|\mathbf{y}\|$ is continuous and $\lim_{\mathbf{y}\to\mathbf{0}} \mathbf{g}(\mathbf{y})/\|\mathbf{y}\| = \mathbf{0}$.

1. The equilibrium solution is asymptotically stable if all the eigenvalues of A have negative real parts.

2. The equilibrium solution is unstable if at least one eigenvalue of A has positive real parts.

3. The stability of the equilibrium solution cannot be determined from the stability of the equilibrium solution for the linear system $\dot{\mathbf{y}} = A\mathbf{y}$ when all the eigenvalues of A have real parts zero or negative with at least one eigenvalue having real part zero. ▪

The classical way this result is applied to a general autonomous system $\dot{\mathbf{y}} = \mathbf{f}(\mathbf{y})$, where $\mathbf{f}(\mathbf{0}) = \mathbf{0}$, is to use Taylor's Theorem with Remainder from calculus to write

$$\mathbf{f}(\mathbf{y}) = \mathbf{f}(\mathbf{0}) + A\mathbf{y} + \mathbf{g}(\mathbf{y}) = A\mathbf{y} + \mathbf{g}(\mathbf{y})$$

where A is the matrix of first-order partial derivatives of $\mathbf{f}(\mathbf{y})$ evaluated at zero and $\mathbf{g}(\mathbf{y})$ is the remainder term of second- and higher-order expressions.

The three conditions of the theorem mimic those shown in the theorem for stability of linear systems with constant matrix A. The last condition is problematic. In the case of linear systems, having some eigenvalues with negative real parts and the rest with zero real parts puts you on the border of stability versus instability. This is a particular problem in the numerical solution of differential equations. If you have a physical model for which theoretically there is a zero eigenvalue of the linearized system, numerical error can make it appear as if the model actually has a small positive eigenvalue, causing the numerical solution to behave erratically.

As an example consider the damped, simple pendulum problem. The equation of motion is $\ddot{\theta} + (g/L)\sin\theta = -c\dot{\theta}, c > 0$, where the right-hand side represents viscous friction at the pendulum joint. Setting $y_1 = \theta$, $y_2 = \dot{\theta}$, $\mathbf{y} = [y_1\ y_2]^{\mathrm{T}}$, and

$$\mathbf{f}(\mathbf{y}) = \begin{bmatrix} f_1(y_1, y_2) \\ f_2(y_1, y_2) \end{bmatrix} = \begin{bmatrix} y_2 \\ -\frac{g}{L}\sin y_1 - cy_2 \end{bmatrix}$$

the system that models the pendulum is $\dot{\mathbf{y}} = \mathbf{f}(\mathbf{y})$, where $\mathbf{f}(\mathbf{0}) = \mathbf{0}$. The linearized system is $\dot{\mathbf{y}} = A\mathbf{y}$, where

$$A = \begin{bmatrix} \frac{\partial f_1(y_1, y_2)}{\partial y_1} & \frac{\partial f_1(y_1, y_2)}{\partial y_2} \\ \frac{\partial f_2(y_1, y_2)}{\partial y_1} & \frac{\partial f_2(y_1, y_2)}{\partial y_2} \end{bmatrix}\Bigg|_{(y_1, y_2)=(0,0)} = \begin{bmatrix} 0 & 1 \\ -\frac{g}{L} & -c \end{bmatrix}$$

The eigenvalues are $r = (-c \pm \sqrt{c^2 - 4g/L})/2$. If $c > 0$ and $c^2 \geq 4g/L$, the eigenvalues are negative real numbers and we have asymptotic stability of $\mathbf{y} \equiv \mathbf{0}$. What this means physically is that if you start the pendulum nearly vertical and give it a small velocity, it will move to the vertical position and stop without oscillating about

the vertical position (strong damping). If $c > 0$ and $c^2 < 4g/L$, the eigenvalues are complex-valued with nonzero imaginary parts and negative real parts. If you start the pendulum nearly vertical and give it a small velocity, it will oscillate about the vertical position and eventually stop in the vertical position (weak damping). If you remove the damping so that $c = 0$, the eigenvalues are $\pm i\beta$ for a value $\beta \neq 0$. The theorem does not provide us any information on the stability in this case. A more detailed analysis will show that the zero solution is stable, but not asymptotically stable. That is, if you start the pendulum in a nearly vertical position and give it a small velocity, it will oscillate about the vertical forever (never stopping).

If you have shied away from eigenvalues and eigenvectors, change your ways! The eigendecomposition of a matrix is related to solving linear systems of differential equations that in turn occur as part of a physical simulation. And you want to program physics in a game environment, do you not? We did not avoid eigenvalues and eigenvectors in the previous chapters of this book, but one topic I intentionally avoided was choosing a differential equation solver for the equations of motion of a physical model. Part of the decision process involves choosing a step size for the numerical solver. This choice depends on the physical stability of equilibria of the system, an analysis that requires eigendecomposition. The choice also depends on the numerical stability of the solver. The relationship between physical stability and numerical stability is discussed in the next chapter.

CHAPTER 9

NUMERICAL METHODS

This chapter is the most fitting one for a computer implementation of a physical simulation. The focus of the book has been on understanding the basic concepts of physics, modeling a physical system, and deriving the equations of motion for that system. The physical simulation itself requires us to implement methods that numerically solve the differential equations that we derive. Many choices exist for numerical solvers. Each choice has its trade-offs to consider, the usual one being an exchange of speed for accuracy and/or stability. We want the solver to be fast, accurate, and robust. In most cases it is not possible to obtain all three simultaneously. A variety of algorithms for numerically solving differential equations are provided here, some to give you a flavor of the ideas even if they are not the best choices for a real application. The issue of stability is revisited, as promised in the chapter on differential equations.

To keep the discussion simple, let us look at a single first-order differential equation with initial conditions

$$\dot{x} = f(t, x), \quad t \geq t_0, \ x(t_0) = x_0 \tag{9.1}$$

The methods presented here extend easily to vector-valued functions that we encounter in the physics applications. Much of the analysis depends on looking at the derivatives of $x(t)$. In particular, recall the following result from calculus:

Taylor's Theorem ■ If $x(t)$ and its derivatives $x^{(k)}(t)$ for $1 \leq k \leq n$ are continuous on the closed interval $[t_0, t_1]$ and $x^{(n)}(t)$ is differentiable on the open interval (t_0, t_1), then there exists $\bar{t} \in [t_0, t_1]$ such that

$$x(t_1) = \sum_{k=0}^{n} \frac{x^{(k)}(t_0)}{k!} \left(t_1 - t_0\right)^k + \frac{x^{(n+1)}(\bar{t})}{(n+1)!} \left(t_1 - t_0\right)^{n+1} \quad ■$$

By convention $x^{(0)}(t) = x(t)$. The polynomial $P_n(t) = \sum_{k=0}^{n} x^{(k)}(t_0)(t - t_0)^k / k!$ is called the *Taylor polynomial of degree n* and may be used to approximate $x(t)$. The *remainder term* is $R_n(t) = x^{(n+1)}(\bar{t})(t - t_0)^{n+1}/(n + 1)!$ In practice we estimate a bound M for which $|x^{(n+1)}(t)| \leq M$ for all $t \in [t_0, t_1]$, thus leading to a bound on the total error $|R_n(t)| \leq M(t_1 - t_0)^{n+1}/(n + 1)!$ for $t \in [t_0, t_1]$.

9.1 Euler's Method

No discussion of numerical methods is complete without mentioning Euler's method, a very simple and popular method for solving differential equations. Its attraction is its simplicity. Its downfall is its large amount of truncation error compared to other methods and its lack of stability and accuracy for many practical examples.

Euler's method is a matter of using Taylor's Theorem with $n = 2$ on the interval $[t_i, t_{i+1}]$, where $h = t_{i+1} - t_i > 0$. Using dot notation, since we only have a couple of derivatives to look at,

$$x(t_{i+1}) = x(t_i) + \dot{x}(t_i)h + \ddot{x}(\bar{t})\frac{h^2}{2} = x(t_i) + hf(t_i, x(t_i)) + \ddot{x}(\bar{t})\frac{h^2}{2}$$

for some $\bar{t} \in [t_i, t_{i+1}]$. Observe that we replaced $\dot{x}(t_i)$ by $f(t_i, x(t_i))$ since we know that $x(t)$ is a solution to the differential equation (9.1). Define $x_i = x(t_i)$ for all i; keep in mind that x_i refers to the exact value of the solution to the differential equation at time t_i. Discarding the remainder term and using y_i to denote the *approximation* to x_i, we obtain Euler's method,

$$y_{i+1} = y_i + hf(t_i, y_i), \quad i \geq 0, \quad y_0 = x_0 \tag{9.2}$$

Certainly this is an easy method to implement. The important question, though, is how well y_i approximates x_i for large i. In particular we would like to know a bound on the error term $|x_i - y_i|$.

In Chapter 8, "Differential Equations," we mentioned an existence and uniqueness theorem whose hypotheses included the continuity of the partial derivative $f_x(t, x)$ on a rectangle containing the initial point (t_0, x_0). This condition implies

$$|f(t, x) - f(t, \bar{x})| \leq L|x - \bar{x}|$$

for some constant $L > 0$ and for any (t, x) and (t, \bar{x}) in the rectangle. Let us assume that there is a value $M > 0$ for which $|\ddot{x}(t)| \leq M$ for all t of interest in our differential equation solving. We can use these facts to obtain an upper bound on the error term $|x_i - y_i|$. Specifically,

$$|x_{i+1} - y_{i+1}| = \left| x_i + hf(t_i, x_i) + \ddot{x}(\bar{t}) \frac{h^2}{2} - y_i - hf(t_i, y_i) \right|$$

$$\leq |x_i - y_i| + h|f(t_i, x_i) - f(t_i, y_i)| + Mh^2/2$$

$$\leq |x_i - y_i| + L|x_i - y_i| + Mh^2/2$$

$$= (1 + Lh)|x_i - y_i| + Mh^2/2$$

Define $e_i = |x_i - y_i|$. The preceding inequality is of the form $e_{i+1} \leq (1 + Lh)e_i + c$ for $c > 0$. We know that $e_0 = 0$. The inequality for $i = 1$ is

$$e_1 \leq (1 + Lh)e_0 + c = c$$

The inequality for $i = 2$ is

$$e_2 \leq (1 + Lh)e_1 + c \leq (1 + Lh)c + c = ((1 + Lh) + 1)c$$

For $i = 3$ the inequality is

$$e_3 \leq (1 + Lh)e_2 + c \leq (1 + Lh)((1 + Lh) + 1)c = ((1 + Lh)^2 + (1 + Lh) + 1)c$$

You should recognize the pattern and deduce that, in general,

$$
\begin{aligned}
e_i &\leq c \sum_{j=0}^{i-1} (1 + Lh)^j \\
&= \frac{Mh^2}{2} \frac{(1 + Lh)^i - 1}{Lh} \\
&\leq \frac{Mh^2}{2} \frac{e^{iLh} - 1}{Lh} \\
&= \frac{M(e^{L(t_i - t_0)} - 1)}{2L} h \\
&\leq Kh
\end{aligned}
\tag{9.3}
$$

for $i \geq 1$. We have used the fact that $(1 + x)^p \leq e^{px}$ for $x \geq 0$ and $p > 0$. We also used $t_i = t_0 + ih$. The final bound K is a constant that absorbs M and L and uses the fact that $\exp(L(t_i - t_0))$ is bounded when we are solving the differential equation on an already specified interval $[t_0, T]$, namely, $\exp(L(t_i - t_0)) \leq \exp(L(T - t_0))$. The

bound K is independent of h; the smaller h is, the more iterations it takes to get to time T, but K is independent of this process.

What we have shown is that the amount of error e_i between the true value of the iterate x_i and the approximate value y_i is bounded by $e_i \leq Kh$ for some constant K. If you were to halve the step size, you would expect only half the error and a better approximation. However, it takes you twice as many steps to reach the maximum time T. This is one of the promised trade-offs you have to decide on: smaller errors in exchange for more computing time.

The analysis that led to the inequality of equation (9.3) is based on truncation error in the mathematical formulation. That is, we discarded the remainder term from Taylor's Theorem and argued how much error occurs in the iterates. As you are well aware, a full numerical analysis of the problem must also deal with errors introduced by a floating point number system. In particular, when you compute $y_i + hf(t_i, y_i)$ using floating point arithmetic, a small round-off error will occur. If δ_{i+1} is the round-off error that occurs when computing y_{i+1}, we can formulate yet another equation for determining the actual floating point values obtained from Euler's method:

$$z_{i+1} = z_i + hf(t_i, z_i) + \delta_{i+1}$$

The iterate z_i is the floating point number that occurs when trying to compute the theoretical value y_i. An argument similar to the one used in the truncation error can be applied to estimate the error $|x_i - z_i|$. Specifically,

$$|x_{i+1} - z_{i+1}| = \left| x_i + hf(t_i, x_i) + \ddot{x}(\bar{t})\frac{h^2}{2} - z_i - hf(t_i, z_i) - \delta_{i+1} \right|$$

$$\leq (1 + Lh)|x_i - z_i| + \frac{Mh^2}{2} + \delta$$

where δ is an upper bound on all the $|\delta_i|$ values. Define $\varepsilon = |x_i - z_i|$. In this case ε_0 is not necessarily zero since the floating point representation z_0 for x_0 might not be an exact representation. The inequality for $i = 1$ is

$$\varepsilon_1 \leq (1 + Lh)\varepsilon_0 + (Mh^2/2 + \delta)$$

The inequality for $i = 2$ is

$$\varepsilon_2 \leq (1 + Lh)\varepsilon_1 + \delta \leq (1 + Lh)^2\varepsilon_0 + ((1 + Lh) + 1)(Mh^2/2 + \delta)$$

For $i = 3$ the inequality is

$$\varepsilon_3 \leq (1 + Lh)\varepsilon_2 + \delta \leq (1 + Lh)^3\varepsilon_0 + ((1 + Lh)^2 + (1 + Lh) + 1)(Mh^2/2 + \delta)$$

The pattern leads to the closed form

$$\varepsilon_i \leq (1 + Lh)^i \varepsilon_0 + \left(\frac{Mh^2}{2} + \delta \right) \sum_{j=0}^{i-1} (1 + Lh)^j$$

$$\leq \varepsilon_0 e^{L(T-t_0)} + \frac{e^{L(T-t_0)} - 1}{L} \left(\frac{Mh}{2} + \frac{\delta}{h} \right) \qquad (9.4)$$

$$= K_0 + K_1 h + K_2 \frac{1}{h}$$

for $i \geq 1$ and for some constants K_0, K_1, and K_2.

The inequality of equation (9.4) differs from that of equation (9.3) in that a term $1/h$ occurs in equation (9.4). The general folklore of numerical differential equation solvers is that to get a better approximation you choose a smaller step size. This analysis shows that in fact this is not always true. Inequality (9.4) shows that as you let h approach zero, the error can become unbounded. Please keep in mind that the bound we produced using the inequality is exactly that—a bound. The actual error can be less; but then again, it might reach the upper bound. Also notice that $(Mh/2 + \delta/h)$ has a global minimum at $h = \sqrt{2\delta/M}$. This choice of h produces the smallest error bound. For an actual floating point number system, the chances are that $\sqrt{2\delta/M}$ is sufficiently small that you would never decrease h to such a small number in your numerical solver.

The analysis of this section was quite lengthy, but I include it to let you know that this is what numerical analysis of an algorithm is all about. You have errors due to mathematical approximations in the algorithms and errors due to representation in a floating point number system. In order to have some assurance of the accuracy of the output of the computer, you might consider doing analyses of this type yourself.

9.2 HIGHER-ORDER TAYLOR METHODS

Euler's method is the algorithm obtained by using the first-degree Taylor polynomial of $x(t)$ to approximate $x(t + h)$. Higher-order approximations may be used, the class of such algorithms called *higher-order Taylor methods*. For example, Taylor's Theorem when using a second-degree polynomial is

$$x(t_{i+1}) = x(t_i) + h\dot{x}(t_i) + \frac{h^2}{2}\ddot{x}(t_i) + \frac{h^3}{6}x^{(3)}(\bar{t})$$

where $h = t_{i+1} - t_i$ and for some $\bar{t} \in [t_i, t_{i+1}]$. We know that $\dot{x}(t) = f(t, x(t))$ since $x(t)$ is a solution to the differential equation. An expression for $\ddot{x}(t)$ is obtained by

differentiating the differential equation and using the chain rule from calculus,

$$\ddot{x}(t) = \frac{d}{dt} f(t, x(t))$$

$$= f_t(t, x(t)) + f_x(t, x(t))\dot{x}(t) = f_t(t, x(t)) + f_x(t, x(t))f(t, x(t))$$

where $f_t = \partial f/\partial t$ and $f_x = \partial f/\partial x$. The numerical method for degree $n = 2$ is

$$y_{i+1} = y_i + hf(t_i, y_i) + \frac{h^2}{2}\left(f_t(t_i, y_i) + f_x(t_i, y_i)f(t_i, y_i)\right), \quad i \geq 0, \ y_0 = x_0 \quad (9.5)$$

Euler's method is a Taylor method of degree 1 and has approximation error bound Kh for some constant K. The degree n Taylor method can be shown to have an error bound Kh^n for some constant K, so generally you expect more accuracy than Euler's method for a given step size h.

The technical problem with Taylor methods is that you need to formally compute the partial derivatives of $f(t, x)$. In many applications such as our physics examples where f represents external forces and torques, we do not have the luxury of computing derivatives since we do not know ahead of time a closed form for f itself.

9.3 METHODS VIA AN INTEGRAL FORMULATION

The initial value problem of equation (9.1) may be formally integrated to obtain

$$x(t_{i+1}) = x(t_i) + \int_{t_i}^{t_{i+1}} f(t, x(t))\, dt \quad (9.6)$$

Define $\phi(t) = f(t, x(t))$; for the sake of illustration, suppose that $\phi(t) > 0$. The integral of equation (9.6) represents the area bounded by the graph of $\phi(t)$, the t-axis, and the vertical lines $t = t_i$ and $t = t_{i+1}$. Figure 9.1(a) illustrates.

Figure 9.1(b) shows an approximation of the area by a rectangle,

$$\int_{t_i}^{t_{i+1}} f(t, x(t))\, dt = \int_{t_i}^{t_{i+1}} \phi(t)\, dt \doteq (t_{i+1} - t_i)\phi(t_i) = (t_{i+1} - t_i)f(t_i, x_i)$$

If $x_i = x(t_i)$, y_i is an approximation to x_i, and $h = t_{i+1} - t_i$, then substituting the integral approximation into equation (9.6) produces Euler's method: $y_{i+1} = y_i + hf(t_i, y_i)$.

Figure 9.1(c) shows an approximation of the area by a trapezoid,

$$\int_{t_i}^{t_{i+1}} f(t, x(t))\, dt \doteq (t_{i+1} - t_i)\frac{f(t_i, x_i) + f(t_{i+1}, x_{i+1})}{2}$$

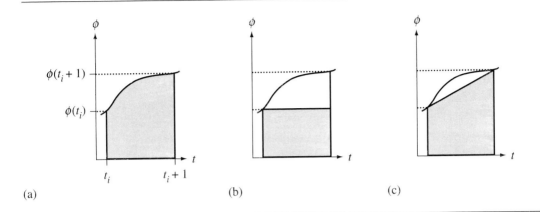

Figure 9.1 (a) Area under a curve. (b) Approximation of the area by a rectangle (leads to Euler's method). (c) Approximation of the area by a trapezoid (leads to the modified Euler's method).

This leads to a numerical algorithm for approximations y_i to x_i,

$$y_{i+1} = y_i + \frac{h}{2}(f(t_i, y_i) + f(t_{i+1}, y_{i+1})), \quad i \geq 0, \quad y_0 = x_0 \tag{9.7}$$

Unfortunately, we cannot immediately use this equation since the quantity we wish to determine, y_{i+1}, occurs on both the left and right sides of the equality. One modification to remedy this is to use an Euler step for the term on the right, $y_{i+1} = y_i + hf(t_i, y_i)$:

$$y_{i+1} = y_i + \frac{h}{2}(f(t_i, y_i) + f(t_i + h, y_i + hf(t_i, y_i))) \tag{9.8}$$

This is referred to as the *modified Euler's method* and is an *explicit method* since y_{i+1} is defined explicitly in terms of the quantities t_i and y_i computed at the previous time.

The method in equation (9.9) is referred to as an *implicit method* since y_{i+1} is defined implicitly by the equation. Implicit equations can use Newton's method for root finding to determine the unknown quantity. In our example, if we define

$$g(z) = \left(x_i + \frac{h}{2}f(t_i, x_i)\right) + \frac{h}{2}f(t_i + h, z) - z$$

then y_{i+1} is a root of $g(z) = 0$; that is, $g(y_{i+1}) = 0$. A reasonable starting guess for z is $z_0 = y_i$. The Newton iterates are

$$z_{j+1} = z_j - \frac{g(z_j)}{g'(z_j)}, \quad j \geq 0$$

You may well compute iterates until you are assured of convergence to a root that is used for y_{i+1}. An alternative that uses a bounded amount of time is just to iterate once and use that as your choice for y_{i+1}, in which case

$$y_{i+1} = y_i - \frac{(h/2)(f(t_i + h, y_i) + f(t_i, y_i))}{(h/2)f_x(t_i + h, y_i) - 1} \tag{9.9}$$

This does require knowing the partial derivative $f_x(t, x)$ in order that you may evaluate it.

An implicit method that occurs in a simpler manner is to think of Euler's method as an algorithm that uses a forward difference to approximate the first derivative of $x(t)$. That is,

$$\dot{x}(t_i) = \lim_{h \to 0} \frac{x(t_i + h) - x(t_i)}{h} \doteq \frac{x(t_i + h) - x(t_i)}{h} = \frac{x_{i+1} - x_i}{h}$$

Choosing y_i as the approximation to x_i and substituting into the differential equation leads to the approximation $(y_{i+1} - y_i)/h = f(t_i, y_i)$ or $y_{i+1} = y_i + hf(t_i, y_i)$, which is Euler's method. If we were to use a backward difference to approximate the first derivative:

$$\dot{x}(t_{i+1}) = \lim_{h \to 0} \frac{x(t_{i+1}) - x(t_{i+1} - h)}{h} \doteq \frac{x(t_{i+1}) - x(t_{i+1} - h)}{h} = \frac{x_{i+1} - x_i}{h}$$

then substituting into the differential equation and multiplying by h leads to an *implicit Euler's method*,

$$y_{i+1} = y_i + hf(t_{i+1}, y_{i+1}) \tag{9.10}$$

The equation is implicit since x_{i+1} occurs on both sides of the equality. Just as we tried earlier, define $g(z) = y_i + hf(t_i + h, z) - z$ and compute y_{i+1} as a root of $g(z) = 0$. Using Newton's method with an initial iterate $z_0 = x_i$ and iterating only once, we have

$$y_{i+1} = y_i - \frac{hf(t_i + h, y_i)}{hf_x(t_i + h, y_i) - 1} \tag{9.11}$$

This also requires knowing the partial derivative $f_x(t, x)$ in order that you may evaluate it.

9.4 RUNGE-KUTTA METHODS

The Taylor methods of Section 9.2 have high-order truncation errors, a good thing for an algorithm, but the methods require that you compute partial derivatives of $f(t, x)$. Runge-Kutta methods are designed to have the same high-order truncation error, yet use only evaluations of the function $f(t, x)$. The derivations require the extension of Taylor's Theorem to bivariate functions.

Taylor's Theorem ▦ Let $f(t, x)$ and its partial derivatives of orders 1 through $n + 1$ be continuous on a rectangular domain D. Let $(t_0, x_0) \in D$. For every $(t, x) \in D$, there is a $\bar{t} \in [t_0, t]$ and an $\bar{x} \in [x_0, x]$ such that $f(t, x) = P_n(t, x) + R_n(t, x)$, where

$$P_n(t, x) = \sum_{j=0}^{n} \frac{1}{j!} \sum_{i=0}^{j} \binom{j}{i} \frac{\partial^i f(t_0, x_0)}{\partial t^{j-i} \partial x^i} (t - t_0)^{j-i} (x - x_0)^i$$

is the *Taylor polynomial of degree n* and where

$$R_n(t, x) = \sum_{i=0}^{n+1} \binom{n+1}{i} \frac{\partial^{n+1} f(\bar{t}, \bar{x})}{\partial t^{n+1-i} \partial x^i} (t - t_0)^{n+1-i} (x - x_0)^i$$

is the remainder term. ▦

The Taylor polynomial you see quite often in practice is the one that includes the first- and second-order partial derivatives:

$$P_2(t, x) = f(t_0, x_0) + f_t(t_0, x_0)(t - t_0) + f_x(t_0, x_0)(x - x_0) + \frac{1}{2} f_{tt}(t_0, x_0)(t - t_0)^2$$

$$+ f_{tx}(t_0, x_0)(t - t_0)(x - x_0) + \frac{1}{2} f_{xx}(t_0, x_0)(x - x_0)^2$$

$$= f(t_0, x_0) + Df(t_0, x_0)^{\mathrm{T}} \begin{bmatrix} t - t_0 \\ x - x_0 \end{bmatrix}$$

$$+ \frac{1}{2} [\, t - t_0 \quad x - x_0 \,] D^2 f(t_0, x_0) \begin{bmatrix} t - t_0 \\ x - x_0 \end{bmatrix}$$

where $Df(t, x)$ is called the *gradient* of $f(t, x)$ (a list of the first-order partial derivatives) and $D^2 f(t, x)$ is called the *Hessian matrix* of $f(t, x)$ (a list of the second-order partial derivatives).

9.4.1 SECOND-ORDER METHODS

The application of Taylor's Theorem to the solution $x(t)$ produces the equation $x(t+h) = x(t) + h\dot{x}(t) + \frac{h^2}{2}\ddot{x}(t) + R(t)$ for a remainder $R(t)$ that is of order $O(h^3)$. Using $\dot{x} = f(t, x)$ and $\ddot{x} = f_t + f f_x$ as we did in deriving Taylor's method in equation (9.5), we have

$$x(t+h) = x(t) + hf(t, x) + \frac{h^2}{2}\left(f_t(t, x) + f(t, x)f_x(t, x)\right) + R(t) \quad (9.12)$$

As indicated, the equation requires evaluating the first-order partial derivatives of f. What we would like to do instead is replace the derivative evaluations by function evaluations. This is possible through an approximation that will change the remainder term R. Specifically, we want to obtain a formal expression

$$x(t+h) = x(t) + haf(t + b, x(t) + c) + \bar{R}(t)$$

for some choice of a, b, and c and a remainder $\bar{R}(t)$ that is of order $O(h^3)$. Using Taylor's Theorem for bivariate functions, we have

$$af(t + b, x + c) = af(t, x) + abf_t(t, x) + acf_x(t, x)c + S(t)$$

where $S(t)$ is $O(h^2)$. The right-hand side appears to be of the form shown in equation (9.12). Matching terms we obtain $a = 1$, $ab = h/2$, and $ac = (h/2)f$. The error terms match up as $R(t) = hS(t) + \bar{R}(t)$. Consequently, $a = 1$, $b = h/2$, and $c = hf/2$, so that

$$x(t+h) = x(t) + hf\left(t + \frac{h}{2}, x(t) + \frac{h}{2}f(t, x(t))\right) + R(t)$$

This suggests a numerical method for solving the differential equation,

$$y_{i+1} = y_i + hf\left(t_i + \frac{h}{2}, y_i + \frac{h}{2}f(t_i, y_i)\right) \quad (9.13)$$

and is called the *midpoint method*.

The midpoint method occurred as a result of using a Taylor polynomial of degree 1 to approximate $x(t)$. The numerical method has error of order $O(h^2)$. The hope is that an approximation using a Taylor polynomial of degree 2 will lead to a method whose error is of order $O(h^3)$. As it turns out, we can use the same method of construction but only obtain $O(h^2)$ methods. From Taylor's Theorem,

$$x(t + h) = x(t) + hf(t, x) + \frac{h^2}{2} \frac{d}{dt} f(t, x) + \frac{h^3}{6} \frac{d^2}{dt^2} f(t, x) + R(t)$$

$$= x(t) + hf + \frac{h^2}{2}(f_t + ff_x) + \frac{h^3}{6}(f_{tt} + 2ff_{tx} + f^2 f_{xx}$$

$$+ f_x(f_t + ff_x)) + R(t)$$

(9.14)

where $R(t)$ is of order $O(h^4)$. To replace the derivative evaluations by function evaluations, we postulate a formal expression,

$$x(t + h) = x(t) + h(a_1 f(t, x(t)) + a_2 f(t + b, x(t) + c)) + \bar{R}(t)$$

for some choice of a_1, a_2, b_2, and c_2 and a remainder $\bar{R}(t)$ that is of order $O(h^4)$. Using Taylor's Theorem to expand the expression involving the functions,

$$a_1 f(t, x) + a_2 f(t + b, x + c)$$

$$= a_1 f + a_2(bf_t + cf_x + (b^2/2)f_{tt} + bcf_{tx} + (c^2/2)f_{xx}) + S(t)$$

where $S(t)$ is of order $O(h^3)$. The right-hand side is *almost* of the form in equation (9.14), except there is no subexpression involving $f_x(f_t + ff_x)$. Regardless, let us try to match as many terms as possible. We can match the f, f_t, and f_x terms: $a_1 + a_2 = 1$, $a_2 b = h/2$, and $a_2 c = hf/2$. The remaining matches overconstrain the problem. This, and the inability to match the term $f_x(f_t + ff_x)$, means that those terms must become part of the remainder $S(t)$, forcing it to be of order $O(h^2)$ instead.

Our matched terms involve four parameters but only three equations. This gives us some flexibility in choosing them. One choice is $a_1 = a_2 = 1/2, b = h$, and $c = hf$, leading to the numerical method

$$y_{i+1} = y_i + \frac{h}{2}(f(t_i, y_i) + f(t_i + h, y_i + hf(t_i, y_i)))$$

(9.15)

You will notice that this is the *modified Euler method* (9.8) derived by other means. Another choice of parameters is $a_1 = 1/4, a_2 = 3/4, b = 2h/3$, and $c = 2hf/3$, leading to the numerical method

$$y_{i+1} = y_i + \frac{h}{4}\left(f(t_i, y_i) + 3f\left(t_i + \frac{2}{3}h, y_i + \frac{2}{3}hf(t_i, y_i)\right)\right)$$

(9.16)

This is referred to as *Heun's method*.

9.4.2 THIRD-ORDER METHODS

The inability to match some of the higher-order terms had to do with choosing an expression with a singly nested evaluation of f. That is, we have attempted to replace derivative evaluations by function evaluations using a term of the form $f(t + \alpha, x + \beta f(t, x))$. We can actually match the higher-order terms if we include a doubly nested term,

$$f(t + \alpha_1, x + \beta_1 f(t + \alpha_2, x + \beta_2 f(t, x)))$$

The method of construction is to expand this using Taylor's Theorem. The algebraic details are tedious because you have to first expand $f(t + \alpha_2, x + \beta_2 f)$, substitute it in the second component of the outermost f, and expand that. A symbolic mathematics package is quite useful here, not that Runge and Kutta could have benefited since their development of the ideas was in about 1900!

A couple of numerical methods of third order that are obtainable from this construction are

$$k_1 = hf(t_i, y_i) \qquad\qquad \text{No nesting}$$

$$k_2 = hf\left(t_i + \frac{h}{2}, y_i + \frac{k_1}{2}\right) \qquad \text{Singly nested}$$

$$k_3 = hf(t_i + h, y_i - k_1 + 2k_2) \qquad \text{Doubly nested} \tag{9.17}$$

$$y_{i+1} = y_i + \frac{1}{6}(k_1 + 2k_2 + k_3)$$

which for lack of a proper name we will call the *RK3a method*, and

$$k_1 = hf(t_i, y_i)$$

$$k_2 = hf\left(t_i + \frac{h}{3}, y_i + \frac{k_1}{3}\right)$$

$$k_3 = hf(t_i + \frac{2h}{3}, y_i + \frac{2k_2}{3}) \tag{9.18}$$

$$y_{i+1} = y_i + \frac{1}{4}(k_1 + 3k_3)$$

which we will call the *RK3b method*.

9.4.3 FOURTH-ORDER METHOD

To obtain a fourth-order method, the Taylor polynomial used to approximate $x(t)$ is

$$x(t+h) \doteq x(t) + hf + \frac{h^2}{2} \frac{df}{dt} + \frac{h^3}{6} \frac{d^2 f}{dt^2} + \frac{h^4}{24} \frac{d^3 f}{dt^3}$$

The symbolic expansion of $d^3 f/dt^3$ is quite complicated. The replacement of derivative evaluations by function evaluations uses a matching scheme by postulating a combination of function terms, one term with no nesting, one singly nested term, one doubly nested term, and one triply nested term. The details of matching are not shown here as they are quite complicated. The resulting numerical method is

$$k_1 = hf(t_i, y_i) \qquad\qquad \text{No nesting}$$

$$k_2 = hf\left(t_i + \frac{h}{2}, y_i + \frac{k_1}{2}\right) \qquad\qquad \text{Singly nested}$$

$$k_3 = hf\left(t_i + \frac{h}{2}, y_i + \frac{k_2}{2}\right) \qquad\qquad \text{Doubly nested} \qquad (9.19)$$

$$k_4 = hf(t_i + h, y_i + k_3) \qquad\qquad \text{Triply nested}$$

$$y_{i+1} = y_i + \frac{1}{6}(k_1 + 2k_2 + 2k_3 + k_4)$$

and is known as a *Runge-Kutta fourth-order method* (or the *RK4a method*). I specifically used the article *a*, not *the*. Other fourth-order methods are possible, just like the midpoint, modified Euler, and Heun methods were different second-order methods. A concise summary of many of these methods may be found in [AS65, Section 25.5]. Two of these are

$$k_1 = hf(t_i, y_i)$$

$$k_2 = hf\left(t_i + \frac{h}{3}, y_i + \frac{k_1}{3}\right)$$

$$k_3 = hf\left(t_i + \frac{2h}{3}, y_i - \frac{k_1}{3} + k_2\right) \qquad (9.20)$$

$$k_4 = hf(t_i + h, y_i + k_1 - k_2 + k_3)$$

$$y_{i+1} = y_i + \frac{1}{8}(k_1 + 3k_2 + 3k_3 + k_4)$$

which I will refer to as the *RK4b method*. The other is

$$k_1 = hf(t_i, y_i)$$

$$k_2 = hf\left(t_i + \frac{h}{2}, y_i + \frac{k_1}{2}\right)$$

$$k_3 = hf\left(t_i + \frac{h}{2}, y_i + \left(-\frac{1}{2} + \sqrt{\frac{1}{2}}\right)k_1 + \left(1 - \sqrt{\frac{1}{2}}\right)k_2\right)$$

$$k_4 = hf\left(t_i + h, y_i - \sqrt{\frac{1}{2}}k_2 + \left(1 + \sqrt{\frac{1}{2}}\right)k_3\right)$$

$$y_{i+1} = y_i + \frac{1}{6}\left(k_1 + 2\left(1 - \sqrt{\frac{1}{2}}\right)k_2 + 2\left(1 + \sqrt{\frac{1}{2}}\right)k_3 + k_4\right)$$

(9.21)

which is known as *Gill's method*.

9.5 MULTISTEP METHODS

The methods previously discussed in this chapter are referred to as one-step methods. Each numerical method computes y_{i+1} using information only about y_i. Euler's method is an explicit one-step method, $y_{i+1} = y_i + hf(t_i, y_i)$. We also mentioned the implicit Euler's method—a one-step method, $y_{i+1} = y_i + hf(t_{i+1}, y_{i+1})$—that requires root finding to solve for y_{i+1}. *Multistep methods* are a generalization of these two equations. An m-step method generates the iterate y_{i+1} from the previous iterates y_i through $y_{i-(m-1)}$. The general method is summarized by

$$y_{i+1} = \sum_{j=0}^{m-1} a_j y_{i-j} + h \sum_{j=0}^{m} b_j f(t_{i+1-j}, y_{i+1-j}), \quad i \geq m - 1 \qquad (9.22)$$

where the method is *implicit* if $b_0 \neq 0$ (y_{i+1} occurs on the right-hand side) or *explicit* if $b_0 = 0$ (y_{i+1} does not occur on the right-hand side). Initial conditions are required to start the iteration and must include known values for y_0 through y_{m-1}. In practice you typically know only y_0 at time t_0. The other iterates can be generated by using a 1-step method, a bootstrapping process of sorts.

The differential equation in its integral form is mentioned in equation (9.6). For $f > 0$ the motivation for numerical methods was to approximate the area under the curve $\phi(t) = f(t, x(t))$ for $t_i \leq t \leq t_{i+1}$. Multistep methods are derivable in a similar manner. The approximation by the area of a rectangle is equivalent to approximating $\phi(t)$ by a constant function $P(t) = \phi(t_i)$ and integrating. The approximation by

the area of a trapezoid is equivalent to approximating $\phi(t)$ by a linear function $P(t) = \phi(t_i) + (\phi(t_{i+1}) - \phi(t_i)(t - t_i)/(t_{i+1} - t_i)$ but leads to an implicit method because of the occurrence of the future value $\phi(t_{i+1})$. We may approximate $\phi(t)$ by a polynomial $P(t)$ of higher degree and obtain either explicit or implicit methods.

The explicit m-step method using the higher-degree approximation is to choose $P(t)$ as the interpolating polynomial of degree $m - 1$ of the iterates (t_j, y_j) for $i - m + 1 \leq j \leq i$. If we set $t = t_i + sh$, where s is a continuous variable and $f_i = f(t_i, y_i)$, the polynomial is

$$P(t) = f_i + s \nabla f_i + \frac{s(s+1)}{2} \nabla^2 f_i + \cdots + \frac{s(s+1) \cdots (s+m-2)}{(m-1)!} \nabla^{m-1} f_i$$

where $\nabla^j f_i$ terms are backward differences defined by $\nabla f_i = f_i - f_{i-1}$, and $\nabla^{k+1} f_i = \nabla(\nabla^k f_i)$ for $k \geq 1$. The numerical method obtained by integrating $P(t)$ and using it as an approximation to the integral is referred to as the *Adams-Bashforth m-step method*. The local truncation error is $O(h^m)$. Some special cases are shown:

$$y_{i+1} = y_i + h f_i \qquad\qquad \text{Euler's method}$$

$$y_{i+1} = y_i + \frac{h(3 f_i - f_{i-1})}{2} \qquad\qquad \text{two-step method}$$

$$y_{i+1} = y_i + \frac{h(23 f_i - 16 f_{i-1} + 5 f_{i-2})}{12} \qquad\qquad \text{three-step method}$$

$$y_{i+1} = y_i + \frac{h(55 f_i - 59 f_{i-1} + 37 f_{i-2} - 9 f_{i-3})}{24} \qquad\qquad \text{four-step method}$$

$$y_{i+1} = y_i + \frac{h(1901 f_i - 2774 f_{i-1} + 2616 f_{i-2} - 1274 f_{i-3} + 251 f_{i-4})}{720} \qquad \text{five-step method}$$

$$(9.23)$$

The derivation of the two-step method uses $P(t) = f_i + s(f_i - f_{i-1})$ and

$$\int_{t_i}^{t_{i+1}} P(t)\, dt$$

$$= h \int_0^1 f_i + s(f_i - f_{i-1})\, ds = h(f_i + (f_i - f_{i-1})/2) = (h/2)(3 f_i - f_{i-1})$$

A small observation: The coefficients of the f-terms add up to the denominator of the h-term.

In the Adams-Bashforth explicit solver the polynomial $P(t)$ interpolates the iterates occuring at times $t \leq t_i$. The values of $P(t)$ for $t \in [t_i, t_{i+1}]$ are *extrapolated*. In a sense the solver *predicts* the value y_{i+1} by this extrapolation. An implicit solver

is obtained by interpolating the iterates at times $t \leq t_{i+1}$. For example, if a two-step implicit method interpolates (t_{i-1}, f_{i-1}), (t_i, f_i), and (t_{i+1}, f_{i+1}) by a quadratic polynomial,

$$P(t) = f_i + \left(\frac{f_{i+1} - f_{i-1}}{2h} \right)(t - t_i) + \left(\frac{f_{i+1} - 2f_i + f_{i-1}}{2h^2} \right)(t - t_i)^2$$

The integral is

$$\int_{t_i}^{t_{i+1}} P(t)\, dt = \frac{h}{12}(5f_{i+1} + 8f_i - f_{i-1})$$

The implicit solver is $y_{i+1} = y_i + (h/12)(5f_{i+1} + 8f_i - f_{i-1})$. The m-step implicit method obtained in this manner is referred to as the *Adams-Moulton m-step method*. In general the local truncation error of an m-step implicit method is $O(h^{m+1})$, one degree larger than for an m-step explicit method. As a rule of thumb you get better accuracy with the implicit method, but the cost is that you have to solve the implicit equation for y_{i+1}. Some special cases are shown:

$$y_{i+1} = y_i + h(f_{i+1} + f_i)$$ Trapezoid method, equation (9.7)

$$y_{i+1} = y_i + \frac{h(5f_{i+1} + 8f_i - f_{i-1})}{12}$$ two-step method

(9.24)

$$y_{i+1} = y_i + \frac{h(9f_{i+1} + 19f_i - 5f_{i-1} + f_{i-2})}{24}$$ three-step method

$$y_{i+1} = y_i + \frac{h(251f_{i+1} + 646f_i - 264f_{i-1} + 106f_{i-2} - 19f_{i-3})}{720}$$ four-step method

9.6 PREDICTOR-CORRECTOR METHODS

The Adams-Bashforth m-step solver is an explicit method that interpolates the iterates through time t_i with a polynomial and integrates the polynomial on $[t_i, t_{i+1}]$. As such we are using the polynomial to extrapolate the behavior for times $t \geq t_i$. The resulting approximation is used to generate the iterate y_{i+1}. The Adams-Moulton m-step solver is an implicit method that interpolates the iterates through time t_{i+1} with a polynomial and integrates the polynomial on $[t_i, t_{i+1}]$. We are using the polynomial to interpolate the behavior for times $t \geq t_i$, but since we do not know y_{i+1} we obtain the implicit behavior. Rather than solve the implicit equation via a root finder or fixed point iteration, something not guaranteed to be stable or robust, we use the two methods together. The pair forms what is called a *predictor-corrector method*. The explicit method is used to *predict* the value of y_{i+1}. This value is used on the right-hand side of the implicit equation to *correct* the value. The left-hand side of the implicit equation is the corrected value. Of course, you may iterate the corrector portion of

the system by taking the left-hand side value and feeding it back to the right-hand side, effectively implementing a fixed point iteration that hopefully converges.

9.7 EXTRAPOLATION METHODS

In this section we look at the prospect of applying extrapolation methods to increase the accuracy of our approximations to the solutions of differential equations. The basic approach will be to compute three approximations to $x(t)$ using different step sizes whose ratios in pairs are integers; each approximation will require a different number of iterations. The approximations are all $O(h^2)$ but can be combined to produce an approximation that is $O(h^6)$.

9.7.1 RICHARDSON EXTRAPOLATION

Accurate approximations may be obtained from low-order formulas using a method called *Richardson extrapolation* [RG27]. Let Q be an unknown quantity, which is approximated by $A(h)$. Think of $A(h)$ as a black-box process that can approximate Q depending on some parameter h that you may choose as you like. For our purposes h is the step size in the differential equation solver. Suppose that the approximation is of the following form for some constant c_1:

$$Q = A(h) + c_1 h^2 + O(h^4) = A(h) + O(h^2)$$

We can generate another approximation with the process by selecting $h/2$ instead, namely,

$$Q = A(h/2) + c_1 h^2/4 + O(h^4) = A(h/2) + O(h^2)$$

In practice, of course, we would use $A(h)$ or $A(h/2)$ as the approximation since we do not know what c_1 is; after all, A represents a black-box process. The two approximations can be combined to eliminate the quadratic term in h, even though we do not know c_1. Specifically, another approximation for the quantity is

$$Q = \frac{1}{3} \left(4(A(h/2) + c_1 h^2/4 + O(h^4)) - (A(h) + c_1 h^2 + O(h^4)) \right)$$

$$= \frac{4A(h/2) - A(h)}{3} + O(h^4)$$

That is, the value $(4A(h/2) - A(h))/3$ is an approximation for Q, but the surprising conclusion is that the error is $O(h^4)$ rather than $O(h^2)$ of the two original approximations.

Define $A_1(h) = A(h)$ and $A_2(h) = (4A(h/2) - A(h))/3$. We have seen that $Q = A_2(h) + O(h^4)$. If additionally we know that

$$Q = A_2(h) + c_2 h^4 + O(h^6)$$

we can repeat the process. Using half the input parameter, we have another approximation

$$Q = A_2(h/2) + c_2 h^4/16 + O(h^6)$$

The two approximations combine to produce

$$Q = \frac{16 A_2(h/2) - A_2(h)}{15} + O(h^6)$$

with yet another increase in the order of the error. Define $A_3(h) = (16A_2(h/2) - A_2(h))/15$. Assuming more structure in the error terms so that powers $c_k h^{2k}$ appear for constants c_k, further repetitions lead to the approximation

$$Q = A_k(h) + O(h^{2k}), \qquad A_k(h) = \frac{4^{k-1} A_{k-1}(h/2) - A_{k-1}(h)}{4^{k-1} - 1}$$

9.7.2 APPLICATION TO DIFFERENTIAL EQUATIONS

Let us look at the application of a slight variation of the Richardson extrapolation to numerical methods for differential equations. The method is attributed to [Gra65]. The differential equation is $\dot{x} = f(t, x)$. Suppose we have a numerical method of the form

$$y_{i+1} = y_i + h\phi(t_i, y_i, h)$$

Let $A(t, h)$ denote the process of solving the numerical method to approximate $y(t)$. As long as the approximation is of the form

$$x(t) = A(t, h) + \sum_{k=1}^{n} c_k(t) h^{2k} + O(h^{2n+2})$$

where the $c_k(t)$ are independent of h, we can use extrapolation to produce a high-order approximation from low-order ones. Choose a value $h > 0$ and choose three step sizes $h_j = h/q_j$, $0 \le j \le 2$, where the q_j are positive integers. We solve the

numerical method for these step sizes. The approximation using h_j requires q_j steps. The actual solutions are

$$x(t) = A(t, h_j) + c_1(t)h_j^2 + c_2(t)h_j^4 + O(h^6)$$

$$= A(t, h_j) + \frac{c_1(t)}{q_j^2} h^2 + \frac{c_2(t)}{q_j^4} h^4 + O(h^6)$$

for $0 \le j \le 2$.

Define $A_{j,0} = A(t, h_j)$ for $0 \le j \le 2$. We can combine the first two equations for $x(t)$ to eliminate the h^2 term:

$$x(t) = \frac{q_1^2 A_{1,0} - q_0^2 A_{0,0}}{q_1^2 - q_0^2} - \frac{c_2(t)}{q_0^2 q_1^2} h^4 + O(h^6) = A_{1,1} - \frac{c_2(t)}{q_0^2 q_1^2} h^4 + O(h^6)$$

where the last equality defines $A_{1,1}$. We can also combine the last two equations to eliminate the h^2 term:

$$x(t) = \frac{q_2^2 A_{2,0} - q_1^2 A_{1,0}}{q_2^2 - q_1^2} - \frac{c_2(t)}{q_1^2 q_2^2} h^4 + O(h^6) = A_{2,1} - \frac{c_2(t)}{q_1^2 q_2^2} h^4 + O(h^6)$$

where the last equality defines $A_{2,1}$. Both combined equations have error terms of $O(h^4)$, whereas the original ones had error terms of $O(h^2)$. Combining the combined equations to eliminate the h^4 term,

$$x(t) = \frac{q_2^2 A_{1,1} - q_0^2 A_{2,1}}{q_2^2 - q_0^2} + O(h^6) = A_{2,2} + O(h^6)$$

where the last equality defines $A_{2,2}$, a quantity that approximates $x(t)$ with error term $O(h^6)$ rather than the errors $O(h^2)$ that occurred in the initial approximations. You may view this construction as building a table of approximations,

$$A_{0,0}$$

$$A_{1,0} \qquad A_{1,1}$$

$$A_{2,0} \qquad A_{2,1} \qquad A_{2,2}$$

where an entry $A_{i,j}$ is obtained by combining $A_{i,j-1}$ and $A_{i-1,j-1}$ in the appropriate manner. The first column represents different $O(h^2)$ approximations to the solution, the second column represents $O(h^4)$ approximations, and the third column represents an $O(h^6)$ approximation.

Although the presentation here uses three approximations of $O(h^2)$ to construct an approximation of $O(h^6)$, it is clear that the ideas easily extend to using m approximations of $O(h^2)$ generated from step sizes $h_j = h/q_j$ for m distinct integers q_j in

order to obtain a final approximation of $O(h^{2m})$. The table of approximations is

$$
\begin{array}{lllll}
A_{0,0} & & & & \\
A_{1,0} & A_{1,1} & & & \\
A_{2,0} & A_{2,1} & A_{2,2} & & \\
\vdots & \vdots & \vdots & \ddots & \\
A_{m-1,0} & A_{m-1,1} & A_{m-1,2} & \cdots & A_{m-1,m-1}
\end{array}
\tag{9.25}
$$

where the entries in column j represent approximations of order $O(h^{2(j+1)})$.

9.7.3 POLYNOMIAL INTERPOLATION AND EXTRAPOLATION

Given points (t_i, y_i) for $0 \le i \le n$, the interpolating polynomial of degree n is the Lagrange polynomial,

$$
P(t) = \sum_{i=0}^{n} y_i \left(\prod_{\substack{j=1 \\ j \ne i}}^{n} (t - t_j) \right)
$$

Direct evaluation of the right-hand side is not the recommended way to compute $P(t)$ on a computer. A more robust method uses a recursion formula for Lagrange polynomials, called *Neville's method*. For $i \ge j$ define $P_{i,j}(t)$ to be the interpolating polynomial of degree j of (t_k, y_k), where $i - j \le k \le i$. The recursion is started by $P_{i,0} = y_i$ for $0 \le i \le n$ and the recursion itself is

$$
P_{i,j}(t) = \frac{(t - t_{i-j}) P_{i,j-1}(t) - (t - t_i) P_{i-1,j-1}(t)}{t_i - t_{i-j}}
\tag{9.26}
$$

for $1 \le j \le n$ and $j \le i \le n$. The resulting values can be stored in a table identical to the format shown in equation (9.25) with $P_{i,j}$ as the general term rather than $A_{i,j}$. This is no coincidence! The construction is in essence a Richardson extrapolation.

The diagonal term $P_{i,i}$ is determined by the inputs (t_j, y_j) for $0 \le j \le i$. An application might want to add new points to the system and continue evaluation until the diagonal terms do not change significantly. That is, the application supplies an error tolerance $\varepsilon > 0$ and requires a stopping condition $|P_{i,i} - P_{i-1,i-1}| < \varepsilon$. If the condition is met, $P_{i,i}$ is the output of the method. If the condition is not met, the application provides another data point (t_{i+1}, y_{i+1}) and evaluates another row in the table.

9.7.4 RATIONAL POLYNOMIAL INTERPOLATION AND EXTRAPOLATION

A set of points (t_i, y_i) for $0 \le i \le n$ can be interpolated by rational polynomials rather than by polynomials. The idea is that some functions are not well interpolated by

polynomials but do have reasonable approximations by rational polynomials. The form of the interpolating rational polynomial is chosen to be

$$R(t) = \frac{\sum_{i=0}^{d_p} p_i t^i}{\sum_{i=0}^{d_q} q_i t^i}$$

where the degrees of the polynomials satisfy $d_p + d_q = n$. The coefficients allow us one arbitrary choice, so we set $q_0 = 1$. If we choose any other nonzero value for q_0, we can always divide the coefficients in both numerator and denominator by q_0 so that in fact the constant term of the denominator becomes 1.

Bulirsch and Stoer developed an algorithm for interpolating and extrapolating rational polynomials that is similar to the algorithm for polynomial interpolation and extrapolation [BS64]. If n is even, the degrees of the numerator and denominator are equal, $d_p = d_q = n/2$. If n is odd, the denominator is one degree larger than the numerator, $d_p = \lfloor n/2 \rfloor$ and $d_q = d_p + 1$. The recursion is started with $R_{i,0} = y_i$ for $0 \le i \le n$ and the recursion itself is

$$R_{i,j}(t) = R_{i,j-1}(t) + \frac{R_{i,j-1}(t) - R_{i-1,j-1}(t)}{\left(\frac{t-t_{i-j}}{t-t_i}\right)\left(1 - \frac{R_{i,j-1}(t)-R_{i-1,j-1}(t)}{R_{i,j-1}(t)-R_{i-1,j-2}(t)}\right) - 1} \tag{9.27}$$

for $1 \le j \le n$ and $j \le i \le n$. In evaluating the recursion, it is understood that $R_{i,j} = 0$ whenever $i < j$.

Just as for polynomials, the diagonal term $R_{i,i}$ is determined by the inputs (t_j, y_j) for $0 \le j \le i$. The application supplies an error tolerance $\varepsilon > 0$ and requires a stopping condition $|R_{i,i} - R_{i-1,i-1}| < \varepsilon$. If the condition is met, $R_{i,i}$ is the output of the method. If the condition is not met, the application provides another data point (t_{i+1}, y_{i+1}) and evaluates another row in the table.

9.7.5 MODIFIED MIDPOINT METHOD

The *modified midpoint method* is a numerical method for solving a differential equation that takes a large step in time to produce an approximation. If y_i is an approximation to $x(t_i)$, we wish to approximate $x(t_i + H)$ using n substeps, each of size $h = H/n$. The approximation is denoted y_{i+n} to reflect the fact that we are approximating $x(t_i + nh) = x(t_{i+n})$.

The process is initialized with $z_0 = y_i$. The first iterate is generated by Euler's method,

$$z_1 = z_0 + hf(t_i, z_0)$$

Other iterates are generated by

$$z_{j+1} = z_{j-1} + 2hf(t + jh, z_j), \quad 1 \le j \le n - 1$$

The final approximation is

$$y_{i+n} = \frac{1}{2}(z_n + z_{n-1} + hf(t + nh, z_n))$$

This process is part of the Bulirsch-Stoer numerical method for solving a differential equation, as we will see in the next section.

9.7.6 BULIRSCH-STOER METHOD

The Bulirsch-Stoer method [BS66] is designed to obtain highly accurate solutions to a differential equation for which $f(t, x)$ is smooth and to do so with a minimal amount of computation. The idea is analogous to the method we discussed in an earlier section that uses polynomial extrapolation to improve the order of the error term. The final, highly accurate approximation was generated by combining the low accuracy approximations in the appropriate manner. The Bulirsch-Stoer method uses the modified midpoint method for solving the differential equation for a sequence of decreasing step sizes and uses rational polynomial extrapolation to improve the accuracy.

A step size $H > 0$ is chosen and the equation is solved three times using the modified midpoint method with substep counts of $q_0 = 2$, $q_1 = 4$, and $q_2 = 6$. These values are used to construct a table of rational polynomial approximations, the table of the form in equation (9.25) and consisting of three rows. The differential equation is solved again by the modified midpoint method using substep counts generated by $q_j = 2q_{j-2}$ for $j \geq 3$. For each numerical solution, the rational polynomial approximation table has a new row added and a comparison is made between the new diagonal term $R_{i,i}$ and the old one $R_{i-1,i-1}$, as mentioned in Section 9.7.4 on rational polynomial interpolation and extrapolation. If the difference is suitably small, the value $R_{i,i}$ is used as the approximation to $x(t + H)$. If not, the next substep count is used and the process is repeated.

9.8 VERLET INTEGRATION

A numerical method that has its origins in molecular dynamics is due to Verlet [Ver67]. The method and its variations were made popular in the game programming industry through the work of Thomas Jakobsen [Jak01]. The scheme is based on Taylor's Theorem using

$$\mathbf{x}(t + h) = \mathbf{x}(t) + \dot{\mathbf{x}}(t)h + \frac{1}{2}\ddot{\mathbf{x}}(t)h^2 + \frac{1}{6}\mathbf{x}^{(3)}(t)h^3 + O(h^4)$$

$$\mathbf{x}(t - h) = \mathbf{x}(t) - \dot{\mathbf{x}}(t)h + \frac{1}{2}\ddot{\mathbf{x}}(t)h^2 - \frac{1}{6}\mathbf{x}^{(3)}(t)h^3 + O(h^4)$$

The first expansion is forward in time, the second backward in time. Summing these and keeping only the $\mathbf{x}(t + h)$ term on the left-hand side leads to

$$\mathbf{x}(t+h) = 2\mathbf{x}(t) - \mathbf{x}(t-h) + \ddot{\mathbf{x}}(t)h^2 + O(h^4)$$

The velocity terms cancel as well as the third-order terms, leaving an approximation error on the order of $O(h^4)$. Assuming the physical system is modeled by Newton's second law of motion, $\ddot{\mathbf{x}} = \mathbf{F}(t, \mathbf{x}, \dot{\mathbf{x}})/m$, the iteration scheme is

$$\mathbf{y}_{i+1} = 2\mathbf{y}_i - \mathbf{y}_{i-1} + \frac{h^2}{m}\mathbf{F}(t_i, \mathbf{y}_i, \dot{\mathbf{y}}_i), \quad i \geq 1 \tag{9.28}$$

The iterate \mathbf{y}_i is an approximation to the position $\mathbf{x}(t_i)$ and $\dot{\mathbf{y}}_i$ is an approximation to the velocity $\dot{\mathbf{x}}(t_i)$. In this most general form of the force function, the general iteration scheme requires estimates of the velocity.

One of the main advantages of the Verlet approach is that the difference method is *reversible in time*, something that a differential equation for a physical model satisfies when the force is conservative. The reversibility shows up in that we could just as easily have solved for $\mathbf{y}_{i-1} = 2\mathbf{y}_i - \mathbf{y}_{i+1} + h^2\mathbf{F}(t_i, \mathbf{y}_i, \dot{\mathbf{y}}_i)/m$ and iterate to approximate position *backward in time*. The implication of reversibility in time is that the method maintains conservation of energy, at least when treating the quantities in the equation as true real numbers. On a computer, numerical round-off errors can cause an apparent change in energy. Another advantage is that only one evaluation of \mathbf{F} is required per time step, as compared to the multiple evaluations in methods such as the ones of the Runge-Kutta type. The computational time is minimized to some extent. The disadvantage of the Verlet method is that it is not as accurate as other methods. Variations on the method were developed in attempts to maintain the advantages of reversibility in time and minimum computational time but improve accuracy. We will discuss a few of these variations later in this section.

9.8.1 FORCES WITHOUT A VELOCITY COMPONENT

In its original formulation, the force is assumed to depend only on time and position, $\mathbf{F}(t, \mathbf{x})$. This rules out frictional forces, of course, which depend on velocity. Moreover, in nearly all applications you see to molecular dynamics, the force is conservative, $\mathbf{F}(\mathbf{x}) = -\nabla V(\mathbf{x})$, where V is the potential energy function. The iteration scheme in this restricted case is a two-step method and requires two initial positional conditions. The initial value problem for the second-order differential equation has one positional condition \mathbf{y}_0 and one velocity condition $\dot{\mathbf{y}}_0$. The second positional condition can be generated with an Euler step:

$$\begin{aligned} &\mathbf{y}_0, \ \dot{\mathbf{y}}_0 \quad \text{are specified} \\ &\mathbf{y}_1 = \mathbf{y}_0 + h\dot{\mathbf{y}}_0 \\ &\mathbf{y}_{i+1} = 2\mathbf{y}_i - \mathbf{y}_{i-1} + \frac{h^2}{m}\mathbf{F}(t_i, \mathbf{y}_i), \quad i \geq 1 \end{aligned} \tag{9.29}$$

This fits the mold of an explicit two-step method of the form in equation (9.22).

Notice that the method does not calculate velocity explicitly. The new position is computed from the previous two steps and the force on the particle. If an estimate of velocity is required by your application, you have a couple of possibilities. One is to use the previous two positions and select $\dot{\mathbf{y}}_{i+1} = (\mathbf{y}_i - \mathbf{y}_{i-1})/h$, an $O(h)$ approximation. The other possibility is to use a centered difference $\dot{\mathbf{y}}_i = (\mathbf{y}_{i+1} - \mathbf{y}_{i-1})/(2h)$, an $O(h^2)$ approximation at the same cost of calculation as the $O(h)$ one. The trade-off, though, is that you have to wait until the $(i+1)$-th time step to estimate the velocity at the ith time step.

9.8.2 FORCES WITH A VELOCITY COMPONENT

If frictional forces are part of the physical model and/or if you need to compute the velocity for the purposes of computing the energy of the system, then the velocity approximations must be generated. The force is of the form $\mathbf{F}(t, \mathbf{x}, \dot{\mathbf{x}})$. An application using forces of this type does need approximations to the velocity at each time step in order to evaluate the force function. A few variations are possible.

Using our suggestion for estimating velocity when the force does not have a velocity component, an explicit method is provided by

$$\mathbf{y}_0, \quad \dot{\mathbf{y}}_0 \text{ are specified}$$

$$\mathbf{y}_1 = \mathbf{y}_0 + h\dot{\mathbf{y}}_0$$

$$\dot{\mathbf{y}}_i = \frac{1}{h}(\mathbf{y}_i - \mathbf{y}_{i-1}), \quad i \geq 1 \tag{9.30}$$

$$\mathbf{y}_{i+1} = 2\mathbf{y}_i - \mathbf{y}_{i-1} + \frac{h^2}{m}\mathbf{F}(t_i, \mathbf{y}_i, \dot{\mathbf{y}}_i), \quad i \geq 1$$

The $\dot{\mathbf{y}}_i$ term must be evaluated first, then used in the evaluation of \mathbf{y}_{i+1}. Notice that $\dot{\mathbf{y}}_1 = \dot{\mathbf{y}}_0$, so effectively the explicit method assumes no change in velocity over the first time step.

The other suggestion for estimating velocity when the force does not have a velocity component leads to an implicit method:

$$\mathbf{y}_0, \quad \dot{\mathbf{y}}_0 \text{ are specified}$$

$$\mathbf{y}_1 = \mathbf{y}_0 + h\dot{\mathbf{y}}_0$$

$$\dot{\mathbf{y}}_i = \frac{1}{2h}(\mathbf{y}_{i+1} - \mathbf{y}_{i-1}), \quad i \geq 1 \tag{9.31}$$

$$\mathbf{y}_{i+1} = 2\mathbf{y}_i - \mathbf{y}_{i-1} + \frac{h^2}{m}\mathbf{F}(t_i, \mathbf{y}_i, \dot{\mathbf{y}}_i), \quad i \geq 1$$

As with any implicit method, you must decide how to solve for the implicit quantity \mathbf{y}_{i+1}. A fixed point iteration or Newton's method each require a force-function

evaluation per iteration, something that would negate the advantage of minimum computational time in the Verlet method. A cheaper alternative is to use a predictor-corrector approach where you predict $\dot{\mathbf{y}}_i = (\mathbf{y}_i - \mathbf{y}_{i-1})/h$, use it to compute \mathbf{y}_{i+1} from the other difference equation, then correct the value with $\dot{\mathbf{y}}_i = (\mathbf{y}_{i+1} - \mathbf{y}_{i-1})/(2h)$.

9.8.3 SIMULATING DRAG IN THE SYSTEM

The iteration of the Verlet equation can be modified to simulate drag in the system. The difference equation is rewritten as

$$\mathbf{y}_{i+1} = \mathbf{y}_i + (\mathbf{y}_i - \mathbf{y}_{i-1}) + \frac{h^2}{m}\mathbf{F}(t, \mathbf{y}_i, \dot{\mathbf{y}}_i)$$

The term $\mathbf{y}_i - \mathbf{y}_{i-1}$ is related to an estimate of velocity. Drag is introduced by including a *drag coefficient* $\delta \in [0, 1)$,

$$\mathbf{y}_{i+1} = \mathbf{y}_i + (1 - \delta)(\mathbf{y}_i - \mathbf{y}_{i-1}) + \frac{h^2}{m}\mathbf{F}(t, \mathbf{y}_i, \dot{\mathbf{y}}_i)$$

A reasonable requirement is that you choose δ to be a small positive number, say, on the order of 10^{-2}.

9.8.4 LEAP FROG METHOD

The velocity estimates in the standard Verlet approach might not be as accurate as an application requires. The estimate $\dot{\mathbf{y}}_i = (\mathbf{y}_i - \mathbf{y}_{i-1})/h$ is $O(h)$ and the estimate $\dot{\mathbf{y}}_i = (\mathbf{y}_{i+1} - \mathbf{y}_i)/(2h)$ is $O(h^2)$. The *leap frog method* is designed to improve on the velocity estimates.

Let us take a different look at the velocity by using Taylor's Theorem:

$$\dot{\mathbf{x}}(t + h) = \dot{\mathbf{x}}(t) + h\ddot{\mathbf{x}}(t) + \frac{h^2}{2}\mathbf{x}^{(3)}(t) + \frac{h^3}{6}\mathbf{x}^{(4)}(t) + \frac{h^4}{24}\mathbf{x}^{(5)}(t) + O(h^5)$$

$$\dot{\mathbf{x}}(t - h) = \dot{\mathbf{x}}(t) - h\ddot{\mathbf{x}}(t) + \frac{h^2}{2}\mathbf{x}^{(3)}(t) - \frac{h^3}{6}\mathbf{x}^{(4)}(t) + \frac{h^4}{24}\mathbf{x}^{(5)}(t) + O(h^5)$$

Subtracting leads to

$$\dot{\mathbf{x}}(t + h) = \dot{\mathbf{x}}(t - h) + 2h\ddot{\mathbf{x}}(t) + \frac{h^3}{3}\mathbf{x}^{(4)}(t) + O(h^5) = \dot{\mathbf{x}}(t - h) + 2h\ddot{\mathbf{x}}(t) + O(h^3)$$

This represents a time step of h. If we were to use half the step $h/2$, the equation becomes

$$\dot{\mathbf{x}}(t + h/2) = \dot{\mathbf{x}}(t - h/2) + h\ddot{\mathbf{x}}(t) + \frac{h^3}{24}\mathbf{x}^{(4)}(t) + O(h^5)$$

$$= \dot{\mathbf{x}}(t - h/2) + h\ddot{\mathbf{x}}(t) + O(h^3)$$

The order term is $O(h^3)$ in either case, and the third-order term includes $\mathbf{x}^{(4)}(t)$ in both cases. By using only a half step, the second equation produces a coefficient of $h^3/24$, which is 1/8 of the coefficient generated by the full step h. The intuitive appeal is that the error generated by the second equation is less than that of the first, so the velocity estimates should be better than with the straightforward Verlet method.

We need to estimate the position as well, but our goal is to approximate the positions using the full step h. The previous paragraph tells us how to estimate the velocities for half steps $h/2$. The leap frog method interleaves the velocity and position iteration. The informal manner in which you normally see the leap frog method stated is

$$\mathbf{v}(t + h/2) = \mathbf{v}(t - h/2) + h\mathbf{a}(t)$$

$$\mathbf{x}(t + h) = \mathbf{x}(t) + h\mathbf{v}(t + h/2)$$

where $\mathbf{x}(t)$ is position, $\mathbf{v}(t)$ is velocity, and $\mathbf{a}(t)$ is acceleration given by \mathbf{F}/m. The velocity is updated on the time interval $[t - h/2, t + h/2]$ by using the acceleration computation at the midpoint t of the interval. The position is updated on the time interval $[t, t + h]$ by using the velocity estimate at the midpoint of the interval, $t + h/2$. As with any second-order differential equation, the initial conditions $\mathbf{x}(0)$ and $\mathbf{v}(0)$ must be specified. The leap frog method requires $\mathbf{v}(h/2)$, not $\mathbf{v}(0)$, to approximate the first position $\mathbf{x}(h) = \mathbf{x}(0) = h\mathbf{v}(h/2)$. We may not use $\mathbf{v}(h/2) = \mathbf{v}(-h/2) + h\mathbf{a}(0)$ since we have no information about the velocity at negative times. Instead, we should estimate $\mathbf{v}(h/2) = \mathbf{v}(0) + (h/2)\mathbf{a}(0)$, an Euler iterate for the half step $h/2$.

The implicit assumption in this formulation is that the force \mathbf{F} is a function of time t and position $\mathbf{x}(t)$ only. If the force were also to depend on velocity $\mathbf{v}(t)$, then the velocity approximations involve times $t - h/2$, t, and $t + h/2$, thereby requiring velocity estimates at all times $t + ih/2$ for $i \geq 0$. In this setting, the method is no longer the one intended by leap frog, yet is still a valid numerical method.

When the force is of the form $\mathbf{F}(t, \mathbf{x})$, the formulation of the difference equations in the style to which we have become accustomed is shown next, where $t_i = ih/2$ and initial time is 0.

$$\mathbf{y}_0, \ \dot{\mathbf{y}}_0 \text{ are specified}$$

$$\dot{\mathbf{y}}_1 = \dot{\mathbf{y}}_0 + \frac{h}{m}\mathbf{F}(0, \mathbf{y}_0)$$

$$\dot{\mathbf{y}}_{i+1} = \dot{\mathbf{y}}_{i-1} + \frac{h}{m}\mathbf{F}(t_i, \mathbf{y}_i), \quad i \geq 1 \tag{9.32}$$

$$\mathbf{y}_{i+2} = \mathbf{y}_i + h\dot{\mathbf{y}}_{i+1}, \quad i \geq 0$$

Notice the "leap frog" behavior in that the velocity iterates are computed for the odd indices and the position iterates are computed for the even indices. When the force is of the form $\mathbf{F}(t, \mathbf{x}, \dot{\mathbf{x}})$, the formulation is in terms of an explicit two-step solver. The

step size $H = h/2$, where h is the original step size and $t_i = iH$ where initial time is 0.

$$\mathbf{y}_0, \quad \dot{\mathbf{y}}_0 \text{ are specified}$$

$$\mathbf{y}_1 = \mathbf{y}_0 + H\dot{\mathbf{y}}_0$$

$$\dot{\mathbf{y}}_1 = \dot{\mathbf{y}}_0 + \frac{H}{m}\mathbf{F}(0, \mathbf{y}_0, \dot{\mathbf{y}}_0) \tag{9.33}$$

$$\mathbf{y}_{i+2} = \mathbf{y}_i + 2H\dot{\mathbf{y}}_{i+1}, \quad i \geq 0$$

$$\dot{\mathbf{y}}_{i+2} = \dot{\mathbf{y}}_i + \frac{2H}{m}\mathbf{F}(t_{i+1}, \mathbf{y}_{i+1}, \dot{\mathbf{y}}_{i+1}), \quad i \geq 0$$

An Euler step is also needed to estimate \mathbf{y}_1. The position and velocity iterates are computed for all indices, so no leap-frogging going on here.

The general rule of thumb on the advantages of the leap frog over the standard Verlet method is that the position and velocity estimates are better but come at the cost of slightly more computation time.

9.8.5 VELOCITY VERLET METHOD

Another variation on the Verlet method is called the *Velocity Verlet method*. The velocity estimate is produced using an integral formulation of the same type that led to equation (9.7), using $d\mathbf{v}/dt = \mathbf{a}(t)$ and an integration:

$$\mathbf{v}(t + h) = \mathbf{v}(t) + \int_t^{t+h} \mathbf{a}(\tau)\, d\tau \doteq \mathbf{v}(t) + \frac{h}{2}(\mathbf{a}(t) + \mathbf{a}(t + h))$$

This provides a slightly better estimate than what the leap frog method used. Specifically, Taylor's Theorem gives us

$$\mathbf{v}(t + h) - \mathbf{v}(t - h) - 2h\mathbf{a}(t) = \frac{h^3}{6}\ddot{\mathbf{a}}(t) + O(h^5)$$

Taylor expansions for velocity and acceleration are

$$\mathbf{v}(t + h) = \mathbf{v}(t) + h\mathbf{a}(t) + \frac{h^2}{2}\dot{\mathbf{a}}(t) + \frac{h^3}{6}\ddot{\mathbf{a}}(t) + O(h^4)$$

$$\mathbf{a}(t + h) = \mathbf{a}(t) + h\dot{\mathbf{a}}(t) + \frac{h^2}{2}\ddot{\mathbf{a}}(t) + O(h^4)$$

so that

$$\mathbf{v}(t + h) - \mathbf{v}(t) - (h/2)(\mathbf{a}(t) + \mathbf{a}(t + h)) = -\frac{h^3}{12}\ddot{\mathbf{a}}(t) + O(h^4)$$

The velocity in the leap frog method is

$$\mathbf{v}(t+h) = \mathbf{v}(t-h) + 2h\mathbf{a}(t) + \frac{h^3}{6}\ddot{\mathbf{a}}(t) + O(h^5)$$

and the velocity using the Velocity Verlet method is

$$\mathbf{v}(t+h) = \mathbf{v}(t) + \frac{h}{2}(\mathbf{a}(t) + \mathbf{a}(t+h)) - \frac{h^3}{12}\ddot{\mathbf{a}}(t) + O(h^4)$$

All other things being equal, you expect the latter velocity estimate to have about half the error of the former since the coefficient of the h^3 term is half that in the other expression. The price for less error, though, is more computational time. The leap frog method uses one evaluation of acceleration whereas the Velocity Verlet method uses two evaluations. But the comparison is not quite fair. The leap frog computes velocity on every other time step. The Velocity Verlet method computes velocity on each time step. If you need the velocity information in the leap frog method, such as in the implicit scheme of equation (9.33), then both methods use the same number of acceleration evaluations. The Velocity Verlet produces a better estimate for the same cost.

The position in the Velocity Verlet method is estimated from Taylor's Theorem. The numerical method stated in the manner in which it normally is found in the literature is

$$\mathbf{x}(t+h) = \mathbf{x}(t) + h\mathbf{v}(t) + \frac{h^2}{2}\mathbf{a}(t)$$

$$\mathbf{v}(t+h) = \mathbf{v}(t) + \frac{h}{2}(\mathbf{a}(t) + \mathbf{a}(t+h))$$

Once again the implicit assumption is that the force is of the form $\mathbf{F}(t, \mathbf{x})$ with no explicit dependence on velocity. The idea of the iteration is that $\mathbf{x}(t)$, $\mathbf{v}(t)$, and $\mathbf{a}(t) = \mathbf{F}(t, \mathbf{x}(t))/m$ are known. The next position $\mathbf{x}(t+h)$ is calculated from the first difference equation. This value is used to compute $\mathbf{a}(t+h) = \mathbf{F}(t+h, \mathbf{x}(t+h))/m$ and is substituted into the second difference equation to obtain the next velocity $\mathbf{v}(t+h)$. Many literature sources describe the process with one intermediate step. First, $\mathbf{x}(t+h)$ is computed. Second, the velocity for a half step is computed, $\mathbf{v}(t+h/2) = \mathbf{v}(t) + (h/2)\mathbf{a}(t)$. Third, $\mathbf{a}(t+h) = \mathbf{F}(t+h, \mathbf{x}(t+h))/m$ is computed. Fourth, the velocity for the full step is computed, $\mathbf{v}(t+h) = \mathbf{v}(t+h/2) + (h/2)\mathbf{a}(t+h)$. However, it is not necessary to do so in an implementation unless for some reason you need estimates of the velocities at the half steps. In our standard formulation, the numerical method is

$\mathbf{y}_0, \ \dot{\mathbf{y}}_0$ are specified

$$\mathbf{y}_{i+1} = \mathbf{y}_i + h\dot{\mathbf{y}}_i + \frac{h^2}{2m}\mathbf{F}(t_i, \mathbf{y}_i), \quad i \geq 0 \tag{9.34}$$

$$\dot{\mathbf{y}}_{i+1} = \dot{\mathbf{y}}_i + \frac{h}{2m}\left(\mathbf{F}(t_i, \mathbf{y}_i) + \mathbf{F}(t_{i+1}, \mathbf{y}_{i+1})\right), \quad i \geq 0$$

The \mathbf{y}_{i+1} term must be computed first since it is used in the equation to produce $\dot{\mathbf{y}}_{i+1}$. When the force is of the form $\mathbf{F}(t, \mathbf{x}, \dot{\mathbf{x}})$, the numerical method becomes implicit:

$\mathbf{y}_0, \ \dot{\mathbf{y}}_0$ are specified

$$\mathbf{y}_{i+1} = \mathbf{y}_i + h\dot{\mathbf{y}}_i + \frac{h^2}{2m}\mathbf{F}(t_i, \mathbf{y}_i, \dot{\mathbf{y}}_i), \quad i \geq 0 \tag{9.35}$$

$$\dot{\mathbf{y}}_{i+1} = \dot{\mathbf{y}}_i + \frac{h}{2m}\left(\mathbf{F}(t_i, \mathbf{y}_i, \dot{\mathbf{y}}_i) + \mathbf{F}(t_{i+1}, \mathbf{y}_{i+1}, \dot{\mathbf{y}}_{i+1})\right), \quad i \geq 0$$

The implicitness is because $\dot{\mathbf{y}}_{i+1}$ occurs on both sides of the last difference equation. As always, a predictor-corrector method could be used. For example, you could predict $\dot{\mathbf{y}}_{i+1} = (\mathbf{y}_{i+1} - \mathbf{y}_i)/h$ and substitute in the right-hand side of the last difference equation to obtain the correction for $\dot{\mathbf{y}}_{i+1}$.

The Velocity Verlet method gives you the best estimates of velocity of all the Verlet-style methods, but the cost is additional function evaluations. It is a one-step method, whereas the other explicit Verlet methods are two-step methods.

9.8.6 GEAR'S FIFTH-ORDER PREDICTOR-CORRECTOR METHOD

A method that is sometimes used as an alternative to the Velocity Verlet method is called *Gear's fifth-order predictor-corrector method* [Gea71]. The prediction portion of the algorithm is based once again on Taylor's Theorem:

$$\mathbf{x}(t + h) = \mathbf{x}(t) + h\mathbf{x}^{(1)}(t) + \frac{h^2}{2!}\mathbf{x}^{(2)}(t) + \frac{h^3}{3!}\mathbf{x}^{(3)}(t) + \frac{h^4}{4!}\mathbf{x}^{(4)}(t) + \frac{h^5}{5!}\mathbf{x}^{(5)}(t) + O(h^6)$$

$$\mathbf{x}^{(1)}(t + h) = \mathbf{x}^{(1)}(t) + h\mathbf{x}^{(2)}(t) + \frac{h^2}{2!}\mathbf{x}^{(3)}(t) + \frac{h^3}{3!}\mathbf{x}^{(4)}(t) + \frac{h^4}{4!}\mathbf{x}^{(5)}(t) + O(h^5)$$

$$\mathbf{x}^{(2)}(t + h) = \mathbf{x}^{(2)}(t) + h\mathbf{x}^{(3)}(t) + \frac{h^2}{2!}\mathbf{x}^{(4)}(t) + \frac{h^3}{3!}\mathbf{x}^{(5)}(t) + O(h^4)$$

$$\mathbf{x}^{(3)}(t + h) = \mathbf{x}^{(3)}(t) + h\mathbf{x}^{(4)}(t) + \frac{h^2}{2!}\mathbf{x}^{(5)}(t) + O(h^3)$$

$$\mathbf{x}^{(4)}(t + h) = \mathbf{x}^{(4)}(t) + h\mathbf{x}^{(5)}(t) + O(h^2)$$

$$\mathbf{x}^{(5)}(t + h) = \mathbf{x}^{(5)}(t) + O(h)$$

Subscripting the predicted values with p and the corrected values with c, the matrix form of the prediction step is

$$
\begin{bmatrix}
\mathbf{x}_p(t+h) \\
h\mathbf{x}_p^{(1)}(t+h) \\
\frac{h^2}{2!}\mathbf{x}_p^{(2)}(t+h) \\
\frac{h^3}{3!}\mathbf{x}_p^{(3)}(t+h) \\
\frac{h^4}{4!}\mathbf{x}_p^{(4)}(t+h) \\
\frac{h^5}{5!}\mathbf{x}_p^{(5)}(t+h)
\end{bmatrix}
=
\begin{bmatrix}
1 & 1 & 1 & 1 & 1 & 1 \\
0 & 1 & 2 & 3 & 4 & 5 \\
0 & 0 & 1 & 3 & 6 & 10 \\
0 & 0 & 0 & 1 & 4 & 10 \\
0 & 0 & 0 & 0 & 1 & 5 \\
0 & 0 & 0 & 0 & 0 & 1
\end{bmatrix}
\begin{bmatrix}
\mathbf{x}_c(t) \\
h\mathbf{x}_c^{(1)}(t) \\
\frac{h^2}{2!}\mathbf{x}_c^{(2)}(t) \\
\frac{h^3}{3!}\mathbf{x}_c^{(3)}(t) \\
\frac{h^4}{4!}\mathbf{x}_c^{(4)}(t) \\
\frac{h^5}{5!}\mathbf{x}_c^{(5)}(t)
\end{bmatrix}
$$

Notice that the nonzero entries of the columns of the 6×6 matrix are the rows of Pascal's Triangle. The predicted values are used to evaluate the force function and obtain a corrected second-order derivative,

$$
\mathbf{x}_c^{(2)}(t+h) = \frac{1}{m}\mathbf{F}(t+h, \mathbf{x}_p(t+h), \dot{\mathbf{x}}_p(t+h))
$$

Define:

$$
\Delta = \frac{h^2}{2!}(\mathbf{x}_c^{(2)}(t+h) - \mathbf{x}_p^{(2)}(t+h))
$$

The corrected values are

$$
\begin{bmatrix}
\mathbf{x}_c(t+h) \\
h\mathbf{x}_c^{(1)}(t+h) \\
\frac{h^2}{2!}\mathbf{x}_c^{(2)}(t+h) \\
\frac{h^3}{3!}\mathbf{x}_c^{(3)}(t+h) \\
\frac{h^4}{4!}\mathbf{x}_c^{(4)}(t+h) \\
\frac{h^5}{5!}\mathbf{x}_c^{(5)}(t+h)
\end{bmatrix}
=
\begin{bmatrix}
\mathbf{x}_p(t+h) \\
h\mathbf{x}_p^{(1)}(t+h) \\
\frac{h^2}{2!}\mathbf{x}_p^{(2)}(t+h) \\
\frac{h^3}{3!}\mathbf{x}_p^{(3)}(t+h) \\
\frac{h^4}{4!}\mathbf{x}_p^{(4)}(t+h) \\
\frac{h^5}{5!}\mathbf{x}_p^{(5)}(t+h)
\end{bmatrix}
+ \Delta
\begin{bmatrix}
\lambda \\
251/360 \\
1 \\
11/18 \\
1/6 \\
1/60
\end{bmatrix}
$$

where $\lambda = 3/16$ if the force is of the form $\mathbf{F}(t, \mathbf{x})$ or $\lambda = 3/20$ if the force is of the form $\mathbf{F}(t, \mathbf{x}, \dot{\mathbf{x}})$. Starting the iteration does require that estimates be made for the second- and higher-order derivatives at initial time.

Compared to the Velocity Verlet method, the Gear method will require more memory usage, potentially of importance if your physical system has a large number of rigid bodies. The trade-off, though, is that the Gear method makes one function evaluation per time step, whereas the Velocity Verlet method uses two function evaluations. Thus, we have the classic space versus time trade-off. Experience in the molecular dynamics field has shown that the velocity estimates from the Velocity Verlet method tend to degenerate over time faster than those computed in the Gear

method. The Gear method also has a higher degree of energy conservation with a larger time step compared to the Velocity Verlet method. However, the Gear method is not reversible in time as are the Verlet methods.

Finally, if you should want to choose variable step sizes for the Verlet methods rather than fixed step sizes, see [HOS99].

9.9 NUMERICAL STABILITY AND ITS RELATIONSHIP TO PHYSICAL STABILITY

Stability of solutions to a system of differential equations was discussed in Section 8.6. The intuitive description is that a solution $\boldsymbol{\phi}(t)$ is *stable* if each solution $\boldsymbol{\psi}(t)$ that starts out close to $\boldsymbol{\phi}(t)$ remains close to it for all time. In effect this is a statement about the *continuous dependence of a solution on its initial conditions*. If $\dot{\mathbf{x}} = \mathbf{f}(t, \mathbf{x})$ is the system of differential equations with initial data $\mathbf{x}(t_0) = \mathbf{x}_0$, the solution is denoted $\mathbf{x}(t; \mathbf{x}_0)$. If we compare solutions $\mathbf{x}(t; \mathbf{x}_0 + \boldsymbol{\delta})$ and $\mathbf{x}(t; \mathbf{x}_0)$, where $\boldsymbol{\delta}$ is a nonzero vector of small length, we want to know about the differences $|\mathbf{x}(t; \mathbf{x}_0 + \boldsymbol{\delta}) - \mathbf{x}(t; \mathbf{x}_0)|$ as time t increases. We do know that $|\mathbf{x}(t_0; \mathbf{x}_0 + \boldsymbol{\delta}) - \mathbf{x}(t_0; \mathbf{x}_0)| = |(\mathbf{x}_0 + \boldsymbol{\delta}) - \mathbf{x}_0| = |\boldsymbol{\delta}|$, which is small. The question is whether or not the differences remain bounded or become unbounded with increasing time. I will refer to this measure of stability as *physical stability* since the differential equations are obtained as the equations of motion for a physical system.

Our earlier discussion involved understanding the stability of linear systems $\dot{\mathbf{x}} = A\mathbf{x}$ for which A has constant entries. As we saw, the stability is directly related to the signs on the real parts of the eigenvalues of A. If all eigenvalues have negative real parts, the system is stable. If at least one eigenvalue has positive real parts, the system is unstable. If all eigenvalues have negative or zero real parts with at least one eigenvalue having zero real parts, the stability depends on the dimension of the eigenspace of the eigenvalue.

We then used our knowledge of linear stability to determine the stability properties of equilibrium solutions to nonlinear autonomous systems $\dot{\mathbf{x}} = \mathbf{f}(\mathbf{x})$. For the sake of argument, let us assume that the equilibrium solution of interest is $\mathbf{x}(t) \equiv \mathbf{0}$. If this were not the case and $\mathbf{x}(t) \equiv \mathbf{x}_0 \neq \mathbf{0}$ were an equilibrium solution, we could always transform the system to one that does have a zero equilibrium solution by $\mathbf{y} = \mathbf{x} - \mathbf{x}_0$ and $\mathbf{F}(\mathbf{y}) = \mathbf{f}(\mathbf{y} + \mathbf{x}_0)$, so $\dot{\mathbf{y}} = \mathbf{F}(\mathbf{y})$ has the equilibrium solution $\mathbf{y}(t) \equiv \mathbf{0}$. Taylor's Theorem allows us to write

$$\mathbf{f}(x) = A\mathbf{x} + \mathbf{R}(\mathbf{x})$$

where A is the matrix of first-order derivatives of the components of \mathbf{f} that are evaluated at $\mathbf{0}$. The remainder \mathbf{R} consists of quadratic and higher-order terms. The *linearized system* is $\dot{\mathbf{x}} = A\mathbf{x}$. If the eigenvalues of A all have negative real parts, then the equilibrium solution of the physical system is stable. If at least one eigenvalue has positive real parts, the equilibrium solution is unstable. No immediate conclusions

can be drawn when the eigenvalues have negative or zero real parts with at least one having zero real parts.

This result addresses the physical stability of the equilibrium solution. However, we will solve $\dot{\mathbf{x}} = \mathbf{f}(\mathbf{x})$ using a numerical method. It is important that the approximations generated by the method are themselves close to the true solution. The concept of closeness in this context is referred to as *numerical stability*. In general, to obtain numerical stability, you will need to carefully choose your step size h in the numerical solvers. The end result of our discussion will be that you can do this safely only by understanding the relationship between numerical stability and physical stability.

9.9.1 STABILITY FOR SINGLE-STEP METHODS

Three concepts are of interest: *consistency*, *convergence*, and *stability*. Recall that the *local truncation error* refers to the terms we discard when generating a numerical method from something such as a Taylor expansion. For example, Euler's method arose from Taylor's Theorem in representing a solution to $\dot{x} = f(t, x)$ as

$$x(t_{i+1}) = x(t_i) + h\dot{x}(t_i) + \frac{h^2}{2}\ddot{x}(\bar{t}_i) = x(t_i) + hf(t_i, x(t_i)) + \frac{h^2}{2}\ddot{x}(\bar{t}_i)$$

where $\bar{t}_i \in [t_i, t_{i+1}]$, but whose value is generally unknown to us. We discarded the second-order term to obtain the numerical method,

$$y_{i+1} = y_i + hf(t_i, y_i)$$

where y_i is the approximation to $x(t_i)$. The discarded term is the local truncation error for Euler's method and is of order $O(h^2)$. As we make h small, the local truncation error for a single iteration is small. If we can make the local truncation errors become small for n iterations, that is a good thing for our numerical method. This leads us to the definition that follows.

Definition ■ Let τ_i denote the local truncation error at the ith step of the numerical method. The method is said to be *consistent* with the differential equation it approximates if

$$\lim_{h \to 0} \max_{1 \le i \le n} |\tau_i| = 0$$

Intuitively, this says that for very small step sizes, the local truncation error made at any time t is very small. ■

According to this definition, Euler's method is consistent. In general having very small local truncation errors at any time is not enough to guarantee that y_i is a good approximation to $x(t_i)$. We need a definition about closeness.

Definition ▪ A numerical method is said to be *convergent* with respect to the differential equation if

$$\lim_{h \to 0} \max_{1 \le i \le n} |x(t_i) - y_i| = 0$$

Intuitively, this says that for very small step sizes, the maximum error at any time *t* between the approximation and the true solution is very small. ▪

Our derivation that led to the inequality of equation (9.3) shows that Euler's method is convergent. Our last definition is about stability itself.

Definition ▪ A numerical method is said to be *stable* if small changes in the initial data for the differential equation produce correspondingly small changes in the subsequent approximations. In formal terms, let x_0 and x_1 be two initial values for the differential equation. Let y_i be the approximation to $x(t_i; x_0)$ and let \bar{y}_i be the approximation to $x(t_i; x_1)$. For each $\varepsilon > 0$, there is a $\delta > 0$ sufficiently small so that $|y_i - \bar{y}_i| < \varepsilon$ whenever $|x_1 - x_0| < \delta$. ▪

This definition is a statement about continuous dependence of solutions on the initial data. The relationship between consistency, convergence, and stability for a one-step numerical method is summarized by the following result.

Theorem ▪ Consider the initial value problem $\dot{x} = f(t, x)$ for $t \in [t_0, t_0 + \alpha]$ with initial data $x(t_0) = x_0$. Let a numerical method for the equation be of the form $y_0 = x_0$ and $y_{i+1} = y_i + h\phi(t_i, y_i, h)$ for $i \ge 0$. If there is a value $h_0 > 0$ such that $\phi(t, y, h)$ is continuous on the domain

$$D = \{(t, y, h) : t \in [t_0, t_0 + \alpha], \ y \in \mathbb{R}, \ h \in [0, h_0]\}$$

and if there exists a constant $L > 0$ such that

$$|\phi(t, y, h) - \phi(t, \bar{y}, h)| \le L|y - \bar{y}|$$

for all $(t, y, h), (t, \bar{y}, h) \in D$, which is called a *Lipschitz condition*.

1. The numerical method is stable.

2. The method is convergent if and only if it is consistent; that is, if and only if $\phi(t, x, 0) = f(t, x, 0)$ for all $t \in [t_0, t_0 + \alpha]$.

3. If the local truncation errors are bounded by $|\tau_i| \le T(h)$ for some function $B(h)$ independent of i and for $h \in [0, h_0]$, then

$$|x(t_i) - y_i| \le B(h) \exp(L(t_i - t_0))/L. \ ▪$$

The condition in item 2 of the conclusion is easily verified for all the single-step numerical methods we have encountered. Notice that for Euler's method, $\phi(t, y, 0) = f(t, y)$. The same is true for the Runge-Kutta methods. Item 3 of the conclusion gives us an upper bound on the error of the approximation and looks similar to what we derived for Euler's method.

9.9.2 STABILITY FOR MULTISTEP METHODS

A stability result for multistep methods is only slightly more complicated than the one for single-step methods. The general multistep method can be formulated as

$$y_{i+1} = \sum_{j=0}^{m-1} a_j y_{i-j} + h F(t_i, h, y_{i+1}, y_i, \ldots, y_{i+1-m}), \qquad i \geq 0$$

with start-up conditions $y_i = b_i$ for selected constants b_i with $0 \leq i \leq m - 1$. Since we started with a differential equation with initial condition $x(t_0) = x_0$, we choose $y_0 = x_0$. The other start-up values are generated by some single-step method. The prototypical explicit method is Adams-Bashforth and the prototypical implicit method is Adams-Moulton.

The concepts of convergence and stability are the same as for single-step methods, but consistency requires there be a slight bit more to it. The local truncation errors for a multistep method are of the form

$$\tau_{i+1} = \frac{x(t_{i+1}) - \sum_{j=0}^{m-1} x(t_{i-j})}{h} - F(t_i, h, x(t_{i+1}), \ldots, x(t_{i+1-m}))$$

The analysis of the algorithm for the m-step Adams-Bashforth method will show that the local truncation error is $\tau_{i+1} = O(h^m)$. The m-step Adams-Moulton method has a local truncation error of $\tau_{i+1} = O(h^{m+1})$. The definition for consistency of a multistep method includes the same condition we used for single-step methods,

$$\lim_{h \to 0} \max_{1 \leq i \leq n} |\tau_i| = 0$$

so the local truncation errors go to zero as the step size becomes small. But, in addition, we need to make sure that the local truncation errors for the start-up conditions become small also.

$$\lim_{h \to 0} \max_{1 \leq i \leq m-1} |x(t_i) - b_i| = 0$$

The result for multistep methods that is the analogy of the one for single-step methods follows.

Theorem ▪ Consider the initial value problem $\dot{x} = f(t, x)$ for $t \in [t_0, t_0 + \alpha]$ with initial data $x(t_0) = x_0$. Consider a multistep method of the form $y_{i+1} = \sum_{j=0}^{m-1} a_j y_{i-j} + hF(t_i, h, y_{i+1}, y_i, \ldots, y_{i+1-m})$ with start-up conditions $y_0 = x_0$ and $y_i = b_i$ for specified constants b_i with $1 \leq i \leq m - 1$. Suppose that $F \equiv 0$ whenever $f \equiv 0$. Suppose that F satisfies a Lipschitz condition,

$$|F(t_i, h, y_{i+1}, \ldots, y_{i+1-m}) - F(t_i, h, \bar{y}_{i+1}, \ldots, \bar{y}_{i+1-m})|$$

$$\leq L \sum_{j=0}^{m} |y_{i+1-j} - \bar{y}_{i+1-j}| \quad \text{for each } i \text{ with } m - 1 \leq i \leq n$$

Define the polynomial $p(\lambda) = \lambda^m - \sum_{j=0}^{m-1} a_j \lambda^{m-1-j}$.

1. The numerical method is stable if and only if all roots of $p(\lambda) = 0$ satisfy $|\lambda| \leq 1$ and any root such that $|\lambda| = 1$ must be a simple root (multiplicity is 1).

2. If the numerical method is consistent with the differential equation, the method is stable if and only if it is convergent. ▪

The important aspect of this theorem for practical purposes is the analysis of the roots of $p(\lambda)$. Note that the roots can be nonreal. Also note that $p(1) = 0$ because of the way the a_j were defined for multistep methods. Thus, $\lambda = 1$ is always a root and has magnitude $|\lambda| = 1$. If $\lambda = 1$ is the only root of magnitude 1, all other roots satisfying $|\lambda| < 1$, then the numerical method is said to be *strongly stable*. If more than one root has magnitude one, the others satisfying $|\lambda| < 1$, the numerical method is said to be *weakly stable*. The numerical method is said to be *unstable* if any root has magnitude $|\lambda| > 1$,

9.9.3 CHOOSING A STABLE STEP SIZE

In fact, we can go one step further. The analysis of the roots of $p(\lambda)$ when using the linearized equation instead of the original $\mathbf{f}(\mathbf{x})$ allows us to decide what step sizes h lead to stability, an important issue for solving the equations on a computer. More details can be found in Chapter 5 of [BF01], although they are listed in the section on stiff equations. A presentation of the material in the context of game development may also be found in [Rho01].

Assuming an equilibrium solution of $\mathbf{x}(t) \equiv \mathbf{0}$, the linearized equation is $\dot{\mathbf{x}} = A\mathbf{x}$, where A is an $n \times n$ matrix of constants occuring in the expansion $\mathbf{f}(\mathbf{x}) = A\mathbf{x} + \mathbf{R}$. Let us assume that the eigenvalues of A all have negative real parts so that the equilibrium solution is physically stable. For each eigenvalue λ, consider what is called the *modal equation*, $\dot{\mathbf{x}} = \lambda \mathbf{x}$. An m-step method ($m \geq 1$) is applied to the modal equation. The resulting difference equation is linear and has a characteristic polynomial of the type $p(z)$ whose coefficients involve the eigenvalue λ and the step size h. This polynomial includes the linear contribution from the function F in the

multistep method. The conditions of $|z| \leq 1$ for all roots and unit-magnitude roots being simple are required for a stable method. These in turn impose conditions on how we can choose h.

The best way to illustrate this is with an example. We will once again revisit the simple pendulum problem of Example 3.4.

EXAMPLE 9.1

The equation of motion for a simple pendulum with viscous friction at the joint is

$$\ddot{\theta} + b\dot{\theta} + c \sin(\theta) = 0, \quad t \geq 0, \quad \theta(0) = \theta_0, \quad \dot{\theta}(0) = \dot{\theta}_0$$

where $b \geq 0$ represents the coefficient of viscous friction ($b = 0$ for a frictionless joint) and $c = g/L > 0$, where g is the gravitational constant and L is the length of the pendulum rod. The angle $\theta(t)$ is measured from the vertical position. The initial angle is θ_0 and the initial angular speed is $\dot{\theta}_0$. We may write this equation as a first-order system $\dot{\mathbf{x}} = \mathbf{f}(t, \mathbf{x})$ by defining

$$\mathbf{x} = \begin{bmatrix} x_1 \\ x_2 \end{bmatrix} = \begin{bmatrix} \theta \\ \dot{\theta} \end{bmatrix}, \quad \mathbf{f}(t, \mathbf{x}) = \begin{bmatrix} f_1 \\ f_2 \end{bmatrix} = \begin{bmatrix} \dot{\theta} \\ -b\dot{\theta} - c\sin(\theta) \end{bmatrix} = \begin{bmatrix} x_2 \\ -bx_2 - c\sin(x_1) \end{bmatrix}$$

In fact, the system is autonomous since \mathbf{f} does not depend explicitly on t, only on x_1 and x_2. The first-derivative matrix is

$$D\mathbf{f}(\mathbf{x}) = \begin{bmatrix} \frac{\partial f_1}{\partial x_1} & \frac{\partial f_1}{\partial x_2} \\ \frac{\partial f_2}{\partial x_1} & \frac{\partial f_2}{\partial x_2} \end{bmatrix} = \begin{bmatrix} 0 & 1 \\ -c\cos(x_1) & -b \end{bmatrix}$$

The equilibrium solutions of the system are $\mathbf{x}_0(t) \equiv (0, 0)$ and $\mathbf{x}_1(t) \equiv (\pi, 0)$. The first equilibrium solution corresponds to the pendulum hanging vertically downward with no angular speed. Physically you expect this to be stable. If you move the pendulum slightly, you expect it to stay near the vertical. The second solution corresponds to the pendulum positioned vertically upward with no angular speed. Physically you expect this to be unstable because any slight movement of the pendulum will cause it to fall downward. Let us see what the mathematical model has to say about this.

The first-derivative matrix at the first equilibrium solution is

$$D\mathbf{f}(0, 0) = \begin{bmatrix} 0 & 1 \\ -c & -b \end{bmatrix}$$

and has the characteristic equation $\lambda^2 + b\lambda + c = 0$. For the case of viscous friction where $b > 0$, the roots are

$$\lambda = \frac{-b \pm \sqrt{b^2 - 4c}}{2}$$

Both roots are negative real numbers when $b^2 \geq 4c$ or are complex numbers with negative real parts when $b^2 < 4c$. In either case the real parts are both negative, so

$(0, 0)$ is a stable equilibrium solution. For the case of no friction where $b = 0$, the roots are

$$\lambda = 0 \pm ci$$

Both roots are complex-valued with zero real parts. Each root is an eigenvalue of $D\mathbf{f}(0, 0)$ with one linearly independent eigenvector. According to our theorem on stability of linear systems, the equilibrium solution is stable. Thus, the equilibrium solution $(0, 0)$ is stable for any $b \geq 0$, so the mathematical model appears to be a reasonable match to what we expect physically.

The first-derivative matrix at the second equilibrium solution is

$$D\mathbf{f}(\pi, 0) = \begin{bmatrix} 0 & 1 \\ c & -b \end{bmatrix}$$

and has the characteristic equation $\lambda^2 + b\lambda - c = 0$. The roots are

$$\lambda = \frac{-b \pm \sqrt{b^2 + 4c}}{2}$$

Regardless of $b = 0$ or $b > 0$, both roots are real-valued with one negative and one positive. The second equilibrium solution is therefore unstable, once again showing that the mathematical model exhibits properties that we expect in the physical system.

Before doing the analysis for numerical stability, let us try four different numerical methods for the simple pendulum problem where $b = 0$, $c = 1$, $\theta_0 = 0.1$, $\dot{\theta}_0 = 1.0$, and $h = 0.1$. The experiments generate $n = 256$ iterates. The test driver is

```
double c = 1.0f;  // global constant used by numerical methods
void SolveSystem (double* (*NumericalMethod)(double,double,double,int))
{
    int n = 256;
    double theta0 = 0.1, dtheta0 = 1.0, h = 0.1;
    double theta* = NumericalMethod(theta0,dtheta0,h,n);
    // plot the output...
}
```

EXPLICIT EULER'S METHOD

The numerical method is

$$\mathbf{y}_{i+1} = \mathbf{y}_i + h\mathbf{f}(t_i, \mathbf{y}_i)$$

with initial data $\mathbf{y}_0 = (\theta_0, \dot{\theta}_0)$. Pseudocode for generating the iterates is

(Example 9.1 continued)

```
double* ExplicitEuler (double theta0, double dtheta0, double h, int n)
{
    double* theta = new double[n];
    for (int i = 0; i < n; i++)
    {
        double theta1 = theta0 + h * dtheta0;
        double dtheta1 = dtheta0 - h * c * sin(theta0);
        theta[i] = theta1;
        theta0 = theta1;
        dtheta0 = dtheta1;
    }
    return theta;
}
```

Figure 9.2 shows a plot of the output of the numerical method.

Observe that the angles are becoming unbounded over time, contrary to how the physical solution should behave. The true solution should be periodic, implying that the maximum angles are all the same and the minimum angles are all the same. Also, the time between two consecutive zeros should be a constant. The results should make you question whether choosing Euler's method without analysis was a good thing to do.

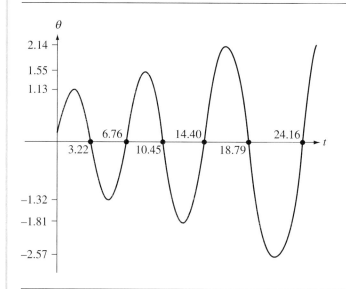

Figure 9.2 The explicit Euler's method applied to the simple pendulum problem. The image shows a plot of the pendulum angles over time.

IMPLICIT EULER'S METHOD

The numerical method is

$$\mathbf{y}_{i+1} = \mathbf{y}_i + h\mathbf{f}(t_{i+1}, \mathbf{y}_{i+1})$$

with initial data $\mathbf{y}_0 = (\theta_0, \dot{\theta}_0)$. The iterate \mathbf{y}_{i+1} appears on both sides of the equation. For the simple pendulum, $\mathbf{y}_i = (\theta_i, \dot{\theta}_i)$ and the iteration scheme is

$$\theta_{i+1} = \theta_i + h\dot{\theta}_{i+1}, \qquad \dot{\theta}_{i+1} = \dot{\theta}_i - hc \, \sin(\theta_{i+1})$$

My implementation combines these into a single equation,

$$\theta_{i+1} + h^2 c \, \sin(\theta_{i+1}) - \theta_i - h\dot{\theta}_i = 0$$

and applies Newton's method to $g(z) = z + h^2 c \, \sin(z) - \theta_i - h\dot{\theta}_i$ with initial guess $z_0 = \theta_i$ and

$$z_{m+1} = z_m - \frac{g(z_m)}{g'(z_m)}, \qquad m \geq 0$$

where $g'(z) = 1 + h^2 c \, \cos(z)$. The final iterate z_M is chosen to be the value θ_{i+1}. Pseudocode for generating the differential equation iterates is

```
double* ImplicitEuler (double theta0, double dtheta0, double h,
    int n)
{
    const int maxIterations = 32;
    double* theta = new double[n];
    for (int i = 0; i < n; i++)
    {
        double theta1 = theta0;
        for (int j = 0; j < maxIterations; j++)
        {
            double g = theta1 + h * h * c * sin(theta1) - theta0
                - h * dtheta0;
            double gder = 1.0 + h * h * c * cos(theta1);
            theta1 -= g/gder;
        }
        double dtheta1 = dtheta0 - h * c * sin(theta1);
        theta[i] = theta1;
        theta0 = theta1;
        dtheta0 = dtheta1;
    }
    return theta;
}
```

*(Example 9.1
continued)*

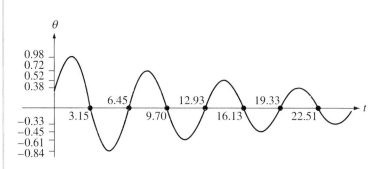

Figure 9.3

The implicit Euler's method applied to the simple pendulum problem. The image shows a plot of the pendulum angles over time.

For simplicity, no convergence or stopping criterion is used in the inner loop that constructs the Newton's iterates; the loop just runs a fixed number of times. A more sophisticated loop with an eye toward minimizing inner loop cycles may certainly be tried. Figure 9.3 shows a plot of the output of the numerical method.

Now the angles are dampened over time, contrary to how the physical solution should behave, although in this case someone observing the numerical pendulum behavior might think the physical system had friction at the joint causing the oscillations to dampen. The time between two consecutive zeros in the Euler's method was significantly increasing over time. In the implicit Euler's method, the time between zeros is only gradually decreasing.

RUNGE-KUTTA FOURTH-ORDER METHOD

The numerical method is

$$\mathbf{k}_1 = h\mathbf{f}(t_i, \mathbf{y}_i)$$

$$\mathbf{k}_2 = h\mathbf{f}(t_i + h/2, \mathbf{y}_i + \mathbf{k}_1/2)$$

$$\mathbf{k}_3 = h\mathbf{f}(t_i + h/2, \mathbf{y}_i + \mathbf{k}_2/2)$$

$$\mathbf{k}_4 = h\mathbf{f}(t_i + h, \mathbf{y}_i + \mathbf{k}_3)$$

$$\mathbf{y}_{i+1} = \mathbf{y}_i + (\mathbf{k}_1 + 2\mathbf{k}_2 + 2\mathbf{k}_3 + \mathbf{k}_4)/6$$

with initial data $\mathbf{y}_0 = (\theta_0, \dot{\theta}_0)$. Pseudocode for generating the iterates is

```
double* RungeKutta (double theta0, double dtheta0, double h, int n)
{
    double* theta = new double[n];
```

```
for (int i = 0; i < n; i++)
{
    double K1theta = h * dtheta0;
    double K1dtheta = -h * c * sin(theta0);
    double theta1 = theta0 + 0.5 * K1theta;
    double dtheta1 = dtheta0 + 0.5 * K1dtheta;
    double K2theta = h * dtheta1;
    double K2dtheta = -h * c * sin(theta1);
    theta1 = theta0 + 0.5 * K2theta;
    dtheta1 = dtheta0 + 0.5 * K2dtheta;
    double K3theta = h * dtheta1;
    double K3dtheta = -h * c * sin(theta1);
    theta1 = theta0 + K3theta;
    dtheta1 = dtheta0 + K3dtheta;
    double K4theta = h * dtheta1;
    double K4dtheta = -h * c * sin(theta1);
    theta1 = theta0 + (K1theta + 2.0 * K2theta
        + 2.0 * K3theta + K4theta) / 6.0;
    dtheta1 = dtheta0 + (K1dtheta + 2.0 * K2dtheta
        + 2.0 * K3dtheta + K4dtheta) / 6.0;
    theta[i] = theta1;
    theta0 = theta1;
    dtheta0 = dtheta1;
}
return theta;
}
```

Figure 9.4 shows a plot of the output of the numerical method.

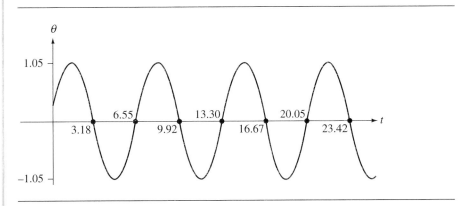

Figure 9.4 The Runge-Kutta fourth-order method applied to the simple pendulum problem. The image shows a plot of the pendulum angles over time.

(Example 9.1 continued)

The results appear to indicate that this method is stable. The zeros of $\theta(t)$ are evenly spaced and the four maximum values, in order of increasing time, are 1.05289, 1.05117, 1.05285, and 1.05249. The four minimum values are -1.05232, -1.05291, -1.05221, and -1.05293.

LEAP FROG METHOD

This is a two-step method,

$$\mathbf{y}_{i+2} = \mathbf{y}_i + 2h\mathbf{f}(t_i, \mathbf{y}_{i+1})$$

where the initial data is \mathbf{y}_0 and the first iterate is generated by an Euler step, $\mathbf{y}_1 = \mathbf{y}_0 + h\mathbf{f}(t_0, \mathbf{y}_0)$. Pseudocode for generating the iterates is

```
double* LeapFrog (double theta0, double dtheta0, double h, int n)
{
    double* theta = new double[n];

    // generate first iterate with Euler's to start up the process
    double theta1 = theta0 + h * dtheta0;
    double dtheta1 = dtheta0 - h * c * sin(theta0);
    theta[0] = theta1;

    for (int i = 1; i < n; i++)
    {
        double theta2 = theta0 + 2.0 * h * dtheta1;
        double dtheta2 = dtheta0 - 2.0 * h * c * sin(theta1);
        theta[i] = theta2;
        theta0 = theta1;
        dtheta0 = dtheta1;
        theta1 = theta2;
        dtheta1 = dtheta2;
    }
    return theta;
}
```

Figure 9.5 shows a plot of the output of the numerical method.

The results appear to indicate that this method is stable. The zeros of $\theta(t)$ are evenly spaced and the four maximum values, in order of increasing time, are 1.05816, 1.05079, 1.05582, and 1.05810. The four minimum values are -1.05750, -1.05410, -1.05730, and -1.05820.

We now analyze the numerical stability of the four methods for the physically stable equilibrium solution $(0, 0)$ when $b = 0$ and $c = 1$. The eigenvalues of $D\mathbf{f}(0, 0)$

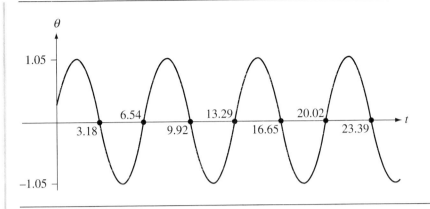

Figure 9.5

The leap frog method applied to the simple pendulum problem. The image shows a plot of the pendulum angles over time.

are $\lambda = \pm i$. The modal equation is $\dot{\mathbf{x}} = \lambda \mathbf{x}$. We apply the numerical methods using $\mathbf{f}(t, \mathbf{x}) = \lambda \mathbf{x}$.

EXPLICIT EULER'S METHOD

The application to the modal equation is

$$\mathbf{y}_{i+1} = \mathbf{y}_i + h\lambda \mathbf{y}_i = (1 + h\lambda)\mathbf{y}_i$$

The characteristic polynomial equation $p(z) = 0$ of a linear difference equation is obtained by subtracting all terms to the left-hand side of the equation and formally replacing \mathbf{y}_{i+j} by z_j for $j \geq 0$. In this case the characteristic polynomial is

$$p(z) = z - (1 + h\lambda)$$

and has the single root $z = 1 + h\lambda$. For stability we need $|z| \leq 1$, so $|1 + h\lambda| \leq 1$. This is an inequality that defines a set of points in the complex plane. We can plot the set in terms of the complex variable $h\lambda$. Figure 9.6 shows the region for $|1 + h\lambda| \leq 1$.

Regardless of choice of $h > 0$, $h\lambda = \pm hi$ is never inside the gray region. The explicit Euler's method is not stable for the simple pendulum problem for any choice of h and cannot be used to obtain good approximations.

(Example 9.1 continued)

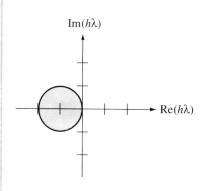

Figure 9.6 The region of stability for the explicit Euler's method is shown in gray.

IMPLICIT EULER'S METHOD

The application to the modal equation is

$$\mathbf{y}_{i+1} = \mathbf{y}_i + h\lambda\mathbf{y}_{i+1}$$

The characteristic polynomial is

$$p(z) = (1 - h\lambda)z - 1$$

and has the single root $z = 1/(1 - h\lambda)$. For stability we need $|z| \leq 1$, so $|1 - h\lambda| \geq 1$. Figure 9.7 shows the region of stability.

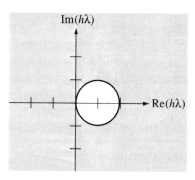

Figure 9.7 The region of stability for the implicit Euler's method is shown in gray.

Regardless of choice of $h > 0$, $h\lambda = \pm hi$ is always inside the gray region. The implicit Euler's method is always stable for the simple pendulum problem for any choice of h. However, the approximations are not accurate over time.

RUNGE-KUTTA FOURTH-ORDER METHOD

The application to the modal equation is

$$\mathbf{k}_1 = h\lambda\mathbf{y}_i$$

$$\mathbf{k}_2 = h\lambda(1 + h\lambda/2)\mathbf{y}_i$$

$$\mathbf{k}_3 = h\lambda(1 + (h\lambda/2)(1 + h\lambda/2))\mathbf{y}_i$$

$$\mathbf{k}_4 = h\lambda(1 + h\lambda(1 + (h\lambda/2)(1 + h\lambda/2)))\mathbf{y}_i$$

These combine to form

$$\mathbf{y}_{i+1} = \left[1 + (h\lambda) + \frac{1}{2}(h\lambda)^2 + \frac{1}{6}(h\lambda)^3 + \frac{1}{24}(h\lambda)^4\right]\mathbf{y}_i = q(h\lambda)\mathbf{y}_i$$

where the last equality defines the fourth-degree polynomial $q(h\lambda)$. The characteristic polynomial is

$$p(z) = z - q(h\lambda)$$

and has a single root $z = q(h\lambda)$. For stability we need $|q(h\lambda)| \leq 1$. Figure 9.8 shows the region of stability.

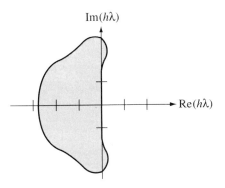

Figure 9.8 The region of stability for the Runge-Kutta fourth-order method is shown in gray.

*(Example 9.1
continued)*

Although Figure 9.8 does not show this, the right boundary of the gray region is slightly to the right of the imaginary axis, except at the origin, which is a point on the boundary. An evaluation at $h = 0.1$ for either eigenvalue $\pm i$ shows that $|q(\pm 0.1i)| \doteq 0.999999986 < 1$. Thus, the Runge-Kutta method is stable for the simple pendulum problem and it turns out to be accurate over time.

LEAP FROG METHOD

The application to the modal equation is

$$\mathbf{y}_{i+2} = \mathbf{y}_i + 2h\lambda\mathbf{y}_{i+1}$$

The characteristic polynomial is

$$p(z) = z^2 - 2h\lambda z - 1$$

and has two roots $z = h\lambda \pm \sqrt{1 + (h\lambda)^2}$. For stability we need two conditions satisfied, $|h\lambda + \sqrt{1 + (h\lambda)^2}| \le 1$ and $|h\lambda - \sqrt{1 + (h\lambda)^2}| \le 1$. Figure 9.9 shows the region of stability. The region consists of the line segment $z = wi$, where $|w| \le 1$. In our case $z = \pm 0.1i$, so the leap frog method is stable for the simple pendulum problem with our chosen step size.

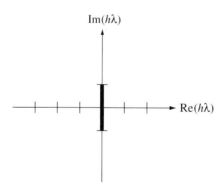

Figure 9.9

The region of stability for the leap frog method is shown as a heavy black line and consists of a line segment on the imaginary axis.

9.10 STIFF EQUATIONS

When dealing with a system of differential equations, numerical stability is clearly important in order that the output of the numerical method be meaningful. A somewhat related problem that can also occur is the problem of *stiffness*. These types of problems arise when the differential equation has two or more functional terms that have widely different scales. If the solution relevant to the application is the one that yields a steady state, a transient term that rapidly decays to zero can affect the calculations and generate significant error. The prototypical behavior is illustrated by a second-order linear equation or, equivalently, a system of two first-order linear equations.

EXAMPLE 9.2

Consider the second-order equation

$$\ddot{x} = c^2 x, \qquad t \geq 0, x(0) = x_0, \qquad \dot{x}(0) = \dot{x}_0$$

where $c > 0$ is a constant. The solution is

$$x(t) = \left(\frac{cx_0 + \dot{x}_0}{2c} \right) e^{ct} + \left(\frac{cx_0 - \dot{x}_0}{2c} \right) e^{-ct}$$

A physical application will no doubt be interested only in the steady state solution that has the decaying term e^{-ct}. We can make this happen by choosing the initial conditions so that $\dot{x}_0 = -cx_0$. The solution for such conditions is

$$x(t) = x_0 e^{-ct}$$

and has the property $\lim_{t \to \infty} x(t) = 0$. Choosing $c^2 = 2$, $x_0 = 1$, $\dot{x}_0 = -\sqrt{2}$, and $h = 0.01$, the Runge-Kutta fourth-order method produces iterates as shown in Figure 9.10.

As you can see, the approximation appears to be stable and accurate for quite some time, but then becomes unbounded. Two problems are occurring here. The first is that we cannot exactly represent $c = \sqrt{2}$ on the computer, so our theoretical requirement of $cx_0 + \dot{x}_0 = 0$ cannot be enforced. Numerical errors cause $cx_0 + \dot{x}_0 = \varepsilon$ for a very small value of $\varepsilon \neq 0$. This causes the functional term e^{ct} to influence the approximations and cause the unbounded behavior as shown in Figure 9.10. Even if we could represent the initial data exactly, the numerical method still introduces errors, both local truncation errors and round-off errors. This, too, causes e^{ct} to affect the solution eventually. Consequently, this problem is stiff.

*(Example 9.2
continued)*

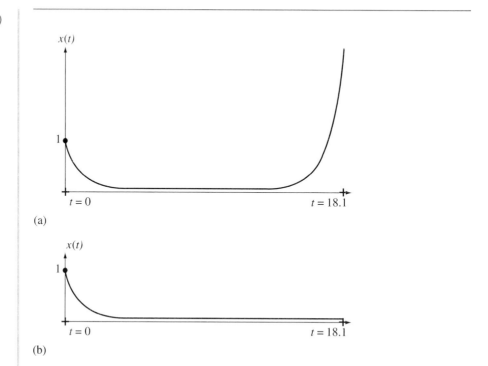

(a)

(b)

Figure 9.10 (a) An approximation to $x(t)$ using the Runge-Kutta fourth-order method. (b) The graph of the actual solution $x_0 e^{-ct}$. ∎

You might be tempted to conclude that the problem occurs only because of the occurrence of a positive eigenvalue $c > 0$ and a negative one $-c < 0$. However, even if the theoretical solution has two negative eigenvalues, stiffness can occur. The following example from [BF01] illustrates this.

EXAMPLE 9.3 Consider the first-order linear system

$$\dot{x} = 9x + 24y + 5\cos(t) - \frac{1}{3}\sin(t)$$

$$\dot{y} = -24x - 51y - 9\cos(t) + \frac{1}{3}\sin(t)$$

with initial data $x(0) = 4/3$ and $y(0) = 2/3$. The solution is

$$x(t) = 2e^{-3t} - e^{-39t} + \frac{1}{3}\cos(t)$$

$$y(t) = -e^{-3t} + 2e^{-39t} - \frac{1}{3}\cos(t)$$

The homogeneous linear system is physically stable about the equilibrium solution $(0, 0)$ since the eigenvalues of the first-derivative matrix are $\lambda = -3$ and $\lambda = -39$. The Runge-Kutta fourth-order method was used to numerically solve this problem with step sizes of $h = 0.1$ and $h = 0.05$. Table 9.1 shows the iterates for times between 0 and 1. It also shows the actual values.

Table 9.1 The actual and approximate values for the solution to the system of equations

			$h = 0.05$		$h = 0.1$	
t	$x(t)$	$y(t)$	x_i	y_i	x_i	y_i
0.1	1.793063	−1.032002	1.712221	−0.870315	−2.645182	7.844543
0.2	1.423902	−0.874681	1.414072	−0.855015	−18.451691	38.876595
0.3	1.131577	−0.724999	1.130526	−0.722892	−87.473297	176.484833
0.4	0.909409	−0.608214	0.909278	−0.607948	−394.077576	789.365967
0.5	0.738788	−0.515658	0.738752	−0.515581	−1760.050049	3521.062256
0.6	0.605710	−0.440411	0.605684	−0.440356	−7848.706055	15698.184570
0.7	0.499860	−0.377404	0.499837	−0.377355	−34990.457031	69981.546875
0.8	0.413671	−0.322953	0.413650	−0.322908	−155983.609375	311967.750000
0.9	0.341614	−0.274409	0.341595	−0.274368	−695351.062500	1390702.750000
1.0	0.279675	−0.229888	0.279658	−0.229852	−3099763.500000	6199527.500000

As you can see, the method appears to be stable when $h = 0.05$ but not when $h = 0.1$. The differences in behavior for the two step sizes is explained by something we already talked about: determining if the chosen step size puts us in the region of stability associated with the numerical method. The region of stability for the Runge-Kutta fourth-order (RK4) method is shown in Figure 9.8. The eigenvalues for the current problem are $\lambda_1 = -3$ and $\lambda_2 = -39$. For step size $h = 0.1$, $h\lambda_1 = -0.3$ is in the region of stability, but $h\lambda_2 = -3.9$ is *outside* the region (to the left of it). However, when $h = 0.05$, both $h\lambda_1 = -0.15$ and $h\lambda_2 = -1.95$ are *inside* the region, so the RK4 method is stable. Our experiments agree with this analysis. ∎

As the last example shows, the analysis of numerical stability for the linearized system is important for choosing a step size for which the method is stable and,

hopefully, that avoids the problems of stiffness. Numerical methods that lead to as large a region of stability as possible are clearly desirable. Of course, since the physical stability requires eigenvalues with negative real parts and since the step sizes are positive, the only relevant portion of the region of stability is that part in the left half of the complex plane. For example, the region of stability for the implicit Euler's method includes the entire left half of the complex plane. In general, if the region of stability for a numerical method includes the entire left half of the complex plane, the method is called *A-stable*. Another example of an A-stable method is the trapezoid method listed in equation (9.7). This happens to be the only multistep method that is A-stable.

Although I have not discussed the topic here, the numerical methods of this chapter all use fixed-size steps. A class of numerical methods that might be important to you are those involving variable-size steps. It is not clear if variable step sizes gain you much in a real-time physics simulation, but if you do decide to use such a method, you need to balance the desire to choose large steps against the need to retain stability and avoid stiffness. Error monitoring is implemented in methods using variable step sizes in order to allow you to decide that the local truncation errors warrant choosing a larger step size. However, that larger step could take you outside the region of stability. Your implementation should additionally determine, if possible, whether the desired larger step size keeps you in the region of stability.

CHAPTER **10**

QUATERNIONS

Q uaternions are a powerful way to represent rotations within computer graphics and physics applications. Unfortunately, the mathematical complexity of quaternions seems to discourage some practitioners from any attempt at understanding them. As an aid to such understanding, a section is provided that constructs a matrix representing rotation about an arbitrary axis. The matrix is based on knowing how to rotate about the z-axis and uses the concept of change of basis from linear algebra. Afterwards, three sections are presented, each with a different view of what a quaternion is. Section 10.1 is the classical approach that defines quaternions in terms of symbols i, j, and k and shows how they are related to rotation. Section 10.2 presents quaternions based solely on concepts from linear algebra. In this setting a quaternion is a rotation matrix in 4D whose geometric actions are easy to understand. Section 10.4, written by Ken Shoemake, is yet another view of quaternions using matrices.

10.1 ROTATION MATRICES

Let us review a concept that you are no doubt already familiar with, rotation in the xy-plane. The rotation of the vector (x, y) about the origin by an angle $\theta > 0$ is the vector (x', y') specified by

$$x' = \cos(\theta)x - \sin(\theta)y, \qquad y' = \sin(\theta)x + \cos(\theta)y$$

The formula is derivable using a standard trigonometric construction. The direction of rotation is counterclockwise about the origin. In vector-matrix form the equation is

$$\begin{bmatrix} x' \\ y' \end{bmatrix} = \begin{bmatrix} \cos(\theta) & -\sin(\theta) \\ \sin(\theta) & \cos(\theta) \end{bmatrix} \begin{bmatrix} x \\ y \end{bmatrix}$$

If we now add a third dimension, the rotation of the vector (x, y, z) about the z-axis by an angle $\theta > 0$ is just a rotation of the (x, y) portion about the origin in the xy-plane. The rotated vector (x', y', z') is specified by

$$\begin{bmatrix} x' \\ y' \\ z' \end{bmatrix} = \begin{bmatrix} \cos(\theta) & -\sin(\theta) & 0 \\ \sin(\theta) & \cos(\theta) & 0 \\ 0 & 0 & 1 \end{bmatrix} \begin{bmatrix} x \\ y \\ z \end{bmatrix}$$

Setting $\mathbf{v} = [x\ y\ z]^{\mathrm{T}}$, $\mathbf{v}' = [x'\ y'\ z']^{\mathrm{T}}$, $s = \sin(\theta)$, and $c = \cos(\theta)$, the rotation is $\mathbf{v}' = R_0 \mathbf{v}$, where R_0 is the rotation matrix

$$R_0 = \begin{bmatrix} c & -s & 0 \\ s & c & 0 \\ 0 & 0 & 1 \end{bmatrix} \tag{10.1}$$

The standard coordinate axis directions, represented as 3×1 vectors, are $\imath = [1\ 0\ 0]^{\mathrm{T}}$, $\jmath = [0\ 1\ 0]^{\mathrm{T}}$, and $k = [0\ 0\ 1]^{\mathrm{T}}$. Observe that

$$R_0 \imath = \begin{bmatrix} c \\ s \\ 0 \end{bmatrix} = c\imath + s\jmath, \quad R_0 \jmath = \begin{bmatrix} -s \\ c \\ 0 \end{bmatrix} = -s\imath + c\jmath, \quad R_0 k = \begin{bmatrix} 0 \\ 0 \\ 1 \end{bmatrix} = k \tag{10.2}$$

The vectors $R_0 \imath$, $R_0 \jmath$, and $R_0 k$ are the columns of the rotation matrix R_0.

The equation for rotation of a vector $\mathbf{v} \in \mathbb{R}^3$ by an angle $\theta > 0$ about an axis with unit-length direction \mathbf{d} is derived next. Let \mathbf{a} and \mathbf{b} be vectors in the plane that contains the origin and has normal \mathbf{d}. Moreover, choose these vectors so that $\{\mathbf{a}, \mathbf{b}, \mathbf{d}\}$ is a right-handed orthonormal set: each vector is unit length; the vectors are mutually perpendicular; and $\mathbf{a} \times \mathbf{b} = \mathbf{d}$, $\mathbf{b} \times \mathbf{d} = \mathbf{a}$, and $\mathbf{d} \times \mathbf{a} = \mathbf{b}$. Figure 10.1 shows a typical choice.

The orthonormal set of vectors may be used as a basis for \mathbb{R}^3, both as domain and range of the rotational transformation. The matrix R_0 in equation (10.1) represents the rotation in this basis. A matrix R_1 that represents the rotation in the standard basis will transform \mathbf{a}, \mathbf{b}, and \mathbf{d} as

$$R_1 \mathbf{a} = c\mathbf{a} + s\mathbf{b}, \qquad R_1 \mathbf{b} = -s\mathbf{a} + c\mathbf{b}, \qquad R_1 \mathbf{d} = \mathbf{d} \tag{10.3}$$

The similarity between equations (10.3) and (10.2) is no coincidence. The equations in (10.2) may be collected into a single equation using the convenient bookkeeping that block matrices provide,

Figure 10.1 A right-handed orthonormal set of vectors. A rotation is desired about **d** by the angle $\theta > 0$.

$$R_1 \left[\, \mathbf{a} \mid \mathbf{b} \mid \mathbf{d} \,\right] = \left[\, c\mathbf{a} + s\mathbf{b} \mid -s\mathbf{a} + c\mathbf{b} \mid \mathbf{d} \,\right]$$

$$= \left[\, \mathbf{a} \mid \mathbf{b} \mid \mathbf{d} \,\right] \begin{bmatrix} c & -s & 0 \\ s & c & 0 \\ 0 & 0 & 1 \end{bmatrix}$$

The matrix $P = [\mathbf{a} \mid \mathbf{b} \mid \mathbf{d}]$ is itself a rotation since $\{\mathbf{a}, \mathbf{b}, \mathbf{d}\}$ is a right-handed orthonormal set, so its inverse is just its transpose. The last displayed equation is $R_1 P = P R_0$. Solving for $R_1 = P R_0 P^{\mathrm{T}}$, we have

$$R_1 = \left[\, \mathbf{a} \mid \mathbf{b} \mid \mathbf{d} \,\right] \begin{bmatrix} c & -s & 0 \\ s & c & 0 \\ 0 & 0 & 1 \end{bmatrix} \left[\, \mathbf{a} \mid \mathbf{b} \mid \mathbf{d} \,\right]^{\mathrm{T}}$$

$$= \left[\, \mathbf{a} \mid \mathbf{b} \mid \mathbf{d} \,\right] \begin{bmatrix} c & -s & 0 \\ s & c & 0 \\ 0 & 0 & 1 \end{bmatrix} \begin{bmatrix} \mathbf{a}^{\mathrm{T}} \\ \mathbf{b}^{\mathrm{T}} \\ \mathbf{d}^{\mathrm{T}} \end{bmatrix}$$

$$= \left[\, \mathbf{a} \mid \mathbf{b} \mid \mathbf{d} \,\right] \begin{bmatrix} c\mathbf{a}^{\mathrm{T}} - s\mathbf{b}^{\mathrm{T}} \\ s\mathbf{a}^{\mathrm{T}} + c\mathbf{b}^{\mathrm{T}} \\ \mathbf{d}^{\mathrm{T}} \end{bmatrix}$$

$$= \mathbf{a}(c\mathbf{a}^{\mathrm{T}} - s\mathbf{b}^{\mathrm{T}}) + \mathbf{b}(s\mathbf{a}^{\mathrm{T}} + c\mathbf{b}^{\mathrm{T}}) + \mathbf{d}\mathbf{d}^{\mathrm{T}}$$

$$= c(\mathbf{a}\mathbf{a}^{\mathrm{T}} + \mathbf{b}\mathbf{b}^{\mathrm{T}}) + s(\mathbf{b}\mathbf{a}^{\mathrm{T}} - \mathbf{a}\mathbf{b}^{\mathrm{T}}) + \mathbf{d}\mathbf{d}^{\mathrm{T}}$$

(10.4)

Keep in mind that \mathbf{aa}^T is the product of a 3×1 matrix and a 1×3 matrix, the result being a 3×3 matrix. This is not the same as $\mathbf{a}^T\mathbf{a}$, a product of a 1×3 matrix and a 3×1 matrix, the result being a 1×1 matrix (a scalar). Similarly, \mathbf{bb}^T, \mathbf{dd}^T, \mathbf{ba}^T, and \mathbf{ab}^T are 3×3 matrices. From a computational perspective, R_1 is easily computed from equation (10.4), but requires selecting \mathbf{a} and \mathbf{b} for the specified axis direction \mathbf{d}. Your intuition, though, should tell you that the rotation about the axis is independent of which pair of orthonormal vectors you choose in the plane. The following construction shows how to remove the dependence.

The representation of \mathbf{v} in the basis $\{\mathbf{a}, \mathbf{b}, \mathbf{d}\}$ is

$$\mathbf{v} = (\mathbf{a} \cdot \mathbf{v})\mathbf{a} + (\mathbf{b} \cdot \mathbf{v})\mathbf{b} + (\mathbf{d} \cdot \mathbf{v})\mathbf{d} = \alpha\mathbf{a} + \beta\mathbf{b} + \delta\mathbf{d} \tag{10.5}$$

where the last equality defines α, β, and δ as the dot products of the basis vectors with \mathbf{v}. This renaming is done for simplicity of notation in the ensuing constructions. A couple of vector quantities of interest are

$$\mathbf{d} \times \mathbf{v} = \mathbf{d} \times (\alpha\mathbf{a} + \beta\mathbf{b} + \delta\mathbf{d}) = \alpha\mathbf{d} \times \mathbf{a} + \beta\mathbf{d} \times \mathbf{b} + \delta\mathbf{d} \times \mathbf{d} = -\beta\mathbf{a} + \alpha\mathbf{b} \tag{10.6}$$

and

$$\mathbf{d} \times (\mathbf{d} \times \mathbf{v}) = \mathbf{d} \times (\alpha\mathbf{b} - \beta\mathbf{a}) = \alpha\mathbf{d} \times \mathbf{b} - \beta\mathbf{d} \times \mathbf{a} = -\alpha\mathbf{a} - \beta\mathbf{b} \tag{10.7}$$

The cross product $\mathbf{d} \times \mathbf{v}$ can be written as a matrix multiplied by a vector:

$$\begin{aligned}
\mathbf{d} \times \mathbf{v} &= \begin{bmatrix} d_1 \\ d_2 \\ d_3 \end{bmatrix} \times \begin{bmatrix} v_1 \\ v_2 \\ v_3 \end{bmatrix} \\
&= \begin{bmatrix} d_2 v_3 - d_3 v_2 \\ d_3 v_1 - d_1 v_3 \\ d_1 v_2 - d_2 v_1 \end{bmatrix} \\
&= \begin{bmatrix} 0 & -d_3 & d_2 \\ d_3 & 0 & -d_1 \\ -d_2 & d_1 & 0 \end{bmatrix} \begin{bmatrix} v_1 \\ v_2 \\ v_3 \end{bmatrix} \\
&= D\mathbf{v}
\end{aligned} \tag{10.8}$$

where the last equality defines the 3×3 matrix D. This matrix is skew-symmetric since $D^T = -D$. The cross product $\mathbf{d} \times (\mathbf{d} \times \mathbf{v})$ is written as a matrix multiplied by a vector by applying equation (10.8) twice:

$$\mathbf{d} \times (\mathbf{d} \times \mathbf{v}) = D(\mathbf{d} \times \mathbf{v}) = D(D\mathbf{v}) = D^2\mathbf{v} \tag{10.9}$$

We now take a closer look at the vectors $\mathbf{v} = I\mathbf{v}$, $\mathbf{d} \times \mathbf{v} = D\mathbf{v}$, and $\mathbf{d} \times (\mathbf{d} \times \mathbf{v}) = D^2\mathbf{v}$ to determine how \mathbf{a}, \mathbf{b}, and their various products are related to the matrices I, D, and D^2.

First, observe that equation (10.5) may be manipulated as

$$I\mathbf{v} = \mathbf{v}$$
$$= (\mathbf{a} \cdot \mathbf{v})\mathbf{a} + (\mathbf{b} \cdot \mathbf{v})\mathbf{b} + (\mathbf{d} \cdot \mathbf{v})\mathbf{d}$$
$$= \mathbf{a}(\mathbf{a}^\mathrm{T}\mathbf{v}) + \mathbf{b}(\mathbf{b}^\mathrm{T}\mathbf{v}) + \mathbf{d}(\mathbf{d}^\mathrm{T}\mathbf{v})$$
$$= (\mathbf{a}\mathbf{a}^\mathrm{T} + \mathbf{b}\mathbf{b}^\mathrm{T} + \mathbf{d}\mathbf{d}^\mathrm{T})\mathbf{v}$$

The equation is true for all vectors \mathbf{v}, so

$$I = \mathbf{a}\mathbf{a}^\mathrm{T} + \mathbf{b}\mathbf{b}^\mathrm{T} + \mathbf{d}\mathbf{d}^\mathrm{T} \tag{10.10}$$

Second, equations (10.5), (10.6), and (10.8) imply the relationship

$$D\mathbf{v} = \mathbf{d} \times \mathbf{v}$$
$$= \alpha\mathbf{b} - \beta\mathbf{a}$$
$$= (\mathbf{a} \cdot \mathbf{v})\mathbf{b} - (\mathbf{b} \cdot \mathbf{v})\mathbf{a}$$
$$= \mathbf{b}(\mathbf{a}^\mathrm{T}\mathbf{v}) - \mathbf{a}(\mathbf{b}^\mathrm{T}\mathbf{v})$$
$$= (\mathbf{b}\mathbf{a}^\mathrm{T} - \mathbf{a}\mathbf{b}^\mathrm{T})\mathbf{v}$$

This equation is true for all vectors \mathbf{v}, so

$$D = \mathbf{b}\mathbf{a}^\mathrm{T} - \mathbf{a}\mathbf{b}^\mathrm{T} \tag{10.11}$$

Third, equations (10.5), (10.7), and (10.9) imply the relationship

$$D^2\mathbf{v} = \mathbf{d} \times (\mathbf{d} \times \mathbf{v})$$
$$= -\alpha\mathbf{a} - \beta\mathbf{b}$$
$$= (\mathbf{d} \cdot \mathbf{v})\mathbf{d} - \mathbf{v}$$
$$= \mathbf{d}(\mathbf{d}^\mathrm{T}\mathbf{v}) - \mathbf{v}$$
$$= (\mathbf{d}\mathbf{d}^\mathrm{T} - I)\mathbf{v}$$

This equation is true for all vectors \mathbf{v}, so

$$D^2 = \mathbf{d}\mathbf{d}^\mathrm{T} - I \tag{10.12}$$

Combining these relationships with equation (10.4),

$$R_1 = c(\mathbf{aa}^T + \mathbf{bb}^T) + s(\mathbf{ba}^T - \mathbf{ab}^T) + \mathbf{dd}^T \qquad \text{Restatement of equation (10.4)}$$

$$= c(I - \mathbf{dd}^T) + s(\mathbf{ba}^T - \mathbf{ab}^T) + \mathbf{dd}^T \qquad \text{By equation (10.10)}$$

$$= c(I - \mathbf{dd}^T) + sD + \mathbf{dd}^T \qquad \text{By equation (10.11)} \qquad (10.13)$$

$$= I + sD + (1 - c)(\mathbf{dd}^T - I)$$

$$= I + sD + (1 - c)D^2 \qquad \text{By equation (10.12)}$$

This equation provides the rotation matrix R_1 in terms of the unit-length axis direction \mathbf{d} stored as the matrix D and the angle θ occurring in $s = \sin(\theta)$ and $c = \cos(\theta)$. The application of the rotation matrix to a vector is

$$R_1\mathbf{v} = (I + sD + (1 - c)D^2)\mathbf{v}$$

$$= I\mathbf{v} + sD\mathbf{v} + (1 - c)D^2\mathbf{v} \qquad (10.14)$$

$$= \mathbf{v} + s\mathbf{d} \times \mathbf{v} + (1 - c)\mathbf{d} \times (\mathbf{d} \times \mathbf{v})$$

Make sure you understand the constructions used to obtain equations (10.4) and (10.13). The same idea is used in Section 10.3 to explain how a quaternion is related to a rotation matrix in four dimensions.

10.2 THE CLASSICAL APPROACH

A *quaternion* is specified by the abstract quantity $q = w + xi + yj + zk$, where w, x, y, and z are real numbers. This quantity can be thought of as a vector $(w, x, y, z) \in \mathbb{R}^4$. As it turns out, the quaternions that are related to rotations are unit-length quaternions, those quaternions for which the length of (w, x, y, z) is 1. As vectors in \mathbb{R}^4, the unit-length quaternions are located on the hypersphere of radius 1, given algebraically as $w^2 + x^2 + y^2 + z^2 = 1$. Many practitioners use the term quaternion in place of unit-length quaternion. In this section I will use *quaternion* to mean any quantity of the form $w + xi + yj + zk$ and *unit-length quaternion* when I intend the vector (w, x, y, z) to have length 1.

10.2.1 ALGEBRAIC OPERATIONS

Addition of two quaternions is defined by

$$q_0 + q_1 = (w_0 + x_0i + y_0j + z_0k) + (w_1 + x_1i + y_1j + z_1k)$$

$$= (w_0 + w_1) + (x_0 + x_1)i + (y_0 + y_1)j + (z_0 + z_1)k \qquad (10.15)$$

Scalar multiplication of a quaternion by a real number c is defined by

$$cq = c(w + xi + yj + zk) = (cw) + (cx)i + (cy)j + (cz)k \qquad (10.16)$$

The *subtraction* operation is defined as a consequence of these two definitions, $q_0 - q_1 = q_0 + (-1)q_1$.

Multiplications are allowed between quaternions. The symbols i, j, and k have multiplicative properties similar to pure imaginary numbers: $i^2 = -1$, $j^2 = -1$, and $k^2 = -1$. They also have multiplicative properties that are superficially similar to cross products of the 3D vectors \imath, \jmath, and k: $ij = -ji = k$, $jk = -kj = i$, and $ki = -ik = j$. Observe that $ij \neq ji$, so multiplication is not a commutative operation. The analogy to cross products is not fully valid, though. Multiplication is associative; for example, $(ij)k = -1 = i(jk)$, but the cross product operation is not associative. Generally, the product of quaternions is defined by allowing the distributive law to apply and by using the various product formulas for the i, j, and k terms:

$$\begin{aligned}
q_0 q_1 &= (w_0 + x_0 i + y_0 j + z_0 k)(w_1 + x_1 i + y_1 j + z_1 k) \\
&= (w_0 w_1 - x_0 x_1 - y_0 y_1 - z_0 z_1) \\
&\quad + (w_0 x_1 + w_1 x_0 + y_0 z_1 - z_0 y_1)i \\
&\quad + (w_0 y_1 + w_1 y_0 + z_0 x_1 - x_0 z_1)j \\
&\quad + (w_0 z_1 + w_1 z_0 + x_0 y_1 - y_0 x_1)k
\end{aligned} \qquad (10.17)$$

As noted multiplication is not generally commutative. The product in the other order obtained from equation (10.17) by interchanging the 0 and 1 subscripts is

$$\begin{aligned}
q_1 q_0 &= (w_1 + x_1 i + y_1 j + z_1 k)(w_0 + x_0 i + y_0 j + z_0 k) \\
&= (w_0 w_1 - x_0 x_1 - y_0 y_1 - z_0 z_1) \\
&\quad + (w_0 x_1 + w_1 x_0 + y_1 z_0 - y_0 z_1)i \\
&\quad + (w_0 y_1 + w_1 y_0 + z_1 x_0 - z_0 x_1)j \\
&\quad + (w_0 z_1 + w_1 z_0 + x_1 y_0 - x_0 y_1)k
\end{aligned} \qquad (10.18)$$

The w-components of $q_0 q_1$ and $q_1 q_0$ are the same. On the other hand, the last two terms of each of the i-, j-, and k-components in the second equation of (10.18) are opposite in sign to their counterparts in the first equation. Those terms should remind you of the components of a cross product. Symbolically, equations (10.17) and (10.18) are different, but it is possible for *some* (but not all) quaternions that

$q_0 q_1 = q_1 q_0$. For this to happen we need

$$(x_0, y_0, z_0) \times (x_1, y_1, z_1) = (y_0 z_1 - y_1 z_0, z_0 x_1 - z_1 x_0, x_0 y_1 - y_0 x_1)$$

$$= (y_1 z_0 - y_0 z_1, z_1 x_0 - z_0 x_1, x_1 y_0 - x_0 y_1)$$

$$= (x_1, y_1, z_1) \times (x_0, y_0, z_0)$$

The only way the two cross products can be the same for a pair of vectors is if they are parallel. In summary, $q_0 q_1 = q_1 q_0$ if and only if $(x_1, y_1, z_1) = t(x_0, y_0, z_0)$ for some real-valued scalar t.

The complex number $\zeta = w + xi$ has *real part* w and *imaginary part* x. I refer to xi as the *imaginary portion* of ζ. To allow a closer parallel between properties of quaternions and properties of complex numbers, a quaternion may be written as $q = w + \hat{v}$, where $\hat{v} = xi + yj + zk$. The separation of quaternions into two portions allows us to think of w as the *real part* of q and \hat{v} as the *imaginary portion* of q. The conjugate of ζ is defined as $\bar{\zeta} = w - xi$; that is, the sign of the imaginary portion is changed. A consequence is that $\zeta \bar{\zeta} = w^2 + x^2$. The right-hand side is called the *norm* of ζ and is denoted $N(\zeta) = \zeta \bar{\zeta}$. As long as $N(\zeta) \neq 0$, the multiplicative inverse of ζ exists and is $\zeta^{-1} = \bar{\zeta}/N(\zeta)$. If $N(\zeta) = 1$, the complex number is said to be unit length. Similar definitions apply to a quaternion $q = w + \hat{v}$. The *conjugate* is

$$q^* = w - \hat{v} \tag{10.19}$$

For historical reasons and reasons of mathematical nomenclature, a superscript asterisk is used to denote the conjugate rather than an overline bar as is done for complex numbers. The *norm* of q is $N(q) = qq^* = w^2 + x^2 + y^2 + z^2$ and the *length* of q is naturally defined as the square root of the norm, $L(q) = \sqrt{N(q)}$. If $L(q) = 1$, q is said to be *unit length*. As long as $N(q) \neq 0$, the *inverse* of q is $q^{-1} = q^*/N(q)$. If $L(q) = 1$, the inverse and conjugate are the same, $q^{-1} = q^*$. For purposes of rotations the norm, length, and inverse do not play a role, so I mention them here merely for completeness.

The polar form of a unit-length complex number is $\zeta = \cos \phi + i \sin \phi$. A unit-length quaternion has a similar representation,

$$q = \cos \phi + \hat{d} \sin \phi \tag{10.20}$$

where $\hat{d} = xi + yj + zk$ and $x^2 + y^2 + z^2 = 1$. Note the similarity in form to ζ. The imaginary number i has the property $i^2 = -1$. The imaginary portion \hat{d} has the similar property $\hat{d}^2 = -1$. The polar form is important in understanding how unit-length quaternions are related to rotations, the topic of Section 10.2.2.

The representation of any quaternion as $q = w + \hat{v}$ may be viewed in a sense as a coordinate-free description. We may identify $\hat{v} = xi + yj + zk$ with the vector $\mathbf{v} = (x, y, z)$. This allows us to define two operations on the imaginary portions

based on how those operations apply to vectors. The *dot product* of \hat{v}_0 and \hat{v}_1 is denoted $\hat{v}_0 \cdot \hat{v}_1$ and defined to be the real-valued vector dot product $\mathbf{v}_0 \cdot \mathbf{v}_1$. The *cross product* of \hat{v}_0 and \hat{v}_1 is denoted $\hat{v}_0 \times \hat{v}_1$, another quaternion with a zero w-component. Its x, y, and z values are the components of the vector cross product $\mathbf{v}_0 \times \mathbf{v}_1$. In this formulation, the product of two quaternions is

$$(w_0 + \hat{v}_0)(w_1 + \hat{v}_1) = (w_0 w_1 - \hat{v}_0 \cdot \hat{v}_1) + w_0 \hat{v}_1 + w_1 \hat{v}_0 + \hat{v}_0 \times \hat{v}_1 \qquad (10.21)$$

We will make use of this identity in the next section. Other identities are provided:

1. $(q^*)^* = q$
2. $(pq)^* = q^* p^*$
3. If $\hat{d} = xi + yj + zk$ with $x^2 + y^2 + z^2 = 1$, then $\hat{d}^2 = -1$
4. $(w_0 + \hat{v}_0)(w_1 + \hat{v}_1) = (w_1 + \hat{v}_1)(w_0 + \hat{v}_0)$ if and only if $\hat{v}_0 \times \hat{v}_1 = 0$

I leave the proofs of these as an exercise.

10.2.2 RELATIONSHIP OF QUATERNIONS TO ROTATIONS

A vector \mathbf{v} is to be rotated about an axis with unit-length direction \mathbf{d} by an angle θ. The sense of the rotation is counterclockwise: If you look at the origin of a plane perpendicular to \mathbf{d}, your view direction is $-\mathbf{d}$, and $\theta > 0$, then any vector in that plane is rotated counterclockwise about the origin. Let \mathbf{u} be the rotation of \mathbf{v} about axis \mathbf{d} by angle θ. Figure 10.1 illustrates the rotation.

The quaternions \hat{d}, \hat{v}, and \hat{u} are those identified with the vectors \mathbf{d}, \mathbf{v}, and \mathbf{u}. Define the quaternion $q = \gamma + \sigma \hat{d}$, where $\gamma = \cos(\theta/2)$ and $\sigma = \sin(\theta/2)$. The quaternion $\hat{u} = q \hat{v} q^*$ has a zero w-component; the left-hand side is written as if there is no w-component, but we do need to verify this. The vector \mathbf{u} turns out to be the rotation of \mathbf{v}. The formal calculations are shown:

$$q\hat{v}q^* = (\gamma + \sigma\hat{d})(0 + \hat{v})(\gamma - \sigma\hat{d}) \qquad \text{Definition of } q \text{ and } q^*$$

$$= (-\sigma\hat{d} \cdot \hat{v} + \gamma\hat{v} + \sigma\hat{d} \times \hat{v})(\gamma - \sigma\hat{d}) \qquad \text{Using equation (10.21)}$$

$$= [(-\sigma\hat{d} \cdot \hat{v})(\gamma) - (\gamma\hat{v} + \sigma\hat{d} \times \hat{v})(-\sigma\hat{d})]$$

$$\quad + (\gamma)(\gamma\hat{v} + \sigma\hat{d} \times \hat{v}) + (-\sigma\hat{d} \cdot \hat{v})(-\sigma\hat{d}) \qquad \text{Using equation (10.21)}$$

$$\quad + (\gamma\hat{v} + \sigma\hat{d} \times \hat{v}) \times (-\sigma\hat{d})$$

$$= \gamma^2\hat{v} + \sigma^2(\hat{d} \cdot \hat{v})\hat{d} + 2\sigma\gamma\hat{d} \times \hat{v} + \sigma^2\hat{d} \times (\hat{d} \times \hat{v})$$

The last equality uses the facts that $(\hat{d} \times \hat{v}) \cdot \hat{d} = 0$, $\hat{v} \times \hat{d} = -\hat{d} \times \hat{v}$ and $\hat{d} \times (\hat{d} \times \hat{v}) = -(\hat{d} \times \hat{v}) \times \hat{d}$, the same identities that the vector counterparts of \hat{d} and \hat{v} satisfy. Continuing with the calculations:

$$q\hat{v}q^* = (1 - \sigma^2)\hat{v} + 2\sigma\gamma\hat{d} \times \hat{v} + \sigma^2[(\hat{d} \cdot \hat{v})\hat{d} + \hat{d} \times (\hat{d} \times \hat{v})]$$

$$= \hat{v} + 2\sigma\gamma\hat{d} \times \hat{v} + \sigma^2[(\hat{d} \cdot \hat{v})\hat{d} - \hat{v} + \hat{d} \times (\hat{d} \times \hat{v})]$$

An identity from vector algebra is $\mathbf{d} \times (\mathbf{d} \times \mathbf{v}) = (\mathbf{d} \cdot \mathbf{v})\mathbf{d} - (\mathbf{d} \cdot \mathbf{d})\mathbf{v} = (\mathbf{d} \cdot \mathbf{v})\mathbf{d} - \mathbf{v}$, the last equality a consequence of \mathbf{d} being unit length. The quaternion counterpart satisfies the same identity, so

$$q\hat{v}q^* = \hat{v} + 2\sigma\gamma\hat{d} \times \hat{v} + 2\sigma^2\hat{d} \times (\hat{d} \times \hat{v})$$

Recall also the trigonometric identities $\sin\theta = 2\sin(\theta/2)\cos(\theta/2) = 2\sigma\gamma$ and $1 - \cos\theta = 2\sin^2(\theta/2) = 2\sigma^2$, so we finally arrive at

$$q\hat{v}q^* = \hat{v} + (\sin\theta)\hat{d} \times \hat{v} + (1 - \cos\theta)\hat{d} \times (\hat{d} \times \hat{v}) \qquad (10.22)$$

This is the quaternion counterpart of equation (10.14), the general rotation of \mathbf{v} about an axis \mathbf{d} by an angle θ. The vector \mathbf{u} corresponding to $\hat{u} = q\hat{v}q^*$ is therefore the rotation of \mathbf{v}.

The rotation matrix R corresponding to the quaternion q may be obtained by symbolically computing the right-hand side of $\hat{u} = q\hat{v}q^*$ and factoring the coefficients of the i-, j-, and k-terms to obtain $\mathbf{u} = R\mathbf{v}$, where

$$R = \begin{bmatrix} 1 - 2y^2 - 2z^2 & 2xy - 2wz & 2xz + 2wy \\ 2xy + 2wz & 1 - 2x^2 - 2z^2 & 2yz - 2wx \\ 2xz - 2wy & 2yz + 2wx & 1 - 2x^2 - 2y^2 \end{bmatrix} \qquad (10.23)$$

Composition of rotations is easily stated in terms of quaternion algebra. If p and q are unit-length quaternions that represent rotations, and if \hat{v} is the quaternion identified with vector \mathbf{v}, then the rotation represented by q is accomplished by $\hat{u} = q\hat{v}q^*$ as shown earlier. The vector \mathbf{u} identified with \hat{u} is further modified by the rotation represented by p:

$$p\hat{u}p^* = p(q\hat{v}q^*)p^*$$

$$= (pq)\hat{v}(q^*p^*) \qquad \text{Quaternion multiplication is associative}$$

$$= (pq)\hat{v}(pq)^* \qquad \text{Property of conjugation}$$

This equation shows that composite rotation is represented by the quaternion product pq.

10.3 A LINEAR ALGEBRAIC APPROACH

The classical approach of the last section is unappealing to those who are new to the topic because it neither appeals to the geometric nature of quaternions nor indicates what reasoning led to the definitions in the first place. This section provides a geometric understanding of quaternions, one that is based only on concepts of linear algebra. Instead of analyzing a rotation in three dimensions, we analyze it in a four-dimensional setting. A unit-length quaternion is shown to correspond to a rotation matrix in 4D and a transformation equation analogous to equation (10.22) is constructed. The construction is motivated by a change of basis, the same motivation used in the construction of equations (10.4) and (10.13).

Let us return to the standard basis $\{\imath, \jmath, k\}$ and the rotation matrix R_0 from equation (10.1) that represents rotation about the z-axis by angle θ. Instead of viewing the rotation as an operation on vectors $\mathbf{v} = (x, y, z) \in \mathbb{R}^3$, let us look at it as an operation on vectors $\tilde{\mathbf{v}} = (x, y, z, w) \in \mathbb{R}^4$. The inclusion of the fourth component gives us an additional degree of freedom that allows the creation of a more efficient representation of rotations than what is possible in three dimensions. By efficient, I mean in the sense of a computer implementation. The 4D representation requires less memory than its 3D counterpart. Composition of rotations in 3D involves multiplication of rotation matrices. Composition using the 4D representation can be computed faster than its 3D counterpart.

A natural choice for representing the rotation in 4D is

$$\mathcal{R}_0 = \begin{bmatrix} c & -s & 0 & 0 \\ s & c & 0 & 0 \\ 0 & 0 & 1 & 0 \\ 0 & 0 & 0 & 1 \end{bmatrix} = \left[\begin{array}{c|c} R_0 & \mathbf{0} \\ \hline \mathbf{0}^{\mathrm{T}} & 1 \end{array} \right] = \left[\begin{array}{c|c} R_{xy} & 0 \\ \hline \mathbf{0}^{\mathrm{T}} & I \end{array} \right] \tag{10.24}$$

where the first equality defines a 2×2 block matrix whose upper-left block is the 3×3 rotation matrix, whose upper-right block is the 3×1 zero vector, whose lower-left block is the 1×3 zero vectors, and whose lower-right block is the scalar 1. The second equality defines a 2×2 block matrix where each block is itself a 2×2 matrix. The matrix R_{xy} is just the rotation within the xy-plane, the matrices 0 and $\mathbf{0}^{\mathrm{T}}$ have all zeros, and I is the 2×2 identity matrix. The vector (x, y, z, w) is transformed to $(cx - sy, sx + cy, z, w)$. The next step, a strange thing to do at first glance, is the key observation in the construction. The rotation by angle θ within the xy-plane can be thought of as a composition of two rotations, each by angle $\theta/2$:

$$R_{xy} = \begin{bmatrix} c & -s \\ s & c \end{bmatrix} = \begin{bmatrix} \gamma & -\sigma \\ \sigma & \gamma \end{bmatrix} \begin{bmatrix} \gamma & -\sigma \\ \sigma & \gamma \end{bmatrix} = H^2$$

where $\sigma = \sin(\theta/2)$, $\gamma = \cos(\theta/2)$, and H is the rotation matrix for the half angle

$\theta/2$ that controls the rotation in the xy-plane. The matrix in equation (10.24) may be factored into

$$\mathcal{R}_0 = \left[\begin{array}{c|c} H & 0 \\ \hline 0^{\mathrm{T}} & I \end{array}\right] \left[\begin{array}{c|c} H & 0 \\ \hline 0^{\mathrm{T}} & I \end{array}\right]$$

Although certainly the simplest factorization you might think of, the identity matrix I that keeps z and w fixed during the rotations can be replaced by H and H^{T}. That is, we actually can allow z and w to change during each half-angle rotation in the xy-plane *as long as we make sure z returns to its original value after both operations.* The corresponding factorization is

$$\mathcal{R}_0 = \left[\begin{array}{c|c} H & 0 \\ \hline 0^{\mathrm{T}} & H \end{array}\right] \left[\begin{array}{c|c} H & 0 \\ \hline 0^{\mathrm{T}} & H^{\mathrm{T}} \end{array}\right] =: \overline{\mathcal{Q}}_0 \mathcal{Q}_0 \qquad (10.25)$$

where the last equality defines the matrices \mathcal{Q}_0 and $\overline{\mathcal{Q}}_0$, themselves rotations in 4D. In summary, the half-angle rotation H is applied twice to (x, y) to obtain the full-angle rotation in the xy-plane. The inverse half-angle rotation H^{T} is applied to (z, w), a rotation within the zw-plane, but that rotation is undone by H in the second operation, the end result being that (z, w) is unchanged by the composition. Figure 10.2 illustrates this.

What does this really gain us? For the 3D rotation matrix R_0 we have a loss rather than a gain. The 3D matrix requires storing two precomputed numbers, s and c. The zeros and one are in known positions and do not need to be stored in general memory. The application of R to (x, y, z) is computed as $R_{xy}(x, y)$ since z is unchanged. This requires a product of a 2×2 matrix and a 2×1 vector that uses 6 operations (four multiplications and two additions). The 4D matrix requires storing σ and γ—no change in memory requirements. However, the blind application of the right-hand-side matrices in equation (10.25) leads to computing terms $H(x, y)$, $H(H(x, y))$, $H^{\mathrm{T}}(z, w)$, and $H(H^{\mathrm{T}}(z, w))$ for a total of 24 operations. We could be clever and realize that (z, w) will not change, but that still leaves us with computing $H(x, y)$ and $H(H(x, y))$ for a total of 12 operations. Being even more clever, we realize that $H^2 = R_{xy}$ and just compute $R_{xy}(x, y)$. This just brings us full circle with no gain.

The real gain occurs by constructing a 4D rotation matrix \mathcal{R}_1 that corresponds to the general 3D rotation matrix R_1 constructed by equations (10.4) and (10.13). We need to "lift" all our basis vectors into \mathbb{R}^4 by appending a zero w-component. These vectors will be written as block matrices to preserve the notion of the first three components living in \mathbb{R}^3. Additional vectors are defined to allow us to have a standard basis and an alternate basis for \mathbb{R}^4. The standard basis is $\{\tilde{\imath}, \tilde{\jmath}, \tilde{k}, \tilde{\ell}\}$, where

$$\tilde{\imath} = \left[\begin{array}{c} \imath \\ \hline 0 \end{array}\right], \qquad \tilde{\jmath} = \left[\begin{array}{c} \jmath \\ \hline 0 \end{array}\right], \qquad \tilde{k} = \left[\begin{array}{c} k \\ \hline 0 \end{array}\right], \qquad \tilde{\ell} = \left[\begin{array}{c} 0 \\ \hline 1 \end{array}\right] \qquad (10.26)$$

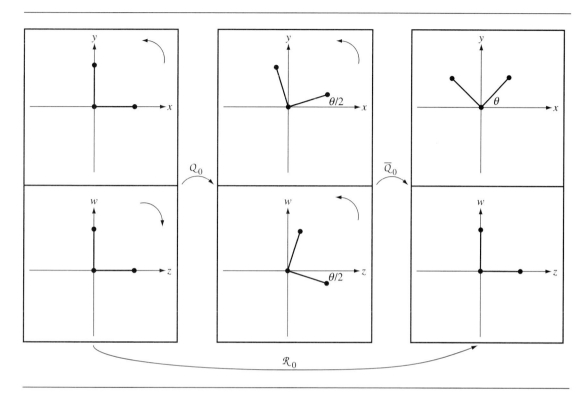

Figure 10.2 A 3D rotation about the z-axis that is represented as the product of two 4D rotations.

The alternate basis is $\{\tilde{\mathbf{a}}, \tilde{\mathbf{b}}, \tilde{\mathbf{d}}, \tilde{\boldsymbol{\ell}}\}$, where

$$\tilde{\mathbf{a}} = \begin{bmatrix} \mathbf{a} \\ \hline 0 \end{bmatrix}, \qquad \tilde{\mathbf{b}} = \begin{bmatrix} \mathbf{b} \\ \hline 0 \end{bmatrix}, \qquad \tilde{\mathbf{d}} = \begin{bmatrix} \mathbf{d} \\ \hline 0 \end{bmatrix} \qquad (10.27)$$

The construction in equation (10.4) is mimicked by choosing $\mathcal{P} = [\tilde{\mathbf{a}} \mid \tilde{\mathbf{b}} \mid \tilde{\mathbf{d}} \mid \tilde{\boldsymbol{\ell}}]$ and computing

$$\mathcal{R}_1 = \mathcal{P}\mathcal{R}_0\mathcal{P}^{\mathrm{T}} = \mathcal{P}\overline{\mathcal{Q}}_0\mathcal{Q}_0\mathcal{P}^{\mathrm{T}} = (\mathcal{P}\overline{\mathcal{Q}}_0\mathcal{P}^{\mathrm{T}})(\mathcal{P}\mathcal{Q}_0\mathcal{P}^{\mathrm{T}}) =: \overline{\mathcal{Q}}_1\mathcal{Q}_1$$

where the last equality defines \mathcal{Q}_1 and $\overline{\mathcal{Q}}_1$. The matrix \mathcal{Q}_0 represents a general 4D rotation with respect to the alternate basis. The matrix \mathcal{Q}_1 represents the same rotation,

but with respect to the standard basis, and is obtained by

$$\mathcal{Q}_1 = \mathcal{P}\mathcal{Q}_0\mathcal{P}^{\mathrm{T}}$$

$$= \left[\, \tilde{\mathbf{a}} \;\middle|\; \tilde{\mathbf{b}} \;\middle|\; \tilde{\mathbf{d}} \;\middle|\; \tilde{\boldsymbol{\ell}} \,\right]
\begin{bmatrix}
\gamma & -\sigma & 0 & 0 \\
\sigma & \gamma & 0 & 0 \\
0 & 0 & \gamma & \sigma \\
0 & 0 & -\sigma & \gamma
\end{bmatrix}
\begin{bmatrix}
\tilde{\mathbf{a}}^{\mathrm{T}} \\
\tilde{\mathbf{b}}^{\mathrm{T}} \\
\tilde{\mathbf{d}}^{\mathrm{T}} \\
\tilde{\boldsymbol{\ell}}^{\mathrm{T}}
\end{bmatrix} \tag{10.28}$$

$$= \gamma(\tilde{\mathbf{a}}\tilde{\mathbf{a}}^{\mathrm{T}} + \tilde{\mathbf{b}}\tilde{\mathbf{b}}^{\mathrm{T}} + \tilde{\mathbf{d}}\tilde{\mathbf{d}}^{\mathrm{T}} + \tilde{\boldsymbol{\ell}}\tilde{\boldsymbol{\ell}}^{\mathrm{T}}) + \sigma(\tilde{\mathbf{b}}\tilde{\mathbf{a}}^{\mathrm{T}} - \tilde{\mathbf{a}}\tilde{\mathbf{b}}^{\mathrm{T}} + \tilde{\mathbf{d}}\tilde{\boldsymbol{\ell}}^{\mathrm{T}} - \tilde{\boldsymbol{\ell}}\tilde{\mathbf{d}}^{\mathrm{T}})$$

A construction analogous to the one that produced equation (10.10) may be used to obtain

$$\mathcal{I} = \tilde{\mathbf{a}}\tilde{\mathbf{a}}^{\mathrm{T}} + \tilde{\mathbf{b}}\tilde{\mathbf{b}}^{\mathrm{T}} + \tilde{\mathbf{d}}\tilde{\mathbf{d}}^{\mathrm{T}} + \tilde{\boldsymbol{\ell}}\tilde{\boldsymbol{\ell}}^{\mathrm{T}} \tag{10.29}$$

where \mathcal{I} is the 4×4 identity matrix. Equation (10.11) extends to four dimensions as

$$\tilde{\mathbf{b}}\tilde{\mathbf{a}}^{\mathrm{T}} - \tilde{\mathbf{a}}\tilde{\mathbf{b}}^{\mathrm{T}} = \begin{bmatrix} \mathbf{b} \\ 0 \end{bmatrix} \left[\, \mathbf{a}^{\mathrm{T}} \;\middle|\; 0 \,\right] - \begin{bmatrix} \mathbf{a} \\ 0 \end{bmatrix} \left[\, \mathbf{b}^{\mathrm{T}} \;\middle|\; 0 \,\right]$$

$$= \left[\begin{array}{c|c} \mathbf{b}\mathbf{a}^{\mathrm{T}} - \mathbf{a}\mathbf{b}^{\mathrm{T}} & \mathbf{0} \\ \hline \mathbf{0}^{\mathrm{T}} & 0 \end{array}\right] = \left[\begin{array}{c|c} D & \mathbf{0} \\ \hline \mathbf{0}^{\mathrm{T}} & 0 \end{array}\right]$$

It is easy to verify that

$$\tilde{\mathbf{d}}\tilde{\boldsymbol{\ell}}^{\mathrm{T}} - \tilde{\boldsymbol{\ell}}\tilde{\mathbf{d}}^{\mathrm{T}} = \left[\begin{array}{c|c} 0 & \mathbf{d} \\ \hline -\mathbf{d}^{\mathrm{T}} & 0 \end{array}\right]$$

The two matrices may be added to form a new matrix,

$$\mathcal{D} = \left[\begin{array}{c|c} D & \mathbf{d} \\ \hline -\mathbf{d}^{\mathrm{T}} & 0 \end{array}\right] = \tilde{\mathbf{b}}\tilde{\mathbf{a}}^{\mathrm{T}} - \tilde{\mathbf{a}}\tilde{\mathbf{b}}^{\mathrm{T}} + \tilde{\mathbf{d}}\tilde{\boldsymbol{\ell}}^{\mathrm{T}} - \tilde{\boldsymbol{\ell}}\tilde{\mathbf{d}}^{\mathrm{T}} \tag{10.30}$$

Equations (10.29) and (10.30) are replaced in equation (10.28), leading to the representation:

$$\mathcal{Q}_1 = \gamma \mathcal{I} + \sigma \mathcal{D} = \left[\begin{array}{c|c} \gamma I + \sigma D & \sigma \mathbf{d} \\ \hline -\sigma \mathbf{d}^{\mathrm{T}} & \gamma \end{array}\right] \tag{10.31}$$

where I is the 3×3 identity and D is the skew-symmetric matrix defined in the last section. A similar construction leads to

$$\overline{Q}_1 = \left[\begin{array}{c|c} \gamma I + \sigma D & -\sigma \mathbf{d} \\ \hline \sigma \mathbf{d}^{\mathsf{T}} & \gamma \end{array} \right] \tag{10.32}$$

A quick calculation that uses equation (10.13) will verify that

$$\mathcal{R}_1 = \overline{Q}_1 Q_1 = \left[\begin{array}{c|c} \gamma I + \sigma D & -\sigma \mathbf{d} \\ \hline \sigma \mathbf{d}^{\mathsf{T}} & \gamma \end{array} \right] \left[\begin{array}{c|c} \gamma I + \sigma D & \sigma \mathbf{d} \\ \hline -\sigma \mathbf{d}^{\mathsf{T}} & \gamma \end{array} \right] = \left[\begin{array}{c|c} R_1 & \mathbf{0} \\ \hline \mathbf{0}^{\mathsf{T}} & 1 \end{array} \right]$$

The application to a vector $\mathbf{v} \in \mathbb{R}^3$ is to apply \mathcal{R}_1 as shown:

$$\left[\frac{\mathbf{v}'}{0} \right] = \mathcal{R}_1 \left[\frac{\mathbf{v}}{0} \right]$$

The 3D result is $\mathbf{v}' = R_1 \mathbf{v}$.

The matrix Q_1 has a special form:

$$Q_1 = \begin{bmatrix} \gamma & -\sigma d_3 & \sigma d_2 & \sigma d_1 \\ \sigma d_3 & \gamma & -\sigma d_1 & \sigma d_2 \\ -\sigma d_2 & \sigma d_1 & \gamma & \sigma d_3 \\ -\sigma d_1 & -\sigma d_2 & -\sigma d_3 & \gamma \end{bmatrix} = \begin{bmatrix} w & -z & y & x \\ z & w & -x & y \\ -y & x & w & z \\ -x & -y & -z & w \end{bmatrix} \tag{10.33}$$

where the last equality defines $x = \sigma d_1$, $y = \sigma d_2$, $z = \sigma d_3$, and $w = \gamma$. The names x, y, z, and w of these quantities are not to be confused with the names of the variable components for vectors in \mathbb{R}^4. I use these names because that is the standard choice for the components of a quaternion to which Q_1 happens to be related. Although Q_1 has 16 entries, only 4 of them are unique—the last column values. Moreover, \overline{Q}_1 uses those same 4 values. The 4×4 matrix Q requires less storage than the 9 values for a 3×3 rotation matrix.

One issue that has not yet been addressed is composition of rotations. Let us do so now. Let $\mathcal{R} = \overline{Q}Q$ and $\mathcal{S} = \overline{P}P$ be two of our 4D rotations that correspond to 3D rotation matrices R and S, respectively. The composition in the 4D setting is

$$\mathcal{SR} = \left(\overline{P}P \right) \left(\overline{Q}Q \right) = \overline{P} \left(P\overline{Q} \right) Q = \overline{P} \left(\overline{Q}P \right) Q = \left(\overline{PQ} \right) (PQ)$$

The astute reader will say, Wait a moment, and remind me that matrix multiplication is generally not commutative, so how can we switch the order in $P\overline{Q} = \overline{Q}P$? As it turns out, the matrices P and \overline{Q} do commute. This can be verified with a moderate amount of symbolic manipulation. What this means is that we can store Q to represent \mathcal{R}, store P to represent \mathcal{S}, and compute the product PQ and store to represent

the composition $\mathcal{S}\mathcal{R}$. If \mathfrak{Q} is stored as the 4-tuple (x_0, y_0, z_0, w_0) and \mathcal{P} is stored as the 4-tuple (x_1, y_1, z_1, w_1), we need compute only the unique values in $\mathcal{P}\mathfrak{Q}$, call them (x_2, y_2, z_2, w_2). We can do this by computing \mathcal{P} times the last column of \mathfrak{Q}, the result being the last column of \mathcal{P}:

$$\begin{bmatrix} x_2 \\ y_2 \\ z_2 \\ w_2 \end{bmatrix} = \begin{bmatrix} w_1 & -z_1 & y_1 & x_1 \\ z_1 & w_1 & -x_1 & y_1 \\ -y_1 & x_1 & w_1 & z_1 \\ -x_1 & -y_1 & -z_1 & w_1 \end{bmatrix} \begin{bmatrix} x_0 \\ y_0 \\ z_0 \\ w_0 \end{bmatrix} = \begin{bmatrix} w_1x_0 - z_1y_0 + y_1z_0 + x_1w_0 \\ z_1x_0 + w_1y_0 - x_1z_0 + y_1w_0 \\ -y_1x_0 + x_1y_0 + w_1z_0 + z_1w_0 \\ -x_1x_0 - y_1y_0 - z_1z_0 + w_1w_0 \end{bmatrix}$$

The product $\mathcal{P}\mathfrak{Q}$ effectively represents the composition of the 3D rotations. Notice that the right-hand side values in the equation are those of equation (10.18), the definition for quaternion multiplication, when computing $q_1q_0 = (w_1 + x_1i + y_1j + z_1k)(w_0 + x_0i + y_0j + z_0k)$. To rotate a vector using $\mathcal{R} = \overline{\mathfrak{Q}}\mathfrak{Q}$,

$$\tilde{\mathbf{u}} = \begin{bmatrix} \mathbf{u} \\ 0 \end{bmatrix} = \overline{\mathfrak{Q}}\mathfrak{Q} \begin{bmatrix} \mathbf{v} \\ 0 \end{bmatrix} = \overline{\mathfrak{Q}}\mathfrak{Q}\tilde{\mathbf{v}}$$

This is the matrix equivalent of equation (10.22).

10.4 FROM ROTATION MATRICES TO QUATERNIONS[1]

Quaternions are a valuable supplement to 3D matrices. Here we distill them from rotation matrices and their algebra, reducing space and time costs. We implicitly generate *spin groups* within *Clifford algebras* made from *complex structures*, but despite that exotic connection our tools are elementary. Any reader who understands rotation matrices can learn quaternions.

Although rotation matrices are the most efficient way known to transform the many points and vectors comprising a 3D scene and combine well with other transforms such as translation and scaling, they are not ideal for every task. They are triply redundant, using nine numbers instead of the minimal three. Maintaining that bulk requires enforcing constraints, another unwelcome expense. And when two rotations are combined the result is again a rotation, but matrix arithmetic is again redundant. Interpolation, used to smoothly animate from one rotation to another to another, is a notable task for which matrices are both expensive and poorly behaved.

Quaternions, on the other hand, are compact, easy to maintain, quick to combine, and nice to animate. To build intuition, we proceed as follows.

Beginning in 2D, we not only recall necessary facts about all rotations, but also get a first taste of methods we will use later. After that brief warm-up, we construct a general 3D rotation matrix and show how trigonometric substitution can simplify

1. Section 10.4 (pages 522–538) was written by Ken Shoemake.

it, as both a review of 3D rotations and a preview of quaternions. We then begin to construct quaternion algebra, but from 4D, not 3D, matrices; this, our reduction method demands. Applying the 4D results to 3D rotations, we produce the famous quaternion rotation formula. And we explicitly construct a rotation matrix based on that formula, one that matches our earlier 3D simplification.

10.4.1 2D Rotations

A rotation transforms one vector, \mathbf{v}, into another, \mathbf{v}', without changing the length. Almost everything there is to know about rotations comes from this first of two essential facts.

In 2D coordinates a vector has two components, x and y, and its squared length is $x^2 + y^2$. One vector perpendicular to such a \mathbf{v}, which we'll denote PERP \mathbf{v}, has components $-y$ and x. Trigonometry tells us we can rotate \mathbf{v} by angle θ using cosine times \mathbf{v} and sine times PERP \mathbf{v}:

$$\mathbf{v}' = \cos(\theta)\mathbf{v} + \sin(\theta) \text{ PERP } \mathbf{v}$$

In components the formula is

$$x' = \cos(\theta)x - \sin(\theta)y$$
$$y' = \cos(\theta)y + \sin(\theta)x$$

Figure 10.3 illustrates this rotation.

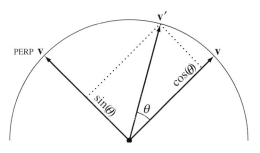

Figure 10.3 2D rotation.

Abbreviating $c = \cos(\theta)$, $s = \sin(\theta)$, and using the trigonometric identity $c^2 + s^2 = 1$, we confirm the (squared) length does not change:

$$
\begin{aligned}
(x')^2 + (y')^2 &= (cx - sy)^2 + (cy + sx)^2 \\
&= c^2 x^2 - 2csxy + s^2 y^2 \\
&\quad + c^2 y^2 + 2csxy + s^2 x^2 \\
&= (c^2 + s^2)x^2 + (c^2 + s^2)y^2 \\
&= x^2 + y^2
\end{aligned}
$$

Writing $\mathbf{v}' = \mathbf{R}\mathbf{v}$, in matrix form the transformation formula is

$$
\begin{bmatrix} x' \\ y' \end{bmatrix} = \begin{bmatrix} \cos(\theta) & -\sin(\theta) \\ \sin(\theta) & \cos(\theta) \end{bmatrix} \begin{bmatrix} x \\ y \end{bmatrix}
$$

We can also restate length preservation in matrix form. Denoting the transpose of \mathbf{R} as \mathbf{R}^{T}, the requirement is $(\mathbf{v}^{\mathrm{T}}\mathbf{R}^{\mathrm{T}})(\mathbf{R}\mathbf{v}) = \mathbf{v}^{\mathrm{T}}\mathbf{v}$, or simply

$$
\mathbf{R}^{\mathrm{T}}\mathbf{R} = \mathbf{I}
$$

For any rotation angle θ the determinant of \mathbf{R} is the constant $\cos^2(\theta) + \sin^2(\theta) = 1$. This fits the second and last essential fact about rotations: A rotation matrix must have determinant $+1$ (otherwise, we have reflection).

Rotation by 90° gives a particularly simple and important matrix, our PERP operator,

$$
\begin{bmatrix} 0 & -1 \\ 1 & 0 \end{bmatrix}
$$

Thus, any rotation matrix is a weighted sum of this matrix and the identity:

$$
\begin{bmatrix} \cos(\theta) & -\sin(\theta) \\ \sin(\theta) & \cos(\theta) \end{bmatrix} = \cos(\theta) \begin{bmatrix} 1 & 0 \\ 0 & 1 \end{bmatrix} + \sin(\theta) \begin{bmatrix} 0 & -1 \\ 1 & 0 \end{bmatrix}
$$

If we call the identity matrix \mathbf{I} and the 90° rotation matrix \mathbf{J}, a little calculation reveals some interesting facts.

$$
\mathbf{II} = \mathbf{I} \qquad \mathbf{IJ} = \mathbf{J} \qquad \mathbf{I}^{\mathrm{T}} = \mathbf{I}
$$

$$
\mathbf{JJ} = -\mathbf{I} \qquad \mathbf{JI} = \mathbf{J} \qquad \mathbf{J}^{\mathrm{T}} = -\mathbf{J}
$$

Suppose a and b are real numbers. Then $a\mathbf{I} + b\mathbf{J}$ is a 2×2 matrix but not necessarily a rotation. It is redundant compared to a simple 2D vector but works well with our rotations. For if instead of multiplying one of our rotation matrices times

a vector, we rather multiply it times such a 2×2 matrix, we can reduce each matrix product using our known products:

$$(c\mathbf{I} + s\mathbf{J})(a\mathbf{I} + b\mathbf{J}) = ca\mathbf{II} + sb\mathbf{JJ} + sa\mathbf{JI} + cb\mathbf{IJ}$$

$$= ca\mathbf{I} - sb\mathbf{I} + sa\mathbf{J} + cb\mathbf{J}$$

$$= (ca - sb)\mathbf{I} + (sa + cb)\mathbf{J}$$

So we can replace the four elements of a 2×2 matrix with a two-element pair (c, s) or (a, b) accompanied by a simple multiplication table. That is, all we really need are the multiplication properties of \mathbf{I} and \mathbf{J}. Rotations look like points (c, s) on a unit circle, $c^2 + s^2 = 1$.

Remarkably, we have rediscovered complex numbers, $a + b\mathbf{i}$, and the fact that multiplying by a unit magnitude complex number acts like a rotation, as the following summarizes:

Matrix Form	*acts like*	*Complex Form*
matrix **I**	acts like	real 1
scaled $r\mathbf{I}$	acts like	real r
matrix **J**	acts like	imaginary $\mathbf{i} = \sqrt{-1}$
transpose \cdot^{T}	acts like complex conjugation \cdot^*	

Complex numbers require half the space of 2×2 matrices, distilling four numbers to two; and their multiplication, a perfect substitute for matrix multiplication, requires half the time. We cannot do this with just any matrix, such as a shear matrix, but that's not important for our needs here. Quite unexpectedly, the clear distinction between matrix and vector has given way to a unified framework where both take the same form.

Attempting to do this for 3D, we encounter a few obstacles, but nothing we can't get around. Our principal tool is linearity.

10.4.2 LINEARITY

Mathematics uses the term "linear" in several different ways. We will depend especially on the fact that matrix multiplication is a *linear transformation*, meaning that, for matrices **M**, **A**, **B** and scalar r,

$$\mathbf{M}(\mathbf{A} + \mathbf{B}) = \mathbf{MA} + \mathbf{MB}$$

$$\mathbf{M}(r\mathbf{A}) = r\mathbf{MA}$$

Matrix multiplication acts as a linear transformation from the right as well as from the left—it is *bilinear*.

$$(\mathbf{A} + \mathbf{B})\mathbf{M} = \mathbf{AM} + \mathbf{BM}$$

$$(r\mathbf{A})\mathbf{M} = r\mathbf{AM}$$

A linear transformation f acts in a particularly simple way on weighted sums (*linear combinations*):

$$f(r_1\mathbf{A}_1 + r_2\mathbf{A}_2 + \cdots + r_n\mathbf{A}_n) = r_1 f(\mathbf{A}_1) + r_2 f(\mathbf{A}_2) + \cdots + r_n f(\mathbf{A}_n)$$

In other words, linearity provides a "distributive law" like that of common arithmetic: $2 \times 31 = 2 \times 3 \times 10 + 2 \times 1 \times 1$. If we can dissect an object into a sum of smaller pieces, linearity lets us operate on each piece independently. The consequent simplification and speedup make linearity the single most valuable tool in all of applied mathematics. In 3D graphics it is common to dissect vectors; here, we instead dissect matrices, choosing pieces that multiply in a special way.

10.4.3 3D ROTATIONS: GEOMETRY

A rotation in any dimension keeps one point fixed, but a rotation in 3D fixes a whole line of points. This could be the x-axis, using

$$\begin{bmatrix} 1 & 0 & 0 \\ 0 & \cos(\theta) & -\sin(\theta) \\ 0 & \sin(\theta) & \cos(\theta) \end{bmatrix}$$

or the y-axis, using

$$\begin{bmatrix} \cos(\theta) & 0 & \sin(\theta) \\ 0 & 1 & 0 \\ -\sin(\theta) & 0 & \cos(\theta) \end{bmatrix}$$

or the z-axis, using

$$\begin{bmatrix} \cos(\theta) & -\sin(\theta) & 0 \\ \sin(\theta) & \cos(\theta) & 0 \\ 0 & 0 & 1 \end{bmatrix}$$

or any direction desired, using a geometric extension of our 2D method.

It is helpful to present this in stages. We establish the necessary geometry; we express that as algebra; we turn the algebra into a matrix; and then we use two suspiciously well-chosen substitutions to simplify the matrix greatly. (Later we derive the final matrix more honestly.)

Suppose the axis is given by unit vector $\hat{\mathbf{u}}$ with coordinates (x, y, z) and that we wish to rotate vector \mathbf{v} by angle θ. We work with three pieces: the part of \mathbf{v} that is parallel to $\hat{\mathbf{u}}$, the part that's not, and the PERP of that. The parallel component has length $\hat{\mathbf{u}} \cdot \mathbf{v}$ along $\hat{\mathbf{u}}$, or matrix form

$$\mathbf{v}_\| = (\hat{\mathbf{u}}\hat{\mathbf{u}}^{\mathrm{T}})\mathbf{v} = \begin{bmatrix} x^2 & xy & xz \\ yx & y^2 & yz \\ zx & zy & z^2 \end{bmatrix} \mathbf{v}$$

What remains is \mathbf{v} minus that, which has matrix form

$$\mathbf{v}_\perp = (\mathbf{I} - \hat{\mathbf{u}}\hat{\mathbf{u}}^T)\mathbf{v} = \begin{bmatrix} 1 - x^2 & -xy & -xz \\ -yx & 1 - y^2 & -yz \\ -zx & -zy & 1 - z^2 \end{bmatrix} \mathbf{v}$$

And the perpendicular of that, also perpendicular to $\hat{\mathbf{u}}$, is simply $\hat{\mathbf{u}} \times \mathbf{v}$. Note the cross product automatically kills any component of \mathbf{v} parallel to $\hat{\mathbf{u}}$. We can write the cross product $\mathrm{PERP}_{\hat{\mathbf{u}}}\, \mathbf{v} = \hat{\mathbf{u}} \times \mathbf{v}$ in matrix form,

$$\mathrm{PERP}_{\hat{\mathbf{u}}}\, \mathbf{v}_\perp = \mathrm{PERP}_{\hat{\mathbf{u}}}\, \mathbf{v} = \begin{bmatrix} 0 & -z & y \\ z & 0 & -x \\ -y & x & 0 \end{bmatrix} \mathbf{v}$$

Now we have the three pieces that comprise our matrix. Rotating \mathbf{v} leaves the parallel component unchanged and again combines cosine and sine of the remaining component and its PERP:

$$\mathrm{rot}(\hat{\mathbf{u}}, \theta)\mathbf{v} = \mathbf{v}_\| + \cos(\theta)\mathbf{v}_\perp + \sin(\theta)\, \mathrm{PERP}_{\hat{\mathbf{u}}}\, \mathbf{v}_\perp$$

$$= \left\{ \hat{\mathbf{u}}\hat{\mathbf{u}}^T + \cos(\theta)\left(\mathbf{I} - \hat{\mathbf{u}}\hat{\mathbf{u}}^T\right) + \sin(\theta)\, \mathrm{PERP}_{\hat{\mathbf{u}}} \right\} \mathbf{v}$$

Figure 10.4 illustrates.

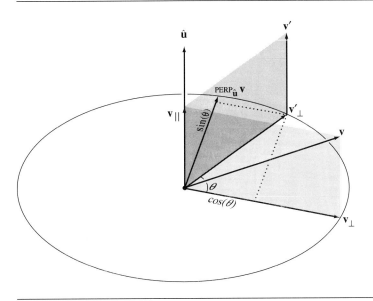

Figure 10.4 3D rotation.

Abbreviating $c_\theta = \cos(\theta)$, $s_\theta = \sin(\theta)$, the matrix is

$$
\begin{bmatrix}
(1 - x^2)c_\theta + x^2 & -zs_\theta - xyc_\theta + xy & ys_\theta - xzc_\theta + xz \\
zs_\theta - xyc_\theta + xy & (1 - y^2)c_\theta + y^2 & -xs_\theta - yzc_\theta + yz \\
-ys_\theta - xzc_\theta + xz & xs_\theta - yzc_\theta + yz & (1 - z^2)c_\theta + z^2
\end{bmatrix}
$$

We can often simplify trigonometric polynomials by using half angles, and we do so here. Let $c = \cos(\theta/2)$, $s = \sin(\theta/2)$, so that

$$c_\theta = 1 - 2s^2$$

$$s_\theta = 2cs$$

and substitute to get a revised matrix,

$$
\begin{bmatrix}
2x^2s^2 - 2s^2 + 1 & 2xys^2 - 2zcs & 2xzs^2 + 2ycs \\
2xys^2 + 2zcs & 2y^2s^2 - 2s^2 + 1 & 2yzs^2 - 2xcs \\
2xzs^2 - 2ycs & 2yzs^2 + 2xcs & 2z^2s^2 - 2s^2 + 1
\end{bmatrix}
$$

All components of $\hat{\mathbf{u}}$ occur scaled by s, so rename them x', y', z', and replace $\hat{\mathbf{u}}$ with $\mathbf{u} = s\hat{\mathbf{u}}$, switching to new variable meanings

$$w = c$$

$$
\begin{bmatrix} x \\ y \\ z \end{bmatrix} = s \begin{bmatrix} x' \\ y' \\ z' \end{bmatrix}
$$

Now $s^2 = \|\mathbf{u}\|^2$, and we get a much cleaner four-parameter matrix,

$$
\begin{bmatrix}
2x^2 - 2\|\mathbf{u}\|^2 + 1 & 2xy - 2wz & 2xz + 2wy \\
2xy + 2wz & 2y^2 - 2\|\mathbf{u}\|^2 + 1 & 2yz - 2wx \\
2xz - 2wy & 2yz + 2wx & 2z^2 - 2\|\mathbf{u}\|^2 + 1
\end{bmatrix}
$$

Numerically, the four parameters x, y, z, w make up a quaternion; but this derivation gives no hint of algebraic properties. To reveal the algebra we need a set of basis matrices with simple multiplication, as we saw in 2D. We also note the occurrence of two parameters in each term, suggesting we'll need not just linearity, but bilinearity.

We soon discover that 3D rotations provide no matrix that squares to minus the identity, which is critical for our distillation. Luckily, we can detour through 4D to get around that problem.

10.4.4 **4D ROTATIONS**

In 2D we could rotate only in the xy-plane, so one matrix, \mathbf{J}, was all we needed (along with the identity, \mathbf{I}) to create all rotations. In 3D we have three independent planes: yz (for the x-axis), zx (for the y-axis), and xy (for the z-axis). In 4D we no longer have an axis, and we add three new independent planes: wx, wy, and wz.

The 4×4 matrix for a zx-plane ("y-axis") rotation is

$$\begin{bmatrix} \cos(\theta) & 0 & \sin(\theta) & 0 \\ 0 & 1 & 0 & 0 \\ -\sin(\theta) & 0 & \cos(\theta) & 0 \\ 0 & 0 & 0 & 1 \end{bmatrix}$$

We recognize the upper-left 3×3 corner as a 3D rotation matrix. Now consider a $90°$ rotation of the xy-plane ("z-axis"), with matrix

$$\begin{bmatrix} 0 & -1 & 0 & 0 \\ 1 & 0 & 0 & 0 \\ 0 & 0 & 1 & 0 \\ 0 & 0 & 0 & 1 \end{bmatrix}$$

Its square is

$$\begin{bmatrix} -1 & 0 & 0 & 0 \\ 0 & -1 & 0 & 0 \\ 0 & 0 & 1 & 0 \\ 0 & 0 & 0 & 1 \end{bmatrix}$$

which is halfway to $-\mathbf{I}$. If we simultaneously rotate in the wz-plane, squaring matrix

$$\begin{bmatrix} 0 & -1 & 0 & 0 \\ 1 & 0 & 0 & 0 \\ 0 & 0 & 0 & 1 \\ 0 & 0 & -1 & 0 \end{bmatrix}$$

then we are there. Thus, the 4×4 matrices we will employ to build our 3D rotation algebra are

$$\mathbf{X} = \begin{bmatrix} 0 & 0 & 0 & 1 \\ 0 & 0 & -1 & 0 \\ 0 & 1 & 0 & 0 \\ -1 & 0 & 0 & 0 \end{bmatrix} \quad \mathbf{Y} = \begin{bmatrix} 0 & 0 & 1 & 0 \\ 0 & 0 & 0 & 1 \\ -1 & 0 & 0 & 0 \\ 0 & -1 & 0 & 0 \end{bmatrix} \quad \mathbf{Z} = \begin{bmatrix} 0 & -1 & 0 & 0 \\ 1 & 0 & 0 & 0 \\ 0 & 0 & 0 & 1 \\ 0 & 0 & -1 & 0 \end{bmatrix}$$

More succinctly, using our previous 2×2 matrices \mathbf{I} and \mathbf{J} as building blocks, these are

$$\mathbf{X} = \begin{bmatrix} 0 & -\mathbf{J} \\ -\mathbf{J} & 0 \end{bmatrix} \quad \mathbf{Y} = \begin{bmatrix} 0 & \mathbf{I} \\ -\mathbf{I} & 0 \end{bmatrix} \quad \mathbf{Z} = \begin{bmatrix} \mathbf{J} & 0 \\ 0 & -\mathbf{J} \end{bmatrix}$$

Using either the explicit 4×4 forms or the block 2×2 forms, we can begin to build a multiplication table. Note that we always use **I** to mean an identity matrix; its size should be clear from context.

$$\mathbf{XX} = -\mathbf{I} \qquad \mathbf{YY} = -\mathbf{I} \qquad \mathbf{ZZ} = -\mathbf{I}$$

All three matrices square as intended, so no surprises here. As with **J**, transposition simply negates each matrix; thus, we easily verify the first essential property of rotation matrices for all.

$$\mathbf{X}^{\mathrm{T}} = -\mathbf{X} \qquad \mathbf{Y}^{\mathrm{T}} = -\mathbf{Y} \qquad \mathbf{Z}^{\mathrm{T}} = -\mathbf{Z}$$

$$\mathbf{X}^{\mathrm{T}}\mathbf{X} = \mathbf{I} \qquad \mathbf{Y}^{\mathrm{T}}\mathbf{Y} = \mathbf{I} \qquad \mathbf{Z}^{\mathrm{T}}\mathbf{Z} = \mathbf{I}$$

We leave it as an exercise to verify that all have determinant $+1$, the second essential property. (Three simple rules suffice: The determinant as a function of the columns is linear on each column, changes sign if any two columns are swapped, and equals $+1$ on the identity matrix.)

Next we explore mixed multiplication.

$$\mathbf{XY} = \mathbf{Z} \qquad \mathbf{YZ} = \mathbf{X} \qquad \mathbf{ZX} = \mathbf{Y}$$

$$\mathbf{YX} = -\mathbf{Z} \qquad \mathbf{ZY} = -\mathbf{X} \qquad \mathbf{XZ} = -\mathbf{Y}$$

These mixed products, impossible in 2D, are both a curse and a blessing. We must constantly take care because the sign of the result depends on the order—that's the curse. The blessing: that same difference will give us our route back to 3D.

We will explore this shortly; but for now the important thing is that we again have a basis for a new number system. It is somewhat like complex numbers, but with four terms instead of two. From our experiments we can write the general multiplication rule:

$$
\begin{aligned}
(a\mathbf{X} + b\mathbf{Y} + c\mathbf{Z} + d\mathbf{I})(x\mathbf{X} + y\mathbf{Y} + z\mathbf{Z} + w\mathbf{I}) = \quad & (dx + aw + bz - cy)\mathbf{X} \\
& + (dy + bw + cx - az)\mathbf{Y} \\
& + (dz + cw + ay - bx)\mathbf{Z} \\
& + (dw - ax - by - cz)\mathbf{I}
\end{aligned}
$$

Using rotations without an **I** component, we get a revealing special case.

$$
\begin{aligned}
(a\mathbf{X} + b\mathbf{Y} + c\mathbf{Z})(x\mathbf{X} + y\mathbf{Y} + z\mathbf{Z}) = \quad & (bz - cy)\mathbf{X} \\
& + (cx - az)\mathbf{Y} \\
& + (ay - bx)\mathbf{Z} \\
& - (ax + by + cz)\mathbf{I}
\end{aligned}
$$

Thinking of (a, b, c) and (x, y, z) as vectors, this is a cross product minus a dot product, and a nice way to remember the general case.

We call these new four-part numbers *quaternions*, and again list correspondences.

Matrix Form	acts like	Quaternion Form
matrix **I**	acts like	real 1
scaled r**I**	acts like	real r
matrix **X**	acts like	one imaginary $\mathbf{i} = \sqrt{-1}$
matrix **Y**	acts like	another imaginary $\mathbf{j} = \sqrt{-1}$
matrix **Z**	acts like	yet another imaginary $\mathbf{k} = \sqrt{-1}$
transpose \cdot^{T}	acts like	conjugation \cdot^*

Conjugation of a quaternion negates all three imaginary components. We can summarize our multiplication results with Hamilton's famous equation,

$$\mathbf{i}^2 = \mathbf{j}^2 = \mathbf{k}^2 = \mathbf{ijk} = -1$$

Instead of the 16 components of a 4×4 rotation matrix, or even the nine components of a 3×3 rotation matrix, we have an algebra on just four components, $[(x, y, z), w]$, or $x\mathbf{i} + y\mathbf{j} + z\mathbf{k} + w\mathbf{1}$, three with negative squares and one with a positive square. Rather than multiply matrices, we merely refer to a small table of precomputed combinations. The product of any two of our four base matrices is plus-or-minus another base matrix; and that plus linearity is enough to compute the product of weighted sums of them.

The rotation matrix constraint $\mathbf{Q}^{\mathrm{T}}\mathbf{Q} = \mathbf{I}$, with

$$\mathbf{Q} = x\mathbf{X} + y\mathbf{Y} + z\mathbf{Z} + w\mathbf{I}$$

implies the scalar equation

$$x^2 + y^2 + z^2 + w^2 = 1$$

as can be shown with little computation. (Because $\mathbf{Q}^{\mathrm{T}}\mathbf{Q}$ equals its own transpose, only the **I** component of the product can be nonzero; and the transpose merely negates the **X**, **Y**, and **Z** components of **Q**.) Furthermore, though we won't prove it here, any matrix constructed from weights satisfying the scalar equation is a 4D rotation. Not all 4D rotations can be written this way, but we have all we need for our purposes.

10.4.5 3D Rotations: Algebra

Now let's make our way back to 3D. Our **X**, **Y**, **Z** base rotations alter all four components of a 4D vector. We need a way to isolate the last dimension and leave it unchanged so that all the rotation is restricted to the first three dimensions. Our tool

will be the *similarity transform,*

$$\mathbf{M}' = \mathbf{QMQ}^{-1}$$

routinely used to rewrite a matrix \mathbf{M} in a different basis.

To get more familiar with our new algebra, we'll use its notation for our next calculations. Suppose that q is either \mathbf{i}, \mathbf{j}, \mathbf{k}, or $\mathbf{1}$. We know that

$$q^*q = 1$$

and we also can easily show that

$$qq^* = 1$$

So we can avoid rotating $w\mathbf{1}$ by making a "sandwich" with q for "bread."

$$q(w\mathbf{1})q^* = (w\mathbf{1})qq^*$$
$$= w\mathbf{1}$$

In fact, any rotation q constructed as a weighted sum of \mathbf{i}, \mathbf{j}, \mathbf{k}, and $\mathbf{1}$ (so that the sum of the squares is 1) satisfies $qq^* = 1$ and will also preserve $w\mathbf{1}$ unchanged.

But have we done too much? Have we completely canceled all rotation? Thanks to product order dependence, we have not. For example, we can combine weights of \mathbf{i}, \mathbf{j}, \mathbf{k}, and $\mathbf{1}$ and put that "meat" inside a sandwich with \mathbf{i} for bread. Because matrix (and now quaternion) multiplication is linear, and from both sides, we can distribute inside the parentheses term by term. We then pull the weight outside each term and simplify using what we know about mixed multiplication and conjugation (transposition).

$$\mathbf{i}(x\mathbf{i} + y\mathbf{j} + z\mathbf{k} + w\mathbf{1})\mathbf{i}^* = \mathbf{i}(x\mathbf{i})\mathbf{i}^* + \mathbf{i}(y\mathbf{j})\mathbf{i}^* + \mathbf{i}(z\mathbf{k})\mathbf{i}^* + \mathbf{i}(w\mathbf{1})\mathbf{i}^*$$
$$= x(-\mathbf{iii}) + y(-\mathbf{iji}) + z(-\mathbf{iki}) + w(-\mathbf{i1i})$$
$$= x\mathbf{i} + (-y)\mathbf{j} + (-z)\mathbf{k} + w\mathbf{1}$$

This duplicates the effect of a homogeneous rotation matrix for a 180° flip around the x-axis.

$$\begin{bmatrix} 1 & 0 & 0 & 0 \\ 0 & -1 & 0 & 0 \\ 0 & 0 & -1 & 0 \\ 0 & 0 & 0 & 1 \end{bmatrix}$$

We leave it as an exercise to verify that

$$\mathbf{j}(x\mathbf{i} + y\mathbf{j} + z\mathbf{k} + w\mathbf{1})\mathbf{j}^*$$

matches a 180° flip around y,

$$\begin{bmatrix} -1 & 0 & 0 & 0 \\ 0 & 1 & 0 & 0 \\ 0 & 0 & -1 & 0 \\ 0 & 0 & 0 & 1 \end{bmatrix}$$

and

$$\mathbf{k}(x\mathbf{i} + y\mathbf{j} + z\mathbf{k} + w\mathbf{1})\mathbf{k}^*$$

matches a 180° flip around z,

$$\begin{bmatrix} -1 & 0 & 0 & 0 \\ 0 & -1 & 0 & 0 \\ 0 & 0 & 1 & 0 \\ 0 & 0 & 0 & 1 \end{bmatrix}$$

Apparently in the process of getting back to 3D we doubled our rotation angle. We did use the rotation twice, so this is understandable. Thus, we find, for example, that a 45° sandwich made with

$$\sin(45°)\mathbf{i} + \cos(45°)\mathbf{1}$$

namely,

$$\frac{1 + \mathbf{i}}{\sqrt{2}}(x\mathbf{i} + y\mathbf{j} + z\mathbf{k} + w\mathbf{1})\frac{1 - \mathbf{i}}{\sqrt{2}}$$

gives a 90° x rotation,

$$x\mathbf{i} + (-z)\mathbf{j} + y\mathbf{k} + w\mathbf{1}$$

The savings for single rotations are welcome, but it's also important to be able to combine rotations. Does angle doubling make this expensive? Not at all, because applying first q_1, then q_2, gives

$$q_2(q_1(x\mathbf{i} + y\mathbf{j} + z\mathbf{k} + w\mathbf{1})q_1^*)q_2^* = (q_2q_1)(x\mathbf{i} + y\mathbf{j} + z\mathbf{k} + w\mathbf{1})(q_1^*q_2^*)$$

$$= (q_2q_1)(x\mathbf{i} + y\mathbf{j} + z\mathbf{k} + w\mathbf{1})(q_2q_1)^*$$

$$= q(x\mathbf{i} + y\mathbf{j} + z\mathbf{k} + w\mathbf{1})q^*$$

where

$$q = q_2q_1$$

The simplification of quaternion conjugation follows from the same well-known property of matrix transposition. Thus, a modest quaternion product replaces a full matrix product. Also note that because the inverse of a rotation matrix is its transpose, the inverse of q is q^*.

So we must remember product order and angle doubling, a minor burden given the savings in space and time. A four-component quaternion can replace a nine-component matrix, and one quaternion multiply requires only 16 real multiplies and 12 real additions to replace a matrix multiply's 27 real multiplies and 18 real additions. Also, the expensive constraint on the rotation matrix,

$$\mathbf{R}^\mathrm{T}\mathbf{R} = \mathbf{I}$$

has been replaced by a cheap *unit quaternion* constraint

$$q^*q = \mathbf{1}$$

As noted earlier, this merely says that the sum of the squares of the weights must be 1. Actually, we can loosen even this requirement. We know that

$$\mathrm{N}(q) = q^*q$$

is just the sum of the squares of the weights. If, as similarity transforms suggest, we replace q^* in our sandwich by the more general inverse,

$$q^{-1} = \frac{1}{\mathrm{N}(q)}q^*$$

we can show that

$$q(x\mathbf{i} + y\mathbf{j} + z\mathbf{k} + w\mathbf{1})q^{-1}$$

is always a rotation, so long as $\mathrm{N}(q)$ is not zero. That's about as cheap a constraint as we could hope for!

We have gone from 3×3 rotation matrices to 4×4 rotation matrices to quaternions, and discovered how to cheaply replace any 3D rotation with a quaternion sandwich. But we have left a gap we must now close.

10.4.6 4D Matrix

Because of the way we use a quaternion twice to perform a 3D rotation, it does not directly give a single 4×4 rotation matrix to act on a vector. We need a way to combine \mathbf{Q} and \mathbf{Q}^T, taking account of the fact that they're on opposite sides of the "meat." We cannot do this in the quaternion algebra (nor do we need to), but we can do it with matrices.

When we multiply \mathbf{Q} from the *left* times the matrix $a\mathbf{X} + b\mathbf{Y} + c\mathbf{Z} + d\mathbf{I}$, we get a matrix result that is consistent with multiplying \mathbf{Q} from the *left* times the column vector $[\,a \quad b \quad c \quad d\,]^{\mathsf{T}}$. For example,

$$\mathbf{X}(a\mathbf{X} + b\mathbf{Y} + c\mathbf{Z} + d\mathbf{I}) = d\mathbf{X} + (-c)\mathbf{Y} + b\mathbf{Z} + (-a)\mathbf{I}$$

$$\mathbf{X}[a \quad b \quad c \quad d]^{\mathsf{T}} = [d \quad -c \quad b \quad -a]^{\mathsf{T}}$$

However, when we multiply \mathbf{Q} from the *right* times the matrix, we get a matrix result that is consistent with multiplying some other matrix, say, $\overleftarrow{\mathbf{Q}}$, from the *left* times the column vector. For example,

$$(a\mathbf{X} + b\mathbf{Y} + c\mathbf{Z} + d\mathbf{I})\mathbf{X} = d\mathbf{X} + c\mathbf{Y} + (-b)\mathbf{Z} + (-a)\mathbf{I}$$

$$\overleftarrow{X}[a \quad b \quad c \quad d]^{\mathsf{T}} = [d \quad c \quad -b \quad -a]^{\mathsf{T}}$$

A brief inspection shows that all we need for right-left "mutation" is transposition of the upper-left 3×3 corner.

$$\mathbf{X} = \begin{bmatrix} 0 & 0 & 0 & 1 \\ 0 & 0 & -1 & 0 \\ 0 & 1 & 0 & 0 \\ -1 & 0 & 0 & 0 \end{bmatrix} \qquad \overleftarrow{\mathbf{X}} = \begin{bmatrix} 0 & 0 & 0 & 1 \\ 0 & 0 & 1 & 0 \\ 0 & -1 & 0 & 0 \\ -1 & 0 & 0 & 0 \end{bmatrix}$$

$$\mathbf{Y} = \begin{bmatrix} 0 & 0 & 1 & 0 \\ 0 & 0 & 0 & 1 \\ -1 & 0 & 0 & 0 \\ 0 & -1 & 0 & 0 \end{bmatrix} \qquad \overleftarrow{\mathbf{Y}} = \begin{bmatrix} 0 & 0 & -1 & 0 \\ 0 & 0 & 0 & 1 \\ 1 & 0 & 0 & 0 \\ 0 & -1 & 0 & 0 \end{bmatrix}$$

$$\mathbf{Z} = \begin{bmatrix} 0 & -1 & 0 & 0 \\ 1 & 0 & 0 & 0 \\ 0 & 0 & 0 & 1 \\ 0 & 0 & -1 & 0 \end{bmatrix} \qquad \overleftarrow{\mathbf{Z}} = \begin{bmatrix} 0 & 1 & 0 & 0 \\ -1 & 0 & 0 & 0 \\ 0 & 0 & 0 & 1 \\ 0 & 0 & -1 & 0 \end{bmatrix}$$

Of course, $\overleftarrow{\mathbf{I}} = \mathbf{I}$, and linearity assures us weighted sums mutate term by term. Conveniently, the mutation of a transpose is the transpose of the mutation. With these results in hand, we can immediately state that the 4×4 rotation matrix corresponding to 3D rotation by the unit quaternion

$$q = x\mathbf{i} + y\mathbf{j} + z\mathbf{k} + w\mathbf{1}$$

is the product

$$QQ^T = \begin{bmatrix} w & -z & y & x \\ z & w & -x & y \\ -y & x & w & z \\ -x & -y & -z & w \end{bmatrix} \begin{bmatrix} w & -z & y & -x \\ z & w & -x & -y \\ -y & x & w & -z \\ x & y & z & w \end{bmatrix}$$

$$= \begin{bmatrix} R & 0 \\ 0 & xx + yy + zz + ww \end{bmatrix}$$

with

$$R = \begin{bmatrix} ww - zz - yy + xx & -wz - zw + yx + xy & wy + zx + yw + xz \\ zw + wz + xy + yx & -zz + ww - xx + yy & zy - wx - xw + yz \\ -yw + xz - wy + zx & yz + xw + wx + zy & -yy - xx + ww + zz \end{bmatrix}$$

The term in the bottom right corner is $N(q)$, and since we assume it is 1 we can simplify R to

$$\begin{bmatrix} 1 - 2(z^2 + y^2) & 2(xy - wz) & 2(zx + wy) \\ 2(xy + wz) & 1 - 2(x^2 + z^2) & 2(yz - wx) \\ 2(zx - wy) & 2(yz + wx) & 1 - 2(x^2 + y^2) \end{bmatrix}$$

Although its diagonal looks different, this matrix agrees with the one derived earlier in 3×3 form.

For the more relaxed case when $N(q) = s$, we need merely replace each 2 with $2/s$. Even in the formally disallowed case when $s = 0$, we can replace each 2 with a 0 and get a rotation matrix: the identity!

Taking advantage of common subexpressions, we arrive at the algorithm shown in Figure 10.5 for constructing a 3×3 rotation matrix from any quaternion, whether zero or of any norm.

Naturally we also want the opposite conversion, from rotation matrix to quaternion. Properly done, this can be both efficient and numerically robust, especially compared to other forms of reduction. However, the quaternion components always appear in pairs, so some manipulation is unavoidable.

In weighing our algebraic options, we must be careful to avoid two pitfalls: loss of sign information and loss of precision. To begin, look at signed sums, along either the diagonal or the cross-diagonal. For example, attach a plus sign to the corner two diagonal entries and a minus sign to the inner two and sum to get $4x^2$. Or add the two cross-diagonal entries adjacent to the top left corner to get $4xy$, from which y can be obtained with the correct sign, if x is known and not too small.

To avoid sign loss, we extract only one component using the diagonal and divide that into cross-diagonal sums. We can freely choose the sign for the square root; either yields a correct result. To avoid precision loss, we look for a component of large magnitude as our divisor, with subtlety. The first diagonal element is $2x^2 + t$, where $t = w^2 - x^2 - y^2 - z^2$. Similarly, the second diagonal element is $2y^2 + t$ and the third is $2z^2 + t$. Thus, the largest of those three diagonal elements tells us which of

$$Nq := q_x^2 + q_y^2 + q_z^2 + q_w^2$$

$s :=$ **if** $Nq > 0.0$ **then** $2.0/Nq$ **else** 0.0

$xs := q_x\, s \qquad\qquad ys := q_y\, s \qquad\qquad zs := q_z\, s$

$wxs := q_w\, xs \qquad wys := q_w\, ys \qquad wzs := q_w\, zs$

$xxs := q_x\, xs \qquad xys := q_x\, ys \qquad xzs := q_x\, zs$

$yys := q_y\, ys \qquad yzs := q_y\, zs \qquad zzs := q_z\, zs$

$$R := \begin{bmatrix} 1.0 - (yys + zzs) & xys - wzs & xzs + wys \\ xys + wzs & 1.0 - (xxs + zzs) & yzs - wxs \\ xzs - wys & yzs + wxs & 1.0 - (xxs + yys) \end{bmatrix}$$

Figure 10.5 Convert any quaternion q to rotation matrix **R**.

$$tr := R_{xx} + R_{yy} + R_{zz}$$

if $tr < 0.0$

then

 $(i, j, k) := (x, y, z)$

 if $R_{yy} > R_{xx}$ **then** $(i, j, k) := (y, z, x)$

 if $R_{zz} > R_{ii}$ **then** $(i, j, k) := (z, x, y)$

 $r := \sqrt{R_{ii} - R_{jj} - R_{kk} + 1.0}$

 $s := 0.5/r$

 $q_i := 0.5\, r$

 $q_j := (R_{ij} + R_{ji})\, s$

 $q_k := (R_{ki} + R_{ik})\, s$

 $q_w := (R_{kj} - R_{jk})\, s$

else

 $r := \sqrt{tr + 1.0}$

 $s := 0.5/r$

 $q_x := (R_{zy} - R_{yz})\, s$

 $q_y := (R_{xz} - R_{zx})\, s$

 $q_z := (R_{yx} - R_{xy})\, s$

 $q_w := 0.5\, r$

Figure 10.6 Convert rotation matrix **R** to unit quaternion q.

x, y, or z has the largest magnitude. Still, they might all be too small if w dominates; so we first test for that by comparing the sum of all three diagonal elements to zero, which is the same as comparing the magnitude of w to $1/2$. The algorithm shown in Figure 10.6 brings it all together.

10.4.7 RETROSPECT, PROSPECT

The nine entries of a 3×3 rotation matrix are redundant, since a 3D rotation has only three degrees of freedom; but we have seen how to create any 3D rotation matrix from four parameters having the same minimal redundancy as homogeneous coordinates, an overall scale factor. We also learned how to combine rotations more quickly, in the process discovering a new algebra that blurs the line between number and matrix.

An even-dimensional rotation matrix that squares to minus the identity is called a *complex structure*. Necessarily, it is skew, since $\mathbf{R}^T\mathbf{R} = \mathbf{I}$ and $\mathbf{R}\mathbf{R} = -\mathbf{I}$ together imply $\mathbf{R}^T = -\mathbf{R}$. The technique employed, a set of such matrices that anticommute with each other, extends to rotations in any dimension by generating a *Clifford algebra*, which is an algebra built up from vectors by using a special bilinear product. The general construction of a *spin group* within a Clifford algebra differs slightly from what we have done here, because we took advantage of simplifying coincidences. (The spin group in 2D acts just like a 1D Clifford algebra, which acts like complex numbers; and the spin group in 3D acts like a 2D Clifford algebra, which acts like quaternions.)

So, in one sense, complex numbers, quaternions, and general Clifford algebras are no more exotic than matrices. This once again attests to the generality of matrices, though historically it was quaternions that inspired matrix algebra, not the other way around.

However, this account does not do justice to the remarkable properties of quaternions in their own right. The most glaring omission is the beautiful link between the geometry of quaternions seen as 4D vectors and the geometry of 3D rotations.

A hint of this connection, so essential to interpolation, can be seen by looking at the 4D dot product of two unit quaternions:

$$[\,a \quad b \quad c \quad d\,]^T \cdot [\,x \quad y \quad z \quad w\,]^T = ax + by + cz + dw$$

In geometric terms, it gives the cosine of the angle between the two quaternions considered as vectors. But it can also be written in terms of the quaternion algebra as the **1**-component of

$$(a\mathbf{i} + b\mathbf{j} + c\mathbf{k} + d\mathbf{1})(x\mathbf{i} + y\mathbf{j} + z\mathbf{k} + w\mathbf{1})^*$$

which from our 3D reduction is the cosine of half the angle between the two rotations represented. Thus, we have, in one view, two points on a sphere with a central angle between them; and in another view, two rotations with a direct turn connecting them. We exploit this to interpolate the two rotations in a surprisingly simple but effective way: we draw the spherical arc between the two quaternions.

Matrix notation streamlines linear transformations; quaternion notation goes even further in the case of 3D rotations. I hope exploring the similarity of the two, as we have done here, illuminates both. Some complexity remains, but that is an inevitable consequence of the behavior of rotations, not a quirk of quaternions.

10.5 Interpolation of Quaternions

An application that benefits from a quaternion representation of rotation is *keyframe animation*. The rotational keyframes must be interpolated to produce reasonable in-between rotations. The quaternions representing the rotations can themselves be interpolated in a natural manner, as described in this section.

$10.5.1$ Spherical Linear Interpolation

The 4-tuple (x, y, z, w) that represents the matrix \mathcal{Q} was already shown to be unit length when viewed as a vector in \mathbb{R}^4. That means it is a point on the hypersphere of radius 1 that is centered at the origin of \mathbb{R}^4. This is just a fancy way of stating the geometry associated with the algebraic equation $x^2 + y^2 + z^2 + w^2 = 1$.

A standard problem in computer graphics and animation is to interpolate two 3D rotation matrices R_0 and R_1 for various choices of $t \in [0, 1]$. The interpolant is denoted $R(t)$, a rotation matrix itself, and it is required that $R(0) = R_0$ and $R(1) = R_1$. The 4-tuple representations of the rotation matrices and the corresponding hypersphere geometry allow for a simple yet elegant interpolation called *spherical linear interpolation*, or *slerp* for short. If $\mathbf{q}_i = (x_i, y_i, z_i, w_i)$ are the 4-tuple representations for R_i $(i = 0, 1)$ and if $\mathbf{q}(t)$ is the 4-tuple representing $R(t)$, then a reasonable geometric condition to impose is that $\mathbf{q}(t)$ lie on the hyperspherical arc connecting \mathbf{q}_0 and \mathbf{q}_1. Moreover, the angle between $\mathbf{q}(t)$ and \mathbf{q}_0 should be proportional to the angle ϕ between \mathbf{q}_0 and \mathbf{q}_1 with constant of proportionality t. Figure 10.7 illustrates this by showing the plane spanned by \mathbf{q}_0 and \mathbf{q}_1 and the circular arc connecting them within that plane.

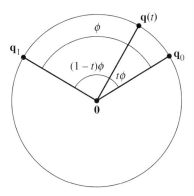

Figure 10.7 Illustration of the spherical linear interpolation, or slerp, of two vectors.

The angle $\phi \in (0, \pi)$ between \mathbf{q}_0 and \mathbf{q}_1 is indirectly obtained by a dot product, $\cos(\phi) = \mathbf{q}_0 \cdot \mathbf{q}_1$. The interpolant is required to be of the form $\mathbf{q}(t) = c_0(t)\mathbf{q}_0 + c_1(t)\mathbf{q}_1$ for some to-be-determined coefficient functions $c_0(t)$ and $c_1(t)$. Construction of $\mathbf{q}(t)$ uses only trigonometry and solving two equations in two unknowns. As t uniformly varies between 0 and 1, the values $\mathbf{q}(t)$ are required to uniformly vary along the circular arc from \mathbf{q}_0 to \mathbf{q}_1. That is, the angle between $\mathbf{q}(t)$ and \mathbf{q}_0 is $t\phi$ and the angle between $\mathbf{q}(t)$ and \mathbf{q}_1 is $(1-t)\phi$. Dotting the equation for $\mathbf{q}(t)$ with \mathbf{q}_0 yields

$$\cos(t\phi) = c_0(t) + \cos(\phi)c_1(t)$$

and dotting the equation with \mathbf{q}_1 yields

$$\cos((1-t)\phi) = \cos(\phi)c_0(t) + c_1(t)$$

These are two equations in the two unknowns c_0 and c_1. The solution for c_0 is

$$c_0(t) = \frac{\cos(t\phi) - \cos(\phi)\cos((1-t)\phi)}{1 - \cos^2(\phi)} = \frac{\sin((1-t)\phi)}{\sin(\phi)}$$

The last equality is obtained by applying double-angle formulas for sine and cosine. By symmetry, $c_1(t) = c_0(1-t)$. Or solve the equations for

$$c_1(t) = \frac{\cos((1-t)\phi) - \cos(\phi)\cos(t\phi)}{1 - \cos^2(\phi)} = \frac{\sin(t\phi)}{\sin(\phi)}$$

The spherical linear interpolation is

$$\text{slerp}(t; \mathbf{q}_0, \mathbf{q}_1) = \frac{\sin((1-t)\phi)\mathbf{q}_0 + \sin(t\phi)\mathbf{q}_1}{\sin\phi} \tag{10.34}$$

for $0 \le t \le 1$. It is easy to verify that $\text{slerp}(0; \mathbf{q}_0, \mathbf{q}_1) = \mathbf{q}_0$, and $\text{slerp}(1; \mathbf{q}_0, \mathbf{q}_1) = \mathbf{q}_1$. Using trigonometry applied directly to equation (10.34), you can also verify that $|\text{slerp}(t; \mathbf{q}_0, \mathbf{q}_1)| = 1$ for all t.

The derivative of slerp with respect to time is

$$\text{slerp}'(t; \mathbf{q}_0, \mathbf{q}_1) = \frac{-\phi \cos((1-t)\phi)\mathbf{q}_0 + \phi \cos(t\phi)\mathbf{q}_1}{\sin\phi} \tag{10.35}$$

It is easy to verify that $\text{slerp}'(0; \mathbf{q}_0, \mathbf{q}_1) = \phi(-(\cos\phi)\mathbf{q}_0 + \mathbf{q}_1)/\sin\phi$, and $\text{slerp}'(1; \mathbf{q}_0, \mathbf{q}_1) = \phi(-\mathbf{q}_0 + (\cos\phi)\mathbf{q}_1)/\sin\phi$. Using trigonometry applied directly to equation (10.35), you can also verify that $|\text{slerp}'(t; \mathbf{q}_0, \mathbf{q}_1)| = \phi$ for all t. The derivative vector has constant length, so a uniform sampling of t produces a uniform sampling of points on the circular arc.

If you were to specify a unit-length vector \mathbf{T} that is tangent to the unit hypersphere at a point \mathbf{q} on the hypersphere, and if you specify an angular speed ϕ, a circular arc starting at \mathbf{q} in the direction of \mathbf{T} is

$$\mathbf{p}(t) = \cos(t\phi)\mathbf{q} + \sin(t\phi)\mathbf{T} \tag{10.36}$$

for $t \geq 0$. In terms of the slerp function, \mathbf{q} is the starting point \mathbf{q}_0, ϕ is the angle between \mathbf{q}_0 and the ending point \mathbf{q}_1, and $\mathbf{T} = \text{slerp}'(0; \mathbf{q}_0, \mathbf{q}_1)/\phi$.

10.5.2 SPHERICAL QUADRANGLE INTERPOLATION

In many applications there is a need for higher-order interpolation than what slerp provides. This section introduces *spherical quadrangle interpolation* as an iteration of slerp operations to produce a higher-order result. The motivation for this comes from *quadrangle interpolation* of four points in the plane that form a convex quadrilateral, call the points \mathbf{v}_i for $0 \leq i \leq 3$. Figure 10.8 shows a typical configuration.

Bilinear interpolation is used to generate points inside the quadrilateral. To represent the linear interpolation, or lerp, of the two input vectors, we use the notation $\text{lerp}(r; \mathbf{a}, \mathbf{b}) = (1 - r)\mathbf{a} + r\mathbf{b}$ for $r \in [0, 1]$. The bottom and top edges are linearly interpolated using parameter $t \in [0, 1]$. The interpolated point for the bottom edge is

$$\mathbf{u}_0 = (1 - t)\mathbf{v}_0 + t\mathbf{v}_3 = \text{lerp}(t; \mathbf{v}_0, \mathbf{v}_3)$$

and the interpolated point for the top edge is

$$\mathbf{u}_1 = (1 - t)\mathbf{v}_1 + t\mathbf{v}_2 = \text{lerp}(t; \mathbf{v}_1, \mathbf{v}_2)$$

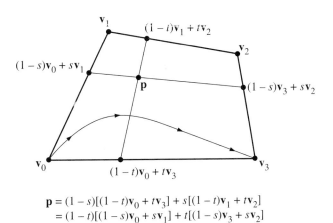

$$\mathbf{p} = (1 - s)[(1 - t)\mathbf{v}_0 + t\mathbf{v}_3] + s[(1 - t)\mathbf{v}_1 + t\mathbf{v}_2]$$
$$= (1 - t)[(1 - s)\mathbf{v}_0 + s\mathbf{v}_1] + t[(1 - s)\mathbf{v}_3 + s\mathbf{v}_2]$$

Figure 10.8 Four points forming a convex quadrilateral. Any interior point of the quadrilateral can be generated using bilinear interpolation with parameters s and t. The curve connecting \mathbf{v}_0 and \mathbf{v}_3 indicates that we want a particular function $s = f(t)$ with $f(0) = f(1) = 0$.

The line segment connecting \mathbf{u}_0 and \mathbf{u}_1 can itself be generated by linear interpolation of the end points using parameter $s \in [0, 1]$. Such points are of the form

$$\mathbf{p} = (1 - s)\mathbf{u}_0 + s\mathbf{u}_1$$

$$= (1 - s)[(1 - t)\mathbf{v}_0 + t\mathbf{v}_3] + s[(1 - t)\mathbf{v}_1 + t\mathbf{v}_2]$$

$$= \mathrm{lerp}(s; \mathrm{lerp}(t; \mathbf{v}_0, \mathbf{v}_3), \mathrm{lerp}(t; \mathbf{v}_1, \mathbf{v}_2))$$

We want a curve that connects the initial point \mathbf{v}_0 and the final point \mathbf{v}_3. This requires imposing a functional constraint $s = f(t)$ for some function f. It is necessary that $f(t) \in [0, 1]$ since $s \in [0, 1]$. For the curve to contain the initial point and final point, we need $f(0) = 0$ and $f(1) = 0$, respectively. The function $f(t)$ should also be symmetric about the t-interval midpoint $1/2$ so that the curve generated by the ordered input points and the curve generated by the reverse-ordered input points are the same. The constraint is therefore $f(1 - t) = f(t)$ for all $t \in [0, 1]$. The simplest function to use that satisfies the constraints is the quadratic $f(t) = ct(1 - t)$ for some $c \leq 4$; the bound on c guarantees $f(t) \leq 1$. Although there are many choices for c, a natural one is $c = 2$ so that at the midpoint $t = 1/2$, the interpolation produces the average of the four points. The curve is given parametrically as

$$\mathbf{p}(t) = \mathrm{quad}(t; \mathbf{v}_0, \mathbf{v}_1, \mathbf{v}_2, \mathbf{v}_3)$$

$$= \mathrm{lerp}(2t(1 - t); \mathrm{lerp}(t; \mathbf{v}_0, \mathbf{v}_3), \mathrm{lerp}(t; \mathbf{v}_1, \mathbf{v}_2)) \tag{10.37}$$

A couple of observations are in order. First, as a function of s and t the interpolation scheme is bilinear. The coefficients of the input points are quadratic functions; however, once the constraint $s = 2t(1 - t)$ is imposed, the coefficients are *cubic polynomials* in t. Second, equation (10.37) is *not* the cubic Bézier curve corresponding to four control points. The Bézier curve is

$$\mathbf{b}(t) = (1 - t)^3\mathbf{v}_0 + 3(1 - t)^2 t\mathbf{v}_1 + 3(1 - t)t^2\mathbf{v}_2 + t^3\mathbf{v}_3$$

$$= \mathrm{lerp}(t; \mathrm{lerp}(t; \mathrm{lerp}(t; \mathbf{v}_0, \mathbf{v}_1), \mathrm{lerp}(t; \mathbf{v}_1, \mathbf{v}_2)),$$

$$\mathrm{lerp}(t; \mathrm{lerp}(t; \mathbf{v}_1, \mathbf{v}_2), \mathrm{lerp}(t; \mathbf{v}_2, \mathbf{v}_3)))$$

The coefficient of \mathbf{v}_0 in equation (10.37) is $(1 - 2t(1 - t))(1 - t)$ and is not the same as the coefficient of \mathbf{v}_0 in $\mathbf{b}(t)$, namely, $(1 - t)^3$. The Bézier curve has end tangents $\mathbf{b}'(0) = 3(\mathbf{v}_1 - \mathbf{v}_0)$ and $\mathbf{b}'(1) = 3(\mathbf{v}_3 - \mathbf{v}_2)$. The quadratic interpolation curve has end tangents $\mathbf{p}'(0) = (\mathbf{v}_3 - \mathbf{v}_0) + 2(\mathbf{v}_1 - \mathbf{v}_0)$ and $\mathbf{p}'(1) = (\mathbf{v}_3 - \mathbf{v}_0) - 2(\mathbf{v}_2 - \mathbf{v}_3)$.

Using the analogy of the iterated lerp function to define the quad function, we define the *squad* function of quaternions as

$$\mathrm{squad}(t; \mathbf{q}_0, \mathbf{q}_1, \mathbf{q}_2, \mathbf{q}_3) = \mathrm{slerp}(2t(1 - t); \mathrm{slerp}(t, \mathbf{q}_0, \mathbf{q}_3), \mathrm{slerp}(t, \mathbf{q}_1, \mathbf{q}_2)) \quad (10.38)$$

You may verify that $\mathrm{squad}(0; \mathbf{q}_0, \mathbf{q}_1, \mathbf{q}_2, \mathbf{q}_3) = \mathbf{q}_0$ and $\mathrm{squad}(1; \mathbf{q}_0, \mathbf{q}_1, \mathbf{q}_2, \mathbf{q}_3) = \mathbf{q}_3$.

10.6 Derivatives of Time-Varying Quaternions

In equation (5.9) of Section 5.1 we stated that the derivative of a time-varying quaternion $q(t)$ is

$$\frac{dq(t)}{dt} = \frac{1}{2}\omega(t)q(t)$$

where $\omega(t)$ is the quaternion representation of the angular velocity vector $\mathbf{w}(t) = (w_1, w_2, w_3)$. As such, $\omega(t) = w_1 i + w_2 j + w_3 k$; that is, $\omega(t)$ has a zero real part. It is not necessary that $\omega(t)$ be a unit-length quaternion since we know that the angular velocity $\mathbf{w}(t)$ is not necessarily a unit-length vector.

The derivative formula is proved according to the following construction that is a slightly more formal and detailed version of what occurs in the fine book [Kui99]. Let $q(t) = \cos(\theta(t)/2) + u(t)\sin(\theta(t)/2)$, where $u = u_1 i + u_2 j + u_3 k$ with $u_1^2 + u_2^2 + u_3^2 = 1$. The rotation angle for $q(t)$ is θ and the rotation axis has unit-length direction $\mathbf{u} = (u_1, u_2, u_3)$. The quaternions $q(t+h)$ and $q(t)$ are both unit length, so the product $q(t+h)q^{-1}(t)$ is unit length; write it as

$$q(t+h)q^{-1}(t) = p(t,h) = \cos(\alpha(t,h)/2) + v(t,h)\sin(\alpha(t,h)/2) \quad (10.39)$$

where $v = v_1 i + v_2 j + v_3 k$ with $v_1^2 + v_2^2 + v_3^2 = 1$. The quaternion $p(t,h)$ has angle of rotation $\alpha(t,h)$ and rotation axis direction $\mathbf{v} = (v_1, v_2, v_3)$. When $h = 0$ the left-hand side is $q(t)q^{-1}(t) = 1$, so $\alpha(t,0) = 0$. Multiplying equation (10.39) by $q(t)$, subtracting $q(t)$, and dividing by h leads to

$$\frac{q(t+h) - q(t)}{h} = \frac{\cos(\alpha(t,h)/2) - 1 + v(t,h)\sin(\alpha(t,h)/2)}{h} q(t)$$

Taking the limit as h goes to zero:

$$\frac{dq}{dt} = \lim_{h \to 0} \frac{q(t+h) - q(t)}{h}$$

$$= \lim_{h \to 0} \left(\frac{\cos(\alpha(t,h)/2) - 1 + v(t,h)\sin(\alpha(t,h)/2)}{h} q(t) \right)$$

$$= \left(\lim_{h \to 0} \frac{\cos(\alpha(t,h)/2) - 1}{h} + v(t,0)\lim_{h \to 0} \frac{\sin(\alpha(t,h)/2)}{h} \right) q(t)$$

$$= \left(\lim_{h \to 0} \frac{-(\alpha_h(t,h)/2)\sin(\alpha(t,h)/2)}{1} + u(t)\lim_{h \to 0} \frac{(\alpha_h(t,h)/2)\cos(\alpha(t,h)/2)}{1} \right) q(t)$$

$$= (\alpha_h(t,0)/2)u(t)q(t)$$

where the next to last equality uses l'Hôpital's rule and $\alpha_h(t, h) = \partial\alpha(t, h)/\partial h$. So we have

$$\frac{dq}{dt} = \frac{1}{2}(\alpha_h(t, 0)u(t))q(t) = \frac{1}{2}\omega q \qquad (10.40)$$

Alternatively, we can use the approach taken in [DKL98]. Specify $q(t) = \gamma + \sigma u$, where $\gamma = \cos(\theta(t)/2)$, $\sigma = \sin(\theta(t)/2)$, and $u = u(t)$ has a zero real part and its corresponding vector **u** is unit length. Differentiating directly with respect to t:

$$\frac{dq}{dt} = -(\dot{\theta}/2)\sigma + \sigma\dot{u} + (\dot{\theta}/2)\gamma u$$

$$= (\dot{\theta}/2)(\gamma u - \sigma) + \sigma\dot{u}$$

$$= (\dot{\theta}/2)uq + \sigma\dot{u}$$

$$= \frac{1}{2}\left(\dot{\theta}u + 2\sigma\dot{u}q^{-1}\right)q$$

Since $\mathbf{u} \cdot \mathbf{u} = 1$, the derivative $\dot{\mathbf{u}}$ satisfies $\mathbf{u} \cdot \dot{\mathbf{u}} = 0$; that is, $\dot{\mathbf{u}}$ is perpendicular to \mathbf{u}. Consider:

$$\dot{u}q^{-1} = \dot{u}(\gamma - \sigma u)$$

$$= \gamma\dot{u} - \sigma\dot{u}u$$

$$= \gamma\dot{u} - \sigma(-\dot{u} \cdot u + \dot{u} \times u) \qquad \text{By equation (10.21)}$$

$$= \gamma\dot{u} - \sigma(\dot{u} \times u) \qquad \text{Since } \dot{u} \text{ and } u \text{ are perpendicular as vectors}$$

$$= 0 + (\gamma\dot{u} - \sigma(\dot{u} \times u))$$

The last equality stresses the fact that the real part is zero. This is true since \dot{u} and $\dot{u} \times u$ both have zero real parts. The derivative of $q(t)$ is therefore

$$\frac{dq}{dt} = \frac{1}{2}(\dot{\theta}u + 2\sigma\gamma\dot{u} - 2\sigma^2\dot{u} \times u)q$$

$$= \frac{1}{2}(\dot{\theta}u + \sin(\theta)\dot{u} + (\cos(\theta) - 1)\dot{u} \times u)q = \frac{1}{2}\omega q \qquad (10.41)$$

Notice that u, \dot{u}, and $\dot{u} \times u$ in the term for angular velocity form an orthonormal set as vectors. Compare this to equation (2.40) to see, indeed, that the quaternion $\omega(t)$ does correspond to the angular velocity vector $\mathbf{w}(t)$.

Yet another approach is given in [KKS96] and uses logarithmic and exponential maps. However, this complicated approach is unnecessary as evidenced by the simplicity of the preceding proofs.

APPENDIX A

LINEAR ALGEBRA

A.1 A REVIEW OF NUMBER SYSTEMS

A.1.1 THE INTEGERS

We are all familiar with various number systems whose properties we take for granted. The simplest set of numbers is the *integers*. The basic operations on this set are addition and multiplication. Each operation takes a pair of integers and produces another integer. If n and m are integers, then $n + m$ and $n \cdot m$ are integers. The result of the operation does not depend on the order of the operands: $n + m = m + n$ and $n \cdot m = m \cdot n$. The operations are said to be *commutative*. When adding or multiplying three integers n, m, and p, the grouping of the operands is unimportant: $n + (m + p) = (n + m) + p$ and $n \cdot (m \cdot p) = (n \cdot m) \cdot p$. The operations are said to be *associative*. Because the grouping is unimportant, we may unambiguously write the sum as $n + m + p$ and the product as $n \cdot m \cdot p$. Multiplication is distributive across a sum: $n \cdot (m + p) = n \cdot m + n \cdot p$. The number zero is the *additive identity* in that $n + 0 = n$. Each integer n has an *additive inverse* $-n$ where $n + (-n) = 0$. This concept supports the definition of *subtraction* of two numbers n and m, namely, $n - m = n + (-m)$. Finally, the number one is the *multiplicative identity* in that $n \cdot 1 = n$.

A.1.2 THE RATIONAL NUMBERS

The set of integers is deficient in a sense. Other than the numbers 1 and -1, no integer has a *multiplicative inverse* that is itself an integer. If n is an integer such that $|n| \neq 1$, there is no integer m for which $n \cdot m = 1$. The remedy for this is to define a superset of numbers that do have multiplicative inverses within that set. You are also

545

familiar with this set, the *rational numbers*, that consists of all ratios n/m where n and m are integers and $m \neq 0$. A single rational number has many representations, for example, 2/5 and 4/10 represent the same number. The standard representative is one for which the greatest common divisor of the numerator and denominator is 1. In the example, the greatest common divisor of 2 and 5 is 1, so this is the standard representative. The greatest common divisor of 4 and 10 is 2, so this number is not the standard, but can be reduced by dividing both numerator and denominator by 2. An integer n represented as a rational number is $n/1$, but for notational convenience, we still use n to represent the number.

Addition of rational numbers is based on addition of integers. If n_1/m_1 and n_2/m_2 are rational numbers, then the sum and product are defined by

$$\frac{n_1}{m_1} + \frac{n_2}{m_2} = \frac{n_1 \cdot m_2 + n_2 \cdot m_1}{m_1 \cdot m_2} \quad \text{and} \quad \frac{n_1}{m_1} \cdot \frac{n_2}{m_2} = \frac{n_1 \cdot n_2}{m_1 \cdot m_2}$$

The addition and multiplication operators on the left-hand sides of the definitions are those for the rational numbers. The addition and multiplication operators on the right-hand sides of the definitions are those for the integers. The rational operations have all the properties that the integer operations do: commutative, associative, and distributive. The rational number 0/1 (or 0 for short) is the additive identity. The additive inverse of n/m is $(-n)/m$ (or $-n/m$ for short). The rational number 1/1 (or 1 for short) is the multiplicative identity. The multiplicative inverse of n/m with $n \neq 0$ is m/n.

A.1.3 THE REAL NUMBERS

The rational numbers may also be thought of as deficient in the sense that certain algebraic equations with rational coefficients may not have rational roots. For example, the equation $16x^2 = 9$ has two rational roots, $x = \pm 3/4$. The equation $x^2 = 2$ does not have rational roots. Looking ahead, we need the concept of *irrational numbers*. The remedy is, once again, to define a superset of numbers, in this case the *real numbers*. The formal construction is nontrivial, normally taught in a course on real analysis, and is not presented here. The construction includes defining the addition and multiplication operations for real numbers in terms of the operations for rational numbers. The operations are commutative and associative and multiplication distributes across addition. The additive identity is the real number 0 and each number r has an additive inverse denoted $-r$. The multiplicative identity is the real number 1 and each nonzero number r has a multiplicative inverse denoted $1/r$. In this book, the set of real numbers is denoted by \mathbb{R}.

A.1.4 THE COMPLEX NUMBERS

And yet one more time we have another deficiency. Algebraic equations with real coefficients may not have real roots. We can now solve $x^2 = 2$ to obtain two real

solutions $x = \pm\sqrt{2}$, but $x^2 = -1$ does not have real solutions since the square of a nonzero real number must be positive. The remedy is to define a subset of numbers, in this case the *complex numbers*. The symbol i is defined to be a complex number for which $i^2 = -1$. Complex numbers are written in the form $x + iy$, where x and y are real numbers. Addition is defined by

$$(x_1 + iy_1) + (x_2 + iy_2) = (x_1 + x_2) + i(y_1 + y_2)$$

and multiplication is defined by

$$(x_1 + iy_1) \cdot (x_2 + iy_2) = (x_1 x_2 - y_1 y_2) + i(x_1 y_2 + x_2 y_1)$$

The additive identity is $0 + i0$ (or 0 for short). The additive inverse of $x + iy$ is $(-x) + i(-y)$ (or $-x - iy$ for short). The multiplicative identity is $1 + i0$ (or 1 for short). The multiplicative identity of $x + iy$, assuming not both x and y are zero, is

$$\frac{1}{x + iy} = \frac{x}{x^2 + y^2} - i\frac{y}{x^2 + y^2}$$

The addition and multiplication operators are commutative and associative and multiplication distributes across addition. The set of complex numbers is finally *complete* in the sense that the roots of any polynomial equation with complex-valued coefficients are always representable as complex numbers. This result is the Fundamental Theorem of Algebra.

A.1.5 FIELDS

The arithmetic properties of the rational numbers, the real numbers, and the complex numbers may be abstracted. The general concept is a *field* that consists of a set F of numbers, an addition operator ($+$), and a multiplication operator (\cdot) that satisfy the following axioms. In the axioms, x, y, and z are elements of F.

1. $x + y$ is in F (set is closed under addition).
2. $x + y = y + x$ (addition is commutative).
3. $(x + y) + z = x + (y + z)$ (addition is associative).
4. There is an element 0 in F such that $x + 0 = x$ for all x in F (additive identity).
5. For each x in F, there is an element $-x$ in F such that $x + (-x) = 0$ (additive inverses).
6. $x \cdot y$ is in F (set is closed under multiplication).
7. $x \cdot y = y \cdot x$ (multiplication is commutative).
8. $(x \cdot y) \cdot z = x \cdot (y \cdot z)$ (multiplication is associative).
9. $x \cdot (y + z) = x \cdot y + x \cdot z$ (multiplication distributes across addition).

10. There is an element 1 in F such that $x \cdot 1 = c$ for all x in F (multiplicative identity).

11. For each $x \neq 0$ in F, there is an element x^{-1} such that $x \cdot x^{-1} = 1$ (multiplicative inverses).

This topic and related ones are usually presented in an undergraduate course in abstract algebra.

A.2 SYSTEMS OF LINEAR EQUATIONS

Suppose that a_1 through a_m and b are known constants and that x_1 through x_m are variables. The equation

$$a_1 x_1 + \cdots + a_n x_m = b$$

is called a *linear equation*. A common problem in applications is to have to solve a system of n linear equations in m unknown variables. In most cases $n = m$, but the method of solution applies even if this is not the case. As we shall see, the system has no solutions, one solution, or infinitely many solutions. The method of solution involves elimination of one variable at a time from the equations. This phase is referred to as *forward elimination*. At the end of the phase, the first equation has m variables, the second equation has $m - 1$ variables, and so on, the last equation having 1 variable. The equations are then processed in reversed order to eliminate variables and obtain the final solution (if any). This phase is referred to as *back substitution*.

EXAMPLE A.1

Here is a simple example for mixing two acid solutions to obtain a desired ratio of acid to water. Determine how many liters of a 10% and a 15% solution of acid must be used to produce 3 liters of a 12% solution of acid. Let x and y represent the number of liters of 10% and 15% solutions, respectively. Intuitively, $x > y$ since 12 is closer to 10 than 15. Two conservation rules apply. Conservation of volume implies

x	$+$	y	$=$	3
Liters of 10 % solution		Liters of 15% solution		Liters of 12% solution

Conservation of acid implies

$0.10x$	$+$	$0.15y$	$=$	$0.12(3)$
Acid in 10 % solution		Acid in 15% solution		Acid in 12% solution

Thus, we have two equations in two unknowns, $x + y = 3$ and $0.10x + 0.15y = 0.36$. Forward elimination is used to remove x from the second equation. The first equation implies $x = 3 - y$. Substitute in the second equation to eliminate x and

obtain $0.36 = 0.10(3 - y) + 0.15y = 0.05y + 0.30$. The last equation is solved for $y = 6/5$. Back substitution is used to replace the occurrence of y in the first equation, $x = 3 - 6/5 = 9/5$. The final answer is that 9/5 liters of the 10% solution and 6/5 liters of the 15% solution combine to produce 3 liters of the 12% solution. ▪

EXAMPLE
A.2

Here is an example of a system of three linear equations in three unknowns: (1) $x + y + z = 6$, (2) $x + 2y + 2z = 11$, and (3) $2x + 3y - 4z = 3$. The forward elimination process is applied first. Use the first equation to eliminate x in the other equations. Multiply equation 1 by -1 and add to equation 2:

$$
\begin{array}{rrrrrr}
-x & - & y & - & z & = & -6 \\
x & + & 2y & + & 2z & = & 11 \\
\hline
 & & y & + & z & = & 5
\end{array}
$$

Multiply equation 1 by -2 and add to equation 3:

$$
\begin{array}{rrrrrr}
-2x & - & 2y & - & 2z & = & -12 \\
2x & + & 3y & - & 4z & = & 3 \\
\hline
 & & y & - & 6z & = & -9
\end{array}
$$

We now have two equations in two unknowns: $y + z = 5$ and $y - 6z = -9$. Multiply equation 1 by -1 and add to equation 2:

$$
\begin{array}{rrrrr}
-y & - & z & = & -5 \\
y & - & 6z & = & -9 \\
\hline
 & -7z & & = & -14
\end{array}
$$

We now have one equation in one unknown: $-7z = 14$. In summary, forward elimination has produced the equations $x + y + z = 6$, $y + z = 5$, and $-7z = 14$. Back substitution is the next process. Solve equation 3 for $z = 2$. Substitute this z value in equation 2, $5 = y + z = y + 2$, and solve for $y = 3$. Substitute the z and y values in equation 1, $6 = x + y + z = x + 3 + 2$, and solve for $x = 1$. The system has a single solution $x = 1$, $y = 3$, and $z = 2$. ▪

There are a couple of snags that can be encountered in forward elimination. The next two examples illustrate these and how to get around them.

EXAMPLE
A.3

In this example, the right-hand side values are unimportant in the illustration. We simply put asterisks in these places. Consider

$$
\begin{array}{rrrrrrr}
x & + & y & + & z & = & * \\
2x & + & 2y & + & 5z & = & * \\
4x & + & 6y & + & 8z & = & *
\end{array}
$$

(Example A.3 continued) Use equation 1 to eliminate x from equations 2 and 3. Multiply equation 1 by -1 and add to equation 2. Multiply equation 1 by -4 and add to equation 3 to obtain the system

$$
\begin{array}{rcrcrcr}
x &+& y &+& z &=& * \\
 & & & & 3z &=& * \\
 & & 2y &+& 4z &=& *
\end{array}
$$

There is no y-term in equation 2, so you cannot use it to eliminate the y-term in equation 3. In order to continue the formal elimination process, you must swap the last two equations. The swap has no effect on the algebraic process of solving the equations, but it is convenient in establishing an algorithm that a computer could use in solving systems. After swapping we have

$$
\begin{array}{rcrcrcr}
x &+& y &+& z &=& * \\
 & & 2y &+& 4z &=& * \\
 & & & & 3z &=& *
\end{array}
$$

Forward elimination is now complete and back substitution may be applied to obtain a solution. ▧

EXAMPLE A.4 In the following system, the constants on the right-hand side of the equations are denoted a, b, and c, but are still considered to be known values:

$$
\begin{array}{rcrcrcr}
x &+& y &+& z &=& a \\
2x &+& 2y &+& 5z &=& b \\
4x &+& 4y &+& 8z &=& c
\end{array}
$$

Use equation 1 to eliminate x from equations 2 and 3. Multiply equation 1 by -2 and add to equation 2. Multiply equation 1 by -4 and add to equation 3. The resulting system is

$$
\begin{array}{rcrcrcr}
x &+& y &+& z &=& a \\
 & & & & 3z &=& b - 2a \\
 & & & & 4z &=& c - 4a
\end{array}
$$

There is no y-term in either equation 2 or 3. Instead we proceed to the next variable, z, in the second equation and use it to eliminate z in the third equation. Multiply equation 2 by $-4/3$ and add to equation 3.

$$\begin{aligned}
x + y + z &= a \\
3z &= b - 2a \\
0 &= (c - 4a) - 4(b - 2a)/3
\end{aligned}$$

The last equation contains none of the original variables, but nonetheless must still be a true statement. That is, the constants a, b, and c, whatever they might be, must satisfy $(c - 4a) - 4(b - 2a)/3 = 0$. If they do not, the system of equations has no solutions; no choice of x, y, and z can force the last equation to be true. For example, if $a = 1$, $b = -1$, and $c = 1$, $(c - 4a) - 4(b - 2a)/3 = 1 \neq 0$, and the system has no solutions. If the constants do satisfy the last equation, the first two equations can be manipulated further. The second equation is solved for $z = (b - 2a)/3$. Replacing this in the first equation and moving the constant terms to the right-hand side, we have

$$x + y = a - (b - 2a)/3 = (5a - b)/3$$

One of the variables may be freely chosen, the other variable depending on the choice. If y is freely chosen, then $x = (5a - b)/3 - y$. There are infinitely many choices for y (any real number), so the system of equations has infinitely many solutions. For example, if $a = 1$, $b = -1$, and $c = 0$, $(c - 4a) - 4(b - 2a)/3 = 0$ and the solutions are tabulated as

$$(x, y, z) = (-y + 2, y, -1) = y(-1, 1, 0) + (2, 0, -1)$$

which emphasizes the dependence on the free parameter y. ▪

A.2.1 A CLOSER LOOK AT TWO EQUATIONS IN TWO UNKNOWNS

Let us take a closer look at the forward elimination for a system of two equations,

$$\begin{aligned}
a_{11}x_1 + a_{12}x_2 &= b_1 \\
a_{21}x_1 + a_{22}x_2 &= b_2
\end{aligned}$$

The coefficients a_{ij} and the right-hand sides b_j are known constants. The x_j are the unknowns. For the sake of argument, assume $a_{11} \neq 0$ so that no row-swapping is needed. To eliminate x_1 from equation 2, multiply equation 1 by a_{21}/a_{11} and subtract from equation 2. The resulting system is

$$a_{11}x_1 + \left(a_{12}\right) x_2 = b_1$$

$$\left(a_{22} - a_{12} * \frac{a_{21}}{a_{11}}\right) x_2 = b_2 - b_1 * \frac{a_{21}}{a_{11}}$$

Observe that you do not need to compute $a_{21} - a_{11} * a_{21}/a_{11}$ since the multiplier was chosen so that this term is zero. To solve using back substitution, solve the second equation for x_2:

$$x_2 = \frac{b_2 - b_1 * \frac{a_{21}}{a_{11}}}{a_{22} - a_{12} * \frac{a_{21}}{a_{11}}}$$

Substitute this in the first equation and solve for x_1:

$$x_1 = \frac{b_1 - a_{12} * x_2}{a_{11}}$$

The method of solution needs to be implemented for a computer. A practical concern is the amount of time required to compute a solution. The number of cycles for floating point addition/subtraction, multiplication, and division can vary on different processors. Historically, additions and subtractions were the fastest to compute, multiplication somewhat slower, and division the slowest. A speedy implementation had to be concerned about the cycle counts for the operations, sometimes replacing the slower operations with fast ones. For example, if addition requires α cycles and multiplication requires μ cycles, then the floating point expression 2 * x requires μ cycles to compute. The expression written instead as x + x requires α cycles. If $\alpha < \mu$, then the application most likely would choose to use the latter expression. A variation on this is to compute 3 * x using μ cycles or x + x + x using 2α cycles. Again, if the cost for an addition is less than half that for a multiplication, then the latter expression is a better choice for speed.

A more interesting example is in the product of two complex numbers, $(a + bi) * (c + di) = (a * c - b * d) + (a * d + b * c)i$. The expression on the right-hand side requires 4 multiplications and 2 additions for a cost of $4\mu + 2\alpha$ cycles. An alternate form of the right-hand side is $(d * (a - b) + a * (c - d)) + (d * (a - b) + b * (c + d))i$. The expression $d * (a - b)$ is common to the real and imaginary parts, so only needs to be computed once. The alternate form requires 3 multiplications and 5 additions for a cost of $3\mu + 5\alpha$. As long as an addition is less than one-third the cost of a multiplication, the alternate form is cheaper to compute.

On some current-generation processors, additions and multiplications require the same number of cycles. Tricks of the form discussed previously are no longer of use in this setting. In fact, as hardware has evolved to eliminate the disparity between cycle counts for basic arithmetic operations, other issues have become important. Inexpensive comparisons were once used to steer the flow of computation along a path that minimizes the cycle count for arithmetic operations. Now comparisons can be more expensive to compute than additions or multiplications, so the steering might lead to a larger cycle count than by just using a direct path. Cache misses, floating point stalls, branch penalties, parallel integer and floating point units, and a collection of other issues must be dealt with when implementing algorithms. They will certainly make your programming life interesting!

Well, that was a long digression. How does it relate to linear systems? In the example of a system of two equations, the expressions that are computed, in order, are listed below:

1. Compute $c_1 = a_{21}/a_{11}$.
2. Compute $d_1 = a_{22} - a_{12} * c_1$.
3. Compute $e_1 = b_2 - b_1 * c_1$.
4. Solve for $x_2 = e_1/d_1$.
5. Compute $f_1 = b_1 - a_{12} * x_2$.
6. Solve for $x_1 = f_1/a_{11}$.

The algorithm requires 3 additions, 3 multiplications, and 3 divisions. Divisions are still typically more expensive to compute than additions and multiplications, so you might try to eliminate them (if possible). Convince yourself that the following sequence also leads to a solution:

1. Compute $c_2 = a_{11} * a_{22} - a_{21} * a_{12}$.
2. Compute $d_2 = a_{11} * b_2 - a_{21} * b_1$.
3. Solve for $x_2 = c_2/d_2$.
4. Compute $e_2 = b_1 - a_{12} * x_2$.
5. Solve for $x_1 = e_2/a_{11}$.

This algorithm requires 3 additions, 5 multiplications, and 2 divisions. The trade-off is that 1 division has been replaced by 2 multiplications. Whether that is a reduction in cycles depends on your processor. On most current processors, it is.

Other time-saving options depend on how you plan on using the solution (x_1, x_2). For example, if your application needs only to compare the solution to see if it lies in a rectangle, the divisions are not required at all. Suppose the comparisons to be tested are $x_1 \in [u_1, v_1]$ and $x_2 \in [u_2, v_2]$. The pseudocode using x_1 and x_2 directly is

```
bool Contains (float x1, float x2, float u1, float v1, float u2, float v2)
{
    return u1 <= x1 && x1 <= v1 && u2 <= x2 && x2 <= v2;
}
```

The divisions can be avoided:

```
bool Contains (float e2, float a11, float c2, float d2, float u1, float v1,
               float u2, float v2)
{
```

```
if ( a11 > 0 )
{
    if ( d2 > 0 )
        return a11 * u1 <= e2 && e2 <= a11 * v1 && d2 * u2 <= c2 &&
            c2 <= d2 * v2;
    else
        return a11 * u1 >= e2 && e2 >= a11 * v1 && d2 * u2 >= c2 &&
            c2 >= d2 * v2;
}
else
{
    if ( d2 > 0 )
        return a11 * u1 >= e2 && e2 >= a11 * v1 && d2 * u2 >= c2 &&
            c2 >= d2 * v2;
    else
        return a11 * u1 <= e2 && e2 <= a11 * v1 && d2 * u2 <= c2 &&
            c2 <= d2 * v2;
}
}
```

The 2 divisions have been replaced by 4 multiplications and 2 comparisons, in worst case. It is possible that not all multiplications are performed since an early return can occur if one of the Boolean subexpressions is false. On most current processors, the alternate method will reduce the cycle count.

A.2.2 GAUSSIAN ELIMINATION AND ELEMENTARY ROW OPERATIONS

I believe we now have a sufficient grasp on the methods of forward elimination and back substitution to look at the general setting. The total process is called *Gaussian elimination* and starts with n linear equations in m unknowns:

$$
\begin{array}{ccccccccc}
a_{11}x_1 & + & a_{12}x_2 & + & \cdots & + & a_{1m}x_n & = & b_1 \\
a_{21}x_1 & + & a_{22}x_2 & + & \cdots & + & a_{2m}x_m & = & b_2 \\
& & & & \vdots & & & & \\
a_{n1}x_1 & + & a_{n2}x_2 & + & \cdots & + & a_{nm}x_m & = & b_n
\end{array}
$$

where the coefficients a_{ij} and inputs b_i are known and where the x_j are unknown $(1 \le i \le n, 1 \le j \le m)$. The system can be written more concisely as

$$
\sum_{j=1}^{m} a_{ij}x_j = b_i, \quad 1 \le i \le n
$$

The coefficients a_{ij} can be written in tabular form, called a *matrix*, $A = [a_{ij}]$. The table has n rows indexed by i and m columns indexed by j. The numbers b_i can be written in tabular form, called a *column matrix*, $\mathbf{b} = [b_i]$. This table also has n rows indexed by i but only a single column. The variables x_j can be written as a column matrix, $\mathbf{x} = [x_j]$, that has m rows indexed by j. Using the tabular forms, the system may be suggestively written as $A\mathbf{x} = \mathbf{b}$, where the implied product $A\mathbf{x}$ denotes the operations necessary to reconstruct the left-hand sides of the equations in the system. In a later section I will define the general operation for multiplying matrices. The elimination process algebraically manipulates the entries of the A and \mathbf{b} matrices. The bookkeeping is concisely represented in terms of operations on A, \mathbf{b}, and the *augmented matrix* $[A|\mathbf{b}]$, the matrix with n rows and $m + 1$ columns that is obtained by appending \mathbf{b} on the right of A.

Forward elimination is equivalent to applying what are called *elementary row operations* to the augmented matrix. These operations are

1. Interchange row i with row j. Notation: $R_i \leftrightarrow R_j$.

2. Multiply row i by a scalar $c \neq 0$. Notation: $cR_i \rightarrow R_i$.

3. Multiply row i by a scalar c_i, multiply row j by a scalar c_j, then add the results and replace row j. Notation: $c_i R_i + c_j R_j \rightarrow R_j$.

The sequential application of the operations is performed until the following rules are satisfied:

1. If row r has its first nonzero entry in column c, then every entry in column c *below* row r is zero.

2. If row r_1 has its first nonzero entry in column c_1, row r_2 has its first nonzero entry in column c_2, and $r_1 < r_2$, then $c_1 < c_2$ is required.

3. Each row having all zero entries must lie below any other row having at least one nonzero entry.

EXAMPLE
A.5

Solve $x_1 + x_2 + x_3 = 6$, $x_1 + 3x_2 + 2x_3 = 11$, $2x_1 + 3x_2 - 4x_3 = 3$. The augmented matrix is

$$[A|\mathbf{b}] = \begin{bmatrix} 1 & 1 & 1 & | & 6 \\ 1 & 2 & 2 & | & 11 \\ 2 & 3 & -4 & | & 3 \end{bmatrix}$$

Apply elementary row operations to $[A|\mathbf{b}]$ so that the above rules are satisfied. For each row of the matrix, try to satisfy rule 1. The entry in the row that is used to eliminate the column entries below it is called a *pivot* and is nonzero. The pivots are indicated by boxes (in the following matrices). The process of getting from one matrix to another is denoted by the operator symbol \sim (row equivalent). The elementary

row operations applied in that step are written below that symbol.

$$
\begin{bmatrix}
\boxed{1} & 1 & 1 & 6 \\
1 & 2 & 2 & 11 \\
2 & 3 & -4 & 3
\end{bmatrix}
\begin{array}{c} \sim \\ -R_1 + R_2 \to R_2 \\ -2R_1 + R_3 \to R_3 \end{array}
\begin{bmatrix}
1 & 1 & 1 & 6 \\
0 & \boxed{1} & 1 & 5 \\
0 & 1 & -6 & -9
\end{bmatrix}
$$

$$
\begin{array}{c} \sim \\ -R_2 + R_3 \to R_3 \end{array}
\begin{bmatrix}
1 & 1 & 1 & 6 \\
0 & 1 & 1 & 5 \\
0 & 0 & -7 & -14
\end{bmatrix}
$$

The system of equations corresponding to this reduced matrix is $x_1 + x_2 + x_3 = 6$, $x_2 + x_3 = 5$, and $-7x_3 = -14$. ■

Back substitution involves solving for $x_n, x_{n-1}, \ldots, x_1$, one at a time using the system obtained by forward elimination. In the last example we can solve the third equation for $x_3 = 2$. Substituting x_3 in the second equation: $x_2 = 5 - x_3 = 5 - 2 = 3$. Substituting x_2 and x_3 in the first equation: $x_1 = 6 - x_2 - x_3 = 6 - 3 - 2 = 1$.

We will now count operations, just like we did for the case of two equations in two unknowns. To simplify matters, let us assume that $m = n$ and that no rows need to be swapped. The first step of forward elimination is to zero out all entries below a_{11} in the first column.

$$
[A|\mathbf{b}] =
\begin{bmatrix}
a_{11} & a_{12} & \cdots & a_{1n} & b_1 \\
a_{21} & a_{22} & \cdots & a_{2n} & b_2 \\
\vdots & \vdots & & \vdots & \vdots \\
a_{n1} & a_{n2} & \cdots & a_{nn} & b_n
\end{bmatrix}
\begin{array}{c} \sim \\ a_{11}R_2 - a_{21}R_1 \to R_2 \\ \vdots \\ a_{11}R_n - a_{n1}R_1 \to R_n \end{array}
$$

$$
\begin{bmatrix}
a_{11} & a_{12} & \cdots & a_{1n} & b_1 \\
0 & a_{11}a_{22} - a_{21}a_{12} & \cdots & a_{11}a_{2n} - a_{21}a_{1n} & a_{11}b_2 - a_{21}b_1 \\
\vdots & \vdots & & \vdots & \vdots \\
0 & a_{11}a_{n2} - a_{n1}a_{12} & \cdots & a_{11}a_{nn} - a_{n1}a_{1n} & a_{11}b_n - a_{n1}a_{11}b_1
\end{bmatrix}
$$

$$
=
\begin{bmatrix}
a_{11} & a_{12} & \cdots & a_{1n} & b_1 \\
0 & a'_{11} & \cdots & a'_{1,n-1} & b'_1 \\
\vdots & \vdots & & \vdots & \vdots \\
0 & a'_{n-1,1} & \cdots & a'_{n-1,n-1} & b'_{n-1}
\end{bmatrix}
$$

Note that the $(n - 1) \times n$ submatrix consisting of the a'_{ij} and b'_i is set up for the next forward elimination step, thus leading to a recursive process.

Define C_n to be the cost of the arithmetic operations for solving the system of equations using Gaussian elimination. Let F_n be the cost of forward elimination and let B_n be the cost of back substitution; then $C_n = F_n + B_n$. The forward elimination phase takes an augmented matrix of size $n \times (n+1)$ and reduces the problem to one involving an augmented matrix of size $(n-1) \times n$. The cost for forward elimination on the reduced augmented matrix is F_{n-1}. The elimination requires $n-1$ elementary row operations. Each row operation modifies n column entries; we do not count the replacement of the first column entry by zero. Each modified column entry requires 2 multiplications and 1 addition. If α represents the cost of an addition and μ represents the cost of a multiplication, the zeroing of the first column entries has a cost $(2\mu + \alpha)n(n-1)$. The forward elimination cost must satisfy

$$F_n = (2\mu + \alpha)n(n-1) + F_{n-1}, \quad n \geq 2$$

For a single equation in a single unknown ($n=1$), no forward elimination is necessary, so $F_1 = 0$. This is an example of a *linear difference equation*. This equation, though, is easy to solve. Note that

$$F_i - F_{i-1} = (2\mu + \alpha)i(i-1)$$

$$\sum_{i=2}^{n} (F_i - F_{i-1}) = \sum_{i=2}^{n} (2\mu + \alpha)i(i-1)$$

$$F_n - F_1 = (2\mu + \alpha)\sum_{i=2}^{n} i(i-1)$$

$$F_n = (2\mu + \alpha)\frac{n(n^2-1)}{3}$$

The summation on the left-hand side is called a *telescoping sum*. The quantity $-F_j$ appears in one term of the summation, then appears as F_j in the next term and is canceled. The cancellation occurs for all but F_1 and F_n. The right-hand summation is evaluated using standard formulas for summation, $\sum_{i=1}^{n} i = n(n+1)/2$ and $\sum_{i=1}^{n} i^2 = n(n+1)(2n+1)/6$. The number of operations for forward elimination is therefore on the order of n^3.

Now let us compute the cost of back substitution. After forward elimination, the augmented matrix is of the form

$$\begin{bmatrix} \alpha_{11} & \alpha_{12} & \cdots & \alpha_{1n} & \beta_1 \\ 0 & \alpha_{22} & \cdots & \alpha_{2n} & \beta_2 \\ \vdots & \vdots & \ddots & \vdots & \vdots \\ 0 & 0 & \cdots & \alpha_{nn} & \beta_n \end{bmatrix}$$

where $\alpha_{ij} = 0$ for $i > j$. The back substitution is

$$x_n = \frac{\beta_n}{\alpha_{nn}} \qquad\qquad \text{1 division}$$

$$x_{n-1} = \frac{\beta_{n-1} - \alpha_{n-1,n} * x_n}{\alpha_{n-1,n-1}} \qquad\qquad \text{1 multiply, 1 add, 1 division}$$

$$\vdots$$

$$x_1 = \frac{\beta_1 - \alpha_{12} * x_2 - \cdots - \alpha_{1n} * x_n}{\alpha_{11}} \qquad n - 1 \text{ multiplies, } n - 1 \text{ adds, 1 division}$$

If δ is the cost of a division and α and μ are as before,

$$B_n = (\delta) + (\mu + \alpha + \delta) + \cdots + ((n - 1)\mu + (n - 1)\alpha + \delta)$$

$$= \delta n + \sum_{i=0}^{n-1} (\mu + \alpha)i$$

$$= \delta n + (\mu + \alpha)\frac{n(n - 1)}{2}$$

The number of operations is on the order of n^2, so clearly forward elimination is the dominant cost in solving the system. The total cost for Gaussian elimination is

$$C_n = F_n + B_n = (2\mu + \alpha)\frac{n(n^2 - 1)}{3} + (\mu + \alpha)\frac{n(n - 1)}{2} + \delta n$$

A long story, but this is the classical method for solving linear systems and counting how many operations it takes to estimate the cost of solving systems. The cost is not particularly important for small n, but for very large n it becomes an issue.

EXERCISE Ⓔ
A.1
The forward elimination is designed to satisfy the constraint mentioned earlier: *If row r has its first entry in column c, then every entry in column c below row r is zero.* Change this constraint to: *If row r has its first entry in column c, then every other entry in column c is zero.* The entries above as well as below entry (r, c) must be zeroed out using elementary row operations. Determine the total cost C_n for this new elimination method. Compare it to the cost for Gaussian elimination. ▪

A.2.3 NONSQUARE SYSTEMS OF EQUATIONS

Although I illustrated Gaussian elimination for systems of equations with the same number of unknowns as equations, the same process applies to systems with any number of equations and unknowns. Some examples are shown below for solving general linear systems.

In general after application of the relevant elementary row operations, if row r has its first nonzero entry in column c, then the variable x_c is referred to as a *basic variable*. All other variables are referred to as *free variables*. The quantity of basic variables is called the *rank* of the matrix, denoted rank(A), where A is the matrix of coefficients. Gaussian elimination allows us to solve for the basic variables in terms of the free variables.

A.2.4 THE GEOMETRY OF LINEAR SYSTEMS

The last section was about the algebraic manipulations needed to solve a system of linear equations. The linear equations have geometric counterparts that, perhaps, provide greater insight about what the solution set of a system really is. Let us look at the simplest example, a system of two equations in two unknowns.

Consider $a_{11}x_1 + a_{12}x_2 = b_1$ and $a_{21}x_1 + a_{22}x_2 = b_2$. I assume that either a_{11} or a_{12} is nonzero and either a_{21} or a_{22} is nonzero. Each of these equations represents a line in the plane. The geometric possibilities are listed below.

1. The lines are not parallel. They intersect in a single point.

2. The lines are parallel and disjoint. They do not intersect.

3. The lines are the same. The set of points common to both is infinite.

Figure A.1 shows these configurations.

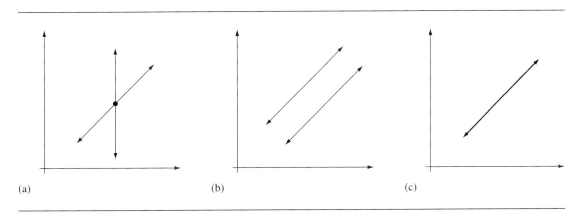

(a) (b) (c)

Figure A.1 (a) Two nonparallel lines. (b) Two parallel and disjoint lines. (c) Two coincident lines (shown in bold black).

The vector (a_{11}, a_{12}) is normal to the first line and the vector (a_{21}, a_{22}) is normal to the second line. If the two lines are parallel or the same line, then their normals are parallel. Consequently, one vector is a multiple of the other, say, $(a_{11}, a_{12}) = t(a_{21}, a_{22})$ for some nonzero scalar t. Define $a_{11}a_{22} - a_{12}a_{21}$; then

$$a_{11}a_{22} - a_{12}a_{21} = ta_{21}a_{22} - a_{12}ta_{21} = 0$$

Conversely, the two lines are not parallel when $a_{11}a_{22} - a_{12}a_{21} \neq 0$, an algebraic condition that guarantees that the two lines intersect in a single point and the linear system has a unique solution. If $a_{11}a_{22} - a_{12}a_{21} = 0$, the lines are parallel and either disjoint or coincident. The second equation of the system can be multiplied by t to obtain

$$tb_2 = ta_{21}x_1 + ta_{22}x_2 = a_{11}x_1 + a_{12}x_2 = b_1$$

These equalities are valid only when $b_1 = tb_2$, in which case the two lines are coincident. Notice that $(a_{11}, a_{12}, b_1) = t(a_{21}, a_{22}, b_2)$ in this case. The value d is computed without explicty computing the multiplier t. We may obtain a similar expression without t that indicates that the lines are coincident. Specifically, $(a_{11}, b_1) = t(a_{21}, b_2)$ implies $a_{11}b_2 - a_{21}b_1 = 0$. Equivalently, $(a_{12}, b_1) = t(a_{22}, b_2)$ implies $a_{12}b_1 - a_{22}b_2 = 0$. If $b_1 \neq tb_2$, the lines are parallel and disjoint. The algebraic equivalents to the three geometric possibilites mentioned earlier are summarized below.

1. $a_{11}a_{22} - a_{12}a_{21} \neq 0$: The lines are not parallel. The linear system has a unique solution.

2. $a_{11}a_{22} - a_{12}a_{21} = 0$ and $a_{11}b_2 - a_{21}b_1 \neq 0$: The lines are parallel and disjoint. The linear system has no solution.

3. $a_{11}a_{22} - a_{12}a_{21} = 0$ and $a_{11}b_2 - a_{21}b_1 = 0$: The two lines are the same. The linear system has infinitely many solutions.

A similar algebra-geometry relationship exists for equations involving three variables. Consider three equations in three unknowns, $\sum_{j=1}^{3} a_{ij}x_j = b_i$ for $1 \leq i \leq 3$. A single equation represents a plane in three dimensions. If this is the only equation of the system, the set of solutions is infinite and is represented by all the points on the plane. The possibilities for two equations in three unknowns are listed below.

1. The planes are not parallel. They intersect in a line.

2. The planes are parallel and disjoint. They do not intersect.

3. The planes are parallel and coincident.

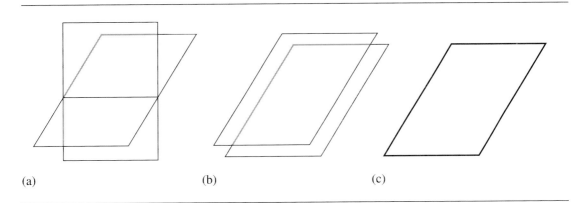

(a) (b) (c)

Figure A.2 (a) Two nonparallel planes. (b) Two parallel and disjoint planes. (c) Two coincident planes (shown in bold black).

Figure A.2 shows these configurations.
Three equations in three unknowns lead to yet more possibilities.

1. No two planes are parallel.

 (a) The planes intersect in a single point.
 (b) The planes intersect in a line.
 (c) The three planes have no common point.

2. Two planes are parallel; the third is not parallel to them.

 (a) The two parallel planes are disjoint. The three planes have no common point.
 (b) The two parallel planes are coincident. The three planes intersect in a line.

3. All three planes are parallel.

 (a) At least two planes are not coincident. The three planes have no common point.
 (b) All planes are coincident. The intersection set is the common plane.

Figure A.3 shows these configurations. The intersection set is either empty, a single point, a line, or a plane. Further geometric interpretations of linear equations and their solutions are discussed later in Section A.4.7.

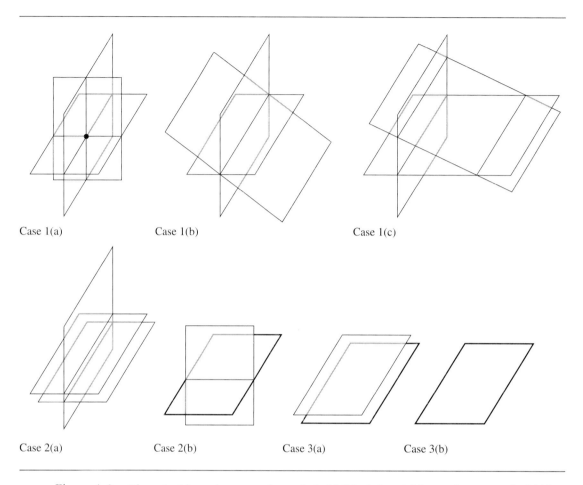

Case 1(a) Case 1(b) Case 1(c)

Case 2(a) Case 2(b) Case 3(a) Case 3(b)

Figure A.3 The coincident planes are shown in bold (black for visible portions, gray for hidden portions).

A.2.5 NUMERICAL ISSUES

The method of Gaussian elimination was discussed previously in mathematical terms without regard to numerical issues that can arise when implemented on a computer. The main issue is using the first nonzero entry in a row, the pivot, to zero out the column entries below it. The reciprocal of the pivot is required in the process. If the pivot is nearly zero, the division can be a source of numerical errors.

Consider a system whose augmented matrix is

$$\left[\begin{array}{cc|c} \varepsilon & 1 & 1 \\ 1 & 2 & -1 \end{array} \right] \tag{A.1}$$

where ε is a number that is nearly zero. If that entry is used as the pivot, then formally we can row-reduce the augmented matrix to

$$\left[\begin{array}{cc|c} 1 & 1/\varepsilon & 1/\varepsilon \\ 0 & 2 - 1/\varepsilon & -1 - 1/\varepsilon \end{array} \right]$$

This matrix now has very large entries due to $1/\varepsilon$. The numerical representations of some of the numbers are now suspect. For example, the floating point calculation for $2 - 1/\varepsilon$ could effectively ignore the 2 if $1/\varepsilon$ is so large that in matching the exponents of the two numbers to allow the floating point sum of the mantissas, the intermediate representation of 2 is the floating point number zero.

A better algorithm involves searching the entries in the first column of the augmented matrix and looking for the pivot that is largest in absolute magnitude. In the example we should have swapped the two equations:

$$\left[\begin{array}{cc|c} 1 & 2 & -1 \\ \varepsilon & 1 & 1 \end{array} \right] \tag{A.2}$$

The forward elimination produces

$$\left[\begin{array}{cc|c} 1 & 2 & -1 \\ 0 & 1 - 2\varepsilon & 1 + \varepsilon \end{array} \right]$$

The last equation is solved for $x_2 = (1 + \varepsilon)/(1 - 2\varepsilon)$. For ε nearly zero, the denominator is nearly 1 and the division is numerically well behaved. The other variable is $x_1 = -3/(1 - 2\varepsilon)$.

EXERCISE A.2

Write a computer program to solve the system in equation (A.1) using Gaussian elimination so that the first pivot *is* ε. Allow this parameter to be supplied by the caller of the function for solving the system. The program should also have a function for solving the system in the form of equation (A.2), where ε is a parameter to the function. The test program should implement a loop that starts with $\varepsilon = 0.1$ and solves the system. On each successive iteration, replace ε by $\varepsilon/2$. The system should be solved using each of the two functions. Compare the results as ε becomes very small. ■

The search for a pivot entry of largest absolute magnitude is a good approach in solving systems. However, the next example shows that even this can be a problem. The system is

$$\varepsilon_1 x_1 + x_2 = 1$$
$$\varepsilon_2 x_1 + 2x_2 = -1$$

where ε_1 and ε_2 are both nearly zero. Regardless of which of these entries is largest in absolute magnitude, forward elimination will require a division by a number that is nearly zero. A close inspection of the system will show that we were unfortunate to name the variables as shown! Had we made x_2 the "first" variable and x_1 the "second" variable, the division problem disappears. That is, name $y_1 = x_2$ and $y_2 = x_1$ and obtain the system

$$y_1 + \varepsilon_1 y_2 = 1$$

$$2y_1 + \varepsilon_2 y_2 = -1$$

The augmented matrix and the forward elimination are shown:

$$\left[\begin{array}{cc|c} 1 & \varepsilon_1 & 1 \\ 2 & \varepsilon_2 & -1 \end{array}\right] \sim \left[\begin{array}{cc|c} 1 & \varepsilon_1 & 1 \\ 0 & \varepsilon_2 - 2\varepsilon_1 & -3 \end{array}\right]$$

The forward elimination step is well behaved numerically, but now we need to solve for $x_2 = -3/(\varepsilon_2 - 2\varepsilon_1)$ where the denominator is nearly zero. This is unavoidable; the system is ill-conditioned in the sense that if ε_1 and ε_2 really were zero, the equations would be $y_1 = 1$ and $2y_1 = -1$, implying that $y_1 = 1$ and $y_1 = -1/2$, an impossibility. Even so, the divisions in the back substitution can be deferred (by using back elimination instead) to make sure any numerical round-off errors from one division are not propagated (and magnified) through the remaining divisions. In our example, the operation is $R_1 \leftarrow (\varepsilon_2 - 2\varepsilon_1)R_1 - \varepsilon_1 R_2$:

$$\left[\begin{array}{cc|c} \varepsilon_2 - 2\varepsilon_1 & 0 & \varepsilon_1 + \varepsilon_2 \\ 0 & \varepsilon_2 - 2\varepsilon_1 & -3 \end{array}\right]$$

If the application decides inversion of $\varepsilon_2 - 2\varepsilon_1$ is justified, the division $\lambda = 1/(\varepsilon_2 - 2\varepsilon_1)$ is calculated once. The system solution is $y_1 = (\varepsilon_1 + \varepsilon_2)\lambda$ and $y_2 = -3\lambda$.

The renaming of x_1 and x_2 to y_2 and y_1 amounts to swapping *columns* of the augmented matrix. This is not an elementary row operation, so additional bookkeeping must be done to reconstruct the solution components in the order in which they were specified. You can do this by maintaining a permutation vector of indices. In the example the original variable indices are stored as $(1, 2)$. When the column swap is deemed appropriate, and memory swapping is actually performed in a computer implementation, the permutation vector indices are swapped to $(2, 1)$. If the final values obtained on the right-hand sides of the equations after Gaussian elimination are

(c_1, c_2) and the permutation vector is (i_1, i_2), one of $(1, 2)$ or $(2, 1)$, then the system solution is $x_{i_1} = c_1$ and $x_{i_2} = c_2$.

Generally, for a system of n equations in n unknowns, you can search the entire matrix of coefficients looking for the entry of largest absolute magnitude to be used as the pivot. This process is known as *full pivoting*. If that entry occurs in row r and column c, then rows r and 1 are swapped followed by a swap of column c and column 1. The original permutation vector is $(1, 2, \ldots, c, \ldots, n)$; the new vector is $(c, 2, \ldots, 1, \ldots, n)$. After both swaps, the entry in row 1 and column 1 is the largest absolute magnitude entry in the matrix. If nearly zero, the linear system is ill-conditioned and you may choose to stop solving and notify the user of this situation. If you choose to continue, the division can be performed to make the pivot 1 and forward elimination commences. The process is repeated for the submatrix of $n - 1$ rows and $n - 1$ columns. Many column swaps can occur during the process. Let the final values obtained on the right-hand sides of the equation be listed as (c_1, \ldots, c_n). Let the permutation vector be (i_1, \ldots, i_n), a permutation of $(1, \ldots, n)$. The system solution is $x_{i_j} = c_j$ for $1 \le j \le n$.

A.2.6 ITERATIVE METHODS FOR SOLVING LINEAR SYSTEMS

As it turns out, Gaussian elimination is not the final word in solving systems. Iterative methods can be used. After all, why look for the exact mathematical solution when a good numerical approximation will do! Such algorithms are typically used in *sparse linear systems*. These systems have a large number of equations, but each equation involves only a small subset of the variables. The matrix A for the system is large, but has only a small number of nonzero entries. I will not go into great detail as this topic is quite extensive, but here are a couple of possibilities on which to ponder.

The first method we look at is known as a *splitting method*. I will illustrate for a system of two equations in two unknowns:

$$a_{11}x_1 + a_{12}x_2 = b_1$$
$$a_{21}x_1 + a_{22}x_2 = b_2$$

For simplicity of the presentation, suppose that $a_{11} \ne 0$ and $a_{22} \ne 0$. The system can be rewritten as

$$x_1 = \frac{b_1 - a_{12}x_2}{a_{11}}$$

$$x_2 = \frac{b_2 - a_{21}x_1}{a_{22}}$$

The term *splitting* refers to splitting up the equations into the terms corresponding to the diagonal entries and the terms corresponding to the nondiagonal entries. Why bother with this form when it clearly does not give us a solution? The concept

is to generate a sequence of iterates $x^{(1)}, x^{(2)}, \ldots, x^{(n)}$, where n is large enough that $x^{(n)}$ is an acceptable approximation to the actual solution to the equation. At the same time we want n small enough to minimize the computational time in producing the approximation. Each iterate is of the form $x^{(i)} = (x_1^{(i)}, x_2^{(i)})$. The key idea is to relate the iterates by modifying the split equations to

$$x_1^{(i+1)} = \frac{b_1 - a_{12}x_2^{(i)}}{a_{11}}$$

$$x_2^{(i+1)} = \frac{b_2 - a_{21}x_1^{(i)}}{a_{22}}$$

The left-hand side is the next iterate and is obtained by substituting the current iterate into the right-hand side. Whether or not the sequence of iterates converges to the exact solution depends on your particular system. Another issue is that if any of the a_{ii} are nearly zero, the division by that small number can cause numerical problems. The splitting used here to illustrate the concept is not the only one. In fact, each equation on the right-hand side of the split system might very well contain all of the original variables. Such is the case when one of the a_{ii} is zero or nearly zero. Ideally, you want to split your terms so that you get rapid convergence and avoid numerical problems.

The second iterative method involves formulating the linear system $\mathbf{A}\mathbf{x} = \mathbf{b}$ as a minimization problem. The illustration here is for a system of two equations in two unknowns. The two equations may be written as $a_{11}x_1 + a_{12}x_2 - b_1 = 0$ and $a_{21}x_1 + a_{22}x_2 - b_2 = 0$. The sum of squares of the left-hand sides must be zero:

$$f(x_1, x_2) = (a_{11}x_1 + a_{12}x_2 - b_1)^2 + (a_{21}x_1 + a_{22}x_2 - b_2)^2 = 0$$

Observe that $f(x_1, x_2) \geq 0$ no matter the choice of input. Assuming the system has a unique solution, the graph of this function is a paraboloid whose vertex lies in the x_1x_2-plane and is the solution to the system of equations. An iterative minimization algorithm takes the current iterate $x^{(i)}$, where $f(x^{(i)}) > 0$, and produces the next iterate $x^{(i+1)}$ so that (hopefully) $f(x^{(i+1)}) < f(x^{(i)})$. You can visualize the iterates on the graph of f as a sequence of points $(x_1^{(i)}, x_2^{(i)}, f(x_1^{(i)}, x_2^{(i)}))$ for $i \geq 1$ that descend toward the vertex of the paraboloid. A good choice for generating the iterates is the *conjugate gradient method*, but other methods may be applied as well. See [PFTV88] for a discussion of numerical methods for function minimization.

A.3 MATRICES

Gaussian elimination applied to a system of linear equations is accomplished by setting up a table of numbers called an *augmented matrix*. The algebraic operations are applied only to the equation coefficients. The variable names themselves are unimportant in the manipulations. The concept of matrices is more powerful if we allow

additional structure to be placed on them. Part of that structure is introduced here in the context of solving linear systems of equations. More structure is introduced later where matrices are shown to be naturally related to the concept of a linear transformation.

The matrix of coefficients for the system of n equations in m unknowns is denoted $A = [a_{ij}]$ and has n rows and m columns. The column matrix for the right-hand side values is denoted $\mathbf{b} = [b_i]$ and has n rows and, of course, one column. Similarly we define the column matrix $\mathbf{x} = [x_j]$ that has m rows and one column. The concise representation for a linear system using summation notation is

$$\sum_{j=1}^{m} a_{ij}x_j = b_i, \quad 1 \le i \le n$$

A suggestive shorthand notation is $A\mathbf{x} = \mathbf{b}$ and makes the linear system appear symbolically to be a single linear equation with known values A and \mathbf{b} and unknown value \mathbf{x}. For this to really make sense, we need to formalize what it means to multiply the matrices A and \mathbf{x} and obtain the product $A\mathbf{x}$. Consider a system with two equations and three unknowns: $a_{11}x_1 + a_{12}x_2 + a_{13}x_3 = b_1, a_{21}x_1 + a_{22}x_2 + a_{23}x_3 = b_2$. The symbolic form $A\mathbf{x} = \mathbf{b}$ with juxtaposed matrices is

$$\begin{bmatrix} a_{11} & a_{12} & a_{13} \\ a_{21} & a_{22} & a_{23} \end{bmatrix} \begin{bmatrix} x_1 \\ x_2 \\ x_3 \end{bmatrix} = \begin{bmatrix} b_1 \\ b_2 \end{bmatrix}$$

In order to re-create the linear equations, it appears that we need to multiply each row of A with the column \mathbf{x}, then equate the resulting product with the corresponding row of the column \mathbf{b}. For this to work, clearly the number of columns of A must equal the number of rows of \mathbf{x}. We will use this as motivation for defining the product of two matrices A and B. Let A have n rows and m columns. For the product $C = AB$ to make sense, the number of rows of B must be m. Let B have p columns. The product C itself is a matrix of numbers. Your intuition from the example of a linear system should convince you that C has n rows and p columns. Symbolically $AB = C$ is shown next.

$$\begin{bmatrix} a_{11} & a_{12} & \cdots & a_{1m} \\ a_{21} & a_{22} & \cdots & a_{2m} \\ \vdots & \vdots & \ddots & \vdots \\ a_{n1} & a_{n2} & \cdots & a_{nm} \end{bmatrix} \begin{bmatrix} b_{11} & b_{12} & \cdots & b_{1p} \\ b_{21} & b_{22} & \cdots & b_{2p} \\ \vdots & \vdots & \ddots & \vdots \\ b_{m1} & b_{m2} & \cdots & b_{mp} \end{bmatrix}$$

$$= \begin{bmatrix} (a_{11}b_{11} + \cdots + a_{1m}b_{m1}) & (a_{11}b_{12} + \cdots + a_{1m}b_{m2}) & \cdots & (a_{11}b_{1p} + \cdots + a_{1m}b_{mp}) \\ (a_{21}b_{11} + \cdots + a_{2m}b_{m1}) & (a_{21}b_{12} + \cdots + a_{2m}b_{m2}) & \cdots & (a_{21}b_{1p} + \cdots + a_{2m}b_{mp}) \\ \vdots & \vdots & \ddots & \vdots \\ (a_{n1}b_{11} + \cdots + a_{nm}b_{m1}) & (a_{n1}b_{12} + \cdots + a_{nm}b_{m2}) & \cdots & (a_{n1}b_{1p} + \cdots + a_{nm}b_{mp}) \end{bmatrix}$$

$$= \begin{bmatrix} c_{11} & c_{12} & \cdots & c_{1p} \\ c_{21} & c_{22} & \cdots & c_{2p} \\ \vdots & \vdots & \ddots & \vdots \\ c_{n1} & c_{n2} & \cdots & c_{np} \end{bmatrix}$$

In summation notation, the general entry of the product is

$$c_{ij} = \sum_{k=1}^{m} a_{ik}b_{kj}$$

for $1 \le i \le n$ and $1 \le j \le p$.

EXAMPLE A.6

Consider the matrices

$$A = \begin{bmatrix} 1 & 0 & -1 \\ -1 & 2 & 0 \end{bmatrix} \quad \text{and} \quad B = \begin{bmatrix} -1 & 1 & 2 \\ 0 & 1 & -3 \\ -2 & 3 & 0 \end{bmatrix}$$

The product AB is

$$AB = \begin{bmatrix} 1 & 0 & -1 \\ -1 & 2 & 0 \end{bmatrix} \begin{bmatrix} -1 & 1 & 2 \\ 0 & 1 & -3 \\ -2 & 3 & 0 \end{bmatrix} = \begin{bmatrix} c_{11} & c_{12} & c_{13} \\ c_{21} & c_{22} & c_{23} \end{bmatrix}$$

To compute c_{ij}, use the summation formula shown earlier,

$$c_{ij} = a_{i1}b_{1j} + a_{i2}b_{2j} + a_{i3}b_{3j} = \begin{bmatrix} a_{i1} & a_{i2} & a_{i3} \end{bmatrix} \begin{bmatrix} b_{1j} \\ b_{2j} \\ b_{3j} \end{bmatrix}$$

In the example, the product is

$$AB = \begin{bmatrix} 1 & -2 & 2 \\ 1 & 1 & -8 \end{bmatrix} \quad \blacksquare$$

A matrix that has n rows and m columns is referred to as an $n \times m$ matrix. In defining the product $C = AB$, A is an $n \times m$ matrix, B is an $m \times p$ matrix, and C is an $n \times p$ matrix. It is important to note that the order of the matrices in a product is relevant. For example, if A is 2×3 and B is 3×4, the product AB is defined and is 2×4. On the other hand, BA is not defined since the number of columns of B is different than the number of rows of A. Now, it is possible that both products are defined. This is the case when A is $n \times m$ and B is $m \times n$. The product AB is $n \times n$ and the product BA is $m \times m$. If $n \ne m$, then AB and BA cannot be the same matrix since their sizes are different. Even if $n = m$, the products still might differ. For example,

$$AB = \begin{bmatrix} 1 & 0 \\ 0 & 0 \end{bmatrix} \begin{bmatrix} 0 & 1 \\ 0 & 0 \end{bmatrix} = \begin{bmatrix} 0 & 1 \\ 0 & 0 \end{bmatrix} \ne \begin{bmatrix} 0 & 0 \\ 0 & 0 \end{bmatrix} = \begin{bmatrix} 0 & 1 \\ 0 & 0 \end{bmatrix} \begin{bmatrix} 1 & 0 \\ 0 & 0 \end{bmatrix} = BA$$

Matrix multiplication is therefore considered *not commutative*. It is the case that matrix multiplication is *associative*. That is, $A(BC) = (AB)C$ for matrices A, B, and C where the relevant pairwise products are defined.

A.3.1 SOME SPECIAL MATRICES

A few special types of matrices arise frequently in practice. Here are some that are of interest, some of general size $n \times m$ and some that are called *square matrices* where $n = m$ (number of rows and number of columns are the same).

The *diagonal entries* of an $n \times m$ matrix $A = [a_{ij}]$ are those entries a_{ii}. A square matrix $A = [a_{ij}]$ is a *diagonal matrix* if $a_{ij} = 0$ whenever $i \neq j$. That is, the nondiagonal terms are all zero. The diagonal terms can be anything, including zero. For example, consider

$$A = \begin{bmatrix} 1 & 2 & 3 \\ 4 & 5 & 6 \end{bmatrix} \quad \text{and} \quad B = \begin{bmatrix} 0 & 0 \\ 0 & 1 \end{bmatrix}$$

The diagonal entries of A are 1 and 5. The matrix B is diagonal. A shorthand notation for the diagonal matrix is to list only its diagonal entries, $B = \text{Diag}(0, 1)$.

A special diagonal matrix is the *identity matrix* I. All the diagonal entries are 1. The identity matrices for $n = 2$ and $n = 3$ are shown:

$$I = \begin{bmatrix} 1 & 0 \\ 0 & 1 \end{bmatrix} \quad \text{and} \quad I = \begin{bmatrix} 1 & 0 & 0 \\ 0 & 1 & 0 \\ 0 & 0 & 1 \end{bmatrix}$$

The identity matrix has the property that $IA = A$. That is, the product of the $n \times n$ identity matrix with the $n \times m$ matrix A does not change A.

If $A = [a_{ij}]$ is an $n \times m$ matrix, the *transpose* of A is the $m \times n$ matrix $A^T = [a_{ji}]$. That is, the entry a_{ij} in the ith row and jth column of A becomes the entry in the jth row and ith column of A^T. For example,

$$A = \begin{bmatrix} 1 & 2 & 3 \\ 4 & 5 & 6 \end{bmatrix} \quad \text{and} \quad A^T = \begin{bmatrix} 1 & 4 \\ 2 & 5 \\ 3 & 6 \end{bmatrix}$$

EXERCISE Ⓔ Verify that the transpose satisfies the property $(AB)^T = B^T A^T$. ▪
A.3

A square matrix A is *symmetric* if $A = A^T$. It is *skew-symmetric* if $A = -A^T$. For example, consider

$$A = \begin{bmatrix} 1 & 2 & 3 \\ 2 & 4 & 5 \\ 3 & 5 & 6 \end{bmatrix} \quad \text{and} \quad B = \begin{bmatrix} 0 & 1 & 2 \\ -1 & 0 & 3 \\ -2 & -3 & 0 \end{bmatrix}$$

The matrix A is symmetric and the matrix B is skew-symmetric. The diagonal entries of a skew-symmetric matrix are necessarily zero.

An $n \times m$ matrix $U = [u_{ij}]$ is said to be *upper echelon* if $u_{ij} = 0$ for $i > j$. In addition, if $n = m$, then U is said to be *upper triangular*. Similarly, an $n \times m$ matrix $L = [\ell_{ij}]$ is said to be *lower echelon* if $\ell_{ij} = 0$ for $i < j$. If $n = m$, then L is said to be *lower triangular*. For example, consider

$$U = \begin{bmatrix} 1 & 2 & 3 \\ 0 & 4 & 5 \end{bmatrix} \quad \text{and} \quad L = \begin{bmatrix} 1 & 0 \\ 2 & 3 \end{bmatrix}$$

The matrix U is upper echelon and the matrix L is lower triangular.

A.3.2 ELEMENTARY ROW MATRICES

Now that we have a concise symbolic representation of a system of equations, $A\mathbf{x} = \mathbf{b}$, let us review the forward elimination algorithm that reduces the augmented matrix $[A|\mathbf{b}]$. In our earlier discussion, the elimination was accomplished by applying elementary row operations to the augmented matrix in order to zero out various column entries below pivot elements. A reminder of the operations:

1. Interchange row i with row j. Notation: $R_i \leftrightarrow R_j$.

2. Multiply row i by a scalar $c \neq 0$. Notation: $cR_i \rightarrow R_i$.

3. Multiply row i by a scalar c_i, multiply row j by a scalar c_j, then add the results and replace row j. Notation: $c_i R_i + c_j R_j \rightarrow R_j$.

Each elementary row operation can be represented by a square matrix that multiplies the augmented matrix on its left.

Consider a general matrix A that is $n \times m$ (not necessarily an augmented matrix for a linear system). Let \mathcal{O} be an elementary row operation applied to A to obtain a matrix B of the same size as A. The notation we introduced in Example 4.5 was $A \sim_{\mathcal{O}} B$. There is an $n \times n$ matrix E such that $B = EA$. The elementary row matrix E corresponding to the elementary row operation \mathcal{O} is obtained by applying \mathcal{O} to the $n \times n$ identity matrix: $I \sim_{\mathcal{O}} E$.

EXAMPLE A.7

Consider the 3×4 matrix

$$A = \begin{bmatrix} 1 & -1 & 0 & 2 \\ 0 & 4 & -1 & -2 \\ 2 & 0 & 1 & 0 \end{bmatrix}$$

A type 1 operation is

$$A = \underset{R_1 \leftrightarrow R_2}{\sim} \begin{bmatrix} 0 & 4 & -1 & -2 \\ 1 & -1 & 0 & 2 \\ 2 & 0 & 1 & 0 \end{bmatrix} = \begin{bmatrix} 0 & 1 & 0 \\ 1 & 0 & 0 \\ 0 & 0 & 1 \end{bmatrix} A$$

A type 2 operation is

$$A = \underset{-2R_1 \to R_1}{\sim} \begin{bmatrix} -2 & 2 & 0 & -4 \\ 0 & 4 & -1 & -2 \\ 2 & 0 & 1 & 0 \end{bmatrix} = \begin{bmatrix} -2 & 0 & 0 \\ 0 & 1 & 0 \\ 0 & 0 & 1 \end{bmatrix} A$$

A type 3 operation is

$$A = \underset{-2R_1 + R_3 \to R_3}{\sim} \begin{bmatrix} 1 & -1 & 0 & 2 \\ 0 & 4 & -1 & -2 \\ 0 & 2 & 1 & -4 \end{bmatrix} = \begin{bmatrix} 1 & 0 & 0 \\ 0 & 1 & 0 \\ -2 & 0 & 1 \end{bmatrix} A$$

Observe that in all cases the 3×3 elementary row matrices shown on the right-hand side of the equations are obtained by applying the row operations to the 3×3 identity matrix. ∎

The final result of forward elimination can be stated in terms of elementary row matrices applied to the augmented matrix $[A|\mathbf{b}]$. Namely, if E_1 through E_k are the elementary row matrices corresponding to the applied elementary row operations, then the final augmented matrix is the product

$$[U|\mathbf{v}] = E_k \cdots E_1[A|\mathbf{b}]$$

The matrix $U = [u_{ij}]$ is *upper triangular*; that is, $u_{ij} = 0$ whenever $i > j$. The only possible nonzero entries are on or above the diagonal, the diagonal defined by entries where $i = j$. Back substitution is achieved by another sequence of elementary row operations, E_{k+1} through E_ℓ. The end result, assuming the diagonal entries of U are all nonzero, is

$$[I|\mathbf{w}] = (E_\ell \cdots E_{k+1})[U|\mathbf{v}] = (E_\ell \cdots E_1)[A|\mathbf{b}]$$

The solution to the linear system is $\mathbf{x} = \mathbf{w}$.

EXAMPLE A.8

This example was shown earlier, but is revisited in terms of elementary row matrices. Solve $x_1 + x_2 + x_3 = 6$, $x_1 + 3x_2 + 2x_3 = 11$, $2x_1 + 3x_2 - 4x_3 = 3$. The forward elimination is

$$[A|b] = \begin{bmatrix} 1 & 1 & 1 & | & 6 \\ 1 & 2 & 2 & | & 11 \\ 2 & 3 & -4 & | & 3 \end{bmatrix} \underset{-R_1 + R_2 \to R_2}{\sim} \begin{bmatrix} 1 & 1 & 1 & | & 6 \\ 0 & 1 & 1 & | & 5 \\ 2 & 3 & -4 & | & 3 \end{bmatrix} \underset{-2R_1 + R_3 \to R_3}{\sim}$$

$$\begin{bmatrix} 1 & 1 & 1 & | & 6 \\ 0 & 1 & 1 & | & 5 \\ 0 & 1 & -6 & | & -9 \end{bmatrix} \underset{-R_2 + R_3 \to R_3}{\sim} \begin{bmatrix} 1 & 1 & 1 & | & 6 \\ 0 & 1 & 1 & | & 5 \\ 0 & 0 & -7 & | & -14 \end{bmatrix} = [U|v]$$

(Example A.8 continued)

The backward substitution is

$$[U|v] = \begin{bmatrix} 1 & 1 & 1 & | & 6 \\ 0 & 1 & 1 & | & 5 \\ 0 & 0 & -7 & | & -14 \end{bmatrix} \quad \overset{\sim}{\underset{-(1/7)R_3 \to R_3}{}} \quad \begin{bmatrix} 1 & 1 & 1 & | & 6 \\ 0 & 1 & 1 & | & 5 \\ 0 & 0 & 1 & | & 2 \end{bmatrix}$$

$$\overset{\sim}{\underset{-R_3 + R_2 \to R_2}{}} \begin{bmatrix} 1 & 1 & 1 & | & 6 \\ 0 & 1 & 0 & | & 3 \\ 0 & 0 & 1 & | & 2 \end{bmatrix} \quad \overset{\sim}{\underset{-R_3 + R_1 \to R_1}{}} \begin{bmatrix} 1 & 1 & 0 & | & 4 \\ 0 & 1 & 0 & | & 3 \\ 0 & 0 & 1 & | & 2 \end{bmatrix}$$

$$\overset{\sim}{\underset{-R_2 + R_1 \to R_1}{}} \begin{bmatrix} 1 & 0 & 0 & | & 1 \\ 0 & 1 & 0 & | & 3 \\ 0 & 0 & 1 & | & 2 \end{bmatrix} = [I|w]$$

The solution is $x_1 = 1$, $x_2 = 3$, and $x_3 = 2$. The elementary row matrices listed in the order of operations shown previously are

$$E_1 = \begin{bmatrix} 1 & 0 & 0 \\ -1 & 1 & 0 \\ 0 & 0 & 1 \end{bmatrix}, \quad E_2 = \begin{bmatrix} 1 & 0 & 0 \\ 0 & 1 & 0 \\ -2 & 0 & 1 \end{bmatrix}, \quad E_3 = \begin{bmatrix} 1 & 0 & 0 \\ 0 & 1 & 0 \\ 0 & -1 & 1 \end{bmatrix},$$

$$E_4 = \begin{bmatrix} 1 & 0 & 0 \\ 0 & 1 & 0 \\ 0 & 0 & -1/7 \end{bmatrix}, \quad E_5 = \begin{bmatrix} 1 & 0 & 0 \\ 0 & 1 & -1 \\ 0 & 0 & 1 \end{bmatrix}, \quad E_6 = \begin{bmatrix} 1 & 0 & -1 \\ 0 & 1 & 0 \\ 0 & 0 & 1 \end{bmatrix},$$

$$E_7 = \begin{bmatrix} 1 & -1 & 0 \\ 0 & 1 & 0 \\ 0 & 0 & 1 \end{bmatrix} \quad \blacksquare$$

A.3.3 INVERSE MATRICES

The linear system is symbolically written as $A\mathbf{x} = \mathbf{b}$. The product of the elementary row operations used in solving the system is $P = E_\ell \cdots E_1$. The application of all the elementary row matrices at one time is $\mathbf{x} = PA\mathbf{x} = P\mathbf{b} = \mathbf{w}$. An implication of the construction is that $PA = I$, where I is the identity matrix. We use this as motivation for the *inverse* of a square matrix. That is, if A is an $n \times n$ matrix and if P is another $n \times n$ matrix for which $PA = I$, then P is the inverse of A and is denoted A^{-1}.

EXAMPLE A.9

In the last example, the product of the elementary row matrices is

$$P = E_7 \cdot E_1 = \begin{bmatrix} 2 & -1 & 0 \\ -\frac{8}{7} & \frac{6}{7} & \frac{1}{7} \\ 1 & 1 & -1 \end{bmatrix}$$

It is easily verified that

$$PA = \begin{bmatrix} 2 & -1 & 0 \\ -\frac{8}{7} & \frac{6}{7} & \frac{1}{7} \\ 1 & 1 & -1 \end{bmatrix} \begin{bmatrix} 1 & 1 & 1 \\ 1 & 2 & 2 \\ 2 & 3 & -4 \end{bmatrix} = \begin{bmatrix} 1 & 0 & 0 \\ 0 & 1 & 0 \\ 0 & 0 & 1 \end{bmatrix} = I$$

If you are curious, verify that $AP = I$ also. ▪

EXAMPLE A.10

Not all square matrices are invertible. The 2×2 *zero matrix* is clearly not invertible:

$$Z = \begin{bmatrix} 0 & 0 \\ 0 & 0 \end{bmatrix}$$

since $PZ = Z$ no matter which 2×2 matrix P you choose. A more interesting example of a noninvertible matrix is

$$A = \begin{bmatrix} 1 & -1 \\ -1 & 1 \end{bmatrix}$$

You may attempt to construct one, say,

$$P = \begin{bmatrix} a & b \\ c & d \end{bmatrix}$$

For this matrix to be the inverse, we need

$$\begin{bmatrix} 1 & 0 \\ 0 & 1 \end{bmatrix} = I = PA = \begin{bmatrix} a - b & b - a \\ c - d & d - c \end{bmatrix}$$

Equating the first row entries yields $a - b = 1$ and $b - a = 0$. The second of these forces $b = a$. Replacing in the first leads to $0 = 1$, a false statement. Thus, A is not invertible. ▪

The elementary row matrices have inverses. The list of the elementary row operations and their inverse operations is provided:

Row Operation	Inverse Operation
$R_i \leftrightarrow R_j$	$R_i \leftrightarrow R_j$
$cR_i \to R_i$	$\frac{1}{c} R_i \to R_i$
$cR_i + R_j \to R_j$	$-cR_i + R_j \to R_j$

If E represents an elementary row operation, then E^{-1} denotes the matrix that represents the inverse operation.

EXAMPLE
A.11

The 3×3 elementary row matrix corresponding to the row operation $-2R_1 + R_3 \rightarrow R_3$ is

$$E = \begin{bmatrix} 1 & 0 & 0 \\ 0 & 1 & 0 \\ -2 & 0 & 1 \end{bmatrix}$$

The inverse row operation is $2R_1 + R_3 \rightarrow R_3$ and

$$E^{-1} = \begin{bmatrix} 1 & 0 & 0 \\ 0 & 1 & 0 \\ 2 & 0 & 1 \end{bmatrix}$$

It is easily shown that $E^{-1} E = I$, where I is the 3×3 identity matrix. ∎

A.3.4 PROPERTIES OF INVERSES

Here are some important properties of inverses. The first one is quite subtle. The definition of inverse was that P is an inverse of A when $PA = I$. More precisely, P is a *left inverse*. I already pointed out that matrix multiplication is generally not commutative, so $PA = I$ does not immediately imply $AP = I$.

1. If $A^{-1}A = I$, then $AA^{-1} = I$. This is the same as saying that the inverse of A^{-1} is A: $(A^{-1})^{-1}$.

2. Inverses are unique.

3. If A and B are invertible, then so is AB. Its inverse is $(AB)^{-1} = B^{-1}A^{-1}$.

To prove the first item, I use the method of solution for linear systems as motivation. The system is $Ax = b$ and, assuming A is invertible, has solution $x = A^{-1}b$. Symbolically, this is obtained as

$$x = Ix = (A^{-1}A)x = A^{-1}(Ax) = A^{-1}b$$

Now replace this in the original equation to obtain

$$(AA^{-1})b = A(A^{-1}b) = Ax = b$$

The column matrix b can be anything you like. Regardless of the choice it is the case that $(AA^{-1})b = b$. Some clever choices will help us out. Define e_i to be the $n \times 1$ row matrix with a 1 in row i and 0 in all other rows. For any $n \times n$ matrix M, the product Me_i is the $n \times 1$ matrix that stores the entries of M from the ith column. In particular, $(AA^{-1})e_i = e_i$, so the ith column of AA^{-1} is the vector e_i. Consequently, AA^{-1} consists of columns e_1 through e_n, in that order, which is exactly the identity matrix I. It is always the case for an invertible matrix A that $A^{-1}A = I = AA^{-1}$.

The second item is proved by contradiction. Suppose that A has two inverses, B and C; then $AB = I = BA$ and $AC = I = CA$. Also,

$AB = I$	B is an inverse for A
$C(AB) = C(I)$	Multiply by C
$(CA)B = C$	Matrix multiplication is associative; I is the identity
$(I)B = C$	C is an inverse for A
$B = C$	I is the identity

and so there is only one inverse.

The third item is proved by a simple set of calculations:

$$
\begin{aligned}
(B^{-1}A^{-1})(AB) &= B^{-1}(A^{-1}A)B & &\text{Matrix multiplication is associative} \\
&= B^{-1}IB & &A^{-1} \text{ is the inverse of } A \\
&= B^{-1}B & &I \text{ is the identity} \\
&= I & &B^{-1} \text{ is the inverse of } B
\end{aligned}
$$

By direct verification, $B^{-1}A^{-1}$ is the inverse of AB.

A.3.5 CONSTRUCTION OF INVERSES

This is illustrated with 3×3 matrices, but the ideas clearly carry over to the $n \times n$ case. Let

$$
\mathbf{e}_1 = \begin{bmatrix} 1 \\ 0 \\ 0 \end{bmatrix}, \qquad
\mathbf{e}_2 = \begin{bmatrix} 0 \\ 1 \\ 0 \end{bmatrix}, \qquad
\mathbf{e}_3 = \begin{bmatrix} 0 \\ 0 \\ 1 \end{bmatrix}
$$

Any 3×3 matrix $M = [m_{ij}]$ can be thought of as a *block matrix* consisting of three column vectors:

$$
M = \begin{bmatrix} m_{11} & m_{12} & m_{13} \\ m_{21} & m_{22} & m_{23} \\ m_{31} & m_{32} & m_{33} \end{bmatrix} = \begin{bmatrix} M\mathbf{e}_1 & M\mathbf{e}_2 & M\mathbf{e}_3 \end{bmatrix}
$$

In particular, if A is invertible, then A^{-1} exists and

$$
A^{-1} = \begin{bmatrix} A^{-1}\mathbf{e}_1 & A^{-1}\mathbf{e}_2 & A^{-1}\mathbf{e}_3 \end{bmatrix} = \begin{bmatrix} \mathbf{v}_1 & \mathbf{v}_2 & \mathbf{v}_3 \end{bmatrix}
$$

where the column vectors \mathbf{v}_k ($k = 1, 2, 3$) are unknowns to be determined. Matching the similar entries in the block matrices yields

$$A^{-1}\mathbf{e}_k = \mathbf{v}_k \quad \text{or} \quad A\mathbf{v}_k = \mathbf{e}_k, \qquad k = 1, 2, 3$$

Each of these systems of equations can be solved separately by row-reducing $[A|\mathbf{e}_k]$ to $[I|\mathbf{v}_k]$. However, we can solve these systems simultaneously by row-reducing $[A|\mathbf{e}_1|\mathbf{e}_2|\mathbf{e}_3] = [A|I]$ to $[I|\mathbf{v}_1|\mathbf{v}_2|\mathbf{v}_3] = [I|A^{-1}]$.

EXAMPLE A.12

Compute the inverse of

$$A = \begin{bmatrix} -2 & 1 & 1 \\ 0 & 1 & 1 \\ -3 & 0 & 6 \end{bmatrix}$$

Row-reduce:

$$[A|I] = \begin{bmatrix} -2 & 1 & 1 & | & 1 & 0 & 0 \\ 0 & 1 & 1 & | & 0 & 1 & 0 \\ -3 & 0 & 6 & | & 0 & 0 & 1 \end{bmatrix}$$

$$\underset{-\frac{1}{2}R_1 \to R_1}{\sim} \begin{bmatrix} 1 & -\frac{1}{2} & -\frac{1}{2} & | & -\frac{1}{2} & 0 & 0 \\ 0 & 1 & 1 & | & 0 & 1 & 0 \\ -3 & 0 & 6 & | & 0 & 0 & 1 \end{bmatrix}$$

$$\underset{3R_1 + R_3 \to R_3}{\sim} \begin{bmatrix} 1 & -\frac{1}{2} & -\frac{1}{2} & | & -\frac{1}{2} & 0 & 0 \\ 0 & 1 & 1 & | & 0 & 1 & 0 \\ 0 & -\frac{3}{2} & \frac{9}{2} & | & -\frac{3}{2} & 0 & 1 \end{bmatrix}$$

$$\underset{\substack{\frac{1}{2}R_2 + R_1 \to R_1 \\ \frac{3}{2}R_2 + R_3 \to R_3}}{\sim} \begin{bmatrix} 1 & 0 & 0 & | & -\frac{1}{2} & \frac{1}{2} & 0 \\ 0 & 1 & 1 & | & 0 & 1 & 0 \\ 0 & 0 & 6 & | & -\frac{3}{2} & \frac{3}{2} & 1 \end{bmatrix}$$

$$\underset{\frac{1}{6}R_3 \to R_3}{\sim} \begin{bmatrix} 1 & 0 & 0 & | & -\frac{1}{2} & \frac{1}{2} & 0 \\ 0 & 1 & 1 & | & 0 & 1 & 0 \\ 0 & 0 & 1 & | & -\frac{1}{4} & \frac{1}{4} & \frac{1}{6} \end{bmatrix}$$

$$\underset{-R_3 + R_2 \to R_2}{\sim} \begin{bmatrix} 1 & 0 & 0 & | & -\frac{1}{2} & \frac{1}{2} & 0 \\ 0 & 1 & 0 & | & \frac{1}{4} & \frac{3}{4} & -\frac{1}{6} \\ 0 & 0 & 1 & | & -\frac{1}{4} & \frac{1}{4} & \frac{1}{6} \end{bmatrix} = [I|A^{-1}]. \quad \blacksquare$$

EXAMPLE
A.13

The matrix

$$A = \begin{bmatrix} 1 & -1 \\ -2 & 2 \end{bmatrix}$$

has no inverse. Row-reduce:

$$[A|I] = \begin{bmatrix} 1 & -1 & | & 1 & 0 \\ -2 & 2 & | & 0 & 1 \end{bmatrix} \underset{2R_1 + R_2 \to R_2}{\sim} \begin{bmatrix} 1 & -1 & | & 1 & 0 \\ 0 & 0 & | & 2 & 1 \end{bmatrix}$$

This last matrix can never be row-reduced to the form $[I|B]$, so A has no inverse. ∎

A.3.6 LU DECOMPOSITION

The forward elimination of a matrix A produces an upper echelon matrix U. Suppose this happens with only row operations of the form $cR_i + R_j \to R_j, i < j$. Let E_1, \ldots, E_k be the corresponding elementary row matrices; $U = E_k \cdots E_1 A$. The matrices E_i are all lower triangular, the product $E_k \cdots E_1$ is lower triangular, and $L = (E_k \cdots E_1)^{-1} = E_1^{-1} \cdots E_k^{-1}$ is lower triangular. Thus, $A = LU$ where L is lower triangular and U is upper echelon. This is called the *LU decomposition* of the matrix A.

EXAMPLE
A.14

$$A = \begin{bmatrix} 1 & 0 & -4 & 0 & 6 \\ 5 & 1 & -3 & -3 & 9 \\ 6 & 3 & 7 & -3 & 1 \end{bmatrix}$$

$$\underset{\substack{-5R_1 + R_2 \to R_2 \\ -6R_1 + R_3 \to R_3}}{\sim} \begin{bmatrix} 1 & 0 & -4 & 0 & 6 \\ 0 & 1 & 17 & -3 & -21 \\ 0 & 3 & 31 & -3 & -35 \end{bmatrix}$$

$$\underset{-3R_2 + R_3 \to R_3}{\sim} \begin{bmatrix} 1 & 0 & -4 & 0 & 6 \\ 0 & 1 & 17 & -3 & -21 \\ 0 & 0 & -20 & 6 & 28 \end{bmatrix} = U$$

The elementary row matrices corresponding to these operations are

$$E_1 = \begin{bmatrix} 1 & 0 & 0 \\ -5 & 1 & 0 \\ 0 & 0 & 1 \end{bmatrix}, \qquad E_2 = \begin{bmatrix} 1 & 0 & 0 \\ 0 & 1 & 0 \\ -6 & 0 & 1 \end{bmatrix}, \qquad E_3 = \begin{bmatrix} 1 & 0 & 0 \\ 0 & 1 & 0 \\ 0 & -3 & 1 \end{bmatrix}$$

We have

$$U = E_3 E_2 E_1 A = \begin{bmatrix} 1 & 0 & 0 \\ -5 & 1 & 0 \\ -6 & -3 & 1 \end{bmatrix} A, \quad \text{and} \quad A = E_1^{-1} E_2^{-1} E_3^{-1} U = \begin{bmatrix} 1 & 0 & 0 \\ 5 & 1 & 0 \\ 6 & 3 & 1 \end{bmatrix} U = LU \quad ∎$$

The matrix U can be factored further by applying row operations of the type $cR_i \to R_i$ to obtain pivot values of 1. With a renaming of U to DU, we have the *LDU decomposition* of the matrix, $A = LDU$, where L is lower triangular, D is a diagonal matrix, and U is upper echelon with diagonal entries either 1 or 0.

EXAMPLE A.15

This is the continuation of the last example.

$$U = E_3 E_2 E_1 A = \begin{bmatrix} 1 & 0 & -4 & 0 & 6 \\ 0 & 1 & 17 & -3 & -21 \\ 0 & 0 & -20 & 6 & 28 \end{bmatrix}$$

$$\overset{\sim}{-\frac{1}{20}R_3 \to R_3} \begin{bmatrix} 1 & 0 & -4 & 0 & 6 \\ 0 & 1 & 17 & -3 & -21 \\ 0 & 0 & 1 & -\frac{3}{10} & -\frac{7}{5} \end{bmatrix}$$

The elementary row matrix representing this last row operation is

$$E_4 = \begin{bmatrix} 1 & 0 & 0 \\ 0 & 1 & 0 \\ 0 & 0 & -\frac{1}{20} \end{bmatrix}$$

Let $D = E_4^{-1} = \text{Diag}(1, 1, -20)$, a diagonal matrix. With a renaming of U to be the upper echelon matrix whose diagonal elements are 1,

$$A = LDU = \begin{bmatrix} 1 & 0 & 0 \\ 5 & 1 & 0 \\ 6 & 3 & 1 \end{bmatrix} \begin{bmatrix} 1 & 0 & 0 \\ 0 & 1 & 0 \\ 0 & 0 & -20 \end{bmatrix} \begin{bmatrix} 1 & 0 & -4 & 0 & 6 \\ 0 & 1 & 17 & -3 & -21 \\ 0 & 0 & 1 & -\frac{3}{10} & -\frac{7}{5} \end{bmatrix} \blacksquare$$

If row swappings are needed in the forward elimination, then the *LDU* decomposition method must be slightly modified since matrices representing row swappings are not lower triangular. A matrix that represents swapping rows is called a *permutation matrix*.

EXAMPLE A.16

$$A = \begin{bmatrix} 1 & 1 & 0 \\ 2 & 2 & 1 \\ -1 & 0 & 1 \end{bmatrix} \overset{\sim}{\underset{R_1 + R_3 \to R_3}{-2R_1 + R_2 \to R_2}} \begin{bmatrix} 1 & 1 & 0 \\ 0 & 0 & 1 \\ 0 & 1 & 1 \end{bmatrix} \overset{\sim}{R_2 \leftrightarrow R_3} \begin{bmatrix} 1 & 1 & 0 \\ 0 & 1 & 1 \\ 0 & 0 & 1 \end{bmatrix} = U$$

If E_k ($k = 1, 2, 3$) represent the row operations, then $U = E_3 E_2 E_1 A$. Consequently,

$$A = E_1^{-1} E_2^{-1} E_3^{-1} U = \begin{bmatrix} 1 & 0 & 0 \\ 2 & 0 & 1 \\ -1 & 1 & 0 \end{bmatrix} \begin{bmatrix} 1 & 1 & 0 \\ 0 & 1 & 1 \\ 0 & 0 & 1 \end{bmatrix}$$

The first matrix in the decomposition is not lower triangular. However, apply the operation $R_2 \leftrightarrow R_3$ to A first. Let $P = E_3$, a permutation matrix. Then

$$PA = \begin{bmatrix} 1 & 1 & 0 \\ -1 & 0 & 1 \\ 2 & 2 & 1 \end{bmatrix} = \begin{bmatrix} 1 & 0 & 0 \\ -1 & 1 & 0 \\ 2 & 0 & 1 \end{bmatrix} \begin{bmatrix} 1 & 1 & 0 \\ 0 & 1 & 1 \\ 0 & 0 & 1 \end{bmatrix} = LU \quad \blacksquare$$

In general, the factorization can be written as $PA = LDU$, where

1. P represents row operations of type $R_i \leftrightarrow R_j$;
2. L is lower triangular, represents row operations of type $c_i R_i + R_j \rightarrow R_j$, and has diagonal entries 1;
3. D is diagonal and represents row operations of type $c R_i \rightarrow R_i$; and
4. U is upper echelon with diagonal entries 1.

In practice, we cannot expect to know which row swappings must be performed first in order to obtain $PA = LDU$. The following procedure allows us to postprocess the elementary row operations so that the row swappings are applied first. Apply row operations in the usual manner: Do $c R_i + R_j \rightarrow R_j$ and $R_i \leftrightarrow R_j$ first, $c R_i \rightarrow R_i$ last.

**EXAMPLE
A.17**

$$A = \begin{bmatrix} 1 & 3 & 0 \\ 2 & 6 & 1 \\ -1 & 0 & 2 \end{bmatrix} \begin{array}{c} \sim \\ -2R_1 + R_2 \rightarrow R_2 \\ R_1 + R_3 \rightarrow R_3 \end{array} \begin{bmatrix} 1 & 3 & 0 \\ 0 & 0 & 1 \\ 0 & 3 & 2 \end{bmatrix}$$

$$\begin{array}{c} \sim \\ R_2 \leftrightarrow R_3 \end{array} \begin{bmatrix} 1 & 3 & 0 \\ 0 & 3 & 2 \\ 0 & 0 & 1 \end{bmatrix} \begin{array}{c} \sim \\ \frac{1}{3}R_2 \rightarrow R_2 \end{array} \begin{bmatrix} 1 & 3 & 0 \\ 0 & 1 & \frac{2}{3} \\ 0 & 0 & 1 \end{bmatrix}$$

Instead of switching rows 2 and 3 of A first and re-reducing, do the following. Write down the operations in the order applied:

$$-2R_1 + R_2 \rightarrow R_2, \qquad R_1 + R_3 \rightarrow R_3, \qquad R_2 \leftrightarrow R_3, \qquad \frac{1}{3}R_2 \rightarrow R_2$$

The row swapping operations should appear *first*. Interchange the row swapping operation with the one directly to its left. In doing so, swap any row indices on that operation matching those of the row interchange. In the example,

$$-2R_1 + R_2 \rightarrow R_2, \qquad R_2 \leftrightarrow R_3, \qquad R_1 + R_2 \rightarrow R_2, \qquad \frac{1}{3}R_2 \rightarrow R_2$$

and

$$R_2 \leftrightarrow R_3, \qquad -2R_1 + R_3 \rightarrow R_3, \qquad R_1 + R_2 \rightarrow R_2, \qquad \frac{1}{3}R_2 \rightarrow R_2$$

(Example A.17 continued)

give the correct ordering of the operations, with row swappings first. Therefore,

$$
P = \begin{bmatrix} 1 & 0 & 0 \\ 0 & 0 & 1 \\ 0 & 1 & 0 \end{bmatrix}, \qquad
L = \begin{bmatrix} 1 & 0 & 0 \\ 1 & 1 & 0 \\ -2 & 0 & 1 \end{bmatrix}, \qquad
D = \begin{bmatrix} 1 & 0 & 0 \\ 0 & 3 & 0 \\ 0 & 0 & 1 \end{bmatrix},
$$

$$
U = \begin{bmatrix} 1 & 3 & 0 \\ 0 & 1 & \frac{2}{3} \\ 0 & 0 & 1 \end{bmatrix} \; \blacksquare
$$

The examples so far have been relatively simple. Here is a physics application that is a bit more in-depth. If you are not yet ready for the calculus portion of the problem (the exact solution), skip to the part after the point where an approximation is made to the second derivative function.

EXAMPLE A.18

Given a homogeneous, thin rod of constant cross-section and length 1, which is insulated except at its ends, a simple model of steady-state heat distribution in the rod is

$$
-u''(x) = f(x), \quad 0 < x < 1
$$

$$
u(0) = u(1) = 0
$$

where $u(x)$ is the quantity of heat at position x, $f(x) \geq 0$ is a given heat source, and $u(0) = u(1) = 0$ represents fixed temperature 0 at the ends.

EXACT SOLUTION

Integrate the differential equation $u''(x) = -f(x)$ from 0 to x to obtain

$$
u'(x) = u'(0) - \int_0^x f(t)\, dt
$$

where $u'(0)$ needs to be determined. Integrate again from 0 to x to obtain

$$
u(x) = u(0) + u'(0)x - \int_0^x \int_0^s f(t)\, dt\, ds
$$

Using the conditions $u(0) = u(1) = 0$ yields

$$
u'(0) = \int_0^1 \int_0^s f(t)\, dt\, ds
$$

so that

$$
u(x) = x \int_0^1 \int_0^s f(t)\, dt\, ds - \int_0^x \int_0^s f(t)\, dt\, ds
$$

The double integral can be manipulated so that

$$u(x) = \int_0^1 G(x, t) f(t) \, dt$$

where

$$G(x, t) = \begin{cases} (1 - t)x, & x \le t \\ (1 - x)t, & x \ge t \end{cases}$$

In most cases for $f(t)$, the integral for $u(x)$ cannot be evaluated symbolically to obtain a closed-form solution in terms of elementary functions. However, you can resort to numerical integration methods to obtain approximate values for $u(x)$.

APPROXIMATE SOLUTION

Find approximations to the values $u(jh)$ for $1 \le j \le n$, where $h = 1/(n + 1)$ for some large positive integer n. From calculus,

$$u''(x) = \lim_{h \to 0} \frac{u(x + h) - 2u(x) + u(x - h)}{h^2}$$

The approximation below is reasonable for small values of h:

$$u''(x) \doteq \frac{u(x + h) - 2u(x) + u(x - h)}{h^2}$$

Replace h by $1/(n + 1)$ and $x = jh$, $j = 0, 1, \ldots, n + 1$. Define $u_j = u(jh)$ (so that $u_0 = u_{n+1} = 0$) and $f_j = f(jh)$. The differential equation is approximated by the second-order linear difference equation

$$-u_{j+1} + 2u_j - u_{j-1} = h^2 f_j, \quad 1 \le j \le n$$

$$u_0 = u_{n+1} = 0$$

We can rewrite this as a system of n equations in n unknowns as

$$A\mathbf{u} = \begin{bmatrix} 2 & -1 & 0 & 0 & \cdots & 0 \\ -1 & 2 & -1 & 0 & \cdots & 0 \\ 0 & -1 & 2 & -1 & \cdots & 0 \\ \vdots & \vdots & \vdots & \vdots & & \vdots \\ 0 & 0 & 0 & 0 & \cdots & 2 \end{bmatrix} \begin{bmatrix} u_1 \\ u_2 \\ u_3 \\ \vdots \\ u_n \end{bmatrix} = h^2 \begin{bmatrix} f_1 \\ f_2 \\ f_3 \\ \vdots \\ f_n \end{bmatrix} = h^2 \mathbf{f}$$

The $n \times n$ matrix $A = [a_{ij}]$ can be written concisely as

$$a_{ij} = \begin{cases} 2, & i = j \\ -1, & i = j \pm 1 \\ 0, & \text{otherwise} \end{cases}$$

Such a matrix is said to be *tridiagonal*.

(*Example A.18 continued*)

Consider the case $n = 4$; then

$$A = \begin{bmatrix} 2 & -1 & 0 & 0 \\ -1 & 2 & -1 & 0 \\ 0 & -1 & 2 & -1 \\ 0 & 0 & -1 & 2 \end{bmatrix} \quad \underset{\frac{1}{2}R_1 + R_2 \to R_2}{\sim} \quad \begin{bmatrix} 2 & -1 & 0 & 0 \\ 0 & \frac{3}{2} & -1 & 0 \\ 0 & -1 & 2 & -1 \\ 0 & 0 & -1 & 2 \end{bmatrix}$$

$$\underset{\frac{2}{3}R_2 + R_3 \to R_3}{\sim} \begin{bmatrix} 2 & -1 & 0 & 0 \\ 0 & \frac{3}{2} & -1 & 0 \\ 0 & 0 & \frac{4}{3} & -1 \\ 0 & 0 & -1 & 2 \end{bmatrix} \quad \underset{\frac{3}{4}R_3 + R_4 \to R_4}{\sim} \begin{bmatrix} 2 & -1 & 0 & 0 \\ 0 & \frac{3}{2} & -1 & 0 \\ 0 & 0 & \frac{4}{3} & -1 \\ 0 & 0 & 0 & \frac{5}{4} \end{bmatrix}$$

$$\underset{\substack{\frac{1}{2}R_1 \to R_1 \\ \frac{2}{3}R_2 \to R_2 \\ \frac{3}{4}R_3 \to R_3 \\ \frac{4}{5}R_4 \to R_4}}{\sim} \begin{bmatrix} 1 & -\frac{1}{2} & 0 & 0 \\ 0 & 1 & -\frac{2}{3} & 0 \\ 0 & 0 & 1 & -\frac{3}{4} \\ 0 & 0 & 0 & 1 \end{bmatrix}$$

Therefore,

$$A = \begin{bmatrix} 1 & 0 & 0 & 0 \\ -\frac{1}{2} & 1 & 0 & 0 \\ 0 & -\frac{2}{3} & 1 & 0 \\ 0 & 0 & -\frac{3}{4} & 1 \end{bmatrix} \begin{bmatrix} 2 & 0 & 0 & 0 \\ 0 & \frac{3}{2} & 0 & 0 \\ 0 & 0 & \frac{4}{3} & 0 \\ 0 & 0 & 0 & \frac{5}{4} \end{bmatrix} \begin{bmatrix} 1 & -\frac{1}{2} & 0 & 0 \\ 0 & 1 & -\frac{2}{3} & 0 \\ 0 & 0 & 1 & -\frac{3}{4} \\ 0 & 0 & 0 & 1 \end{bmatrix} = LDU$$

Note that $L^T = U$ and the diagonal entries of D are positive. Also note that A can be factored into

$$A = LDU = L\sqrt{D}\sqrt{D}U = (L\sqrt{D})(L\sqrt{D})^T = M M^T$$

where $\sqrt{\text{Diag}(d_1, \ldots, d_n)} = \text{Diag}(\sqrt{d_1}, \ldots, \sqrt{d_n})$. ∎

A couple of observations are in order. First, if A is invertible, then its LDU decomposition is unique. The proof is by contradiction. Assume that we have two decompositions, $A = L_1 D_1 U_1 = L_2 D_2 U_2$. Then $(L_2^{-1} L_1) D_1 = D_2 (U_2 U_1^{-1})$. The left-hand side is lower triangular and the right-hand side is upper triangular. The only way this can happen is if both are diagonal. Since D_1 is invertible, $L_2^{-1} L_1$ must be diagonal. Since the diagonal entries of L_1 and L_2^{-1} are all 1, the diagonal of their product must all be 1. Therefore, $L_2^{-1} L_1 = I$ and $L_1 = L_2$. Similarly, $U_1 = U_2$. Finally, canceling the L and U matrices yields $D_1 = D_2$. The conclusion is there can be only one decomposition.

Second, if A is symmetric, then U in the LDU decomposition must be $U = L^T$. That is, $A = LDL^T$. If, in addition, the diagonal entries of D are nonnegative, then $A = (L\sqrt{D})(L\sqrt{D})^T$. To prove this, let $A = LDU$. Then $A = A^T = U^T D L^T$.

This is another LDU decomposition, so by the uniqueness we proved in the last paragraph, $U = L^T$. The additional factorization when D has nonnegative entries follows trivially.

A.4 VECTOR SPACES

The central theme of linear algebra is the study of vectors and the sets in which they live, called *vector spaces*. Our intuition about vectors comes from their manipulation in the xy-plane. The classical introduction in a physics setting introduces vectors to represent velocities, accelerations, or forces. In this setting, a vector is normally introduced as a quantity with *direction* and *magnitude*. As such, it does not matter where you place that vector in the plane—it is still the same vector. Figure A.4 shows a vector **v** occurring at two locations in the plane. The standard convention is used to draw the vector as an arrow to indicate its direction, the length of the arrow corresponding to its magnitude. Regardless of location, the two arrows have the same direction and same magnitude, so they represent the same vector.

The visual approach of drawing arrows is also used to illustrate various operations on vectors. Figure A.5 illustrates the addition of two vectors **u** and **v**, the result denoted **u** + **v**.

You think of this as starting at the initial point of the arrow **u**, walking to the end of the arrow to get to the initial point of the arrow **v**, then walking to the end of that arrow to arrive at your final destination. That destination may be achieved by starting at the initial point of the arrow **u** + **v** (placed conveniently at the initial point of **u**) and walking to the end of the arrow for the sum. The concept of aligning the

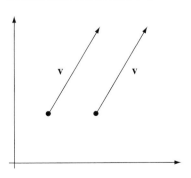

Figure A.4 A vector **v** at two locations in the plane.

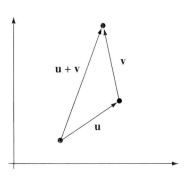

Figure A.5 Addition of **u** and **v**.

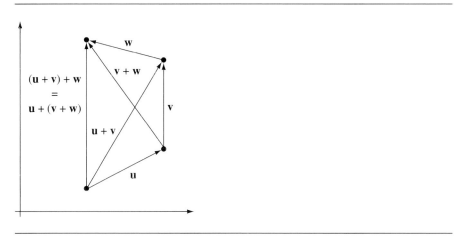

Figure A.6 Addition of **u**, **v**, and **w**. Which pair of vectors is added first is irrelevant.

vectors from initial point to final point and walking along the path may be used for motivation in the remaining rules mentioned next.

Figure A.6 illustrates that vector addition is associative: $\mathbf{u} + (\mathbf{v} + \mathbf{w}) = (\mathbf{u} + \mathbf{v}) + \mathbf{w}$. Not only is the grouping irrelevant, but also the ordering. Figure A.7 illustrates that vector addition is commutative: $\mathbf{u} + \mathbf{v} = \mathbf{v} + \mathbf{u}$.

If you start at the initial point of an arrow **v**, walk to its final point, then walk back to the initial point, the net effect is as if you never moved in the first place. The symbol **0** is used to represent the zero vector that has length zero, but undefined

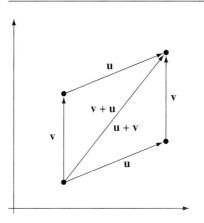

Figure A.7 Addition of **u** and **v**. The order of the vectors is irrelevant.

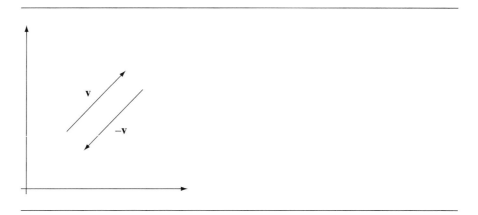

Figure A.8 A vector **v** and its additive identity −**v**.

direction, and corresponds to the net effect of no motion. As such, the following rule is suggested: $\mathbf{v} + \mathbf{0} = \mathbf{v}$. The arrow representing moving from the final point of **v** to its initial point is denoted −**v** and is called the *additive identity* of **v**. Figure A.8 illustrates this vector.

Using our intuition about walking along the vectors, it is always true that $\mathbf{v} + (-\mathbf{v}) = \mathbf{0}$. The concept of an additive identity allows us to naturally define *subtraction* of a vector **v** from a vector **u** as $\mathbf{u} - \mathbf{v} = \mathbf{u} + (-\mathbf{v})$. The quantity on the left of the

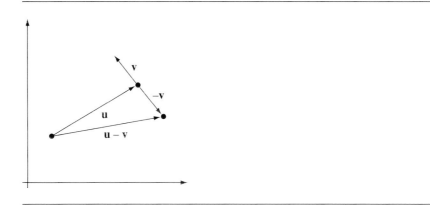

Figure A.9 The vectors **u** and **v** and the difference **u** − **v**.

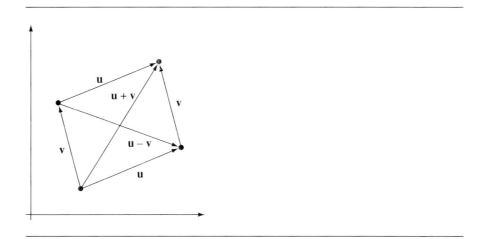

Figure A.10 The vectors **u** and **v**, the parallelogram formed by them, and the sum **u** + **v** and difference **u** − **v** shown as diagonals of the parallelogram.

equality is also referred to as the *difference* of **u** and **v**. Figure A.9 shows two vectors and their difference. Typically, though, the sum and difference vectors are visualized as the diagonals of a parallelogram formed by **u** and **v**. Figure A.10 illustrates this.

The direction of a vector **v** can be preserved, but its length changed by a multiplicative factor $c > 0$. The resulting vector is denoted by c**v**. Figure A.11 shows a vector whose length is scaled by 2. The vector 2**v** has the same direction as **v** but twice the length. The figure also shows the vector $(-2/3)$**v**, which may be thought of as having

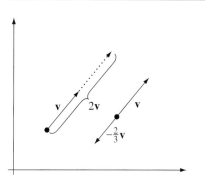

Figure A.11 The vector **v** and two scalar multiples of it, one positive and one negative.

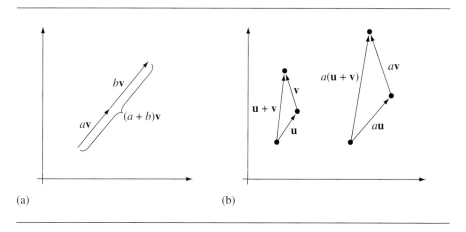

(a) (b)

Figure A.12 (a) Distributing across a scalar sum. (b) Distributing across a vector sum.

the direction of −**v** but two-thirds of the length. We may as well allow c to be negative in the definition.

A simple yet relevant observation: If you multiply a vector by the scalar 1, the length is unchanged. This suggests the rule $1 \cdot \mathbf{v} = \mathbf{v}$. The dot is included to emphasize that the left-hand side is a scalar multiple of the vector. It should also be intuitive that you can scale a vector by a, scale that vector by b, and obtain the same vector if you just scaled by ab. The formal rule is $a(b\mathbf{v}) = (ab)\mathbf{v}$.

Figure A.12 shows two distributive laws that apply to scalar multiplication of vectors. Figure A.12(a) illustrates the rule for distributing across a scalar sum

$(a + b)\mathbf{v} = a\mathbf{v} + b\mathbf{v}$. Figure A.12(b) illustrates the rule for distributing across a vector sum $a(\mathbf{u} + \mathbf{v}) = a\mathbf{u} + a\mathbf{v}$.

The various rules that apply to vectors in the plane also apply to vectors in space. More generally, a lot of systems in practice follow the same rules. The abstraction of the objects we call vectors and of the rules that apply to them leads us to the heart of linear algebra—vector spaces, as defined next.

A.4.1 DEFINITION OF A VECTOR SPACE

Let V be a set whose elements are called *vectors*. Assume that *equality* of vectors is well defined. Suppose that there are two operations, *vector addition* ($+$) and *scalar multiplication* (\cdot), such that the following properties hold. To help distinguish vectors from scalars, vectors are typeset in boldface. In the properties, $\mathbf{u}, \mathbf{v}, \mathbf{w} \in V$ and $a, b \in \mathbb{R}$. We can now state the following 10 axioms:

1. (closure under $+$): $\mathbf{u} + \mathbf{v} \in V$

2. ($+$ is associative): $\mathbf{u} + (\mathbf{v} + \mathbf{w}) = (\mathbf{u} + \mathbf{v}) + \mathbf{w}$

3. ($+$ is commutative): $\mathbf{u} + \mathbf{v} = \mathbf{v} + \mathbf{u}$

4. (additive identity): There is a vector $\mathbf{0} \in V$ such that $\mathbf{v} + \mathbf{0} = \mathbf{v}$ for any $\mathbf{v} \in V$

5. (additive inverses): For each $\mathbf{v} \in V$ there is a vector $-\mathbf{v} \in V$ such that $\mathbf{v} + (-\mathbf{v}) = \mathbf{0}$

6. (closure under \cdot): $c \cdot \mathbf{v} \in V$, written simply as $c\mathbf{v}$

7. (\cdot is distributive over real addition): $(a + b)\mathbf{v} = a\mathbf{v} + b\mathbf{v}$

8. (\cdot is distributive over vector addition): $a(\mathbf{u} + \mathbf{v}) = a\mathbf{u} + a\mathbf{v}$

9. (\cdot is associative): $a(b\mathbf{u}) = (ab)\mathbf{v}$

10. (multiplicative identity): The number $1 \in \mathbb{R}$ has the property $1 \cdot \mathbf{v} = \mathbf{v}$

The triple $(V, +, \cdot)$ is called a *vector space* over the real numbers. As it turns out, any field of numbers is allowable, not just the field of real numbers. For example, the complex numbers or even the rational numbers could be used. There are also fields that have a finite number of elements; such fields could be used. In the applications in this book, the field of real numbers invariably is the appropriate choice.

A few comments are in order about the axioms for a vector space. First, the notation for the additive inverse of $\mathbf{v} \in V$, namely, $-\mathbf{v} \in V$, is not to be confused with the scalar multiple $-1 \cdot \mathbf{v}$. However, we will prove that in fact, $-\mathbf{v} = -1 \cdot \mathbf{v}$. Second, the zero vector is indicated as $\mathbf{0}$, but as we will see in a later example, there are vector spaces where the numerical value of $\mathbf{0}$ has nothing to do with "zero." Third, the numerical value of the multiplicative identity 1 for a field may not be related to the number "one." (For example, $S = \{0, 2, 4, 6, 8\}$ with addition and multiplication modulo 10 is an example of something called a *finite field*. It has additive identity 0 and multiplicative identity 6.)

EXAMPLE
A.19

This is the classic example of a vector space, n-tuples of numbers whose components are real numbers. Let $V = \mathbb{R}^n = \{(x_1, \ldots, x_n) : x_k \in \mathbb{R}, k = 1, \ldots, n\}$ be the set of ordered n-tuples of real numbers. Let $\mathbf{x}, \mathbf{y} \in V$, where $\mathbf{x} = (x_1, \ldots, x_n)$ and $\mathbf{y} = (y_1, \ldots, y_n)$, and let $c \in \mathbb{R}$.

Define *vector equality* by $\mathbf{x} = \mathbf{y}$ if and only if $x_k = y_k$ for every $k = 1, \ldots, n$. That is, the vectors must be the same component-wise. Define *vector addition* by

$$\mathbf{x} + \mathbf{y} = (x_1, \ldots, x_n) + (y_1, \ldots, y_n) = (x_1 + y_1, \ldots, x_n + y_n)$$

and define *scalar multiplication* by

$$c \cdot \mathbf{x} = c\mathbf{x} = c(x_1, \ldots, x_n) = (cx_1, \ldots, cx_n)$$

The triple $(\mathbb{R}^n, +, \cdot)$ is a vector space over the real numbers. The additive identity is $\mathbf{0} = (0, \ldots, 0)$. For $\mathbf{x} = (x_1, \ldots, x_n)$, the additive inverse is $-\mathbf{x} = (-x_1, \ldots, -x_n)$. Each of the 10 axioms for a vector space must be verified. For example, the proof that axiom 3 is satisfied is given as

$$
\begin{aligned}
\mathbf{x} + \mathbf{y} &= (x_1, \ldots, x_n) + (y_1, \ldots, y_n) & & \text{Definition of } \mathbf{x} \text{ and } \mathbf{y} \\
&= (x_1 + y_1, \ldots, x_n + y_n) & & \text{Definition of vector addition} \\
&= (y_1 + x_1, \ldots, y_n + x_n) & & \text{Since real addition is commutative} \\
&= (y_1, \ldots, y_n) + (x_1, \ldots, x_n) & & \text{Definition of vector addition} \\
&= \mathbf{y} + \mathbf{x} & & \text{Definition of } \mathbf{x} \text{ and } \mathbf{y}
\end{aligned}
$$

The verification of the other axioms is left as an exercise. ▪

EXAMPLE
A.20

Consider the set of all polynomials with real-valued coefficients,

$$V = \mathbb{R}[x] = \left\{ \sum_{k=0}^{n} a_k x^k : a_k \in \mathbb{R}, n \in \mathbf{W} \right\}$$

where $\mathbf{W} = \{0, 1, 2, \ldots\}$ is the set of whole numbers. Let $\mathbf{p}, \mathbf{q} \in V$ where

$$\mathbf{p} = \sum_{i=0}^{n} p_i x^i \quad \text{and} \quad \mathbf{q} = \sum_{i=0}^{m} q_i x^i$$

In the following verifications, we can assume for the sake of argument that $n \geq m$. Define *vector equality* by $\mathbf{p} = \mathbf{q}$ iff $n = m$ and $p_k = q_k$ for all $k = 0, \ldots, n$. Define *vector addition*, $\mathbf{p} + \mathbf{q}$, by

$$\mathbf{p} + \mathbf{q} = \sum_{i=0}^{m} (p_i + q_i)x^i + \sum_{i=m+1}^{n} p_i x^i$$

(*Example A.20 continued*)

By convention, if in the summation $S = \sum_{i=L}^{U} t_i$, the lower index L is larger than the upper index U, then $S = 0$. Thus, in the above definition if $n = m$, in which case $m + 1 > n$, the second summation is zero. Finally, define *scalar multiplication*, $c\mathbf{p}$ for $c \in \mathbb{R}$, by

$$c\mathbf{p} = \sum_{i=0}^{n} cp_i x^i$$

For example, if $\mathbf{p} = p_0 + p_1 x + p_2 x^2$ and $\mathbf{q} = q_0 + q_1 x$, then

$$\mathbf{p} + \mathbf{q} = (p_0 + q_0) + (p_1 + q_1)x + p_2 x^2 \quad \text{and} \quad c\mathbf{p} = (cp_0) + (cp_1)x + (cp_2)x^2$$

The triple $(\mathbb{R}[x], +, \cdot)$ is a vector space. The additive identity is the zero polynomial, which can be represented as $\mathbf{0} = 0$, where the right-hand side denotes a constant polynomial (degree zero) whose only coefficient is the scalar zero. The additive inverse for $\mathbf{p} = \sum_{k=0}^{n} p_k x^k$ is

$$-\mathbf{p} = \sum_{k=0}^{n} (-p_k) x^k$$

Of course, you need to verify the 10 axioms for a vector space. ▪

EXAMPLE A.21

Define $V = F(\mathbb{R}, \mathbb{R})$ to be the set of all real-valued functions of a real-valued variable. Two functions $f(x)$ and $g(x)$ are represented as the vectors $\mathbf{f}, \mathbf{g} \in V$. The vectors are *equal*, denoted $\mathbf{f} = \mathbf{g}$, whenever

$$f(x) = g(x), \quad \text{for all } x \in \mathbb{R}$$

Define *vector addition*, $\mathbf{f} + \mathbf{g}$, to be the usual addition of functions:

$$(f + g)(x) = f(x) + g(x), \quad \text{for all } x \in I$$

That is, the vector $\mathbf{f} + \mathbf{g}$ represents the function $f + g$. Note that the addition on the left represents vector addition, whereas the addition on the right is real addition. Let $c \in \mathbb{R}$ and $\mathbf{f} \in V$. Define *scalar multiplication*, $c \cdot \mathbf{f}$, to be the usual scalar multiplication for functions:

$$(cf)(x) = c \cdot f(x), \quad \text{for all } x \in I$$

The scalar multiplication on the left is that for V, but the scalar multiplication on the right is multiplication of real numbers. The triple $(F(\mathbb{R}, \mathbb{R}), +, \cdot)$ is a vector space.

▪

EXAMPLE A.22

The final example is a strange one, but illustrates how abstract the concept of vector space really is. Let $V = (0, \infty)$ denote the set of positive real numbers. Each positive

number $x \in V$ is a vector. Define *vector equality* by $x = y$ iff x and y are equal as real numbers. Define *vector addition*, denoted \oplus because of its lack of resemblance to real-valued addition, by $x \oplus y = xy$. That is, the vector addition of two positive numbers is defined to be their product! Define *scalar multiplication*, denoted \odot because of its lack of resemblance to real-valued multiplication, by $c \odot x = x^c$, where c is a scalar and x is a vector. That is, scalar multiplication of a positive number by a real number is defined to be the positive number raised to a power! Note that the additive identity is the positive number 1, *not the real number* 0. The multiplicative identity is the scalar $1 \in \mathbb{R}$. The additive inverse of x is the reciprocal $1/x$. The triple (V, \oplus, \odot) is a vector space, albeit a strange one. ▪

Some consequences of the axioms for a vector space are listed here.

1. The additive identity **0** is unique.
2. The additive inverse of **x** is unique.
3. For any **x**, $0\mathbf{x} = \mathbf{0}$.
4. For any $c \in \mathbb{R}$, $c\mathbf{0} = \mathbf{0}$.
5. If $-\mathbf{x}$ is the additive inverse of **x**, then $-\mathbf{x} = (-1) \cdot \mathbf{x}$.
6. If $c\mathbf{x} = \mathbf{0}$, then either $c = 0$ or $\mathbf{x} = \mathbf{0}$.

Proof of Item 1 ▪ Suppose there are two additive identities, call them $\mathbf{0}_1$ and $\mathbf{0}_2$. Then

$$\mathbf{0}_1 = \mathbf{0}_1 + \mathbf{0}_2 \qquad \text{Since } \mathbf{0}_2 \text{ is an additive identity}$$

$$= \mathbf{0}_2 \qquad \text{Since } \mathbf{0}_1 \text{ is an additive identity}$$

so there can only be one additive identity. ▪

Proof of Item 2 ▪ Suppose **x** has two additive inverses, call them **y** and **z**. Then

$$\mathbf{z} = \mathbf{z} + \mathbf{0} \qquad \text{Since } \mathbf{0} \text{ is the additive identity}$$

$$= \mathbf{z} + (\mathbf{x} + \mathbf{y}) \qquad \text{Since } \mathbf{y} \text{ is an additive inverse for } \mathbf{x}$$

$$= (\mathbf{z} + \mathbf{x}) + \mathbf{y} \qquad \text{Since vector addition is associative}$$

$$= (\mathbf{x} + \mathbf{z}) + \mathbf{y} \qquad \text{Since vector addition is commutative}$$

$$= \mathbf{0} + \mathbf{y} \qquad \text{Since } \mathbf{z} \text{ is an additive inverse for } \mathbf{x}$$

$$= \mathbf{y} + \mathbf{0} \qquad \text{Since vector addition is commutative}$$

$$= \mathbf{y} \qquad \text{Since } \mathbf{0} \text{ is the additive identity}$$

Therefore, **x** has only one additive inverse. ▪

Proof of Item 3 ▪ Let \mathbf{y} be the additive inverse for $0\mathbf{x}$. Then

$$0\mathbf{x} = (0 + 0)\mathbf{x} \qquad \text{Since } 0 = 0 + 0$$
$$= 0\mathbf{x} + 0\mathbf{x} \qquad \text{By axiom 7}$$
$$0\mathbf{x} + \mathbf{y} = (0\mathbf{x} + 0\mathbf{x}) + \mathbf{y}$$
$$= 0\mathbf{x} + (0\mathbf{x} + \mathbf{y}) \qquad \text{By axiom 2}$$
$$\mathbf{0} = 0\mathbf{x} + \mathbf{0} \qquad \text{Since } \mathbf{y} \text{ is the additive inverse for } 0\mathbf{x}$$
$$= 0\mathbf{x} \qquad \text{Since } \mathbf{0} \text{ is the additive identity } ▪$$

Proof of Item 4 ▪ Let $c \in \mathbb{R}$ and let \mathbf{y} be the additive inverse for $c\mathbf{0}$. Then

$$c\mathbf{0} = c(\mathbf{0} + \mathbf{0}) \qquad \text{Since } \mathbf{0} \text{ is the additive identity}$$
$$= c\mathbf{0} + c\mathbf{0} \qquad \text{By axiom 8}$$
$$c\mathbf{0} + \mathbf{y} = (c\mathbf{0} + c\mathbf{0}) + \mathbf{y}$$
$$= c\mathbf{0} + (c\mathbf{0} + \mathbf{y}) \qquad \text{By axiom 2}$$
$$\mathbf{0} = c\mathbf{0} + \mathbf{0} \qquad \text{Since } \mathbf{y} \text{ is the additive inverse for } c\mathbf{0}$$
$$= c\mathbf{0} \qquad \text{Since } \mathbf{0} \text{ is the additive identity } ▪$$

Proof of Item 5 ▪ $\mathbf{x} + (-1)\mathbf{x} = 1\mathbf{x} + (-1)\mathbf{x} \qquad \text{By axiom 10}$
$$= [1 + (-1)]\mathbf{x} \qquad \text{By axiom 7}$$
$$= 0\mathbf{x} \qquad \text{Since } 1 + (-1) = 0$$
$$= \mathbf{0} \qquad \text{By item 3, proved earlier}$$

The vector $(-1)\mathbf{x}$ is the additive inverse of \mathbf{x}. By item 2 above, additive inverses are unique; therefore, $-\mathbf{x} = (-1)\mathbf{x}$. ▪

Proof of Item 6 ▪ If $c = 0$, then the conclusion is clearly true. If $c \neq 0$, then

$$\mathbf{0} = c\mathbf{x} \qquad \text{By hypothesis}$$
$$\frac{1}{c}\mathbf{0} = \frac{1}{c}(c\mathbf{x})$$

$$\mathbf{0} = \frac{1}{c}(c\mathbf{x}) \qquad \text{By item 4, proved earlier}$$

$$= (\frac{1}{c} c)\mathbf{x} \qquad \text{By axiom 9}$$

$$= 1\mathbf{x}$$

$$= \mathbf{x} \qquad \text{By axiom 10}$$

so $\mathbf{x} = 0$. ∎

A.4.2 LINEAR COMBINATIONS, SPANS, AND SUBSPACES

Let $\mathbf{x}_k \in V$, a vector space, and let $c_k \in \mathbb{R}$ for $k = 1, \ldots, n$. The expression

$$c_1\mathbf{x}_1 + \cdots + c_n\mathbf{x}_n = \sum_{k=1}^{n} c_k\mathbf{x}_k$$

is called a *linear combination* of the vectors.

EXAMPLE A.23

All vectors in \mathbb{R}^2 can be written as a linear combination of the vectors $(1, 1)$ and $(1, -1)$. To prove this, we verify that each vector $(x, y) = c_1(1, 1) + c_2(1, -1)$ for some choice of c_1, c_2.

$$(x, y) = c_1(1, 1) + c_2(1, -1)$$

$$= (c_1, c_1) + (c_2, -c_2) \qquad \text{By definition of scalar multiplication}$$

$$= (c_1 + c_2, c_1 - c_2) \qquad \text{By definition of vector addition}$$

Using the definition for vector equality, $x = c_1 + c_2$ and $y = c_1 - c_2$. We have two equations in the two unknowns c_1, c_2. Solve these to obtain $c_1 = \frac{x+y}{2}$ and $c_2 = \frac{x-y}{2}$. Thus,

$$(x, y) = \frac{x + y}{2}(1, 1) + \frac{x - y}{2}(1, -1)$$

a unique representation of (x, y) as a linear combination of $(1, 1)$ and $(1, -1)$. ∎

Let V be a vector space and let $A \subset V$. The *span* of A is the set

$$\text{Span}[A] = \left\{ \sum_{k=1}^{n} c_k\mathbf{x}_k : n > 0, c_k \in \mathbb{R}, \mathbf{x}_k \in A \right\}$$

That is, the span is the set of all finite linear combinations of vectors in A. The subset A need not be finite, and the number of terms in the sums can be arbitrarily

large. For example, in the last example all vectors $(x, y) \in \mathbb{R}^2$ can be written as linear combinations of $(1, 1)$ and $(1, -1)$, which implies $\mathbb{R}^2 = \text{Span}[(1, 1), (1, -1)]$.

A general result may be stated now. Let $(V, +, \cdot)$ be a vector space. Let A be a nonempty subset of V. The triple $(\text{Span}[A], +, \cdot)$ is also a vector space. To prove this, we must verify the 10 axioms for a vector space.

1. Let $\mathbf{x}, \mathbf{y} \in \text{Span}[A]$. Then $\mathbf{x} = \sum_{i=1}^{n} a_i \mathbf{x}_i$ and $\mathbf{y} = \sum_{j=1}^{m} b_j \mathbf{y}_j$ for some $a_i, b_j \in \mathbb{R}$ and for some $\mathbf{x}_i, \mathbf{y}_j \in V$. Thus, $\mathbf{x} + \mathbf{y} = \sum_{i=1}^{n} a_i \mathbf{x}_i + \sum_{j=1}^{m} b_j \mathbf{y}_j = \sum_{k=1}^{n+m} c_k \mathbf{z}_k \in \text{Span}[A]$ where

$$c_k = \left\{ \begin{array}{ll} a_k, & 1 \leq k \leq n \\ b_{k-n}, & n+1 \leq k \leq n+m \end{array} \right\}, \qquad \mathbf{z}_k = \left\{ \begin{array}{ll} \mathbf{x}_k, & 1 \leq k \leq n \\ \mathbf{y}_{k-n}, & n+1 \leq k \leq n+m \end{array} \right\}$$

2. Since $+$ is associative in V, it is associative in any subset of V. The set $\text{Span}[A]$ of linear combinations of elements in $A \subset V$ must itself be a subset of V. Thus, $+$ is associative in $\text{Span}[A]$.

3. Since $+$ is commutative in V, it is commutative in any subset of V. Thus, $+$ is commutative in $\text{Span}[A]$.

4. If $\mathbf{0}$ is the additive identity in V, then we show also that $\mathbf{0} \in \text{Span}[A]$. The set $A \neq \emptyset$ implies $\text{Span}[A] \neq \emptyset$. Let $\mathbf{x} \in \text{Span}[A]$. Then $\mathbf{x} = \sum_{i=1}^{n} a_i \mathbf{x}_i$ for some $a_i \in \mathbb{R}$ and for some $\mathbf{x}_i \in A$. Moreover, $\mathbf{x} + (-1)\mathbf{x} = \sum_{i=1}^{n} [a_i + (-1)a_i] \mathbf{x}_i \in \text{Span}[A]$. But $\mathbf{0} = \mathbf{x} + (-1)\mathbf{x}$ by an earlier result, so $\mathbf{0} \in \text{Span}[A]$.

5. Let $\mathbf{x} \in \text{Span}[A] \subset V$. We need to show that $-\mathbf{x} \in \text{Span}[A]$. Since \mathbf{x} is in the span, $\mathbf{x} = \sum_{i=1}^{n} a_i \mathbf{x}_i$ for some $a_i \in \mathbb{R}$ and for some $\mathbf{x}_i \in A$. Then $-\mathbf{x} = (-1)\mathbf{x}x = \sum_{i=1}^{n} -a_i \mathbf{x}_i$ is a linear combination of elements of A, so $-\mathbf{x} \in \text{Span}[A]$.

6. Let $c \in \mathbb{R}$ and $\mathbf{x} \in \text{Span}[A]$. Then $\mathbf{x} = \sum_{i=1}^{n} a_i \mathbf{x}_i$ for some $a_i \in \mathbb{R}$ and for some $\mathbf{x}_i \in A$. But

$$c\mathbf{x} = c \sum_{i=1}^{n} a_i \mathbf{x}_i$$

$$= \sum_{i=1}^{n} c(a_i \mathbf{x}_i) \qquad \text{By axiom 8 for } V$$

$$= \sum_{i=1}^{n} (ca_i) \mathbf{x}_i \qquad \text{By axiom 9 for } V$$

$$\in \text{Span}[A]$$

7. Since scalar multiplication is distributive over real addition in V, it is distributive in any subset of V. Thus, scalar multiplication is distributive over real addition in $\text{Span}[A]$.

8. Since scalar multiplication is distributive over vector addition in V, it is distributive in any subset of V. Thus, scalar multiplication is distributive over vector addition in $\text{Span}[A]$.

9. Since scalar multiplication is associative in V, it is associative in any subset of V. Thus, scalar multiplication is associative in $\text{Span}[A]$.

10. Since $1 \cdot \mathbf{x} = \mathbf{x}$ for all vectors in V, the same property is true in any subset. Thus, $1 \cdot \mathbf{x} = \mathbf{x}$ for $\mathbf{x} \in \text{Span}[A]$.

If a nonempty subset S of a vector space V is itself a vector space, S is said to be a *subspace* of V. For any given subset S, the 10 axioms for a vector space can be checked to see if S is a subspace. However, an analysis of the proof that the span of a set is a subspace shows that many of the vector space axioms are automatically satisfied just because of the fact that you are working with a subset of V. As it turns out, to show that $S \subset V$ is a subspace, we need only to verify closure under scalar multiplication and vector addition. That is, $S \subset V$ is a subspace if and only if $a\mathbf{x} + b\mathbf{y} \in S$ for any $a, b \in \mathbb{R}$ and $\mathbf{x}, \mathbf{y} \in S$.

EXAMPLE A.24

Let $V = \mathbb{R}^3$ and $S = \{(x_1, x_2, x_3) : x_1 = x_2\}$. The subset S is a subspace. To verify, let $a, b \in \mathbb{R}$ and $\mathbf{x}, \mathbf{y} \in S$; then

$$a\mathbf{x} + b\mathbf{y} = a(x_1, x_2, x_3) + b(y_1, y_2, y_3) \qquad \text{Notation}$$

$$= a(x_1, x_1, x_3) + b(y_1, y_1, y_3) \qquad \text{Since } \mathbf{x}, \mathbf{y} \in S$$

$$= (ax_1, ax_1, ax_3) + (by_1, by_1, by_3) \qquad \text{Definition of scalar multiplication}$$

$$= (ax_1 + by_1, ax_1 + by_1, ax_3 + by_3) \qquad \text{Definition of vector addition}$$

Since the first two components of the last vector in the displayed equation are equal, that vector is in S. That is, $a\mathbf{x} + b\mathbf{y} \in S$ and S must be a subspace of V. ▪

EXAMPLE A.25

Let $V = \mathbb{R}^2$ and $S = \{(x_1, x_2) : x_2 = x_1 + 1\}$. The subset S is not a subspace for many reasons, one of which is that $(0, 0) \notin S$. ▪

A.4.3 LINEAR INDEPENDENCE AND BASES

Let V be a vector space. If possible, we would like to find sets $A \subset V$ such that $\text{Span}[A] = V$. For example, let $V = \mathbb{R}^2$. If $A = \{(x, y) : x \geq 0\}$, then it is easily shown that $\text{Span}[A] = \mathbb{R}^2$. If $B = \{(1, 1), (1, -1)\}$, then also $\text{Span}[B] = \mathbb{R}^2$. In some sense, B is a "smaller" set than A. Given a suitable definition for "smallness," we want to find the "smallest" sets $A \subset V$ for which $\text{Span}[A] = V$. The following concept gives

us a handle on this. Let $(V, +, \cdot)$ be a vector space. The vectors $\mathbf{x}_1, \ldots, \mathbf{x}_n \in V$. The vectors are *linearly dependent* if

$$\sum_{k=1}^{n} c_k \mathbf{x}_k = c_1 \mathbf{x}_1 + \cdots + c_n \mathbf{x}_n = \mathbf{0}$$

for some set of scalars c_1, \ldots, c_n which are *not all zero*. If there is no such set of scalars, then the vectors are *linearly independent*. A set of vectors is said to be a *linearly independent set* (*linearly dependent set*) if the vectors in that set are linearly independent (linearly dependent).

EXAMPLE A.26

For $V = \mathbb{R}^3$, the vectors $\mathbf{x}_1 = (1, 0, -1)$, $\mathbf{x}_2 = (2, 1, 0)$, $\mathbf{x}_3 = (0, 0, 1)$, and $\mathbf{x} = (-1, 1, 2)$ are linearly dependent. Set:

$$(0, 0, 0) = c_1(1, 0, -1) + c_2(2, 1, 0) + c_3(0, 0, 1) + c_4(-1, 1, 2)$$

$$= (c_1 + 2c_2 - c_4, c_2 + c_4, -c_1 + c_3 + 2c_4)$$

This equation can be formulated as a linear system of equations,

$$\begin{bmatrix} 1 & 2 & 0 & -1 \\ 0 & 1 & 0 & 1 \\ -1 & 0 & 1 & 2 \end{bmatrix} \begin{bmatrix} c_1 \\ c_2 \\ c_3 \\ c_4 \end{bmatrix} = \begin{bmatrix} 0 \\ 0 \\ 0 \end{bmatrix}$$

This system of three equations in four unknowns has infinitely many solutions. In particular, it must have a nonzero solution. We could also solve the system:

$$A = \begin{bmatrix} 1 & 2 & 0 & -1 \\ 0 & 1 & 0 & 1 \\ -1 & 0 & 1 & 2 \end{bmatrix} \underset{R_1 + R_3 \to R_3}{\sim} \begin{bmatrix} 1 & 2 & 0 & -1 \\ 0 & 1 & 0 & 1 \\ 0 & 2 & 1 & 1 \end{bmatrix}$$

$$\underset{\substack{-2R_2 + R_1 \to R_1 \\ -2R_2 + R_3 \to R_3}}{\sim} \begin{bmatrix} 1 & 0 & 0 & -3 \\ 0 & 1 & 0 & 1 \\ 0 & 0 & 1 & -1 \end{bmatrix} = A_r$$

The general solution is

$$\begin{bmatrix} c_1 \\ c_2 \\ c_3 \\ c_4 \end{bmatrix} = c_4 \begin{bmatrix} 3 \\ -1 \\ 1 \\ 1 \end{bmatrix}$$

Choose $c_4 = 1$; then $c_1 = 3$, $c_2 = -1$, and $c_3 = 1$. We can write

$$3(1, 0, -1) - 1(2, 1, 0) + 1(0, 0, 1) + 1(-1, 1, 2) = (0, 0, 0)$$

and the vectors are linearly dependent. ■

**EXAMPLE
A.27**

In $V = \mathbb{R}^2$, the vectors $(1, 1)$ and $(1, -1)$ are linearly independent. Let $c_1(1, 1) + c_2(1, -1) = (0, 0)$. Then $(c_1 + c_2, c_1 - c_2) = (0, 0)$ and so $c_1 + c_2 = 0$, $c_1 - c_2 = 0$. The *only* solution to this system is $c_1 = c_2 = 0$, so the vectors are linearly independent. ∎

**EXAMPLE
A.28**

Let $V = F(\mathbb{R}, \mathbb{R})$ be the vector space of all real-valued functions whose domain is the set of real numbers. The vectors \mathbf{f} and \mathbf{g} that represent the functions $f(x) = \sin x$ and $g(x) = \cos x$, respectively, are linearly independent. The vector $\mathbf{h} = c_1\mathbf{f} + c_2\mathbf{g}$ represents the function $h(x) = c_1 f(x) + c_2 g(x)$. Setting $\mathbf{h} = \mathbf{0}$ is equivalent to requiring $h(x) \equiv 0$; that is, $h(x) = 0$ is true for *all* values of x. In particular, $0 = h(0) = c_1 \sin(0) + c_2 \cos(0) = c_2$ and $0 = h(\pi/2) = c_1 \sin(\pi/2) + c_2 \cos(\pi/2) = c_1$. Since both $c_1 = 0$ and $c_2 = 0$, the vectors \mathbf{f} and \mathbf{g} are linearly independent. ∎

The following result is an important one. Let V be a vector space and let $A = \{\mathbf{x}_i \in V : i = 1, \ldots, n\}$ be a linearly independent set of vectors. Each vector $\mathbf{x} \in \text{Span}[A]$ has a *unique representation* $\mathbf{x} = \sum_{i=1}^{n} a_i\mathbf{x}_i$. The proof of this result is by contradiction. Suppose that there are two distinct representations $\mathbf{x} = \sum_{i=1}^{n} a_i\mathbf{x}_i$ and $\mathbf{x} = \sum_{i=1}^{n} b_i\mathbf{x}_i$, where not all $a_i = b_i$. Subtract \mathbf{x} from itself:

$$\mathbf{0} = \mathbf{x} - \mathbf{x} = \sum_{i=1}^{n} a_i\mathbf{x}_i - \sum_{i=1}^{n} b_i\mathbf{x}_i = \sum_{i=1}^{n}(a_i - b_i)\mathbf{x}_i = \sum_{i=1}^{n} c_i\mathbf{x}_i$$

where $c_i = a_i - b_i$. Since the vectors in A are linearly independent, all $c_i = 0$, so $a_i = b_i$ for all $i = 1, \ldots, n$, a contradiction to the assumption that not all $a_i = b_i$. Thus, there can be only one representation of \mathbf{x}. The values a_i in the unique representation are called the *coefficients of* \mathbf{x} *with respect to A*.

**EXAMPLE
A.29**

In an earlier example we had shown that $\mathbb{R}^2 = \text{Span}[\{(1, 1), (1, -1)\}]$, where

$$\mathbf{x} = (x_1, x_2) = \frac{x_1 + x_2}{2}(1, 1) + \frac{x_1 - x_2}{2}(1, -1)$$

The coefficients of \mathbf{x} with respect to $A = \{(1, 1), (1, -1)\}$ are $\frac{x_1 + x_2}{2}$ and $\frac{x_1 - x_2}{2}$, where the order is important. ∎

A couple of useful algorithms are provided for manipulating sets based on linear independence or dependence.

Removing Vectors from a Linearly Dependent Set
to Obtain a Linearly Independent Set

Let $\mathbf{x}_1, \ldots, \mathbf{x}_n$ ($n \geq 2$) be linearly dependent vectors; then $\sum_{k=1}^{n} c_k \mathbf{x}_k = \mathbf{0}$ for coefficients c_k that are not all zero. Suppose that $c_m \neq 0$ for some index m. We can solve for \mathbf{x}_m to obtain

$$\mathbf{x}_m = -\sum_{\substack{k=1 \\ k \neq m}}^{n} \frac{c_k}{c_m} \mathbf{x}_k$$

Moreover,

$$\text{Span}[\{\mathbf{x}_1, \ldots, \mathbf{x}_n\} \setminus \{\mathbf{x}_m\}] = \text{Span}[\{\mathbf{x}_1, \ldots, \mathbf{x}_n\}]$$

since for any vector \mathbf{y} that is a linear combination of the \mathbf{x}_k, just replace the \mathbf{x}_m term by the relationship given above for \mathbf{x}_m as a linear combination of the other \mathbf{x}_k.

Inserting Vectors into a Linearly Independent Set
to Retain a Linearly Independent Set

Let $A = \{\mathbf{x}_1, \ldots, \mathbf{x}_n\}$ be a linearly independent set. Let $\mathbf{y} \notin \text{Span}[A]$; then $A \cup \{\mathbf{y}\}$, the union of A and the singleton set containing \mathbf{y}, is also a linearly independent set. Consider the linear combination

$$c_0 \mathbf{y} + c_1 \mathbf{x}_1 + \cdots c_n \mathbf{x}_n = \mathbf{0}$$

If $c_0 \neq 0$, then we can solve the equation for \mathbf{y},

$$\mathbf{y} = -\frac{c_1}{c_0} \mathbf{x}_1 - \cdots - \frac{c_n}{c_0} \mathbf{x}_n \in \text{Span}[A]$$

a contradiction to the assumption that $y \notin \text{Span}[A]$. It must be that $c_0 = 0$. Consequently, $c_1 \mathbf{x}_1 + \cdots + c_n \mathbf{x}_n = \mathbf{0}$. But the \mathbf{x}_k are linearly independent, so $c_k = 0$ for $k = 1, \ldots, n$. We have shown that $c_k = 0$ for $k = 0, \ldots, n$, and so $A \cup \{y\}$ is a linearly independent set.

This leads us to an important concept in linear algebra. Let V be a vector space with subset $A \subset V$. The set A is said to be a *basis for V* if A is linearly independent and $\text{Span}[A] = V$. The plural of the term *basis* is *bases*.

EXAMPLE A.30

Let $V = \mathbb{R}^2$ with the usual vector addition and scalar multiplication. Accordingly,

1. $\{(1, 0), (0, 1)\}$ is a basis for V. It is easy to show that the two vectors are linearly independent. To show that they span V, note that

$$(x, y) = (x, 0) + (0, y) = x(1, 0) + y(0, 1)$$

2. $\{(1, 1), (1, -1), (0, 1)\}$ is not a basis for V since the vectors are linearly dependent:

$$1(1, 1) - 1(1, -1) - 2(0, 1) = (0, 0)$$

However, they do span V since

$$(x, y) = \frac{x + y - 2}{2}(1, 1) + \frac{x - y + 2}{2}(1, -1) + 2(0, 1)$$

3. $\{(0, 1)\}$ is not a basis for V. The set is linearly independent, but $v \ne \text{Span}[\{(0, 1)\}]$, since $(1, 0) \in V$ but $(1, 0) \notin \text{Span}[\{(0, 1)\}]$. ∎

The last example is designed to illustrate that, in fact, a basis for V is the "smallest" set of vectors whose span is V. The term "smallest" in this sense is the number of vectors in the set. Now it is the case that V can have many bases. For example, $\{(1, 0), (0, 1)\}$ and $\{(1, 1), (1, -1)\}$ are bases for \mathbb{R}^2. Note that the two bases have the same number of elements. The number of elements of a set A, called the *cardinality* of the set, is denoted by $|A|$. The properties in the following list are valid for a vector space V that has a basis B of cardinality $|B| = n$. The set A in the first three items is any subset of V.

1. If $|A| > n$, then A is linearly dependent. The contrapositive of this statement is, If A is linearly independent, then $|A| \le n$.

2. If $\text{Span}[A] = V$, then $|A| \ge n$.

3. Every basis of V has cardinality n. The vector space is said to have dimension $\dim(V) = n$ and is referred to as a *finite dimensional vector space*.

Proof of Item 1 ∎ Let the known basis be $B = \{\mathbf{y}_1, \dots, \mathbf{y}_n\}$. Choose $A = \{\mathbf{x}_1, \dots, \mathbf{x}_{n+1}\}$ to be a linearly independent set of $n + 1$ vectors, so $|A| = n + 1$. Since B is a basis, each vector \mathbf{x}_i has a unique representation with respect to that basis,

$$\mathbf{x}_i = \sum_{j=1}^{n} c_{ij} \mathbf{y}_j$$

for $1 \le i \le n + 1$. To show that the \mathbf{x}_i are linearly dependent, show that there are values d_i, not all zero, such that $\sum_{i=1}^{n+1} d_i \mathbf{x}_i = 0$:

$$0 = \sum_{i=1}^{n+1} d_i \mathbf{x}_i$$

$$= \sum_{i=1}^{n+1} d_i \left(\sum_{j=1}^{n} c_{ij} \mathbf{y}_j \right)$$

$$= \sum_{i=1}^{n+1} \sum_{j=1}^{n} d_i c_{ij} \mathbf{y}_j$$

$$= \sum_{j=1}^{n} \left(\sum_{i=1}^{n+1} d_i c_{ij} \right) \mathbf{y}_j$$

Since the \mathbf{y}_j are linearly independent, $\sum_{i=1}^{n+1} c_{ij} d_i = 0$ for $1 \leq j \leq n$. But this is a system of n equations in $n + 1$ unknowns, so there must be a nonzero solution. That is, there must be a solution for which not all d_i are zero. Indeed, the \mathbf{x}_i must be linearly dependent and A is a linearly dependent set. ∎

Proof of Item 2 The proof is by contradiction. Suppose that $A \subset V$ and $V = \text{Span}[A]$. Assume that $|A| = m < n$, say, $A = \{\mathbf{x}_1, \ldots, \mathbf{x}_m\}$. Remove linearly dependent vectors until we have a set $A' = \{\mathbf{y}_1, \ldots, \mathbf{y}_\ell\}$ that is linearly independent and for which $V = \text{Span}[A']$. Since we have potentially removed vectors from the set, $\ell \leq m < n$. The fact that A' is a linearly independent set and the fact that the span of A' is V means that A' is a basis for V with cardinality ℓ. The basis B is a set whose cardinality $|B| = n > \ell$, to which (by item 1), B must be a linearly dependent set, a contradiction to B being a basis. The assumption $|A| < n$ cannot be valid, so in fact $|A| \geq n$. ∎

Proof of Item 3 The basis B for V has cardinality n, the number mentioned in the first two items. Let C be a basis for V. Since C is a linearly independent set, item 1 says that $|C| \leq n$. Since $V = \text{Span}[C]$, item 2 says that $|C| \geq n$. The two conditions require that $|C| = n$. ∎

**EXAMPLE
A.31**

Observe that $\dim(\mathbb{R}^n) = n$ since a basis is given by $\{\mathbf{e}_1, \ldots, \mathbf{e}_n\}$, where \mathbf{e}_j is the n-tuple whose jth component is 1, and all other components are 0. It is easy to verify that these vectors are linearly independent. To see that they span \mathbb{R}^n:

$$(x_1, \ldots, x_n) = (x_1, 0, \ldots, 0) + (0, x_2, 0, \ldots, 0) + \cdots + (0, \ldots, 0, x_n)$$

$$= x_1(1, 0, \ldots, 0) + x_2(0, 1, 0, \ldots, 0) + \cdots + x_n(0, \ldots, 0, 1)$$

$$= x_1 \mathbf{e}_1 + x_2 \mathbf{e}_2 + \cdots + x_n \mathbf{e}_n$$

$$= \sum_{i=1}^{n} x_i \mathbf{e}_i$$

The basis of vectors $\{\mathbf{e}_1, \ldots, \mathbf{e}_n\}$ is called the *standard Euclidean basis* for \mathbb{R}^n.

The vector space \mathbb{R}^n is an example of a finite dimensional vector space; that is, $\dim(\mathbb{R}^n)$ is a finite number. Not all vector spaces are finite dimensional. For example, $F(\mathbb{R}, \mathbb{R})$, the set of all real-valued functions whose domain is the real numbers, is infinite dimensional. ∎

The remaining material in this section is restricted to the vector spaces \mathbb{R}^n. The concepts generalize to other vector spaces, but for the purposes of this book are not necessary to investigate in detail.

A.4.4 INNER PRODUCTS, LENGTH, ORTHOGONALITY, AND PROJECTION

Let $\mathbf{x} = (x_1, \ldots, x_n)$, $\mathbf{y} = (y_1, \ldots, y_n) \in \mathbb{R}^n$. When they are represented as $n \times 1$ column vectors, the *standard inner product* of \mathbf{x} and \mathbf{y} is the real number,

$$\langle \mathbf{x}, \mathbf{y} \rangle = \mathbf{x}^T \mathbf{y} = \sum_{i=1}^{n} x_i y_i \tag{A.3}$$

The inner product satisfies the conditions $\langle c\mathbf{x} + \mathbf{y}, \mathbf{z} \rangle = c\langle \mathbf{x}, \mathbf{z} \rangle + \langle \mathbf{y}, \mathbf{z} \rangle$ and $\langle \mathbf{x}, c\mathbf{y} + \mathbf{z} \rangle = c\langle \mathbf{x}, \mathbf{y} \rangle + \langle \mathbf{x}, \mathbf{z} \rangle$. It is possible to define other inner products that satisfy the same constraints, hence the use of the adjective *standard* in this definition. Treating \mathbf{x} and \mathbf{y} as n-tuples, a common notation for the standard inner product is $\mathbf{x} \cdot \mathbf{y}$, called the *dot product*. The *length* of \mathbf{x} is defined by

$$|\mathbf{x}| = \sqrt{\mathbf{x} \cdot \mathbf{x}} = \sqrt{\sum_{i=1}^{n} x_i^2} \tag{A.4}$$

The dot product is related to *orthogonality* of vectors. Two vectors \mathbf{x} and \mathbf{y} are *orthogonal* (perpendicular) if and only if $\mathbf{x} \cdot \mathbf{y} = 0$. To see that this is true, Figure A.13 shows two orthogonal vectors drawn in the plane that they span.

Applying the Pythagorean Theorem,

$$|\mathbf{x}|^2 + |\mathbf{y}|^2 = |\mathbf{x} - \mathbf{y}|^2$$

$$= (\mathbf{x} - \mathbf{y}) \cdot (\mathbf{x} - \mathbf{y})$$

$$= (\mathbf{x} \cdot \mathbf{x}) - (\mathbf{x} \cdot \mathbf{y}) - (\mathbf{y} \cdot \mathbf{x}) + (\mathbf{y} \cdot \mathbf{y})$$

$$= |\mathbf{x}|^2 + |\mathbf{y}|^2 - 2\mathbf{x} \cdot \mathbf{y}$$

Subtracting $|\mathbf{x}|^2 + |\mathbf{y}|^2$ from both sides and dividing by -2 yields $\mathbf{x} \cdot \mathbf{y} = 0$. The argument is reversible; the converse of the Pythagorean Theorem is, If $|\mathbf{x}|^2 + |\mathbf{y}|^2 = |\mathbf{x} - \mathbf{y}|^2$, then the triangle must be a right triangle. Thus, $\mathbf{x} \cdot \mathbf{y} = 0$ implies \mathbf{x} and \mathbf{y} are orthogonal.

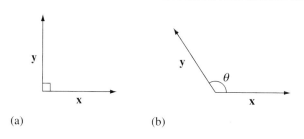

(a) (b)

Figure A.13 (a) Two orthogonal vectors drawn in the plane spanned by them. (b) Two nonorthogonal vectors and the angle between them.

An alternative formulation for the standard inner product is in terms of the angle θ between vectors \mathbf{x} and \mathbf{y},

$$\mathbf{x} \cdot \mathbf{y} = |\mathbf{x}|\,|\mathbf{y}|\cos\theta \tag{A.5}$$

Figure A.13 shows a pair of vectors and the angle between them. The construction of equation (A.5) uses the same geometry argument for a triangle having sides \mathbf{x}, \mathbf{y}, and $\mathbf{x} - \mathbf{y}$, but now the *Law of Cosines* for a general triangle applies. In the special case of a right triangle, $\theta = \pi/2$ and $\cos(\pi/2) = 0$, in which case $\mathbf{x}^T\mathbf{y} = 0$ and the vectors are orthogonal. Equation (A.3) defines the dot product in terms of coordinates, but equation (A.5) is referred to as a *coordinate-free* description since the individual coordinates of the vectors are not part of the equation.

The dot product is similarly related to *projection* of vectors. If \mathbf{u} is a unit-length vector and \mathbf{v} is any vector, the projection of \mathbf{v} onto \mathbf{u} is illustrated in Figure A.14.

Figure A.14(a) illustrates the algebraic construction. If θ is the angle between \mathbf{v} and \mathbf{u}, then basic trigonometry tells us $\cos\theta = L/|\mathbf{v}|$. Solving for L and using $|\mathbf{u}| = 1$, we have $L = |\mathbf{v}|\cos\theta = |\mathbf{v}||\mathbf{u}|\cos\theta = \mathbf{v} \cdot \mathbf{u}$. The projection of \mathbf{v} onto \mathbf{u} is

$$\text{proj}(\mathbf{v}, \mathbf{u}) = (\mathbf{v} \cdot \mathbf{u})\mathbf{u} \tag{A.6}$$

As illustrated in two dimensions in Figure A.14, the vector obtained by subtracting the projection of \mathbf{v} from itself is

$$\mathbf{w} = \mathbf{v} - (\mathbf{v} \cdot \mathbf{u})\mathbf{u} \tag{A.7}$$

and is necessarily orthogonal to \mathbf{u}. The calculation is simple:

$$\mathbf{u} \cdot \mathbf{w} = \mathbf{u} \cdot \mathbf{v} - (\mathbf{v} \cdot \mathbf{u})\mathbf{u} \cdot \mathbf{u} = \mathbf{u} \cdot \mathbf{v} - \mathbf{u} \cdot \mathbf{v} = 0$$

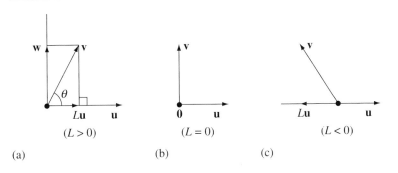

Figure A.14 The projection of vectors onto a unit-length vector **u**. (a) **v** projects to L**u** with $L > 0$. The angle θ between **u** and **v** is shown. The vector **w** is obtained as $\mathbf{w} = \mathbf{v} - L\mathbf{u}$ and is itself a projection. (b) **v** is perpendicular to **u**, so the projection onto **u** is the zero vector **0**. (c) The projection is L**u** with $L < 0$.

One last observation: The vector **u** was deemed to be unit length. Projection is still well-defined if the vector is not unit length. Let **d** be a non–unit-length vector in the direction of **u**; then $\mathbf{u} = \mathbf{d}/|\mathbf{d}|$. Replacing this in equation (A.6), but changing the left-hand-side argument from **u** to **d** to indicate the target of the projection is **d**,

$$\text{proj}(\mathbf{v}, \mathbf{d}) = \left(\mathbf{v} \cdot \frac{\mathbf{d}}{|\mathbf{d}|} \right) \frac{\mathbf{d}}{|\mathbf{d}|} = \left(\frac{\mathbf{v} \cdot \mathbf{d}}{\mathbf{d} \cdot \mathbf{d}} \right) \mathbf{d} \qquad (A.8)$$

A set of nonzero vectors $\{\mathbf{x}_1, \ldots, \mathbf{x}_m\}$ consisting of *mutually orthogonal* vectors (each pair is orthogonal) must be a linearly independent set. To see this:

$$\mathbf{0} = \sum_{i=1}^{m} c_i \mathbf{x}_i$$

$$\mathbf{x}_j^{\mathrm{T}} \mathbf{0} = \mathbf{x}_j^{\mathrm{T}} \sum_{i=1}^{m} c_i \mathbf{x}_i$$

$$0 = \sum_{i=1}^{m} c_i \mathbf{x}_j \cdot \mathbf{x}_i \qquad \text{Since inner product is distributive}$$

$$= c_j \mathbf{x}_j^{\mathrm{T}} \mathbf{x}_j \qquad \text{Since } \mathbf{x}_j^{\mathrm{T}} \mathbf{x}_i = 0 \text{ for } i \neq j$$

Since $\mathbf{x}_j \neq \mathbf{0}$, $\mathbf{x}_j \cdot \mathbf{x}_j$ is not zero and it must be that $c_j = 0$. The argument is valid for every $j = 1, \ldots, m$, so all c_j are zero and the vectors are linearly independent. A set

of mutually orthogonal vectors is said to be an *orthogonal set of vectors*. Additionally, if all the vectors in the set are unit length, the set is said to be an *orthonormal set of vectors*.

It is always possible to construct an orthonormal set of vectors $\{\mathbf{u}_1, \ldots, \mathbf{u}_m\}$ from any linearly independent set of vectors, $\{\mathbf{v}_1, \ldots, \mathbf{v}_m\}$. The process is referred to as *Gram-Schmidt orthonormalization*.

**EXAMPLE
A.32**

Consider $\mathbf{v}_1 = (1, 2)$ and $\mathbf{v}_2 = (-3, 0)$ in \mathbb{R}^2. Figure A.15 illustrates the process, one based on projection of the input vectors. Choose:

$$\mathbf{u}_1 = \frac{\mathbf{v}_1}{|\mathbf{v}_1|} = \frac{(1, 2)}{\sqrt{5}}$$

so that \mathbf{u}_1 is a unit vector in the direction of \mathbf{v}_1. The component of \mathbf{v}_2 in the direction of \mathbf{u}_1 can be removed, the remainder vector necessarily orthogonal to \mathbf{u}_1,

$$\mathbf{w}_2 = \mathbf{v}_2 - \left(\mathbf{u}_1 \cdot \mathbf{v}_2\right) \mathbf{u}_1 = \frac{6}{5}(-2, 1)$$

It is easily verified that $\mathbf{u}_1 \cdot \mathbf{w}_2 = 0$. The remainder is not necessarily unit length, but we can normalize it to obtain

$$\mathbf{u}_2 = \frac{\mathbf{w}_2}{|\mathbf{w}_2|} = \frac{(-2, 1)}{\sqrt{5}}$$

The set $\{\mathbf{u}_1, \mathbf{u}_2\}$ is orthonormal.

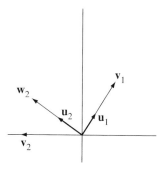

Figure A.15 Gram-Schmidt orthonormalization applied to two vectors in the plane. ▪

EXAMPLE
A.33

Let $\{\mathbf{v}_1, \mathbf{v}_2, \mathbf{v}_3\}$ be a linearly independent set in \mathbb{R}^3. Figure A.16 illustrates a typical case.

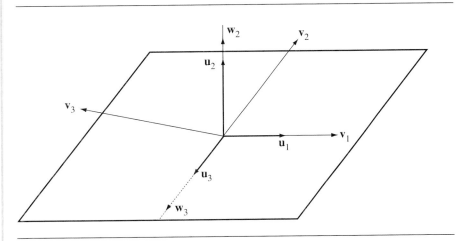

Figure A.16

Gram-Schmidt orthonormalization applied to three vectors in space.

Let \mathbf{u}_1, \mathbf{w}_2, and \mathbf{u}_2 be constructed as in the last example,

$$\mathbf{u}_1 = \frac{\mathbf{v}_1}{|\mathbf{v}_1|}, \qquad \mathbf{w}_2 = \mathbf{v}_2 - (\mathbf{u}_1 \cdot \mathbf{v}_2), \quad \text{and} \quad \mathbf{u}_2 = \frac{\mathbf{w}_2}{|\mathbf{w}_2|}$$

The components of \mathbf{v}_3 in the directions of \mathbf{u}_1 and \mathbf{u}_2 can be removed, the remainder vector necessarily orthogonal to both \mathbf{u}_1 and \mathbf{u}_2,

$$\mathbf{w}_3 = \mathbf{v}_3 - (\mathbf{v}_3 \cdot \mathbf{u}_1)\,\mathbf{u}_1 - (\mathbf{v}_3 \cdot \mathbf{u}_2)\,\mathbf{u}_2$$

It is easily verified that $\mathbf{u}_1 \cdot \mathbf{w}_3 = 0$ and $\mathbf{u}_2 \cdot \mathbf{w}_3 = 0$. The remainder is normalized to obtain

$$\mathbf{u}_3 = \frac{\mathbf{w}_3}{|\mathbf{w}_3|}$$

The set $\{\mathbf{u}_1, \mathbf{u}_2, \mathbf{u}_3\}$ is orthonormal. ■

The process for n vectors is iterative,

$$\mathbf{u}_1 = \frac{\mathbf{v}_1}{|\mathbf{v}_1|} \quad \text{and} \quad \mathbf{u}_j = \frac{\mathbf{v}_j - \sum_{i=1}^{j-1} (\mathbf{v}_j \cdot \mathbf{u}_i)\,\mathbf{u}_i}{\left| \mathbf{v}_j - \sum_{i=1}^{j-1} (\mathbf{v}_j \cdot \mathbf{u}_i)\,\mathbf{u}_i \right|}, \qquad 2 \le j \le n \qquad \text{(A.9)}$$

The key idea, as shown in the examples, is that each new input vector from the original linearly independent set has components removed in the direction of the already constructed vectors in the orthonormal set. The remainder is then normalized to produce the next vector in the orthonormal set.

A.4.5 DOT PRODUCT, CROSS PRODUCT, AND TRIPLE PRODUCTS

In the last section we defined the dot product of two vectors **u** and **v** and named it **u · v**. We saw its relationship to projection of one vector onto another and found it to be a useful concept for constructing an orthonormal set of vectors from a linearly independent set of vectors.

Cross Product

In three dimensions we have another type of product between vectors **u** and **v** that fits in naturally with the topics of the last section, namely, the *cross product*, a vector we will denote by **u** × **v**. This vector is required to be perpendicular to each of its two arguments, and its length is required to be the area of the parallelogram formed by its arguments. Figure A.17 illustrates the cross product.

Your intuition should tell you that there are infinitely many vectors that are perpendicular to both **u** and **v**, all such vectors lying on a normal line to the plane spanned by **u** and **v**. Of these, only two have the required length. We need to make

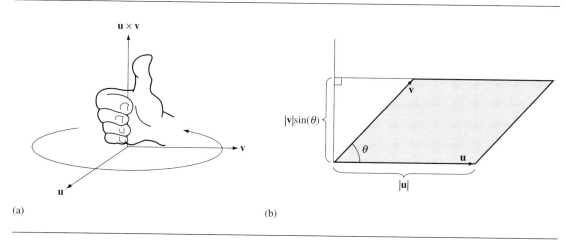

(a) (b)

Figure A.17 (a) The cross product of **u** and **v** according to the right-hand rule. (b) The parallelogram formed by **u** and **v** with angle θ and parallelogram base length and height marked.

a selection between the two. The standard convention uses what is called the *right-hand rule*. If you place your right hand so the fingers point in the direction of \mathbf{u} (the first argument) as shown in Figure A.17(a), then rotate your fingers toward \mathbf{v} (the second argument) so that you make a closed fist, the cross product is selected to be that vector in which direction your thumb points.

The area of the parallelogram is $\alpha = bh$, where b is the length of the base (the length of \mathbf{u}) and h is the height (the length of the projection of \mathbf{v} onto a vector perpendicular to \mathbf{u}):

$$\alpha = bh = |\mathbf{u}||\mathbf{v}| \sin(\theta) \tag{A.10}$$

Let \mathbf{w} be a unit-length vector perpendicular to both \mathbf{u} and \mathbf{v} and in the direction consistent with the right-hand rule. The coordinate-free definition of the cross product is therefore

$$\mathbf{u} \times \mathbf{v} = (|\mathbf{u}||\mathbf{v}| \sin(\theta))\, \mathbf{w} \tag{A.11}$$

A coordinate-dependent definition can be constructed by solving a system of two linear equations in three unknowns plus the length and direction constraints. Let $\mathbf{u} \times \mathbf{v} = (x_1, x_2, x_3)$. The orthogonality conditions are

$$0 = \mathbf{u} \cdot (\mathbf{u} \times \mathbf{v}) = (u_1, u_2, u_3) \cdot (x_1, x_2, x_3) = u_1 x_1 + u_2 x_2 + u_3 x_3$$

$$0 = \mathbf{v} \cdot (\mathbf{u} \times \mathbf{v}) = (v_1, v_2, v_3) \cdot (x_1, x_2, x_3) = v_1 x_1 + v_2 x_2 + v_3 x_3$$

We solve this system symbolically by choosing x_3 to be the free parameter and solve for x_1 and x_2 as basic parameters:

$$u_1 x_1 + u_2 x_2 = -u_3 x_3$$

$$v_1 x_1 + v_2 x_2 = -v_3 x_3$$

Multiplying the first equation by v_2, the second equation by u_2, and subtracting second from first yields

$$(u_1 v_2 - u_2 v_1) x_1 = (u_2 v_3 - u_3 v_2) x_3$$

Multiplying the first equation by v_1, the second equation by u_1, and subtracting the first from the second yields

$$(u_1 v_2 - u_2 v_1) x_2 = (u_3 v_1 - u_1 v_3) x_3$$

The term $u_1 v_2 - u_2 v_1$ appears on the left-hand side of both equations, so a convenient replacement for the free parameter is $x_3 = t(u_1 v_2 - u_2 v_1)$, where t now is the free variable. In terms of t, the two basic parameters are $x_1 = t(u_2 v_3 - u_3 v_2)$ and $x_2 = t(u_3 v_1 - u_1 v_3)$. Thus,

$$(x_1, x_2, x_3) = t(u_2 v_3 - u_3 v_2,\ u_3 v_1 - u_1 v_3,\ u_1 v_2 - u_2 v_1)$$

The value of t is determined by the length and direction constraints. In the enforcement of the length constraint, we use equations (A.11) and (A.5):

$$
\begin{aligned}
|\mathbf{u} \times \mathbf{v}|^2 &= |\mathbf{u}|^2 |\mathbf{v}|^2 \sin^2 \theta \\
&= |\mathbf{u}|^2 |\mathbf{v}|^2 (1 - \cos^2 \theta) \\
&= |\mathbf{u}|^2 |\mathbf{v}|^2 \left(1 - \frac{(\mathbf{u} \cdot \mathbf{v})^2}{|\mathbf{u}|^2 |\mathbf{v}|^2} \right) \\
&= |\mathbf{u}|^2 |\mathbf{v}|^2 - (\mathbf{u} \cdot \mathbf{v})^2 \\
&= (u_1^2 + u_2^2 + u_3^2)(v_1^2 + v_2^2 + v_3^2) - (u_1 v_1 + u_2 v_2 + u_3 v_3)^2 \\
&= (u_2 v_3 - u_3 v_2)^2 + (u_3 v_1 - u_1 v_3)^2 + (u_1 v_2 - u_2 v_1)^2
\end{aligned}
\tag{A.12}
$$

The last equality is obtained by quite a few algebraic manipulations, albeit simple ones. From earlier,

$$
|\mathbf{u} \times \mathbf{v}|^2 = |(x_1, x_2, x_3)|^2 = t^2 \left((u_2 v_3 - u_3 v_2)^2 + (u_3 v_1 - u_1 v_3)^2 + (u_1 v_2 - u_2 v_1)^2 \right)
$$

For the last two displayed equations to be equal we need $t^2 = 1$. The direction constraint narrows our final choice to $t = 1$. That is, the coordinate-dependent definition for the cross product of two vectors is

$$
\mathbf{u} \times \mathbf{v} = (u_2 v_3 - u_3 v_2, \ u_3 v_1 - u_1 v_3, \ u_1 v_2 - u_2 v_1)
\tag{A.13}
$$

The coordinate-dependent and coordinate-free descriptions of the dot product are equations (A.3) and (A.5), respectively. The coordinate-dependent and coordinate-free descriptions of the cross product are equations (A.13) and (A.11), respectively.

There are a couple of important properties of the cross product of which to be aware. First, the cross product is not commutative; in general $\mathbf{u} \times \mathbf{v}$ and $\mathbf{v} \times \mathbf{u}$ are not the same vector. The two vectors, however, point in opposite directions. The cross product is said to be *anti-commutative*,

$$
\mathbf{v} \times \mathbf{u} = -\mathbf{u} \times \mathbf{v}
\tag{A.14}
$$

The geometric intuition for this identity is given in Figure A.17. If you apply the right-hand rule to \mathbf{v} and \mathbf{u}, in that order, you should get a vector that is opposite in direction to $\mathbf{u} \times \mathbf{v}$. Equation (A.14) is simple to verify algebraically by use of equation (A.13). The other important property is that the cross product is a linear transformation in each component (called a *bilinear transformation*). That is,

$$
\begin{aligned}
(c\mathbf{u} + \mathbf{w}) \times \mathbf{v} &= c(\mathbf{u} \times \mathbf{v}) + (\mathbf{w} \times \mathbf{v}) \qquad \text{Linear in first component} \\
\mathbf{u} \times (c\mathbf{v} + \mathbf{w}) &= c(\mathbf{u} \times \mathbf{v}) + (\mathbf{u} \times \mathbf{w}) \qquad \text{Linear in second component}
\end{aligned}
\tag{A.15}
$$

EXERCISE (E) Prove that the identities in equations (A.14) and (A.15) are true. ▪
A.4

EXERCISE (E) If $\mathbf{u} + \mathbf{v} + \mathbf{w} = \mathbf{0}$, then $\mathbf{u} \times \mathbf{v} = \mathbf{v} \times \mathbf{w} = \mathbf{w} \times \mathbf{u}$. What is the geometric interpretation
A.5 of this statement? ▪

Triple Scalar Product

The cross product of two vectors \mathbf{v} and \mathbf{w} is a vector that can be dotted with a third vector \mathbf{u} to obtain a scalar, $v = \mathbf{u} \cdot \mathbf{v} \times \mathbf{w}$. No parentheses are needed about the cross product portion. If you were to compute the dot product of \mathbf{u} and \mathbf{v}, the resulting scalar cannot be crossed with \mathbf{w} since we have defined no such operation between scalars and vectors. The quantity $\mathbf{u} \cdot \mathbf{v} \times \mathbf{w}$ is referred to as the *triple scalar product* of the three vectors. This quantity has an important geometric interpretation as a *signed volume* of a parallelepiped. Figure A.18 illustrates this where \mathbf{u} forms an acute angle with $\mathbf{v} \times \mathbf{w}$.

The volume v of the parallelepiped is the product area of the base $\alpha = |\mathbf{v}||\mathbf{w}| \sin \theta$ as determined by equation (A.10) and the height $h = |\mathbf{u}| \cos \phi$ as determined by the dot product between \mathbf{u} and $\mathbf{v} \times \mathbf{w}$,

$$v = \mathbf{u} \cdot \mathbf{v} \times \mathbf{w} = |\mathbf{v} \times \mathbf{w}||\mathbf{u}| \cos \phi$$
$$= (|\mathbf{v}||\mathbf{w}| \sin \theta)(|\mathbf{u}| \cos \phi) = \alpha h = |\mathbf{u}||\mathbf{v}||\mathbf{w}| \sin \theta \cos \phi \tag{A.16}$$

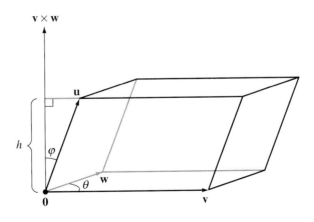

Figure A.18 A parallelepiped formed by vectors \mathbf{u}, \mathbf{v}, and \mathbf{w}, where \mathbf{u} forms an acute angle with $\mathbf{v} \times \mathbf{w}$. The angle between \mathbf{v} and \mathbf{w} is θ and the angle between \mathbf{u} and $\mathbf{v} \times \mathbf{w}$ is ϕ.

In the configuration of vectors in Figure A.18, the volume is $v > 0$. If \mathbf{u} were to form an obtuse angle with $\mathbf{v} \times \mathbf{w}$, $\phi \in (\pi/2, \pi)$, then $v < 0$ and $|v|$ is the volume. If $\phi = \pi/2$, then $v = 0$ and the parallelepiped is degenerate (all three vectors are coplanar) and has volume zero. Thus, v is referred to as a signed volume. Observe that equation (A.16) is a coordinate-free description of the triple scalar product. The coordinate-dependent formulas for dot product and cross product allow us to construct a coordinate-dependent description of the triple scalar product,

$$
\begin{aligned}
\mathbf{u} \cdot \mathbf{v} \times \mathbf{w} &= (u_1, u_2, u_3) \cdot (v_1, v_2, v_3) \times (w_1, w_2, w_3) \\
&= u_1(v_2 w_3 - v_3 w_2) + u_2(v_3 w_1 - v_1 w_3) + u_3(v_1 w_2 - v_2 w_1)
\end{aligned}
\tag{A.17}
$$

EXERCISE Ⓔ Prove the following:
A.6

 1. The identity in equation (A.17)

 2. $\mathbf{u} \times \mathbf{v} \cdot \mathbf{w} = \mathbf{u} \cdot \mathbf{v} \times \mathbf{w}$

 3. $\mathbf{u} \cdot \mathbf{w} \times \mathbf{v} = -\mathbf{u} \cdot \mathbf{v} \times \mathbf{w}$

 4. If $\{\mathbf{u}, \mathbf{v}, \mathbf{w}\}$ is an orthonormal set of vectors, then $|\mathbf{u} \cdot \mathbf{v} \times \mathbf{w}| = 1$. ∎

EXERCISE Ⓜ Let \mathbf{u}, \mathbf{v}, and \mathbf{w} be linearly independent vectors.
A.7

 1. Prove that any vector \mathbf{p} has the representation

$$
\mathbf{p} = \frac{(\mathbf{p} \cdot \mathbf{v} \times \mathbf{w})\mathbf{u} + (\mathbf{u} \cdot \mathbf{p} \times \mathbf{w})\mathbf{v} + (\mathbf{u} \cdot \mathbf{v} \times \mathbf{p})\mathbf{w}}{\mathbf{u} \cdot \mathbf{v} \times \mathbf{w}}
$$

 2. Prove that any vector \mathbf{p} has the representation

$$
\mathbf{p} = \frac{(\mathbf{w} \cdot \mathbf{p})\mathbf{u} \times \mathbf{v} + (\mathbf{u} \cdot \mathbf{p})\mathbf{v} \times \mathbf{w} + (\mathbf{v} \cdot \mathbf{p})\mathbf{w} \times \mathbf{u}}{\mathbf{u} \cdot \mathbf{v} \times \mathbf{w}}
$$
∎

Triple Vector Product

Another type of product of three vectors \mathbf{u}, \mathbf{v}, and \mathbf{w} is the *triple vector product* $\mathbf{p} = \mathbf{u} \times (\mathbf{v} \times \mathbf{w})$, itself a vector. For the sake of argument, let us assume that $\mathbf{v} \times \mathbf{w}$ is not the zero vector (the two vectors are linearly independent). The cross product of two vectors is perpendicular to each of those vectors. In our case, \mathbf{p} must be perpendicular to $\mathbf{v} \times \mathbf{w}$. But $\mathbf{v} \times \mathbf{w}$ is perpendicular to the plane spanned by \mathbf{v} and \mathbf{w}, so \mathbf{p} must lie in that plane. Figure A.19 illustrates this.

 Consequently, there must be scalars s and t such that $\mathbf{u} \times (\mathbf{v} \times \mathbf{w}) = s\mathbf{v} + t\mathbf{w}$. The scalars can be computed in a coordinate-dependent manner, but the algebraic details will be quite tedious. The following construction is coordinate-free.

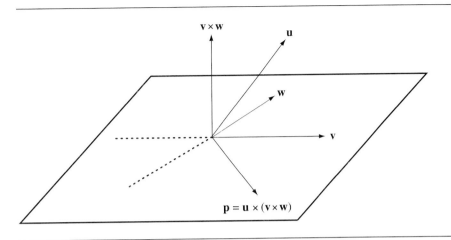

Figure A.19 The triple vector product $\mathbf{p} = \mathbf{u} \times (\mathbf{v} \times \mathbf{w})$. Note that \mathbf{p} must lie in the plane spanned by \mathbf{v} and \mathbf{w}.

Consider the special case

$$\mathbf{v} \times (\mathbf{v} \times \mathbf{w}) = s\mathbf{v} + t\mathbf{w} \tag{A.18}$$

Dotting equation (A.18) with \mathbf{v} and using the fact that \mathbf{v} is perpendicular to the cross product $\mathbf{v} \times \mathbf{w}$, we have

$$0 = \mathbf{v} \cdot \mathbf{v} \times (\mathbf{v} \times \mathbf{w}) = (\mathbf{v} \cdot \mathbf{v})s + (\mathbf{v} \cdot \mathbf{w})t \tag{A.19}$$

Now dot equation (A.18) with \mathbf{w}. The left-hand side is

$$\mathbf{w} \cdot \mathbf{v} \times (\mathbf{v} \times \mathbf{w}) = (\mathbf{w} \times \mathbf{v}) \cdot (\mathbf{v} \times \mathbf{w})$$
$$= -(\mathbf{v} \times \mathbf{w}) \cdot (\mathbf{v} \times \mathbf{w}) \qquad \text{By equation (A.14)}$$
$$= -|\mathbf{v} \times \mathbf{w}|^2$$

The second equation in s and t is

$$-|\mathbf{v} \times \mathbf{w}|^2 = (\mathbf{v} \cdot \mathbf{w})s + (\mathbf{w} \cdot \mathbf{w})t \tag{A.20}$$

The equations (A.19) and (A.20) are a system of two linear equations in two unknowns that can be written in matrix form as

$$\begin{bmatrix} \mathbf{v} \cdot \mathbf{v} & \mathbf{v} \cdot \mathbf{w} \\ \mathbf{v} \cdot \mathbf{w} & \mathbf{w} \cdot \mathbf{w} \end{bmatrix} \begin{bmatrix} s \\ t \end{bmatrix} = \begin{bmatrix} 0 \\ -|\mathbf{v} \times \mathbf{w}|^2 \end{bmatrix}$$

The matrix of coefficients on the right-hand side is inverted to produce the solution

$$\begin{bmatrix} s \\ t \end{bmatrix} = \frac{1}{(\mathbf{v} \cdot \mathbf{v})(\mathbf{w} \cdot \mathbf{w}) - (\mathbf{v} \cdot \mathbf{w})^2} \begin{bmatrix} \mathbf{w} \cdot \mathbf{w} & -\mathbf{v} \cdot \mathbf{w} \\ -\mathbf{v} \cdot \mathbf{w} & \mathbf{v} \cdot \mathbf{v} \end{bmatrix} \begin{bmatrix} 0 \\ -|\mathbf{v} \times \mathbf{w}|^2 \end{bmatrix} = \begin{bmatrix} \mathbf{v} \cdot \mathbf{w} \\ -\mathbf{v} \cdot \mathbf{v} \end{bmatrix}$$

where we have used the fact that $|\mathbf{v} \times \mathbf{w}|^2 = (\mathbf{v} \cdot \mathbf{v})(\mathbf{w} \cdot \mathbf{w}) - (\mathbf{v} \cdot \mathbf{w})^2$ from the derivation in equation (A.12). Therefore, we have the identity

$$\mathbf{v} \times (\mathbf{v} \times \mathbf{w}) = (\mathbf{v} \cdot \mathbf{w})\mathbf{v} - (\mathbf{v} \cdot \mathbf{v})\mathbf{w} \tag{A.21}$$

This identity may be used to construct a formula for the general case. We need to determine scalars s and t such that

$$\mathbf{u} \times (\mathbf{v} \times \mathbf{w}) = s\mathbf{v} + t\mathbf{w} \tag{A.22}$$

Dotting equation (A.22) with \mathbf{u} produces

$$(\mathbf{u} \cdot \mathbf{v})s + (\mathbf{u} \cdot \mathbf{w})t = \mathbf{u} \cdot \mathbf{u} \times (\mathbf{v} \times \mathbf{w}) = 0 \tag{A.23}$$

Dotting equation (A.22) with \mathbf{v} produces

$$\begin{aligned} (\mathbf{v} \cdot \mathbf{v})s + (\mathbf{v} \cdot \mathbf{w})t &= \mathbf{u} \times (\mathbf{v} \times \mathbf{w}) \cdot \mathbf{v} \\ &= \mathbf{u} \cdot (\mathbf{v} \times \mathbf{w}) \cdot \mathbf{v} & \text{(A.24)} \\ &= -\mathbf{u} \cdot (\mathbf{v} \times \mathbf{w}) \times \mathbf{v} & \text{By equation (A.14)} \\ &= -\mathbf{u} \cdot ((\mathbf{v} \cdot \mathbf{w})\mathbf{v} - (\mathbf{v} \cdot \mathbf{v})\mathbf{w}) & \text{By equation (A.21)} \\ &= (\mathbf{v} \cdot \mathbf{v})(\mathbf{u} \cdot \mathbf{w}) - (\mathbf{v} \cdot \mathbf{w})(\mathbf{u} \cdot \mathbf{v}) \end{aligned}$$

The equations (A.23) and (A.24) are a system of two linear equations in two unknowns that can be written in matrix form as

$$\begin{bmatrix} \mathbf{u} \cdot \mathbf{v} & \mathbf{u} \cdot \mathbf{w} \\ \mathbf{v} \cdot \mathbf{v} & \mathbf{v} \cdot \mathbf{w} \end{bmatrix} \begin{bmatrix} s \\ t \end{bmatrix} = \begin{bmatrix} 0 \\ (\mathbf{v} \cdot \mathbf{v})(\mathbf{u} \cdot \mathbf{w}) - (\mathbf{v} \cdot \mathbf{w})(\mathbf{u} \cdot \mathbf{v}) \end{bmatrix}$$

The matrix of coefficients on the right-hand side is inverted to produce the solution

$$\begin{aligned} \begin{bmatrix} s \\ t \end{bmatrix} &= \frac{1}{(\mathbf{u} \cdot \mathbf{v})(\mathbf{v} \cdot \mathbf{w}) - (\mathbf{u} \cdot \mathbf{w})(\mathbf{v} \cdot \mathbf{v})} \begin{bmatrix} \mathbf{v} \cdot \mathbf{w} & -\mathbf{u} \cdot \mathbf{w} \\ -\mathbf{v} \cdot \mathbf{v} & \mathbf{u} \cdot \mathbf{v} \end{bmatrix} \begin{bmatrix} 0 \\ (\mathbf{v} \cdot \mathbf{v})(\mathbf{u} \cdot \mathbf{w}) - (\mathbf{v} \cdot \mathbf{w})(\mathbf{u} \cdot \mathbf{v}) \end{bmatrix} \\ &= \begin{bmatrix} \mathbf{u} \cdot \mathbf{w} \\ -\mathbf{u} \cdot \mathbf{v} \end{bmatrix} \end{aligned}$$

Therefore, we have the identity

$$\mathbf{u} \times (\mathbf{v} \times \mathbf{w}) = (\mathbf{u} \cdot \mathbf{w})\mathbf{v} - (\mathbf{u} \cdot \mathbf{v})\mathbf{w} \tag{A.25}$$

A similar formula is

$$(\mathbf{u} \times \mathbf{v}) \times \mathbf{w} = (\mathbf{u} \cdot \mathbf{w})\mathbf{v} - (\mathbf{v} \cdot \mathbf{w})\mathbf{u} \qquad (A.26)$$

Equations (A.25) and (A.26) show that, in general, $\mathbf{u} \times (\mathbf{v} \times \mathbf{w}) \neq (\mathbf{u} \times \mathbf{v}) \times \mathbf{w}$. That is, the *cross product operation is not associative.*

EXERCISE Ⓜ Prove the following:
A.8

1. The identity in equation (A.26)
2. $(\mathbf{u} \times \mathbf{v}) \cdot (\mathbf{w} \times \mathbf{p}) = (\mathbf{u} \cdot \mathbf{w})(\mathbf{v} \cdot \mathbf{p}) - (\mathbf{u} \cdot \mathbf{p})(\mathbf{v} \cdot \mathbf{w})$
3. $(\mathbf{u} \times \mathbf{v}) \times (\mathbf{w} \times \mathbf{p}) = (\mathbf{u} \times \mathbf{v} \cdot \mathbf{p})\mathbf{w} - (\mathbf{u} \times \mathbf{v} \cdot \mathbf{w})\mathbf{p}$ ▪

A.4.6 ORTHOGONAL SUBSPACES

Let U and V be subspaces of \mathbb{R}^n. The subspaces are said to be *orthogonal subspaces* if $\mathbf{x} \cdot \mathbf{y} = 0$ for every $\mathbf{x} \in U$ and for every $\mathbf{y} \in V$.

EXAMPLE Let $U = \mathrm{Span}[(1, 1)]$ and $V = \mathrm{Span}[(1, -1)]$ in \mathbb{R}^2. Geometrically, these sets are per-
A.34 pendicular lines in \mathbb{R}^2 passing through the origin. A vector $\mathbf{x} \in U$ is of the form $\mathbf{x} = a(1, 1)$ and a vector $\mathbf{y} \in V$ is of the form $\mathbf{y} = b(1, -1)$. The inner product is $(a, a) \cdot (b, -b) = ab - ab = 0$, so U and V are orthogonal subspaces. ▪

EXAMPLE Let $U = \mathrm{Span}[(1, 0, 0, 0), (1, 1, 0, 0)]$ and $V = \mathrm{Span}[(0, 0, 4, 5)]$. Let $\mathbf{x} \in U$ and $\mathbf{y} \in$
A.35 V; then

$$\mathbf{x} = a \begin{bmatrix} 1 \\ 0 \\ 0 \\ 0 \end{bmatrix} + b \begin{bmatrix} 1 \\ 1 \\ 0 \\ 0 \end{bmatrix} = \begin{bmatrix} a + b \\ b \\ 0 \\ 0 \end{bmatrix}, \qquad \mathbf{y} = c \begin{bmatrix} 0 \\ 0 \\ 4 \\ 5 \end{bmatrix} = \begin{bmatrix} 0 \\ 0 \\ 4c \\ 5c \end{bmatrix}$$

and so

$$\mathbf{x} \cdot \mathbf{y} = \begin{bmatrix} a + b & b & 0 & 0 \end{bmatrix} \begin{bmatrix} 0 \\ 0 \\ 4c \\ 5c \end{bmatrix} = (a + b)(0) + (b)(0) + (0)(4c) + (0)(5c) = 0$$

The subspaces are therefore orthogonal. ▪

Given two subspaces U and V, some analysis of the subspaces is applied to verify that they are (or are not) orthogonal subspaces. For example, $U = \mathrm{Span}[(1, 1, 0)]$ and $V = \mathrm{Span}[(1, -1, 0)]$ are orthogonal subspaces since a general vector in U is $(a, a, 0)$, a general vector in V is $(b, -b, 0)$, and $(a, a, 0) \cdot (b, -b, 0) = 0$, regardless of choice for a and b. Geometrically, the two subspaces are perpendicular lines containing the

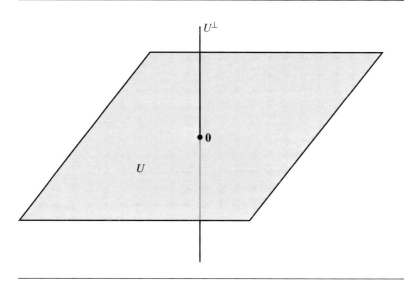

Figure A.20 A subspace U of \mathbb{R}^3 and its orthogonal complement U^\perp.

origin. Vectors on the line representing V are perpendicular to any vector in U, but there are other vectors perpendicular to those in U that are *not* in V. Specifically, the plane containing the origin and having the normal vector $(1, 1, 0)$ is a subspace W that is orthogonal to U, and V is a strict subset of W. The general problem, then, is to find the largest dimension subspace V of \mathbb{R}^n that is orthogonal to a specified subspace U. That subspace is called the *orthogonal complement of U* and is denoted by U^\perp. The formal set definition is

$$U^\perp = \{\mathbf{x} \in \mathbb{R}^n : \mathbf{x} \cdot \mathbf{y} = 0 \qquad \text{for all } \mathbf{y} \in U\} \tag{A.27}$$

Figure A.20 illustrates this concept for \mathbb{R}^3.

Figure A.20 suggests that the orthogonal complement of U^\perp is U itself; that is, $(U^\perp)^\perp = U$. This is true for finite dimensional vector spaces, but there are examples of infinite dimensional vector spaces for which it is not true. The most you can say in those spaces is that $U \subseteq (U^\perp)^\perp$, something that is easily verified just by the definition of U^\perp. For finite dimensional vector spaces, the proof that $(U^\perp)^\perp = U$ is presented next.

Let us consider the trivial case first. If $U = \{\mathbf{0}\}$, the subspace consisting of only the zero vector, the orthogonal complement is $U^\perp = \mathbb{R}^n$ since every vector is trivially perpendicular to the zero vector. Conversely, the only vector perpendicular to all vectors in \mathbb{R}^n is the zero vector, so $(U^\perp)^\perp = (\mathbb{R}^n)^\perp = \{\mathbf{0}\} = U$.

The nontrivial cases require a bit more work. Let U be a nontrivial subspace of \mathbb{R}^n. It has a basis $A = \{\mathbf{u}_1, \ldots, \mathbf{u}_m\}$, $1 < m < n$, that is an orthonormal set of vectors. Given any basis of U, it is always possible to construct an orthonormal one from it using Gram-Schmidt orthonormalization. Let B be a basis for \mathbb{R}^n. The set A can be extended to a basis for \mathbb{R}^n by attempting to insert, one at a time, the vectors from B into A. The insertion of a vector is allowed only if the resulting set of vectors is linearly independent. See the subsection on linear independence and bases to understand why this algorithm works. Let the resulting basis for \mathbb{R}^n be $\{\mathbf{u}_1, \ldots, \mathbf{u}_m, \mathbf{v}_1, \ldots, \mathbf{v}_{n-m}\}$. Now define:

$$\mathbf{w}_i = \mathbf{v}_i - \sum_{j=1}^{m} \left(\mathbf{v}_i \cdot \mathbf{u}_j \right) \mathbf{u}_j, \qquad 1 \le i \le n - m$$

The set $C = \{\mathbf{w}_1, \ldots, \mathbf{w}_{n-m}\}$ is linearly independent. To see this, set

$$\mathbf{0} = \sum_{i=1}^{n-m} c_i \mathbf{w}_i$$

$$= \sum_{i=1}^{n-m} c_i \mathbf{v}_i - \sum_{j=1}^{m} \left(\sum_{i=1}^{n-m} c_i \sum_{j=1}^{m} \left(\mathbf{v}_i \cdot \mathbf{u}_j \right) \right) \mathbf{u}_j$$

$$= \sum_{i=1}^{n-m} c_i \mathbf{v}_i + \sum_{j=1}^{m} d_j \mathbf{u}_j$$

where the last equality defines the coefficients d_j. The right-hand side is a linear combination of basis vectors for \mathbb{R}^n, so all the c_i and d_j must be zero. Since all the c_i are zero, the set of \mathbf{w}_i vectors are in fact linearly independent. Moreover, observe that

$$\mathbf{u}_k \cdot \mathbf{w}_i = \mathbf{u}_k \cdot \mathbf{v}_i - \sum_{j=1}^{m} \left(\mathbf{v}_i \cdot \mathbf{u}_j \right) \mathbf{u}_k \cdot \mathbf{u}_j$$

$$= \mathbf{u}_k \cdot \mathbf{v}_i - \sum_{j=1}^{m} \left(\mathbf{v}_i \cdot \mathbf{u}_j \right) \left\{ \begin{array}{ll} 1, & j = k \\ 0, & j \ne k \end{array} \right\}$$

$$= \mathbf{u}_k \cdot \mathbf{v}_i - \mathbf{u}_k \cdot \mathbf{v}_i$$

$$= 0$$

The $n - m$ vectors in C are all orthogonal to the m vectors in A. The set C is therefore a basis for U^{\perp}. The construction applies equally to U^{\perp} to obtain a basis D of m vectors for $(U^{\perp})^{\perp}$. At this point we know that $U \subseteq (U^{\perp})^{\perp}$ and that $\dim(U) = m = \dim((U^{\perp})^{\perp})$, the last condition disallowing proper containment; that is, $U = (U^{\perp})^{\perp}$.

A.4.7 THE FUNDAMENTAL THEOREM OF LINEAR ALGEBRA

Let us revisit linear systems of equations. Given an $n \times m$ matrix A, there are four subspaces associated with it. Each of these subspaces—kernel (A), range (A), kernel (A^T), and range (A^T)—is discussed in this section.

Kernel of A

Define the *kernel* or *nullspace* of A to be the set

$$\text{kernel}(A) = \{\mathbf{x} \in \mathbb{R}^m : A\mathbf{x} = \mathbf{0}\}$$

This subset of \mathbb{R}^m is a subspace. As discussed earlier we only need to verify that $a\mathbf{x} + b\mathbf{y} \in \text{kernel}(A)$ for any $a, b \in \mathbb{R}$ and any $\mathbf{x}, \mathbf{y} \in \text{kernel}(A)$. This is the case since

$$A(a\mathbf{x} + b\mathbf{y}) = aA\mathbf{x} + bA\mathbf{y} = a\mathbf{0} + b\mathbf{0} = \mathbf{0}$$

If $U = EA$, where E is a product of elementary row matrices and U is upper echelon, then $A\mathbf{x} = 0$ and $U\mathbf{x} = 0$ have the same set of solutions. Therefore, $\text{kernel}(A) = \text{kernel}(U)$. A basis for $\text{kernel}(A)$ is constructed by solving the system $A\mathbf{x} = 0$. If $r = \text{rank}(A)$, then $\dim(\text{kernel}(A)) = m - r$.

EXAMPLE A.36

Consider $A\mathbf{x} = \mathbf{0}$ where

$$A = \begin{bmatrix} 1 & 3 & 2 \\ 2 & 6 & 9 \\ 3 & 9 & 8 \end{bmatrix} \begin{array}{c} \sim \\ -2R_1 + R_2 \to R_2 \\ -3R_1 + R_3 \to R_3 \end{array} \begin{bmatrix} 1 & 3 & 2 \\ 0 & 0 & 5 \\ 0 & 0 & 2 \end{bmatrix} \begin{array}{c} \sim \\ \frac{1}{5}R_2 \to R_2 \end{array} \begin{bmatrix} 1 & 3 & 2 \\ 0 & 0 & 1 \\ 0 & 0 & 2 \end{bmatrix}$$

$$\begin{array}{c} \sim \\ -2R_2 + R_1 \to R_1 \\ -2R_2 + R_3 \to R_3 \end{array} \begin{bmatrix} 1 & 3 & 0 \\ 0 & 0 & 1 \\ 0 & 0 & 0 \end{bmatrix} = U$$

The basic variables are x_1 and x_3, and the only free variable is x_2. The general solution is

$$\mathbf{x} = \begin{bmatrix} x_1 \\ x_2 \\ x_3 \end{bmatrix} = \begin{bmatrix} -3x_2 \\ x_2 \\ 0 \end{bmatrix} = x_2 \begin{bmatrix} -3 \\ 1 \\ 0 \end{bmatrix}$$

The kernel is $\text{kernel}(A) = \text{Span}[(-3, 1, 0)]$ and $\dim(\text{kernel}(A)) = 1$. ∎

EXAMPLE
A.37

Suppose A is a matrix such that its complete row-reduced form is

$$U = \begin{bmatrix} 1 & 2 & -1 & 0 & 3 & -1 \\ 0 & 0 & 0 & 1 & 2 & -1 \\ 0 & 0 & 0 & 0 & 0 & 0 \\ 0 & 0 & 0 & 0 & 0 & 0 \end{bmatrix}$$

The basic variables are x_1 and x_4, and the free variables are x_2, x_3, x_5, and x_6. The general solution is

$$x = \begin{bmatrix} x_1 \\ x_2 \\ x_3 \\ x_4 \\ x_5 \\ x_6 \end{bmatrix} = \begin{bmatrix} -2x_2 + x_3 - 3x_5 + x_6 \\ x_2 \\ x_3 \\ -2x_5 + x_6 \\ x_5 \\ x_6 \end{bmatrix}$$

$$= x_2 \begin{bmatrix} -2 \\ 1 \\ 0 \\ 0 \\ 0 \\ 0 \end{bmatrix} + x_3 \begin{bmatrix} 1 \\ 0 \\ 1 \\ 0 \\ 0 \\ 0 \end{bmatrix} + x_5 \begin{bmatrix} -3 \\ 0 \\ 0 \\ -2 \\ 1 \\ 0 \end{bmatrix} + x_6 \begin{bmatrix} 1 \\ 0 \\ 0 \\ 1 \\ 0 \\ 1 \end{bmatrix}$$

The kernel is

$$\text{kernel}(A) = \text{Span}[(-2, 1, 0, 0, 0, 0), (1, 0, 1, 0, 0, 0),$$
$$(-3, 0, 0, -2, 1, 0), (1, 0, 0, 1, 0, 1)]$$

with $\dim(\text{kernel}(A)) = 4$. ∎

Range of A

Let A be written as a block matrix of $n \times 1$ column vectors,

$$A = \begin{bmatrix} \boldsymbol{\alpha}_1 | \cdots | \boldsymbol{\alpha}_m \end{bmatrix}$$

where $\boldsymbol{\alpha}_k = [a_{ik}]$ for $1 \leq k \leq m$. The expression $A\mathbf{x}$ can be written as a linear combination of these columns:

$$A\mathbf{x} = \sum_{k=1}^{m} a_{ik}x_k = x_1\boldsymbol{\alpha}_1 + \cdots + x_m\boldsymbol{\alpha}_m$$

Treating A as a function $A : \mathbb{R}^m \to \mathbb{R}^n$, the *range* of the function is

$$\text{range}(A) = \{\mathbf{y} \in \mathbb{R}^m : \mathbf{y} = A\mathbf{x} \quad \text{for some } \mathbf{x} \in \mathbb{R}^n\} = \text{Span}[\boldsymbol{\alpha}_1, \ldots, \boldsymbol{\alpha}_m]$$

This subset of \mathbb{R}^n is a subspace since the span of any subset is itself a subspace. The columns of A are not required to be linearly independent, in which case they do not form a basis for the range.

Suppose that $U = EA$, where E is a product of elementary row matrices and U is upper echelon. It is usually the case that $\text{range}(A) \neq \text{range}(U)$. However, if the pivot elements of U are in columns k_1, \ldots, k_r where $r = \text{rank}(A)$, then the corresponding columns of A form a basis for the $\text{range}(A)$. That is,

$$\text{range}(A) = \text{Span}[\boldsymbol{\alpha}_{k_1}, \ldots, \boldsymbol{\alpha}_{k_r}]$$

with $\dim(\text{range}(A)) = r$. We prove this assertion. Construct the block matrices $\widetilde{U} = [\omega_{k_1} | \cdots | \omega_{k_r}]$ and $\tilde{A} = [\boldsymbol{\alpha}_{k_1} | \cdots | \boldsymbol{\alpha}_{k_r}]$. Note that

$$\widetilde{U} = \left[\begin{array}{c} I_{r \times r} \\ \hline 0_{(n-r) \times r} \end{array} \right]$$

where $I_{r \times r}$ is an identity matrix, $r = \text{rank}(A)$, and $0_{(n-r) \times r}$ is a block matrix with all zero entries. Also note that $U = EA$ implies $\widetilde{U} = E\tilde{A}$.

Set $\sum_{j=1}^r c_j \boldsymbol{\alpha}_{k_j} = 0$. To show linear independence, we need to show that the only possibility is $c_j = 0$ for all $j = 1, \ldots, r$. But this equation is simply $\tilde{A}\mathbf{c} = \mathbf{0}$ where $\mathbf{c} = [c_j]$ is an $r \times 1$ column vector, so

$$\mathbf{0} = \tilde{A}\mathbf{c} = E^{-1}\widetilde{U}\mathbf{c} = E^{-1} \left[\begin{array}{c} I_{r \times r} \\ \hline 0_{(n-r) \times r} \end{array} \right] \mathbf{c}$$

which implies

$$\left[\begin{array}{c} I_{r \times r} \\ \hline 0_{(n-r) \times r} \end{array} \right] \mathbf{c} = E\mathbf{0} = \mathbf{0}$$

The only solution is $\mathbf{c} = \mathbf{0}$, and so the vectors $\boldsymbol{\alpha}_1, \ldots, \boldsymbol{\alpha}_r$ are linearly independent.

Moreover, $\text{range}(A) = \text{Span}[\boldsymbol{\alpha}_{k_1}, \ldots, \boldsymbol{\alpha}_{k_r}]$. The proof is as follows. Suppose $\{\boldsymbol{\alpha}_{k_1}, \ldots, \boldsymbol{\alpha}_{k_r}, \boldsymbol{\alpha}_\ell\}$ is a linearly independent set for some $\ell \notin \{k_1, \ldots, k_r\}$; then $[\tilde{A}|\boldsymbol{\alpha}_\ell]\mathbf{c} = \mathbf{0}$, where \mathbf{c} is $(r+1) \times 1$, has the unique solution $\mathbf{c} = \mathbf{0}$. Consequently,

$$\mathbf{0} = E[\tilde{A}|\boldsymbol{\alpha}_\ell]\mathbf{c} = [E\tilde{A}|E\boldsymbol{\alpha}_\ell]\mathbf{c} = [\widetilde{U}|\mathbf{b}]\mathbf{c}$$

This row-reduced system has more unknowns than equations, so it has infinitely many solutions \mathbf{c}, a contradiction to the uniqueness $\mathbf{c} = \mathbf{0}$. Therefore, $\{\boldsymbol{\alpha}_{k_1}, \ldots, \boldsymbol{\alpha}_{k_r}\}$

is the maximal linearly independent set of columns of A and must form a basis for the range of A.

EXAMPLE A.38

Consider the same matrix A as in Example A.36:

$$A = \begin{bmatrix} 1 & 3 & 2 \\ 2 & 6 & 9 \\ 3 & 9 & 8 \end{bmatrix} \sim \begin{bmatrix} 1 & 3 & 0 \\ 0 & 0 & 1 \\ 0 & 0 & 0 \end{bmatrix} = U$$

Then

$$\widetilde{U} = \begin{bmatrix} 1 & 0 \\ 0 & 1 \\ 0 & 0 \end{bmatrix}, \qquad \widetilde{A} = \begin{bmatrix} 1 & 2 \\ 2 & 9 \\ 3 & 8 \end{bmatrix}$$

and

$$\text{range}(A) = \text{Span}[(1, 2, 3), (2, 9, 8)], \qquad \text{range}(U) = \text{Span}[(1, 0, 0), (0, 1, 0)]$$

Note that $\text{range}(A) \neq \text{range}(U)$. ▪

Kernel of A^{T}

As a function, $A^{\mathrm{T}} : \mathbb{R}^n \to \mathbb{R}^m$ since A^{T} is an $m \times n$ matrix when A is an $n \times m$ matrix. The kernel of A^{T} is

$$\text{kernel}(A^{\mathrm{T}}) = \{\mathbf{y} \in \mathbb{R}^m : A^{\mathrm{T}}\mathbf{y} = \mathbf{0}\}$$

and is a subspace of \mathbb{R}^n. Construction of a basis is similar to that of $\text{kernel}(A)$. Since rank $A^{\mathrm{T}} = \text{rank}(A) = r$, $\dim(\text{kernel}(A^{\mathrm{T}})) = n - r$.

Range of A^{T}

Write A^{T} as a block matrix of column vectors: $A^{\mathrm{T}} = [\boldsymbol{\beta}_1| \cdots |\boldsymbol{\beta}_n]$, where $\boldsymbol{\beta}_i$ is an $m \times 1$ column vector for each $i = 1, \ldots, n$. The range of the transpose is

$$\text{range}(A^{\mathrm{T}}) = \text{Span}[\boldsymbol{\beta}_1, \ldots, \boldsymbol{\beta}_n]$$

and is a subspace of \mathbb{R}^m with dimension $\dim(\text{range}(A^{\mathrm{T}})) = r$.

These four subspaces are related by the following theorem.

The Fundamental Theorem of Linear Algebra ▪ If A is an $n \times m$ matrix with $\text{kernel}(A)$ and $\text{range}(A)$, and if A^{T} is the $m \times n$ transpose of A with $\text{kernel}(A^{\mathrm{T}})$ and $\text{range}(A^{\mathrm{T}})$, then $\text{kernel}(A) = \text{range}(A^{\mathrm{T}})^{\perp}$, $\text{kernel}(A)^{\perp} = \text{range}(A^{\mathrm{T}})$, $\text{kernel}(A^{\mathrm{T}}) = \text{range}(A)^{\perp}$, and $\text{kernel}(A^{\mathrm{T}})^{\perp} = \text{range}(A)$. ▪

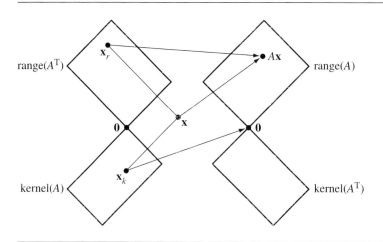

Figure A.21 The four fundamental subspaces.

Proof ▪ Let us prove that $\text{kernel}(A) = \text{range}(A^T)^\perp$. To prove that $\text{kernel}(A) \subseteq \text{range}(A^T)^\perp$, let $\mathbf{x} \in \text{kernel}(A)$ so that $A\mathbf{x} = \mathbf{0}$. For each $\mathbf{y} \in \text{range}(A^T)$, $\mathbf{y} = A^T\mathbf{z}$ for some $\mathbf{z} \in \mathbb{R}^n$. Consequently,

$$\mathbf{x}^T\mathbf{y} = \mathbf{x}^T(A^T\mathbf{z}) = (\mathbf{x}^T A^T)\mathbf{z} = (A\mathbf{x})^T\mathbf{z} = \mathbf{0}^T\mathbf{z} = 0$$

and so \mathbf{x} is orthogonal to all vectors in $\text{range}(A^T)$. That is, $\mathbf{x} \in \text{range}(A^T)$.

To prove that $\text{range}(A^T)^\perp \subseteq \text{kernel}(A)$, let $\mathbf{x} \in \text{range}(A^T)^\perp$; then $\mathbf{x}^T\mathbf{y} = 0$ for all $\mathbf{y} \in \text{range}(A^T)$. As \mathbf{z} varies over all vectors in \mathbb{R}^n, $\mathbf{y} = A^T\mathbf{z}$ varies over all vectors in $\text{range}(A^T)$. Thus, $0 = \mathbf{x}^T(A^T\mathbf{z}) = (A\mathbf{x})^T\mathbf{z}$ for *all* $\mathbf{z} \in \mathbb{R}^n$. In particular, the equation is true for the Euclidean basis vectors $\mathbf{e}_1, \ldots, \mathbf{e}_n$: $(A\mathbf{x})^T\mathbf{e}_i = 0$. In block matrix form,

$$(A\mathbf{x})^T = \left[\ (A\mathbf{x})^T\mathbf{e}_1\ \middle|\ \cdots\ \middle|\ (A\mathbf{x})^T\mathbf{e}_n\ \right] = \left[\ 0\ \middle|\ \cdots\ \middle|\ 0\ \right] = \mathbf{0}^T$$

so $A\mathbf{x} = \mathbf{0}$ and $\mathbf{x} \in \text{kernel}(A)$. The containment has been shown in both directions, so $\text{kernel}(A) = \text{range}(A^T)^\perp$.

We proved earlier that $(U^\perp)^\perp = U$. This result and the one of the previous paragraph implies that $\text{range}(A^T) = (\text{range}(A^T)^\perp)^\perp = \text{kernel}(A)^\perp$. The other two subspace equalities are valid by replacing A with A^T in the previous constructions. Figure A.21 illustrates the relationship between the four subspaces. They are drawn to indicate the orthogonality to each other. Note that $\mathbf{x} = \mathbf{x}_k + \mathbf{x}_r$ since $\text{kernel}(A)$ and $\text{range}(A^T)$ are orthogonal subspaces. ▪

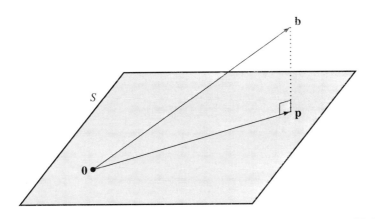

Figure A.22 The projection $\mathbf{p} \in S$ of $\mathbf{b} \in \mathbb{R}^3$, where S is a two-dimensional subspace of \mathbb{R}^3 (a plane through the origin).

A.4.8 PROJECTION AND LEAST SQUARES

The projection \mathbf{p} of a vector $\mathbf{b} \in \mathbb{R}^n$ onto a line through the origin with direction \mathbf{a} (not necessarily unit length) is provided by equation (A.8). I will write this in a different form by grouping together the terms involving \mathbf{a}. This form appears strange at first but is suggestive of what is to follow:

$$\mathbf{p} = \mathbf{a} \left(\mathbf{a}^\mathrm{T} \mathbf{a} \right)^{-1} \mathbf{a}^\mathrm{T} \mathbf{b} \qquad (A.28)$$

The line is a one-dimensional subspace of \mathbb{R}^n. The projection of \mathbf{b} onto a higher-dimensional subspace S may be similarly constructed. In this context, projection of a vector b onto a subspace S will amount to finding the point in S that is closest to \mathbf{b}. Figure A.22 illustrates this for a two-dimensional subspace in \mathbb{R}^3.

The quantity $\mathbf{a}^\mathrm{T}\mathbf{a}$ appears in equation (A.28). For higher-dimensional subspaces, the analogous quantity is $A^\mathrm{T}A$, where A is a matrix.

The construction of a projection onto a subspace is motivated by attempting to solve the system of linear equations $A\mathbf{x} = \mathbf{b}$, where A is an $n \times m$ matrix, \mathbf{x} is an $m \times 1$ column matrix, and \mathbf{b} is an $n \times 1$ column matrix. A solution exists if and only if $\mathbf{b} \in \mathrm{range}(A)$. If \mathbf{b} is not in the range of A, an application might be satisfied with a vector \mathbf{x} that is "close enough"; that is, find an \mathbf{x} so that $A\mathbf{x} - \mathbf{b}$ is as close to the zero vector as possible. Rather than attempting to solve the linear system, we can instead try to find \mathbf{x} that minimizes the length $|A\mathbf{x} - \mathbf{b}|^2$. This is called the *least-squares problem*. "Least" refers to minimum and "squares" refers to the distance-squared quantity to be minimized. If the squared distance has a minimum of zero, any such \mathbf{x}

that attains that minimum must be a solution to the linear system. If the minimum distance is positive, the linear system has no solution, but the minimization problem always does.

Geometrically, the minimizing process amounts to finding the point $\mathbf{p} \in$ range(A) that is closest to \mathbf{b}. Such a point \mathbf{p} always exists and is obtained by a *projection onto* range(A). As shown in Figure A.22, there is also always a point $\mathbf{q} \in$ range(A)$^\perp =$ kernel(A^T) such that the distance from \mathbf{b} to kernel(A^T) is a minimum. The figure should also make it clear that the quantity $|A\mathbf{x} - \mathbf{b}|^2$ is minimized if and only if $A\mathbf{x} - \mathbf{b} \in$ kernel(A^T). Since $\mathbf{p} \in$ range(A), there must be a vector $\mathbf{x} \in \mathbb{R}^m$ such that $\mathbf{p} = A\mathbf{x}$, and $A\mathbf{x} - \mathbf{b} \in$ kernel(A^T). Therefore, $|A\mathbf{x} - \mathbf{b}|^2$ is a minimum and $A^T(A\mathbf{x} - \mathbf{b}) = 0$. The equations $A^T A\mathbf{x} = A^T\mathbf{b}$ are called the *normal equations* corresponding to the linear system $A\mathbf{x} = \mathbf{b}$.

Solving the normal equations requires the following information. If A is an $n \times m$ matrix, then $A^T A$ is symmetric and rank($A^T A$) = rank(A). The symmetry of $A^T A$ follows from $(A^T A)^T = A^T (A^T)^T = A^T A$. The equality of the ranks is proved by showing that kernel(A) = kernel($A^T A$). Let $\mathbf{x} \in$ kernel(A); then $A\mathbf{x} = \mathbf{0}$. Multiply by A^T to obtain

$$\mathbf{0} = A^T \mathbf{0} = A^T A\mathbf{x}$$

which implies $\mathbf{x} \in$ kernel($A^T A$). Thus, kernel(A) \subseteq kernel($A^T A$). To show the subset inclusion in the other direction, let $\mathbf{x} \in$ kernel($A^T A$); then $A^T A\mathbf{x} = \mathbf{0}$. Multiply by \mathbf{x}^T to obtain

$$\mathbf{0} = \mathbf{x}^T \mathbf{0} = \mathbf{x}^T A^T A\mathbf{x} = |A\mathbf{x}|^2$$

The length of $A\mathbf{x}$ is zero, so $A\mathbf{x} = \mathbf{0}$ is the only possibility. This implies $\mathbf{x} \in$ kernel(A), so we have shown kernel($A^T A$) \subseteq kernel(A). The subset inclusion is true in both directions, so kernel(A) = kernel($A^T A$). The equality of the ranks follows by a direct application of the Fundamental Theorem of Linear Algebra. As we saw earlier, dim(kernel(A)) + rank(A) = m. Similarly, dim(kernel($A^T A$)) + rank($A^T A$) = m. Since dim(kernel(A)) = dim(kernel($A^T A$)), a subtraction of the two equations leads to rank(A) = rank($A^T A$).

A consequence of this result is that if the columns of A are linearly independent, then $A^T A$ is an invertible matrix. The linear independence of the columns means that $m =$ rank(A) = rank($A^T A$). The matrix $A^T A$ is an $m \times m$ matrix of full rank m, so it must be invertible. In this case the normal equations have the unique solution $\mathbf{x} = (A^T A)^{-1} A^T$. Finally, the projection of \mathbf{b} onto range(A) is

$$\mathbf{p} = A\mathbf{x} = A \left(A^T A \right)^{-1} A^T \mathbf{b} \tag{A.29}$$

Observe the similarity in form between this and equation (A.28). Also observe that the matrix $M = (A^T A)^{-1} A^T$ has the property $MA = I$. It is called the *left inverse* of

A, but note that A is *not* a square matrix! The product $P = AM = A(A^TA)^{-1}A^T$ is not generally the identity matrix. Geometrically, this is clear since $\mathbf{p} = P\mathbf{b}$. And, P cannot be the identity when $\mathbf{b} \notin \text{range}(A)$.

Let us take a closer look at the *projection matrix* $P = A(A^TA)^{-1}A^T$. As shown previously, the projection of \mathbf{b} onto range(A) is $\mathbf{p} = P\mathbf{b}$. If we attempt to project \mathbf{p} itself onto range(A), nothing should happen since \mathbf{p} is already in the range. That is,

$$P\mathbf{b} = \mathbf{p} = P\mathbf{p} = P^2\mathbf{b}$$

This equation suggests that $P^2 = P$, intuitively saying that projecting a second time does not produce anything different than projecting once. We can verify the identity using the definition of P:

$$P^2 = (A(A^TA)^{-1}A^T)(A(A^TA)^{-1}A^T)$$

$$= A(A^TA)^{-1}(A^TA)(A^TA)^{-1}A^T = A(A^TA)^{-1}A^T = P$$

Also notice that

$$P^T = (A(A^TA)^{-1}A^T)^T$$

$$= (A^T)^T((A^TA)^{-1})^TA^T = A((A^TA)^T)^{-1}A^T = A(A^TA)^{-1}A^T = P$$

so P is a symmetric matrix. Finally, Figure A.22 suggests the following. Let Q be the projection matrix onto kernel(A^T). The subspaces range(A) and kernel(A^T) are orthogonal complements of each other. The sum of the projections onto those subspaces should be the original vector. That is, $\mathbf{b} = P\mathbf{b} + Q\mathbf{b} = (P + Q)\mathbf{b}$. This equation is true for all vectors \mathbf{b}, so it must be that $P + Q = I$, or $Q = I - P$. A projection onto one subspace followed by a projection onto the orthogonal complement should always produce the zero vector. Algebraically, we can see this is true: $PQ = P(I - P) = P - P^2 = 0$, which is the zero matrix.

So far all is well as long as the $m \times m$ matrix A^TA is invertible, which is the case if and only if rank$(A) = m$. What if $r = \text{rank}(A) < m$? The range of A is spanned by the columns of A. Let the columns of A be denoted \mathbf{c}_i for $1 \le i \le m$. Reorder the columns as \mathbf{c}_{i_j} for $1 \le i_j \le m$, where the first r vectors are linearly independent $(1 \le j \le r)$ and the last $m - r$ vectors are dependent on them $(r < j \le m)$. The left-hand side of the equation $A\mathbf{x} = \mathbf{b}$ is expanded into a linear combination of the columns of A, then reordered:

$$\mathbf{b} = A\mathbf{x} = \sum_{i=1}^{m} x_i \mathbf{c}_i = \sum_{j=1}^{r} x_{i_j} \mathbf{c}_{i_j} + \sum_{j=r+1}^{m} x_{i_j} \mathbf{c}_{i_j}$$

The dependent \mathbf{c}_{i_j} terms are written as linear combinations of the independent ones. The linear combination of the dependent vectors becomes a linear combination of

the independent vectors and is folded into the already existing combination of independent vectors:

$$\mathbf{b} = \sum_{j=1}^{r} y_{i_j} \mathbf{c}_{i_j} = C\mathbf{y}$$

where y_{i_j} is a linear combination of x_{i_j} and x_{i_k} where $r < k \leq m$. We now have a linear system where the $n \times r$ matrix C has linearly independent columns. Moreover, by the construction range(C) = range(A), and the projection \mathbf{p} of \mathbf{b} onto the range of A is exactly the projection onto the range of C. Thus, the projection matrix is

$$P = C \left(C^\mathrm{T} C \right)^{-1} C^\mathrm{T} \mathbf{b}$$

Since all we need is C, and not a vector \mathbf{y} from the previous construction, it is enough to identify the columns of A that form a basis for range(A) and use them to construct C, then P.

A.4.9 LINEAR TRANSFORMATIONS

The discussion of systems of linear equations naturally leads us to the concept of a matrix, whether it be the $n \times m$ coefficient matrix A of the system, the $m \times 1$ column matrix \mathbf{x} of the unknown variables, or the $n \times 1$ column matrix of outputs \mathbf{b}. The definition for the product of matrices was motivated by solving linear systems using elementary row operations that are represented by matrices. In this section we will discover an approach to defining matrices and operations on them, one that is more natural in the framework of vector spaces.

Let V and W be vector spaces. A function $L : V \to W$ is said to be a *linear transformation* whenever

1. $L(\mathbf{x} + \mathbf{y}) = L(\mathbf{x}) + L(\mathbf{y})$ for all $\mathbf{x}, \mathbf{y} \in V$, and
2. $L(c\mathbf{x}) = cL(\mathbf{x})$ for all $c \in \mathbb{R}$ and for all $\mathbf{x} \in V$.

In words, the linear transformation of a sum of vectors is the sum of linear transformations of those vectors, and the linear transformation of a scalar multiple of a vector is the scalar multiple of the linear transformation of that vector. The two conditions can be summarized as a single condition, $L(c\mathbf{x} + \mathbf{y} = cL(\mathbf{x}) + L(\mathbf{y})$ for all $c \in \mathbb{R}$ and for all $\mathbf{x}, \mathbf{y} \in V$. We will refer to V as the *domain of L* and W as the *codomain of L*. The last term is used to avoid confusion in nomenclature. Sometimes W is said to be the *range of the function*, but in our development we use the term *range* to refer to the set of vectors in W that are obtained by applying the function to the domain vectors. In many cases the range is a proper subset of W.

A couple of simple consequences of the definition: $L(\mathbf{0}) = \mathbf{0}$ and $L(-\mathbf{x}) = -L(\mathbf{x})$. The first identity follows from

$$L(\mathbf{0}) = L(0\mathbf{0}) = (0)L(\mathbf{0}) = \mathbf{0}$$

The first and third equalities are a consequence of the fact that the scalar zero multiplied by any vector is the zero vector. The second equality is valid since L is a linear transformation (item 2 in the definition). The second identity is proved similarly:

$$L(-\mathbf{x}) = L(-1\mathbf{x}) = (-1)L(\mathbf{x}) = -L(\mathbf{x})$$

In a finite dimensional vector space, if a vector is written as an n-tuple $\mathbf{x} = (x_1, \ldots, x_n)$, you would write $L(\mathbf{x}) = L((x_1, \ldots, x_n))$. In these specific cases the extra parentheses are dropped for readability: $L(x_1, \ldots, x_n)$.

EXAMPLE
A.39

Define $L : \mathbb{R}^3 \to \mathbb{R}^2$ by $L(x_1, x_2, x_3) = (x_1 + x_2, x_1 - 3x_3)$. Let $c \in \mathbb{R}$, $\mathbf{x} = (x_1, x_2, x_3)$, and $\mathbf{y} = (y_1, y_2, y_3)$; then

$$
\begin{aligned}
L(c\mathbf{x} + \mathbf{y}) &= L(c(x_1, x_2, x_3) + (y_1, y_2, y_3)) \\
&= L(ax_1 + by_1, ax_2 + by_2, ax_3 + by_3) \\
&= ((cx_1 + y_1) + (cx_2 + y_2), (cx_1 + y_1) - 3(cx_3 + y_3)) \\
&= (c(x_1 + x_2) + (y_1 + y_2), c(x_1 - 3x_3) + (y_1 - 3y_3)) \\
&= c(x_1 + x_2, x_1 - 3x_3) + (y_1 + y_2, y_1 - 3y_3) \\
&= cL(\mathbf{x}) + L(\mathbf{y})
\end{aligned}
$$

so L is a linear transformation.

If $\{\mathbf{e}_1, \mathbf{e}_2, \mathbf{e}_3\}$ is the standard Euclidean basis, then $\mathbf{x} = (x_1, x_2, x_3) = x_1\mathbf{e}_1 + x_2\mathbf{e}_2 + x_3\mathbf{e}_3$ and

$$L(\mathbf{x}) = L(x_1\mathbf{e}_1 + x_2\mathbf{e}_2 + x_3\mathbf{e}_3) = x_1 L(\mathbf{e}_1) + x_2 L(\mathbf{e}_2) + x_3 L(\mathbf{e}_3)$$

since L is linear. Thus, L is determined completely by the values of $L(\mathbf{e}_i)$ for $1 \le i \le 3$. As we will see, in general L is determined by its values for any specified basis.

In column vector form,

$$L(\mathbf{x}) = L\left(\begin{bmatrix} x_1 \\ x_2 \\ x_3 \end{bmatrix}\right) = \begin{bmatrix} x_1 + x_2 \\ x_1 - 3x_3 \end{bmatrix} = \begin{bmatrix} 1 & 1 & 0 \\ 1 & 0 & -3 \end{bmatrix} \begin{bmatrix} x_1 \\ x_2 \\ x_3 \end{bmatrix} = A\mathbf{x}$$

(Example A.39 continued)

The transformation $L(\mathbf{x})$ is represented by a matrix multiplication $A\mathbf{x}$. Since the kth column of A is $A\mathbf{e}_k$, $L(\mathbf{e}_k)$ is the kth column of A:

$$L\left(\begin{bmatrix} 1 \\ 0 \\ 0 \end{bmatrix}\right) = \begin{bmatrix} 1 \\ 1 \end{bmatrix}, \qquad L\left(\begin{bmatrix} 0 \\ 1 \\ 0 \end{bmatrix}\right) = \begin{bmatrix} 1 \\ 0 \end{bmatrix}, \qquad L\left(\begin{bmatrix} 0 \\ 0 \\ 1 \end{bmatrix}\right) = \begin{bmatrix} 0 \\ -3 \end{bmatrix}$$

This relationship naturally ties together linear transformations and matrices. ▪

EXAMPLE A.40

Let P be the vector space of all polynomials with real coefficients. Define $L : P \to P$ by $L(p(x)) = p'(x)$. That is,

$$L\left(\sum_{i=0}^{n} p_i x^i\right) = \sum_{i=1}^{n} i p_i x^i = \sum_{j=0}^{n-1} (j+1) p_{j+1} x^j$$

You should recognize L as differentiation of the polynomial $p(x)$. Let $p(x) = \sum_{i=0}^{n} p_i x^i$ and $q(x) = \sum_{i=0}^{m} q_i x^i$, where $n \leq m$. If we define $p_i = 0$ for $i > n$, then $p(x) = \sum_{i=0}^{m} p_i x^i$ so that the upper limits of summation on $p(x)$ and $q(x)$ are the same. Let $c \in \mathbb{R}$; then

$$L(cp(x) + q(x)) = L\left(c \sum_{i=0}^{m} p_i x^i + \sum_{i=0}^{m} q_i x^i\right)$$

$$= L\left(\sum_{i=0}^{m} (cp_i + q_i) x^i\right) \qquad \text{Using vector space operations}$$

$$= \sum_{j=0}^{m-1} (j+1)(cp_{j+1} + q_{j+1}) x^j \qquad \text{Definition of } L$$

$$= c \sum_{j=0}^{m-1} (j+1) p_j x^j + \sum_{j=0}^{m-1} (j+1) q_j x^j \qquad \text{Using vector space operations}$$

$$= cL\,(p(x)) + L\,(q(x)) \qquad \text{Definition of } L$$

This proves that L is a linear transformation. ▪

The next result establishes for certain the relationship between linear transformations and matrices: $L : \mathbb{R}^m \to \mathbb{R}^n$ is a linear transformation if and only if $L(\mathbf{x}) = A\mathbf{x}$ for some $n \times m$ matrix $A = [a_{ij}]$. The proof follows.

Define the function $L(\mathbf{x}) = A\mathbf{x}$, where \mathbf{x} is treated as an $m \times 1$ column vector and where $L(\mathbf{x})$ is treated as an $n \times 1$ column vector. For $c \in \mathbb{R}$ and $\mathbf{x}, \mathbf{y} \in \mathbb{R}^m$,

$$
\begin{aligned}
L(c\mathbf{x} + \mathbf{y}) &= A(c\mathbf{x} + \mathbf{y}) && \text{Definition of } L \\
&= A(c\mathbf{x}) + A\mathbf{y} && \text{Matrix multiplication is distributive} \\
&= c(A\mathbf{x}) + A\mathbf{y} && \text{Property of matrix arithmetic} \\
&= cL(\mathbf{x}) + L(\mathbf{y}) && \text{Definition of } L
\end{aligned}
$$

This proves that L is a linear transformation.

Conversely, let $L : \mathbb{R}^m \to \mathbb{R}^n$ be a linear transformation, where \mathbf{x} and $L(\mathbf{x})$ are treated as column vectors. Let $\{\mathbf{e}_1, \ldots, \mathbf{e}_n\}$ be the standard Euclidean basis for \mathbb{R}^n; then $L(\mathbf{e}_k) \in \mathbb{R}^m$ for all k. As such, these vectors can be represented as

$$
L(\mathbf{e}_k) = \begin{bmatrix} a_{1k} \\ \vdots \\ a_{mk} \end{bmatrix}_{m \times 1}, \quad k = 1, \ldots, n
$$

If $\mathbf{x} = \sum_{k=1}^{n} x_k \mathbf{e}_k$, then

$$
\begin{aligned}
L(\mathbf{x}) &= L\left(\sum_{k=1}^{n} x_k \mathbf{e}_k \right) \\
&= \sum_{k=1}^{n} x_k L(\mathbf{e}_k) && \text{Since } L \text{ is linear} \\
&= \sum_{k=1}^{n} x_k \begin{bmatrix} a_{1k} \\ \vdots \\ a_{mk} \end{bmatrix} \\
&= \sum_{k=1}^{n} \begin{bmatrix} a_{1k} x_k \\ \vdots \\ a_{mk} x_k \end{bmatrix} \\
&= \begin{bmatrix} \sum_{k=1}^{n} a_{1k} x_k \\ \vdots \\ \sum_{k=1}^{n} a_{mk} x_k \end{bmatrix} \\
&= A\mathbf{x}
\end{aligned}
$$

The argument actually provides the construction of the $n \times m$ matrix A given L.

EXAMPLE
A.41

Define $L : \mathbb{R}^2 \to \mathbb{R}^2$ by $L(x_1, x_2 = (3x_1 + 6x_2, -2x_1 + x_2)$. In column vector form,

$$L\left(\begin{bmatrix} L \\ 0 \end{bmatrix}\right) = \begin{bmatrix} 3 \\ -2 \end{bmatrix}, \qquad L\left(\begin{bmatrix} 0 \\ 1 \end{bmatrix}\right) = \begin{bmatrix} 6 \\ 1 \end{bmatrix}$$

and

$$L\left(\begin{bmatrix} x_1 \\ x_2 \end{bmatrix}\right) = \begin{bmatrix} 3 & 6 \\ -2 & 1 \end{bmatrix} \begin{bmatrix} x_1 \\ x_2 \end{bmatrix} = \begin{bmatrix} 3x_1 + 6x_2 \\ -2x_1 + x_2 \end{bmatrix}$$

The transformation has been written as $L(\mathbf{x}) = A\mathbf{x}$, where

$$A = [L(e_1) \quad L(e_2)]_{2 \times 2} = \begin{bmatrix} 3 & 6 \\ -2 & 1 \end{bmatrix}$$

This representation depends on our choice of the Euclidean basis for \mathbb{R}^2. That is,

$$\begin{bmatrix} x_1 \\ x_2 \end{bmatrix} = x_1 \begin{bmatrix} 1 \\ 0 \end{bmatrix} + x_2 \begin{bmatrix} 0 \\ 1 \end{bmatrix} \quad \text{and}$$

$$L\left(\begin{bmatrix} x_1 \\ x_2 \end{bmatrix}\right) = (3x_1 + 6x_2) \begin{bmatrix} 1 \\ 0 \end{bmatrix} + (-2x_1 + x_2) \begin{bmatrix} 0 \\ 1 \end{bmatrix} \quad \blacksquare$$

What happens if you use different bases? Let $L : V \to W$ be a linear transformation where V has basis $F = \{\mathbf{f}_1, \ldots, \mathbf{f}_m\}$ and W has basis $G = \{\mathbf{g}_1, \ldots, \mathbf{g}_n\}$. Treating the elements of V and W as column vectors, we can represent L by $L(\mathbf{x}) = A\mathbf{x}$, where A depends on the definition for L, the basis F for V, and the basis G for W. A vector $\mathbf{x} \in V$ is represented in the F basis as $\mathbf{x} = \sum_{j=1}^{m} x_j \mathbf{f}_j$. Each vector $L(\mathbf{f}_j) \in W$ is represented in the G basis as $L(\mathbf{f}_j) = \sum_{i=1}^{n} a_{ij} \mathbf{g}_i$. The linear transformation is expanded as

$$L(\mathbf{x}) = L\left(\sum_{j=1}^{m} x_j f_j\right)$$

$$= \sum_{j=1}^{m} x_j L(\mathbf{f}_j)$$

$$= \sum_{j=1}^{m} x_j \left(\sum_{i=1}^{n} a_{ij} \mathbf{g}_i\right)$$

$$= \sum_{i=1}^{n} \left(\sum_{j=1}^{m} a_{ij} x_j\right) \mathbf{g}_i$$

$$= \sum_{i=1}^{n} y_i \mathbf{g}_i$$

where the last equality defines the $y_i = \sum_{j=1}^{m} a_{ij} x_j$. The coefficient vector \mathbf{x}, which is $m \times 1$, and the coefficient vector \mathbf{y}, which is $n \times 1$, are related by the matrix

equation $\mathbf{y} = A\mathbf{x}$, where $A = [a_{ij}]$ is an $n \times m$ matrix. This matrix represents the linear transformation *with respect to the chosen bases F and G*. Different choices for bases will lead to different matrices for A.

EXAMPLE
A.42

Let $L : \mathbb{R}^2 \to \mathbb{R}^2$ be given by $L(x_1, x_2) = (3x_1 + 6x_2, -2x_1 + x_2) = (y_1, y_2)$. The standard Euclidean basis is $E = \{(1, 0), (0, 1)\}$. The matrix representation of L where E is the basis used for both the domain and codomain is

$$\mathbf{y}_E = \begin{bmatrix} 3 & 6 \\ -2 & 1 \end{bmatrix} \mathbf{x}_E$$

The notations \mathbf{x}_E and \mathbf{y}_E indicate that the vectors are to be represented in the basis E. The input 2-tuple (x_1, x_2) and output 2-tuple (y_1, y_2) have the obvious representations in E as

$$\mathbf{x}_E = \begin{bmatrix} x_1 \\ x_2 \end{bmatrix} \quad \text{and} \quad \mathbf{y}_E = \begin{bmatrix} y_1 \\ y_2 \end{bmatrix}$$

Choose different bases, $F = \{\mathbf{f}_1, \mathbf{f}_2\} = \{(1, 1), (1, -1)\}$ for the domain and $G = \{\mathbf{g}_1, \mathbf{g}_2\} = \{(0, 1), (1, 0)\}$ for the codomain. The representation of (x_1, x_2) in the F basis is

$$\mathbf{x}_F = \frac{x_1 + x_2}{2}(1, 1) + \frac{x_1 - x_2}{2}(1, -1) = \frac{x_1 + x_2}{2}\mathbf{f}_1 + \frac{x_1 - x_2}{2}\mathbf{f}_2$$

The representation of (y_1, y_2) in the G basis is

$$\mathbf{y}_G = y_2(0, 1) + y_1(1, 0) = y_2\mathbf{g}_1 + y_1\mathbf{g}_2$$

The linear transformation applied to the F basis vectors has results written in the G basis,

$$L(\mathbf{f}_1) = L(1, 1) = (9, -1) = -1(0, 1) + 9(1, 0) = -\mathbf{g}_1 + 9\mathbf{g}_2$$

$$L(\mathbf{f}_2) = L(1, -1) = (-3, -3) = -3(0, 1) - 3(1, 0) = -3\mathbf{g}_1 - 3\mathbf{g}_2$$

so the matrix that represents L with respect to the bases F and G is

$$A = \begin{bmatrix} -1 & -3 \\ 9 & -3 \end{bmatrix}$$

A quick verification shows

$$\begin{bmatrix} y_2 \\ y_1 \end{bmatrix} = \mathbf{y}_G = A\mathbf{x}_F = \begin{bmatrix} -1 & -3 \\ 9 & -3 \end{bmatrix} \begin{bmatrix} \frac{x_1+x_2}{2} \\ \frac{x_1-x_2}{2} \end{bmatrix} = \begin{bmatrix} -2x_1 + x_2 \\ 3x_1 + 6x_2 \end{bmatrix}$$

and reproduces exactly the linear transformation $(y_1, y_2) = (3x_1 + 6x_2, -2x_1 + x_2)$.

EXAMPLE
A.43

Let P_n be the set of polynomials with real-valued coefficients and of degree at most n. That is,

$$P_n = \left\{ \sum_{i=0}^{n} a_i x^i : a_i \in \mathbb{R} \right\}$$

Define $L : P_1 \rightarrow P_2$ by

$$L(p(x)) = \int_0^x p(t)\, dt$$

You should recognize this as the definite integral of the polynomial over the interval $[0, x]$, where the upper limit x is variable. Polynomials in P_1 are of the form $p(x) = a_0 + a_1 x$ and polynomials in P_2 are of the form $p(x) = b_0 + b_1 x + b_2 x^2$. The linear transformation can be restated as $L(a_0 + a_1 x) = a_0 x + (a_1/2)x^2$. A basis for P_1 is $F = \{\mathbf{f}_1, \mathbf{f}_2\} = \{1, x\}$ and a basis for P_2 is $G = \{\mathbf{g}_1, \mathbf{g}_2, \mathbf{g}_2\} = \{1, x, x^2\}$. Applying the linear transformation to the F basis vectors produces

$$L(\mathbf{f}_1) = L(1) = x = 0 \cdot 1 + 1 \cdot x + 0 \cdot x^2 = \mathbf{g}_2$$

$$L(\mathbf{f}_2) = L(x) = \frac{1}{2}x^2 = 0 \cdot 1 + 0 \cdot x + \frac{1}{2} \cdot x^2 = (1/2)\mathbf{g}_3$$

The matrix A that represents the linear transformation with respect to the bases F and G is

$$A = \begin{bmatrix} 0 & 0 \\ 1 & 0 \\ 0 & \frac{1}{2} \end{bmatrix}$$

In terms of the polynomial coefficients, the application of the matrix is

$$A \begin{bmatrix} a_0 \\ a_1 \end{bmatrix} = \begin{bmatrix} 0 \\ a_0 \\ \frac{a_1}{2} \end{bmatrix} \quad \blacksquare$$

Let $L : V \rightarrow V$ be a linear transformation where V is both the domain and codomain and has dimension n. A matrix representation of L is an $n \times n$ matrix. We have seen that the matrix representation depends on the bases selected for the domain and codomain. If a basis $F = \{\mathbf{f}_1, \ldots, \mathbf{f}_n\}$ is chosen for domain and codomain with corresponding matrix representation A, and a basis $G = \{\mathbf{g}_1, \ldots, \mathbf{g}_n\}$ is chosen for domain and codomain with corresponding matrix representation B, the question is how are A and B related? The key idea is *change of basis*, the process of representing basis vectors in F in terms of the basis G. Each vector \mathbf{f}_j is represented in G as

$$\mathbf{f}_j = \sum_{i=1}^{n} c_{ij} \mathbf{g}_i, \quad 1 \le j \le n$$

$$(V, F) \xrightarrow{A} (V, F)$$

$$C \downarrow \qquad\qquad \downarrow C$$

$$(V, G) \xrightarrow{B} (V, G)$$

Figure A.23 A linear transformation from V to V with respect to two different bases (horizontal arrows). The change of basis for V (vertical arrows).

The matrix $C = [c_{ij}]$ is called the *change of basis matrix* and itself represents a linear transformation from V to V. Figure A.23 is a diagram that indicates how all the matrices map V to itself. The bases are explicitly paired with V for clarity.

To get from (V, F) to (V, F) you can directly apply matrix A. Or you can go from (V, F) to (V, G) by applying matrix C, then from (V, G) to (V, G) by applying matrix B, then from (V, G) to (V, F) by applying the inverse matrix C^{-1}. The two alternatives suggest that $A = C^{-1}BC$. This is in fact the case as the following algebraic construction shows. The inverse matrix C^{-1} has entries named d_{ij}. The basis vectors in G are related to the basis vectors in F by

$$\mathbf{g}_i = \sum_{\ell=1}^{n} d_{\ell i} \mathbf{f}_\ell$$

The linear transformation is expanded as

$$L(\mathbf{f}_j) = L\left(\sum_{k=1}^{n} c_{kj}\mathbf{g}_k\right) \qquad \text{Using the change of basis matrix } C$$

$$= \sum_{k=1}^{n} c_{kj} L(\mathbf{g}_k) \qquad \text{Since } L \text{ is linear}$$

$$= \sum_{k=1}^{n} c_{kj} \left(\sum_{i=1}^{n} b_{ik}\mathbf{g}_i\right) \qquad \text{Using the matrix } B \text{ that represents } L$$

$$= \sum_{i=1}^{n} \sum_{k=1}^{n} b_{ik} c_{kj}\mathbf{g}_i$$

$$= \sum_{i=1}^{n} \sum_{k=1}^{n} b_{ik} c_{kj} \left(\sum_{\ell=1}^{n} d_{\ell i} f_i\right) \qquad \text{Using the change of basis matrix } C^{-1}$$

(continued)

$$= \sum_{\ell=1}^{n} \left(\sum_{i=1}^{n} \sum_{k=1}^{n} d_{\ell i} b_{ik} c_{kj} \right) \mathbf{f}_{\ell}$$

$$= \sum_{\ell=1}^{n} a_{\ell j} \mathbf{f}_{j} \qquad \text{Using the matrix } A \text{ that represents } L$$

so $a_{\ell j} = \sum_{i=1}^{n} \sum_{k=1}^{n} d_{\ell i} b_{ik} c_{kj}$. Using the definition of matrix multiplication, we have $A = C^{-1} B C$.

The relationship between A and B is called a *similarity relationship*. In general if A and B are square matrices for which there exists an invertible matrix C with $A = C^{-1} B C$, then A and B are said to be *similar*. The importance of similarity of matrices will become more apparent in Sections A.5.2 and A.5.3 on eigenvalues and eigenvectors.

**EXAMPLE
A.44**

Consider the linear transformation $L : \mathbb{R}^2 \to \mathbb{R}^2$ defined by $L(x_1, x_2) = (x_1 - 3x_2, x_1 + x_2)$. Two bases for \mathbb{R}^2 are $F = \{(2, 1), (1, -1)\}$, and $G = \{(0, 1), (1, 0)\}$. Compute the matrix A representing $L : (\mathbb{R}^2, F) \to (\mathbb{R}^2, F)$. Solve

$$L(\mathbf{f}_1) = L(2, 1) = (-1, 3) = a_{11}(2, 1) + a_{21}(1, -1) = a_{11}\mathbf{f}_1 + a_{21}\mathbf{f}_2$$

$$L(\mathbf{f}_2) = L(1, -1) = (4, 0) = a_{12}(2, 1) + a_{22}(1, -1) = a_{12}\mathbf{f}_1 + a_{22}\mathbf{f}_2$$

The coefficients a_{ij} are solutions to

$$\begin{bmatrix} 2 & 1 \\ 1 & -1 \end{bmatrix} \begin{bmatrix} a_{11} & a_{12} \\ a_{21} & a_{22} \end{bmatrix} = \begin{bmatrix} -1 & 4 \\ 3 & 0 \end{bmatrix}$$

therefore,

$$A = \begin{bmatrix} a_{11} & a_{12} \\ a_{21} & a_{22} \end{bmatrix} = \begin{bmatrix} 2 & 1 \\ 1 & -1 \end{bmatrix}^{-1} \begin{bmatrix} -1 & 4 \\ 3 & 0 \end{bmatrix} = \begin{bmatrix} \frac{2}{3} & \frac{4}{3} \\ -\frac{7}{3} & \frac{4}{3} \end{bmatrix}$$

and

$$L(\mathbf{f}_1) = \frac{2}{3}\mathbf{f}_1 - \frac{7}{3}\mathbf{f}_2, \qquad L(\mathbf{f}_2) = \frac{4}{3}\mathbf{f}_1 + \frac{4}{3}\mathbf{f}_2$$

Compute the matrix B representing $L : (\mathbb{R}^2, G) \to (\mathbb{R}^2, G)$. Solve

$$L(\mathbf{g}_1) = L(0, 1) = (-3, 1) = b_{11}(0, 1) + b_{21}(1, 0) = b_{11}\mathbf{g}_1 + b_{21}\mathbf{g}_2$$

$$L(\mathbf{g}_2) = L(1, 0) = (1, 1) = b_{12}(0, 1) + b_{22}(1, 0) = b_{12}\mathbf{g}_1 + b_{22}\mathbf{g}_2$$

The coefficients b_{ij} are solutions to

$$\begin{bmatrix} 0 & 1 \\ 1 & 0 \end{bmatrix} \begin{bmatrix} b_{11} & b_{12} \\ b_{21} & b_{22} \end{bmatrix} = \begin{bmatrix} -3 & 1 \\ 1 & 1 \end{bmatrix}$$

therefore,

$$B = \begin{bmatrix} b_{11} & b_{12} \\ b_{21} & b_{22} \end{bmatrix} = \begin{bmatrix} 0 & 1 \\ 1 & 0 \end{bmatrix}^{-1} \begin{bmatrix} -3 & 1 \\ 1 & 1 \end{bmatrix} = \begin{bmatrix} 1 & 1 \\ -3 & 1 \end{bmatrix}$$

and

$$L(\mathbf{g}_1) = \mathbf{g}_1 - 3\mathbf{g}_2, \qquad L(\mathbf{g}_2) = \mathbf{g}_1 + \mathbf{g}_2$$

Finally, compute the change of basis matrix C from

$$\mathbf{f}_1 = (2,\ 1) = c_{11}(0,\ 1) + c_{21}(1,\ 0) = c_{11}\mathbf{g}_1 + c_{21}\mathbf{g}_2$$
$$\mathbf{f}_2 = (1,\ -1) = c_{12}(0,\ 1) + c_{22}(1,\ 0) = c_{12}\mathbf{g}_1 + c_{22}\mathbf{g}_2$$

the solution being

$$C = \begin{bmatrix} 1 & -1 \\ 2 & 1 \end{bmatrix}, \qquad C^{-1} = \frac{1}{3}\begin{bmatrix} 1 & 1 \\ -2 & 1 \end{bmatrix}$$

The similarity relationship between A and B is

$$C^{-1}BC = \frac{1}{3}\begin{bmatrix} 1 & 1 \\ -2 & 1 \end{bmatrix}\begin{bmatrix} 1 & 1 \\ -3 & 1 \end{bmatrix}\begin{bmatrix} 1 & -1 \\ 2 & 1 \end{bmatrix} = \frac{1}{3}\begin{bmatrix} 2 & 4 \\ -7 & 4 \end{bmatrix} = A$$

There is one last topic on vector spaces to consider, finally. Composition of linear transformations is the foundation for the definition of matrix multiplication. Let $R : \mathbb{R}^n \to \mathbb{R}^p$ and $S : \mathbb{R}^m \to \mathbb{R}^n$ be linear transformations, say $\mathbf{y} = S(\mathbf{x})$ and $\mathbf{z} = R(\mathbf{y})$. The composition is $T = R \circ S(\mathbf{x})R(S(\mathbf{x}))$ and is a linear function $T : \mathbb{R}^m \to \mathbb{R}^p$. (The circle symbol denotes composition of functions.) To see that T is linear, let $c \in \mathbb{R}$ and $\mathbf{x}_1, \mathbf{x}_2 \in \mathbb{R}^m$:

$$
\begin{aligned}
T(c\mathbf{x}_1 + \mathbf{x}_2) &= R(S(c\mathbf{x}_1 + \mathbf{x}_2)) && \text{Definition of } T \\
&= R(cS(\mathbf{x}_1) + S(\mathbf{x}_2)) && S \text{ is linear} \\
&= cR(S(\mathbf{x}_1)) + R(S(\mathbf{x}_2)) && R \text{ is linear} \\
&= cT(\mathbf{x}_1) + T(\mathbf{x}_2) && \text{Definition of } T
\end{aligned}
$$

If A is a matrix representation of R and B is a matrix representation of S, with respect to specified bases, of course, then what is the matrix representation of T with respect to those same bases? The answer is simply put: $R(\mathbf{y})$ is represented by $\mathbf{z} = A\mathbf{y}$ and $S(\mathbf{x})$ is represented by $\mathbf{y} = B\mathbf{x}$. The composition is $\mathbf{z} = A\mathbf{y} = A(B\mathbf{x}) = (AB)\mathbf{x} = C\mathbf{x}$. The matrix representing T is C and is a product of A and B. Observe that A is $p \times n$, B is $n \times m$, and C is $p \times m$.

A.5 ADVANCED TOPICS

A.5.1 DETERMINANTS

A *determinant* is a scalar quantity associated with a square matrix and is encountered frequently in applications. You are most likely familiar with the determinant formulas for 2×2 and 3×3 matrices. I will take a closer look at these definitions and provide a geometric interpretation for them.

Determinant of a 2×2 Matrix

The determinant for a 2×2 matrix A is defined by

$$\det(A) = \det \begin{bmatrix} a_{11} & a_{12} \\ a_{21} & a_{22} \end{bmatrix} = a_{11}a_{22} - a_{12}a_{21} \tag{A.30}$$

which is a simple enough formula to commit to memory. As it turns out, $\det(A)$ is nonzero if and only if A is an invertible matrix. Formally, the inverse of A is the matrix

$$A^{-1} = \frac{1}{a_{11}a_{22} - a_{12}a_{21}} \begin{bmatrix} a_{22} & -a_{12} \\ -a_{21} & a_{11} \end{bmatrix}$$

Verify for yourself that $AA^{-1} = A^{-1}A = I$, where I is the identity matrix. Observe that the scalar before the matrix is the reciprocal of the determinant, $1/\det(A)$, so clearly the determinant must not be zero in order that A^{-1} exist. This algebraic requirement is perhaps unsatisfying to someone wanting a geometric understanding of the problem. Let us go ahead and take a closer look.

Let $\imath = [1\ 0]^{\mathrm{T}}$ and $\jmath = [0\ 1]^{\mathrm{T}}$ be the standard basis vectors for \mathbb{R}^2. These vectors are transformed to $A\imath = [a_{11}\ a_{21}]^{\mathrm{T}}$ and $A\jmath = [a_{12}\ a_{22}]^{\mathrm{T}}$, the columns of the matrix A. Figure A.24 shows the unit-area square whose sides are determined by the basis vectors and shows various possibilities for the transformed square.

Although Figure A.24(d) shows $A\imath$ and $A\jmath$ as nonzero vectors, either or both can be the zero vector; that is, one or both columns of A can be the zero vector. It is also possible that the transformed basis vectors are nonzero but point in opposite directions.

Set $\mathbf{u} = A\imath$ and $\mathbf{v} = A\jmath$. The area of the parallelogram formed by \mathbf{u} and \mathbf{v} is $\alpha = bh$, where b is the base (the length of \mathbf{u}) and where h is the height (the length of the projection of \mathbf{v} onto a vector perpendicular to \mathbf{u}). We will do the calculations in squared form, that is, $\alpha^2 = b^2h^2$. The squared base is just

$$b^2 = |\mathbf{u}|^2$$

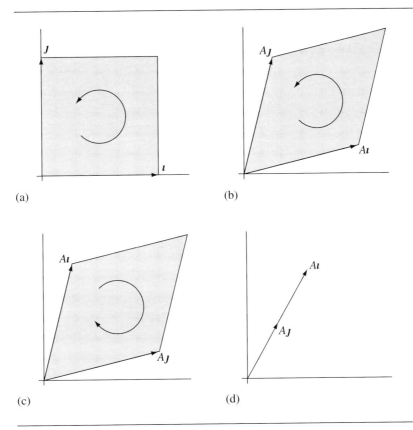

Figure A.24 (a) A unit-area square. (b) The parallelogram obtained by transforming the square when the transformed basis vectors have the same order as the basis vectors. (c) The parallelogram obtained by transforming the square when the transformed basis vectors have the opposite order as the basis vectors. (d) The basis vectors mapped to parallel vectors, in which case A is not invertible.

The squared height is calculated from the aforementioned projection that is calculated using equation (A.8):

$$\mathbf{p} = \mathbf{v} - \frac{\mathbf{u} \cdot \mathbf{v}}{|\mathbf{u}|^2} \mathbf{u}$$

The squared height is

$$h^2 = |\mathbf{p}|^2 = \left| \mathbf{v} - \frac{\mathbf{u} \cdot \mathbf{v}}{|\mathbf{u}|^2} \mathbf{u} \right|^2 = |\mathbf{v}|^2 - \frac{2(\mathbf{u} \cdot \mathbf{v})^2}{|\mathbf{u}|^2} + \frac{(\mathbf{u} \cdot \mathbf{v})^2}{|\mathbf{u}|^2} = |\mathbf{v}|^2 - \frac{(\mathbf{u} \cdot \mathbf{v})^2}{|\mathbf{u}|^2}$$

The squared area is

$$\alpha^2 = b^2 h^2$$
$$= |\mathbf{u}|^2 |\mathbf{p}|^2$$
$$= |\mathbf{u}|^2 |\mathbf{v}|^2 - (\mathbf{u} \cdot \mathbf{v})^2$$
$$= (a_{11}^2 + a_{21}^2)(a_{12}^2 + a_{22}^2) - (a_{11}a_{12} + a_{21}a_{22})^2$$
$$= a_{11}^2 a_{22}^2 + a_{21}^2 a_{12}^2 - 2a_{11}a_{12}a_{21}a_{22}$$
$$= (a_{11}a_{22} - a_{12}a_{21})^2$$
$$= (\det(A))^2$$

The area of the parallelogram is $\alpha = |\det(A)|$, the absolute value of the determinant of the matrix. To distinguish between the two cases corresponding to Figure A.24(b), (c) we will use a *signed area*. Part (b) occurs when the order of the basis vectors is preserved; we will assign a positive area to that parallelogram. Part (c) occurs when the order is switched; we will assign a negative area to that paralleogram. The signed area formula (using the same variable name) is $\alpha = \det(A)$. This equation captures all the geometry in parts (a)–(c) of the figure, part (d) representing the case when the determinant is zero. In this case, the parallelogram is degenerate and may be considered to bound a region of zero area.

Determinant of a 3 × 3 Matrix

The determinant for a 3 × 3 matrix is defined by

$$\det(A) = \det \begin{bmatrix} a_{11} & a_{12} & a_{13} \\ a_{21} & a_{22} & a_{23} \\ a_{31} & a_{32} & a_{33} \end{bmatrix} \tag{A.31}$$
$$= a_{11}(a_{22}a_{33} - a_{23}a_{32}) + a_{12}(a_{23}a_{31} - a_{21}a_{33}) + a_{13}(a_{21}a_{32} - a_{22}a_{31})$$
$$= a_{11}a_{22}a_{33} + a_{12}a_{23}a_{31} + a_{13}a_{21}a_{32} - a_{13}a_{22}a_{31} - a_{12}a_{21}a_{33} - a_{11}a_{23}a_{32}$$

This equation is more difficult to commit to memory than its 2 × 2 counterpart. One method that is taught to help remember the formula is the *butterfly rule* as shown in Figure A.25.

The matrix is written down and its first two columns are repeated after it. The three terms along each directed arrow are multiplied together. The diagonals from upper left to lower right are given a plus sign (use the product as is). The diagonals from lower left to upper right are given a minus sign (negate the product before using it). (*Important note:* The buttefly rule does not apply to larger matrices.)

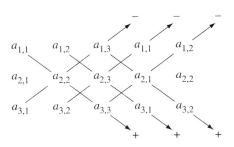

Figure A.25 An illustration of the butterfly rule for the determinant of a 3×3 matrix.

The inverse of a 3×3 matrix A is formally

$$A^{-1} = \frac{1}{\det(A)} \begin{bmatrix} a_{11}a_{22} - a_{12}a_{21} & a_{13}a_{32} - a_{12}a_{33} & a_{12}a_{23} - a_{13}a_{22} \\ a_{23}a_{31} - a_{21}a_{33} & a_{11}a_{33} - a_{13}a_{31} & a_{13}a_{21} - a_{11}a_{23} \\ a_{21}a_{32} - a_{22}a_{31} & a_{12}a_{31} - a_{11}a_{32} & a_{11}a_{22} - a_{12}a_{21} \end{bmatrix}$$

and may be verified by symbolically calculating $AA^{-1} = A^{-1}A = I$, where I is the identity matrix. As in the 2×2 case, the scalar before the matrix is the reciprocal of the determinant, $1/\det(A)$, so the determinant must be nonzero for the inverse to exist.

The geometric interpretation of the determinant for a 3×3 matrix is analogous to that of the 2×2 matrix. Let $\imath = [1\,0\,0]^{\mathrm{T}}$, $\jmath = [0\,1\,0]^{\mathrm{T}}$, and $k = [0\,0\,1]^{\mathrm{T}}$ be the standard basis vectors for \mathbb{R}^3. These vectors are transformed to $A\imath = [a_{11}\,a_{21}\,a_{31}]^{\mathrm{T}}$, $A\jmath = [a_{12}\,a_{22}\,a_{32}]^{\mathrm{T}}$, and $Ak = [a_{13}\,a_{23}\,a_{33}]^{\mathrm{T}}$, the columns of the matrix A. Figure A.26 shows a typical situation when the transformed vectors are linearly independent and have the same ordering as the basis vectors.

The degenerate cases that have zero volume occur when all three transformed vectors are coplanar or collinear. The signed volume v of a parallelepiped formed by $A\imath$, $A\jmath$, and Ak is computed in a coordinate-dependent manner using equation (A.17):

$$v = A\imath \cdot (A\jmath \times Ak)$$

$$= (a_{11}, a_{21}, a_{31}) \cdot (a_{12}, a_{22}, a_{32}) \times (a_{13}, a_{23}, a_{33})$$

$$= a_{11}(a_{22}a_{33} - a_{23}a_{32}) + a_{12}(a_{23}a_{31} - a_{21}a_{33}) + a_{13}(a_{21}a_{32} - a_{22}a_{31})$$

$$= \det(A)$$

This is exactly the determinant as defined by equation (A.31).

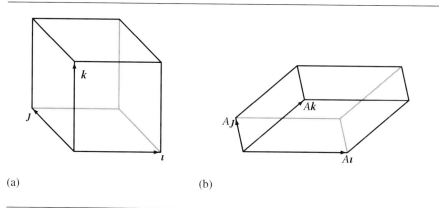

(a) (b)

Figure A.26 (a) A unit-volume cube. (b) The parallelepiped obtained by transforming the cube when the transformed basis vectors have the same order as the basis vectors.

Formal Construction of Determinant Functions

A general and formal construction of the determinant function is given next. First, though, we need to define a few concepts. Let V and W be vector spaces. Recall that a function $L : V \to W$ is a linear transformation if $L(c\mathbf{x} + \mathbf{y}) = cL(\mathbf{x}) + L(\mathbf{y})$ for all $c \in \mathbb{R}$ and for all $\mathbf{x}, \mathbf{y} \in V$. Define $V^n = \{(\mathbf{x}_1, \ldots, \mathbf{x}_n) : \mathbf{x}_j \in V \text{ for all } j\}$, the set of n-tuples of vectors from V. A function $L : V^n \to W$ is a *multilinear transformation* if it is linear with respect to each argument. That is, $L(\mathbf{x}_1, \ldots, \mathbf{x}_n)$ satisfies the conditions:

$$L(c\mathbf{x}_1 + \mathbf{y}_1, \mathbf{x}_2, \ldots, \mathbf{x}_n) = cL(\mathbf{x}_1, \mathbf{x}_2, \ldots, \mathbf{x}_n) + L(\mathbf{y}, \mathbf{x}_2, \ldots, \mathbf{x}_n)$$

$$L(\mathbf{x}_1, c\mathbf{x}_2 + \mathbf{y}_2, \ldots, \mathbf{x}_n) = cL(\mathbf{x}_1, \mathbf{x}_2, \ldots, \mathbf{x}_n) + L(\mathbf{x}_1, \mathbf{y}_2, \ldots, \mathbf{x}_n)$$

$$\vdots$$

$$L(\mathbf{x}_1, \mathbf{x}_2, \ldots, c\mathbf{x}_n + \mathbf{y}_n) = cL(\mathbf{x}_1, \mathbf{x}_2, \ldots, \mathbf{x}_n) + L(\mathbf{x}_1, \mathbf{x}_2, \ldots, \mathbf{y}_n)$$

You have already seen an example of a multilinear function, the dot product $L(\mathbf{x}, \mathbf{y}) = \mathbf{x} \cdot \mathbf{y}$.

Let $S = \{1, \ldots, n\}$. A *permutation on S* is any one-to-one, onto function $\sigma : S \to S$. For example, if $S = \{1, 2, 3\}$, then $\sigma(1) = 2$, $\sigma(2) = 1$, and $\sigma(3) = 3$ defines a permutation. Typically, we indicate the permutation by listing the elements of S and $\sigma(S)$ as n-tuples. In the last example, $S = (1\,2\,3)$ and $\sigma(S) = (2\,1\,3)$. A *transposition* is a permutation that swaps two elements in S. The permutation σ in the last example is a transposition since 1 and 2 were swapped. The permutation $\sigma(1\,2\,3) = (3\,1\,2)$ is not a transposition. However, a permutation can always be factored into a composition of transpositions.

E X A M P L E
A.45

Let $S = (1\,2\,3\,4\,5)$ and define σ by $\sigma(1\,2\,3\,4\,5) = (4\,3\,5\,2\,1)$. Begin swapping pairs of numbers. The circle symbol denotes composition of functions.

$(1\,2\,3\,4\,5) \qquad S$

$(4\,2\,3\,1\,5) \qquad$ Transpose 1, 4, $\tau_1(S)$

$(4\,3\,2\,1\,5) \qquad$ Transpose 2, 3, $\tau_2(\tau_1(S)) = \tau_2 \circ \tau_1(S)$

$(4\,3\,2\,5\,1) \qquad$ Transpose 1, 5, $\tau_3(\tau_2 \circ \tau_1(S)) = \tau_3 \circ \tau_2 \circ \tau_1(S)$

$(4\,3\,5\,2\,1) \qquad$ Transpose 2, 5, $\tau_4(\tau_3 \circ \tau_2 \circ \tau_1(S)) = \tau_4 \circ \tau_3 \circ \tau_2 \circ \tau_1(S) = \sigma(S)$

Note that $\tau_1(S) = (4\,2\,3\,1\,5)$, $\tau_2(S) = (1\,3\,2\,4\,5)$, $\tau_3(S) = (5\,2\,3\,4\,1)$, and $\tau_4(S) = (1\,5\,3\,4\,2)$. ▪

The factorization of a permutation into transpositions is not unique. However, the parity of the number of transpositions in the factorizations is. That is, if a permutation can be factored into an even number of transpositions, then any other factorization contains an even number of transpositions. We call such a permutation an *even permutation*. A similar statement can be made for a permutation with an odd number of transpositions in the factorization. We call such a permutation an *odd permutation*.

Let V be a vector space with $\dim(V) = n$. A *determinant function* is any function $\Delta : V^n \to \mathbb{R}$ such that:

1. Δ is a multilinear transformation; and

2. Δ is skew-symmetric with respect to all arguments. That is, given a permutation σ on $\{1, \ldots, n\}$, $\Delta\left(\mathbf{x}_{\sigma(1)}, \ldots, \mathbf{x}_{\sigma(n)}\right) = \varepsilon_\sigma(\mathbf{x}_1, \ldots, \mathbf{x}_n)$, where $\varepsilon_\sigma = 1$ if σ is even, and $\varepsilon_\sigma = -1$ if σ is odd.

We will work with $V = \mathbb{R}^n$, so V^n is the set of n-tuples of vectors in \mathbb{R}^n. If we represent the vectors as $n \times 1$ row vectors, the n-tuple of rows may be represented as an $n \times n$ matrix. In this framework the domain of a determinant function is the set of all $n \times n$ matrices. When the argument is explicitly a matrix A, we will use $\det(A)$ to denote a determinant. If we specify an additional constraint,

3. $\Delta(\mathbf{e}_1, \ldots, \mathbf{e}_n) = 1$

where the \mathbf{e}_j are the standard Euclidean basis vectors, then the three conditions uniquely determine Δ.

Assuming the three conditions, let us proceed to construct the determinant function. If $\{\mathbf{x}_1, \ldots, \mathbf{x}_n\}$ is a set of linearly dependent vectors, then $\Delta(\mathbf{x}_1, \ldots, \mathbf{x}_n) = 0$. For

simplicity, let \mathbf{x}_n be dependent on the other vectors in the set. That is, $\mathbf{x}_n = \sum_{i=1}^{n-1} c_i \mathbf{x}_i$ for some coefficients c_i that are not all zero; then

$$\Delta(\mathbf{x}_1, \ldots, \mathbf{x}_n) = \Delta\left(\mathbf{x}_1, \ldots, \sum_{i=1}^{n-1} c_i \mathbf{x}_i\right) = \sum_{i=1}^{n-1} c_i \Delta(\mathbf{x}_1, \ldots, \mathbf{x}_{n-1}, \mathbf{x}_i)$$

where the last equality is a consequence of Δ being a multilinear transformation. Define $(\mathbf{y}_1, \ldots, \mathbf{y}_i, \ldots, \mathbf{y}_n) = (\mathbf{x}_1, \ldots, \mathbf{x}_i, \ldots, \mathbf{x}_i)$. If σ is a transposition of i and n, then σ is odd, and by condition 2 in the definition of a determinant function:

$$\begin{aligned}
\Delta(x_1, \ldots, x_i, \ldots, x_i) &= \Delta(y_1, \ldots, y_i, \ldots, y_n) \\
&= -\Delta(y_{\sigma(1)}, \ldots, y_{\sigma(i)}, \ldots, y_{\sigma(n)}) \\
&= -\Delta(y_1, \ldots, y_n, \ldots, y_i) \\
&= -\Delta(x_1, \ldots, x_i, \ldots, x_i)
\end{aligned}$$

The only way a number can equal its negative is if that number is zero, $\Delta(x_1, \ldots, x_i, \ldots, x_i) = 0$. Replacing this in the summation expansion for $\Delta(x_1, \ldots, x_n)$ produces $\Delta(x_1, \ldots, x_n) = 0$.

Let $c \in \mathbb{R}$ and $i \neq j$. Replace the jth argument \mathbf{x}_j in the determinant function by $c\mathbf{x}_i + \mathbf{x}_j$; then

$$\Delta(x_1, \ldots, x_i, \ldots, cx_i + x_j, \ldots, x_n) = \Delta(x_1, \ldots, x_n)$$

That is, the determinant function does not change value. To see that this is true, use the linearity in component i:

$$\begin{aligned}
\Delta(x_1, \ldots, x_i, \ldots, cx_i + x_j, \ldots, x_n) &= c\Delta(x_1, \ldots, x_i, \ldots, x_i, \ldots, x_n) \\
&\quad + \Delta(x_1, \ldots, x_i, \ldots, x_j, \ldots, x_n) \\
&= c(0) + \Delta(x_1, \ldots, x_i, \ldots, x_j, \ldots, x_n)
\end{aligned}$$

where the zero term is obtained by the argument of the previous paragraph.

We are now ready to construct the determinant function. Let $\mathbf{e}_1, \ldots, \mathbf{e}_n$ be the standard Euclidean basis vectors. Let $\mathbf{x}_i = \sum_{j=1}^{n} a_{ji} \mathbf{e}_j$ for $1 \leq i \leq n$. Using linearity of Δ a component at a time:

$$\Delta(x_1, \ldots, x_n) = \Delta \left(\sum_{j_1=1}^{n} a_{j_11} e_{j_1}, \sum_{j_2=1}^{n} a_{j_22} e_{j_2}, \ldots, \sum_{j_n=1}^{n} a_{j_n1} e_{j_n} \right)$$

$$= \sum_{j_1=1}^{n} a_{j_11} \Delta(e_{j_1}, \sum_{j_2=1}^{n} a_{j_22} e_{j_2}, \ldots, \sum_{j_n=1}^{n} a_{j_n1} e_{j_n})$$

$$= \sum_{j_1=1}^{n} \sum_{j_2=1}^{n} a_{j_11} a_{j_22} \Delta(e_{j_1}, e_{j_2}, \ldots, \sum_{j_n=1}^{n} a_{j_n1} e_{j_n})$$

$$\vdots$$

$$= \sum_{j_1=1}^{n} \sum_{j_2=1}^{n} \cdots \sum_{j_n=1}^{n} a_{j_11} a_{j_22} \cdots a_{j_nn} \Delta(e_{j_1}, e_{j_2}, \ldots, e_{j_n})$$

If $j_u = j_v$ for some $u \neq v$, then $\Delta(\mathbf{e}_{j_1}, \ldots, \mathbf{e}_{j_u}, \ldots, \mathbf{e}_{j_v}, \ldots, \mathbf{e}_{j_n}) = 0$ using the skew symmetry of Δ. Therefore, in the above summations, the only nonzero terms occur when all components of the multi-index (j_1, j_2, \ldots, j_n) are distinct. Each such multi-index is just a permutation of the numbers 1 through n. That is, $(j_1, j_2, \ldots, j_n) = \sigma(1, \ldots, n)$ for some permutation σ. Consequently,

$$\Delta(x_1, \ldots, x_n) = \sum_{\sigma} a_{\sigma(1)1} a_{\sigma(2)2} \cdots a_{\sigma(n)n} \Delta\left(e_{\sigma(1)}, e_{\sigma(2)}, \ldots, e_{\sigma(n)}\right)$$

$$= \varepsilon_{\sigma} \Delta(e_1, e_2, \ldots, e_n)$$

$$= \sum_{\sigma} \varepsilon_{\sigma} a_{\sigma(1)1} a_{\sigma(2)2} \cdots a_{\sigma(n)n}$$

where the summation is over all permutations σ (there are $n!$ of them) and where we have used condition 3 in the definition of the determinant function.

EXAMPLE A.46

Let $n = 2$. Let A be the block matrix whose first row is vector \mathbf{x}_1 and whose second row is vector \mathbf{x}_2. There are only two permutations on $\{1, 2\}$, namely, $\sigma_1(1, 2) = (1, 2)$ and $\sigma_2(1, 2) = (2, 1)$ with $\varepsilon_{\sigma_1} = +1$ and $\varepsilon_{\sigma_2} = -1$. The determinant of A is

$$\det(A) = \Delta(\mathbf{x}_1, \mathbf{x}_2)$$

$$= \sum_{\sigma} \varepsilon_{\sigma} a_{\sigma(1)1} a_{\sigma(2)2}$$

$$= (+1) a_{\sigma_1(1)1} a_{\sigma_1(2)2} + (-1) a_{\sigma_2(1)1} a_{\sigma_2(2)2}$$

$$= a_{11} a_{22} - a_{21} a_{12} \quad \blacksquare$$

EXAMPLE
A.47

For $n = 3$, let A be a matrix whose rows are x_1, x_2, and x_3. There are six permutations on $\{1, 2, 3\}$, so

$$\det(A) = \Delta(\mathbf{x}_1, \mathbf{x}_2, \mathbf{x}_3)$$

$$= \sum_\sigma \varepsilon_\sigma a_{\sigma(1)1} a_{\sigma(2)2} a_{\sigma(3)3}$$

$$= a_{11}a_{22}a_{33} + a_{12}a_{23}a_{31} + a_{13}a_{21}a_{32} - a_{31}a_{22}a_{13} - a_{21}a_{12}a_{33} - a_{11}a_{32}a_{23} \quad \blacksquare$$

EXERCISE Ⓜ Compute the formal expression for the determinant when $n = 4$. ▪
A.9

We now take a closer look at the determinant function in terms of its application to matrices. Let $A = [a_{ij}]$ be an $n \times n$ matrix. Let m_{ij} be the determinant of the $(n-1) \times (n-1)$ matrix obtained from A by deleting row i and column j. The value m_{ij} is called the *minor of* a_{ij}. The *cofactor of* a_{ij} is defined by $c_{ij} = (-1)^{i+j} m_{ij}$.

EXAMPLE
A.48

Let

$$A = \begin{bmatrix} -2 & 1 & 1 \\ 0 & 1 & 1 \\ -3 & 0 & 6 \end{bmatrix}$$

The minors are

$$m_{11} = \det \begin{bmatrix} 1 & 1 \\ 0 & 6 \end{bmatrix} = 6, \quad m_{12} = \det \begin{bmatrix} 0 & 1 \\ -3 & 6 \end{bmatrix} = 3, \quad m_{13} = \det \begin{bmatrix} 0 & 1 \\ -3 & 0 \end{bmatrix} = 3$$

$$m_{21} = \det \begin{bmatrix} 1 & 1 \\ 0 & 6 \end{bmatrix} = 6, \quad m_{22} = \det \begin{bmatrix} -2 & 1 \\ -3 & 6 \end{bmatrix} = -9, \quad m_{23} = \det \begin{bmatrix} -2 & 1 \\ -3 & 0 \end{bmatrix} = 3$$

$$m_{31} = \det \begin{bmatrix} 1 & 1 \\ 1 & 1 \end{bmatrix} = 0, \quad m_{32} = \det \begin{bmatrix} -2 & 1 \\ 0 & 1 \end{bmatrix} = -2, \quad m_{33} = \det \begin{bmatrix} -2 & 1 \\ 0 & 1 \end{bmatrix} = -2$$

The matrix of minors is

$$M = [m_{ij}] = \begin{bmatrix} 6 & 3 & 3 \\ 6 & -9 & 3 \\ 0 & -2 & -2 \end{bmatrix}$$

To obtain the matrix of cofactors, the minors are multiplied by either 1 or -1 depending on whether $i + j$ is even or odd. The matrix of cofactors is

$$C = [c_{ij}] = \begin{bmatrix} +(6) & -(3) & +(3) \\ -(6) & +(-9) & -(3) \\ +(0) & -(-2) & +(-2) \end{bmatrix} = \begin{bmatrix} 6 & -3 & 3 \\ -6 & -9 & -3 \\ 0 & 2 & -2 \end{bmatrix} \quad \blacksquare$$

The *cofactor expansion of A by row k* is $\sum_{j=1}^{n} a_{kj}c_{kj}$. The *cofactor expansion of A by column k* is $\sum_{i=1}^{n} a_{ik}c_{ik}$. For an $n \times n$ matrix, there are $2n$ such summations to compute; all summations have the same value $\det(A)$.

EXAMPLE A.49

Consider the matrix

$$A = \begin{bmatrix} -2 & 1 & 1 \\ 0 & 1 & 1 \\ -3 & 0 & 6 \end{bmatrix}$$

from the last example. Expanding by row 1:

$$\det A = a_{11}c_{11} + a_{12}c_{12} + a_{13}c_{13} = (-2)(6) + (1)(-3) + (1)(3) = -12$$

Expanding by column 2:

$$\det A = a_{12}c_{12} + a_{22}c_{22} + a_{32}c_{32} = (1)(-3) + (1)(-9) + (0)(2) = -12 \quad \blacksquare$$

EXAMPLE A.50

Let us compute the determinant of the matrix

$$A = \begin{bmatrix} -5 & 0 & 1 & 6 \\ 2 & -1 & 3 & 7 \\ 4 & 4 & -5 & -8 \\ 1 & -1 & 6 & 2 \end{bmatrix}$$

Since any cofactor expansion will produce the determinant, you should choose to expand by that row or column that contains the maximum number of zeros. In any term $a_{ij}c_{ij}$ where $a_{ij} = 0$, you do not need to compute c_{ij}. Expand by row 1:

$$\det A = +(-5) \det \begin{bmatrix} -1 & 3 & 7 \\ 4 & -5 & -8 \\ -1 & 6 & 2 \end{bmatrix} + (1) \det \begin{bmatrix} 2 & -1 & 7 \\ 4 & 4 & -8 \\ 1 & -1 & 2 \end{bmatrix}$$

$$- (6) \det \begin{bmatrix} 2 & -1 & 3 \\ 4 & 4 & -5 \\ 1 & -1 & 6 \end{bmatrix}$$

$$= +(-5)(95) + (1)(-40) - (6)(43) = -773 \quad \blacksquare$$

We will now compute the number of arithmetic operations it takes to evaluate the determinant of an $n \times n$ matrix by a row or column expansion. Let θ_n be the number of such operations.

■ Case $n = 1$. For $A = [a]$, there are no operations required. Therefore, $\theta_1 = 0$.

- Case $n = 2$. For $A = [a_{ij}]$, expanding by row 1 produces the quantity $\det A = a_{11} \det[a_{22}] - a_{12} \det[a_{21}]$. This requires 2 multiplications and 1 addition (subtraction). Therefore, $\theta_2 = 2\theta_1 + 2 + 1 = 3$.

- Case $n = 3$. Expanding A by row 1 produces

$$\det A = a_{11} \det \begin{bmatrix} a_{22} & a_{23} \\ a_{32} & a_{33} \end{bmatrix} - a_{12} \det \begin{bmatrix} a_{21} & a_{23} \\ a_{31} & a_{33} \end{bmatrix} + a_{13} \det \begin{bmatrix} a_{21} & a_{22} \\ a_{31} & a_{32} \end{bmatrix}$$

Each 2×2 matrix requires θ_2 operations. Additionally, there are 3 multiplications and 2 additions. Therefore, $\theta_3 = 3\theta_2 + 3 + 2 = 14$.

Inductively, the determinant of A reduces to a combination of n determinants of $(n-1) \times (n-1)$ matrices. Each of these requires θ_{n-1} operations. Additionally, there are n multiplications and $n-1$ additions. Therefore, $\theta_n = n\theta_{n-1} + 2n - 1$ operations are required. This is a first-order linear difference equation with initial data $\theta_1 = 0$ whose solution is (for $n \geq 2$):

$$\theta_n = \sum_{i=1}^{n-1} \frac{n!}{(i+1)!}(2i+1) > n!$$

This is a lot of operations, even for values of n on the order of 10.

EXERCISE Ⓜ An earlier exercise had you compute the formal expression for the determinant when
A.10 $n = 4$. Verify that $\theta_4 = 63$. Derive an alternate formula for $n = 4$ that uses 47 operations. ▪

The determinant can be evaluated in a more reasonable amount of time by row-reducing the matrix, as we will see later. Row reductions require on the order of n^3 operations. For large n, this is much smaller than $n!$. A computer program written to evaluate determinants should avoid cofactor expansion for large n. For small n the overhead costs of Gaussian elimination may outweigh the costs of using a cofactor expansion. The best advice is to profile the function to determine when to switch between the two methods. On current hardware, cofactor expansion for $n \leq 4$ appears to be a reasonable choice.

Some properties of the determinant for a matrix A follow immediately from the definition and constructions given earlier. If any row of A has all zero entries, then $\det(A) = 0$. This is a consequence of the linearity in *any* component of the determinant function. A linear transformation has the property $L(\mathbf{0}) = \mathbf{0}$. The same is true for a multilinear transformation that has a zero in any component. The proof is exactly the same used for a linear transformation.

The determinants of elementary row operations are easy to construct. A swap of two rows of A is equivalent to transposing two arguments in the determinant function. Condition 2 of the definition for a determinant function is that the function is skew-symmetric with respect to its arguments; a transposition of two arguments

changes the sign of the determinant. If E is an elementary row matrix for swapping two rows, then $\det(E) = -1$. Multiplication of a row of A by a nonzero scalar c is equivalent to replacing an argument of the determinant function with a scalar times the original argument. By multilinearity, that scalar can be factored outside the function: $\Delta(\ldots, c\mathbf{x}_j, \ldots) = c\Delta(\ldots, \mathbf{x}_j, \ldots)$. If E is an elementary row matrix that represents multiplying a row by a nonzero scalar, then $\det(E) = c$. Finally, if E is the elementary row matrix to add to row j a nonzero scalar multiple of row i, then $\det(E) = 1$. We proved this earlier when we showed that replacing argument \mathbf{x}_j by $c\mathbf{x}_i + \mathbf{x}_j$ in the determinant function Δ did not change the function's value. An application of two elementary row operations is equivalent to a composition of two linear functions of the argument of the determinant function. The last section on transformations showed us that composition of linear functions is represented by multiplication of matrices of the functions involved in the composition. Therefore, if E_1 and E_2 are two elementary row matrices, then

$$\det(E_1 E_2) = \det(E_1)\det(E_2)$$

That is, the determinant of a product is the product of the determinants.

Forward plus backward elimination of the $n \times n$ matrix A reduces that matrix to an upper echelon matrix U that either is the identity I or is a matrix with at least one row of zeros. The determinant of the identity is 1, just a restatement of condition 3 in the definition for the determinant function. If U has a row of zeros, then $\det(U) = 0$, as proved earlier. Therefore, $\det(U)$ is 0 or 1. If E_1 through E_m are the elementary row matrices used in the elimination, then

$$E_m \cdots E_1 A = U$$

The determinant of a product was shown to be the product of the determinants, so

$$\det(E_m) \cdots \det(E_1)\det(A) = \det(U)$$

Since elementary row matrices all have nonzero determinants,

$$\det(A) = \frac{\det(U)}{\det(E_m) \cdots \det(E_1)} \tag{A.32}$$

The full elimination can be done with the order of n^3 operations, clearly asymptotically better than cofactor expansion that uses the order of $n!$ operations. Actually, we need only apply forward elimination. The backward elimination is not necessary. For an invertible matrix A, after forward elimination, the matrix U is upper triangular. The determinant of such a matrix is just the product of its diagonal entries.

EXERCISE Ⓔ Prove that the determinant of an upper triangular matrix is the product of its diagonal
A.11 entries. ▪

EXERCISE Ⓜ For an invertible matrix A, prove that $\det(A^{-1}) = 1/\det(A)$. ▪
A.12

A.5.2 EIGENVALUES AND EIGENVECTORS

Eigenvalues and eigenvectors represent a topic vital to the study of difference and differential equations and to the analysis of the stability of mathematical models that describe physical phenomena. It is also a topic that many shy away from, but please do not since you need it later!

Although we have been working with vector spaces \mathbb{R}^n, the initial discussion here will involve the vector space of n-tuples of complex numbers, \mathbf{C}^n, whose scalar field is itself the set of complex numbers. Let A be an $n \times n$ matrix of complex-valued entries. The scalar $\lambda \in \mathbf{C}$ is said to be an *eigenvalue* of A if there is a nonzero vector \mathbf{x} such that $A\mathbf{x} = \lambda\mathbf{x}$. In this case, \mathbf{x} is said to be an *eigenvector corresponding to* λ. Geometrically, an eigenvector is a vector that when transformed does not change direction. If $\lambda \neq 1$, the length changes, but if $\lambda = 1$, the eigenvector changes neither direction nor length.

EXAMPLE A.51

The number -1 is an eigenvalue for

$$A = \begin{bmatrix} -1 & 0 & 0 \\ 1 & 1 & 0 \\ 0 & 1 & 1 \end{bmatrix}$$

with a corresponding eigenvector $\mathbf{x} = (-4, 2, -1)$ (written as a 3-tuple). To verify this,

$$A\mathbf{x} = \begin{bmatrix} -1 & 0 & 0 \\ 1 & 1 & 0 \\ 0 & 1 & 1 \end{bmatrix} \begin{bmatrix} -4 \\ 2 \\ -1 \end{bmatrix} = \begin{bmatrix} 4 \\ -2 \\ 1 \end{bmatrix} = (-1) \begin{bmatrix} -4 \\ 2 \\ -1 \end{bmatrix} \quad \blacksquare$$

Let λ be an eigenvalue of the $n \times n$ matrix A. The *eigenspace of* λ is the set

$$S_\lambda = \{\mathbf{x} \in \mathbf{C}^n : A\mathbf{x} = \lambda\mathbf{x}\}$$

This set is a subspace of \mathbf{C}^n. The proof is simple. Let $c \in \mathbf{C}$ and let $\mathbf{x}, \mathbf{y} \in S_\lambda$. By definition of S_λ, $A\mathbf{x} = \lambda\mathbf{x}$ and $A\mathbf{y} = \lambda\mathbf{y}$. Applying A to the linear combination,

$$A(c\mathbf{x} + \mathbf{y}) = cA\mathbf{x} + A\mathbf{y} = c\lambda\mathbf{x} + \lambda\mathbf{y} = \lambda(c\mathbf{x} + \mathbf{y})$$

This shows that $c\mathbf{x} + \mathbf{y} \in S_\lambda$, so S_λ is a subspace. An alternate proof is to note that $S_\lambda = \text{kernel}(A - \lambda I)$. We had proved earlier that the kernel of a matrix is a subspace.

The method of construction of eigenvalues λ and eigenvectors \mathbf{x} is as follows. Observe that

$$A\mathbf{x} = \lambda\mathbf{x} \quad \Leftrightarrow \quad A\mathbf{x} = \lambda I\mathbf{x} \quad \Leftrightarrow \quad A\mathbf{x} - \lambda I\mathbf{x} = 0 \quad \Leftrightarrow \quad (A - \lambda I)\mathbf{x} = \mathbf{0}$$

We want *nonzero* solutions \mathbf{x} to this homogeneous system of equations. The only way this can happen is if $(A - \lambda I)$ is *not* invertible. For if it were invertible, then

$\mathbf{x} = (A - \lambda I)^{-1}\mathbf{0} = \mathbf{0}$ is the only possible solution. An equivalent condition for $(A - \lambda I)$ not to be invertible is that $p(\lambda) = \det(A - \lambda I) = 0$. This determinant is a polynomial in λ of degree n since A is $n \times n$. The eigenvalues are therefore roots of the polynomial equation $p(\lambda) = 0$. The equation $\det(A - \lambda I) = 0$ is called the *characteristic equation* for the matrix A.

The Fundamental Theorem of Algebra states that every polynomial of degree n with complex coefficients can be factored as

$$p(\lambda) = \prod_{i=1}^{k}(\lambda - \lambda_i)^{m_i}$$

where λ_i, $1 \le i \le k$, are the distinct roots of the equation $p(\lambda) = 0$ and where $\sum_{i=1}^{k} m_i = n$. For each root λ_i, solve the system $(A - \lambda_i I)\mathbf{x} = \mathbf{0}$ to find the corresponding eigenvectors.

EXAMPLE A.52

Find the eigenvalues and corresponding eigenspaces for

$$A = \begin{bmatrix} -2 & 0 \\ 1 & 4 \end{bmatrix}$$

Solve $\det(A - \lambda I) = 0$:

$$0 = \det(A - \lambda I) = \det \begin{bmatrix} -2 - \lambda & 0 \\ 1 & 4 - \lambda \end{bmatrix} = (-2 - \lambda)(4 - \lambda)$$

The eigenvalues are the roots $\lambda = -2, 4$. For each eigenvalue solve the system $(A - \lambda I)\mathbf{x} = \mathbf{0}$. Start with $\lambda = -2$ and solve $(A + 2I)\mathbf{x} = \mathbf{0}$:

$$A + 2I = \begin{bmatrix} 0 & 0 \\ 1 & 6 \end{bmatrix} \sim \begin{bmatrix} 1 & 6 \\ 0 & 0 \end{bmatrix}$$

If $\mathbf{x} = (x_1, x_2)$, then x_1 is basic and x_2 is free with $x_1 + 6x_2 = 0$. Therefore, $\mathbf{x} = x_2(-6, 1)$ and $S_{-2} = \mathrm{Span}[(-6, 1)]$. Now select $\lambda = 4$ and solve $(A - 4I)\mathbf{x} = \mathbf{0}$:

$$A - 4I = \begin{bmatrix} -6 & 0 \\ 1 & 0 \end{bmatrix} \sim \begin{bmatrix} 1 & 0 \\ 0 & 0 \end{bmatrix}$$

If $\mathbf{x} = (x_1, x_2)$, then x_1 is basic and x_2 is free with $x_1 = 0$. Therefore, $\mathbf{x} = x_2(0, 1)$ and $S_4 = \mathrm{Span}[(0, 1)]$. ▪

EXAMPLE A.53

Find the eigenvalues and corresponding eigenspaces for

$$A = \begin{bmatrix} 1 & -1 & 4 \\ 3 & 2 & -1 \\ 2 & 1 & -1 \end{bmatrix}$$

(Example A.53 continued)

Solve $\det(A - \lambda I) = 0$:

$$0 = \det(A - \lambda I) = \begin{bmatrix} 1 - \lambda & -1 & 4 \\ 3 & 2 - \lambda & -1 \\ 2 & 1 & -1 - \lambda \end{bmatrix}$$

$$= +(1 - \lambda) \det \begin{bmatrix} 2 - \lambda & -1 \\ 1 & -1 - \lambda \end{bmatrix} - (-1) \det \begin{bmatrix} 3 & -1 \\ 2 & -1\lambda \end{bmatrix} + (4) \det \begin{bmatrix} 3 & 2 - \lambda \\ 2 & 1 \end{bmatrix}$$

$$= (1 - \lambda)[(2 - \lambda)(-1 - \lambda) + 1] + [3(-1 - \lambda) + 2] + 4[3 - 2(2 - \lambda)]$$

$$= -\lambda^3 + 2\lambda^2 + 5\lambda - 6$$

$$= -(\lambda + 2)(\lambda - 1)(\lambda - 3)$$

The eigenvalues are the roots $\lambda = -2, 1, 3$. For each eigenvalue, solve the system $(A - \lambda I)\mathbf{x} = \mathbf{0}$. For $\lambda = -2$, solve $(A + 2I)\mathbf{x} = \mathbf{0}$:

$$A + 2I = \begin{bmatrix} 3 & -1 & 4 \\ 3 & 4 & -1 \\ 2 & 1 & 1 \end{bmatrix} \sim \begin{bmatrix} 1 & 0 & 1 \\ 0 & 1 & -1 \\ 0 & 0 & 0 \end{bmatrix}$$

where the row operations are $-R_3 + R_1 \rightarrow R_1, -3R_1 + R_2 \rightarrow R_2, -2R_1 + R_3 \rightarrow R_3,$ $\frac{1}{10}R_2 \rightarrow R_2, -5R_2 + R_3 \rightarrow R_3,$ and $2R_2 + R_1 \rightarrow R_1$. If $\mathbf{x} = (x_1, x_2, x_3)$, then the only free variable is x_3, so $S_{-2} = \text{Span}[(-1, 1, 1)]$.

For $\lambda = 1$, solve $(A - I)\mathbf{x} = \mathbf{0}$:

$$A - I = \begin{bmatrix} 0 & -1 & 4 \\ 3 & 1 & -1 \\ 2 & 1 & -2 \end{bmatrix} \sim \begin{bmatrix} 1 & 0 & 1 \\ 0 & 1 & -4 \\ 0 & 0 & 0 \end{bmatrix}$$

where the row operations are $-R_3 + R_2 \rightarrow R_2, R_1 \leftrightarrow R_2, -2R_1 + R_3 \rightarrow R_3, R_2 + R_3 \rightarrow R_3,$ and $-R_2 \rightarrow R_2$. If $\mathbf{x} = (x_1, x_2, x_3)$, then the only free variable is x_3, so $S_1 = \text{Span}[(-1, 4, 1)]$.

For $\lambda = 3$ solve $(A - 3I)\mathbf{x} = \mathbf{0}$:

$$A - 3I = \begin{bmatrix} -2 & -1 & 4 \\ 3 & -1 & -1 \\ 2 & 1 & -4 \end{bmatrix} \sim \begin{bmatrix} 1 & 0 & -1 \\ 0 & 1 & -2 \\ 0 & 0 & 0 \end{bmatrix}$$

where the row operations are $R_1 + R_2 \rightarrow R_2, R_1 + R_3 \rightarrow R_3, R_1 \leftrightarrow R_2, 2R_1 + R_2 \rightarrow R_2, -\frac{1}{5}R_2 \rightarrow R_2,$ and $2R_2 + R_1 \rightarrow R_1$. If $\mathbf{x} = (x_1, x_2, x_3)$, then the only free variable is x_3, so $S_3 = \text{Span}[(1, 2, 1)]$. ∎

EXAMPLE
A.54

This next example shows that the dimension of the eigenspace can be larger than one. Let

$$A = \begin{bmatrix} 1 & -1 & 2 \\ 0 & 1 & 0 \\ 0 & 0 & 1 \end{bmatrix}$$

Solve $\det(A - \lambda I) = 0$:

$$\det(A - \lambda I) = \det \begin{bmatrix} 1 - \lambda & -1 & 2 \\ 0 & 1 - \lambda & 0 \\ 0 & 0 & 1 - \lambda \end{bmatrix} = (1 - \lambda)^3$$

so $\lambda = 1$ is the only eigenvalue. Solve $(A - I)\mathbf{x} = \mathbf{0}$:

$$A - I = \begin{bmatrix} 0 & -1 & 2 \\ 0 & 0 & 0 \\ 0 & 0 & 0 \end{bmatrix} \sim \begin{bmatrix} 0 & 1 & -2 \\ 0 & 0 & 0 \\ 0 & 0 & 0 \end{bmatrix}$$

If $\mathbf{x} = (x_1, x_2, x_3)$, then x_1 and x_3 are free variables with $x_2 - 2x_3 = 0$. Thus, $\mathbf{x} = x_1(1, 0, 0) + x_3(0, 2, 1)$ and $S_1 = \text{Span}[(1, 0, 0), (0, 2, 1)]$. ▪

Suppose that A is an $n \times n$ matrix with real-valued entries. If λ is an eigenvalue of A that has a nonzero imaginary part and has corresponding eigenvector \mathbf{x}, then $\bar{\lambda}$, the complex conjugate of λ, is also an eigenvalue of A and has corresponding eigenvector $\bar{\mathbf{x}}$, the component-wise complex conjugate of vector \mathbf{x}. Define the complex conjugate of a matrix $A = [a_{ij}]$ by $\bar{A} = [\bar{a}_{ij}]$; then the following sequence of steps is valid:

$$A\mathbf{x} = \lambda \mathbf{x}, \; \overline{A\mathbf{x}} = \overline{\lambda \mathbf{x}}, \; \bar{A}\bar{\mathbf{x}} = \bar{\lambda}\bar{\mathbf{x}}, \; A\bar{\mathbf{x}} = \bar{\lambda}\bar{\mathbf{x}}$$

where we have used $\bar{A} = A$ since A has only real-valued entries. The last statement indicates that $\bar{\lambda}$ is an eigenvalue of A with a corresponding eigenvector $\bar{\mathbf{x}}$.

EXAMPLE
A.55

Let

$$A = \begin{bmatrix} \cos\theta & -\sin\theta \\ \sin\theta & \cos\theta \end{bmatrix}$$

where θ is not an integer multiple of π. This matrix represents rotation of vectors in the plane by θ radians (counterclockwise rotation when $\theta > 0$). An intuitive argument is that there should be no real-valued eigenvalues since any vector must have its direction changed by the rotation. The algebraic construction is to solve $\det(A - \lambda I) = 0$:

$$\det(A - \lambda I) = \begin{bmatrix} \cos\theta - \lambda & -\sin\theta \\ \sin\theta & \cos\theta - \lambda \end{bmatrix} = (\cos\theta - \lambda)^2 + \sin^2\theta = 0$$

*(Example A.55
continued)*

so the eigenvalues are $\lambda = \cos\theta \pm i\sin\theta$. For $\lambda = \cos\theta + i\sin\theta$, solve $(A - \lambda I)\mathbf{x} = \mathbf{0}$:

$$A - \lambda I = \sin\theta \begin{bmatrix} -i & -1 \\ 1 & -i \end{bmatrix} \sim \sin\theta \begin{bmatrix} 1 & -i \\ 0 & 0 \end{bmatrix}$$

If $\mathbf{x} = (x_1, x_2)$, then x_2 is the free parameter with $x_1 - ix_2 = 0$. Therefore, $\mathbf{x} = x_2(i, 1)$ and $S_\lambda = \text{Span}[(i, 1)] \subset \mathbf{C}^2$. The other eigenvalue is the complex conjugate $\bar{\lambda} = \cos\theta - i\sin\theta$. The eigenvectors are $\bar{\mathbf{x}} = x_2(-i, 1)$ and the eigenspace is $S_{\bar{\lambda}} = \text{Span}[(-i, 1)]$. ∎

Let A be an $n \times n$ matrix with n linearly independent eigenvectors $\mathbf{x}_1, \ldots, \mathbf{x}_n$. If $\lambda_1, \ldots, \lambda_n$ are the corresponding eigenvalues, not necessarily distinct, and if $S = [\mathbf{x}_1 \mid \cdots \mid \mathbf{x}_n]$, then $P^{-1}AP = \text{Diag}(\lambda_1, \ldots, \lambda_n) =: D$. The proof is as follows:

$$AP = A \begin{bmatrix} \mathbf{x}_1 & \mid & \cdots & \mid & \mathbf{x}_n \end{bmatrix} \qquad \text{Definition of } S$$

$$= \begin{bmatrix} A\mathbf{x}_1 & \mid & \cdots & \mid & A\mathbf{x}_n \end{bmatrix} \qquad \begin{array}{l}\text{Distributive property} \\ \text{of block multiplication}\end{array}$$

$$= \begin{bmatrix} \lambda_1\mathbf{x}_1 & \mid & \cdots & \mid & \lambda_n\mathbf{x}_n \end{bmatrix} \qquad \text{Since } \lambda_i \text{ are eigenvalues}$$

$$= \begin{bmatrix} \mathbf{x}_1 & \mid & \cdots & \mid & \mathbf{x}_n \end{bmatrix} \text{Diag}(\lambda_1, \ldots, \lambda_n)$$

$$= PD$$

Since the columns of P are the linearly independent eigenvectors of A, P must be invertible; thus, $AP = PD$ implies $P^{-1}AP = D$. For example, we had

$$A = \begin{bmatrix} -2 & 0 \\ 1 & 4 \end{bmatrix}, \quad \lambda_1 = -2, \quad S_{-2} = \text{Span}[(-6, 1)], \quad \lambda_2 = 4, \quad S_4 = \text{Span}[(0, 1)]$$

Therefore,

$$P = \begin{bmatrix} -6 & 0 \\ 1 & 1 \end{bmatrix} \quad \text{and} \quad P^{-1}AP = \text{Diag}(-2, 4)$$

Recall from the section on linear transformations that the condition $P^{-1}AP = D$ means that A and D are similar matrices. Not all $n \times n$ matrices have n linearly independent eigenvectors. However, it might still be possible to find a similarity transformation $P^{-1}AP = D$ where D is diagonal. If so, A is said to be *diagonalizable*.

A specific instance where A is diagonalizable is when it has n distinct eigenvalues λ_1 through λ_n. Let \mathbf{x}_1 through \mathbf{x}_n be corresponding eigenvectors. This set of eigenvectors is linearly independent. The proof of this fact is by mathematical induction. The first case is $n = 2$. Let $c_1\mathbf{x}_1 + c_2\mathbf{x}_2 = \mathbf{0}$. Multiply by A to obtain

$$\mathbf{0} = A(c_1\mathbf{x}_1 + c_2\mathbf{x}) = c_1A\mathbf{x}_1 + c_2A\mathbf{x}_2 = c_1\lambda_1\mathbf{x}_1 + c_2\lambda_2\mathbf{x}_2$$

Replace $c_2\mathbf{x}_2 = -c_1\mathbf{x}_1$ in this equation and group terms to obtain

$$c_1(\lambda_1 - \lambda_2)\mathbf{x}_1 = \mathbf{0}$$

where $\mathbf{x}_1 \neq \mathbf{0}$ since it is an eigenvector and $\lambda_1 \neq \lambda_2$ by assumption, so $c_1 = 0$. Replacing in the original equation yields $c_2\mathbf{x}_2 = \mathbf{0}$. Again, $\mathbf{x}_2 \neq \mathbf{0}$ since it is an eigenvector, so it must be that $c_1 = 0$. Therefore, \mathbf{x}_1 and \mathbf{x}_2 are linearly independent.

The inductive hypothesis is that \mathbf{x}_1 through \mathbf{x}_k are linearly independent. We need to use this to show that \mathbf{x}_1 through \mathbf{x}_{k+1} are linearly independent. Let $c_1\mathbf{x}_1 + \cdots + c_{k+1}\mathbf{x}_{k+1} = 0$. Multiply by A to obtain

$$0 = A(c_1\mathbf{x}_1 + \cdots + c_{k+1}\mathbf{x}_{k+1})$$

$$= c_1A\mathbf{x}_1 + \cdots + c_{k+1}A\mathbf{x}_{k+1} = c_1\lambda_1\mathbf{x}_1 + \cdots + c_{k+1}\lambda_{k+1}\mathbf{x}_{k+1}$$

Replace $c_{k+1}\mathbf{x}_{k+1} = -c_1\mathbf{x}_1 - \cdots - c_k\mathbf{x}_k$ in this equation and group terms to obtain

$$c_1(\lambda_1 - \lambda_{k+1})\mathbf{x}_1 + \cdots + c_k(\lambda_k - \lambda_{k+1})\mathbf{x}_k = \mathbf{0}$$

By the inductive hypothesis, the k vectors in the linear combination are linearly independent, so all the coefficients must be zero: $c_i(\lambda_i - \lambda_{k+1}) = 0$. The eigenvalues are distinct, so $\lambda_i \neq \lambda_{k+1}$ for $1 \leq i \leq k$, thus forcing $c_i = 0$ for $1 \leq i \leq k$. Replacing in the original equation yields $c_{k+1}\mathbf{x}_{k+1} = \mathbf{0}$. Amd, again, $\mathbf{x}_{k+1} \neq \mathbf{0}$ since it is an eigenvector, so it must be that $c_{k+1} = 0$. Therefore, the vectors \mathbf{x}_1 through \mathbf{x}_{k+1} are linearly independent. The result is true for all $n \geq 2$ by the principle of mathematical induction.

Generally, two similar matrices A and B have the same characteristic polynomial, so their eigenvalues are identical. Because the matrices are similar, $B = P^{-1}AP$ for some invertible matrix P. The characteristic polynomial of B, $\det(B - \lambda I) = 0$, can be manipulated as

$$0 = \det(B - \lambda I)$$

$$= \det(P^{-1}AP - \lambda P^{-1}IP)$$

$$= \det(P^{-1}(A - \lambda I)P)$$

$$= \det(P^{-1})\det(A - \lambda I)\det(P)$$

$$= \det(A - \lambda I)$$

since $\det(P^{-1})\det(P) = \det(P^{-1}P) = \det(I) = 1$. Although the eigenvalues are the same for A and B, the corresponding eigenvectors are not necessarily the same, but are related. Define $\mathbf{y} = P^{-1}\mathbf{x}$ where $A\mathbf{x} = \lambda\mathbf{x}$. Multiplying the eigensystem by P^{-1} and replacing $\mathbf{x} = P\mathbf{y}$ leads to

$$B\mathbf{y} = P^{-1}AP\mathbf{y} = \lambda P^{-1}P\mathbf{y} = \lambda\mathbf{y}$$

The vector $\mathbf{y} = P^{-1}\mathbf{x}$ is an eigenvector for B corresponding to λ whenever \mathbf{x} is an eigenvector for A with respect to the same eigenvalue.

A.5.3 EIGENDECOMPOSITION FOR SYMMETRIC MATRICES

A special class of matrices that arises most frequently in applications, especially physics applications, is the class of $n \times n$ *symmetric matrices* with real-valued entries. A symmetric matrix A satisfies the condition that $A^{\mathrm{T}} = A$. Within the class of symmetric matrices are subclasses of importance.

- If $\mathbf{x}^{\mathrm{T}} A \mathbf{x} > 0$ for all $\mathbf{x} \neq \mathbf{0}$, then A is said to be *positive definite*.
- If $\mathbf{x}^{\mathrm{T}} A \mathbf{x} \geq 0$ for all $\mathbf{x} \neq \mathbf{0}$, then A is said to be *positive semidefinite* or *nonnegative definite*.
- If $\mathbf{x}^{\mathrm{T}} A \mathbf{x} < 0$ for all $\mathbf{x} \neq \mathbf{0}$, then A is said to be *negative definite*.
- If $\mathbf{x}^{\mathrm{T}} A \mathbf{x} \leq 0$ for all $\mathbf{x} \neq \mathbf{0}$, then A is said to be *negative semidefinite* or *nonpositive definite*.

The eigenvalues of a real-valued symmetric matrix must themselves be real-valued, and the corresponding eigenvectors are naturally real-valued. If A were to have a possibly complex-valued eigenvector \mathbf{x}, then $\bar{\mathbf{x}}^{\mathrm{T}} A \mathbf{x}$ must be real-valued. To see this:

$$
\begin{aligned}
\bar{\mathbf{x}}^{\mathrm{T}} A \mathbf{x} &= \sum_{i,j} \bar{x}_i a_{ij} x_j \\
&= \sum_{i=j} \bar{x}_i a_{ij} x_j + \sum_{i<j} \bar{x}_i a_{ij} x_j + \sum_{i>j} \bar{x}_i a_{ij} x_j \\
&= \sum_i a_{ii} |x_i|^2 + \sum_{i<j} \bar{x}_i a_{ij} x_j + \sum_{j>i} \bar{x}_j a_{ji} x_i && \text{Interchange names on } i \text{ and } j \\
&= \sum_i a_{ii} |x_i|^2 + \sum_{i<j} \bar{x}_i a_{ij} x_j + \sum_{i<j} x_i a_{ij} \bar{x}_j && \text{Since } A \text{ is symmetric} \\
&= \sum_i a_{ii} |x_i|^2 + \sum_{i<j} \left(\bar{x}_i a_{ij} x_j + x_i a_{ij} \bar{x}_j \right) \\
&= \sum_i a_{ii} |x_i|^2 + \sum_{i<j} 2 \operatorname{Re}(\bar{x}_i a_{ij} x_j) && \text{Re(z) denotes the real part of z}
\end{aligned}
$$

The right-hand side of the last equality is a real number, so $\bar{\mathbf{x}}^{\mathrm{T}} A \mathbf{x}$ is real-valued. Also, $\bar{\mathbf{x}}^{\mathrm{T}} \mathbf{x} = |\mathbf{x}|^2$, another real number. Since \mathbf{x} is an eigenvector, $A \mathbf{x} = \lambda \mathbf{x}$, where λ is the corresponding eigenvalue. Thus, $\bar{\mathbf{x}}^{\mathrm{T}} A \mathbf{x} = \lambda \bar{\mathbf{x}}^{\mathrm{T}} \mathbf{x}$ and

$$
\lambda = \frac{\bar{\mathbf{x}}^{\mathrm{T}} A \mathbf{x}}{\bar{\mathbf{x}}^{\mathrm{T}} \mathbf{x}}
$$

The right-hand side is the ratio of real numbers, so must be real-valued itself. That is, the eigenvalue λ must be real. Moreover, since the eigenvalues are real, the nonzero solutions to $(A - \lambda I)\mathbf{x} = \mathbf{0}$ must be real-valued.

Another interesting result for a real-valued symmetric matrix: If λ_1 and λ_2 are distinct eigenvalues for A, then corresponding eigenvectors \mathbf{x}_1 and \mathbf{x}_2 are orthogonal. The proof is straightforward:

$$\lambda_1 \mathbf{x}_1^\mathrm{T} \mathbf{x}_2 = (\lambda_1 \mathbf{x}_1)^\mathrm{T} \mathbf{x}_2$$

$$= (A\mathbf{x}_1)^\mathrm{T} \mathbf{x}_2 \qquad \mathbf{x}_1 \text{ is an eigenvector for } \lambda_1$$

$$= \mathbf{x}_1^\mathrm{T} A^\mathrm{T} \mathbf{x}_2$$

$$= \mathbf{x}_1^\mathrm{T} A \mathbf{x}_2 \qquad A \text{ is symmetric}$$

$$= \mathbf{x}_1^\mathrm{T} (\lambda_2 \mathbf{x}_2) \qquad \text{Since } \mathbf{x}_2 \text{ is an eigenvector for } \lambda_2$$

$$= \lambda_2 \mathbf{x}_1^\mathrm{T} \mathbf{x}_2$$

But then $(\lambda_1 - \lambda_2)\mathbf{x}_1^\mathrm{T}\mathbf{x}_2 = 0$ and $\lambda_1 \neq \lambda_2$ imply that $\mathbf{x}_1^\mathrm{T}\mathbf{x}_2 = 0$. That is, \mathbf{x}_1 and \mathbf{x}_2 are orthogonal.

We are now in a position to characterize the eigenvectors for a real-valued symmetric matrix A. The construction makes use of a more general result that applies to square matrices. If A is a square matrix, there always exists an orthogonal matrix Q such that $Q^\mathrm{T} A Q = U$, where U is an upper triangular matrix. The diagonal entries of U are necessarily the eigenvalues of A. The proof is as follows. Let λ_1 be an eigenvalue for A. There is at least one linearly independent eigenvector \mathbf{y}_1 corresponding to it. Let $\mathbf{x}_1 = \mathbf{y}_1/|\mathbf{y}_1|$, such that \mathbf{x}_1 is a unit-length eigenvector. Define the matrix

$$Q_1 = [\mathbf{x}_1 | \mathbf{z}_2 | \cdots | \mathbf{z}_n]$$

where $\{\mathbf{z}_2, \ldots, \mathbf{z}_n\}$ is an orthonormal basis for the orthogonal complement of $\mathrm{Span}[\mathbf{x}_1]$. The matrix Q_1 is orthogonal by construction and

$$Q_1^\mathrm{T} A Q_1 = \begin{bmatrix} \lambda_1 & * & \cdots & * \\ \hline 0 & * & \cdots & * \\ \vdots & \vdots & & \vdots \\ 0 & * & \cdots & * \end{bmatrix}$$

The process is recursively applied to the lower right-hand corner submatrix to obtain an orthogonal matrix P_2 such that

$$Q_2 = \begin{bmatrix} 1 & 0 \\ \hline 0 & P_2 \end{bmatrix} \quad \text{and} \quad Q_2^{\mathrm{T}} \left(Q_1^{\mathrm{T}} A Q_1 \right) Q_2 = \begin{bmatrix} \lambda_1 & * & * & \cdots & * \\ 0 & \lambda_2 & * & \cdots & * \\ 0 & 0 & * & \cdots & * \\ \vdots & \vdots & \vdots & & \vdots \\ 0 & 0 & * & \cdots & * \end{bmatrix}$$

At the last step of the reduction, we have $Q = \prod_{i=1}^{n} Q_i$ and $Q^{\mathrm{T}} A Q = U$, where U is upper triangular and its diagonal entries are the eigenvalues of A.

The primary consequence of this result is that if A is symmetric and $Q^{\mathrm{T}} A Q = U$, where Q is orthogonal and U is upper triangular, then in fact U must be a diagonal matrix. This follows from $U^{\mathrm{T}} = (Q^{\mathrm{T}} A Q)^{\mathrm{T}} = Q^{\mathrm{T}} A^{\mathrm{T}} (Q^{\mathrm{T}})^{\mathrm{T}} = Q^{\mathrm{T}} A Q = U$, which forces U to be symmetric. The only upper triangular symmetric matrices are the diagonal matrices. The diagonal entries of U are the eigenvalues of A and the columns of Q are the corresponding eigenvectors. This means that an $n \times n$ real-valued symmetric matrix always has n linearly independent eigenvectors.

Finally, an important classification for the "definite" matrices: The symmetric matrix A is (positive, nonnegative, negative, nonpositive) definite if and only if its eigenvalues are (positive, nonnegative, negative, nonpositive). Let us prove this for the case of positive-definite matrices. The other cases are similar.

■ (\Rightarrow): Let A be positive-definite. Let λ be an eigenvalue for A with corresponding eigenvector \mathbf{x}; then $A\mathbf{x} = \lambda \mathbf{x}$, $\mathbf{x}^{\mathrm{T}} A \mathbf{x} = \mathbf{x}^{\mathrm{T}}(\lambda \mathbf{x}) = \lambda \mathbf{x}^{\mathrm{T}} \mathbf{x}$, and so $\lambda = (\mathbf{x}^{\mathrm{T}} A \mathbf{x})/(\mathbf{x}^{\mathrm{T}} \mathbf{x})$. But A is positive-definite, so $\mathbf{x}^{\mathrm{T}} A \mathbf{x} > 0$. Moreover, $\mathbf{x}^{\mathrm{T}} \mathbf{x}$ is the squared length of \mathbf{x}, so it is positive. Thus, $\lambda = (\mathbf{x}^{\mathrm{T}} A \mathbf{x})/(\mathbf{x}^{\mathrm{T}} \mathbf{x}) > 0$. The argument works for every eigenvalue of A.

■ (\Leftarrow): Let λ be an eigenvalue for A and assume that $\lambda > 0$. Then as in the first part, $0 < \lambda = (\mathbf{x}^{\mathrm{T}} A \mathbf{x})/(\mathbf{x}^{\mathrm{T}} \mathbf{x})$, where \mathbf{x} is a corresponding eigenvector. Therefore, $\mathbf{x}^{\mathrm{T}} A \mathbf{x} > 0$ for every eigenvector of A. Since A is symmetric, it must have a set of linearly independent eigenvectors $\mathbf{x}_1, \ldots, \mathbf{x}_n$ given by the columns of Q in the decomposition. Let $\mathbf{x} = a_1 \mathbf{x}_1 + \cdots + a_n \mathbf{x}_n \neq \mathbf{0}$; then

$$\mathbf{x}^{\mathrm{T}} A \mathbf{x} = \left(\sum_{i=1}^{n} a_i \mathbf{x}_i \right)^{\mathrm{T}} A \left(\sum_{j=1}^{n} a_j \mathbf{x}_j \right)$$

$$= \left(\sum_{i=1}^{n} a_i \mathbf{x}_i^{\mathrm{T}} \right) \left(\sum_{j=1}^{n} a_i A \mathbf{x}_i \right)$$

$$
= \left(\sum_{i=1}^{n} a_i \mathbf{x}_i^{\mathrm{T}} \right) \left(\sum_{j=1}^{n} \lambda_i a_i \mathbf{x}_i \right)
$$

$$
= \sum_{i,j} \lambda_j a_i a_j \mathbf{x}_i^{\mathrm{T}} \mathbf{x}_j
$$

$$
= \sum_{i} \lambda_i a_i^2 \quad \mathbf{x}_i \text{ are orthonormal}
$$

$$
> 0 \quad \text{since } \lambda_i > 0 \text{ and } \mathbf{x} \neq 0
$$

Similar arguments apply to negative, nonpositive, or nonnegative definite matrices.

The eigenvalues of a symmetric matrix can be calculated directly by solving the characteristic equation $\det(A - \lambda I) = 0$; however, for large n, root finding in this manner is typically ill-conditioned. A better approach reduces A to a tridiagonal matrix T via a finite sequence of similarity transformations by orthogonal matrices (i.e., *Householder reduction*) followed by an iterative reduction to a diagonal matrix using the QR algorithm. In the second phase, the reductions involve more similarity transformations by orthogonal matrices. In the end, $A = RDR^{-1}$, where D is a diagonal matrix whose diagonal entries are the eigenvalues of A, and R is an orthogonal matrix whose columns are the corresponding linearly independent eigenvectors, ordered according to the eigenvalue ordering on the diagonal of D.

A.5.4 S + N Decomposition

Given a square matrix A, we are going to show that it may be decomposed into a sum $A = S + N$, where S is diagonalizable (the S comes from *semisimple*, a term that is synonymous with diagonalizable) and N is *nilpotent*, a matrix for which $N^p = 0$ for some $p > 0$, but $N^i \neq 0$ for $0 < i < p$, and $SN = NS$. The decomposition allows us to efficiently compute powers A^k that arise in solving linear difference equations and to compute the exponential e^A (a formal power series $e^A = \sum_{k=0} A^k/k!$) that arise in solving linear differential equations. Both types of equations occur in physics applications.

Let V be an n-dimensional vector space. Let V_1, \ldots, V_r be subspaces of V. V is said to be the *direct sum* of the V_i if every $\mathbf{x} \in V$ can be written uniquely as $\mathbf{x} = \sum_{i=1}^{r} \mathbf{x}_i$, where $\mathbf{x}_i \in V_i$. The notation for indicating that V is the direct sum of the subspaces is

$$
V = V_1 \oplus \cdots \oplus V_r = \bigoplus_{i=1}^{r} V_i
$$

We have already seen this concept in the section introducing orthogonal subspaces. If U is an m-dimensional subspace of \mathbb{R}^n and U^\perp is its $(n - m)$-dimensional orthogonal complement, we proved that $\mathbb{R}^n = U \oplus U^\perp$ by constructing a basis of vectors, the first m in U and the last $n - m$ in U^\perp. A special case comes from the Fundamental Theorem of Linear Algebra. If A is an $n \times m$ matrix, then $\mathbb{R}^m = \text{kernel}(A) \oplus \text{range}(A^T)$ and $\mathbb{R}^m = \text{kernel}(A^T) \oplus \text{range}(A)$. Let's look at one last example. Let $\{\mathbf{f}_1, \ldots, \mathbf{f}_n\}$ be a basis for \mathbb{R}^n; then $\mathbb{R}^n = \bigoplus_{i=1}^n \text{Span}[\mathbf{f}_i]$ since every vector in \mathbb{R}^n can be written uniquely as a linear combination of basis vectors.

Linear transformations can be decomposed in a manner similar to the vector space. Let $L : V \to V$ be a linear transformation. Let $L_i : V_i \to V_i$ for $1 \le i \le r$ be linear transformations. Define $L(V_i) = \{L(\mathbf{x}) : \mathbf{x} \in V_i\}$. L is said to be the *direct sum* of the L_i if

1. $V = \bigoplus_{i=1}^r V_i$ (V is the direct sum of the V_i);
2. $L(V_i) \subseteq V_i$ for all i (V_i is *invariant* under L); and
3. $L(x) = L_i(x)$ for $x \in V_i$ (L restricted to the set V_i is just the transformation L_i).

The notation for indicating L is a direct sum of the transformations is

$$L = L_1 \oplus \cdots \oplus L_r = \bigoplus_{i=1}^r L_i$$

A direct sum of transformations is applied as follows,

$$L(\mathbf{x}) = \left(\bigoplus_{i=1}^r L_i \right) \left(\sum_{i=1}^r \mathbf{x}_i \right) = \sum_{i=1}^r L_i(\mathbf{x}_i)$$

If L_i is represented by the matrix A_i with respect to the basis β_i for V_i, then the union of the bases $\beta = \bigcup_{i=1}^r \beta_i$ is a basis for V and the diagonal block matrix $A = \text{Diag}(A_1, \ldots, A_r)$ represents L with respect to β.

EXAMPLE
A.56

Let $V = \mathbb{R}^2$ and $L(x_1, x_2) = (-2x_1, x_1 + 4x_2)$. The matrix that represents L with respect to basis $B_1 = \{(1, 0), (0, 1)\}$ is

$$M = \begin{bmatrix} -2 & 0 \\ 1 & 4 \end{bmatrix}$$

Another basis for V is $B_2 = \{\mathbf{v}_1, \mathbf{v}_2\}$, where $\mathbf{v}_1 = (-6, 1)$ and $\mathbf{v}_2 = (0, 1)$. Note that \mathbf{v}_1 is an eigenvector of M corresponding to the eigenvalue $\lambda_1 = -2$ and \mathbf{v}_2 is an eigenvector of A corresponding to the eigenvalue $\lambda_2 = 4$. Let $V_i = \text{Span}[\mathbf{v}_i]$ for each i, so $\mathbb{R}^2 = \text{Span}[\mathbf{v}_1] \oplus \text{Span}[\mathbf{v}_2]$, a direct sum of the eigenspaces of M.

Define $L_1 : V_1 \rightarrow V_1$ by $L_1(\alpha \mathbf{v}_1) = -2\alpha \mathbf{v}_1$. Since V_1 is one-dimensional, we can think of L_1 as $L_1(\alpha) = -2\alpha$. Its matrix of representation is $A_1 = [-2]$. Similarly, define $L_2 : V_2 \rightarrow V_2$ by $L_2(\beta \mathbf{v}_2) = 4\beta \mathbf{v}_2$. As a one-dimensional transformation, $L_2(\beta) = 4\beta$ and the matrix representation is $A_2 = [4]$. Observe that

$$L(\alpha(-6, 1)) = \alpha L(-6, 1) = \alpha(12, -2) = -2\alpha(-6, 1) = L_1(\alpha(-6, 1))$$

$$L(\beta(0, 1)) = \beta L(0, 1) = \beta(0, 4) = 4\beta(0, 1) = L_2(\beta(0, 1))$$

Consequently, L is the direct sum $L = L_1 \oplus L_2$. The matrix representing L with respect to the basis B_2 is

$$A = \mathrm{Diag}(A_1, A_2) = \begin{bmatrix} -2 & 0 \\ 0 & 4 \end{bmatrix}$$

The intent of the example is to show that the behavior of L is determined by its behavior on certain special subspaces. In this particular case, the subspaces are one-dimensional eigenspaces and L acts like the classic linear function $f(x) = ax$ on each eigenspace. In some cases it is possible to have eigenspaces of dimension larger than 1, but the vector space V is a direct sum of eigenspaces. The representation of L as a direct sum of transformations on the eigenspaces is constructed in a manner similar to the example. In other cases, though, V is not a direct sum of eigenspaces, but it is a direct sum of *generalized eigenspaces*.

Since a change of basis is a similarity transformation between two matrix representations of a linear transformation $L : V \rightarrow V$, the characteristic polynomials of the matrix representations are the same (we proved this earlier), call it

$$p(\lambda) = \prod_{k=1}^{r} (\lambda - \lambda_k)^{n_k}$$

where $\dim(V) = \sum_{k=1}^{r} n_k$ and where the λ_k are the distinct roots of the polynomial. This allows us to refer to eigenvalues λ_k of L rather than having to explicitly associate the eigenvalues with a specific matrix A that represents L. Similarly, we will refer to the eigenspace of λ_k as the set kernel$(L - \lambda_k I)$ without reference to a specific matrix A since $L - \lambda_k I$ is itself a linear transformation with a kernel and a range. The *generalized eigenspace of L corresponding to λ_k* is the set

$$E_k = \mathrm{kernel}\left(L - \lambda_k I\right)^{n_k}$$

The sets E_k are invariant subspaces of L; that is, $L(E_k) \subseteq E_k$. To see this, select $\mathbf{y} \in L(E_k)$; then $\mathbf{y} = L(\mathbf{x})$ for some $\mathbf{x} \in E_k$. Also,

$$
\begin{aligned}
(L - \lambda_k I)^{n_k}(\mathbf{y}) &= (L - \lambda_k I)^{n_k}(L(\mathbf{x})) && \\
&= ((L - \lambda_k I)^{n_k} \circ L)(\mathbf{x}) && \text{Definition of composition} \\
&= (L \circ (L - \lambda_k I)^{n_k})(\mathbf{x}) && \text{L commutes with itself} \\
&= L(L - \lambda_k I)^{n_k})(\mathbf{x})) && \text{Definition of composition} \\
&= L(\mathbf{0}) && \text{Since $\mathbf{x} \in E_k$} \\
&= \mathbf{0} && \text{L is a linear transformation}
\end{aligned}
$$

Thus, $\mathbf{y} \in E_k$ and so $L(E_k) \subseteq E_k$.

The main result is now stated, without proof. Let $L : V \to V$ be a linear transformation. The vector space is a direct sum of the generalized eigenspaces, $V = \bigoplus_{k=1}^{r} E_k$, where E_k is the generalized eigenspace of L with respect to eigenvalue λ_k. The proof involves showing that (1) E_k has a basis of n_k vectors and (2) eigenvectors corresponding to distinct eigenvalues are linearly independent. If L_k is the restriction of L to E_k, a consequence of the direct sum decomposition and the result $L(E_k) \subseteq E_k$ (proved in the last paragraph) is that L can be decomposed as $L = \bigoplus_{k=1}^{r} L_k$.

The most important consequence of the direct sum decomposition is that there are transformations S and N such that $L = S + N$ (a sum of transformations), any matrix representation of S is a diagonalizable matrix, any matrix representation of N is a nilpotent matrix, and the order of composition of S and N is irrelevant: $SN = NS$. To prove this, let us look at the special case when there is a single eigenvalue λ_1. The characteristic polynomial is $p(\lambda) = (\lambda - \lambda_1)^n$. The generalized eigenspace is $E = \text{kernel}(L - \lambda_1 I)^n$. Define $S = \lambda_1 I$ and $N = L - \lambda_1 I$. Clearly, $S \circ N = N \circ S$ since the identity transformation commutes with any transformation. $E = \text{kernel}(N^n)$ implies $N^n = 0$ since the only transformation that maps everything to 0 is the zero transformation.

Let L_k be the restriction of L to E_k. Each L_k has characteristic polynomial $(\lambda - \lambda_k)_k^n$ (just the special case mentioned in the previous paragraph) so $L_k = S_k + N_k$, where $S_k = \lambda_k I$ and $N_k = L_k - \lambda_k I$ are defined on E_k with $S_k N_k = N_k S_k$. Define $S = \bigoplus_{k=1}^{r} S_k$ and $N = \bigoplus_{k=1}^{r} N_k$. First,

$$
L = \bigoplus_{k=1}^{r} L_k
$$

$$
= \bigoplus_{k=1}^{r} (S_k + N_k)
$$

$$= \bigoplus_{k=1}^{r} S_k + \bigoplus_{k=1}^{r} N_k$$

$$= S + N$$

so $L = S + N$ as claimed. Second,

$$SN = \left(\bigoplus_{k=1}^{r} S_k \right) \left(\bigoplus_{k=1}^{r} N_k \right)$$

$$= \bigoplus_{k=1}^{r} S_k N_k$$

$$= \bigoplus_{k=1}^{r} N_k S_k$$

$$= \left(\bigoplus_{k=1}^{r} N_k \right) \left(\bigoplus_{k=1}^{r} S_k \right)$$

$$= NS$$

so $SN = NS$ as claimed.

EXAMPLE A.57

Let $L : \mathbb{R}^3 \to \mathbb{R}^3$ be defined by $L(x_1, x_2, x_3) = (x_1 - x_2 + 2x_3, x_2, x_3)$. The matrix representing L with respect to the Euclidean basis is

$$A = \begin{bmatrix} 1 & -1 & 2 \\ 0 & 1 & 0 \\ 0 & 0 & 1 \end{bmatrix}$$

The characteristic polynomial is $p(\lambda) = -(\lambda - 1)^3$, so

$$S = \lambda I = I, \qquad N = A - I = \begin{bmatrix} 0 & -1 & 2 \\ 0 & 0 & 0 \\ 0 & 0 & 0 \end{bmatrix}$$

Note that $N^2 = 0$, so N is nilpotent. Clearly, S is diagonalizable since it is already diagonal. ∎

EXAMPLE A.58

Let $L : \mathbb{R}^3 \to \mathbb{R}^3$ be defined by $L(x_1, x_2, x_3) = (-x_1 + x_2 - 2x_3, -x_2 + 4x_3, x_3)$. The matrix representing L with respect to the Euclidean basis is

$$A = \begin{bmatrix} -1 & 1 & -2 \\ 0 & -1 & 4 \\ 0 & 0 & 1 \end{bmatrix}$$

(Example A.58
continued)
The characteristic polynomial is $p(\lambda) = -(\lambda + 1)^2(\lambda - 1)$. The generalized eigenspaces are $E_1 = \ker(A + I)^2$ and $E_2 = \ker(A - I)$. To construct these, row-reduce:

$$(A + I)^2 = \begin{bmatrix} 0 & 0 & 0 \\ 0 & 0 & 8 \\ 0 & 0 & 4 \end{bmatrix} \sim \begin{bmatrix} 0 & 0 & 1 \\ 0 & 0 & 0 \\ 0 & 0 & 0 \end{bmatrix}$$

so that $E_1 = \text{Span}[(1, 0, 0), (0, 1, 0)]$. Also,

$$A - I = \begin{bmatrix} -2 & 1 & -2 \\ 0 & -2 & 4 \\ 0 & 0 & 0 \end{bmatrix} \sim \begin{bmatrix} 1 & 0 & 0 \\ 0 & 1 & -2 \\ 0 & 0 & 0 \end{bmatrix}$$

so that $E_2 = \text{Span}[(0, 2, 1)]$.

Restrict L to E_1:

$$L(\alpha(1, 0, 0) + \beta(0, 1, 0)) = \alpha L(1, 0, 0) + \beta L(0, 1, 0)$$
$$= \alpha(-1, 0, 0) + \beta(1, -1, 0)$$
$$= (\beta - \alpha)(1, 0, 0) + (-\beta)(0, 1, 0)$$

Therefore, $L_1(\alpha, \beta) = (\beta - \alpha, -\beta)$. Similarly, restrict L to E_2:

$$L(\gamma(0, 2, 1)) = \gamma L(0, 2, 1)$$
$$= \gamma(0, 2, 1)$$

so $L_2(\gamma) = \gamma$.

The matrix representing L_1 with respect to the basis $\{(1, 0, 0), (0, 1, 0)\}$ is

$$A_1 = \begin{bmatrix} L_1(1, 0) & L_1(0, 1) \end{bmatrix} = \begin{bmatrix} -1 & 1 \\ 0 & -1 \end{bmatrix}$$

and the matrix representing L_2 with respect to the basis $\{(0, 2, 1)\}$ is

$$A_2 = [L_2(1)] = [1]$$

We can write $A_1 = S_1 + N_1$, where

$$S_1 = \begin{bmatrix} -1 & 0 \\ 0 & -1 \end{bmatrix}, \qquad N_1 = \begin{bmatrix} 0 & 1 \\ 0 & 0 \end{bmatrix}$$

and $A_2 = S_2 + N_2$, where

$$S_2 = [1], \qquad N_2 = [0]$$

Therefore, $L = L_1 \oplus L_2$ is represented by

$$B = \mathrm{Diag}(A_1, A_2) = \left[\begin{array}{cc|c} -1 & 1 & 0 \\ 0 & -1 & 0 \\ \hline 0 & 0 & 1 \end{array}\right] = \left[\begin{array}{cc|c} -1 & 0 & 0 \\ 0 & -1 & 0 \\ \hline 0 & 0 & 1 \end{array}\right] + \left[\begin{array}{cc|c} 0 & 1 & 0 \\ 0 & 0 & 0 \\ \hline 0 & 0 & 0 \end{array}\right]$$

$$= S + N$$

The original matrix A and this matrix B are similar, $B = P^{-1}AP$. The columns of the matrix P consist of the generalized eigenvectors:

$$P = \begin{bmatrix} 1 & 0 & 0 \\ 0 & 1 & 2 \\ 0 & 0 & 1 \end{bmatrix}, \qquad P^{-1} = \begin{bmatrix} 1 & 0 & 0 \\ 0 & 1 & -2 \\ 0 & 0 & 1 \end{bmatrix}$$

The decomposition is not necessarily unique. For example, we could choose $E_1 = \mathrm{Span}[(1, 1, 0), (1, -1, 0)]$; then

$$L(\alpha(1, 1, 0) + \beta(1, -1, 0)) = \alpha(0, -1, 0) + \beta(-2, 1, 0)$$

$$= -\left(\frac{\alpha + \beta}{2}\right)(1, 1, 0) + \frac{\alpha - 3\beta}{2}(1, -1, 0)$$

and

$$L_1(\alpha, \beta) = \left(-\frac{\alpha + \beta}{2}, \frac{\alpha - 3\beta}{2}\right)$$

The matrix representing L_1 with respect to this new basis is

$$A_1 = \begin{bmatrix} -\frac{1}{2} & -\frac{1}{2} \\ \frac{1}{2} & -\frac{3}{2} \end{bmatrix} = \begin{bmatrix} -1 & 0 \\ 0 & -1 \end{bmatrix} + \begin{bmatrix} \frac{1}{2} & -\frac{1}{2} \\ \frac{1}{2} & \frac{1}{2} \end{bmatrix} = S_1 + N_1$$

Finally,

$$B = \mathrm{Diag}(A_1, A_2) = S + N = \left[\begin{array}{cc|c} -1 & 0 & 0 \\ 0 & -1 & 0 \\ \hline 0 & 0 & 1 \end{array}\right] + \left[\begin{array}{cc|c} \frac{1}{2} & -\frac{1}{2} & 0 \\ \frac{1}{2} & -\frac{1}{2} & 0 \\ \hline 0 & 0 & 0 \end{array}\right]$$

A.5.5 APPLICATIONS

Three applications of interest regarding eigendecomposition are computing the powers of a matrix, computing the exponential of a matrix, and constructing the local extrema of multivariate functions. We discuss each application in this section.

Powers of a Matrix

The decomposition of a matrix $A = S + N$ where S is diagonalizable, N is nilpotent with $N^p = 0$ and $N^i \neq 0$ for $i < p$, and $SN = NS$ allows us to efficiently evaluate powers A^j for $j \geq 2$. Because $SN = NS$, the binomial expansion formula applies to $(S + N)^j$. That is,

$$A^j = (S + N)^j = \sum_{k=0}^{j} \binom{j}{k} S^{j-k} N^k = \sum_{k=0}^{\min(j,p-1)} \binom{j}{k} S^{j-k} N^k \qquad \text{(A.33)}$$

The last equality follows since $N^k = 0$ for $k \geq p$. Since S is diagonalizable, $S = PDP^{-1}$ for some diagonal matrix D. The powers on S are efficiently computed as $S^{j-k} = (PDP^{-1})^{j-k} = PD^{j-k}P^{-1}$.

Let us do an operation count to see why the right-hand side of equation (A.33) is a more efficient way of computing A^j than the obvious iterative product. We will do this in general for an $n \times n$ matrix. Let Θ_j denote the number of operations needed to compute A^j in the usual manner. The product A^2 requires n multiplications and $n - 1$ additions per entry. The matrix has n^2 entries, so the total operations are given by $\Theta_2 = n^2(2n - 1)$. For $j > 2$, $A^j = A \cdot A^{j-1}$, so each additional multiplication requires $n^2(2n - 1)$ operations. The total count is $\Theta_j = (j - 1)n^2(2n - 1)$ for $j \geq 2$.

Define Φ_j to be the number of operations needed to compute A^j using the $S + N$ decomposition. The simplest case is when A is already diagonalizable, $A = PDP^{-1}$, so that $N = 0$. The powers are $A^j = PD^jP^{-1}$. The product DP^{-1} requires n^2 multiplications. Once computed and cached, the next product is $D^2P^{-1} = D(DP^{-1})$, which takes an additional n^2 multiplications. Once D^jP^{-1} is computed in this manner, the last multiplication on the left by P requires $n^2(2n - 1)$ operations. The total count is $\Phi_j = jn^2 + n^2(2n - 1)$. It is the case that $\Phi_j \geq \Theta_j$ when $j \geq 1 + (2n - 1)/(2n - 2)$.

When $N \neq 0$, the operation count increases as the power of nilpotency, p, becomes large. Consider the case when $N \neq 0$, but $N^2 = 0$; then

$$A^j = S^j + jS^{j-1}N = PD^jP^{-1} + jPD^{j-1}P^{-1}N = PD^{j-1}(DP^{-1} + jP^{-1}N)$$

PD^{j-1} requires $(j - 1)n^2$ multiplications; DP^{-1} requires n^2 multiplications; $P^{-1}N$ requires $n^2(2n - 1)$ operations; the product $j(P^{-1}N)$ requires an additional n^2 multiplications; the sum $(DP^{-1}) + (jP^{-1}N)$ requires n^2 additions; and finally $(PD^{j-1})(DP^{-1} + jP^{-1}N)$ uses $n^2(2n - 1)$ operations. The total count is $\Phi_j = (j - 1)n^2 + 2n^2(2n + 1)$. It is the case that $\Phi_j \geq \Theta_j$ when $j \geq 1 + (2n + 1)/(2n - 2)$. The break-even point for j occurs when $N^2 = 0$ is larger than in the case $N = 0$.

As it turns out, the power of nilpotency p is bounded by the matrix size, $p < n$. Even though A^j might be more cheaply computed for small j using the obvious multiplication, as j becomes large the $S + N$ decomposition will be cheaper.

Exponential of a Matrix

A system of ordinary differential equations with constant coefficients is of the form

$$\frac{d\mathbf{x}}{dt} = A\mathbf{x}, \quad t \geq 0, \quad \mathbf{x}(0) = \mathbf{x}_0$$

where A is an $n \times n$ matrix of constants and \mathbf{x}_0 is a specified initial condition. As we will see, the solution is

$$\mathbf{x}(t) = e^{tA}\mathbf{x}_0, \quad t \geq 0$$

where e^{tA} is the power series for the function $f(x) = e^x$ formally evaluated with the matrix argument tA. Recall that

$$e^x = \sum_{k=0}^{\infty} \frac{x^k}{k!}$$

a power series that converges for any real-valued x. Although not proved here, the formal series

$$e^{tA} = \sum_{k=0}^{\infty} \frac{t^k}{k!} A^k$$

also converges for any real-valued matrix A. We could use the $A = S + N$ decomposition to calculate A^k for each k, but we can actually do better. The exponential of a matrix happens to satisfy the condition $e^{A+B} = e^A e^B$ whenever $AB = BA$. However, do not make the mistake of using this formula when $AB \neq BA$; the formula is not true in these cases. Using $A = S + N$, the fact that $SN = NS$, and the exponential identity,

$$e^{tA} = e^{t(S+N)} = e^{tS+tN} = e^{tS}e^{tN}$$

The right-hand side requires evaluating the power series for e^x twice. The power series for e^{tS} is simplified by using the fact that S is diagonalizable, $S = PDP^{-1}$. The series is

$$e^{tS} = \sum_{k=0}^{\infty} \frac{t^k}{k!} S^k = \sum_{k=0}^{\infty} \frac{t^k}{k!} (PDP^{-1})^k = \sum_{k=0}^{\infty} \frac{t^k}{k!} PD^k P^{-1} = P \left(\sum_{k=0}^{\infty} \frac{t^k}{k!} D^k \right) P^{-1}$$

$$= Pe^{tD}P^{-1}$$

The diagonal matrix is $D = \text{Diag}(d_1, \ldots, d_n)$ and the exponential of tD is

$$e^{tD} = e^{\text{Diag}(td_1, \ldots, td_n)} = \text{Diag}(e^{td_1}, \ldots, e^{td_n})$$

The power series for e^{tN} is actually a finite sum since $N^p = 0$ for some positive power p. That is,

$$e^{tN} = \sum_{k=0}^{\infty} \frac{t^k}{k!} N^k = \sum_{k=0}^{p-1} \frac{t^k}{k!} N^k$$

In summary, the exponential of A is

$$e^{tA} = P \operatorname{Diag}(e^{td_1}, \dots, e^{td_n}) P^{-1} = \sum_{k=0}^{p-1} \frac{t^k}{k!} N^k \tag{A.34}$$

Local Extrema of Multivariate Functions

Let $y = f(x)$ for $x \in \mathbb{R}$, where f is twice-differentiable for all x. The *critical points* for f are those points x_0 such that $f'(x_0) = 0$. At such a point, three possibilities occur for the function as illustrated in Figure A.27.

In studying calculus you discussed the concept of *Taylor polynomials*. If f is twice-differentiable at x_0, then for x near x_0,

$$f(x) = f(x_0) + \frac{f'(x_0)}{1!}(x - x_0) + \frac{f''(x_0)}{2!}(x - x_0)^2 + R(x, x_0)$$

where R is a remainder term such that

$$\lim_{x \to x_0} \frac{R(x, x_0)}{(x - x_0)^2}$$

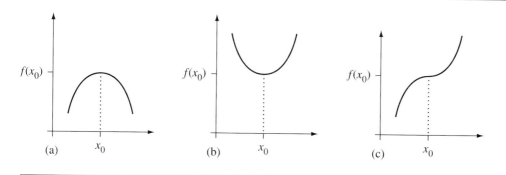

Figure A.27 Three graphs showing critical points. (a) $f(x_0)$ is a local maximum. (b) $f(x_0)$ is a local minimum. (c) $(x_0, f(x_0))$ is a point of inflection for the graph of f.

Suppose that $f'(x_0) = 0$; then

$$f(x) = f(x_0) + \frac{1}{2}(x - x_0)^2 \left[f''(x_0) + 2\frac{R(x, x_0)}{(x - x_0)^2} \right]$$

where

$$\lim_{x \to x_0} \left[f''(x_0) + 2\frac{R(x, x_0)}{(x - x_0)^2} \right] = f''(x_0)$$

Consequently,

$$\text{sign} \left[f''(x_0) + 2\frac{R(x, x_0)}{(x - x_0)^2} \right] = \text{sign } f''(x_0)$$

for x sufficiently close to x_0, where

$$\text{sign } (x) = \begin{cases} 1 & x > 0 \\ 0 & x = 0 \\ -1 & x < 0 \end{cases}$$

From the above we can develop the *Second Derivative Test*: If $f'(x_0) = 0$, then

1. $f(x_0)$ is a local maximum if $f''(x_0) < 0$.
2. $f(x_0)$ is a local minimum if $f''(x_0) > 0$.
3. No conclusion can be made if $f''(x_0) = 0$. A more detailed analysis is required to understand the behavior of the graph of f at $(x_0, f(x_0))$.

The idea is that for x near x_0, $f''(x_0) > 0$ implies that $f''(x_0) + 2R(x, x_0)/(x - x_0)^2 > 0$, so $f(x) \geq f(x_0)$ for x near x_0. A similar argument holds if $f''(x_0) < 0$ [$f(x) \leq f(x_0)$ for x near x_0].

The concept of Taylor polynomials can be generalized to functions $w = f(\mathbf{x})$, where $\mathbf{x} \in \mathbb{R}^n$. We will look at the case $n = 2$. A function $f(x_1, x_2)$ is *differentiable at* (x_1, x_2) if the partial first derivatives

$$f_{x_1}(x_1, x_2) = \frac{\partial f(x_1, x_2)}{\partial x_1} \quad \text{and} \quad f_{x_2}(x_1, x_2) = \frac{\partial f(x_1, x_2)}{\partial x_2}$$

exist. Similarly, $f(x_1, x_2)$ is *twice-differentiable at* (x_1, x_2) if the partial second derivatives

$$f_{x_1 x_1} = \frac{\partial^2 f}{\partial x_1^2}, \quad f_{x_1 x_2} = \frac{\partial^2 f}{\partial x_2 \partial x_1}, \quad f_{x_2 x_1} = \frac{\partial^2 f}{\partial x_1 \partial x_2}, \quad \text{and} \quad f_{x_2 x_2} = \frac{\partial^2 f}{\partial x_2^2}$$

exist.

Let $\mathbf{x} = (x_1, x_2)$ and $\mathbf{x}_0 = (a, b)$. If $f(\mathbf{x})$ is twice-differentiable at \mathbf{x}_0, then

$$f(\mathbf{x}) = f(\mathbf{x}_0) + Df(\mathbf{x}_0)(\mathbf{x} - \mathbf{x}_0) + \frac{D^2 f(\mathbf{x}_0)}{2!}(\mathbf{x} - \mathbf{x}_0)^2 + R(\mathbf{x}, \mathbf{x}_0)$$

where the implied operations are defined by

1. $Df(\mathbf{x}) = \vec{\nabla} f(\mathbf{x}) = (f_{x_1}(x_1, x_2), f_{x_2}(x_1, x_2))$ (the gradient of f)
2. $Df(\mathbf{x})\mathbf{y} = \mathbf{y}^T \vec{\nabla} f(\mathbf{x}) = \sum_{i=1}^{2} f_{x_i} y_i$
3. $D^2 f(\mathbf{x}) = [f_{x_i x_j}] = \begin{bmatrix} f_{x_1 x_1} & f_{x_1 x_2} \\ f_{x_2 x_1} & f_{x_2 x_2} \end{bmatrix}$
4. $D^2 f(\mathbf{x})\mathbf{y}\mathbf{z} = \mathbf{y}^T D^2 f(\mathbf{x})\mathbf{z} = \sum_{i=1}^{2} \sum_{j=1}^{2} f_{x_i x_j} y_i z_j$

Generally,

$$D^n f(\mathbf{x})\mathbf{y}^n = \sum_{i_1=1}^{2} \cdots \sum_{i_n=1}^{2} f_{x_{i_1} \cdots x_{i_n}} y_{i_1} \cdots y_{i_n}$$

The quantity $R(\mathbf{x}, \mathbf{x}_0)$ in the above Taylor polynomial expansion has the property

$$\lim_{\mathbf{x} \to \mathbf{x}_0} \frac{R(\mathbf{x}, \mathbf{x}_0)}{|\mathbf{x} - \mathbf{x}_0|^2} = 0$$

The *Second Derivative Test* is the following. If $Df(\mathbf{x}_0) = \mathbf{0}$, then

1. $f(\mathbf{x}_0)$ is a local maximum if $D^2 f(\mathbf{x}_0)(\mathbf{x} - \mathbf{x}_0)^2 < 0$ for all \mathbf{x} near \mathbf{x}_0.
2. $f(\mathbf{x}_0)$ is a local minimum if $D^2 f(\mathbf{x}_0)(\mathbf{x} - \mathbf{x}_0)^2 > 0$ for all \mathbf{x} near \mathbf{x}_0.
3. No conclusion can be made otherwise without more information.

Using our results about the characterization of definite matrices, the Second Derivative Test may be rephrased as follows. If $Df(\mathbf{x}_0) = \mathbf{0}$, then

1. $f(\mathbf{x}_0)$ is a local maximum if $D^2 f(\mathbf{x}_0)$ is negative-definite.
2. $f(\mathbf{x}_0)$ is a local minimum if $D^2 f(\mathbf{x}_0)$ is positive-definite.
3. No conclusion can be made if $D^2 f(\mathbf{x}_0)$ is neither positive- nor negative-definite. A more detailed analysis is required to understand the behavior of the graph of f at $(\mathbf{x}_0, \mathbf{f}(x_0))$.

Figure A.28 shows a graph of f for various possibilities.

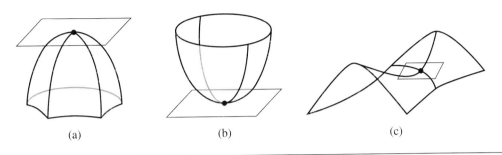

(a) (b) (c)

Figure A.28 Three graphs showing critical points. (a) $f(\mathbf{x}_0)$ is a local maximum. (b) $f(\mathbf{x}_0)$ is a local minimum. (c) $(\mathbf{x}_0, f(\mathbf{x}_0))$ is a saddle point on the graph of f. The tangent planes at the graph points are shown in all three figures.

EXAMPLE A.59

Consider $f(x_1, x_2) = x_1^4 + 4x_1^2 x_2 + x_1^2 + 5x_2^2 - 2x_1 x_2$; then

$$Df(x_1, x_2) = (4x_1^3 + 8x_1 x_2 + 2x_1 - 2x_2, \; 4x_1^2 + 10x_2 - 2x_1)$$

and

$$D^2 f(x_1, x_2) = \begin{bmatrix} 12x_1^2 + 8x_2 + 2 & 8x_1 - 2 \\ 8x_1 - 2 & 10 \end{bmatrix}$$

Solve $Df = (0, 0)$:

$$4x_1^3 + 8x_1 x_2 + 2x_1 - 2x_2 = 0$$

$$4x_1^2 + 10x_2 - 2x_1 = 0$$

The second equation implies $x_2 = \frac{x_1 - 2x_1^2}{5}$. Replacing in the first equation yields $0 = \frac{4}{5} x_1 (x_1 + 1)(x_1 + 2)$. The critical points are $(0, 0)$, $(-1, -3/5)$, and $(-2, -2)$.

■ Case 1: $(0, 0)$

$$D^2 f(0, 0) = \begin{bmatrix} 2 & -2 \\ -2 & 10 \end{bmatrix}$$

$$\det(D^2 f(0, 0) - \lambda I) = \lambda^2 - 12\lambda + 16 = 0$$

so the eigenvalues are $\lambda \doteq 1.53, 0.76$. Thus, $D^2 f(0, 0)$ is positive-definite and $f(0, 0) = 0$ is a local minimum.

(Example A.59 continued)

- Case 2: $(-1, -3/5)$

$$D^2 f(-1, -3/5) = \begin{bmatrix} \frac{46}{5} & -10 \\ -10 & 10 \end{bmatrix}$$

$$\det(D^2 f(-1, -3/5) - \lambda I) = \lambda^2 - \frac{96}{5}\lambda - 8 = 0$$

so the eigenvalues are $\lambda \doteq 19.61, -0.41$. The Second Derivative Test gives no conclusions. Actually, the function has a *saddle point* at $(-1, -3/5)$.

- Case 3: $(-2, -2)$

$$D^2 f(-2, -2) = \begin{bmatrix} 34 & -18 \\ -18 & 10 \end{bmatrix}$$

$$\det(D^2 f(-2, -2) - \lambda I) = \lambda^2 - 44\lambda + 16 = 0$$

so the eigenvalues are $\lambda \doteq 43.63, 0.37$. Thus, $D^2 f(-2, -2)$ is positive-definite and $f(-2, -2) = 0$ is a local minimum.

Note that $f(x_1, x_2) = (x_1 - x_2)^2 + (x_1^2 + 2x_2)^2$, so 0 is the absolute minimum for the function. ▨

AFFINE ALGEBRA

B.1 INTRODUCTION

As we saw earlier, linear algebra is the study of vectors and vector spaces. In two dimensions, a vector was treated as a quantity with direction and magnitude. It does not matter where you place the vector in the plane; it represents the same vector (see Figure A.4) since the directions and magnitudes are the same. In physics applications, among others, the location of the vector, that is, where its initial point is, may very well be significant. For example, if a particle has a certain velocity at a given instant, the velocity vector necessarily applies to the *position* of the particle at that instant. Similarly, the same force applied to two different positions on a rod have different effects on the rod. The *point* of application of the force is relevant.

Clearly, there needs to be a distinction between *points* and *vectors*. This is the essence of *affine algebra*. Let V be a vector space of dimension n. Let A be a set of elements that are called *points*. A is referred to as an *n-dimensional affine space* whenever the following conditions are met:

1. For each ordered pair of points $\mathcal{P}, \mathcal{Q} \in A$, there is a unique vector in V called the *difference vector* and denoted by $\Delta(\mathcal{P}, \mathcal{Q})$.

2. For each point $\mathcal{P} \in A$ and $\mathbf{v} \in V$, there is a unique point $\mathcal{Q} \in A$ such that $\mathbf{v} = \Delta(\mathcal{P}, \mathcal{Q})$.

3. For any three points $\mathcal{P}, \mathcal{Q}, \mathcal{R} \in A$, it must be that $\Delta(\mathcal{P}, \mathcal{Q}) + \Delta(\mathcal{Q}, \mathcal{R}) = \Delta(\mathcal{P}, \mathcal{R})$.

Figure B.1 illustrates these three items.

If \mathcal{P} and \mathcal{Q} are specified, \mathbf{v} is uniquely determined (item 1). If \mathcal{P} and \mathbf{v} are specified, \mathcal{Q} is uniquely determined (item 2). Figure B.1(b) illustrates item 3.

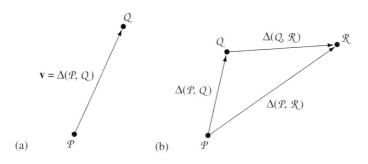

Figure B.1 (a) A vector **v** connecting two points \mathcal{P} and \mathcal{Q}. (b) The sum of vectors, each vector determined by two points.

The formal definition for an affine space introduced the difference vector $\Delta(\mathcal{P}, \mathcal{Q})$. Figure B.1 gives you the geometric intuition about the difference, specifically that it appears to be a subtraction operation for two points. However, certain consequences of the definition may be proved directly without having a concrete formulation for an actual subtraction of points.

A few consequences of the definition for an affine algebra follow.

1. $\Delta(\mathcal{P}, \mathcal{P}) = \mathbf{0}$

2. $\Delta(\mathcal{Q}, \mathcal{P}) = -\Delta(\mathcal{P}, \mathcal{Q})$

3. If $\Delta(\mathcal{P}_1, \mathcal{Q}_1) = \Delta(\mathcal{P}_2, \mathcal{Q}_2)$, then $\Delta(\mathcal{P}_1, \mathcal{P}_2) = \Delta(\mathcal{Q}_1, \mathcal{Q}_2)$

The first consequence follows immediately from item 3 in the definition, where \mathcal{Q} is replaced by \mathcal{P}, $\Delta(\mathcal{P}, \mathcal{P}) + \Delta(\mathcal{P}, \mathcal{R}) = \Delta(\mathcal{P}, \mathcal{R})$. The vector $\Delta(\mathcal{P}, \mathcal{R})$ is subtracted from both sides to obtain $\Delta(\mathcal{P}, \mathcal{P}) = \mathbf{0}$.

The second consequence also follows from item 3 in the definition, where \mathcal{R} is replaced by \mathcal{P}, $\Delta(\mathcal{P}, \mathcal{Q}) + \Delta(\mathcal{Q}, \mathcal{P}) = \Delta(\mathcal{P}, \mathcal{P}) = \mathbf{0}$. The last equality is what we just proved in the previous paragraph. The first vector is subtracted from both sides to obtain $\Delta(\mathcal{Q}, \mathcal{P}) = -\Delta(\mathcal{P}, \mathcal{Q})$.

The third consequence is called the *parallelogram law*. Figure B.2 illustrates. Item 3 in the definition can be applied in two ways:

$$\Delta(\mathcal{P}_1, \mathcal{P}_2) + \Delta(\mathcal{P}_2, \mathcal{Q}_2) = \Delta(\mathcal{P}_1, \mathcal{Q}_2) \quad \text{and} \quad \Delta(\mathcal{P}_1, \mathcal{Q}_1) + \Delta(\mathcal{Q}_1, \mathcal{Q}_2) = \Delta(\mathcal{P}_1, \mathcal{Q}_2)$$

Subtracting these leads to

$$\mathbf{0} = \Delta(\mathcal{P}_1, \mathcal{P}_2) + \Delta(\mathcal{P}_2, \mathcal{Q}_2) - \Delta(\mathcal{P}_1, \mathcal{Q}_1) - \Delta(\mathcal{Q}_1, \mathcal{Q}_2) = \Delta(\mathcal{P}_1, \mathcal{P}_2) - \Delta(\mathcal{Q}_1, \mathcal{Q}_2)$$

where the last equality is valid since we assumed $\Delta(\mathcal{P}_1, \mathcal{Q}_1) = \Delta(\mathcal{P}_2, \mathcal{Q}_2)$. Therefore, $\Delta(\mathcal{P}_1, \mathcal{P}_2) = \Delta(\mathcal{Q}_1, \mathcal{Q}_2)$.

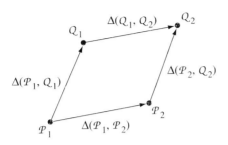

Figure B.2 The parallelogram law for affine algebra.

In the formal sense of affine algebra, points and vectors are distinct entities. We have already used two different fonts to help distinguish between them: \mathcal{P} is a point, \mathbf{v} is a vector. Even so, the following example shows how powerful the formal setting is. Given a vector space V, the points may be defined as the elements of V themselves, namely, $A = V$. If \mathcal{P} and \mathcal{Q} are points, the corresponding vectors are labeled \mathbf{p} and \mathbf{q}. Think of the vectors geometrically as $\mathcal{P} - \mathcal{O}$ and $\mathcal{Q} - \mathcal{O}$, respectively, where \mathcal{O} is the origin. The difference vector of the points is $\Delta(\mathcal{P}, \mathcal{Q}) = \mathbf{q} - \mathbf{p}$, a subtraction of the two vectors. The three items in the definition for affine space can be easily verified. The example also shows that you must be steadfast in maintaining that points and vectors are different abstract quantities, even if you happen to represent them in a computer program in the same way, say, as n-tuples of numbers.

Any further discussion of affine spaces in the abstract will continue to use the notation $\Delta(\mathcal{P}, \mathcal{Q})$ for the vector difference of two points. However, in situations that have a computational flavor, we will instead use the more intuitive notation $\mathcal{Q} - \mathcal{P}$ with the warning that the subtraction operator is a convenient notation that is not necessarily indicative of the actual mechanism used to compute the vector difference of two points in a particular application. We also use the suggestive notation $\mathcal{Q} = \mathcal{P} + \mathbf{v}$ when $\mathbf{v} = \Delta(\mathcal{P}, \mathcal{Q})$.

To avoid inadvertent confusion between points and vectors in a computer implementation, separate data structures for points and vectors are recommended. For example, in C++ you can define the vector class by

```
template class <T real, int n> Vector
{
public:
    // construction
    Vector ();
    Vector (const real tuple[n]);
    Vector (const Vector& v);
```

```
        // tuple access as an array
        operator const real* () const;
        operator real* ();
        real operator[] (int i) const;
        real& operator[] (int i);

        // assignment and comparison
        Vector& operator= (const Vector& v);
        bool operator== (const Vector& v) const;
        bool operator!= (const Vector& v) const;

        // arithmetic operations
        Vector operator+ (const Vector& v) const;
        Vector operator- (const Vector& v) const;
        Vector operator* (real scalar) const;
        Vector operator/ (real scalar) const;
        Vector operator- () const;
        friend Vector operator* (real scalar, const Vector& v);

private:
    real m_tuple[n];
};
```

where real allows you to support both float and double and where n is the dimension of the underlying vector space. The point class is defined by

```
template class <T real, int n> Point
{
public:
    // construction
    Point ();
    Point (const real tuple[n]);
    Point (const Point& p);

    // tuple access as an array
    operator const real* () const;
    operator real* ();
    real operator[] (int i) const;
    real& operator[] (int i);

    // assignment and comparison
    Point& operator= (const Point& p);
    bool operator== (const Point& p) const;
    bool operator!= (const Point& p) const;
```

```
// arithmetic operations
Point operator+ (const Vector& v) const;
Vector operator- (const Point& p) const;

private:
    real m_tuple[n];
};
```

Of course, these are just the basic operations, but other members can be added as needed for your applications.

B.2 COORDINATE SYSTEMS

Let A be an n-dimensional affine space. Let a fixed point $\mathcal{O} \in A$ be labeled as the *origin* and let $\{\mathbf{v}_1, \ldots, \mathbf{v}_n\}$ be a basis for V. The set $\{\mathcal{O}; \mathbf{v}_1, \ldots, \mathbf{v}_n\}$ is called an *affine coordinate system*. Each point $P \in A$ can be uniquely represented in the coordinate system as follows. The difference $\mathcal{P} - \mathcal{O}$ is a vector and can be represented uniquely with respect to the basis for V,

$$\mathcal{P} - \mathcal{O} = \sum_{i=1}^{n} a_i \mathbf{v}_i$$

or using our suggestive notation for sum of a point and a vector,

$$\mathcal{P} = \mathcal{O} + \sum_{i=1}^{n} a_i \mathbf{v}_i$$

The numbers (a_1, \ldots, a_n) are called the *affine coordinates* of \mathcal{P} relative to the specified coordinate system. The origin \mathcal{O} has coordinates $(0, \ldots, 0)$. Figure B.3 shows three coordinate systems in the plane.

A natural question is how to change coordinates from one system to another. Let $\{\mathcal{O}_1; \mathbf{u}_1, \ldots, \mathbf{u}_n\}$ and $\{\mathcal{O}_2; \mathbf{v}_1, \ldots, \mathbf{v}_n\}$ be two affine coordinate systems for A. A point $\mathcal{P} \in A$ has affine coordinates (a_1, \ldots, a_n) and (b_1, \ldots, b_n), respectively. The origin \mathcal{O}_2 has affine coordinates (c_1, \ldots, c_n) in the first coordinate system. The relationship

$$\mathcal{P} = \mathcal{O}_1 + \sum_{i=1}^{n} a_i \mathbf{u}_i = \mathcal{O}_2 + \sum_{i=1}^{n} b_i \mathbf{v}_i = \mathcal{O}_1 + \sum_{i=1}^{n} c_i \mathbf{u}_i + \sum_{i=1}^{n} b_i \mathbf{v}_i$$

implies

$$\sum_{i=1}^{n} b_i \mathbf{v}_i = \sum_{i=1}^{n} (a_i - c_i) \mathbf{u}_i$$

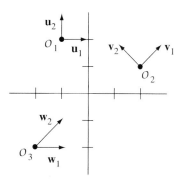

Figure B.3 Three coordinate systems in the plane. Observe that the vectors in the coordinate
system are not required to be unit length or perpendicular in pairs.

The two bases are related by a change of basis transformation, $\mathbf{u}_i = \sum_{j=1}^{n} m_{ji}\mathbf{v}_j$ for
$1 \le i \le n$, so

$$\sum_{i=1}^{n} b_i \mathbf{v}_i = \sum_{i=1}^{n}(a_i - c_i) \sum_{j=1}^{n} m_{ji}\mathbf{v}_j$$

Renaming the index i to j on the left-hand side and rearranging terms on the right-
hand side,

$$\sum_{j=1}^{n} b_j \mathbf{v}_j = \sum_{j=1}^{n} \left(\sum_{i=1}^{n} m_{ji}(a_i - c_i) \right) \mathbf{v}_j$$

The uniqueness of the representation for a vector requires

$$b_j = \sum_{i=1}^{n} m_{ji}(a_i - c_i), \qquad 1 \le j \le n,$$

which is the desired relationship between the coordinate systems.

EXAMPLE B.1 Here are two coordinate systems in the plane, the ones shown in Figure B.3. The
origin of the first is $\mathcal{O}_1 = (-1, 2)$ and the basis vectors (coordinate axis directions)
are $\mathbf{u}_1 = (1, 0)$ and $\mathbf{u}_2 = (0, 1)$. The origin of the second is $\mathcal{O}_2 = (2, 1)$ and the basis
vectors are $\mathbf{v}_1 = (1, 1)/\sqrt{2}$ and $\mathbf{v}_2 = (-1, 1)/\sqrt{2}$. Let us represent the origin of the
second system in terms of the first:

$$(3, -1) = (2, 1) - (-1, 2) = \mathcal{O}_2 - \mathcal{O}_1 = c_1\mathbf{u}_1 + c_2\mathbf{u}_2 = c_1(1, 0) + c_2(0, 1) = (c_1, c_2)$$

The change of basis matrix is determined by $\mathbf{u}_1 = m_{11}\mathbf{v}_1 + m_{21}\mathbf{v}_2$ and $\mathbf{u}_2 = m_{12}\mathbf{v}_1 + m_{22}\mathbf{v}_2$. In block matrix form where the basis vectors are written as columns,

$$\begin{bmatrix} 1 & 0 \\ 0 & 1 \end{bmatrix} = [\,\mathbf{u}_1 \quad \mathbf{u}_2\,] = [\,\mathbf{v}_1 \quad \mathbf{v}_2\,]\begin{bmatrix} m_{11} & m_{12} \\ m_{21} & m_{22} \end{bmatrix} = \frac{1}{\sqrt{2}}\begin{bmatrix} 1 & -1 \\ 1 & 1 \end{bmatrix}\begin{bmatrix} m_{11} & m_{12} \\ m_{21} & m_{22} \end{bmatrix}$$

The solution is

$$\begin{bmatrix} m_{11} & m_{12} \\ m_{21} & m_{22} \end{bmatrix} = \frac{1}{\sqrt{2}}\begin{bmatrix} 1 & 1 \\ -1 & 1 \end{bmatrix}$$

If $\mathcal{P} = \mathcal{O}_1 + a_1\mathbf{u}_1 + a_2\mathbf{u}_2 = \mathcal{O}_2 + b_1\mathbf{v}_1 + b_2\mathbf{v}_2$, then

$$\begin{bmatrix} b_1 \\ b_2 \end{bmatrix} = \begin{bmatrix} m_{11} & m_{12} \\ m_{21} & m_{22} \end{bmatrix}\begin{bmatrix} a_1 - c_1 \\ a_2 - c_2 \end{bmatrix} = \frac{1}{\sqrt{2}}\begin{bmatrix} a_1 + a_2 - 2 \\ -a_1 + a_2 + 4 \end{bmatrix}$$

The point $(0, 0)$ is represented as $\mathcal{O}_1 + (1)\mathbf{u}_1 + (-2)\mathbf{u}_2$ in the first coordinate system. Using the change of coordinate relationship above, verify that the representation in the second coordinate system is $\mathcal{O}_2 + (-3/\sqrt{2})\mathbf{v}_1 + (1/\sqrt{2})\mathbf{v}_2$. Carefully sketch a picture to convince yourself that the coordinates are accurate. ∎

EXERCISE (E)
B.1
How does the analysis of Example B.1 change when you have the common origin $\mathcal{O}_1 = \mathcal{O}_2 = (0, 0)$? In the first coordinate system, let R be the matrix that represents a counterclockwise rotation about the origin by an angle $\pi/4$. What is the matrix R? How is it related to the change of basis matrix? ∎

EXERCISE (E)
B.2
Repeat the construction in Example B.1, but use the coordinate system $\{\mathcal{O}_3; \mathbf{w}_1, \mathbf{w}_2\}$ instead of $\{\mathcal{O}_2; \mathbf{v}_1, \mathbf{v}_2\}$, where $\mathcal{O}_3 = (-2, -2)$, $\mathbf{w}_1 = (1, 0)$, and $\mathbf{w}_2 = (1, 1)$. ∎

B.3 SUBSPACES

Let A be an affine space. An *affine subspace* of A is a set $A_1 \subseteq A$ such that $V_1 = \{\Delta(\mathcal{P}, \mathcal{Q}) \in V : \mathcal{P}, \mathcal{Q} \in S\}$ is a subspace of V. The geometric motivation for this definition is quite simple. If $V = \mathbb{R}^3$, the one-dimensional subspaces are lines through the origin and the two-dimensional subspaces are planes through the origin. If A is the set of points in space, the one-dimensional subspaces are lines (not necessarily through the origin) and the two-dimensional subspaces are planes (not necessarily through the origin). That is, the affine subspaces are just translations of the vector subspaces.

Let A_1 and A_2 be affine subspaces of A with corresponding vector subspaces V_1 and V_2 of V, respectively. The subspaces are said to be *parallel* if $V_1 \subseteq V_2$ or if $V_2 \subseteq V_1$. If it is the case that $V_1 \subseteq V_2$, then as sets either A_1 and A_2 are disjoint $(A_1 \cap A_2 = \emptyset)$ or A_1 is contained in A_2 $(A_1 \subseteq A_2)$.

**EXAMPLE
B.2**

Let A be the set of points in space and $V = \mathbb{R}^3$. Let $\mathcal{P} = (0, 0, 1)$, $\mathbf{u}_1 = (1, 0, 0)$, and $\mathbf{u}_2 = (0, 1, 0)$. Let $\mathcal{Q} = (0, 0, 2)$ and $\mathbf{v}_1 = (1, 1, 0)$. The sets $A_1 = \{\mathcal{P} + s_1\mathbf{u}_1 + s_2\mathbf{u}_2 : s_1, s_2 \in \mathbb{R}\}$ and $A_2 = \{\mathcal{Q} + t_1\mathbf{v}_1 : t_1 \in \mathbb{R}\}$ are parallel, affine subspaces. In this case, A_1 and A_2 are disjoint. If instead $A_2 = \{\mathcal{P} + t_1\mathbf{v}_1 : t_1 \in \mathbb{R}\}$, A_1 and A_2 are still parallel subspaces, but A_2 is a proper subset of A_1. ▪

EXERCISE Ⓔ
B.3

Let A be the set of points in space and $V = \mathbb{R}^3$. Let $\mathcal{P} = (0, 0, 0)$, $\mathbf{u} = (1, 0, 0)$, $\mathcal{Q} = (0, 0, 1)$, and $\mathbf{v} = (0, 1, 0)$. Are the sets $A_1 = \{\mathcal{P} + s\mathbf{u} : s \in \mathbb{R}\}$ and $A_2 = \{\mathcal{Q} + t\mathbf{v} : t \in \mathbb{R}\}$ parallel subspaces? ▪

B.4 TRANSFORMATIONS

Just as we defined linear transformations for vector spaces, we can define *affine transformations* for affine spaces. Let A be an affine space with vector space V and vector difference operator Δ_A. Let B be an affine space with vector space W and vector difference operator Δ_B. An affine transformation is a function $T : A \to B$ such that the following are true:

1. $\Delta_A(\mathcal{P}_1, \mathcal{Q}_1) = \Delta_A(\mathcal{P}_2, \mathcal{Q}_2)$ implies that $\Delta_B(T(\mathcal{P}_1), T(\mathcal{Q}_1)) = \Delta_B(T(\mathcal{P}_2), T(\mathcal{Q}_2))$.
2. The function $L : V \to W$ defined by $L(\Delta_A(\mathcal{P}, \mathcal{Q})) = \Delta_B(T(\mathcal{P}), T(\mathcal{Q}))$ is a linear transformation.

Figure B.4 illustrates condition 1 in the definition. Setting $\mathbf{u} = \Delta_A(\mathcal{P}_1, \mathcal{Q}_1)$ and $\mathbf{v} = \Delta_B(T(\mathcal{P}_1), T(\mathcal{Q}_1))$, in geometric terms the condition states that no matter what point \mathcal{P} is used as the initial point for \mathbf{u}, the initial point for \mathbf{v} must be $T(\mathcal{P})$. Condition 2 just states that the vectors themselves must be transformed linearly.

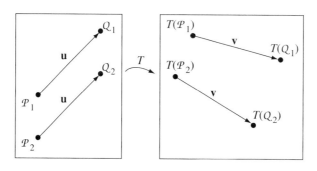

Figure B.4 An illustration of condition 1 of the definition for affine transformation.

If \mathcal{O}_A is selected as the origin for A and if $\mathcal{O}_B = T(\mathcal{O}_A)$ is selected as the origin for B, then the affine transformation is of the form

$$T(\mathcal{O}_A + \mathbf{x}) = T(\mathcal{O}_A) + L(\mathbf{x}) = \mathcal{O}_B + L(\mathbf{x})$$

Consider the special case when the two affine spaces are the same $B = A$, $W = V$, and $\Delta_B = \Delta_A$. Define $\mathcal{O}_B - \mathcal{O}_A = \mathbf{b}$. The affine transformation is now of the form

$$T(\mathcal{O}_A + \mathbf{x}) = \mathcal{O}_A + \mathbf{b} + L(\mathbf{x})$$

Thus, for a fixed origin \mathcal{O}_A and for a specific matrix representation M of the linear transformation L, the induced action of the affine transformation on the vector space elements is

$$\mathbf{y} = M\mathbf{x} + \mathbf{b} \tag{B.1}$$

Hopefully this form looks familiar! If M is the identity matrix, then the affine transformation is a *translation* by \mathbf{b}. If M is an orthogonal matrix with determinant 1 and \mathbf{b} is the zero vector, the affine transformation is a pure *rotation* about the origin. If M is an orthogonal matrix of determinant 1 and \mathbf{b} is any vector, the affine transformation is called a *rigid motion*, quite an important concept for physics applications.

B.5 BARYCENTRIC COORDINATES

The definition of an affine space allows for computing the difference of two points and for computing the sum of a point and a vector. The latter operation is the natural way you "move" from one point to another. The sum of two points is just not defined. However, there is an operation on two points that does make intuitive sense, that of a weighted average of two points. If \mathcal{P} and \mathcal{Q} are two points and $\mathbf{v} = \mathcal{Q} - \mathcal{P}$, then $\mathcal{Q} = \mathcal{P} + \mathbf{v}$. For each $t \in \mathbb{R}$, the quantity $t\mathbf{v}$ is, of course, a vector, so $\mathcal{P} + t\mathbf{v}$ is a point itself. Using our suggestive notation for subtraction of points, we have

$$\mathcal{P} + t\mathbf{v} = \mathcal{P} + t(\mathcal{Q} - \mathcal{P})$$

It is an error to distribute the multiplication by t across the difference of points, because the definition of affine algebra does not allow the operation of a scalar times a point. That is, $t(\mathcal{Q} - \mathcal{P})$ is well defined since t is a scalar and $\mathcal{Q} - \mathcal{P}$ is a vector, but $t\mathcal{Q} - t\mathcal{P}$ is ill defined. But let's go ahead and distribute anyway, then combine the \mathcal{P} terms to obtain

$$\mathcal{R} = (1 - t)\mathcal{P} + t\mathcal{Q} \tag{B.2}$$

\mathcal{R} is said to be a *barycentric combination* of \mathcal{P} and \mathcal{Q} with *barycentric coordinates* $1 - t$ and t, respectively. Observe that the sum of the coordinates is 1, a necessity for a

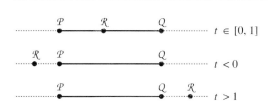

Figure B.5 Various barycentric combinations of two points \mathcal{P} and \mathcal{Q}.

pair of numbers to be barycentric coordinates. For $t \in [0, 1]$, \mathcal{R} is a point on the line segment connecting \mathcal{P} and \mathcal{Q}. For $t < 0$, \mathcal{R} is on the line through \mathcal{P} and \mathcal{Q} with \mathcal{P} between \mathcal{R} and \mathcal{Q}. Similarly, for $t > 1$, \mathcal{R} is on the line with \mathcal{Q} between \mathcal{R} and \mathcal{P}. Figure B.5 illustrates these cases.

To support barycentric combinations, the C++ template code for points has one additional member function. The other two arithmetic operations are shown just for comparison.

```
template class <T real, int n> Point
{
public:
    // return_point = this + v
    Point operator+ (const Vector& v) const;

    // return_vector = this - p
    Vector operator- (const Point& p) const;

    // return_point = (1 - t) * this + t * p (barycentric combination)
    Point operator+ (real t, const Point& p) const;
}
```

B.5.1 TRIANGLES

The concept of barycentric coordinates extends to three noncolinear points \mathcal{P}, \mathcal{Q}, and \mathcal{R}. The points, of course, form a triangle. Two vectors located at \mathcal{P} are $\mathbf{u} = \mathcal{Q} - \mathcal{P}$ and $\mathbf{v} = \mathcal{R} - \mathcal{P}$. For any scalars s and t, $s\mathbf{u}$ and $t\mathbf{v}$ are vectors and may be added to any point to obtain another point. In particular,

$$\mathcal{P} + s\mathbf{u} + t\mathbf{v} = \mathcal{P} + s(\mathcal{Q} - \mathcal{P}) + t(\mathcal{R} - \mathcal{P})$$

is a point. Just as equation (B.2) was motivated by distributing the scalar product across the differences and collected terms, we do the same here to obtain

$$\mathcal{B} = (1 - s - t)\mathcal{P} + s\mathcal{Q} + t\mathcal{R} \tag{B.3}$$

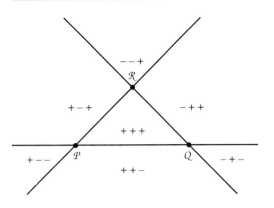

Figure B.6 The triangle partitions the plane into seven regions. The signs of c_1, c_2, and c_3 are listed as ordered triples.

\mathcal{B} is said to be a *barycentric combination* of \mathcal{P}, \mathcal{Q}, and \mathcal{R} with *barycentric coordinates* $c_1 = 1 - s - t$, $c_2 = s$, and $c_3 = t$, respectively. As with a barycentric combination of two points, the barycentric coordinates must sum to 1: $c_1 + c_2 + c_3 = 1$. The location of \mathcal{B} relative to the triangle formed by the three points is illustrated in Figure B.6.

The signs of c_1, c_2, and c_3 are listed as ordered triples. On a boundary between two regions, not including the vertices, one of the c_i is 0. At a vertex, two of the c_i are 0, the other coordinate necessarily 1. The coordinates cannot be simultaneously negative since the sum of three negative numbers cannot be 1.

EXERCISE Ⓜ *Linear interpolation over a triangle.* A real-valued function $f(x, y)$, unknown to you,
B.4 has been sampled at three noncolinear points (x_i, y_i) with function values f_i, $0 \leq i \leq 2$. If you are given the information that $f : \mathbb{R}^2 \to \mathbb{R}$ is an affine transformation, construct an explicit formula for f. ▨

B.5.2 TETRAHEDRA

The concept of barycentric coordinates also extends to four noncoplanar points \mathcal{P}_i, $0 \leq i \leq 3$. The points form a tetrahedron. Using a construction similar to that for a segment and a triangle, a *barycentric combination* of the points is

$$\mathcal{B} = (1 - c_1 - c_2 - c_3)\mathcal{P}_0 + c_1\mathcal{P}_1 + c_2\mathcal{P}_2 + c_3\mathcal{P}_3 \qquad (B.4)$$

The values $c_0 = 1 - c_1 - c_2 - c_3$, c_1, c_2, and c_3 are the *barycentric coordinates* of \mathcal{B} and they sum to 1. The tetrahedron partitions space into 15 regions, each region labeled with an ordered quadruple of signs for the four coefficients. The only invalid

combination of signs is all negative since the sum of four negative numbers cannot equal 1.

EXERCISE Ⓜ
B.5

Linear interpolation over a tetrahedron. A real-valued function $f(x, y, z)$, unknown to you, has been sampled at four noncoplanar points (x_i, y_i, z_i) with function values f_i, $0 \leq i \leq 3$. If you are given the information that $f : \mathbb{R}^3 \to \mathbb{R}$ is a linear transformation, construct an explicit formula for f. ▪

B.5.3 SIMPLICES

We have seen barycentric coordinates relative to a segment, a triangle, and a tetrahedron. The concept extends to affine spaces of n-tuples for any $n \geq 2$. The name of the object that generalizes triangle and tetrahedron is *simplex* (plural *simplices*). A simplex is formed by $n + 1$ points \mathcal{P}_i, $0 \leq i \leq n$, such that the set of vectors $\{\mathcal{P}_i - \mathcal{P}_0\}_{i=1}^{n}$ are linearly independent. A *barycentric combination of the points* is

$$\mathcal{B} = \sum_{i=0}^{n} c_i \mathcal{P}_i \tag{B.5}$$

and the c_i are the *barycentric coordinates* of \mathcal{B} with respect to the given points. As before, the coefficients sum to 1, $\sum_{i=0}^{n} c_i = 1$.

Although we tend to work in 2D or 3D, let us be abstract for a moment and ask the same question we did for segments, triangles, and tetrahedra. A segment, a simplex in \mathbb{R}, partitioned \mathbb{R} into 3 regions. A triangle, a simplex in \mathbb{R}^2, partitioned \mathbb{R}^2 into 7 regions. A tetrahedron, a simplex in \mathbb{R}^3, partitioned \mathbb{R}^3 into 15 regions. How many regions in \mathbb{R}^n are obtained by a partitioning of a simplex? The sequence with increasing dimension is 3, 7, 15, so you might guess that the answer is $2^{n+1} - 1$. This is correct. An intuitive reason is supported by looking at the signs of the $n + 1$ coefficients. Each region is labeled with an ordered $(n + 1)$-tuple of signs, each sign positive or negative. There are two choices of sign for each of the $n + 1$ components, leading to 2^{n+1} possibilities. As in the cases we've already looked at, all negative signs are not allowed since the sum would be negative and you cannot obtain a sum of 1. This means only $(2^{n+1} - 1)$ tuples of signs are possible.

A more geometric approach to counting the regions is based on an analysis of the components of the simplices. A segment has two vertices. The interior of the segment is formed by both vertices, so you can think of that region as occuring as the only possibility when choosing two vertices from a set of two vertices. That is, the number of interior regions is $C(2, 2) = 1$, where

$$C(n, k) = \frac{n!}{k!(n - k)!}$$

is the number of combinations of n items choosing k at a time. The segment has two exterior regions, each formed by a single vertex. The number of such regions

is $C(2, 1) = 2$ since you have two vertices, but choose only one at a time. The total number of regions in the partition of the line is $C(2, 1) + C(2, 2) = 2 + 1 = 3$.

A triangle has three vertices. The interior is formed by choosing all three vertices. The number of interior regions is $C(3, 3) = 1$. Figure B.6 shows that each edge has a corresponding exterior region. An edge is formed by two vertices and you have three vertices to choose from. The total number of edges is $C(3, 2) = 3$. The figure also shows that each vertex has a corresponding exterior region. The total number of vertices is $C(3, 1) = 3$. The total number of regions in the partition of the plane is $C(3, 1) + C(3, 2) + C(3, 3) = 3 + 3 + 1 = 7$.

The same argument applies to a tetrahedron with four vertices. The interior is formed by all four vertices; the number of interior regions is $C(4, 4) = 1$. A face is formed by three vertices; there are $C(4, 3) = 4$ such possibilities. An edge is formed by two vertices; there are $C(4, 2) = 6$ such possibilities. Finally, there are $C(4, 1) = 4$ vertices. An exterior region is associated with each vertex, each edge, and each face. The total number of regions is $C(4, 1) + C(4, 2) + C(4, 3) + C(4, 4) = 4 + 6 + 4 + 1$.

Consider now the general case, a simplex formed by $n + 1$ points. The components, so to speak, of the simplex are classified by how many vertices form them. If a component uses k vertices, let's call that a k-vertex component. The interior of the simplex is the only $(n + 1)$-vertex component. Each k-vertex component where $1 \le k < n + 1$ has a single exterior region associated with it. The total number of regions is therefore

$$C(n + 1, n + 1) + C(n + 1, n) + \cdots + C(n + 1, 1) = \sum_{k=1}^{n+1} C(n + 1, k) = 2^{n+1} - 1$$

The term $C(n, k)$ indicates the number of k-vertex components, the number of combinations of n vertices choosing k at a time. Where did that last equality come from? Recall the binomial expansion for a power of a sum of two values:

$$(x + y)^m = C(m, 0)x^m + C(m, 1)x^{m-1}y + \cdots + C(m, m-1)xy^{m-1} + C(m, m)y^m$$

$$= \sum_{k=0}^{m} C(m, k)x^{m-k}y^k$$

Setting $x = 1$, $y = 1$, and $m = n + 1$, we arrive at

$$2^{n+1} = (1 + 1)^{n+1} = \sum_{k=0}^{n+1} C(n + 1, k) = 1 + \sum_{k=1}^{n+1} C(n + 1, k)$$

B.5.4 LENGTH, AREA, VOLUME, AND HYPERVOLUME

The constructions in this section are designed to show that the area of a triangle (simplex in 2D) can be computed as a sum (in an integration sense) of lengths

of line segments (simplices in 1D). I also show that the volume of a tetrahedron (simplex in 3D) can be computed as a sum of areas of triangles (simplices in 2D). These two facts indicate the process is recursive in dimension. Intuitively, a simplex in 4D has a "volume," so to speak, that can be computed as a sum of volumes of tetrahedra (simplices in 3D). Sometimes this is called a *hypervolume*, but that leads us to wanting names for the similar concept in yet higher dimensions. I will use the term *hypervolume* for any dimension and note that hypervolume in 1D is length, hypervolume in 2D is area, and hypervolume in 3D is volume. Given a simplex formed by points \mathcal{P}_i for $0 \leq i \leq n$, the hypervolume is denoted $H(\mathcal{P}_0, \ldots, \mathcal{P}_n)$.

Length of a Segment

A line segment with end points \mathcal{P}_0 and \mathcal{P}_1 is a simplex with two vertices. The length of the simplex is $|\mathcal{P}_1 - \mathcal{P}_0|$. Using our notation for hypervolume,

$$H(\mathcal{P}_0, \mathcal{P}_1) = |\mathcal{P}_1 - \mathcal{P}_0| \tag{B.6}$$

Area of a Triangle

Recall that the area of a triangle with base length b and height h is $A = bh/2$. Figure B.7(a) shows the standard drawing one normally uses to show b and h. Fig-

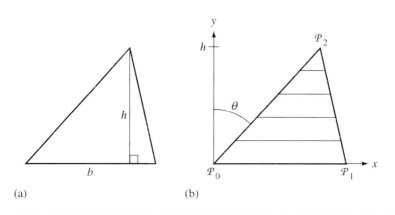

(a) (b)

Figure B.7 (a) A triangle with base length b and height h marked. The area of the triangle is $bh/2$. (b) A triangle viewed as a union of an infinite number of line segments of varying lengths (only a few are shown). The area of the triangle is the sum of the lengths of those line segments.

ure B.7(b) shows a triangle viewed as the union of line segments of varying lengths. The drawing shows the bottom edge aligned with the x-axis, but the ensuing arguments do not depend on this. The area of the triangle may be thought of as the sum of the lengths of all the line segments in the union. This is an informal and mathematically nonrigorous view of the situation, but intuitively it works quite well. The number of line segments is infinite, one segment per y-value in the interval $[0, h]$. The sum cannot be computed in the usual sense. In this setting it becomes an integration of the lengths as a function of y.

Select a value of $y \in [0, h]$. The line segment has two end points, one on the triangle edge from \mathcal{P}_0 to \mathcal{P}_2 and one on the triangle edge from \mathcal{P}_1 to \mathcal{P}_2. The fraction of the distance along each edge on which the end points lie is $y/h \in [0, 1]$. That is, the end points are the barycentric combinations $(1 - y/h)\mathcal{P}_0 + (y/h)\mathcal{P}_2$ and $(1 - y/h)\mathcal{P}_1 + (y/h)\mathcal{P}_2$. The length of the segment is the length of the vector connecting the end points,

$$\mathbf{v} = ((1 - y/h)\mathcal{P}_1 + (y/h)\mathcal{P}_2) - (1 - y/h)\mathcal{P}_0 + (y/h)\mathcal{P}_2 = (1 - y/h)(\mathcal{P}_1 - \mathcal{P}_0)$$

The length of the segment as a function of y is

$$L(y) = |\mathbf{v}| = (1 - y/h)|\mathcal{P}_1 - \mathcal{P}_0| = (1 - y/h)b$$

where b is the length of the base of the triangle. To "add" all the values $L(y)$ for $y \in [0, h]$ in order to obtain the area A, we need to integrate

$$A = \int_0^h L(y)\, dy = \int_0^h (1 - y/h)b\, dy = b \left. \frac{-h(1 - y/h)^2}{2} \right|_0^h = \frac{bh}{2}$$

In terms of our hypervolume notation,

$$H(\mathcal{P}_0, \mathcal{P}_1, \mathcal{P}_2) = \frac{h}{2} H(\mathcal{P}_0, \mathcal{P}_1) \tag{B.7}$$

where $h = |\mathcal{P}_2 - \mathcal{P}_0| \cos\theta$ with θ the angle as shown in figure B.7.

The height h also may be computed as the length of the projection of $\mathcal{P}_2 - \mathcal{P}_0$ onto the vertical axis. A convenient vector to use, whose direction is that of the vertical axis, is the following. Let $\mathcal{P}_1 - \mathcal{P}_0 = \mathbf{v} = (v_1, v_1)$. A perpendicular vector in the direction of the positive vertical axis as shown in Figure B.7 is $-\text{Perp}(\mathcal{P}_0, \mathcal{P}_1)$, where

$$\text{Perp}(\mathcal{P}_0, \mathcal{P}_1) = (v_2, -v_1) \tag{B.8}$$

is called the *perp* vector. You will notice that the perp vector itself is in the direction of the *negative* vertical axis as shown in Figure B.7. Using the coordinate-free definition of dot product, equation (A.5),

$$(\mathcal{P}_2 - \mathcal{P}_0) \cdot (-\text{Perp}(\mathcal{P}_0, \mathcal{P}_1)) = |\mathcal{P}_2 - \mathcal{P}_0| |\text{Perp}(\mathcal{P}_0, \mathcal{P}_1)| \cos\theta = h |\text{Perp}(\mathcal{P}_0, \mathcal{P}_1)|$$

The perp vector has the same length as $\mathcal{P}_1 - \mathcal{P}_0$, so the dot product in the previous equation is twice the area of the triangle, bh. This gives us the nonrecursive formula for the area of a triangle,

$$H(\mathcal{P}_0, \mathcal{P}_1, \mathcal{P}_2) = -\frac{1}{2}(\mathcal{P}_2 - \mathcal{P}_0) \cdot \text{Perp}(\mathcal{P}_0, \mathcal{P}_1) \tag{B.9}$$

Volume of a Tetrahedron

The volume of a tetrahedron may be computed in the same intuitive way that was used for the area of a triangle. Let $\mathcal{P}_i, 0 \le i \le 3$, denote the vertices of the tetrahedron. The base of the tetrahedron will be selected as the triangle formed by $\mathcal{P}_i, 0 \le i \le 2$. The tetrahedron may be informally thought of as an infinite union of triangles that are parallel to its base. Figure B.8 shows a tetrahedron and one of its triangle slices.

Select a value of $z \in [0, h]$. The corresponding triangle has three vertices, one on each tetrahedron edge with end points \mathcal{P}_i and \mathcal{P}_3 for $0 \le i \le 2$. The fraction of the distance along each edge which the end points lie is $z/h \in [0, 1]$. The end points are the barycentric combinations $\mathcal{Q}_i = (1 - z/h)\mathcal{P}_i + (z/h)\mathcal{P}_3$ for $0 \le i \le 2$. If $A(z)$ denotes the area of this triangle, the volume of the tetrahedron is

$$V = \int_0^h A(z)\,dz$$

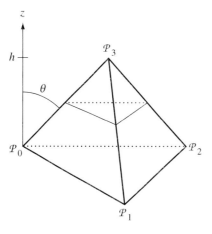

Figure B.8 A tetrahedron with base formed by \mathcal{P}_0, \mathcal{P}_1, and \mathcal{P}_2. A triangle slice parallel to the base is shown. The direction perpendicular to the base is marked as the positive z-axis.

We would like to use equation (B.9) to compute $A(z)$, but there is a problem. Even though that equation is written in a coordinate-free manner, it is implicitly tied to 2D points via the definition of the perp vector in equation (B.8) that requires points in two dimensions. For the time being, let's instead use the area formula from equation (A.10). We will later return to the issue of the perp vector and provide a definition that is valid in any dimension.

Set $\mathbf{v}_i = \mathcal{Q}_i - \mathcal{Q}_0 = (1 - z/h)(\mathcal{P}_i - \mathcal{P}_0)$ for $1 \le i \le 2$. The triangle slice is half of a parallelogram formed by \mathbf{v}_1 and \mathbf{v}_2, so using equation (A.10) the area of the triangle is

$$A(z) = \frac{1}{2}|\mathbf{v}_1 \times \mathbf{v}_2| = \frac{(1 - z/h)^2}{2}|(\mathcal{P}_1 - \mathcal{P}_0) \times (\mathcal{P}_2 - \mathcal{P}_0)| = (1 - z/h)^2 b$$

where b is the area of the base of the tetrahedron. The volume of the tetrahedron is

$$V = \int_0^h A(z)\,dz = \int_0^h (1 - z/h)^2 b\,dz = b\left.\frac{-h(1 - z/h)^3}{3}\right|_0^h = \frac{bh}{3}$$

In our hypervolume notation, the volume is

$$H(\mathcal{P}_0, \mathcal{P}_1, \mathcal{P}_2, \mathcal{P}_3) = \frac{h}{3}H(\mathcal{P}_0, \mathcal{P}_1, \mathcal{P}_2) \tag{B.10}$$

where $h = |\mathcal{P}_3 - \mathcal{P}_0|\cos\theta$ with θ the angle shown in Figure B.8.

The height may also be computed as the length of the projection of $\mathcal{P}_3 - \mathcal{P}_0$ onto the vertical axis. We already know a vector with that direction, the cross product $(\mathcal{P}_1 - \mathcal{P}_0) \times (\mathcal{P}_2 - \mathcal{P}_0)$. Using equation (B.8) as motivation, define

$$\mathrm{Perp}(\mathcal{P}_0, \mathcal{P}_1, \mathcal{P}_2) = (\mathcal{P}_1 - \mathcal{P}_0) \times (\mathcal{P}_2 - \mathcal{P}_0) \tag{B.11}$$

Using the coordinate-free definition of dot product, equation (A.5),

$$(\mathcal{P}_3 - \mathcal{P}_0) \cdot \mathrm{Perp}(\mathcal{P}_0, \mathcal{P}_1, \mathcal{P}_2) = |\mathcal{P}_3 - \mathcal{P}_0||\mathrm{Perp}(\mathcal{P}_0, \mathcal{P}_1, \mathcal{P}_2)|\cos\theta$$
$$= h|\mathrm{Perp}(\mathcal{P}_0, \mathcal{P}_1, \mathcal{P}_2)| = 2hb$$

where b is the area of the triangle base of the tetrahedron. Dividing by 6 we have a nonrecursive formula for the volume,

$$H(\mathcal{P}_0, \mathcal{P}_1, \mathcal{P}_2, \mathcal{P}_3) = \frac{1}{6}(\mathcal{P}_3 - \mathcal{P}_0) \cdot \mathrm{Perp}(\mathcal{P}_0, \mathcal{P}_1, \mathcal{P}_2) \tag{B.12}$$

Hypervolume of a Simplex

Notice the strong similarities between equations (B.7) and (B.10) and between equations (B.9) and (B.12). The first pair of equations suggests that for a simplex formed from $n + 1$ points \mathcal{P}_i, $0 \le i \le n$, the recursive formula for the hypervolume is

$$H(\mathcal{P}_0, \dots, \mathcal{P}_n) = \frac{h}{n} H(\mathcal{P}_0, \dots, \mathcal{P}_{n-1}) \tag{B.13}$$

where $h = |\mathcal{P}_n - \mathcal{P}_0| \cos \theta$ with θ the angle between $\mathcal{P}_n - \mathcal{P}_0$ and a vector that is perpendicular to the base of the simplex. The base is itself a simplex but formed by n points \mathcal{P}_i for $0 \le i \le n - 1$. As we saw in the cases $n = 2$ and $n = 3$, we want the perpendicular vector chosen so that θ is an acute angle. In 2D we used $- \operatorname{Perp}(\mathcal{P}_0, \mathcal{P}_1)$ and in 3D we used $\operatorname{Perp}(\mathcal{P}_0, \mathcal{P}_1, \mathcal{P}_2)$. This suggests that in general dimension n, we will use a vector $(-1)^{n+1} \operatorname{Perp}(\mathcal{P}_0, \dots, \mathcal{P}_{n-1})$, where the perp vector $\operatorname{Perp}(\mathcal{P}_0, \dots, \mathcal{P}_{n-1})$ is appropriately defined. The second pair of equations suggests the nonrecursive formula

$$H(\mathcal{P}_0, \dots, \mathcal{P}_n) = \frac{(-1)^{n+1}}{n!} (\mathcal{P}_n - \mathcal{P}_1) \cdot \operatorname{Perp}(\mathcal{P}_0, \dots, \mathcal{P}_{n-1}) \tag{B.14}$$

This leaves us with the task of finding a formula for $\operatorname{Perp}(\mathcal{P}_0, \dots, \mathcal{P}_{n-1})$, hopefully in a way that applies to any dimensional input points. We accomplish this last goal by introducing an indexed quantity that stores information about permutations. In tensor calculus, this is called the *Levi-Civita permutation tensor*, but the name and tensor calculus are not really important in our context.

Let's look at the 2D problem first. The doubly indexed quantity e_{ij} for $1 \le i \le 2$ and $1 \le j \le 2$ represents four numbers, each number in the set $\{-1, 0, 1\}$. The value is 0 if the two indices are the same: $e_{11} = 0$ and $e_{22} = 0$. The other values are $e_{12} = 1$ and $e_{21} = -1$. The choice of 1 or -1 is based on whether the ordered index pair (i, j) is an even or odd permutation of $(1, 2)$. In the current case, $(1, 2)$ is an even permutation of $(1, 2)$ (zero transpositions, zero is an even number) so $e_{12} = 1$. The pair $(2, 1)$ is an odd permutation of $(1, 2)$ (one transposition, one is an odd number) so $e_{21} = -1$. You should notice that $e_{ji} = -e_{ij}$. Treating e_{ij} as the elements of a 2×2 matrix E, that matrix is skew-symmetric: $E^{\mathrm{T}} = -E$.

The arguments of the area function and perp operation are points. Since the area and perp vector are invariant under translations, we may as well replace the arguments by vectors $\mathbf{v}^{(i)} = \mathcal{P}_i - \mathcal{P}_0$ for $i \ge 1$. In 2D, $\mathbf{v}^{(i)} = (v_1^{(i)}, v_2^{(i)})$. Thus,

$$(u_1, u_2) = \mathbf{u} = \operatorname{Perp}(\mathbf{v}^{(1)}) = (v_2^{(1)}, -v_1^{(1)}) = (e_{12} v_2^{(1)}, e_{21} v_1^{(1)})$$

In summation notation the components of **u** are

$$u_j = \sum_{i=1}^{2} e_{ji} v_i^{(1)} \tag{B.15}$$

The area of the triangle is

$$H(\mathbf{v}^{(1)}, \mathbf{v}^{(2)}) = -\frac{1}{2} \mathbf{v}^{(2)} \cdot \text{Perp}(\mathbf{v}^{(1)}) \qquad \text{Using equation (B.9)}$$

$$= -\frac{1}{2} \sum_{i=1}^{2} \sum_{j=1}^{2} e_{ji} v_j^{(2)} v_i^{(1)} \qquad \text{Using equation (B.15)} \tag{B.16}$$

$$= \frac{1}{2} \sum_{i=1}^{2} \sum_{j=1}^{2} e_{ij} v_i^{(1)} v_j^{(2)} \qquad e_{ij} = -e_{ji} \text{ and swapping terms}$$

In 3D the triply indexed permutation tensor is e_{ijk} for $1 \le i \le 3$, $1 \le j \le 3$, and $1 \le k \le 3$. Each value is in the set $\{-1, 0, 1\}$. If any pair of indices is the same, the value is zero; for example, $e_{111} = 0$, $e_{112} = 0$, and $e_{233} = 0$ (there are 21 zero elements). Otherwise, $e_{ijk} = 1$ if (i, j, k) is an even permutation of $(1, 2, 3)$ or $e_{ijk} = -1$ if (i, j, k) is an odd permutation of $(1, 2, 3)$. Under these conditions only six elements are nonzero: $e_{123} = e_{231} = e_{312} = 1$ and $e_{132} = e_{321} = e_{213} = -1$. As in the 2D case, if a pair of indices is swapped, the sign is changed: $e_{jik} = e_{ikj} = e_{kji} = -e_{ijk}$. Define $\mathbf{v}^{(i)} = \mathcal{P}_i - \mathcal{P}_0 = (v_1^{(i)}, v_2^{(i)}, v_3^{(i)})$, $1 \le i \le 3$; then

$$(u_1, u_2, u_3) = \mathbf{u}$$

$$= \text{Perp}(\mathbf{v}^{(1)}, \mathbf{v}^{(2)})$$

$$= \mathbf{v}^{(1)} \times \mathbf{v}^{(2)}$$

$$= \left(v_2^{(1)} v_3^{(2)} - v_3^{(1)} v_2^{(2)}, v_3^{(1)} v_1^{(2)} - v_1^{(1)} v_3^{(2)}, v_1^{(1)} v_2^{(2)} - v_2^{(1)} v_1^{(2)} \right)$$

$$= \left(e_{123} v_2^{(1)} v_3^{(2)} + e_{132} v_3^{(1)} v_2^{(2)}, e_{231} v_3^{(1)} v_1^{(2)} + e_{213} v_1^{(1)} v_3^{(2)}, \right.$$

$$\left. e_{312} v_1^{(1)} v_2^{(2)} + e_{321} v_2^{(1)} v_1^{(2)} \right)$$

In summation notation the components of **u** are

$$u_k = \sum_{i=1}^{3} \sum_{j=1}^{3} e_{kij} v_i^{(1)} v_j^{(2)} \tag{B.17}$$

The volume of the tetrahedron is

$$H(\mathbf{v}^{(1)}, \mathbf{v}^{(2)}, \mathbf{v}^{(3)}) = \frac{1}{6}\mathbf{v}^{(3)} \cdot \text{Perp}(\mathbf{v}^{(1)}, \mathbf{v}^{(2)}) \qquad \text{Using equation (B.12)}$$

$$= \frac{1}{6}\sum_{i=1}^{3}\sum_{j=1}^{3}\sum_{k=1}^{3} e_{kij} v_k^{(3)} v_i^{(1)} v_j^{(2)} \qquad \text{Using equation (B.17)} \qquad \text{(B.18)}$$

$$= \frac{1}{6}\sum_{i=1}^{3}\sum_{j=1}^{3}\sum_{k=1}^{3} -e_{ikj} v_i^{(1)} v_j^{(2)} v_k^{(3)} \qquad e_{kij} = -e_{ikj} \text{ and swapping terms}$$

$$= \frac{1}{6}\sum_{i=1}^{3}\sum_{j=1}^{3}\sum_{k=1}^{3} e_{ijk} v_i^{(1)} v_j^{(2)} v_k^{(3)} \qquad e_{ikj} = -e_{ijk}$$

The last couple of steps are just to swap the k into the last position. In 2D one swap was required. In 3D two swaps were required.

The pattern holds for general dimension n. The permutation tensor is an n-indexed quantity $e_{i_1 \ldots i_n}$ that is zero if any pair of indices is repeated, is 1 if (i_1, \ldots, i_n) is an even permutation of $(1, \ldots, n)$, or is -1 if (i_1, \ldots, i_n) is an odd permutation of $(1, \ldots, n)$. Only $n!$ values are nonzero where $n!$ is the number of permutations of n numbers. The vectors of interest are $\mathbf{v}^{(i)} = \mathcal{P}_i - \mathcal{P}_0$ for $1 \le i \le n$. The vector $(u_1, \ldots, u_n) = \mathbf{u} = \text{Perp}(\mathbf{v}^{(1)}, \ldots, \mathbf{v}^{(n)})$ has components

$$u_j = \sum_{i_1=1}^{n} \cdots \sum_{i_{n-1}=1}^{n} e_{i_n i_1 \ldots i_{n-1}} v_{i_1}^{(1)} \cdots v_{i_{n-1}}^{(n-1)} \qquad \text{(B.19)}$$

The hypervolume of the simplex is

$$H(\mathbf{v}^{(1)}, \ldots, \mathbf{v}^{(n)})$$

$$= \frac{(-1)^{n+1}}{n!}\mathbf{v}^{(n)} \cdot \text{Perp}(\mathbf{v}^{(1)}, \ldots, \mathbf{v}^{(n-1)}) \qquad \text{Using equation (B.14)}$$

$$= \frac{(-1)^{n+1}}{n!}\sum_{i_1=1}^{n} \cdots \sum_{i_n=1}^{n} e_{i_n i_1 \ldots i_{n-1}} v_{i_n}^{(n)} v_{i_1}^{(1)} \cdots v_{i_{n-1}}^{(n-1)} \qquad \text{Using equation (B.19)}$$

$$= \frac{1}{n!}\sum_{i_1=1}^{n} \cdots \sum_{i_n=1}^{n} e_{i_n i_1 \ldots i_{n-1}} v_{i_1}^{(1)} \cdots v_{i_{n-1}}^{(n-1)} v_{i_n}^{(n)} \qquad \text{(B.20)}$$

The last equation is the result of swapping i_n with each of the $n-1$ other indices. Each swap introduces a factor of -1, so the total swaps introduces the factor $(-1)^{n-1}$. Combining with the other sign factor $(-1)^{n+1}$ results in a factor of $(-1)^{n-1}(-1)^{n+1} = (-1)^{2n} = 1$.

The final interesting observation is that the summations in the hypervolume equation (B.20) are just the determinant of a matrix. The n-indexed quantity $e_{i_1 \ldots i_n}$ is the same quantity as e_σ introduced in Section A.5.1 on determinants. If the vectors $\mathbf{v}^{(i)}$ are written as the columns of an $n \times n$ matrix, say, $[\mathbf{v}^{(1)} \mid \cdots \mid \mathbf{v}^{(n)}]$, then the hypervolume of the simplex is

$$H(\mathbf{v}^{(1)}, \ldots, \mathbf{v}^{(n)}) = \frac{1}{n!} \det \left[\mathbf{v}^{(1)} \mid \cdots \mid \mathbf{v}^{(n)} \right] \tag{B.21}$$

The formula was developed with a certain ordering in mind for the input vectors. For general ordering, equation (B.21) can produce negative numbers, in which case the formula generates the *signed hypervolume*. To be sure you have the nonnegative hypervolume, just take the absolute value of the right-hand side of the equation.

APPENDIX C

CALCULUS

This appendix provides a brief summary of topics in calculus that you should be familiar with in order to fully understand how to model a physical system and implement the physical simulation on a computer. Calculus occurs in two flavors, *differential calculus* and *integral calculus*. Both disciplines are founded on the concepts of *infinitesimal quantities* and a *limit*, the measurement of what happens to a quantity as one or more parameters are varied.

Calculus involves processing functions, the topic further subdivided based on the number of independent and dependent variables. *Univariate calculus* studies functions $y = f(x)$, where x is an independent variable and y is the dependent variable. Formally, the function is written as $f : \mathcal{D} \to \mathcal{R}$, where $\mathcal{D} \subset \mathbb{R}$ is the *domain* of the function and $\mathcal{R} \subset \mathbb{R}$ is the *range* of the function. To be somewhat loose with the notation, an emphasis will be placed on the sets containing the domain and range by writing $f : \mathbb{R} \to \mathbb{R}$. The domain and range are most likely proper subsets of \mathbb{R}, but those will be known within the context of the problem at hand.

Multivariate calculus studies functions $y = f(x_1, \ldots, x_n)$, where x_1 through x_n are n independent variables and y is a single dependent variable. The function may be written as $f : \mathbb{R}^n \to \mathbb{R}$, where \mathbb{R}^n denotes the set of n-tuples of real numbers. As indicated in the last paragraph, the domain of f may be a proper subset of \mathbb{R}^n and the range of f may be a proper subset of \mathbb{R}.

The next natural extension is to study a collection of functions $y_i = f_i(x_1, \ldots, x_n)$ for $1 \le i \le m$. We now have n independent variables and m dependent variables. Using vector notation, let $\mathbf{Y} = (y_1, \ldots, y_m)$, $\mathbf{X} = (x_1, \ldots, x_n)$, and $\mathbf{F} = (f_1, \ldots, f_m)$. The function may be written as $\mathbf{Y} = \mathbf{F}(\mathbf{X})$, or $\mathbf{F} : \mathbb{R}^n \to \mathbb{R}^m$. This coordinate-free representation looks just like the univariate case where $n = m = 1$. For physical applications attention is focused on the case of $m = 1$ and $n = 2$ or $n = 3$. That is, $y_i = f_i(t)$

for all *i* with a single independent variable *t* (time). Extensive discussion of this case is already a large portion of Chapter 2!

Section C.1 is a summary of the key ideas for univariate calculus, whereas Section C.2 is a summary for multivariate calculus. Section C.3 provides a few applications that are related to physical simulations. Optimization involves computing maxima and minima of functions. Constrained optimization also involves computing maxima and minima, but with additional constraints related to the problem at hand. This appendix will cover only *equality constraints* that can be solved using the method of Lagrange multipliers. *Inequality constraints* are a bit more challenging, but we actually talk about these in this book! See Chapter 7 for the details. The final topic in Section C.3 on applications covers approximation of derivatives by finite differences. This topic is relevant to constructing numerical methods for solving differential equations.

C.1 Univariate Calculus

Differential calculus generalizes the idea of the rate of change of a quantity over a fixed time interval to the limit of rate of change over time intervals of decreasing duration. The prototypical example is a measurement of speed of an object traveling along a straight-line path. If the position of an object at an initial time $t_{initial}$ is $x_{initial}$ and the position at a final time t_{final} is x_{final}, the average speed of the object on the time interval is

$$s_{average} = \frac{x_{final} - x_{initial}}{t_{final} - t_{initial}}$$

The measurement is the difference of final and initial positions divided by the difference of final and initial times. As an average, the measurement does not give you any information about the position or speed of the object at intermediate times. It is simply a statistic that summarizes the behavior of the object on the given time interval.

If we think of the position as a function of time, say, $x(t)$, the initial position of the object at time *t* is $x_{initial} = x(t)$, the final position at time $t + \Delta t$ for some $\Delta t > 0$ is $x_{final} = x(t + \Delta t)$, and the average speed is

$$s_{average}([t, t + \Delta t]) = \frac{x(t + \Delta t) - x(t)}{\Delta t}$$

I have included the time interval on the left-hand side to stress over which time interval the average is computed. Now suppose we are able to compute the position of the object at any time. Consider how the average speed changes as we look at smaller and smaller time intervals; that is, we will choose smaller values of Δt to make the measurements. Example C.1 illustrates.

EXAMPLE C.1

Suppose the position is measured as $x(t) = t(1 - t)$ for $t \in [0, 1]$. The initial position is $x(0) = 0$ and the final position is $x(1) = 0$; that is, the object starts and ends at the same position. The average speed for the time interval $[0, 1]$ is $s_{average} = 0$. Although you know the object is moving, it does begin and end at the same position. If you looked at the object at the initial time, closed your eyes for one second, and then opened them, you would see the object in the same position. In this sense an average speed of zero is meaningful!

Now suppose that you opened your eyes after a half a second. The position of the object is $x(1/2) = 1/4$ and the average speed on the time interval $[0, 1/2]$ is $s_{average} = (1/4 - 0)/(1/2 - 0) = 1/2$. In fact, you now know that the object has moved because you kept your eyes closed for a shorter period of time. It has moved away from you, so a nonzero average speed makes sense.

Table C.1 displays average speed calculations on intervals $[0, \Delta t]$ of decreasing duration.

Table C.1 Average speed calculation on intervals $[0, \Delta t]$ with decreasing Δt

Δt	$x(\Delta t)$	$s_{average}$
1	0	0
0.5	0.25	0.5
0.25	0.1875	0.75
0.125	0.109375	0.875
0.01	0.0099	0.99
0.001	0.000999	0.999
0.0001	0.00009999	0.9999

The pattern in our example is evident. As we make Δt smaller, the average speed is apparently getting closer to 1. ■

In Example C.1, we say that in the limit as Δt approaches zero, the average speed approaches 1. At time zero, the value 1 is said to be the *instantaneous speed* of the object. This measurement is only valid for time zero. At any other time we may go through the same process to reach an instantaneous measurement as a limit of average measurements. The instantaneous speed is referred to as the *derivative* of position and is denoted by dx/dt or $x'(t)$. The former notation uses *infinitesimals* dx and dt. Think of dx/dt intuitively as specifying a really small (infinitesimal) change in position per really small (infinitesimal) change in time. Before we introduce the formal construction of the derivative, let us take a closer look at what it means to be a limit.

C.1.1 LIMITS

Given a univariate function $f(x)$ that may be computed for values of x near a specified value c, we can repeat the experiment of Example C.1 by looking at how the function values change for values of x closer and closer to c. If those function values appear to be getting close to some number L, we may formally state this using *limit notation*:

$$\lim_{x \to c} f(x) = L$$

The notation $x \to c$ means that you think of choosing x closer and closer to c, or phrased mathematically: The limit as x approaches c of $f(x)$ is L. The intuition for what a limit is should come from our earlier example. A more formal presentation uses the limit notation. The mathematicians say: For each $\varepsilon > 0$ you can find a $\delta > 0$ such that $|f(x) - L| < \varepsilon$ whenever $|x - c| < \delta$. In less formal terms, think of ε as an error tolerance that you select to be small. Your goal is to make the function values $f(x)$ to be within this tolerance of the number L; that is, $|f(x) - L| < \varepsilon$ is just a requirement on how large the absolute error can be between the function values and L. The allowable error is most likely not met by any value of x you so choose. Rather, the error will cause you to constrain your attention to values of x close to c. That is, as long as $|x - c|$ is small enough (i.e., the absolute difference is smaller than δ), then you will achieve your goal of bounding the function error.

Visually you can think of this process as "boxing the point $(f(x), L)$" in the xy-plane. An example will illustrate this.

EXAMPLE C.2

Let $f(x) = x^2 + x$ and let $c = 1$. Table C.2 shows various function values for x near c. The pattern shows that as x approaches 1, $f(x)$ approaches 2. In our limit notation,

Table C.2 Function values for x near c

x	$f(x)$
0.9	1.71
0.99	1.9701
0.999	1.997001
1.001	2.003001
1.01	2.0301
1.1	2.31

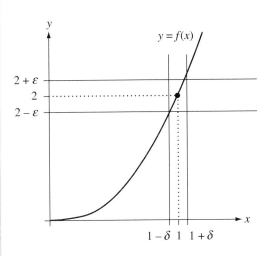

Figure C.1 The graph of $f(x) = x^2 + x$ for x near 1.

$$\lim_{x \to 1}(x^2 + x) = 2$$

The graph of $f(x)$ near $x = 1$ is shown in Figure C.1.

The point $(c, L) = (1, 2)$ is "boxed" in by two pairs of parallel lines. You get to choose $\varepsilon > 0$ and require the function values to be within that tolerance of $L = 2$. The horizontal parallel lines provide two edges of the box. In order for you to be on the graph of $f(x)$ and within the horizontal strip, vertical bars must be drawn sufficiently close to 1. If you find a pair of such bars, any pair closer to 1 will also work, but one pair is all you need. This boxing process must succeed for any choice of ε, no matter how small. Of course, the smaller you choose ε, the smaller you expect to have to choose δ. ▪

This process of boxing in (c, L) is made formal mathematically by actually constructing δ as a function of ε. We will not go into such a construction. The intuition is what is important.

In Example C.2 you might ask yourself why we bothered with the formalism in the first place. Clearly, if you evaluate the function at $x = 1$, you get $f(1) = 1^2 + 1 = 2$. As it turns out, it is not always possible to evaluate $f(x)$ to see what its limit is. For example,

$$f(x) = \frac{\sin(x)}{x}$$

is defined for all $x \neq 0$. You cannot evaluate $f(0)$ because the denominator is zero. However, the limit as x approaches 0 does exist:

$$\lim_{x \to 0} \frac{\sin(x)}{x} = 1$$

Construct a table of numbers x and $f(x)$ for x closer and closer to zero to see why this is the case. The formal proof of the limit is provided in standard calculus textbooks and requires some trigonometry, algebra, and a bit of patience to complete.

C.1.2 LIMITS OF A SEQUENCE

The concept of a limit was discussed in terms of a *continuous variable x*; that is, x is a real-valued number that is allowed to approach some other real-valued number. A similar concept exists for a limit of a sequence of numbers f_n for $n \geq 1$. The formal notation for a sequence is $\{f_n\}_{n=1}^{\infty}$ to indicate that the index n is a positive integer and is allowed to become increasingly large. For example, $f_n = 1/n$ denotes a sequence of real numbers 1, 1/2, 1/3, and so on. You should notice that the numbers in this sequence are decreasing in size as n increases. In fact, your intuition should tell you that the numbers have a limiting value of zero.

Just as we had a formal notation for a limit of a function, we have one for a limit of a sequence. The definitions are quite similar. We say that the limit of the sequence $\{f_n\}_{n=1}^{\infty}$ as n increases without bound is L, denoted as

$$\lim_{n \to \infty} f_n = L$$

when the following is true: For each $\varepsilon > 0$ you can find an integer $N > 0$ such that $|f_n - L| < \varepsilon$ whenever $n \geq N$. The intuition is similar to that of a function. Your goal is to make the sequence values f_n be within the error tolerance ε of the number L; that is, $|f_n - L| < \varepsilon$ is just a requirement on how large the absolute error can be between the sequence values and L. In order for this to happen, you most likely have to choose n significantly large, the condition indicated by $n \geq N$. Generally, as you choose ε smaller, the index N becomes larger. In our example of $f_n = 1/n$, we believe that the limit is $L = 0$. If you choose a small $\varepsilon > 0$, $|f_n - L| = |1/n| < \varepsilon$ happens whenever $n > 1/\varepsilon$. You may choose N to be the smallest integer that is larger than $1/\varepsilon$. Clearly, the smaller you choose ε, the larger N is.

Limits of sequences are more commonly encountered when working with iterative methods in computer science. Although we have not reached the point in the appendix where we discuss derivatives, you no doubt are familiar with derivatives since computational physics requires that you be so. An iterative method that you most likely encountered is Newton's method for estimating the root of a function $F(x) = 0$. An initial guess x_0 is made for the root. The guess is refined by a sequence

$$x_{n+1} = x_n - \frac{F(x_n)}{F'(x_n)}, \qquad n \geq 0$$

where $F'(x)$ is the derivative of $F(x)$. What you hope is that the limit

$$\lim_{n \to \infty} x_n = L$$

really is a root to F, namely, $F(L) = 0$. In order to have a good estimate, you get to choose how close to the root L you would like to be by selecting the error tolerance ε. The corresponding index N tells you how many times to apply the iteration method before you can be confident that x_N is an estimate that meets your tolerance criterion.

C.1.3 CONTINUITY

Example C.2 illustrated the limit $L = 2$ of a function $f(x) = x^2 + x$ as x approaches $c = 1$. As noted earlier, the function value $f(1)$ and limit 2 are the same number. This happens for most functions you tend to encounter in your applications. The property has a special name. If

$$\lim_{x \to c} f(x) = f(c)$$

then f is said to be *continuous* at $x = c$. The idea is shown in Figure C.1. The graph of $f(x)$ at $x = 1$ is a solid curve; that is, the graph to the left of $(1, f(1))$ and the graph to the right of $(1, f(1))$ both meet at the common point $(1, f(1))$.

The function $f(x) = \sin(x)/x$ is not continuous at $x = 0$ because the function is not even defined there. However, if we extend the function as follows:

$$g(x) = \begin{cases} \frac{\sin(x)}{x}, & x \neq 0 \\ 1, & x = 0 \end{cases}$$

the function $g(x)$ is continuous at $x = 0$ since $\lim_{x \to 0} g(x) = 1 = g(0)$.

If $\lim_{x \to c} f(x) = L$ exists and $f(c)$ is defined, but $f(c) \neq L$, the function f is said to be *discontinuous* at c. For example, consider:

$$f(x) = \begin{cases} 1, & x > 0 \\ 0, & x = 0 \\ -1, & x < 0 \end{cases}$$

The graph of this function is shown in Figure C.2.

The function is discontinuous at $x = 0$. In fact, no matter how we define $f(0)$, we cannot make this function continuous at zero because there is no way to make a

Figure C.2 The graph of a function that is discontinuous at $x = 0$.

"solid" connection between the graph to the left of zero and the graph to the right of zero.

C.1.4 DIFFERENTIATION

As motivation for the concept of derivative and differentiation, let us return to our initial example of computing the instantaneous speed of an object whose position at time t is $x(t)$. By an intuitive limiting process, we computed this speed to be a limit of average speeds of the form $(x(t + \Delta t) - x(t))\Delta t$. In formal terms the limit is

$$x'(t) = \lim_{\Delta t \to 0} \frac{x(t + \Delta t) - x(t)}{\Delta t}$$

The function $x'(t)$ is referred to as the *derivative* of $x(t)$. The derivative exists only when the limit on the right-hand side of the definition exists.

The derivative has a geometric implication that is quite important. Consider the position function in our ongoing example, $x(t) = t(1 - t)$ for $t \in [0, 1]$. Figure C.3 shows the graph of the function.

The line containing $(0, x(0))$ and $(t_2, x(t_2))$ is called a *secant line* of the graph. The average speed $(x(t_2) - x(0))/(t_2 - 0)$ is the slope of the secant line. The line through $(0, x(0))$ and $(t_1, x(t_1))$ is yet another secant line and has slope given by the average speed $(x(t_1) - x(0))/(t_1 - 0)$. As t_1 is chosen to be closer and closer to zero, the limit of the secant lines is the line shown at the left in the figure. This is called the *tangent line* of the graph at the point $(0, x(0))$. The derivative $x'(t)$ may therefore be viewed as the slope of the tangent line to the graph at $(t, x(t))$.

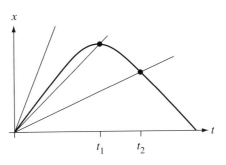

Figure C.3 The graph of $x(t) = t(1 - t)$ with two points marked at times t_1 and t_2. The lines connecting the origin $(0, 0)$ to $(t_1, x(t_1))$ and $(t_2, x(t_2))$ are secant lines to the graph. The line at the left is the tangent line to the graph at $(0, x(0)) = (0, 0)$.

In the example $x(t) = t(1 - t)$, we had a good guess at the instantaneous speed at $t = 0$ by looking at the average speeds for values of t close to zero. This would be quite a time-consuming process at other values of t. Instead, we can construct a general formula for the derivative by directly applying the limit definition.

$$x'(t) = \lim_{\Delta t \to 0} \frac{x(t + \Delta t) - x(t)}{\Delta t}$$

$$= \lim_{\Delta t \to 0} \frac{(t + \Delta t)(1 - t - \Delta t) - t(1 - t)}{\Delta t}$$

$$= \lim_{\Delta t \to 0} \frac{(\Delta t)(1 - 2t) - (\Delta t)^2}{\Delta t}$$

$$= \lim_{\Delta t \to 0} (1 - 2t - \Delta t)$$

$$= 1 - 2t$$

The last equality is valid since $1 - 2t - \Delta t$ is a continuous function of Δt; that is, we can just evaluate the argument of the limit with $\Delta t = 0$. Notice that $x'(0) = 1$, but we can evaluate $x'(t)$ at any other t of our choosing.

A function f with domain $[a, b]$ is said to be *differentiable at* $x \in (a, b)$ with derivative

$$f'(x) = \lim_{h \to 0} \frac{f(x + h) - f(x)}{h}$$

as long as the limit on the right-hand side exists. For most functions we work with, the derivative exists for all points in the domain, but sometimes we meet functions for

Table C.3 Derivatives of some common functions

$f(x)$	$f'(x)$	$f(x)$	$f'(x)$
x^p	px^{p-1}	$\cot(x)$	$\csc^2(x)$
$\sin(x)$	$\cos(x)$	$\exp(x)$	$\exp(x)$
$\cos(x)$	$-\sin(x)$	$\ln(x)$	$\frac{1}{x}$
$\tan(x)$	$\sec^2(x)$		

which this is not the case. The typical example is the function $f(x) = |x|$. The graph consists of two rays, $y = x$ for $x \geq 0$ and $y = -x$ for $x < 0$. The derivative for $x > 0$ is $f'(x) = 1$ (the slope of the ray for $x > 0$). The derivative for $x < 0$ is $f'(x) = -1$ (the slope of the ray for $x < 0$). However, $f'(0)$ is not defined, so f is not differentiable at $x = 0$. The graph of f has a *cusp*, or *kink*, at the origin.

In a standard calculus course you will spend a lot of time constructing derivatives for many functions that you will encounter in your applications. Table C.3 provides some common derivatives without going through the formal constructions here.

The function $\exp(x)$ is the natural exponential function and $\ln(x)$ is the natural logarithm function. Derivatives of other functions can be found in calculus or other reference books.

Also of use are some standard identities for working with derivatives. The *product rule* is

$$\frac{d}{dx}(f(x)g(x)) = f(x)g'(x) + f'(x)g(x) \tag{C.1}$$

The notation on the left-hand side indicates the derivative of the product of two functions $f(x)$ and $g(x)$. The right-hand side is that derivative. For example, if $f(x) = x^2$ and $g(x) = \sin(x)$, then

$$\frac{d}{dx}\left(x^2 \sin(x)\right) = x^2 \cos(x) + 2x \sin(x)$$

The *quotient rule* is

$$\frac{d}{dx}\left(\frac{f(x)}{g(x)}\right) = \frac{f'(x)g(x) - f(x)g'(x)}{(g(x))^2} \tag{C.2}$$

Using the same f and g as in the last example,

$$\frac{d}{dx}\left(\frac{x^2}{\sin(x)}\right) = \frac{2x \sin(x) - x^2 \cos(x)}{\sin^2(x)}$$

The *chain rule* tells you how to compute the derivative of a composition of two functions, $f(g(x))$,

$$\frac{d}{dx}(f(g(x))) = f'(g(x))g'(x) \qquad (\text{C.3})$$

You compute the derivative of $f(y)$ with respect to its argument y, evaluate it at $y = g(x)$, then multiply by the derivative of $g(x)$. Once again, using the same f and g as before, the composition is $f(g(x)) = (\sin(x))^2$. The derivative is

$$\frac{d}{dx}(\sin(x))^2 = 2(\sin(x))\cos(x)$$

C.1.5 L'HÔPITAL'S RULE

In some instances, a limit of a quotient of functions needs to be evaluated where both numerator and denominator become zero at the target independent variable value. A rule for evaluating such limits is *l'Hôpital's rule*, named after Guillaume François Antoine Marquis de l'Hôpital, who wrote (in the 1600s) the first introductory differential calculus textbook in which the rule appeared.

Specifically, if $f(x)$ and $g(x)$ are continuous functions at $x = c$ and $f(c) = g(c) = 0$, an attempt to evaluate

$$\lim_{x \to c} \frac{f(x)}{g(x)}$$

by direct substitution of $x = c$ fails because the fraction $0/0$ is an *indeterminate form*. If the functions are differentiable at $x = c$ and if $g'(c) \neq 0$, then the limit is, in fact,

$$\lim_{x \to c} \frac{f(x)}{g(x)} = \lim_{x \to c} \frac{f'(x)}{g'(x)} = \frac{f'(c)}{g'(c)}$$

For example,

$$\lim_{x \to 0} \frac{\sin(x)}{x} = \lim_{x \to 0} \frac{\cos(x)}{1} = \cos(0) = 1$$

which is a result I stated earlier without proof.

C.1.6 INTEGRATION

The other flavor of calculus is *integral calculus*. The concept is motivated by the desire to compute the area of an irregular-shaped region. We are familiar with area formulas for standard geometric objects. The area of a square of width W and height H is $A = WH$. The area of a circle of radius R is $A = \pi R^2$. However, consider as an

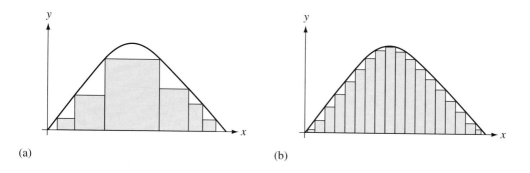

(a) (b)

Figure C.4 An attempt to compute the area bounded by a parabola and the x-axis by filling it with rectangles.

example the region in the first quadrant of the xy-plane bounded by the x-axis and the graph of $y = x(1 - x)$. The graph is a parabola. The natural approach to solving this problem is to attempt to decompose it into regions for which we do know how to compute the area. What is more natural than trying rectangles? Figure C.4 shows an attempt to fill the region with a few rectangles, all of whose bases are on the x-axis.

The problem, of course, is that no matter how many rectangles we select, we cannot fill the region. However, the more rectangles we choose and the smaller their widths, the more we can fill the bounded region. The sum of the areas of the rectangles in Figure C.4(b) provides a better approximation to the true area than does the sum of the areas of the rectangles in Figure C.4(a).

Have we failed in the attempt? No, as long as we rely on our old friend the limit to help us out. Intuitively, if we let the maximum width of the rectangles approach zero, all the time requiring more rectangles, in a limiting sense we can fill the region with rectangles. The classical argument from a physicist's or engineer's perspective is to think of choosing a rectangle whose width is *infinitesimal*—call this width dx. The rectangle is positioned at x on the axis. The height of the rectangle is just the function value $f(x)$. The rectangle has an *infinitesimal area*, $dA = f(x)dx$, which is just the product of the (infinitesimal) width and height. Sum up all such rectangles as x varies over the relevant domain to obtain the area of the region. The *summation* is not finite, so to speak, so rather than using the standard capital sigma (Σ) to denote the summation, historically a large **S**-shaped symbol was used (S for sum). In our example the area is indicated by the notation

$$A = \int_0^1 x(1 - x)\, dx$$

The right-hand side is referred to as the *definite integral* of $f(x) = x(1 - x)$ on the domain $[0, 1]$. For a function $f(x)$ on a domain $[a, b]$, the definite integral is

$$\int_a^b f(x)\, dx \qquad\qquad (\text{C.4})$$

The function $f(x)$ is referred to as the *integrand* of the definite integral.

The process of computing the definite integrals is called *integration*. Our intuitive approach leads us to believe that the sum of the infinitesimal areas should be the area of the bounded region, but to obtain the actual area we would need to provide more formal details on computing a general formula for the area. Once again, these are details you discuss in a standard calculus course. For our purposes, we just need to know the end result, the mechanical means by which you *integrate* the function $f(x)$. One of the most important results from calculus relates differentiation and integration:

Fundamental Theorem of Calculus ▨ If $F(x) = \int_a^x f(\xi)\, d\xi$ is the definite integral of $f(\xi)$ on the interval $[a, x]$, then $F'(x) = f(x)$. That is, the derivative of $F(x)$ is just the integrand $f(x)$. The function $F(x)$ is said to be an *antiderivative* of $f(x)$. The relationship is sometimes written concisely as

$$\frac{d}{dx} \int_a^x f(\xi)\, d\xi = f(x)$$

which says that the derivative is the inverse operation of integration. ▨

The result is general knowledge for us, but historically differential calculus and integral calculus were developed independently. Pierre de Fermat and René Descartes worked on the aspects of computing tangent lines to graphs (differential calculus), whereas Bonaventura Francesco Cavalieri and Christian Huygens worked on the aspects of calculating areas (integral calculus), all of this in the 1600s. Also in the 1600s, Isaac Newton and Gottfried Wilhelm von Leibniz independently discovered that, in fact, differentiation and integration were directly related, the result being the Fundamental Theorem of Calculus.

With the Fundamental Theorem at hand, let us revisit the problem of computing the area bounded by a parabola and the x-axis. We had stated this as a definite integral, $A = \int_0^1 x(1 - x)\, dx$. An antiderivative $F(x)$ for $f(x) = x(1 - x) = x - x^2$ is a function for which $F'(x) = f(x)$. Using our knowledge about derivatives of polynomial terms, we can integrate a polynomial term in the reverse manner. That is, an antiderivative of x^p is $x^{p+1}/(p + 1)$ as long as $p \neq -1$. An antiderivative of $x - x^2$ is therefore $F(x) = x^2/2 - x^3/3$. The antiderivative mentioned in the Fundamental Theorem has the property that $F(a) = 0$, but in general an antiderivative can be any

function for which $F'(x) = f(x)$. That is, the antiderivative is not unique. When we choose one, we integrate by

$$\int_a^b f(x)\, dx = F(x)|_a^b = F(b) - F(a)$$

where the vertical bar in the middle expression is a notation that says to evaluate F at the top number and subtract from it F evaluated at the bottom number. The area of the bounded region is, therefore,

$$A = \int_0^1 x(1-x)\, dx = \frac{x^2}{2} - \frac{x^3}{3}\bigg|_0^1 = \left(\frac{1}{2} - \frac{1}{3}\right) - \left(\frac{0}{2} - \frac{0}{3}\right) = \frac{1}{6}$$

C.2 MULTIVARIATE CALCULUS

Multivariate calculus involves studying functions $y = f(x_1, \ldots, x_n)$ with n independent variables x_1 through x_n and one dependent variable y. The heart of the topic is once again *limits*, but the introduction of multiple independent variables makes it somewhat more challenging and interesting. For the sake of making the constructions look like the ones for univariate functions, define $\mathbf{x} = (x_1, \ldots, x_n)$ and $y = f(\mathbf{x})$.

C.2.1 LIMITS AND CONTINUITY

If we choose values of \mathbf{x} close to a specified point \mathbf{c} and if the corresponding function values $f(\mathbf{x})$ are close to a number L, we say that L is the limit of $f(\mathbf{x})$ as \mathbf{x} approaches \mathbf{c}. The formal notation is

$$\lim_{\mathbf{x} \to \mathbf{c}} f(\mathbf{x}) = L$$

The mathematical definition is just like the one for univariate functions. The limit exists and is the value L if for each $\varepsilon > 0$, there is a $\delta > 0$ such that $|f(\mathbf{x}) - L| < \varepsilon$ whenever $|\mathbf{x} - \mathbf{c}| < \delta$. The value ε may once again be viewed as an error tolerance. In order to make $f(\mathbf{x})$ differ from L by no more than the tolerance, we need to choose \mathbf{x} suitably close to \mathbf{c}. The value δ tells you how close. Observe that $|\mathbf{y}|$ denotes the length of the vector \mathbf{y}. This definition applies for any number $n \geq 1$ of independent variables, so the univariate case $n = 1$ is automatically covered by the definition.

The function $f(\mathbf{x})$ is said to be *continuous at* \mathbf{c} whenever f is defined at \mathbf{c}, the limit of f as \mathbf{x} approaches \mathbf{c} exists, and the limit is

$$\lim_{\mathbf{x} \to \mathbf{c}} f(\mathbf{x}) = f(\mathbf{c})$$

Many functions you will encounter in physical applications are continuous. For example, polynomial functions are continuous at all points and the process of computing the limit is simply one of evaluating the function.

C.2.2 DIFFERENTIATION

A univariate function $y = f(x)$ that is differentiable has derivative $dy/dx = f'(x)$, a measure of instantaneous rate of change of f at the value x. We can make similar measurements of instantaneous rates of change for a multivariate function $y = f(x_1, \ldots, x_n)$ with respect to each independent variable. If x_i is the independent variable of interest, the rate of change is called the *partial derivative of f with respect to x_i*. Its definition is similar to the one for univariate functions,

$$\frac{\partial f}{\partial x_i} = \lim_{h \to 0} \frac{f(x_1, \ldots, x_i + h, \ldots, x_n) - f(x_1, \ldots, x_i, \ldots, x_n)}{h}$$

The term *partial* is used to indicate that the rate of change is with respect to only one of the variables. The univariate differential operator was named d/dx and uses a regular italic letter d. The partial derivative operator is $\partial/\partial x_i$; the symbol ∂ is used to indicate that the setting involves multiple independent variables.

EXAMPLE C.3

When working with two independent variables, rather than indexing them, we sometimes use $z = f(x, y)$. The partial derivatives are $\partial f/\partial x$ and $\partial f/\partial y$. Consider $z = f(x, y) = x^2 y^3$. The partial derivatives are

$$\frac{\partial f}{\partial x} = 2xy^3, \qquad \frac{\partial f}{\partial y} = 3x^2 y^2$$

Notice that in computing $\partial f/\partial x$, the variable y was treated as a constant as far as x is concerned. As a function of x alone, think of $F(x) = cx^2$ (the constant c is y^3) whose derivative is $F'(x) = 2cx^2$. ∎

All the derivative formulas that you know for univariate functions apply to multivariate functions. You simply treat the function as one that depends only on the independent variable x_i of interest, with all other x_j $(j \neq i)$ treated as constants. The product rule and quotient rule both apply to multivariate differentiation.

The Chain Rule

The chain rule, that differentiation rule that applies to composition of functions, is more complicated when multiple independent variables are present. The issue is that each independent variable may be a function of other variables; composition

can occur in multiple components. For example, consider the function $g(y_1, y_2) = f(x_1(y_1, y_2), x_2(y_1, y_2), x_3(y_1, y_2))$, where f is a function of three independent variables x_1, x_2, and x_3, but each of these variables is a function of two other variables y_1 and y_2. The resulting composition is named $g(y_1, y_2)$, a function of two independent variables. We would like to see how g varies with respect to each of the independent variables. As y_1 varies, notice that each of the three components of f varies since those components are compositions involving y_1. You should expect that the rate of change of g with respect to y_1 involves the rates of change of f with respect to all of its independent variables. In fact, the partial derivative of g with respect to y_1 is

$$\frac{\partial g}{\partial y_1} = \frac{\partial f}{\partial x_1}\frac{\partial x_1}{\partial y_1} + \frac{\partial f}{\partial x_2}\frac{\partial x_2}{\partial y_1} + \frac{\partial f}{\partial x_3}\frac{\partial x_3}{\partial y_1}$$

Each term in the summation on the right-hand side looks like the term you see in the univariate version of the chain rule. Similarly, the partial derivative of g with respect to y_2 is

$$\frac{\partial g}{\partial y_2} = \frac{\partial f}{\partial x_1}\frac{\partial x_1}{\partial y_2} + \frac{\partial f}{\partial x_2}\frac{\partial x_2}{\partial y_2} + \frac{\partial f}{\partial x_3}\frac{\partial x_3}{\partial y_2}$$

Generally, if f depends on n independent variables x_1 through x_n and each of the x_i depends on m independent variables y_1 through y_m, then the partial derivative of f when viewed as a function of the y_j is

$$\frac{\partial}{\partial y_j} f(x_1, \ldots, x_n) = \sum_{i=1}^{n} \frac{\partial f}{\partial x_i}\frac{\partial x_i}{\partial y_j}$$

In the event that the x_i depend only on another single variable t—say, $x_i(t)$ are the components as functions of t—then the notation changes slightly (but not the idea):

$$\frac{d}{dt} f(x_1, \ldots, x_n) = \sum_{i=1}^{n} \frac{\partial f}{\partial x_i}\frac{dx_i}{dt}$$

The change is due to the fact that f viewed as a function of t alone is univariate, so the d notation is used rather than ∂.

We used the chain rule many times in our coverage of Lagrangian dynamics to compute the partial derivatives of the kinetic energy function.

Directional Derivatives

Consider a multivariate function $f(\mathbf{x})$ where $\mathbf{x} \in \mathbb{R}^n$. The partial derivatives measure rates of change with respect to each independent variable of the function. Effectively, the rate of change is measured with respect to the direction vector associated with the independent variable. For example, the function $f(x_1, x_2)$ has partial derivatives

$$\frac{\partial f}{\partial x_1} = \lim_{h \to 0} \frac{f(x_1 + h, x_2) - f(x_1, x_2)}{h}$$

The measurements are made in the $x_1 x_2$-plane in the direction $(1, 0)$ associated with x_1. That is, the limit formula can be thought of as

$$\frac{\partial f}{\partial x_1} = \lim_{h \to 0} \frac{f((x_1, x_2) + h(1, 0)) - f((x_1, x_2))}{h}$$

Similarly,

$$\frac{\partial f}{\partial x_2} = \lim_{h \to 0} \frac{f(x_1, x_2 + h) - f(x_1, x_2)}{h} = \lim_{h \to 0} \frac{f((x_1, x_2) + h(0, 1)) - f((x_1, x_2))}{h}$$

and the rate of change is measured in the direction $(0, 1)$ associated with x_2.

It is natural to ask how f changes in another unit-length direction (u_1, u_2). Using the pattern you see in the partial derivatives, that rate of change should be as shown:

$$\lim_{h \to 0} \frac{f((x_1, x_2) + h(u_1, u_2)) - f((x_1, x_2))}{h}$$

As it turns out, this quantity can be shown to be equal to

$$u_1 \frac{\partial f}{\partial x_1} + u_2 \frac{\partial f}{\partial x_2}$$

which is a weighted sum of the partial derivatives of f. The sum is called the *directional derivative of f* in the specified direction. We can write this in a coordinate-free manner by defining $\mathbf{x} = (x_1, x_2)$, and $\mathbf{u} = (u_1, u_2)$, and by defining the *gradient of f* to be the vector of partial derivatives of f, namely,

$$\nabla f = \left(\frac{\partial f}{\partial x_1}, \frac{\partial f}{\partial x_2} \right)$$

The directional derivative at \mathbf{x} in the direction \mathbf{u} is $\mathbf{u} \cdot \nabla f(\mathbf{x})$. This form of the directional derivative applies to any number of independent variables,

$$\mathbf{u} \cdot \nabla f(\mathbf{x}) = \sum_{i=1}^{n} u_i \frac{\partial f}{\partial x_i}$$

EXAMPLE C.4

Let $f(x, y) = x^2 y^3$. The directional derivative at $(1, 2)$ in the direction $(3/5, 4/5)$ is

$$(3/5, 4/5) \cdot (2xy^3, 3x^2 y^2)\Big|_{(1, 2)} = (3/5, 4/5) \cdot (16, 12) = 19.2$$

The vertical bar notation means that you evaluate the variable terms on the right using the specific point that occurs as a subscript on the bar. ∎

The partial derivatives $\partial f / \partial x$ and $\partial f / \partial y$ of $f(x, y)$ have a geometric interpretation, just as the ordinary derivative $f'(x)$ of $f(x)$ did. In the univariate case, $f'(x)$ is the slope of the tangent line to the graph of $f(x)$ at x. That is, the tangent line at $(x, f(x))$ has direction $(1, f'(x))$. In the multivariate case, and assuming the function is differentiable, the graph at $(x, y, f(x, y))$ has a *tangent plane*. If you walk in a specific direction in the xy-plane, there is a corresponding *tangent line* in the tangent plane. If the planar direction is $(1, 0)$, the corresponding tangent line has direction $(1, 0, \partial f / \partial x)$. If the direction is $(0, 1)$, the tangent line has direction $(0, 1, \partial f / \partial y)$. Generally, the direction (u_1, u_2) in the xy-plane generates a tangent line whose direction is

$$\left(u_1, u_2, u_1 \frac{\partial f}{\partial x} + u_2 \frac{\partial f}{\partial y} \right)$$

In coordinate-free form, this vector is $(\mathbf{u}, \mathbf{u} \cdot \nabla f)$. Given two linearly independent tangent line directions, the tangent plane normal \mathbf{N} must be the normalized cross product of those directions. In particular, as long as $\nabla f \neq \mathbf{0}$, the tangent line directions corresponding to $(1, 0)$ and $(0, 1)$ are linearly independent and the tangent plane normal is

$$\mathbf{N} = \frac{(1, 0, \partial f / \partial x) \times (0, 1, \partial f / \partial y)}{|(1, 0, \partial f / \partial x) \times (0, 1, \partial f / \partial y)|} = \frac{(-\partial f / \partial x, -\partial f / \partial y, 1)}{\sqrt{1 + (\partial f / \partial x)^2 + (\partial f / \partial y)^2}}$$

C.2.3 INTEGRATION

The motivation for the definite integral of a univariate function was based on computing the area bounded by the graph of a function $f(x)$ and the x-axis. A similar motivation applies for multivariate functions. In particular, let us consider bivariate functions $f(x, y)$ that are nonnegative. Let $\mathcal{D} \subset \mathbb{R}^2$ be the domain of the function whose boundary is a simple closed curve. The region \mathcal{R} bounded by the graph of $z = f(x, y)$, the xy-plane, and the boundary of \mathcal{D} extruded vertically has a finite volume. We can attempt to "fill" \mathcal{R} with vertical rectangular solids whose bases are axis-aligned in the xy-plane. Figure C.5 shows the bases of some rectangular solids as an attempt to fill the region.

Naturally, just as in the univariate case, we cannot fill \mathcal{R} with a finite number of rectangular solids because the graph of the function has variable slope. Moreover, we cannot even fill \mathcal{D} with rectangular bases because its shape is also not a union of a finite number of rectangles. In a limiting sense, though, we can obtain better and better approximations by using rectangles with smaller area bases and lots more of them. From the infinitesimal perspective, if an axis-aligned rectangular base is chosen to be very small, say, of dimensions dx by dy, and placed at $(x, y) \in \mathcal{D}$, the height of the rectangle is $f(x, y)$. The infinitesimal volume covered by the rectangular solid is the product of the infinitesimal area of the base, $dx \, dy$, with the height $f(x, y)$,

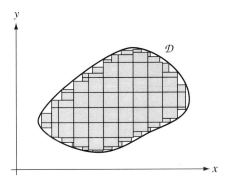

Figure C.5 Bases of some rectangular solids as an attempt to fill the domain \mathcal{D}.

namely, $dV = f(x, y)dx\,dy$. If we "add" these up for all $(x, y) \in \mathcal{D}$, we obtain the volume

$$V = \int_{\mathcal{D}} f(x, y)dx\,dy$$

a multidimensional integral. The question is how do we make sense of this and evaluate it. The answer is to use *iterated integration* by decomposing the domain so that we can fix y, integrate with respect to x, then integrate with respect to y. When we use iterated integrals, the integral sign in the last displayed equation is replaced by two integral signs.

EXAMPLE C.5

Let us compute the volume of the solid bounded by the graph of $f(x, y) = 4 - x^2 - y^2$ on the closed disk \mathcal{D}, $x^2 + y^2 \le 1$. The volume is

$$V = \iint_{\mathcal{D}} 4 - x^2 - y^2 dx\,dy$$

A fixed value of y in the domain corresponds to a horizontal line segment that touches the left and right hemispheres of the disk. The x values on that segment vary from $-\sqrt{1 - y^2}$ to $\sqrt{1 - y^2}$. The y values themselves vary from -1 to 1. The iterated integral is

$$V = \int_{-1}^{1} \int_{-\sqrt{1-y^2}}^{\sqrt{1-y^2}} 4 - x^2 - y^2 dx\,dy$$

(Example C.5 continued)

Treating y as a constant, the "innermost integral" is evaluated.

$$V = \int_{-1}^{1} \left(\int_{-\sqrt{1-y^2}}^{\sqrt{1-y^2}} 4 - x^2 - y^2 dx \right) dy$$

$$= \int_{-1}^{1} (4 - y^2)x - \frac{1}{3}x^3 \Big|_{-\sqrt{1-y^2}}^{\sqrt{1-y^2}} dy$$

$$= 2 \int_{-1}^{1} (4 - y^2)\sqrt{1 - y^2} - \frac{1}{3}(1 - y^2)^{3/2} dy$$

The last integral is univariate. Although one is apparently taught in calculus courses that closed-form antiderivatives are the goal, in practice that is typically not the case. An integral of the type we now have can be approximated using numerical integration algorithms. ▪

The same iterated integration method applies in more dimensions. The technical challenge in higher dimensions is invariably the decomposition of the domain of the function in order to construct the limits of integration. However, numerical methods do exist for numerical integration without having to formally decompose the domain. These methods are discussed in standard numerical analysis textbooks such as [BF01].

Other examples of multivariate integrals are found in Section 2.5. Computing centers of mass and inertia tensors are the main application of multivariate integration in a physics simulation.

C.3 APPLICATIONS

This section contains a few applications that are relevant to physical simulation. The first section is on optimization of a function, the process of constructing minima and/or maxima of the function. An illustrative example of optimization for a univariate function is provided: determining whether or not an oriented bounding box intersects a plane where the box is both translating and rotating in space. The specified time interval is $[0, T]$. The distance between the box and plane is time varying, say, $D(t)$. The box will intersect the plane if the minimum value of $D(t)$ on $[0, T]$ is zero. An example for a multivariate function is provided and arises in the problem of computing the closest point on a triangle to a specified point.

Constrained optimization involves computing minima and/or maxima of a function, but with additional constraints on the variables. Only equality constraints are considered here. The method of solution uses Lagrange multipliers. An illustrative example of constrained optimization is provided: computing the distance between two

objects whose boundary surfaces are level surfaces, ellipsoids being the prototypical case.

Finally, in constructing numerical methods for solving differential equations, we need to approximate derivatives by finite differences. The numerical methods of Chapter 9 all require such approximations. The last application discussed here is about obtaining approximations of a specified order of error.

C.3.1 OPTIMIZATION

The ideas for optimization are first summarized for univariate functions. The extension of the ideas to multivariate functions is then provided.

Univariate Functions

Let $f(x)$ be a differentiable function with domain $[a, b]$. We wish to locate the value x_{min} for which $f(x_{min})$ is a minimum. That is, $f(x_{min}) \leq f(x)$ for all $x \in [a, b]$. Similarly, we want to locate the value x_{max} for which $f(x)$ is a maximum: $f(x) \leq f(x_{max})$ for all $x \in [a, b]$. A typical function with these values is shown in Figure C.6.

The function has a *local maximum* at x_{loc}. Such a point has the property that $f(x) \leq f(x_{loc})$ for all x *nearby* x_{loc}. That is, the maximum value for the function is only relevant in the locale near x_{loc}. The function has a *local minimum* at x_{min}. Such a point has the property that $f(x) \geq f(x_{min})$ for all x *nearby* x_{min}. That is, the minimum value for the function is only relevant in the locale near x_{min}. In this particular example the local minimum happens to be the *global minimum* for the

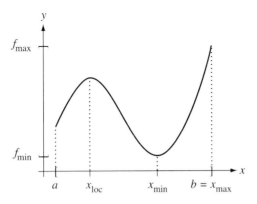

Figure C.6 The graph of a function $f(x)$ on its domain $[a, b]$.

function. The *global maximum* for the function occurs at $x_{max} = b$, an end point of the domain interval.

Generally, a *global extremum* (minimum or maximum) occurs at a point where the derivative of the function exists and is zero, or where the derivative does not exist, or at an end point of the interval. The process of function optimization involves locating all such candidate points, evaluating the function at these points, and then choosing the optimum value. In Figure C.6 we would find x_{loc} and x_{min} as solutions to $f'(x) = 0$ and we would look at $x = a$ and $x = b$ since they are the end points of the domain interval. An analysis of $f(a)$, $f(b)$, $f(x_{loc})$, and $f(x_{min})$ shows that $f_{min} = f(x_{min})$ and $f_{max} = f(b)$.

The technical challenge in computing global extrema is, of course, solving the equation $f'(x) = 0$ and/or determining where $f'(x)$ is undefined. Even when $f(x)$ is a polynomial, implementing fast and robust numerical methods to solve for zeros of the derivative is sometimes difficult.

EXAMPLE C.6

Compute the global extrema of $f(x) = x^3 - 2x^2 - 4x - 5$ on the interval $[-1, 3]$. The derivative of f is $f'(x) = 3x^2 - 4x - 4$. The roots to $f'(x) = 0$ are computed using the quadratic equation: $x = 2$ and $x = -2/3$. The function values that contain the extrema are $f(-1) = -4$, $f(3) = -8$, $f(2) = -13$, and $f(-2/3) = -95/27 \doteq -3.518$. The global minimum is $f_{min} = -13$ and the global maximum is $f_{max} = -95/27$. ▪

EXAMPLE C.7

An oriented bounding box (OBB) is translating and rotating through space. Its center at time t is $\mathbf{C}(t)$. The box axis directions are $\mathbf{U}_0(t)$, $\mathbf{U}_1(t)$, and $\mathbf{U}_2(t)$. The directions are unit length and mutually perpendicular. The extents (half-widths) along each axis are e_0, e_1, and e_2. Points in the OBB are

$$\mathbf{X}(t) = \mathbf{C}(t) + R(t)\mathbf{Y}$$

where $R(t) = [\mathbf{U}_0(t) \mid \mathbf{U}_1(t) \mid \mathbf{U}_2(t)]$ is a rotation matrix whose columns are the box axis directions and where $\mathbf{Y}(t) = (y_0, y_1, y_2)$ with $|y_i| \le e_i$ for all i.

We are interested in when the OBB will first contact a stationary plane given by $\mathbf{N} \cdot \mathbf{X} = d$, where \mathbf{N} is a unit-length normal to the plane and \mathbf{X} is any point on the plane. At first time of contact, the distance between the OBB and the plane is a minimum.

At time zero, the OBB and plane are assumed not to be intersecting and the OBB is on the side of the plane to which the normal points. The distance from the OBB to the plane at time t is the distance between the plane and a corner of the OBB that is closest to the plane. This corner has the property that its projection onto the normal line $s\mathbf{N}$ is closer to the plane than are other corners (possibly two or more corners are equally close). The projection of any OBB point $\mathbf{X}(t)$ is $s(t)\mathbf{N}$, where

$$s(t) = \mathbf{N} \cdot \mathbf{X}(t) = \mathbf{N} \cdot (\mathbf{C}(t) + R(t)\mathbf{Y})$$

At first time of contact it is the case that $s = d$, the plane constant. The smallest $s(t)$ for all points occurs at one of the eight corners. These corners occur for one of the eight possibilities $\mathbf{Y} = (\pm e_0, \pm e_1, \pm e_2)$. The eight projection values are

$$s(t) = \mathbf{N} \cdot \mathbf{X}(t)$$

$$= \mathbf{N} \cdot (\mathbf{C}(t) \pm e_0 \mathbf{U}_0(t) \pm e_1 \mathbf{U}_1(t) \pm e_2 \mathbf{U}_2(t))$$

$$= \mathbf{N} \cdot \mathbf{C}(t) \pm e_0 \mathbf{N} \cdot \mathbf{U}_0(t) \pm e_1 \mathbf{N} \cdot \mathbf{U}_1(t) \pm e_2 \mathbf{N} \cdot \mathbf{U}_2(t)$$

The closest corner occurs when $s(t)$ is as small as possible, so

$$s(t) = \mathbf{N} \cdot \mathbf{C}(t) - e_0 |\mathbf{N} \cdot \mathbf{U}_0(t)| - e_1 |\mathbf{N} \cdot \mathbf{U}_1(t)| - e_2 |\mathbf{N} \cdot \mathbf{U}_2(t)|$$

Because we required the OBB to be initially on the side of the plane to which \mathbf{N} points, it is the case that $s(0) > d$. If we define $f(t) = (s(t) - d)^2$ and limit our collision query to $t \in [0, T]$ for some user-specified maximum time $T > 0$, we have reduced the problem to calculating the minimum of $f(t)$ on the interval $[0, T]$ and testing if that minimum is zero. The roots to $f'(t) = 0$ occur when $s(t) = d$ or when $s'(t) = 0$. The ease or difficulty with which we can solve this problem depends on the simplicity or complexity of the translation $\mathbf{C}(t)$ and the orientation matrix $R(t)$. ▪

Multivariate Functions

Locating the global extrema of multivariate functions has similarities to the univariate case but is geometrically more challenging. The abstract idea of the univariate case extends naturally. A global extremum must occur either at a point where the "derivative" is zero, a point where the "derivative" is undefined, or at a boundary point of the domain. The "derivative" in the multivariate case is the gradient vector of the function $f(\mathbf{x})$, namely, ∇f.

When we have n independent variables, the equation $\nabla f = \mathbf{0}$ represents n equations in n unknowns. The equations are generally nonlinear, so numerical methods must be applied to solve them. The standard method is a multidimensional Newton's method. Once the solutions are found, they can be classified as maxima points, minima points, or saddle points by using second-order partial derivatives. The classification requires knowing about eigenvalues and eigenvectors and is covered in detail in Section A.5.5.

The analysis of the function f restricted to its boundary points can itself be complicated depending on the function, but in fact the analysis is one of *recursive descent in dimension*. Consider a bivariate function $f(x, y)$ with an irregular-shaped domain \mathcal{D} in the xy-plane. Suppose that the boundary of \mathcal{D} is a simple closed curve parameterized by $(x(t), y(t))$ for $t \in [a, b]$. The restriction of f to the boundary is $g(t) = f(x(t), y(t))$. The global extrema of $g(t)$ on $[a, b]$ may be found. This is a one-dimensional problem (one independent parameter t), whereas finding the points where $\nabla f = \mathbf{0}$ is a two-dimensional problem (two independent variables x

and y). Thus, the analysis of the boundary is in one fewer dimensions than that of the interior of \mathcal{D}.

The recursive descent for a function $f(x, y, z)$ is similar. Let \mathcal{D} be the domain of the function whose boundary is a simple closed surface. The candidate extrema points in the interior of \mathcal{D} are obtained by solving $\nabla f = \mathbf{0}$, a system of three equations in three unknowns. The boundary surface can be parameterized by two variables, say, s and t, that parameterization being $(x(s, t), y(s, t), z(s, t))$. The parameter domain is denoted \mathcal{P}; that is, each parameter pair $(s, t) \in \mathcal{P}$. The function f restricted to the boundary is $g(s, t) = f(x(s, t), y(s, t), z(s, t))$. We now need to compute the global extrema of $g(s, t)$ for $(s, t) \in \mathcal{P}$. This is a two-dimensional problem, whereas the original was in three dimensions. The two-dimensional problem, involves determining where $\nabla g = \mathbf{0}$, a system of two equations in two unknowns. The global extrema of g on the boundary of \mathcal{P} (a curve) is performed by parameterizing the boundary by a parameter r. The boundary curve is $(s(r), t(r))$ for $r \in [a, b]$ and the restriction of g to the boundary is $h(r) = g(s(r), t(r))$. The reduction in dimension has led us to a one-dimensional problem.

EXAMPLE C.8

Compute the global minimum of $f(s, t) = a_{00}s^2 + 2a_{01}st + a_{11}t^2 + 2b_0 s + 2b_1 t + c$ for (s, t) in the triangular domain $s \geq 0$, $t \geq 0$, and $s + t \leq 1$. We will assume that $a_{00} > 0$ and $a_{00}a_{11} - a_{01}^2 > 0$ so that the graph of f is a paraboloid opening upward, thus a global minimum exists.

The gradient of f is

$$\nabla f = 2(a_{00}s + a_{01}t + b_0, a_{01}s + a_{11}t + b_1)$$

The equation $\nabla f = \mathbf{0}$ leads to two linear equations in the two unknowns s and t. The solution is

$$\bar{s} = \frac{-a_{11}b_0 + a_{01}b_1}{a_{00}a_{11} - a_{01}^2}, \qquad \bar{t} = \frac{+a_{01}b_0 - a_{00}b_1}{a_{00}a_{11} - a_{01}^2}$$

If (\bar{s}, \bar{t}) is inside the triangular domain, then $f(\bar{s}, \bar{t})$ must be the global minimum since the graph is a paraboloid opening upward. If it is not in the triangular domain, then we need to search for the minimum of f restricted to the boundary.

On the boundary $s = 0$ with $t \in [0, 1]$, the function is $g(t) = f(0, t) = a_{11}t^2 + 2b_1 t + c$. The minimum of g occurs when $g'(t) = 0$ or at $t = 0$ or $t = 1$. The equation $g'(t) = 0$ has solution

$$\hat{t} = -\frac{b_1}{a_{11}}$$

The candidate minima are $g(0) = c$, $g(1) = a_{11} + 2b_1 + c$, and $g(\hat{t})$.

On the boundary $t = 0$ with $s \in [0, 1]$, the function is $h(s) = f(s, 0) = a_{00}s^2 + 2b_0s + c$. The minimum of h occurs when $h'(s) = 0$ or at $s = 0$ or $s = 1$. The equation $h'(s) = 0$ has solution

$$\hat{s} = -\frac{b_0}{a_{00}}$$

The candidate minima are $h(0) = c$, $h(1) = a_{00} + 2b_0 + c$, and $h(\hat{s})$.

Finally, on the boundary $s + t = 1$ with $s \in [0, 1]$, the function is $p(s) = f(s, 1 - s) = (a_{00} - 2a_{01} + a_{11})s^2 + 2(a_{01} - a_{11} + b_0 - b_1)s + (a_{11} + 2b_1 + c)$. The minimum of p occurs when $p'(s) = 0$ or at $s = 0$ or $s = 1$. The equation $p'(s) = 0$ has solution

$$\tilde{s} = \frac{-a_{01} + a_{11} - b_0 + b_1}{a_{00} - 2a_{01} + a_{11}}$$

The candidate minima are $p(0) = a_{11} + 2b_1 + c$, $p(1) = a_{00} + 2b_0 + c$, and $p(\tilde{s})$.

The global minimum is the smallest of $g(0)$, $g(1)$, $g(\hat{t})$, $h(1)$, $h(\hat{s})$, and $p(\tilde{s})$. Notice that $g(0)$ corresponds to $f(0, 0)$, $g(1)$ corresponds to $f(0, 1)$, and $h(1)$ corresponds to $f(1, 0)$, the function values at the vertices of the triangular domain. The values $g(\hat{t})$, $h(\hat{s})$, and $p(\tilde{s})$ correspond to local minima on the lines containing the edges of the triangular domain.

By the way, this exact problem arises when computing the distance from a point to a triangle in 2D or in 3D. The s and t values are the variables of the standard parameterization for a triangle. The point (s, t) at which the global minimum of f occurs corresponds to the closest point on the triangle to the specified point. ▪

EXERCISE Ⓜ Establish the connection just described in Example C.8 between distance from point
C.1 to triangle and minimization of $f(s, t)$. ▪

C.3.2 CONSTRAINED OPTIMIZATION

We have already seen that local extrema of multivariate functions $f(\mathbf{x})$ occur when the gradient is zero, $\nabla f(\mathbf{x}) = \mathbf{0}$. Sometimes an additional equality constraint is placed on the independent variable, say, $g(\mathbf{x}) = 0$ for some multivariate function g. The constraint causes dependencies within the set of independent variables, thus reducing the number of independent ones.

Constrained optimization is the term used to refer to problems of this type. A classical method for handling these is called the *method of Lagrange multipliers*. The method involves introducing another parameter into the problem, call it λ, and analyzing

$$h(\mathbf{x}, \lambda) = f(\mathbf{x}) + \lambda g(\mathbf{x})$$

The constraint $g = 0$ generally causes a reduction from n independent variables to $n - 1$. The introduction of λ raises this back to n independent variables. The function h is optimized in the manner mentioned earlier, by determining those \mathbf{x} and λ for which the gradient of h is zero. Notice that the gradient of h has one more component than the gradient of f. To stress this difference, we use the notation

$$\nabla h = \left(\frac{\partial h}{\partial x}, \frac{\partial h}{\partial \lambda} \right) = (\nabla f + \lambda \nabla g, g)$$

Setting $\nabla h = \mathbf{0}$ leads to $\nabla f + \lambda \nabla g = \mathbf{0}$ and $g = 0$. The second equation is just the constraint with which we started. The first equation is solved by dotting with ∇g,

$$\lambda = -\frac{\nabla f \cdot \nabla g}{|\nabla g|^2}$$

assuming of course that ∇g is not identically the zero vector. Resubstituting this in the first equation, we obtain

$$\nabla f - \frac{\nabla f \cdot \nabla g}{|\nabla g|^2} \nabla g = \mathbf{0}$$

This equation provides n equations in the n unknown variables x_1 through x_n and may be solved by numerical methods for multidimensional root finding.

If m multiple constraints are specified, say, $g_j(\mathbf{x}) = 0$ for $1 \le j \le m$, the same introduction of parameters λ_j allows for a similar method of solution. The λ_j are called *Lagrange multipliers*. The new function to optimize is

$$h(\mathbf{x}, \lambda_1, \ldots, \lambda_m) = f(\mathbf{x}) + \sum_{j=1}^{m} g_j(\mathbf{x})$$

The gradient of h is

$$\nabla h = \left(\frac{\partial h}{\partial x}, \frac{\partial h}{\partial \lambda_1}, \ldots, \frac{\partial h}{\partial \lambda_1} \right) = \left(\nabla f + \sum_{j=1}^{m} \lambda_j \nabla g_j, g_1, \ldots, g_m \right)$$

Setting the first component of the gradient vector to the zero vector yields

$$\nabla f + \sum_{j=1}^{m} \lambda_j \nabla g_j = \mathbf{0} \tag{C.5}$$

Setting the other components to zero reproduces the constraints $g_j = 0$ for all j.

Dotting equation (C.5) with ∇g_i for $1 \le i \le m$ gives us a set of m equations in the m unknown Lagrange multipliers,

$$\sum_{j=1}^{m} \nabla g_i \cdot \nabla g_j \lambda_j = -\nabla f \cdot \nabla g_i$$

If $A = [a_{ij}]$ is an $m \times m$ matrix with $a_{ij} = \nabla g_i \cdot \nabla g_j$, if $\mathbf{B} = [b_i]$ is an $m \times 1$ vector with $b_i = -\nabla f \cdot \nabla g_i$, and if $\mathbf{\Lambda} = [\lambda_j]$, the system of equations is $A\mathbf{\Lambda} = \mathbf{B}$, a linear system that can be solved whenever A is invertible: $\mathbf{\Lambda} = A^{-1}\mathbf{B}$. The λ_j from the solution are resubstituted into equation (C.5), thereby giving us a single vector-valued equation of n equations in the n unknowns x_1 through x_n.

EXAMPLE C.9

Two ellipsoids are defined implicitly by the quadratic equations $g_j(\mathbf{x}) = \mathbf{x}^{\mathrm{T}} A_j \mathbf{x} + \mathbf{b}_j^{\mathrm{T}} \mathbf{x} + c_j = 0$, $j = 1$ and $j = 2$. The 3×3 matrices A_j are positive-definite (symmetric with positive eigenvalues). Let us assume that the ellipsoids are separated, so the distance between them is positive. How do we go about computing the distance?

Let \mathbf{x} be a point on the first ellipsoid, so $g_1(\mathbf{x}) = 0$. Let \mathbf{y} be a point on the second ellipsoid, so $g_2(\mathbf{y}) = 0$. The squared distance between these two points is

$$f(\mathbf{x}, \mathbf{y}) = |\mathbf{x} - \mathbf{y}|^2$$

We wish to select \mathbf{x} and \mathbf{y} that minimize $f(\mathbf{x}, \mathbf{y})$ subject to the constraints that $g_1(\mathbf{x}) = 0$ and $g_2(\mathbf{y}) = 0$. The number of independent variables is six, three for the first ellipsoid and three for the second ellipsoid. Each constraint reduces the number of independent variables by one, leaving us (implicitly) with four independent variables. This makes sense in that \mathbf{x} and \mathbf{y} each lie on an ellipsoid, a two-dimensional surface. We have two degrees of freedom for each point, a total of four degrees of freedom.

Using the method of Lagrange multipliers, define

$$h(\mathbf{x}, \mathbf{y}, \lambda_1, \lambda_2) = f(\mathbf{x}, \mathbf{y}) + \lambda_1 g_1(\mathbf{x}) + \lambda_2 g_2(\mathbf{y})$$
$$= |\mathbf{x} - \mathbf{y}|^2 + \lambda_1(\mathbf{x}^{\mathrm{T}} A_1 \mathbf{x} + \mathbf{b}_1^{\mathrm{T}} \mathbf{x} + c_1) + \lambda_2(\mathbf{y}^{\mathrm{T}} A_2 \mathbf{y} + \mathbf{b}_2^{\mathrm{T}} \mathbf{y} + c_2)$$

Setting the gradient of h to zero yields four vector-valued equations:

$$\partial h / \partial \mathbf{x} = 2(\mathbf{x} - \mathbf{y}) + \lambda_1(2A_1 \mathbf{x} + \mathbf{b}_1) = \mathbf{0}$$
$$\partial h / \partial \mathbf{y} = 2(\mathbf{y} - \mathbf{x}) + \lambda_2(2A_2 \mathbf{y} + \mathbf{b}_2) = \mathbf{0}$$
$$\partial h / \partial \lambda_1 = \mathbf{x}^{\mathrm{T}} A_1 \mathbf{x} + \mathbf{b}_1^{\mathrm{T}} \mathbf{x} + c_1 = 0 \qquad \text{(C.6)}$$
$$\partial h / \partial \lambda_2 = \mathbf{y}^{\mathrm{T}} A_2 \mathbf{y} + \mathbf{b}_2^{\mathrm{T}} \mathbf{y} + c_2 = 0$$

(*Example C.9 continued*)

The last two equations of equation C.6 are just the original constraints. The first two equations have a geometric interpretation. The minimum distance between the ellipsoids is attained by points \mathbf{x} on the first and \mathbf{y} on the second and is the closest pair of points, one point per ellipsoid. Sketch a picture to convince yourself that the vector connecting these two, $\mathbf{x} - \mathbf{y}$, is perpendicular to both ellipsoids at the closest points. The gradient vectors of the implicitly defined surfaces are perpendicular to their respective surfaces. The gradient of the first ellipsoid is $\nabla g_1(\mathbf{x}) = 2A_1\mathbf{x} + \mathbf{b}_1$, the gradient of the second is $\nabla g_2(\mathbf{y}) = 2A_2\mathbf{y} + \mathbf{b}_2$. The vectors $\mathbf{x} - \mathbf{y}$ and $2A_1\mathbf{x} + \mathbf{b}_1$ are parallel, so some linear combination of the two vectors must be the zero vector. This is exactly what the first equation in (C.6) says. The same argument applies to $\mathbf{x} - \mathbf{y}$ and $2A_2\mathbf{y} + \mathbf{b}_2$; the second equation of (C.6) says the two vectors are parallel.

The first two equations of (C.6) may be solved directly to obtain the Lagrange multipliers, then we resubstitute the multipliers into the equations to obtain the following system of two equations in two vector-valued unknowns:

$$\mathbf{x} - \mathbf{y} - \frac{(\mathbf{x} - \mathbf{y}) \cdot (2A_1\mathbf{x} + \mathbf{b}_1)}{|2A_1\mathbf{x} + \mathbf{b}_1|^2}(2A_1\mathbf{x} + \mathbf{b}_1) = \mathbf{0}$$

and

$$\mathbf{x} - \mathbf{y} - \frac{(\mathbf{x} - \mathbf{y}) \cdot (2A_2\mathbf{y} + \mathbf{b}_2)}{|2A_2\mathbf{y} + \mathbf{b}_2|^2}(2A_2\mathbf{y} + \mathbf{b}_2) = \mathbf{0}$$

A multidimensional numerical root finder may be used to compute the solutions. ▪

C.3.3 DERIVATIVE APPROXIMATIONS BY FINITE DIFFERENCES

In numerical methods for solving ordinary differential equations of the type shown in Chapter 9, and in numerical methods for solving partial differential equations, we invariably need to use approximations to ordinary derivatives and to partial derivatives in order to establish the iterative method itself. The following material shows how to obtain such approximations.

Given a small value $h > 0$, the dth-order derivative satisfies the following equation where the integer order of error $p > 0$ may be selected as desired,

$$\frac{h^d}{d!}F^{(d)}(x) + O(h^{d+p}) = \sum_{i=i_{\min}}^{i_{\max}} C_i F(x + ih) \tag{C.7}$$

for some choice of extreme indices i_{\min} and i_{\max} and for some choice of coefficients C_i. The equation becomes an approximation by throwing away the $O(h^{d+p})$ term. The vector $\vec{C} = (C_{i_{\min}}, \ldots, C_{i_{\max}})$ is called the *template* for the approximation. Approximations for the derivatives of multivariate functions are constructed as tensor products of templates for univariate functions.

Derivatives of Univariate Functions

The following approximations are valid for the derivative of $F(x)$. A *forward differ-ence approximation* is

$$F'(x) = \frac{F(x+h) - F(x)}{h} + O(h) \qquad (C.8)$$

a *backward difference approximation* is

$$F'(x) = \frac{F(x) - F(x-h)}{h} + O(h) \qquad (C.9)$$

and a *centered difference approximation* is

$$F'(x) = \frac{F(x+h) - F(x-h)}{2h} + O(h^2) \qquad (C.10)$$

The approximations are obtained by throwing away the error terms indicated by the O notation. The order of the error for each of these approximations is easily seen from formal expansions as Taylor series about the value x,

$$F(x+h) = F(x) + hF'(x) + \frac{h^2}{2!}F''(x) + \cdots = \sum_{n=0}^{\infty} \frac{h^n}{n!} F^{(n)}(x)$$

and

$$F(x-h) = F(x) - hF'(x) + \frac{h^2}{2!}F''(x) + \cdots = \sum_{n=0}^{\infty} (-1)^n \frac{h^n}{n!} F^{(n)}(x)$$

where $F^{(n)}(x)$ denotes the nth-order derivative of F. The first equation leads to the forward difference $F'(x) = (F(x+h) - F(x))/h + O(h)$. The second equation leads to the backward difference $F'(x) = (F(x) - F(x-h))/h + O(h)$. Both ap-proximations have error $O(h)$. The centered difference is obtained by subtracting the second equation from the first to obtain $(F(x+h) - F(x-h))/(2h) + O(h^2)$.

Higher-order approximations to the first derivative can be obtained by using more Taylor series, more terms in the Taylor series, and cleverly weighting the various expansions in a sum. For example,

$$F(x+2h) = \sum_{n=0}^{\infty} \frac{(2h)^n}{n!} F^{(n)}(x) \quad \text{and} \quad F(x-2h) = \sum_{n=0}^{\infty} (-1)^n \frac{(2h)^n}{n!} F^{(n)}(x)$$

lead to a forward difference approximation with second-order error,

$$F'(x) = \frac{-F(x+2h) + 4F(x+h) - 3F(x)}{2h} + O(h^2) \qquad (C.11)$$

to a backward difference approximation with second-order error,

$$F'(x) = \frac{3F(x) - 4F(x - h) + F(x - 2h)}{2h} + O(h^2) \tag{C.12}$$

and to a centered difference approximation with fourth-order error,

$$F'(x) = \frac{-F(x + 2h) + 8F(x + h) - 8F(x - h) + F(x - 2h)}{12h} + O(h^4) \tag{C.13}$$

Higher-order derivatives can be approximated in the same way. For example, a forward difference approximation to $F''(x)$ is

$$F''(x) = \frac{F(x + 2h) - 2F(x + h) + F(x)}{h^2} + O(h) \tag{C.14}$$

and centered difference approximations are

$$F''(x) = \frac{F(x + h) - 2F(x) + F(x - h)}{h^2} + O(h^2) \tag{C.15}$$

and

$$F''(x) = \frac{-F(x + 2h) + 16F(x) - 30F(x) + 16F(x - h) - F(x - 2h)}{12h^2} + O(h^4) \tag{C.16}$$

Each of these formulas is easily verified by expanding the $F(x + ih)$ terms in a formal Taylor series and computing the weighted sums on the right-hand sides. However, of greater interest is to select the order of derivative d and the order of error p and determine the weights C_i for the sum in equation (C.7). A formal Taylor series for $F(x + ih)$ is

$$F(x + ih) = \sum_{n=0}^{\infty} i^n \frac{h^n}{n!} F^{(n)}(x)$$

Replacing this in equation (C.7) yields

$$\frac{h^d}{d!} F^{(d)}(x) + O(h^{d+p}) = \sum_{i=i_{\min}}^{i_{\max}} C_i \sum_{n=0}^{\infty} i^n \frac{h^n}{n!} F^{(n)}(x)$$

$$= \sum_{n=0}^{\infty} \left(\sum_{i=i_{\min}}^{i_{\max}} i^n C_i \right) \frac{h^n}{n!} F^{(n)}(x)$$

$$= \sum_{n=0}^{d+p-1} \left(\sum_{i=i_{\min}}^{i_{\max}} i^n C_i \right) \frac{h^n}{n!} F^{(n)}(x) + O(h^{d+p})$$

Table C.4 Parameters for various finite difference approximations

Equation	d	p	Approximation Type	i_{min}	i_{max}
(C.8)	1	1	forward	0	1
(C.9)	1	1	backward	−1	0
(C.10)	1	2	centered	−1	1
(C.11)	1	2	forward	0	2
(C.12)	1	2	backward	−2	0
(C.13)	1	4	centered	−2	2
(C.14)	2	1	forward	0	2
(C.15)	2	2	centered	−1	1
(C.16)	2	4	centered	−2	2

Multiplying by $d!/h^d$, the desired approximation is

$$F^{(d)}(x) = \frac{d!}{h^d} \sum_{n=0}^{d+p-1} \left(\sum_{i=i_{min}}^{i_{max}} i^n C_i \right) \frac{h^n}{n!} F^{(n)}(x) + O(h^p) \tag{C.17}$$

In order for equation (C.17) to be satisfied, it is necessary that

$$\sum_{i=i_{min}}^{i_{max}} i^n C_i = \begin{cases} 0, & 0 \leq n \leq d+p-1 \text{ and } n \neq d \\ 1, & n = d \end{cases} \tag{C.18}$$

This is a set of $d + p$ linear equations in $i_{max} - i_{min} + 1$ unknowns. If we constrain the number of unknowns to be $d + p$, the linear system has a unique solution. A *forward difference approximation* occurs if we set $i_{min} = 0$ and $i_{max} = d + p - 1$. A *backward difference approximation* occurs if we set $i_{max} = 0$ and $i_{min} = -(d + p - 1)$. A *centered difference approximation* occurs if we set $i_{max} = -i_{min} = (d + p - 1)/2$ where it appears that $d + p$ is necessarily an odd number. As it turns out, p can be chosen to be even regardless of the parity of d and $i_{max} = \lfloor (d + p - 1)/2 \rfloor$.

Table C.4 indicates the choices for d and p, the type of approximation (forward, backward, or centered), and the corresponding equation number.

EXAMPLE C.10 Approximate $F^{(3)}(x)$ with a forward difference with error $O(h)$, $d = 3$, and $p = 1$. We need $i_{min} = 0$ and $i_{max} = 3$. The linear system from equation (C.18) is

$$\begin{bmatrix} 1 & 1 & 1 & 1 \\ 0 & 1 & 2 & 3 \\ 0 & 1 & 4 & 9 \\ 0 & 1 & 8 & 27 \end{bmatrix} \begin{bmatrix} C_0 \\ C_1 \\ C_2 \\ C_3 \end{bmatrix} = \begin{bmatrix} 0 \\ 0 \\ 0 \\ 1 \end{bmatrix}$$

(Example C.10 continued)

and has solution $(C_0, C_1, C_2, C_3) = (-1, 3, -3, 1)/6$. Equation (C.17) becomes

$$F^{(3)}(x) = \frac{-F(x) + 3F(x + h) - 3F(x + 2h) + F(x + 3h)}{h^3} + O(h)$$

Approximate $F^{(3)}(x)$ with a centered difference with error $O(h^2)$, $d = 3$, and $p = 2$. We need $i_{\max} = -i_{\min} = 2$. The linear system from equation (C.18) is

$$\begin{bmatrix} 1 & 1 & 1 & 1 & 1 \\ -2 & -1 & 0 & 1 & 2 \\ 4 & 1 & 0 & 1 & 4 \\ -8 & -1 & 0 & 1 & 8 \\ 16 & 1 & 0 & 1 & 16 \end{bmatrix} \begin{bmatrix} C_{-2} \\ C_{-1} \\ C_0 \\ C_1 \\ C_2 \end{bmatrix} = \begin{bmatrix} 0 \\ 0 \\ 0 \\ 1 \\ 0 \end{bmatrix}$$

and has solution $(C_{-2}, C_{-1}, C_0, C_1, C_2) = (-1, 2, 0, -2, 1)/12$. Equation (C.17) becomes

$$F^{(3)}(x) = \frac{-F(x - 2h) + 2F(x - h) - 2F(x + h) + F(x + 2h)}{2h^3} + O(h^2)$$

Finally, approximate with a centered difference with error $O(h^4)$, $d = 3$, and $p = 4$. We need $i_{\max} = -i_{\min} = 3$. The linear system from equation (C.18) is

$$\begin{bmatrix} 1 & 1 & 1 & 1 & 1 & 1 & 1 \\ -3 & -2 & -1 & 0 & 1 & 2 & 3 \\ 9 & 4 & 1 & 0 & 1 & 4 & 9 \\ -27 & -8 & -1 & 0 & 1 & 8 & 27 \\ 81 & 16 & 1 & 0 & 1 & 16 & 81 \\ -243 & -32 & -1 & 0 & 1 & 32 & 243 \\ 729 & 64 & 1 & 0 & 1 & 64 & 729 \end{bmatrix} \begin{bmatrix} C_{-3} \\ C_{-2} \\ C_{-1} \\ C_0 \\ C_1 \\ C_2 \\ C_3 \end{bmatrix} = \begin{bmatrix} 0 \\ 0 \\ 0 \\ 1 \\ 0 \\ 0 \\ 0 \end{bmatrix}$$

and has solution $(C_{-3}, C_{-2}, C_{-1}, C_0, C_1, C_2, C_3) = (1, -8, 13, 0, -13, 8, -1)/48$. Equation (C.17) becomes

$$F^{(3)}(x) = \frac{F(x - 3h) - 8F(x - 2h) + 13F(x - h) - 13F(x + h) + 8F(x + 2h) - F(x + 3h)}{8h^3}$$
$$+ O(h^4) \quad \blacksquare$$

EXAMPLE C.11

Approximate $F^{(4)}(x)$ with a forward difference with error $O(h)$, $d = 4$, and $p = 1$. We need $i_{\min} = 0$ and $i_{\max} = 4$. The linear system from equation (C.18) is

$$\begin{bmatrix} 1 & 1 & 1 & 1 & 1 \\ 0 & 1 & 2 & 3 & 4 \\ 0 & 1 & 4 & 9 & 16 \\ 0 & 1 & 8 & 27 & 64 \\ 0 & 1 & 16 & 81 & 256 \end{bmatrix} \begin{bmatrix} C_0 \\ C_1 \\ C_2 \\ C_3 \\ C_4 \end{bmatrix} = \begin{bmatrix} 0 \\ 0 \\ 0 \\ 0 \\ 1 \end{bmatrix}$$

and has solution $(C_0, C_1, C_2, C_3, C_4) = (1, -4, 6, -4, 1)/24$. Equation (C.17) becomes

$$F^{(4)}(x) = \frac{F(x) - 4F(x+h) + 6F(x+2h) - 4F(x+3h) + F(x+4h)}{h^4} + O(h)$$

Approximate $F^{(4)}(x)$ with a centered difference with error $O(h^2)$, $d = 4$, and $p = 2$. We need $i_{\max} = -i_{\min} = 2$. The linear system from equation (C.18) is

$$\begin{bmatrix} 1 & 1 & 1 & 1 & 1 \\ -2 & -1 & 0 & 1 & 2 \\ 4 & 1 & 0 & 1 & 4 \\ -8 & -1 & 0 & 1 & 8 \\ 16 & 1 & 0 & 1 & 16 \end{bmatrix} \begin{bmatrix} C_{-2} \\ C_{-1} \\ C_0 \\ C_1 \\ C_2 \end{bmatrix} = \begin{bmatrix} 0 \\ 0 \\ 0 \\ 0 \\ 1 \end{bmatrix}$$

and has solution $(C_{-2}, C_{-1}, C_0, C_1, C_2) = (1, -4, 6, -4, 1)/24$. Equation (C.17) becomes

$$F^{(4)}(x) = \frac{F(x-2h) - 4F(x-h) + 6F(x) - 4F(x+h) + F(x+2h)}{h^4} + O(h^2)$$

Finally, approximate with a centered difference with error $O(h^4)$, $d = 4$, and $p = 4$. We need $i_{\max} = -i_{\min} = 3$. The linear system from equation (C.18) is

$$\begin{bmatrix} 1 & 1 & 1 & 1 & 1 & 1 & 1 \\ -3 & -2 & -1 & 0 & 1 & 2 & 3 \\ 9 & 4 & 1 & 0 & 1 & 4 & 9 \\ -27 & -8 & -1 & 0 & 1 & 8 & 27 \\ 81 & 16 & 1 & 0 & 1 & 16 & 81 \\ -243 & -32 & -1 & 0 & 1 & 32 & 243 \\ 729 & 64 & 1 & 0 & 1 & 64 & 729 \end{bmatrix} \begin{bmatrix} C_{-3} \\ C_{-2} \\ C_{-1} \\ C_0 \\ C_1 \\ C_2 \\ C_3 \end{bmatrix} = \begin{bmatrix} 0 \\ 0 \\ 0 \\ 0 \\ 1 \\ 0 \\ 0 \end{bmatrix}$$

and has solution

$$(C_{-3}, C_{-2}, C_{-1}, C_0, C_1, C_2, C_3) = (-1, 12, -39, 56, -39, 12, -1)/144.$$

Equation (C.17) becomes

$$F^{(4)}(x)$$

$$= \frac{-F(x-3h) + 12F(x-2h) - 39F(x-h) + 56F(x) - 39F(x+h) + 12F(x+2h) - F(x+3h)}{6h^4}$$

$$+ O(h^4) \quad \blacksquare$$

Derivatives of Bivariate Functions

For functions with more variables, the partial derivatives can be approximated by grouping together all of the same variables and applying the univariate approximation for that group. For example, if $F(x, y)$ is our function, then some partial derivative approximations are

$$F_x(x, y) \doteq \frac{F(x + h, y) - F(x - h, y)}{2h}$$

$$F_y(x, y) \doteq \frac{F(x, y + k) - F(x, y - k)}{2k}$$

$$F_{xx}(x, y) \doteq \frac{F(x + h, y) - 2f(x, y) + F(x - h, y)}{h^2}$$

$$F_{yy}(x, y) \doteq \frac{F(x, y + k) - 2f(x, y) + F(x, y - k)}{k^2}$$

$$F_{xy}(x, y) \doteq \frac{F(x + h, y + k) - F(x + h, y - k) - F(x - h, y + k) + F(x - h, y - k)}{4hk}$$

Each of these can be verified in the limit: the x-derivatives by taking the limit as h approaches zero, the y-derivatives by taking the limit as y approaches zero, and the mixed second-order derivative by taking the limit as both h and k approach zero.

The derivatives F_x, F_y, F_{xx}, and F_{yy} just use the univariate approximation formulas. The mixed derivative requires slightly more work. The important observation is that the approximation for F_{xy} is obtained by applying the x-derivative approximation for F_x, then applying the y-derivative approximation to the previous approximation. That is,

$$F_{xy}(x, y) \doteq \frac{F(x + h, y) - F(x - h, y)}{2h}$$

$$\doteq \frac{\frac{F(x+h, y+k)-F(x-h, y+k)}{2h} - \frac{F(x+h, y-k)-F(x-h, y-k)}{2h}}{2k}$$

$$= \frac{F(x + h, y + k) - F(x + h, y - k) - F(x - h, y + k) + F(x - h, y - k)}{4hk}$$

The approximation implied by equation (C.7) may be written as

$$\frac{h^m}{m!} \frac{d^m}{dx^m} F(x) \doteq \sum_{i=i_{\min}}^{i_{\max}} C_i^{(m)} F(x + ih) \tag{C.19}$$

The inclusion of the superscript on the C coefficients is to emphasize that those coefficients are constructed for each order m. For bivariate functions, we can use the

natural extension of equation (C.19) by applying the approximation in x first, then applying the approximation in y to that approximation, just as in our example of F_{xy}.

$$\frac{k^n}{n!} \frac{\partial^n}{\partial y^n} \frac{h^m}{m!} \frac{\partial^m}{\partial x^m} F(x, y) \doteq \frac{k^n}{n!} \frac{\partial^n}{\partial y^n} \sum_{i=i_{\min}}^{i_{\max}} C_i^{(m)} F(x + ih, y)$$

$$\doteq \sum_{i=i_{\min}}^{i_{\max}} \sum_{j=j_{\min}}^{j_{\max}} C_i^{(m)} C_j^{(n)} F(x + ih, y + jk) \qquad \text{(C.20)}$$

$$= \sum_{i=i_{\min}}^{i_{\max}} \sum_{j=j_{\min}}^{j_{\max}} C_{i,j}^{(m,n)} F(x + ih, y + jk)$$

where the last equality defines

$$C_{i,j}^{(m,n)} = C_i^{(m)} C_j^{(n)}$$

The coefficients for the bivariate approximation are just the tensor product of the coefficients for each of the univariate approximations.

Derivatives of Multivariate Functions

The approximation concept extends to any number of variables. Let (x_1, \ldots, x_n) be those variables and let $F(x_1, \ldots, x_n)$ be the function to approximate. The approximation is

$$\left(\frac{h_1^{m_1}}{m_1!} \frac{\partial^{m_1}}{\partial x_1^{m_1}} \cdots \frac{h_n^{m_n}}{m_n!} \frac{\partial^{m_n}}{\partial x_1^{m_n}} \right) F(x_1, \ldots, x_n)$$

$$\doteq \sum_{i_1=i_1^{\min}}^{i_1^{\max}} \cdots \sum_{i_n=i_n^{\min}}^{i_n^{\max}} C_{(i_1,\ldots,i_n)}^{(m_1,\ldots,m_n)} F(x_1 + i_1 h_1, \ldots, x_n + i_n h_n) \qquad \text{(C.21)}$$

where

$$C_{(i_1,\ldots,i_n)}^{(m_1,\ldots,m_n)} = C_{i_1}^{(m_1)} \cdots C_{i_n}^{(m_n)}$$

a tensor product of the coefficients of the n univariate approximations.

ORDINARY DIFFERENCE EQUATIONS

D.1 DEFINITIONS

Let $\{y_k\}_{k=0}^{\infty}$ be a sequence of numbers whose terms are dependent based on the equation

$$y_{k+n} = f(k, y_k, y_{k+1}, \ldots, y_{k+n-1}) \tag{D.1}$$

for some function f, for some $n > 0$, and for all $k \geq 0$. The equation is called an *explicit nth-order difference equation*. The first n terms of the sequence y_0 through y_{n-1} are called the *initial values* for the difference equation. Once selected, the next term is determined from the previous terms by $y_n = f(0, y_0, \ldots, y_{n-1})$. The terms y_1 through y_n may in turn be used to construct y_{n+1}. The process is repeated as often as an application requires. The adjective *explicit* refers to the explicit occurrence of the next term y_{k+n} on the left-hand side of the equation. An *implicit nth-order difference equation* is

$$F(k, y_k, \ldots, y_{k+n}) = 0 \tag{D.2}$$

For all practical purposes, the function is assumed to be differentiable in its last component with $\partial F / \partial y_{k+n} \neq 0$ for any generated sequence. If it is possible to solve the implicit equation in closed form for y_{k+n}, then the solution is an explicit equation. In many cases it is not possible to solve in closed form, so y_{k+n} must be calculated by some numerical method.

If the function in the definition for an explicit difference equation does not have a k-component, that is, $y_{k+n} = f(y_k, \ldots, y_{k+n-1})$, then the equation is said to be *autonomous*. The autonomous implicit difference equation is $F(y_k, \ldots, y_{k+n}) = 0$.

In some applications, the behavior of y_k in the limit as k becomes infinite is important to know. The possibilities are that the limit is a finite number, is infinite ($+\infty$ or $-\infty$), or does not exist.

EXAMPLE
D.1

The equation $y_{k+1} = y_k^2$, $y_0 \geq 0$, is an explicit, autonomous, first-order difference equation. It is of the form $y_{k+1} = f(y_k)$, where $f(u) = u^2$. In this example we can construct a general formula. The first few terms of the sequence are

$$y_1 = y_0^2, \qquad y_2 = y_1^2 = \left(y_0^2\right)^2 = y_0^4, \qquad y_3 = y_2^2 = \left(y_0^4\right)^2 = y_0^8, \ldots, \qquad y_k = y_0^{2^k}$$

A check to make sure we observed the correct pattern:

$$y_{k+1} = y_0^{2^{k+1}} = \left(y_0^{2^k}\right)^2 = y_k^2$$

and in fact we do have a solution. If $y_0 = 0$, all terms in the sequence are zero. If $y_0 = 1$, all terms in the sequence are 1. For $0 < y_0 < 1$, the sequence terms decrease in size and $\lim_{k \to \infty} y_k = 0$. For $y_0 > 1$, the sequence terms increase in size and $\lim_{k \to \infty} y_k = +\infty$. ■

EXAMPLE
D.2

The equation $y_{k+1}^3 + (k+1)y_k^2 - 1 = 0$ is an implicit, nonautonomous, first-order difference equation. It is of the form $F(k, y_k, y_{k+1}) = 0$, where $F(k, u, v) = v^3 + (k+1)u^2 - 1$. This equation may be solved explicitly as

$$y_{k+1} = \left(1 - (k+1)y_k^2\right)^{1/3}$$

A few iterations are shown:

$$y_1 = \left(1 - y_0^2\right)^{1/3}$$

$$y_2 = \left(1 - 2y_1^2\right)^{1/3} = \left(1 - 2\left(1 - y_0^2\right)^{2/3}\right)^{1/3}$$

$$y_3 = \left(1 - 3y_2^2\right)^{1/3} = \left(1 - 3\left(1 - 2\left(1 - y_0^2\right)^{2/3}\right)^{2/3}\right)^{1/3}$$

A general solution for this example is intractable, but it can be shown that the limiting behavior is $\lim_{k \to \infty} y_k = -\infty$. ■

EXAMPLE
D.3

The equation $y_{k+2} + \exp(-y_{k+2}) - y_{k+1} - y_k = 0$ is an autonomous, implicit, second-order difference equation. The initial values are y_0 and y_1. It is not possible to

explicitly solve for y_{k+2}. Define $g(x) = x + \exp(-x) - c$, where $c = y_{k+1} + y_k$. The value y_{k+2} is a root to $g(x) = 0$. First, $g(x) = 0$ might not have roots. The first and second derivatives are $g'(x) = 1 - \exp(-x)$ and $g''(x) = \exp(-x)$. The first derivative is zero when $x = 0$. The second derivative is always positive. These conditions imply that $g(x)$ has a global minimum at $x = 0$, so $g(x) \geq g(0) = 1 - c$. If $c < 1$, then $g(x) > 0$ for all x, which means g has no roots. In order to have a next (real-valued) term y_{k+2} in the sequence, it is necessary that $y_{k+1} + y_k \geq 1$. If this constraint is met, then $g(0) < 0$. Because $g(0)$ is a global minimum and $g''(x) > 0$, there are exactly two roots to $g(x) = 0$. We will always choose the positive one.

Let's look at constructing y_2 when the initial values satisfy the constraint $c = y_1 + y_0 \geq 1$. We must solve $g(x) = 0$ for its positive root. Newton's method can be applied to approximate the root. For $x \geq 0$, define $h(x) = x - c$. A quick sketch of the graph shows that the $h(x) < g(x)$, so the positive root must be in $(0, c)$ since $h(c) = 0$. We may as well choose the initial guess for Newton's method to be $x_0 = c$. The other iterates are

$$x_{j+1} = x_j - \frac{g(x_j)}{g'(x_j)}, \quad j \geq 0$$

This is yet another ordinary difference equation, an autonomous and first-order one. A few iterates x_j are generated until some stopping condition is met, usually a combination of making sure $g(x_j)$ is close to zero and $|x_{j+1} - x_j|$ is close to zero. The last iterate is the number used for y_2. The iterate y_3 can now be computed in a similar manner as long as $c = y_2 + y_1 \geq 1$. Assuming $y_{k+1} + y_k \geq 1$ at each step of the process, the limit as k becomes infinite exists, call it L, and it must be a solution to $0 = L + \exp(-L) - 2L$ (replace the y_k, y_{k+1}, and y_{k+2} terms in the difference equation by L). This simplifies to $\exp(-L) = L$. The equation cannot be solved in closed form. A numerical construction leads to the approximation $L \doteq 0.567143$. Observe that when the y_k terms are close to L, $y_{k+1} + y_k$ will in fact be larger than 1 (the sum is approximately 1.134286). ∎

EXAMPLE D.4

Compute an approximation to $1/\sqrt{x}$ for $x > 0$. Let $y = 1/\sqrt{x}$. Equivalently, $x = 1/y^2$. We may formulate the problem in terms of root finding. For a specified x, define $g(y) = 1/y^2 - x$. The root to $g(y) = 0$ is the number $1/sqrtx$. Applying Newton's method, let y_0 be some initial guess to the root. The other iterates are determined by

$$y_{k+1} = y_k - \frac{g(y_k)}{g'(y_k)} = y_k - \frac{\frac{1}{y_k^2} - x}{-\frac{2}{y_k^3}} = \frac{y_k(3 - xy_k^2)}{2}$$

Once again we have an autonomous, first-order, explicit difference equation. The number of iterations to produce a reasonable approximation to $1/\sqrt{x}$ depends on how good an initial guess you choose. Suppose that x is written as $x = (1 + m)2^e$,

(Example D.4 continued)

where $0 \leq m < 1$; then $1/\sqrt{x} = 1/\sqrt{1+m}2^{-e/2}$. This reduces the problem to computing $1/\sqrt{z}$ for $0 \leq z < 2$, where $z = 1 + m$. Now we need to select a good initial guess. One way to do this is to approximate the function $R(m) = 1/\sqrt{1+m}$ for $m \in [0, 1]$ by a straight line $L(m)$ and use $L(m)$ as the approximation to $R(m)$. One such line is $L(m) = 0.966215 - 0.25m$.

To illustrate, let $m = 0.5$. Using a hand calculator, $1/\sqrt{1+m} = 1/\sqrt{1.5} \doteq 0.81649658$. The initial guess is $y_0 = L(0.5) = 0.841215$. A couple of iterations of Newton's method are shown next:

$$y_1 = \frac{y_0(3 - (1+m)y_0^2)}{2} = 0.81536277, \qquad y_2 = \frac{y_1(3 - (1+m)y_1^2)}{2} = 0.81649422$$

One iteration is a reasonable approximation. Two iterations is a really good approximation. ∎

D.2 LINEAR EQUATIONS

A restricted class of explicit difference equations is the set of *nth-order linear difference equations*,

$$a_k^{(n)} y_{k+n} + a_k^{(n-1)} y_{k+n-1} + \cdots + a_k^{(1)} y_{k+1} + a_k^{(0)} y_k = b_k, \quad k \geq 0 \qquad \text{(D.3)}$$

where the $a_k^{(m)}$ and b_k coefficients are known sequences. The initial values for the equation are y_0 through y_n. The order of the equation is degenerate if $a_k^{(n)} = 0$ for some k. In many applications we have $a_k^{(n)} \neq 0$ for all k. In this case equation (D.3) is of the form

$$y_{k+n} + a_k^{(n-1)} y_{k+n-1} + \cdots + a_k^{(1)} y_{k+1} + a_k^{(0)} y_k = b_k, \quad k \geq 0 \qquad \text{(D.4)}$$

which will be used in the remainder of Section D.2. The linear difference equation is *homogeneous* if $b_k = 0$ for all k; otherwise, it is *nonhomogeneous*. The theory of linear difference equations is analogous to the theory of ordinary differential equations as the following sections will show.

D.2.1 FIRST-ORDER LINEAR EQUATIONS

The first-order linear equation is

$$y_{k+1} + a_k y_k = b_k, \quad k \geq 0 \qquad \text{(D.5)}$$

The initial value y_0 and the coefficient sequences a_k and b_k are known quantities.

The homogeneous equation sets $b_k = 0$ for all k. The *homogeneous solution* is presented here with h_k denoting the sequence. The equation is rewritten as $h_{k+1} = -a_k h_k$ for $k \geq 0$ with $h_0 = y_0$. The first few iterations are

$$h_1 = -a_0 h_0 = -a_0 y_0, \qquad h_2 = -a_1 h_1 = a_1 a_0 y_0, \qquad h_3 = -a_2 h_2 = -a_2 a_1 a_0 y_0$$

The observed pattern of terms leads to

$$h_k = \left(\prod_{i=0}^{k-1} (-a_i) \right) y_0, \quad k \geq 0 \tag{D.6}$$

where the "capital pi" symbol (Π) denotes a product of terms, analogous to "capital sigma" (Σ) denoting a sum of terms. The convention for products is $\prod_{i=\ell}^{u} T_i = 1$ whenever $u < \ell$. A similar convention for sums is $\sum_{i=\ell}^{u} T_i = 0$ whenever $u < \ell$.

A *particular solution* is a sequence p_k such that $p_{k+1} + a_k p_k = b_k$ for $k \geq 0$, but with initial value $p_0 = 0$. This equation can also be solved by iterating and observing the pattern:

$$p_1 = b_0 - a_0 p_0 = b_0, \qquad p_2 = b_1 - a_1 p_1 = b_1 - a_1 b_0,$$

$$p_3 = b_2 - a_2 p_2 = b_2 - a_2 b_1 + a_2 a_1 b_0$$

The observed pattern of terms leads to

$$p_k = \sum_{i=1}^{k} \left(\prod_{j=i}^{k-1} (-a_j) \right) b_i, \quad k \geq 0 \tag{D.7}$$

The *general solution* to equation (D.5) is the sum of the homogeneous solution (D.6) and particular solution (D.7):

$$y_k = h_k + p_k, \quad k \geq 0 \tag{D.8}$$

D.2.2 SECOND-ORDER LINEAR EQUATIONS

The second-order linear equation is

$$y_{k+2} + a_k y_{k+1} + b_k y_k = c_k, \quad k \geq 0 \tag{D.9}$$

where y_0 and y_1 are known initial values. The coefficient sequences a_k, b_k, and c_k are known quantities. Establishing a pattern for the solution by writing down the first few iterates is difficult at best, although it can be done as we will see in the section on systems of equations.

For now, let us take a look at the homogeneous equation where $c_k = 0$ for all k. The homogeneous solution h_k can be written as two other solutions u_k and v_k, where the second sequence is not a constant multiplied by the first. In this sense the sequences u_k and v_k are linearly independent. Any linear combination of the sequences is also a homogeneous solution, so $h_k = \alpha u_k + \beta v_k$, where α and β are chosen so that $y_0 = h_0 = \alpha u_0 + \beta v_0$ and $y_1 = h_1 = \alpha u_1 + \beta v_1$.

Define $\Delta_k = u_k v_{k+1} - u_{k+1} v_k$. This quantity is analogous to the *Wronskian* of two linearly independent solutions to a second-order linear differential equation. The initial value is $\Delta_0 = u_0 v_1 - u_1 v_0$. We know that $u_{k+2} + a_k u_{k+1} + b_k u_k = 0$ and $v_{k+2} + a_k v_{k+1} + b_k v_k = 0$. Multiplying the first equation by v_{k+1}, the second equation by u_{k+1}, and subtracting produces

$$0 = (u_{k+2}v_{k+1} - u_{k+1}v_{k+2}) + b_k(u_k v_{k+1} - u_{k+1}v_k) = -\Delta_{k+1} + b_k \Delta_k$$

which is a first-order equation whose solution is

$$\Delta_k = \prod_{i=0}^{k-1} b_k, \quad k \geq 1, \quad \Delta_0 = u_0 v_1 - u_1 v_0$$

If we happen to know in advance the solution u_k, we can determine v_k from the first-order equation in the v-terms:

$$u_k v_{k+1} - u_{k+1} v_k = \prod_{i=0}^{k-1} b_k$$

Another method for obtaining one homogeneous solution from another is *reduction of order*. If u_k is a known homogeneous solution, we attempt a solution of the form $v_k = \lambda_k u_k$. Replacing this in the homogeneous equation yields

$$0 = v_{k+2} + a_k v_{k+1} + b_k v_k$$
$$= \lambda_{k+2} u_{k+2} + a_k \lambda_{k+1} u_{k+1} + b_k \lambda_k u_k$$
$$= \lambda_{k+2} u_{k+2} + \lambda_{k+1}(-u_{k+2} - b_k u_k) + b_k \lambda_k u_k$$
$$= u_{k+2}(\lambda_{k+2} - \lambda_{k+1}) - b_k u_k(\lambda_{k+1} - \lambda_k)$$
$$= u_{k+2} D_{k+1} - b_k u_k D_k$$

where $D_k = \lambda_{k+1} - \lambda_k$. The term D_k satisfies a first-order linear equation that we know how to solve,

$$\lambda_{k+1} - \lambda_k = D_k = \prod_{i=0}^{k-1} \frac{b_i u_i}{u_{i+2}}$$

Summing over k and canceling all the common terms on the left,

$$\lambda_n - \lambda_0 = \sum_{k=0}^{n-1} \prod_{i=0}^{k-1} \frac{b_i u_i}{u_{i+2}}$$

The value λ_0 is chosen so that the solutions u_k and v_k are linearly independent.

Now let us try to construct a particular solution p_k whose initial values are $p_0 = p_1 = 0$. The method shown here is analogous to the *variation of parameters* that is used for second-order linear differential equations. Let u_k and v_k be linearly independent solutions to the homogeneous equation. Assume that a particular solution is of the form $p_k = d_k u_k + e_k v_k$. The initial values for p_k require $d_0 = d_1 = e_0 = e_1 = 0$. Replacing this in equation (D.9) yields

$$
\begin{aligned}
c_k &= p_{k+2} + a_k p_{k+1} + b_k p_k \\
&= (d_{k+2} u_{k+2} + e_{k+2} v_{k+2}) + a_k (d_{k+1} u_{k+1} + e_{k+1} v_{k+1}) + b_k (d_k u_k + e_k v_k) \\
&= (d_{k+2} u_{k+2} + e_{k+2} v_{k+2}) - d_{k+1}(u_{k+2} + b_k u_k) - e_{k+1}(v_{k+2} + b_k v_k) \\
&\quad + b_k (d_k u_k + e_k v_k) \\
&= [u_{k+2}(d_{k+2} - d_{k+1}) + v_{k+2}(e_{k+2} - e_{k+1})] - b_k [u_k(d_{k+1} - d_k) + v_k(e_{k+1} - e_k)]
\end{aligned}
$$

As in the variation of parameters for ordinary differential equations, an arbitrary equation may be selected to relate the parameters d_k and e_k. The simplest is to require $u_k(d_{k+1} - d_k) + v_k(e_{k+1} - e_k) = 0$. The previously displayed equation reduces to $u_{k+2}(d_{k+2} - d_{k+1}) + v_{k+2}(e_{k+2} - e_{k+1}) = 0$. Incrementing the index k by 1 in the arbitrary equation and defining $D_k = d_{k+2} - d_{k+1}$ and $E_k = e_{k+2} - e_{k+1}$, the two equations are written as the system

$$
\begin{bmatrix} u_{k+1} & v_{k+1} \\ u_{k+2} & v_{k+2} \end{bmatrix} \begin{bmatrix} D_k \\ E_k \end{bmatrix} = \begin{bmatrix} 0 \\ c_k \end{bmatrix}, \quad k \ge 0
$$

The solution follows, where $\Delta_k = u_k v_{k+1} - u_{k+1} v_k$:

$$
\begin{bmatrix} d_{k+2} - d_{k+1} \\ e_{k+2} - e_{k+1} \end{bmatrix} = \begin{bmatrix} D_k \\ E_k \end{bmatrix} = \frac{1}{\Delta_{k+1}} \begin{bmatrix} -c_k v_{k+1} \\ c_k u_{k+1} \end{bmatrix}
$$

Summing over k, canceling all the common terms on the left, and using $d_1 = e_1 = 0$, we obtain

$$
d_k = -\sum_{i=0}^{k-2} \frac{c_i v_{i+1}}{\Delta_{i+1}}, \qquad e_k = \sum_{i=0}^{k-2} \frac{c_i u_{i+1}}{\Delta_{i+1}}
$$

and

$$
p_k = \sum_{i=0}^{k-2} \frac{c_i (u_i v_k - u_k v_i)}{u_i v_{i+1} - u_{i+1} v_i}, \qquad k \ge 2, \quad p_0 = p_1 = 0 \tag{D.10}
$$

D.3 CONSTANT-COEFFICIENT EQUATIONS

For the general linear difference equation, obtaining closed-form homogeneous solutions can be difficult, if not impossible. A special class of linear equations includes those whose coefficient sequences are all constants:

$$y_{k+n} + a_{n-1}y_{k+n-1} + \cdots + a_1 y_{k+1} + a_0 y_k = 0 \qquad \text{(D.11)}$$

where the a_j are constant and $a_0 \neq 0$. We attempt a solution of the form $y_k = r^k$, where $r \neq 0$ is a constant. Replacing this in equation (D.11) and dividing by r^k leads to

$$r^n + a_{n-1}r^{n-1} + \cdots + a_1 r + a_0 = 0$$

This is a polynomial equation, say, $p(r) = 0$, whose roots may be found in closed form for $1 \leq n \leq 4$ or by numerical root finding for any n.

Let r_1 through r_ℓ be the distinct roots of $p(r)$. Let each root r_j have multiplicity m_j. That is, the polynomial is factored into

$$p(r) = \prod_{j=1}^{\ell} (r - r_j)^{m_j}$$

Necessarily, $n = \sum_{j=1}^{\ell} m_j$. If r is a real-valued root with multiplicity m, then by the construction, r^k is a solution to the difference equation. However, there are m linearly independent solutions to the difference equation corresponding to r:

$$r^k, \, kr^k, \, k^2 r^k, \, \ldots, \, k^{m-1} r^k$$

If r is a complex-valued root with a nonzero imaginary part, say, $r = \alpha + \beta i$ with $\beta \neq 0$, and if r has multiplicity m, then the conjugate \bar{r} is also a root with multiplicity m. There are $2m$ linearly independent solutions corresponding to r and \bar{r}. In complex-valued form, these are

$$r^k, \, kr^k, \, \ldots, \, k^{m-1}r^k; \bar{r}^k, \, k\bar{r}^k, \, \ldots, \, k^{m-1}\bar{r}^k$$

Using the polar representation $r = \rho(\cos\theta + i \sin\theta)$, the real-valued form for the solutions are generated from $k^t r^k$ and $k^t \bar{r}^j$ by taking combinations $k^t (r^k + \bar{r}^k)/2$ and $k^t (r^k - \bar{r}^k)/(2i)$. These are

$$k^t \rho^k \cos(k\theta), \qquad k^t \rho^k \sin(k\theta), \quad 0 \leq t \leq m - 1$$

When a root r has multiplicity $m > 1$, the question is how did we arrive at the solutions $k^t r^k$ for $t > 0$? The answer is variation of parameters, a method discussed

in Section D.2.2. As an example, consider the fourth-order equation

$$y_{k+4} - 3y_{k+3} - 6y_{k+2} + 28y_{k+1} - 24 = 0$$

The polynomial equation obtained by trying a solution $y_k = r^k$ is $p(r) = r^4 - 3r^3 - 6r^2 + 28r - 24 = 0$. The polynomial factors into $p(r) = (r-2)^3(r+3)$. The root $r = 2$ has multiplicity 3, and the root $r = -3$ has multiplicity 1. Two linearly independent solutions to the difference equation are $y_k = 2^k$ and $y_k = (-3)^k$. Since $r = 2$ has multiplicity larger than 1, attempt a reduction by $y_k = a_k 2^k$ for some sequence a_k. Replacing this in the difference equation yields

$$\begin{aligned}
0 &= y_{k+4} - 3y_{k+3} - 6y_{k+2} + 28y_{k+1} - 24 \\
&= a_{k+4} 2^{k+4} - 3a_{k+3} 2^{k+3} - 6a_{k+2} 2^{k+2} + 28a_{k+1} 2^{k+1} - 24a_k 2^k \\
&= 8 \cdot 2^k (2a_{k+4} - 3a_{k+3} - 3a_{k+2} + 7a_{k+1} - 3a_k)
\end{aligned}$$

Consequently, the a_k satisfy yet another fourth-order constant-coefficient equation:

$$2a_{k+4} - 3a_{k+3} - 3a_{k+2} + 7a_{k+1} - 3a_k = 0$$

An important observation is that the sum of the coefficients is zero. This allows the following reduction:

$$\begin{aligned}
0 &= 2a_{k+4} - 3a_{k+3} - 3a_{k+2} + 7a_{k+1} - 3a_k \\
&= 2(a_{k+4} - a_{k+3}) - a_{k+3} - 3a_{k+2} + 7a_{k+1} - 3a_k \\
&= 2(a_{k+4} - a_{k+3}) - (a_{k+3} - a_{k+2}) - 4a_{k+2} + 7a_{k+1} - 3a_k \\
&= 2(a_{k+4} - a_{k+3}) - (a_{k+3} - a_{k+2}) - 4(a_{k+2} - a_{k+1}) + 3a_{k+1} - 3a_k \\
&= 2(a_{k+4} - a_{k+3}) - (a_{k+3} - a_{k+2}) - 4(a_{k+2} - a_{k+1}) + 3(a_{k+1} - a_k)
\end{aligned}$$

Define $b_k = a_{k+1} - a_k$. The previous equation is restated as

$$2b_{k+3} - b_{k+2} - 4b_{k+1} + 3b_k = 0$$

This is a third-order equation, a reduction in order by one from the original equation. The sum of the coefficients in this equation is also zero, allowing yet another reduction:

$$\begin{aligned}
0 &= 2b_{k+3} - b_{k+2} - 4b_{k+1} + 3b_k \\
&= 2(b_{k+3} - b_{k+2}) + b_{k+2} - 4b_{k+1} + 3b_k \\
&= 2(b_{k+3} - b_{k+2}) + (b_{k+2} - b_{k+1}) - 3b_{k+1} + 3b_k \\
&= 2(b_{k+3} - b_{k+2}) + (b_{k+2} - b_{k+1}) - 3(b_{k+1} - b_k)
\end{aligned}$$

Define $c_k = b_{k+1} - b_k$. The previous equation is restated as

$$2c_{k+2} + c_{k+1} - 3c_k = 0$$

The order has been reduced by one again. The sum of the coefficients in this equation is zero, allowing yet one more reduction:

$$0 = 2c_{k+2} + c_{k+1} - 3c_k$$
$$= 2(c_{k+2} - c_{k+1}) + 3(c_{k+1} - c_k)$$

Define $d_k = c_{k+1} - c_k$. The previous equation is restated as

$$2d_{k+1} + 3d_k = 0$$

The general solution is $d_k = d_0(-3/2)^k$, but as it turns out, we need consider only the instance when $d_0 = 0$, in which case $d_k = 0$ for all k. Backtracking, we now know that $c_{k+1} - c_k = d_k = 0$. The c_k must be constant, so choose $c_k = c_0 \neq 0$ for all k. Backtracking again, $b_{k+1} - b_k = c_k = c_0$. Summing over k and canceling terms leads to $b_k = b_0 + \sum_{i=0}^{k-1} c_0 = b_0 + c_0 k$. Backtracking for the last time, $a_{k+1} - a_k = b_k = b_0 + c_0 k$. Summing over k and canceling terms leads to

$$a_k = a_0 + \sum_{i=0}^{k-1}(b_0 + c_0 i) = a_0 + b_0 k + c_0(k-1)k/2 = \alpha + \beta k + \gamma k^2$$

for appropriately selected values α, β, and γ. The choice of $\alpha = 1$ and $\beta = \gamma = 0$ leads to $a_k = 1$ and the already known solution 2^k. The choice of $\beta = 1$ and $\alpha = \gamma = 0$ leads to $a_k = k$ and a new solution $k2^k$. The choice of $\gamma = 1$ and $\alpha = \beta = 0$ leads to $a_k = k^2$ and a new solution $k^2 2^k$.

D.4 SYSTEMS OF EQUATIONS

Equation (D.1) provides a relationship between the terms of a single sequence. Some applications might involve multiple sequences that are interrelated. For example, two sequences $\{x_k\}_{k=0}^{\infty}$ and $\{x_k\}_{k=0}^{\infty}$ might be interrelated by

$$x_{k+n} = f_0(k, x_k, \ldots, x_{k+n-1}, y_k, \ldots, y_{k+n-1})$$
$$y_{k+n} = f_1(k, x_k, \ldots, x_{k+n-1}, y_k, \ldots, y_{k+n-1})$$

for some $n > 0$, for all $k \geq 0$, and for some specified functions f_0 and f_1. The initial values are x_0 through x_{n-1} and y_0 through y_{n-1}. The pair of equations is evaluated to obtain the next terms x_n and y_n, which in turn can be used to generate subsequent

terms. The pair of relationships is an example of a *system of difference equations*. The system in the example can be written in vector form. Define:

$$\mathbf{u}_k = \begin{bmatrix} x_k \\ y_k \end{bmatrix} \quad \text{and}$$

$$\mathbf{f}(k, (s_0, t_0), \ldots, (s_{n-1}, t_{n-1})) = \begin{bmatrix} f_0(k, s_0, \ldots, s_{n-1}, t_0, \ldots, t_{n-1}) \\ f_1(k, s_0, \ldots, s_{n-1}, t_0, \ldots, t_{n-1}) \end{bmatrix}$$

In terms of these quantities, the system is

$$\mathbf{u}_{k+n} = \mathbf{f}(k, \mathbf{u}_k, \ldots, \mathbf{u}_{k+n-1}), \quad k \geq 0$$

with initial values \mathbf{u}_0 through \mathbf{u}_{n-1}. Systems may contain explicit equations (as in our example), implicit equations, or a mixture of both.

A convenient use for a system of equations is in solving the nth-order linear equation (D.4). Define the vector sequence:

$$\mathbf{u}_k = \begin{bmatrix} u_k^{(0)} \\ u_k^{(1)} \\ \vdots \\ u_k^{(n-1)} \end{bmatrix} = \begin{bmatrix} y_k \\ y_{k+1} \\ \vdots \\ y_{k+n-1} \end{bmatrix}$$

Increasing the index by 1,

$$\mathbf{u}_{k+1} = \begin{bmatrix} y_{k+1} \\ y_{k+2} \\ \vdots \\ y_{k+n} \end{bmatrix} = \begin{bmatrix} y_{k+1} \\ y_{k+2} \\ \vdots \\ b_k - a_k^{(n-1)} y_{k+n-1} - \cdots - a_k^{(0)} y_k \end{bmatrix}$$

$$= \begin{bmatrix} u_k^{(1)} \\ u_k^{(2)} \\ \vdots \\ b_k - a_k^{(n-1)} u_k^{(n-1)} - \cdots - a_k^{(0)} u_k^{(0)} \end{bmatrix}$$

In matrix form, the system is

$$\mathbf{u}_{k+1} + A_k \mathbf{u}_k = \mathbf{B}_k, \quad k \geq 0 \tag{D.12}$$

where \mathbf{u}_0 is a known quantity and where A_k is an $n \times n$ matrix and \mathbf{B}_k is an $n \times 1$ vector given by

$$
A_k = \begin{bmatrix}
0 & 1 & 0 & \cdots & 0 \\
0 & 0 & 1 & \cdots & 0 \\
\vdots & \vdots & \vdots & \ddots & \vdots \\
0 & 0 & 0 & \cdots & 1 \\
a_k^{(0)} & a_k^{(1)} & a_k^{(2)} & \cdots & a_k^{(n-1)}
\end{bmatrix}
\quad \text{and} \quad
\mathbf{B}_k = \begin{bmatrix}
0 \\
0 \\
\vdots \\
b_k
\end{bmatrix}
$$

Equation (D.12) has exactly the form of equation (D.5) and can be solved symbolically in the same way. The homogeneous solution is

$$
\mathbf{h}_k = \left(\prod_{i=0}^{k-1} (-A_i) \right) \mathbf{u}_0, \quad k \geq 0 \tag{D.13}
$$

The particular solution is

$$
\mathbf{p}_k = \sum_{i=1}^{k} \left(\prod_{j=i}^{k-1} (-A_j) \right) \mathbf{B}_i, \quad k \geq 0 \tag{D.14}
$$

The general solution to equation (D.12) is the sum of the homogeneous solution (D.13) and particular solution (D.14):

$$
\mathbf{u}_k = \mathbf{h}_k + \mathbf{p}_k, \quad k \geq 0 \tag{D.15}
$$

BIBLIOGRAPHY

[Arv91] James Arvo, editor. *Graphics Gems II*. Academic Press, San Diego, CA, 1991.

[AS65] Milton Abramowitz and Irene A. Stegun. *Handbook of Mathematical Functions with Formulas, Graphs, and Mathematical Tables*. Dover, New York, 1965.

[Bar94] David Baraff. Fast contact force computation for nonpenetrating rigid bodies. *Proceedings of SIGGRAPH 1994*, 1994, pp. 23–34.

[Bar01] David Baraff. Physically based modeling: Rigid body simulation. *www.pixar .com/companyinfo/research/pbm2001/notesg.pdf*, 2001, (68 pages).

[Barr84] A. Barr. Global and local deformations of solid primitives. *Proceedings of SIGGRAPH 1984*, 1984, pp. 21–30.

[BF01] Richard L. Burden and J. Douglas Faires. *Numerical Analysis*, 7th ed. Brooks/ Cole, Belmont, CA, 2001.

[Bra84] Martin Braun. *Differential Equations and Their Applications, Applied Mathematical Sciences*. Springer-Verlag, Heidelberg, Germany, 1984, vol. 15.

[BS64] R. Bulirsch and J. Stoer. Fehlerabschätzungen und extrapolation mit rationalen Funktionen bei Verfahren von Richardson-typus. *Numerische Mathematik*, 6:413–427, 1964.

[BS66] R. Bulirsch and J. Stoer. Numerical treatment of ordinary differential equations by extrapolation methods. *Numerische Mathematik*, 8:1–13, 1966.

[BS99] Matthias Buck and Elmar Schömer. Interactive rigid body manipulation with obstacle contacts. *www.mpi-sb.mpg.de/~schoemer/publications/JVCA98.pdf*, 1999.

[Cam97] S. Cameron. Enhancing GJK: Computing minimum and penetration distances between convex polyhedra. *Proceedings of the IEEE Conference on Robotics and Automation*, 1997, pp. 591–596.

[CLMP95] J. Cohen, M. Lin, D. Manocha, and K. Ponamgi. I-COLLIDE: An interactive and exact collision detection system for large-scaled environments. *Proceedings of ACM International 3D Graphics Conference*, 1995, pp. 189–196.

[CLR90] Thomas H. Cormen, Charles E. Leiserson, and Ronald L. Rivest. *Introduction to Algorithms*. MIT Press, Cambridge, MA, 1990.

[Coq90] S. Coquillart. Extended free form deformation: A sculpturing tool for 3D geometric design. *Proceedings of SIGGRAPH 1990*, 1990, pp. 187–193.

[CRE01] Elaine Cohen, Richard F. Riesenfeld, and Gershon Elber. *Geometric Modeling with Splines: An Introduction*. A. K. Peters, Natick, MA, 2001.

[CW96] K. Chung and W. Wang. Quick collision detection of polytopes in virtual environments. *Proceedings of ACM Symposium on Virtual Reality Software and Technology*, 1996, pp. 125–131.

[Dan63] G. B. Dantzig. *Linear Programming and Extensions*. Princeton University Press, Princeton, NJ, 1963.

[DK90] D. P. Dobkin and D. G. Kirkpatrick. Determining the separation of preprocessed polyhedra—a unified approach. In *Proceedings of the 17th International Colloquium on Automata, Languages, and Programming (ICALP), Lecture Notes in Computer Science*. Springer-Verlag, Heidelberg, Germany, vol. 443, 1990, pp. 400–413.

[DKL98] Erik B. Dam, Martin Koch, and Martin Lillholm. Quaternions, animation and interpolation. *http://citeseer.nj.nec.com/dam98quaternions.html*, 1998, (103 pages).

[DZ91] Michael J. Dehaemer and Michael J. Zyda. Simplification of objects rendered by polygonal approximations. *Computer & Graphics*, 15(2):175–184, 1991.

[Ebe00] David H. Eberly. *3D Game Engine Design*. Morgan Kaufmann, San Francisco, CA, 2000.

[Ede87] H. Edelsbrunner. *Algorithms in Computational Geometry*. Springer-Verlag, Heidelberg, Germany, 1987.

[EL00] S. Ehmann and M. C. Lin. Accelerated proximity queries between convex polyhedra using multi-level Voronoi marching. *Proceedings of IEEE/RSJ International Conference on Intelligent Robots and Systems*, 2000, p. 7.

[EL01] S. Ehmann and M. C. Lin. Accurate and fast proximity queries between polyhedra using surface decomposition. In *Computer Graphics Forum (Proceedings of Eurographics 2001)*, 2001, p. 11.

[EM85] H. Edelsbrunner and H. A. Maurer. Finding extreme points in three dimensions and solving the post-office problem in the plane. *Information Processing Letters*, 21:39–47, 1985.

[EMP⁺03] David S. Ebert, F. Kenton Musgrave, Darwyn Peachey, Ken Perlin, and Steve Worley. *Texturing and Modeling: A Procedural Approach*, 3rd ed. Morgan Kaufmann, San Francisco, CA, 2003.

[Eng02] Wolfgang F. Engel. *ShaderX: Vertex and Pixel Shader Tips and Tricks*. Wordware, Plano, TX, 2002.

[Eriar] Christer Ericson. *Real Time Collision Detection*. Morgan Kaufmann, San Francisco, CA, forthcoming.

[Far90] Gerald Farin. *Curves and Surfaces for Computer Aided Geometric Design: A Practical Guide*. Academic Press, San Diego, CA, 1990.

[Far99] Gerald Farin. *NURBS: From Projective Geometry to Practical Use*. A. K. Peters, Natick, MA, 1999.

[Fau96] François Faure. An energy-based approach for contact force computation. In *Computer Graphics Forum (Proceedings of Eurographics 1996)*, vol. 16, 1996, pp. 357–366.

[Fri98] Joel Friedman. Linear complementarity and mathematical (non-linear) programming. *www.math.ubc.ca/~jf/courses/340/pap.pdf*, April 1998, (22 pages).

[GAM03] GAMMA, or Geometric Algorithms for Modeling, Motion, and Animation), University of North Carolina. *www.cs.unc.edu/~geom*, 2003.

[Gea71] C. W. Gear. *Numerical Initial-Value Problems in Ordinary Differential Equations*. Prentice Hall, Englewood Cliffs, NJ, 1971.

[GH97] Michael Garland and Paul Heckbert. Surface simplification using quadric error metrics. *Proceedings of SIGGRAPH 1997*, 1997, pp. 209–216.

[GJK88] E. G. Gilbert, D. W. Johnson, and S. S. Keerthi. A fast procedure for computing the distance between complex objects in three-dimensional space. *IEEE Journal of Robotics and Automation*, 4(2):193–203, 1988.

[GLM96] Stefan Gottschalk, Ming Lin, and Dinesh Manocha. OBBtree: A hierarchical structure for rapid interference detection. *Proceedings of SIGGRAPH 1996*, 1996, pages 171–180.

[GP89] J. Griessmair and W. Purgathofer. Deformation of solids with trivariate B-splines. In *Proceedings of Eurographics 1989*, 1989, pp. 134–148.

[GPS02] Herbert Goldstein, Charles Poole, and John Safko. *Classical Mechanics*, 3rd ed. Addison-Wesley, San Francisco, CA, 2002.

[Gra65] W. B. Gragg. On extrapolation algorithms for ordinary initial-value problems. *SIAM Journal on Numerical Analysis*, 2:384–403, 1965.

[GV91] G. Vanecek, Jr. Brep-index: A multi-dimensional space partitioning tree. In *ACM/SIGGRAPH Symposium on Solid Modeling Foundations and CAD Applications*, 1991, pp. 35–44.

[HDD+93] Hugues Hoppe, Tony DeRose, Tom Duchamp, John McDonald, and Werner Stuetzle. Mesh optimization. *Proceedings of SIGGRAPH 1993*, 1993, pp. 19–26.

[Hec98] Chris Hecker. Rigid body dynamics. *www.d6.com/users/checker/dynamics .htm*, 1998.

[HJ85] Roger A. Horn and Charles R. Johnson. *Matrix Analysis*. Cambridge University Press, Cambridge, England, 1985.

[HKL+99] G. Hotz, A. Kerzmann, C. Lennerz, R. Schmid, E. Schmer, and T. Warken. Calculation of contact forces. In *Proceedings of the ACM Symposium on Virtual Reality Software and Technology*, 1999, pp. 180–181.

[HLC+97] T. Hudson, M. Lin, J. Cohen, S. Gottschalk, and D. Manocha. V-COLLIDE: Accelerated collision detection for VRML. *Proceedings of VRML 1997*, 1997, p. 7.

[HML99] Gentaro Hirota, Renee Maheshwari, and Ming C. Lin. Fast volume-preserving free form deformation using multi-level optimization. *ACM Solid Modeling 1999*, 1999, pp. 234–245.

[HOS99] D. J. Hardy, D. I. Okunbor, and R. D. Skeel. Symplectic variable stepsize integration for N-body problems. *Applied Numerical Mathematics*, 29:19–30, 1999.

[HS74] Morris W. Hirsch and Stephen Smale. *Differential Equations, Dynamical Systems, and Linear Algebra*. Academic Press, San Diego, CA, 1974.

[Hub96] P. M. Hubbard. Approximating polyhedra with spheres for time-critical collision detection. *ACM Transactions on Graphics*, 15(3):179–210, 1996.

[IZLM01] Kenneth E. Hoff III, Andrew Zaferakis, Ming Lin, and Dinesh Manocha. Fast and simple 2D geometric proximity queries using graphics hardware. *Proceedings of ACM Symposium on Interactive 3D Graphics*, 2001.

[IZLM02] Kenneth E. Hoff III, Andrew Zaferakis, Ming Lin, and Dinesh Manocha. Fast 3D geometric proximity queries between rigid and deformable models using graphics hardware acceleration. Technical Report TR02-004, Department of Computer Science, University of North Carolina, 2002.

[Jak01] Thomas Jakobsen. Advanced character physics. In *Game Developers Conference Proceedings 2001*, CMP Media, Inc., San Francisco, CA, 2001, pp. 383–401.

[Kir83] D. G. Kirkpatrick. Optimal search in planar subdivisions. *SIAM Journal on Computing*, 12:28–35, 1983.

[KKS96] Myoung-Jun Kim, Myung-Soo Kim, and Sung Yong Shin. A compact differential formula for the first derivative of a unit quaternion curve. *The Journal of Visualization and Computer Animation*, 7(1):43–58, 1996.

[KLM02] Young J. Kim, Ming C. Lin, and Dinesh Manocha. DEEP: Dual-space expansion for estimating penetration depth between convex polytopes. *Proceedings of the IEEE International Conference on Robotics and Automation*, 2002, p. 6.

[Kui99] Jack B. Kuipers. *Quaternions and Rotation Sequences: A Primer with Applications to Orbits, Aerospace, and Virtual Reality*. Princeton University Press, Princeton, NJ, 1999.

[LC87] William E. Lorensen and Harvey Cline. Marching cubes: A high resolution 3D surface construction algorithm. *Proceedings of SIGGRAPH 1987*, 1987, pp. 163–169.

[LC91] Ming C. Lin and John F. Canny. A fast algorithm for incremental distance calculation. In *Proceedings of IEEE International Conference on Robotics and Automation*, 1991, pp. 1008–1014.

[Lev00] Ron Levine. Collision of moving objects. On the game developer algorithms list. *www.sourceforce.net*, November 2000.

[LGLM99] Eric Larsen, Stefan Gottschalk, Ming C. Lin, and Dinesh Manocha. Fast proximity queries with swept sphere volumes. Technical Report TR99-018, Department of Computer Science, University of North Carolina, 1999.

[Lin93] Ming C. Lin. *Efficient Collision Detection for Animation and Robotics*. Doctoral dissertation, University of California at Berkeley, Berkeley, California, 1993.

[Mir96a] Brian Mirtich. Fast and accurate computation of polyhedral mass properties. *Journal of Graphics Tools*, 1(2):31–50, 1996.

[Mir96b] Brian Mirtich. *Impulse-Based Dynamic Simulation of Rigid Body Systems*. Doctoral dissertation, University of California at Berkeley, Berkeley, California, 1996.

[Mir98] Brian Mirtich. V-Clip: Fast and robust polyhedral collision detection. *ACM Transactions on Graphics*, 17(3):177–208, 1998.

[OHHM02] Marc Olano, John C. Hart, Wolfgang Heidrich, and Michael McCool. *Real-Time Shading*. A. K. Peters, Natick, MA, 2002.

[O'R98] Joseph O'Rourke. *Computational Geometry in C*, 2nd ed. Cambridge University Press, Cambridge, England, 1998.

[PFTV88] W. H. Press, B. P. Flannery, S. A. Teukolsky, and W. T. Vetterling. *Numerical Recipes in C: The Art of Scientific Computing*. Cambridge University Press, Cambridge, England, 1988.

[PS85] Franco P. Preparata and Michael I. Shamos. *Computational Geometry: An Introduction*. Springer-Verlag, Heidelberg, Germany, 1985.

[PSC92] Richard W. Cottle, Jong-Shi Pang, and Richard E. Stone. *The Linear Complementarity Problem*. Academic Press, San Diego, CA, 1992.

[RG27] L. F. Richardson and J. A. Gaunt. The deferred approach to the limit. *Philosophical Transactions of the Royal Society of London*, 226A:299–361, 1927.

[Rho01] Graham S. Rhodes. Stable rigid-body physics. In *Game Developers Conference Proceedings 2001*, CMP Media, Inc., San Francisco, CA, 2001, pp. 651–669.

[RKC00] S. Redon, A. Kheddar, and S. Coquillart. An algebraic solution to the problem of collision detection for rigid polyhedral objects. In *Proceedings of IEEE International Conference on Robotics and Automation*, 2000, pp. 3733–3738.

[RKC01] S. Redon, A. Kheddar, and S. Coquillart. Contact: Arbitrary in-between motions for continuous collision detection. In *Proceedings of the 10th IEEE International Workshop on Robot-Human Interactive Communication*, 2001, p. 6.

[RKC02a] S. Redon, A. Kheddar, and S. Coquillart. Fast continuous collision detection between rigid bodies. In *Proceedings of Eurographics*, 2002, p. 9.

[RKC02b] S. Redon, A. Kheddar, and S. Coquillart. Gauss' least constraints principle and rigid body simulations. In *Proceedings of IEEE International Conference on Robotics and Automation*, 2002, p. 6.

[Rog01] David F. Rogers. *An Introduction to NURBS with Historical Perspective*. Morgan Kaufmann, San Francisco, CA, 2001.

[SE02] Philip J. Schneider and David H. Eberly. *Geometric Tools for Computer Graphics*. Morgan Kaufmann, San Francisco, CA, 2002.

[SP86] T. Sederberg and S. Parry. Free-form deformation of solid geometric models. *Proceedings of SIGGRAPH 1986*, 1986, pp. 151–160.

[SSW99] Elmar Schömer, Jürgen Sellen, and Markus Welsch. Exact geometric collision detection. *www.mpi-sb.mpg.de/~schoemer/publications/EGCD.pdf* , 1999.

[ST99] Elmar Schömer and Christian Tiel. Efficient collision detection for moving polyhedra. *www.mpi-sb.mpg.de/~schoemer/publications/ECDFMP.pdf* , 1999.

[Str88] Gilbert Strang. *Linear Algebra and Its Applications*, 3rd ed. International Thomson Publishing, 1988.

[SZL92] William J. Schroeder, Jonathan A. Zarge, and William E. Lorensen. Decimation of triangle meshes. *Proceedings of SIGGRAPH 1992*, 1992, pp. 65–70.

[Tur92] Greg Turk. Re-tiling of polygonal surfaces. *Proceedings of SIGGRAPH 1992*, 1992, pp. 55–64.

[vdB97] Gino van den Bergen. Efficient collision detection of complex deformable models using AABB trees. *Journal of Graphics Tools*, 2(4):1–13, 1997.

[vdB99] Gino van den Bergen. A fast and robust GJK implementation for collision detection of convex objects. *Journal of Graphics Tools*, 4(2):7–25, 1999.

[vdB01a] Gino van den Bergen. Physical behavior and resting contacts with friction. Post to the USENET newsgroup *comp.games.development.programming .algorithms*, August 2001.

[vdB01b] Gino van den Bergen. Proximity queries and penetration depth computation on 3D game objects. In *Proceedings of the Game Developers Conference 2001*, 2001, pp. 821–837.

[vdB03] Gino van den Bergen. *Collision Detection in Interactive 3D Environments*. Morgan Kaufmann, San Francisco, CA, 2003.

[Ver67] L. Verlet. Computer experiments on classical fluids. I. Thermodynamic properties of Lennard-Jones molecules. *Physical Review*, 159:98–103, 1967.

[Wel67] D. A. Wells. *Lagrangian Dynamics*. Schaum's Outline Series. McGraw-Hill, New York, 1967.

[WLML99] A. Wilson, E. Larsen, D. Manocha, and M. Lin. Partitioning and handling massive models for interactive collision detection. In *Computer Graphics Forum (Proceedings of Eurographics 1999)*, vol. 18, 1999, pp. 319–329.

[Wu00] David Wu. Penalty methods for contact resolution. *www.pseudointeractive .com/games/penaltymethods.ppt*, 2000.

INDEX

Dave Eberly is the president of Magic Software, Inc. (*www.magic-software.com*), a company known for its web site that offers free source code and documentation for computer graphics, image analysis, and numerical methods. Previously, he was the director of engineering at Numerical Design Limited, the company responsible for the real-time 3D game engine, NetImmerse. His background includes a B.A. degree in mathematics from Bloomsburg University, M.S. and Ph.D. degrees in mathematics from the University of Colorado at Boulder, and M.S. and Ph.D. degrees in computer science from the University of North Carolina at Chapel Hill. He is author of *3D Game Engine Design* (2001) and coauthor with Philip Schneider of *Geometric Tools for Computer Graphics* (2003), both published by Morgan Kaufmann.

As a mathematician, Dave did research in the mathematics of combustion, signal and image processing, and length-biased distributions in statistics. He was an associate professor at the University of Texas at San Antonio with an adjunct appointment in radiology at the U.T. Health Science Center at San Antonio. In 1991 he gave up his tenured position to re-train in computer science at the University of North Carolina. After graduating in 1994, he remained for one year as a research associate professor in computer science with a joint appointment in the Department of Neurosurgery, working in medical image analysis. His next stop was the SAS Institute, working for a year on SAS/Insight, a statistical graphics package. Finally, deciding that computer graphics and geometry were his real calling, Dave went to work for Numerical Design Limited, then later to Magic Software, Inc. Dave's participation in the newsgroup *comp.graphics.algorithms* and his desire to make 3D graphics technology available to all are what has led to the creation of his company's web site and this book.

Ken Shoemake first caught the attention of the computer graphics community by using unit quaternions and spherical curves to animate rotation. Trained in computer science and mathematics at Yale, Stanford, and the University of Pennsylvania, he supplemented his formal education with experience in compilers, digital music, flight graphics, video, and user interfaces in a career spanning CCRMA, Link, Ampex, PDI, and Xerox PARC. Beyond his quaternion papers, he has also taught mathematics to SIGGRAPH audiences. Ken now consults, and he still enjoys research bringing together abstract mathematics and practical tasks.

APPLICATIONS DIRECTORY

The directory has two important subdirectories, `Application2` that contains a 2D-application layer and `Application3` that contains a 3D-application layer. The application layer is an abstract API. Each platform of interest implements this (DirectX, GLUT, Wgl, Agl). The other subdirectories are

GRAPHICS. Illustrations of the real-time graphics engine. Bézier surface tessellation, bump maps, camera and light nodes, environment maps, gloss maps, intersection of cylinders (uses bounding volume hierarchy), inverse kinematics, light maps, morphing face, particle system, point system, polygon offset (to avoid z-buffer fighting), polylines, portals, projected textures, skinned and animated biped, specular lighting after texturing is applied, terrain (uses continuous level of detail), illustration of combine modes for texturing.

IMAGICS. Illustrations of some basic image analysis. Binary operations on 2D images, extraction of level curves from 2D images, extraction of level surfaces from 3D images (two different algorithms), image tessellation based on continuous level of detail.

MISCELLANEOUS. Reduction of control points for B-spline curves using least-squares methods. Continuous level of detail for polylines. Ray trace implicit surfaces. Dynamic intersection of circle and rectangle. TCB keyframe animation. Perspective mapping of a texture onto a quadrilateral. Perspective and bilear mappings between quadrilaterals. Perspective projection of convex polyhedron (useful for shadow calculations and occlusion culling). Tessellation of a sphere. Dynamic intersection of two triangles.

PHYSICS. Applications, examples, and exercises that come directly out of this book. Ball rolling down frictionless hill. Bouncing ball (deformation of implicit surfaces). B-spline curves for deformation. Cloth flapping in a breeze. Flowing skirt subject to gravity and wind (generalized cylinder surface). Foucault pendulum. Freeform deformation using B-spline volumes. Gelatin blob (arbitrary mass-spring system with energy dissipation). Gelatin cube (3D array mass-spring system with energy dissipation). Fly-through of tube surface. Mass-pulley-spring system. NURBS curves for deformation. Distance between convex polygons or between convex polyhedra using LCP methods. Rope blowing in a breeze. Spinning top. Water drop formation using deformable NURBS surfaces of revolution. Wriggling snake (deformable tube surface with B-spline medial curve).

SHADERS. Applications that are based on vertex and/or pixel shaders. A basic example illustrating a vertex shader and a pixel shader. Shading with a charcoal appearance. Fresnel reflectance. Iridescence. Refraction and reflection. Rippling ocean waves (mixture of vertex shaders to handle the physics and pixel shaders for specular effects). Skin and bones animation. Deformation by vertex displacement.